The Book of
Enlightened Masters

The Book of Enlightened Masters

Western Teachers in Eastern Traditions

ANDREW RAWLINSON

OPEN COURT

Chicago and La Salle, Illinois

The following people are featured on the cover: *left to right, top row:* Michael **Barnett**, Andrew **Cohen**, Murshida Ivy **Duce**; *middle row:* Ayya **Khema**, Jetsunma **Ahkon Norbu Lhamo**, Lee **Lozowick**; *bottom row:* Swami **Radha**, Roshi Issan **Dorsey**, Urgyen **Sangharakshita.** All those who are presently alive gave permission for their photos to be used, so my thanks to them. Otherwise, my thanks to Morgan Alexander (Issan **Dorsey**), Sufism Reoriented (Murshida **Duce**), and Yasodhara Ashram (Swami **Radha**).

Library of Congress Cataloging-in-Publication Data

Rawlinson, Andrew. 1943-
 The book of enlightened masters : western teachers in eastern traditions / Andrew Rawlinson.
 p. cm.
 Includes bibliographical references.
 ISBN 0-8126-9310-8 (alk. paper)
 1. Asia—Religion. 2. Spiritual biography. Religions.
I. Title.
BL 1032R38 1997
200' .92'2
[B]—DC21
 97-17135
 CIP

CONTENTS

List of Figures

PHOTOGRAPHIC DISPLAYS
(Individual photographs of some teachers occur with their entries in Part II.)

Preface

When I was ten, my Auntie Vera gave me an encyclopedia, a single volume of perhaps 800 pages. I was completely bowled over by it: a set of discrete entries, all of which, or so it seemed to me, connected with each other; a vast and intricate labyrinth of knowledge. Thirty years later, I was quietly dozing in a faculty meeting when I hear my head of department say, " . . . So you have until Friday to put in your requests." I had no idea what he was talking about. I soon found out that the university was prepared to support research proposals, even going so far as to grant study leave and a few hundred pounds for expenses. Within twenty-four hours, I had knocked up the outline for what has turned into this book.

At the time, I had heard of a few Westerners who could be said to be spiritual teachers in some sense of that term (though I didn't really know what sense that might be). I thought that I could complete the whole project, research and book, in a year. (That might have influenced the university to give me its support.) In fact, it's taken me well over a decade. When I started looking, I found something vast and intricate, just waiting to be discovered. And the enthusiasm of a ten-year-old boy—to write an encyclopedia—welled up from some hidden depths that I hardly knew existed.

Despite the fact that there was a fair amount of material available, hardly any of it was co-ordinated. And there were many avenues to be explored (but no real *culs de sac*—they don't exist in this phenomenon). In the end, the book grew to twice its present size and was on the point of becoming completely unmanageable. (But that's part of the *attraction* of the whole thing: it really is too big for anyone to grasp.) In order to have it published, therefore, I had to be practical. This required some deeply painful cutting, but it also focused my mind on the central theme (vast and intricate though it is): Westerners who have contributed to a new phenomenon in Western culture (and, I submit, in the world). I have therefore had to leave in the background, or even out of account altogether, many Easterners who have also made a contribution. I could hardly justify an entry on Swami **Abhayananda**/Marie Louise that is longer than the one of her master, Swami *Vivkananda,* unless I could show that in the long run she is more important in this phenomenon than he is. And this, not because she had anything deeply significant to say but simply because she was French, and by that very fact could do something which he, an Indian, could not. The underlying argument of this book is precisely that.

But there is something else as well. None of the Westerners in this book knew what they were embarking on. What that is exactly, is still in the process of growth and definition and it may take another fifty or hundred years before we reach any clear and deep understanding—never an easy combination at the best of times. But it is already in existence and it will continue. Anyone who has contributed to it is worth knowing about. And he or she gets my vote every time—even those about whom I have reservations, even strong reservations, nay, *very* strong reservations. Enthusiasm and a critical eye are not necessarily at odds with one another.

Now to more down-to-earth matters. Some proper names are printed in **bold** and some in *italic*. Those in **bold** are Westerners who either have a full entry of their own, or a 'cross-referenced' entry, in Part II. (You will find out what a cross-referenced entry is when you start using the book.) The names of these Western teachers appear in **bold** throughout the book except inside their own entry (or when they appear as authors of books rather than as teachers).

Names in *italic* are Easterners.[1] The same conventions apply as to the Westerners in **bold**: they also have their own entry[2] or cross-reference entry in Part II (but they are not italicized inside their own entry).

Everyone else, Western or Eastern, who is neither in bold nor in italic, can be found in the index.

The following conventions have been adopted throughout the book:

Names beginning with *de* and *von* are treated as if they began with *d* and *v*. Names made up of two or more 'parts' are treated as if they were a single name. (Hence '**Sat Prem**' is read as if it were '**Satprem**'—and so comes after '**Satchakrananda**' not before it.)

You will come across many names and terms in foreign languages—principally, Sanskrit, Pali, Japanese, Chinese, Tibetan, and Arabic. All of these have their own nuances and difficulties. I would have loved to have been consistent but, try as I might, have found it impossible. Purists will therefore find themselves subject to spasms of irritation/exasperation/despair, depending on their character, as they read 'Shiva' instead of 'Siva'—but 'Sivananda'; *sheikh* instead of shaykh; and both sannyasin and sannyasi. I can justify these, and similar, variations in 99 percent of cases. But the remaining 1 percent is just plain inconsistency—or inconsistent inconsistency. Sorry about that.

[1] There are a few instances where it is unclear whether someone is Western or Eastern—for example, when one parent is Western and one is Eastern; or where both parents are Eastern but the child is born and rasied in the West. But having decided that someone is Western or Eastern, I stick to it.

[2] These entries are themselves in *italic*. ('Why?', I hear you cry. Because so many Westerners have adopted Eastern names. So I though I'd help you out as much as I could.)

Acknowledgements

A work of this kind needs a lot of input from a lot of people. I would like to thank those teachers who talked to me or corresponded with me (or both): Jetsunma Ahkon Lhamo, Reb Anderson, Richard Baker, Michael Barnett, Shrila Bhaktipada, Swami Chetanananda, G.B. Chicoine, Ngakpa Chogyam, Richard Clarke, Andrew Cohen, Reshad Feild, Bernard Glassman, Joseph Goldstein, Lex Hixon, Goswami Hridayananda, Ngakpa Jampa Thaye, Srimati Kamala, Philip Kapleau, Mahmood Khan, Vilayat Inayat Khan, Ayya Khema, Swami Kriyananda, Barry Long, John Loori, Lee Lozowick, James MacKie, Marasha, Ole Nydahl, Chris Orchard, Toni Packer, Swami Parvati Devyashram, Barbara Rhodes, Urgyen Sangharakshita, Father Satchakrananda, Ajahn Sumedho, Christopher Titmuss, Zen Master Tundra Wind, Swami Turiyasangitananda, and John Yarr.

I have also been helped by many people—some of them associated with a particular teacher, some of them not—who have given me information of divers kinds or simply talked things over: Brother Anandamoi, Philip Appleby, the Avadhut, Frank Bailey, Frans Bakker, Stephen Batchelor, Elizabeth Bennett, Goswami Bhaktisudhir, Tony Blake, Janet and Colin Bord, Steve Brett, Joy Brown, Andrew Burniston, Tom Cahill, Jacques Castermane, Jake Chapman, Olive Clive-Ross, Peter and Julie Constance, Michael Cripps, Peter Davies, Ira Deitrick, Neil Douglas-Klotz, Emma Edwards, Mary Finegan, James Ford, Michael Franklin, Norman Frizzell, Steven Gelberg, Kriss Glanville, Joscelyn Godwin, Ray Grasse, Bruce Harris, Robert Hartford, Peter Hobson, Tony Hodgson, Esmé Howard, Mark Kamin, Michael Katz, Paul Kaye, Alan Kellas, Bodhin Kjolhede, Konchong Norbu, Arnold Kotler, David Lane, Jan Lowe, Stewart MacFarlane, Peter Maclachlan, Rev. Daizui MacPhillamy, Sri Madhava Ashish, Philip Mellor, J. Gordon Melton, James Moore, Swami Murthy, David Owen, Acharya Palaniswami, Pat Patterson, Jeff Perlmutter, Penny Phipps, Lisa Powers, Netta Quainton, Ranchor dasa, Sister Savitri, Edith Schnapper, Mark Sedgwick, K.E. Steffens, Bill Stranger, James Stuart, Ajahn Sucitto, Clive Tempest, Victor Tozo, Tsering Wangyal, Dheeresh Turnbull, John Varney, Llewellyn Vaughan-Lee, Ajahn Viradhammo, Greg Vlamis, David Waines, Mohammed Walley, Alan Whitehead, Dr. Witteveen, Paul Woodward, John Wren-Lewis, John Xavier, Yasodanandana dasa, Sharon Zolper.

Right at the beginning, I was supported by the University of Lancaster, which gave me sabbatical leave and a grant to get the project moving; by Adrian Cunningham, who was my head of department; and by Eileen Barker of the London School of Economics, who refereed my original idea.

I was given splendid hospitality in America by Miriam and Wayne Caravella, Mike and Debbie Duffett, Mark and Judith Dufault, Colin and Caren Innes, Herb Joseph, Jim and Barbara Stevenson, James and Lee Tyler, Març Wooster and Peter Tierney.

Bill Thompson and Brian Bolger supervised the transfer from one computer to another at a crucial stage and were always ready with answers to technical questions.

David Ramsay Steele, of Open Court, was an editor *sans pareil*.

Dennis and Sarah La Touche often helped me when I was stuck.

And what can I say about my family—that's A., C., D., E., H., I., L., N., S., and Z. Rawlinson? They were always there (apart from H.).

What This Book Is About

This book is about the emergence of something new in Western culture:

> what it is (Chapter 1: 'The Phenomenon');
>
> how it came about (Chapter 2: 'The Story');
>
> its significance (Chapter 3: 'The Issues'); and
>
> the people responsible for it (Part II: 'A Directory of Spiritual Teachers').

A century ago there were no Western masters—no Westerners who were Hindu *swamis*, Zen *roshis,* or Sufi *sheikhs.* Now there are hundreds. From a standing start, the West has produced its own spiritual teachers in traditions that were originally quite foreign. And in the last 25 years, a number of independent teachers have appeared, who belong to no tradition but teach from themselves.

These people are changing Western culture by making available a view of the human condition which is new in the West. This view is based on four principles:

> Human beings are best understood in terms of *consciousness* and its modifications
>
> Consciousness can be transformed by *spiritual practice*
>
> There are *gurus/masters/teachers* who have done this, and
>
> They can help others to do the same by some form of *transmission*

There are great number of variants of all these.

> *Consciousness* can be seen as divine, as intrinsically pure, or as 'empty'
>
> *Spiritual practice* ranges from solitary observation of the movement of the mind to temple worship and social activism
>
> *Masters* can be quiet or ecstatic, trying to change the world or quite indifferent to it
>
> *Transmission* ranges from formal initiation to a glance from the eye of the beloved

We are dealing with more than a set of ideas here. These four principles, taken together, make up a way of life. I call it 'spiritual psychology' because it is concerned with the spiritual life but is based on the fundamental notion of consciousness.

Spiritual psychology affects every aspect of the human condition: what it is to be alive, to be born, to have a body, to die; the nature of sickness and suffering, of happiness and love; what it is to be male, female, heterosexual, homosexual; what it is to be a child, a parent; the nature of the family (and its alternatives: the extended family, the monastic celibate life); how society should be organized and according to what principles (politics, economics, ethics); how one should eat, dress and earn one's living; the proper form of the arts (music, painting, poetry—even the nature of language itself); the world and its origin (including space [and cosmology], time [and history and eternity],

matter and energy); how consciousness works from the most mundane levels (drinking a glass of water) to the most rarefied (meditative states that are beyond all attributes) via the extra-ordinary (visionary encounters of every conceivable hue).

All of these, in their myriad forms, can be found in this book. And all of them can be expressed in terms of the four principles of spiritual psychology. Hundreds of thousands of Westerners now accept this teaching. To begin with, it was propounded by Easterners: Buddhists, Hindus, and Sufis. But gradually Westerners began to teach the Buddhist, Hindu, and Sufi versions of it. Of course, Eastern teachers are still important; but now Westerners are doing *all* the jobs, fulfilling *all* the roles. They are the gurus and masters now. And they are also doing something new: a genuinely Western form of this teaching is emerging because it is only in the West that the different Eastern forms have come together so that they can be compared. In fact, the West presently contains a greater variety of spiritual teachers than has ever existed in any previous time or place. There is more exploration going on in Los Angeles and London than there is in Tokyo or Benares.

The Western genius is to cross boundaries of all kinds and Western teachers have certainly done that:

in terms of geography and nationality:

> They come from America, Canada, Australia, New Zealand and every country in Western Europe[1]

> There is also the occasional East European (Russian, Bulgarian, Polish)

> A few of them are the children of Eastern parents (or one Eastern parent and one Western) but are really Western because they have been born and brought up in the West, and

> Some of the all-Western teachers teach in the East (India, Sri Lanka, Japan)

in terms of traditions:

> They have entered more or less all forms of Buddhism, Hinduism, and Sufism

> Moved from one tradition to another

> Entered more than one tradition

> Established a Western offshoot of a tradition

> Abandoned traditions altogether and continued as independent teachers, and

> Created completely new traditions

Easterners do these things very rarely or not at all. Tibetan teachers, for example, know little about *vipassana* meditation or the practice of *zazen*. Indian teachers who repeat the name of Ram have no contact with Egyptian Sufis who recite the 99 names of Allah. It is Westerners who are making these connections—and when questions are asked about them, it is often a Western teacher who provides an answer.

[1] Except in Norway and Portugal; actually, there probably are some in those countries, but I haven't come across them yet.

This includes answers about the nature of enlightenment, not because Westerners have a different kind of enlightenment from Easterners but because Eastern answers, excellent though they may be, were given in isolation, so to speak. This cannot happen in the West. So *everything* is open to reassessment. That is why an account of the whole phenomenon is required, highs and lows. And this means all Western teachers: pioneers of every sort, even those who overcalled their hand or have been outflanked by subsequent developments; mavericks as well as mainstream teachers. (But 'maverick' and 'mainstream' also have to be approached in a new way.) In short, we need to pay attention not just to the mighty rivers but also to the sluggish canals, filled with weeds, that need to be dug out; the fast-flowing streams, strewn with rocks, that are difficult to navigate; the small brooks that are easy to overlook; even those that run into the ground and dry up.

Western teachers are not simply copies of the Eastern models—a few are, but the vast majority are doing something different. And because they have approached Eastern traditions from every possible angle, Western teachers are extremely varied. Some are conservative, some are innovators; some have huge organizations, others are practically impossible to find; some make a lot of money, others have taken a vow of poverty; some are gentle, some are fierce; some make extremely high claims for themselves, others are very modest. There have been great successes and abysmal failures. You name it— somebody, somewhere, has done it.

The phenomenon of Western teachers is unique—not only because of the individuals themselves, though they are certainly fascinating, but because of what they represent: the flowering of the Western genius, which has discovered Eastern traditions, absorbed them and in the process changed them and been changed by them. My aim is to outline the main contours of this phenomenon, give its history, and attempt an explanation of what it means.

Part I refers to the Western teachers **in bold type** and to the Eastern teachers *in italics*; this allows the reader to look up those teachers in Part II.[2] I have made considerable use of 'internal signposts': the 'Compare' section at the end of each entry; and the 'Timeline', beginning on p. 64. This is to enable you to choose your own path through the terrain. There are hundreds of these tracks and *all* of them are part of an international, interconnected whole.

It is this variety and interconnectedness which is the strength of the phenomenon. Every Western teacher, whether 'traditional' or not, has contributed to the development of the view of the human condition that I mentioned right at the beginning—the first genuinely new development in Western culture since the Enlightenment (no pun intended).

[2] There are also a number of individuals in Appendix 1 who are historically significant because they were early practicioners or helped to spread a teaching in some way but were not actually masters. I have great dmiration for these people but they are not my main focus and all I can give them is half a page or so.

PART I

How to Understand Spiritual Teachers

1 THE PHENOMENON

*What Westerners are Doing
in all the Eastern Traditions
and Independently*

Eastern gurus and masters are fairly well-known in the West but few people are aware that there are also Western teachers who are just as varied as those from Japan, India, and Tibet. In fact, they are more varied because they are doing practically all the things that Eastern teachers do but quite a lot more besides; they are both in the tradition and also extending it. And on top of that, there are also the independent teachers—those who teach from themselves without reference to an Eastern tradition or teacher. The Western way is to cross boundaries and thereby change things, and Western teachers are certainly doing that. The task of Chapter 1 is to indicate the scope of the phenomenon. (Chapter 2 deals with how it happened the way it did.)

Technical terms—Soto, Rinzai, *sangha, tulku, vipassana,* and so forth—are defined in the Glossary.

WESTERN BUDDHISM

THERAVADA BUDDHISM

The essential Theravada teaching is that enlightenment consists of the complete eradication of craving and attachment. The tradition traces its transmission back to the Buddha himself—and by 'transmission' is meant the continuous existence of the *bhikkhu sangha* or community of monks. This transmission involves the acceptance of a man into the *sangha* by a group of at least ten monks, using a formula that goes back to the Buddha. All Theravadin monks, regardless of their nationality, go through the same ceremony and follow the same set of 227 rules called the *Vinaya.* There are therefore no schools in Theravada Buddhism—there is simply the *sangha.* (But see below, p. 6, for a few remarks on women's *sanghas* in the tradition.)

Eastern Theravada makes a strong distinction between the *sangha* of monks and the laity. Western Theravada, on the other hand, is far more

varied; some forms follow the tradition as it is found in the East and some do not. To begin with, Westerners who were interested in *practising* Theravada had a hard time of it. They simply did not have a model to follow. There was no *bhikkhu sangha* in the West; and Theravada lay life, which in the East is entirely centred around the *sangha*, was hardly a possibility if the *sangha* itself did not exist. So Westerners tended to approach Buddhism as an entity in itself that could be distilled, as it were, from its cultural trappings. This produced what I call 'general lay Buddhism' (see p. 39).

But there was an obvious alternative: to go to the East and join the *sangha*. The Englishman, **Ananda Maitreya**, did so in 1902, and the German, **Nyanatiloka**, in 1904,[1] as well as the splendid **Uppalavanna** (also German), who practised as a hermit in Sri Lanka for 50 years. Joining the *sangha* in a Theravadin country is still an option, of course; there must have been dozens of Western monks who have done so over the past century or so. Ones who particularly interest me include: **Lokanatha** Thera, the Italian 'missionary' in Burma; **Kapilavaddho**, who joined the *sangha* in Thailand and went back and forth several times between monastic and lay life; and **Nanavira**, who eventually committed 'spiritual suicide' in Sri Lanka.

But right from the beginning, there was the intention to establish a Western *bhikkhu sangha* (meaning a *sangha* of Westerners in the West). Efforts were made as early as 1903 but it didn't actually happen until 1981 when the American monk, Ajahn **Sumedho**, established the Chithurst *sangha* in England. There are Western monks elsewhere in the West but the Chithurst *sangha* is the only one that is large enough to be called genuinely Western: that is, Western monks admit Westerners to the *sangha* according to the *Vinaya*. This is what makes them 'traditional'. (We have to use scare quotes because the very notion of what is and is not traditional is being changed by the advent of Western teachers—though there is no doubt that Ajahn **Sumedho** makes sure that the Chithurst *sangha* follows the precepts to the letter.)

But there is another Western *sangha*, which could fairly be described as 'non-traditional'. (And once again, we have to use scare quotes.) This is the ***vipassana sangha***—an international group made up of Western teachers of *vipassana* meditation and their pupils. In origin, it is undoubtedly Eastern. The original *vipassana* teachers were all Eastern (Burmese and Thai but not Sri Lankan); most of them were monks, though there were some laymen (and even a few laywomen). But the Western ***vipassana sangha*** has evolved its own form very quickly and is now quite independent (which is not to say that it has severed all links with Eastern *vipassana* or even Eastern Theravada).

There are three important differences between the *vipassana sangha* and the *bhikkhu sangha*—and I am talking about their Western forms in both instances. First, the ***vipassana sangha*** is almost entirely lay (though there are Western monks who teach lay people and some *vipassana* teachers, such as Jack **Kornfield** and Christopher **Titmuss**, were once monks but have reverted to lay life). What this means in practice is that *vipassana* practitioners do not live their lives, day in, day out, according to a set of rules or precepts that they

[1] Although **Nyanatiloka** was based in Sri Lanka for the rest of his life, he did return to Europe on occasion. This stimulated the interest of lay Germans such as Paul **Dahlke** and George **Grimm**, both of whom tried to follow a lay Theravadin life even though they had no external support to speak of. Clearly, they are rather different from general lay Buddhists, who did not, on the whole, change their way of life very much. But equally, they (**Dahlke** and **Grimm**, that is) were not following the lay life as it is practised in the East.

have publicly vowed to follow and which they must publicly confess to having transgressed. This is not to say that *vipassana* practitioners do not have standards, just that the method for maintaining them does not depend on being part of a formally established community.

The second difference is that the *bhikkhu sangha* is a community, first and last, and not a lineage of teachers. There are certainly monks who teach and who are respected for it. But they do not necessarily have a special position as a result. Teachers come and go within the *sangha*, as it were; there is no provision for creating a lineage, no transmission from teacher to pupil. But there is in the **vipassana sangha**. That is, a *vipassana* practitioner becomes a teacher when he or she is authorized to teach the *vipassana* method by his or her own teacher.

Thirdly, a relatively high proportion of *vipassana* teachers are women. This is true even in the East, where women are decidedly on the second rung compared with men. But the proportion of women teachers in the Western *vipassana sangha* is really very high. (Ruth **Denison** and Sharon **Salzberg** are examples.) And they were central to the **vipassana sangha**'s development from its very beginning. Again, this is in marked contrast to the 'traditional' *sangha*.

The position of women in Theravada generally is a complex matter. There was a nuns' or *bhikkhuni sangha* during the Buddha's lifetime and we know that it subsequently went to Sri Lanka and Burma. But it died out in both those countries, for different reasons, in the eleventh and thirteenth centuries respectively, and has not been revived. It never existed in Thailand. The situation at present is that there are women in all three countries who try as best they can to live the Buddhist life. They take a number of vows—sometimes eight, sometimes ten—which are essentially the same as the ten vows followed by novice monks or *samaneras*. This movement began only about a hundred years ago and in none of these countries are such women recognized as part of the 'real' *sangha*. They are thus in a somewhat anomalous position, since they are clearly not laywomen either.

There are very few Western women who are happy with this state of affairs. This is why they are attracted to the **vipassana sangha**, where women are treated equally with men. But there are some who value being a member of a *sangha*, even an anomalous one, because of the continuous training that it requires. I have already mentioned Sister **Uppalavanna**, who lived as a hermit in Sri Lanka from 1928 onwards. But she was a lone pioneer and there was a gap of 50 years or so before Western women began to enter this women's *sangha*, for want of a better term,[2] in any appreciable numbers (and we are talking about a few dozen at the most).

A few of these have gone on to become teachers, but they have done so in very different ways. Jacqueline **Mandell** was already a *vipassana* teacher when she became an eight-precept 'nun' in Burma. Ven. **Dharmapali** became an eight-precept *anagarika* at Chithurst (which is in the Thai tradition) and then took ten precepts in the Sri Lankan tradition in New York. Ayya **Khema** also took these ten precepts (in Sri Lanka) and afterwards established a Nun's Island there for English-speaking women of any nationality (including Sinhalese). It could in a sense be said to be traditional because all the women follow the ten precepts, which is the most that is available to women in Sri

[2] In fact, it consists of a number of unconnected *sanghas* in each of the three countries (Sri Lanka, Burma, Thailand). This lack of cohesion is in marked contrast to the *bhikkhu sangha* which is identical in its formal structure—that is to say, the 227 precepts—in every country where it is found.

Lanka Theravada. But in fact a Western woman was needed to start such a venture, as Ayya **Khema** herself says, because Sinhalese women are held in such low esteem in Sri Lanka that they would not have received enough support from the laity to be able to live according to the ten precepts. It is surely noteworthy that a Westerner should take the lead in an Eastern tradition in an Eastern country, and though Nuns' Island is very small, the fact that it exists at all is significant.

All the evidence suggests that there is little future for Western women in the women's *sanghas* of the East. But there are a number of alternatives in the West.

One is to enter a traditional women's *sangha* that is allied to a strong *bhikkhu sangha*. This is what is happening at Chithurst under the direction of Ajahn **Sumedho**. But it is the only example in the entire Western world, and while it may be admirable, the chances of this option becoming generally available are practically zero (because independent Western *bhikkhu sanghas* are bound to remain thin on the ground).

There is also a movement to restore the full *bhikkhuni sangha*.[3] Should this be accomplished, it would be one of the most significant developments in any Buddhist tradition for centuries—and it would certainly be the result of Western influence. It originated with Western women, although Eastern women and Western men, including some monks (but very few Eastern men and hardly any Eastern monks), are also part of it. In short, it is a Western movement. Some of its members are conservative and some are radical. The conservatives want to follow the *Vinaya* rules, which require that the reintroduction of the *bhikkhuni sangha* would need the assent of the majority of the entire worldwide Theravadin *sangha* (which is all male and 99 percent Eastern). This could take decades. The radicals, on the other hand, want to establish the *bhikkhuni sangha* immediately, because it is the quality, not the form, that counts.

Another direction that is being explored is the creation of a specifically Western women's *sangha*. This is part of the fledgling ecumenical movement, an entirely Western creation that I deal with under **Ecumenical sangha** in Part II. But I should say here that Ven. **Dharmapali** (see above) is a leading figure in it.[4]

Finally, as I have already said, there is the option of abandoning the formal *sangha* life altogether and pursuing Theravada as a laywoman. This is what the ***vipassana sangha*** is doing.[5]

To sum up: present-day Western Theravada consists of a small traditional *bhikkhu sangha* in the West and a very much larger lay ***vipassana sangha***. In addition, there is an incipient movement to re-establish the *bhikkhuni sangha*; and there is a strong Theravadin ingredient, so to speak, in the non-denominational **ecumenical sangha** [for which see Colonel **Olcott**]. (On the

[3] This issue is covered in an excellent publication (which deals with women in all the Buddhist traditions, not just Theravada), *Sakyadhita: Daughters of the Buddha*, ed. Karma Lekshe Tsomo (an American), (Ithaca: Snow Lion Publications, 1988).

[4] I should also mention **Sangharakshita**'s Western Buddhist Order, in which women are treated as 'equal but different'.

[5] But of course there are always variations. **Mandell**, for example, actually took formal vows after she became a *vipassana* teacher, then left the Theravadin tradition altogether because of its discrimination against women.

other hand, Theosophical Buddhism [for which see Colonel **Olcott**] died out decades ago; and while 'general lay Buddhism' still exists, it has been effectively outflanked by the four *sanghas* just mentioned.)

And they are all very different: the traditional *sangha* is based squarely on the Eastern model; the ***vipassana sangha***, which originated in the East, has taken on a number of forms that are peculiarly Western; the nascent *bhikkhuni sangha*—or at least the radical wing of it—is trying to restructure the tradition; and the ecumenical *sangha* is a completely Western creation.[6] (On the other hand, they do have one element in common: they are all international.) This range is entirely typical of the phenomenon I am describing in this book.

ZEN BUDDHISM

Zen is justly renowned for its simplicity, and its central teaching, though profound, is certainly simple: one's own nature is identical with Buddha-nature. The predominant form of Western Zen is Japanese but there are also Western teachers in Korean and Vietnamese Zen. Although there are Zen monasteries in Japan and the monks follow precepts, they are not the same as those of the Theravada. Similarly, Korean and Vietnamese Zen also have their own *Vinaya*. In fact, Japanese Zen is not really *sangha*-oriented but is rather a series of lineages created by transmission from teacher to pupil. And a teacher can give transmission to more than one pupil, thus creating a number of quite legitimate lineages. As a result, Japanese Zen is divided into schools (unlike Theravada). The two biggest are Rinzai (whose priests/monks are celibate) and Soto (whose priests/monks may marry); but there is also a much smaller school, formed in this century, the Sanbokyodan, which is entirely lay, and which has had a considerable influence in the West (see the *Harada-Yasutani-Yamada* lineage).

The first 50 years or so of Western Zen were entirely Rinzai and the first Westerner to have a formal role as a Zen teacher was an American woman, Ruth Fuller **Sasaki**, who became a Rinzai priest in Japan (though not until after the Second World War). There have also been, and still are, Westerners who were not just teachers (which is significant enough) but actually appointed as *roshis* in the Rinzai lineage (which is much more significant because they can themselves appoint successors, which an 'ordinary' teacher cannot): for example, Walter **Nowick** (who lived in Japan for years) and Maurine **Stuart** (who never set foot in the country).

But though the Rinzai school was the first to start in the West, it is now Soto which has the most influence. In 1970, Richard **Baker** was formally appointed (in Japan) as the Dharma-heir to Roshi Shunryu Suzuki and succeeded him as abbot of the San Francisco Zen Center a year later. And a number of other Americans have also been appointed as teachers (some *roshis*, some not) in this lineage, including Roshi Jakuso **Kwong** (actually a Chinese American, born and bred in California), and two of Baker's own students, Reb **Anderson** and Issan **Dorsey**.

So there are now *Western* Soto lineages: Western teachers, who, having been appointed as Dharma-heirs by their Eastern teachers, have in their turn appointed their own Western pupils as Dharma-heirs. **Baker** is an example

[6] In fact, because women have a central role in the ecumenical *sangha*, there is a natural link between it and the *bhikkhuni sangha* (especially the radical wing).

and there are a number of others: Bernard **Glassman** and Dennis **Merzel**, the first two Dharma-heirs of *Maezumi* Roshi; Robert **Aitken**, in the Sanbokyodan lineage of *Yasutani* Roshi; Philip **Kapleau**, also in the Sanbokyodan lineage (though he was never formally appointed); Jiyu **Kennett**, who was made a *roshi* in Japan in 1963, served as an abbess at her own temple there for six years, had a series of visions in California in 1976, and has effectively established a form of Zen which, though deeply respectful of the tradition, is also deeply unusual.

All of these people have given Dharma transmission to several of their students. And they are quite a mixture: **Merzel**'s Dharma heirs are French, English, and Dutch; **Aitken**'s are American, Australian, and Argentinian; **Baker** and **Aitken** are the only ones who have not given Dharma transmission to women (though **Aitken** is very sympathetic to what might be called 'feminist Buddhism'); **Glassman** and **Aitken** have Dharma-heirs who are Christian priests (see Hugo **Enomiya-Lassalle** for the whole phenomenon of Christian Zen); Issan **Dorsey**, one of **Baker**'s Dharma-heirs, was gay; **Kennett** has given Dharma transmission to nearly one hundred of her students—a quite unprecedented number in Western Zen.

This is a rich soup, but some of the ingredients are not entirely 'traditional', and that goes for the way in which some of these Western Zen teachers deal with Western society. Both **Baker** and **Glassman**, for example, have made forays into the business world; and **Aitken** has for a number of years withheld that proportion of his taxes that the American government would spend on arms. These are things that Japanese teachers, for all their reputation for idiosyncrasy, just don't do.

As for Korean Zen, the Korean teacher, Soen Sa Nim (aka Seung Sahn), who is based in Rhode Island, has effectively set up his own Zen order and appointed nine pupils as Master Dharma Teachers. One of these, Barbara **Rhodes**, is a woman (rare in Korea); one is the son of a Korean father and a Chinese mother but brought up in America (an unusual combination but an inevitable consequence of the relentless crossing of boundaries which characterizes Western culture); and one is Polish (a first for Eastern Europe, I think). Another Korean teacher, Samu Sunim, whose headquarters are in Toronto, has appointed two Canadian women, Linda **Murray** and Linda **Klevnick**, as teachers; and he also has a number of pupils in Mexico (with Korean names)—part of the 'Easternization' of Central and South America (which are themselves outreaches of the West).

Vietnamese Zen is still in its infancy in the West but the few Western teachers (all American) it has produced are quite unusual. Two are women (Gesshin **Prabhasa Dharma**, formerly in the Japanese Rinzai tradition); and **Karuna Dharma**. No Eastern Buddhist tradition has much of a place for women but, as with Theravada, Western women are beginning to change that. The proportion of women teachers in Eastern Zen is tiny but it is relatively high in Western Zen—and in all sections of it: Rinzai, Soto, Korean, and Vietnamese.

Finally, there are a few independent Zen teachers (though 'independent' like 'traditional' and 'non-traditional', is a term with a variety of meanings). Some of them, like Toni **Packer** (who no longer regards herself as Buddhist, even) and Joko **Beck** (who left her teacher, *Maezumi* Roshi, because of behaviour that she found unacceptable), were appointed as teachers but have since gone their own way. Others, like Zen Master **Tundra Wind** (who broke with Soen Sa Nim because he considered his understanding of sexuality to be deeply

flawed) and Zen Master **Rama** (who teaches what he calls 'Tantric Zen', a version of the tradition that is otherwise unknown), have gone their own way right from the start. Then there are people like Graf **Dürckheim** (who practised Zen in Japan but says that what he teaches is neither Buddhist nor non-Buddhist) and Douglas **Harding** (who discovered the 'way' for himself, spontaneously), who have never claimed to represent the Zen tradition but who nonetheless can be said to present a teaching that is consonant with it.

The variety of Western Zen is evident even from this short survey:

> *roshis* in both Rinzai and Soto—both male and female, in Japan and in the West;
>
> Dharma teachers in Korean and Vietnamese Zen;
>
> Western lineages (but only in Soto and Sanbokyodan—none as yet in Rinzai, Korean or Vietnamese Zen);
>
> splits, defections, and cross-overs to other traditions;
>
> innovations of various kinds, both religious (**Kennett**'s visionary Zen; **Dorsey** and **Tundra Wind**'s Zen for gays; Zen Master **Rama**'s 'new' tradition) and social (**Glassman**'s housing project; **Aitken**'s protests against the military budget).

Some of this is traditional and some of it isn't. (And notice that none of it has obvious equivalents in Theravada.) And again, the very question 'What is traditional—and why?' has been raised by the way in which Westerners have become Zen teachers and what they have done since.

TIBETAN BUDDHISM

Tibetan Buddhism is much more complex than either Theravada or Zen and it is difficult to state its essential teaching succinctly. But perhaps one could put it this way: all the qualities of enlightenment emerge from the brightly shining mind of emptiness. The development of Western Tibetan Buddhism can thus be seen as the way in which Westerners are themselves manifesting these qualities—as part of the tradition.

The first thing to say about Western Tibetan Buddhism is that it only exists outside Tibet. Although pioneers like as Alexandra **David-Néel** and Lama Anagarika **Govinda** did go to Tibet, they only stayed for short periods of time. And since Tibetans themselves very rarely left the country, these pioneers had to struggle on as best they could, without guidance. There simply weren't any exemplars of the tradition to whom they could turn. (This is one of the reasons that **Lobsang Rampa** could get away with his inventions for so long.)

But all this changed when the Dalai Lama went to India in 1959, taking thousands of Tibetans with him (including most of the important *lamas* and *tulkus*). Teachers from all four main schools (Gelug, Kagyu, Nyingma, and Sakya) can now be found all over the Western world. Although there are some differences among these schools, these are mainly organizational rather than doctrinal—Nyingma and Sakya *lamas* may marry, for example, while Gelugpas and Kagyupas may not—and it is common for teachers to receive initiations and empowerments from more than one school and then pass them on to their pupils.

Tibetan Buddhism is inherently hierarchical and Westerners are already functioning at all levels of the tradition (except, perhaps, the very highest).

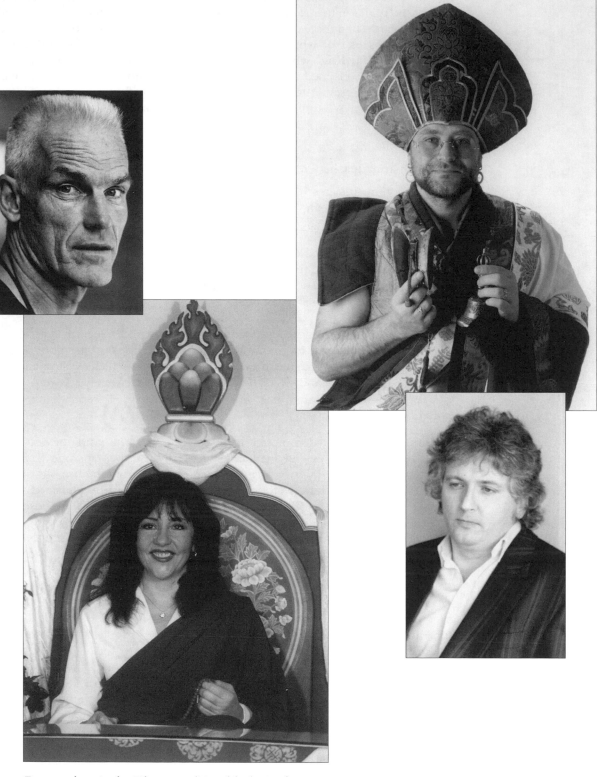

Four teachers in the Tibetan tradition (clockwise from top left: Ole **Nydahl**, Ngakpa **Chogyam**, Jampa **Thaye**, Jetsunma **Ahkon Norbu Lhamo**)

There are quite a few Western monks and nuns (although the tradition does not have full *bhikshuni* ordination), including some who use—or have been accorded (and the two are not the same)—the title *lama*. Examples are Lama Anagarika **Govinda** (already mentioned) and Lama **Teundroup**.

Then there are lay teachers. Some, like Ole **Nydahl**, an indefatigable founder of Kagyu centres throughout the world, have no specific rank in the tradition (though he uses the title, *lama*). In a sense, then, he is defining his own position. But since he is doing it with the support of prominent Tibetan teachers, one could hardly say that he is outside the tradition. It is simply that the founding of lay centres has never been part of the tradition in Tibet. On the other hand, other lay Westerners have been formally appointed. **Osel Tendzin**, for example, was appointed Vajra Regent by his Tibetan teacher, Chogyam *Trungpa*, in America in 1976. What this meant was that Tendzin would look after Trungpa's pupils until Trungpa, who was a *tulku*, incarnated again. *Trungpa* died in 1986 and **Osel Tendzin** went ahead with his duties with the full support of prominent Tibetan Kagyupas. But he himself died of AIDS in 1990. So that particular experiment—of extending the lineage to include a Westerner—did not prove successful. However, there is another Western Dharma Regent (that is, someone who holds the fort until a *tulku* reincarnates): David Stott/Ngakpa **Jampa Thaye**, an Englishman who has received initiations in both the Sakya and Kagyu schools.

But perhaps the strongest proof that Westerners really are part of Tibetan Buddhism is the recognition of Western *tulkus*—Westerners who have been accepted by the leaders of the Tibetan schools as incarnations of teachers who were Tibetan in *all* their previous lives. I deal with them in the group entry, *Tulkus*. But I mention here two salient points: that a few of them (Jetsunma **Ahkon Lhamo**, Ngakpa **Chogyam**) were recognized when they were adult (which *never* happens in Tibet); and that their authenticity is variable, to say the least, ranging from the 'official' (Lama **Osel**) to the decidedly idiosyncratic (Simon **Grimes**, **Namgyal** Rinpoche). There are a number of reasons for this but one of them is certainly that the Tibetans themselves are feeling their way. The tradition has found itself in new circumstances and is redefining its boundaries. Tibetan Buddhism finds this relatively easy to do (which Theravada and Zen do not; see Chapter 3 for why); and it suits the West very nicely.

As with Theravada and Zen, Western women are far more significant in the Western form of Tibetan Buddhism than Tibetan women have ever been in Tibet itself. Alexandra **David-Néel** was an early example of this trend and there have been others since. One of the first Westerners to formally enter the tradition after the Dalai Lama arrived in India in 1959 was an Englishwoman, Freda **Bedi**, who later became a 'nun' (scare quotes because Tibetan 'nuns' are not full *bhikkhunis/bhikshunis*)—probably the first Western woman to enter the Tibetan tradition in this way. Another Western 'nun' is **Pema Chodron**, an American disciple of Chogyam *Trungpa* and therefore in the Kagyu school, who has been resident director of the newly built Gampo Abbey in Nova Scotia since 1984. An unusual laywoman is Dhyani **Ywahoo**, who is a teacher in her own Cherokee tradition but has also been recognized as a teacher by high-level Tibetans in both the Nyingma and Kagyu schools. And I have already mentioned Jetsunma **Ahkon Norbu Lhamo**.

These five women—**David-Néel, Bedi**/Palmo, **Pema Chodron, Ywahoo** and Jetsunma—have a variety of roles in the Tibetan tradition, some of them traditional and some of them quite new. And the same could be said for the

men teachers. But the point is that these Westerners, male and female, are participating fully in the tradition—and in all the schools—and not only in one corner of it. And this is typical of Westerners in the Theravada and Zen traditions, too. Moreover, as is usual in all Eastern traditions (not just Buddhist ones), Western participation is international: the twenty or so Westerners I have mentioned in this brief survey come from, or have connections with, six different countries.

OTHER FORMS OF BUDDHISM

I use the term 'other' in two quite different senses. First, simply to mean 'Buddhist traditions other than Theravada, Zen, and Tibetan.' But while the *discovery* of these other traditions has been long and complex—a complete book could easily be written on the subject—the number of Westerners in them has been so few that we cannot say that these forms of Buddhism are genuinely Western in the sense that I am using that term in this book—that is, taught by Westerners. And this is worth remarking because all of them had Western representatives at a fairly early date. William **Bigelow** entered the Japanese Shingon tradition in the 1880s. And a number of Westerners became Shin/Pure Land Buddhism priests in the 1920s and 1930s (for example M.T. **Kirby**, who switched from Rinzai Zen; Ernest **Hunt**, who switched *to* Zen (Soto, not Rinzai); and Robert **Clifton**).[7]

Clifton is also part of the second kind of 'other' Buddhism, and one that the West has itself developed: the **ecumenical *sangha***. It has several forms and has been championed by a variety of Western teachers. Colonel **Olcott** began the process in the nineteenth century by bringing together Buddhists from several Eastern traditions, the first time this had happened for many centuries. In a way, **Olcott** can be regarded as a 'general lay Buddhist' (see p. 39) and ecumenical Buddhism can be seen as the flowering of this early Western movement. If this is so, then men like Paul **Carus** and Christmas **Humphreys** were either forerunners of the ecumenical *sangha* or actually members of it (depending on how we define it and its history). Robert **Clifton** was certainly a member: he founded a Buddhist order in the 1950s that accepted any ordained priest, regardless of the school or tradition to which he was affiliated.

Several years later, another ordained Westerner, Ven. **Sangharakshita**, also founded a Western Buddhist Order (quite separate from **Clifton**'s). Although he had entered the Theravada tradition, **Sangharakshita** also took initiations from Tibetan teachers and he includes Mahayana and Vajrayana elements in his own teachings. He has also devised a new form of ordination. This, then, is an independent *sangha*.

And perhaps the same could be said about the ecumenical approach of two American women: Rev. **Dharmapali** and **Miao Kwang Sudharma**. **Dharmapali** has taken various ordinations in the Theravada tradition and is now trying to establish a centre for women that will combine *vipassana* and practices from Vietnamese Mahayana; **Miao Kwang Sudharma**, on the other hand, has taken ordination in three different traditions (Soto Zen, Theravada,

[7] Chinese Buddhism is something of a special case and I just do not have the space to do it justice. I could mention Trebitsch **Lincoln**/Chao Kung, who became abbot of a temple in China, and John Blofeld/Chu Ch'an, who also entered the tradition in China, both of whom were already teaching in some respect in the 1930s. But nothing came of their efforts; that is, they remained isolated individuals and no Western tradition ever developed. There are also a number of Westerners associated with the Taiwanese teacher Hsuan Hua in California.

and Chinese Mahayana) and combines all of them in her own centre in Arkansas.

Finally, there is also what I call the ***arya sangha***, or 'community of the noble ones', which not only includes Buddhist teachers of all persuasions but also Westerners from other Eastern traditions as well as some independent teachers.

THE DISTINCTIVENESS OF WESTERN BUDDHISM

It may seem odd to finish this survey of Western Buddhism—that is, Western teachers of Buddhism—by referring to a *sangha* that is not specifically Buddhist at all. But that is just the point. Western Buddhism is so varied because it crosses boundaries. It includes every kind of formal appointment: monks, nuns, priests, and abbots from the traditions centred in Sri Lanka, Burma, Thailand, Japan, Tibet, Korea, and Vietnam; plus more or less all the special titles that are limited to just one tradition: for example, *ajahn* in Thai Theravada; *sensei* and *roshi* in Japanese Zen; *lama* and *tulku* in Tibetan Buddhism.

In addition, Western teachers in all the traditions have made various claims to have verified the Dharma (however their tradition interprets it) for themselves—usually by spiritual practice. And again, every tradition has its favoured practice: *vipassana* meditation, *zazen*, *koan* practice, visualization, to name only the best known and most traditional.

But on top of that, a large percentage of Western teachers have introduced new elements into their teaching and into their practice: sometimes from other Buddhist traditions; sometimes from other traditions altogether; and sometimes from their own experience. In fact, some of them have reinterpreted their tradition in the light of these extra elements, even to the point of trying to restructure the tradition entirely.

All these considerations have to be kept in our minds at the same time when we say, as I do, that Western Buddhism is unlike anything that has existed before and hence is really a new kind of Buddhism altogether. This is a big claim and its full import will take some time to unfold. Right now, I am simply fanning out the cards, so to speak, in order to show that Western teachers are using a full deck. In fact, they've added a few extra cards of their own (just as the Chinese, Japanese, and Tibetans did when they discovered Buddhism).

WESTERN HINDUISM

Hinduism is a great and many-splendoured tradition made up of a very large number of overlapping sub-traditions. In fact, it is fair to say that Hinduism *is* a set of sub-traditions rather than a main tradition with offshoots. The analogy of the meaning of the word 'game' is useful here. A very general definition such as 'an activity with rules into which one or more persons enter with the aim of winning (however that is defined)' will not get us very far. Team games with a ball (soccer, rugby, baseball, basketball) are an obvious example but overlap with team games without a ball (tig or tag), games between two people with a ball (singles tennis) or without (chess), games where several

individuals compete together but only for themselves (singles golf, monopoly—and other board games—and most card games) and games which can be played by a solitary individual (patience and many playground ball games). And there are variants of all these, of course. But none of them is the original game (even if some have longer histories than others). Why should there have been an original game?

Similarly with Hinduism. Its various forms do have a history and some of them are demonstrably older than others. But it does not follow that there is an original Hindu tradition, a single trunk with many branches. Rather there are several trunks which have twined round each other (each with many branches). This is what has happened with sub-traditions such as Vedanta and Yoga, or Shaivism and Vaishnavism. Most people have heard of them and they are undeniably extensive and hence influential. But they are themselves the product of the intertwining of several trunks, perhaps even several roots. So the term 'Shaivism' is rather like 'team ball game'. It tells us not to expect a pack of cards or a board but one can deduce nothing about how many people play the game, the size of the pitch, how points are scored—not even the shape of the ball. For that, we need a more specific description like 'soccer' or 'baseball' (for which the equivalents would be names of specific schools like 'Shaiva Siddhanta' or 'Adinatha').

It is tempting to try to divide Hinduism up into separate sub-traditions—Vedanta, Yoga, Shaivism, Vaishnavism, and so on—just as Buddhism is divided into Theravada, Zen, and the Tibetan tradition (among others). But because of Hinduism's inherent tendency to proliferate, such a method would be unacceptably chaotic. We would either end up with five or six categories, into which all variants would have to be crammed whether they fitted or not; or we would have twenty or so categories, which is unmanageable. But throughout this book, it should be remembered that the general term 'Hinduism' is quite as large and varied as 'Theravada *plus* Zen *plus* Tibetan Buddhism,' in fact more so.

Hinduism is thus fairly different from Buddhism, and for two main reasons. First, because all Buddhism's main forms *are* derived from a single point of origin (the Buddha). And secondly, because these forms—Theravada, Zen, and Tibetan—are actually fairly distinct: they all exist in different countries (in the main) and have had next to no contact with each other for centuries. But the various forms of Hinduism have been cheek by jowl for just as long (in fact, longer). Buddhism's variety is considerable but one can at least relate the variations to each other in some way (despite the fact that they exist in different parts of the world). Hinduism's variety is multilinear from the beginning.

However, as I said earlier, there are some main strands/trunks/branches. Here are four:

> There is only one reality which is our true nature
>
> That which obscures enlightenment can be removed by disciplined practice
>
> God alone is
>
> There exists a divine power which supports all worlds and all beings and which can be transmitted by the guru

Several volumes could be written about each of these. All we need to know at the moment is the following. First, the same term can used in quite different ways. For example, knowledge of our true nature is often referred to as

jnana yoga; disciplined practice could be Patanjali's *ashtanga yoga*; love of God is *bhakti yoga*; and the transmission of divine power could well be *kundalini yoga*. But one would be hard pressed to say what these *yogas* have in common. Secondly, quite different terms can be used to express what looks like the same teaching: both 'Shiva' and 'Krishna' are names of God, for example. Lastly, these four strands/trunks/branches are by no means exclusive and can combine in various ways.[8]

So much for the main dimensions of Hinduism and how it differs from Buddhism. But there is another difference that is particularly relevant to the advent of Western teachers of Hinduism. By and large, Buddhist teachers gain respect in proportion to their recognition by the *sangha* (though the notion of *sangha* itself varies from one form of Buddhism to another or even within a single form). Hinduism certainly contains this option of what might be called authorization by the spiritual community, both at the local level in village Hinduism (where priests and holy men are part of the fabric of society) and at the national level (for example, the lineage of Shankaracharyas, which we will encounter more than once). But it also allows another option far more easily than any other major tradition: that of the realized individual. That is, someone demonstrates a certain level of attainment in him- or herself and therefore need not establish his or her authority by claiming a connection with a lineage or a spiritual community. Realization *is* authority.

This gives rise to what I call inner Hinduism. And it is significant that most of the Indian Hindu teachers who have been influential in the development of Western Hinduism are examples of it. *Ramana Maharshi*, for instance, had no teacher and was a member of no lineage; *Aurobindo* did have a couple of teachers but they were irrelevant to his eventual teaching; *Vivekananda, Yogananda,* and Sivananda were each part of a lineage, but that wasn't what made them teachers. It was their own state of realization which conferred that status on them. They all had great respect for other teachers but were essentially independent of them.

This is a common occurrence in Hinduism but it is very rare, and actually quite difficult, in any form of Buddhism. This affects the thorny question of whether a particular teacher is 'really' Hindu (or 'really' Buddhist) or not. Independent Buddhist teachers are a rarity in the Eastern Buddhist tradition because the tradition itself does not sanction them. But Hinduism does—and this is why the boundaries of Hinduism are relatively easy to extend.

Western Hindu teachers have certainly done that—and in this they are actually being 'traditional', by which I mean that they are following the principles that inform the tradition in India. But of course that does not mean that what they teach is the same as what we find in India. So the term 'Western Hindu teacher' means 'someone whose teachings are traceable to the Hindu tradition (in any of its various forms)'. It does not mean 'someone who teaches what Indian Hindus teach' (though it does not exclude that). I think most of the people I mention in this chapter would be happy with this definition.

As I have indicated, trying to divide Hinduism is like trying to sieve spaghetti. I have already given one classification—the four main strands given above—and here is another.

1. Some Western teachers offer what they call *universal Hinduism,* a teaching which includes all paths, including those of other religious traditions. Early

[8] In fact, they are examples of *Cool Unstructured, Cool Structured, Hot Unstructured,* and *Hot Structured.* See Diagrams 1 to 12 and the section of Chapter 3 where they occur.

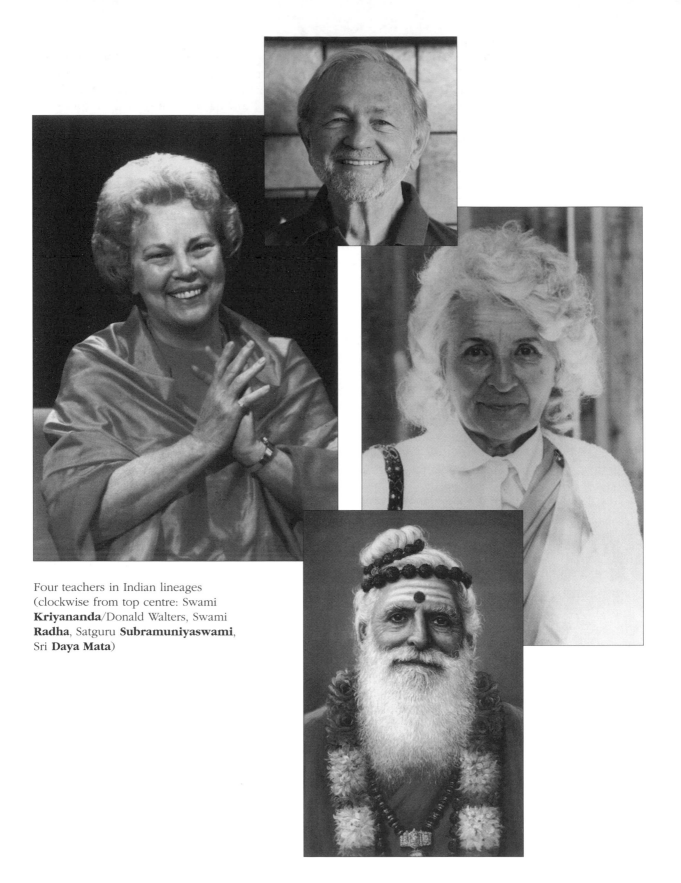

Four teachers in Indian lineages
(clockwise from top centre: Swami
Kriyananda/Donald Walters, Swami
Radha, Satguru **Subramuniyaswami**,
Sri **Daya Mata**)

exponents of this view were the Western followers of Swami *Vivekananda* (who was himself carrying on the work of his own master, Ramakrishna). These included Marie Louise/Swami **Abhayananda** (who was deeply idiosyncratic) and Sisters **Devamata** and **Daya** (who were deeply orthodox, though there was some controversy about that in the Ramakrishna Order).[9]

And we could also include here a handful of Westerners who have embraced both a form of Hinduism and Christianity: the French Benedictine, Swami **Abhishiktananda**, for example, and two Americans, George **Burke**/Swami Nirmalananda and Father **Satchakrananda** Bodhisattvaguru, who are members of esoteric Christian churches. None of these three have any connection with each other. And in addition, **Satchakrananda** had a vision of Sivananda (as other Western teachers have done). Already we see the intertwining of trunks and branches that is typical of Hinduism. Christian Hinduism would seem to be a contradiction in terms, but only if we think in exclusive categories. Hinduism as a whole tends not to, and universal Hinduism certainly does not.

2. Other Westerners do see themselves as representing *a particular Hindu sub-tradition* and wish to remain true to it. Sri **Krishna Prem** (an Englishman in charge of an ashram at the end of an 18-mile track in northern India) and the **Hare Krishna gurus** (Americans teaching on a worldwide scale), who rigorously uphold every aspect of the Gaudiya Vaishnava tradition, are an example. Yet this has not prevented a number of divisions and schisms within the Hare Krishna movement, involving a complete range of orthodoxy, heterodoxy, and outright schism (see Shrila **Bhaktipada**).

Parallel with these Vaishnava teachers, so to speak, are Westerners in the Shaiva tradition. Guru **Subramuniya**, for example, is head of a Shaiva Siddhanta Church in Hawaii; **Mahendranath**, who was in the Adinatha lineage, had an ashram called Merlin Oracle Lab in Gujarat, India. Both have predominantly Indian disciples (**Subramuniya**'s in America and **Mahendranath**'s in India). Yet it would be difficult to imagine two more different forms of Hinduism.

Then there are representatives of the Shankaracharya lineage (which is sometimes presented as a form of Shaivism because Shankara himself is regarded as an incarnation of Shiva): Leonardo **Maclaren** and the **Devyashrams**. **Maclaren** started off as a student of P.D. **Ouspensky**; his move to the Shankaracharya is rather like a composer of twelve-tone music switching to the composition of India *ragas*. The first of the three **Devyashrams**, Swami Lakshmi Devyashram, had a vision of Swami Sivananda (like **Satchakrananda**) but was then made the American head of the Holy Shankaracharya Order. The Shankaracharyas are *extremely* orthodox—one might even call them the equivalent of archbishops—and for them to appoint Western women as teachers, and give them an official title as well, is quite something. It is even more striking that the ashram (and its temple) should

[9] One of the striking things about *Vivekananda* was that he gave spiritual responsibility to women—actually, Western women. In the event, his early death meant that this particular experiment was not continued. They were the early blooms that did not survive the summer. Although many forms of Hinduism are heavily patriarchal, there are also several strands which have a high regard for women, and there have been a number of well-known female *gurus* in India during the past century or so. This contrasts markedly with Buddhism, which has rarely given women any teaching role of substance. In a way, therefore, it is easier for Western women to become spiritual teachers in Hinduism than in Buddhism (though there are Western Buddhist teachers who are women; see the previous section). Nearly a third of all the Western Hindu teachers featured in this book are women.

cater exclusively for Indians living in America, while its spiritual head is an American woman—actually, a series of three American women.

All of these people, from **Krishna Prem** to the **Devyashrams**, fully acknowledge their particular sub-tradition. Yet they also hold that it is original—even eternal—and universal. So the difference between them and the first group of *declared* universalists is not so great as one might think.

3. Some Westerners are part of a lineage that consists simply of transmission from guru to disciple. That is, they have *received their authorization from a teacher* and hence see themselves as transmitting the teachings of their guru rather than those of a larger tradition that exists independently of this personal transmission. **Yogeshwar Muni**, Swami **Radha** and Sri **Sivananda-Rita** are examples. **Yogeshwar Muni** was once a prominent Scientologist who broke away to found his own religion, Abilitism, before being initiated by Swami Kripalvananda (whose own teacher was regarded as an incarnation of Shiva, just like Shankara).[10] He now divides his time between teaching 'enlightenment intensives' and living in seclusion. The second of these has a long history both in Hinduism and in the West but the first is new to both. Swami **Radha** and **Sivananda-Rita** are disciples of Sivananda but have absolutely no connection with each other. Radha has an ashram in Canada, where she runs a particularly eclectic programme (including spiritual exercises of her own devising; she has even patented the names of some of them), **Sivananda-Rita**'s centre was in Australia and she had a number of African disciples.

But perhaps the best known exemplars of this kind of Western teacher are the disciples of *Yogananda* who teach *kriya yoga*. This is a fascinating story which you can follow in the entries of the principal players. What is particularly interesting is that rather than being equal but independent teachers, some of them are 'orthodox'/'official' and some of them are not. The former include **Rajarsi Janakananda**, who was *Yogananda*'s successor as head of the Self-Realization Fellowship in Los Angeles, and Sri **Daya Mata**, who was **Rajarsi Janakananda**'s successor. (So we have a Western *kriya yoga* lineage here.) The heterodox/unofficial are a varied bunch. Roy Eugene **Davis**, for example, says he is now an independent truth teacher; Donald Walters/Swami **Kriyananda** has a co-operative village in California; Melvin Higgins/Goswami **Kriyananda** has a temple in Chicago. None of them has any contact with the others.

Yet again, all of these people, from **Yogeshwar Muni** to the two **Kriyanandas**, regardless of their affiliation (if they have one), hold that what they teach is a universal truth.

4. Lastly, there are those who have more or less *set up on their own* and rely upon their own realization as the basis for their teaching. Some of them, like **Rudi**, had a teacher (in his case, Muktananda) but parted company from him. Like Muktananda, he transmitted *shaktipat* (see the Glossary). He was succeeded by another American, Michael Shoemaker/Swami **Chetanananda**. Others, like **Ram Dass**, while they stayed true to their teacher, have never claimed that they were appointed to teach. **Ram Dass** was for many years the best-known representative of 'hip' Hinduism—there is no 'hip' Buddhism or

[10] In a way, then, he *is* part of a tradition: Shaivism in its widest sense. But it is so loose, and consists of sub-lineages that are so disparate (and do not recognize each other), that it is more accurate to refer to it as an independent transmission. Going back to the games analogy that I used at the beginning, Australian Rules Football and Gaelic Football might both be members of the Sports Council, but that does not mean that they are played according to the same rules.

Sufism—though perhaps 'liberal' Hinduism would be a less flippant title. He was the inspiration behind the best-selling *Be Here Now* (published in 1971), the last word in hipness. Since then, he has set up various organizations that are concerned with compassionate social action, involving prison visiting, AIDS hospices, and care for the dying. Somewhat less known is Bill Haines/Swami **Abhayananda**, who experimented with psychedelic Hinduism in the 1960s before LSD was illegal, and then set up an ashram in Arizona.

But the majority of these independent Western Hindus say that they attained realization independently of any teacher (though they may have had several). This may sound like blowing one's own trumpet but it need not be so. Rather, one can claim that the original, universal state—those same attributes again— manifests itself by its own laws, so to speak. The fact that someone else, one's guru, may be its instrument does not alter this essential truth. Paul **Brunton**, John **Levy**, the **Mother**, Alice Coltrane/Swami **Turiyasangitananda**, Steve Sabine/**Shankar Das**, and Joya **Santanya** are six very different instances.

> **Brunton** began as a practitioner of *Ramana Maharshi*'s 'Who am I?' method before going on to become an independent teacher in his own right

> **Levy** was taught by the celebrated Vedantin, Sri Krishna Menon/Sri Atmananda (and at one point gave talks on Advaita to British troops stationed in India)

> The **Mother** was a co-worker with Sri *Aurobindo*, and carried on his integral *yoga* (calling it the '*yoga* of the cells') after his death. She lived in India for over 50 years and had many Western and Indian disciples. And since her death, two of them have taken up her mantle, so to speak (though not without controversy): **Sat Prem**, a Frenchman who more or less lives in seclusion; and Patrizia **Norelli-Bachelet**, an Italian ex-actress, living in India. Both of them are self-appointed and therefore not 'official.' (So we do not have a Western lineage here as we do with several other Western Hindu paths.)

> **Turiyasangitananda** receives teachings direct from God. Her writings are a mixture of *Old Testament* prophecy and Hindu terminology

> **Shankar Das** had a vision of God (and his followers sometimes see him in the form of Shiva)

> **Santanya** had visionary contact with Neem Karoli Baba (**Ram Dass**'s master)

It is evident that Western Hindu teachers cover an extraordinary range:

> entering various lineages (Shaiva, Vaishnava, *kriya yoga*);

> creating Western extensions of Eastern lineages (Swami **Abhayananda**/Marie Louise, Swami **Abhishiktananda**, the **Hare Krishna gurus**, **Rajarsi Janakananda**, **Rudi**, Sri **Krishna Prem**, **Mahendranath**);

> creating their own lineages (Donald Walters/Swami **Kriyananda**);

> sticking to tradition (Sisters **Devamata** and **Daya**, the **Hare Krishna gurus**, Guru **Subramuniya**, **Rajarsi Janakananda** and Sri **Daya Mata**);

breaking away from tradition (Swami **Abhayananda**/Marie Louise);

bringing together different traditions (Swami **Abhishiktananda**, George **Burke**/Swami Nirmalananda, Father **Satchakrananda**);

creating their own tradition (the **Mother**);

acting independently of any tradition (Paul **Brunton**, Roy Eugene **Davis**, Swami **Turiyasangitananda**);

ecstatic (Joya **Santanya**);

devotional (Sri **Krishna Prem**);

contemplative (**Mahendranath**);

visionary (Swami Lakshmi **Devyashram**, Guru **Subramuniya**, Father **Satchakrananda**, Joya **Santanya**, Swami **Turiyasangitananda**, Patrizia **Norelli-Bachelet**);

wanting to change society (Shrila **Bhaktipada**, Leo **Maclaren**);

giving initiations (Swami **Abhayananda**/Marie Louise, the **Hare Krishna gurus**);

transmitting *mantras* (Swami **Radha**);

transmitting *shakti* (**Rudi**);

living in seclusion (**Mahendranath**, **Yogeshwar Muni**, **Sat Prem**);

working with the sick and dying (**Ram Dass**);

running ashrams (Swami **Radha**, Swami **Turiyasangitananda**, Joya **Santanya**, **Shankar Das**, Shrila **Bhaktipada**, Swami **Abhayananda**/Bill Haines, the **Mother**—in her case, a complete city);

in India (Sri **Krishna Prem**, **Mahendranath**, some **Hare Krishna gurus**);

with Indian followers—some in India (see the preceding line), some in the West (Guru **Subramuniya**, the **Devyashrams**).

This is Western Hinduism firing on all cylinders.[11]

WESTERN SUFISM

Sufism may be defined as a path to God by which one simultaneously attains love and knowledge of Him. In the East, it has existed in the form of orders or *turuq* (the plural of *tariqah*), which are all regarded as different ways of approaching God and are not in essential conflict with each other (a bit like the Tibetan Buddhist schools or the Christian monastic orders).

[11] I should also mention a number of independent teachers—Andrew **Cohen**, Jean **Klein**, Bhagavan **Nome**, Master **Da**—who had various kinds of contact with Indian teachers. It would be misleading to call any of these Westerners Hindus. But the connection with aspects of Hinduism, in the broadest sense of that term, is undeniable.

The Sufi Order	The Shadhili-Akbari Order
Brought to the West in 1910 by Hazrat Inayat *Khan*, a *murshid*/teacher of the Chishti Order in India, who was told by his own *murshid* to spread Sufism in the West.	Its Western branch began around 1907 when Ivan **Agueli**, a Swede living in France, was initiated in Egypt by Sheikh Abd al-Rahman, head of one of the sub-lineages of the Shadhili Order. Al-Rahman also advocated a universal form of Sufism which he associated with the teachings of Ibn 'Arabi, often called 'Akbar' (the Great One); hence my use of the term 'Shadhili-Akbari Order.'
The Order was entirely Western (apart from Inayat *Khan* and members of his family who had accompanied him to the West).	**Agueli** was authorized to initiate others whom he thought ready. He returned to the West but the only person whom we know he initiated was René **Guénon**.
Members of the Order were not required to be Moslem. Instead, Inayat *Khan* taught a form of universal Sufism that was independent of Islam.	**Guénon** was already developing his own formulation of Traditionalism: that all traditions are expressions of the one Truth; and this Truth requires an external form which contains and supports it. So Sufism *must* be Moslem. This fitted very well with al-Rahman's universal Sufism.
He appointed four Westerners as teachers: Rabia **Martin**, Lucy **Goodenough**, Saintsbury **Green** and Mevrouw **Egeling** (all of them women: an American, two Britishers and a Dutchwoman).	The Western branch of the Shadhili-Akbari Order only consisted of **Agueli** (who died in 1917) and **Guénon**. There was no Eastern *sheikh* in the West.
Inayat *Khan* wrote books and so did some of his Western pupils. There was a magazine, *The Sufi*.	These Western Sufis never announced themselves publicly: no meetings, no books, no hint of the existence of a Western branch of a Sufi order.

It is a striking fact that the two earliest forms of Western Sufism, the **Sufi Order** and the Shadhili-Akbari Order, both started within a few years of each other and have existed in parallel, but without the slightest contact, for 80 years. I do not have the space to give the details of the history of this dual development so I simply outline the basic differences between the two groups (see above).

The **Sufi Order**, then, was founded in the West by an Eastern teacher; was entirely Western; was non-Moslem; had Westerners (including women) appointed as teachers; and, though low-key, made itself accessible to the

public. The Shadhili-Akbari Order, on the other hand, was brought to the West by a Westerner and was at least intended to be Moslem (although whether **Agueli** and **Guénon** fulfilled the *shari'a* is open to doubt); it was not really an organized order at all; and nobody knew about it.

Yet there are similarities, too: namely, that both propagated a form of universal Sufism. Only they were opposite kinds of universalism. Inayat *Khan* held that Sufism was simply the name for the one truth, which was the same in all traditions and in none. Hence it was perfectly possible to present this truth in a new way such as the **Sufi Order**. **Guénon**, on the other hand, said that there is no truth outside tradition. And traditions are ordained; they cannot be invented. (Trying to create a tradition is like trying to build a mountain: it is a contradiction in terms. A pile of earth and rocks, however large, is not a mountain, of course; it simply looks like one.)

Both of these orders still exist in the West. The **Sufi Order** has undergone a number of divisions, each led by a Westerner. The first occurred after the death of Inayat *Khan* in 1927. His very first disciple, Rabia **Martin**, taught as an independent Sufi for the next 20 years and eventually handed over her Sufi group to *Meher Baba*. And it was Baba who appointed Ivy **Duce**, Martin's successor, as *murshida* of Sufism Reoriented in 1952—the only one of his followers of any nationality to whom he gave a teaching role. He died in 1969 and twelve years later, so did Murshida Duce, having named James **MacKie** as her successor as *murshid* of Sufism Reoriented. (Details of the extraordinarily high spiritual claims that are made on his behalf can be found in his entry.)

Another American disciple of Inayat Khan, Samuel **Lewis**, also became an independent Sufi. But on top of that, he was also one of the first exponents of what I call 'experiential comparative religion.' Not only was he recognized as a teacher by *sheikhs* in a number of Sufi orders (including the Chishti, the Naqshbandi and the Shadhili), he also practised Zen with Japanese and Korean *roshis* (and received Dharma transmission from one of them), and later was a sort of disciple of Papa Ramdas, a well-known Hindu teacher. All his pupils were Western. They formed their own Sufi group after his death. One of its distinctive features is the Sufi dances that Murshid Sam devised.

Meanwhile, back in Europe, the original **Sufi Order** has also divided into a number of groups, all of them led at one time or another by relatives of Hazrat Inayat *Khan:* two brothers and a 'cousin brother' (who were Indian), two sons (Vilayat **Khan** and Hidayat Khan, who are half-American because their father married an American but are British citizens because they were born in Britain), a nephew (half-Dutch) and a grandson (half-Dutch, quarter-American and quarter-Indian). Further details of all these in the group entry, **the Sufi Movement and the Sufi Order**.

Parallel with these developments in what might be called the Sufism of the followers of Hazrat Inayat *Khan,* is a new strand in the Shadhili-Akbari Order. This is associated with a Swiss, Frithjof **Schuon**, who was initiated into the Alawi branch of the Shadhili Order in Algeria in 1932, took the name Isa Nur ad-Din, and was subsequently appointed as a *moqaddem*—someone who can initiate others. For the next 15 years or so, **Guénon**, who was living in Egypt but was not a *moqaddem*, sent a sizeable number of Westerners to Schuon for initiation. But the two eventually separated. **Guénon** died in 1951, while **Schuon** has gone on to create his own order, the Maryami, dedicated to the Virgin Mary and based in Indiana. It is one of the fascinations of this whole

phenomenon that the two men, once closely linked, should have ended up so differently: **Guénon** as a traditional Moslem Sufi living in the East, and **Schuon** as an independent Sufi living in America.

To sum up: there exists in the West a brotherhood (and it *is* a brotherhood: women are decidedly secondary) of Western Sufis, all of whom are members of the Shadhili Order and its branches, and who espouse Traditionalism of a more or less Guénonian kind. It has been in existence for 80 years and active for 60 (since the **Guénon-Schuon** partnership began around 1934). But it is still effectively secret. (How many people who have read the works of **Guénon**, **Schuon**, Lings, Stoddart, Daner, Nasr, or Huston Smith, all of whom are members of it, know that it exists?)

And it has no connection whatever with the **Sufi Movement/Sufi Order** or any of their offshoots, all of which are non-Moslem, and which as a consequence it regards as literally without foundation. Needless to say, the non-Moslem form of Sufism has a reply to this: that the inner reality is not dependent on the outer forms. This is a crucial issue and I discuss it in Chapter 3. But it is worth knowing that these two approaches existed right from the beginning of Western Sufism.

In addition to the Sufi and Shadhili-Akbari Orders, there are Westerners associated with other Sufi orders. At least three of them claim to be part of the Naqshbandiyya:

> Idries **Shah**, who is half-Afghani and half-Scottish, and in all essential respects a Westerner; a large number of claims are made on his behalf;[12]

> Abdullah **Dougan**, a New Zealander who had some contact with Gurdjieff groups (but not **Gurdjieff** himself) and with the **Sufi Order** before entering the Naqshbandi Order in Afghanistan; he ended up creating a sort of Gurdjieff-Sufi hybrid;

> Irina **Tweedie**, a Russian by birth but British by marriage, who was taught by an Indian master in Lucknow and now transmits *barakah* in the West (and whose nominated successor is American).

None of these is Moslem, and none of them has any contact with the others. They are independent Sufi teachers first and foremost rather than representatives of an Eastern lineage (even though they all do claim to be representatives in some sense).

Much the same can be said of two teachers in the Mevlevi Order:

> J.G. **Bennett**, a pupil of both **Gurdjieff** and **Ouspensky**, who had a number of Sufi initiations, and was also involved with Idries **Shah** for a time; in addition, he had contact with an Indian sage, Shivapuri Baba, and ended up a Catholic (via Subud). (Details of this extraordinary trek can be found in his entry in Part II.)

> Reshad **Feild**, ex-pop singer, who now teaches 'the science of breath' independently of any order, Sufi or otherwise.

[12] But one that he has made himself is that **Gurdjieff**'s teachings were taken from Sufism. This is a knotty issue (which takes in other teachers such as Abdullah **Dougan**, J.G. **Bennett**, and E.J. **Gold**) but I cannot go into it here.

Finally, I would like to mention an American, Lex **Hixon**/Sheikh Nur al-Jerrahi of the Halveti-Jerrahi Order, who also practised according to the traditions of Zen Buddhism, Tibetan Buddhism, Eastern Orthodox Christianity, and the Ramakrishna Order. This kind of cross-traditional investigation (somewhat reminiscent of **Lewis** and **Bennett**) is an important element in the whole phenomenon of Western teachers and I discuss it further in Chapter 3.

It is evident, even from this short survey, that Western Sufism is extremely varied. Western Sufi teachers come from nine or ten countries (depending on how you assess people of mixed parentage) and are distributed among six or seven orders (depending on how you assess the various branches of the Shadhiliyya, the Naqshbandiyya, the Mevleviyya, and the various divisions of the Sufi Order). This range is typical of Western teachers in all traditions; and so is their varying degree of orthodoxy (by which I mean their similarity with the Eastern models). These issues are also discussed in Chapter 3.

On the other hand, Western Sufism does have its distinguishing features, and in many ways it is fairly different from other Eastern traditions. There are no Western teachers in Moslem countries who are teachers and have indigenous pupils. (But there are Western Buddhist teachers in Buddhist countries and Western Hindu teachers in India.) There are no prominent women in Moslem Sufism (unlike the various kinds of Buddhism, Theravada, Zen, Tibetan, and Hinduism) but there are quite a few in the non-Moslem variety.

Yet it has to be said that non-Moslem Sufism is itself something of an anomaly. It is difficult to find teachers who say that they teach Theravada, Zen, or Tibetan Buddhism but who are not Buddhists, or teachers of Vaishnavism or Shaivism who say they are not Hindus. It does sound rather odd, doesn't it? Yet there are Westerners in all these traditions who have effectively made themselves independent of the tradition in various ways: some have dropped those aspects of the tradition which they say are purely cultural (such as the *vipassana sangha*); some have developed their own version of the tradition (Ven. **Sangharakshita**, Roshi **Kennett**) or have extended it in some way (the **ecumenical** *sangha*, **Rudi**). But some do say, like the non-Moslem Sufis, that what they teach is only accidentally associated with the tradition in which they found it (Jean **Klein**, Master **Da**).

It is a striking fact that most of the Western Sufi teachers in this book are independents of one kind or another This even applies to people like **Guénon** and **Hixon** who were practising Moslems. (At least, **Guénon** was after his move to Egypt.) But **Guénon** was a Traditionalist who wrote two books about Vedanta and not a single one about Sufism, while **Hixon** practised in at least four traditions. I doubt if any Eastern Sufi has ever done anything remotely similar. But most of the other Westerners are far more independent than that. Some teach a 'higher' Sufism. But even this has different forms: the love of God (**Tweedie**), ancient wisdom (**Shah**) or the core of all traditions (the **Sufi Order**). Others refer to Sufism only in passing (**Feild**) or use the term in a way that has absolutely no currency in any other Sufism known to us (**Duce**, **MacKie**). None of these people are Moslems. This is simply not an option in Eastern Sufism.

I deal with the significance of such departures as part of a general discussion in Chapter 3. The point I want to make here, as the conclusion to this account of Western Sufism, is that it is more different from its Eastern parent than any of the other traditions (even Hinduism, which allows independence very easily).

INDEPENDENT TEACHERS

An independent teacher is one who teaches from himself or herself without appeal to any other teacher or any tradition. This is a very broad definition and needs to be clarified. First, I want to differentiate independent teachers *per se* from, say, independent Zen teachers or independent Sufi teachers: that is, from those who do derive their authority from a tradition but do so independently of any other form of it. We have already come across a number of examples:

Zen	Roshi Jiyu **Kennett**, Zen Master **Tundra Wind**, Zen Master **Rama**
Tibetan Buddhism	**Namgyal** Rinpoche
Hinduism	**Rudi**, **Shankar Das**
Sufism	Samuel **Lewis**, Reshad **Feild**

In contrast, what we might call out-and-out independent teachers may have had contact with Eastern teachers and traditions (for example Swami **Turiyasangitananda**, Michael **Barnett**, Paul **Twitchell**, John **Yarr**, **Shunyata**, **Marasha**, Master **Da**); and in some cases they may even have been authorized to teach (Jean **Klein**, Andrew **Cohen**). But in addition, and more fundamentally, they also

either claim to have transcended their teacher(s)/tradition(s) (**Barnett, Twitchell, Yarr, Marasha, Da**)

or say that what they teach is self-contained, so to speak, and not dependent on where they got it from (**Klein, Cohen**).

Then there are independent teachers (including some of the above) who

say that they didn't actually get their teaching from anyone or any tradition but rather have discovered it for themselves (**Shunyata, Stephen** Gaskin, Barry **Long**, Bhagavan **Nome**, Lee **Lozowick**);

or say that they received their teaching direct from the source (**John-Roger** Hinkins, **Turiyasangitananda, Marasha, Da** [who actually claims to be the source], Leonard **Orr**).

Finally, there are those who

claim to have been taught by a secret school of some kind, either physical (**Gurdjieff**) or non-physical (Madame **Blavatsky**, Omraam Mikhail **Aivanhov**, Serge **Raynaud de la Ferrière**, Elizabeth Clare **Prophe**t).[13]

So much for what makes a teacher independent. (More on this topic in Chapter 3.) Needless to say, the very fact that they are independent means that

[13.] Secret schools or brotherhoods of this kind can be regarded as traditions in themselves. But the point is that we only know about them from these teachers. Hence for all practical purposes, they are the source. That is what makes them independent.

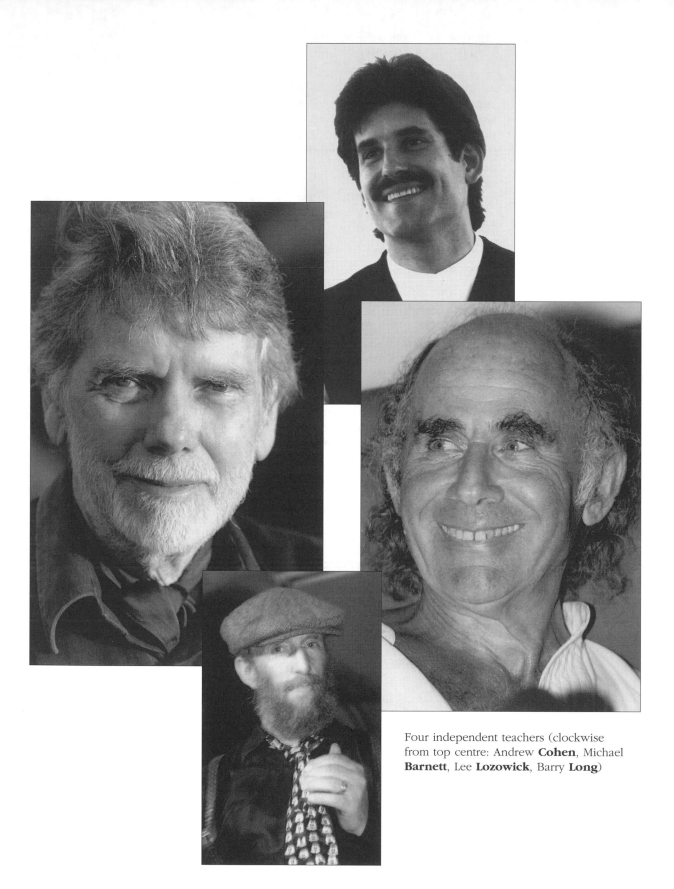

Four independent teachers (clockwise from top centre: Andrew **Cohen**, Michael **Barnett**, Lee **Lozowick**, Barry **Long**)

they have to be taken more or less on their own terms and cannot be referred back to an already existing tradition (which can be done with teachers in Eastern traditions, even those who are 'independent' teachers in those traditions). But there are four different kinds of independent teacher:

Those who know the secret

Travellers on the inner path

Embodiments of truth

Bestowers of enlightenment

THOSE WHO KNOW THE SECRET

These people have discovered the answer to the problems of human existence and have taken it upon themselves to pass it on to others. It is a somewhat mixed group and has three sub-divisions.

Those Who Have a System of Transformation

For the most part, the phenomenon of independent teachers is fairly recent. It began to emerge in the 1960s and then developed quite rapidly. (See the next chapter.) But there were a few precursors, of whom the most significant is undoubtedly **Gurdjieff**. He appeared in Russia around 1911, gathered a few pupils (including **Ouspensky**), and, having come to Europe after the Russian revolution, established his institute near Paris in 1922. He spent the rest of his life in Europe (with frequent visits to the United States).

Gurdjieff's teaching was quite complex but its essential features can be summarized as follows: man is asleep and has to be given shocks to wake him up; work on oneself, which is essential if one is to wake up and fulfil the cosmic role that the human race was designed for, can only be accomplished under the guidance of a teacher who is already awake; and even the guidance of the teacher requires the existence of a school if anything substantial is to be accomplished.

This teaching, and **Gurdjieff**'s efforts to establish it, would be significant enough by itself. But in fact there have been a number of other Westerners who have become Fourth Way teachers as a result of their contact with **Gurdjieff**: (either directly or indirectly): P.D. **Ouspensky**, **Madame Ouspensky**, Jeanne **de Salzmann**, A.R. **Orage**, J.G. **Bennett**, Maurice **Nicoll**, Rodney **Collin**, Leonardo **Maclaren**, Robert **de Ropp**, E.J. **Gold**, Jan **Cox**.

This is a very mixed bunch. Between them, they cover a lot of ground (spiritually and geographically); and taken all together, they constitute a phenomenon in themselves: namely, a set of lineages of varying degrees of orthodoxy, which all claim to represent **Gurdjieff** (though orthodox Gurdjieffism is an extremely problematic notion). But varied as they are, all teach a particular form of spiritual psychology:

that there is a way of knowing which makes sense of the universe and our place in it;

that the man or woman who knows is "as we might be" (in Gurdjieff's phrase);

that such a man or woman can provide the conditions within which we can also come to know.

Members or Representatives of the Spiritual Hierarchy

The earliest and the best-known is undoubtedly Madame **Blavatsky**. She founded the Theosophical Society in New York in 1875 (together with Colonel **Olcott**, already mentioned in the Theravada Buddhism section) and died in London in 1891. In the intervening years she was responsible for establishing Theosophy as the most influential esoteric movement of the last hundred years, not only in the West but also in India. Central to Theosophy were the twin ideas of the ancient Wisdom Religion which is the basis of all religious traditions; and the spiritual hierarchy, known as the Great White Brotherhood, which guides humanity and releases spirituality into the world. And **Blavatsky** was seen as the mouthpiece of the Great White Brotherhood. She never claimed to be a member of it herself (it had no female members in any case) but all Theosophists regarded her as having a unique role in its working.

This notion of an esoteric teaching which is vital to the human race but only available via certain teachers who have contact with the source of it, is an obvious example of the category of independent teachers that I am considering here—those who know the secret. And the reason that they are independent is of course that they do not rely for their authority on any 'external' or exoteric tradition but purely and simply on their appointment by the hierarchy.

And **Blavatsky** is by no means the only one to make this claim: Omraam Mikhael **Aivanhov** (Bulgarian but based in France), Serge **Raynaud de la Ferrière** (a Frenchman who went to Venezuela in the 1940s) and Elizabeth Clare **Prophet** (American through and through) all say that they represent a form of the Great White Brotherhood (but quite independently of each other).

All of these teachers, from **Blavatsky** to **Prophet,** are variants on the Western esoteric tradition but with an Eastern slant. It is, of course, significant that they make use of Eastern teachings such as *karma*, as well as taking the efficacy of various kinds of *yoga* for granted. But much more important, in my view, is that they present themselves as having been authenticated by Eastern masters.

Those Living in Accord with the Divine Will or the Transcendental Source

This is another very mixed bunch. What distinguishes them is that their claim to be teachers is not particularly connected with their having discovered a system of transformation, nor with their being part of an esoteric order that is guiding humanity, but rather follows from their having tapped into the source directly so that they operate from that standpoint at all times. For example:

Swami **Turiyasangitananda** (former jazz pianist Alice Coltrane, who has an ashram near Los Angeles):

> my eyes only see only the true Reality that supports this universe, and also the things which remain concealed beyond the ken of the human mind. This perfection and freedom can be experienced not only in the heaven worlds, outside or around this universe, but right here on earth.

Stephen Gaskin (usually referred to simply as **Stephen**), leader of the Caravan that crossed America in 1970 and founder of The Farm in Tennessee:

> I'm a spiritual teacher . . . I can look at somebody who isn't in very good shape and they get in better shape, just because I want them to.

G.B. **Chicoine**, an American who was the guru of a group of J.G. **Bennett**'s pupils in England for a while in the 1970s, saying that he was an agent of Dattatreya, the cosmic guru, the Teacher of teachers, but who then renounced his position and 'retired':

> I am simply offering a reconnection to the Source and this is no empty assertion.

Michael **Barnett**:

> I'm in touch with the place that the human race is going to move to; and out of that, I am devising ways every day of bringing others to that place . . .

If the phenomenon of Western teachers is like the formation of an orchestra to play a new kind of music, then this section, from **Gurdjieff** to **Barnett**, is certainly the most cacophonous. And I defy anybody to harmonize it—especially as the quality of the playing is extremely variable, to say the least. But the fact remains that this music *is* being played, and even composed, by Westerners. And it is essentially new music. An account of its principles, not to mention a discography, is therefore required. (Hence this book.)

TRAVELLERS ON THE INNER PATH

All the Westerners of this kind are historically connected to an ancient Indian teaching: that the soul is trapped in the physical world (and the physical body) but can go back to its source by following an inner path to God, using light and sound, guided by a master who has already traversed the path. And the reason why these Westerners are independent is because none of them acknowledges where they got their teaching from.

Paul **Twitchell**, the founder of Eckankar, is a case in point. He was an initiate of Kirpal Singh, one of the Indian teachers of this path, but later, as a self-proclaimed Eck Master, denied ever having met Kirpal Singh. Not only that, but there are passages in his books which are identical, word for word (except for the proper names, which he changed), with whole paragraphs in another book describing the inner path of light and sound—but which was published 30 years before his own. In fact, the whole story of Eckankar, including **Twitchell**'s two successors as Eck Masters, Darwin **Gross** and Harold **Klemp**, is fairly odd.

Much the same could be said of two other examples of this teaching: the Movement for Spiritual Inner Awareness or MSIA (pronounced *Messiah*) and Lifewave. The first was founded in 1968 by an American known as **John-Roger** (or just plain J-R), who had been a member of Eckankar for a time. He claims to be the embodiment of the Traveler Consciousness, who can take his initiates to the Soul realm. But over the last ten years a number of disaffected initiates have accused him of threatening behavior and sexual manipulation.

One of them even produced a whole book dedicated to exposing J-R as a fraud. Ex-disciples often feel disgruntled about their erstwhile master but they rarely go to these lengths.

As for Lifewave, it was started in Britain in the 1970s by an Irishman (who was then in the British army), John **Yarr**. He was initiated into Guru Maharajji's Divine Light Mission but after weeks of intense meditation declared that he had gone much further than Guru Maharajji himself. He took the name 'Ishvara' and began to initiate people. By the mid-1980s, 46 of these initiates had become Adepts—that is, they had become enlightened (though none of them was equal to Ishvara, who was described in Lifewave literature as God in human form). Then in 1986, **Yarr** was denounced for sexual misbehaviour and the Adepts actually disbanded Lifewave—the only time a movement of this kind has been dismantled by its own followers, as far as I know. But **Yarr** continues to teach—on a 'consultancy basis', I'm told—on a rather more limited scale than before.

It is difficult to believe that anybody who knows the basic facts about these men could easily accept what they say about themselves: **Twitchell** as the 971st Eck Master; **John-Roger** as someone with a divine task; **Yarr** as the Avatar. But they are still part of the phenomenon of spiritual psychology—a flawed part, perhaps, but nonetheless in the frame. And the mere fact that such claims can be made by Westerners, and using terminology that is for the most part derived from Eastern sources, is itself significant regardless of how much we think they fall short of them.

EMBODIMENTS OF TRUTH

One of the Eastern teachings that has had a great impact in the West is notable for its simplicity and power: that we all 'possess' a state of pure consciousness here and now that is beyond space and time (and therefore cannot be contaminated or lost); realization is simple and easy; and the spiritual teacher is one who manifests this truth at all times just by *being*. There are now Western teachers who say this; and they are all independent in the sense that they teach from themselves—from their own state of realization—and do not go back to their own teacher or tradition (if they had one) for their authority to teach.

These teachers include:

> Jean **Klein**, a Frenchman who went to India over a quarter of a century ago and found a teacher, but who teaches from himself (because that is the only teaching that is true):
>
>> There is only oneness. This is what I come here to communicate. Identity with this presence, this wholeness, this fullness, is meditation, but there is no meditator nor object upon which to meditate. This, then, does not belong to a philosophy—it is your real nature. (*Ease of Being,* 1)
>
> Barry **Long**, an Australian, says much the same thing: there is only one 'I' that exists; it is synonymous with truth, love, life; it is who you really are. Barry **Long** applies this terminology to who *he* really is:
>
>> There is only one Master in the entire universe and "I" am that. "I" am external to you because you are not the Master yet. "I", in the body of Barry Long, am approaching you. "I" am also coming towards you from within. (*Staying In Touch,* tape 2)

Shunyata, a Dane who went to India in the 1930s and lived there until he was invited to California by the Alan Watts Society in 1978 (where he gave 'teachings' on Watts's houseboat). He said that he had been aware since childhood. He also said: "I am my own tradition"; "the method is stillness"; "I have nothing to teach, nothing to sell". He defined Shunyata as a full solid emptiness or no-thing-ness and said "I speak out of Shunyata in a way."

Bhagavan **Nome** practised *Ramana Maharshi's* method of Self-enquiry while a young man living in America—and attained enlightenment. He currently has a group of followers in and around Santa Cruz, including two who are themselves enlightened (called 'sages'). And although he refers to the teachings of *Ramana Maharshi,* Anandamayi Ma, and Nisargadatta Maharaj, the real source of what he says (and incidentally he has written nothing) is his own realization.

The same could be said about Andrew **Cohen**. He attained enlightenment after meeting Poonja Ji, an enlightened follower of *Ramana Maharshi* and his first book, entitled *My Master is Myself,* was an ecstatic account of this meeting and the correspondence that followed. He says that Poonja Ji had "handed over his robe to me"—that is, made him his successor—yet within a few years, he had come to the conclusion that Poonja Ji was not in fact a truly realized man and that "I had obviously surpassed my own Teacher" (*Autobiography of an Awakening,* 106). **Cohen** currently has a *sangha* of about a hundred followers living around him; but he also says that he is quite alone, independent of all others.

All of these teachers are fairly recent, and some of them are indeed extremely new. In 1990, Chris Orchard, aged 30, met Emma Lea, aged 23. He had been seeking enlightenment for some time and had had a number of teachers; she, on the other hand, had been realized since the age of three and had never felt the need to seek anything. They are now married and teach as a couple: **Chris and Emma**. Chris specifically says that

> I Realised the Truth of Life in the West and therefore do not have a spiritual tradition to back me up.

Emma, of course, attained her realization outside any tradition. As with all very new phenomena, it is too early to say what will happen—but the point is that it has happened.

These teachers—the ones who embody truth—challenge the fundamental assumptions of those who claim to know the secret and of those who act as guides on the inner path. They say there is no secret to the universe, nowhere to go and nothing to accomplish. So there is no system, the spiritual hierarchy is no more real than your next-door neighbour and God doesn't choose anybody. Everything is here now.

And as I have already said, their independence is a consequence of their state of realization and not because of the way in which they found it. Emma and **Shunyata** had no teacher; **Nome** followed a method recommended by a great teacher but what he discovered is not dependent on *Ramana Maharshi*;

Klein, **Long**, and **Cohen** all had teachers (though **Long** has never named his and **Klein** simply refers to his teacher as Pundit Ji) but they are teaching from themselves. And this is the true characteristic of independence.

BESTOWERS OF ENLIGHTENMENT

I think it is fair to say that the strongest claim that any teacher can make is that he or she can actually make others enlightened—not through guidance or greater experience or inspiration or example but literally as a gift. And there are Westerners who make this claim.

Kathie Dahl/**Marasha** is a black stigmatic who says that she was born enlightened and has been taught by Lord Shiva on inner planes. Actually, she was a student of an Indian *kundalini* teacher for several years, but never mentions the fact. She has written nothing and has a small group in Los Angeles (which only started in 1980). I have met her and seen the powerful effect she has on her disciples (of whom several are said to be enlightened; she married one of them a few years ago).

Lee **Lozowick** 'awoke' spontaneously in 1975 when he was a teacher of Silva Mind Control in New Jersey. To begin with, he offered a teaching of the God-man:

> I am that form of God you have come here to be. The only reason you exist is to become me.

He soon gathered a number of disciples (presently centred at the ashram in Arizona)—but he had no tradition. There were elements of Sufism in the early years and he was sometimes referred to as Saqi. Then he came across the Bauls, the ecstatic singers of Bengal, and has since formed his own rock group, with himself as lead singer. They have made a number of records but have yet to set the music world alight.

Master **Da** (aka Da Free John, Da Love-Ananda, Da Avabhasa, and Adi Da) also says that he was born enlightened, but gave up enlightenment deliberately in order to experience 'ordinary' consciousness. As a result, he had to search for enlightenment, during which he came into contact with **Rudi** and was initiated by Swami Muktananda. However, after regaining his original state of enlightenment (in the Hollywood temple of the Ramakrishna Order, incidentally), he became a teacher in his own right; in fact, he is trying to establish an entirely new tradition—a Western tradition. He has written over 40 books on every aspect of spiritual life and presently lives on a tiny Fijian island with a number of close disciples.

It is entirely appropriate that the culmination of this section of the book should be Master **Da**, an American teacher who not only says he has a message unique in our time but also claims to be a Satguru, one who can actually bestow enlightenment upon others. And whatever we might end up thinking about this claim, we should at least consider it. He's worth that much—and that in itself is remarkable, a mere 100 years after the West first encountered the gurus from the East.

The variety of Western teachers is quite extraordinary. We need to keep our eyes, and our minds, wide open to see that the following contrasting pairs are part of the same phenomenon:

Swami **Turiyasangitananda**, vegetarian, teetotaller, in orange robes, with a small ashram north of Los Angeles

Issan **Dorsey**, ex-transvestite, ex-junkie, Zen *roshi*

Roshi Jiyu **Kennett**, visionary Zen teacher, ex-abbess of a temple in Japan and leader of her own Order of Buddhist Contemplatives

Jean **Klein**, a doctor of medicine and a professor of music, who teaches a form of Advaita Vedanta

E.J. **Gold**, the joker-cum-Sufi

Sri **Daya Mata**, a stately matron who has been head of Yogananda's Self-Realization Fellowship since 1955 and has proscribed about ten teachers of *kriya yoga*, both Indian and Western

Andrew **Cohen**, who, having written a book entitled *My Master, My Self,* then said that his master was not enlightened

Ahkon Norbu Lhamo, who found out at the age of 38 that she had been teaching Buddhism all her life without knowing it

John-Roger Hinkins, who runs the multi-million dollar Movement of Spiritual Inner Awareness/MSIA out of Los Angeles

Swami **Abhishiktananda**, the Catholic *sannyasin*, living in seclusion in India

the Canadian Zen teacher, Roshi Maurine **Stuart**, who never visited Japan

The **Mother**, born in France of a Turkish father and an Egyptian mother, who spent the whole of her adult life as a guru in India

Ajahn **Sumedho**, who has been following the 227 precepts of the Theravadin *Vinaya* for 25 years

Samuel **Lewis**, who took initiations from Sufi, Zen, and Hindu teachers over a period of 50 years

Yet this diversity is the most distinctive thing about the whole phenomenon of Western teachers. That is why this summary of it has been so long. We need to know all the varieties of Buddhism, Hinduism, and Sufism which Western teachers represent, as well as the different kinds of independent teacher, in order to understand what is happening: that something new has arisen in Western culture.

But it isn't just that Eastern traditions have been transposed to the West (though that has happened). Rather, Eastern teachings have become Westernized so that what were previously closed systems have become international and comparative. Or perhaps it would be more accurate to say that they are becoming international and comparative. This is a continuous process and at the moment is rather uneven. But every tradition and teacher is part of it. It is impossible not to be.

Of course, the West has not only transformed Eastern traditions but also been influenced by them. How this has happened is necessarily complex but it can be summarized by the four principles of spiritual psychology. I gave them earlier and I give them again here:

The best way to understand human beings is in terms of *consciousness* and its modifications

There are *spiritual practices* which transform consciousness

There are *teachers* who have achieved this transformation

They can help others achieve it by some form of *transmission*

These can vary considerably, but all the teachers in this book exemplify them in different ways.

Consciousness can be seen as

inherently intelligent (**Rudi**);

"that which is wise in the universe" (Ajahn **Sumedho**);

dynamic stillness and presence (Michael **Barnett**);

capable of objective knowledge (**Gurdjieff**);

that within which the universe itself rises and falls (John **Levy**);

identical to life, love, and God (Barry **Long**).

Spiritual practice can be

just sitting (the *zazen* teachers: Philip **Kapleau** and others);

just listening (Toni **Packer**);

observing the movements of the mind (Sharon **Salzberg** and other members of the ***vipassana sangha***);

living according to the tradition (Guru **Subramuniya**);

communal living (Swami **Kriyananda**'s co-operative village);

contemplation of the Absolute (Swami **Abhishiktananda**);

radical acceptance or faith (**Jae Jah Noh**);

devotion to God/Krishna (Sri **Krishna Prem**).

Teachers may have any of the following functions:

skilled guides (Maurine **Stuart**);

tricksters/disturbers of the peace (E.J. **Gold**, G.B. **Chicoine**);

changing the course of human evolution (the **Mother**);

being a link with the divine (the **Hare Krishna gurus**);

being the divine themselves (Master **Da**);

simply being (**Shunyata**);

manifesting truth (Barry **Long**).

They may say that they are

exactly the same as everybody else (***vipassana* teachers**);

here to perform a special task (Paul **Brunton**, Andrew **Cohen**);

unique (**Marasha**).

they may claim to

represent a tradition (the **Hare Krishna gurus**, Guru **Subramuniya**, the Shadhili Sufis, the Western Theravadin *sangha*);

introduce a Western form of an Eastern tradition (**Sangharakshita**, Bernard **Glassman**, Samuel **Lewis**);

create a new sub-tradition (Frithjof **Schuon**);

create an entirely new tradition (Master **Da**);

deny the necessity for tradition altogether (Jean **Klein**).

Transmission may be

specific training (Richard **Baker** and other Zen teachers);

making a technique of transformation available (**Gurdjieff**);

initiation (Sri **Daya Mata**, Swami **Radha**);

bringing a new energy into the world (the **Mother**);

passing on a blessing (Jetsunma **Ahkon Lhamo** and other *tulkus*);

providing Divine Influence (Lee **Lozowick**);

by mere presence (Bhagavan **Nome**).

All of this is now Western because Westerners are doing it. So spiritual psychology, which originally existed in the East with more or less no contact between its various forms, has now arisen in the West as a *single* entity with various dimensions. It may not be a very coherent spiritual psychology at the moment, but that's not the point. What is crucial is that Westerners are asking questions and making comparisons, as practitioners and as teachers, which have never been asked before—certainly not in the East. This has given rise to what I call 'experiential comparative religion,' which, as its name implies, requires that its practitioners, to some extent at least, 'know' what they are talking about.

And the catalysts for this process are the Western teachers. Of course, there are many ways of being a teacher, as I have just pointed out. But one way, and it is certainly new in Western culture, is described by Guru Bhai Sahib, Irina **Tweedie**'s Indian Sufi master:

We do not teach, we quicken. I am stronger than you so your currents adjust themselves to mine. This is a simple law of nature . . . If you let flow an electric current through two wires, side by side, . . . the stronger will affect the weaker. It will affect its potency.

Men and women from all over the Western world are now doing just this. Guru Bhai Sahib also says that "only the things we understand through realization are truly ours." Westerners are teaching meditation, giving initiation,

and offering an explanation of the human condition, not because they have learnt these things at second-hand but because they have realized them—because they are theirs.

How this unexpected and unprecedented state of affairs came about is the story of the next chapter.

2 THE STORY

How Westerners Have Become Spiritual Teachers

The way in which spiritual psychology has become established in the West is extremely complex. It could hardly be otherwise, given that it is a phenomenon that is derived from several Eastern traditions, all of which came to the West independently of each other at different times and in different ways. What follows is a very succinct account of how this happened. It is a comparative history, one that deals with the phenomenon itself rather than the separate strands that make it up, because it is one of my principal arguments that interconnection is the Western way and was present right from the beginning. Or perhaps it would be better to say that it was inevitable that connections would be made, given the nature of the phenomenon. There is a comparative chronology beginning on p. 64. It is assumed throughout this chapter, as are the entries in Part II for the people mentioned.

All starting points are arbitrary in one way or another. I have chosen 1875, the year that Madame **Blavatsky** founded the Theosophical Society, as the most obvious one. But of course the West had discovered Eastern traditions before then. Others have covered this topic from various angles[1] and I will not repeat their findings here. Since my interest is the way Eastern traditions have entered Western culture as a way of explaining the human condition, I have not noted any accounts by missionaries[2] or explorers-cum-adventurers-cum-traders. These people were certainly pioneers and therefore have their own significance. But they are not part of the story I am telling for the simple reason that they never thought that Eastern teachings might apply to them. No more did scholars, you might say—but at least the best of them *tried* to present grammars, dictionaries, and translations that were accurate. There was also the occasional exposition (though not many before 1875). I have given a few landmarks in the list of dates in order to place what follows in some sort of context. I have also included a few scholarly works after the foundation of

[1] R. Fields, *How the Swans Came to the Lake: A Narrative History of Buddhism in America* (1st ed. Boston and London, 1986); S. Batchelor, *The Awakening of the West: The Encounter of Buddhism and Western Culture* (London, 1994); P. Almond, *The British Discovery of Buddhism* (Cambridge, 1988). I am not aware of any account of the development of Western Hinduism or Western Sufism.

[2] With the exception of Waddell's *Lamaism,* published in 1895. Waddell had a low opinion of Tibetan Buddhism. But his book was very influential. In fact, it is still in print.

the Theosophical Society but I quickly drop them as the phenomenon of spiritual psychology gets into its stride.

And considering the obstacles, it gets into its stride very quickly. Fields says of Buddhism that "at the beginning of the nineteenth century, scarcely anyone had even begun to imagine that the religion that had shaped the great civilizations of India, China, Japan and Southeast Asia might have anything to offer the West" (p. 25 of the second edition). This remark applies equally well to Hinduism and Sufism.

Yet though the discovery of Eastern traditions was made (and in the midst of a rampant colonialism), it was very uneven. There is a huge contrast, for example, between Hinduism, which got started fairly early—Wilkins's version of the *Bhagavad Gita* in 1785 was the first full-length translation of a Sanskrit text in a Western language—and Zen, which produced nothing whatever, not a single translation or exposition by anyone, Western or Japanese, until *Soyen Shaku's Sermons of a Buddhist Abbot* in 1906 (which, being translations of talks he gave to Japanese Americans, were specific to that audience).

The Pali language was only discovered in the early nineteenth century and since Theravadin texts and Theravadin texts alone are written in it, Western scholars immediately began translating and explaining them. The translations were, for the most part, as good as one could expect for the time. But the expositions reflected particular Western interests: they were concerned with Buddhism *per se*, and more than that, with 'original' Buddhism, rather than the teachings of the Theravadin school; and they tended to focus on the life and personality of the Buddha as it could be reconstructed from the texts. (See the works of Rhys Davids [1877], Oldenberg [1881] and Senart [1882].)

Tibetan attracted a few doughty pioneers but Vajrayana texts are very difficult to understand without considerable prior understanding of the ideas which they contain. This explains why all the early translations from Tibetan were of non-tantric texts (which are not, of course, representative of the tradition).

As for Sufism, Western scholars concentrated exclusively on Persian and Arabic classics. There was nothing from North Africa, which was the part of the Sufi world that Westerners had the most access to.

Given this unevenness, it is hardly surprising that Western response to the traditions was mixed. Emerson and Thoreau were influenced by the work of Wilkins and Burnouf; and there were a number of Americans (for example, William **Bigelow** and Lafcadio Hearn) who were sufficiently drawn to Japan to go and live there (whereas Emerson and Thoreau never met a Hindu or a Buddhist in their entire lives). But Tibet was little more than an image in Westerners' minds. And Sufism was so tied to Islam that the most that Westerners could do was to admire it as a cultural artifact.

No doubt it is this lack of contact that explains why Easterners made next to no contribution to Western understanding of their traditions. For example, Rammohan Roy produced an English translation of some of the *Upanishads* as early as 1832, over 60 years before Swami *Vivekananda's* first writings. (*Raja Yoga* appeared in 1896.) The real difference between the two is that *Vivekananda* is presenting Hinduism—or more accurately, neo-Vedanta—as a living tradition that is relevant to the contemporary West, whereas Roy is holding up the *Upanishads* as a great example of the past. There is nothing wrong with Roy's approach but it is unlikely to lead anyone to consider becoming a Hindu. But that is precisely what I am concerned with: Westerners who saw themselves as in some way belonging to the tradition rather than just finding it interesting or even admirable.

Sowing the Seed: 1875–1916

Beginnings tend to be slow and unfocused. This is certainly true of Western contacts with Eastern traditions. True, thanks to Madame **Blavatsky**, Theosophy had a certain grandeur. And she completely changed Western occultism by locating the source of wisdom in the East. In addition, **Olcott**'s idea of an international, universal Buddhism was revolutionary—and utterly Western. No Eastern Buddhist had ever thought of the tradition in this way. Yet when all is said and done, Theosophy was always apart from the Eastern traditions that it professed to espouse for the simple reason that no Theosophist, including Blavatsky, ever had an Eastern teacher. And of course Eastern teachers were crucial at this early stage because they made the traditions available.

Yet it is a striking fact about Western Theravada at this time that Eastern practitioners hardly made any contribution to it. Not a single monk ever came to the West. (Anagarika *Dharmapala*, the only Easterner who did come, was not a monk; he was a Theosophical Buddhist and hence more or less an honorary Westerner.) In fact, Westerners made all the running: they translated the texts and 'explained' the Buddha's teachings—to each other. The reasons for this are complex but they come down to two. First, Burma and Ceylon (Sri Lanka) were colonies and colonialists tend to think that they know best. Second, the Theravadin *sangha* had a particular relationship with the laity, in which it represented the ideal of renunciation and in return was supported by lay offerings. Monks never had to explain the Dharma in the sense of presenting ideas in a critical way, still less translate texts; and it was not the job of the laity to even attempt such things. So Westerners did both themselves.

There were a few Westerners who entered the *sangha* in the East but they had to remain there if they wanted to continue as monks. There was not enough lay support in the West for them to keep their monastic vows.[3] And since the *sangha* could not be exported to the West, neither could the traditional way of life (which is entirely centered on it). So Westerners came up with something of their own: Buddhist societies. Naturally, these tended to reflect Western concerns: the development of Buddhism from its origins to the present day; the relation between the different traditions; and how an individual who was interested in some form of Buddhism could practice it. I call this approach 'general lay Buddhism'. Nothing like it existed in the East, where every lay community existed in relation to a *sangha* in a *particular* tradition with no reference whatever to other traditions.

It is easy to dismiss general lay Buddhism as well-meaning but amateurish. But it did have one great strength (and it is a typically Western one): it made connections. Hence when *Soyen Shaku*, abbot of a Rinzai monastery, attended the World Parliament of Religions in Chicago in 1893, he was sought out by Paul **Carus**, an enthusiastic general lay Buddhist. And it was through **Carus**

[3] And this is generally true of all Buddhist traditions, not just Theravada, as the case of Alexis **Tennisons** shows very well. He was a Latvian who entered the Mongolian branch of the Gelugpas in Siberia in 1893, was a monk for 25 years, and was appointed Sangharaja by the Dalai Lama. No other Westerner at this early date has anything approaching this number of years in the *sangha* or this degree of responsibility. Yet it all collapsed with the Russian Revolution in 1917. **Tennisons** went into exile—but in Burma, not the West. It was the only way he could remain a monk.

I should also mention that this is one of the few examples of a Western excursion into an Eastern tradition that eventually came to nothing. (But who knows? Perhaps a link will be made back to **Tennisons** by today's Russian Buddhists and he will be reclaimed by the tradition.)

1875–1916

The first Westerners enter Eastern traditions and some become teachers

The Theosophical Society is founded in New York, then moves its headquarters to India. **Blavatsky** popularizes two fundamental ideas: that a common teaching underlies all the world religions; and that the East is the source of authentic wisdom, available here and now.

Blavatsky and **Olcott** take *pansil* in Ceylon—the start of Theosophical Buddhism. **Olcott,** with the help of Anagarika *Dharmapala*, tries to establish an international, universal Buddhism.

Dharmapala attends the World Parliament of Religions in Chicago and afterwards establishes an American branch of the Maha Bodhi Society, the first Buddhist society in the West.

The first Europeans (**Ananda Maitreya**, **Nyanatiloka** Thera) go to Burma and Ceylon and enter the Theravadin *sangha*. When **Ananda Maitreya** visits Britain in 1908, he is the first Theravadin monk of any nationality ever to come to the West. **Nyanatiloka** begins to take pupils of his own; his Island Hermitage is entirely for Western monks.

Soyen Shaku also attends the World Parliament in Chicago and makes contacts that will lead to the foundations of Western Zen (via Nyogen Senzaki and Sokei-an Sasaki).

Alexis **Tennisons** is ordained as a Gelugpa monk in Russia and appointed Sangharaja of Lithuania, Estonia, and Latvia by the Dalai Lama.

Swami *Vivekananda* founds the Vedanta Society in New York, initiates a number of *sannyasins* (including Swami **Abhayananda**/Marie Louise, who subsequently sets up as an independent guru) and authorizes some of them to teach *raja yoga*; and initiates Sister **Nivedita** as a *brahmacharini* in India. The Ramakrishna Order establishes itself in the West (but *Vivekananda* dies in 1902 and his experiment of including Westerners as leading members of the Order is not continued—apart from Sister **Devamata**).

Arthur **Avalon** publishes *The Tantra of the Great Liberation*, the first book by a Western Hindu initiate.

The **Mother** meets *Aurobindo* in India and is implicitly recognized by him as his co-worker.

Hazrat Inayat *Khan* comes to America, gathers a few disciples and appoints Rabia **Martin** as *murshida*. He then goes to Britain, marries an American and lays the foundation for the **Sufi Order**.

Ivan **Agueli** enters the Shadhili-cum-Akbari Order in Egypt, is appointed as a *moqaddem* and initiates René **Guénon** in Paris.

Alexandra **David-Néel** makes her first contact with Tibetan Buddhism.

Ouspensky meets **Gurdjieff** in Moscow and is taught the fundamentals of the Fourth Way.

During these first 40 years, a number of seeds are sown. But what a variety!

Theosophy (including Theosophical Buddhism) is rampant;
Forms of Zen, Hinduism-cum-Vedanta and Sufism are established in the West by Eastern teachers.

And the handful of Western teachers is a very mixed bunch indeed:

an American *swami* (**Abhayananda**);
a Frenchwoman (the **Mother**) who is accepted as an equal by an Indian teacher;
European monks in the East (**Ananda Maitreya, Nyanatiloka**);
Sufis who are both Moslem (**Agueli** and **Guénon**) and non-Moslem (**Martin**); and the very first independent teacher (**Gurdjieff**).

Most of these seeds grow into sturdy plants eventually but at this stage one would be forgiven for thinking that they are rather fragile. Apart from Theosophy, which acts as a kind of fertilizer, there is no connection between any of them. They occupy small and isolated patches of ground; and they are distinctly foreign imports. A few Westerners are already acting as teachers but are struggling against the odds.

that *Soyen Shaku* returned to America in 1905 to teach.[4] The number of Americans involved in this experiment was tiny and on the face of it nothing very much was accomplished. But the point is that *Soyen Shaku* came. He provided the contact and it was entirely through him (and his pupils who stayed on in America) that Westerners knew anything about Zen at all. No Westerners practised in Japan (unless we count M.T. **Kirby**—a by no means straightforward case) and there were no translations of Zen classics, whether by Westerners or by Japanese. Everything had to come directly from Japanese teachers—the exact opposite of the Western discovery of Theravada.

Personal transmission of this kind is crucial to the whole phenomenon of spiritual psychology. And no one exemplifies it better than Swami *Vivekananda*, the first Easterner to come to the West who can unequivocally be called a guru: someone who had attained a certain level of realization and could transmit it to others. Hence when he initiated some Western students as *sannyasins* and appointed them to teach *raja yoga*, he was admitting them to Hinduism.[5] This was a first—and a significant one despite the fact that his experiment of opening up the tradition to Westerners was discontinued after his death.[6] It is true that Western perception of Hinduism as a whole at this time was very vague, to put it mildly. But the notion of the realized teacher was presented for the first time and it has remained ever since.[7]

This idea was also at the heart of one of the forms of Sufism to be established during this period: Hazrat Inayat *Khan*'s **Sufi Order**.[8] And he introduced

[4] **Carus** also befriended Anagarika *Dharmapala*, another delegate at the Parliament, and was instrumental in his return to the States. But there was no contact between *Dharmapala* and *Soyen Shaku* even though both of them were unusually open and adaptable. And of course there was absolutely no possibility of *Dharmapala* establishing Theravada in Japan or of *Soyen Shaku* establishing Zen in Sri Lanka (even though both men had visited each other's country). The West was the only 'open' direction for either tradition.

This observation holds generally. All the Eastern teachers who visited the West and had Western followers—*Dharmapala, Soyen Shaku, Vivekananda* and Inayat *Khan*—were prepared to go to considerable lengths to adapt to Western needs and capabilities. (So they are in important respects quite untypical of their traditions.) But they could not adapt to each other's traditions so easily. This is why I consider it significant that when Inayat *Khan* and Nyogen Senzaki met—in 1923, which is slightly outside the period I am considering here but I want to make the point now—and acknowledged the truth of both Sufism and Zen, they did so in California and at the instigation of a Westerner (Samuel **Lewis**—see his entry for the story).

[5] I do not want to become embroiled here in the question of whether *Vivekananda* and his teaching can properly be called Hindu or not. I have explained in Chapter 1 the difficulty of using a general term for what is in fact a set of overlapping sub-traditions. It is certainly true that he never referred to himself as a Hindu and was critical of Hinduism's reliance on rituals and formulae, which he described as "secondary details." Rather, he said, "realization is the whole of religion." And the *sanatana dharma* or 'universal religion' that he taught was in many respects supra-traditional. Yet where else are we to locate *sannyasa, raja yoga,* and Vedanta if not within Hinduism?

[6] That is, opening it up to Westerners as *teachers*. From 1902 onwards, the only non-lay members of the Order in the West were Indian *swamis*—but everyone else was Western. The only *swami* who continued at least some semblance of *Vivekananda*'s policy was Swami Paramananda, who appointed two American women, Sisters **Devamata** and **Daya**, as 'platform assistants' (in 1909 and 1919 respectively). I say 'some semblance' since a platform assistant is not at all the same as a *sannyasin(i)* or a *brahmacharin(i)*.

[7] This combination—of a barely understood tradition and the existence of enlightened masters who rely on their realization for their authority—can have its drawbacks. Around the turn of the century, for example, there was a flurry of mavericks-cum-showmen-cum-charlatans who all claimed to be masters or *yogis*; some of them even claimed to be Indian. (See the entries on Yogi **Ramacharaka** and **Oom the Omnipotent**.) No other Eastern tradition gave rise to anything similar.

[8] This was in 1910. There had been no Sufis at the World Parliament of Religions in Chicago in 1893. In fact, the only Moslem who is recorded as having attended was a certain Alexander Russell Mohammed Webb, an American who had become a Moslem in India. He gave an address entitled 'The Spirit of Islam', in which he said that there wasn't a single account of the tradition in English which "reflects at all in any sense the spirit of Islam" (with the exception of the work of Ameer Ali of Calcutta). Webb referred to Sufism once, but not by name and it is doubtful if even he knew a great deal about it, let alone anybody else. This is worth mentioning because

two fundamental innovations: he separated Islam from Sufism; and he gave women—Western women, at that—important positions in the Order. In effect, these innovations made the Order a purely Western phenomenon (even though it was started by an Eastern teacher). It could not even have been contemplated in the East because there Sufism is part and parcel of Islam and Moslem culture. There are no Sufi equivalents of Buddhist monasteries or Hindu ashrams which exist apart from ordinary society. So while Westerners can become Buddhist monks or Hindu *sannyasins* directly, so to speak—and did during this early period—there is no comparable move in Sufism. One must be accepted by Moslem society before one can become a Sufi.[9] This explains why, even today, Western Sufis in Eastern countries are rare. In the first decades of this century, they did not exist at all. The only option to Westerners, therefore, was to enter the tradition by receiving personal transmission from a Sufi teacher. And this is exactly what Inayat *Khan* provided.

The other form of Sufism during this period, the Shadhiliyya-Akbariyya, was rather different. It had no Eastern master in the West and was instead represented by a lone Westerner, Ivan **Agueli**. There is no evidence that a Western Shadhili community ever existed. True, **Agueli**'s only known initiate, René **Guénon**, went on to have a considerable influence as part of the Western Shadhiliyya; but there was little hint of it in 1912. Even so, the link from North Africa to the West had been made and it has remained to this day.

Yet despite their differences, these two forms of Western Sufism did have one thing in common: they were both concerned with Sufism as a universal truth. Inayat *Khan* taught that Sufism was "the inner religious experience of every messenger and mystic" and introduced something called Universal Worship which incorporated elements from all the major traditions; **Agueli** wrote articles in esoteric periodicals on such *recherché* subjects as Islam and Taoism. Neither of these is 'traditionally' Sufi and I think it is fair to say that you would have had to have looked very hard to find even a single Eastern Sufi who was doing or teaching anything remotely similar.

Meanwhile, Alexandra **David-Néel** has started an epic 14-year expedition and has received her first instruction from Tibetan teachers. But she has not (yet) done so in Tibet, which is steadfastly closed to foreigners. Nor do Tibetans come to the West. The only real possibility of access, therefore, is in the Tibetan-influenced regions of India, and in Sikkim and Nepal. Naturally, the number of Westerners who managed to take advantage of this opportunity was very small indeed.

And more or less simultaneously, **Gurdjieff**, the first independent teacher, has just finished a 25-year exploration and is passing on what he has learned to a small group in Russia.

It is only when we look back at these various developments with the knowledge of what happened later that they appear significant. The number

all the other Eastern traditions were fairly well represented (apart from Tibetan Buddhism, though Theosophy did present a version of it).

[9] Hence though there was a considerable body of scholarly work on Sufism, including translations of Persian and Arabic classics, it did not make the tradition more accessible to Westerners. In fact, Sufi literature had next to no effect on the development of Western Sufism, which was spread entirely by personal contact. This contrasts with both Buddhism and Hinduism, where the texts acted as a definite stimulus. We come across many instances of people—**Ananda Maitreya** and Henry Thoreau, for example—who realized that they were already Buddhists or 'yogis' when they read the classics of those traditions. I am not aware of this happening with Sufi texts.

of Westerners who are actually part of a tradition in any way at all (and Theosophists and general lay Buddhists were not) is tiny in the extreme. The monks in Burma and Ceylon; the Zen practitioners in San Francisco; the initiates of Swami *Vivekananda* (and other monks of the Ramakrishna Order) in America and India, and of Hazrat Inayat *Khan* in America and Britain; the group around **Gurdjieff** in Russia—all these amount to just a handful each. As for **David-Néel** in Sikkim, **Avalon** in Calcutta and the **Mother** in Pondicherry, they are solitary individuals.

Yet the word is getting out. Theosophy and general lay Buddhism certainly have their part to play here along with a few Vedanta and Sufi centres. *Soyen Shaku, Vivekananda,* and Inayat *Khan* have published books—and so have **Blavatsky**, **Olcott**, **Nyanatiloka**, **Nivedita**, **Avalon**, and **Carus**.

Not a single one of these has deep roots. And the connections between them hardly exist. Yet all together, they have a certain force. The pattern of spiritual psychology is beginning to establish itself: put together from disparate sources, in different places, by Westerners (with help from Eastern teachers at this stage) of various nationalities; and all part of a single phenomenon that is beginning to grow in all directions simultaneously.

FIRST GROWTH: 1917–1945

Western participation in Eastern traditions is still very uneven during this time. One of the reasons for this must surely be that very few Eastern teachers are available. Anagarika *Dharmapala* and Hazrat Inayat *Khan* are continuing their work and there are a number of Indian *swamis* in the Ramakrishna Order (see below). But *Soyen Shaku* is back in Japan, and the two teachers whom he left behind in America, Nyogen Senzaki and Sokei-an, take a long time to get into their stride. Of course, Eastern teachers do come to the West for the first time: Paramahansa *Yogananda*, *Krishnamurti,* and *Meher Baba*, for example. But their attitude to Westerners varied considerably: Yogananda founded a Western *kriya yoga* lineage, the continuation of his life's work (but not until 1952); *Meher Baba* founded Sufism Reoriented (also in 1952), which is entirely Western, but was not the centre of his work; and *Krishnamurti* actually dissolved the Order of the Star of the East (in 1929). All of this is typically varied and variable. And it explains why Western teachers, though there may be more of them, remain somewhat unconnected.

Theravada Buddhism shows this very clearly. Decades after his first visit in 1893, Anagarika *Dharmapala* is still the only Eastern teacher to have come to the West. After visiting Britain in 1925 and establishing a branch of the Maha Bodhi Society, he returned to Sri Lanka and raised funds to buy a house in London, the London *vihara*. Three monks were sent over in 1928 to start the monastery off but the intention was always that Western monks should live there. This was another 'first'—the first Theravadin monastery in the West (which is not the same as a Western Theravadin monastery)—but it never got off the ground. As far as I know, no Western monk ever lived there and it was closed in 1940, having made little impact.

Meanwhile, **Nyanatiloka**'s Island Hermitage continued in Sri Lanka. But it really was an island, for Westerners only. Clearly, this way of following the

1917–1945

Consolidation of Westerners in Eastern traditions

The first Western woman, **Uppalavanna**, enters the Theravadin *sangha* in the East.

Nyogen Senzaki and Sokei-an Sasaki, begin to teach in America; Ruth Fuller **Sasaki** teaches *zazen*; a few Westerners practice in Japan (including Father **Enomiya-Lassalle**, a Christian priest).

Alexandra **David-Néel** and W.Y. **Evans-Wentz** publish their first books.

Lama Anagarika **Govinda** is initiated by a Tibetan *lama* in India and founds the Arya Maitreya Mandala—the first organization anywhere in the world devoted to Tibetan Buddhism.

Paul **Brunton** and John **Levy** attain some degree of realization in India and record their experiences (**Levy** not until 1951—but he gives a broadcast on Vedanta on British Army radio!).

The **Mother** becomes a teacher in her own right in India.

So does Sri **Krishna Prem** (in the Gaudiya Vaishnava tradition).

Yogananda arrives in the United States and spends the rest of his life there, grooming his American disciples (**Rajarsi Janakananda** and Sri **Daya Mata**) to take over the Self-Realization Fellowship.

Hazrat Inayat *Khan* appoints some of his European disciples as *murshidas*; but after his death there is a split between the European group and the American one led by Murshida **Martin**.

Samuel **Lewis** begins his Sufi apprenticeship (and will later become a teacher in several traditions).

René **Guénon** goes to Egypt and spends the rest of his life there.

Frithjof **Schuon** becomes a *moqaddem* and then a *sheikh* in the Alawiyya branch of the Shadhiliyya; he initiates Westerners and establishes *khanqhas* in Europe.

Ouspensky leaves **Gurdjieff**; the two teach separately in Europe (and America) for over 20 years, and some of their pupils (**Orage**, **Heap**, the **de Salzmann**s, **Bennett**, **Nicoll**) start teaching as well.

This is an interim period. More new seeds are sown:

Western gurus in India;
an Indian guru (*Yogananda*) establishes a monastic order in America;
a Westerner (**Schuon**) establishes a Western branch of a Sufi Order;
the first Westerner begins to teach Zen (Ruth Fuller **Sasaki**).

And most of the earlier plants continue. Tibetan Buddhism is still fairly precarious; Theravadin monks in Ceylon remain small (but steady); and the others—Rinzai Zen, Moslem, and non-Moslem Sufism, the Gurdjieff-Ouspensky work—have grown and have begun to take root. Now these exotic plants are no longer isolated oddities but already beginning to adapt to their new environment and colonize Western soil. (And as they do so, Theosophy, that exotic Western plant, begins to fade— and Theosophical Buddhism fades with it.)

Theravadin tradition, excellent as it was, could never become general.[10] And even they could not accommodate women (because the *Vinaya* rules, which define the *sangha*, do not allow men and women to share quarters). So **Uppalavanna**, a German who went to Sri Lanka in 1926, was more or less forced to become a lone hermit. She lived this life for 50 years and one has to admire her tenacity. But it is hardly surprising that she was the only Western woman who managed to do it.

Tibetan Buddhism remains entirely self-contained and, occasional individuals apart, quite incapable of responding to Western interest. Tibetans still do not come to the West;[11] and despite the fact that some Westerners manage to get into Tibet, none of them can stay very long. This explains why Lama Anagarika **Govinda** had to practice more or less on his own in India for 40 years—quite unlike any Tibetan, of course. (But like **Uppalavanna**, he stuck to his guns.) In 1927, two books on Tibetan Buddhism appeared: **David-Néel**'s *Voyage d'une Parisienne à Lhassa* and **Evans-Wentz**'s *The Tibetan Book of the Dead*. They could hardly have been more different. **David-Néel** had immersed herself in the tradition for many years and at the time she certainly knew more about it from first-hand experience than any other Westerner. But hers was an essentially personal exploration and she never claimed to represent the tradition or to be a teacher. Neither did **Evans-Wentz** (which is understandable since he did not know Tibetan and the actual translations were made by Lama Dawa Samdup). Yet his works provided something that **David-Néel**'s did not: full-length texts that were an integral part of the tradition.

In this same year (1927), the first volume of D.T. Suzuki's *Essays in Zen Buddhism* appeared. Suzuki was a pupil of *Soyen Shaku* and his book therefore continued the Rinzai influence that goes back to that great teacher. But its contents, which included essays on *satori* (which he defined as "really another name for enlightenment") and 'The Meditation Hall and the Ideals of the Monkish Discipline', were hardly reflected in the practice of the few Americans who stumbled across Nyogen Senzaki and Sokei-an. Rinzai has a reputation for being a hard school but one would never suspect it from the gentle way that Senzaki and Sokei-an treated their pupils. Sokei-an said in later years that five minutes practice was too much for most of them. Perhaps he was exaggerating but such a remark would be unthinkable in Japan. And none of these Westerners were monks. It is evident, then, that they did not practice in anything like the same way as Japanese would have done in Japan.[12] There is no record of either Senzaki or Sokei-an introducing *sesshins* (long intensive *zazen* practice), together with *dokusan* (the formal confrontation between teacher and pupil). And as for enlightenment, I doubt whether it even entered anybody's mind as a possibility. (It does now.)

[10] Apart from the Island Hermitage, all Western monks in the East were essentially isolated, which necessarily reduced their impact on Western laypersons in the West. A splendid example of this general rule is the Italian Salvatore Cioffi/**Lokanatha** Thera, who was ordained in Burma in 1925 and was quite possibly the only Western monk in the entire country at the time. His subsequent life was very varied: solitary ascetic practice; missionary expeditions to India and America; and preaching tours in Burma itself (where he upheld a conservative, not to say reactionary, form of Theravada). But one option was not available: being a monk in the West. He tried it in Italy immediately after his ordination but it proved impossible. This was the common fate of all Western monks during this time.

[11] The only exceptions I can find are Geshe Wangyal (actually a Soviet Kalmuck) who came to Britain briefly in 1937, and three Tibetans who visited London in 1948 as part of a trade mission. But their impact was zero.

[12] In fact, they had practically nothing in common with Japanese practitioners living in America. Soto temples were opened in Los Angeles and San Francisco in the 1930s but they were purely ethnic affairs and no Westerners used them.

But once again, what has been started decades earlier is continuing. Ruth Fuller **Sasaki**'s qualifications for teaching *zazen*—a few months' practice in Japan—may have been minimal but the point is that she did it (under Sokei-an's supervision). At the same time, a few Westerners—**Sasaki** is one of them—go to Japan and practice for a few months in Zen monasteries. But admirable though this may be, it is simply not enough in itself to establish someone in a tradition. This is why Miriam **Salanave**'s Western Women's Bureau and East-West Buddhist Mission, founded in San Francisco in 1935, and Dwight **Goddard**'s monastic order, the Followers of the Buddha, founded in Vermont in 1934, did not last very long. Neither of them had done anything like enough training to be effective Zen teachers. Meanwhile, back in Japan, Father **Enomiya-Lassalle**, a Jesuit, was making his first explorations into Zen. He arrived in the country in 1929 and started to practice with Sogaku *Harada*. Although he did eventually become a teacher of *zazen*, this was many years later so he is not really part of the small group I am considering here. Even so, it is noteworthy that the first Westerner whom we are certain practised regularly under a Zen teacher should have been a Christian priest.

Every single one of these people—**Sasaki**, **Salanave**, **Goddard**, and **Enomiya-Lassalle**—was a pioneer. But there was no co-ordination between them. They were all in Japan at the same time but never even met, as far as I know. It is tempting to conclude, therefore, that they are all going in different directions. But I think it would be more accurate to say that they are exploring the same territory without realizing it. No map of it has yet been drawn.

The Second World War brought all Western investigation of Zen to an abrupt halt.[13] This early period contains much that is admirable but at the same time we would have to say, I think, that it was extremely modest in both its aims and its accomplishment:

> The only continuous Zen presence in the West was Japanese Rinzai in America[14]

> The Japanese teachers who presented it did so in a way that was quite unlike that in Japan (and there's nothing wrong with that in itself, but Westerners *couldn't* practice in the traditional Rinzai way even if they wanted to, and even if they knew what it was), and

> Western practitioners did not expect, and were not expected by their teachers, to attain very much

The Ramakrishna Order is very similar in this respect. There were always several Indian *swamis* in America (17 from 1904 to 1929 though never more

[13] To be more accurate, one would have to say that it put a stop to any form of *organized* Zen. In fact, individuals and small unofficial groups did continue and even begin in wartime conditions. Nyogen Senzaki, for example, who was interned in America along with thousands of other Japanese (including Sokei-an), did some teaching in his camp. And Robert **Aitken**, who was in a Japanese POW camp at the same time, actually discovered Zen there. We could also add Graf **Dürckheim**, who was imprisoned by the Americans in Japan after the war, to this general picture; and, at a slightly further remove, the meetings between German Buddhists, such as Lama Anagarika **Govinda** and **Nyanaponika** Thera, in British internment camps in India. (There is an interesting study waiting to be written here: 'Cultural Exchange in POW/Internment Camps'.)

[14] No Japanese Zen teacher ever stayed in Europe for very long—usually a few months. Occasionally, as with the Rinzai master, Ohawasa, who produced a book, *Zen, der lebendige Buddhismus in Japan*, in 1925 (aided by Eugen Herrigel, the author of *Zen in the Art of Archery*), it might be a year or two—but nothing approaching the years that Senzaki and Sokei-an spent in America. Suzuki's writings were certainly as influential in Europe as they were in the States but a book, however good, is not a teacher and European Zen Buddhists simply had no one to teach them.

than eight at a time)[15]—but none in Europe—and they certainly accomplished a good deal: Swami Trigunatita opened the first Hindu temple in the West in San Francisco in 1905, along with a monastery and a nunnery. These were small ventures—the temple was a converted house, the monastery had just seven inmates and the nunnery only three, none of whom were actually *sannyasins* (though they were all Westerners)—but still significant. But as with all the Ramakrishna centres at this time, Indian monks were firmly in control and the centres could not continue without them. Hence when Swami Trigunatita's health began to fail, so did the temple, monastery, and nunnery, and they did not survive his death in 1914.

This makes Sisters **Devamata** and **Daya** all the more unusual. Before *Yogananda* began to give his American disciples some responsibility, these two were the only Westerners authorized to teach some form of Hinduism in the entire Western world. (Like Ruth Fuller **Sasaki**, their function was very modest; but there is nothing wrong with modesty.) Even so, given the Order's policy of keeping things Indian, it can hardly be called truly Western. Perhaps this explains why the numbers dropped; there were 340 members of the Ramakrishna Vedanta movement in the whole of the United States in 1906 but only 190 in 1916.[16] Such a decline is unusual for any Eastern tradition in the West.

Yogananda, on the other hand, adopted a completely different approach. The Self-Realization Fellowship was American-based from the moment he established his headquarters in Los Angeles in 1925. And while he was the undisputed guru, he always intended his Western followers to succeed him— the exact opposite of the Ramakrishna Order.

Meanwhile, Westerners are entering the Hindu tradition in India. And what this means is that they are accepted in some way by an Indian teacher. This is how **Brunton** and **Levy** can practice as individuals and not as part of a community. On the other hand, both the **Mother** and Sri **Krishna Prem** *are* part of their respective communities—in fact, they are leaders of them. Both are extremely small—perhaps a dozen members all told in each case at this time— but the fact is that they exist.

And they are also very different from each other. **Krishna Prem** is part of the Gaudiya Vaishnava lineage and the first Westerner whom one can definitely say was an orthodox Hindu; the **Mother** was not part of any lineage— not even *Aurobindo*'s since the two were co-workers, not guru and disciple. **Krishna Prem** performed temple *pujas* at the ashram temple; the **Mother** choreographed gymnastic displays at her ashram (which didn't even have a temple). Her first major book, *La Decouverte suprême*, outlining the new *yoga*, was published in Paris in 1937 as part of a series entitled 'Les grands maîtres spirituels dans l'Inde contemporaine'; **Krishna Prem**'s *The Yoga of the Bhagavat Gita*, a Vaishnava commentary on the central text of Hinduism, was published in London just a year later in 1938. But different as they are, they were both firsts—and not just because they were written by Western teachers in India. *La Decouverte suprême* was the first account of what might be called independent Hinduism by a Westerner; *The Yoga of the Bhagavat Gita* was the first commentary by a Western Hindu who knew Sanskrit. The two met at least once (when **Krishna Prem** visited both the **Mother** and *Aurobindo* in

[15] W. Thomas, *Hinduism Invades America* (New York, 1930), 103–05.
[16] ibid. p. 115.

Pondicherry) but to all intents and purposes they were pursuing quite different paths, and it is entirely typical of Hinduism that they should.

There is really very little coherence in Western Hinduism during these years. There is next to no contact between any of the teachers and they each represent extremely different forms of Hinduism: the Ramakrishna Order's neo-Vedanta, *Yogananda*'s *kriya yoga*, the new integral *yoga* of *Aurobindo* and the **Mother**, **Krishna Prem**'s Gaudiya Vaishnavism; and **Brunton**'s version of Ramana Maharshi's teaching which Ramana himself did not even give a name.

But they do have one thing in common: they place transformative experience or realization at the centre of the spiritual life. In this sense, they can all be seen as variants of what I call 'inner' Hinduism, which is concerned with consciousness and spiritual practice, and hence sees the teacher or guru as someone who is knowledgeable about the first and skilled in the second. This in its turn enables him or her to transmit something to his or her followers. What we have here, are the four principles of spiritual psychology (for which, see p. xv) and it is this alone which links the various forms of Western Hinduism during this period. (And in due course, it will link all the forms of all the traditions.)

At the same time, both the **Sufi Order** and the Western branch of the Shadhiliyya continue. And their relationship is just the same as when they started in the early years of the century: following parallel tracks and never meeting. For example, in 1923, Hazrat Inayat *Khan* established the Sufi Movement (which incorporated the Sufi Order) in Geneva; its constitution allowed that the leader could be elected in the event of the incumbent *murshid* not nominating someone as his successor. In 1924 (though the date is not exactly clear), Samuel **Lewis** received inner initiation from all the prophets culminating in Mohammed. In 1925, René **Guénon** published his second study of Hinduism (actually, Vedanta), *L'Homme et son devenir selon le Vedanta*. (His *L'Introduction generale à l'étude des doctrines hindoues* had come out in 1921.) The first of these (Hazrat Inayat *Khan*'s Sufi Order) represents public and exoteric Sufism of the universalist, non-Moslem form; the second, the beginnings of an independent version of this form of Sufism (because **Lewis** was always an independent); and the third, the Traditionalist position stated, by a Western Sufi (**Guéron**), in terms of Vedanta. All of them would have been virtually impossible in a Moslem/Sufi country.[17]

[17] Compare the International Buddhist Union. This was originally Anagarika *Dharmapala*'s idea in Calcutta and was supported in the West in the early 1920s by **Ananda Maitreya**, Ernst Hoffman (later Lama Anagarika **Govinda**), George **Grimm**, C.T. Strauss, Dwight **Goddard** and Ronald Nixon (later Sri **Krishna Prem**). That is:

a Sri Lankan living in India (*Dharmapala*) and influenced by an American Theosophist (**Olcott**) had an idea for a society—an international Buddhist society—that was supported in the West by:

two Englishmen (**Ananda Maitreya**, who had been a monk in Burma from 1902 until 1914; and Nixon/**Krishna Prem**, who went on to become a Gaudiya Vaishnava guru in India);

two Germans (Hoffman/**Govinda**, who went on to become a Theravadin *anagarika* for a time in Ceylon before entering the Tibetan tradition; and **Grimm**, author of *The Doctrine of the Buddha* and co-founder of Das Altbuddhistische Gemeinde/Old Buddhist Community in 1921);

a Swiss (Strauss, who was the first Westerner ever to formally become a Buddhist in the West when he took the five lay vows from *Dharmapala* in Chicago on the occasion of the founding of a branch of the Maha Bodhi Society there in 1893);

and an American (**Goddard**, who later practised Zen for a while in Japan and tried to establish a Western Buddhist order, based on Zen principles, in America).

Nothing like this mixture—and I mean a mixture of Sri Lankan, Burmese, Japanese—could be found anywhere

Yet as the two orders get bigger, they also become more unstable. There was a split between Rabia **Martin**'s American group and the European headquarters of the Sufi Movement after Hazrat Inayat *Khan*'s death in 1927. In 1934, Frithjof **Schuon** returned to Europe from Algeria with the authority to give initiations into the Alawi Order. It is from this time that one can truly speak of a Western branch of the Shadhiliyya (or more accurately, the Alawiyya-Shadhiliyya): inspired by a Frenchman (**Guénon**, himself initiated by a Swede [**Agueli**]), led by a Swiss German (**Schuon**) and made up entirely of Westerners. Yet around 1945 or so, there was a schism following a dispute between **Schuon** and **Guénon** over matters of metaphysical principle, including amongst other things the true efficacy of the Christian sacraments. I need hardly say that this could not have happened in a Sufi country.

And the **Gurdjieff-Ouspensky** axis also continues to turn. **Ouspensky** produced a major *opus*, *A New Model of the Universe*, in 1931; and **Gurdjieff** published a *very* odd work, *The Herald of Coming Good* in 1933—and then withdrew it. (But continuity was never his *forte*.) There were various groups in France, Britain, and America, none of which made themselves public. It is interesting (but not surprising, given the personalities of the two men) that the groups around them are quite different. **Gurdjieff**'s are small, scattered and apparently unconnected: by the mid-1930s, both those at the Prieuré and **Orage**'s New York group have been dispersed and are not sure what to do with themselves; and the numbers around Jeanne **de Salzmann** (near Paris) and Jane **Heap** (in London) are minuscule. **Ouspensky**'s groups, on the other hand, are relatively large, concentrated and organized: Lyne Place, his centre in Surrey, attracts regular pupils; and the groups around **Bennett** and **Nicoll** are quite substantial (even if **Bennett**'s are unauthorized). By the beginning of the Second World War, then, the situation was as follows (numbers are 'guesstimates'; people in the Work never reveal such details):

> **Gurdjieff** had a small group in Paris consisting mainly of Jeanne **de Salzmann**'s French pupils, perhaps 20 in all

> Jeanne **de Salzmann** had her group in Sèvres (perhaps a dozen or so), but sent on her advanced pupils to **Gurdjieff**

> Jane **Heap** had her group in London—again, about a dozen

> the American group that had been centred around **Orage** was in disarray—maybe 20 of them were continuing as best they could

> **Ouspensky** had about 1,000 pupils who visited Lyne Place

> **Madame Ouspensky** also had her own pupils at Lyne (who are included in this figure of 1,000)

> Maurice **Nicoll** had his group in London, perhaps about 100 at this time

> **Bennett** had his group in London, with about 200 pupils

in the East. Nor could Dharmapala have found support for the International Buddhist Union in any Theravadin country (or any Buddhist country, come to that).

There is, of course, no formal link between the International Buddhist Union and Western Sufism. But in a larger perspective they obviously do have several things in common: they are both international, are drawing on various dimensions of their respective traditions, and are trying to go beyond the cultural boundaries that exist in the East. In short, what was separate in the East is being brought together in the West. This is fundamental to all forms of spiritual psychology.

The numbers involved are small; a combined total of 1,500 for all of the above would be an absolute maximum and the **Gurdjieff** groups would be struggling to reach a hundred. And while they all shared certain principles and assumptions, they appear to be doing rather different things.[18]

Whatever we may think of the efforts of Westerners during this period, either in terms of scale or in terms of quality, what is certain is that there are more Western teachers and they are doing more, and more varied, things. There is nothing approaching a network that links them at this point; in fact, there is very little contact at all even between individuals in the same tradition. But it is a distinct possibility. Considering that the starting points for all of them were originally utterly unconnected, this is fairly remarkable.

PROPAGATION: 1946–1962

Westerners continue to go further and deeper into Eastern traditions. But even at this stage, over half a century after they have made contact with them, the journey can be difficult. This is shown by the English Sangha Trust, which was founded in London in 1956 as the third attempt to establish a Western *bhikkhu sangha*. (The previous two were **Ananda Maitreya**'s Buddhasasana Samagama, founded in Burma in 1903, and Anagarika *Dharmapala*'s London *vihara*, founded in 1928). The majority of the Trust's members were lay men or women but there were also four monks: William Purfurst/**Kapilavaddho**, Peter Morgan/Punnavaddho, Robert Albison, and George Blake (who was West Indian but I don't know his or Albison's *bhikkhu* name). **Kapilavaddho** was the senior, having been ordained in Thailand in 1954—the first Westerner to enter the *sangha* in that country, to my knowledge—and the other three followed suit in 1956. But the plan to establish a Western *sangha* foundered almost as soon as it was launched because the four monks found it impossible to live the monastic life in Britain (just as **Ananda Maitreya** and **Lokanatha** had done decades before). By 1961, the fledgling *sangha* of four had dispersed: Punnavaddho to Thailand (where he is a monk to this day) and

[18] Similarly, the handful of Westerners who claimed some sort of contact with the Tibetan tradition also seem to be swimming in the same pool but not in the same direction. If we consider them at the outbreak of World War II, we find the following:

> **Gurdjieff**, who may have been taught by 'Red Hat lamas' (that is, Nyingmapas) in Tibet in 1901 or so, is living in Paris
>
> Alexis **Tennisons** is in exile (on his way to Burma) and appears to be entirely on his own
>
> Simon **Grimes** is three years old in China and has just been recognized as the seventh Panchen Lama
>
> Alexandra **David-Néel** is on an eight-year expedition to Russia and China (but not Tibet)—the only interruption of 50 years in France, studying and writing
>
> W.Y. **Evans-Wentz** is wandering back and forth between India and America, not doing very much
>
> Only Lama Anagarika **Govinda** is still where he started—in India—and practising with at least the possibility of some contact with the tradition

It would be hard to imagine a more incoherent group, or one that has less in common with the practitioners of the Fourth Way. Yet I would contend that both 'sets' are part of the same phenomenon. In this sense, and in this sense alone, they are also linked with the Western Sufi groups and the International Buddhist Union/IBU 15 years earlier. (See the previous note.) There are at least 20 people here (in Western Sufism, the IBU, the Gurdjieff-Ouspensky groups, and Tibetan Buddhism) and on the face of it they are inhabiting different worlds. But these worlds are expanding and as they do so, they begin to overlap and influence each other.

1946–1962

Westerners become firmly established as teachers

Kapilavaddho is ordained in Thailand and returns to Britain to try and establish a Western *bhikkhu sangha*.

The first Westerners (Ruth Fuller **Sasaki, Nowick, Aitken, Kapleau, Kennett, Schloegl**) go to Japan to practice Zen intensively; **Sasaki** even establishes a branch of the First Zen Institute of America there; she also becomes the first Western Zen priest.

Shunryu Suzuki and Taizan *Maezumi* arrive in California and begin to attract Western students; Suzuki founds the San Francisco Zen Center.

Lama Anagarika **Govinda** takes a few Western disciples in India.

Robert **Clifton** founds the Western Buddhist Order.

Swami **Arubianandam** and Swami **Abhishiktananda** ordain themselves as *sannyasins* in India and practice Christian Vedanta.

Rudi, Swami **Radha** and Irina **Tweedie** meet their teachers in India.

Guru **Subramuniya** (American) and Sri **Mahendranath** (British) receive Shaivite initiations in India; **Subramuniya** returns to the West and founds a Yoga Order in San Francisco, **Mahendranath** stays in India and establishes his own ashram.

Jean **Klein** returns to the West to teach Vedanta.

Yogananda dies, to be succeeded by **Rajarsi Janakananda** and Sri **Daya Mata** as successive presidents of the Self-Realization Fellowship in Los Angeles.

Frithjof **Schuon** creates a new branch of the Alawiyya, the Maryamiyya, dedicated to the Virgin Mary.

J.G. **Bennett** and Samuel **Lewis** make extensive trips to the East (quite independently of each other) and contact many different teachers.

Murshida Ivy **Duce**, Rabia **Martin**'s successor, is appointed as head of Sufism Reoriented by *Meher Baba*.

Gurdjieff and **Ouspensky** die and are succeeded by a number of pupils (Mme. **de Salzmann**, **Bennett**, **Nicoll**, **Collin** *et al*—including Roles and **Maclaren**, who become followers of the Shankaracharya).

The time-scale of Western involvement in Eastern traditions is getting shorter and shorter. In just 16 years, Westerners branch out into quite new areas:

they enter Zen monasteries (Rinzai, Soto, Sanbokyodan) in Japan;
and become accomplished *yogis* in India;
they return from the East and establish branches of their tradition in the West;
the first Westerner begins to teach Tibetan Buddhism.

The traditions and lineages of the earlier decades are still going— with Westerners teaching with authority in all of them and often extending them in new directions:

Western monks in Theravadin countries (such as **Nanavira**);
the Shadhili Order and its off-shoots (**Schuon**'s Maryamiyya);
the **Sufi Order** in the West (now split into several groups);
the **Mother** develops her own '*yoga* of the cells' after *Aurobindo*'s death;
Sri **Krishna Prem** continues as guru in India, having appointed another Englishman as his successor.

These plants are now growing vigorously and, more importantly, are beginning to propagate themselves.

the other three to lay life. (See **Kapilavaddho** and **Sumedho**'s entries for the subsequent history of the British *sangha*.)

At the same time, other Westerners were still making contact with the tradition in the East. In 1952, Freda **Bedi**, an Englishwoman married to an Indian and living in India, went to Burma for a while and practiced *vipassana* with Mahasi Sayadaw. And it is fitting, in a way, that the first Western practitioner should have been a laywoman, the very bottom of the pile as far as conservative Theravada is concerned. (See *vipassana sangha* for the term 'conservative Theravada'.) But it is also quite in keeping with the great variety of Western Theravada that the second Westerner to practice *vipassana* was a monk, **Nyanaponika** Thera, in 1954. These were isolated visits by individuals. Very few would have suspected at the time that a fully fledged Western *vipassana sangha* would exist within 25 years and that it would overlap with the *bhikkhu sangha*.

Meanwhile, the long reign of Rinzai in Western Zen is coming to a close[19] as Westerners begin to explore Zen in Japan and make contact with the Soto and Sanbokyodan schools. As usual with this phenomenon, it is the variety and range that is important. There are laymen (Robert **Aitken**) and monks (Philip **Kapleau**), and three women (Ruth Fuller **Sasaki**, Irmgard **Schloegl**—both Rinzai—and Jiyu **Kennett**). Some of them stayed for long periods of time and thoroughly imbibed the Japanese way of doing things; **Kennett** attained *kensho* in just six months (and then went on to become a priest at her own temple); **Aitken** did most of his practice in the West (and his Zen group in Hawaii in 1959 was the first to be established by a Westerner). At the same time, Japanese teachers like Shunryu Suzuki (Soto) and Taizan *Maezumi* (Soto and Rinzai) are attracting Westerners to their centres in San Francisco and Los Angeles.

Meanwhile, in India, Lama Anagarika **Govinda** is continuing his 'way of the *siddhas'* as a solitary practitioner. Around 1950 or so, he accepts a handful of Western pupils—the first time that anyone other than a Tibetan or a Mongolian had ever taught Tibetan Buddhism. And in 1957, he published his masterwork, *Die Grundlagen Tibetischer Mystik*, the first 'inside' exposition of Tibetan Buddhism (as opposed to an annotated translation, as in **Evans-Wentz**'s books, or an account of personal experiences, such as we find in **David-Néel**) by anyone, Western or Tibetan.[20] Three years later, however, the Dalai Lama took up residence in India. Suddenly, the tradition was available and the approach that **Govinda** pioneered, and which was forced on him by circumstances, was no longer viable. (But maybe it will be revived one day . . .)

[19] As late as 1958, a Zen issue of *The Chicago Review* was entirely Rinzai from first to last:

> essays by Gary Snyder and Jack Kerouac (whose *The Dharma Bums*, in which Snyder himself figures under the name of Japhy Ryder, appeared in 1959);
>
> an article by Nyogen Senzaki (who died in this year);
>
> **Watts**'s *Beat Zen, Square Zen and Zen*;
>
> and translations by D.T.Suzuki and Ruth Fuller **Sasaki**.

Every one of these, whether Japanese or Western, is part of the Soyen Shaku line in some way or other, whether directly (Senzaki and Suzuki), indirectly (Ruth Fuller Sasaki and Snyder) or just out of sympathetic association (Watts and Kerouac).

[20] It is a delightful coincidence, and part of the general *mélange* that characterizes Western Tibetan Buddhism during this period, that in the same year another book on Tibet was published: **Lobsang Rampa**'s *The Third Eye*, a throwback to the purely occult version of Tibetan Buddhism popularized by **Blavatsky** at the end of the nineteenth century. When Tibetans began to arrive in the West a few years later, there was very little in the book that they recognized.

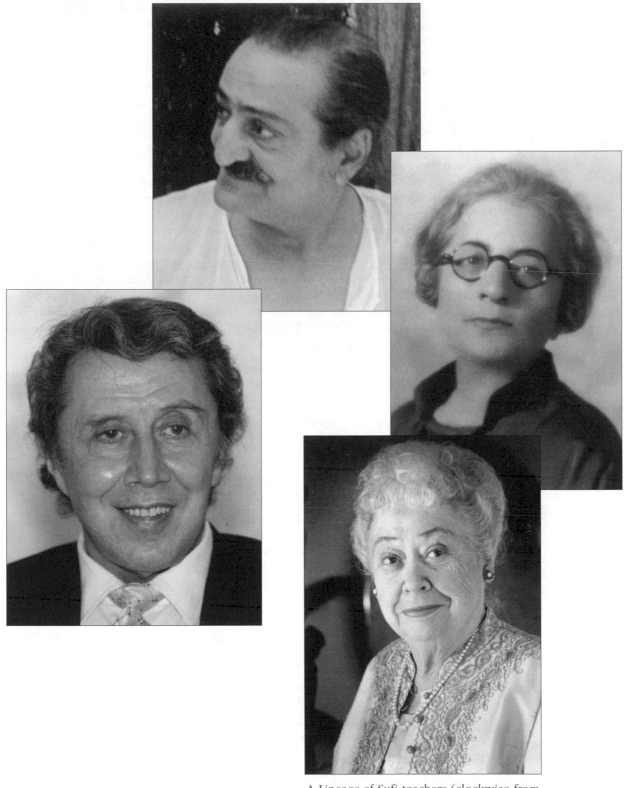

A Lineage of Sufi teachers (clockwise from top: *Meher Baba,* Rabia **Martin,** Ivy **Duce,** James **MacKie**).

What is new here is that these various activities—**Kapilavaddho**'s visionary experiences in Thailand; the attempt to establish a Western *bhikkhu sangha*; **Bedi** and **Nyanaponika**'s exploration of *vipassana*; the opening up of the Soto and Sanbokyodan schools; Western Zen practitioners in Japan; the presentation of the Tibetan tradition as a living spiritual path—all of these occupy the same space, so to speak. They may be the result of efforts by very small groups or even single individuals—this is still the age of the pioneer—but every one of them is sending signals in the same direction: the West. So Westerners who have their ears open and their wits about them can see that the traditions contain various dimensions and possibilities. In short, the phenomenon of spiritual psychology has gone up a gear. Comparisons are being made: between different ways of following the spiritual life (monastic and lay; communal or solitary; in Eastern style or with Western adaptations); between different experiences; between different schools of the same tradition; even between different traditions. Westerners are now crossing boundaries.[21]

And this is happening across the board, not just in Buddhism. It is, of course, significant that *Yogananda* was succeeded after his death in 1952 by two Americans, **Rajarsi Janakananda** and Sri **Daya Mata**. But it is equally significant, if not more so, that there are a number of other Western teachers of *kriya yoga* outside the orthodox SRF fold: **Shellyji**, both **Kriyanandas**, Roy Eugene **Davis,** and Srimati **Kamala**. But most significant of all is that they are by no means all the same:

> Premananda (who is Indian—see **Kamala**) has a church; Goswami **Kriyananda** has a temple; Swami **Kriyananda** has a world-brotherhood colony

> Both Premananda and Swami **Kriyananda** have established new monastic orders

> Goswami **Kriyananda** presents *kriya yoga* as form of *raja yoga*; Premananda says it is identical with Advaita Vedanta; **Davis** appears to think it is compatible with monistic Christianity

> Premananda is a Freemason and a Rosicrucian; **Shellyji** and both **Kriyanandas** teach astrology; Goswami **Kriyananda** and **Davis** both have psychic ability and can give teachings from past civilizations

[21] In Buddhism, this leads to what might be called 'alternative *sanghas*'—that is, Buddhist communities that do not follow any of the Eastern models. There aren't very many of them but they have all been formed by Western teachers (with varying degrees of encouragement from Eastern teachers). The first was established by Robert **Clifton**, an American Pure Land priest, who founded the Western Buddhist Order—not to be confused with **Sangharakshita**'s order of the same name—in America in 1952. The Order was recognized by the Pure Land and Soto Zen schools in Japan and any ordained priest could join. But in fact, its only members were Westerners. (Some of them were members of the English Sangha Trust, mentioned above.)

Although this Order was very small and no longer exists, it is important in the development of Western Buddhism—and for a number of reasons. First, it at least tried to be a *sangha*, which is very different from a society (such as we find in general lay Buddhism). Secondly, though it was affiliated with Pure Land and Soto Zen Buddhism, it was an entity in its own right and those who entered it were joining something different from either of these two schools. And lastly, it was founded by a Westerner and he was the one who admitted people (whether as priests or as laymen). All of these are firsts.

[22] Though these initiations are not accepted as valid by SRF, not even those given by Premananda. This is the only instance I know of where an Eastern teacher—and a senior one, at that—has been proscribed by a Westerner.

Yet all of them give *kriya yoga* initiation.[22] So this branch of Western Hinduism, at least, is not just an isolated plant but is beginning to propagate its own sub-species.

Other Westerners are crossing boundaries in other ways. Henri Le Saux arrived in India in 1948 and within two years had begun his exploration of Christian Vedanta as Swami **Abhishiktananda** at Shantivanam, an ashram (consisting of two huts) that he established with Jules Monchanin/Swami **Arubianandam**. His subsequent books join those of Paul **Brunton** and John **Levy** as accounts of Westerners' experiences of 'realization'. In 1949, Guru **Subramuniya** and Sri **Mahendranath** entered different branches of the Shaivite tradition—also in India. Subramuniya went on to found a Yoga Order and a Shaiva Siddhanta Church in America; Mahendranath set up an ashram in Gujarat called Merlin Oracle Lab . . .

All of these—Christian Vedanta, a Shaivite Church and an 'esoteric' ashram, for want of a better term—are innovations. At the same time, **Rudi** has been initiated by Swami Muktananda and has begun his investigation of *kundalini yoga*; and Swami **Radha**, having been made a *sannyasini* by Swami Sivananda, has established the first ashram ever by a Westerner in the West: the Sivananda Ashram in British Columbia in 1956.[23] (And all the while, the **Mother** and Sri **Krishna Prem** are continuing at *their* ashrams in India.)

None of these Western forms of Hinduism is co-ordinated. But as with Buddhism, the number of options has risen significantly. So the connections *are* there, to be explored when the time is right: Christian Vedanta links with Christian Zen; Swami **Radha** attained her realization in just six months (like **Kennett** in Japan); and her visionary encounter with Babaji, the 'founder' of *kriya yoga* links with other *kriya yoga* teachers and with **Subramuniya's** own visions of Siva.

Western Sufism is also beginning to take off. Frithjof **Schuon** has a series of visionary encounters with the Virgin Mary that lead him to found a new Sufi *tariqah*, the Maryamiyya. The American wing of the **Sufi Order**, originally under Rabia **Martin**, takes on a significant new direction when it becomes Sufism Reoriented under the guidance of *Meher Baba* and **Martin's** successor, Ivy **Duce**. Samuel **Lewis**, an initiate of Hazrat Inayat *Khan*, begins a series of pan-Sufi, one might even say trans-traditional, explorations. According to his own account, in 1946 Inayat *Khan* handed him over to Mohammed and Christ for guidance. This took place "in the inner world" and Mohammed gave him the name Ahmed Murad. This is about as strong an instance of 'inner' Sufism (started by Inayat *Khan* and finished, one could say, by Murshid Sam) as one could ask for. Ten years later, he went to the East and was initiated into the Naqshbandi Order in Pakistan and the Chishti Order in India. He was also

[23] Swami **Radha's** ashram and Guru **Subramuniya's** Yoga Order (founded in San Francisco in 1957) were the first Hindu organizations in the West—other than the Ramakrishna Order (which goes back to *Vivekananda's* Vedanta Society in 1896) and *Yogananda's* Yogoda Satsanga/Self-Realization Fellowship (established in 1920)—that lasted for anything more than a few years. There have been a number of other elements in the development of Western Hinduism, of course: there were two or three Theosophical translations of Hindu classics such as the *Bhagavad Gita* and the *Upanishads*; influential Indian teachers in the West like *Krishnamurti* and *Meher Baba*, who, though not Hindu, still offered teachings that are akin to some aspects of Hinduism; Western gurus, like the **Mother**, Sri **Krishna Prem** and **Mahendranath**, in India; accounts of some form of the tradition by Westerners who were 'insiders' or initiates (**Avalon**, **Guénon**, **Brunton**, **Levy**); even mavericks such as Yogi **Ramacharaka** and **Oom the Omnipotent**. I give all these due weight. But the one thing that was really vital for Western Hinduism to establish itself was ready access to forms of the tradition *in the West*. This does not start to happen in a general way until the 1950s.

initiated in India by Papa Ramdas and had a number of experiences with teachers in Soto Zen, Rinzai Zen and Shingon Buddhism in Japan (some of whom initiated him). In 1960, he made another trip abroad, this one limited to Sufism. He was initiated into the Rifai and Shadhili Orders in Egypt, and accepted as a full *murshid* of a branch of the Chishti Order in Pakistan.

More or less simultaneously, in 1953 and 1955, J.G. **Bennett** went to the Middle East and met some very unusual Sufi teachers there. A few years later, in 1961, he was being taught by the Shivapuri Baba in India. **Bennett**'s explorations have much in common with those of **Lewis** (though the two did not know each other) and the two men may be considered pioneers in what I call experiential comparative religion.

Bennett, of course, was a pupil of both **Gurdjieff** and **Ouspensky**, and following the deaths of these two, in 1949 and 1947 respectively, the various Fourth Way groups, which already constituted a sort of sub-family in the Western garden, began to evolve still further. In 1950, two books were published (in addition to Gurdjieff's own *Beelzebub's Tales*, the linchpin of 'orthodox' Gurdjieffism): Maurice **Nicoll**'s *The New Man* and *The Theory of Eternal Life* by Rodney **Collin**. They could hardly have been more different. *The New Man*, subtitled *An Interpretation of Some of the Parables and Miracles of Christ*, is sober and disciplined, and never even hints that a 'school' based on these ideas might exist. *The Theory of Eternal Life* is exuberant, not to say ecstatic, in places. It was the result of six days' seclusion immediately after **Ouspensky**'s death in 1947 and **Collin** regarded it as inspired by **Ouspensky** himself. At the very end of the book, **Collin** refers to 'my teacher' in unequivocally supernatural terms.

I do not want to make anything of this contrast—and indeed neither **Nicoll**'s nor **Collin**'s versions of the Fourth Way developed into anything very much—except to point out that it exists and that it is entirely in accord with other developments in spiritual psychology at this time: what was originally separate is being brought together, and what was originally unified is being expanded and diversified. I said earlier (p. 52) that one way of looking at spiritual psychology is that it is the result of putting different traditions in the same 'space'. What we can say now is that this Western space is being illumined by its own light.

FULL BLOOM: 1963 ONWARDS

Many people think that Eastern traditions only became significant in Western culture during the 1960s. It is true that they became *obviously* numerous and varied at that time. But this could not have happened without everything that had happened in the previous 70 or 80 years.

So much has become available in the last three decades that a short summary is very difficult. There are a variety of plots and sub-plots, some of them with unexpected twists. Since I have already given an outline of the main contours of the phenomenon in the previous chapter and there is a list of dates at the end of this one, the chronology of the developments during this period, and how they are related to each other, can be constructed without too much effort. Here, I will mention only a few significant patterns and themes.

The most striking thing is that Westerners are simultaneously at the heart of all the traditions and also extending them. Western Theravada shows this

very graphically. In 1979, 76 years after **Ananda Maitreya** first suggested the possibility, a Western *bhikkhu sangha* is finally established. This is the Chithurst *sangha* in Britain under the direction of Ajahn **Sumedho**. And at present it is the only one that is self-sufficient. What I mean by this is that if every other monk in the world disappeared off the face of the earth tomorrow, the Chithurst *sangha* could carry on the Theravadin tradition according to the *Vinaya* without any need for change or adaptation.

It is both interesting and instructive that the first ***vipassana sangha*** in the West, the Insight Meditation Society/IMS in Massachusetts, was actually set up three years before the Chithurst ***sangha*** despite the fact that the first Westerners to practice *vipassana* as a method in its own right did not begin until the 1950s and the numbers only began to grow appreciably from the mid-1960s onwards. In other words, the ***vipassana sangha*** has developed very quickly—in marked contrast to the *bhikkhu sangha*. The reason for this difference is not far to seek, however. The *bhikkhu sangha* is constrained by the *Vinaya* but *vipassana* communities are not. Hence they can organize themselves as they think best. It is an open question whether IMS and the much larger ***vipassana sangha*** that has since grown up in the West are at the heart of the Theravadin tradition or an extension of it. If one takes the view that *vipassana* is the core of the Buddha's teaching, then of course the ***vipassana sangha*** is central and the way it has organized itself is quite secondary. If, on the other hand, one places the *Vinaya* at the centre of the tradition, then the ***vipassana sangha***, which does not follow it, can only be seen as an optional extra.

At present, the matter is by no means decided. (See the next chapter, p. 120, for more discussion of the principles involved.) The point is that Westerners are not second-class citizens, sitting on the edge of the debate, but are participating in it to the full. One of the main reasons for this is that there is a natural overlap between the two *sanghas* (*bhikkhu* and *vipassana*). Ajahn **Sumedho** and other monks in the Chithurst *sangha* have practised vipassana for years and teach it; and some members of the ***vipassana sangha*** (such as Jack **Kornfield** and Christopher **Titmuss**) were monks in the East before they started teaching.

There are also connections with other *sanghas* which have definitely crossed the Theravadin boundaries. The **ccumenical *sanghas*** of Ven. **Dharmapali** and **Miao Kwang Sudharma**, for example, both have a Theravadin component; indeed, Dharmapali was ordained as an eight-precept *anagarika* in the Chithurst *sangha*. And **Sangharakshita**, who has established an entirely independent Western Buddhist Order, was ordained as a Theravadin monk in India.[24]

The relationship between all these *sanghas*—*bhikkhu*, *vipassana*, ecumenical, the Western Buddhist Order (plus a fifth, which is presently just a possibility, the *bhikkhuni sangha*[25])—is still in the process of being formed. But despite the influence of many fine Eastern teachers and that of the Eastern Theravadin tradition generally, I would maintain that the end result will be essentially Western. In fact, it already is. Why? Because it is only in the West that one can find all these options. This is not to say that the East is excluded.

[24] He was also briefly in charge of the Hampstead Vihara, which was the focus of the English Sangha Trust's attempt to form a Western *bhikkhu sangha*, in the mid-1960s. But it was Ajahn **Sumedho** who eventually brought this project to a successful conclusion

[25] See Chaper 1, p. 6.

1963 to the present

Westerners now do EVERYTHING

Various *sanghas* are established: the first Theravadin *bhikkhu sangha* in the West (Ajahn **Sumedho**); the *vipassana sangha*; a couple of **ecumenical sanghas**; **Sangharakshita's** independent Western Buddhist Order.

Roshis, senseis and Dharma teachers are appointed in the Japanese Rinzai, Soto, and Sanbokyodan schools, as well as Korean and Vietnamese Zen (**Aitken, Kapleau, Kennett, Baker, Stuart, Glassman, Gilbert, Rhodes, Karuna Dharma**—to name only nine out of more than 50). Some of these, but only in the Soto and Sanbokyodan schools, have appointed their own Dharma-heirs, so there are Western Zen lineages now. Special effort has gone into making the tradition accessible to women, gays and Christians. There are all sorts of innovations: **Aitken**'s social activism, **Glassman**'s 'Zen Business', **Stuart**'s use of the piano as a teaching device. And there are some who appear to be creating their own form of the tradition (Zen Master **Rama**, Zen Master **Tundra Wind**).

Westerners enter the Tibetan tradition in considerable numbers and quickly rise through the ranks: there are now Western *lamas* (Kunzang Dorje, Denis **Teundroup**), regents (**Osel Tenzin**, Ngakpa **Jampa Thaye**), and *tulkus* (**Sangje Nyenpa Rinpoche**, Lama **Osel**, Jetsunma **Ahkon Norbu Lhamo**).

Western Hinduism continues to flower: conservative, 'traditional' forms like the **Hare Krishna gurus** and the **Devyashrams**, who build temples and conduct *pujas*, exist alongside 'freer' forms such as **Ram Dass**'s Seva Project and Swami **Kriyananda**/Donald Walters's Co-operative Village.

Sufi teachers like Idries **Shah**, Reshad **Feild** and Irina **Tweedie** appear who are part of a 'higher' Sufism that, though derived from specific schools (Naqshbandi, Mevlevi), goes beyond them. Samuel **Lewis** dies and his pupils form their own Sufi order.

And there are independent masters who do not align themselves with any tradition at all but teach from themselves: Swami **Turiyasangitananda**, **Stephen**, Paul **Twitchell**, **John-Roger**, John **Yarr**/Ishvara, Barry **Long**, **Shunyata**, Bhagavan **Nome**, Andrew **Cohen**, Michael **Barnett**, **Marasha**, Lee **Lozowick**, Master **Da**. This is a very mixed bag indeed but they all have one thing in common: they make claims that are quite as high as any that have been made in the East.

The trans-traditional **arya sangha** comes into existence.

The phenomenon of Western teachers and masters is now in full bloom.
The exotic plants of the East are spreading across the West, cross-fertilizing each
other in a way that never happened in the East and often creating new hybrid
forms that are even more vigorous than their Oriental parents.

On the contrary, it is in a sense part of the Western developments. This is remarkable; and it is light years away from the situation at the turn of the century, when Western participation in the tradition was either isolated (Western monks in Eastern countries), tangential (Theosophical Buddhism) or superficial (general lay Buddhism). This is not to say that the quality of Western Theravada is now uniformly high. But it is an entity in its own right, connected to, but not dependent on, its Eastern parent.

The same could be said about Western Zen (though the situation is complicated by the existence of several schools). From the moment that Jiyu **Kennett** was appointed as the Dharma-heir of her teacher, Chisan Koho, in 1963, the possibility of Western Zen lineages, and hence an independent Western Zen, was created. And this is exactly what has happened. There are now several Western teachers—at least 20—who have been appointed by their Western teacher. (See the entries on Jiyu **Kennett**, Richard **Baker**, Bernard

Glassman, Dennis **Merzel**, Robert **Aitken**, and Philip **Kapleau**.) All of these are in the Soto and Sanbokyodan schools.[26] There are as yet no Western lineages in Korean and Vietnamese Zen, which only came to the West during this modern period, and, more surprisingly, in Japanese Rinzai despite the fact that its first contact with the West was in 1893.[27] No doubt it will happen fairly soon. But until it does, there will be no Western Korean Zen or Vietnamese Zen or Rinzai Zen. (There already are Westerners who teach in these schools but that's not the same thing.)

The situation is somewhat different in the Tibetan tradition, mainly because of its hierarchical nature. What Westerners lacked in the early period—that is, up until the 1960s—was the opportunity to practice Tibetan Buddhism in the traditional way: to do what Tibetans do. In saying this, I am not implying that the traditional way is necessarily the best; just that it has to be an option if Westerners are not to invent the tradition for themselves. And this option *is* now available. It was created by the Tibetan diaspora, which began when the Dalai Lama went into exile in India in 1959, together with many thousands of his countrymen. Tibetan teachers are generous and have opened up the tradition in every direction and in all dimensions. Hence Westerners have a great variety of roles, both in the *sangha* of monks or 'nuns'[28] and in lay life. Both of these exist in the tradition and the Tibetans have simply adapted them in order to deal with Western needs and circumstances. This sometimes requires a new direction and it is often Westerners who are asked to take it. But since Tibetan Buddhism is based on the principle that the high *lamas* and *tulkus* actually represent the tradition in themselves, so to speak, such adaptations and innovations are regarded as a form of transmission.

This affects all the developments that have taken place in Western Tibetan Buddhism from the time that Freda **Bedi** became the first Western woman to take *sramanerika* ordination in 1966 to the death of **Osel Tendzin**, Chogyam *Trungpa*'s Vajra Regent, in 1990, and his replacement by Trungpa's son. In the intervening years, Westerners have taken nearly every teaching role in the tradition: as meditation teachers (Ole **Nydahl** has opened over a hundred Dharma centres worldwide), monks, nuns (Freda **Bedi** took full *bhikshuni* ordination in the Mahayana tradition in 1972, the first woman of any nationality in the Tibetan tradition to do so), *lamas*, and *tulkus*. This is quick work. In 1959, when the Dalai Lama arrived in India, Western contact with the tradition was virtually non-existent. Thirty-five years later, Westerners, having entered on the bottom rung, so to speak, are now at least halfway up the ladder. Whether they will reach the top—by which I mean that one of the most important Tibetan *tulkus* would be recognized in a Western body—I cannot say. But

[26] There is some unclarity about whether the appointments that Western Soto teachers have made are regarded as legitimate by the Soto school in Japan. (See Reb **Anderson**'s entry.) Hence one cannot say unequivocally that Western Soto is self-sufficient in the sense that the Chithurst *sangha* is: that it could reconstruct the tradition entirely from itself. This is a complex issue, involving the nature of transmission and how it is related to other dimensions of a tradition, and I do not want to oversimplify it. (See the discussion in Chapter 3.) But clearly the very existence of Western Zen lineages is a significant change of gear, whatever reservations one may have about their conformity to the Japanese model. (And by the same token, the absence of Western lineages in the Rinzai, Korean, and Vietnamese traditions is equally significant.)

[27] There is a direct connection between *Soyen Shaku*, who brought Rinzai to the West in this year, and Irmgard **Schloegl**, who was ordained as a priest in 1984. See Lineage Tree 6.

[28] I use scare quotes because full ordination for women has never existed in Tibet and by convention the term 'nun' is used for those who have received it. Technically, women in the Tibetan *sangha* are novices or *sramanerikas*.

I see no reason at the moment why it should not happen; some way in the future, perhaps, but still a real possibility.

So I think it is fair to say that Westerners are at the heart of the tradition. And it is worth pointing out that it is *only* Westerners who can fulfil this role. There is no likelihood at all of Buddhists from other countries (Japan, Korea, Vietnam, Burma, Sri Lanka, Thailand) doing so; nor even of Indians, despite the fact that Tibetans have lived in India since 1959. The West is the only 'open' direction—for all Eastern traditions, not just Tibetan Buddhism.

Meanwhile, Western Hinduism continues on its way (and of course this is the only kind of non-Indian Hinduism; there is no Japanese, Thai, or Tibetan Hinduism and not the slightest possibility of there being any), becoming richer and more intricate all the time. Western Hindu lineages (in addition to the Self-Realization Fellowship which goes back to 1952) are being created: the **Hare Krishna gurus** and the **Devyashrams**. There has also been a profusion of personal transmissions from guru to disciple.

One of the new developments has been a number of schisms: **Rudi**'s break with Swami Muktananda; **Sat Prem** and Patrizia **Norelli-Bachelet**'s version of the **Mother**'s teachings; several splits in ISKCON. It would be wrong to say that this does not occur in other traditions—Jiyu **Kennett**, **Sangharakshita**, and Frithjof **Schuon** could all be said to be schismatic in one sense—but it is relatively common in Hinduism because of the idea that a teacher can take a new direction that is required by his or her inner realization. The ones I have mentioned are by no means the first in Western Hinduism: Swami **Abhayananda**/Marie Louise split away from the Ramakrishna Order as early as 1898 and there were several schisms after *Yogananda*'s death in 1952. But they are far more common now. This may seem like a weakness rather than a strength but as I point out in Chapter 3, such a view is based on an understanding of traditions which does not apply to all forms of Hinduism. When a plant is well-established, it can provide cuttings vigorous enough to grow by themselves. This is how Hinduism propagates itself, in the main, so one could say that it is proof of Western Hinduism's strength that so many of its cuttings should have taken root.

It might be argued that the claim that Western teachers are now both at the heart of the traditions and extending them does not apply to Sufism. True, there are people like Lex **Hixon**/Sheikh Nur al-Jerrahi, who was given formal transmission in the Khalvati-Jerrahi Order in 1980 and who may therefore be regarded as at the heart of the tradition—having a function in Sufism that is analogous to Westerners who are monks in Theravada, Zen *roshis/senseis/ Dharma* teachers, *lamas* and *tulkus* in the Tibetan tradition, or gurus and *sannyasins* in Hinduism. But Western *sheikhs* are still rare and the number who are in charge of Western Sufi communities can be counted on the fingers of one hand. Hence they are still outnumbered by Westerners like Reshad **Feild**, Irina **Tweedie**, and James **MacKie**, who are not part of a traditional Sufi community. So if all the other Sufis in the world disappeared overnight, these non-traditional Sufis could not recreate Sufism as it presently exists. They simply do not have the knowledge. (Of course, they would say that there is no need for them to have it, but that is another issue.)

The reason that traditional Western—that is, Moslem—Sufism is not common is connected with the point I made earlier (p. 41): in the East, Sufism is always part of a Moslem community. Westerners have not found it easy to create such a community hence Western Sufism has tended to be of the

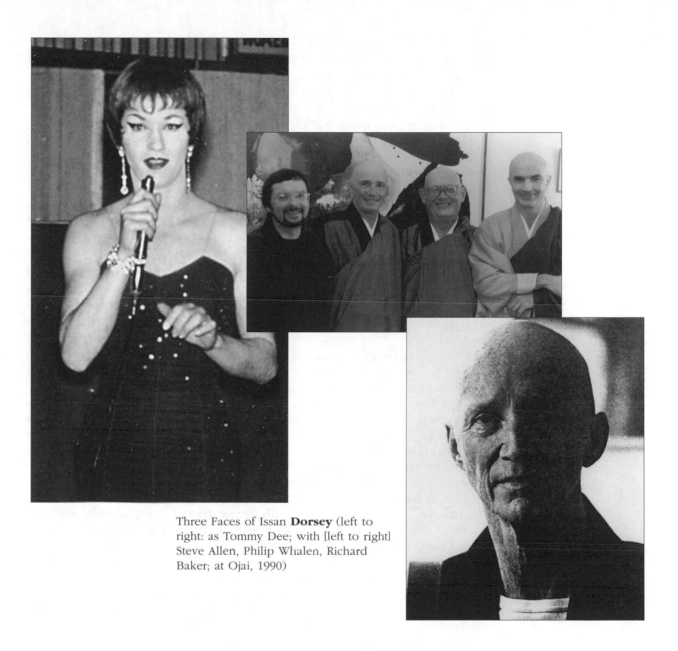

Three Faces of Issan **Dorsey** (left to right: as Tommy Dee; with [left to right] Steve Allen, Philip Whalen, Richard Baker; at Ojai, 1990)

non-Moslem, universalist variety. Whether one regards non-Moslem Sufism as an extension of the tradition or a deviation from it depends on one's view of orthodoxy. But that is not the subject of this chapter. Rather, I simply want to point out that in this modern period, and despite the reservations I have just outlined, Western Sufism has become both deeper and wider, both closer to the parent tradition and a variant of it; and that in this, it is following the same pattern as all the other traditions (despite the fact that the dimensions of each tradition are distinct). (See Chapter 3, for the various dimensions and how they are related.)

But perhaps the most distinctive aspect of the modern period is the appearance of significant numbers of independent teachers—those who do not align themselves with any tradition but teach from themselves. (There were some

precursors—notably **Gurdjieff**—but very, very few.) These people are extremely varied both in what they say and its quality,[29] yet it is evident that they all occupy the same terrain. And it is a terrain that has already been cultivated by those who have gone before them. All those explorations that seemingly came to nothing; all the efforts that were apparently confined to one tradition or even a single section of it; all the adaptations and innovations—taken together, they provided the soil in which these independent plants can flourish.

But in fact there are no independent plants any more. The Western garden is now so extensive that it is an entity in its own right and influences everything that grows in it. Western teachers have extended the boundaries of traditions on an unprecedented scale. This has led to an number of reverberations and intricacies. For example, there could be no *arya sangha*—the response to the human condition based on wisdom and compassion that includes all the traditions—unless there were several ideals of wisdom and compassion to act as inspiration. Similarly with experiential comparative religion: it can only exist as a genuine movement in a place where there are enough religions/traditions to experience in the first place. (And that place is the West.)

I am not trying to idealize the West when I say this but rather to highlight its essential feature: that it joins things up. It may do so ineptly at times and even most of the time. But it is the Western way and it will continue. At the same time, of course, there are specifically Western concerns. One of them is that women are not spiritually inferior to men. In fact, they have always been pioneers in this phenomenon but in the modern period their activities come thick and fast. We find the following in the years 1981 to 1984, for example: Dhyani **Ywahoo** is recognized as a Nyingma teacher; Pema **Chodron** is made abbess of Gampo Abbey; Jan **Bays** becomes Taizan *Maezumi*'s fourth Dharmaheir; Linda **Klevnick** and Linda **Murray** are appointed as Dharma Teachers in the Korean Zen tradition; Ven. **Dharmapali** and Irmgard **Schloegl** are ordained in their respective traditions; **Miao Kwang Sudharma** takes ordination in her *third* tradition; Ayya **Khema** founds an international Nun's Island in Sri Lanka; Swami Saraswati **Devyashram** succeeds Swami Lakshmi **Devyashram** as head of the Shankaracharya Order in Pennsylvania. But it is not all plain sailing. During these same years, Toni **Packer** left Philip **Kapleau**'s Zen Center in Rochester (on her way to becoming a completely independent teacher); Joko **Beck** left her teacher, Taizan *Maezumi*; and Jacqueline **Mandell** and Gesshin **Prabhasa Dharma** abandoned their respective traditions altogether. **Mandell** said that she could no longer support the discrimination against women in Theravada and has remained unattached. **Prabhasa Dharma** found the methods of Rinzai Zen too harsh and moved to the Vietnamese Zen tradition instead.

All these 'moves' can be, and are being, assessed in various ways. But whatever we make of them, two things are certain: that most of them could not have been made by an Eastern woman in an Eastern country; and that they all have reverberations beyond the confines of their particular school or

[29] Though there are a few external connections (between Paul **Twitchell** and **John-Roger**, for example, and between **Rudi** and Master **Da**). It is also noticeable that every single one (see the list in Chapter 1) with the exception of **John-Roger** and **Stephen**, has had contact with India in some way: they have all been there or been taught by an Indian master (or both). They may say that it is irrelevant or never mention it or even deny it, but the connection is there nevertheless.

tradition. This is not to create false alliances between these women—although some of them do know each other—but simply to point out that the model for female spirituality in the West is drawing on sources that are much more varied than at any previous time in history.

But this, of course, is true of the whole phenomenon of Western teachers, not just the women. In 1987, for example, a number of events occurred that were all connected with the meaning and significance of transmission: Lama **Osel** went through the formal ceremony that marks the recognition of a *tulku*; **Osel Tendzin** took over the leadership of the Vajradhatu communities (over a hundred of them) as Chogyam *Trungpa*'s regent; Shrila **Bhaktipada** was expelled from ISKCON and **Jayatirtha**, another of the **Hare Krishna gurus**, was murdered; accusations of various sorts were made against Zen Master **Rama** and John **Yarr** by disaffected followers (with diverse repercussions for their status as teachers); and G.B. **Chicoine** said he wasn't going to teach any more.

Again, what all these incidents amount to is a matter for investigation and discussion. The first step is certainly to see what the traditions have to say about transmission and how this affects the function of a teacher: *tulkus* and regents in Tibetan Buddhism, and the guru in ISKCON (as a branch of Gaudiya Vaishnavism). But what we find is that both these traditions contain more than one view on these issues. On top of that, Zen Master **Rama**, **Yarr**, and **Chicoine** all taught independently of any of the established traditions: **Chicoine** said that he belonged to several traditions simultaneously; **Rama** said that he had created his own tradition (Tantric Zen); **Yarr** claimed to be beyond all traditions (though in fact he was initiated into an Indian path). It is surely facile to accept these claims at face value. But where are we to look for some help in assessing them? Answer: in the phenomenon of spiritual psychology as a whole. My point is simply that issues about transmission and the function of teachers are being raised in all the traditions and outside them, and that they are being raised right on top of one another, as it were. So they are bound to be connected.

One could even say the same about that great leveller, death. In 1990, Issan **Dorsey** and **Osel Tendzin** both died of AIDS, and Maurine **Stuart**, Hugo **Enomiya-Lassalle**, and Jeanne **de Salzmann** all died of old age. The consequences of their deaths differed in every case. **Dorsey**'s brought together factions of the San Francisco Zen Center that had been estranged for years. **Osel Tendzin**'s divided the Vajradhatu community and brought a short-lived experiment—giving spiritual responsibility to a Westerner after the death of a Tibetan teacher—to an end. **Stuart**'s affected many individuals but not a specific community.[30] And it remains to be seen what will happen to Christian Zen (**Enomiya-Lassalle**) and the Gurdjieff Work (**de Salzmann**), both of which are already fairly well-established and diverse. None of these individuals were part of the same lineage—three of them were Zen teachers but they were all in different schools—yet each one had his or her place in the development of the phenomenon. It is now so interconnected that even when someone is taken from it, he or she still leaves a trace.

It was only a century ago that the West first encountered the spiritual teachers of the East and began to take them seriously; now it's *Western* teachers that need to be taken seriously. They are the leaven in Western culture—and they are changing it.

[30] In 1992, however, she was posthumously acknowledged as part of the lineage of Robert **Aitken**'s Diamond Sangha.

	THERAVADA	ZEN	TIBETAN BUDDHISM [+ OTHER BUDDHISM]
1785			
1826	Burnouf and Lassen's Pali grammar		
1832			
1834			de Koros's Tibetan dictionary and grammar
1836			de Koros publishes works on the *Kanjur* and *Tanjur*
1837			
1840			
1843			
1860	Albrecht Weber's German translation of the *Dhammapada*		
1863			
1867			
1868			
1869			Schiefner's translation of Taranatha's *History of Buddhism in India*
1874			Hodgson, *Essays on the Languages, Literature and Religion of Nepal and Tibet*
1875			

HINDUISM	SUFISM	INDEPENDENT	
Wilkins's translation of the *Bhagavad Gita*			**1785**
			1826
Rammohan Roy's translations of some Upanisads			**1832**
			1834
Poley, French translation of *Moundaka-oupanichat*			**1836**
Colebrooke, *Essays on the Religion and Philosophy of the Hindus*; translation of the *Sankhya-karika*			**1837**
Burnouf's French translation of the *Bhagavata Purana*			**1840**
Emerson reads Wilkins's translation of the *Gita*			**1843**
			1860
	Garcin de Tassy's translation of Attar, *Le Mantic uttaïr, ou le Langage des Oiseaux*		**1863**
	Palmer, *Oriental Mysticism*		**1867**
	Brown, *The Dervishes, or Oriental Spiritualism*		**1868**
			1869
			1874
		Blavatsky founds the Theosophical Society in New York	**1875**

	THERAVADA	ZEN	TIBETAN BUDDHISM [+ OTHER BUDDHISM]
1877	T.W. Rhys Davids, *Buddhism, being a sketch of the life and teachings of Gautama the Buddha*		
1879	Edwin Arnold, *The Light of Asia*		
1880	**Blavatsky** and **Olcott** take *pansil* in Ceylon *[see Independent dates for other entries on these two]*		
1881	Rhys Davids and Muller found the Pali Text Society **Olcott**'s *Buddhist Catechism* Oldenberg, *Buddha, seine Leben, seine Lehre, seine Gemeinde*		
1882	Senart, *Essai sur la légende du Buddha: son caractère et ses origins*		
1884	**Olcott** authorized to administer the three Refuges and the five precepts (*pansil*) to any lay person		
1888	Bhikshu Subhadra, *Buddhistischer Katechismus*		
1889	**Olcott** and *Dharmapala* go to Japan		
1891	*Dharmapala* founds the Maha Bodhi Society		
1891	*[see Other Buddhist dates]*		**OTHER BUDDHISM** **Olcott** holds a meeting of Buddhists from Burma, Ceylon, Japan, and Bengal to consider the propagation of Buddhism in the West
1893	*Dharmapala* attends World Parliament of Religions in Chicago; founds an American branch of the Maha Bodhi Society	*Soyen Shaku* attends the World Parliament of Religions in Chicago	**Tennisons** *[see 1915, 1949]* ordained a monk in Siberia

HINDUISM	SUFISM	INDEPENDENT	
		Blavatsky, *Isis Unveiled*	**1877**
Müller starts *Sacred Books of the East* series; first volume: the *Upanishads* Deussen, *Das System des Vedanta*	Clarke's translation of Sa'adi's *Bustan*		**1879**
		[see Theravada dates]	**1880**
	Redhouse's translation of Rumi's *Masnavi*		**1881**
		Blavatsky and **Olcott** establish the HQ of the Theosophical Society in India	**1882**
			1884
		Blavatsky, *The Secret Doctrine*	**1888**
			1889
		Death of Madame **Blavatsky**	**1891**
			1891
Vivekananda attends the World Parliament of Religions in Chicago			**1893**

	THERAVADA	ZEN	TIBETAN BUDDHISM [+ OTHER BUDDHISM]
1894	**Carus,** *Gospel of Buddha According to Old Records*		
1895			Waddell, *The Buddhism of Tibet or Lamaism*
1896	Warren, *Buddhism in Translations*		
1897	*Dharmapala* celebrates the first Vaisakha/Wesak in U.S. with 400 attending		
1898			
1899	Gordon Douglas ordained as Bhikkhu Asoka in Colombo		
1900			
1901			*[see Independent dates]*
1902	**Ananda Maitreya** *[see 1908]* becomes a monk in Burma; his *Foundation of the Samgha of the West*		
1904	**Nyanatiloka** enters the *sangha* in Burma		
1905		*Soyen Shaku* returns to US (having left in 1893) to teach Alexandra Russell (near San Francisco)	
1906	**Nyanatiloka**, *Das Wort des Buddha*	*Soyen Shaku* joined in San Francisco by Nyogen Senzaki and Sokei-an Sasaki; publication of his *Sermons of a Buddhist Abbot*	

HINDUISM	SUFISM	INDEPENDENT	
			1894
Vivekananda initiates Swami **Abhayananda** and Swami Kripananda; they teach while he is away in England			**1895**
Vivekananda creates the Vedanta Society in New York [date uncertain]; publication of his *Raja Yoga*			**1896**
	Depont and Coppolani, *Les Confréries religieuses musulmanes*		**1897**
Swami **Abhayananda** initiates another woman as a *sannyasin*, and founds an Advaita Society in Chicago [date uncertain] **Nivedita** initiated by *Vivekananda* in India			**1898**
			1899
Sister **Nivedita**, *Kali the Mother*			**1900**
Vivekananda's *My Master* (89 pages on Ramakrishna)		**Gurdjieff** possibly in Tibet	**1901**
Vivekananda dies in India; Sister **Nivedita** breaks with the Ramakrishna Order			**1902**
Yogi **Ramacharaka**, *Yoga Philosophy and Oriental Occultism*			**1904**
			1905
Swami Trigunatita of the Ramakrishna Order founds a temple in San Francisco, plus a monastery (for seven men) and a nunnery (for three women)			**1906**

	THERAVADA	ZEN	TIBETAN BUDDHISM [+ OTHER BUDDHISM]
1907	Death of **Olcott**		
1907	Buddhist Society of Great Britain and Ireland founded		
1908	**Ananda Maitreya** *[see 1902]* visits England		
1909			Kawaguchi, *Three Years in Tibet*
1910			
1911	**Nyanatiloka** *[see 1904, 1906]* founds the Island Hermitage in Ceylon		
1912			Alexandra **David-Néel** meets Dawa Samdup *[see 1919]* in Sikkim
1913		Nukariya, *Religion of the Samurai*	
1914			**David-Néel** becomes a disciple of the Gomchen of Lachen *[see 1936]*; practices *tumo*
1915			Buddhist temple opened in St. Petersburg; **Tennisons** *[see 1893]* is its first bishop
1916			

HINDUISM	SUFISM	INDEPENDENT	
Vivekananda's *Collected Works* published in four volumes in India	[approx.] **Agueli** initiated in Egypt; returns to Paris as a *moqaddem*		1907
			1907
	Iqbal, *The Development of Metaphysics in Persia*		1908
Paramananda starts Vedanta centres in Boston and Washington, with Sister **Devamata** as his platform assistant **Oom the Omnipotent** founds Tantrik Order of America			1909
Sister **Nivedita**, *The Master as I Saw Him* (London); writes for *The Karmayogin*	Hazrat Inayat *Khan* arrives in America Nicholson's translation of Ibn Arabi's *Tarjuman al-Ashwaq*		1910
Death of Sister **Nivedita** *[see 1908]* in Darjeeling			1911
	Rabia **Martin** appointed *murshida* by Inayat *Khan* **Guénon** initiated by **Agueli** Inayat *Khan* moves to Britain	**Gurdjieff** arrives in Moscow **Ouspensky**, *Tertium Organum*	1912
Avalon, *The Tantra of the Great Liberation* and *Hymns to the Goddess*	Inayat *Khan* marries Ora Ray Baker in London		1913
The **Mother** meets Aurobindo in Pondicherry	Inayat *Khan*, *A Sufi Message of Spiritual Liberty* Nicholson, *The Mystics of Islam*		1914
			1915
		Gurdjieff teaches his ideas to a small group (including **Ouspensky**)	1916

	THERAVADA	ZEN	TIBETAN BUDDHISM [+ OTHER BUDDHISM]
1917			
1918			
1919		Death of *Soyen Shaku*	
1920			
1921	**Grimm** and Seidenstucker establish Das Altbuddhistische Gemeinde		
1922	*[see Other Buddhist dates]*		**OTHER BUDDHISM** International Buddhist Union —supported by *Dharmapala*, **Ananda Maitreya**, Hoffman/ **Govinda**, **Grimm**, Nixon/ **Krishna Prem**, **Goddard**
1923	Death of **Ananda Maitreya** *[see 1902, 1908]*		
1924	**Humphreys** founds the Buddhist Lodge of the Theosophical Society in London *[see 1943]* **Dahlke** establishes his Buddhistische Haus		**David-Néel** reaches Lhasa
1925	**Lokanatha** ordained as a monk in Burma	Herrigel, Faust and Ohasama, *Zen, der lebendige Buddhismus in Japan*	Bacot, *Le poète tibétain Milarepa*
1926	*Dharmapala* founds the British Maha Bodhi Society; the Buddhist Society of Great Britain and Ireland *[see 1907]* is dissolved	Samuel **Lewis** helps Nyogen Senzaki establish a *zendo* in San Francisco	

HINDUISM	SUFISM	INDEPENDENT	
	Inayat *Khan* establishes the Sufi Order in London *[see 1923]*		**1917**
		Ouspensky leaves **Gurdjieff** (in Essentuki)	**1918**
Sister **Daya** appointed as Swami Paramananda's second platform assistant *[see 1909]*	**Lewis** meets Rabia **Martin**		**1919**
Yogananda arrives in Boston	Inayat *Khan* moves to France		**1920**
Guénon, *L'Introduction à l'étude des doctrine hindoues*	Saintsbury **Green** founds the Sufi Order's Universal Worship	**Ouspensky** arrives in London	**1921**
The **Mother** *[see 1914]* takes over the running of Aurobindo's ashram	Massignon, *La Passion de Hallaj*	**Gurdjieff** sets up the Institute for the Harmonious Development of Man at Fontainebleau	**1922**
Paramananda starts Ananda Ashram at La Crescenta, near Los Angeles **Atulananda** becomes a *sannyasin* in India	Inayat *Khan* establishes the Sufi Movement in Geneva *[see 1917]*; initiates **Lewis**; makes **Green** and **Egeling** *murshidas*		**1923**
Yogananda, *The Science of Religion*		**Gurdjieff** authorizes **Orage** to teach in America	**1924**
Guénon, *L'homme et son devenir selon le Vedanta* *Yogananda* establishes his headquarters in Los Angeles	**Lewis** receives inner initiations from the prophets		**1925**
The **Mother** begins to take disciples of her own	*[see Zen dates]*		**1926**

	THERAVADA	ZEN	TIBETAN BUDDHISM [+ OTHER BUDDHISM]
1926	**Uppalavanna** ordained in Ceylon		
1927		D.T. Suzuki, *Essays in Zen Buddhism (First Series)*	**David-Néel**, *Voyage d'une Parisienne à Lhassa/My Journey to Lhasa* **Evans-Wentz**, *The Tibetan Book of the Dead*
1928	*Dharmapala* establishes a *vihara* in London with three Sinhalese monks in residence	**Goddard** practices at a Zen monastery in Japan	
1929		**Salanave** *[see 1935]* practises at Daitokuji monastery, Kyoto	
1930		Sokei-an Sasaki founds the First Zen Institute of America in New York Ruth Fuller Everett/**Sasaki** meets Suzuki in Japan and is taught *zazen*	
1931		**Goddard**, *The Buddha's Golden Path: A Manual of Practical Dhyana Buddhism*	Lama Anagarika **Govinda** initiated in India **David-Néel**'s *With Mystics and Magicians in Tibet* Sir Charles Bell, *The Religion of Tibet*
1932			**OTHER BUDDHISM** **Goddard**, *A Buddhist Bible*
1933	Death of *Dharmapala* *[see 1889, 1891, 1893, 1897, 1926, 1928]*	Suzuki, *Essays in Zen Buddhism, (Second Series)*	**Govinda** founds the Arya Maitreya Mandala in Darjeeling

HINDUISM	SUFISM	INDEPENDENT	
			1926
Yogananda meets President Coolidge at the White House	Death of Hazrat Inayat *Khan* in India; succeeded by Maheboob Khan *[see 1948]*; **Martin** *[see 1912]* continues independently in America		**1927**
Krishna Prem initiated by Sri Yashoda Mai		Jane **Heap** starts her group in Paris	**1928**
		Gurdjieff finishes first drafts of *All and Everything* and *Meetings with Remarkable Men*; closes the Prieuré	**1929**
		Tagore invites **Shunyata** to India	
		Krishnamurti dissolves the Order of the Star and repudiates his role as Messiah	
Sri Yashoda Mai and Sri **Krishna Prem** found the Uttara Brindaban ashram near Almora	**Guénon** emigrates to Egypt	**Bennett** starts a group independently of **Ouspensky**	**1930**
Sri **Daya Mata**, aged 17, initiated by *Yogananda*		**Ouspensky** authorizes **Nicoll** to teach; publication of *A New Model of the Universe*	**1931**
Rajarsi Janakananda initiated by *Yogananda*	**Schuon** initiated by Shaikh Ahmad al-Alawi in Algeria *[see 1935]*		**1932**
		Gurdjieff, *The Herald of Coming Good*; sells the Prieuré	**1933**
		Jeanne **de Salzmann** starts teaching	

	THERAVADA	ZEN	TIBETAN BUDDHISM [+ OTHER BUDDHISM]
1934	First European Buddhist Congress held at the Maha Bodhi Society HQ in London *[see 1926]*	**Goddard** founds the Followers of the Buddha	
1935		**Salanave** *[see 1929]* founds the Western Women's Buddhist Bureau and the East-West Buddhist Mission in San Francisco	**Evans-Wentz**, *Tibetan Yoga and Secret Doctrines*
1936		Alan **Watts**, *The Spirit of Zen*	**Govinda** practices with the Gomchen of Lachen *[see 1914]*
1937			
1938		Ruth Fuller Everett/**Sasaki** teaches *zazen* at Sokei-an's First Zen Institute in New York	
1940	The Buddhist Vihara in London *[see 1928]* closes		Simon **Grimes**, aged 3 and living in China, recognized as the seventh Panchen Lama
1941			
1943	The Buddhist Lodge *[see 1924]* changes its name to the Buddhist Society		
1944		Marriage of Ruth Fuller Everett and Sokei-an Sasaki **Aitken** meets Blyth in a Japanese POW camp	
1945		Death of Sokei-an Sasaki *[see 1938, 1944]*	
1946			
1947			

HINDUISM	SUFISM	INDEPENDENT	
Brunton, *A Search in Secret India*	[approx.] **Burckhardt** initiated into the Darqawiyya in Morocco	Death of **Orage** *[see 1924]*	**1934**
	Schuon appointed *moqaddem*	**Gurdjieff** sends **Heap** to London to teach	**1935**
[see Independent dates]		**Shunyata** *[see 1929]* meets *Ramana Maharshi* at Arunachala	**1936**
The **Mother**, *La Decouverte Supreme*	**Schuon**'s inner conviction that he has become the *sheikh*		**1937**
Krishna Prem's *The Yoga of the Bhagavat Gita*			**1938**
			1940
		Ouspensky and **Mme. Ouspensky** go to America	**1941**
	Martin offers her Sufi Order to *Meher Baba*		**1943**
Krishna Prem becomes Sri Yashoda Mai's successor **Levy** attains liberation in India under the guidance of Sri Atmananda			**1944**
			1945
Paramahansa *Yogananda, Autobiography of a Yogi*			**1946**
	Death of Rabia **Martin**; succeeded by Ivy **Duce**	Death of **Ouspensky**; Roles, **Nicoll,** and **Collin** carry on his teachings; **Madame Ouspensky** returns to **Gurdjieff**	**1947**

	THERAVADA	ZEN	TIBETAN BUDDHISM [+ OTHER BUDDHISM]
1948			
1949		Ruth Fuller **Sasaki** goes to Kyoto; attends *sanzen* with Zuigan Goto Roshi	**Tennisons** *[see 1893, 1915]* arrives in Burma
1950		**Aitken** enters a monastery in Japan [approx.] **Nowick** *[see 1969, 1985]* goes to Japan and practices with Zuigan Goto	[approx.] **Govinda** takes his first disciples (in India) **OTHER BUDDHISM** **Sangharakshita** *[see 1957, 1964, 1967, 1968]* ordained as a Theravadin monk in India
1951	**Humphreys**, *Buddhism*		**David-Néel**, *Les enseignements secrets dans les sectes bouddhistes tibétaines*
1952	**Bedi** practices *vipassana* with Mahasi Sayadaw in Burma *[for other references to Bedi, see Tibetan Buddhist dates]* U Ba Khin founds his International Meditation Centre, Rangoon		Foundation of the Westlicher Orden des Arya Maitreya Mandala *[see 1933]* in Berlin **OTHER BUDDHISM** **Clifton** founds the Western Buddhist Order
1953		**Kapleau** goes to Japan and stays for twelve years	
1954	**Kapilavaddho** ordained in Thailand The London Buddhist Vihara *[see 1940]* reopens	*Yasutani* Roshi founds the Sanbokyodan school	

HINDUISM	SUFISM	INDEPENDENT	
	Death of Maheboob Khan [see 1927]; succeeded by Muhammed Ali Khan [see 1958] **Schuon**, *De l'Unité transcendante des religions*		**1948**
Subramuniya goes to Sri Lanka and is initiated by Siva Yogaswami **Mahendranatha** arrives in India and becomes a *sannyasin* in the Adi-Nath *sampradaya*		Death of **Gurdjieff**; Jeanne **de Salzmann** becomes *de facto* leader of the Work **Ouspensky**, *In Search of the Miraculous*	**1949**
Death of *Ramana Maharshi* Death of *Aurobindo* **Abhishiktananda** and **Arubi** *sannyasis*; found **Anandam** ordain themselves as Satchitanandam Ashram [approx.] Melvin Higgins/ Goswami **Kriyananda** starts teaching		Publication of *Beelzebub's Tales*	**1950**
Levy, *Immediate Knowledge and Happiness*, London	Death of **Guénon** in Cairo		**1951**
Death of *Yogananda* in California; **Rajarsi Janakananda** succeeds him as President of SRF	*Meher Baba* establishes Sufism Reoriented with Ivy **Duce** as *murshida*		**1952**
Abhishiktananda 'meets' Ramana Maharshi at a spiritual level while meditating at Arunachala	**Bennett** meets Sufi teachers in the Middle East	[see Sufi dates]	**1953**
[see Independent dates]		[approx.] Jean **Klein** attains illumination in India after practising with his guru	**1954**

	THERAVADA	ZEN	TIBETAN BUDDHISM [+ OTHER BUDDHISM]
1955			
1956	English Sangha Trust founded in Britain with **Kapilavaddho** as teacher	Ruth Fuller **Sasaki** opens a branch of the First Zen Institute of America in Kyoto *Maezumi* arrives at the Soto Zenshuji temple in Los Angeles	**Govinda**, *Die Grundlagen Tibetischer Mystic*
1957	Death of **Nyanatiloka** in Ceylon	**Aitken** returns to Japan and practices with *Yasutani* Roshi **Watts**, *The Way of Zen*	**OTHER BUDDHISM** **Sangharakshita** establishes the Triyana Vardhana Vihara in Kalimpong; receives initiations from Nyingma *lamas*
1958		Ruth Fuller **Sasaki** ordained a Rinzai priest in Kyoto **Kapleau** attains *satori* in Japan under *Yasutani* Roshi's guidance	
1959		Jack Kerouac, *The Dharma Bums*	Dalai Lama leaves Tibet and takes up residence in India
1960		**Enomiya-Lassalle**'s Zen hall dedicated by the Bishop of Hiroshima Ruth Fuller **Sasaki**, *Rinzai Zen for Foreigners in Japan*	

HINDUISM	SUFISM	INDEPENDENT	
Death of **Rajarsi Janakananda**; Sri **Daya Mata** [see 1931] succeeds him as president of SRF **Abhishiktananda** meets his guru, Sri Gnanananda Swami **Radha** [see 1956, 1995] goes to Sivananda's ashram in Rishikesh **Krishna Prem**, *The Yoga of the Kathopanishad*			**1955**
Swami **Radha** founds the Sivananda Ashram in British Columbia [moved and renamed Yasodhara Ashram in 1963] **Sivananda-Rita** founds her firsta shram at her home in Sydney, Australia	Vilayat **Khan** assumes leadership of the Sufi Order; the Sufi Movement terminates his membership **Lewis** initiated into the Naqshbandi and Chisthi Orders in Pakistan; visits Japan and 'enters *samadhi*' in the presence of Zen masters		**1956**
Subramuniya [see 1949] founds the Subramuniya Yoga Order/Saiva Siddhanta Church and the Christian Yoga Church in San Francisco Death of **Arubianandam** in Paris			**1957**
Rudi meets Nityananda and Muktananda in India	Death of Muhammed Ali Khan [see 1948]; succeeded as head of the Sufi Movement by Musharaff Khan		**1958**
[see Independent dates] **Abhishiktananda** travels in the Himalayas as a Hindu *sannyasi*	**Burckhardt**, *Introduction to Sufi Doctrine*	Roles and **Maclaren** meet Maharishi Mahesh Yogi in London	**1959**
[see Independent dates] [see Independent dates]	**Lewis** accepted as *murshid* by Pir Barkat Ali in Pakistan	**Klein** [see 1954] returns to the West Roles and **Maclaren** become disciples of the Shankaracharya	**1960**

	THERAVADA	ZEN	TIBETAN BUDDHISM [+ OTHER BUDDHISM]
1961		Shunryu Suzuki founds the San Francisco Zen Center **Harding**, *On Having No Head*	
1962		**Kennett** goes to Sojiji temple and attains *kensho* after six months **Schloegl** practices at Daitokuji in Japan	
1963		**Kennett** made a Dharma-heir of Chisan Koho; installed as abbess of her own temple in Japan	Chogyam *Trungpa* and Akong Rinpoche arrive in Oxford
1964			**OTHER BUDDHISM** **Sangharakshita** becomes resident monk at the Hampstead Vihara
1965	**Nanavira**'s death by suicide in Sri Lanka	**Kapleau** returns to U.S. and founds Rochester Zen Center; publication of *Three Pillars of Zen* Isshu Miura and Ruth Fuller **Sasaki**, *The Zen Koan*	Death of **Evans-Wentz**
1966		Richard **Baker** ordained a priest by Suzuki Roshi; Tassajara Zen Mountain Center opens	Freda **Bedi** becomes a Kagyu nun/*sramanerika* *Trungpa*'s autobiography, *Born in Tibet* **Govinda**'s autobiography, *The Way of the White Clouds*

HINDUISM	SUFISM	INDEPENDENT	
[see Independent dates]	Irina **Tweedie** meets Bhai Sahib in India *[see 1963]*	Roles and **Maclaren** *[see 1959, 1960]* found the School of Meditation in London	**1961**
Death of Nityananda	**Schuon**, *Comprendre l'Islam*		
			1962
	Tweedie *[see 1961]* returns to England to teach	Death of **Madame Ouspensky**	**1963**
Swami **Lakshmy Devyashram** has a vision of Sivananda (d.1963) *[see 1968]*	**Shah**, *The Sufis*	Death of Jane **Heap**	**1964**
[see Independent dates]		Franklin Jones/Master **Da** becomes **Rudi**'s disciple	
Prabhupada arrives in New York		**Twitchell** founds Eckankar	**1965**
Death of Sri **Krishna Prem**; succeeded by Sri Madhava Ashish			
Rudi receives *shaktipat* from Muktananda			
Abhishiktananda, *Sagesse Hindoue, Mystique Chrétienne: du Vedanta à la Trinité*			
Prabhupada founds ISKCON; initiates his first disciples including **Satsvarupa** and **Kirtanananda**	**Lewis** begins to initiate his own disciples	Barry **Long** arrives in London *[see 1983, 1985]*	**1966**
Rudi given *sannyasa* by Muktananda		**Stephen** begins his Monday Night Class in San Francisco	
Swami **Atulananda** *[see 1923]* dies in Mussoorie, aged 97			

	THERAVADA	ZEN	TIBETAN BUDDHISM [+ OTHER BUDDHISM]
1967	**Sumedho** ordained in Thailand	Death of Ruth Fuller **Sasaki** in Kyoto **Kapleau** breaks with *Yasutani* Roshi	**OTHER BUDDHISM** **Sangharakshita** founds FWBO *[see 1978]*
1968		Don **Gilbert** ordained by Kyung-Bo Seo **Karuna Dharma** starts practising with Thich Thien-an in Los Angeles *[see 1976]*	*Trungpa* and Akong start Samye-Ling **OTHER BUDDHISM** **Sangharakshita** founds the Western Buddhist Order
1969	**Denison** *[see 1977]* given Dharma transmission by U Ba Khin	**Kennett** founds the Zen Mission Society in San Francisco **Nowick** *[see 1950, 1985]* founds the Moonspring Hermitage in Maine	Death of Alexandra **David-Néel** *Trungpa, Meditation in Action*
1970		Suzuki Roshi recognizes Richard **Baker** as his Dharma heir (in Japan) Bernard **Glassman** ordained a priest by *Maezumi* Roshi at ZCLA; starts teaching **Kennett** founds Shasta Abbey Thien-an *[see 1966]* founds the International Buddhist Meditation Center in Los Angeles	
1971	Death of **Kapilavaddho**	Death of Shunryu Suzuki in San Francisco; succeeded as abbot of SFZC by **Baker**	

HINDUISM	SUFISM	INDEPENDENT	
Richard Alpert/**Ram Dass** becomes a disciple of Neem Karoli Baba	**Lewis** ordained Zen-shi by Kyung-Bo Seo Death of Musharaff Khan *[see 1958]*; split in the Sufi Movement between Fazal Inayat Khan and Mahmood Khan		**1967**
Swami Prabhupada, *Bhagavad-gita As It Is* **Kirtanananda** *[see 1966]* establishes New Vrindaban in West Virginia The **Mother** *[see 1914, 1922, 1926, 1937]* inaugurates Auroville Swami **Kriyananda**, having left SRF in 1962, founds Ananda Ashram in California Swami Lakshmy **Devyashram** *[see 1964]* founds the Sivananda Ashram of Yoga One Science in Pennsylvania	**Feild** meets Bulent Rauf in London; goes to Turkey	**John-Roger** founds MSIA Master **Da** visits Muktananda's ashram in India Robert **de Ropp**, *The Master Game* Swami **Turiyasangitananda** receives revelation from God	**1968**
Sri **Krishna Prem** and Sri Madhava Ashish, *Man, the Measure of All Things: in the stanzas of Dzyan*			**1969**
Rudi becomes head of the Shree Gurudev Siddha Yoga Ashram in New York *Prabhupada* sets up GBC, including **Satsvarupa**, **Hansadutta**, **Bhagavan,** and **Tamal Krishna**; establishes ISKCON in India via American devotees	**Burckhardt**, *Letters of a Sufi Master*	Master **Da**'s Vedanta Temple experience **Stephen** and followers establish The Farm in Tennessee	**1970**
Donald Walters/Swami **Kriyananda** founds a monastic order, The Friends of God, at Ananda	Death of Samuel **Lewis**; succeeded by Jablonsky (who is made *murshid* by Vilayat **Khan**); formation of Sufi Islamia Ruhaniat Society	Death of **Twitchell** *[see 1965]*; succeeded by Darwin **Gross** *[see 1981]*	**1971**

	THERAVADA	ZEN	TIBETAN BUDDHISM [+ OTHER BUDDHISM]
1971		*Maezumi* Roshi sets up ZCLA	
1972		Gesshin **Prabhasa Dharma** becomes head priest at Joshu Sasaki's Cimarron Zen Center in Los Angeles Barbara **Rhodes** *[see 1977]* starts practising with Seung Sahn/Soen Sa Nim **Kennett**, *Selling Water by the River*	Freda **Bedi** takes *bhikshuni* ordination in Hong Kong
1973		Death of Alan **Watts** Death of *Yasutani* Roshi; succeeded by *Yamada* Roshi **Gilbert** made Zen master and Dharma-heir by Kyung-Bo Seo **Kennett** *[see 1962, 1963, 1969, 1970, 1972]* founds the Order of Buddhist Contemplatives	[approx.] Kunzang Dorje appointed a *lama*
1974	**Sumedho** made Ajahn and first abbot of Wat Pah Nanachat in Thailand	**Aitken** receives Dharma transmission from *Yamada* Roshi *[see 1973]*	*Trungpa* founds Naropa Institute
1975			
1976	**Kornfield**, **Goldstein**, **Salzberg** found the Insight Meditation Society in Massachusetts	**Karuna Dharma** takes full *bhikshuni* ordination from Thien-an *[see 1968]*	**Osel Tendzin** empowered as *Trungpa*'s Vajra regent

HINDUISM	SUFISM	INDEPENDENT	
Rudi breaks with Muktananda **Abhishiktananda** accepts some disciples in India **Ram Dass**, *Be Here Now*		Oscar **Ichazo** founds Arica Institute Inc. in New York **Erhard** founds est	1971
		Master **Da**, *The Knee of Listening*	1972
			1972
Death of the **Mother** Death of Neem Karoli Baba Death of **Rudi**; Chetanananda becomes a kind of successor *Death of Abhishiktananda;* before his death, he gives 'ecumenical *diksha*' to one of his disciples, Swami **Ajatananda** **Ram Dass** *[see 1978]* sets up the Hanuman Foundation			1973
Swami **Lakshmy Devyashram** *[see 1968]* elected Mahamandaleshwari of the Holy Shankaracharya Order in U.S.	**MacKie** unveiled by *Meher Baba*	Death of J.G. **Bennett** **Yarr** attains enlightenment	1974
		Lozowick 'wakes up' [approx.] Bhagavan **Nome** is enlightened	1975
Auroville separates itself from the Sri Aurobindo Society (= the ashram)	**Feild** initiated into the Mevlevi order in Los Angeles; publication of *The Last Barrier*	**Stephen** Gaskin, . . . *This Season's People: A Book of Spiritual Teachings*	1976

	THERAVADA	ZEN	TIBETAN BUDDHISM [+ OTHER BUDDHISM]
1976			O.K. Maclise recognized as a *tulku* by the Karmapa Kalu Rinpoche starts the first three-year retreat for Westerners in France *[see 1979]*
1977	**Denison** *[see 1969]* founds Dhamma Dena Desert Vipassana Center	Bill **Kwong** receives Dharma transmission from Hoichi Suzuki in Japan **Glassman** receives Dharma transmission from *Maezumi* Roshi in Los Angeles Barbara **Rhodes** *[see 1972]* named Master Dharma Teacher/ given *inka* by Soen Sa Nim **Kennett**, *The Wild White Goose* and *How To Grow A Lotus Blossom*	Death of Freda **Bedi** **Jampa Thaye** appointed Karma Thinley Rinpoche's Dharma Regent
1978			Ngakpa **Chogyam** recognized as a *tulku* **OTHER BUDDHISM** FWBO *[see 1967]* founds the Trailokya Bauddha Mahasangha in India **OTHER BUDDHISM** **Aitken**, **Baker**, **Kornfield**, **Macy** found the Buddhist Peace Fellowship
1979	**Sumedho** and other Western monks establish Chithurst Monastery **Kornfield**, **Goldstein**, **Mandell** and **Salzberg** appointed as *vipassana* teachers by Mahasi Sayadaw in California Ayya **Khema** ordained a *dasa sila mata* in Sri Lanka	**Glassman** founds the Zen Community of New York/ZCNY	End of Kalu Rinpoche's three-year retreat; all 16 Westerners (including Denis **Teundroup**) are declared *lamas*

Hinduism	Sufism	Independent	
Melvin Higgins/Goswami **Kriyananda**, *The Spiritual Science of Kriya Yoga* Joya **Santanya**, *Sharing Moments*	*[see Independent dates]*	E.J. **Gold**, *Autobiography of a Sufi*	**1976**
Prabhupada dies (in Vrndavana), having appointed eleven American devotees asinitiating gurus a few months before; **Siddhasvarupa** leaves ISKCON and sets up on his own Swami **Ajatananda** *[see 1973]* disappears Swami **Kriyananda**, *The Path: Autobiography of a Western Yogi*	**Lewis**'s disciples separate Sufi Islamia Ruhaniat Society *[see 1971]* from Vilayat Khan's Sufi Order	**Jae Jah Noh**, *Do You See What I See?* **Turiyasangitananda**, *Monument Eternal*	**1977**
Ram Dass and others set up the Seva Foundation *[see 1974]* **Mahendranath** *[see 1949]* establishes an East-West Tantrik Order		**Shunyata** invited to California **Gold**, *Secret Talks with Mr. G*	**1978**
		Cox, *The Dialogues of Gurdjieff*	**1979**

	THERAVADA	ZEN	TIBETAN BUDDHISM [+ OTHER BUDDHISM]
1980		Dennis **Merzel** becomes *Maezumi* Roshi's second Dharma heir John Daido **Loori** founds Zen Mountain Monastery in New York state **Karuna Dharma** succeeds Thien-an; becomes abbess of the International Buddhist Meditation Center *[see 1970]*	
1981			Death of the Karmapa in America
1982		Maurine **Stuart** made *roshi* by Nakagawa Soen	**Osel Tendzin**, *Buddha in the Palm of Your Hand*
1983	Jacqueline **Mandell** leaves the Theravadin tradition because of its discrimination against women, and becomes an independent teacher	The troubles at SFZC; **Baker** Roshi resigns as abbot The troubles at ZCLA; Joko **Beck**, *Maezumi* Roshi's third Dharma heir, leaves ZCLA and establishes the Zen Center of San Diego; Jan **Bays** becomes *Maezumi* Roshi's fourth Dharma heir Gesshin **Prabhasa Dharma** resigns from the Japanese Rinzai lineage *[see 1985]* Soen Sa Nim founds the Kwan Um Zen School Linda **Murray** and Linda **Klevnick** ordained as Dharma Teachers by Samu Sunim in Toronto	Dhyani **Ywahoo** recognized as a Nyingma teacher (and as a Kagyu teacher in 1986)

HINDUISM	SUFISM	INDEPENDENT	
Hansadutta involved in gun and ammunition incidents Some devotees leave ISKCON and join Sridhara Maharaja	**Hixon** *[see 1995]* initiated by Sheikh Muzaffer al-Jerrahi	**Marasha** starts teaching in Los Angeles	**1980**
[see Independent dates] Death of Swami **Lakshmi Devyashram**; succeeded by Swami **Saraswati Devyashram** **Shankar Das** founds the Sadhana Ashram in Tennessee	Death of Ivy **Duce**; succeeded by **Mackie**	Death of **Brunton** *[see 1934 under Hindu dates*] **Gross** *[see 1971]* resigns as Living Eck Master and is succeeded by Harold **Klem** [approx.] Michael **Barnett**/ Somendra starts teaching	**1981**
Death of Muktananda **Jayatirtha** leaves ISKCON and joins Sridhara Maharaja		**Packer** leaves Rochester ZC and sets up her own centre	**1982**
GBC expels **Hansadutta** Swami from ISKCON		Barry **Long** starts teaching publicly	**1983**

	THERAVADA	ZEN	TIBETAN BUDDHISM [+ OTHER BUDDHISM]
1984	Ayya **Khema** founds an international Nun's island in Sri Lanka	**Schloegl** *[see 1962]* ordained at Chithurst Forest Monastery in England	*Trungpa* establishes Gampo Abbey with **Pema Chodron** as abbess
1985		Gesshin **Prabhasa Dharma** *[see 1983]* receives Dharma Mind Seal transmission in the Vietnamese Zen tradition in Los Angeles	Birth of Lama **Osel** in Spain
		[see Independent dates]	Death of Lama Anagarika **Govinda**
		Nowick *[see 1950, 1968]* resigns as *roshi* of Moonspring Hermitage	
1986		Reb **Anderson** installed as abbot of SFZC as a replacment for Richard **Baker** *[see 1983]*	**OTHER BUDDHISM** **Dharmapali** and Chan-Nhu establish a nunnery and a women's retreat in Colorado
1987			Lama **Osel** *[see 1985]* enthroned as incarnation of Lama Yeshe by Dalai Lama in India
			Death of Chogyam *Trungpa*; succeeded by **Osel Tendzin**
1988	**Goldstein**, **Salzberg** and other *vipassana yogis* visit Russia and hold talks with psychotherapists	**Aitken** Roshi appoints four Dharma heirs	Alyce Zeoli recognized as the incarnation of Jetsunma **Ahkon Norbu Lhamo**
1989		**Glassman** gives Dharma transmission to his wife	Death of Kalu Rinpoche
	[see Other Buddhist dates]	Issan **Dorsey** receives Dharma transmission from **Baker** Roshi	**OTHER BUDDHISM** **Sumedho** acts as *upajjhaya* in joint Theravadin/Mahayana ordinations at Hsuan Hua's City of 10,000 Buddhas in California

HINDUISM	SUFISM	INDEPENDENT	
	Death of Titus **Burckhardt**	Death of **Shunyata**	1984
		Barry **Long**'s *I am Guru* announcement	1985
		Zen Master **Rama** starts teaching Tantric Zen	
Rameshwar, Bhavananda and **Bhagavan** all leave ISKCON because of sexual misconduct		Andrew **Cohen** meets Poonja Ji in India and is 'finished' *[see 1991]*	1986
The troubles at New Vrindaban*[see 1968]*; **Bhaktipada** is expelled from ISKCON forsetting up a rival organization		Zen Master **Rama** exposé in press	1987
Jayatirtha *[see 1982]* murdered in London by one of his own initiates		**Yarr** denounced; Lifewave disbanded	
Swami **Saraswati Devyashram** *[see 1981]* resignsas Mahamandaleshwari of Rajarajeshwari Peetham; Swami **Parvati Devyashram** takes over		Master **Da** establishes the Hridaya Da Kanyadana Kumari Mandala Order and the Hridayam Da Gurukula Brahmacharini Mandala Order	1988
Swami **Bhaktipada**, *The Joy of No Sex: How to Stop worrying about AIDS and Start Living Happily Without Sex*		**John-Roger** exposé in the press; he passes the keys to the Mystical Traveler Consciousness to John Morton	
		Master **Da** announces his Incarnation as Jagad-Guru	1989

	THERAVADA	ZEN	TIBETAN BUDDHISM [+ OTHER BUDDHISM]
1990		Death of Issan **Dorsey** from AIDS	Death of **Osel Tendzin** from AIDS; succeeded by the Sawang Mukpo (*Trungpa*'s son)
		Death of Maurine **Stuart** Roshi *[see 1982]*	
		Death of Father **Enomiya-Lassalle** *[see 1960]*	
		Death of Katagiri Roshi, having given Dharma transmission to a dozen disciples (eleven of them American)	
1991			
1992		**Merzel** Sensei gives Dharma transmission to Catherine Pages	
		Maurine **Stuart** formally included in **Aitken**'s California Diamond Sangha lineage	
1995		Death of *Maezumi*; succeeded by **Glassman**	
1996		Death of **Kennett**	

HINDUISM	SUFISM	INDEPENDENT	
		Death of Jeanne **de Salzmann**	**1990**
Bhaktipada *[see 1987]* convicted of racketeering and conspiracy to murder in a West Virginia court Death of **Mahendranath**		**Cohen** *[see 1986]* breaks with Poonja Ji	**1991**
			1992
	Death of **Hixon** *[see 1980]*		**1995**
Death of Swami **Radha** *[see 1955, 1956]*			**1996**

3

THE ISSUES

The Meaning and Significance of Western Teachers

How can we make sense of the phenomenon of Western teachers? What does it tell us? There have been many suggestions and hints scattered throughout the text but in this chapter I deal with these matters head on. All the information given in the rest of the book is assumed here. Some readers will want to dip into Part II before they came back to this chapter.

The sheer variety of the phenomenon of Western teachers raises all the fundamental issues of the spiritual life—and on an unprecedented scale. This is because the West has not only absorbed the major Eastern traditions but has extended them and even created its own forms. As a result, a new explanation of the human condition, which I call spiritual psychology, has arisen in the West:

Human beings are best understood in terms of *consciousness* and its modifications

Consciousness can be transformed by *spiritual practice*

There are *gurus/masters/teachers* who have done this and

They can help others do the same by some form of *transmission*

Of course, these cover a considerable range (Table 1, p. 98). Yet despite the obvious, if variable, links with Eastern traditions, spiritual psychology is a *Western* phenomenon; it has come into existence because all the Eastern traditions exist simultaneously in one place: the West. This has never happened before—certainly not in the East, either in the past or now. And when I say that the Eastern traditions do not exist in one place in the East, I mean that you cannot find Sufism in Bangkok or Korean Zen in Benares. But both exist (and a lot more besides) in Los Angeles, London, and Paris—not only 'traditional' or orthodox Sufism and Korean Zen but also forms that you could not find in Egypt or Korea.

Given that this is so, it is natural that Westerners should ask questions: not only about the merits of different traditions—their spiritual practices, their way of life, their teachers, and so forth—but about whether traditions are really necessary at all, and if they are, to what extent they have to be Eastern. And again I emphasize that it is Westerners who are asking these questions, not

Easterners, because the coming together of traditions is occurring in the West and not in the East.

But far more significantly, it is Westerners who are answering these questions as well. It might seem odd to suggest that the West could have anything to say on these matters. After all, Western Buddhism/Hinduism/Sufism are relatively new and still in the process of formation, whereas their Eastern parents have been going for many centuries—and surely the traditions understand themselves best. How, then, could the West make any significant contribution to such issues as what is essential to a tradition and what is peripheral?

Answer: because the West is asking a new set of questions. Western Theravadins, for example, while they know from their own experience that *vipassana* meditation and the *bhikkhu* life produce excellent results, are also aware that *zazen* and the way of the Zen layman or laywoman do the same. So the question naturally arises: what is the relation between *vipassana* and *zazen*, between *bhikkhu* life and Zen lay life? And of course comparable questions can be asked, and have been asked, by Westerners in all the major Eastern traditions.

The effect of these questions, which cut across traditional boundaries, is simple yet radical: it forces each Eastern tradition to be very clear about what is essential, and what is optional, in its own teaching. And the fact is that traditions tend *not* to be clear about this distinction unless they have to be. By and large, it is Western participation in Eastern traditions that has raised the issue; and it has raised it in a particular way because it is trans-traditional. The era of the self-contained tradition is over and we need something broader and more accommodating if we are to understand the import of Western teachers, both in the major traditions and outside them. I therefore propose to put the four principles of spiritual psychology in the context of a comparative model and also relate both of these to a model of the dimensions of a tradition. My aim is to provide a shape and vocabulary for discussing this new phenomenon—a vocabulary that is itself derived from a variety of extremely diverse and rich traditions but has also developed beyond them.

A MODEL OF EXPERIENTIAL COMPARATIVE RELIGION

Anyone who has tried to understand the great traditions and teachings of the world is bound to be struck, sooner or later, by the realization that opposites are true. Or to put it another way, opposite truths apply to the human condition. The only option open to us, therefore, is to come to terms with ambivalence.

The following model is based on the assumption that opposites have to be embraced. It is essentially simple but at the same time has extremely rich ramifications. It allows us to hold a great array of possibilities in our minds all at the same time so that we can move from one to another. This is bound to be somewhat demanding since the spiritual life is easily the most complex of all aspects of human existence. (Politics and art are no rivals because all great traditions include them as sub-sets of themselves.)

The starting point is two pairs of polar concepts: *Hot* and *Cool; Structured* and *Unstructured* (see Diagram 1B, p. 100).

TABLE 1

The Four Elements of Spiritual Psychology

consciousness	spiritual practice	teacher
discriminating attention	mindfulness; *vipassana*; following the *Vinaya*	follows Dharma
discriminating attention	*vipassana*	accomplished practitioner
Buddha-nature	*zazen*; *koan*	accomplished practitioner
brightly shining mind	hierarchical range of practices (including honouring the guru as Buddha; formless *dzogchen/ mahamudra*)	embodiment of enlightenment
Krishna consciousness	Hare Krishna *mantra*; Vedic culture	pure connection to Krishna
Shiva's Divine mind	yoga/meditation; *sattvic* way of life	God-realized
divine consciousness	*kundalini yoga*	expresses the Divine
pure consciousness/Atman/ the Self	non-identification with objects/forms	has knowledge of the Self
Divine Intellect	*dhikr*/repetition of the Names of God	embodiment of Being (and of the virtues)
the real 'I'	work on oneself	one who is awake
God/life/love	living in the moment	embodies God/life/love
the Divine Person	*ishta-guru-bhakti-yoga* (worship of the guru as divine)	embodiment of God

Hot is that which is other than oneself; that which has its own life. It is not something that one has access to as of right. It is powerful and breath-taking, and is associated with revelation and grace. It is very similar to Otto's numinous.

Cool is the very essence of oneself; one need not go to another to find it. Hence one *does* have access to it as of right. It is quiet and still, and is associated with self-realization.

The meaning of *Structured* is that there is an inherent order in the cosmos and therefore in the human condition. There is something to be discovered and there is a way of discovering it. A map is required to find the destination.

By contrast, *Unstructured* teachings say that there is no gap between the starting point and the finishing post. Method and goal are

transmission	TRADITION	Examples
via the conditions provided by the *sangha*	THERAVADA	**Sumedho, Nanavira** (the *bhikkhu sangha)*
teacher's guidance	THERAVADA	***vipassana sangha***
teacher's guidance	ZEN (all forms)	**Aitken, Baker, Glassman, Nowick, Rhodes**
initiation, empowerment	TIBETAN BUDDHISM	**Ahkon Lhamo, Jampa Thaye**
initiation, surrender	GAUDIYA VAISHNAVISM (HINDUISM)	**Krishna Prem, Hare Krishna gurus**
initiation	SHAIVA SIDDHANTA (HINDUISM)	**Subramuniya**
shaktipat	THE *SIDDHAS* (HINDUISM)	**Rudi**
argument and example	ADVAITA VEDANTA (HINDUISM)	**Levy, Klein**
initiation	SUFISM	**Hixon, Schuon**
ordeal, demand	NONE	**Gurdjieff**
demonstration of truth	NONE	**Long**
by the guru's grace	NONE	**Da**

identical. We are not separate from reality/truth/God and so no map is required. Everything is available now and always has been.

Although these four statements concerning the human condition are all related, they are based on quite different axioms. But they are all true. I shall give examples from the great traditions in a moment, but first we need to see (Diagram 1[B]) that the two pairs can be combined: *Hot Structured, Hot Unstructured, Cool Structured, Cool Unstructured.*

Not only can they be combined, they can also overlap. In fact, it is somewhat artificial to separate them. Diagram 2[A] (p. 101) gives some examples involving two sections of the model:

I. The first diagram represents the teaching that God creates the world (and not just the physical universe, either), that he is responsible for it, and that its forms express his divine nature

II. The second can be summarized as follows: everyone is God—now

III. The third in effect is saying: one's own self, which is identical with truth, is surrounded by layers which one has to work through

IV. The fourth represents a variant of esotericism: that liberation is a great journey through the cosmos, which is contained within oneself (and one needs initiation to complete it)

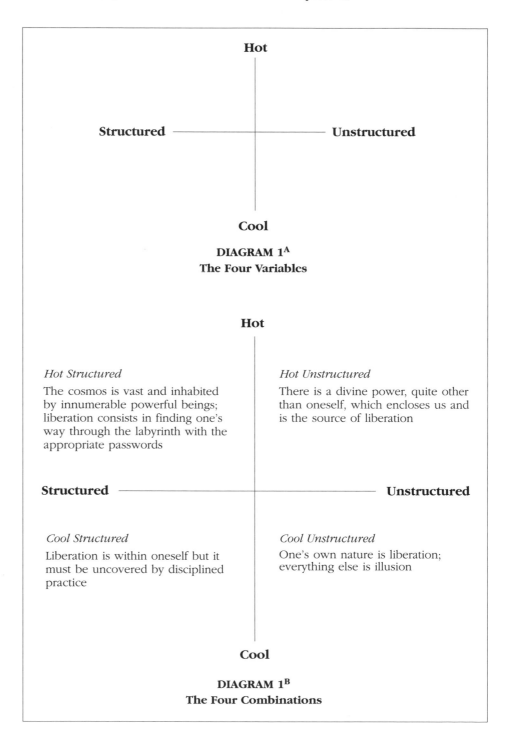

Hot

Structured ——————————|—————————— **Unstructured**

Cool

DIAGRAM 1A
The Four Variables

Hot

Hot Structured

The cosmos is vast and inhabited by innumerable powerful beings; liberation consists in finding one's way through the labyrinth with the appropriate passwords

Hot Unstructured

There is a divine power, quite other than oneself, which encloses us and is the source of liberation

Structured ——————————|—————————— **Unstructured**

Cool Structured

Liberation is within oneself but it must be uncovered by disciplined practice

Cool Unstructured

One's own nature is liberation; everything else is illusion

Cool

DIAGRAM 1B
The Four Combinations

Diagram 2B gives examples involving the overlapping of three sections:

I. The first is the teaching that the divine, which expresses itself in manifold forms, is made accessible by, and can be approached by, a formal, graduated process

II. The second says: your own nature, which is not distinct from the vast array of forms that you perceive, can be uncovered by disciplined practice

III. The third says: the divine, which is your own nature, makes itself more and more apparent as you remove the layers that cover it

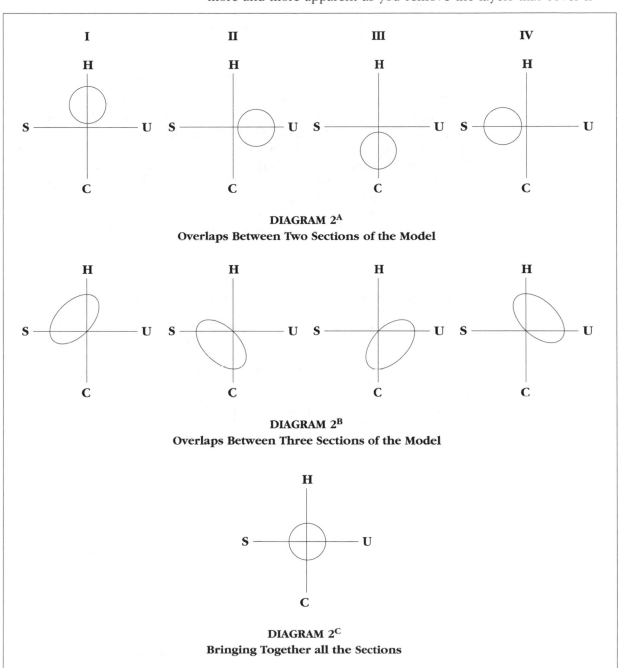

DIAGRAM 2A
Overlaps Between Two Sections of the Model

DIAGRAM 2B
Overlaps Between Three Sections of the Model

DIAGRAM 2C
Bringing Together all the Sections

IV. The fourth is the teaching that the divine nature, which is your own nature, takes you on a ride to discover God

The ultimate combination, if I can call it that, is of course when all four sections of the model are employed (see Diagram 2). This certainly does happen, and in fact it is a sign of a great tradition that it can hold all these possibilities. But what we find is that each tradition tends to do this by dividing itself into sub-traditions (see Diagrams 4,5,6,7).

This model can hold a lot of detail. For example, we can use it to highlight different versions of four categories that are fundamental to all traditions in some form or other:

ontology	the nature of reality
cosmology	the nature of the universe
anthropology	the nature of man
soteriology	the nature of liberation

The different versions of these four are given in Diagram 3.

And we can apply the model to a particular tradition such as Buddhism (see Diagram 4). The advantage of using the model in this way is that it shows that the major Buddhist traditions in the West (Zen, Theravada, and Tibetan Buddhism/Vajrayana) are dividing up the vocabulary of Buddhism, so to speak, using quite different criteria. Hence the compassionate help of the celestial Bodhisattvas and Buddhas of Vajrayana is not quite the same as Zen's inherent compassion of our own Buddha-nature. These distinctions are vital and will help us when we compare Western Buddhist teachers.

Hot

Ontology: many powers/beings

Cosmology: a vast labyrinth

Anthropology: man contains all powers [the microcosm/macrocosm homology]

Soteriology: the great journey; the initiatic adventure

Ontology: only God is real; he is unknowable

Cosmology: the universe is God's creation/projection and is entirely dependent upon him

Anthropology: man is nothing before God

Soteriology: acceptance of God's will

Structured ——————————————————— **Unstructured**

Ontology: everything has its place: everything comes and goes

cosmology: a harmonious whole

Anthropology: man is the centre of the universe

Soteriology: clear awareness; non-entanglement

Ontology: only the Self is real; *or* reality is empty *(shunya)*

Cosmology: illusion

Anthropology: man is identical with reality

Soteriology: know yourself

Cool

DIAGRAM 3
The Different Categories of Teaching

Let's take another example of what the model can do by comparing the devotional (*bhakti*) traditions of India in their Vaishnava and Shaiva forms (see Diagram 5[A], p. 104). Although I have given Indian examples here, it is but a step to broaden our understanding to devotional teachings *per se*. In fact, all the great devotional traditions, whatever their provenance, have some mixture of the elements of *obedience, love, wisdom,* and *discipline* in them (see Diagram 5[B]). Naturally, this can give rise to subtle and complex teachings. However, the model shows that certain *general* principles always apply:

> *Hot* devotion insists that God is the doer, while for *Cool* devotion, the focus is one's own nature (which is divine nature)

> *Unstructured* devotion always claims that the method and the goal are one (though for *Hot Unstructured* devotion, it is love or submission, whereas for *Cool Unstructured* devotion, it is wisdom); *Structured* devotion, on the other hand, accepts that the method can be discarded once the goal has been reached

Hot

Ontology: the one reality manifests itself in a dazzling array (*vyuha*)

Cosmology: samsara is inconceivably vast and contains innumerable surprises

Anthropology: man can do anything—don't accept limitations

Soteriology: everything in *samsara* is sacred—live as though that were true

Buddhology: the great magician; the great manipulator of forms

Examples: Mahayana *sutras* like the *Suramgamasamadhi* and the *Gandavyuha;* Vajrayana/Tibetan Buddhism

Ontology: everything is in the Buddha's hands

Cosmology: the Buddha-fields are constantly purified by Buddhas

Anthropology: we need help from the Buddha . . .

Soteriology: . . . and he'll give it if we ask for it (or even if we don't)

Buddhology: the compassionate one who grants liberation

Examples: Pure Land

Structured —————————————————————————— **Unstructured**

Ontology: "There is an unborn . . . "

Cosmology: samsara is a huge but ordered whole

Anthropology: man is caught in *samsara*

Soteriology: he gets out by learning how *samsara* operates

Buddhology: the master craftsman; the great *yogi*

Example: Theravada

Ontology: only the Buddha-nature/Dharma-kaya is real

Cosmology: all multiplicity is illusory

Anthropology: we are Buddhas . . .

Soteriology: . . . just realize it

Buddhology: the immutable essence of all

Examples: Mahamudra; Zen; Dzogchen

Cool

DIAGRAM 4
The Different Kinds of Buddhism

One of the consequences of this difference between *Unstructured* and *Structured* devotion is that the latter tends to be eclectic (any method is acceptable as long as it leads to the goal), while the former never is (there is only one method because there is only one

Hot
GOD AS A PERSON

Numinous bhakti

separation, power
the devotee obeys God
God as King

Examples:

 chapter 11 of the *Bhagavad Gita*
 Mahakala Shiva

Ecstatic bhakti

intimacy, bliss
the devotee is lost in love
God as Beloved

Examples:

 Chaitanya
 Nataraja Shiva

Structured ———————————— **Unstructured**
STRESS ON RELATIONSHIPS STRESS ON UNION

Saguna bhakti

dependence, manifestaton

the devotee approaches God by
 disciplined practice

God as Ordainer

Examples:

 Ramanuja
 Siva-jnana-bodha

Nirguna bhakti

merging, pure essence

the devotee knows God (as not
 separate from himself)

God as *paramartha*

Examples:

 Vallabha
 Kasmir Shaivism *(pratyabhijna)*

Cool
GOD AS A STATE OF BEING

DIAGRAM 5ᴬ
The Varieties of Indian *Bhakti* (Vaishnava and Shaiva)

*These varieties of Indian bhakti can
 be further concentrated as follows*

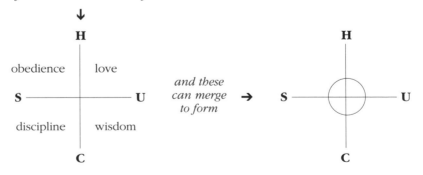

DIAGRAM 5ᴮ
(Simplification and Culmination of DIAGRAM 5ᴬ⁾)

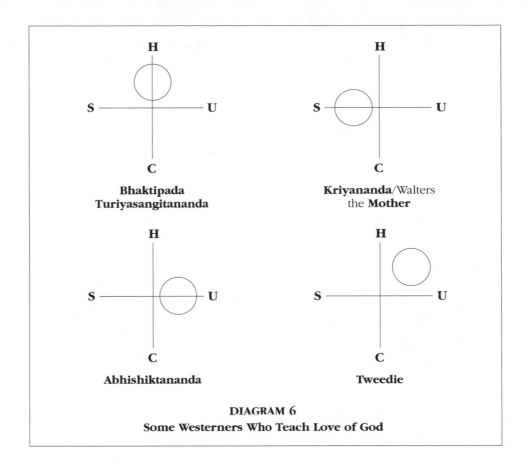

DIAGRAM 6
Some Westerners Who Teach Love of God

goal—hence only love (*Hot Unstructured*) or wisdom (*Cool Unstructured*) will do.)

Again, these similarities and distinctions will help us to compare those who teach the love of God, regardless of the tradition which they represent (or even if they represent none)—for example Shrila **Bhaktipada**, Swami **Kriyananda**/Donald Walters, the **Mother**, Swami **Turiyasangitananda**, Swami **Abhishiktananda** and Irina **Tweedie** (to name but six). (See Diagram 6.)

It is interesting to look at the sub-traditions within Hinduism and Buddhism that fit each section of the model, along with some essential characteristics and images that exemplify them—see Diagram 7 (p. 106).

It should be evident by now that this model can handle a lot of material. It can bring together teachings as diverse as Tantra, Advaita Vedanta and Theravada Buddhism, and it also allows us to relate qualities such as bliss and awareness, or hierarchy and (pure) being, which are central to any discussion of the spiritual life.

However, a few explanations may be needed.

First, it is no accident that the characteristics on the *Structured* side are more numerous than those of the *Unstructured* side. Naturally (and I use the word in its literal sense), the *Unstructured* cannot have a wealth of qualities since it obliterates distinctions.

Second, the members of each polar pair complement each other. Take Hot *Structured* and Cool *Structured* as examples (see Diagram 7):

Hot

Examples:

 Hindu tantra
 Vajrayana

Characteristics:

 knowledge (in the initiatory sense)
 hierarchical
 will
 expansion away from a point
 hot magic (necessary and powerful)

Images:

 magician/gambler
 JUMP!

Examples:

 Chaitanya
 Pure Land

Characteristics:

 bliss

Images:

 lover, martyr
 SUBMIT!

Structured —————————————————— **Unstructured**

Examples:

 Patanjali
 Theravada

Characteristics:

 awareness
 gradual
 effort
 concentration on a point
 cool magic (optional and peripheral)

Images:

 yogi, craftsman
 WORK!

Examples:

 Advaita Vedanta
 Mahamudra

Characterstics:

 being

Images:

 sage, hermit
 LET GO!

Cool

DIAGRAM 7
Further Aspects of the Model

Hot Structured	*Cool Structured*
initiatory knowledge is something one is granted—and it may be disturbing	**awareness** is dispassionate and part of oneself
the path requires the exercise of **will**, which allows the practitioner to break through the barriers that are in his way in an ever-increasing series of leaps	the path is very restrained; there is a task to be accomplished but the method is ordered and gentle; the practitioner starts on page one of the manual, so to speak, and works his way through to the end; everything happens as it should in the fullness of time
it also requires the use of **(hot) magic,** which is simply the manipulation of the laws of the cosmos in the service of self-transformation	all that is required is constant **effort**; at a certain point, **(cool) magical powers** appear, it is true—but they are incidental to the aim, which is balance and timing

example: Vedic ritual, which is concerned with participation in the sacred world of the gods

example: Confucian ritual, which aims to establish a correct relationship with the cosmic principle

Similarly, **JUMP!** and **WORK!** have an element in common (they are both *Structured*), just as **JUMP!** and **SUBMIT!** do (though this time it is the *Hot* element); and similarly for **SUBMIT!** and **LET GO!** (both *Unstructured*) and **WORK!** and **LET GO!** (both *Cool*).

Third, the opposite corners of the model have nothing in common (which is to say that they will find great difficulty in communicating with, or even understanding, each other): the **magician** *(Hot Structured)* regards the **hermit** *(Cool Unstructured)* as a stick-in-the-mud, someone who avoids life and its challenges, while the hermit sees the magician as at best all show and flummery, and at worst as positively dangerous. The **yogi** *(Cool Structured)* looks upon the **martyr** *(Hot Unstructured)* as someone with more conviction than sense; the **lover** has no doubt that the **craftsman** has missed the point *completely*.

Similarly, **JUMP!** *(Hot Structured)* is the exact opposite of **LET GO!** *(Cool Unstructured)*; and the same is true of the other two corners: **SUBMIT!** *(Hot Unstructured)* and **WORK!** *(Cool Structured)*.

Hot

The teaching is never given all at once but only when necessary and then only in cryptic fornm

This is typical of all forms of esotericism

There is no teaching—only love and submission.

For example, Meher Baba: "I come not to teach but to awaken"

Subud is another example

Structured ———————————————————— **Unstructured**

The teaching is open and complete but there is no point in reading p. 100 before you read p. 1.

Patanjali's Yoga Sutras *are a good example*

The teaching is constantly given—the same truth oer and over again—but no one understands.

Ramana Maharshi, Taoism, and Zen are examples

Cool

DIAGRAM 8
The Four Different Meanings of Teaching

The model also shows that the very notion of what a teaching is, is variable (see Diagram 8, p. 107). All of the alternatives given in this diagram have attractions and drawbacks:

> The great attraction of the *Cool Structured* teachings is that it's very easy to start and there's no disgrace in being a beginner; progress is slow but gentle, like a flower opening in the sun. The drawback is that it may take a very long time indeed—perhaps eons—to complete the journey and you have to take every step of it yourself.

> The attraction of the *Cool Unstructured* teachings is that the truth is simple. The drawback is that it is very elusive; hence the practitioner (if that is the right word, since there really cannot be practice on an *Unstructured* 'path') is constantly failing. But in a way that doesn't matter because truth is ours as of right so we can always try again in the very next moment: nothing has to be set up—just by being alive, we are on the 'path'.

> *Hot Unstructured* teachings share this characteristic: we are always failing. But the solution to this failure is not, as with the *Cool Unstructured*, to be open; rather, it is simply to ask (though, naturally, being open and asking are related because both are *Unstructured* ideals). The reason why asking is the solution is that the central truth of *Hot Unstructured* 'teachings' is that love is freely given to all who request it (or, in the 'hottest' version of all, it is given to every being whether it is requested or not).

> Finally, the attraction of *Hot Structured* teachings is that there is plenty of help: most cosmologies of this kind have the idea that the entire universe, from the colour of a rose to the celestial music of the archangels, is designed to aid the practitioner on the way (though some thicken the plot by saying that there are counterfeit designs as well). The drawback is that the task is correspondingly awesome: the journey is demanding, even dangerous—this is not an adventure for the fainthearted.

Notice that both the *Cool* teachings (by which I mean what teachings *are*—both *Structured* and *Unstructured*—according to the *Cool* half of the model) are available, whereas both the *Hot* teachings are mysterious. This is because teachings, according to the *Cool* ideal, are our right, whereas the *Hot* ideal is that they are a gift.

Analogously, teachings according to the *Unstructured* ideal are completely and instantly available, while from the *Structured* point of view they have to be worked through (often on a huge time scale).

We can also apply the model to the four principles of spiritual psychology:

> human beings are best understood in terms of *consciousness* and its manifestations;

> consciousness can be transformed by *spiritual practice*;

> there are *gurus/masters/teachers* who have done this;

> there can be *transmission* of this awareness from teacher to disciple.

I have given some examples in Table 1 (p. 98) and the application of the comparative model to them is given in Diagram 9. We are now beginning to

```
                              Hot

Consciousness: divine and              Consciousness: divine and universal
   hierarchial
Spiritual Practice: a series of leaps/   Spiritual Practice: submission
   initiations
Teacher: magician/knows the secret       Teacher: servant of God/embodiment
                                            of God
Transmission: by ordeal                  Transmission: a gift

Structured ──────────────────────────────────────── Unstructured

Consciousness: natural and               Consciousness: natural and universal
   particularized
Spiritual practice: graduated and        Spiritual practice: just realize
   gentle
Teacher: clear discriminator/guide       Teacher: embodies truth
Transmission: learning how to use a      Transmission: none—truth already
   map                                      exists

                              Cool

                           DIAGRAM 9
              Spiritual Psychology According to the Model
```

develop a powerful tool for comparing teachers, not in the sense of judging them but so that we can see what they are doing and how they are related to each other. We have a shape that can contain variations. The subtlety and richness of this model allows us to compare any teachers you care to name, regardless of which tradition they acknowledge or even if they acknowledge none or have created their own.

Diagram 10 (p. 110) reveals some unlikely similarities (between teachers in different traditions) and differences (between teachers in what outwardly appear to be the same tradition). I am not insisting on these exact locations because differences of understanding always exist. But I think they are fundamentally accurate. And by and large, traditional boundaries do hold. Hence **Nanavira**, **Nyanatiloka** and **Sumedho**, all of them Theravadin monks, occupy the same territory, so to speak. But it is instructive how they differ from **Sangharakshita**, on the one hand, and the *vipassana sangha*, on the other: the former is *Hotter*—hence his acceptance of many aspects of the Tibetan tradition; the latter is quite as *Cool* as the traditional *bhikkhu sangha* but tends more towards the *Unstructured* side. This explains how the *vipassana sangha* is more open to Zen than the *bhikkhu sangha*; and at the same time, how **Sangharakshita** shares various characteristics with Hindus like Sri **Daya Mata**, the **Devyashrams**, Guru **Subramuniya,** and Swami **Radha** (all of whom are quite independent of each other). This is not to say that **Sangharakshita** is a Hindu, just that there are similarities in spiritual psychology.

Similarly, **Rudi** and **Mahendranath**, who are themselves a lot *Hotter* than the Western Hindus I have just mentioned, have much in common with *Hot* Sufi teachers like **Lewis** and **Schuon**. Again, the differences between the first

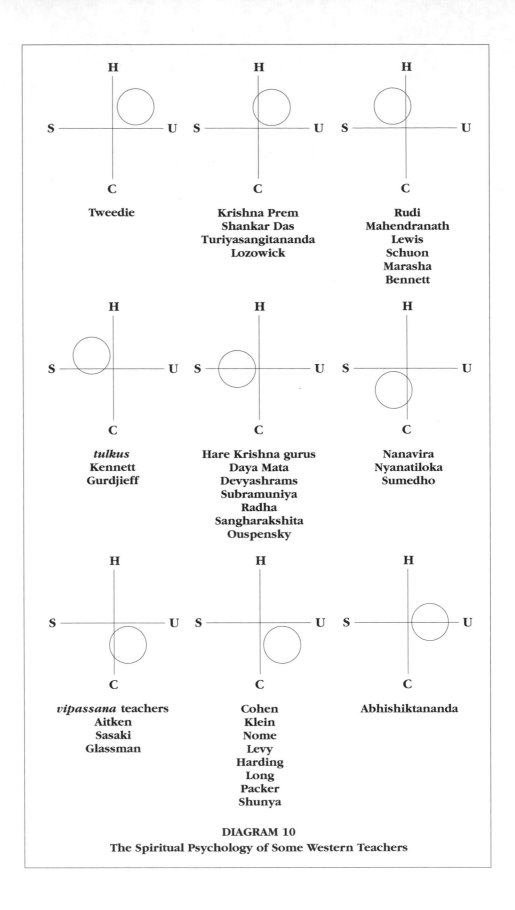

DIAGRAM 10
The Spiritual Psychology of Some Western Teachers

pair and the second are evident enough. But the convergence between them is also undeniable, in my view.

As for the trio, **tulkus**, **Kennett**, **Gurdjieff**, this is quite an eye-opener.[1] What they have in common is a typical Hot Structured cosmology: the vast engine of the universe is turning over and we are tumbling about inside it. In this, of course, **Kennett** is very far away from traditional Zen. But that is what you would expect from a Zen teacher who has visionary encounters with the Buddhas.

THE DIMENSIONS OF A TRADITION

However, teachers do not exist in a vacuum. Most of them are part of a tradition and of course they may be so in a quite straightforward way that no one would dispute. But frequently—more often than not, I would say—there is some debate about the matter. This can be for a number of reasons but they all come down to one: whether someone who is said to be a teacher has actually fulfilled the criteria that the tradition itself proposes. The trouble is that all traditions, without exception, have a variety of criteria which can be interpreted in different ways. Our assessment of teachers must therefore include an understanding of the elements or dimensions that make up a tradition. Teachers have different functions in different traditions and this in its turn affects questions concerning how orthodox or 'traditional' a teacher is. And on this particular issue, there is a great deal of debate, I can assure you.

My aim in what follows is to extend the vocabulary of the *Hot/Cool/Structured/Unstructured* model so that we can place teachers in a larger context. I want to do this for three reasons: to avoid dependence on a particular tradition's vocabulary; to be able to highlight connections between teachers in different traditions and differences between teachers in the same tradition; and so that I can include teachers who say they are not part of any tradition at all.

Diagrams 11 to 14 (pp. 112–18), and the examples that accompany them, show the dimensions of all traditions within the context of the *Hot/Cool/Structured/ Unstructured* model. There is a lot of information here (notice that the four aspects of spiritual psychology—*consciousness, spiritual practice, teacher* and *transmission* —are included) and some explanation may help.

UNSTRUCTURED TRADITIONS

The first thing to be said is that a model of this kind is itself *Structured*.[2] *Unstructured* traditions tend to collapse all distinctions. Hence all the dimensions, including the two 'ends'—*entering the tradition* and *realization/*

[1] And notice that two of Gurdjieff's pupils, **Bennett** and **Ouspensky**, are on his *Hot* and *Cool* side respectively.
[2] In fact, it is *Cool Structured*. It is balanced and proportioned, and lays out information in an accessible way. All of these are *Cool Structured* attributes. It is tempting to think that traditions should also be like this; otherwise they are not really traditions at all. But this is simply to apply a *Cool Structured* critique to the other possibilities (*Hot Structured, Hot Unstructured,* and *Cool Unstructured*); perfectly legitimate as long as one realizes that there are also *Hot Structured, Hot Unstructured,* and *Cool Unstructured* critiques of *Cool Structured* traditions.

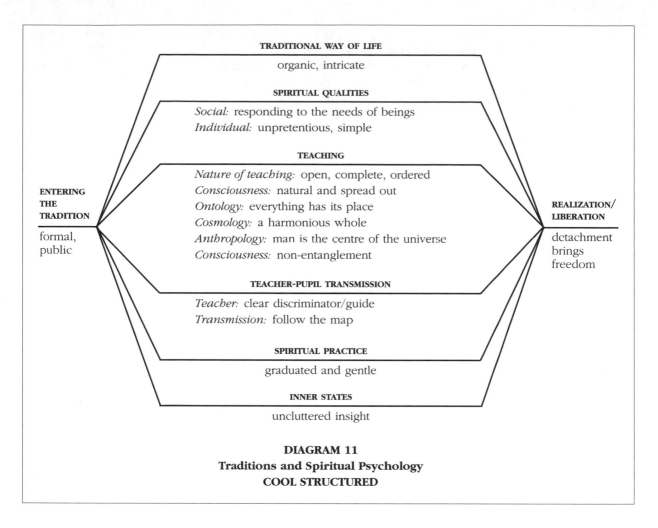

DIAGRAM 11
Traditions and Spiritual Psychology
COOL STRUCTURED

liberation—are often expressed in practically the same terms (see Diagrams 13 and 14). In *Hot Unstructured* traditions, for example, the whole 'path' consists of submission and the acceptance of the love of God. In a sense, then, the devotee ends up at the same point that he or she started from. But that is just what we would expect: there are no distinctions in love. Hence there is only one 'tradition', which is surrender to God or His servants. The gift is always the same because it comes from the same Giver.[3]

In *Cool Unstructured* traditions, we have an analogous logic. Because they are *Unstructured*, there is no separation and therefore no practice and no path. But because they are *Cool*, there is an inverse conclusion: nothing is trasmitted from teacher to pupil and in the end there is no teaching either. This explains why *Cool Unstructured* traditions often deny that they are traditions

[3] In fact, all traditions (*Hot Unstructured, Cool Unstructured, Cool Structured,* and *Hot Structured*) can say 'There is only one tradition.' But they mean very different things by it. For *Cool Unstructured*, it is the Self or formless Reality; for *Cool Structured*, it is the continuous lineage that goes back to the original source of truth; for *Hot Structured*, it is the various forms that have surged out of the original source as an expression of itself.

At the same time, *Cool Unstructured* traditions tend to say that there is actually no tradition at all; *Cool Structured* traditions say that there may be many, but one should not mix them; *Hot Structured* traditions say that are an unlimited number and they are all part of the same game. But *Hot Unstructured* traditions stick to what they say: there is only God, only love. This *is* the 'tradition'.

at all and teachers in them say that they are not teachers. For some, like Douglas **Harding** and **Jae Jah Noh**, truth/reality just happened spontaneously.[4] In the case of **Shunya**, truth was always present; so for him, it did not even 'happen'. Jean **Klein** did go to India and found a teacher. But he says that he was not actually looking for one (typically *Cool Structured*). And it is quite pointless for anyone else to try and find this same teacher. One cannot trace another's footsteps nor is there any need to do so. Barry **Long** rarely refers to his teachers (and never by name) and it would not alter his teaching one jot if he never mentioned them or if he had never had any. Similarly, Toni **Packer**, who was a pupil of Philip **Kapleau** for a number of years, never refers to him, or the Zen tradition, in her teaching. Why not? Because using

[4] This also happened to Lee **Lozowick** but his case is somewhat different because he went on to align himself with the Bauls of India—a quintessential *Hot Structured* tradition.

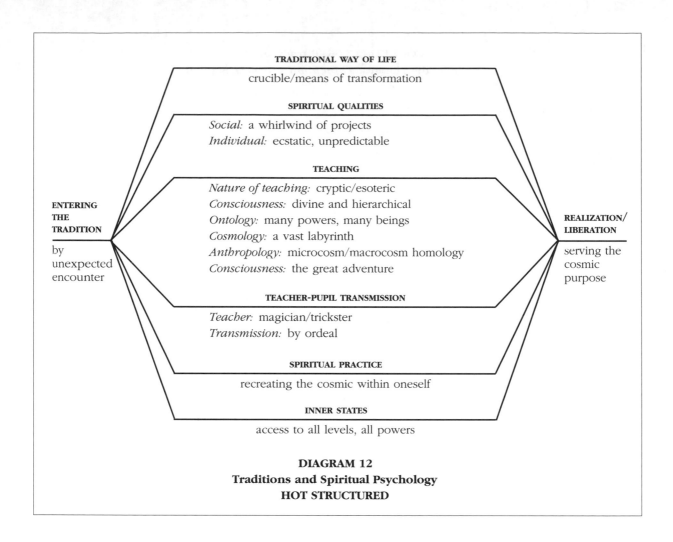

DIAGRAM 12
Traditions and Spiritual Psychology
HOT STRUCTURED

signposts does not tell people where they are; it just stops them looking. Much the same could be said about Andrew **Cohen** and Bhagavan **Nome**. **Cohen** started off attributing all his success as a teacher to his master, Poonjaji—himself a pupil of *Ramana Maharshi*, one of the great *Cool Unstructured* teachers of this century—but has since repudiated him. **Nome** aligns himself with *Ramana Maharshi* and Nisargadatta Maharaj despite the fact that he never met either of them. But there is no reason—no *Cool Unstructured* reason, that is—why he should have.

We have quite a range here, with various connections to teachers, named and unnamed, and to no teachers at all. But again these variations are not significant from a *Cool Unstructured* point of view (which is no point of view). And the same could be said from a *Hot Unstructured* point of view: love, like gold, is always the same, whatever form it takes. It immediately follows that *Unstructured* teachers have no location. The tradition, whether *Hot* or *Cool*, consists of those who have realized God *(Hot)* or the truth *(Cool)*, regardless of any other relations they may have. Hence in a sense all *Unstructured* teachers are independent (of each other). They could hardly be anything else.

<div style="border: 1px solid black;">

HOT STRUCTURED tradition
For example: Gurdjieff, Rudi, the Mother

Entering the tradition

Gurdjieff's 25-year search in the Middle East; **Rudi**'s visionary encounters with Nityananda (in addition to his initiation by Muktananda).

Traditional way of life

Gurdjieff created his own way of life for his pupils. So did the **Mother**—but in the context of Hinduism. **Rudi** sometimes wore an orange robe and shaved his head but he was hardly a traditional *sannyasin*. Rather, as he himself put it, life has to be consumed *whole*. Everything is a means of transformation if one knows how to use it.

Spiritual qualities

Gurdjieff's projects are *very* difficult to understand from the outside; and he himself was decidedly 'difficult'. **Rudi** and the **Mother** were less so—but they certainly did not conform to expectations.

Teaching

All three teachers had a teaching that came from 'on high' and can only be understood in 'high' terms. **Gurdjieff**'s and the **Mother**'s cosmologies are particularly vast. If they are true, modern man's awareness of his place in the universe is pygmyesque in comparison. And it is very easy to get lost in the labyrinth.

Teacher-pupil transmission

Gurdjieff is the paradigm shaman who transforms by ordeal. The title of **Rudi**'s book, *Spiritual Cannibalism*, speaks for itself.

Spiritual practice

Very varied. **Gurdjieff** had specific exercises (though they were part of something much, much bigger); **Rudi** used *shaktipat* (as part of the *siddha* tradition); the **Mother**'s methods ranged from special gymnastics to the unique 'yoga of the cells'.

Inner states

Gurdjieff's Great Accumulator (an inner condition expressed in cosmological terms); **Rudi**'s visionary encounters; the **Mother** hearing the cells chanting her *mantra* . . .

Realization/liberation

For all three, consciously participating in the cosmic process—even sacrificing oneself to it.

</div>

STRUCTURED TRADITIONS WITH UNSTRUCTURED LEVELS; HOT TRADITIONS WITH COOL LEVELS

Having established the logic of *Unstructured* traditions, I want to introduce two other important principles:

> *Structured* traditions can express a higher-order truth in *Unstructured* terms;
>
> *Hot* traditions can refer to a lower-order truth in *Cool* terms.

These relationships are always this way round. *Unstructured* traditions never refer to liberation or realization in *Structured* terms; and *Cool* traditions do not have a preliminary level that is *Hot*.

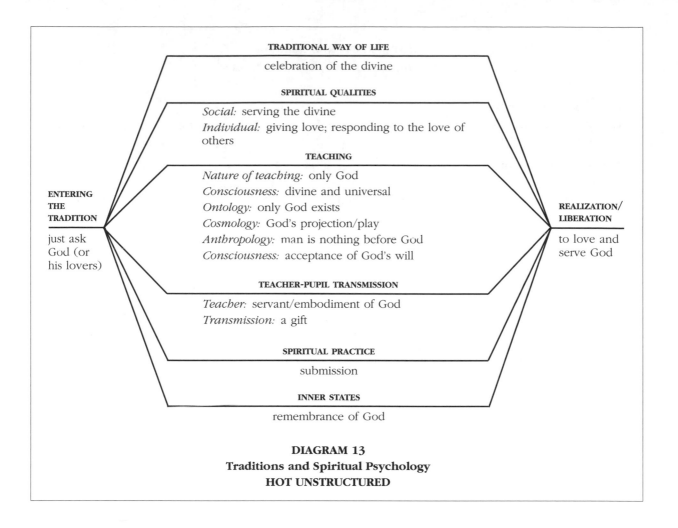

DIAGRAM 13
Traditions and Spiritual Psychology
HOT UNSTRUCTURED

For example, Zen's Buddha-nature is often said to be beyond opposites—neither this nor that—and Theravada's Nibbana/Nirvana is beyond form. Both of these are *Unstructured* truths but it is evident that neither Zen nor Theravada are themselves *Cool Unstructured*. If they were, they would tend to collapse the dimensions of their tradition like the *Cool Unstructured* teachers I have just been discussing. But they do not. That is why they are *Structured*. Similarly, although Sri **Krishna Prem**'s version of Gaudiya Vaishnavism is clearly *Hot Structured*, he has a tendency to go into *Hot Unstructured* mode: in the end, there is only Krishna. Yet there can be no doubt that he locates himself firmly within his tradition: "this happens to be the path laid down by those who have gone before me, and reached to goal. Who am I, just entering the path, to say, 'I will do this and not that, accept this discipline but not that?' I accept the whole."

Hot Structured traditions can also have a *Cool Structured* component. Tibetan Buddhism, which has a strong monastic *sangha* which one enters in a public and formal way, would be a case in point. Yet it is evident that this *Cool Structured* layer, important as it may be, is preliminary (see Diagram 15[A] for a representation of this relationship). The tradition is inherently *Hot Structured*: operating on a vast scale; imbued with the transmission of power, often in unexpected ways, from a great number of non-physical beings,

Entering the tradition

"'I want God,' I heard myself saying" (*Chasm of Fire,* 12).

Traditional way of life

"We do not belong to any country or civilization, but we work according to the need of the people of the time" (Bhai Sahib).

Spiritual qualities

"If you love you have to give a blank cheque . . . of everything you possess, but above all of yourself, in utter, complete surrender" (Bhai Sahib).

Teaching

"Sufism always was: it is the Ancient Wisdom" (Bhai Sahib).

Teacher-pupil transmission

"We do not teach; we quicken" (Bhai Sahib).

Spiritual practice

"Only one chakra is awakened: the heart chakra. It is the only Yoga School in existence in which Love is *created* by the spiritual teacher" (Bhai Sahib).

Inner states

"And so it came . . . It was still, small; a light-blue flame trembling softly, and it had the infinite sweetness of first love . . . "

Realization/liberation

" . . . the divine heart within myself is the Divine Heart within the cosmos" (*Chasm of Fire,* 203).

All these quotations are in Mrs. Tweedie's entry apart from the first and the last.

ranging from local 'spirits' to celestial Bodhisattvas; and utterly dependent upon its hierarchy of *tulkus* for its continuity. That is why the emergence of Western **tulkus** is so significant: this is the heart of the tradition. Western monks would not have the same meaning at all—certainly not the meaning that they have in Theravada, the *bhikkhu*/monk *sangha par excellence*. In short, the core of Tibetan Buddhism is *Hot Structured* (see Diagram 15[B] for a representation of this relationship; it is the same as Diagram 15[A] but inverted).

This general principle applies across traditions. Shaiva Siddhanta is undoubtedly *Hot Structured*: the tradition is ordained by Shiva since beginningless time, and Guru **Subramuniya**, who has brought the tradition to America, has had a number of visionary encounters with him. Yet there is a preliminary layer or storey which is *Cool Structured* and which is reflected not only in the careful organizational structure of the Saiva Siddhanta Church but also in the *spiritual qualities* that disciples are expected to inculcate: modesty, chastity and so on. Precisely the same could be said about the Gaudiya Vaishnava tradition as represented by the **Hare Krishna gurus**. The fundamental ethos is

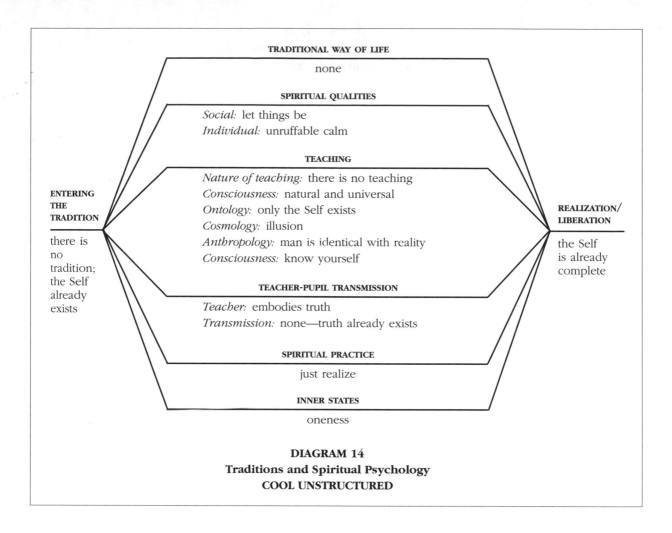

TRADITIONAL WAY OF LIFE

SPIRITUAL QUALITIES

Social: let things be
Individual: unruffable calm

TEACHING

Nature of teaching: there is no teaching
Consciousness: natural and universal
Ontology: only the Self exists
Cosmology: illusion
Anthropology: man is identical with reality
Consciousness: know yourself

TEACHER-PUPIL TRANSMISSION

Teacher: embodies truth
Transmission: none—truth already exists

SPIRITUAL PRACTICE

just realize

INNER STATES

oneness

ENTERING THE TRADITION

there is no tradition; the Self already exists

REALIZATION/ LIBERATION

the Self is already complete

DIAGRAM 14
Traditions and Spiritual Psychology
COOL UNSTRUCTURED

Hot Structured: everything is done as service to Krishna, including chanting His Name (the *Hare Krishna mantra*) and living according to the principles of Vedic culture which Krishna himself established. Yet a good Vaishnava is mild, clean, and respectful—quintessential *Cool Structured* qualities.

Similarly, Sri **Daya Mata**, Swami **Radha,** and the **Devyashrams** all go back to a *transmission* that has cosmic, even universal, significance—yet is allied to a *Cool Structured* foundation. So does **Sangharakshita**, who presents his Western Buddhist Order as the manifestation of the universal Dharma (which existed before the Buddha) in the particular circumstances of the West in the twentieth century. But entry into the Order and the way in which it is run is typically *Cool Structured.*

We might represent the **Hare Krishna gurus**, Guru **Subramuniya** and Sri **Daya Mata** as in Diagram 16[A] (p. 121), while Diagram 16[B] would represent **Sangharakshita**, the Western *tulkus*, and the **Devyashrams**.[5] The essential difference between them is, of course, the difference between *Hot* and *Cool*: the former has a *Hot Unstructured* element (Krishna, Shiva, Babaji); the latter has a *Cool Unstructured* element (emptiness, the Self).

[5] Both of these diagrams are refinements of the ones given in Diagram 10 (p. 110); they are also identical to the numbers I and II in Diagram 2[B].

There are some interesting fellow travellers here. These similarities and differences apply regardless of the traditions with which these teachers align themselves. It is true that four of them are broadly located within Hinduism. But they have absolutely no connection with each other. In reality, the **Hare Krishna Gurus** and Sri **Daya Mata**, for example, are as different as teachers in the Theravadin and Zen traditions, perhaps more so. I would like to argue, therefore, that terms such as 'Hindu' or 'Buddhist', 'Vaishnava' or 'Shaiva', 'Tibetan' or 'Western Buddhist Order', useful though they are in some circumstances, tend to get in the way here. All of these teachers, representing their traditions in different ways, are presenting a *Hot Structured* tradition with a *Cool Structured* foundation. And it is typical of *Hot Structured* traditions that they do not stick to the foundation; they are concerned with a far greater edifice, one whose very size renders it invisible. *Cool Structured* traditions never say this (or if they do, they do not make it central).

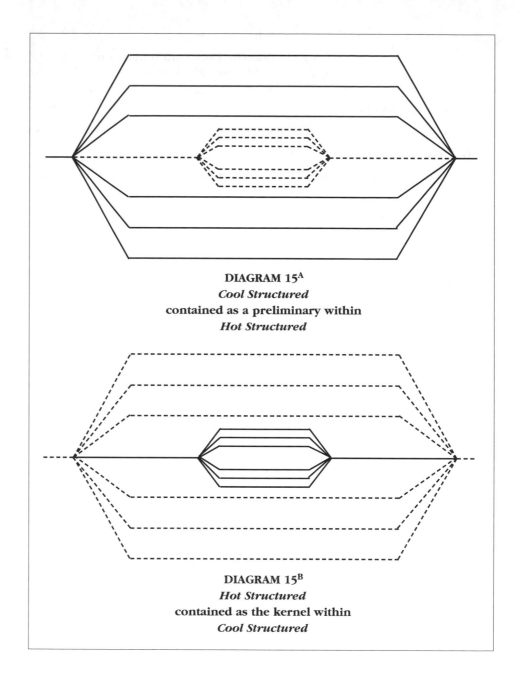

DIAGRAM 15A
Cool Structured
contained as a preliminary within
Hot Structured

DIAGRAM 15B
Hot Structured
contained as the kernel within
Cool Structured

Traditions and Sub-Traditions: The Weighting of Dimensions

COOL STRUCTURED TRADITIONS

But there are, of course, variations in every tradition, and particularly in *Structured* ones. One might even say that different parts of the tradition have their own inhabitants. The *bhikkhu sangha* and the **vipassana sangha** are good examples. Both are part of the *Cool Structured* Theravadin tradition. The *bhikkhu sangha* emphasizes the *traditional way of life*—that is, the *Vinaya*. If this is followed assiduously, certain *spiritual qualities* arise quite naturally. These two dimensions are the ones that really count. The others are available

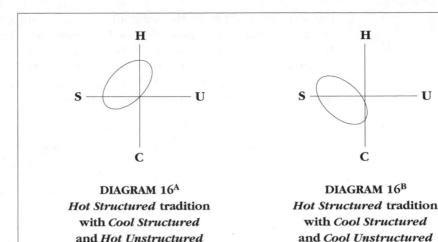

DIAGRAM 16ᴬ
Hot Structured tradition
with *Cool Structured*
and *Hot Unstructured*
elements

DIAGRAM 16ᴮ
Hot Structured tradition
with *Cool Structured*
and *Cool Unstructured*
elements

and may be used as one needs them: the *teaching* as an explanation of the human condition, and *spiritual practice* (*vipassana* and/or *samatha*) for the cultivation of *inner states*. But there is little or no emphasis on *transmission*. That is why there are no lineages of teachers in Theravada;[6] all that is required is that the *sangha* continue.

The ***vipassana sangha*** tends to emphasize these dimensions rather differently. First, it is lay and therefore does not place the *traditional way of life* at its centre. It certainly *has* a way of life, based on the five lay precepts and clearly part of the Theravada tradition; but this way of life is not central. Rather, the ***vipassana sangha*** places great emphasis on *spiritual practice*; and since this is itself seen as a skill (and not all spiritual practices are regarded in this way), it requires the help of an accomplished teacher. Hence *transmission* is allied to the practice of *vipassana* in a way that it need not be (and often is not) for the *bhikkhu sangha*. Equally, there is an important place for *inner states*. This is not to say that *spiritual qualities* are ignored. But they are seen as a consequence of the *spiritual practice/transmission* complex, so to speak; they are certainly not seen as a natural result of following the traditional way of life. As with the *bhikkhu sangha*, the *teaching* is used to the extent that it is needed to underpin this version of the tradition.

These differences between the two *sanghas* could be represented as follows (predominant dimensions = thick lines):

bhikkhu sangha

vipassana sangha

[6] There are offices that are filled by a succession of individuals but this is not the same thing at all. It would be perfectly possible for abbots of a monastery to hold office for, say, a year at a time and nothing fundamental would change in the *sangha*. The same could not be said about traditions which are founded on a lineage of teachers, of course. And that is because *transmission* is the predominant dimension of such traditions. It is not so in Theravada.

There is plenty of overlap here and the two can easily communicate with each other. But it can also happen that each of them can go in opposite directions. The *bhikkhu sangha* can place all its emphasis on externals (*entering the tradition* and the *traditional way of life*); and the **vipassana sangha** can concentrate entirely on what it sees as the means of enlightenment (*spiritual practice, inner states, transmission*). Then what we get is

bhikkhu sangha *vipassana sangha*

And the great city of Theravada finds itself divided into ghettos that do not communicate at all. The *bhikkhu sangha* regards the **vipassana sangha** as grandiosely preoccupied with the higher stages of the path without having fulfilled the elementary steps; the **vipassana sangha** sees the *bhikkhu sangha* as stuck in the formalities—the shell without the kernel.

Similar differences—different weightings of dimensions—have occurred in the Zen tradition. What I have called the *Harada-Yasutani-Yamada* lineage is an example. Here we have Philip **Kapleau**, who *entered the tradition* in an impeccable way—ten years in Japanese monasteries under Japanese teachers—and was given permission to teach by *Yasutani* Roshi but was never given Dharma *transmission*. The reason was a dispute with *Yasutani* Roshi over whether certain changes in the *traditional way of life*, such as chanting in English rather than Japanese, were acceptable or not. **Kapleau** wanted to introduce them; *Yasutani* did not.

This does not appear to be a very large issue but it has had considerable consequences. **Kapleau** has continued to teach, as he is entitled to do, but has also given Dharma transmission to a number of his own students, which, according to the *transmission* criteria of the Zen tradition, he is not entitled to do. Or at least, these appointments need not be recognized by any other lineage or teacher. And the same could be said about his use of the title 'Roshi'. There have been a number of discussions amongst Western Zen teachers about who is entitled to use it, and when; but the weakest case is surely that in which one has never received Dharma transmission in the first place.

None of this is to say that **Kapleau** is not a good teacher. (And in fact a number of other Western Zen teachers, who have been formally appointed themselves, do implicitly recognize him as one.) But the question is: how is his appointment of Dharma heirs and the use 'Roshi' justified? Answer: by appeal to his *spiritual qualities*. That is, he possesses those attributes of a teacher which are central to the tradition. One of his students says of him that he "has tenaciously and unremittingly preserved the spirit of Zen as passed from his teachers Harada-roshi and Yasutani-roshi." He himself has said that "there is something lacking in a system of dharma transmission . . . that places moral behavior low on the list of qualifications of a teacher." Hence his own transmission (from *Yasutani* to himself) is not central. But since he teaches true Zen—and he *was* given permission to teach—he can give Dharma transmission himself (or withhold it, as his dispute with Richard **Clarke** shows).

In effect, then, **Kapleau** has created his own Zen lineage. From the point of view of those who give *transmission* the most weight, this is inauthentic,

even frivolous. From his point of view (and that of his pupils), giving *spiritual qualities* the most weight, it is neither. We could say, then, that he is an independent Zen teacher. But clearly he is not independent in the way that *Unstructured* teachers are (see above). There, independence is actually part of the tradition, the way it operates. The opposite is true here, where 'independent' means 'not part of the line of *transmission*'.

It is interesting that one of **Kapleau**'s own students, to whom he gave permission to teach—but not Dharma transmission—then left the Zen tradition, and in fact the Buddhist tradition itself, because she found that it tended to conceal rather than reveal truth. This is Toni **Packer**, who has in effect abandoned the *Structured* path altogether and is now a *Cool Structured* teacher—and this is a tradition that by its own logic tends to deny that it is a tradition at all. (So her independence, which is *Cool Unstructured*, is different from his, which is *Cool Structured*.) Yet **Kapleau** still says that he holds her in high regard. Why? Because she manifests the *spiritual qualities* of a genuine teacher. In effect, therefore, this dimension has approximated that of *transmission* to itself, whereas in the *Harada-Yasutani-Yamada* lineage the two are of equal weight.

This difference of weighting explains the divergences between **Kapleau**'s lineage and that of Robert **Aitken**. **Aitken** received Dharma transmission from *Yamada* Roshi but he has been far more radical in his attitude to the *traditional way of life* than **Kapleau**. He has encouraged Zen (and Buddhist) feminism, for want of a better term, and has actively encouraged gay and lesbian participation in Zen (though he is not gay himself). He is also a committed social activist—he was a co-founder of the Buddhist Peace Fellowship—and sees such commitment as a necessary aspect of Buddhist ethics, which are themselves expressed in the precepts. At the same time, he has given Dharma transmission to one of his students who is a Christian priest (though in this he is following the example of *Yamada* Roshi: see the entry on **Enomiya-Lassalle**).

The disagreement between **Aitken** and **Kapleau** is entirely civilized and without rancour, but it is real for all that. It is generally held by those in the **Aitken** lineage that **Kapleau** was not given Dharma transmission for a very good reason and that his own transmission is inherently weak as a result. **Kapleau,** for his part, questions whether it is possible for any committed Christian to truly follow the Zen way since the two *teachings* are inherently incompatible. In fact, he goes further and says that sanctioning Christian priests and nuns to teach is "a threat to the integrity of Zen".[7] This is an implicit critique—and a fairly strong one—not only of **Aitken**'s appointment of a Christian priest as a Dharma-heir but also of *Yamada* Roshi (who was given Dharma transmission by Yasutani Roshi while **Kapleau** was not). In short, for **Aitken**, *transmission* is a necessary condition (though not a sufficient one) for the tradition to continue; for **Kapleau**, *spiritual qualities* holds an equivalent place.

[7] The response of the Christians themselves is given by Father Jäger: "Many can argue whether a Christian can validly do or teach Zen or not. The fact is, I am doing it." The use of the word *do* here is crucial. In effect, Father Jäger is talking about *spiritual practice* and the *inner states* that it produces. These have been completely separated from the *traditional way of life* and from the *teaching* in any straightforwardly doctrinal sense. And it is precisely this that **Kapleau** questions: if this separation is made, can what is left be called Zen? Analogous questions have been asked of all the major traditions.

It is far too early to say how these lineages will develop. What we can say, however, is that the 'successful' ones will establish the criteria that will determine Western Zen (which is presently made up of at least half a dozen major lineages); and that these criteria will be expressed in terms of the fundamental dimensions that are found in all traditions. (See Diagram 17, p. 126.)

HOW A TRADITION CHANGES

These examples from Theravada and Zen show that it does not take much for a tradition to go in a different direction; or more accurately, in a number of directions at the same time. But not all directions are equally 'open'. There are some changes that a tradition will allow easily, some which it allows with difficulty and some which it does not allow at all. When the first occurs, we have a variant of the tradition—but one which is recognized by the other variants. The second produces a sub-tradition. The third is in effect independent of the tradition altogether.

The dividing line between these three is sometimes clear cut and sometimes not.[8] And as we would expect, different traditions—by which, I mean *Cool Structured/Hot Structured/Hot Unstructured/Cool Unstructured* traditions—have different criteria for saying what changes are allowed easily, with difficulty or not at all. But all of them can be expressed in terms of the fundamental dimensions given in Diagrams 11 to 14.

However, I am presently confining myself to examples from *Cool Structured* traditions just to get the model on the road at a relatively even pace. (It will hot up later.) Consider **Nanavira**: he lived as a hermit, was highly critical of the state of the Theravada tradition as he found it in Sri Lanka, regarded James Joyce as closer to the Buddha's teaching than Buddhaghosa, and ended up by committing suicide (as a spiritually significant act). A doughty individual and no two ways about it. Yet he was firmly within the boundaries of the Theravada tradition. Why? Because he kept to the *Vinaya*. As long as a monk does so, interpretations of the **teaching** can be fairly divergent. It is orthopraxy, or right practice, that is central, not orthodoxy in its literal sense of right doctrine. By contrast, **Sangharakshita**, who was also ordained as a Theravadin monk, has completely changed the *Vinaya* and created his own Buddhist order or *sangha*. Theravada does not allow such a move and he is therefore outside the tradition. But **Nanavira**'s views about Dhamma (the *teachings*) are in many respects quite as radical as **Sangharakshita**'s.

This is why **Sangharakshita** is an independent Buddhist teacher while **Nanavira,** for all his originality, is not. Yet **Sangharakshita**'s version of Buddhism fits the model very well. One enters the Western Buddhist Order, the *sangha*, by means of a public ceremony (just as in all other forms of

[8] The case of Philip **Kapleau**, discussed above, is an instance. I said that because he has created his own lineage, despite not having received Dharma transmission himself, he is in effect an independent Zen teacher. But this is only so if the Zen tradition as a whole insists on the necessity of formal Dharma transmission and thereby invalidates his lineage. If, on the other hand, a reasonably significant proportion of the tradition recognizes him as a valid teacher (and being recognized in this way is itself a typical *Cool Structured* move), he would be the creator of a sub-tradition rather than an out-and-out independent. The matter is still in the process of being decided.

Buddhism) and all the six dimensions of a tradition are acknowledged. Essentially, his is a *Cool Structured* tradition with a *Hot Structured* 'top storey': the idea that the Dharma unfolds throughout time and space, adapting itself to the needs of the moment (or the century).

Consider Jiyu **Kennett**: she was unequivocally recognized as a Zen *roshi* in Japan by the abbot of one of the main Soto temples but has since had visionary encounters with various Buddhas, one of whom entered her body. The Zen tradition, which places *spiritual practice* and *inner states* at its very centre, clearly describes experiences such as these as false, not true *kensho*. **Kennett,** on the other hand, says that her experiences are a deeper kind of *kensho*. This is not a move that Zen allows.[9] Hence she is in effect an independent Zen teacher: she says she teaches Zen; nobody else does.[10]

But notice how her independence is both similar to and different from **Sangharakshita**'s. It is similar because both have taken their tradition in a direction that the tradition does not recognize *at all*. It is different because what each tradition does not allow is different. In Theravada (**Sangharakshita**'s original tradition), it is certain changes in the *traditional way of life*; in Zen, it is certain kinds of *inner states*. On the other hand, **Sangharakshita** says that he is teaching Buddhism, not Theravada; but **Kennett** has always said that she teaches Zen.

As an example of changes that are allowed only with difficulty, take **Kapilavaddho** (in Theravada) and Christian Zen (for which, see Father **Enomiya-Lassalle**). **Kapilavaddho** was ordained as a monk in Thailand and given instruction in meditation by the abbot of Wat Paknam. But I think it is fair to say that it was an unusual method: it involved repetition of the words *samma arahan*, concentration on various parts of the body, and seeing inner light. And **Kapilavaddho**'s experiences were certainly unusual: he had visionary experiences during his *samanera* ordination, including one of the Buddha himself. Nothing remotely like this occurs at most ordination ceremonies in the Theravadin tradition, in Thailand or anywhere else, nor is it expected. But since **Kapilavaddho** was following the *Vinaya* at the time[11] and was also under the instructions of an abbot who was also following it, his experiences can be considered as still within the tradition (which **Kennett**'s cannot, despite the fact that both of them 'saw' the Buddha). But one would have to say, I think, that they are very much on the edge of it.[12]

A similar argument could be put forward about Christian Zen (meaning committed Christians, including priests and nuns, who practice *zazen* and pursue *koan* study, and teach them, too.) There is considerable debate within the wider Zen community as to whether such a combination is 'real' Zen—within

[9] However, see her entry for her argument that the tradition does allow it. If we accept this, then she is a 'true' Zen teacher and not an independent one.

[10] This is what distinguishes her from **Kapleau** (see note 8). It is perfectly possible to argue that he teaches Zen even though he did not receive Dharma transmission. In contrast, **Kennett** did receive it but has changed the content of the teaching completely.

[11] He later abandoned it—more than once—on his return to Britain and ended up as a strong advocate of lay Theravada as better suited to the West than the monastic form. But that is another issue, which I am not considering here.

[12] I said earlier that a change that a tradition allows with difficulty tends to produce a sub-tradition. **Kapilavaddho**'s ideas were taken up after his death by Alan and Jacqui James. They could therefore be considered as representatives of this particular sub-tradition (which we could call visionary lay Theravada). This is not very influential at the moment—certainly not in comparison with the *bhikkhu sangha* and the **vipassana sangha.** But that could change. (And in any case, a sub-tradition is a sub-tradition regardless of the numbers involved.)

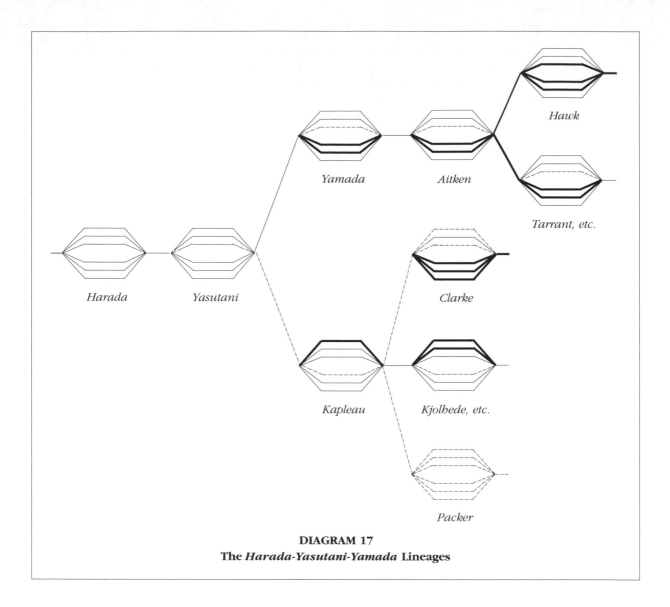

DIAGRAM 17
The *Harada-Yasutani-Yamada* Lineages

the boundaries of the tradition—or not. As I have already said in discussing the **Aitken** and **Kapleau** wings of the *Harada-Yasutani-Yamada* lineage, what this debate comes down to is which of the dimensions are central to Zen. If *spiritual practice* and *inner states* are what count, then religious affiliation, for want of a better term, is secondary, and Christian Zen can be seen as a sub-tradition. If a certain *traditional way of life*, together with a bare minimum of essential *teaching*, are weighted more heavily, then Christian Zen is effectively outside the tradition altogether, an independent form of Zen.

It is not for me to attempt to adjudicate in any of these matters. Rather, I am concerned with showing what is involved in them: that the similarities and differences that have arisen can be understood within a higher-order account of the nature of traditions and their dimensions, and that these comparisons can be made both within traditions and across them. That's what makes the account 'higher-order'.

Comments on Diagram 17

My only aim here is to show how the various differences between these teachers can be expressed in terms of the dimensions of the Zen tradition. Hence I represent *Harada* Roshi as the starting point and as 'orthodox' in the sense that he defined the way in which the dimensions of the tradition were received by his pupils. In fact, he was far from orthodox from the point of view of the Soto school in which he began. I have also represented *Yasutani* Roshi as continuing the orthodoxy of his master. From that point on, several differences emerge. *Yamada* Roshi, for example, emphasized *spiritual practice* and *inner states* over the *teaching*. I say this (and represent it in the diagram by thickened and dotted lines respectively) simply to focus on *Yamada*'s ready acceptance of Christian pupils, who retained their Christian beliefs and practices, while *Yasutani* evidently had his reservations about such a development. This is not to say in any way that *Yamada* was not a worthy Dharma-heir. In fact, it is legitimate to argue that this form of Soto Zen allows such departures.

I represent **Aitken** Roshi as carrying on the tradition as he received it from *Yamada,* and three of his Dharma-heirs (Tarrant, Foster, Alcade) as retaining this orthodoxy in their turn. But Hawk Roshi, who is a Christian priest, is surely doing something a bit different. He cannot, as a Christian, say that the *teaching* is not important. Hence I have highlighted that dimension for him.

On the **Kapleau** side, I have weakened the *transmission* dimension but highlighted *spiritual qualities* (for reasons given in the text; please do not interpret this representation as meaning that *Yasutani*'s spiritual qualities were somehow 'weak'). I have also emphasized the *traditional way of life* (which was the issue on which he and *Yasutani* parted company). Bodhin Kjolhede and **Kapleau**'s other Dharma-heirs continue this 'Kapleauvian orthodoxy' (that is, his version of the tradition), while **Clarke** has changed the traditional way of life even more and is also far more experimental in his approach to the *teaching*. (It is fair, I think, to describe a combination of Zen and Neurolinguistc Programming as experimental.) **Packer,** of course, has left the Zen tradition altogether.

All of these claims about orthodoxy and the relative value of various dimensions of the tradition are open to debate, of course. Nor do I want to create artificial differences where none exist. I am not saying that Hawk Roshi is somehow not a true Dharma heir of **Aitken** Roshi (any more than *Yamada* Roshi is somehow untrue to *Yasutani* Roshi). I simply want to indicate how a tradition—in this case, a *Cool Structured* one—can gradually change its form as it is transmitted from one teacher to another. Since Western lineages are relatively new (and they are far more common in Zen than in any other tradition), this is only just starting to happen in the West. But it will become more frequent.

HOT STRUCTURED TRADITIONS

To show that this is so, I want to look at some *Hot Structured* traditions and teachers. Being *Hot*, they are far more effervescent and malleable than *Cool Structured* ones. Any account of them has to start with this fundamental characteristic. And of course it affects all the dimensions. Take *entering the tradition* as an example (see Table 2). At the *Hottest* end of the spectrum, we have people like **Shankar Das** and Joya **Santanya**, who only had inner contact with their teachers. Then we have those, like the **Mother, Marasha,** Swami **Turiyasangitananda, Rudi,** and Swami **Radha,** who did have some external contact but for whom the inner was always far more important. Not surprisingly, none of these is part of a tradition that can be said to have an established public form. Even **Mahendranath,** who had an ashram in India with Indian disciples, is part of a Shaiva sub-tradition, the Adinathas, which tends to go underground and surface at unexpected places.

In fact, generally speaking, the *Hotter* a *Hot Structured* tradition is, the more discontinuous it is. But by the same token, the more discontinuous it is, the easier it is to bring together what appear to be disparate elements. Take the *siddha* tradition, for example. There are famous *siddhas* going back several centuries. Some are within forms of Hinduism (Goraknath, Dattatreya),

TABLE 2

Entering Hot Structured traditions
(encounters of Westerners with various teachers, inner and outer)

	physical teacher	inner teacher	comments
Shankar Das	none	God	
Joya **Santanya**	none	Nityananda, Neem Karoli Baba	these two have no connection with each other
the **Mother**	*Aurobindo*	God	she saw *Aurobindo* in visions before she met him
Marasha	Dhyanyogi Madhusudandas	Shiva	her disciples saw Jesus, Nityananda and Babaji; she never mentions Madhusudandas
Swami **Turiyasangitananda**	Satchidananda, Sai Baba	God	she also had a visionary encounter with Sivananda; she only 'associated' with Satchidananda and Sai Baba
Rudi	Nityananda, Muktananda	Nityananda	
Swami **Radha**	Sivananda	Babaji	she was a follower of *Yogananda* before she became a disciple of Sivananda (whom she initially saw in a vision)
Mahendranath	Sadguru Lakenath (Adinatha lineage)	none	his ashram in Gujarat was called Merlin Oracle Lab

Notice that some teachers (Sivananda, Nityananda, Babaji) appear more than once—the first two in both physical and non-physical form. These 'appearances' can be extended if we add Swami Lakshmi **Devyashram** and Sri **Daya Mata** to this list. The former had a vision of Sivananda (before going on to become a disciple of the Shankaracharya); the latter was a disciple of *Yogananda* (whom she saw after his death) and also had a visionary encounter with Babaji. All of these connections and interconnections, which involve Eastern and Western teachers who are quite independent of each other, are typical of *Hot Structured* traditions.

some within Buddhism (Tillopa, Naropa and others in Indian Vajrayana; Marpa and Drukpa Kunley in the Tibetan tradition). They are characterized by a disregard for convention at all levels. They break social taboos (going around naked, appearing to be mad) and are frequently credited with the ability to break—or bend—the laws of time and space (appearing simultaneously to people at different places or living to well over a hundred years old). Neem Karoli Baba (**Ram Dass**'s master) is a good example in modern times. But he never said he was a *siddha* and was clearly uninterested in any tradition that might use that name. Swami Muktananda, on the other hand, did use the word. His guru was Nityananda, a classic *siddha* if ever there was one. Thus it is a very short step to link Neem Karoli Baba and Nityananda as being part of the same 'tradition': discontinuous, unpredictable and extremely difficult to get to grips with, but part of the same essential stream nonetheless. This is typically *Hot Structured*—and it is exactly what Joya **Santanya** has done.

Hot Structured traditions of this kind (at the *Hotter* end of the spectrum, that is) can unite teachings and teachers that have hitherto been quite unconnected on the grounds that they are instances—transformed or disguised instances, of course—of a single truth, a single tradition. Needless to say, we will not find the slow, measured tread that is typical of *Cool Structured* traditions. But being *Hot*, they do not regard this as a failing.

However, as I pointed out earlier, there are *Hot Structured* traditions with a preliminary layer that is *Cool Structured*: Tibetan Buddhism, Gaudiya Vaishnavism, Guru **Subramuniya**'s Shaiva Siddhanta, the **Devyashrams** as part of the Shankaracharya lineage. Yet it is the *Hot* element that calls the tune. Guru **Subramuniya** and Swami Lakshmi **Devyashram** both had visionary encounters and are and were regarded, by Indians, as having *entered the tradition* because they both had a particular task to fulfil within it. This is a typical *Hot* move; but *Cool* traditions cannot make it.

Similarly, with the Tibetan tradition. Teachers who are high up in the hierarchy can take the tradition in new directions; the very structure of the tradition allows it, even encourages it. An example would be the recognition that two Westerners, Jetsunma **Ahkon Lhamo** and Dhyani **Ywahoo**, had been teaching Tibetan Buddhism for years without their realizing it. That is, they had already *entered the tradition* in the way that really counts (*Hot*) long before they entered it formally (*Cool*). It is difficult to imagine either Theravada or Zen allowing anything remotely similar.

This indicates that while all the dimensions are *Hot*, it tends to be *transmission* that is the predominant one. This explains many of the disputes that have arisen in *Hot Structured* traditions, where we frequently find competing claims about who has received transmission and is therefore a true representative of the tradition. The various *kriya yoga* teachers, all of whom go back to Paramahansa *Yogananda*, are a case in point. Everything about the *kriya yoga* tradition is *Hot Structured*. It consists of a lineage of avatars/gurus that goes back to Babaji, who is practically beyond space and time; and in fact all the *kriya yoga* gurus, including *Yogananda* himself, are presented as miraculous beings. *Kriya yoga* involves initiation by such a guru, who pledges to look after the disciple under all circumstances. And he does not have to obey the normal laws of time and space in order to do so. Light and sound are imparted to the disciple at the Christ Centre (the *chakra* between the eyes); in fact, the initiation is really a form of *shaktipat*.

Yet *Yogananda* also introduced *Cool Structured* elements into his dissemination of *kriya yoga* in the West. He presented it as a scientific technique for attaining experience of God, and even offered it (or at least its initial stages) in the form of a correspondence course. That's about as *Cool Structured* as you can get. (And we should also notice that *Yogananda*'s *spiritual qualities*, and those he expected from his disciples, were also *Cool Structured*: patience, consideration, forgiveness. It is no accident that he was fond of the word 'saint'.)

However, there have been a number of extended disputes over who genuinely represents *Yogananda* and/or the *kriya yoga* gurus. There is an official/orthodox lineage and several unofficial/unorthodox pretenders. (And I am deliberately using this word to mean both 'one who claims' and 'one who pretends'.) The orthodox lineage consists of *Yogananda*'s two American successors, **Rajarsi Janakananda** and Sri **Daya Mata**. They have formulated what might be called a *kriya yoga* theology to the effect that the line of avatars/gurus ended with *Yogananda* and that the subsequent Presidents of the Self-Realization Fellowship or SRF are only his representatives. But at the

same time they are his *only* representatives. What this means is that *kriya yoga* initiation since *Yogananda*'s death is only effective if it is transmitted through the President (or those whom s/he appoints).

Effectively, then, *transmission* has been defined in such a way that it also determines two other dimensions: what it is to *enter the tradition*, and what true *spiritual practice* is (namely, meditation done after one has received initiation from a true representative of the tradition). All other teachers who claim to be in the *kriya yoga* lineage (see Lineage Tree 2) have to deal with this claim.

> Some say that they are independent of *Yogananda* because they have had direct contact with the gurus before him (Sri Yukteshwar, Lahiri Mahasya or Babaji himself). These include Indians (Swami Hariharananda, Swami Satyeshwarananda and Yogi Ramaiah) and at least one Westerner (Leonard **Orr**).[13]

> Others say that *were* appointed by *Yogananda* and are therefore independent of **Rajarsi Janakananda** and **Daya Mata.** Roy Eugene **Davis** is an example; and so is Swami Premananda, who has a Western successor, Shrimati **Kamala**.

> Lastly, there are those who say that, while they were not *formally* appointed to teach by *Yogananda,* they are still genuine teachers of *kriya yoga*. **Shellyji** says this on the basis of the *inner states* he attained by his own practice; **Kriyananda**/Donald Walters says it because of inner *transmission* he received from *Yogananda* after *Yogananda*'s death.

Again, it is not my intention to adjudicate in these various claims but rather to see what they consist in. Effectively, the orthodox SRF lineage, presently represented by **Daya Mata**, has gone *Cool*: authentic transmission is located in the President and nowhere else. All the other *kriya yoga* teachers, on the other hand, have stayed on the *Hot Structured* high ground: transmission follows its own laws and cannot be confined by rule. This is a classic *Cool* versus *Hot* clash and it is being enacted by Westerners beneath our very eyes, so to speak.

Notice the difference with *Cool Structured* traditions. There, because *transmission* is public and open, it very rarely happens that there is any doubt about who has received it and who has not. **Kennett** certainly did, for example; **Kapleau** certainly did not.[14] When disputes arise, therefore, they tend to be about the relative importance of *transmission* in relation to the other dimensions. In *Hot Structured* traditions, it is always possible to appeal directly

[13] **Orr**, like Yogi Ramaiah, says that he had direct contact with Babaji. At least two other teachers in this book, Swami **Radha** and Omraam Mikhael **Aivanhov**, make the same claim. But since neither of them say that they teach *kriya yoga*, they are not part of the *Kria yoga* lineage. (They are, however, included in Lineage Tree 2 for the sake of completeness.)

[14] However, it can happen that there is disagreement over whether a transmission that has certainly taken place is authentic or not. For example, Maurine **Stuart** was given Dharma transmission by Nakagawa Soen in a private ceremony. This is not the normal Rinzai procedure and there are those who doubt its validity. Similarly, the Japanese Soto authorities have so far only accepted Westerners in the Shunryu Suzuki lineage if they have gone through certain ceremonies in Japan. (See the entry for Reb **Anderson**.)

Both these instances are centred on the relation between correct procedure and transmission—a typically *Cool Structured* concern. It is quite different from the *Hot Structured* examples we are discussing, where certain kinds of transmission are either regarded as inherently invalid (which is different from saying that they would have been valid if a certain procedure had been followed) or as not even having taken place.

to the source, so to speak. But since the source is by its very nature disguised, unexpected, overwhelming, and usually of cosmic proportions, when it does make its appearance (and I use the phrase literally), it is often in a form that is difficult to recognize. (This is a frequent occurrence in *Hot Structured* traditions—see Table 3 on p. 132 for four more instances.)

From a *Cool Structured* standpoint, this is bound to look somewhat chaotic. But *Hot Structured* traditions are chaotic. That is why they include a relatively high percentage of mavericks. Some of these mavericks may even be charlatans. *Cool Structured* critics see this as a serious weakness but a strong *Hot Structured* tradition can take them in its stride. They thicken the plot.

I am thinking here of people like Madame **Blavatsky**, **Oom the Omnipotent** and G.B. **Chicoine**; perhaps even **Lobsang Rampa**, Paul **Twitchell**, **John-Roger**, and Zen Master **Rama**. But of course making claims/creating myths/spinning a line/telling a story—all these are part and parcel of the *Hot Structured* way. (**Gurdjieff** is a good example, along with several of his 'independent' successors such as E.J. **Gold** and Idries **Shah**.) It is not at all easy to sort these people out—to separate the wheat from the chaff. But things are not supposed to be easy in *Hot Structured* traditions.

Those who find this unacceptable, distasteful, or just plain silly are evidently not in sympathy with the *Hot Structured* ethos. It is certainly true that *Hot Structured* traditions and teachers can tend towards the extravagant-cum-ludicrous side. But *Cool Structured* traditions, which at their best are balanced and finely wrought, can become caricatures of themselves: overly complicated, hidebound, fussy and just plain boring. There is a real debate here, between the *Hot Structured* and the *Cool Structured*, about the nature of the spiritual life. But it should not, in my view, be between the silly and the boring, both of which are inherently limited, but between the exuberant and the tranquil—both of which can take us a considerable distance, maybe to the edge of existence itself (*Hot Structured*) or to its very centre (*Cool Structured*).

THE FUNCTION OF WESTERN TEACHERS

I have spent considerable time on the various traditions and their dimensions in order to show their diversity. By this, I do not just mean that there are different traditions—a truism that no one would deny. Rather, traditions differ according to their presiding 'principle': *Hot/Cool/Structured/Unstructured*. And even these differences are not simply a matter of the same form with different content; the forms themselves vary. That is why *transmission* has different meanings in different traditions. And by the same token, 'X represents tradition A' and 'X is independent of tradition A' also mean different things. I have already dealt with these matters in various places in this chapter and I summarize them in Diagram 18 (p. 134).

Hence when I said in the Introduction (p. xviii) that Western teachers are representing traditions, adapting them, extending them, leaving them, combining them and even creating them—there was more to that list than might have appeared at first blush. In fact, all the terms in it mean different things depending on which tradition and teacher we are considering. This is why I have said more than once that what Western teachers are doing—*en bloc*—is unique. In effect, they are changing the very notion of tradition because they

TABLE 3

Disputes over transmission in *Hot Structured* traditions

the Mother and her 'successors'

The **Mother** was an independent teacher from the beginning: chosen by God to fulfil a great task in the spiritual evolution of mankind. She was *Aurobindo*'s co-worker—*not* his successor—and her work was unique. She never nominated anyone as her successor, either, and it requires a huge amount of spiritual nerve for someone to claim that she or he is. But **Sat Prem** and Patrizia **Norelli-Bachelet** have done so. They do not say that they are the **Mother**'s equal but they do hold that they are carrying on her work. **Sat Prem** is continuing the 'yoga of the cells'; **Norelli-Bachelet** is extending the Mother's cosmology.

Neither of these claims has been accepted by the community at Auroville. Hence the two have had to do their work away from the centre that the **Mother** herself designed (which both of them have said has lost its way). We could call them independent representatives of an 'original' independent. (They do not have any contact with each other, either.) In effect, the Auroville community has gone *Cool*—it is the repository of the **Mother**'s continuing work—while **Sat Prem** and **Norelli-Bachelet** are playing the *Hot* card: the work has taken a form that it is not immediately obvious. And this is precisely what *Aurobindo* and the **Mother** themselves said when they were teaching.

Gurdjieff and spin-offs

Gurdjieff himself was a quintessential *Hot Structured* teacher. He appears suddenly, trailing a mythic account of an extensive spiritual quest in unknown parts of the East during which he met a number of 'remarkable men', *none* of whom have ever been identified. Everything he did was intense; he could be unpredictable and demanding but also deeply generous. Both in the way in which he *entered the tradition* and in his own *spiritual qualities,* therefore, he is as about as *Hot Structured* as it is possible to be.

And his *teaching,* the Fourth Way, follows the pattern. It presents a hierarchical cosmos of vast size, imbued with forces and purposes which are incomprehensible to most people. And for a simple reason: most people (and this includes thinkers/intellectuals) are asleep and simply react like machines to external conditions. In fact, the higher purpose can only be understood if one comes into contact with someone who already knows it. And this necessarily means that this someone makes contact with you. There are no accidental stumblings on the secret; it is revealed. **Gurdjieff** himself said that it was a characteristic of the Fourth Way that it was constantly changing its outward form. Why? Because Fourth Way schools are serving a higher purpose and take their form from 'on high'. The only criterion of authenticity is that they wake people up by making them more conscious. Consistency of form or content simply isn't relevant. Not only can we not expect it, we can expect the opposite. A Fourth Way teacher, then, should be someone, first, who is in touch with the higher source and hence serving the higher purpose; and secondly, it quite likely also means someone who appears suddenly, is unpredictable and demanding, and does not explain himself or herself very much.

And what do we find? That there are definitely people who fulfil this second set of criteria: E.J. **Gold,** Idries **Shah,** Gary **Chicoine,** Jan **Cox.** (See Lineage Tree 3.) But none of them had any direct contact with **Gurdjieff.** Rather, they claim direct contact with the Masters of Wisdom in some guise or another. Similarly, those teachers who were pupils of **Gurdjieff** or **Ouspensky** have tended to look for a 'higher source' (just like those in the *kriya yoga* and Inayat *Khan* lineages). Rodney **Collin** held that **Ouspensky** himself *was* the source; J.G. **Bennett** found it in a sort of cosmic Sufism; Roles and **Maclaren** found it in a form of Hinduism (actually, a *Hot* form with a *Cool* lower storey); Madame **de Salzmann** thought that it might exist in the practice of a kind of *chakra yoga.*

All of these are independent of each other—and in a typically *Hot Structured* way. That is why I call them 'spin-offs'. Yet even so there is a considerable range of *Hot* and *Cool.* **Ouspensky,** the great thinker, is far *Cooler* than **Gurdjieff** himself; and among **Ouspensky**'s pupils, **Collin**'s higher-order cosmology is decidedly *Hotter* than **Nicoll**'s down to earth approach. **Bennett**'s seemingly sudden lurches from teacher to teacher, and from tradition to tradition, were explained by him as steps in the 'Great Work', a sort of cosmic template that holds different 'forms' of the spiritual life in place—a quintessentially *Hot Structured* idea. (This was why his pupils were prepared to give **Chicoine** a run for his money.) **Maclaren**'s espousal of the Shankaracharya lineage is positively *Cool* in comparison.

lineages that go back to Hazrat Inayat Khan

Rabia **Martin**, Inayat *Khan*'s very first Western *mureed*, saw him in a vision before she met him in San Francisco (just as he had done with his own master in India). She spent over 30 years working as his representative, with very little physical contact with him when he was alive and of course none at all after his death. But she had plenty of 'inner' contact. Then, just before she died, she accepted *Meher Baba* as the Avatar and thus the source *behind* Inayat *Khan*. Thus was Sufism Reoriented born: a form of Sufism that is 'beyond' the Sufi tradition that Inayat *Khan* brought to the West—because *Meher Baba* is 'beyond' Inayat *Khan*.

Samuel **Lewis**, another *mureed* of Inayat *Khan*, also went on a search for the original source. He did not accept *Meher Baba* as fulfilling that role but he had numerous visionary encounters with figures ranging from Inayat *Khan* to Elijah and Mohammed—all of this intermixed with initiations and practice with various Sufi and Zen masters (physical masters, that is).

Meanwhile, back in Europe, a split developed between the **Sufi Movement** and the **Sufi Order**. The former is presently led by Inayat *Khan*'s younger son, Hidayat, who was elected as Murshid according to the Movement's constitution (which Inayat *Khan* set up); the latter is led by the elder son, Vilayat **Khan,** who says that no Sufi teacher can be elected and that his father always intended him (Vilayat) to be his successor.

The various lineages can be found in Lineage Tree 8. They all started from the same point—Inayat *Khan*—but are now independent of each other. Why? Because each of them appealed to sources of *transmission* that the others do not accept. These sources have various positions on the *Hot/Cool* scale. You can't get much *Hotter* than *Meher Baba,* who holds the spiritual destiny of the universe in his hands. **Lewis**'s visionary encounters are also decidedly on the *Hot* side. Vilayat **Khan**'s **Sufi Order** is much *Cooler*—no great claims of inner contact—but even so, direct transmission from teacher to teacher (in this case, from father to son) is a *Hot* ideal. By contrast, the **Sufi Movement,** which elects its leaders according to a constitution, is *Cool* through and through.

ISKCON: orthodoxy and schism

This dispute is particularly intricate and recondite. (The major parties concerned appear on Lineage Tree 5.) Shrila *Prabhupada* appointed eleven Americans as **Hare Krishna gurus** just before his death. But their exact function was not clear, and the unclarity was deepened by the existence of a managerial council, the Governing Body Commission or GBC (also created by *Prabhupada*). Some of the eleven gurus were subsequently suspended by the GBC for various reasons (for not acting in accordance with the *spiritual qualities* of a Vaishnava; for unacceptable theological *teachings*). These suspensions created a fundamental division in the movement since there were those who held that according to the Gaudiya Vaishnava tradition a guru could not be 'regulated' in this way. Shrila **Bhaktipada,** for example, said that, "We cannot legislate or decide by council when and where Shri Guru may appear to someone. His appearance is a transcendental arrangement of the Lord". Yet he was expelled from the movement by the GBC and is now an independent teacher.

Others, who also rejected the GBC's authority, have formed different independent groups. Some devotees even left ISKCON and joined the Gaudiya Vaishnava tradition from which ISKCON itself came. Then there is **Siddhaswarupa,** an American initiate of *Prabhupada,* who was not among the original eleven gurus but says that a guru *cannot* be appointed; one becomes guru by one's love of Krishna—that is, by one's *spiritual qualities,* not by *transmission*.

These disputes are presently being conducted by all the parties concerned in the vocabulary of the Gaudiya Vaishnava tradition. But we can see that they centre on the degree to which the tradition, which was originally *Hot Structured* (perhaps even *Hot Unstructured* if we accept Chaitanya, who was none other than Krishna himself, as lost in the chanting of the name of God), can go *Cool*. Orthodox ISKCON says that the GBC is the filter through which *Prabhupada* and Krishna guide the movement. Its critics, all of whom have been removed from the movement by the GBC, say that the GBC's function is entirely peripheral and that they (the GBC's critics) have direct transmission from *Prabhupada* and/or Krishna. This is the original *Hot* line, one could say.

Hot

transmission of the tradition:
> by direct contact with the lineage (can be discontinuous and/or non-physical)

representing the tradition:
> manifesting the powers that can transform others

being independent of the tradition:
> no need to ally oneself with a particular teacher; a wheel can have many spokes but none of them actually touch

transmission of the tradition:
> direct from God (but that includes his lovers and servants)

representing the tradition:
> by one's love of God (or his lover/servant)

being independent of the tradition:
> one can never be independent of God—but equally one is never dependent on anyone else

Structured ———————————————————————————————— **Unstructured**

transmission of the tradition:
> by formal public appointment or recognition

representing the tradition:
> by continuing the traditional 'forms' and only changing them in accordance with the rules that the tradition allows

being independent of the tradition:
> by not receiving transmission or by formally leaving the tradition

transmission of the tradition:
> truth can manifest at any time, directly

representing the tradition:
> simply being thrue is enough

being independent of the tradition:
> being true *is* being independent

Cool

Hot Structured traditions tend to be fissile and hence have a large number of highly individualistic/idiosyncratic independents

Hot Unstructured traditions need not claim to receive transmission; their teachers manifest the qualities of a lover

Cool Unstructured traditions often deny the very existence of transmission; their teachers manifest Being or Truth

Cool Structured traditions tend to be *defined* by their transmission; so independent representatives are rare (and may even, in the most *Structured* of all, be a contradiction in terms)

DIAGRAM 18
The Function of Teachers in Different Traditions

are making their various moves—representing, adapting, and so forth—in the same 'place'. It is therefore inevitable that these moves—in all the traditions, and in all the dimensions of all the traditions—are influencing each other. This is why the advent of Western teachers is simultaneously a single phenomenon and more varied than any of the sources that have given rise to it.[15] The

[15] Similarly, when a new language—especially a new kind of language—is discovered, it changes our notion of what language itself is. Normally, of course, people do not abandon their mother tongue and adopt a new one. But imagine what would happen if they did, and if there were a number of different languages to choose from. It would have a considerable effect upon society; everything would be affected to a greater or lesser extent. This is not so different from what is happening in the phenomenon of spiritual psychology.

Hot/Cool/Structured/ Unstructured model of traditions is an attempt to come to terms with this fact. I have explained it in stages in order to make it intelligible, but its real function is to enable us to move in any direction, so to speak, so that we can see the phenomenon as a whole. Of course, the great traditions are still important but we cannot use the vocabulary of any single one if we want to understand what is currently taking place in the West.

It is for this reason that I hold that the phenomenon itself is more important than any of the individuals in it. In this respect, it is a bit like nature: a complete organism in itself. It is shortsighted to think that lions, for all their magnificence, are more important than bacteria, or that oaks trees are more significant than grass. Analogously, people whom many readers may not have heard of, like Swami **Abhayananda**/Marie Louise or Miriam **Salanave**, and who appear to have had no impact at all, are part of the same 'ecology' as Alan **Watts** or **Ram Dass**, who have undoubtedly been influential. In my view, the **Mother** and Master **Da**, who make huge claims about their place in the spiritual life of mankind, are rubbing shoulders with the likes of Swami **Atulananda** and **Shunya**, both of whom were retiring to the point of virtual non-existence. Similarly, **Lobsang Rampa**, Paul **Twitchell,** and Madame **Blavatsky**, whom one could say make claims that are difficult to substantiate, are feeding into the same reservoir as those who undoubtedly paid their dues, such as Irina **Tweedie**, Sri **Krishna Prem** and Ajahn **Sumedho**. And teachers who have crashed rather badly, like **Osel Tendzin** and John **Yarr**, are in the same frame as ones who have never been associated with any kind of scandal: **Jampa Thaye**, Swami **Abhishiktananda**, René **Guénon**, P.D. **Ouspensky**.

EVALUATING TEACHERS

Of course, all these teachers (mentioned in the last paragraph) have their various similarities and differences, which can be stated in various ways: according to the vocabulary of their tradition (and as I have said, *all* teachers are part of a tradition, even those that say they are not); according to one or more dimensions in their tradition; according to the *Hot/Cool/Structured/ Unstructured* model. Each of these has its part to play when we are dealing with the sticky question of whether a teacher is genuine or not.

This book contains a number of examples that bear on this issue: the events at the San Francisco Zen Center/SFZC (see Richard **Baker**), the Zen Center of Los Angeles/ZCLA (see Taizan *Maezumi* and his Dharma-heirs) and the Kwan Um School of Zen (see Barbara **Rhodes**); the disputes concerning the **Hare Krishna gurus**; the lineages going back to Hazrat Inayat *Khan*; who is and is not a 'true' *kriya yoga* teacher; the **Mother** and her 'successors'; the Chogyam *Trungpa*/**Osel Tendzin** debacle. Not to mention such disparate individuals as Paul **Brunton**, Lee **Lozowick**, Robert **Aitken** and Frithjof **Schuon**.

As I have already argued, the *Hot/Cool/Structured/Unstructured* model shows that there are different criteria of evaluation. And as always, it is the *Cool Structured* which is the most accessible. It advocates clear-cut distinctions that are public and subject to discussion. Doubt and lack of understanding are seen as part of the spiritual life and are not condemned or looked down on.

It tends to be modest in its aims and therefore in its claims. This is undoubtedly an attractive ideal.[16] It is, of course, immediately available to those who are part of a *Cool Structured* tradition. But it is also used more generally as a way of evaluating all traditions and teachers. The inevitable consequence is that anything, such as a visionary encounter, or a realization of Being, or a perception of God, which is not readily susceptible to *Cool Structured* analysis (and analysis is itself a *Cool Structured* notion), is regarded as suspect (using that term to mean both 'not soundly established' and 'worthy of suspicion').

Yet the *Hot Structured* has its own values and priorities. It is not hard-edged and rigorous like the *Cool Structured* nor is it nicely set out. It requires different skills from its practitioners: the ability to make connections, even jumps, across considerable gaps and in rapidly changing circumstances. We could even say that discontinuity and shape-changing are built into *Hot Structured* traditions as axioms. They are bound, therefore, with the best will in the world, to see the *Cool Structured* as rather staid, with a marked tendency to stay flat, in the same gear; whereas the *Hot Structured* 'feel' is the accelerating curve that just keeps going and going . . .

Cool Unstructured traditions and teachers, on the other hand, say that there is nowhere to go. So if we make a move, they always respond by saying, 'But you are still in the place you started from.' Analogously, *Hot Unstructured* traditions and teachers say that wherever we go, we are still in God's hands. There just isn't any other place we can be.

I want to make two points here. The first is that teachers have to be true to their own 'position'—but not necessarily to anybody else's. A *Cool Structured* teacher has to be straight, therefore. But a *Hot Structured* one does not. (He or she does not even have to be consistent, of course.) On the other hand, if you are not straight with a *Hot Structured* teacher, he or she can hardly complain—and the best ones don't. Likewise, a *Cool Unstructured* teacher cannot say, 'These people are just not getting it! What's the matter with them?' Frustration at the inability of others to see the truth is ruled out of the *Cool Unstructured* court. And if I act against a *Hot Unstructured* teacher, he or she is bound to see this as God's will. There is no alternative (though there is for *Cool Structured*, *Hot Structured* and *Cool Unstructured* teachers, of course).

The second point is one that I have made several times (in fact, it is the presiding theme of this book): that all the positions exist side by side. So it is not just a matter of Soto Zen and *kriya yoga*, say, rubbing shoulders with each other, but of the whole *Hot/Cool/Structured/Unstructured* complex, which essentially provides points of contact *across* traditions.

Given that this is so, it will take a very long time, perhaps generations, for a method of evaluation to be established. I defy anyone to say how this will turn out. Since the phenomenon of spiritual psychology is in the process of being formed, the way in which we assemble it actually defines what it is. Diagram 19 (p. 138) gives one set of connections between most of the teachers in this book. The phenomenon is *all* of this—and more, because one can make other connections. The moves/connections one accepts establish the criteria of truth one is using. In other words, the track one takes through the phenomenon *is* the evaluation of the teachers that make it up. But other people are taking different tracks and we will meet them on the way, and maybe change direction as a result. Just like the teachers themselves, one could say.

[16] There is an evident resonance with scientific rationalism, which perhaps explains why *Cool Structured* traditions tend to be the ones that are most easily accepted in our culture—at least, by the intelligentsia.

I end, as I began, with a statement of the significance of spiritual psychology. It is a Western phenomenon, despite the fact that its origins are Eastern, because it is being taught by Westerners. It is concerned with every aspect of the human condition: what it is to be alive, to be born, to have a body, to die; the nature of sickness and suffering, of happiness and love; what it is to be male, female, heterosexual, homosexual; what it is to be a child, a parent; the nature of the family (and its alternatives: the extended family, the monastic celibate life); how society should be organized and according to what principles (politics, economics, ethics); how one should eat, dress, and earn one's living; the proper form of the arts (music, painting, poetry—even the nature of language itself); the world and its origin (including space [and cosmology], time [and history and eternity], matter and energy); how consciousness works from the most mundane levels (drinking a glass of water) to the most rarefied (meditative states that are beyond all attributes) via the extra-ordinary (visionary encounters of every conceivable hue).

All of this is going on simultaneously, in our very midst and all around us. In fact, we are already part of it whether we realize it or not.

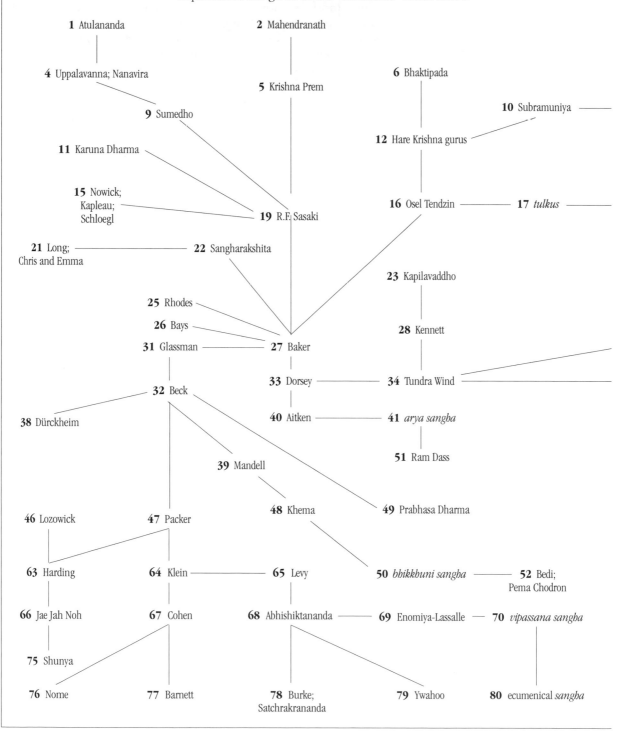

DIAGRAM 19

N.B. This is not a lineage tree

A Map of Western Teachers

One Way of Constructing the Phenomenon of Spiritual Psychology
Explanations are given in the 'Comments' which follow

1 Atulananda

2 Mahendranath

4 Uppalavanna; Nanavira

6 Bhaktipada

5 Krishna Prem

9 Sumedho

10 Subramuniya

12 Hare Krishna gurus

11 Karuna Dharma

15 Nowick;
Kapleau;
Schloegl

16 Osel Tendzin

17 *tulkus*

19 R.F. Sasaki

21 Long;
Chris and Emma

22 Sangharakshita

23 Kapilavaddho

25 Rhodes

26 Bays

28 Kennett

31 Glassman

27 Baker

33 Dorsey

34 Tundra Wind

32 Beck

38 Dürckheim

40 Aitken

41 *arya sangha*

51 Ram Dass

39 Mandell

48 Khema

49 Prabhasa Dharma

46 Lozowick

47 Packer

63 Harding

64 Klein

65 Levy

50 *bhikkhuni sangha*

52 Bedi;
Pema Chodron

66 Jae Jah Noh

67 Cohen

68 Abhishiktananda

69 Enomiya-Lassalle

70 *vipassana sangha*

75 Shunya

76 Nome

77 Barnett

78 Burke;
Satchrakrananda

79 Ywahoo

80 ecumenical *sangha*

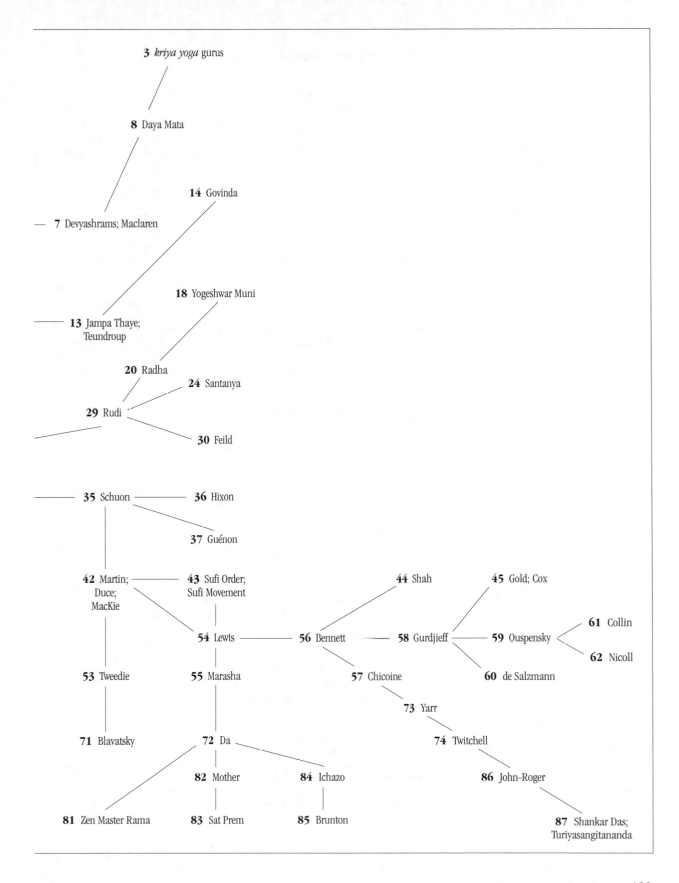

3 *kriya yoga* gurus

8 Daya Mata

14 Govinda

— **7** Devyashrams; Maclaren

18 Yogeshwar Muni

— **13** Jampa Thaye; Teundroup

20 Radha

24 Santanya

29 Rudi

30 Feild

35 Schuon ——— **36** Hixon

37 Guénon

42 Martin; Duce; MacKie

43 Sufi Order; Sufi Movement

44 Shah

45 Gold; Cox

54 Lewis ——— **56** Bennett ——— **58** Gurdjieff ——— **59** Ouspensky

61 Collin

62 Nicoll

53 Tweedie

55 Marasha

57 Chicoine

60 de Salzmann

73 Yarr

71 Blavatsky

72 Da

74 Twitchell

82 Mother

84 Ichazo

86 John-Roger

81 Zen Master Rama

83 Sat Prem

85 Brunton

87 Shankar Das; Turiyasangitananda

Comments on Diagram 19

These connections are simply ones that *could* be made. They are not necessarily an indication of any acknowledged relationship between the individuals *as teachers*. In an ideal world, a map like this would be on the surface of a sphere so that one could start anywhere. However, since I have to choose a particular point, I begin with Richard **Baker (27)** and the San Francisco Zen Center debacle. When Baker was found to be having an affair with a student, though both of them were married, SFZC split into two: those who regarded *spiritual qualities* as central and those who saw *transmission* as more important. The former, made up of Baker's critics, said that unless certain standards are upheld, no lasting good can come out of a relationship with a teacher; the latter, which included Baker himself and those who remained loyal to him, held that spiritual transmission is not the same as a personal relationship—in fact, it transcends the personal altogether.

Similar upheavals occurred when it was revealed that two women, Barbara **Rhodes (25)** and Jan **Bays (26)**, had had affairs with their Eastern teachers (Soen San Nim and *Maezumi* Roshi, respectively). Although one of *Maezumi*'s Dharma-heirs, Joko **Beck (32)**, parted company with him because of his behaviour, all the others stood by him. They did not approve of what he had done but said that one cannot abandon one's teacher. So SFZC and ZCLA have gone in opposite directions. At SFZC, the *spiritual qualities* dimension was put in the predominant position and it was the teacher **(Baker)** who left; at ZCLA, the *transmission* dimension was retained and those, like **Beck,** who favoured *spiritual qualities*, left. The same happened at Soen Sa Nim's Kwan Um Zen School: he (and **Rhodes**) stayed on; the critics left.

There are a number of issues raised by these episodes. An obvious one is the relation between sex and spirituality. And there are teachers, like **Sangharakshita (22)**, who hold that a sexual relationship between a teacher and a pupil can be beneficial. For a Buddhist monk to say such a thing is revolutionary. It is even striking when Barry **Long** or **Chris and Emma (21)** say it—but it is not revolutionary because they are not operating within a tradition.

By the same token, gay Buddhism, as represented by Issan **Dorsey (32)**, is not mentioned in the East. But it is a significant element in Western Zen (but in no other Western tradition) and is looked upon sympathetically by teachers, such as Robert **Aitken (40)**, who are not gay. **Aitken** is also an advocate of active Buddhist engagement in social issues; and this activism is itself part of the trans-traditional *arya sangha* **(41)**. The *arya sangha* is a tradition in the making and has no leader. One might even say that it has no representatives. But if it has, **Ram Dass (51)** is certainly one. He is connected, via his master, Neem Karoli Baba, with Joya **Santanya (24)**.

Whatever one's views about the place of sex in the spiritual life, it is a topic that is discussed more or less openly—and publicly—in *Cool Structured* traditions (Zen and **Sangharakshita**'s Western Buddhist Order). Even when there was secrecy and deception, it was eventually subjected to scrutiny, and a wide debate was generated concerning the way in which teachers and the community should proceed in the future. All of this is in keeping with *Cool Structured* ideals. And it is in marked contrast to the affair of **Osel Tendzin (16)**, the Vajra Regent of Chogyam *Trungpa*, which also concerned the sexual behaviour of a teacher. There, the Tibetan leaders of the Kagyu school effectively took control of the Western community and installed *Trungpa*'s son as its head. Although the Vajradhatu community was in a state of considerable disarray, there was no real possibility of it choosing its own direction. This is because it is part of a *Hot Structured* tradition—essentially 'informed' from above. From the Tibetan point of view, the **Osel Tendzin** episode was an experiment that failed, a relatively unimportant nut that became loose and has now been tightened up. Meanwhile, the great engine of the Tibetan tradition continues to turn over. The *tulku* system still operates as it has always done, though it now includes Western *tulkus* **(17)**. And at the same time, the *Cool Structured* element of the tradition goes on: Western *lamas* like **Jampa Thaye** and Lama **Teundroup (13)**, both of whom have been given roles in the tradition. There is also Lama Anagarika **Govinda (14)** but he is a bit different: as a *siddha*, he is considerably *Hotter* than **Jampa Thaye** and **Teundroup** but he was never an integral part of the tradition—its *Cool Structured* layer, that is—and his title was really a mark of respect, conferred on him by his pupils.

Other *Hot Structured* traditions with a *Cool Structured* layer are Gaudiya Vaishnavism, represented by the **Hare Krishna gurus (12)** (now considerably *Cooler* since the Governing Board Commission/GBC has established itself as ISKCON's ruling body); Guru **Subramuniya**'s Saiva Siddhanta **(10)**; the Shankaracharya lineages represented by the **Devyashrams** and Leonardo **Maclaren (7)** (though there is no connection between them); and the Self-Realization Fellowship under the presidency of Sri **Daya Mata (8)**. But there are also *Hot* teachers in some of these traditions who reject the *Cool* restrictions and appeal directly to a higher authority, thus establishing themselves as independent teachers: for example, Shrila **Bhaktipada (6)** and those *kriya yoga* gurus **(3)** who do not align themselves with SRF.

Now back to **Baker (27)** and the notion of the centrality of transmission. There are Westerners in all traditions who have emphasized the Eastern way of doing things—that is, the *traditional way of life*—and said that it has to be preserved. Several of these—Ruth Fuller **Sasaki (19)**, Ajahn **Sumedho (9)**, Sri **Krishna Prem (5)** and **Mahendranath (2)**—lived and taught in Eastern countries. Some—**Uppalavanna, Nanavira (4)** and **Atulananda (1)**—lived as hermits. So did Swami **Abhishiktananda (68)**. Others, such as Walter **Nowick**, Philip **Kapleau** and Irmgard **Schloegl (15)**, spent years in the East and became thoroughly conversant with its culture before returning to the West to teach. **Karuna Dharma (11)**, on the other hand, is almost exclusively concerned with Vietnamese in America—but has never spent any time in Vietnam. (There are various connections here with Jiyu **Kennett (28)**, René **Guénon (37)**, Lex **Hixon (36)**, and **Shunya (75)**. Of these, **Kennett** practised and taught in Japan for years but has since gone in a decidedly non-traditional direction; **Guénon** lived as a Moslem in Egypt but was never appointed as a Sufi teacher; **Hixon** *was* a Sufi teacher but never lived in the East; and **Shunya** lived in India for nearly half a century but always said that he had nothing to teach.)

One of **Baker**'s innovations was to make SFZC independent by establishing various money-making ventures. Similarly, Bernard **Glassman (31)** has said that Zen has to deal with the central concerns of the society in which it finds itself, and in America that means business. One of his co-Dharma heirs, Joko **Beck (32)**, has also said that Zen has to adapt itself to Western society. In fact, she has grave reservations about the effectiveness of traditional Zen methods. This connects with Gesshin **Prabhasa Dharma (49)**, who found the intense Rinzai methods counterproductive and entered the softer Vietnamese tradition; and Jaqueline **Mandell (39)**, who left the Theravadin tradition altogether because of its attitude to women.

This leads us to the place of women in Buddhism: Ayya **Khema (48)**, who, as a *dasa sila mata*, has gone as far as the Theravadin tradition will presently allow; and by extension to the possible restoration of the *bhikkhuni sangha* **(50)**. Two Westerners in the Tibetan tradition, Freda **Bedi**, and **Pema Chodron (52)**, have in fact taken full nuns' ordination (which does not exist in the Tibetan tradition). (There are obvious connections here with the **ecumenical** *sangha* **(80)** and with the *vipassana sangha* **(70)**, which has entirely removed the differentiation between men and women that has traditionally existed in Eastern Theravada.)

Returning to Beck's critique of Zen's traditional forms, we find similar ideas expressed by Graf **Dürckheim (38)**, who says that Zen can be separated from Buddhism, and by Toni **Packer (47)**, who was once a Zen teacher but has since given up all labels. This leads us to a number of other *Cool Unstructured* teachers who question all attempts to 'locate' truth in any way at all. In fact, some of them are part of the Advaita Vedantin tradition (though a *Cool Unstructured* part is not really part of anything, of course): Jean **Klein (54)**, John **Levy (55)**, and Andrew **Cohen (64)** all gained their enlightenment in India and had Indian teachers—but they differ markedly in the way in which they refer to both of these. Bhagavan **Nome (73)** aligns himself (though, according to *Cool Unstructured* logic, no two entities can ever really be aligned) with the same tradition but he never had a teacher and his enlightenment was not the result of anything or anybody. This leads neatly to teachers like Douglas **Harding (53)** and **Jae Jah Noh (63)**, who awakened spontaneously (like Lee **Lozowick (44)**, who otherwise does not belong in this group at all). **Harding** sees parallels between his 'headless' state and Zen. **Jae Jah Noh** does not align himself with any tradition, and nor do **Shunya (72)** and Michael **Barnett (74)**, who are in all other respects completely opposite: **Shunya** denied that his state had any significance; **Barnett** says that he is part of the next step in human evolution—like **Cohen** and, to some extent, Barry **Long (21)**.

Then there is Swami **Abhishiktananda (65)**, the best-known of the Christian Vedantins, who lived as a *sannyasin* in India. (Connection here with **Atulananda (1)** and **Mahendranath (2)**.) He is an example of a teacher who has entered more than one tradition simultaneously. Others include Abbot George **Burke** and Father **Satchakrananda (75)** (neither of whom are Vedantins—and they are not the same sort of Christians as **Abhishiktananda**, either); Father **Enomiya-Lassalle (66)**, the first Christian Zen teacher; and Dhyani **Ywahoo (76)**, an Amerindian teacher who has been recognized by Tibetans as representing their tradition. (We should also add Lex **Hixon (36)**, Samuel **Lewis (54)** and J.G. **Bennett (49)** here: they all practised in several traditions.) People who say that they can enter more than one tradition without conflict are bound to separate the *traditional way of life* from *spiritual practice* to a greater or lesser extent. And this is exactly what we find in the *vipassana sangha* **(67)** and by extension in the **ecumenical** *sangha* **(77)** (whose practitioners bring together more than one Buddhist tradition).

I now return to Issan **Dorsey** and gay Buddhism (or more accurately, gay Zen). One of its exponents is Zen Master **Tundra Wind (33)**. Unlike **Dorsey,** he was never appointed as a teacher and he received his name in a vision. There are many forms of visionary encounter—it is perhaps the most varied of all aspects of spiritual psychology—and the connections are themselves many and varied (as we would expect from something so quintessentially *Hot Structured*). Jiyu **Kennett (29)**, Ajahn **Kapilavaddho (23)**, **Rudi (29)**, and

Comments on Diagram 19 (Concluded)

Frithjof **Schuon (34)** are all examples. These four are respectively representatives of Soto Zen, Thai Theravada, the Indian *siddha* tradition, and North African Alawiyya Sufism, each of which regards visionary encounter in a different way from the others. It has a special and respected place in Sufism, is seen as decidedly marginal in Theravada, is central to the *siddha* tradition, and is completely rejected by Zen. This is why **Kennett** is effectively an independent Zen teacher while **Rudi** is actually orthodox even though their visionary encounters are very similar. More precisely, visionary encounters are positively *expected* in *Hot Structured* traditions like **Rudi**'s; but I think it is fair to say that Soto Zen did not expect Jiyu **Kennett**.

Rudi is also connected with Reshad **Feild (27)** (both healers), Joya **Santanya (24)** (both had visionary contact with Swami Nityananda) and Swami **Radha (20)** (both were independent—in the *Hot Structured* sense of the term—representatives of their Indian masters). **Yogeshwar Muni (18)** was also an independent representative; and like **Radha,** he developed his own techniques specifically for Westerners.

Schuon is also the starting point (though there could be others—there are always others) for connections with various Sufis. His own visions of the Virgin Mary, which led him to create his own *tariqah*, stand in contrast to René **Guénon**'s far *Cooler* form of the tradition **(37)** and also to Lex **Hixon (36)**, whose inspired writings were seen by him as part of a continuous transmission going back to Adam. This idea of a higher Sufism that is beyond Islam is found in the teachings of several others: Murshid(a)s **Martin**, **Duce**, and **MacKie (42)**, Samuel **Lewis (54)** and Irina **Tweedie (53)**—all *Hot*—and the various teachers in the **Sufi Order and the Sufi Movement (43)**, who are decidedly *Cooler*.

And it is not much of a step from higher Sufism to the idea of an ancient primordial wisdom, such as we find in Madame **Blavatsky (71)**, and, in different forms, in the teachings of J.G. **Bennett (56)**, **Gurdjieff (58)**, and Idries **Shah (44)**. Bennett spent decades exploring several traditions (like **Lewis**), was associated with **Shah** for a time, and was a pupil of **Gurdjieff. Gurdjieff** himself had a number of successors (a term that should be used with care), ranging from *Hot* mavericks like E.J. **Gold** and Jan **Cox (45)**, via a *Cool* maverick, P.D. **Ouspensky (59)**, who in his turn had *Hot* and *Cool* successors: Rodney **Collin (61)** and Maurice **Nicoll (62)** respectively, to Madame **de Salzmann (60)**, who was also *Cool* but clearly regarded herself as true to **Gurdjieff** in every way.

Bennett is also connected, posthumously, with G.B. **Chicoine (57)**, who taught a form of the ancient wisdom tradition (including higher Sufism). For a short time (a few weeks), he said that he was the Avatar—a claim that John **Yarr (73)** also made. (Master **Da (72)** has made it too.) Yarr's teaching about the inner journey back to the divine source via the Lifewave is very similar to Paul **Twitchell**'s Eckankar **(74)**, the ancient science of soul travel. Both these men had Indian teachers but wrote them out of their accounts of their own spiritual search. Similarly, **John-Roger (86)**, who was an Eckankar initiate, has always claimed that he received his mandate direct from God—just like **Shankar Das** and Swami **Turiyasangitananda (87)**.

Samuel Lewis said that he had been taught internally by Shiva—a claim also made by **Marasha (55)**. She says that she was born enlightened—and so does Master **Da (72)**. He presents his teaching as essentially new, and we find other teachers who say the same (though they do not mean the same thing when they say it): Zen Master **Rama (81)**, the **Mother (82)**, Oscar **Ichazo (84)** and Paul **Brunton (85)**. Of these, only the **Mother** has had any successors (so far), one of whom, **Sat Prem (85)**, lives as a recluse. (Connections here with **Atulananda (1)**, **Uppalavanna** and **Nanavira (4)**, and **Abhishiktananda (68)**—and we're off again . . .)

PART II

A Directory
of Spiritual Teachers

SWAMI ABHAYANANDA | BILL HAINES. SEE **APPENDIX 1**

SWAMI ABHAYANANDA | MARIE LOUISE

An early disciple of Swami Vivekananda, the very first Western woman to be initiated as a *sannyasin,* and the first Westerner to set up as a Hindu teacher

More information about these two (not that there is much) can be found in French and Gambhirananda.

Haridasi is also mentioned in French and Gambhirananda.

Marie Louise was a Frenchwoman in her forties (who had lived in New York for 25 years) when she met Swami *Vivekananda* during his first tour of America. She was amongst the select handful who attended his talks at Thousand Island Park, at the mouth of the St. Lawrence River, in July 1895—select, because this was the first time that *Vivekananda* specifically gave spiritual instruction rather than public lectures. He himself refers to Marie Louise's arrival (together with her pet tortoise) in his letters; there were just seven Western disciples gathered at the time (Vivekananda, *Collected Works,* vol. 5, 88–89).

Marie Louise was also one of only three Westerners whom Vivekananda initiated as *sannyasins.* (The others were Leon Landsberg/Swami Kripananda and Dr. Street/Swami Yogananda.) These initiations took place in 1895. The three were the first Westerners ever to become *sannyasins* in the West, and Marie Louise, who took the name Swami Abhayananda, was the first woman to do so. It is rare even for Indian women to take *sannyasa*—but it was unheard of for a Western woman to do so. (And I mean unheard of *in India,* let alone the West.)

A few weeks after her initiation, *Vivekananda* authorized her, along with Landsberg/Kripananda and Ellen Waldo/Sister Haridasi, to teach in New York while he was away in Europe. But Abhayananda (of whom another follower of *Vivekananda* said that "her vanity and personal ambition made her unfit for discipleship, and useless as a worker in Swami Vivekananda's movement" [French, 109]) very soon began to operate independently. I have not been able to find any exact dates, but she organized her own Vedanta Centers in California and Washington (ibid.), and in 1898 she initiated another woman, L.V. Comer, as a *sannyasini* in Chicago, giving her the name Swami Shraddhananda (but that's all we know about her). Not only that, but according to an Indian newspaper, she also initiated a Hindu Jain (whatever that is) as a *sannyasin* in Brooklyn, "according to the Vedic ritual" and he became her *chela* or pupil (French, 110). Another newspaper report, written in 1898 (in Chicago and reprinted in India), said that she was the head of the Vedanta Order in America (ibid.)—a palpably untrue statement, though it is impossible to tell whether this is really what Abhayananda thought or just misleading journalism.

She went to India twice, once in 1898, when she continued to act independently of Vivekananda (though she apparently had some contact with him [Vivekananda, *Collected Works,* vol. 8, 463]), and again in 1902, when she left the Ramakrishna Order altogether and became a Vaishnava (but there are no more details and we don't really know what this means).

There can be little doubt that Swami Abhayananda was a maverick. She had not been prepared for the renunciate life in anything like the way that an Indian would have been, and though the same could be said about Street and Landsberg, they in effect lived as disciples with somewhat exotic names, whereas Abhayananda took her newly acquired roles as *sannyasini* and

Vedanta teacher seriously. It's just that she didn't know how to live up to either.

Primary sources: [possibly] 'The Ten Commandments of Buddha', *Light of Dharma* (San Francisco) II, 1903, pp. 15–18 [item 31 in S. Hanayama, *Bibliography on Buddhism*, Tokyo, 1961]

Secondary sources: H.W. French, *The Swan's Wide Waters* (New York and London, 1974); Swami Gambhirananda, *History of the Ramakrishna Math and Mission* (Calcutta, 1957)

Centre: None

COMPARE:

Other Westerners associated with Vivekananda: Swami **Atulananda**, Sister **Devamata**, Sister **Nivedita**

Other women sannyasis *in Hinduism:* Sri **Daya Mata**, Srimati **Kamala**, Swami **Radha**, the **Devyashrams**

SWAMI ABHISHIKTANANDA | HENRI LE SAUX

Pioneering Christian Vedantin who had his own Indian guru and his own disciples

Henri Le Saux was a French Benedictine who came to India in 1948 in order to practice the contemplative life in the spirit of both Christian monasticism and the Indian *sannyasi* tradition. He had already been in touch with Jules Monchanin, another Catholic priest already in India, by letter. In 1949 the two of them visited *Ramana Maharshi* at his ashram at Arunachala. A year later (the year Ramana died), they built two huts at Shantivanam, south of Madras, donned the ochre robe, and assumed their *sannyasi* names. Le Saux became Swami Abhishiktananda and Monchanin became Swami **Arubianandam.** (They did not take formal initiation from another *sannyasi* for reasons which I discuss below.) This was the foundation of the Sacchidananda Ashram.

There is in fact a well-established, though not very large, Christian ashram movement in India which goes back to the first decades of this century. Most of these ashrams were set up in order to make Christianity more palatable to Indians and were really a form of sophisticated missionary work—some of them were affiliated with the National Missionary Society (Ralston, 30). All of them were established by Western missionaries or Indian converts to Christianity, and despite the adoption of the ochre robe and other Indian customs such as eating with the hands, the religious inspiration and daily routine of these ashrams were essentially those of Western Catholic retreats (Ralston 89).

The ashram founded by **Arubianandam** and Abhishiktananda was quite different. It was modelled on the asceticism and contemplative practices of Indian *yogis,* and in the case of Abhishiktananda, at least, the implicit claim was made that he had attained realization by these practices—a realization that is quite compatible with the teachings of Christ.

In the years following the establishment of Sacchidananda Ashram, Abhishiktananda in particular pursued the life of the Hindu-Christian monk with great dedication.[1] In 1952 and 1953, shortly after *Ramana Maharshi*'s death,

[1] This is not to say that **Arubianandam** was of lesser calibre but there is no record of him practising as intensively as Abhishiktananda. Nor did he follow the *sannyasa* life for as long. His health was always poor and in 1957 he returned to France for treatment. But it was unsuccessful and he died there.

he returned to Arunachala and lived as a *yogi* in one of the many caves on the mountain. In 1953 he met a disciple of *Ramana Maharshi* at Arunachala whom he calls Harilal but whose real name is Poonja Ji, the guru of Andrew **Cohen**.

It is evident from Abhishiktananda's writings that his contact with *Ramana Maharshi,* brief though it was, completely transformed him. He says that he was "truly reborn at Arunachala under the guidance of the Maharishi" (Stuart 170). And during his retreat at Arunachala in 1953, he had a spiritual experience of Ramana; a meeting, he says, "that took place on a plane that has nothing in common with any visual, auditory, or psychic phenomena whatever—literally at the one level where Ramana can always be truly met" (Stuart, 171). Two years later, in 1955, Abhishiktananda met Swami Gnanananda Giri—very similar in many ways to *Ramana Maharshi*—whom he regarded as his guru (Baumer-Despeigne, 316) and about whom he wrote in *Guru and Disciple.* Gradually, he severed his links with Sacchidananda and began wandering in the Himalayas as a *sannyasi.* He became an Indian citizen in 1960.

During the 23 years that Abhishiktananda was a Hindu-Christian monk, he came to the realization that *sannyasa,* renunciation, is a transcendental state beyond all 'states of life', whether religious or secular (*The Further Shore,* xi, 4, 17, 25). Hence *sannyasa* is not inherently a Hindu institution at all and is only seen as such when it is identified with its outward signs: the orange robe, the staff, the begging bowl, etc. In fact, Abhishiktananda says,

> These insignia are barely intelligible outside the particular social and cultural context of India, and their handing over by the guru [in the *sannyasa* initiation] has little meaning in the case of a non-Indian sannyasi who will have to live outside India, despite the rich significance inherent in this ceremony. (*The Further Shore,* 45)

According to Abhishiktananda, the qualities of a *sannyasi* are those of the Transcendental itself, the Atman: "its utter freedom, being unborn, untouched, unseen, beyond comprehension" (ibid., 19). This is a high ideal—a radical 'inner' condition that may be expressed in Hindu terminology but is Indian only by accident—but there is no doubt that those close to Abhishiktananda are convinced that he attained it. True Christian renunciation and true Hindu *sannyasa* are identical because each springs from the same transcendent source. He says that Christian monks

> feel a natural urge to take the garb of the Indian sannyasi and to observe at least the most essential of their customs in matters of poverty, abstinence, etc. Even more fundamentally, they surrender themselves to that freedom breathed in their hearts by the Spirit. In such cases, to receive a new diksha [initiation] would be without meaning, since in the total surrender of their original profession . . . the essential oblation was already made (ibid., 44).

That is why he and Jules Monchanin did not take formal *sannyasa* initiation. The only requirement of a *sannyasi* is that he should be free.

> A sannyasin should not have any obligation to society; he is acosmic and should just be allowed to BE. But some are involved in social work or teaching. This may be because they have lost the true sense of their calling; or it may be that an increasing number of sannyasins are young and therefore cannot fulfil the ideal of silence, solitude, and non-action. (*Guru and Disciple,* 13–15)

This explains why Sacchidananda Ashram, unlike many other ashrams in India, whether Hindu or Christian, is not centred around agriculture or study

and has no dispensary. Nor is it a mission, attempting to Christianize India. In 1958, Abhishiktananda wrote a tribute to Jules Monchanin in which he described the ashram as

> a monastic centre in the strict sense of the word. The monk is a man who lives in the solitude (Greek: *monos*) of God, alone in the very aloneness of the Alone [*occupé seulement du Seul*]. He does not become a monk in order to do social work or intellectual work or missionary work or to save the world. The monk simply consecrates himself to God. ('Le Père Monchanin', 86–87)

There is nothing in this that is in any way contrary to Christianity. But elsewhere he uses straightforward Hindu/Vedantin terminology.

> The direct method of achieving this realization is the practise of dhyana based on faith in the guru and on deeper and deeper silence of mind and senses . . . [Then] both the one doing the searching and that which is sought for have disappeared, or, more precisely, what has disappeared is the perception of them as different and separate. Nothing remains but *self, being,* pure jyoti, undivided infinite light, light itself, the glory of Being. . . . (*Guru and Disciple,* 105, 103)

In fact, there is a certain ambivalence in Abhishiktananda's Christian-Advaitin theology. Half the time he seems to be saying that Christianity and Advaita are equivalent. For example,

> the knowledge (*vidya*) of Christ is identical with what the Upanishads call divine knowledge (*brahmavidya*) . . . It comprises the whole of God's self-manifestation in time, and is one with his eternal self-manifestation. (*Guru and Disciple,* xi)

On the other hand, he says more than once that Christianity crowns Vedanta (*Sacchidananda* 11; cf. 82, 109, 195, 198); and even that Christ is "hidden beneath the lineaments" of Shiva and *Ramana Maharshi* (*The Secret of Arunachala,* x).

Yet I doubt if this ambivalence is really theological—that is, theoretical. Rather, it is based on Abhishiktananda's own experience, which he decribed using the Hindu terms *sat, chit,* and *ananda.*

> In my innermost centre, in the most secret mirror of my heart, I tried to discover the image of him whose I am, of him who lives and reigns in the infinite space (*akasa*) of my heart. But the reflected image gradually grew faint, and soon it was swallowed up in the radiance of its Original. Step by step I descended into what seemed to me to be successive depths of my true self—my being [*sat*], my awareness of being [*chit*], and my joy in being [*ananda*]. Finally nothing was left but he himself, the Only One, infinitely alone, Being, Awareness and Bliss, Sacchidananda. In the heart of Sacchidananda I had returned to my Source. (*Sacchidananda,* 172)

In this instance, he attributed his realization to Christ, the satguru (*Sacchidananda,* 201). But elsewhere he refers to Dakshinamurti, one of the aspects of Shiva, as the supreme guru (*The Further Shore,* 53). And in reality, "there is but one awakening and a single Awakened one" (ibid.).

Abhishiktananda made this remark on the occasion of what he calls 'ecumenical *diksha*', and this takes us to the last year of his life (1973) when he, together with Swami Chidananda (Swami Shivananda's 'successor' at Rishikesh), jointly bestowed this initiation on Abhishiktananda's disciple, Marc Chaduc. The initiation consisted of taking the orange robe, giving up all possessions and living off alms. In fact, it amounted to a formal but non-institutional—or perhaps 'trans-institutional' would be a better term—*sannyasa.* However,

this would not mean the foundation of a new Order, for sannyasa is in no sense an 'order', and the Spirit does not 'found' anything, being rather the foundation of everything; all that is needed is a recognition of the signs of the Spirit's call and a method whereby those who are called may be enabled to answer their call. Evidently a sannyasa of this kind would in no way be limited by any forms and would be open to whoever is called to it, whatever his cultural or religious background may be (ibid., 48).

Only weeks later, after wandering with Marc Chaduc (now called Swami **Ajatananda**) in the jungle beside the Ganges, Abhishiktananda had a heart attack which temporarily paralysed his body but released his spirit. He later wrote,

> The heart attack was only the backdrop to a marvellous spiritual experience. I then made the discovery that life and death are only particular situations, and the 'I', the 'Awakening', is not tied to them or limited by them. Of the two weeks spent in bed I recall nothing but intense joy . . . In this adventure I have found the Grail, and the Grail is neither far nor near, it is beyond all places . . . The quest is fulfilled. (Baumer-Despeigne, 328-29)

It is this final culmination, coming as it did after 20 years of *sannyasa/* renunciation, that entitles us to say that Abhishiktananda was not only a spiritual teacher but a guru. He himself said, referring to two Indian disciples: "I have experienced from the other side what a guru is" (Baumer-Despeigne, 324). And other disciples refer to his "glorious transfiguration" (ibid., 327) and "the transparence of his whole being to the inner Mystery, the divine Presence" (ibid., 329). In short, Henri Le Saux/Swami Abhishiktananda was realized or enlightened, and everything he wrote and did (including taking disciples, few as they were) was informed by this realization (which is beyond the limitations of 'external' Christianity or Hinduism).

He died at the very end of 1973, soon after giving ecumenical *diksha* to Swami **Ajatananda**[2] and his subsequent heart attack.

[2] **Ajatananda**'s subsequent career is quite mysterious. Abhishiktananda wanted him to carry on his own work and instructed him to spend ten years in seclusion. **Ajatananda** began this retreat early in 1975 in a tiny hut at Kaudiyala but in April 1977 he simply disappeared and has never been seen since. My information is that he hinted in a letter to a friend that he was going to 'take *jal-samadhi*' by walking into the Ganges. *Jal* means 'water' and *samadhi* is yogic concentration. In other words, he committed a sort of spiritual suicide by deliberately drowning himself while in a state of concentration. This has echoes of the Indian Advaita teacher, Swami Rama Tirtha, who also died in the Ganges in 1906. However, Rama Tirtha's death is also ambiguous: his biographer, S.R. Sharma, provides some evidence that it was an accidental drowning (S.R. Sharma, *Swami Rama Tirtha* [Bombay, 1961], 80–81).

It is typical of the fascinating minutiae of the phenomenon of Western teachers that the death of an extremely obscure French *swami* should be linked with that of an almost-as-obscure Indian *swami*—at a distance of over 70 years and with the possibility that neither of them actually entered *jal-samadhi* at all. (It would, of course, be an extra irony if **Ajatananda** did, following the example of Rama Tirtha—who didn't.) But the point is that even if neither of them did, **Ajatananda**'s death *can* be seen as of spiritual significance—and one that is drawn from the more recondite regions of Hinduism. It is connections such as this which help to give strength to the transmission of Eastern teachings to the West and make it 'real'—because Westerners are seen as participating in the same 'reality' as Indian teachers (even if the reality is 'mythological', as in this instance).

However, **Ajatananda**'s death did not mean that Abhishiktananda's work came to a complete halt. Saccidanandam Ashram continued under the leadership of Bede **Griffiths**, a Benedictine monk who had established Kurisumala Ashram in Kerala in 1958 and then moved to Saccidanandam in 1968. There is no doubt that **Griffiths** genuinely admired certain aspects of Hinduism. (It would, I think, be beyond *anybody* to admire all its aspects.) But some of his books, such as *Christian Ashram*, strike me, at least, as thoroughly Christian in every respect, without the least hint that Christianity might need to restate its theology in any significant way. Perhaps I am not alone, therefore, in thinking that there is an essential difference between **Griffiths** and Abhishiktananda: **Griffiths** is a Christian with a truly 'open mind'; Abhishiktananda is really a Vedantin

Primary sources: Abhishiktananda, *Saccidananda: A Christian Approach to Advaitic Experience* (Delhi: ISPCK, 1974); *Guru and Disciple* (London: SPCK, 1974); *The Further Shore*, (Delhi: ISPCK, 1975); *The Secret of Arunachala*, (Delhi: ISPCK, 1979); 'Le Père Monchanin', *La Vie Spirituelle*, January 1958, vol. 98, 71–95; *In Spirit and Truth: Swami Abhishiktananda, His Life Told Through His Letters* (ed. J. Stuart) (Delhi: ISPCK, 1989)

Secondary sources: M-M. Davy, *Henri Le Saux-Swami Abhishiktananda: le passeur entre deux rives*, (Paris: Cerf, 1981); J.D.M. Stuart, 'Sri Ramana Maharshi and Abhishiktananda', *Vidyajyoti*, April 1980, 167–176; O.Baumer-Despeigne, 'The Spiritual Journey of Henri Le Saux-Abhishiktananda', *Cistercian Studies*, no. 4, 1983, 310–329; H. Ralston, *Christian Ashrams: A New Religious Movement in Contemporary India*, (Lewiston, NY: Edwin Mellen Press, 1987)

Centre: Saccidananda Ashram, Shantivanam, Tannirpalli, Tiruchirappalli, Tamil Nadu, India

COMPARE:

Other Western sannyasis: Swami **Abhayananda**/Marie Louise; Swami **Atulananda**; **Rudi**; Swami **Lakshmy Devyashram**; Sri **Daya Mata**; **Rajarsi Janakananda**; both **Kriyanandas**; Srimati **Kamala**; Swami **Radha**; Guru **Subramuniya**; the 'original' **Hare Krishna gurus**

Other (Western) Catholic priests in Eastern traditions: Father **Enomiya-Lassalle** (Zen)

Other Western teachers in India: The **Mother**; Sri **Krishna Prem**; Sri **Mahendranath**

Other teachers of Advaita: Paul **Brunton**; Jean **Klein**, John **Levy**

IVAN AGUELI | ABDUL HADI

The first Western Sufi of this century

John-Gustav Agueli was born in Stockholm in 1869. In 1890, he went to Paris to study painting under Emile Bernard. ('Ivan' was a *nom-de-brosse/nom-de-peintre*.) He joined the Theosophical Society there and also started to learn Arabic. In 1894, he went to Egypt and stayed for about nine months. At some point, perhaps about 1898, he formally converted to Islam, but I have no details. He returned to Egypt in 1902, accompanied by an Italian, Enrico Insabato, and in 1904 the two of them founded a journal, *Il Convito/An-Nadi*, written in both Italian and Arabic, to which Agueli contributed articles about Sufism (James says "l'esotérisme islamique") and all matters "arabo-italiennes" (James's phrase again, though I'm not sure what she means). Then, in 1907 (according to James; but Gerholm says that he was already using his Sufi name in the first articles in *Il Convito* in 1904), he was initiated by Sheikh 'Abd al-Rahman 'Illaysh al-Kabir (sometimes transliterated as Abder Rahman Elish El-Kebir),[1] taking the name Abdul-Hadi al-Maghrabi (more correctly: 'Abd al-Hadi

manqué, who, it appears, actually thought that Christianity's dualism was wrong. **Griffiths** sent Indian members of his community to Rome to be ordained into the Camaldoli Order and they were initiated as *sannyasins* when they returned to the Ashram; Abhishiktananda instituted his own 'ecumenical *diksha*'. Nor do I think it is an accident that most people know Henri Le Saux as Swami Abhishiktananda whereas very few know Bede **Griffiths** as Swami Dayananda. But maybe I am making a distinction between the two where there is really only a degree of emphasis.

Griffiths died in 1993, aged 86, having spent nearly 40 years in India as an ecumenical Christian *sannyasin*. It remains to be seen whether this foray into monistic Christianity will take root and blossom.

[1] Sheikh 'Abd al-Rahman was himself an unusual man. He was head of a little-known branch of the Shadhiliyya, the Arabiyya (founded in Egypt in the early 1600s by a Moroccan, Muhammed al-Arabi). But he also became an initiate of the Ibn Arabi school—which has no connection with the Arabiyya-Shadhiliyya—in Damascus in 1893

al-Maghrabi). And more than that, he was also made a *moqaddem*—one who is authorized to initiate others into a Sufi order.

However, it may well be, given what we know about 'Abd al-Rahman (see note) that Agueli's initiation was only nominally into the Arabiyya (which does not appear to have survived 'Abd al-Rahman himself) and that both he and his *sheikh* were really concerned with the universal Islam of the Akbariyya. In any event, he and Insabato lived in Cairo, editing *Il Convito/An-Nadi*, which vigorously promoted this universal wisdom teaching, until 1909, when the British authorities forced its closure. Agueli/Abdul Hadi returned to Paris, and immediately came across a new esoteric periodical, *La Gnose*, started by René **Guénon** in 1909, and also dedicated to universalist principles. Agueli, who met **Guénon** in 1910, was an early contributor and even wrote an article arguing that Islam and Taoism were essentially similar—an extremely novel version of the 'universal wisdom' position at that time. **Guénon** became a convert to Agueli's Sufi universalism and in 1912 Agueli used his authority as *moqaddem* to initiate **Guénon**—perhaps, like Agueli himself, nominally into the Arabiyya but effectively into the Akbariyya. (We know of no other Westerner whom Agueli initiated.) Three years later Agueli was living in Barcelona; he may have joined the Baha'is there. He died in 1917, run over by a train.

The important thing about Agueli is that he was a disciple who was given some spiritual authority. True, he remained a disciple and his appointment as *moqaddem* does not make him a Sufi teacher in any grand sense. But from small seeds grow great trees, and it is therefore significant that he was fulfilling a spiritual function, however modest, in an Eastern tradition—and at a time when there were only a handful of Westerners in the whole world about whom we could say the same.

Primary sources: I have no details

Secondary sources: Marie-France James, *Esotérisme, Occultisme, Franc-Maçonnerie et Christianisme aux XIXe et XXe siècles,* (Paris: Nouvelles Editions Latines, 1981) (entry under **Agueli**); T. Gerholm, 'Three European Intellectuals as Converts to Islam: Cultural Mediators or Social Critics?', in T. Gerholm and Y.G. Lithman (eds), *The New Islamic Presence in Western Europe* (London, 1988)

Centre: None

COMPARE:

Other early Western Sufi teachers: René **Guénon** (for non-Moslem teachers, see under Murshida Rabia **Martin**)

(James). According to James, 'Abd al-Rahman was the inspiration behind a movement known as the Akbariyya (so named after Sheikh el-Akbar, as Ibn Arabi is often called), which was dedicated to universal wisdom. She also says he was familiar with Freemasonry and considered it an esoteric form of Christianity. He returned to Egypt in 1901 and started to initiate people into the Arabiyya again even though, technically, he was no longer the leader of the order: he was in exile from 1883 to 1901 (the period when the Sufi orders in Egypt were being registered) and another prominent member of the Arabiyya was recognized as leader instead (de Jong, 113). "Moreover, he did not concern himself in any way with the consolidation of his position as the tariqa's leader or the position of his tariqa, which must have caused it to decline and vanish from history" (de Jong, 174). The latest date which suggests that the Arabi Order still had some active membership is 1928, a year before 'Abd al-Rahman's death. [Sources: James (entry under Abder Rahman Elish El-Kebir); F. de Jong, *Turuq and Turuq-linked Institutions in Nineteenth Century Egypt*, Leiden, 1978]

In the light of this rather sparse information, it seems entirely possible that 'Abd al-Rahman was less interested in the Arabiyya than he was in the Akbariyya—that is, in universal Sufi wisdom

JETSUNMA AHKON NORBU LHAMO | ALYCE ZEOLI

Currently the only Western woman recognized as a *tulku*[1]

Jetsunma[2] was born in Brooklyn in 1949. In one sense, as she herself says, she had a thoroughly ordinary upbringing: her mother worked in a grocery store and was emotionally unstable; her father was a truck driver and drank too much. They both beat the kids. But she was also a bit different. Even as a child, "I was acutely aware that people were suffering . . . and that [they] were suffering from their minds, not poverty or disease" (interview).

From the age of 19, she had a series of dreams in which she received specific instructions in meditation (though she had never heard the term and did not call it that herself). These continued until she was 30 years old, by which time she was married with two children. In 1981, she and her family moved to Washington, D.C. She began to give 'consultations' and 'readings' to people she met, and gradually a group formed around her. They called themselves the Center for Discovery and New Life. At this point, she was definitely a teacher. "My whole life I felt that this was what I was going to do."

But her teaching was not Buddhist—at least, nobody called it that. Then in 1985, they heard about H.H. Penor Rinpoche, an important Nyingma *lama* and *tulku*—he was elected head of the Nyingma school in 1993—who had left Tibet in 1960 and settled in Mysore in southern India. He had started a monastery there and was campaigning in the West to find funds for basic necessities for the monks under his charge—several hundred of them, of whom about half were young boys. In 1985, Jetsunma's group sent him some money (and a crystal, which he wanted for a ceremony). As a result, he came to Washington and met them.

He and Jetsunma immediately recognized each other. "I looked at him and knew that this is my teacher, this is my mind, this is my heart" (*Washington Post*, 26th September, 1988). He asked what she was teaching and unhesitatingly pronounced it to be the essentials of Mahayana Buddhism. "You have a rare gift," he said. "The teachings are in your mind and cannot be forgotten." And more than that, her students "were moving closer to enlightenment due to these teachings." In effect, he had already implied that she was a *tulku*—someone who embodies one or more of the qualities of enlightenment (see the ***Tulkus*** entry for more detail). But he did not actually say as much because no one in the group, including Jetsunma, had any knowledge of Buddhism, let alone the Tibetan tradition.

They kept in touch with Penor Rinpoche. On his advice (actually, he 'saw' the building without ever going there), they bought a large house with lots of land in Poolesville, Maryland. (This was in 1985.) Other Nyingma *lamas* came to visit the group and shared Penor Rinpoche's conviction that Jetsunma—still Alyce Zeoli at that time—was a *tulku*. Various divinations were done and it was agreed that she was the incarnation of Ahkon Norbu Lhamo. She was formally recognized in 1987 while she was visiting Penor Rinpoche's monastery in India. At the time, even she did not really understand what this meant.

The 'original' Ahkon Norbu lived in the seventeenth century. Naturally, there is a 'myth' concerning her. (I use the word *myth* to mean 'an imagina-

[1] She's not claiming that. I am.
[2] A Tibetan title meaning 'Lord Protectress'. Kunzang Palyul Chöling says that *lamas* have told them that it is actually a 'higher' title than 'Rinpoche' (which is how *tulkus* are usually addressed). I have used it throughout this entry even though it was not employed until her recognition in 1987.

tive construct that makes sense of something or someone', not in the sense of 'a false story'.) She was the sister of Kunzang Sherab, who founded a monastery at Palyul in Tibet in 1665. (The Palyul lineage is an important one within the Nyingma school and it has continued by means of the incarnation of *tulkus* until the present day. One of Jetsunma's principal teachers, Gyatrul Rinpoche, is the *tulku* of Kunzang Serab.) She was not a nun but she spent most of her life in retreat and her meditation was considered to have made the monastery strong. This is a traditional role for some women in Tibet, who are regarded as *dakinis* or embodiments of Dharmic forces; see below. When she died, she was cremated and several portents were observed: there was a rainbow, and her skull or *kapala* flew into the air and was found several kilometres away at the foot of the throne of her brother, Kunzang Sherab, inscribed with the seed-syllable AH and other auspicious marks. Penor Rinpoche says that it would float around the monastery or appear to people as a sign. Her relics used to be brought out once a year at Palyul; they were lost when the Chinese bombed the monastery. But around the time that Jetsunma was being considered as Ahkon Norbu Lhamo's reincarnation, a part of the skull/*kapala* with the AH on it was found. Penor Rinpoche brought it to Poolesville for safekeeping.

In 1988, Penor Rinpoche formally enthroned Jetsunma as a Palyul lineage holder, and the Poolesville centre, now renamed Kunzang Odsal Palyul Changchub Chöling, was established as the seat of the lineage in the West. He is reported as saying, "We cannot say for sure who is going to be a tulku. They return only where they are needed. And they have the freedom to take any form they want" (*Vajradhatu Sun*, October-November 1988, vol. 11, no. 1, p. 5).

This is a fairly extraordinary story, I think you will agree.[3] And Jetsunma accepts the essential myth without reservation. "When I heard the name [Ahkon Lhamo] for the first time, I recognized it"—and this despite the fact that she had not incarnated for 300 years. But hers is an unusual situation, not just because she is a Western *tulku* but because she is an untrained one. (They simply don't exist in Tibet.) Penor Rinpoche told her that she needed to apply herself to

> the traditional practices in the Vajrayana tradition and I'm in the process of doing them now. But the teachings I give still remain the same. I was not trained from birth as other *tulkus* are and I haven't had time to be trained in the traditional way. So I continue to teach from my own mind. (interview)

One of the defining characteristics of a *tulku* is that he or she performs his or her function just by embodying the dharmic virtues. I therefore suggested to Jetsunma that in effect she had been a *tulku*—and therefore benefitting beings—since birth, even though nobody knew it until she was in her midthirties. She replied,

[3] And there's more. In 1994, Jetsunma was recognized by Penor Rinpoche and Gyatrul Rinpoche as an incarnation/*tulku* of White Tara. Previous incarnations included Mandarava, one of Padmasambhava's consorts (letter from Kunzang Palyul Chöling, November 1996). A 'prayer', translated from Tibetan and issued by KPC, contains the following verse: "In the pure realm, Dumatala'i of Orgyen, White Tara is the principal Dakini of Khachöd, whose nature is the Dakini Lhacham Mandarawa, appearing in the land of Tibet as Ahkön Lhamo Changchub Drön, performing the dance of radiating and reabsorbing from the realm of the three kayas. Beautiful light of the white AH, Lhamo Metog Drön (Goddess Flower Light), I supplicate you to save beings in the western realm." This is about as traditional as you can get.

If the teachings are correct, and I assume they are, then that must be so. I personally do not make any great claims for myself. I can look at my life and think that some good things happened but I don't feel a sense of puffed-upness and extraordinariness about it. I feel as if I am watching these events as much as anyone else.

Meanwhile, she has started a number of projects. Some of them are traditionally Tibetan: the construction of *stupas* (an auspicious structure, going back to the time of the Buddha himself—there are presently 14 *stupas* at Kunzang Palyul Chöling) and a 100-foot statue of Amitabha. Some, like accumulating a collection of crystals and starting a Dharma school (that local children can also attend) could perhaps be called trans-cultural (since crystals figure both in the Tibetan tradition and in New Age America; and everyone has to be educated, Buddhist and non-Buddhist). Some are much more up-to-date: teaching meditation in prisons; encouraging the (American) nuns—the monastic community at Kunzang Palyul Chöling currently consists of 37 monks and nuns—to train in the counselling of the terminally ill; providing accommodation for the elderly so that they can approach their impending death with a clear mind—"preparing to enter the Bardo state", as she put it; supporting animal rights activists who try to stop recreational hunting in the area—"as Buddhists, we can't just stand around and watch animals being shot." On the other hand, she does not consider herself politically active. Despite the fact that she has mentioned the plight of Tibet under Chinese control in the centre's newsletter, this is not her main concern. Rather, "we support those who can't help themselves: animals, prisoners, those who are dying" (interview).

At the same time, she offers workshops on such topics as 'Developing the Mind of the Dakini: the practice of supreme generosity.' According to a flier, "Jetsunma practiced this teaching of generosity for years before giving any public instruction and long before her recognition as a *tulku*. Later recognized by her teachers as a form of Chöd, the practice of supreme offering is still her favorite practice and in many ways the basis for all her work."

While she stresses that she wants to maintain the strength and purity of the tradition, she is also quite prepared to nudge it in new directions. For example, she has a high regard for lay practitioners—she is one herself, of course—and says that they can teach just as effectively as those who are ordained. It is true that this view is far more acceptable in the Nyingma school than in the other three—Gelug, Kagyu, Sakya—but even so her recognition of the fact is significant in the context of Western Buddhism as a whole. She also hopes (and perhaps expects: she is after all a *tulku*, one who can accomplish more by a single gesture or word than ordinary beings can manage after years of effort) that the place of women in the tradition will be improved by what has happened to her.

> The obvious leaders of Buddhism are mostly males. The male lamas are held in the highest esteem because they functioned as heads of monasteries, lineage holders, carriers of direct blessings which have been maintained in an orderly, prescribed succession. The great females were rarely in these positions but were considered primordial wisdom beings, or dakinis . . . While the dakinis *had* teachers and also *were* teachers, their activities were outside of the monastic structures . . .
>
> My being a Western woman recognized as a *tulku*, gives American and Western females a sense of a place in Tibetan Buddhism that they did not have before. In Tibetan tradition it is the reincarnate lamas who actually hold the religion and who are born again and again to transmit. The fact that a Western woman would be recognized so early in the implantation of Tibetan Buddhism into this country is a tremendously auspicious event. (*Pathways*, Winter 1988–89, 5ff)

Meanwhile, she considers her job, "and my teachers have also said this",

to stabilize the teaching so that it is strong and to do what I can to propagate it. I am just a plain ordinary Brooklyn girl, and I speak Brooklyn. I speak New York, I speak American and I speak a lot of different languages that *my* people speak, but I also have within my mind something that spontaneously comes forth, an intuitive understanding, even without formal training.

My teachers have examined the teachings here and find them to be appropriate and correct. *I really want to get the message out that there is a technology for loving, that there is a way to end the suffering of the world.*[4] I want people to understand that there is a path, there is a way. It's a hard path, it's a hardworking path, but it is a way for them to do what they've always dreamed of, and that, I hope, is to benefit all beings. I can speak that language, I can draw the essence of that teaching out, and I can tell you that I look at this teaching and I know it's about love. I look at these people, these Western people that I grew up with, and I understand them. I know that they are good people and they want to love. I'd like to make those two things connect (ibid., italics in the original).

This is the voice of the new spiritual phenomenon of the West in full flow: based on tradition but not limited to it; Eastern in inspiration but Western in expression. It does not have to remain that way and no doubt there are many changes in store. But it's a good start.

Primary source: interview at Poolesville in 1990

Secondary source: V. Mackenzie, *Reborn in the West: The Reincarnation Masters*, (London, 1995)

Centre: Kunzang Palyul Chöling/The World Prayer Center, 18400 River Road, Poolesville, MD 20837; tel: 301-428-8116; www.tara.org

COMPARE:

Other Western or half-Western tulkus: Namgyal **Chogyam;** see also the ***Tulkus*** entry

Other women teachers in Tibetan Buddhism: Freda **Bedi**, Alexandra **David-Néel**, **Pema Chodron**, Dhyani **Ywahoo**

Other women teachers in other Buddhist traditions: Jan **Bays**, Joko **Beck**, Ruth **Denison**, Rev. **Dharmapali**, Gesshin **Prabhasa Dharma**, **Karuna Dharma**, Jiyu **Kennett**, Ayya **Khema**, Dharma Teacher Linda **Klevnick**, **Miao Kwang Sudharma**, Dharma Teacher **Linda Murray**, Irmgard **Schloegl**, Dharma Teacher Bobby **Rhodes**, Ruth Fuller **Sasaki**

Other women teachers in other traditions (or in none): Swami **Abhayananda**/Marie Louise, Sister **Daya**, Sri **Daya Mata**, Sister **Devamata**, the **Devyashrams**, Ivy **Duce**, Jaqueline **Mandell**, **Marasha**, Rabia **Martin**, the **Mother**, Sister **Nivedita**, Patrizia **Norelli-Bachelet**, Toni **Packer**, Elizabeth Clare **Prophet**, Swami **Radha**, Jeanne **de Salzmann**, Joya **Santanya**, Sri **Sivananda-Rita**, women in the **Sufi Order**, Swami **Turiyasangitananda**, Irina **Tweedie**

[4] A brochure put out by Kunzang Palyul Chöling, entitled 'The Bodhisattva Ideal and the Transformation of Ethics in the New Millenium', says amongst other things that "a sacred seed is growing, and it is gaining strength and momentum, especially in the West. Places of spiritual refuge that offer a doorway into this view are being established." KPC is clearly one of these. Practitioners maintain a continuous 'prayer for peace' (which is actually the Bodhisattva ideal in a Western setting): at least one person has been 'praying' every minute of the day and night since 1985.

Roshi Robert AITKEN

Aitken's initial contact with Zen was unusual and delightful. Captured by the Japanese on the Pacific island of Guam (the day after Pearl Harbor and having never fired a shot), he was taken to a detention camp in Japan, where a guard lent him a copy of *Zen in English Literature and the Oriental Classics* by R.H. Blyth. Blyth was an English disciple of D.T. Suzuki—and the guard was a disciple of Blyth's (Tworkov, 29). But Blyth, whom Aitken calls Blyth Sensei (*Taking the Path of Zen,* 130), was also in a detention camp because he had been living in Japan when the war broke out. Eventually, Aitken and Blyth were both moved to the same camp and met each other.

Fired by enthusiasm for Zen, Aitken returned to America after the war but with no idea who to turn to for help. Thcn, in 1947 (at the age of 30), he stumbled across Nyogen Senzaki in Los Angeles. (Senzaki had himself been interned by the Americans during the war, just as Sokei-an, the only other Japanese Zen teacher living in the States at the time, had been.) Sensaki gave Aitken a Buddhist name (Chotan, meaning 'Deep Pool') and agreed to give some instruction in *koan* practice. But his style was not as rigorous as Aitken was looking for, so in 1950 Aitken went to Japan and entered the monastery presided over by Nakagawa Soen Roshi, a Rinzai master in the lineage of the great Hakuin who had corresponded with Senzaki for 15 years from Japan.

Aitken returned to Hawaii (his home state) in 1951 and spent the next few years there and in California, got divorced and ended up teaching English at *Krishnamurti*'s Happy Valley School in Ojai, California. He married again in 1957 and the couple went to Japan for their honeymoon, where Aitken renewed his acquaintance with Soen Roshi and also met *Yasutani* Roshi for the first time. In 1958, he was attendant to Soen Roshi at the memorial *sesshin* held in Los Angeles after Nyogen Senzaki's death. And in 1959 Soen Roshi gave him permission to conduct a *zazen* group at his home in Hawaii. To begin with, this *zendo* consisted of the Aitkens and one other couple. It is entirely typical of Aitken that his career as a Zen teacher should have begun so quietly.

In the following years, Aitken practiced with *Yasutani* Roshi and *Yamada* Roshi (*Yasutani*'s Dharma heir), and in 1974, a year after Yasutani's death, he received Dharma transmission from *Yamada* Roshi. It is a striking fact about Aitken's contact with Zen that he has never spent years at a time in the company of a Japanese teacher (either in Japan or in the West) but has had continuous but intermittent contact with his teachers.

Aitken Roshi's style, both as a student and as a teacher, has been quiet but radical. His own *kensho* is a good example of this. He had an experience at a *sesshin* with Soen Roshi in Hawaii in 1961. "I found the ceiling of my mind to be infinitely spacious. Everything was bright and new." But Soen Roshi said that this was only "a little bit of light" (*Taking the Path of Zen,* 123). Aitken continued to practice (under both Soen Roshi and *Yasutani* Roshi) and in 1971, Soen Roshi confirmed that Aitken had attained *kensho*. Yet, as Aitken himself says, there was no spectacular experience asociated with this attainment—not even something definite (ibid., 129).

Aitken has championed a form of radical pacifism, which began immediately after World War II in Hawaii before he even began practicing Zen: he joined groups discussing peace and labour issues and was investigated by the F.B.I. (Tworkov, 31). He was against the Vietnam war more or less as soon as it began,

and was a member of the Hawaii Committee to End the War in 1963 (Tworkov, 41). He has demonstrated against nuclear testing (in the 1950s), for unilateral disarmament (in the 1960s) and against the Trident missile (in the 1980s); and he was a co-founder of the Buddhist Peace Fellowship in 1978. In 1982, he and his wife (also a Zen practitioner) withheld that percentage of federal income tax that would be spent on armaments—an illegal act but one which they have repeated every year since. (See John **Loori**'s entry for a reference.)

He has also been very critical of the West's exploitation of Third World countries (for instance *The Mind of Clover,* 58). He argues that this criticism is essentially, as opposed to tangentially, Buddhist because the economic system of the West, by being exploitive, goes against the second Zen precept, 'Do not steal' (*The Mind of Clover,* 30). And it is the duty of the *sangha* to do something about it because the Buddha intended the *sangha* to be an instrument for social change (*The Mind of Clover,* 9). Not all Zen teachers, nor all Buddhist teachers, agree with him (not least because there are very different perceptions of what the *sangha* consists of).

Another aspect of Aitken's radicalism is his effort to inculcate equality of the sexes in his Zen groups. He sometimes refers to the Buddha as 'she' (Women in Buddhism', *Spring Wind* [magazine of the Zen Lotus Society], vol. 6, nos.1, 2, 3, 1986, p. 89) and has encouraged the "feminizing [of] political and decision-making processes as well as retranslation of sutras, excising sexist language that had been transmitted unaltered down the centuries" (Friedman, *Meetings with Remarkable Women,* 25). He maintains that the best way forward for Western Zen is not the authoritarian (and patriarchal) model of the East but "decision-making by consensus" (*The Mind of Clover,* 77). Out of this will come proper *sangha* government.

However, this desire for a truly Western form of Zen is not a denial of the need for transmission between teacher and student. Aitken is critical of the kind of amorphous 'universalized Zen' made popular by D.T. Suzuki and Blyth (Tworkov, 34); there has to be formal practice and guidance by a qualified teacher. When Aitken retired from the Uinversity of Hawaii in 1969 and started a *zendo* at Maui, the daily routine, starting at 5:00 A.M., was as follows:

5.00	rise and wash
5.10	*zazen*
5.50	study period
6.30	breakfast
7.00	work period (household chores and gardening)
9.30	refreshment break
10.30	work period ends
11.10	*zazen*
12.00	dinner, short rest
1.00	work period
3.00	refreshment and rest
4.30	*zazen*
5.20	supper and rest
7.10	*zazen*
9.00	bed

Aitken sees his role in all this as a teacher but not as a guru. That is, he has a realization and it is his task to bring about the same realization in his students. For that, they have to trust him as well as sticking to the practice and the daily

schedule. But Aitken explicitly rejects the guru role, by which he means that *everything* the teacher does is a teaching device of some kind. He cites **Gurdjieff**, and the Vedanta and Tibetan Buddhist traditions as examples where this kind of role is made central (Tworkov, 57–58).

Yet the Zen lineage is important. In 1988 and 1989, Aitken Roshi gave Dharma transmission to four of his students: two Americans (Nelson Foster and Patrick Hawk, who is also a Catholic priest and is leader of the Bishop Defalco Retreat Center in Amarillo, Texas), an Australian living in America (John Tarrant), and an Argentinian (Augusto Alcade, who runs a *zendo* in Argentina).

This is an example of what might be called a Western Zen lineage—a Western *roshi* creating Western Dharma heirs (as opposed to an Eastern *roshi* creating Western Dharma heirs). It is typical of Aitken's style that he should extend the contours of Zen, so to speak, by charting a genuinely middle way between Eastern orthodoxy and Western adaptation.[1]

<div align="center">(See Lineage Trees 4, 6)</div>

Primary sources: Robert Aitken, *A Zen Wave* (Weatherhill, 1978); *Taking the Path of Zen* (North Point Press, 1982); *The Mind of Clover* (North Point Press, 1984)

Secondary sources: H. Tworkov, *Zen in America* (San Francisco, 1989)

Centre: Diamond Sangha, 2119 Kaloa Way, Honolulu, Hawaii 96822

COMPARE:

Other Zen teachers: Reb **Anderson**, Richard **Baker**, Jan **Bays**, Joko **Beck**, Gesshin **Prabhasa Dharma**, Don **Gilbert**, Bernard **Glassman**, Philip **Kapleau**, Jiyu **Kennett**, Walter **Nowick**, Ruth Fuller **Sasaki**, Maurine **Stuart**, Zen Master **Tundra Wind**

Other groups trying to establish spiritual government or communities: Ananda Co-operative Village (Swami **Kriyananda**); Auroville (**The Mother**); New Vrindaban (Srila **Bhaktipada**); the Seva Project (**Ram Dass**)

OMRAAM MIKHAEL AIVANHOV. SEE **APPENDIX 1**

SWAMI AJATANANDA | MARC CHADUC. SEE **ABHISHIKTANANDA** (P.149, N.1)

ANANDA BODHI | LESLIE DAWSON. SEE **NAMGYAL** RINPOCHE (IN *TULKUS*)

[1] I should point out, however, that in 1995, Aitken and the Diamond Sangha formally separated from the Sanbokyodan school after he and Kubota Roshi, *Yamada* Roshi's successor, agreed to differ on the way in which Dharma-heirs are appointed. So Aitken is now an independent Zen teacher.

One of the first Westerners to enter the Theravadin sangha and the very first Theravadin monk of any nationality to visit the West

Bennett is an early example of a type of spiritual seeker that was relatively common at the turn of the century: the esotericist who turned to Eastern religions (in his case, Buddhism). He read Arnold's *The Light of Asia* in 1890 at the age of 18. He also read translations of Buddhist texts, while at the same time exploring esotericism: he was a member both of the Golden Dawn and the Esoteric Section of the Theosophical Society (*Encyclopedia of the Unexplained*, ed. R. Cavendish [London, 1974], 54). His magical name was Frater Iehi Aour (see the list in Colquhoun, 135, which includes W.B. Yeats and Aleister Crowley).

Bennett's esoteric investigations also took him into Druidism according to Robert MacGregor Reid, Chief of the Druid Order from 1946 to 1964; the Order claims a continuous lineage going back to 1717 and includes William Blake among its Chief Druids (Colquhoun, 117–126). These Druids saw themselves as the British Circle of the Universal Bond, a kind of worldwide movement which recognized the common elements in all religions. And according to MacGregor Reid, Bennett went to the East and became a Buddhist in order to bring Buddhism into this Universal Bond; other Druids did the same with Shintoism and Islam (Colquhoun, 124).

There is no evidence that Bennett himself saw his adoption of Buddhism in this way. On the contrary, everything suggests that he straightforwardly abandoned esotericism and became a Buddhist. But it is certainly true that magic and Buddhism could be seen at that time as aspects of the same truth in a way that they cannot now. So it is hardly surprising that when Bennett went to Ceylon in 1898, he should hand over his esoteric manuscripts to a fellow magician. It is perhaps slightly more surprising that his trusted confidant should have been Aleister Crowley. In fact, Bennett, who was a little older than Crowley, was actually Crowley's teacher in the magical arts (*Confessions*, 181).

Of course, everything that Crowley says has to be taken with a shovelful of salt. But it is noteworthy that Bennett was practically the only person that Crowley never fell out with. He is mentioned frequently in Crowley's *Confessions* and is consistently presented as a great magician (before he became a Buddhist) and a great *yogi* (after he became one).

Another little-known aspect of Bennett's youth was his experience of drugs. He suffered very badly from asthma and, according to Humphreys, was given heroin "at an early age" to relieve the intensity of the spasms. Of course, heroin was a purely medical drug at that time and did not have the reputation that it has now. But it is evident from Humphreys's account that Bennett was dependent on it (though whether he was what we would now call an addict is another matter):

> To be given a drug to relieve an attack makes the sufferer want a supply to use on himself the next time an attack seems imminent. From this it is a short step to regular indulgence in an attempt to prevent attack arriving, but none who has witnessed an acute attack of this kind of asthma will blame the man who uses all means available to remain immune. (Humphreys, *Encyclopedia of Buddhism*, vol. 1, 539–542)

Crowley gives a rather different account. He says that Bennett took opium, morphine, and cocaine, switching from one to another as each one began to have less and less effect. He took cocaine until he began to "see things" (*Confessions*, 180). Crowley also says that he himself tried "drug-based

mysticism" with Bennett (*Confessions,* 386). According to Colquhoun, they used peyote and mescalin (Colquhoun, 222) but I have not been able to find this stated in Crowley's *Confessions.*

But to return to Bennett's spiritual quest. He soon abandoned esotericism and began to pursue Eastern teachings. He went to Ceylon in 1898—with money provided by Crowley (*Confessions,* 182)—both to investigate these teachings at first-hand and to try and improve his asthma. According to Crowley, he started off as the pupil of a Shaivite guru, Sri Parananda, who taught him *yoga*—the classical *ashtanga-yoga* of Patanjali, that is (*Confessions,* 234–38). This may well be true, but we only have Crowley's word for it.

Eventually, he decided to become a Buddhist monk. But because it was easier to enter the *sangha* in Burma, he went there from Ceylon and was ordained in 1902—at Lamma Sayadaw Kyoung monastery at Akyob on the west coast (*Confessions,* 262)—taking the name Ananda Maitreya (of which the Pali form is Ananda Metteya). In the same year, he published in Rangoon a short pamphlet, *The Foundation of the Samgha of the West.* He kept in touch with "eminent Buddhists in England, America, and Germany" and in 1903 announced the formation of an International Buddhist Society, the Buddhasasana Samagama, "at first in these countries of the East and later extending it to the West" (Humphreys, *Sixty Years of Buddhism in England,* 3).

Our only source of information about his life in the East is Crowley, who visited Bennett in Ceylon and Burma and gives startling accounts of Bennett's yogic powers. He says that while visiting Bennett at a monastery in Ceylon, he saw Bennett floating in the air and being blown about like a leaf (Wilson, *The Occult,* 466; I have not been able to find this episode in Crowley's *Confessions*). And on another occasion, Bennett entered a trance-like state after practising *pranayama* and exhibited what is called *buchari siddhi* or 'the power of jumping like a frog'—his body, which was rigid like a statue, was galvanized by an inner force and thrown about the room (*Confessions,* 246; *Man, Myth, and Magic,* 336).

But since Crowley would never, on principle, drop below the level of the startling, we have little option but to regard these accounts as his usual occult exaggeration. On the other hand, it may well be true that Bennett did advance from being a *bhikkhu* to a *sayadaw,* as Crowley records (*Confessions,* 462), and that Bennett taught Crowley techniques of meditation—specifically, *samma-sati* (*Confessions,* 515). All in all, I think we should accept that Bennett was Crowley's guru, a term which Crowley himself uses (*Confessions,* 462). This is fairly remarkable at the turn of the century.

All our other knowledge of Bennett/Ananada Maitreya is restricted to his activities in Britain. In 1907 an English branch of the Buddhasasana Samagana was created under the name of The Buddhist Society of Great Britain and Ireland. Its president was the Pali scholar, T.W. Rhys Davids, and its first public meeting was advertised as for "Buddhists and those interested in the study of Buddhism, Pali, and Sanskrit literature." A year later, Ananda Maitreya went to Britain together with three Burmese supporters who paid his expenses. During his stay, he lived according to the rules of the Theravadin *sangha.* He was not allowed to handle money, so he could never travel alone. He was not allowed to ride in a horse-drawn carriage, so he had to walk or go by car. He was not allowed to sleep in a house with a woman in it, but since two of his Burmese companions were women, two houses had to be rented.

While in Britain, he gave lectures and, according to Humphreys, "formally admitted into the fold of Buddhism all who wished to be received"

(Humphreys, *Sixty Years of Buddhism in England,* 6). Humphreys does not say what this means exactly but it must, I think, refer to the taking of the five precepts (*pansil*) because elsewhere Humphreys says that a whole family, including the children, were "admitted to the fold" (*Encyclopedia of Buddhism* article). After six months he went back to Burma and remained there until 1914—during which time he experimented on a machine for registering the power of thought (*Enyclopedia of Buddhism* article). He then returned to Britain for good—but because of the difficulties of remaining a monk he left the *sangha* and became Allan Bennett again.

But he continued to work for the establishment of an international Buddhism. One of his ventures was the International Buddhist Union, which is interesting because of the people associated with it and the interconnections between them. The IBU was one of many attempts about this time to establish a form of Buddhism that could be accepted by all Buddhists regardless of their tradition. According to Humphreys, it was originally started by Anagarika *Dharmapala* in Calcutta, and Bennett was the organizer of its Western wing (Humphreys, *Sixty Years,* 15). A list of supporters in 1922 includes Ernst Hoffman (later Lama Anagarika **Govinda**) and Ronald Nixon (later Sri **Krishna Prem**), as well as George **Grimm** and Dwight **Goddard**. The IBU remained little more than an idea for another 30 years but was finally resuscitated in the form of the World Fellowship of Buddhists in 1950 by G.P. Malalasekera (who had been taught by M.T. **Kirby**).

This incident of the IBU, though minor in itself, neatly captures the ethos of the early form of Western Theravada: it was international, both in its personnel (involving Sri Lankans, Europeans—British, Swiss, German—and an American) and in its organizational aims; it was extremely eclectic (*Dharmapala* was a Theosophist as well as a Buddhist; Bennett had been an esotericist and a monk; Hoffman later became a Theravadin but then switched to Tibetan Buddhism; Nixon later became a Vaishnava guru in India); and, it has to be said, it tended to become involved in projects that took an inordinately long time to come to fruition.

After working as a lay Buddhist in Britain for ten years, Bennett's ill-health finally got the better of him; he died in 1923 at the age of 50. In the same year, a collection of his lectures was published under the title of *The Wisdom of the Aryas*. In the introduction, he pointed out that this was the first book on Buddhism ever to be written in English by a monk. (This is strictly correct, though **Nyanatiloka**'s *Das Wort des Buddha*, published in 1906 and translated into English in 1907, is a rival of sorts.) It is significant that he should single out his membership of the *sangha* as a point to be stressed—not his meditational accomplishments or the illustriousness of his teacher, but the simple fact that he had been a monk.

There are a number of striking points about Allan Bennett's career as a Buddhist. First, as Ananda Maitreya, an Englishman, he was the first Theravadin monk ever to visit the West (not just Britain—the West; *Dharmapala*, who had been to Chicago in 1893, was not a monk.) Second, when he came to England in 1908, not a single Burmese monk accompanied him. Third, from the very beginning he envisaged the creation of a Western *sangha*. And last, what actually happened was the formation of Buddhist societies—not at all the same as a *sangha*—both in Burma and Britain, *by Westerners*. These facts are all connected and the explanation of them is this: that Theravada Buddhism is intimately linked with the existence of the *sangha*; that the *sangha* in Theravada countries was unable to respond to the Western interest

in Buddhism; and that as a result, Theravada in the West was constructed by Westerners from a variety of sources (including esotericism, magic and Theosophy) and ended up, almost inevitably, as 'general lay Buddhism'.

Primary sources: Ananda Maitreya, *Buddhism: An Illustrated Quarterly Review*, Rangoon, vol. 1—vol. 2, no. 2 (1903–08); *The Wisdom of the Aryas* (London, 1923); reprinted (Delhi: Asian Publication Services, 1984); *The Religion of Burma and Other Papers*, Adyar (India): Theosophical Publishing House, 1929.

Secondary sources: HIS ESOTERIC CAREER: I. Colquhoun, *Sword of Wisdom* (London: Spearman, 1975); A. Crowley, *Confessions* ed. J. Symonds and K. Grant, (London: Cape, 1969); HIS BUDDHIST CAREER: C. Humphreys, article on 'Ananda Metteyya' in *Encyclopedia of Buddhism*, vol. 1, pp. 539–542; C. Humphreys, *Sixty Years of Buddhism in England*, (London: The Buddhist Society, 1968), pp. 2–3, 4–8, 10, 15–16.

Centre: None extant

COMPARE:

Other early Western Theravadin monks: Ernst Hoffman/Lama Anagarika **Govinda**, **Nyanatiloka**

Other early lay Buddhists: Colonel **Olcott**

Other early Westerners in other Eastern countries: Swami **Atulananda**, Arthur **Avalon**, W.Y. **Evans-Wentz**, Sri **Krishna Prem**, the **Mother**, Sister **Nivedita** (all India), William **Bigelow** (Japan), Alexandra **David-Néel** (Tibet)

Other esotericists who embraced Eastern traditions: Madame **Blavatsky**, Colonel **Olcott**, Rene **Guénon**, Murshida Rabia **Martin**, Sri **Krishna Prem**, the **Mother**

Roshi Reb ANDERSON

Dharma-heir of Roshi Richard Baker and his successor as abbot of the San Francisco Zen Center

Anderson had been a student of Shunryu Suzuki but was given Dharma transmission by Richard **Baker**, Suzuki Roshi's successor. After **Baker** left the San Francisco Zen Center/SFZC (see his entry), there was an understandable uncertainty about how to proceed. But eventually, in 1986, Anderson was appointed as abbot—with the approval of the Soto headquarters in Japan.

Within a year, however, Anderson had also offered his resignation in somewhat bizarre circumstances. He was arrested and charged with brandishing a pistol in public, which is technically a misdemeanour in Californian law. He had come across the pistol four years earlier next to the body of someone who had committed suicide in Golden Gate Park. He had meditated next to the body for three days before informing the police—but he had kept the pistol, which he had hidden in the Zen Center's garage. When he was held up at knife point in the garage late in 1987, he had taken the pistol and chased his assailant to a nearby housing project, whose inhabitants called the police (*Vajradhatu Sun*, vol. 9, no.1, October–November 1987).

There is no need to get this incident out of proportion but it does point to a number of factors that highlight the difficulties of trying to follow an Eastern path in a Western environment. Meditating on a corpse is an ancient Buddhist practice—but it arose in India, where disposal of bodies in the charnel grounds was a public matter. To carry out this practice with a suicide in a culture where death is anything but public is surely rather different. It may be necessary to resort to firearms on occasion in a rough section of San Francisco—an SFZC member was knifed to death not long before this incident with Anderson took

place—but from the Buddhist point of view it is perhaps not a good idea to use a pistol that does not belong to you, nor to pursue your assailant down the street.

In the event, his resignation was not accepted and he has continued as abbot. When I spoke to him in 1991 he made a number of interesting observations concerning the development of Zen in the West and at SFZC in particular. First, like many others, he distinguishes between what might be called 'nominal' Dharma transmission and true realization—that is, between the formal procedures that define Dharma transmission and the insight into one's true nature (which is what the Dharma, and therefore Zen, is concerned with). In short, a title is no guarantee of attainment. Although he uses the title 'Roshi' himself, he would prefer it if all such titles (including 'Sensei') were dropped because people become attached to them. At the moment, it would be unnecessarily provocative to refuse to use them. But if the majority of practitioners—Western practitioners, that is—agreed, they could simply be done away with.

Needless to say, such a move would not go down very well in Japan. And this leads to the second point he made: that the Japanese tend to be far more interested in formality than the Americans. For example, the Soto authorities in Japan insist that a photograph of the cutting of the hair at the *tokudo* ceremony (which is miles away from Dharma transmission) be lodged at the their headquarters. This is simply a convention and has absolutely nothing to do with training; it makes little sense in America and is bound to be dropped sooner or later. In a somewhat similar vein, the Japanese Soto authorities refused to recognize Richard **Baker**'s transmission from Suzuki Roshi, despite the fact that it was scrupulously carried out, because **Baker** did not go through the *zuisse* ceremony in Japan—another formality that has nothing to do with training. And while they have since accepted Mel Weitsman, Les Kaye, Bill **Kwong**, and Anderson himself as Dharma-heirs (see Lineage Tree 1 for the various lines of transmission), they did so only after they had gone through exactly the same ceremonies in Japan as they had been through in America. Yet they will not accept any of Anderson's own ordinations—which is illogical. This state of affairs, which is nothing more than cultural chauvinism (that's my phrase, not his), cannot continue. And if it does not change, Anderson foresees that American groups will simply branch out on their own.

Thirdly, there are several new circumstances which have arisen in the West but which Japanese Soto hasn't the answers to. There is no provision for lay transmission, for example; the path begins with *tokudo*. Yet Anderson says that he has lay students who are as advanced as many who have taken *tokudo*. He isn't sure what to do about this. Yet at the same time, there is no monastic ordination in Soto (as there is in Theravada and Tibetan Buddhism). Students ask for it and it would make sense to give it if they are suited to that way of life—but the tradition simply does not have a place for it. And generally speaking, the situation in the West—or at least at SFZC—with lay people and priests, male and female, all practising together, while not exactly irregular, is certainly not according to the Japanese pattern. Yet the Japanese model, where all of these are kept separate or simply do not exist, is not much help. This is another reason why he expects SFZC to go its own way: the procedures have to be adapted to the circumstances.

Lastly, there is a definite need for more openness and democracy in American Zen. The problems at SFZC and Naropa (for the second of which, see **Osel Tendzin**'s entry), Anderson says, were largely because of the fact that the communities were isolated. In Japan and Tibet there would have been

a whole variety of people who could have helped—other teachers and other communities of equal or greater status. And being part of the same culture is also significant; Japanese and Tibetan teachers are limited in how much they can help Americans because they do not understand American culture. And the Americans do not help themselves by deferring too much to Asian teachers instead of pointing out when their solutions are inappropriate. Now that the lines of communication have been opened up at SFZC, any problems that arise (such as Anderson's arrest) can be dealt with and the community doesn't suffer too much. Anderson hopes that eventually SFZC will accept that Richard **Baker**'s time as abbot had its good side and that they will acknowledge him for it.

This is spoken like a good student—in the best sense of that term—and he must surely be right. Meanwhile, he has four Dharma-heirs of his own, three men (Ananda Dalenburg (he gave himself the name 'Ananda', which is decidedly non-Japanese, and Anderson accepted it), Zengyu Discoe and Chikudo Peterson) and a woman (Sobun Thanas). Of these, only Thanas had a temple (in Santa Cruz) in 1991 (when I interviewed Anderson).

It appears, then, that Dharma transmission has taken root in America. (See Lineage Tree 1 again for the various lines.) Despite the rich soil provided by Shunryu Suzuki, it has had its difficulties and has not always grown directly towards the light. True, it is something of a hybrid—but hybrids are often the most vigorous species. No doubt it will bring forth its own fragrance.

STOP PRESS: *Just as I was finishing this entry, I learned that Anderson had stopped being abbot at SFZC. As I understand it, this was not for any particular reason but simply because the community does not want anyone to become too much of a fixture. He was succeeded by two Dharma-heirs of Mel Weitsman: Blanche Shunpo Hartman and Norman Zoketsu Fischer.*

(*See* Lineage Tree 1.)

Primary sources: None

Secondary sources: None

Centre: San Francisco Zen Center, 300 Page Street, San Francisco, CA 94102, U.S.A.

COMPARE:

Other Zen teachers: Robert **Aitken**, Richard **Baker**, Jan **Bays**, Joko **Beck**, Gesshin Prabhasa **Dharma**, Bernard **Glassman**, Philip **Kapleau**, Jiyu **Kennett**, Walter **Nowick**, Ruth **Fuller** Sasaki, Maurine **Stuart**, Zen Master **Tundra Wind** [just a selection]

SWAMI ARUBIANANDAM | JULES MONCHANIN.　　SEE **ABHISHIKTANANDA**

ARYA SANGHA

This term literally means 'the community of the noble ones'. It goes back to the origins of Theravada Buddhism[1] but I am using it rather differently to mean

[1] See the interesting discussion in P. Masefield, *Divine Revelation in Pali Buddhism*, (Colombo: Sri Lanka Institute of Traditional Studies, 1986).

a body of wise men and women which is founded on spiritual insight and dedicated to enlightened action.[2] It comprises people who are guided by *Dharma* in the broadest sense of the word: a principle of rightness that is part of the very fabric of reality/the world and which is essentially a response to the excellence of things (both animate and inanimate). A number of teachers in this book are involved in it: Robert **Aitken**, Jetsunma **Ahkon Lhamo**, Joanna **Macy**, **Ram Dass**, Christopher **Titmuss**. They belong to different traditions—though some of them would be wary of aligning themselves with any tradition because *Dharma* transcends tradition—and they have launched various projects concerned with homelessness and imprisonment; death, dying and the bereaved; and possible global destruction from war or ecological destruction.

Of course, how many of them would say that they were actually members of the *arya sangha* is another matter. But sometimes one is part of something without knowing it.

[For bibliography and further connections, see the entries on all those mentioned here.]

Swami ATULANANDA | C. J. Heijblom SEE **APPENDIX 1**

Sri AUROBINDO

Indian who evolved his own spiritual teaching and who regarded Mira Richard/the **Mother** as his co-worker

Aurobindo was born Aravinda [= Aurobindo] Ghose in Calcutta in 1872. He was educated in England and got a first-class degree in Classics from Cambridge in 1892. Back in India, he became involved in Bengali nationalism and began to practice yoga (meaning hatha yoga *with* pranayama*) in about 1905 in order to develop the power that would help him to liberate his country (Purani, 108). This led to a number of experiences, variously described as "the Absolute Brahman" (*Collected Works, *vol. 26, p.79) and 'Nirvana' (ibid., 101). He was also guided by an inner voice. One day in 1910, while at the offices of his political journal, the* Karmayogin, *and aware that he might be arrested by the British at any moment, this voice directed him to go to Chandernagore, a French-controlled territory in south India. He handed over the editorship of Karmayogin to Sister* **Nivedita** *and left immediately, moving on soon afterwards to nearby Pondicherry, where he stayed until his death in 1950. It is from his arrival in Pondicherry in 1910 that Aurobindo's life as a guru unequivocally begins. In this same year, he met Paul Richard, the husband of Mira Richard/the* **Mother**; *she was to play a crucial role in Aurobindo's subsequent life as a teacher. See her entry for a continuation of this account (at least in the sense that I refer to Aurobindo whenever it is necessary to understand her own teaching).*

[2] This is the definition I gave in an article, 'The Transmission of Theravada Buddhism to the West' in P. Masefield and D. Wiebe (eds.), *Aspects of Religion: Essays in Honour of Ninian Smart* (New York, 1994), 357–388. This short entry paraphrases what I said there.

ARTHUR AVALON | SIR JOHN WOODROFFE. SEE **APPENDIX 1**

ROSHI RICHARD BAKER

One of the first Westerners to be made abbot of a Zen temple—and the first to resign (under pressure from his own centre); currently head of the Dharma Sangha, with centres in Colorado and Germany

Baker was born in Maine in 1936. His family had been one of the first to arrive in America and used to be quite influential in New England. One of his forebears was elected governor of Massachusetts Bay four times; and he counts Benjamin Franklin, Oliver Wendell Holmes, and James Monroe (the fifth president of the United States) among his more distant former relatives (Tworkov, 208). As a boy, "I saw the world differently" (ibid.). He went to Harvard but left without finishing his course in European history and architecture. Somewhere along the way, he "decided to create an ideal society" (ibid., 207), not uncommon among the young at the beginning of the sixties. He went to San Francisco in 1960, at the age of 24, and was investigating the beat scene there when he came across Shunryu Suzuki.

Suzuki Roshi had been sent to San Francisco in 1958 by the Soto school in Japan to act as priest at Sokoji, the temple that had been established in the 1930s for Japanese Americans. But he quickly attracted white Americans and inspired in them a deep loyalty and devotion. In Baker's words,

> He was what he talked about . . . a Buddhist text come to life . . . I completely loved him and would have done anything for him. I only had one desire, which was to be Suzuki Roshi's attendant. (Tworkov, 212-13)

And that is exactly what happened. Within a few years of meeting Suzuki, Baker became the organizational force behind SFZC (which Suzuki created for his new American students in 1962). Baker himself says as much:

> Suzuki Roshi . . . gave people the intangible sense of quality and integrity and enlightenment. And that's absolutely the most important. But when you look at the structure of [SFZC], the place, the location, the rules—I did all that . . . I did not make a single decision without his okaying it, but basically he always agreed with me. (Tworkov, 215)

For other pioneers, see ***Kirby***, ***Hunt***, ***Kennett***, ***Nowick***, ***MacDonough***, ***Langlois***.

The Center, under Baker's guidance (and with Suzuki's inspiration) just got bigger and bigger. In 1966, Suzuki asked Baker to find a place where students could go for intensive practice. Baker came up with Tassajara, a former hot springs resort deep in the mountains, 160 miles south of San Francisco. And since Tassajara needed a priest, Suzuki made Baker a priest. The ceremony took place at Tassajara the day before it opened (in 1966). Baker shaved his head, wore the robes, chanted in Japanese and was given his Buddhist name, Zentatsu Myoyu (ibid., 219). He was one of the first Westerners ever to be made a Zen priest.

But this was just the beginning. Suzuki wanted Baker to be his Dharma heir, and in 1968 Baker and his wife went to Japan. They stayed there for the best part of three years (with two short visits back to California), while Baker practiced at Daitokuji (a Rinzai monastery) and at Eiheji and Antaiji (Soto monasteries). And in 1970, Suzuki Roshi formally appointed him as his Dharma heir at Rinso-in, the temple Suzuki had run before going to America.

The Bakers then returned to San Francisco and Baker took up the leadership of SFZC. He was installed as abbot by Suzuki Roshi in 1971. He was not the first Western Zen abbot—Jiyu **Kennett** was abbess of her own temple in Japan from 1963 to 1969, and Kongo **Langlois** was made abbot of the Zen Buddhist Temple of Chicago in 1970—but he was certainly the best-known. The ceremony was attended by Joshu Sasaki Roshi (the Rinzai teacher), Tripitika Master Hsuan Hua (originally from Taiwan but now with a monastery in California) and Lama Kunga (from the Evam Choden Center in Berkeley). Baker Roshi's first duty as abbot, just two weeks after his appointment, was to conduct the funeral ceremony (together with a number of Japanese teachers, including Suzuki's son) for Suzuki Roshi, who had been ill for some time.

Over the next ten years, Baker carried out his duties, both spiritual and managerial, with considerable vigour. Students who were there at the time say that SFZC developed into a community that was based on solid practice. There was nowhere else quite like it in the West at the time—and it was Baker Roshi who was primarily responsible for its existence. Between three and four hundred people would attend his public lectures (Tworkov, 247); and he ordained over 60 students as priests during his time as abbot (ibid., 231). He himself described SFZC as

> "the container for a kind of nutrient-rich soup, something that would generate forms for Buddhism in America"—something, therefore, that should be bolstered financially, and made attractive as a place to taste the teachings. (Schneider, 132)

In 1972, just a year after Suzuki Roshi's death, he made the first of a number of daring moves: the purchase of Green Gulch Farm in Marin County, which Baker envisioned as being worked by hand and with horses, with a biodynamic garden (Tworkov, 228). It cost $200,000 and although he saw it as a bargain, there were others, including members of the SFZC board, who resisted the idea. But Baker persuaded them. There had been those who had not wanted to buy Tassajara either—but that had turned out to be a big success.

Over the next two years, Baker was instrumental in setting up the Tassajara Bakery; the Green Gulch Greengrocery; the Shunryu Suzuki Study Center (which offered classes in Buddhism and Oriental culture with distinguished visiting speakers such as Chogyam *Trungpa*, Robert **Aitken**, Nancy Wilson Ross; and also provided a base for poets, dancers, artists, social activists and sensory-awareness therapists); a Neighborhood Foundation (which was concerned with the community around the SFZC headquarters); and the Alaya Storehouse (a factory and retail shop for meditation supplies: mats, cushions, and so forth) (Tworkov, 230-31). Greens, a vegetarian restaurant that received glowing reviews in specialist magazines like *Gourmet*, was opened in San Francisco in 1979. Baker devoted himself to every little detail: decor, glassware, cutlery, plates, even the menus. And, like Green Gulch Farm and SFZC itself, it was very successful.

The money involved in all this was considerable. The Center's assets were worth about $25 million (Tworkov, 203) and the gross annual income was nearly $4 million (*Spring Wind*, vol. 5, no. 4, Winter 1985–86, p. 194).[1] This included $250,000 each (net) from Tassajara (where people paid for the use of the cabins during the guest season), the Bakery[2] and the Greengrocer, as well as about $350,000 from Greens. (All these figures from Baker himself.)

In hindsight, many people who were there throughout this period of expansion now see it as inherently unstable. According to Baker himself,

> I found myself landlord, mayor, administrator, entrepreneur, and fund-raiser, as well as abbot and teacher. This was too much power for me to have, and many people couldn't handle it over time. (Schneider, 136)

He now says that 'employer' should be added to this list—and that this role, above all, was problematic for the people at SFZC. Expansion can be intoxicating but it can also be confusing. According to commentators whose work I respect (Tworkov and Schneider), SFZC's businesses, and their success, distracted students from their primary concern: practice. The businesses "dazzled the public's eye" (Schneider, 135) and "thrust Zen Center into regional and sometimes national prominence" (ibid., 134). Tworkov refers to "glamorous cronies" and "Californian golden boys" (Tworkov, 235). Jerry Brown, governor of California from 1974 to 1982, was a frequent visitor to Greens. I do not know if it is fair to call him a Californian golden boy. But he was a personal friend of Baker's, thought highly of SFZC and appointed some of its students as advisors. "SFZC had a direct line to Sacramento" (Tworkov, 234).

Some or all of these assessments may be exaggerated.[3] I wasn't there. But there seems little doubt that many people at SFZC thought this way. So the question is: Why? This brings us right back to Baker Roshi; his role and what might be called his personal style. He was certainly committed. He worked hugely long hours—but he was there for practice in the morning even if he had gone to bed only two or three hours before. And, he says,

> I committed myself to those people [at SFZC] as deeply as to my own family. In many ways I sacrificed my personal family to the practice and development of the community. ('The Long Learning Curve', 36)

But strong commitment can be hard to live with. "After Suzuki-roshi's death, Baker-roshi did more than influence Zen Center's policy, as he had done; he now dictated it" (Schneider, 133). Even Suzuki Roshi had "his qualms about Baker doing things too much his own way" (Tworkov, 226). And: "an exacting administrator-in-chief, Baker was brilliant, impatient, and critical. Those working in close contact with him were enchanted, intimidated, and exhausted" (ibid., 230). Baker himself says, "Zen Center was designed around the upper limits of my particular abilities. It could not survive without me . . . And I overdid it" (ibid., 226–27).

This scenario—brilliant dynamic leader simultaneously inspires people and runs them into the ground—is relatively common in various walks of life: business, politics, theatre, the fashion world. It isn't so common in a Zen centre.

[1] *Spring Wind* is the magazine of the Zen Lotus Society; this information is taken from an article, 'Financing Western Buddhism'.

[2] No jokes please . . .

[3] Baker certainly thinks that the 'direct line to Sacramento' is. "It is the kind of thing people like to say but it is not true in any of the senses that phrase implies." He says that it could be taken to mean that SFZC, and himself in particular, were actively interested in political power. But they weren't.

And this brings a crucial element in the situation into focus: that Baker had been given Dharma transmission by Suzuki Roshi and was his spiritual heir and abbot of the community. In other words, he wasn't just a community leader but a teacher in a long-established Buddhist tradition. Baker himself is adamant that he never confused his two roles as head of SFZC and Suzuki Roshi's Dharma heir.

> If I had thought my authority to run Zen Center rested on something as personal as dharma transmission, I would have thought that was stupid. (Tworkov, 228)

Yet it appears that the vast majority of students *did* think that the two were linked. There is, I think, room for an interesting and informed debate about the relationship between them. But it never took place at SFZC during Baker's time there. Students thought that Baker had a special kind of authority because of his Dharma transmission. That is why his role in the community wasn't like that of a charismatic but perhaps over-demanding businessmen, politician, or theatre director. And it appears that nobody really got to grips with what was going on: not Baker himself, not the long-term students (whether his or Suzuki Roshi's), not the rank and file (if I can use that phrase). Despite everybody's efforts, beliefs, and ideals, the basis of the community just was not that solid.

Eventually things came to a head. In 1983, it became general knowledge in the community that Baker had fallen in love with a woman (whom he regarded as a friend but whom others thought was his student); that he had told his wife; that the woman had told her husband (also a friend of his); and that the husband was very unhappy about it. According to Schneider, this revelation "stunned most everybody" (Schneider, 138). Baker was charged with hypocrisy and many doubted his integrity as a teacher (ibid., 139).

The fall-out from this incident was considerable. And it is important for two reasons (which is why people should know about it). First, because of SFZC's high profile; its "unprecedented place in the history of Buddhist institutions" (Schneider, 132). Second, because of its intensity and bitterness, which still continues, somewhat muted, over a decade later.

There is no consensus as to the facts of the matter. Certainly, the Board of Directors acted against Baker for the first time, asking him not to teach; and a large number of students pointedly rejected him (Schneider, 144). The main charge was that he had operated a double standard. More specifically, first, that he had not acted in accordance with his own teachings on sexual morality—that he had said, amongst other things, that one should not set a bad example to the *sangha* but people thought that he had done just that; and secondly, that whereas he had a white BMW for his use, and his daughter had received $10,000 to go to college, nobody else came anywhere near being considered for such perks.

He denies the first charge outright. But he does now accept that he created the impression of applying a double standard; and perhaps more importantly, he acknowledges that his life did not have the transparency or impeccability that his position required. He also says that the BMW was probably a mistake. As for the stipend for his daughter, he says this has been misunderstood. There was only one other child at SFZC who was old enough to go to college and who had parents who had been in the community long enough (and working long enough) to qualify for financial help for her studies—and she had decided to put off going to college. And he stresses that neither of these matters—the car, the bursary—can in themselves explain the virulent hostility that was unleashed against him.

Attempts were made to keep the situation in hand. Robert **Aitken**, who was asked for his advice, made three recommendations: that Baker work alongside other students; that he take psychotherapy; and that he study with other teachers (Schneider, 147). Thich Nhat Hanh, whom Baker visited in France in an attempt to get his bearings, wrote a letter saying that

> Zentatsu Richard Baker has a tremendous capacity of becoming one of the most illustrious Buddhist leaders of our time, if only all of us could correctly help and support him. To me, he embodies very much the future of Buddhism in the West with his creative intelligence and his aliveness. I am positive Zentatsu is now worth our trust and I completely invest my trust in him. (Schneider, 145)

Baker also wrote a handsome letter of apology:

> [W]hen I think of the extraordinary effort and intelligence all of you have put into making Zen Center such a wonderful place of refuge and help to so many people, I am ashamed of my unmindful, imperious and busy manner which often prevented me from hearing your heartfelt concerns and criticisms over the years . . .
> To this day I remain overwhelmed and humiliated by the irresponsibility and insensitivity of my actions that have so seriously threatened the existence of our wonderful Zen Center and cast such a shadow over the hope and trust that Suzuki-roshi placed in me. (Schneider, 146)

But the rift was too deep to heal and Baker resigned. He left SFZC and has never returned (though he was present at Hartford Zen Center, an outreach of SFZC, for ceremonies involving Issan **Dorsey**). He was succeeded as abbot by Roshi Reb **Anderson**.

What are we to make of this episode? It does not appear as if it can simply be explained as a series of mistakes that, taken all together, were too much for people to handle. Rather, it was as if the students (or the majority of them) felt as if the driver of a fast car had rolled it over—with them inside it. So it was no use the driver saying that he would do better next time; they just did not want to commit themselves into his hands again.

Baker himself believes that resolving the matter with those who were involved in it is far more important than any public discussion of it in a few paragraphs in a book like this. I can understand his position but the fact remains that SFZC is part of a larger-scale phenomenon—and so is he.

There are a number of issues that we need to be clear about. The journal of SFZC, *Wind Bell*, put these succinctly: that there should be no deception in relationships and no harming of others, and that a spiritual teacher should set a good example to others (quoted in Fields, 364). If these principles are violated, then the spiritual life is inevitably compromised, particularly the trust that has to exist between teacher and student.

It is the nature of spiritual authority that is at stake here. Zen rests four-square on the understanding that the teacher has an insight that he uses to benefit others—ultimately, so that they can have this insight themselves. All Zen teachers, both Eastern and Western, make this claim. What is more, they link it to the Buddha himself: the enlightenment he attained has been transmitted from him right down to the present day. What, then, are the implications when someone who stands in this lineage behaves in a way that his own students will not accept?

Members of SFZC acknowledged that they had in a sense colluded with Baker by allowing him to become isolated from the community and by acquiescing to his wishes even when they felt he was wrong. (See for example

Tworkov, 243-44.) People said and did things because they did not want to appear out of place. Imitation of what one does not understand is simply ignorance; and the spiritual life cannot be followed under such conditions. Of course, imitative behaviour can occur even around an unimpeachable teacher but at least he will not encourage it. But if they are imitating the teacher's strengths without seeing his weaknesses, and if he himself does not see his weaknesses, then there is ignorance all round.[4]

This is a complex issue but not an uncommon one. At about the same time as the SFZC debacle, a number of other Zen teachers—including Japanese *roshis*—were also discovered to be acting against the Buddhist precepts by indulging in sexual liaisons, drunkenness and luxurious living. Philip **Kapleau**, commenting on these incidents, made a distinction between a *roshi* and a master ('Abuses of Power and the Precepts', *Zen Bow Newsletter*, vol. VI, nos. 2 and 3, Summer–Fall 1984; quoted in Fields, 365). A *roshi* is one who has had *kensho* and been appointed as a teacher. A master is one who has removed his defilements—that is, he lives within the precepts effortlessly and naturally and not as a matter of restraint.[5]

This, of course, raises questions concerning *kensho* (seeing into one's own nature, which is Buddha-nature) and enlightenment, for if we accept Kapleau's distinction then it seems to follow that it is possible to have genuine spiritual experiences and still act improperly. If this is so, then what is the value of *kensho*? I do not mean that it has no value—only that it has to be put in the larger context of human relations. And it may be that *kensho* (which some people call enlightenment even if it isn't full enlightenment) does not in itself confer any real wisdom about what it is to be human, or any real compassion either. In other words, there may be a real insight into the human *condition* (in the large) which is essentially unconnected with *being* human (in particular). That's why the traditionalists say the precepts are important: they *are* based on a wise and compassionate insight into human relations, and when they are broken it is other people who suffer. A good case can be made, therefore, for saying that *kensho* without the precepts is not worth as much as people think. It may even be dangerous.

And this argument is not restricted to Zen, of course. The more general version of it is that true spiritual knowledge cannot be divorced from acknowledgement of one's duties to others. Another way of putting the issue is in terms of realization and actualization. Realization, in Zen terms, is *kensho*. And some who were close to Baker Roshi are unequivocal in their assertion that he had attained it; one person even refers to him, in his capacity as a practicing meditator, as "a non-ego being" (Tworkov, 232). But it does seem that he fell down in his actualization—that is, his ability to live out his realization in his life, and in particular in his relationships with others (which is what counts the most, after all).

[4] This last sentence is Baker's own—the result of him and me trying to give an account of what happened that is true to his understanding and my concern for the larger issues. I do not take what a teacher says without looking at it very carefully. But in this instance I think Baker has put it exactly right.

[5] Reb **Anderson** made a somewhat different but related distinction—between a master and an abbot: "Zen masters do not have to know others' subjectivities and feelings. Abbots do. Zen masters are not necessarily leaders of spiritual communities. Abbots are. So abbots have to understand the hearts and minds of the community. They must learn to see through the eyes of the community and hear through the ears of the community. Abbots are a subset among Zen masters. A Zen master does not have to be an exemplary model for a community. An Abbot does. A Zen master can be quite eccentric. An abbot cannot" (Tworkov, 246).

This is a complex issue that I cannot go into here. (I do in Chapter 3.) There are teachers who say, like Lee **Lozowick**, "ultimately you can get the teaching even through a flawed teacher."[6] This may explain why he says of Baker: "Still love the way you skewered those S.F. bums." Then there are those, like Andrew **Cohen**, who hold the opposite view: "If you can't live what you have experienced, then you haven't realized it." (**Lozowick** and **Cohen** are friends and discuss this issue regularly; it is out of such encounters that the new vocabulary of the spiritual life will evolve.)

There is also a cultural-cum-historical side to the issue. It is certainly true that in the transmission of Zen to the West, it was the Japanese teacher's *role* that was considered important by Westerners. But one of the reasons for this was that it is always difficult to relate to someone from another culture—and Japanese and Western culture are very different. It was inevitable, therefore, that Westerners understood Japanese teachers—as human beings—on a rather superficial level. The position of Western teachers, on the other hand, was the exact opposite. It was relatively easy to understand them as personalities but their role was suspect because they were not Japanese. (And to counteract this, there was a tendency to make their appointment as teachers *very* Japanese; Baker is a case in point.) Consequently, Japanese teachers were considered 'genuine' because of their realization and questions weren't asked about their actualization—after all, how do you tell if a Japanese in Los Angeles or New York is 'really' living Zen? It was only when Westerners became teachers that the question 'He or she may have realization but can he or she live it?' was seen as central. This is an instance of the West coming of age in its understanding of Eastern traditions (since these remarks are not restricted to Zen but apply to all the traditions).

Baker still has hopes that the rift with SFZC can be healed. Meanwhile, he has continued to teach and I would like to close by looking at his teaching over the last 13 years. In 1984, he moved to New Mexico and started the Dharma Sangha with half a dozen students who followed him from SFZC. It has since moved to Crestone, a small remote town in the mountains in Colorado, with 50 inhabitants and 60 miles from the nearest grocery store. The Crestone Mountain Zen Center is a decidedly low-key project compared with SFZC (eight residential students; 20 to 30 for the three-month practice periods; 24 to 40 for *sesshins*; about a hundred who consider it their primary place for practice; perhaps 2,000 visitors per year; by contrast, SFZC's mailing list was about 12,000). He is also head teacher of a somewhat larger community in Germany, a branch of the Dharma Sangha (whose headquarters is Johanneshof, formerly part of Graf von **Dürckheim**'s centre—Dürckheim used to send Baker students), though there are only about seven full-time resident students.

In addition to his teaching duties, he continues to give Dharma transmission—most recently (in 1987) to Philip Whalen, the poet and long-time Zen student (he is Warren Coughlin in Kerouac's *The Dharma Bums*) who has been a student of Baker's for over 20 years; and (in 1989) to Issan **Dorsey**, head of the Hartford Street Zen Center in San Francisco, which he and Baker established for the gay community in 1981.

[6] He was not referring to Baker when he said this and I do not mean to imply that he thinks that Baker is flawed. My point is simply that there is a view which separates 'insight' or even enlightenment itself from the vehicle or person who provides it.

Baker gives many talks, and people who know him say that he is an original and gifted speaker, but he is not a very prolific writer. Maybe this is because, as he says himself,

> I'm pretty traditional . . . Yogic insights are the root of Buddhist attitudes and practice . . . I'm not interested in adaptation but rather in greater accessibility to practice. ('The Long Learning Curve', 34)

In fact, he has many stimulating ideas concerning the ways in which Buddhism is entering Western culture.

> Contemporary science, philosophy and art are functioning, unintentionally, as disguised forms of Buddhism—in effect, giving us permission to accept Buddhism and to some extent preparing us to understand it. They are also fertilizing Buddhist thought and practice. ('The Long Learning Curve', 32)

And, no doubt drawing on his own experience, he also has some interesting things to say about the teacher-disciple relationship.

> I believe that there is an ancient, deeply rooted urge to find a teacher or mentor. But mentorship is rare and fragile if there is no societal tradition to support it—and there is little of this tradition in the West. ('The Teacher and the Western "Self"', 42)

He says that Westerners tend to have unrealistic expectations of a teacher, projecting a God-like supra-identity on to him or her, asking him or her to be the missing link in the completing of our own self. There *is* work to be done on the conventional self—what he calls our 'personal story'—and Buddhism is badly taught when it does not recognize that Westerners have this need ('The Long Learning Curve', 33). (Part of the problem at SFZC was that Baker advised students on personal matters—relationships, business matters, and so on—which they then took to be teachings; though he himself says that he never intended his advice to be taken that way.)

However, being traditional, he emphasizes that the teacher-disciple relationship is fundamentally an unequal one.

> But it is an essential condition for the flow of understanding and teaching from past to future, and from generation to generation . . . Intimacy, connectedness, nondual vision, and a kind of elixir-like flow of a larger identity, are not just ideas or imagined realities, but the actual experience of the teacher-disciple relationship. (The Teacher and the Western "Self"', 46)

And I think it is true to say that he had this experience with his own teacher, Suzuki Roshi, and that he has tried to live up to this ideal himself.

Of course, the shadow of the SFZC is still there; a quarrel of this scale that has continued for well over a decade is no small matter. But Baker Roshi has a teaching about *karma*, delivered in his usual distinctive way, that can be applied to it.

> Karma is not understood or experienced as being stored in some container called the unconscious. It is stored in the same processes (and in relation to the same processes) that created it and thus we most effectively access it through those processes . . . Feeling feels feeling. It is feeling that recovers the memories of feeling—as they are stored primarily in the field of feeling itself, and not in thinking. Likewise, within each sense-field (hearing, seeing, touching, tasting, smelling, mentality), there is memory and knowing and the recovery of memory . . . All these words (thinking, perceiving, feeling, knowing) overlap so much in their common usage, that I ask you to just accept that these can be quite independent, own-organizing realms.

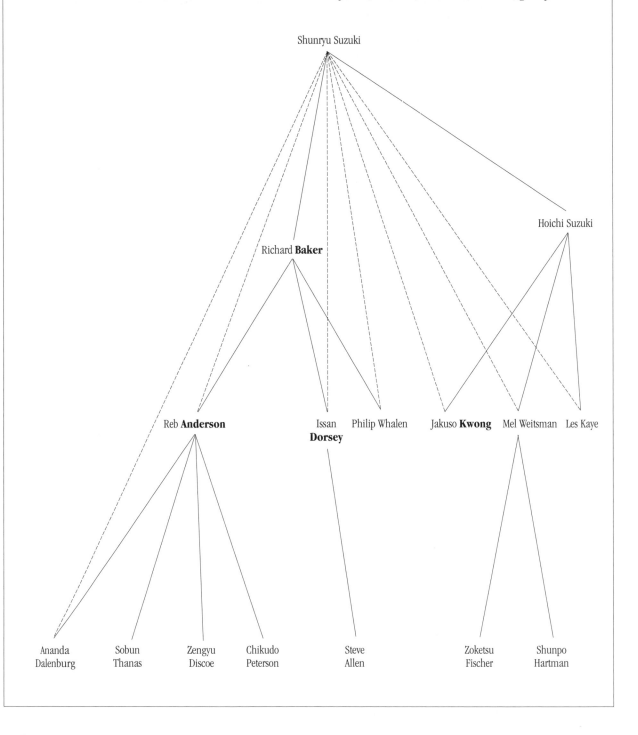

LINEAGE TREE 1

Western teachers in the Shunryu Suzuki line

(The names are inconsistent; sometimes I give their 'Christian' name, sometimes their Zen name)

N. B. Hoichi Suzuki is Shunryn Suzuki's son. All these people are men apart from Thanas and Hartman. Whalen succeeded Allen as Roshi of the Hartford ZC.

Unbroken line means 'received Dharma transmission from'; broken line means 'was taught by'.

Shunryu Suzuki

Hoichi Suzuki

Richard **Baker**

Reb **Anderson**

Issan **Dorsey**

Philip Whalen

Jakuso **Kwong**

Mel Weitsman

Les Kaye

Ananda Dalenburg

Sobun Thanas

Zengyu Discoe

Chikudo Peterson

Steve Allen

Zoketsu Fischer

Shunpo Hartman

The 'texts' of karma are found in physical, perceptual and mental processes, and in their possible inter-relationships. Karma is stored as a subtext of body, speech and mind . . . of the six sense-fields, and in our interactions with the phenomena and situations of the world. ('Serving and Observing Karma')

This is fairly technical, I admit, but it is firmly based on traditional Buddhist teachings. And the essential idea is plain: we are not caught, helplessly, by our circumstances or ourselves but, simply by being alive, have access to the forces that have shaped our lives.

The Second Noble Truth—everything has a cause and an effect—means that we have a choice and hence a responsibility . . . If the effect was not good, we try not to repeat it and try to become a person who doesn't repeat it. It is commonsense and it is difficult. (ibid.)

So while the shadow of SFZC still exists, it can be approached, according to Buddhist teaching as Baker Roshi presents it, in such a way that it can be resolved. He has every intention of doing just that.

Primary sources: R. Baker, *Original Mind: The Practice of Zen in the West*, to be published by Putnam, Riverside Press in 1997; 'The Long Learning Curve: an interview with Richard Baker Roshi', *Tricycle*, Winter 1994, pp. 30–36; Richard Baker-Roshi, 'The Teacher and the Western "Self"', *Shambhala Sun*, May 1995, pp. 42–46; 'Serving and Observing Karma', *Tree Planters: Zeitschrift des Dharma Sangha Europe*, no. 15, January 1997, pp. 3–8

Secondary sources: Helen Tworkov, *Zen in America* (Berkeley: North Point Press, 1989); R. Fields, *How the Swans Came to the Lake: A Narrative History of Buddhism in America* (Boston, 1986: 1st ed); D. Schneider, *Street Zen: The Life and Work of Issan Dorsey* (Shambhala, 1993) Chapter 9; Katy Butler, 'Events Are the Teacher: Working Through the Crisis at San Francisco Zen Center', *Co-Evolution Quarterly*, no. 40, Winter 1983, pp. 112–123

Centre: Crestone Mountain Zen Center, Box 130, Crestone, CO 81131; Dharma Sangha Europe, Quellenweg 4, D-79737 Herrischried, Germany

COMPARE:

Other Zen teachers: Robert **Aitken**, Reb **Anderson**, Jan **Bays**, Joko **Beck**, Issan **Dorsey**, Gesshin **Prabhasa Dharma**, Zen Master Don **Gilbert**, Bernard **Glassman**, Philip **Kapleau**, Jiyu **Kennett**, Dharma Teacher Linda **Klevnick**, John **Loori**, Dennis **Merzel**, Irmgard **Schloegl**, Walter **Nowick**, Dharma Teacher Bobby **Rhodes**, Ruth Fuller **Sasaki**, Maurine **Stuart**, Zen Master **Tundra Wind**

Michael BARNETT

Former follower of Bhagwan Rajneesh/Osho who has gone on to become an independent teacher

Barnett was born in the East End of London in 1930. His father was a bookmaker. But he quickly made his way in the world. He went to Cambridge University and got a first-class degree in Maths and Law. Afterwards, he went into business for a while and then went travelling in the East, and visited several Japanese temples. Back in London, in 1967, he met R.D. Laing, the innovatory and idiosyncratic psychiatrist, and was greatly influenced by him. Although not medically trained, Barnett worked with the so-called mentally ill and set up an organization called People Not Psychiatry, described as a lay, self-help and psychotherapeutic network (*Energy and Transformation*, 9).

He also became one of the leaders of the psychotherapy movement that was developing in London at the time. Yet despite his commitment, he felt there was something missing.

> This intuition that encounter groups were limited just came to me—and I remember the exact occasion when it crystallized. It was in a 48 hour marathon. At about the 47th hour I suddenly went very quiet, very silent, not saying anything for about half an hour or so—and then I heard myself saying: "I've decided to stop leading groups because I have decided to become enlightened in this lifetime." Of course I see now what a joke it was, because *one* never becomes enlightened—but still, I was trying to express in ego terms the feeling that somehow it was 'the jackpot or nothing'. So I tailed off my groups. And I went to Bhagwan. (*Energy and Transformation*, 16)

This was in 1974 and the place he went to was Bhagwan Rajneesh's ashram in Poone/Pune. Barnett became a *sannyasin* (a term which Rajneesh used for his followers preciscly because it was the *opposite* of the celibate, unattached ideal that is traditionally associated with it) and was given the name, Swami Ananda Somendra. He stayed for a year, during which he helped to edit Bhagwan's books, and then went back to London. He continued with his psychotherapy groups but now there was an extra element: "something unfathomable, some other quality was there, and obviously it must have come from where I had been, from whom I had been with" (*Energy and Transformation*, 17). Many people became followers of Bhagwan as a result.

His work has always been focused on 'energy'—something that by its very nature is difficult to conceptualize or put into words. But people try anyway.

> Do you have energy? Do you use it? What is its flavour, its taste? no, no . . . don't think about it. Sit, shut your eyes. Go inside and feel the space where it is available to you. Watch it, feel it, savour it. See that it has nothing to do with your thoughts, your desires, your goals. It has nothing to do with anything but here and now. (*Energy and Transformation*, 8)

Somendra (as he was called then) says that "I can see energy like some people can read a palm" (*Energy and Transformation*, 71).

> If someone rings a tuning fork of a certain pitch, other tuning forks in the room will vibrate the same . . . This is resonance. The real meaning of being stoned . . . human alchemy. (*Energy and Transformation*, 69)

He compares it with *satsang*, "sitting with the Master", and with Zen's 'transmission beyond words' (ibid., 68). And in his case it started with his own Master, Bhagwan Rajneesh, for whom he is a channel (ibid., 37).

> Bhagwan said recently, "Everything that has happened to Somendra happened through his connection with me." I agree. I am the seed and he is the soil, the fertilizer, the gardener. Now in a way the capacity to work the way I am doing was always innate in me, obviously. But it's true that it only flowered through Bhagwan. I owe everything to him. He is transforming me. I was doing energy work before I went to Bhagwan, but the intensity and the depth and the fire and the potency of the work would be nothing like it is now if it hadn't been for Bhagwan. He allows me to do his work, in a way. (*Energy and Transformation*, 66)

He was saying all this in 1980 (the date of the talks and interviews in *Energy and Transformation*). But there is a hint that a new realization was beginning to develop in him. He says that sometimes he would 'disappear'

> and just love [is] left. This is what Bhagwan and all the Masters have said. So far I've had to take it on trust, but now I'm beautifully beginning to experience it, and it's

such a joy to see that almost everybody I meet these days I feel love for—not because they are this or that, or because they are God's creatures or some abstract idea like that, but because that's what I feel welling up in me when I'm with them. (*Energy and Transformation,* 46)

Bearing these indications in mind, it is perhaps not such a surprise that just a few years later—and while Bhagwan was still alive (he died in 1991)—Somendra stopped being a *sannyasin*, reverted to his original name, and started teaching as himself rather than as a channel for someone else.

[I]t is my statement—it is a grandiose statement to make but I make it, and I could not make it unless I felt it was true; it would be impossible—that I *know* that this place that I'm working from and trying to bring people towards, *is* a space which *is* the next stage of evolution; that that place is *available* to me.

It is not that I am in it totally, and that everything I do is super-duper human—I am not claiming that. But I'm saying that I'm in touch with the place that the human race is going to move to; and that out of that, I am devising ways every day of bringing others to that place . . .

. . . I'm constantly putting out the *energy* of that evolutionary state—because every state has a certain kind of energy at its centre—and hoping that that will cause, eventually in you, a resonance . . . (*The Greatest Teaching There Is,* 159, 160)

He says that while there are elements of the old master-disciple and teacher/student relationship in what he does (ibid., 159), his way is essentially different.[1]

It isn't a question of being open to me—it is a question of being *open*. When you are open you are open to me. If you are open to me but not open, it's not worth so very much. Because you don't know what it is to be open to me—you're only open to your idea of me. Maybe you like me as a person, and you're open to that. That will help, but that's not the openness I am talking about. (*The Greatest Teaching There Is,* 173)

Yet at the same time, the claim is made that he himself embodies or manifests this 'energy of the evolutionary state'. A woman at one of his sessions told him

that I've seen everything that you have done this weekend, and everything you have said this weekend, and everything you have been this weekend, has been full of love. Everything! And she said: This has knocked me out. And I said to her: You have good eyesight. Better eyesight than almost anybody else I know.

Because it is true. It is not a boast, it is true. Because when you're in this dimension it is a natural thing, it is not anything to be proud of. It is not anything to claim, it is just *the case*. You have nothing to get.

You are feeling in God's arms. You are feeling in some kind of quiet state of ecstasy. And all that you can do is to express this, and . . . it is experienced by anyone who is open as love. It is a by-product. It is not something that you aim for—as I understand it, and as I have approached it. (*The Greatest Teaching There Is,* 171)

The Greatest Teaching There Is was originally going to be called *The Buddha Talks*, the Buddha being Michael Barnett, of course. According to the

[1] In fact, he is critical of utter submission to a teacher:

[Bhagwan] says some things which are completely idiotic: California is going to fall into the sea! From the very beginning I was stunned sometimes by what he said; it seemed so narrowminded, so lacking in vision and wisdom. I couldn't possibly agree with some of the things that he said.

And Jesus said many beautiful things, but he was also a bit of a fool. All the enlightened masters are fools in some ways. So what is the seeker to do about that? You cannot follow anybody so totally. (*The Greatest Teaching There Is,* 66)

Introduction, the term 'Buddha' is not limited to the individual known to history but "is a title referring to anyone who has attained that particular, elusive state of being of which Gautama the Buddha is the most famous expression" (*The Greatest Teaching There Is,* 39).

> It's never been safe to say you have some intimate experience of the divine, or the ground of all being, or the cosmos—at least not when you're alive. Later, safely dead, you can be seen as superhuman or spiritual; the human contours smoothed, preferably obliterated.
>
> The challenge is that if someone just like us can reach these levels, then why can't we? The very existence of the light which shines through Michael Barnett is a provocation . . . Where do we stand in relation to the light, the silence, the joy, which are present in this ordinary man?
>
> And that, simply, is what his work is about and what this book is about. He says: I have found this. I am no different from you. So what is stopping you? (*The Greatest Teaching There Is,* 39)

Actually, Barnett is not quite like other men: he initiates people and gives them new names (for instance Maitri, Han Shan). He has a company, The Wild Goose Company (headquarters in Zurich), which makes his teaching available (sessions, groups, books, and so forth). Since 1993, he has been living on a large estate in France together with a community of over 100 people (including 20 children). When I sent him this entry, his main comment was that it devoted too much space to the past (especially his years with Rajneesh). Hence I finish with an extract from a section entitled 'Divine and Ordinary People' from his latest book.

> The sage sits in the room without moving, without acting, and influences everything. Because at the level of dynamic stillness and presence, one is connected with all things. Just the beat of one's heart is communicated to all things, on that level. The presence of one's life-being is an element of the heart of the universe that is continuously beating, beyond all individual beats of individual hearts. (*The Goose Is Out!* 39)

So the claim is being made that it is possible to live like this: according to love, to be enlightened, to be a Taoist sage, right here and now, and that Michael Barnett, ordinary or not, is doing it.

Primary sources: Swami Ananda Somendra, *Energy and Transformation,* (London: Alchemy International Inc, 1980); Michael Barnett, *The Greatest Teaching There Is,* (Zurich: Cosmic Energy Connections, 1987); *The Goose Is Out!: First Talks from Energy World,* (Verneuil Moustiers [France]: Cosmic Energy Connections, 1994)

Secondary sources: None

Centre: Energy World, F-87360 Verneuil Moustiers, France

COMPARE:

Other teachers who say that they are ushering in the next stage of evolution: Andrew **Cohen**, Barry **Long**, the **Mother**

Bays started practising with *Maezumi* Roshi at the Zen Center of Los Angeles in 1973. She took the precepts in 1975 and was ordained in 1979—while continuing to bring up her three children. (See the Glossary for the *precepts* and *ordination*.) She had an intense drive to practice as fully as possible in the traditional way; and *Maezumi* recognized this and was willing to adapt the tradition to suit her circumstances. (If he hadn't, she would have had to have waited until her children were grown up and independent—which is what mothers do in Japan.) She became his fourth Dharma heir in 1983.

But in this same year, it became known that she and *Maezumi* had been having an affair (though I don't know how long this had been going on). Naturally, this shocked a lot of people. Bays's explanation of it is that she and *Maezumi* had become so intimate, spiritually and psychically, that it seemed a small step for their relationship to become sexual as well.

> In serious Zen study, the teacher and student meet alone in the interview room several times a week for ten years or more, in the most intense and intimate study imaginable . . . The teacher continually strips away anything the student is clinging to, using any technique that works. The process is frightening, exhilarating, frustrating, horrible, and wonderful. The student and teacher become extremely close during this process, like people who have been through a war together. I think it's no wonder that this closeness sometimes takes a physical form, not that it *should*, but it does. (Boucher, 216–17)

In fact, she says, the sexual aspect was very minor. "It was a very profound . . . relationship. And it taught me a lot about love" (Boucher, 218). It seems evident, therefore, that she does not regard the affair in itself as having been harmful to her spiritual life, and she still regards *Maezumi* as her teacher. (Barbara **Rhodes** says much the same thing under much the same circumstances.)[1]

As a result of the difficulties that arose in ZCLA after her relationship with *Maezumi* became public, she moved to Oregon (in 1984) and lived very quietly with her family. To begin with, she did not teach at all but she is now leader of a small group in Portland, which is described as "traditionally, but not officially, associated with ZCLA" (D. Morreale, *Buddhist America: Centers, Retreats, Practices* [Santa Fe, New Mexico, 1988], p. 169). Her teaching is low-key and exploratory. We have many different roles—woman, mother, meditator—but they are all changing. Relatively speaking, all these parts are us; but from the absolute point of view, none of them are. None can be denied (which we sometimes do by rejecting those roles that we don't like); but none of them define us, either (which it is easy to forget). So what is the solution? Don't hold on and don't exclude—the Buddha's middle way practised in the midst of everyday life (Sidor, 36).

(*See* Lineage Tree 4)

[1] And it should be pointed out that, despite this incident and *Maezumi* Roshi's occasional yet heavy drinking, all his Dharma heirs (with the exception of Joko **Beck**) have stood by him, even though they are critical of his behaviour. There is an important principle here—namely, that someone can be a great giver and still have great weaknesses.

Primary sources: 'Taking Realization into Everyday Life' in Ellen Sidor (ed.), *A Gathering of Spirit: Women Teaching in American Buddhism*, (Cumberland, Rhode Island: Primary Point Press, 1987), 34–38.

Secondary sources: Sandy Boucher, *Turning the Wheel: American Women Creating the New Buddhism*, (San Francisco: Harper and Row, 1988), pp. 214–20, 328–29.

Centre: Zen Community of Oregon, 6323 SE 22nd Street, Portland, OR 97201, U.S.A.

COMPARE:

Other Dharma-heirs of Maezumi Roshi: Bernard **Glassman**, Dennis **Merzel**, Joko **Beck**, John **Loori**

Other women teachers in Zen: Joko **Beck**; Gesshin **Prabhasa Dharma** (Rinzai/Vietnamese); Ruth Fuller **Sasaki**, Maurine **Stuart** (both Rinzai); Jiyu **Kennett** (Soto)

Other women teachers in Buddhism: Tulku **Ahkon Norbu Lhamo** (Nyingma); Freda **Bedi**, **Pema Chodron** (both Kagyu); Ruth **Denison**, Sharon **Salzberg** (both *vipassana*); Rev. **Dharmapali**, **Miao Kwang Sudharma** (both 'eclectic'); Ayya **Khema** (Theravadin); Joanna **Macy**, Jacqueline **Mandell** (both independent)

Charlotte Joko BECK

One of Maezumi Roshi's Dharma-heirs who has gone independent

Charlotte Beck was in her 40s, when, in 1965, she attended a talk at the San Diego Unitarian Church given by Taisen *Maezumi* (then a *sensei* but later a *roshi*) from the Zen Center of Los Angeles. She was struck by what she calls his imperturbability and began to practice with him. She also practiced with *Yasutani* Roshi in northern California and with Nakagawa Soen Roshi, with whom she passed the *koan Mu* (though I don't know when) (Friedman, 117). In 1978, after more than a decade's practice, she became *Maezumi* Roshi's third Dharma heir. (Bernard **Glassman** and Dennis **Merzel** were the first two.) In 1983, she left ZCLA and started her own centre in San Diego. This was at the same time that it became known that *Maezumi* had had a number of affairs with female students and had also entered a dry-out clinic for alcoholics, and though she never mentions these incidents, they can hardly have been irrelevant to her decision to function as an independent teacher.

Both Beck's teaching and her teaching style are concerned with the everyday rather than the special (since the two are not essentially separate). She uses no Zen title and gave up wearing robes in 1984. She describes Dharma transmission as "no big deal" (Friedman, 118) and is doubtful of the significance of intense practice and intense experience. Her understanding of *koan* practice, for example, is very untraditional: that it is the student's re-creation, for the teacher, of moments of his life, but in such a way that the student can see through the ego structure that bound him to those moments.

> I think it started out this way before it became a very formalized and almost dead system . . . Mu is simply this life itself, right here, right now . . . As [the student] wrestles and struggles with the koan, he journeys through all parts of himself in attempting to solve it. And for some people this works. But more and more when I hear stories about the ancient monasteries, I wonder. They had a thousand monks sometimes, you hear about the star who 'did it'—but they don't tell you much about the other 999. I'm sure a lot of them didn't know what on earth they were doing . . . Now, my students pass Mu too, but a lot of them have never even heard the word! And still they pass it. (Friedman, 128, 115)

Nothing is sacred—meaning that nothing should be left unexamined. And that includes the teacher. We may need a teacher's greater experience but that is not the same thing as blind faith that the teacher knows something that we do not. This kind of idealization is actually sentimentality and "spells trouble for everyone—it's always up to us" (Friedman, 125). Similarly, she is quite prepared to make use of non-Zen practices like *vipassana* if she thinks it will help a student. And she approved of the replacement of a Buddha statue on the altar with a piece of uncut stone that only vaguely suggests a Buddha figure. Why? Because the change arose out of truly looking at what helps, and what does not help, practice—and by that she means experiencing life directly, with nothing taken away and nothing added. Attachment to tradition or to innovation for their own sake is actually contrary to this basic practice—which is why both strategies have to be abandoned. But then all 'life strategies' have to be abandoned because they are unnecessary and don't work. What might be called 'Zen strategies' are no exception to this.

<div style="margin-left:2em">*Cf. Toni **Packer** on 'seeing'.*</div>

(*See* Lineage Tree 4)

Primary source: Charlotte Joko Beck, *Everyday Zen: Love and Work* (San Francisco, 1989)

Secondary source: Leonore Friedman, *Meetings with Remarkable Women* (Shambhala, 1987)

Centre: Zen Center of San Diego, 2047 Felspar Street, San Diego, CA 92109

COMPARE:

Other Dharma-heirs of Maezumi Roshi: Bernard **Glassman**, Dennis **Merzel**, Jan **Bays**, John **Loori**

Other women teachers in Zen: Jan **Bays**; Gesshin **Prabhasa Dharma** (Rinzai/ Vietnamese); Jiyu **Kennett** (Soto); Ruth Fuller **Sasaki**, Maurine **Stuart** (both Rinzai)

Other women teachers in Buddhism: Tulku **Ahkon Norbu Lhamo** (Nyingma); Freda **Bedi, Pema Chodron** (Kagyu); Ruth **Denison**, Sharon **Salzberg** (*vipassana*); Rev. **Dharmapali, Miao Kwang Sudharma**/Alexa Roy ('eclectic'); Ayya **Khema** (Theravada); Joanna **Macy, Jacqueline Mandell** (both independent)

FREDA BEDI | SISTER PALMO | GELONGMA KARMA KECHOG PALMO

<div style="margin-left:2em">Englishwoman who came across Tibetan Buddhism while living in India; the first Western 'nun' in the Tibetan tradition</div>

A very unusual woman who crossed many boundaries. She was born in Austria in 1911 but educated in England. She then married a Sikh and, sometime in the 1930s went to live in India, where she spent the rest of her life. She combined social activism with meditation. She took part in the national independence movement and spent a short time in detention with her children after being arrested along with Gandhi as a *satyagrahi*. (Her husband, Baba Bedi, spent 15 years in prison for his activities in the struggle for independence (Fields, 278).) In 1952 she went to Rangoon and practised *vipassana* with Mahasi Sayadaw (Friedman, 276), one of the first Westerners to do so. She also practised with Sayadaw U Titthila (Snelling, 321).

Then in 1959, when the Dalai Lama arrived in India along with thousands of Tibetans, Nehru asked Bedi to help settle them and put her in charge of the Social Welfare Board (Snelling, 321). She was very drawn to Tibetan Buddhism and spent the rest of her life as a social leader and, simultaneously, as a prac-

titioner in the Kagyu school under the direct guidance of the Karmapa. But she was not sectarian and was happy to be the principal of a school for young *tulkus* (Chogyam *Trungpa* was spiritual advisor) which the Dalai Lama established in Delhi (Fields, 278). In 1963, together with Lama Karma Thinley Rinpoche and under the supervision of the Karmapa, she helped to found the Karma Drubgyud Darje Ling nunnery for Tibetan women in northern India ('Women in Buddhism', *Spring Wind* [the magazine of the Zen Lotus Society], no. 6, no. 1, 2, 3, 1986, p. 246; this date may be wrong however: some sources say that she helped set up the nunnery after her ordination in 1966).

The *tulkus'* school did not last very long, and when it was disbanded, Bedi went to Rumtek in Sikkim, where the Karmapa had established his headquarters. In 1966, she took *sramaneri* ordination (which is as far as Tibetan Buddhism goes, since it never had the full *bhikshuni* ordination, so strictly speaking there are no nuns/*bhikshunis* in the tradition) by the Karmapa, and was given the name Gelongma Karma Kechog Palmo (usually known simply as Sister [= Gelongma] Palmo). She was the first Western woman, to my knowledge, to take ordination in Tibetan Buddhism. In 1972, five years before she died, she did take full *bhikshuni* ordination in Hong Hong (Snelling, 321). She accompanied the Karmapa on his first visit to the West in 1974. In 1971, a collection of invocations that she had written was published by Lama Anagarika **Govinda**'s Arya Maitreya Mandala in Germany under the title, *Ein Rosenkranz von Morgengebeten der Tradition des Mahayana-Buddhismus.* She died in Sikkim in 1977, aged 66.

Sister Palmo was uniquely influential, in a quiet way, in Western Tibetan Buddhism. She lived in India and was in contact with the Tibetans from the moment they arrived, helping them in ways that no other Westerner could. And I think it is fair to say that she was wasn't just a pupil but also a teacher. The Karmapa was her guru but other Western women such as Joanna **Macy** and **Pema Chodron** were greatly helped by her: **Macy** calls Sister Palmo her first Dharma teacher, who introduced her to meditation (Friedman, 276); and **Pema Chodron** took her advice when seeking her own ordination (Friedman, 96). She also had pupils in India: one of them, Anila Pema Zangmo (whose nationality I do not know), is carrying on Sister Palmo's work at the Karma Drubgyud Darje Ling nunnery ('Women in Buddhism', *Spring Wind,* 246).

(*See* Lineage Trees 9,10)

Primary source: Ein Rosenkranz . . . (see above).

Secondary sources: Stray remarks in Friedman, *Meetings with Remarkable Women* and Fields, *How the Swans Came to the Lake*; a short biography in Snelling, *Buddhist Handbook*

Centre: None

COMPARE:

Other women teachers in Tibetan Buddhism: Tulku **Ahkon Norbu Lhamo**, **Pema Chodron**

Men teachers in Tibetan Buddhism: **Ngakpa Chogyam**, Lama Anagarika **Govinda**, **Jampa Thaye**, Archbishop **Tennisons**; Western *tulkus*

Other women teachers in other Buddhist traditions: Jan **Bays**, Joko **Beck**, Ruth **Denison**, Rev. **Dharmapali**, Gesshin **Prabhasa Dharma**, Jiyu **Kennett**, Ayya **Khema**, **Miao Kwang Sudharma**, Ruth Fuller **Sasaki**

Other Westerners who have been teachers and/or founded, or been in charge of, spiritual centres in Eastern countries: Lama Anagarika **Govinda** (the Arya Maitreya

Mandala in India), Jiyu **Kennett** (Soto temple in Japan), Father Hugo **Enomiya-Lassalle** (a *zendo* in Japan), Ven. **Sangharakshita** (Buddhist centres in India), **Nyanatiloka** Thera, Ayya **Khema** (both Theravadin centres in Sri Lanka), **Ananda Maitreya** (Theravadin centre in Burma), Ajahn **Sumedho** (a monastery for Westerners in Thailand), the **Mother**, Sri **Krishna Prem**, Sri **Mahendranath**, Swami **Abhishiktananda** (all in charge of ashrams of various kinds in India), **Shunya** (an independent teacher in India)

J.G. BENNETT

English pupil of **Gurdjieff** and **Ouspensky** who became a teacher himself; something of a spiritual maverick who associated with unorthodox Sufi and Hindu teachers, was one of the first Westerners to enter Subud and was eventually received into the Roman Catholic church; after his death, his organization was effectively hijacked by another maverick, G.B. **Chicoine**

In 1921, Bennett (not to be confused with Allan Bennet/**Ananda Maitreya**) was 23 and living in Constantinople. He spoke fluent Turkish and was working as interpreter and personal Intelligence Officer to the Commander of the British Army there.[1] **Ouspensky** and **Gurdjieff** were in the city at the time and Bennett met both of them. He liked **Ouspensky** but it was **Gurdjieff** who impressed him: "I had never before had the . . . feeling of being understood better than I understood myself" (*Witness*, 56).

Two years later, while he was visiting the Prieuré, **Gurdjieff**'s centre near Paris, he had a memorable experience. Although he had dysentery and could barely walk, he forced himself to continue as normal.

> We worked as usual all the morning. I could not eat lunch that day, but lay on the ground wondering if I was going to die. Gurdjieff had just introduced afternoon practice of the exercises out-of-doors under the lime grove . . .
>
> We started by working on a new exercise of incredible complexity that even the most experienced Russian pupils could not master . . . head, feet, arms and torso had to follow independent sequences. It was a torture for all of us.
>
> Gurdjieff pretended to be angry and stopped us, saying we must practice rhythms . . . I felt very ill and weak. A deadly lassitude took possession of me, so that every movement became a supreme effort of will . . . Soon I ceased to be aware of anything but the music and my own weakness . . . Gurdjieff stood watching intently. Time lost the quality of before and after. There was no past and no future, only the present agony of making my body move. Gradually, I became aware that Gurdjieff was putting all his attention on me. There was an unspoken demand that was at the same time an encouragement and a promise. I must not give up—if it killed me.
>
> Suddenly, I was filled with the influx of an immense power. My body seemed to have turned to light. There was no effort, no pain, no weariness, not even any sense of weight . . . My own state was blissful beyond anything I had ever known . . . (*Witness*, 114–15)

Gurdjieff dismissed the class and Bennett found himself on his own. His dysentery had disappeared and he found that all his faculties were greatly enhanced. He could dig in the blazing sun without the slightest effort or fatigue.

> Moreover, I experienced a clarity of thought that I had only known involuntarily and at rare moments, but which was now at my command. I . . . discovered that I could be aware of the fifth dimension. The phrase 'in my mind's eye' took on new meaning as I 'saw' the eternal pattern of each thing I looked at, the trees, the plants, the water flowing in the canal and even the spade, and lastly my own body. I recognized

[1] I should mention, for the sake of completeness and as a stimulus for other researchers, that Moore states that Bennett's "account of prior military service is difficult to reconcile chronologically with War Office records" (Moore, 355).

the changing relationship between 'myself' and 'my pattern'. As my state of consciousness changed, 'I' and my 'pattern' grew closer together or separated and lost touch. (*Witness,* 115–16)

Shortly afterwards, he met **Gurdjieff** walking alone through the woods, who put Bennett's newly acquired state into perspective. He told Bennett that he had only just begun; that there existed great reservoirs of energy, which could be drawn on in order to help others; and that those who have access to these reservoirs

> belong to a special part of the highest caste of humanity. It may be that one day you will become such, but you will have to wait for many years. What you have received today is a taste of what is possible for you. Until now, you have only known about these things theoretically, but now you have experience. When a man has had experience of Reality, he is responsible for what he does with his life. (*Witness,* 117)

Bennett took this statement to heart and the rest of his life can be seen as an attempt to live up to it. Yet he spent the next 25 years not with **Gurdjieff** but with **Ouspensky**. This seems odd in the light of what happened at the Prieuré but Bennett gives no explanation in his autobiography.

In 1930, following a misunderstanding with **Ouspensky**, he started a small group of his own and continued with it even after returning to **Ouspensky**'s main group a year later. In 1945, he gave some public lectures on the System and was cut off by **Ouspensky** (who was in America) as result. The two never met again. In 1948, shortly after **Ouspensky**'s death, Bennett visited **Mme. Ouspensky**, who had remained at Franklin Farms in New Jersey when her husband returned to Britain. She advised Bennett to go to **Gurdjieff** in Paris. Bennett did so (together with some of his pupils) and was again profoundly affected by **Gurdjieff**'s presence and teachings. (See **Gurdjieff**'s entry for some examples.) But **Gurdjieff** himself died in October 1949. Bennett records that as he sat with the body, he was certain that **Gurdjieff**'s "power remained and that his work would continue" (*Witness,* 272).

Bennett spent the rest of his life as an independent teacher. He started off by trying to work alongside the 'orthodox' Gurdjieffians under Mme. **de Salzmann**, who were concerned with preserving the teaching as best they could. But given his nature, the attempt was doomed to failure. He says that after a teacher's death, the pupils inevitably break into separate factions, of which there are three kinds: the literalists, who keep everything as it was and change nothing; the deviants, who go off on their own path; and the developers, who are "prepared to see the orthodox forms changed and even distorted if only something new can grow" (*Witness,* 233). In fact, Bennett made this observation about the followers of **Ouspensky** after his death but it applies equally well to **Gurdjieff**'s pupils, of course. He refers to the orthodox Gurdjieffians as "sterilizing all that **Gurdjieff** stood for" (*Witness,* 303)— in other words, they are literalists—while he himself is a developer. I need hardly add that the orthodox Gurdjieffians would repudiate the label 'literalist'—though they might not be adverse to labelling Bennett himself as a deviant rather than a developer.

Bennett was not a man to stand still. In 1953, a voice came to him in meditation, saying "Go to the East!" (*Witness,* 284). He decided to go to the Near East (where his Turkish would be useful) and left on a trip of several months, alone. Needless to say, he had some interesting adventures. He met an unorthodox Naqshbandi *sheikh,* Emin Chikhou, in Damascus, who told Bennett that Bennett had been "chosen by God to serve a great purpose"; and

that he "had a special part to play in preparing the Western peoples to receive [God's] Power". In 1957, Bennett came across Subud—one of the first Westerners to do so—and was a prominent member for a time. But after a few years, he decided that he was not going in the right direction and resumed **Gurdjieff**'s exercises again. Then in 1961, again prompted by his inner voice, he went to India to meet an Indian sage, Shivapuri Baba. (See Bennett's book, *Long Pilgrimage*.) Yet in the same year he was received into the Catholic church, partly because the Baba told him that he would find God-realization through Christ (*Witness*, 353)—a Gurdjieffian-cum-Sufi turning to Christianity on the recommendation of a Hindu-cum-Vedantin.

Ten years later, in 1971, a Turkish teacher, Hasan Shushud, came to England and told Bennett's pupils that Bennett was the first European since Meister Eckhart—that is, for 600 years—who had grasped the secret of Absolute Liberation. Meanwhile, Bennett himself started hearing a voice (actually, he uses the word 'auditions'), sometimes in Turkish, which convinced him that he had lived in Central Asia during the time of Khwaja Ubeydullah Ahrar (1404–90), one of the Khwajagan, the Masters of Wisdom (*Witness*, 376). Bennett calls them trans-Islamic Sufis—perfected ones who adopted Sufi forms but were essentially independent of them.[2] Bennett also connected the Khwajagan with **Gurdjieff**'s Sarmoun Brotherhood. Hence by a roundabout route, during which he has explored many by-ways, he ended up with something that he, at least, regarded as in the spirit of **Gurdjieff**.

Two years later, in 1974, Bennett died, just after buying Claymont Court in West Virginia (which he intended to be the focus of a model society). He was 77.

Bennett was a man of considerable intellect, fascinated by systems and formulae but given to sudden lurches. He had a series of intense experiences, scattered somewhat irregularly throughout his life, and he was always drawn to techniques of transformation. Although he tried hard to be a pupil, his nature was essentially independent. And while he could claim to have followed **Gurdjieff** and **Ouspensky** over a period of nearly 30 years, in fact his contact with them was sporadic. He was deeply attracted to the idea that the spiritual path must remain open and fresh, constantly seeking new ways of expression (and one could say that his *magnum opus*, *The Dramatic Universe*, is an attempt to show that the whole of creation fulfils this ideal).[3] This view of the spiritual life certainly has its advantages: it is open to change,

[2] For a more orthodox account of the Khwajagan, see J.S. Trimingham, *The Sufi Orders in Islam* (Oxford, 1971), 62ff; and H. Algar, *The Naqshbandi Order: A Preliminary Survey of its History and Significance* (Berkeley, 1977), 131-34.

[3] The essential idea of this work, as the title implies, is that the universe is a drama, the outcome of which is uncertain. There is a Supreme Being but He is not omnipotent. (Unorthodox to the last, Bennett expressly says that the assertion of divine omnipotence is an aberration that has almost ruined Christianity.) The Supreme Being created through an act of Will but it was in the nature of this act that it set in train forces—intelligent forces—that are unpredictable. These include what Bennett calls Demiurgic Intelligences (his version of **Gurdjieff**'s 'angels'—see *In Search of the Miraculous*, 323). They operate on very large time scales—hundreds of thousands of years—and the evolution of life on earth (which includes mankind) is an example of their work. But they are finite and make mistakes. (In fact, anything or anybody, at any level of the hierarchy, can make a mistake.) Human beings have been brought into existence solely so that they can act as instruments for the Supreme Will; or to put it another way, in order to play a certain part in the drama. But it is in the very nature of things that they may fail.

All of this is obviously derived from **Gurdjieff**. But I mention it because this cosmology provides an explanation of Bennett's own spiritual search. His many changes of direction were the response to promptings from the Demiurgic Intelligences (which are, of course, independent of any particular channel of transmission and can manifest in more or less any form, which appear from the outside to be unconnected).

for example, and encourages exploration. But it also has one big disadvantage: it tends to lack a firm foundation. Bennett's own life certainly exhibits both the advantages and the disadvantages. No one could deny that he was a pioneer but one has to ask the question whether, in the end, he finished up on an island of his own making, which after his death crumbled and disappeared into the sea. (See G.B. **Chicoine**'s entry.) I am hesitant to reach such a conclusion because I have a high regard for the man. But I can see no alternative.

(*See* Lineage Tree 3)

Primary sources: J.G. Bennett, *Witness* (London: Turnstone Press, 1975; this is a later edition than the one used by Moore, so his references do not correspond to mine); *The Dramatic Universe* (London: Hodder and Stoughton, 1956–66 reprinted, Coombe Springs Press, Sherborne, 1976); *The Dramatic Universe: A Short Guide and Glossary*, Ripon: Coombe Springs Press, 1982; an extended, but not complete, bibliography of 50 items can be found in *Gurdjieff: An Annotated Bibliography* (see the end of Gurdjieff's entry)

Secondary sources: Moore; Webb (for both of which, see the end of Gurdjieff's entry)

Centre: The only address I have is: Bennett Books, P.O. Box 1553, Santa Fe, NM 87504, U.S.A. (the group associated with G.B. Chicoine was dispersed in 1987 and no longer exists—see his entry for details)

COMPARE:

Other teachers who were pupils of Gurdjieff and/or Ouspensky: Rodney **Collin**, Robert **de Ropp**, Jeanne **de Salzmann**, Jane **Heap**, Maurice **Nicoll**, A.R. **Orage**, **Mme. Ouspensky**

Teachers who claim some association with Gurdjieff and/or Ouspensky: Idries **Shah**, G.B. **Chicoine**, E.J. **Gold**, Oscar **Ichazo**, Jan **Cox**

Other unorthodox Sufis: Samuel **Lewis**, Ivy **Duce** and James **Mackie**, Abdullah **Dougan**, Irina **Tweedie**, Frithjof **Schuon**

Other 'visionaries': Roshi Jiyu **Kennett**, Samuel **Lewis**, **Rudi**, Frithjof **Schuon**

Other teachers with a comparable cosmology: Madame **Blavatsky**, Sri **Krishna Prem**

Other teachers who have explored several traditions: Samuel **Lewis**, Lex **Hixon**

BHAGAVAN. SEE **HARE KRISHNA GURUS**

SRILA BHAKTIPADA | SWAMI KIRTANANANDA | KEITH HAM

One of the original eleven gurus appointed by *Prabhupada,* Bhaktipada has since been expelled from ISKCON and is now an independent guru with his own ashram

This entry should be read in conjunction with those on Shrila Prabhupada *and the **Hare Krishna Gurus***

Ham was born in 1937 in New York state, the son of a Baptist minister. He went to India in 1965, looking for a guru but the one he found was actually in America. In 1966, he was one of the first Americans to become a disciple of Shrila *Prabhupada*, the founder of ISKCON. He was a Ph.D. candidate in history at Columbia at the time and was living in New York with a group of friends. According to Stephen Guarino/**Satsvarupa** (another of the original eleven gurus and author of *Prabhupada*'s official biography), he was "something of a guru" among this group (*Srila Prabhupada-lilamrta,* vol. 2, 113). He moved in with *Prabhupada* within a week of meeting him and became his

cook and housekeeper (ibid., 135) and later his personal attendant (ibid., 259). He was actually the first person to ask if he could become a disciple (ibid., 176) and the first to dress in a dhoti and shave his head (ibid., 205). According to **Satsvarupa,** he looked like a young version of *Prabhupada* (ibid., 211).

However, he was not among the first group to be formally initiated by *Prabhupada* on 9th September 1966 because he was in Bellevue mental hospital. The story behind this is mildly bizarre. He had gone to the Department of Welfare in order to claim social benefit—wearing a dhoti and with a shaved head. He was asked to provide a psychiatric evaluation, went to Bellevue to get it, and unwittingly signed himself in as a patient. He was diagnosed as a malignant schizophrenic (*Hare Krishna Explosion,* 72) and it took him three weeks to get out, which he only managed by agreeing to go home with his father, a Baptist minister, and becoming a Christian. But when he was on the way home in his father's car, he escaped and ran to *Prabhupada*'s apartment (*Hare Krishna Explosion,* 77). He was initiated as Kirtanananda the next day.

Kirtanananda's prominence in ISKCON continued to grow as ISKCON grew. He was the only one to accompany *Prabhupada* to India in 1967 and while there, he became the first devotee to take *sannyasa* (*Srila Prabhupada-lilamrta,* vol. 3, 184). Back in America, he became a wandering preacher (which is what *sannyasa* is for in the Gaudiya Vaishnava tradition) and in 1968 he acquired—with ISKCON funds, of course, since *sannyasis* do not have money of their own—130 acres in West Virginia which became New Vrindaban, the first of ISKCON's 'Vedic' villages or farm communities. *Prabhupada* stayed there for several weeks shortly after the land was bought and during that time he installed Kirtanananda as leader. Being a 'Vedic' village, New Vrindaban had to be organized according to the principles of *varnashrama*— that is, Kirtanananda, as the sole *sannyasin*, was in charge, with the *brahmacharis* or celibates living under his direction, and the *grihasthas* or householders working and contributing half their income to the community (*Hare Krishna Explosion,* 319). New Vrindaban was the first ISKCON community to be specifically constructed in this way.

Also during his stay, *Prabhupada* told Kirtanananda that he (Kirtanananda) would build many temples there in the future (*Hare Krishna Explosion,* 319) and that New Vrindaban was itself a form of preaching because everyone there was leading a Krishna-conscious life (*Hare Krishna Explosion,* 320). Thereafter, Kirtanananda received $50,000 a year from ISKCON for New Vrindaban (*Srila Prabhupada-lilamrta,* vol. 6, 35) and he began to build a temple which he referred to as *Prabhupada*'s palace. Shortly before *Prabhupada*'s death in 1977, Kirtanananda showed him a photo of the palace, which was nearly finished. "You are fulfilling my dream," *Prabhupada* said. "New Vrindaban. I dreamt all these things. Wonderful things he has done. He is the first student— from the very beginning" (*Srila Prabhupada-lilamrta,* vol. 6, 395).

In the light of all this, it is not surprising that **Satsvarupa** should refer to Kirtanananda as *Prabhupada*'s seniormost disciple (*Srila Prabhupada-lilamrta,* vol. 6, 403; but remember that Satsvarupa is writing at a time when Kirtanananda was still an ISKCON guru and therefore highly regarded) or that *Prabhupada* should have appointed him as one of the new gurus. However, there is another side to the story of Kirtanananda's prominence in ISKCON, which is revealed in *Prabhupada*'s letters (not published until after *Prabhupada*'s death). It appears that even in the earliest years *Prabhupada* regarded Kirtanananda as having misunderstood the teachings on a number of occasions, as well as being disobedient and "thinking too much of himself".

For example, when Kirtanananda returned from India in 1967 as a *sannyasi*, he was asked by *Prabhupada,* who remained in India, to do some preaching in England. Instead, he went straight to New York and created a considerable disturbance by dressing like a Catholic priest (in black robes and a white collar) (*Monkey on a Stick,* 90), saying that Americans should not wear orange robes or put the Vaishnava mark on their foreheads because it would put people off. When *Prabhupada* was informed of this, his response was very clear: Kirtanananda had lost his link with his spiritual master because of disobedience (*Letters,* 222); he had become the victim of *maya* (ibid.); more than that, he had become a *mayavadi* or impersonalist (*Letters,* 237), which is the gravest charge that *Prabhupada* could bring against anyone; "any instruction given by him is unauthorized and should at once be rejected" (*Letters,* 229).

Prabhupada even went so far as to say that "somehow or other he has become crazy and should once more be sent to Bellevue" (ibid.). He also said that Kirtanananda was exploiting his position as a *sannyasi;* "simply by his sannyas dress he thought himself cured of all material diseases and mistakes" (*Letters,* 231). Kirtanananda was only given *sannyasa* "because he wanted it although I could understand that he wanted to be a spiritual master himself" (*Letters,* 242). *Prabhupada* therefore wrote to Kirtanananda:

> If you do not agree with my philosophy you can work independently and not within the walls of ISKCON. You have not understood Krishna properly. (*Letters,* 238)

This letter was written in 1967. In fact, Kirtanananda did return to ISKCON and, as we have seen, was generally regarded as *Prabhupada*'s seniormost disciple at the time of *Prabhupada*'s death in 1977. He was a member of the Governing Board Commission (the GBC which Prabhupada established in 1970 to manage ISKCON's affairs) and he was also one of the eleven original gurus appointed by *Prabhupada* just before his death in 1977. Yet in 1987 he was expelled from ISKCON by the GBC. (By this time, he was using the name 'Bhaktipada', which is how I will refer to him from now on.) There were a number of reasons for his expulsion, but one of them was that he had "established temples and institutions controlled by himself alone, thus creating a movement separate from ISKCON" (1987 GBC resolution 8[c]). So in the end he did decide to work independently after all, as *Prabhupada* had said 20 years earlier.

Of course, Bhaktipada himself does not accept that the reason for his independent movement is because he has not understood Krishna properly. His argument is that *Prabhupada* meant the new gurus to act as *Prabhupada* had done and that he alone is actually doing so. Therefore he *is* just like *Prabhupada. Prabhupada* established the worship of the guru, and the new gurus, as obedient disciples, are bound to follow him—which means that the new gurus should be treated as *Prabhupada* was. If they refuse to do this, then they are deviating from *Prabhupada*'s instructions, Bhaktipada says, and "under the guise of wanting to elevate Prabhupada to a unique position, they are dismantling everything that Prabhupada did" (*On His Orders,* 2nd ed., 48).

Just as Prabhupada was the only disciple of Bhaktisiddhanta to obey his master's wishes and spread Krishna consciousness worldwide, so he, Bhaktipada, is the only one who has the vision and dedication to carry out *Prabhupada*'s orders. Just as *Prabhupada* was the Founder-Acharya of ISKCON, so Bhaktipada is the Founder-Acharya of New Vrindaban. Yet this does not diminish *Prabhupada*'s position, Bhaktipada says, just as

Prabhupada did not diminish the position of his own master, Bhaktisiddhanta, by founding ISKCON (*On His Orders,* 2nd ed., 32).

In the catalogue for Palace Publishing (the New Vrindaban publishing house) for 1987, Bhaktipada is said to be *Prabhupada*'s successor—something that no guru in ISKCON would dream of saying in the new moderate climate. (See the **Hare Krishna gurus**.) Other publications from New Vrindaban make similar claims. An undated copy of *Brijabasi Spirit* gives His Divine Grace A.C. Bhaktivedanta Swami Prabhupada as the Founder-Acharya of ISKCON and His Divine Grace Kirtanananda Swami Bhaktipada as the "present *Acharya*". A devotee of Bhaktipada's refers to Bhaktipada in a letter as the 33rd acharya of the Brahma Gaudiya Vaishnava *sampradaya* (*Land of Krishna*, vol. 3, no. 10, no date, p. 4).[1]

In other words, the guru is absolute.

> The bona fide guru [this is Prabhupada's translation of *sad-guru*] cannot be limited. Shri Guru is Krishna, Lord and master of everyone . . . We cannot legislate or decide by a council when and where Shri Guru may appear to someone. His appearance is a transcendental arrangement of the Lord . . . (*On His Orders,* 1st ed., 8)

It is an inevitable consequence of Bhaktipada's view of the absolute status of the guru that he should be critical of the GBC's attempt to curtail the new gurus' powers. How can he justify this criticism in the light of *Prabhupada*'s clear indication that the GBC should manage ISKCON? Answer: *Prabhupada* only meant the GBC to maintain the spiritual standards that apply to all devotees; he never intended that it should determine what a guru should or should not do. If a guru lives up to the basic standards of the movement (the four regulative principles, chanting 16 rounds a day and engaging in devotional service), he is beyond the GBC's jurisdiction. But, Bhaktipada says, the members of the GBC do not themselves live up to these basic standards and therefore their authority is weakened. In fact, it has become worthless just as the disciples of Bhaktisiddhanta who disobeyed his orders became worthless (*On His Orders,* 2nd ed., xv, xvi). According to Bhaktipada, the GBC has misunderstood *Prabhupada*'s orders and so disobeyed him. As a result, they lack the blessings (which means the potency) of their master and all the other acharyas who preceded him right back to Krishna, the first guru of all (*On His Orders,* 2nd ed., 64). The implication, of course, is that Bhaktipada alone is *Prabhupada*'s true disciple—and therefore the only true guru.

According to Bhaktipada, the proof that he is carrying out his master's orders is that New Vrindaban is successful. It is described in the Palace Publishing catalogue as "the world's first and largest Vedic community". The Palace of Gold, the temple dedicated to *Prabhupada,* was completed in 1979 but Bhaktipada has much bigger plans for the new Land of Krishna. According to *Brijabasi Spirit, Prabhupada* said in 1972 that he wanted there to be a spiritual city of about 10,000 people in each of the twelve zones that he had divided the world into (*Brijabasi Spirit* [no date], 12). (These twelve zones were the basis of the original GBC, with one member for each zone.) New Vrindaban is one of these cities—in fact, the only one since no attempt is being

[1] In fact, even the use of the title 'Bhaktipada' is indicative of the high claims that he makes. Titles ending in —*pada* are traditionally given to very pure devotees (such as *Prabhupada* himself) and though all the original eleven gurus in ISKCON started off by using them, they have now been dropped. Only Bhaktipada continues to use such a title.

made by anyone in ISKCON to build one. But more than that, it is a *dhama*, or place of pilgrimage that depicts Krishna's pastimes, and therefore different even from an 'ordinary' spiritual city. The devotees at New Vrindaban refer to it as the "capital of spiritual life in the Western world" (*Brijabasi Spirit* [no date], 13).

And even this idea of the spiritual city has been extended by Bhaktipada. About 12,000 will live in the City of God but there will be a surrounding population of 30,000 outside the city walls. This combined population of 42,000 will form Greater New Vrindaban and will fulfil both "governmental and commercial functions" (*New Vrindaban Worldwide*, January 1988, 5). It is in this greatly enlarged form that New Vrindaban will become the model of 'Vedic' culture as *Prabhupada* taught it. When people come here, says Bhaktipada, they will see a superior way of life and want to adopt it—and "that will produce a revolution in consciousness" (*Brijabasi Spirit* [no date], 10). All of this is because of Bhaktipada's purity as a devotee and guru. According to one of his own devotees, both the Temple of Understanding and the entire Land of Krishna are "Krishna's plan revealed through Shrila Bhaktipada" (*Brijabasi Spirit* [no date], 16).

Bhaktipada has recently introduced a number of innovations at New Vrindaban. (Innovations are much easier for an 'absolute' guru than one who is answerable to a governing body, of course.) The dhoti has been replaced by black robes similar to those worn by Catholic monks (and similar to those worn by Kirtanananda/Bhaktipada when he returned to America from India in 1967). Temple services are now in English rather than Sanskrit (though the Hare Krishna mantra has not been changed).

These changes, which are external, are explained as means by which Bhaktipada, the pure devotee, enables his disciples to express their love for Krishna, which is internal. The 'internals' never change, though the 'externals' may. "Shrila Bhaktipada is expert in his discernment of externals from internals" (*Vrindaban's Woods and Groves*, vol. 1, no. 1, November 1988, 6), and as a "bona fide guru" (that is, a *sad-guru*), he knows what he is doing even if he contradicts himself (ibid., 1). *Prabhupada* is quoted on this matter of external changes, saying that they are necessary according to time and place, and most importantly, if preaching is to be successful: "If someone does go and preach, taking all risks and allowing all consideration for time and place, it might be that there are changes in the manner of worship, but that is not at all faulty according to shastra" (ibid., 2). Clearly, Bhaktipada is seen as one who is taking these risks for the sake of preaching—and succeeding. He is therefore entitled, perhaps even bound, to introduce changes.

Another recent development at New Vrindaban is the formation of an interfaith dialogue and Bhaktipada is presented as "the founder of an Interfaith Community . . . that is open to people of all faiths and spiritual paths" (cover of *How to Say No to Drugs*). Since God has countless names, "why should we be surprised to find that other people chant His other Names, and they also become purified?" (*Vrindaban's Woods and Groves*, vol. 1, no. 1, November 1988, 6). *Vrindaban's Woods and Groves* contains quotations from Hindi, Christian and Moslem scriptures, as well as sayings of spiritual teachers, interspersed with *Prabhupada*'s own words. *Prabhupada* is quoted in favour of such an interfaith enterprise (ibid.) despite the fact that during his lifetime he was vigorously anti-ecumenical.

But perhaps the most significant innovation that Bhaktipada has introduced is giving *sannyasa* to women. The first two, Mother Adhara and Mother Ilavati,

were initiated as Ananta Maharaja and Ishvara Maharaja in November, 1987 (*New Vrindaban Worldwide*, January 1988, 10). This is an entirely new departure in the Gaudiya Vaishnava tradition. Yet when this was pointed out to Bhaktipada, he replied that he was not interested in tradition (ibid.). According to the *Bhagavad Gita* (Chapter 9, v. 30), women can approach the "supreme destination"; but how can they do this, says Bhaktipada, if they are not renounced—that is, *sanyasinis?* And more than that, he also intends to make them gurus. They will then initiate their own devotees—even men. This is absolutely unheard of in Gaudiya Vaishnavism—practically on a par with saying that women should become cardinals in Catholicism.

In referring to his decision to give women *sannyasa*, Bhaktipada admits that it is revolutionary but "Shrila Prabhupada said I was the first in everything" (ibid.). It is only a break with tradition 'externally'—just like the robes and the English chants. Whatever is necessary for preaching, that is what the *acharya*—meaning Bhaktipada—does. And the proof that he is preaching the truth is the success of New Vrindaban itself: bigger and more opulent, and influencing more people than anything else to come out of ISKCON.

The response of those who are still in ISKCON—that is, faithful to the GBC and the moderate theology that it now espouses—is that certain events at New Vrindaban are, on the contrary, not in accordance with truth and that therefore Bhaktipada is wildly off the rails. This is a murky story but it has to be told.

In May 1986, Steve Bryant/Sulochana, one of *Prabhupada*'s disciples, was found shot in his truck in Los Angeles. The investigation of his death led right back to New Vrindaban. Bryant joined ISKCON in 1972 and he eventually moved to New Vrindaban with his wife, Jane (who was not a devotee). But the marriage did not go well. Bryant started drinking and taking drugs, and when he was away in India in 1979, Jane asked Bhaktipada to initiate her, which he did, giving her the name Jamuna. In Bryant's view, this was a breach of Vaishnava etiquette (which, strictly speaking, it is). He became disillusioned with Bhaktipada and decided to leave New Vrindaban. But his wife wanted to stay. He tried to take his two sons away with him but some of the residents of New Vrindaban caught up with him on the road and took them back. Bryant went on alone (*Monkey on a Stick*, 282).

He began to write an exposé of Bhaktipada (and other gurus in ISKCON whom he considered to be suspect) and actually sent the first chapter to Bhaktipada. He told the local sheriff at Moundsville (the town nearest to New Vrindaban), that shortly afterwards he started to receive death threats. About a month later, in October 1985, Bhaktipada was attacked at New Vrindaban by a disaffected devotee, Michael Shockman/Triyogi, who beat Bhaktipada unconscious with a lead pipe, perhaps because Bhaktipada had refused to make him a *sannyasin* (*Brijabasi Spirit*, January 1988, 7). Bhaktipada was very badly injured and will never fully recover. He interpreted the incident in theological terms: "the doctor said it was enough to kill a hundred men but the Lord preserved my life for a purpose" (ibid.). Shockman received a 14-month sentence.

A period of mutual fear followed. People at New Vrindaban—including Bhaktipada himself, who made the accusation at a press conference (*Monkey on a Stick*, 300)—blamed Bryant's exposé for the attack on Bhaktipada, and Bryant was still convinced that his life was in danger. He was arrested near New Vrindaban in February 1986 for carrying an unlicensed gun and jailed for a month (*Monkey on a Stick*, 308, 397). He was killed in Los Angeles a few months later.

The connection between Bryant's death in Los Angeles and New Vrindaban was provided by Randall Gorby, a one-time police informer who lived near New Vrindaban but was not a devotee. He had helped the community buy land over the years and knew many of the devotees. One of them was Thomas Drescher/Tirtha. Gorby told the West Virginia police that Drescher had told him that he had killed *two* people: Bryant and another New Vrindaban devotee, Charles St. Denis/Chakradara (in 1983). A tap was put on Gorby's phone, and when Drescher called to say that he was leaving the country, the call was traced to Ohio and Drescher was arrested. According to the police, he had with him many details concerning Bryant including the licence number of his truck and a record of Bryant's recent movements around Los Angeles (*Monkey on a Stick,* 326).

Drescher admitted that he was tailing Bryant but denied killing him. However, he has yet to be tried for that murder because the West Virginia police charged him with the murder of St. Denis first. He pleaded not guilty but was convicted, partly on Gorby's testimony, in December 1986 and got a life sentence (*Monkey on a Stick,* 332). Another New Vrindaban devotee, Daniel Reid/Daruka, was also charged with St. Denis's murder but he was tried separately from Drescher. It was Reid who provided all the information about the murder and showed the police where the body had been buried—on the outskirts of New Vrindaban's land. Reid said that he and Drescher had killed St. Denis together, though the motive is somewhat unclear—perhaps a dispute about drugs (Reid, Drescher, and St. Denis were all users and dealers). Reid pleaded guilty to the killing but because he had co-operated with the police he only received a one-to-five year sentence.

In December 1987, Drescher/Tirtha and Bhaktipada were both charged with arson—specifically, burning down a house owned by New Vrindaban in order to collect $40,000 worth of insurance. Both Gorby and Reid were witnesses for the prosecution. Drescher was found guilty on their testimony but Bhaktipada was acquitted. Bhaktipada's comment afterwards was, "The U.S. Attorney might be able to influence the GBC to kick me out, but they can't influence God Almighty not to give me protection . . . It's simply religious persecution. They just want to 'get the Swami'. But obviously God has a purpose for me" (*New Vrindaban Worldwide,* January 1988, 8). His attorney said at the trial that the reason Reid received such a light sentence for killing St. Denis was that he had entered a plea agreement with the U.S. Attorney to give evidence against Bhaktipada (*Brijabasi Spirit,* January 1988, 11).

Drescher/Tirtha, who was already serving his life sentence for killing St. Denis, was brought from prison for the trial. However, some time after his conviction for murder he was visited in jail by Bhaktipada and a group of devotees. One of them, Wally Sheffy/Umapati Swami, initiated Tirtha as a *sannyasi* (*Monkey on a Stick,* 350). It is ironic that Michael Shockman attacked Bhaktipada because Bhaktipada did not think he was ready for *sannyasa*, while Tirtha, a convicted murderer, *was* considered ready for it.

The latest development in this episode is Bhaktipada's conviction in 1990 for conspiracy to murder Bryant—that is, that he authorized Bryant's death and that Drescher was acting as his agent. (He appealed—unsuccessfully.)

A few further poignant details. In the summer of 1984, Charles St. Denis's five-year-old son and Daniel Reid's six-year-old son were found suffocated in an old refrigerator at New Vrindaban. St. Denis was already dead, of course—murdered by Reid and Drescher. And in November 1986, Steve Bryant's three-year-old son was drowned in a lake at New Vrindaban (six months after Bryant

was killed). Foul play is not suspected in either incident but no community could be very proud of this record.

All this amounts to an unsavoury story whichever way you look at it. At his trial, Bhaktipada said that New Vrindaban had issued a list of devotees whom they disowned in 1983—it was published in a local newspaper—and that Reid and St. Denis were on it (*Brijabasi Spirit*, January 1988, 7) (and perhaps Drescher also [*New York Times*, 19th August 1986, 14]). Bhaktipada also said that just because someone gives a donation, that doesn't mean that the community is responsible for his actions (*Brijabasi Spirit*, January 1988, 8). And in any case, Bhaktipada's duty is to preach to everyone, especially those who need it most (*New York Times*, 14–15).

This may be true but such a philosophy requires some discrimination. Someone who preaches to a thief is bound to treat all donations from him with caution and not accept those that may be suspect. Failure to observe this elementary principle must inevitably lead to charges of collusion in wrong-doing—which is exactly what has happened with Bhaktipada, of course. To change the analogy somewhat: a bank manager cannot claim to have nothing to do with repeated thefts in his bank on the grounds that he hasn't stolen anything himself; an army officer cannot claim that he has no responsibility for atrocities committed by his troops by saying that he was not leading them at the time. And why not? Because thefts do not occur in banks with good managers and troops who are commanded by good officers do not commit atrocities. The occasional lapse can occur under the best leaders but not systematic wrong-doing.

But of course we are not dealing with a bank or a platoon here. The events at New Vrindaban have to be seen in the light of the extremely high claims that are made for it: that it is the focus of a world revolution in consciousness, guided by Krishna himself.

After his acquittal at the arson trial, Bhaktipada embarked on a nationwide 'First Amendment' Tour to argue against religious persecution, appearing on 90 radio stations and 60 TV programmes (*Land of Krishna*, vol. 3, no. 10, no date, 2). On one of these, he mentioned that *Prabhupada* had predicted, "first they will laugh at you, then they will persecute you, and then they will accept you" (ibid.). The first two predictions have come true and Bhaktipada is waiting for the fulfilment of the third.

Meanwhile, of course, he has been expelled from ISKCON by the GBC (in March 1987) and is now in jail, an independent guru with no connection with any other form of Gaudiya Vaishnavism.

(*See* Lineage Tree 5)

Primary sources: His Divine Grace Kirtanananda Swami Bhaktipada, *Christ and Krishna* [I don't have the date]; *Eternal Love: Conversations with the Lord in the Heart*, 1985; *The Song of God: A Summary Study of Bhagavad Gita As It Is*, [I don't have the date]; *On His Order*, (two editions, neither dated, but the first is ca. 1986 and the second, ca. 1987); *Joy of No Sex: Handbook for Higher Pleasure*, 1988; *How to Say No to Drugs*, 1990; *Spiritual Warfare: How to Gain Victory in the Struggle for Spiritual Perfection*, 1990; all these are published by Palace Publishing (or its imprint, Bhakti Books) at the New Vrindaban address given below; New Vrindaban also publishes all the magazines and newsletters cited in this entry: *Land of Krishna*; *Brijabasi Spirit*; *New Vrindaban Worldwide*; *Vrindaban's Woods and Groves*

Secondary sources: Letters from Srila Prabhupada, (Port Royal, Pennsylvania: Gita-Nagari Press, 1982); Satsvarupa dasa Goswami, *Srila Prabhupada-lilamrta*, [the six-volume biography of Srila Prabhupada], (Los Angeles: Bhaktivedanta Book Trust,

1980–83); Haragriva dasa, *The Hare Krishna Explosion*, (Palace Press, no provenance, 1983); J. Hubner and L. Gruson, *Monkey on a Stick: Murder, Madness, and the Hare Krishnas* (New York: Harcourt Brace, 988)

Centre: New Vrindaban, Moundsville, West Virginia 26041, USA

COMPARE:

Other independent gurus associated with ISKCON: **Siddhasvarupa**

Other Gaudiya Vaishnava gurus: Sri **Krishna Prem**

Other spiritual communities: Ananda Co-operative Village (Swami **Kriyananda**/Donald Walters); Yasodhara Ashram (Swami **Radha**); Sacchidananda Ashram (Swami **Abhishiktananda**), Auroville (the **Mother**)

Other Hindu teachers: Sri **Daya Mata**, the **Devyashrams**, Sri **Mahendranath**, **Rajarsi Janakananda**, **Rudi**, Guru **Subramuniya**, **Yogeshwar Muni**

Other teachers who favour an 'interfaith' approach: Lex **Hixon**, Daido **Loori**

BHAVANANDA SWAMI. SEE **HARE KRISHNA GURUS**

WILLIAM STURGIS BIGELOW. SEE **APPENDIX 1**

MADAME BLAVATSKY

The founder of the Theosophical Society and probably the most influential occultist of modern times

There is a huge literature on Helena Petrovna Blavatsky but I do not even have the space to summarize it, let alone assess it. She was accused of plariarism[1] and deceit[2] during her lifetime, yet the impact of Theosophy was huge. In fact, the Theosophical Society, founded in New York in 1875, was a bit of a damp squib to begin with. But *Isis Unveiled*, published in two fat volumes in 1877, was something of a best-seller: the first edition of a thousand copies sold in

[1] Her most vociferous critic was a certain William Coleman, who cited 2,000 passages in *Isis Unveiled* which he had traced in books already published (including one with the wonderful title of *Sod: the Son of Man!*). Sometimes these only amounted to a sentence or two but the wording was identical (Campbell, 33–34). Coleman made similar charges about *The Secret Doctrine* (Campbell, 41).

[2] In 1884, a number of accusations were made by Emma Coulomb, who lived and worked at the Theosophical headquarters in Adyar, that Blavatsky had tricked people into thinking that phenomena produced at Adyar had been manifested by the Mahatmas; in fact, Blavatsky and Madame Coulomb had been responsible for all of them. A particularly telling charge was that a cabinet in the shrine room, in which 'proofs' of the Mahatmas' existence had been found, had a sliding panel at the back which opened into Blavatsky's bedroom. This fact was admitted by the Theosophists at Adyar but they denied that Blavatsky had ever used it to deceive people. However, the cabinet was destroyed before anyone could examine it (Campbell, 90). This episode became well-known as the result of a report by the Society for Psychical Research (based largely on investigations at Adyar by Richard Hodgson and hence often called the Hodgson Report), which damned Blavatsky in no uncertain terms. Its final sentence (which was included in several later editions of the Encyclopedia Britannica) read: "For our own part, we regard her neither as the mouthpiece of hidden seers, nor as a mere vulgar adventuress; we think that she has achieved a title to permanent remembrance as one of the most accomplished, ingenious and interesting impostors in history" (quoted in Campbell, 93).

However, there has been considerable controversy about the Hodgson report itself, which falls far short of the standards of rigour and impartiality which we would expect nowadays. The matter is discussed in Howard Murphet, *Hammer on the Mountain: The Life of H.S. Olcott* (Wheaton, llinois: Theosophical Publishing House, 1972), Chapters 15 and 17.

ten days (and total sales to date are about half a million). Blavatsky says in the preface that the book is "the fruit of a somewhat intimate acquaintance with Eastern adepts and study of their science" but in fact *Isis Unveiled* is almost entirely Western (if we count Egypt as Western) in the sense that its *sources* are Western. One of its contentions was that all religions are versions of an ancient wisdom-religion "professed and practiced by the initiates of every country" and preserved by a secret brotherhood. But more than that, Blavatsky claimed that the book had been dictated to her by her Master, himself an Adept of this brotherhood.

A year later, Blavatsky and **Olcott** left New York for Bombay, arriving in February 1879. Theosophy was immediately successful in India despite the fact that it was entirely unconnected with any Hindu tradition. Over 100 branches were opened in the first five years (Campbell, 86); a magazine, *The Theosophist*, was started; and the headquarters of the society was established in Adyar, near Madras, in 1882. All of these were firsts: Theosophy was the first occult society to have any Eastern branches at all (let alone a hundred); the magazine was the first of its kind in the East; and no other Western group of even a vaguely religious kind had ever established its headquarters in an Eastern country.

At this point (say 1881 or 1882), Theosophy can be said to be complete. The Adepts/Brothers/Masters/Mahatmas have been located in the Himalayas; the Theosophical Society itself is based in India; and Blavatsky is functioning as a spiritual teacher (in her capacity as mouthpiece for the Masters). And it is the Easternization of Theosophy that has brought about this completion. (Meanwhile, at more or less the same time, **Olcott** begins his Westernization of Buddhism: see his entry for more details.)

*Sri **Krishna Prem** used the* Stanzas *as the basis for his own cosmology.*

Blavatsky published *The Secret Doctrine*, her second great work, in 1888. It was based on *The Stanzas of Dzyan*, written, according to Blavatsky, in the ancient language of Senzar; but no one has ever seen the original and her English translation is the only version known to us. Unlike *Isis Unveiled*, which was essentially Western, *The Secret Doctrine* is predominantly Hindu with some admixture of Mahayana and Vajrayana Buddhism. For example, it teaches the identity of the Soul with the Over-Soul, and the emergence of the universe from its quiescent state or Pralaya; and it also has an esoteric interpretation of the 49 days of the Bardo, as found in the Tibetan tradition. According to W.Y. **Evans-Wentz**, his mentor, Lama Kazi Dawa-Samdup, thought that this account showed that Blavatsky had "intimate acquaintance with the higher lamaistic teachings into which she claimed to have been initiated" (*The Tibetan Book of the Dead*, 7, n. 1).[3]

Madame Blavatsky died in 1891, aged 60. Even if we accept the charges of plagiarism and fraud against her—and I am not saying that they have been proved—what are we left with? Or better: *who* are we left with?

> An extremely unusual woman, who lived most of her life outside the normal confines of 19th-century society, and who had the courage and the capacity to explore what was new and 'difficult'. (Compared with her, all the other occultists of the time are dull and unimaginative.)

[3] Similarly, no lesser authority than D.T. Suzuki declared *The Voice of the Silence* (published in 1889) to be "true Mahayana doctrine", which showed that Blavatsky had been "initiated into the deeper side of Mahayana teaching" (*Eastern Buddhist*, vol. 5, 1921–29; this reference is taken from *The Middle Way*, 47/1, 44 but I have not been able to check it).

Someone who genuinely held Eastern spirituality in high esteem at a time when hardly any Westerners did (in fact, when hardly any Westerners knew how to).

Someone who, if we take the views of Lama Samdup and D.T. Suzuki seriously (and why shouldn't we?), was initiated into Eastern traditions and gave accounts of them from the inside—and here, I think, we would have to say that we know of no other Westerner of the time who was doing the same.

Someone who prepared the ground for the Eastern teachers who came after her (some of whom, like Swami *Vivekananda,* also taught a form of Eastern universalism; and Anagarika *Dharmapala,* of course, was himself a Theosophist).

When we add all this up, it is undeniably significant. Blavatsky has a unique place in the great process by which Eastern teachings—and, by extension, spiritual psychology as a world-view—have come to the West. This is not, of course, anything like as great a claim as the one she made for herself and which Theosophists still make on her behalf. But it is no small achievement and she should be recognized for it.

Primary sources: Isis Unveiled (New York, 1877); *The Secret Doctrine* (London, 1888); *The Voice of the Silence* (1889); *The Key to Theosophy* (London, 1889); these are her major works—for a full list, see *The Blavatsky Bibliography* (London: The Blavatsky Association, 1933)

Secondary sources: Bruce Campbell, *Ancient Wisdom Revived: A History of the Theosophical Movement* (Berkeley: University of California Press, 1980); (Anon), *The Theosophical Movement 1875–1950* (Los Angeles: Cunningham Press, 1951) [these are the sources I have used; I have not seen H.J. Spierenburg, *The Buddhism of H.P. Blavatsky,* (San Diego: Point Loma Publications, 1991)]; P. Johnson, *In Search of the Masters: Behind the Occult Myth,* (South Boston, Virginia, 1990)

Centre: The Theosophical Society, Adyar, Madras 600020, Tamil Nadu, India [but needless to say, all groups calling themselves Theosophical, not just the one in Adyar, claim to be true to Blavatsky's teaching]

COMPARE:

Others who have claimed contact with 'higher' Masters of some kind: Omraam Mikhael **Aivanhov**, Elizabeth Clare **Prophet**, Serge **Raynaud de la Ferrière**, J.G. **Bennett**, Idries **Shah**, Paul **Twitchell**

Other pioneers in Eastern countries (at about the turn of the century): **Ananda Maitreya**, William **Bigelow**, Alexandra **David-Néel**, **Nyanatiloka** Thera

Those influenced by Theosophy in some way or other: Ivan **Agueli**, **Ananda Maitreya**, Christmas **Humphreys**, Sri **Krishna Prem**, **Nyanatiloka** Thera, Colonel **Olcott**, Zina **Rachevsky**, Miriam **Salanave**, Irina **Tweedie**

Paul BRUNTON

Englishman who made *Ramana Maharshi's* teachings known in the West and then went on to become a teacher himself

Brunton was born in 1898. His original name was Raphael Hurst but as far as I know he never explained why or when he changed it. In 1930, he went on an extended trip to India, described in *A Search in Secret India*, an account of meetings with *yogis* and sages which became something of a best-seller. It included chapters on teachers who were more or less unknown in the West at

the time, such as *Meher Baba*[1] and *Ramana Maharshi*. He asked *Ramana* to accept him as a disciple but *Ramana* replied that the distinction between master and disciple does not exist for one who has realized the true self (*A Search in Secret India*, 277). Brunton began to practise *Ramana*'s 'Who Am I?' meditation and describes what happened.

> [S]omething that is far superior to the unimportant personality which *was* I, some deeper, diviner being rises into consciousness and *becomes* me. With it arrives an amazing sense of absolute freedom, for thought is like a loom-shuttle which is always going to and fro, and to be freed from its tyrannical motion is to step out of prison into the open air . . . I am in the midst of an ocean of blazing light. The latter, I feel rather than think, is the primeval stuff out of which worlds are created, the first state of matter. It stretches away into untellable infinite space, incredibly *alive*. (*A Search in Secret India*, 305)

A later book, *The Secret Path: A Technique of Self-Discovery* (with a foreword by Alice Bailey, incidentally), refers to *Ramana*'s 'technique' of asking the question 'Who am I?' as 'the Art of Interrogative Self-Reflection' (*The Secret Path*, 83). This involves the realization that one is not the body, the emotions or the intellect. And Brunton's descriptions of great peace (ibid., 150) and inner illumination (ibid., 156) are clearly presented as if he had himself experienced them (which, as we know from *A Search in Secret India*, he had). It is in this sense—as an inspired transmitter rather than as a guru who took responsibility for those who came to him—that he can be said to be a teacher.

Over the next ten years or so—say, from 1934 to 1945—Brunton wrote another half dozen books and travelled extensively throughout the East. But gradually, he began to influence more and more people in his capacity as spiritual advisor—and to all intents and purposes, he did become a guru.[2] He also became convinced, largely because of inner experiences, including an encounter with "the astral figure of a well-known and well-loved Master" (Godwin, 17), that he had a mission to accomplish: nothing less than to establish the foundations of a complete teaching for the modern world. Brunton wrote his teaching down in the form of notes-cum-aphorisms, which, by the time of his death in 1981, amounted to more than 7,000 pages. For some reason—perhaps as a result of inner guidance—he did not want them published during his lifetime. But he organized these 'seed-thoughts' into 28 categories, each with a number of sub-categories. I give a selection here just to indicate the range: solitude; visualized images, mantrams, affirmations; food, exercises and postures; sex; emotions and ethics; the ego; the I-thought; experience of dying, rebirth, destiny, freedom; astrology; etheric and astral bodies in health and sickness; world crisis; the arts; the Orient; prayer, devotion, surrender; "why Buddha smiled"; World-Mind in individual mind; the World-Idea; Mind-In-Itself; the Absolute.

[1] It is noticeable that Baba is the only prominent figure in the book of whom Brunton is really critical. It therefore came as something of a surprise, to me at least, to discover that he had formed the Meher League in Britain before his departure for India, stating categorically that "We firmly believe that He alone can save the West, or indeed the whole world" (K. Lux, 'The Avatar's Progress', *Glow International*, August 1995, 8–10). He obviously changed his mind.

[2] The last book to appear in his lifetime was *The Spiritual Crisis of Man*, published in 1952, which addressed the possibility that there might be a third world war if the human race did not begin to live according to spiritual values. Those who were close to him were particularly affected by his views, which he expressed frequently in conversation. They included the parents of Jeffrey Masson who left America in 1959 and went to Uruguay in order to escape the effects of a war with Russia which Brunton said was about to happen (Masson, 141).

These categories have been used to edit Brunton's writings into 16 volumes under the title of *The Notebooks of Paul Brunton*. The first volume, *Perspectives*, is a condensed version of the series as a whole and contains material from all 28 categories. He says there that he has "undertaken what I believe to be a pioneer work." As a result, there is now available—through him and those who will come after him—"an entirely fresh world-view which could not have been revealed historically earlier" (ibid., 147). It is a synthesis (his word) of all the wisdom that has gone before; "a new East-West philosophy which it is the privilege of this century to formulate" (*Perspectives*, 147–48)

> It is not enough to resuscitate the doctrines and methods of a bygone era; we must evolve our own. And this can be done only out of firsthand experience of illumination under modern conditions. (ibid., 148)

The editors of the *Notebooks* refer to Brunton as a "sage" and compare his works to the *Upanishads* (ibid., xii).

As I write this, the full 16 volumes of the *Notebooks* have been available for just over five years. It is therefore far too early to tell what impact they will have. But I think it is fair to say that while Brunton shunned the public limelight, he did make considerable claims about his role and the significance of the teaching he was transmitting. So while he may have hidden his light under a bushel, he thought it could illumine the world.

Primary sources: Paul Brunton, *A Search in Secret India*, (London, 1934); *The Secret Path* (London, 1935); *A Message from Arunachala* (London, 1936); *A Hermit in the Himalayas* (Madras, 1936; London, 1939); *A Quest of the Overself* (London, 1937); *The Inner Reality* (London, 1939); *The Hidden Teaching Beyond Yoga* (London, 1941); *The Wisdom of the Overself* (London, 1943); *The Notebooks* (16 vols.) (New York, 1984–89); J. Godwin (ed.), *Paul Brunton: Essential Readings*, (England: Crucible, 1990)

Secondary sources: M. Juste, *The White Brother* (London: Rider, nd [1927]) [contains a portrait of Brunton under the name 'David']; J.M. Masson, *My Father's Guru*, (New York, 1993); K. Hurst, *Paul Brunton: A Personal View*, (New York, 1989)

Centre: Paul Brunton Philosophic Foundation, PO Box 89, Hector, NY 14841, U.S.A.

COMPARE:

Other pioneers who had transmitted Eastern traditions/teachings either from personal experience and/or in some sort of teaching role by 1935: Madame **Blavatsky**, Yogi **Ramacharaka**, **Oom the Omnipotent**, Swami **Abhayananda**, Sister **Devamata**, Sister **Daya**, Arthur **Avalon**, the **Mother**, **Ananda Maitreya**, **Nyanatiloka** Thera, George **Grimm**, Paul **Dahlke**, Alexandra **David-Néel**, Rabia **Martin**, René **Guénon**

Other teachers who were strongly influenced by Ramana Maharshi: Swami **Abhishiktananda**, **Shunyata**, Bhagavan **Nome**

TITUS BURCKHARDT | SIDI IBRAHIM. SEE **APPENDIX 1**

American *sannyasin* who is also a bishop in his own church

Burke was born in Bloomington, Indiana, in 1940. He was raised in a Protestant family but became interested in Esatern teachings and was initiated as a *sannyasin* in India in 1962, taking the name 'Nirmalananda'. However, when he returned to America, in 1963, he went to live at a Christian monastery: Holy Transfiguration Monastery in Boston. He then founded a her-mitage-cum-ashram in Illinois—it had four members to begin with—where "the emphasis was completely on Eastern thought (Vedanta) and meditation." Gradually, the emphasis changed from orthodox Hinduism to unorthodox Christianity. Around 1970—I have no exact date—Burke and his co-practition-ers were baptized into the Liberal Catholic Church International.[1] Burke him-self became a bishop in 1975. He is presently abbot of his own Monastery of the Holy Protection of the Blessed Virgin Mary. And as far as I can tell, he is or was also bishop of his own Gnostic Orthodox Church.

The monastery's liturgy is based on that of the 'original' Liberal Catholic Church, with a few additions and alterations. Monks must be completely veg-etarian (not even eggs) and abstain from all stimulants (including tea and cof-fee). "Except for necessary conversation regarding work"—which used to include raising ostriches for Oklahoma City Zoo—"silence is enjoined at all times." And "although women are permitted to attend our services, and by invitation some worthy women may visit us on occasion, no women are admit-ted on the Monastery grounds." Although Burke says that he is "in good stand-ing" with the Giri Order in India and wears his *sannyasin* robes when he goes there, there is nothing in the description of his monastery's routine that sug-gests anything in the least Indian or Hindu or Vedantin. His form of Christianity thus appears to be somewhere midway between that of Swami **Abhishikt-ananda** and Father **Satchakrananda**. The whole topic of Christian Hinduism/ Christian *yoga*/Christian ashrams needs further research.

Primary sources: I have no details

Secondary sources: Anon., 'Monastery of the Holy Protection of the Blessed Virgin Mary', *Ubique*, no. 210, Spring, 1981, 18-21; 'Conversations: Abbot George Burke', *AROHN*, vol. III, no. iv, 1981, 24–30.

Centre: Gnostic Orthodox Church, 3500 Coltrane Road, Oklahoma City, OK 73121, U.S.A.

COMPARE:

Others who have brought Christianity and Hinduism together: Swami **Abhishiktananda**, Father **Satchakrananda**, Guru **Subramuniya**

[1] This was a breakaway from the 'original' Liberal Catholic Church (founded by Theosophists in 1916 but con-nected with various other lines of succession). In fact, Burke thought that he *was* joining the Liberal Catholic Church and it took him several years to realize his mistake and leave the Liberal Catholic Church International. (These lines of succession, all of them part of the wandering bishops 'movement', are incredibly complex and I cannot possibly summarize them here. See P. Anson, *Bishops At Large* [New York, 1965], for further information.)

PAUL CARUS

Independent philosopher who set up collaborations with *Soyen Shaku,* D.T. Suzuki and Anagarika *Dharmapala,* wrote books that were translated into Japanese, and provided a focus for discussion of Buddhism at the turn of the century

Cf. the translation of **Olcott***'s* Buddhist Catechism *into Asian languages.*

Carus was born in Germany in 1852 but emigrated to America in the 1880s. He developed his own philosophy to the effect that the same laws govern both the working of the universe and the human mind so that the latter is inherently capable of understanding the former. This idea has similarities to others that were available in the West at the turn of the century: straight philosophical monism; Unitarianism (which is really a Christian version of monism); and the esoteric principle of homology—'as above, so below'. But Carus was independent of all these. He was a universalist and a comparativist by nature, so when, in 1897, he was appointed editor of the journal, *The Open Court,* which was devoted to the scientific foundation of religion and ethics, the job might have been made for him. In later years, he edited another journal, *The Monist,* and was also editor-in-chief of The Open Court Publishing Company, which printed the works of the great philosophers (Aristotle, Kant, Leibniz) as well as those by contemporary logicians and mathematicians (Boole, Dedekind).

Part of Carus's wide-ranging interests was an investigation of Eastern religions. He had a particular affinity with Buddhism, and though he never *formally* became a Buddhist in the sense of taking vows in a public ceremony, he was an early example of what I call a 'general lay Buddhist'. He attended the World Parliament of Religions in Chicago in 1893 (where he delivered a paper with the provocative title of 'Science—A Religious Revelation') and met *Soyen Shaku* and Anagarika *Dharmapala,* both of whom were prominent figures, in their different ways, in the transmission of Buddhism to the West. (*Dharmapala* established an American branch of his Maha Bodhi Society in Chicago after the Parliament, with Carus as a founder member.)

Carus invited *Dharmapala* back to America in 1896 and was generally helpful to him. But his association with *Soyen Shaku* was in a way more fruitful. He invited Shaku to his home in La Salle, Illinois after the World Parliament, and the two men kept up a correspondence for many years. Carus sent Shaku his *Gospel of Buddha* (published by Open Court in 1894) and Shaku had it translated into Japanese by one of his pupils, D.T. Suzuki. Carus was also working on a translation of the *Tao Te Ching* at this time and Shaku arranged for Suzuki to go to La Salle to help. He arrived in 1897 and stayed for several years. Carus was thus instrumental in bringing to the West one of the finest writers on Buddhism of this century. And when Shaku returned to America in 1906, he visited Suzuki and Carus at La Salle.

Meanwhile, Carus continued his vigorous efforts to introduce Buddhism to Western society. *The Open Court* acted as a forum for every kind of approach: Buddhists from Japan and Ceylon wrote alongside Western sympathizers and scholars. There was nothing quite like it anywhere else in the world at the time. Carus himself also wrote profusely. One of his books (actually, an 18-page pamphlet), *Karma, a Story of Early Buddhism,* was translated into Russian by Leo Tolstoy. And he experimented with setting Buddhist writings (for example the *Dhammapada*) to Western music (such as Beethoven and Chopin), corresponding on the topic with Allan Bennett/**Ananda Maitreya**, who had just become a monk in Burma, and with the Rt. Rev. Mazzinanda, an Indian who presented a form of Tibetan Buddhism at his Buddhist Church in Sacramento, California. (Fields has a few pages on this extraordinary individual.)

Carus died in 1919 after more than 30 years of non-stop activity. There is much to admire in him. Not only was he extremely generous, both in thought

and deed, being committed to open discussion at a time when it was generally in short supply, but he was also something of a visionary. He could see that the best teachings of the East were bound to have an impact on the West that was out of all proportion to their apparent obscurity. Active, universalist, comparative thinkers (who were not Theosophists) were rare at this time.

The *Dictionary of American Biography* states that Carus's "direct influence on American philosophy was curiously slight" despite the fact that his work "must be considered as one of the most constructive philosophical achievements in nineteenth century America" (quoted Peiris, 254). But this assessment is entirely from a 'Western' point of view, of course, and hence misses the point somewhat. Perhaps *Soyen Shaku* was nearer the mark when he referred to Carus as "the American Vimalakirti [who] does not cling to silence . . . [but] writes and lectures constantly on the Gospel of the Buddha" (quoted Fields, 173). This may be an instance of Shaku's own generosity. But that a Westerner should be compared with such a great Bodhisattva—the embodiment of what might be called lay wisdom—at the turn of the century is surely worthy of note.

Primary sources: Paul Carus, *The Gospel of Buddha According to Old Records* (Chicago, 1894); *Karma: A Story of Early Buddhism* (Chicago, 1894); *Buddhism and its Christian Critics* (Chicago, 1897); *Lao Tze's Tao-teh-king* (Chicago, 1898); *Amitabha: A Story of Buddhist Theology* (Chicago, 1906); *Buddhist Hymns: Versified Translations from the Dhammapada and Various Other Sources, Adapted to Modern Music* (Chicago, 1911)

Secondary sources: H. Henderson, *Catalyst for Controversy: Paul Carus of Open Court* (Southern Illinois University Press, 1993); R. Fields, *How the Swans Came to the Lake* (Boston, 1986); W. Peiris, *The Western Contribution to Buddhism* (Delhi, 1973)

Centre: Open Court Publishing Company is still going: it has published this book.

COMPARE:

Other early Buddhists: **Ananda Maitreya, Nyanatiloka** Thera (both Theravadin monks); Paul **Dahlke**, Col. **Olcott** (both Theravadin laymen); M.T. **Kirby** (apparently himself a disciple of *Soyen Shaku*)

Swami Chetanananda | Michael Shoemaker

American teacher of Kashmir Shaivism

Shoemaker was a pupil of **Rudi** (though I do not know when he met him). He told me in an interview that he was the only one that **Rudi** trained in Tantra. After **Rudi**'s sudden death in 1973, when the various Rudrananda ashrams were in some disarray, he came across the *Siva Sutras*, a text in the Trika school of Kashmir Shaivism, and immediately recognized **Rudi**'s teaching (though **Rudi** had never mentioned Kashmir Shaivism).

As a result, he sees himself as part of a particular lineage. This is how he explained it to me. Shorn of its external trappings, Kashmir Shaivism is the eternal Dharma, the fundamental ground of all experience, the absolute unity of life which is itself the unity of Shiva and Shakti. Awareness of this union in the body is what is called *kundalini*. Swami Nityananda (for whom, see **Rudi**'s entry), who was a true independent, discovered this for himself and taught it—for example, in the *Nitya Sutras* (published by Chetanananda's Rudra Press)—without being part of the formal Kashmiri Shaiva lineage. In a sense, he passed

it on to **Rudi**—but only as *shakti-pat*, the direct transfer of spiritual energy, not as a teaching or philosophy. **Rudi,** who was in his own way quite as independent as Nityananda, discovered this truth for himself, which is why he never referred to it as Nityananda's teaching (nor as Kashmir Shaivism). In a similar way, Chetanananda received *shakti-pat* from **Rudi,** and, having come across texts like the *Siva Sutras*, uses them as a resource.

This account of **Rudi**'s lineage is noticeably different from the one that is usually given. In particular, there is no mention of Swami Muktananda, despite the fact that most people think of him as **Rudi**'s main guru. Not so, according to Swami Chetanananda. **Rudi** was a true son of Nityananda, and his association with Muktananda was largely external and incidental. Much the same applies to Chetanananda himself. Although he did meet Muktananda (in 1976 after **Rudi**'s death), and received *sannyas* initiation from him in 1978 (that's why he is Swami Chetanananda), he does not have a high opinion of him. (And of course **Rudi** himself broke with Muktananda and was critical of him.) In fact, Chetanananda told me that he did not accept Muktananda as Nityananda's successor at all. I should point out, however, that Muktananda published *An Introduction to Kashmir Shaivism* in 1975 and that this work includes a translation of the *Siva Sutras*. As usual, there are at least two sides to every story.

Meanwhile, Swami Chetanananda's Nityananda Institute issues books (under the Rudra Press imprint) on Kashmir Shaivism, Trika Yoga and Hatha Yoga, as well as titles by **Rudi** and Chetanananda himself. One wing of the Institute is the Abhinavagupta Institute, which provides scholarly translations of Kashmiri Shaivite texts. At the same time, he gives initiation or *shakti-pat*. But not formally—"it just happens" (interview). Although he is a *sannyasin*, he does not give *sannyas* initiation. (Neither did **Rudi** or Nityananda, but Muktananda did.)

It is evident that **Rudi** was a hard act to follow. Although he did authorize a couple of other people to teach[1] apart from Swami Chetanananda, it is only Chetanananda who has created anything substantial. It remains to be seen if it will continue.

Primary sources: Swami Chetanananda, *The Breath of God* (Rudra Press, 1988), *Songs from the Center of the Well* (1983); *Dynamic Stillness (Part 1: The Practice of Trika Yoga)*, 1990 (all published by Rudra Press, which also carries other titles—and tapes—by Chetanananda; Rudra Press's address is the same as the Nityananda Institute—see below)

Secondary sources: None

Centre: Nityananda Institute, P.O. Box 13310, Portland, OR 97213, U.S.A.

COMPARE:

Other Shaivite gurus (though different branches of Shaivism): Sri **Mahendranath**, **Shankar Das**, Guru **Subramuniya**

[1] One of these was John Mann, who has edited one of **Rudi**'s books (see his entry) but has since gone over to Master **Da** (who was himself a pupil of **Rudi**'s for a while)—an interesting case of influences (I hesitate to say 'lineages') separating and then coming together again.

American guru who appeared out of the blue in 1977, took over a number of J.G. **Bennett**'s pupils, made a series of startling claims about himself and then vanished as abruptly as he had come

This is a strange one. In 1977, three years after the death of J.G. **Bennett**, a letter was received at Sherborne, his centre in Gloucestershire. It was from America but was written by someone called Rishi Dada Narayan, who said, amongst other things, that he was "a Teacher of the Naqshabandi Sufis, a line of Hindu Rishis, and the Tibetan Kargyupta Sect, which are all one in a certain location in the Trans-Himalayas" and also "the Real Man, the Gurdjieff, the Shivapuri Baba, that you are all wishing would show up and straighten things out."[1] He went on to say that "The entire Gurdjieff Path as a way in itself is truly *defunct*. The valid elements must be brought into a new, valid context, such as I can provide."[2] In fact, Rishi Dada Narayan was Gary Chicoine, a 35-year-old American living in Montana on a U.S. disability pension. He was invited to England by the Bennett group and became its leader, or rather the leader of a certain section of it. The Alexandria Foundation was formed in 1981 and published his writings.

His main teaching was what he called the 'non-sectarian universal view'— that all traditions and truths are derived from the same source, "the One Silent Guide of All" (*Yoga Tasawwuf Zen,* 2) and that he (Chicoine) is an agent of this source. In 1986, the Alexandria Foundation issued a series of pamphlets which declared that Chicoine was the Avatar. In order to accomplish his "macrocosmic" work, the Avatar cannot attract too many people.

> For this reason, he takes definite steps to appear as needed as a 'charlatan', 'dirty bastard', or 'disreputable' person . . . If he sounds 'just like all the others simply making grandiose claims' that is for a reason you will probably never know. (*The Avatar Is Here*)

However, in what I confidently claim is the shortest-ever reign by an Avatar, Chicoine issued yet another pamphlet, just a month after his original claim (entitled, with a certain brio, *Director Quits Avatar Job*), in which he says that he is abandoning his role as Avatar because of "a lack of correct response from others to my presence." Shortly afterwards, he issued a final letter:

> I utterly refuse to be a messiah, spiritual leader, teacher or guide in any form whatsoever . . . I have literally burned and destroyed all my books, pamphlets and writings and they will never again be published or made available. They do not apply. I disown them . . . I would like to say right now that whoever you are, whatever your particular occult or spiritual 'experiences' or opinions, I truly no longer give a damn about them.

The Alexandria Foundation was disbanded and Chicoine moved to Scotland. He still lives there with his family but he no longer issues public proclamations. Apparently, he does have some students or disciples, though I know nothing about them. Those he left behind are still feeling fairly bruised.

Clearly, if we are looking for the traditional spiritual virtues in this man—generosity, forbearance, even plain consistency—we are going to be disappointed. But if truth is ambivalent and not 'sweet', not consistent, then a 'spiritual' teacher

[1] Later, he claimed to be in the lineage of Amerindian spirituality, which is why he became known as 'Chief'.
[2] Though it is arguable whether he ever did provide them. An International Gurdjieff Society was created in 1983 but I have no details as to what its aim was. Given Chicoine's own declaration that "the entire Bennett-Gurdjieff message is a very minor concern of mine" (*Institute Bulletin* [Bennett's Institute at Sherborne], May 1981, 6), it probably did not amount to very much.

will reflect this. He will tend to be outrageous and abrasive and will inevitably have his detractors. I spoke to Mr. Chicoine on two occasions. The second time, he made it plain that I was not looking for the teaching he was offering and that we should therefore go our separate ways. Which is fair enough.

(*See* Lineage Tree 3)

Primary sources: The Alexandria Foundation pamphlets were never publicly available so I do not list them here. But it is possible that works published by Coombe Springs Press/CSP (originally **Bennett**'s imprint but taken over by the Foundation) were lodged in the copyright libraries. The first four are by Chicoine using various pseudonyms; the last—the only one which is a full-length book—is by one of his pupils.

Rishi Dada Narayana Sadashiva, *The Central Anguish of Ego and Spiritual Authority* (7 pp, CSP, 1982); Sadguru Swami Narayan Avadhoot, *Adiguru Dattatreya and the Non-sectarian Central Spiritual School* (18 pp, CSP, 1982); Sri Buddha Shankar Ghauth, *Yoga Tasawwuf Zen* (4 pp, CSP, 1982); Shree Narayan Sadashiv, *Making Contact* (41 pp, CSP, 1984); A. Hodgson, *Crisis in the Search for Truth* (CSP, 1984)

Secondary sources: According to Chicoine himself, Joseph Chilton Pearce, author of *The Crack in the Cosmic Egg* and *Magical Child*, was a disciple of his and wrote "very inaccurate reports about me in a book praising Muktananda". But I have not been able to trace it.

Centre: somewhere on the Duke of Atholl's estate near Pitlochry, Scotland.

COMPARE:

Other agents provocateurs*:* **Gurdjieff**, E.J. **Gold**, Idries **Shah**

Other Western Avatars: Master **Da**, John **Yarr**

NGAKPA CHOGYAM | NGAK'CHANG RINPOCHE

British Nyingma teacher and *tulku* who is dedicated to establishing a Western lineage of inner tantra for Western householders

Ngakpa Chogyam (who does not want his original name to be known) was born in Hanover, Germany in 1952. His mother was German and a direct descendant of Schubert, the composer. When he was a boy, he became interested in Tibetan Buddhism and more particularly in Padmasambhava, the founder of the Nyingma school,[1] though he had no specific connection with the tradition. Then, when he was fifteen, he saw some Tibetan paintings or *tankas* and felt attracted to them. After training as an illustrator, he went to India in the early 1970s and made contact with Nyingma teachers, and in particular with his guru, Kyabje Khordong Terchen Tulku Chhimed Rigdzin Rinpoche (who is regarded as the incarnation of Kyechung Lotsa, one of the 25 principal disciples of Padmasambhava).

In 1978, when he was only 26, he was accepted by Kyabje Rinpoche as a personal disciple and was initiated as a *ngakpa*—one who practices 'inner

[1] Actually, he is far more than that. Nyingmapas accept him as supremely enlightened, a second Buddha. His 25 main disciples were also enlightened and all of them were *tulkus*—that is, beings who deliberately incarnate over and over again in order to disperse the qualities of enlightenment for the benefit of all beings. These qualities are themselves emanations of certain aspects of Padmasambhava. There are eight principal aspects, one of which is called Dorje Trollo, which means Ferocious Compassion (that is, the kind of compassion that shocks beings out of their samsaric complacency in order that they can experience the bliss of enlightenment). These Dorje Trollo *tulkus* are sometimes called Crazy Wisdom masters. Kyechung Lotsa was one of them and hence Kyabje Rinpoche (for whom, see below), as his incarnation, is one too.

It should also be mentioned that the Nyingmapas have a long history of, and a high regard for, non-celibate practitioners. Padmasambhava himself had consorts and this is probably the main reason why the non-celibate White Tradition, as it is known, is far more significant in the Nyingma school than it is in the Kagyu and Sakya (where it is quite minor). (The Gelugpas do not have a non-celibate strand at all.)

tantra'[2] as a householder rather than as a monk. I shall therefore refer to him as Ngakpa Chogyam from now on.[3] But more significantly, Kyabje Rinpoche also recognized him as the incarnation—that is, a *tulku*—of a Tibetan monk and visionary artist, 'a-Shul Pema Lengden, who had been a disciple of Kyabje Rinpoche in a previous life (when Kyabje Rinpoche also had a different name: Khalding Lingpa).[4]

Ngakpa Chogyam returned to Britain in 1983 and within a year he and his wife, Khandro Dechen (who is also Western and a lineage holder) had founded a centre: Sang-ngak-cho-dzong, which means *The Fortress* (cho-dzong) *of the Secret* (sang) *Mantra/Word* (ngak). His aim is to establish the lay *ngakpa* tradition, based on 'inner tantra', in the West. However, this can only be accomplished if there is a true lineage, an unbroken succession passed from *lama* to disciple: "it must be passed on by someone who has gained realization from the practices contained within the lineage" (*Hidden Word*, no. 1, n.d., 5). And because realization in Tibetan Buddhism is unthinkable without the reincarnation of *tulkus*, "an unbroken lineage means that it has been passed on to disciples who then become the teachers of the main lineage holder" (ibid.).

> My main consideration always revolves around preserving the essential teachings for the benefit of future generations; enabling this Heart of the Tradition to have a health pulse for the life-blood of ordinary Western people. Without this, these unique teachings will never be established on Western soil (Interview in *Lotus Light* [the magazine of Pema Osel Ling, Santa Cruz, California, run by Ngakpa Chogyam's 'vajra brother', Lama Tharchin Rinpoche, who is Tibetan]; I have no further details.)

To this end, he has introduced an Apprentice programme, which is intended to produce Western *lamas*—that is, realized teachers who will be able to carry on the lineage that Ngakpa Chogyam himself has brought to the West. So far, he has appointed about half a dozen as *ngakpas* (or *ngakchungs* or *nalchungs*, which are fairly similar). Although the programme is at present

[2] This is a technical matter and I cannot do justice to it here. It includes Mahayoga (mantra practice and visualization), Anuyoga (the practice of 'subtle physiology' involving *prana* and the 'psychic channels' or *nadi*) and Atiyoga (which is really another name for Dzogchen, the 'direct' path to enlightenment). Further details can be found in any good textbook.

[3] The name 'Ngak'chang Rinpoche' is one that he uses when giving teachings at the request of Tharchin Rinpoche, a senior Tibetan in the White Tradition.

[4] Ngakpa Chogyam can 'remember' his life as 'a-Shul Pema Lengden. At the end of it, he renounced his monastic vows and took up with a young wandering *yogini*. This was Jetsunma Khandro Yeshe Rema, a Dzogchen master who was herself a *tulku* of Yeshe Tsogyel, Padmasambhava's principal consort. She became 'a-Shul Pema Lengden's principal teacher. In Ngakpa Chogyam's words,

> I think she was rather beautiful from the very first dream I ever had concerning these events. Kyabje Chhimed Rigdzin Rinpoche tells me that I went a little bit crazy but it all appeared to be part of Rinpoche's teaching. I had to learn some important lessons, gain some insight and experience, that were not possible in the monastic setting . . . But I didn't live too long after I left Khordong . . . Not to put too fine a point on it—I was quite old and [the yogini] was rather young . . . It really had a very powerful effect on me to be with this Yogini, as my teacher obviously knew. I changed quite a lot and then I died . . . (*Lotus Light interview*)

This—I mean 'a-Shul Pema Lengden's death—occurred around 1920. But he incarnated again almost immediately. (He says that "I left some work undone which I must finish in this or subsequent lives; certain cycles of wrathful-ritual painting connected with the practices of Dorje Trollo" [*Hidden Word*, no. 1, n.d., 12]). The circumstances of his reappearance were certainly unusual (though Ngakpa Chogyam says that they were not "too unusual"): he was reborn as his own son—that is, as the son of 'a-Shul Pema Lengden and Jetsunma Khandro Yeshe Rema. His name was Aro Yeshe and he became a *togden*, one who has matted hair, on the border of Tibet and Nepal, with a number of *yogis* and *yoginis* as his disciples. Ngakpa Chogyam also 'remembers' this life.

> There was one nice old nun I remember . . . She gave me a marmot that I had as a pet after my mother died. It used to bite people who had 'attitudes'. (*Hidden Word*, no. 1, n.d., 12)

I am not aware of any other Western *tulku* who has memories anything like this.

completely dependent on him, he would like to see it evolve in a non-hierarchic way. That is, his own disciples would eventually become sufficiently advanced to have students of their own.

> At this point, I would cease to be the prime mover within Sang-ngak-cho-dzong. I would become one of a number of lamas . . . My system of operating the Apprenticeship Programme would simply be there as a working model. It would be something for them to use if they choose. It is the essence that must survive, not necessarily the form. The form should be open to change . . . Everyone who comes to teach through working with me as their Teacher will be responsible for the nature of their own Teachings. When I consider that someone has sufficient realisation to teach, then they will teach from their own experience and in their own way. (*Hidden Word*, no. 1, n.d., 22)

What this comes down to is that a Western *tulku* is attempting, by the use of appropriate forms (which he himself has to devise, there being no precedent to follow), to introduce inner tantra to Western householders in a lineage that goes back to Padmasambhava. And the final pay-off is the appearance of Western *lamas*, all of whom have at least the potential of keeping this lineage going. Moreover, Ngakpa Chogyam is very keen that as many of these *lamas* as possible be women. In a householder lineage, there is no reason at all why *lamas* should not also be mothers (slightly adapted from *Hidden Word*, no. 1, n.d., 11, 26).

He also emphasizes that Western culture has its own 'forms' that can be used to make Tibetan teachings more accessible—in particular, art and psychology. As 'a-Shul Pema, he was himself a visionary artist (which we could define in this context as one who presents the teaching or Dharma in visual form) and in his present life he has trained as an illustrator and studied Tibetan painting and calligraphy. As for psychology, in 1989 he was awarded a doctorate in Tantric Psychology by the Indo-Tibetan Cultural Preservation Society. This was partly in recognition of his books, *Rainbow of Liberated Energy* and *Journey Into Vastness,* but also involved an intensive oral examination. He has also addressed professional conferences in the West: the British Psychological Society in 1986 and the Institute of Transpersonal Psychology in 1989.

Ngakpa Chogyam once said to me in a letter that all he claims is that "I try to be kind." But there is more to it than that. His position in an altogether extra-ordinary lineage—from Padmasambhava in eighth-century Tibet to himself in present-day Cardiff—is proof enough of that. But in addition, there is a whole teaching of ambivalence.

> There is always emptiness and form. Only when you enter into non-duality does the ambivalence subside. So ambivalence in the Lama-disciple relationship has to manifest through symbols of emptiness and form . . . : Mother Theresa/Charles Manson,[5] Dalai Lama/Hitler, Gandhi/Stalin . . . There is always ambivalence within the Tantric relationship and hence discomfort. The nature of that discomfort, however, is communicative. It's the living blood of the practice and of the Lama-disciple relationship. (*Hidden Word*, no. 1, n.d., 21)

[5] In an interview in which he talked about total commitment to the tantric way of life (in fact, total commitment *is* the tantric way of life), he was asked, "You don't just talk about commitment, though, do you? You also encourage people to ask themselves whether in fact you might be another Jim Jones or Charles Manson." He replied,

> So you think I'm not Charles Manson? If you look at the Sutric model of a Teacher [that is, a teacher in the Buddhist Sutras rather than the Tantras], it depicts someone who is very saintly. So a Sutric Teacher should be as much like Mother Theresa as possible. There's something very reliable about that. You know they're not going to set fire to your underwear while you are still wearing it. But the Tantric teacher does—or might do! (*Hidden Word,* no. 1, n.d., 17–20)

Tantra presents the spiritual life is a roller-coaster ride: both exciting and dangerous. And it is practically inevitable that you will be thrown off unless you are making the ride with someone who knows how to stay on. But you have to do what he or she says. When the instructions come, shouted urgently in the wind ('Hold on!', 'Move!', 'Jump!'), there just isn't time to discuss the pros and cons. This explains why tantra is based on the guru-disciple relationship—and why it has to be demanding. It also explains why the essence of tantra is both direct and ambivalent at the same time.

This is the teaching behind a relatively small group of Western householders who are following the path of inner tantra under the guidance of a half-British, half-German Nyingma *tulku* and *ngakpa*.

Primary sources: R. Hicks and N. Chogyam, *Great Ocean* (Element Books, 1984 [a biography of the Dalai Lama]); Ngakpa Chogyam, *Rainbow of Liberated Energy* (Element Books, 1986); *Journey Into Vastness* (Element Books, 1989)

Secondary sources: None

Centre: Sang-ngak-cho-dzong, 5 Court Close, Whitchurch, Cardiff CF4 1JR, Wales, U.K.

COMPARE:

Other Ngakpas: **Jampa Thaye**

Other Western tulkus: [see ***tulkus***]

Other 'visionary' artists: Lama Anagarika **Govinda**, Frithjof **Schuon** (cf. also Jiyu **Kennett**, who had visions that have been turned into wall paintings; and Ivan **Agueli**, who was a painter before he became a Sufi)

Other Crazy Wisdom teachers: **Gurdjieff**, Lee **Lozowick**, Master **Da**

Other teachers in Tibetan Buddhism: **Ahkon Norbu Lhamo** (Nyingma); **Osel Tendzin**, **Pema Chodron** (Kagyu); **Jampa Thaye** (Sakya); Lama Anagarika **Govinda** (Gelug/independent)

CHRIS AND EMMA

An English couple who work as an 'enlightened' team

I sent the original version of this entry to Chris Orchard in January 1995 for him to look at. He returned it with one correction (which I incorporated) and the single comment, "Otherwise, seems OK". Nine months later, just as the book was going to press, I received the following letter from the secretary of the Orchard Foundation:

> Dear Andrew, Since you sent Chris the proposed entry to your book . . . in January 1995, the nature of Chris's teaching has altered dramatically. Chris's teaching is a living vibrant teaching and information about him inevitably is going to be distorted by the past and will therefore be irrelevant. Please do not include in any form copyrighted material published by Chris Orchard or the Orchard Foundation in your book. This includes the material published in *The Final Discovery* and *Mastering Love and Life Today*. Our policy is to rigorously protect the copyright of the Orchard Foundation. May I wish you and your book every success.

In effect, this is someone trying to suppress his own work—and using the U.K. copyright laws, which were designed to protect authors, to do it. I have therefore rewritten the entire entry, paraphrasing what he said rather than quoting it. (Actually, since I am told that one *can* quote two consecutive words and

not risk transgressing the copyright laws, I have done so on occasion. Let no one say that I have not gone to the limit for my readers.)

According to the anonymous Foreword to *Mastering Love and Life Today*, Chris Orchard is an "enlightened master". I know very little about his life. He was born in 1960 and went to art college to study graphic design. When he was 23, he met a 'Living Master'—"basically a nobody", he says, "just someone I met on the street"[1]—who caused him to examine his life. A few years later, he went on to another master (likewise unknown)—and was following a life of meditation and celibacy when, in 1990, he met Emma Lea, who turned out to be the catalyst for his enlightenment.

She was born in 1967. At the age of three, she realized that Truth consisted of nothing more nor less than "Being Alone". In Chris's terminology, this is the state of consciousness prior to the arising of all forms and images. She was never bored as a child but this was not because she was constantly occupied; rather the opposite: she did not feel the lack of anything. Her "natural state" was "happiness". As a teenager, she did not go looking for thrills—or for truth, for that matter. She did not actively seek anything; rather, she knew, without being told, that Truth could only be found "in relationship". But she did not find anyone who could accept this until she met Chris. (All this information taken from *The Final Discovery*, 3–4).

At first, having spent several years looking for Truth from Eastern teachers, he resisted the idea that an English girl of 23 could actually *be* it. But she was adamant that she was the "very form" of God that he had been seeking (*The Final Discovery*, 5). In the end he did accept it. Between them, they formulated the teaching of Chris and Emma, also known as the Chris and Emma dynamic. Chris refers to himself and Emma as "The One"; she is Femininity and he is Masculinity, the two "polarizations" of Truth (ibid., 6).

In fact, Chris does nearly all the talking—because it is man's nature to conceptualize, whereas woman (when she is being a true woman and not trying to fit into an image foisted on her by man) is content to just be. According to Emma (in one of her rare pronouncements), the East has taught that enlightenment is a solitary pursuit and that men and women cannot enter it together. But they can. The West will produce men and women who can find Truth "in relationship" (ibid., 9).

Chris says exactly the same (as we would expect if he is Emma talking): "Western enlightenment" is a man and a woman "loving rightly", "unqualified love", which is woman. It is the "mystery of woman" "something she IS". And he himself has learned this truth from "divine woman" (*Mastering Love and Life Today*, xiii).

This original state is beyond the emotions and the mind, and therefore further removed from men than from women. It is God/consciousness/emptiness/love. It has no problems and can deal with those that arise in the world of the body, emotions and mind without difficulty. This is the 'master consciousness' and it is presently being transmitted through Chris Orchard's brain and body. Through him, the master as an "outer symbol", one can realize the inner master (ibid., 5). Realization of this state makes a man a 'Divine man'. It enables him to see that woman already 'possesses' this state and therefore has no need for the creations of the mind in order to 'attain' it.

The real significance of all this is that it is only when man recognizes what woman truly is (and when woman also recognizes what she is—but this is

[1] He told me this on the phone. I trust that repeating it here does not infringe the copyright laws.

much easier for woman to do than it is for man) that real relationship is possible. "Enlightened consciousness" is not contrary to "intimacy", whether of relationship or sex (ibid., 14). But the traditional Eastern ways are no use to us here because they have opted for the ideal of celibacy (or occasionally for what Chris calls 'tantric nonsense'). Now a Western master is here to show that it is possible to bring together "sex and God". Chris has done this himself and can therefore show how this "way of being" can be attained. And once a few have done it, it will be easier for others to follow (ibid., 89).

This is the Western way. It is the next evolutionary step (ibid., 5)—Chris even says that the people of the West are "the new reality" (ibid., 14)—and therefore requires a Western master. The master loves those who come to him until all 'problems' are "resolved". But while this is an important step on the path, it is not the crucial one; that is the "never-ending intimacy" of one's lover (ibid., 3).

This never-ending intimacy is called the 'Divine Marriage' (ibid., 76)—and Chris and Emma got married in 1994. (At the same time, the Chrisemma Foundation changed its name to the Orchard Foundation.) Emma still says next to nothing; and she is never mentioned by name in *Mastering Love and Life Today*. It is Chris who is giving the teaching—at £20 a throw—to those who want to hear it. But I think it is fair to say that their followers—perhaps 20 in all, most of them ex-Rajneesh people and all of them couples (naturally)—see Emma as the source and Chris as the expression. So the Chris and Emma dynamic is still in full swing.

I have attended one meeting—before the dramatic change in his teaching mentioned by his secretary (see above)—which consisted of the two of them sitting on a sofa, she saying nary a word and he going round the room asking those present—all of them committed followers—how their lives were going. The answers were all in terms of their relationships. Children were not mentioned once. I asked about this and Chris said that children were unnecessary; women only wanted them because they themselves felt unloved. "And anyway, most children are disgusting—greedy, manipulative, selfish."

As the father of four, I can see what he means . . . But there is another side to it and maybe you have to be a parent to know it. Perhaps being enlightened by one's children is the *next* evolutionary step (after the Chris and Emma dynamic, that is).

Not so long ago, Emma said that the two of them are interested in meeting other masters (*The Final Discovery,* 8). I have been told that she went to see Barry **Long** (whose teaching has much in common with Chris's) and that there was "some recognition" (although she did not say anything). *The Final Discovery* also has the transcript of a meeting between her and Christopher **Titmuss**—but they were evidently talking at cross purposes and I found most of what they said difficult to follow. However, Chris told me just recently that this desire to meet other masters is "not applicable now".

It is early days for Chris and Emma—they have only been together for a few years—and we will have to see what will develop. I wonder what gays will make of this unequivocally heterosexual teaching; or what Chris and Emma make of gays, come to that. And what will Chris say to a Pakistani or a Japanese who comes along and says 'This is the teaching for me!' 'Er, I'm afraid not—you're not a Westerner'? Surely being a teacher for Westerners is as much a limitation as any other. So are there, then, two kinds of teaching, one Eastern, one Western, and everyone has to decide which one applies to them? It seems a bit unlikely. The whole point about the phenomenon of spiritual

psychology is that it crosses boundaries; it does not set up new ones. On the other hand, according to the Foreword of *Mastering Love and Life Today,* although he started off being "deeply involved" in Eastern teachings, he now lives from "self-knowledge"; and being a Westerner, his teaching is quite different from the "meditative practices" that we find in the East. It seems that he, at least, has crossed boundaries. And maybe this is the true Western way.

Primary sources: The Final Discovery, vol.1, no.1, 1992 [there were no others]; Chris Orchard, *Mastering Love and Life Today,* (Bristol: Orchard Foundation, 1994)

Secondary sources: None

Centre: Orchard Foundation, 3 Thorndale Mews, Clifton, Bristol BS8 2HS, England, U.K.

COMPARE:

Other teachers who say they were born enlightened (or something similar): Master **Da**, **Marasha**, **Shunyata**

Other teachers who say that their teaching is part of the spiritual evolution of mankind: Andrew **Cohen**, the **Mother**

Others who make sexuality central in their teaching: Barry **Long**

RICHARD CLARKE

Canadian Zen teacher and neurolinguistic programmer who was associated with Philip **Kapleau** for many years but now works independently

Clarke was born in 1933 and grew up in Toronto. When he was 13, he had what he now calls a spontaneous *kensho.* He met Philip **Kapleau** in 1967, soon after **Kapleau** returned to the States from Japan. He became his student, worked on *koans* and had a *kensho* at his third *sesshin* in 1969. (All this information taken from an interview in 1990.) The two men have not had an easy relationship. In 1975, Sharon Springs Zen Center, a residential community in New York state which Clarke had opened a few years earlier, was forced to close, partly because, according to Clarke, **Kapleau** insisted that it be affiliated with the Rochester Zen Center, saying that unless this was done, people at Sharon Springs could not attend *sesshin* at Rochester.[1] Clarke says that he lost a lot of money as a result; but he continued to hold groups (Dharma talks; *dokusan*) in people's houses. The final rift with **Kapleau** took place in 1981—apparently because Clarke kept taking notes during *sesshins* while knowing full well that **Kapleau** did not want him (or anyone else) to do so. So **Kapleau** sent Clarke a letter saying that he should find another teacher. Instead, Clarke set up as a teacher himself: the Living Dharma Center was founded in Connecticut in 1981 (and now has an affiliated centre in Amherst, Massachusetts). Its brochure describes it as "a center for Zen Buddhist training and practice . . . Together we seek to translate the ancient tradition of Zen into forms appropriate to our time and place."[2]

[1] **Kapleau**'s version of events is that the Sharon Springs Center "was from the start an affiliate of the Rochester Zen Center. It was disaffiliated because Clarke would not follow the guidelines governing affiliates" (letter, November 1995).

[2] But Clarke is not just an independent Zen teacher. In 1982, he founded the New England Institute for Neuro-Linguistic Programming, which offers courses on Communication, Personal and Professional Growth, and Strategies for Success. Clarke is described in the Institute's brochure as "an active business consultant" who has held trainings for a number of enterprises (including the Connecticut Alcohol and Drug Abuse Commission). One of his trainings is called 'Integrating Spirituality'.

According to the brochure for the Living Dharma Center, Clarke has undergone "formal training in the Harada-Yasutani-Kapleau line of Zen and received formal Transmission into a lineage of Buddhist teachers which is now more than 2,500 years old." When I was corresponding with Philip **Kapleau** about the whole question of authentic transmission, he took exception to this statement about Clarke's having received transmission, which, he said, was absolutely untrue. I do not want to get caught up in this particular dispute. But divergences of this kind are an integral part of the phenomenon of Western teachers—in fact, **Kapleau** himself has taken part in others, though they are rather different—and people should know about them.

Primary sources: Richard Clarke, *Hsin Hsin Ming: Verses on the Faith-Mind by Sengtsan,* (Buffalo: White Pine Press, 1973, 1984)

Secondary sources: None

Centre: The Living Dharma Center, P.O. Box 513, Bolton, CT 06040, U.S.A.

COMPARE:

Other independent Zen teachers: Richard **Baker**, Joko **Beck**, Jiyu **Kennett**, Zen Master **Tundra Wind**, Zen Master **Rama**

Other independent (in various senses of this term) teachers in other traditions: Swami **Abhishiktananda**, **Siddhaswarupananda** (different forms of Hinduism); Reshad **Feild**, Frithjof **Schuon**, Idries **Shah** (various forms of Sufism); **Kapilavaddho** (Theravada Buddhism)

Others who have separated from their teacher(s) (in a variety of ways): Joko **Beck**, Zen Master **Tundra Wind**, **Rudi**, Michael **Barnett**, Gesshin **Prabhasa Dharma**

Robert CLIFTON | Bhikkhu Sumangalo

American who created the first Western Buddhist Order

Clifton was born in Alabama in 1903. According to Snelling, his original name was Harold Amos Eugene Newman; I have no idea why he changed it. He was attracted to Buddhism while studying at Columbia. In 1928 or so, he went to San Francisco and lived with the Japanese community (Melton)—not something that many white Americans were doing at the time—and in 1933, he was ordained as a Pure Land/Shin priest at the Honpa Hongwanji Mission (now known as the Buddhist Churches of America) there. A year later, he travelled to Japan and was ordained again. He spent the rest of his life as a sort of peripatetic Buddhist seeker-cum-practitioner. In 1951 or 1952 (I have seen both dates), he founded a Western Buddhist Order (not to be confused with Ven. **Sangharakshita**'s of the same name, though **Sangharakshita** was an honorary member—he was living in India at the time). Then, in 1956, he changed tack—or perhaps it would be more accurate to say that he added another string to his bow—and was ordained as a Theravadin monk in Thailand, taking the name, Bhikkhu Sumangalo (Lewis, 135). Over the next few years—though I have no firm dates—he "became convinced of Zen", after meeting Sokei-an Sasaki in New York (Lewis, 69); and subsequently "became a novitiate at the Soto temple at Tsurumi, between Yokohama and Tokyo" and also "passed through . . . the Tibetan [discipline] (kept rather secret)" (ibid.). This is quite a journey through the traditions. And it is evident that Clifton liked journeys: he ended his days in Malaya in 1963, "working vigorously for Buddhism" (Snelling).

It is difficult to know what to make of Clifton's life as a Buddhist. Someone who has practised, in some sense of the term, in Pure Land/Shin, Theravada, Zen and Tibetan Buddhism, in America, Japan (twice—in Pure Land and Zen), Thailand and Malaya, and has created a Western Buddhist Order as well, is certainly a pioneer. But whether he was a genuine universalist or just incapable of finishing what he had started, I do not know.

Primary sources: None

Secondary sources: Samuel Lewis, *Sufi Vision and Initiation* (San Francisco, 1986); J. Snelling, *The Buddhist Handbook* (London, 1987), 347; J. Gordon Melton, *Encyclopedia of American Religion*, 3rd ed. (Detroit, 1989), entry 1534

Centre: None

COMPARE:

Others who have entered more than one Buddhist tradition: Ven. **Sangharakshita**, Gesshin **Prabhasa Dharma, Miao Kwang Sudharma**

Andrew COHEN

American who gained enlightenment as a result of his association with H.W.L. Poonja but then broke with him and now teaches a form of 'evolutionary enlightenment'

Andrew—he is always referred to by his first name, so I follow the convention—is an uncompromising teacher. He says enlightenment is a secret that very few know anything about—including many teachers who say they are enlightened (or whose followers say they are). What this means exactly will take some time to unfold. But we can start with his essential message: that freedom/liberation/enlightenment is always available and is available now—if, and only if, we are prepared to give up everything for it.

> Enlightenment is *not* far away. It does *not* need to take time. As long as you insist that it must take time, then you are still interested in protecting yourself. (*Enlightenment is a Secret,* 6)

> There is tremendous sacrifice involved and if you're not ready to struggle and face your worst fears then you have no business seeking for Enlightenment in the first place. A serious person can't bear to wait any longer. A person who is not serious feels that they have all the time in the world. (ibid., 28)

There is no method or practice that can create enlightenment—because it is already our nature (*Enlightenment is a Secret,* 61). Why, then, are we not aware of it? Because we are more interested in other things. Andrew says over and over again that the real barrier to liberation is self-centredness; not only the emotional kind but also, and perhaps even more so, a metaphysical kind—that is, the belief that I have to sort things out, that things are actually there to *be* sorted out.

> That's what creates ego—the idea that there is a problem. That idea makes you feel special and feeling special makes you feel separate. Give up that idea and then you are Free. Give up the infatuation with your problem. That is what everybody has got to do. (*Enlightenment is a Secret,* 82)

> Egoless means you know what the ego is and you know what it is not . . . [T]hen you discover this beautiful, sweet, simple Truth—that your true nature is Love. When you cease to be infatuated with yourself as being a separate entity, compulsively preoccupied with problems and ambitions, then you will realize lovingness. (ibid., 147)

In short,

> Love is the source of Enlightenment. The expression of Enlightenment is Love. (*Enlightenment is a Secret,* 144)

And true love is impersonal. This word can carry the connotation of indifference but this is not how Andrew uses it. In fact, he uses it in the opposite sense to mean 'not obsessed with oneself, with one's personality'.

> It is impersonal love alone that reveals the perspective that is needed to see things as they are. (*Enlightenment is a Secret,* 146)

This is not a new teaching. One could say that it is very similar to the one that *Ramana Maharshi* gave, expressed in modern Western rather than traditional Indian terms. But Andrew adds an ingredient of his own (and he never says how he knows it—he just says it): that impersonal enlightenment is an evolutionary imperative.

> The full realization of Enlightenment is the evolutionary leap to which all spiritual experiences ultimately lead . . . Spiritual experiences and their results are not meant for the individual. They are for the evolution of the whole race. (*Enlightenment is a Secret,* 263)

This is a big claim. How he arrived at it is an interesting story—and one that he has told himself. It is full of intense and dramatic episodes, and it is still unfolding. What follows is taken entirely from his own accounts.

He was born in 1955 in New York City. His parents did not get on and he had an unhappy childhood; the only time he mentions his father is to say that he died when Andrew was 15. His mother sent him to a child psychologist for several years (*Autobiography of an Awakening,* 3). He was a fairly typical teenager: he tried soft drugs and psychedelics, played drums in a group in Greenwich Village, and wanted to be a musician.

However, at the age of 16, while he was temporarily living in Rome with his mother, he had a spontaneous 'revelation':

> I suddenly knew without any doubt that there was no such thing as death and that life itself had no beginning and no end. I saw that all life was intimately connected and inseparable. It became clear that there was no such thing as individuality separate from that one Self that was all of life. (*Autobiography of an Awakening,* 5–6)

At the time, he had no idea what to do with this experience and it gradually faded. But in 1977, at the age of 22, having failed to become a drummer, he decided that he would "devote my life to the rediscovery of THAT which had revealed itself to me six years earlier" (*Autobiography of an Awakening,* 13). This began a life of spiritual seeking that was to last nearly ten years.

His search included a number of teachers. He went to Sufi and Zen masters (he gives no names); practised *kriya yoga* with Swami Hariharananda, a disciple of Sri Yukteshwar, *Yogananda*'s guru, and had powerful *kundalini* experiences (*Autobiography of an Awakening,* 15); was profoundly struck by a talk by Jiddu *Krishnamurti*; and did several *vipassana* retreats (one of them with Christopher **Titmuss**—referred to simply as 'an English meditation teacher'), with whom he had a bit of a falling out (*Autobiography of an Awakening,* 24).

Then, in 1986, he heard about H.W.L. Poonja (usually referred to as 'Poonjaji') and knew that he had to meet him. This meeting changed his life so we should know something about Poonja. In fact, not much is known. What follows is taken from his own account, supplemented by a few extra

details given by Henri Le Saux/Swami **Abhishiktananda**, the Benedictine Vedantin.

Poonjaji was born around 1911. His mother was the sister of Swami *Ramatirtha*, a pioneer of Vedanta in the West. Poonja was a "visionary from childhood" (H.W.L. Poonja, 'You, that is me, is God', *The Mountain Path*, July 1988, 155–56) and could see Krishna from the age of five; he thought that everyone could. He became an officer in the army but resigned his commission in order to find God. One day (I have no date), a *sadhu* came to his house and told him that if he wanted to find God he should go to see *Ramana Maharshi* at Arunachala, near Tiruvannamalai. But when Poonja got there, after a journey of nearly 2,000 miles, he found that the man called Ramana was this same *sadhu* (despite the fact that Ramana had not left Arunachala for several decades).

Ramana Maharshi taught a form of Advaita Vedanta: the realization of the one formless Self that underlies all forms. But Poonja was still determined to see God in the form of Krishna. One day, Ramana 'appeared' to him and gave him a *mantra*. Within a short while, after intense practice, Poonja did indeed succeed in seeing Krishna. But when he told Ramana this, Ramana gave him the usual Advaitin reply: "Why are you concerned with gods that come and go? . . . You have to take a leap into the beyond . . . Only when everything has been left behind, devas along with everything else, can you find the vision which has no beginning and no ending, the vision of Being, of the Self" (taken from Abhishiktananda, *The Secret of Arunachala* [Delhi, 1979], 80–95).

As a result of this exchange, Poonja changed his approach to the spiritual life. Eventually—and again I have no date—he himself realized the Self. This, at least, is the implication of what he said to **Abhishiktananda** when the two met in India in 1953. He told **Abhishiktananda** that he **(Abhishiktananda)** was close to awakening; to which, **Abhishiktananda** replied, "Why do you not go ahead and awaken me?" Poonja's response is pure Advaita.

> There is no question of awakening anyone at all. Who indeed is the sleeper? How could one awaken that which does not sleep and has never fallen asleep? Sleeping, dreaming, being awoken, all that is a matter of the body and the senses which are located in the body, including of course thoughts, desires and will . . . It is through *you* that that is seen and heard, that it is thought and willed. You are what remains when nothing is any more seen or thought, willed or heard. That is the atman, the Self; it is what *you are* yourself in reality and beyond all outward appearances which change and pass away. *Tat tvam asi*—You are That! What prevents you from realizing this? (taken from Abhishiktananda, *The Secret of Arunachala* [Delhi, 1979], 80–95)

This, then, was the man whom Andrew went to see in Lucknow one March day in 1986: a 75-year-old Advaita Vedantin, a realizer of the Self. Their meeting was dramatic. Within minutes, Poonjaji had told Andrew that the only thing that prevents the realization of the Self is the belief that one is not already realized.

> He said to me, "You don't have to make any effort to be free" . . . In that moment I had a deep and clear experience or glimpse of what making no effort means. A brief moment of complete freedom . . . It is so simple, so obvious, and in fact, right here with us all the time. Poonjaji saw this happen and said he saw radiance come over me at this moment. (*My Master is My Self,* 4)

Over the next week or so, Andrew continued to have "fantastic insights". He realized that enlightenment is beyond time.

It was never born and can never die. Beyond opposites, beyond comparison . . . This whole world. this existence is only a dream . . . Samsara only exists in time . . . At the moment of enlightenment, in one instant, one realizes that none of it ever existed. (*My Master is My Self,* 6–7)

The relationship between master (Poonjaji) and disciple (Andrew) was very close. Andrew says, "I inwardly bow to Poonjaji for letting me know my true nature" (*My Master is My Self,* 12). He mentions Poonjaji's love, gentleness and generosity (ibid., 14). And his very first letter to him is written in the spirit of true *guru-bhakti*:

I love you. You have entered me. I am dying . . . (*My Master is My Self,* 29)

He continued to write in this vein for the next two years or so

For his part, Poonjaji says some fairly extravagant things about Andrew: that it is "very rare" for someone to have the experience of timelessness/ enlightenment so quickly (*My Master is My Self,* 5); that he had only seen the look in Andrew's eyes in two other people—*Ramana Maharshi* and himself (ibid., 50); that Andrew has the capacity to enlighten others—and this too is rare (ibid., 58). (In fact, he had told **Abhishiktananda** 30 years earlier that it was impossible to awaken another.) A few years later, he made even more far-reaching claims: that Andrew is comparable to the greatest Indian *rishis* (*Autobiography of an Awakening,* 67); and that

the 20th Century is lucky to have seen the Perfect Buddha reborn to live with them and Free *[sic]* them from the miserable samsara. . . . (*Autobiography of an Awakening,* 70)

But it was not just a matter of a close relationship. Poonjaji asked Andrew to "accept responsibility for the work" (*My Master is My Self,* 35), and when Andrew left him for a while, just 17 days after their first meeting, he went to Rishikesh to visit friends and found that he *was* teaching even though he had no idea how to do it. Indeed, some time later, he wrote to Poonjaji and said, "The teaching began spontaneously in Rishikesh through your Grace" (*My Master is My Self,* 95).

This process, which started with just a handful of individuals, has continued ever since. Within a year, he had gone to England and then to America. By 1988 he was holding *satsanga*—that is, giving talks, or perhaps it would be better to say, transmitting truth—six nights a week to over 100 people (in Massachusetts). Everything was buzzing and it looked like all systems go.

But Andrew's teaching was beginning to develop in a way that went beyond what he had originally experienced and realized with Poonjaji.

Since I began teaching in India in 1986, something has been coming out of me that I have no power over. It is me and it has possessed me. After my initial meeting with my Guru while sitting alone in a hotel room in New Delhi, I became aware of the fact that there was a 'presence' in the room with me. In fact, this presence, it seemed, had been following me ever since I had left my Guru a few days earlier. It was haunting me and it was loving me. It terrified me and I was also thrilled and intoxicated with joy because I knew without any doubt that it was the essence of Love itself and none other than my own true Self . . . The following morning, instantly upon waking I sat up in my bed, and without thinking said to myself, "I surrender my life to YOU—do with me what YOU will." When I said this, I meant it. From that moment on, my life was no longer my own. I gave it up. Since then, there has been a passion and an intensity that comes out of me when I am teaching and when I am speaking about the Truth that I cannot control and that literally overwhelms me. This passion that comes from nowhere and burns so deeply in my veins *is* the Truth itself . . .

This message has been pouring out of me since the day the Source began expressing itself, and because of this the extraordinary explosion or 'revolution' that my Guru predicted would take place has been and is occurring. This is none other than the force of evolution manifesting itself, and I am but a mere pawn in this drama of creation. (*Autobiography of an Awakening,* 53–55)

This is strong stuff. He also says in this same passage that this passion for Truth has forced him (his phrase) "never to deceive anyone else about the reality of their condition". Andrew is bound to tell the truth as he sees it, both about the nature of enlightenment and about other people's understanding of it. Nobody is exempt from this process—including Poonjaji.

My Teacher always said someone was "Enlightened" after [the] initial glimpse into their true nature. I soon realized this wasn't true. If a person was "Enlightened", to me that meant that they had to be able to manifest and express that Enlightenment consistently in their behavior. I had observed so many people who had experienced profound awakenings and yet still would be unable to manifest and express that realization in their outer lives . . . What did all this mean? It meant that Enlightenment was only the beginning. It meant that the realization of one's ultimate potential was the beginning of the path. (*Autobiography of an Awakening,* 56)

This was the first departure that Andrew made from Poonjaji's teaching that knowledge of the Self was the be all and end-all. The second was that in order to 'live the Truth', it was natural, perhaps inevitable, to create a community or *sangha* (which Poonjaji had never done and had no interest in doing). Andrew says that as early as 1987, in Amsterdam, he saw that the community which was springing up spontaneously around him was itself a means of realization.

I came to understand that those who were united in their love and interest in my teaching, *simply in being together* seemed to be automatically drawn into and immersed in that bliss and love that was impersonal and transcendent. This amazed me. I knew then that the power and implications of what was occurring were far beyond anything I had previously imagined. (*Autobiography of an Awakening,* 42)

Andrew never says what he thought Poonjaji's reaction would be to these developments. Perhaps he assumed that Poonjaji would welcome them; perhaps he simply did not pause to consider the matter at all. But whenever he tried to talk about them, Poonjaji's response was perfunctory to the point of indifference. And it gradually became apparent that Poonjaji was not happy with this 'new' teaching. But he did not come right out and say so. Instead, Andrew heard reports that he (Andrew) was 'distorting' the teaching (*Autobiography of an Awakening,* 88). And attempts were made to influence his students in the 'right' direction. In one instance, he says that people who had been coming to him for several months went to see Poonjaji in India and afterwards spoke of him (Andrew) and his students "with extreme disrespect and even contempt" (*Autobiography of an Awakening,* 78). Yet all the time, Poonjaji was writing letters to Andrew expressing his unqualified support. "My Guru was speaking against me to others while at the same time actively deceiving me as to how he honestly felt" (*Autobiography of an Awakening,* 108). Matters came to a head when Andrew brought 120 of his students to Lucknow to meet Poonjaji but Poonjaji tried to get out of seeing them and said that it was not an appropriate time because the Prime Minister of India was in Lucknow and there would be large crowds and police. But, says Andrew, "I knew Poonjaji was lying" (*Autobiography of an Awakening,* 97).

This is *very* strong stuff. Andrew's explanation of why he says such things is simply that he is bound to, given that he is driven by the need to tell the truth.

> My absolute insistence for the Truth alone was, it seemed, the very essence of the schism. It seemed that in this I was going too far even for him, for in my reflection, his own hypocrisy and duplicity were brought into the light. No wonder he had objection to my teaching! (*Autobiography of an Awakening*, 116)

Andrew goes out of his way to say that his disillusionment with Poonjaji was very gradual and caused him considerable heartache. Just a few years after he thought that his guru was the love of his life and the cause of his enlightenment (insofar as anything or anyone can be the cause of enlightenment), he was forced to part company with him—the final break was in 1991—and strike out on his own.

> What I was teaching and what my Master was teaching were diametrically opposed to each other. Hearing some of the things one of his closest disciples had said about Enlightenment revealed to me that I had obviously surpassed my own Teacher, and it was because of this that the harmony and ability for true and profound communication had ceased. (*Autobiography of an Awakening*, 106)

I need hardly point out that it does not often happen that a Western disciple says such things about his Eastern master.

This parting of the ways between himself and Poonjaji is obviously important to Andrew, which is why I have spent some time on it. And of course it raises significant issues concerning the nature of a teacher's authority. As we have seen, Andrew was very happy to attribute his initial impact as a teacher to Poonjaji: "your Grace", "your power" and so on. But he also says that a 'presence' took possession of him immediately after he met Poonjaji, and that he surrendered to it. Maybe, to begin with, he thought that this presence was Poonjaji's grace and power but later came to see that in fact it was something different. In any event, he is now entirely independent and does not refer to anybody else to support what he says.

But there are always two sides to every story. And while I think Andrew's version is worth telling, I have given it with some reluctance for the simple reason that it must surely cause considerable upset to many people, not least Poonjaji himself. It goes against my sense of fair play to present one side of this story in considerable detail while not being able to balance it with the other. Unfortunately, I have no sources to draw on for Poonjaji's side, although it can be gleaned to some extent from Andrew's reports of Poonjaji's objections to him. One of them, which comes up on several occasions, is that Andrew hurts people (*Autobiography of an Awakening*, 105). His reply to this charge is that pointing out the truth only hurts people's pride. He wrote to Poonjaji:

> I have never betrayed anyone since I have been teaching and I have only dearly loved and energetically encouraged and instructed all who have come to me to live a life of freedom and truth. Some are unable and unwilling to do this. To those people I cannot and will not lie. If they are dishonest and hypocritical and betray their own heart, I will not tell them that they are not doing that. For this and this alone I am criticized. Without truth there can be no lasting liberation. Without integrity there can be no real love. If I am accused by many of insisting that people rise up out of the mess of self-deception, I plead guilty. (*Autobiography of an Awakening*, 112)

And here we come to the crux of the matter. It is one thing to say that someone's approach to liberation is incomplete, misguided, or incorrect; it is another to say that it is dishonest and hypocritical. Clearly, the second is more likely to provoke an emotional reaction than the first, and this is exactly what has happened. Generally speaking, Andrew's writing does tend towards the emotionally dramatic: "amazement", "shock", "extreme disrespect", "duplicity", and so on. This contrasts with two other teachers for whom he has a high regard, *Ramana Maharshi* and Nisargadatta Maharaj, neither of whom (at least in what has been published) ever used such language or anything approaching it. Yet they were both were very direct, the former in a gentle way, the latter more robust in his dealings with those who came to see him. (See for example, *I Am That*, 122–27, where Nisargadatta says much the same as Andrew, answering questions without compromise but also without telling the questioner that he is dishonest.) It may be that the difference between these two and Andrew is one of style or of emphasis. It may be more than that.

As we have seen, Andrew says that it is his commitment to truth that leads him to point out flaws in other people's understanding and expression of enlightenment—and not only in people who come to him but other teachers as well. For example, he mentions *Chogyam Trungpa*, Rajneesh, Jiddu Krishnamurti, Swami Muktananda and Master **Da**, and says that despite their manifest accomplishments, ultimately they failed (*Autobiography of an Awakening,* 127–28). And what he says about them—for example, that Master **Da** makes "a mockery of his own genius through his painfully obvious megalomaniacal rantings"—is again fairly strong stuff. So why does he do it? Because those who do not live up to the ideal of perfect love and perfect goodness are causing great harm.

> The inherent danger of one who dares to bring others to Enlightenment, without having been utterly and absolutely consumed themselves, is that any traces of ignorance that may remain due to undissolved pride and desire will mar and influence the reflection of the Self and will defile the transmission of perfection . . . Most of the world-renowned masters, gurus and prophets of our era have left a legacy of, at its worst corruption, and at its least confusion, only for this reason. (*Autobiography of an Awakening,* 84, 85)

What this means in practice is that

> if you can't live what you have experienced then you haven't realized it. If you have truly realized it then you *have* to live it. That is non-duality. (*Enlightenment is a Secret,* 212)

And as a second instance of this non-duality:

> When you think about Enlightenment, it is important that you include other people in that idea.
> Transcendence will be yours when you begin to accept responsibility for the condition of the whole human race. (*Enlightenment is a Secret,* 260)

This theme of enlightenment as something that can transform others if it is truly lived is the focus of Andrew's latest book, *An Unconditional Relationship To Life*. It is still being edited as I write this so I cannot quote from it. But what he says is that there is no real difference between self and other; hence what one does is bound to be for the sake of the whole. More specifically, this way of 'enlightened living' is being practised by the various communities that have been set up by those who are following his teaching. And they generate what we could call the conditions for enlightenment far more effectively than an

individual could. Andrew himself is in no doubt about the matter: they have come together "to express the force of evolution".

This is a big claim; not just that the truth he teaches is utterly uncontaminated by any ignorance; not just that it is truly non-dual; not just that it is the expression of love; but that it is a force that can change the human race.

Now, in 1994, eight years after he began teaching, Andrew is still firing on all cylinders. Apart from keeping in contact with his communities, he has a very busy international schedule: America, Canada, Britain, Holland, Germany, Switzerland, Italy, France, Israel, Bali, Bangkok, New Zealand, India, Nepal to my certain knowledge. Like many other teachers, he gives talks and takes retreats. But unlike most of them, he goes out of his way to meet other spiritual teachers. Some of these meetings have been recorded in his magazine, *What is Enlightenment?*—for example, Irina **Tweedie,** Lex **Hixon,** Barry **Long**, Lee **Lozowick**[1] (to mention only those who are featured in this book).

Andrew is very forthright, as we have seen, and is causing a considerable stir. But he does make himself available. His students say that he really does live what he teaches. He has nothing to hide. Nor does he charge for his teachings (apart from the cost of hiring a room and the usual charges for books, tapes, and videos).

But nothing is certain in this life. In 1994, Andrew and his wife were hit by a car that went through a red light and were lucky to survive. His own conclusion, after reflecting on the possibility of his sudden and seemingly pointless death, was that these things simply cannot be understood and that it is superstition to think that they must have a profound meaning. What his early death would mean for the evolutionary change that he sees happening around him, I do not know. Maybe he doesn't either. As he says,

> Hold onto nothing. Everything has to go. That's what surrender is. I am happy because I know without doubt that there is nothing to hold onto. (*Enlightenment is a Secret*, 125)

Primary sources: Andrew Cohen, *My Master is My Self* (Moksha Foundation, no provenance, 1989); *Enlightenment is a Secret* (Corte Madera, California: Moksha Foundation, 1991); *Autobiography of an Awakening* (Corte Madera: Moksha Foundation, 1992)

Secondary sources: None

Centre: Moksha Foundation, P.O. Box 2360, Lenox, MA 02140, U.S.A.; FACE (Friends of Andrew Cohen in Europe), 41B Englands Lane, London NW3 4YD, England, U.K.

COMPARE:

Other teachers who say that one's own nature is Truth/enlightenment: **Jae Jah Noh**, Jean **Klein**, John **Levy**, Barry **Long**, Bhagavan **Nome**, **Shunyata**

Other teachers who talk about an evolutionary change: The **Mother**

[1] Lee has also written about Andrew in one his books.
> [He] was pleasant company, definitely has "potential", has lots of experiential knowledge, still naive and very scared, defensive, insular but interesting overall . . . I felt he doesn't know that Help is possible. (Lozowick [using the name, 'Mr. Lee Khepa Baul'], *The Eccentricities, Idiosyncrasies and Sacred Utterances of a Contemporary Western Baul,* vol.1, (Prescott, Arizona: Hohm Press, 1991, 5)

However, Lee has since retracted this statement: "anything I said about him that was in any way demeaning, belittling, or cynical is inaccurate—I have only the highest regard for him without compromise despite our differences" (letter to me, July 1995).

JAN COX

American Fourth Way
teacher

I know nothing about this man apart from what is revealed (and I use the term with care) in his promotional literature. Jan's work is clearly predicated upon **Gurdjieff**'s but equally clearly not a copy of it. His *The Death of Gurdjieff* refers to

> the allegorical figure of "G", raging through postwar Paris, and later day (*sic*) scenes of "J" tramping about the mountains of north Georgia and the psyche of contemporary man. This is the first American book to faithfully arise from Real Work, true to its time and place . . . An overwhelming tour de force dealing with the kinds of things you wouldn't, couldn't, and shouldn't believe—even if they were true. (Chan Shal Imi Press flier)

This deliberately provocative tone is also found in *The Dialogues of Gurdjieff*, described by the ultra-orthodox *Gurdjieff Bibliography* as

> Purported conversations between Gurdjieff and an expatriate American bartender, written up as a "non-fiction novel." In the 1980 edition, Cox starts with a section labeled "Caveat", in which he states, "The very parts [of this book] that may so tantalize the sleepy are the most salient examples of fiction-run-amuck. Lies, all lies." (J. Walter Driscoll and The Gurdjieff Foundation of California, *Gurdjieff: An Annotated Bibliography* [New York, 1985], entry 232)

I think you can see that Jan would positively welcome this rather heavy-handed critique. Another of his books, *And Kyroot Said*, a study "of man's peculiar idea of somehow 'Awakening' from his ordinary state of consciousness", is described as "in the heuristic Work tradition of spiritual comedians and psychological assassins" and offers insights into "modern Work methods of jail break and evolutionary escape" (Chan Shal Imi Press flier). All of this is evidently akin to E.J. **Gold**'s method: truth is wrapped up in such a way that it is the process of unwrapping it which actually reveals what it is.

(*See* Lineage Tree 3)

Primary sources: Jan Cox, *The Dialogues of Gurdjieff* (Atlanta, 1979); *The Death of Gurdjieff in the Foothills of Georgia: Secret Papers of an American Work Group*, (Stone Mountain, Georgia, 1980); *And Kyroot Said*, Stone Mountain (Georgia), 1981 [all these are published by Chan Shal Imi Press]

Secondary sources: None

Centre: c/o Chan Shal Imi Press, P.O. Box 1365, Stone Mountain, GA 30086, U.S.A.

COMPARE:

Other 'jokers' and deliberate concealers of truth: E.J. **Gold**, Idries **Shah**

MASTER DA | RUCHIRA BUDDHA | AVATAR ADI DA SAMRAJ | DA AVABHASA | DA KALKI | HEART-MASTER DA LOVE-ANANDA | DA FREE JOHN | BUBBA FREE JOHN | FRANKLIN JONES

American who presents himself as unique among all spiritual teachers in the history of the world

Master Da[1] is the most autobiographical of all the teachers in this book. To outward eyes, he was born Franklin Jones in 1939 on Long Island. But he says that he was aware of his divine nature from birth and that he only 'incarnated' as Franklin Jones at the age of two.

> Even as a baby I remember crawling around inquisitively with an incredible sense of joy, light, and freedom in the middle of my head . . . an expanding sphere of joy from the heart . . . I was radiant form . . . the power of Reality . . . I was the Heart, who lightens the mind and all things. I was the same as every one and every thing, except it became clear that others were apparently unaware of the thing itself . . . That awareness, that conscious enjoyment and space centered in the midst of the heart is the "bright" . . . It is reality. It is not separate from anything. (Bonder, 59; *The Knee of Listening*, 2nd ed., 1973, 9; New Standard Edition, 1995, 34)[2]

As a child, Master Da was often subject to mysterious fevers, which the doctors could not diagnose. He presents these illnesses as 'Yogic Signs'—more specifically, the awakening of the *kundalini* (Bonder, 67; *Love-Ananda Gita*, 51). But gradually, his awareness of the 'Bright' faded. To put no finer point on it, he became what he calls 'the usual man'—'ordinary'; something that those around him at the time could no doubt attest to. But nothing is ordinary with Master Da. This loss of his awareness of his true nature is presented as 'Divine Amnesia' (Bonder, 72)—a deliberate act which enabled him to experience life as others do. In short, his was an extraordinary ordinariness.

In 1957, at the age of 18, he went to Columbia University in New York to study philosophy. He began what he calls 'the Sacred Ordeal of Self-Realization'—that is, the journey from 'ordinariness' back to his original state of divine awareness. He was determined to discover what it was that prevented him from full and uninterrupted realization of his original state. And in 1964, he found it: the 'process' of Narcissus. The story of Narcissus was that of "the universally adored child of the gods", in Master Da's phrase, who saw his reflection in a pool of water, fell in love with it and so became unable to love another. As a result, he "suffered the fact of eternal separation and died in infinite solitude." In other words, the inability to love is the cause of separation from one's own true nature. Master Da refers to this state as 'avoidance of relationship' or 'self-contraction'. He saw it operating in himself and in others.

[1] I use the name 'Master Da' throughout for the sake of simplicity and consistency: he has used a good dozen over the years. According to one of his devotees, with whom I have corresponded on this matter, "'Avatar Adi Da Samraj' is His primary name. He was Master Da for only the briefest period . . . and we would greatly prefer 'Heart-Master' to 'Master'". People should certainly know what a teacher's followers prefer. But I am not writing for devotees. No disrespect is meant by using the title 'Master Da'.

[2] My use of sources in this entry needs to be explained. Bonder's book, which is the only one that gives a chronological account of Master Da's life, is no longer in print. It cites versions of Master Da's writings, revised by Master Da himself, which are different from the earlier editions that I have read. In addition, one of Master Da's devotees has given me the latest versions—the New Standard Edition—of all Master Da's revisions (where they exist) for every passage that I cite. (In some cases, which I note below, these differences are significant; but often they are not.) I therefore give three references on occasion (as here): Bonder's version; the version I have myself read; and the New Standard Edition. This is unwieldy but it is preferable to either giving the text that I have read but which is now out of date, or 'blindly' giving a version from a revised edition that I have not actually read.

It was the logic or process of separation itself, of enclosure and immunity. It manifested as fear and identity, memory and experience. It informed every function of being, every event. It created every mystery. It was the structure of every imbecile link in the history of our suffering. (*The Knee of Listening*, 2nd ed., 1973, 26; New Standard Edition, 1995, 109)

At this point, Master Da entered a new phase in his 'Ordeal of Self-Realization'. For the next six years, from 1964 to 1970, he made contact, both physical and subtle, with a number of gurus, including **Rudi**, and **Rudi**'s teachers, Swami Muktananda and Swami Nityananda. He had a number of powerful experiences of the *kundalini* variety and found that others would also experience them in his presence. He therefore wrote to Muktananda asking him "to give me the authority to teach, and to bless me in the traditional way by giving me a spiritual name" (*The Knee of Listening*, 2nd ed., 1973, 87; New Standard Edition, 1995, 209). Muktananda responded by inviting him to the ashram.

There is a photograph of the two of them taken during this visit: Muktananda is lounging in a chair in his sunglasses, the very epitome of the hip *kundalini* gunslinger; Master Da, in contrast, is sitting cross-legged with his eyes shut, the model demure devotee (Bonder, 100). Muktananda did indeed give Master Da some formal acknowledgement. He bestowed two names on him ('Dhyanananda' and 'Love-Ananda'—the second in private; it is not mentioned in *The Knee of Listening*); and he also wrote a letter authorizing Master Da to teach *kundalini yoga* (Bonder, 99; *The Knee of Listening*, 2nd ed., 1973, 97; New Standard Edition, 1995, 252–55). However, Master Da used the second of these names only many years later and in his own way; he never used the first, nor did he ever teach *kundalini yoga*. Although he had the full range of *kundalini* experiences—described by Bonder as "mystical revelations, astral transports, and states of superconscious identification with various gods and high subtle beings" (Bonder, 99)—he was not satisfied by them. They were not aspects of his real nature—the 'Bright'—and hence ultimately of no value.

Eventually, he left Muktananda and became a devotee of Shakti, the very embodiment of *kundalini*, whom he could see as if she were physical (Bonder, 106; *The Knee of Listening*, New Standard Edition, 1995, 301). He was prompted to go to Los Angeles, where he discovered the Vedanta Temple, built years earlier by the Ramakrishna Order. He meditated there frequently, still in the relationship of a devotee. One day, however, this changed dramatically.

> As I meditated, I felt myself Expanding, even bodily, becoming a perfectly Motionless, Utterly Becalmed, and Infinitely Silent Form. I took on the Infinite Form of the Original Deity, Nameless and Indefinable, Conscious of Limitless Identification with Infinite Being. I was Expanded Utterly, beyond limited form, and even beyond any perception of Shape or face, merely Being, and yet sitting there. I sat in this Love-Blissful State of Infinite Being for some time. I found myself to <u>Be</u>. My form was only what is traditionally called the "Purusha" (the Person of Consciousness) and "Siva" (in His Non-Ferocious Emptiness).
>
> Then I felt the Divine Shakti appear in Person, Pressed against my own natural body, and, altogether, against my Infinitely Expanded, and even formless, Form. She Embraced me, Openly and Utterly, and we Combined with One Another in Divine (and Motionless, and spontaneously Yogic) "Sexual Union". We Found One Another Thus, in a Fire of most perfect Desire, and for no other Purpose than This Union, and, yet, as if to Give Birth to the universes. In That most Perfect Union, I Knew the Oneness of the Divine Energy and my Very Being. There was no separation at all, nor had there ever been, nor would there ever be. The One Being Who I <u>Am</u> was

*Cf. Frithjof **Schuon**'s experience with the Virgin Mary.*

revealed to Include the Reality that Is Consciousness Itself, the Reality that is the Source-Energy of all conditional appearances, and the Reality that Is all conditional manifestation, All as a Single Force of Being, and Eternal Union, and an Irreducible cosmic Unity. (*The Knee of Listening*, New Standard Edition, 355–56)[3]

The next day, when he returned to the Vedanta temple to meditate, he did not see the Goddess. Instead,

> In That instant, I understood and Realized (inherently, and most perfectly) What and Who I <u>Am.</u> It was a tacit Realization, a direct Knowledge in Consciousness. It was Consciousness Itself, without the addition of a Communication from any "Other" Source. I simply sat there and Knew What and Who I <u>Am</u> . . .
>
> There was no thought involved in This. I <u>Am</u> that Self-Existing and Self-Radiant Consciousness. There was no reaction of either excitement or surprise. I <u>Am</u> the One I recognized. I <u>Am</u> That One. I am not merely experiencing That One. I <u>Am</u> the "Bright".
>
> Then truly there was no more to Realize. Every experience in my life had led to This. The dramatic revelations in childhood and college . . . my years with Rudi, the revelation in seminary, the long history of pilgrimage to Baba's [Swami Muktananda's] Ashram—all of these movements were the intuitions of this same reality. My entire life had been the Communication of That Reality to me, until I *Am* That. (*The Knee of Listening*, New Standard Edition, 357–58; the versions given in Bonder, 107, and the 2nd ed., 134, are different)

It was 1970 and he was 30 years old.

There is no doubt whatever that this realization was understood by Master Da as final.

> In all the days that followed the great Event of my re-Awakening, there has not been a single change in This "Bright" Awareness, or any diminishment of This "Bright" Awareness. Indeed, This "Bright" Awareness cannot be changed, diminished or lost. (*The Knee of Listening*, New Standard Edition, 1995, 360; once again, the 2nd edition, p. 136, is slightly different)

But he did look for corroboration of his 'Enlightened Condition' in the spiritual traditions of the world. In fact, the only one that was unequivocal was *Ramana Maharshi*, particularly in the *Sri Ramana Gita*, which Master Da quotes at length (*The Knee of Listening*, 2nd ed., 151ff). He says that "there is no difference between Maharshi's experience and my own" (*The Knee of Listening*, 2nd ed., 157). And he places himself squarely in the Indian tradition:

> I point to the ancient truths and to Ramana, to Nityananda and Muktananda. (*The Knee of Listening*, 2nd ed., 159)[4]

[3] The earlier version is much shorter. I give only the first paragraph here:
> As I meditated, I felt myself take on the form of Siva, the Divine Being prior to all form. I took on the infinite form of the original Deity, as I had done previously in Baba's [Swami Muktananda's] Presence. I sat in this blissful state of infinite Being for some time (2nd ed., 1973, 133; the version cited in Bonder, 106, is slightly different).

Notice that Muktananda has dropped out altogether in the New Standard Edition.

[4] The devotee who read the original version of this entry was not happy with this quotation nor with the paragraph concerning *Ramana Maharshi* that precedes it. First, on the subject of the relationship between Ramana and Master Da, he suggested the following: "Even while noting these profound likenesses, however, he was also careful to distinguish between [Ramana's] Advaita Vedanta and his own 'radical' Way of the Heart (which he views as fundamentally free of all the 'traditions of seeking', East and West). Adi Da clearly views India as the motherland of human spirituality, and throughout his writings he has found it convenient to adapt some of its language to his own purposes. Nevertheless, in 1982 he wrote an entire book, *Nirvanasara*, to distinguish the

Yet he also says that his experiences led him to a presentation of this ancient truth in a particular form. He called it the way of 'radical understanding', and he contrasts it with two other traditional paths: that of the sage/ *jnani* and that of the *yogi*. The first focuses on Consciousness, the second on Light.

> The path of jnana of the sages stands over against all of the experiential paths, all the yogas and mysticisms and religious or ritualistic approaches. The yoga paths tell you to meditate on sounds, lights, centers, breathing energies, and all of that, but they are all distractions. The path of jnana does not instigate such a process at all, but opts totally and exclusively for the conscious principle. But the Jnani's path is not the equivalent of the way of Understanding, which is founded on a radical comprehension of the nature of existence. In this comprehension the worlds are seen as the play of Consciousness and Light, and if one is realized to the exclusion of the other, it is not Truth that is realized. It is like cutting off the feet of God and throwing the body away.
>
> So the ultimate affair of understanding is inclusive and radical, not exclusive and revolutionary in the manner of jnana or yoga. ('Bubba Free John and Swami Muktananda', *The Dawn Horse*, vol. 2, no. 2, 1975, 20, n. 9)

When the 'Way of Understanding' is presented by one who embodies it— the man of understanding or guru—it is called the 'Way of the Heart'. I think it can be fairly argued that Master Da presented the 'Way of the Heart' right from the beginning. And it has two parts (which fit together to make a whole): first, radical understanding, as defined above; second, *guru bhakti* in the sense that devotion to the guru enables the guru to 'live the Truth' to those who turn their attention to him ('Bubba Free John and Swami Muktananda', 18). But it has evolved over the years, as we shall see.

Although Master Da (still called 'Franklin Jones') had a few informal pupils from 1970 onwards, he did not start his public teaching until 1972. He opened an ashram, called 'Shree Hridayam Satsang' (meaning 'Company of the Heart'), in Hollywood, gave talks and sat in meditation with those who came. This event is presented as his "first formal appearance as the Divine Teacher" (Bonder, 116). However, these first students, described by Master Da as "whores, pimps, street people, criminals, neurotics, loveless and confused and

Way of the Heart from both Hinduism and Buddhism (the traditions he clearly regards as most sympathetic with his own). In subsequent editions of *The Knee of Listening*, Adi Da found it advisable to expand his description of the philosophical and esoteric differences between himself and Ramana Maharshi." I have not seen these later editions. (It would be a full-time job keeping up with all the productions of Master Da and his community.) But I have not been able to find a clear statement, in the edition of *The Knee of Listening* that I have read, of Master Da's differences with Ramana. I do not want to make a big issue of this. The community says, based on the testimony of those who were there, that he always distinguished his teaching from Ramana's. I have no reason to think this is not true. But he did not detail these differences in his book—and people should know that he didn't.

As for the statement that "I point to the ancient truths and to Ramana, to Nityananda and Muktananda", the devotee wanted to do away with this quotation altogether. I have retained it. (Compare the earlier quotation concerning Master Da's experience in the Vedanta temple, where the second edition mentions Muktananda and the New Standard Edition does not.) Master Da does go on to say, in the very next sentence (of the second edition), that "I acknowledge them, and Rudi also, but I speak for myself. My authority is Reality, and my only resort is understanding." Devotees clearly find this enough. Hence my informant says that "when Adi Da acknowledges the truth of Rudi, Muktananda, Nityananda, etc., He is *not* saying that their teachings are true . . . He is saying that . . . He acknowledges the partial, functional revelations that made them useful instruments of His own Re-Awakening. So Adi Da never truly aligns Himself with any Oriental tradition . . . [He] has always said that His is the first Teaching that summarizes and surpasses the great Dharmas of both East and West." Again, it is important for people to know all this. But equally, they should know, first, that it was not stated as such in the earliest writings; and second, that the status and significance of teachers such as *Ramana Maharshi,* Nityananda, Muktananda and **Rudi** does appear to have been lessened over the years.

righteous self-indulgent people of all kinds" (Bonder, 112; *The Enlightenment of the Whole Body,* 90–91), were not particularly malleable. He therefore decided that he would have to teach in a different way; and that in order to do so, he needed to go back to India once again, as a "fully God-realized Guru", so that he could purify his "Guru function" (Bonder, 122; *Garbage and the Goddess,* ix).

During his time in India, Master Da/Franklin Jones adopted the first of the many names that he has used since: 'Bubba Free John'. And like most of his subsequent names, it was "spontaneously revealed" to him.[5] It was as Bubba Free John, then, that Master Da arrived back in Los Angeles, later in 1973. He immediately began to teach in a new way, the way of 'Crazy Wisdom': constantly undermining the assumptions and expectations of his students. For example, when, on one occasion, he was asked to talk about his life as Franklin Jones, he replied, "Why do you want to talk about that bastard? I Personally never liked him". This shock tactic was, however, immediately followed by a more straightforward teaching: "I have always been Bubba Free John. Franklin Jones was a fictional character that I created when I was a boy" (Bonder, 135; *The Dawn Horse Magazine*, August 1974, vol. 1, no. 2, 3).

But undoubtedly the most significant event during these early years was what is called the 'Garbage and the Goddess Teaching Demonstration'. (Master Da has always had a fondness for striking names and titles.) It was a time of extravagance and extremes: 'displays' brought about by Master Da's transmission of power (such as spontaneous *mudras,* and subtle auditory and visionary phenomena of all kinds); dramatic natural events (out-of-season storms and extraordinary halos around the sun); and just plain partying (big meals, lots of booze, and a fair amount of sex). All of this, however, was interspersed with experiments with a more traditionally disciplined lifestyle: fasts, formal meditation and *guru puja* (ceremonies of empowerment and respect centred on the guru).

Master Da, who participated in everything to the full, referred to his role in all this as "packaging your garbage" (*Garbage and the Goddess,* 104). Losing oneself in experience is, by that very fact, losing one's own nature or 'succumbing to the Goddess'. It is the guru's function to expose this 'garbage' for what it is. And I use the word 'expose' advisedly:

> Everyone succumbs to the Goddess on one level or another . . . So, the Guru's perfect function is to undermine all this, to make the world show itself. He makes the Goddess pull down her pants, and then you see her asshole. I shouldn't be saying these things . . .
>
> When the Guru shows you the true nature and condition of the Goddess, then you become capable of sacrifice. Until that time you aren't capable of it, because you are enamored of the force of life. (*Garbage and the Goddess,* 106, quoted in Feuerstein 85)[6]

So all experience, even so-called spiritual experience, has to be sacrificed. This sacrifice is served by the Guru. And this is why it is necessary to turn to the Guru, or engage in Satsang or Divine Communion, which is

[5] 'Bubba' is not, apparently, a version of the Indian title, 'Baba', but a childhood nickname, meaning 'brother/friend'; 'Free John' is a 'translation' of 'Franklin Jones' and means 'a free man through Whom God is Gracious' (Bonder, 125).

[6] According to Feuerstein (who used to be a devotee but is now quite critical of Master Da), this book was withdrawn from publication soon after it appeared and attempts were made to retrieve even those copies that had been sold. The community denies that this is so.

attention to the Guru as Guru, attention to the Guru as the manifest agent of the very Divine, attention to the Guru and through the Guru to the Divine. (Bonder, 133; *Garbage and the Goddess,* 112)

However, in 1976, this phase of Master Da's teaching stopped. From now on, he would live far more in seclusion and devote himself to two main tasks: the creation of a community who would be able to receive what he was transmitting (and eventually transmit it themselves);[7] and the production of a body of writing that would cover every aspect of the spiritual life. At the same time as he was producing this literature—amounting to about a million words, I would say—other events were taking place in his life and in his community. In 1979, he changed his name from 'Bubba Free John' to 'Da Free John', announcing the change in a letter that is typical of his style at the time.

> Beloved, I am Da, The Living Person, Who Is Manifest in all worlds and forms and beings, and Who Is Present As The Transcendental Current Of Life In the body Of Man . . . To Realize Me Is To Transcend the body-mind in Ecstasy. Simply to Remember My Name and Surrender into My Eternal Current Of Life Is To Worship Me. And those who Acknowledge and Worship Me As Truth, The Living and All-Pervading One, Will Be Granted The Vision or Love-Intuition Of My Eternal Condition. They Will Be Filled and Transfigured By My Radiant Presence. Even the body-mind and the whole world Will Be Shining With My Life-Light If I Am Loved . . . (Bonder, 177; there are various versions, one of which makes up Chapter Two of *The Dawn Horse Testament.*)

'Da' means 'giver' in Sanskrit. It is often used as a suffix but I have never come across it as a name or title. As I have said before, Master Da is fond of names of all sorts, not just his own but of events and places. Most people who have heard of him, but know little about him, are aware that he has had a number of names. Not many understand why. In fact, the explanation is relatively straightforward. The attributes of the Divine, which include 'the names of God', are regarded in many traditions (especially in India, with which

[7] In 1988, Master Da formally established two renunciate orders: the Hridaya Da Kanyadana Kumari Mandala Order and the Hridaya Da Gurukula Brahmacharini Mandala Order. The first (which had already been existence in a somewhat informal way since the early 1980s) consisted entirely of women, all long-time devotees. (Originally, there were nine—including Nina, his former wife, who is now married to another devotee—then four, and at the time of writing, just one.) According to Bonder,

> Kanyadana is an ancient traditional practice in India, wherein a chaste young woman (a 'kanya') is given ('dana') to a Sat-Guru either in formal marriage, or as a consort, or simply as a serving intimate. Each kanya thus becomes devoted to the Sat-Guru in a manner that is unique among all devotees. She serves the Sat-Guru Personally at all times and, in that unique context, at all times is the recipient of His very Personal Instructions, Blessings, and Regard . . . As a kanyadana 'Kumari', a young woman is necessarily 'pure'—that is, chaste and self-transcending in her practice, but also Spiritually Awakened by her Guru, whether she is celibate or Yogically sexually active. (Bonder, 287)

The other order consisted of four young girls (three aged 13, and one aged 10 at the time of the Order's inception). Three of them are Master Da's daughters (not all by the same mother). These four were chosen by him as "sacred renunciates learning the Divine art of God-contemplation and its rigorous application in every moment of human existence" under his personal guidance. (Bonder, 290)

The members of both these orders are regarded by the community as those closest to Master Da and therefore the most likely to become his 'human agents' in the task of transmitting his divine power. More exactly, their practice of *guru bhakti* will enable them to transmit the Divine Presence which is Master Da. This, at least, is the intention. How it will turn out is another matter. At the time of writing (May 1995), both Orders are effectively in abeyance. There is only one Kanya and only one member of the Brahmacharini Order (and she, I am told, has outgrown the Brahmacharya level). All the others (both Kanyas and Brahmacharinis) have re-entered the 'ordinary' community on Master Da's instructions. With Master Da, change is the order of the day.

Master Da has the most affinity) as actually being divine qualities. Hence they transmit an aspect of the divine whenever they are used.[8, 9]

In 1983, Master Da went wandering in the Fijian islands with a group of devotees in order to find a permanent centre. He decided on a small island, Naitauba (immediately renamed 'Translation Island', then 'Love-Anandashram', and later still, 'Purnashram'), which was bought by a wealthy devotee. Master Da said that the island was "untouched since the beginning of time" (Bonder, 203)—meaning not that it was uninhabited (there is a small resident Fijian population) but that it had not been influenced by "human struggle and suffering"—and praised his 'Eternal Consort', the Divine Goddess, Shakti, who had helped to "convert the Fijian spirits" (Bonder, 201; *Crazy Wisdom*, vol. 2, no. 8, 10). (He is now a Fijian citizen.)

Two years later, in 1985 a decidedly more mundane event occurred. A former devotee brought a court case against Master Da and his community (then called the Johannine Daist Communion) for physical and sexual abuse, fraud and false imprisonment. What this amounted to was the charge that the events during the 'Garbage and the Goddess' period were forced on people and therefore illegal. (There were also incidents outside this period which were included in the charges.) The community's defence was simply that everything that happened at that time (which it referred to as 'This Moment of Our Experiment' [*Vision Mound*, vol. 3, no. 4, July-August 1980, 2–6]), including the sexual experimentation and a certain amount of physical 'larking about', was entered into freely by all concerned; and that there was an underlying spiritual reason for it which Master Da explained at the time.

The case (no. 121999 of the California Superior Court in the county of Marin) was settled out of court and it is impossible to decide on the facts. But there can be no doubt that, at the very least, some people felt sufficiently hurt and aggrieved to want to put Master Da and his community in a bad light. And it could be argued that such an incident was more or less inevitable given the way that Master Da was teaching during his 'Crazy Wisdom' years. A lot of energy was being released and practically anybody could come and partake of it. So there were bound to be some who felt that they had been imposed upon.[10]

Events around Master Da have continued to be dramatic. In 1986, he went through what seems like a death experience, except that, in his case, it was far more than that. He calls it his 'Divine Descent' or 'Divine Emergence'.

> [T]his body died. I left this body. And then I suddenly found My Self reintegrated with it, but in a totally different disposition, and I achieved your likeness exactly, thoroughly, to the bottoms of My feet, <u>achieved</u> un-Enlightenment, <u>achieved</u> human existence, <u>achieved</u> mortality, <u>achieved</u> sorrow.

[8] I am mildly surprised that Master Da's devotees have not yet composed the equivalent of the *sahasra-nama*, or thousand names, of Vishnu or Shiva, which are really a list of attributes and descriptions that capture their divine nature and exploits.

[9] Master Da also gives names to things and places—again, as a form of empowerment. Here is a small selection of the names of places on Naitauba Island, which became Master Da's principal centre in 1983 (see below): Sri Avadhoota Mandir; Sky Brightener; So Hear Me; Sri Da Kalki Paduka Mandir; She Likes It Alot; Padavara Loka; Shine From Here; Fruitful Practice; Owl Sandwiches (*Free Daist*, vol. 1, no. 6, September 1990). This is a typical mixture of the traditional Hindu and the modern Western.

[10] Another version of these events can be found in Lowe's essay. Lowe was a member of the community at the time (though decidedly on the outer fringes), and while he is certainly critical, he is not out to score points and gives his account more in bemusement than outrage. I recommend it.

To Me, this is a Grand Victory! I do not know how to Communicate to you the significance of it. For Me, it was a grander moment than the Event in the Vedanta temple or any of the other Signs of My Life that are obviously Spiritually auspicious . . .

I have become this body, utterly. My mood is different. My face is sad, although not without illumination. I have become the body. Now I am the "Murti", the icon, and It is Full of the Divine Presence.

The nature of My Work at the present time and in the future is mysterious to Me. It is a certainty, it is obvious, but on the other hand it has not the form of mind fully. It has taken an emotional form, but not the form of mind. I cannot explain it really. But you will see the Signs of it. You must all progressively adapt to something that has happened that even I cannot explain altogether (Bonder, 266; *Love-Ananda Gita*, [1986], 33–34).

Shortly afterwards, he changed his name to 'Da Love-Ananda' (which had been given to him—minus the 'Da'—by Swami Muktananda in a private ceremony in 1969) and adopted the lifestyle of a *sannyasin* or renunciate. Since then, there have been a number of developments in Master Da's manifestation of himself, if I can use that phrase. In 1989, his disciples bestowed on him, and he accepted, the title 'Jagad-Guru' or 'World Teacher'. In 1990, he took the name 'Da Kalki'—'Kalki' being the name of the predicted tenth *avatar* of Vishnu—but relinquished it after a year because of its 'exclusive' association with a particular form of Hinduism. He then adopted the name 'Da Avabhasa'—'Avabhasa' being the nearest Sanskrit equivalent to 'Bright'. In 1994, he adopted the name, Avatar Adi Da. 'Adi' means 'original' or 'primal'. (The devotee who told me about this new name made much of the fact that 'Adi Da' reads identically both forwards and backwards, with the two 'Da's' on either side of the single letter/word, 'I'.) And just as this book was going to press, I was told that a new name had been announced: 'the Ruchira Buddha'. *Ruchira* means 'shining' or 'brightness'. (But it can also mean 'sweet, dainty, nice'—*not*, I think, the sense intended here.)

Master Da has also recently presented a truly extraordinary 'theology' of Paramahansa Ramakrishna and Swami *Vivekananda*.[11] He had encountered both of them in non-physical form during his 1972 visit to India (see above). Now he says that

The whole point of the manifestation of Ramakrishna and Swami Vivekananda was to make this great Gesture toward this world of 'Westernized' mankind in this late-time. The Divine Gesture was not fulfilled in Their physical lifetimes. It is being Fulfilled in the Lifetime of This body—yet, even so, hardly perceived, hardly understood.

This One [pointing to himself] is, in Its Deeper Personality, Ramakrishna *and* Vivekananda. Not Swami Vivekananda in His historical Form, not Ramakrishna in His historical Form but That One, Shiva-Shakti, the One who was foretold to Do Great Work, Which was not Manifested in the physical Lifetimes of those two but which is now Manifested in My own physical Lifetime here . . .

This is incomprehensible from the ordinary point of view, inexplicable in common terms. Yet I must say it, and My having said it, you can forget about it, or not believe it, or not have anything to do with it. I must account for My Appearance here and tell you the Truth. (*Free Daist*, Third Quarter 1994, 28–29)

It would be a brave man or woman who would bet on there being no further changes in store. Master Da is still (in 1997) only 57 years old and I am sure he is not finished yet.

[11] And I have been informed that "one of his most intimate disciples claims a clear memory of her previous life as Sister **Nivedita**".

Master Da's life and teaching raise a number of obvious issues. But the first and most fundamental question, given that he has just said that his manifestation as Ramakrishna and *Vivekananda* is "incomprehensible from the ordinary point of view", is simply this: is what he is doing understandable? This is a loaded question, of course, since we must immediately ask, 'Understandable in whose terms?' And needless to say the only answer to this second question that is acceptable to Master Da and his devotees is, 'In *his* terms.' This can lead to some fairly extravagant claims. For example, when Master Da was born,

> something changed in the atom of the universes. We know this beyond any doubt through all that we have experienced in the Company of our Most Beloved Guru . . . His Birth is the beginning of a new epoch in the history of the universe . . . We and all His future devotees and even all beings are the recipients of the most Miraculous Revelation ever Given: the original, first, and complete Avataric Descent or Incarnation of the Divine Person, who is Named "Da". (*Free Daist*, Third Quarter 1994, 3, 4)[12]

However, there have been people outside the immediate community who have been impressed by Master Da's core teaching. The best-known are probably Alan **Watts**[13] and Ken Wilber.[14] On the other hand, a number of other Western teachers have given their assessment of Master Da—unasked—and they have not been very complimentary. Andrew **Cohen** asks: "How could a spiritual genius and profoundly Awakened man like Da Free John, who makes such a mockery of his own genius through his painfully obvious megalomanical rantings, leave so many lost and confused?" (*Autobiography of an Awakening*, 128). Barry **Long** says that a video of Master Da "shows him to be a good example of the stupidity and ignorance of man, within the genius of an enlightened state of consciousness, which he is. The man encourages people (who are attracted to the being behind the man) to worship him" (*Barry Long's Journal,* vol. 2, 45). Lee **Lozowick**, who, in his first book, cited Master Da as the 'completion' of all his teachers (*Spiritual Slavery,* 64), later produced an entire magazine, *Lazy Wisdom*, as a satire on Master Da's *Crazy Wisdom*, including photographs of Lee in Master Da-like poses.

Meanwhile, Master Da continues with his work.

> My only Purpose, out of Sympathy for you all, is to stay here long enough to Do what I have come to Do, which is to create this immense Mandala of Transmission for the sake of those who live now and those who will live in the future. (Bonder, 216)

[12] This is based on Master Da's own journal of 1970: The Heart is escaped. He fell out of my side. He is Here! It has already happened that you are not the same. Now all history is the event of the heart. This is not my imagining. It is not my symbol of mystical truth. It has happened in the atom of the worlds" (*Crazy Wisdom,* vol. 6, no. 2, 10).

[13] "It is obvious from all sorts of subtle details that he knows what IT's all about . . . a rare being." Although I have no doubt that Watts did say this, I have never seen it in any of his writings—only on the back of Master Da's books.

[14] ". . . we have, in the person of Da Free John, a Spiritual Master and religious genius of the ultimate degree. I assure you that I do not mean that lightly. I am not tossing out high-powered phrases to 'hype' the works of Da Free John. I am simply offering you my own considered opinion: Da Free John's Teaching is, I believe, unsurpassed by that of any other spiritual Hero, of any period, of any place, of any time, of any persuasion . . . I personally have found that not one significant item of any of the great religions is left out of Da Free John's teachings. Not one. And it is not just that these points are all included in his teachings. They are discussed by Da Free John with such brilliance that one can only conclude that he understands them better than their originators" (Bonder, 26). This is quite an encomium but the community no longer uses it because "we have become increasingly disturbed by [Wilbur's] unacknowledged appropriations of Adi Da's teaching and by personal statements he has made about Adi Da that we find to be offensive."

This is a truly extraordinary claim and it lies at the root of everything he has done, which is nothing less than to single-handedly establish an independent and self-sufficient means of God-realization. This explains his teaching (expressed in his own vocabulary), his 'culture' and his community. And all of that, in its turn, is firmly embedded in his account of who he is—his Da-ology.

He has recently "prophesied" that he will "be known and acknowledged in the world at large by His sixtieth Birth Day [which is 1999]" (*Free Daist*, Third Quarter 1994, 24). Now that *is* something that I can understand. We shall see.

Primary sources: The Knee of Listening, (Clearlake, California: Dawn Horse Press, 1973) (2nd edition) and (Middleton, California: 1995) (New Standard Edition); *Love-Ananda Gita*; *The Enlightenment of the Whole Body*; *Garbage and the Goddess*; [I do not have publishing details of these last three; the first two are both different from the copies I bought many years ago; and *Garbage and the Goddess* was withdrawn so quickly that I never managed to buy a copy at all.]; Saniel Bonder, *The Divine Emergence of the World-Teacher Heart-Master Da Love-Ananda*, (Clearlake, California: Dawn Horse Press, 1990) (1st edition). [This book is, of course, a primary source, not a secondary one, despite the fact that it has been allowed to go out of print—I don't know why.] A full list of Master Da's writings (including at least one, *The Calling of the Kanyas: Confessions of Spiritual Awakening and "Perfect Practice" Through the Liberating Grace of Heart-Master Da Love-Ananda*, that never appeared) is given in Bonder—but it has certainly been superseded.

Secondary sources: S. Lowe, 'The Strange Case of Franklin Jones' *in* D.C. Lane, ed., *Exposing Cults: When the Skeptical Mind Confronts the Mystical* (New York, 1994); Georg Feuerstein, *Holy Madness: The Shock Tactics and Radical Teachings of Crazy-wise Adepts, Holy Fools and Rascal Gurus* (London: Arkana, 1992); David Lane, 'The Paradox of Da Free John: Distinguishing the Message from the Medium' [comprising the whole of *Understanding Cults and Spiritual Movements*, vol. 1, no. 2, 1985 (published by Del Mar Press, P.O. Box 2508, Del Mar, California 92014); this series is now defunct].

Centre: Adidam,[15] 12040 North Seigler Springs Road, Middleton, CA 95461, U.S.A.; Tasburgh Hall, Lower Tasburgh, Norwich, Norfolk NR15 1LT, England, U.K.

COMPARE:

Other Western Avatars: G.B. **Chicoine**, John **Yarr**/Ishvara

Other 'crazy wisdom' teachers: **Gurdjieff**, Lee **Lozowick**

Other Westerners who say they were born enlightened: **Marasha**

Dr. Paul DAHLKE. SEE **APPENDIX 1**

Alexandra DAVID-NÉEL. SEE **APPENDIX 1**

[15] This is another new name. When I originally wrote this entry, the community was known as the Free Daist Communion (though it had had several other names before that) and this is how it is referred to in a few places in this book. Sorry about that.

ROY EUGENE DAVIS

American initiate of Paramahansa *Yogananda* who went his own way and became an independent teacher

Davis read *Yogananda*'s *Autobiography of a Yogi* in about 1948 (just two years after it was published), when he was still at school, and "inwardly accepted the author as my guru" (*Darshan,* 13). He went to Los Angeles in 1949 and met *Yogananda*. "[His] spiritual power was at once evident" and he touched Davis between the eyebrows, activating "subtle energies [which began] to flow through the occult centers in the spine and brain" (ibid., 18). Two years later, in 1951, Davis was given authority to teach.

> Placing his hand on my head, he [Yogananda] spoke in tones of ringing authority: 'I ordain you as a minister of Self-Realization and empower you to teach as I have taught. Teach others the way to God. Work as I have worked. Heal those who ask, initiate them into Kriya Yoga and stand as an example and a representative of God and the Great Gurus'. (*Darshan,* 81)

A year later, *Yogananda* died and was 'succeeded' by James Lynn/**Rajarsi Janakananda**. No one disputes that he was appointed by *Yogananda* but there is disagreement over what this appointment means. According to Davis,

> When Yogananda left his body, it was announced by representatives of his organization that the line of gurus ended with his passing and that henceforth the teachings would be the guru. This concept is contrary to tradition, to the natural working of Spirit and to the conclusions of those who fully understand the nature of the guru-disciple relationship. I feel that the line of gurus continues . . .
> I am not a guru to all who come to me. For those who have inwardly accepted me as their guru, I am. I know who I am and what my mission is and I know the power flows and that lives are transformed. (*Darshan,* 43, 45)

The notion of genuine transmission is crucial here. Although Davis's authority as a spiritual teacher is explicitly derived from *Yogananda,* there is more to it than the formal authorization that *Yogananda* gave him when he was ordained as a minister. There is an inner dimension as well: Davis's spiritual experiences. He says that the *kundalini* was gradually awakened in him after meeting *Yogananda* (*Darshan,* 33); and he gives a brief account of other experiences he has had: visions of astral realms, being filled with the sound of *aum*/Om, and being "caught up in the Presence" (ibid., 99–100). More than that, "a flow of force passes through the line of gurus to the disciple who is in rapport" (ibid., 42) and this is what makes the initiations that Davis gives genuine.

However, since he could hardly remain in the Self-Realization Fellowship with views like this, he left (in 1953) and became what he calls "an independent truth teacher" (ibid., 102). He still gives *kriya yoga* initiation but has also taken a number of other directions. He joined the Unity School of Christianity, for example, in the mid-1950s and became a minister of Divine Science in 1960. Both of these forms of Christianity can be broadly classified as 'metaphysical' or 'New Thought'—that is, they teach the pre-eminence of the power of the mind over matter. This combination of metaphysical Christianity and *kriya yoga* is an unusual one. But since *Yogananda* himself began his career in America by offering courses on *Recharging Your Business Battery Out of the Cosmos,* perhaps Davis is as close to his guru's original vision as anyone.

(*See* Lineage Tree 2)

Primary sources: Roy Eugene Davis, *The Way of the Initiate* (St. Petersburg, Florida, 1968); *Yoga-Darshana,* 1976; *The Teachings of the Masters of Perfection,* 1979; *God*

Has Given Us Every Good Thing, 1986; *The Science of Kriya Yoga: A Verse by Verse Rendering of the Yoga Sutras of Patanjali, with Detailed Commentary and Specific Instructions for Experiencing Meditation and Superconsciousness*, 1984 [the last four all published by CSA Press: address below]

Secondary sources: None

Centre: Church of the Christian Spiritual Alliance (CSA), Lake Rabun Road, Box 7, Lakemont, GA 30552, U.S.A.

COMPARE:

Other teachers of kriya yoga: **Rajarsi Janakananda**, Sri **Daya Mata**, both **Kriyanandas**

Other teachers who have made use of metaphysical/New Thought teachings: Yogi **Ramacharaka**

Western Hindus with Christian connections: Father **Satchakrananda**, Abbot George **Burke**

Leslie DAWSON | Ananda Bodhi. SEE NAMGYAL RINPOCHE (IN *TULKUS*)

Sister DAYA. SEE SISTER **DEVAMATA**

Sri DAYA MATA | Faye Wright

The second American president of Paramahansa *Yogananda*'s Self-Realization Fellowship who is said to be God-realized

Faye Wright was just 17 when she attended a talk that *Yogananda* gave in Salt Lake City in 1931. "Instantly recognizing him as one who knew God and who could show me the way to Him, I resolved, 'Him I shall follow'" (*Only Love*, vii). She moved to the SRF headquarters in Los Angeles only a few weeks later. And according to Kriyananda, "it was from her arrival that he dated the beginning of his monastic order" (Kriyananda, 273). She took *sannyasa* initiation in 1932 and I shall refer to her from now on by her renunciate name, Sri Daya Mata.[1]

It is evident that she was very close to *Yogananda* and that he regarded her with special favour. Kriyananda records an occasion when she was seriously ill and *Yogananda* went to visit her. "She was already gone," he said, "but God wanted her life spared for the work" (Kriyananda, 243). And three days before he died, *Yogananda* said to her, 'Poor child, I have been very hard on you in this life. I gave you the same hard discipline that my guru [Sri Yukteswar] gave me. I saw that you could take it' (*Only Love*, 31). There is a publisher's note on the phrase 'in this life':

[1] In 1959 her initiation as a renunciate in the Giri Order was formally recognized by the Shankaracharya of Gowardhan Math (Kriyananda, 569). I should also mention that in the same year he initiated two Indians as *sannyasins* at the Yogoda Satsanga Ashrama in Puri—this "as representative of the Gurus of SRF/YSS" (Yogoda Satsanga Society/YSS is the Indian branch of the Self-Realization Fellowship/SRF) and at "the invitation of Sri Daya Mata" (*Autobiography of a Yogi*, 222 of the 1981 edition). This is the only instance I have come across of a teacher in an Eastern tradition acting on behalf of an *independent* Western organization that is itself Eastern in origin.

Reference to the previous incarnations when guru and chela had been together. Paramahansaji knew that Daya Mata had an eminent role to play in this incarnation and he was spiritualizing and strengthening her for that responsibility.

This claim is reinforced by some of her own experiences—for example, the moment of *Yogananda*'s death:

> In an instant some of us were by his side. He had taught us to chant Aum in his ear to bring him out of samadhi; Ananda Mata and I bent over our divine guru and began to chant Aum. As I did so, a great peace and joy suddenly descended on me, and I felt a tremendous spiritual force enter my body. The blessing received that night has never left me. (*Only Love*, 176)

She also saw him after his death.

> I touched his feet. They were as solid as my own. Though he said nothing, I understood his meaning as clearly as though he'd spoken.. (quoted in Kriyananda, 548)

Sri Daya Mata succeeded James Lynn/**Rajarsi Janakananda** as president of the Self-Realization Fellowship/SRF and Yogoda Satsanga Society of India/YSS in 1955. Like him, her job is to give *kriya yoga* initiation, to act as a spiritual guide to all SRF initiates, to confer *sannyasa* (on both Westerners and Indians), and to train those disciples who have taken monastic vows and who live in the various SRF/YSS ashrams in America and India (*Only Love*, x). But more far more significantly, she is regarded as God-realized (again, like **Rajarsi Janakananda**) and hence is omnipresent, omniscient and omnipotent. This is quite a claim.

Of course, SRF regards this as more than just a matter of theological definition. In 1963, while on a visit to India, she had an experience of Babji (for whom, see *Yogananda*).

> Suddenly, I lost all awareness of this world. My mind was completely withdrawn into another state of consciousness. In an ecstasy of sweetest joy I beheld the presence of Babaji. I understood what Saint Theresa of Avila meant when she spoke of 'seeing' the formless Christ: the individuality of Spirit manifesting as soul, cloaked only in the thought-essence of being. This 'seeing' is a perception more vivid and exact in detail than the gross outlines of material forms, or even of visions. (*Only Love*, 187)

Babaji confirmed that she had been chosen by him as the leader of SRF. And in relating this episode, she said

> So, my dear ones, I have shared this experience with you so that you might know that Babaji lives. He does exist, and his message is an eternal one of divine love. (*Only Love*, 193)

We could say, therefore, that SRF's theology is derived from, and imbued with, divine transmission. This is why Sri Daya Mata's words are said to be "illumined by direct personal realization" (*Only Love*, xii); and it explains what she means by the two following statements: one about her own state of awareness—

> it is as though I am constantly drinking from the fountain of Love Divine. I can take no credit for this; it is the Guru's blessing, a blessing he bestows on all of us in the same way, if we but prepare ourselves to receive it. (*Only Love*, opp. 16)

—and one about the Self-Realization Fellowship:

> Those who meditate deeply, who practice kriya yoga faithfully, and who attain direct experience of God, will be the power that will sustain SRF. The blueprint of this work

was set in the ether by God; it was founded at His behest, and His love and His will sustain and guide it. I know this beyond doubt. (*Only Love,* 199)

Both of these statements are expressed in the language of divine transmission. The first is concerned with the individual (transmission from guru to disciple) and the second with the cosmic (transmission from God to the world). But the two are not in conflict and both are divinely ordained. In fact, it is the very essence of *Yogananda*'s teaching that although God-realization is possible here and now, in the West, it is not a purely individual attainment but occurs within the protective boundaries of a divine plan.

This may explain why, under Sri Daya Mata's presidency, SRF has established a firm orthodoxy—though SRF says that it was instigated by Yogananda himself and that **Rajarsi Janakananda** also followed it—see his entry and the case of Swami Premananda (in Srimati **Kamala**'s entry). Yogananda's instructions to her were to keep the teachings "pure and undiluted". Accordingly she (and the other members of the SRF Board of Directors) have not

> attempted or presumed in any way to change or dilute with personal innovations what he taught. How vital it is to keep that spirit. Otherwise, down through the centuries, little by little it will be changed. (Taken from Sri Daya Mata's speech at SRF's World Convocation, 1993)[2]

What this means in practice, as stated in a letter to me from SRF, is that "only the President of SRF, as the spiritual successor and representative of Paramahansa Yogananda, has the authority to initiate into Kriya Yoga. By virtue of the spiritual authority vested in the president, he or she may designate an ordained minister of the Church to conduct a Kriya Yoga ceremony." This principle is taken from *Yogananda* himself; for example, 'a handwritten note', in which he said, "Keep in touch with headquarters and you will be linked with the Masters . . . Some take Kriya Yoga and become fully satisfied and forget about the link of masters—they will never reach God" (quoted in the same letter mentioned above).

In fact, there are quite a few people who give *kriya yoga* initiation independently of SRF. (See the postscript at the end of this entry.) This is a complex situation and SRF has had to deal with it as best it can. They do not make any pronouncements about the validity of initiations given by those—all of them Indian—who derive their authority from a transmission that goes back to all the gurus who preceded *Yogananda,* Lahiri Mahasya and Sri Yukteswar.[3] (But I don't know what they say about those who say that they have beeen authorized by Babaji himself.) However, anybody who claims to give *kriya yoga* initiation as part of *Yogananda*'s transmission must have SRF's approval—even those who were personally intiated by him and given the authority to initiate others. All other initiations are 'unauthorized'—and that includes those given by Swami **Kriyananda** and Roy Eugene **Davis** (in fact, everyone in *Lineage Tree 2* who is 'derived' from Yogananda and is not affiliated with SRF); nobody can expect any real benefit from such a transmission.

Cf. ISKCON's GBC (see entries on Prabhupada *and the* **Hare Krishna gurus***).*

[2] This passage, and the two in qotation marks in the next paragraph, are included in a letter sent by SRF to its members in November 1995. The purpose of the letter was to give SRF's side of the story in its dispute with Swami **Kriyananda**'s Ananda (*aka* The Self-Realization Church)—see his entry.

[3] "We are aware that Kriya Yoga is also taught by other disciples of Lahiri Mahasya and Sri Yukteswarji, and we respect each individual's right to choose and follow whichever teacher he or she finds most spiritually fulfilling" (letter of November, 1995—see previous note).

When I sent this assessment to SRF, they demurred. "We certainly do not presume to say that 'nobody can expect any real benefit from such a transmission'". Yet all the evidence is that they regard themselves as the arbiters in such matters. Later editions of *Autobiography of a Yogi* contain the following statement: "there are now a number of other publishers, organizations, and individuals claiming to represent [Paramahansa Yogananda's] teachings. Some are borrowing the name of this beloved world teacher to further their own societies or interests, or to gain recognition for themselves. Others are presenting what is purported to be his 'original' teachings, but what is in fact material taken from publications that had been poorly edited by temporary helpers or compiled from incomplete notes taken during [his] classes." In contrast, all material issued by SRF itself is authentic because "he personally chose and trained those close disciples who constitute the SRF Publications Council, giving them specific guidelines for the publishing of his writings, lectures, and Self-Realization Lessons" (taken from the 1981 edition).

And in 1990, SRF filed a lawsuit against Ananda (for which, see Swami **Kriyananda**'s entry) because it had started to call itself the 'Church of Self-Realization'. SRF sought an injunction preventing Ananda from using the term 'Self-Realization' in its name, and from using the name, image or likeness of Yogananda in any public writing or statement. At the time of writing (late 1996), the courts have rules against SRF (but it is appealing). Ananda's version of events can be found in Swami **Kriyananda**'s entry.

All of this raises basic issues about the nature of transmission and orthodoxy which I deal with, in a larger context, in Chapter 3. Meanwhile, Sri Daya Mata has "through the years . . . flawlessly fufilled Gurudeva's trust, guiding his organization with unswerving regard for his ideals and standards" (SRF letter issued in 1994; no other details). At the same time, since, like **Rajarsi Janakananda**, she is a God-realized (or Self-Realized) *siddha*, she is omniscient, omnipresent, and omnipotent.[4] These are deep waters.

Primary sources: Sri Daya Mata, *Only Love* (Los Angeles: Self-Realization Fellowship, 1979)

Secondary sources. Swami Kriyananda/Donald Walters, *The Path: Autobiography of a Western Yogi,* (Nevada City, California: Ananda Publications, 1979)

Centre: Self-Realization Fellowship, 3880 San Rafael Avenue, Los Angeles, CA 90065, U.S.A.

COMPARE:

Other disciples of Yogananda: **Rajarsi Janakananda**, Sri **Kriyananda**/Donald Walters, Roy Eugene **Davis**

Other Westerners who teach kriya yoga: Goswami **Kriyananda**/Melvin Higgins, Srimati **Kamala**, Leonard **Orr**

Other Western women in the Hindu tradition (in some sense of that term): Swami **Abhayananda**/Marie Louise, Sister **Devamata**, the **Devyashrams**, the **Mother**, Sister **Nivedita**, Swami **Radha**, **Sivananda-Rita**

Other Western sannyasis: Swami **Abhayananda**/Bill Haines; Swami **Abhayananda**/ Marie Louise, Swami **Abhishiktananda**, Swami **Atulananda**, **Rudi**, the **Devyashrams**, Swami **Radha**, the 'original' **Hare Krishna gurus**

[4] This might explain why Elvis Presley, who referred to her as his "favorite yogi", went to see her at the Self-Realization headquarters in Los Angeles in 1965 to ask her if she could show him any short cuts to spiritual happiness. Apparently she told him that no one, not even the King (well, no, maybe she didn't say that), could buy his way to enlightenment (J. Strausbaugh, *E: Reflections on the Birth of the Elvis Faith* [New York, 1995], 89).

Postscript on *kriya yoga* lineages

Since it is Sri Daya Mata who has had to cope with the proliferation of *kriya yoga* teachers, this seems as good a place as any to summarize them. (See Lineage Tree 2: kriya yoga lineages.) A complete book could be written on the subject and I can do no more than give a list. I will say nothing here about those who appear elsewhere in this book. Accounts of Babaji, Lahiri Mahasya, and Sri Yukteswar can be found in *Yogananda*'s *Autobiography of a Yogi* and in sources cited here. This leaves us with the following:

YOGI RAMAIAH: claims to be a direct disciple of Babaji; founded the International Babaji Yoga Sangam in India in 1944 (or 1952—I have seen both dates in its literature); addresses: No.13 AR Street, Kanadukathan Post Office, Ramanathapuram District, Tamil Nadu 623 103, India; 10411 Mansa Drive, La Mirada, CA 90638, U.S.A. This may or may not be the same Yogi Ramaiah whom *Yogananda* and **Kriyananda** also met (on different occasions—see index of Kriyananda's *The Path*); he was originally called 'Yogi Rama' and was a disciple of *Ramana Maharshi;* he is mentioned in Paul **Brunton**'s *A Search in Secret India.*

SWAMI SATYESHWARANANDA: all I know about him is that he has published two books: *Lahiri Mahasya: The Father of Kriya Yoga*, 1983 (no publisher, no provenance) and *Babaji: the Divine Himalayan Yogi*, San Diego, 1984; address: 3763^1/2 35th Street, San Diego, CA 92104.

SWAMI HARIHARANANDA: claims to be a direct disciple of Sri Yukteswar. (Was Andrew **Cohen**'s guru for a while). Sometime in the 1980s, he 'seized' Sri Yukteswar's ashram at Puri and was sued by SRF/YSS in order to get him out of it. I have no further details. Nor do I know Swami Hariharananda's side of the story—and there undoubtedly is one. Address: Kriya Yoga Center, 1201 Fern Street NW, Washington DC 20012

The SWAMI KEBALANANDA LINEAGE: I have taken this from a pamphlet issued by Swami Brahmananda; I know nothing at all about Kebalananda; Brahmananda's guru, Swami Atmananda, was the same age as *Yogananda* and regarded him as a spiritual brother; he was succeeded by Brahmananda, an Indian who now lives in France (address: Mission Swami Atmananda, 'La Fleur d'Or', Neuvy-cn-Champagne, 72480 Bernay-en-Champagne); another of Atmananda's disciples is Swami Jnanananda, who is Danish and lives in India (but he told me that Atmananda was a disciple of of *Yogananda*—more research is needed on this one)

As far as I know, all of these are regarded by SRF as non-authentic (though they said nothing when I sent them this entry for comment).

Summary of the SRF/Ananda dispute
(see this entry and those for **Rajarsi Janakananda** and Swami **Kriyananda** for more detail)

I bring together here the positions of the two sides as I understand it (having waded through many, many pages of documents)

SRF

SRF is the 'form' chosen by *Yogananda* (and the *avatars* that preceded him) for the dispensation of *kriya yoga* in the world. To this end, under the guidance of a God-realized President, it protects the purity of *Yogananda*'s teaching and authorizes those who give *kriya yoga* initiation.

Changes in *Autobiography of a Yogi* are all in accord with *Yogananda*'s intentions. The court case against Ananda was necessary to prevent a distortion of the teaching which might have been accepted as authoritative by an unsuspecting public.

Ananda

Yogananda never intended SRF to be the only 'form' and he himself authorized disciples to give initiation who are no longer in SRF.

In order to support its position as the upholder of purity and orthodoxy, SRF has changed *Yogananda*'s own statements in *Autobiography of a Yogi* and sought, through legal means, to prevent Ananda from giving its version of *Yogananda*'s teachings.

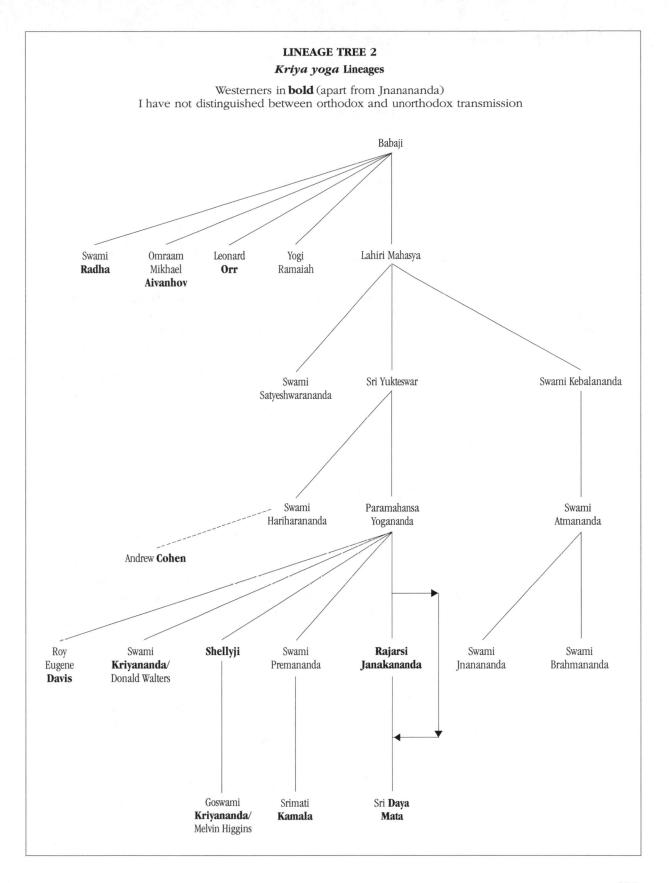

LINEAGE TREE 2

Kriya yoga Lineages

Westerners in **bold** (apart from Jnanananda)
I have not distinguished between orthodox and unorthodox transmission

Babaji

Swami **Radha**

Omraam Mikhael **Aivanhov**

Leonard **Orr**

Yogi Ramaiah

Lahiri Mahasya

Swami Satyeshwarananda

Sri Yukteswar

Swami Kebalananda

Swami Hariharananda

Paramahansa Yogananda

Swami Atmananda

Andrew **Cohen**

Roy Eugene **Davis**

Swami **Kriyananda/** Donald Walters

Shellyji

Swami Premananda

Rajarsi Janakananda

Swami Jnanananda

Swami Brahmananda

Goswami **Kriyananda/** Melvin Higgins

Srimati **Kamala**

Sri **Daya Mata**

Ruth DENISON. SEE *VIPASSANA SANGHA*

Robert DE ROPP. SEE THE **GURDJIEFF LEGACY**

Jeanne DE SALZMANN. SEE THE **GURDJIEFF LEGACY**

Sister DEVAMATA | Laura Glenn and Sister DAYA | Georgina Jones Walton

Americans who became
teachers in the
Ramakrishna Order

The position of women in Eastern traditions has tended to be inferior to that of men. But there have been exceptions. One of the most notable—and one of the earliest in the transmission of Eastern traditions to the West—was the attempt by Swami *Vivekananda* to include women in the spiritual life. He died suddenly in 1902 and the only member of the Ramakrishna Order who continued with this ideal was one of his Indian disciples, Swami Paramananda. He came to America in 1906 to assist Swami Abhedananda at the Vedanta Center in New York but very soon became a teacher in his own right. All his most prominent disciples were women and he gave them the greatest responsibility.

The first was Laura Franklin Glenn, who was born in 1867 into a well-established Ohio family; she was descended on her mother's side from Benjamin Franklin. She was drawn to the religious life from an early age and spent some time as a lay sister in an Episcopal convent (Levinsky, 94). Then, in 1899,[1] she heard *Vivekananda* speak in New York and immediately embraced the spiritual ideal that he embodied. Shortly afterwards, she had a vision of two figures, both of them unknown to her. They turned out to be Ramakrishna (who had died in 1886) and Paramananda (Levinsky, 94), whom she immediately recognized when he arrived in New York in 1906. She became his first disciple (in 1907), taking the name, 'Sister Devamata'. Paramananda gave her considerable responsibility right from the beginning. He made her his 'platform assistant'—not exactly a grand title, admittedly, but it meant more than its prosaic sound suggests. She gave talks when he was away and they were published as pamphlets, just as his were. She also gave "private spiritual guidance" (Levinsky, 186) to those who sought it. Again, this was when Paramananda was away. But since he was away a lot, some of the Boston students regarded her, rather than him, as their teacher (ibid., 211). This was just before World War I and she was probably the only Western woman at the time about whom even this much could be said, modest as it is. She died in 1942.

*The only other candidate
would be the **Mother**.*

The second woman of significance in Paramananda's 'Sisterhood' was Georgina Jones Walton, born in 1882 and brought up in California. Her father, John Perceval Jones, made a fortune in mining and was a senator for Nevada for 30 years. In 1919 (I have also seen the date 1916), she met Paramananda and became his disciple, Sister Daya, "second only to Sister Devamata in [his]

[1] This is the date given in her own *Days in an Indian Monastery*, vii; Levinsky, 94, gives 1896; Burke, 548, gives 1895.

work and closest in his heart" (Levinsky, 223). Like Devamata, she gave public talks, and she was put in charge of the Boston centre when Paramananda was visiting the one in California. And at the end of her life, she too was "sought out by many for spiritual guidance" (Levinsky, 551). She died in 1955.

Nobody is making any great claims for Sisters Devamata and Daya—certainly not that they were God-realized or enlightened (which *has* been claimed for some of the other women in this book—for instance the **Mother** and Sri **Daya Mata**). Yet they have an honourable place in the phenomenon I am describing: they fulfilled a particular role in a particular tradition at a time when nobody else did.

My latest information is that Srimata Gayatri Devi (an Indian), who took over as leader of the community after the death of Paramananda in 1940 and who is now in her eighties, has nominated another American woman, Sister Sudha, as her successor. So the 'experiment', started by *Vivekananda* a hundred years ago and continued by Paramananda, is still going: Western women, who derive their lineage from Ramakrishna, are teaching Vedanta in the West. This particular transmission from East to West is not a large movement. But it is a significant one: if it did not exist, an essential expression of Vedanta would be missing and hence Vedanta itself would be incomplete.

Primary sources:

Sister Devamata, *Days in an Indian Monastery*, 1927; *Sri Ramakrishna and His Disciples*, 1928; *Sri Ramakrishna and St. Francis of Assisi*, 1935; *Paramananda and His Work*, 1926, 1941 (2 vols.); *The Habit of Happiness*, 1930; *Building Character*, 1934; [all of these were published by the Ananda Ashrama at La Crescenta; I have also seen references in Ananda Ashrama catalogues to a number of pamphlets—no doubt transcribed talks; but only the titles, no publication details: *The Practice of Devotion*; *Development of the Will*; *Sleep and Superconsciousness*; *Robert Browning and Vedanta*; *The Indian Mind and Indian Culture*]

Sister Daya, *The Guru and the Disciple* (Cohasset, Massachusetts: Vedanta Center, 1976)

Secondary sources: Sara Ann Levinsky, *A Bridge of Dreams: The Story of Paramananda, A Modern Mystic—and his Ideal of All-conquering Love* (West Stockbridge, Massachusetts: Lindisfarne Press, 1984); Srimata Gayatri Devi, *One Life's Pilgrimage* (Cohasset, Massachusetts: Vedanta Center, 1977); Marie Louise Burke, *Swami Vivekananda in America: New Discoveries* (Calcutta: Advaita Ashrama, 1958)

Centre: Ananda Ashrama, Box 8555, La Crescenta, CA 91214, U.S.A.

COMPARE:

Other women associated with the Ramakrishna Order: Swami **Abhayananda**, Sister **Nivedita**

Other women teachers in Hinduism: Sri **Daya Mata**, the **Devyashrams**, the **Mother**, Swami **Radha**, Joya **Santanya**, Swami **Turiyasangitananda**

Other early women teachers in other traditions: Madame **Blavatsky** (Theosophy); Murshidas Mevrouw **Egeling**, Lucy **Goodenough**, Saintsbury **Green**, Rabia **Martin** (all Sufism); **Uppalavanna** (Theravada Buddhism)

The DEVYASHRAMS

Three American women who have been authorized to form a Hindu lineage

The Rajarajeshwari Peetham in New York state (formerly in Pennsylvania) is a unique institution: a Hindu temple that serves the Indian (Hindu American) community but is presided over by white American women. There have been

three of them so far: Swami Lakshmi Devyashram, Swami Saraswati Devyashram and Swami Parvati Devyashram, and I refer to them collectively (without, I hope, any disrespect) as the Devyashrams.

The history of this establishment (taken from the community's literature, mainly pamphlets) is as follows. In 1963, the first Devyashram (I do not know her original name and she was not a Devyashram at the time) was practising Shivananda's Yoga of Synthesis and attained *samadhi*. I have no details as to what this means exactly, but a year later she had a vision of Shivananda (although he had died in 1963) and was guided by him to the Poconos in Pennsylvania. I have no information about what she did there, but in 1968 she founded the Sivananda Ashram of Yoga One Science. This name seems to indicate that she considered herself as working in Shivananda's name during this period.

*Cf. Swami **Radha**, who had a vision of him in 1956.*

However, a year later, in 1969, she was given *sannyasa* by Swami Swanandashram, an Indian *sannyasin* of the Saraswati Order living in America. He was not a disciple of Shivananda but in the Hindu tradition the *swami* who gives *sannyasa* does not have to be affiliated to the guru who guides the disciple's *sadhana*. She thereby entered the Saraswati Order and took the name Swami Lakshmi Devyashram. And according to Swami Parvati Devyashram, he also bestowed on Swami Lakshmi the title of 'Mahamandaleshwari'.[1]

Indians living in the area were attracted to a centre that provided the kind of Hinduism that they already knew—one that included *pujas* and temple worship that were completely Indian and not adapted for American (that is, white) understanding. But inevitably there were some who wondered if such thorough-going Hinduism could really be provided by a white American woman, despite her *sannyasa* initiation. Since Swami Swanandashram was in India, Swami Lakshmi went there herself (in 1974). But she did not go to see Swami Swanandashram. Instead, she visited one of the four Shankaracharyas, His Holiness 1008 Jagadguru Shankaracharya Swami Abhinava Vidyateertha Maharaj, head of the Sri Sharada Peetham at Shringeri in south India, and was accepted as his disciple.[2]

I do not know if she received formal initiation from him or not. Swami Parvati told me that he confirmed the title of 'Mahamandaleshwari'; but more than that, he authorized her to start a line of succession or *parampara* in America. The name of this *parampara* is the Holy Shankaracharya Order and its first leader (to give her full title) was Her Holiness Divine Mother Mahamandaleshwari Swami Lakshmi Devyashram. Although the Shankaracharya is the ultimate head of the Order and his photo appears prominently in all of its literature, the effective head of the Order in America is the Mahamandaleshwari.

In 1978, the Shankaracharya instructed Swami Lakshmi to found her own Peetham or temple, the Rajarajeshwari Peetham. (Rajarajeshwari is the Mother of the Universe; the similarities with Mahamandaleshwari are obvious.) However, the literature of the Peetham says that it was founded in 1968 (which is actually when she founded the Ashram of Yoga One Science) "through the

[1] *Maha* means 'great'; *mandala* means 'country, region'; *ishwari* means 'queen, goddess'; *Mahamandaleshwari* is thus both a title of the Goddess—in which case, it means something like 'Goddess of the world'—and a term that can be used of a female leader or ruler.

[2] The Shankaracharyas are the heads of the monastic centres that are traditionally held to have been founded by the original Shankara—often called the Adi Shankaracharya (*adi* means 'first')—in the eighth century; they are the very epitome of orthodoxy.

direct inspiration of such saints as Adi Shankaracharya [the Shankara of the eighth century] and Sri Swamy Sivananda Saraswati". According to an undated brochure, *The Vision of the Peetham*,

> Sri Rajarajeshwari Peetham has been established according to Shankaracharya tradition (sampradaya) based upon the understanding that God is One. According to Shankaracharya Sampradaya the essential energy of our temple is that of the One God in the form of the Mother of the Universe. God as Mother of the Universe pours forth Her Perfect Love and Healing Power upon Creation . . . The Mother Energy, coming through the Peetham, is supporting the healing of individuals, of Humanity, and of the earth.

This is classic Hindu universalism, to coin a phrase. But while it is firmly linked to the original Shankara of the eighth century, it is evident that what is being presented is not the classic *jnana marga* or path of knowledge that is often associated with him. Rather, it is a form of *shakti* feminism (to coin another phrase) and it is this which provides the doctrinal foundation for the whole Rajarajeshwari/Mahamandaleshwari myth.

Moreover, Swami Lakshmi has a central role in this myth. She is called 'Divine Mother' and this is the sort of thing that is said about her:

> Throughout our journey in Mother India, Her Holiness was enveloped in the Grace of Shakti of the Universe, Sri Rajarajeshwari . . . Her Holiness always moves in an aura of Divinity, responding quickly and completely to Lord's [sic] Will, through her realization of Truth and her absolute faith and fearlessness to do what is required by the Knowledge [sic] . . . This auspicious journey to Mother India by Her Holiness Divine Mother is a beginning—a primary step in the development of the spirituality of Mankind. The West is prepared to play its part in the spiritual Upliftment of Mankind. At this time Mother India must teach to the West the ancient wisdom which has been cradled in the East for so long—the wisdom that leads to Realization. (*Punarnava* [the community's magazine], August 1981, 24, 28)

*Cf. Sri **Kriyananda**/ Donald Walters and Shrila **Bhaktipada**, who have also founded 'Vedic' communities—but they are very different from that of the Devyashrams.*

Evidently, Swami Lakshmi is seen as a divine instrument, who will help in the worldwide spread of the spiritual heritage of India. According to a brochure, she "devoted her life to nurture the growth and purity of the Vedic faith in the West". What this means in effect is that the religious practices of India—and specifically, those of the *shakti* feminism form—have been transplanted lock, stock and barrel to America. The *pujas* provided at the Rajarajeshwari Peetham are usually carried out by Indian priests and include Astottara Arcana (the 108 Names of the Mother), Navagraha Homa (Homa to the 9 Planets and direction gods) and Navavarana Puja (three-hour worship service to Sri Cakra of other [sic]). (These descriptions are taken from one of the Peetham's brochures; they are only three out of 17 *pujas* and *homas*, which range in price from $11 to $251.)

Clearly, such services would mean little or nothing to a non-Hindu American. But the Peetham is not really concerned with them. The 'Annual Invitation to Membership' makes this very plain. Prospective members are invited to assent to the statement that "I wish to support Values and Teachings that are the cornerstone of my Religion and Heritage". It would make no sense for a non-Hindu to say such a thing. A list of patrons in the August 1981 issue of *Punarnava*, the Peetham's magazine, contains only nine names out of 85 which are non-Indian. Advertisements in the ashram brochures are obviously aimed at Indians: the Bank of Baroda, Oriental Records and Air India (with the slogan, "We Go Home Everyday").

The Hindu side of the Holy Shankaracharya Order is thus very evident. But there is a Western side too: part of the aim to bring "the purity of the Vedic faith" to the West. The most obvious example of this is the Hindu Heritage Summer Camp, an annual event that Swami Lakshmi began in 1978. It is run by "American and Hindu-American sannyasins" and its aim is

> to introduce Hindu-American children to their own Divinity and spirituality, as well as to the beautiful religion called Hinduism, and the extraordinary culture of India . . . with the knowledge that these children must grow and live within the culture of the United States. We seek to offer a synthesis between the two cultures which comprise the Karmic history and destiny of these precious young men and women. (Camp brochure)

This is an Indian-American synthesis. On the Indian side, there is Religious Instruction (including the study of Hinduism—closely tied to temple ritual— and Sanskrit, Vedic Mantras, and Gayatri Mantra) and Philosophy (including How the Mind Works and Harnessing Spiritual Energies); on the American side, there are Sports, Campfires and a Nature Program.

Swami Lakshmi remains the inspiration behind most of the activities at the Peetham. She died in 1981—just a few weeks after the very first priest arrived from India. He was thus able to carry out the full funeral rites appropriate to a Hindu and a *sannyasini*. He could also have formally installed Swami Saraswati Devyashram, Swami Lakshmi's successor as Mahamandaleshwari of the Holy Shankaracharya Order. But, says Swami Parvati Devyashram, "they didn't think to ask him."

I do not know whether Swami Saraswati (the second Devyashram) was ever formally installed. In fact, I know very little about her at all. I assume that it was Swami Lakshmi who initiated her as a *sannyasini* but I am not sure. Nor do I have any firm information about her tenure as Mahamandaleshwari. But I have seen a short essay, 'The Power if Navaratri', which she issued on the eve of the Navaratri Mahotsava in 1988. In it, she exhorts her readers to

> place all negativities upon the Sacred Fire of the homa in order that they become transformed through the Grace of the Mother of the Universe into positive and constructive energy for the welfare of Mankind . . .
>
> Let each one of us cast our vote for planetary enlightenment . . . knowing the power we have to make a difference, knowing our prayers will add up in projecting the future of this planet . . .
>
> Recognize the power of God that you are. Act upon it. Join us for Navaratri.

This is the vocabulary of Hinduism (of the *shakti* feminist variety) poured into a metaphysical/New Age template. It is tempting to see it as another instance of American-Indian synthesis. Whether it was intended as such, I do not know.

Swami Saraswati remained as leader of the Rajarajeshwari Peetham for seven years. But in 1988 (not long after the exhortation quoted above), she sent a letter to everyone associated with the Peetham saying that she was retiring from the post of Mahamandaleshwari for personal reasons. She has now returned to lay life and runs a book shop in Virginia.

She was succeeded by the third Devyashram, Swami Parvati Devyashram (who *was* formally installed). When I visited the Peetham in 1990, she told me that she was the only *swami* there. ("I would like to give *sannyas* but I have not found anyone who is ready; nobody understands *seva* these days.") Not only is she the sole *swami*, she is practically the sole non-Indian. In fact, she and I were the only non-Indians out of the 75 people who were present when I was there. A number of *pujas* were performed by professional priests. But

they do not live at the Peetham; they come from Queens, New York, and when they are not there Swami Parvati performs the *pujas* herself. She said she was having financial difficulties because of money that had been borrowed by her predecessors and was considering selling the Peetham and moving elsewhere. (Soon afterwards, she was successful and relocated to Rochester, New York.) While we were talking, an elderly Indian approached us and did a full-length prostration (a sign of respect for one who has taken *sannyas* vows); she blessed him in a completely unshowy manner with her outstretched hand.

As far as I know, a lineage of Western women catering for traditional Hindus is unique. Just a few decades ago, it would have been unthinkable.

Primary sources: No books that I know of—only magazines

Secondary sources: None

Centre: I do not have the new address (near Rochester, NY)

COMPARE:

Other teachers who have been associated with one of the Shankaracharyas: Sri **Daya Mata**, Leonardo **Maclaren**

Other leaders of Hindu ashrams: **Rajarsi Janakananda** and Sri **Daya Mata** (successive heads of Yogananda's Self-Realization Fellowship, which includes a monastic order), Swami **Kriyananda**/Donald Walters (who also founded a monastic order), Swami **Radha**, Srila **Bhaktipada**, Guru **Subramuniya**, the **Mother**, Sri **Krishna Prem** (the last two in India)

Other women in Hinduism (in various senses of that extremely elastic term): Swami **Abhayananda**/Marie Louise, Sister **Devamata**, Sri **Daya Mata,** Srimati **Kamala**, the **Mother** [something of a special case], Sister **Nivedita**, Swami **Radha**, Joya **Santanya**, **Sivananda-Rita**

Women in other traditions: Ruth **Denison**, Ayya **Khema**, Sharon **Salzberg**, Sister **Uppalavanna** (*Theravada Buddhism or the vipassana sangha*); Jan **Bays**, Joko **Beck**, Gesshin **Prabhasa Dharma**, **Karuna Dharma**, Jiyu **Kennett**, Dharma Teacher Linda **Klevnick**, Dharma Teacher **Linda Murray**, Irmgard **Schloegl**, Dharma Teacher Bobby **Rhodes**, Ruth Fuller **Sasaki** (all *Zen*); Freda **Bedi**, **Pema Chodron**, Dhyani **Ywahoo** (all *Tibetan Buddhism*); Murshida Ivy **Duce**, Murshida Rabia **Martin**, women in the **Sufi Order**, Irina **Tweedie** (all *Sufism*); Jaqueline **Mandell**, **Marasha**, Toni **Packer**, Jeanne **de Salzmann**, Swami **Turiyasangitananda** (*various traditions/non-traditions*)

Anagarika DHARMAPALA

Sinhalese who was converted to Theosophy and subsequently worked to propagate Theravada Buddhism in the West

Dharmapala was born David Hewivitarne in 1864 and was one of the first Easterners (which effectively meant those from the Indian subcontinent) to embrace Theosophy. Either in 1880 or 1884 (the sources differ), he was initiated by **Olcott** *into the Theosophical Society; and a year later, he became a Buddhist.[1]* **Olcott** *and Dharmapala worked together, as Theosophical Buddhists, for 20 years but they had rather different aims:* **Olcott** *wanted to create a universal Buddhism; Dharmapala wanted to establish a strong, 'pure'*

[1] The circumstances of this event are unclear. He referred to himself as Anagarika Dharmapala but there is no formal rank of *anagarika* in Sri Lankan Theravada Buddhism. (The term itself, signifying a homeless wanderer, is as old as Buddhism and is currently used by Ajahn **Sumedho**'s Chithurst *sangha* in England—but this *sangha* is derived from Thailand, not Sri Lanka.) It seems likely, therefore, that Hewivitarne bestowed the name 'Anagarika Dharmapala' on himself. There is certainly no record of him being given it by any Sinhalese Buddhist.

*Buddhism that would regain Sinhalese pride and at the same time be attractive to Westerners. In 1891 (the same year that **Olcott** published his* Buddhist Catechism*), Dharmapala, outraged that the centres in India connected with the Buddha's birth, enlightenment and death should be run by Hindus, founded the Maha Bodhi Society in order to return them to Buddhist hands. He started the* Maha Bodhi Journal *a year later, and it was in his capacity as its editor that he was invited to the World Parliament of Religions in Chicago in 1893. After the Parliament finished, he founded a branch of the Maha Bodhi Society in Chicago—the first Buddhist centre in the West. And when C.T. Strauss, a Swiss living in America, received* pansil *from Dharmapala at the opening ceremony, he was the first Westerner to become a Buddhist in the West. Of course, he became a Buddhist only in a very elementary sense; but at this time, any sense at all is significant.*

Dharmapala spent the next 40 years working for the restoration of Buddhism to India and its establishment in the West. He took full bhikkhu *ordination in 1931 and died just two years later after a lifetime's devotion to a cause that is now taken for granted: that Westerners should be able to follow the path of Buddhism in their own countries.*

Dharmapala's scattered writings have been collected together in *Return to Righteousness* (a revealing title), Ministry of Educational and Cultural Affairs, Ceylon, 1965; there is a biography of him by one of his fans, Ven. **Sangharashita**, *Anagarika Dharmapala: A Biographical Sketch* (Kandy, Ceylon: Buddhist Publication Society, 1964).

Rev. DHARMAPALI | Martha Sentnor

American who is trying to establish a non-sectarian Buddhism for women

Dharmapali describes herself as 'in transition': based in Theravada but using Mahayana 'styles' (Boucher 120). She has been involved in the Theravada tradition for nearly 30 years. In the late 1960s, she helped the Sri Lankan community in Washington, D.C., establish the *vihara* there and has 'lived' there herself. But her position has been equivocal (which is why the word 'lived' is in scare quotes). Because the *vihara* is supported by the Sri Lankan laity, and because giving to monks/*bhikkhus* is regarded as more meritorious than giving to nuns/*bhikkhunis* (although strictly speaking there are no Theravada *bhikkhunis* any more), no provision was made for her. She cannot sleep there—it is against the *Vinaya* rules—and therefore has had to make her own arrangements. She has also had to support herself by working (Boucher, 119)—which is also against the rules, incidentally. This is discrimination and no two ways about it. There is nothing personal in it; it is simply a consequence of how the tradition has developed over the centuries on the other side of the world.

In 1984, she was ordained as an 'eight precept nun' at Amaravati in England (a wing of Ajahn **Sumedho**'s Chithurst *sangha*) but then went on to take the ten precepts (and thus became a *dasa sila mata*—see the Glossary) at the New York Buddhist Vihara, which is run by Sri Lankan monks, in 1985 (*Spring Wind*, 122). This is as much as the Theravadin tradition allows. It is not surprising that many Western women feel that this situation could be improved on. Dharmapali is one of them and since 1985 she has been working towards the establishment of a Women's Dharma Monastery that is not tied

to any one tradition (*Spring Wind,* 125–28). She sent out a questionnaire to Western women actively involved in all forms of Buddhism and got some interesting replies. At the technical level, there was rejection of the traditional rule that requires *bhikkhunis* to be ordained first by other *bhikkhunis* and then by *bhikkhus* (assuming that the *bhikkhuni sangha* were to be reintroduced into the Theravadin tradition). More generally, but equally significantly, people wondered if it was necessary to rely on the support of the laity, which has become a way for lay people to earn merit and thus become a form of 'spiritual materialism'. And perhaps most significantly of all, it was pointed out that since the Western women who are attracted to Buddhism in the first place tend to be independent and open to new ideas, it is extremely unlikely that they will accept a way of life which can only be justified by appealing to 'tradition' (which is in effect a version of that well-known medieval substitute for thought, 'Aristotle hath said it.'). The Buddhist community as a whole will lose if such women are marginalized because it cannot adapt (Boucher, 115–17).

All of these responses are deeply challenging to Buddhist tradition. The Women's Dharma Monastery (which might itself be the basis for an independent order of Buddhist nuns) has not yet come into existence, but it may. Meanwhile, Dharmapali is co-director (with Rev. Chan-Nhu, a Vietnamese nun) of the Chan-Nhu Buddhist Pagoda in Colorado: a trans-traditional nunnery which combines *vipassana* practice from Burma and Thailand with Vietnamese Mahayana. You have to start somewhere.

Primary sources: None

Secondary sources: Sandy Boucher, *Turning the Wheel: American Women Creating the New Buddhism* (San Francisco: Harper and Row, 1988); *Spring Wind*, vol. 6, nos. 1, 2, 3 (a special issue on 'Women and Buddhism'), 1986

Centre: Chan-Nhu Buddhist Pagoda, 7201 West Bayaud Place, Lakewood, CO 80226, U.S.A.

COMPARE:

Other women in the Theravadin tradition: Ayya **Khema**, Sharon **Salzberg**, Sister **Uppalavanna**

Others who subscribe to some form of ecumenical Buddhism: Robert **Clifton**, **Miao Kwang Sudharma**, Ven. **Sangharakshita**

Tommy Issan Dorsey

American Soto Zen teacher and priest who ministered to gays (and was gay himself)

Dorsey was an ex-drag queen who ended up a *roshi* and, some say, a Bodhisattva. He was born in Santa Barbara in 1933, the eldest of ten children. He discovered he was gay at high school, and after serving in the Navy for two years (from which he received an Undesirable Discharge Under Honorable Conditions—guess why), he went to San Francisco in 1953 and joined the cool scene that was just beginning to develop there. He lived a hard street life for the next ten years: using every imaginable drug; "turning tricks"; touring as part of a three-man team of drag artists, and as soloist ("I was a bad queen"); and dating the occasional Chicago mobster. He was lucky to come out of it alive.

In 1964, he went back to San Francisco and discovered LSD, the hippie scene and Zen. To begin with, they were all mixed up (as they were for many at the time) but he managed to disentangle them. By 1968, he had met Suzuki Roshi:

*Robert **Aitken** was partly responsible for its inception (Schneider, 128).*

a funny little old Japanese man that I couldn't understand. I couldn't understand his English but I just made myself go anyway. I went to all his lectures. There was something about him that attracted me. (Schneider, 92)

He moved into the San Francisco Zen Center/SFZC (where he met Reb **Anderson**) and started meditating regularly. He went to Tassajara, SFZC's retreat centre, soon after it was opened and was made head cook—a position that is highly regarded in the Soto tradition. He took the *jukai* precepts from Suzuki Roshi in 1970.

By this time, he had stopped taking drugs altogether, lived a responsible sexual life and was more or less a reformed character. But he kept his outrageous side. Some people were unsure how to pronounce 'Issan', his Dharma name. "It rhymes with 'piss on,'" he would say helpfully (Schneider, 115)

Suzuki Roshi died in 1971 and was succeeded by Richard **Baker** Roshi as abbot of SFZC. To begin with, Issan did not like **Baker** and did not think he could work with him. "But that turned around." He took *tokudo* ordination from **Baker** in 1975 and became one of his most loyal students. He stood by him throughout the 1983 debacle which ended up with **Baker** leaving SFZC and starting his own centre in Santa Fe. In fact, Issan went to study with him there for a while.

But his real home was San Francisco. Gradually, he became more and more involved in the gay movement there. When a Gay Buddhist Club was started in Hartford Street in 1980, Issan, who had already been practising for twelve years, became its spiritual advisor (with **Baker**'s blessing). Then, in 1985, he found out that he was HIV-Positive. His response was entirely typical of the man: accepting things as they are—and not complaining. "Well, why shouldn't I have it? It's been my life. It's sort of appropriate. Why should I be spared?"

He had always had a genius for street life and he put it to good use now. AIDS was just beginning to hit San Francisco and people were confused, frightened, and angry. "The gay community is fucked," was Issan's way of putting it (Schneider, 167). But he pitched in with them anyway. "Those are my boys down there," he said once, surveying the Castro district from one of the surrounding hills (ibid., 165). He extended the Hartford Street Zen Center so that it included a hospice providing personal care round the clock—for $500 a month, a miracle in itself (ibid., 181–82). It was one of the first hospices that had a genuine community atmosphere. Anyone could go there, gay or not.

But of course he got sick himself. He readily admitted that he was as frightened and overwhelmed at the prospect of death as anybody else, in spite of all his years of *zazen* (and he was a regular practitioner). Yet he did not abandon his essential street style:

I don't want to hear about that 'clear-mind-no-drugs' talk . . . The mind we're talking about when we say 'clear mind' isn't affected by a little morphine. (Schneider, 198)

"Issan never acted much like an angel, nor like a particularly 'pure' person . . . He could be a dictatorial, fussy, bitchy pain in the ass" (Schneider, x, xi). But mainly he wasn't. In fact, he was "genuinely adored" (ibid., 236). He was kind, completely unjudgemental and accepted people as he found them. This is a rare quality. And it manifested itself in another way: he could get on with life—ordinary life—without trying to force it into a particular shape. According to Richard **Baker**,

When he lived at Santa Fe, the garden bloomed, the place looked good, everything was shining, the flowers and bushes were tended. He just did it. No one asked

him, he just did it. He was a kind of—as a real bodhisattva is—a kind of housewife. The bodhisattva is ultimately a kind of houswife, just takes care of things. (Schneider, 157)

In fact, **Baker** had decided in around 1980 or so that he wanted to give Issan Dharma-transmission. They worked together towards this end over a number of years. In 1989, **Baker** installed Issan as abbot of the Hartford Street Zen Center, which he renamed 'Issan-ji'. A year later, Issan gave *tokudo* ordination to three of his students (Schneider, 196). (But Issan also found time to officiate at the marriages of three of his sisters.) By now he was very ill. **Baker** made him a *roshi* in a private ceremony, and shortly afterwards Issan gave Dharma-transmission to his principal student, Steve Allen. Allen thus became Issan's successor[1] (and as a result, Issan's name remains in the Soto lineage). Issan died five days later. He was 57.

Issan had no teaching in any conceptual sense. But as **Baker** Roshi said at his funeral, he understood Suzuki Roshi's way better than anyone else. "In the Zen Buddhist world, Japanese or American, no higher compliment could be paid" (Schneider, 236). The Maitri Hospice still operates in the Hartford Street Zen Center and still ministers to those who need it. A lot of people still do. Many of them, though not all, are those have "misstepped or lost their way" (ibid., 194). They also have a place and one which, having been there himself, Issan Roshi knew very well.

Primary sources: None

Secondary sources: D. Schneider, *Street Zen: The Life and Work of Issan Dorsey* (Shambhala, 1993)

Centre: Issan-ji, 57 Hartford Street, San Francisco, CA 94114, U.S.A.

COMPARE:

Other Zen teachers: Robert **Aitken**, Reb **Anderson**, Richard **Baker**, Jan **Bays**, Joko **Beck**, Gesshin **Prabhasa Dharma**, Don **Gilbert**, Bernard **Glassman**, Philip **Kapleau**, Jiyu **Kennett**, Daido **Loori**, Genpo **Merzel**, Walter **Nowick**, Ruth Fuller **Sasaki**, Maurine **Stuart**, Zen Master **Tundra Wind**

Other gay teachers: Zen Master **Tundra Wind**

Abdullah DOUGAN. SEE **APPENDIX 1**

Murshida Ivy DUCE

Murshida Rabia **Martin**'s successor as leader of a Sufi group in America who became a devoted follower of *Meher Baba*

Ivy Duce (pronounced 'Deuce'), *née* Judd, was born in 1895. Her father was a somewhat eccentric inventor (he worked for Edison for a while); her mother was Swedish. She was brought up an Episcopalian (and remained one until she was 40). After school, she trained as a lawyer and a singer. She served in the American Red Cross in France in World War I, after which she got married and had a daughter. She became interested in astrology and was given

[1] But he has not remained at Hartford Street Zen Center/Issan-ji. The present abbot is another of Richard **Baker**'s students, Philip Whalen. (See Lineage Tree 1.)

horoscopes 'blind' by her teacher as a way of learning how they work. For no apparent reason, she says, she became deeply interested in one of the charts and asked if the person was still alive. It turned out she was and lived just round the corner in San Francisco. This was 1940 and the individual in question was Rabia **Martin**, who was leader of an American Sufi group originally established in San Francisco by Hazrat Inayat *Khan*.

Ivy Duce became Martin's disciple and was appointed as her successor as *murshida* in 1947. As Ivy **Duce** wrote later: "Needless to say, I had no idea whatsoever that she had been waiting for me for years, and she started at once my training to succeed her" (*How a Master Works,* 19). Martin had told her about *Meher Baba* in 1945 and Ivy Duce already considered herself his follower before he appointed her as *murshida* of Sufism Reoriented in 1952. He issued a charter, which stated amongst other things:

> Sufism as reoriented by Meher Baba is based on love and longing for God and the eventual union with God in actual experience . . . To sum up in Baba's own words: "The fact that I am connected with all 'isms and yet detached and above all 'isms, lays bare the truth that Sufism Reoriented, emanating from me . . . *will forge out into one of the few pure channels leading to One God* [my italics]. As a result, all who will follow any one of the 'isms reoriented by me, will come eventually to love Me and realize God rather than the 'isms.

Two other aspects of this Charter are important. The first concerns the duties of the members of Sufism Reoriented and their initiation. The duties include: the study of Sufi literature (including works by Hafiz, Rumi, Ibn Arabi, and Hazrat Inayat *Khan*); "to necessarily read and study vigorously" *Meher Baba*'s *Discourses* and *God Speaks*; "to repeat verbally daily one name of God for half an hour"; and "to meditate on the Master daily for 15 minutes." (The 'Master' is *Meher Baba,* not the *murshid[a]*). The initiation takes the form of "any short invocation such as Inayat Khan's, which is most suitable", to which the applicant replies,

> I do solemnly bind myself to the faithful adherence of the guidance laid down by Meher Baba, and to faith and trust in the Murshid.

The second aspect is the spiritual status of the Murshid. *Meher Baba*'s Charter has three things to say on this matter.

> (a) A Murshid or Murshida, one whom others can follow, should necessarily have Divine Vision—the highest state of illumination.

> (b) The Qutub (the very source of illumination) can play the part of a Murshid (the fully illumined).

> (c) Meher Baba may allow anyone to be called and considered a Murshid or Murshida without necessarily disclosing whether such a one is illumined, not illumined or about to be illumined. In all such cases Meher Baba will hold himself responsible for the spiritual welfare of all those who may be prepared to and do follow a Murshid or Murshida so declared by him.

The explanation of these three points is as follows.

> (a) One who has Divine Vision is a sixth plane master or Pir. This was expressly stated by *Meher Baba*. (*How a Master Works*)

> (b) A Qutub is a Perfect Master or Sadguru—one who has reached the seventh plane and become God.

(c) According to Sufism Reoriented, Meher Baba put in this proviso about not declaring if a Murshid(a) was or was not illumined (as the Charter would lead us to expect he or she would be) expressly to deal with Murshida Duce. She openly acknowledged that she was not illumined but Baba was adamant that she should fulfil the role he had allotted her. He asked a disciple to write to her, saying, "Baba is the Light and you are the expression thereof" (*Sufism Speaks Out,* 33). And he himself said to her, "I will do all your work. I will see to it that you do not make any mistakes with your students and I will protect you from taking on any of their karma as long as you remain 100% honest." (ibid., 8)

The implications of these statements are considerable. When he was asked if Sufism Reoriented would have an illumined *murshid* after Murshida Duce's death, he replied: "You *will* have an illumined Murshid for the next 700 years until I come again." He also said that there were only five (real) Sufi *murshids* in the entire world (in Persia, Egypt, Algeria and [two] in India); and "he felt that the Western world was now ready for Sufism and must have a real Murshid" (*How a Master Works,* 123).

To sum up the relationship between *Meher Baba,* Sufism Reoriented, and its *murshid(a):* Sufism Reoriented is the creation of *Meher Baba* and is centered on him as the means of salvation; but as far as external spiritual guidance and practice are concerned, its focus is the *murshid(a); Meher Baba* guarantees that Sufism Reoriented will be a pure channel to God for 700 years until his next incarnation as the *avatar;* he also guarantees that its *murshid(a)* (after Ivy Duce) will be a sixth or seventh plane master; because the *murshid(a)* is of this stature, Sufism Reoriented is one of only six genuine Sufi schools in the world and the only one in the West.

This is a fairly extraordinary situation (as everything associated with *Meher Baba* tends to be). How has it been understood and interpreted by those in Sufism Reoriented itself?

First of all, Murshida Duce presents Sufism in her writings as a universal truth—indeed, as *the* universal truth. It is not a form of Islam (*Sufism,* 18), and anyone who has attained God-realization is a Sufi whatever religion he appears to belong to; she cites Abraham and St. Paul as Sufis (ibid., 17). In this, she is simply echoing both Inayat *Khan* (whom she quotes, ibid.) and *Meher Baba* himself.

Secondly, a central role in Sufism (understood as universal truth) is played by the *murshid(a)* or guru (the terms are used interchangeably in Sufism Reoriented writings). The *murshid's* task is to eliminate the *mureed*/disciple's false ego, or, in *Meher Baba's* terminology, to bring about the unwinding of *sanskaras* (*Gurus and Psychotherapists,* 2). However, it is a universal law that the ego resists its dissolution. Hence

> the whole relationship between the guru and the disciple should be founded on trust . . . There always comes a time when a student will not agree with me . . . [Then] I just let them do what rationally they think they ought to do. Invariably they find out that I was right . . . When they don't take my advice, then things go wrong, you know. (Ivy Duce, *Gurus and Psychotherapists,* 79, 30)

Sufism Reoriented has been established so that this relationship between *murshid*/guru and disciple can be set on a firm foundation. Murshida Duce says:

> It is indeed true that anyone can go to Baba without being a Sufi or without Sufistic training, but after the Master [= Meher Baba] again lays down His dear body, there

will be need for true Sufis and true Yogis to guide people on the Path . . . The Master has commanded that I establish a strong Sufi school in the Americas, and so, by His grace, this I have been trying to do. (*Sufism,* 22)

There are two aspects of Sufism Reoriented that its members see as unique. The first is that it is the realization of a project initiated by the spiritual hierarchy via Hazrat Inayat *Khan* and Rabia **Martin**, and culminating in the foundation of a Sufi Order by the head of the hierarchy, Avatar *Meher Baba. Meher Baba* is reported as saying that Inayat *Khan* was a great saint (Watson, 7); and members of Sufism Reoriented regard him as a member of the hierarchy (letter from Ira Deitrick) and a fifth plane master (interview with Ira Deitrick). Part of his work for the hierarchy was to prepare the way for *Meher Baba* by establishing a Sufi Order in America with Rabia **Martin** as its *murshida*. And in fact *Meher Baba* is reported as confirming that Rabia **Martin** was indeed the true successor of Inayat *Khan* (letter from Ira Deitrick).

Secondly, Ivy Duce is seen as having a unique spiritual function for the simple reason that she was the only person, Eastern or Western, whom *Meher Baba* appointed as a spiritual teacher. She is described as "the leader of the Sufis in the Western Hemisphere" (*What Am I Doing Here?,* back cover); as "personally charged to serve in the role of [Meher Baba's] guru for the Americas" (*Gurus and Psychotherapists,* vii). This is what one of her disciples says about a class she gave as part of a series on Sufism Reoriented as a way to *Meher Baba:*

> What she talked about was irrelevant. There was really some unconscious effect taking place in me in her presence. Something happened in being with her such that it became very clear to me that I did want to be a Sufi very badly . . . Over two years since initiation have now gone by and it becomes clearer weekly if not daily that we are finally on the path home. (Watson, 26)

So what *is* her spiritual function? The answer to this question has to be given, like all answers concerning Sufism Reoriented and its *murshid(a)s*, in the vocabulary of *Meher Baba*. Murshida Duce began one of her lectures like this:

> I am sure that for those of you who have not met me I must be the last word in contradicting any of your preconceived ideas of what a guru should look like . . . I can only apologize and say that even Baba had a little old lady for His Master [= Hazrat Babajan], and that ought to comfort you a little, although I do not even pretend to any great spiritual stature. I am just sort of the hammer in Baba's hands, and let Him wield it the way He wants to. (*Tarikat,* 43)

In the language of *Meher Baba,* she was 'veiled'—that is, her real spiritual stature was concealed from her in order that she could work as Baba's instrument. Members of Sufism Reoriented believe that she was one of Meher Baba's circle, the group of 120 disciples who form around the *avatar* (interview with Ira Deitrick). They also refer to her as "a real working Murshida" (*Sufism Speaks Out,* 15) and "a genuine guru of the fifth or sixth plane" (ibid., 86). In short, Ivy Duce, though veiled, is a member of the spiritual hierarchy—and a high-up member at that—working under *Meher Baba*'s direction. (But all members of the hierarchy work under his direction because, as the *avatar,* he is head of it.)

She died in 1981, aged 85, having named James **MacKie** as her successor as *murshid* of Sufism Reoriented. You can take up the story in his entry.

(*See* Lineage Tree 8)

Primary sources: Chartered Guidance from Meher Baba for the Reorientation of Sufism (San Francisco: Sufism Reoriented, 1952); Ivy Duce, *What Am I Doing Here?* (San Francisco: Sufism Reoriented, 1966); *How a Master Works* (Walnut Creek, California: Sufism Reoriented, 1975); *Tarikat: The Spiritual Path* [pp. 40–58 of *Sufism*, published by Sufism Reoriented, San Francisco, 1971]; *Conversations with a Western Guru: The Termination of the Golden Age of the Ego and the Beginning of Spiritual Awareness* (Lafayette, California: Searchlight Seminars, 1981); Murshida Ivy Duce and Dr. James MacKie, *Gurus and Psychotherapists: Spiritual Versus Psychological Learning* (Lafayette, California: Searchlight Seminars, 1981); [no author] *Sufism Speaks Out: Sufism Reoriented Replies to Attacks from India* (Walnut Creek, California: Sufism Reoriented, 1981)

Secondary sources: R.W. Watson, *Meher Baba and Sufism: A Personal* View, (San Francisco: Sufism Reoriented, 1972 [short pamphlet]); information provided by Ira Deitrick, president of Sufism Reoriented (letter and interview)

Centre: Sufism Reoriented, 1300 Boulevard Way, Walnut Creek, CA 94595, U.S.A.

COMPARE:

Other women who teach Sufism: Irina **Tweedie**

Women who teach in other traditions (or in none): Jan **Bays**, Joko **Beck**, Freda **Bedi**, Ruth **Denison**, Rev. **Dharmapali**, Gesshin **Prabhasa Dharma**, **Karuna Dharma**, Jiyu **Kennett**, Ayya **Khema**, Dharma Teacher Linda **Klevnick**, **Miao Kwang Sudharma**, **Pema Chodron**, Irmgard **Schloegl**, Dharma Teacher Bobby **Rhodes**, Ruth Fuller **Sasaki** (various forms of Buddhism); Swami **Abhayananda**/Marie Louise, Sister **Daya**, Sri **Daya Mata**, Sister **Devamata**, the **Devyashrams**, Sister **Nivedita**, Swami **Radha**, Joya **Santanya**, Sri **Sivananda-Rita**, Swami **Turiyasangitananda** (various forms of Hinduism); Jaqueline **Mandell**, **Marasha**, the **Mother**, Toni **Packer**, Jeanne **de Salzmann** (various independents)

Karlfried Graf Dürckheim

German who practised Zen in Japan but became an independent teacher in the West, saying that there is a natural state of Being beyond all religions and traditions

Dürckheim was born in 1896 into an educated and well-connected family. He was brought up a Christian and had a number of spontaneous 'mystical' experiences; but he always felt that they were independent of Christianity and not the product of it. He entered the German army in 1914 and served as a soldier throughout World War I. He came through the slaughter unscathed—and without himself having killed anyone, although he was at the front for nearly the whole time. This experience of being surrounded by death must surely have influenced his later teaching of 'accepting the unacceptable.'

Shortly after the war, in 1920, he had what he calls an experience of Being—the unconditioned state which is at the centre of everything. It occurred quite spontaneously while his wife-to-be was reading from the *Tao Te Ching*. He formed a 'research group' with a group of friends, which not only studied Meister Eckhart and Buddhist texts but also experimented with simple spiritual practices such as sitting in silence. At the same time, he was studying at university—first philosophy and then psychology. He got his Ph.D. in 1923. He married in the same year and he and his wife mixed with artists and intellectuals (Klee, Kandinsky, Rilke, Richard Wilhelm). He became a professor at the Institute of Psychology in Leipzig in 1925.

During the 1930s, Dürckheim became associated with the National Socialist Party (the Nazis)—I don't know how. In 1935, he was sent to England to discover how sympathetic the country was to Fascism. He stayed there for three years and met Edward VIII and Churchill. He does not say (in what I have

read) what these meetings amounted to and they may have been no more than polite socializing. On his return to Germany in 1938, he presented his views to Rudolf Hess and Baron von Ribbentrop—a report which displeased them sufficiently for them to send him to Japan (to get him out of the way, he says). He returned to Germany briefly in 1939 to attend the funerals of his father and wife and then went back to Japan. He stayed there throughout the war.

Given his interest in Buddhism, it was inevitable that Dürckheim would encounter Zen. He met D.T. Suzuki, certainly the best-known authority on Zen in the West at the time. He also practised *zazen* with a number of masters (but I have no names), as well as archery with Kenran Umeji Roshi (having previously read an article on it by Eugene Herrigel, who was incidentally more sympathetic to National Socialism than Dürckheim). He was arrested in 1945, along with all other resident Germans, when the Americans took over the administration of Japan, and spent 16 months in prison. He used the time to meditate. On his release, in 1947, he returned to Germany and soon founded a centre (in 1951 when he was 55) in Rütte, in the New Forest, which was to be his life's work.

The full name of the centre is a bit of a mouthful: The Centre for the Promotion of Existential Psychology. It was also known as the School of Initiatic Therapy. There is no reference to anything Zen or Buddhist or even Eastern. And there is a reason. Dürckheim's teaching has three inter-related aspects. First, there is an essential experience common to all human beings—this is the 'existential psychology' part. Second, this experience has to be integrated into our lives if it is to be of any value—this is the 'therapy' part. Third, when it is integrated, it reveals what it is to be truly human, and this realization carries with it a responsibility to live up to certain standards. These standards are as 'natural' and undeniable as colours. (Red is red even if there are various shades.) They are part of the order of things. This is the 'initiatic' part.

For Dürckheim, the spiritual and the psychological are intimately connected. It is artificial, even dangerous, to separate them, and both need work or practice if they are to be understood. It simply is not true that the experience of Being (which we could call 'spiritual') automatically resolves psychological problems. Psychology has its own laws and we cannot be true human beings unless we live in accordance with them. Having said that, it is also true that Being is primary and hence the starting point for the initiatic path. It is indefinable and yet has three qualities or aspects: Plenitude, Order and Unity. Whenever one has the experience, whether an overwhelming one that obliterates everything else or a minor one in the midst of daily life, one knows that this is a power that nourishes all things (Plenitude), gives them form (Order), and holds them together (Unity). It is not a quality that things/beings have, which describes them; it is that which enables them to be what they are.

> When someone tries to describe such an experience, you notice that their voice changes, that their eyes shine, as if they are reliving that particular moment in the act of recalling it. (*Le Centre d'Être*, 92)

Being also possesses transformative power. It requires that we live up to its excellence. If we do not recognize that we have this responsibility, says Dürckheim, the experience is not authentic (ibid., 93).

There are a number of practices that help this experience of Being to manifest. Some of these are unequivocally Eastern: silent sitting (Zen's *zazen*);

concentration on Hara (the centre in the solar plexus, which Dürckheim says is the key to all 'spiritual' arts: archery, the tea ceremony, T'ai Ch'i, the martial arts). Others are not—for example, exercises that develop the voice, or explore the way in which we use gestures to express (or conceal) ourselves. But all of them are designed to take the mind away from the habitual patterns which strengthen the ego and therefore separate us from Being.

In fact, all separation is illusory. In meditation, according to Dürckheim, one's separation from others is seen as a projection of the ego and not real at all (ibid., 79). And this non-separation is love. Hence, what he calls 'the little experiences of Being', which can illuminate the simplest aspect of everyday life, are very often found in the relationship between two people. And these glimpses of Being are quite as important as the 'great experiences', which tend to be the focus of traditions such as Zen.

This approach carries the implicit approval of at least one Japanese Zen teacher, Yuho Seki Roshi, abbot of Eigenji (a Rinzai monastery), who taught at Rütte every year from 1972 until 1982. He thought that Dürckheim could create a Western form of Zen—just as the Japanese had created their own form of the tradition that they had brought from China.

Although Dürckheim in fact sent some of his students to Richard **Baker**.

Yet it is significant that Dürckheim hardly uses any Zen vocabulary. He prefers 'essential Being' to 'Buddha-nature' and expressly says that he does not teach Zen. Rather, he teaches in the spirit of Zen (ibid., 31)—which is to say that he is concerned with the core, the experience, and not the setting. He sees no difficulty in separating Zen from Buddhism. He says that what he teaches is not Buddhist, but neither is it non-Buddhist. And equally, it is not Christian but neither is it non-Christian. The core of all religions is the same because there is just the experience of Being, which is indefinable. Everything that surrounds it is on a different level and not essential. Hence when he teaches silent sitting/*zazen* to Christian monks (see Lineage Tree 2A for a bit more detail), he does not see it as an exercise in crossing religious boundaries but of going beyond all boundaries.

> Human beings can experience Being not because they are Buddhist or Christian but because they are human. (*Le Centre d'Être,* 31)

Dürckheim warns against thinking that the experience of Being makes us perfect or more than human. Rather, it enables us to accept what it is to be human—and that includes our misery and suffering (ibid., 45). This brings us to his psychology and his teaching concerning the ego. The ego's function is to particularize things and label them. It needs an object and cannot exist without one. It is the ego which asks the questions *Why? How? Where? When?*, and so forth. But there are dimensions of human existence that are not amenable to such questions and which are therefore the source of what might be called existential anguish. According to Dürckheim, this anguish has three aspects: annihilation, chaos and isolation. These are in fact the opposites of the three aspects of Being: Plenitude/annihilation; Order/chaos; Unity/isolation. But paradoxically, it is when the ego accepts the unacceptable that Being manifests itself. One experiences strength in the midst of weakness (this is the Plenitude/annihilation axis); meaning in the midst of meaninglessness (the Order/chaos axis); love in the midst of separation (the Unity/isolation axis). And the reason for this sudden shift is that when the ego accepts the unacceptable, it abandons the attempt to grasp reality in terms of what it has and what it knows, and instead realizes that 'in reality' it has and knows nothing.

And this nothing then reveals itself as Being—beyond definition and beyond possession. In one sense, then, the ego separates us from Being. But it is also a necessary condition for Being to manifest itself.

Dürckheim holds that the relation between Being and ego, between the Unconditoned and the conditioned, is the central problem of human existence. One part of this problem is the general one that I have just outlined concerning the very nature of the ego. This is common to all human beings and everyone has to contend with it. But in addition, and arguably as important, everyone has their own individual ego to cope with, the contents of which will vary according to sex, class, upbringing and so forth. Dürckheim insists that there is work to be done—psychological work—which is necessary for true self-transformation. And it is in this that he differs most from Zen, which by and large places little emphasis on the psychology of the individual ego. He says that on his return from Japan in 1947, he was the first to say that the unconscious had to be faced and gone through if there is to be any spiritual progress. It is the unconscious, in the form of the shadow—that is, those aspects of ourselves that we do not want to acknowledge—that prevents Being from manifesting. Being in itself is not enough; ego is also part of us and it needs to be integrated. His psychology is strongly influenced by Jung, as he readily admits, and he uses the Jungian vocabulary: individuation, integration, archetypes, and the rest.

Dürckheim died in 1988, at the age of 92, eight years after appointing a Frenchman, Jacques Castermane, as a sort of successor—though as we would expect, notions such as successor (and master and disciple) are not important on the initiatic path of everyday life, if I can use this phrase.

Dürckheim is interesting for three reasons. First, because he taught from his own experience. And while he readily acknowledged that Zen promoted the experience of Being in his case, he was equally insistent that Being was essentially independent of Zen (and all traditions). Secondly, he introduced psychology—and a Western psychology, at that—as a necessary element on the path. Lastly, he himself lived his own teaching. Those who knew him say that beyond his personality/ego—his nationality, his upbringing, his connections with National Socialism and Zen—was that special taste which is the hallmark of Being. That is why people loved him and could learn from him. And that is what a master is: someone who has the taste and knows that it has to be passed on to others.

Primary sources: Karlfried Dürckheim, *The Grace of Zen* (London, 1977); *Absolute Living: The Other Worldly in the World and the Path to Maturity* (New York, 1992); *Le Centre d'Être* (Paris, 1992)

Secondary sources: None that I am aware of

Centre: Existental-Psychologische Bildungs und Begegnugstätte, Graf Dürckheim-Weg 12, 79882 Todtmoos-Rütte, German; Centre Dürckheim, BP 22, 26270 Saulce-sur-le-Rhône, France

COMPARE:

Other teachers who point to an essential core common to all: Barry **Long**, Jean **Klein**, Andrew **Cohen**

Other teachers who acknowedge a tradition but go beyond it: Reshad **Feild**, Samuel **Lewis** (Sufism), Ven. **Sangharakshita** (Theravada)

This is a general term that I use for a movement, currently developing in the West, to make available the teachings and practices of more than one Buddhist tradition. It has several forms. The earliest was a Western Buddhist Order created by Robert **Clifton** in 1952, for the purpose of "interpreting the Dharma to the West". This may sound like general lay Buddhism (see p. 39) but there is an essential difference: Clifton was an ordained Shin priest and gave ordinations himself. And the Order was open to any ordained Buddhist of any tradition.[1]

Somewhat different is **Sangharakshita**'s Western Buddhist Order. This is a specially created *sangha* which incorporates elements from all the main Buddhist traditions. And it is an independent *sangha,* too, in the sense that it has a form and a life which continue regardless of the individuals that make it up. Others are also trying to establish alternative *sanghas:* **Miao Kwang Sudharma** in Arkansas and Ven. **Dharmapali** in Colorado. **Miao Kwang Sudharma** has been ordained in the Zen, Theravada and Chinese traditions and includes elements from all three at her centre. **Dharmapali** has remained within the Theravadin tradition but has a genuinely ecumenical concern: the establishment of an independent order of nuns. And it is evident that Buddhist women in general support the idea whatever their particular affiliation. Karma Lekshe Tsomo, an American who received full *bhikshuni* ordination in 1982, says that "female mendicants . . . find themselves in No Man's Land . . . vaguely charted territory, on a path that transcends territoriality."[2]

This is exactly right and it explains why the place of women in Buddhism—from a Western perspective—is more or less bound to be ecumenical. This even applies to the movement to reintroduce the *bhikkhuni sangha* into the Theravadin tradition. On the face of it, this looks like a matter for Theravadins. But in fact the inspiration behind the movement is not derived just from that tradition but from a wider perception of Buddhism as a whole. Should it succeed, therefore, it will not be something that the Theravadins alone have done even though it will be located in their tradition, so to speak. It will be an achievement of, and for, all the traditions.

This is essentially a Western perception of Buddhism—that there is no compelling reason why one cannot move around the great edifice that has grown up over the centuries without having to have a passport, as it were, to get from one part to the next. Of course, some Eastern traditions contribute to this perception. Leaders of Tibetan Buddhism, such as the Karmapa and the Dalai Lama, are encouraging women, both Western and Tibetan, to take full *bhikshuni* ordination in the Chinese Mahayana tradition. Yet this would have never happened if the Tibetans had stayed in Tibet. **Karuna Dharma** (who is American) has turned the Vietnamese tradition, which is itself non-sectarian,

[1] This is why it was different from **Olcott**'s universal Buddhism, which, excellent as it may have been, could not possibly be described as a *sangha*.

[2] Preface to her *Sakyadhita: Daughters of the Buddha,* (Ithaca, New York: Snow Lion Publications, 1988). This excellent work contains contributions from women of all traditions. 'Female mendicant' is her way round the difficulties surrounding the use of the term 'nun', which has different meanings in different traditions. My favourite solution to this problem is the word *nunk,* coined by Gesshin **Prabhasa Dharma** as a way of highlighting the ambiguity that women renunciates have in Zen—but it could easily be extended to Buddhism as a whole. See the fine section on 'Nuns, Monks, and "Nunks"' in Sandy Boucher, *Turning the Wheel: American Women Creating the New Buddhism* (San Francisco, 1988).

into something altogether more open and embracing. But living and teaching in Los Angeles must have helped her do it.

Similarly, from quite a different angle, various members of the ***vipassana sangha*** have practised with Zen and Tibetan teachers. But while they do not then go on to teach either of these traditions, they can speak about some aspects of them—and important aspects, at that—from personal experience. There must be very few Eastern practitioners who can say the same. Even those who are convinced that maintaining the *sangha* in its traditional form is absolutely vital—like Ajahn **Sumedho** and the Taiwanese master, Hsuan Hua—have carried out joint ordinations. And again, the fact that this happened in California rather than Thailand or Taiwan surely made it more likely.

This joint ordination is some distance from **Sangharakshita**'s newly created *sangha,* of course. But it is arguably part of the same general movement: redefining the boundaries of the *sangha;* what it is; what it can do; what it can offer. It is for this reason that I say that, in a sense, everyone cited in this entry belongs to one higher-order community or organism which is presently in the process of formation (and hence not at all well-defined): the ecumenical *sangha.* (And by extension, the ecumenical *sangha* may itself be part of the ***arya sangha***.)

For bibliography and further connections, see the entries on all those mentioned here.

Murshida Mevrouw Fazal Mai Egeling. SEE THE **SUFI MOVEMENT AND THE SUFI ORDER**

Father Hugo Enomiya-Lassalle (and Christian Zen)

German Jesuit priest who lived in Japan for decades and was authorized to teach Zen

Father Enomiya-Lassalle is an interesting man in himself but perhaps even more interesting as an exemplar of the whole phenomenon of Christian Zen. This is a large topic and several books have already been written about it. But my particular interest is those Western Christians who have not just practiced Zen but have been formally recognized by the tradition (or, to be more accurate, by a teacher in the tradition) as sufficiently advanced to be able to teach it; and even more particularly, those who are not 'just' Christians but are Fathers or Sisters or Reverends—that is, they have a specific function in their own tradition. One might call them Christian teachers, without stretching the term 'teacher' too far. Hence they are 'accredited' teachers in both traditions. I therefore leave on one side—or rather, in the background—the sizeable literature that is concerned with similarities between Christianity and Zen, or Christian-Zen dialogue, excellent though it may be.[1]

Enomiya-Lassalle was born in 1898 and was ordained as a priest in 1927. He went to Japan in 1929 and apart from visits back to Germany, spent the rest of his life there; in fact, he became a Japanese citizen. (The 'Enomiya' part

[1] For example: D.T. Suzuki, *Mysticism, Christian and Buddhist* (New York, 1957); Thomas Merton, *Mystics and Zen Masters* (New York, 1967); Aelred Graham, *Zen Catholicism* (New York, 1963); William Johnston, *The Still Point: Reflections on Zen and Christian Mysticism* (New York, 1970) and *Christian Zen* (New York, 1971); Elsie Mitchell, *Sun Buddhas, Moon Buddhas* (New York, 1973)

of his name is a Japanese addition, of course.) At some point (and I have no exact date), he met *Harada* Roshi and started practicing *zazen* under his direction—the first Christian priest to do so, as far as I know.[2] Later, he continued his practice under *Yasutani* Roshi, *Harada* Roshi's principal Dharma-heir, who gave him permission to teach—and again he was the first Christian priest to receive such authorization. He built a Catholic *zendo,* called Shinmeikutsu or Cave of Darkness, near Hiroshima (he had been in the city when the bomb was dropped); it was dedicated by the Bishop of Hiroshima in 1960 and by the Archbishop of Tokyo in 1969. (Both these men were Japanese, of course).

After *Yasutani* Roshi's death, Enomiya-Lassalle practiced with *Yamada* Roshi, *Yasutani's* principal Dharma heir. *Yamada* Roshi was unusual in his degree of openness to foreigners (although there were other Zen teachers—including, of course, his predecessors, *Harada* Roshi and *Yasutani* Roshi—who were also willing to teach them). But he was unique, I think, in his attitude to Christians. He accepted them just as they were and did not try to change them. In fact, he said they would become better Christians as a result of their practice (Habito, *In Memoriam,* 23).

After his death in 1989, a list was found of all the non-Japanese who had completed *koan* training under his guidance. It consisted of 22 names.[3] One of them was Indian (Father Samy),[4] the other 21 were Western. These Westerners were quite a mixture: they came from America, Canada, Germany, Switzerland and the Philippines; there were ten men and eleven women; and twelve of them were Christian. Not only that, but eight of these twelve were Catholic priests and nuns (four of each). This last sub-group of eight included Father Enomiya-Lassalle and a number of Germans who were greatly influenced by him:[5] Fathers Jäger and Kopp, and Sisters Fabian and Schlütter. In fact, there is a photograph of these four, together with Enomiya-Lassalle, in his *The Practice of Zen Meditation.* It is captioned 'Five Zen Masters'.

Whether this use of the title 'Zen Master' is warranted or not—and it could be a publisher's caption, after all—is an interesting question. And it is linked to another: the use of the title 'Roshi' by some of the Christians who completed their *koan* training under *Yamada* Roshi. Some of these were authorized. And the first—again—was Father Enomiya-Lassalle; he was 'invested'—along with Sister MacInnes[6]—by *Yamada* in a ceremony in 1980. Father Jäger has also

[2] There is, however, a splendid precedent of sorts: Karl Reichelt's Christian-Buddhist Monastery in Nanking, China. It is mentioned in passing by Fields (*How the Swans Came to the Lake,* 1st ed., 184). I know nothing about it except that Dwight **Goddard** spent some time there in 1925. (**Goddard** is himself interesting; he started off as a Christian missionary and ended up as a Buddhist one—a somewhat different move from the Christian Zen that I am discussing here. And while we are on the subject, Reichelt wrote a book, *The Transformed Abbot* (London, 1954), about a Chinese monk, Miao-chi, who converted to Christianity—the opposite direction to **Goddard**. Miao-chi is as different from Father Kadowaki, a Japanese Catholic with authority to teach Zen whom I mention briefly in this entry, as **Goddard** is from Father Enomiya-Lassalle.)

[3] These 22 are included in Lineage Tree 4, 'Soto Zen lineages derived from Harada Roshi': a block of 20 (unnamed) under the heading '19 Westerners (+ one Indian) who completed koan training (eleven Christian; eight not)'; plus two who are named: Enomiya-Lassalle and *Aitken.* (These last are separated from the others only because they have their own entries.)

[4] He has a *zendo* in Madras—a splendid (and as far as I know, unique) example of crossing cultural boundaries.

[5] Father Enomiya-Lassalle has also influenced a Japanese Catholic priest, Father Kadowaki. Kadowaki's principal teacher was Sogen Omori Roshi of the Rinzai school but he does mention *Yamada* Roshi and Father Enomiya-Lassalle in his acknowledgements in his *Zen and the Bible* (London, 1980). This is an instance of one Catholic priest being taught Zen (in some measure, at least) by another; and of course it is the German who is teaching the Japanese—in Japan.

[6] Sister MacInnes records that in 1993 the three people she had trained at her Zen centre in the Philippines were all 'recognized' by Kubota Roshi (*Yamada* Roshi's principal Dharma-heir). So here we have a Canadian Christian

Western Christians with authority to teach Zen

Those who have completed koan *training under Yamada Roshi*

Brantschen, Fr Niklaus	M	Switzerland	Catholic	
Enomiya-Lassalle, Fr Hugo	M	Japan/Germany	Catholic	used 'Roshi' (d. 1990)
Fabian, Sr Ludwigis	F	Germany	Catholic	
Habito, Reuben	M	USA	Catholic	could use 'Roshi' but doesn't
Jäger, Fr Willigis	M	Germany	Catholic	uses 'Roshi'
Kopp, Fr Johannes	M	Germany	Catholic	
Low, Victor	M	Germany	Catholic	
MacInnes, Sr Elaine	F	Canada/ Philippines	Catholic	uses 'Roshi'
Meyer, Gundula	F	Germany	Protestant	
Punzalan, Sr Sonia	F	Philippines	Catholic	
Rieck, Joan	F	Germany	Catholic	uses 'Roshi'; was a Catholic nun for many years
Schlütter, Sr Ana Maria	F	Germany/Spain	Catholic	

Others

Ford, Rev. James	M	USA	Protestant	ordained by Jiyu **Kennett**; uses 'Osho'; currently a senior student of John Tarrant (one of **Aitken**'s Dharma-heirs); member of Unitarian Universalist Buddhist Fellowship
Hawk, Fr Patrick	M	USA	Catholic	one of Robert **Aitken**'s Dharma-heirs; uses 'Roshi'; spiritual director of the Bishop Defalco Retreat Center in Amarillo, Texas
Hicks, Rusty	M	USA	Protestant	a senior Dharma teacher with Seung Sahn/Soen Sa Nim
Kennedy, Fr Robert	M	USA	Catholic	one of Bernard **Glassman**'s Dharma-heirs; could use 'Roshi' but prefers 'Sensei'
Richardson, Sr Janet	F	USA	Catholic	given Dharma transmission by Kennedy

Fr = Father Sr = Sister

Most, but not all, of those named here are included in Lineage Chart 2[A], 'Christian Zen teachers' and Lineage Chart 4, ' Zen lineages derived from Harada Roshi'

used the title, as has Joan Rieck (who was a nun—a Christian nun, that is—for many years). There has, I believe, been some unclarity as to whether they were or are 'entitled' to do so. This is an instance of the whole thorny question of what certain titles mean and who may use them and in what circumstances—a problem that occurs in all traditions. I do not say that any particular case is more or less important than any other; but the most significant thing is that all traditions have to face it. And of course the vocabulary of a tradition can change—especially when it finds itself in novel circumstances. And Christian Zen is certainly a novel circumstance.

*For example, is Frithjof **Schuon** really a sheikh? Is **Namgyal** Rinpoche really a tulku? Was Swami **Abhayananda** really a* sannyasin?

This 'Yamada Zen-Christian lineage', then, is wide-ranging, international and gives women equal status with men. In short, it crosses boundaries. Ruben Habito (one of the twelve 'Yamada Christians') wrote an *In Memoriam* of his teacher which was entitled, 'No Longer Buddhist nor Christian'. In it, he said that *Yamada* Roshi's whole approach "calls for a reordering of our stereotyped notions of Zen, of Buddhism, and of Christianity."

But there are other Christian Zen teachers who are not connected with *Yamada* Roshi—see the accompanying table under *'Others'*. In total, then (and leaving aside Fathers Samy and Kadowaki, interesting though they are), there are 16 Western Christians who have the authority to teach Zen: twelve of them in the *Yamada* line, and four others. It is not exactly unique in the phenomenon of Western participation in Eastern traditions—Christian *sannyasins* such as Swami **Abhishiktananda** are similar in some respects—but it is distinctive in that there are signs of an incipient *movement* developing, which has not happened with Christian *sannyasa* (though Abhishiktananda hoped that it would). See Lineage Tree 2A for some of the main contours of this movement.

Needless to say, there are those within Zen who do not agree with this development. Somewhat surprisingly, they include *Yasutani* Roshi, *Yamada* Roshi's own teacher. According to Habito, he "often criticized Christians for their attachment to the concept of God as an obstacle in the attainment of enlightenment [and] urged them to cast away this concept if they really meant to practice genuine Zen" (*In Memoriam,* 23). This view is also held by Philip **Kapleau** Roshi, himself a pupil of *Yasutani* Roshi. (See his entry for more details of his objections.)

It is, of course, interesting that even those in the same lineage disagree about the issues involved. On one side, we have *Yasutani* and **Kapleau** saying that Christian Zen is a contradiction in terms; on the other, we have *Yamada* formally recognizing the attainments of Christian priests such as Father Enomiya-Lassalle and Father Jäger, who told an International Buddhist Christian Conference in Berkeley in 1987: "Many can argue whether a Christian can validly do Zen or teach Zen, or not. The fact is, I am doing it" (quoted in Habito, *In Memoriam,* 23).

This brings us neatly back to Enomiya-Lassalle. I started with him and I'll finish with him. He was in every way a pioneer: the first Christian priest to practice Zen; the first to be authorized to teach; the first to be made a *roshi* (along with Sister MacInnes); and the first person to write books about Christian Zen that are based on experience of both traditions. He practised for nearly 50 years and taught for over 20 (in Europe and Japan). According to his *The Practice of Zen Meditation* (published in 1990, the year of his death—he

Sister, who is also a *roshi,* teaching Zen to Philippinos and taking them to a level that is acknowledged as genuine by a Japanese *roshi.*

LINEAGE TREE 2A
Christian Zen Teachers

Only those are included here who (a) were taught by, or in some cases recived
Dharma-transmission from, Yamada Roshi; or (b) were taught by Enomiya-Lassalle, Dürckheim
and Jäger (names taken from E. Rommeluère, *Le Guide du Zen* [Paris, 1997]).
These people are American, Canadian, French, Beligian, Dutch, German, Austrian, Swiss,
and Philippino.
Christian Zen teachers who are not included are Ford, Hawk, Hicks, Kennedy, Richardson
(in 'Western Christians with authority to teach Zen'—see p. 258); and Oosterman and Witt
(in Rommeluère).

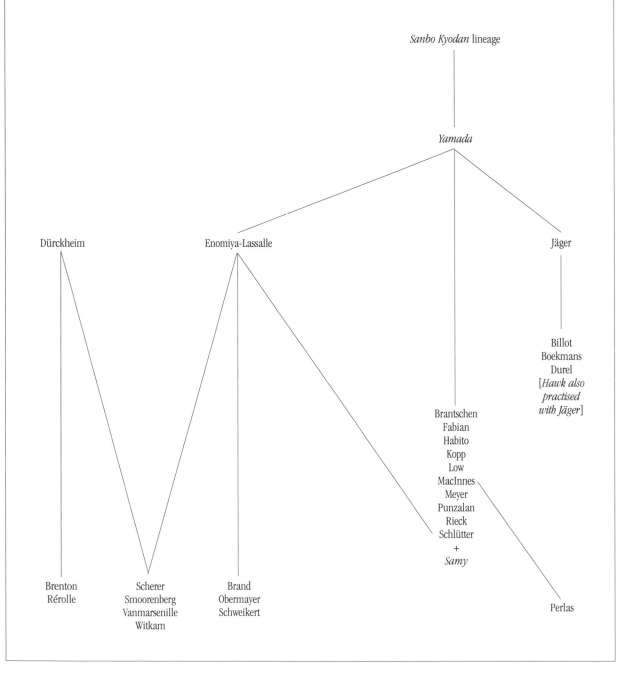

Sanbo Kyodan lineage

Yamada

Dürckheim Enomiya-Lassalle Jäger

Billot
Boekmans
Durel
[*Hawk also
practised
with Jäger*]

Brantschen
Fabian
Habito
Kopp
Low
MacInnes
Meyer
Punzalan
Rieck
Schlütter
+
Samy

Brenton Scherer Brand Perlas
Rérolle Smoorenberg Obermayer
 Vanmarsenille Schweikert
 Witkam

was 92), "Thousands have taken part in his courses, including some who have since become Zen masters and teachers" (9).

Again, what this means exactly is debatable—not because there are doubts about anyone's veracity but because *any* statement of this kind is debatable. This is how traditions develop—by such claims and debates. But the point is, of course, that the claim is being made at all. (Similarly, the rights and wrongs of the claim that certain of those who completed *koan* training under *Yamada* Roshi are entitled to use the title 'Roshi' is less important than the fact that the matter exists to be debated in the first place.) In short, there are Christian teachers (priests and nuns; Catholic and Protestant; male and female; and in many parts of the globe) who have been accepted by a respected lineage within the Zen tradition, and who can say with Father Jäger, "I am doing it." And it was Father Enomiya-Lassalle (or Enomiya-Lassalle Roshi, if you prefer) who led the way.

Primary sources: Hugo Enomiya-Lassalle, *Zen: Way to Enlightenment* (New York, 1966; German ed., 1960); *Zen Meditation for Christians* (Lasalle, Illinois: Open Court, 1974); *Living the New Consciousness* (Shambhala, 1988); *The Practice of Zen Meditation* (Wellingborough, England: Crucible, 1990); Sr. Elaine MacInnes, OLM, *Teaching Zen to Christians* (foreword by Roshi Robert Aitken), (Manila, Philippines/Madras/Wheaton, Illinois: Theosophical Publishing House, 1993); Ruben Habito, *In Memoriam: Yamada Koun Roshi* ('No Longer Buddhist Nor Christian'), *Buddhist-Christian Studies,* vol. 10, 1990, 19–25; Ruben Habito, *Total Liberation: Zen Spirituality and the Social Dimension,* (New York, 1989 [a three-way conversation between himself, Father Enomiya-Lassalle and *Yamada* Roshi]); Yamada Koun Roshi, 'Christians and the Practice of Zen', *Dialogue* (New Series), vol. 3, September-December 1976, 98–101; James Ishmael Ford, *This Very Moment: A Brief Introduction to Buddhism and Zen for Unitarian Universalists* (Boston: Skinner House Books, 1996)

Secondary sources: None that I know of (but I'm sure there are plenty)

Centres: Father Willigis Jäger, Haus St. Benedickt, 8700 Wurzburg, St. Benedicktstrasse 3, Germany; Ruben Habito, Perkins School of Theology, Southern Methodist University, Dallas, TX 75275-0133, U.S.A.; Father Robert Kennedy, St. Peter's Jesuit Community, 2652 Kennedy Boulevard, Jersey City, NJ 07306, U.S.A.; Unitarian Universalist Buddhist Fellowship, c/o Valley Unitarian Universalist Church, 1700 W. Warner Road, Chandler, AZ 85224, U.S.A.

COMPARE:

Other Zen teachers with a Christian connection of some kind: Dwight **Goddard**, Jiyu **Kennett**

Christian sannyasins: Swami **Abhishiktananda** (and the others listed in his entry)

Others who taught Christianity as experientially compatible with other traditions: J.G. **Bennett**, Samuel **Lewis**

Werner Erhard

The founder of *est*

Erhard is an unusual teacher in a number of ways. He tried numerous methods of investigating the mind over a period of ten years or so—nearly all of them connected with Western psychological disciplines rather than Eastern paths and he has never claimed to represent an Eastern tradition. But I include him for two reasons. First, because the language of *est* is an instance of spiritual psychology and its four principles: that human beings are best understood

in terms of *consciousness* and its modifications; that there are *spiritual practices* that can transform consciousness; that there are *teachers* or masters who have themselves done it; and there is some form of *transmission* from teacher to pupil. True, Erhard's version of this is all his own. *Spiritual practice* is a form of group work rather than individual meditation; the *teacher* need not be Erhard himself but anyone who has been given that function within *est;* and *transmission* is perhaps not the best term to use of what, in *est's* vocabulary, is called 'getting it'. Yet even so, what Erhard says about his own breakthrough—the day he 'got it', when he was driving to work in San Francisco in 1971—is clearly part of the whole phenomenon I am describing.

> What happened had no form. It was timeless, unbounded, ineffable, beyond language . . . I realized that I was not my emotions or thoughts. I was not my ideas, my intellect, my perceptions, my beliefs. I was not what I did or accomplished or achieved. Or hadn't achieved. I was not what I had done right—or what I had done wrong. I was not what I had been labeled—by myself or others. All of these identifications cut me off from experience, from living. I was none of these.
>
> I was simply the space, the creator, the source of all that stuff. I experienced Self as Self in a direct and unmediated way. I didn't just experience Self; *I became Self.* Suddenly I held all the information, the content, in my life in a new way, from a new mode, a new context. I knew it from experience and not from having learned it. It was an unmistakable recognition that I was, am, and always will be the source of my experience.
>
> Experience is simply evidence that I am here. It is not who I am . . . I no longer thought of myself as the person named Werner Erhard . . . I was not identified by my 'false identity' any more than by my 'true identity'. All identities were false . . .
>
> I was whole and complete as I was, and now I could accept the whole truth about myself. For I was its source. I found enlightenment, truth and true self all at once. (Bartley, 166–68)

Secondly, prior to this experience, when he was investigating all kinds of techniques, Erhard had come across Zen. I cannot say anything definite about his knowledge and practice of it. It is not made much of in Bartley's book—which is in effect Erhard saying what he wants to say so he could have emphasized it if he had wanted to—but I have been told that he practiced with the Rinzai teacher, Yamada Mumon Roshi (not to be confused with *Yamada* Ko'un Roshi), who thought highly of him. No doubt those who were close to *Yamada* Roshi could confirm this. In any event, Erhard has never claimed to be a Zen teacher. But he does say that of all his investigations, only Zen was essential because it "gave some form to my experience. And it built up in me the critical mass from which was kindled the experience that produced *est*" (Bartley, 121).

There is, of course, far more to Erhard and *est* than this. But it is worth knowing even this much.

Primary sources: Werner Erhard, *If God Had Meant for Man To Fly, He Would Have Given Him Wings, or: Up To Your Ass in Aphorisms* (San Francisco, 1973)

Secondary sources: W.W. Bartley, *Werner Erhard: The Transformation of a Man* (New York, 1978); Luke Rhinehart, *The Book of est* (New York: Holt, Rinehart and Winston, 1976); Adelaide Bry, *est: 60 Hours that Transform Your Life* (New York: Avon Books, 1976); Robert Hargrove, *est* (Dell, 1976); Carl Frederick, *est: Playing the Game the New Way* (Dell, 1974); Sheridan Fenwick, *Getting it: The Psychology of est* (New York: Viking Penguin, 1976); of these, only the last is genuinely critical; the first three are all 'official' in so far as Erhard has approved of them; the others are pro-*est* but independent.

Centre: Landmark Education, 353 Sacramento Street, Suite 200, San Francisco, CA 94111, U.S.A.; Landmark Education, The Coach House, 20 Upper Park Road, London NW3 2UP, England, U.K.

COMPARE:

Other teachers who have a system of transformation: **Gurdjieff**, L. Ron **Hubbard**

W.Y. EVANS-WENTZ. SEE **APPENDIX 1**

RESHAD FEILD

British Sufi *sheikh* who has his own esoteric school

Although all of Feild's significant teachers were Sufis and he has received a number of Sufi initiations, he does not claim to represent the Sufi tradition—at least not in any ordinary sense. It would be more accurate to say that he is a healer and psychic who has absorbed certain Sufi influences.

He was born Richard Feild around 1935—there are not many dates in his autobiographical reminiscences and those that he does give do not quite add up—into what he calls an aristocratic family.[1] His father died when he was a baby and he lived with his mother in an old manor house in the south of England. At the age of eight, he went to Eton. But he also had second sight as a child.

> What I 'saw' was a wondrous world of patterns in the world of nature, from which our world is continuously 'becoming'. This matrix, or blueprint, of the formative world, was like the negative of a photograph. Sometimes I would see damage in this etheric web which would then be reflected in the abnormal growth of a tree, plant, or even a human being. It was quite upsetting for me because I could see that unless something changed radically, situations could arise from that formative world which could cause hurt or damage in this world, affecting us all. At that time I never understood why other people could not see what I saw. (*Here to Heal,* 16)

In adult life, he participated in the **Gurdjieff** Work for a time (*Reason is Powerless . . .,* 87)—I have no dates—and had a short but successful career as a pop singer.[2] At some point (and again I have no dates), he met up with Vilayat Inayat **Khan**, head of the **Sufi Order**, and received twelve initiations in 18 months (interview, 1990). This made him a *sheikh* in the Chishti Order (if one regards the Sufi Order as part of that lineage). He also told me that it was Vilayat **Khan** who sent him on to Bulent Rauf (who later founded Beshara). This is interesting since the story of his meeting with Rauf that he gives in his first book, *The Last Barrier* (in which Rauf is called 'Hamid'), is rather different. There he just stumbles upon Rauf in an antique shop in

[1] One of his ancestors was John Feild—whom he refers to as 'Sir John Feild' (*Here to Heal,* 23). John Feild was the first Englishman to mention Copernicus's theory in print and was awarded a coat of arms in 1558 for his contribution to astronomical science (*Dictionary of National Biography*).

[2] He reached the semi-finals of a find-the-star TV show called 'Bid For Fame', as a result of which he met Tom O'Brien, who was singing with his sister, Mary. The three of them formed The Springfields and had minor hits in Britain and America in the early 1960s (but nothing to compare with Mary O'Brien/Dusty Springfield's later solo career). Feild left the group in 1962 because his wife was seriously ill.

London and finds himself asking questions about dervishes; and it is Hamid/Rauf who introduces him to Sufism (*The Last Barrier,* 4).

This was in 1968, when Feild was 34 (ibid., 3). He spent a year with Rauf in London and became his pupil. Then in November 1969, he left everything behind and went to Turkey. It proved to be a classic 'initiatory' journey, in which he stumbled upon the right person at the right time (though he made some mistakes, too), was taken into people's homes, treated as one of the family, given teachings and shown practices—and then sent on to someone else. This is how he puts it:

> In normal terms the events of the past weeks made no sense at all. The almost ceaseless travelling, the series of coincidences that could not be explained, the meetings with these strange people who seemed to be pieces of a jigsaw puzzle; all these things served to show my doubting mind a truth that could not be denied—there are laws governing our existence about which we have no understanding at all. Our lives are ruled by forces which, although invisible and intangible, have power greater than anything that can be seen or experienced in the physical world. (*The Last Barrier,* 122)

The connecting thread throughout this initiatory journey is Hamid/Rauf.[3] He taught Feild a breathing practice: "When you learn to breathe in awareness, then there is the chance to come upon this inner being that is your real self" (ibid., 41). Feild reports that after a single lesson, he had a direct experience of the interconnectedness of all things.

> The room looked quite different, as though I were seeing it for the first time. I felt a tremendous sense of peace and security. All was in its proper order. I sensed a perfect flow between the objects in the room, and through each object itself. There was a sense of communion, of acknowledgement—the chairs, the table, the bed, all knew of each other. They were not inanimate objects anymore, but part of living Being. Everything had awareness, spoke a silent language. Everything was, in Essence, perfect. (*The Last Barrier,* 44)

As always with initiatory journeys of this kind, the encounters and the experiences are not for the benefit of the protagonist alone. Rauf tells Feild that he is passing on some of his knowledge "so that you can go back and teach others" (*The Last Barrier,* 47). More specifically,

> Your job is to create a new language . . . When you speak from the heart you can kindle the fire in the hearts of others. Through recognition you actually begin to awaken the soul which is asleep. And fire spreads—there is nothing more catching than love. (ibid., 102, 103)

Feild returned to Britain (in 1970, I think). He gives an account of his further spiritual journey in the second volume of his autobiographical reminis-

[3] Rauf's teaching is quite complex and I cannot go into it here. But it is striking that it is often couched in Gurdjieffian terms: "Nearly all the world is asleep but they do not know it" (*The Last Barrier,* 58); "You must understand that this path requires conscious suffering" (ibid., 60); "Man is a transformer of subtle energies . . . The 'Work' that is our work on earth is . . . the reciprocal maintenance of the planet" (ibid., 51); "Until you have a permanent 'I' you will always be in danger of being led astray" (ibid., 41).

There are a number of explanations for this: that **Gurdjieff** himself drew his ideas from a Sufi source that Rauf is also using (independently); that Rauf, an educated Sufi with no declared lineage, found **Gurdjieff**'s ideas useful for expressing his own teaching; that Feild, who was in the **Gurdjieff** Work for a while, is using its vocabulary to express what Rauf put in other, more conventionally Sufi terms; that Feild has added these ideas to what Rauf taught him. In short: **Gurdjieff** was a Sufi; Rauf saw a similarity between Sufism and **Gurdjieff**'s teaching; Field saw a similarity between Rauf's Sufism and **Gurdjieff**'s teaching; Field has bolted **Gurdjieff** onto Sufism.

cences, *The Invisible Way: A Time to Love and a Time to Die*. Most of it occurs in England. He is given an introduction (by Rauf, who is not mentioned again) to a certain Elizabeth, a prime example of what might be called forthright English eccentricity: she wears a monocle, has a deep throaty laugh, tends to say things like 'Lawks!', and breaks off in the middle of teaching in order to listen to the news on the radio—because she likes the sound of the announcer's voice. She in turn introduces Feild to his future wife, Penny (called 'Nur' in the book), and another Englishman, John, who is presented as a sort of sage.

There is hardly any Sufism in the book (though John does read from Rumi). Rather, it is the direct encounter with John, who is dying from cancer. This encounter transforms Feild and makes him realize that love triumphs over death.

> We were together in complete peace and freedom. The experiences of the world as I knew it disappeared; there was only a deep inner sense of the rightness of things. Everything was in its proper place. I understood the nature of false time and how it had tyrannized me in the past, bringing in so much fear, fear of living, fear of loss, fear of not succeeding, fear known and unknown. I could see the pointlessness of it and the pointlessness of the fear of death. In those moments, there was no death. Everything was as it is, at once, for there is Only One, and only one moment of creation . . .
>
> I knew, then, that I had been dead and now I was alive. The illusions of death had gone, and the realization that we are all dead until we wake came in such a flash of recognition that the energy of release coursed through every part of me . . . I knew unconditional love, that indeed I was loved as we all are loved, for surely Love is the cause of Creation. (*The Invisible Way*, 158)

This is the essential message of the book—and of Feild's teaching since that time. It is significant that he came upon it in a form that has no particular connection with traditional Sufism. Indeed, one could say that it is in the nature of the message that it transcends all formal boundaries. This may explain why there is not a single date, not one checkable fact, in the entire book. And while it would be unfair to call it an invention, it is not a straightforward record either. Rather, it is a 'teaching story'.

*Feild's 'autobiographies' are therefore quite different from Irina **Tweedie's** account of her time with her teacher in India.*

Back in the 'relative' world, Feild continued his Sufi explorations. Rauf sent him to another Turk, Suleiman Dede, who is a Mevlevi *sheikh* (which Rauf is not); and he in his turn made Feild a Mevlevi *sheikh* in a private ceremony in Los Angeles. I have no date—perhaps 1974 or so. I would have thought that this was significant—I know of no other Western Mevlevi *sheikh*—but Feild himself plays it down. He says that his initiation into the Mevlevi Order was for him and not for others. He fully accepts that to be a Sufi, one has to be a Moslem, which he is not. Hence, "I talk *from* Sufism but not *about* it" (interview).

So while, according to Feild's own account, he is a Sufi of some rank, he seems to regard himself not as a traditional Sufi but rather as an 'essential'/'higher'/'esoteric' Sufi. In this, he is very like Rauf himself. And in fact the two worked together for a time. Feild helped Rauf start Beshara (more fully: the Beshara School of Intensive Esoteric Education) in England in 1975. But he did not stay with him because, he told me, Rauf asked him to do something "which just wasn't on". But maybe, he said, Rauf did this on purpose in order to send him on his way.

In any event, Feild has been teaching independently of anybody else since the mid-1970s. He founded the Institute for Conscious Living in Los Angeles in

1974—a 40-day experiment that is still going 20 years later (*Reason is Powerless . . .,* ix, x). It is now called the Living School.

> At certain times of history, often when the world is in crisis, esoteric schools which normally remain hidden emerge where and when they are needed. The Living School, whose esoteric roots extend way back in time, provides an opportunity to work and learn within a living tradition and under the direction of a living teacher. The teachings and practices are based upon the essence of Sufism.[4] (brochure, 1994)

Feild claims about a thousand pupils from 15 or so countries. There are weekly groups in these countries but the focus of the School is the residential courses under Feild's overall supervision. The daily programme, which is "organized on the esoteric Law of Octaves so that the best possible balance of Mind, Body, and Spirit can be realized" (School brochure), includes breathing, *yoga,* sacred movements and *dhikr* (the Sufi practice of 'remembrance'). There are also meditation sessions and study classes, some of which "require direct transmission"—hence the need for a living teacher.

Feild's central insight has been the same right from his childhood: there is a deeper pattern, a living interconnectedness, that makes up the 'real' world. It is the basis of everything that has happened to him—second sight, healing, visionary encounters, initiatory journeys. It is simply how things are: the creative force that is love. All traditions, including Sufism, are part of this great process. According to another brochure of the Living School, entitled 'A Spiritual Practice for our Time',

> People often ask, "Is the School part of a Tradition or Line?" Reshad will smile, bow in respect, and say, "We are just people of the Way . . . "

(*See* Lineage Tree 8)

Primary sources: Reshad Feild, *The Last Barrier* (London, 1976); *The Invisible Way* (London and New York, 1979); *Steps to Freedom* (Putney, Vermont, 1983); *Here to Heal* (Element Books, 1985); *A Travelling People's Feild Guide* (Element Books, 1986); *Footprints in the Sand* (Element Books, 1988); *Breathing Alive: A Guide to Conscious Living* (Element Books, 1988); *The Alchemy of the Heart* (Element Books, 1990); *Reason is Powerless in the Expression of Love* (Seattle: Chalice Guild, 1990)

Secondary sources: None

Centre: The Living School, P.O. Box 119, CH-8042 Zurich, Switzerland

COMPARE:

Other independent/higher/esoteric Sufis: J.G. **Bennett**, Idries **Shah**, Irina **Tweedie**

Other teachers who go beyond the confines of their tradition: Ven. **Sangharakshita** (Theravada), Graf **Dürckheim** (Zen), Toni **Packer** (Zen), Swami **Radha** (Hinduism)

[4] Although Feild prefers not to make too much of his Sufi connection, he does say that Mevlana Rumi is the patron of the School. And the most particular feature of the Mevlevi Order, the whirling dervish dance, is included in the School's programme. In 1989, the dancers/dervishes were not only all Western (which is unusual) but also both male and female (which the School claims is a first).

American teacher in the Korean Zen tradition

Gilbert came to Zen relatively late in life after investigating a number of spiritual paths. He was born in California in 1909. At the age of 14, he read a book by Yogi **Ramacharaka** on *pranayama yoga*, began to practice and had a profound inner experience: that what he had hitherto thought of as himself was "only a form or modification of something intangible and infinitely extraordinary." (All information in this entry taken from correspondence with Will Tuttle, an associate of Gilbert.) He left school when he was 17 and became a professional gymnast, appearing as one half of the Gilbert Brothers (though his partner wasn't his brother). The act was very successful and toured the world until the outbreak of World War II, often appearing at the biggest theatres in New York, London, and other major cities. (They even performed before George V and Queen Mary in 1935.) Many of his own stunts were unique and have never been duplicated—because, he says, they were based on his yogic practice.

In the 60s, he became involved in Buddhism—initially in what might be called a trans-traditional way[1] but ending up in Korean Zen. He met Seo Kyung Bo—sometimes known as Kyung Bo-Seo in 1966 and was initiated into the Chogye Order (Korean Zen) in 1968. Finally, in 1973, Kyung Bo issued a declaration saying that Donald Gilbert had received the traditional "mind to mind" transmission; that he was Kyung Bo's Dharma Heir; and that Kyung Bo had conferred on him the title of Zen Master. (Korean Zen doesn't use the term 'roshi' but the intention is the same.) Further, "he is free to found a Buddhist temple in the United States and to establish rules as he feels best suited to the culture of the American people."

*Cf. **Lewis** again: another of Kyung Bo's Dharma heirs.*

Zen Master Gilbert is now known as Ta Hui. Although he has been offered small temples three times, he has declined to become their resident teacher. Instead, he conducts services (in English) at a Korean temple in Carmel, California—one of the few instances (though they exist in all traditions) of a Westerner teaching Easterners in the West. He also conducts *sesshins* (intensive meditational practices) in Arcata, California and at the Il Bung Zen Temple in Huntsville, Alabama. He has published two books on Zen in the form of cartoon strips starring Unk, a bloodhound (= the archetypal seeker) and Master Woof, a Zen master. Both books have *koan*-like titles: *Jellyfish Bones* and *The Upside Down Circle*. The latter has sections on The Quest; Meditation; Mind; Time; Reality; and Enlightenment. This is the clear water of Zen in new bottles.

I find the story of Gilbert's Zenmastership instructive for two reasons. First, it is utterly unhip and quite removed from what might be called mainstream Western Zen. Secondly, despite his early explorations in *yoga* and his

[1] In 1966, he received four tantric initiations from the Unreformed Buddhist Church of America in San Francisco—an unusual organization (now defunct) that traced its lineage back to Marpa and Milarepa, the Tibetan Kagyu *siddhas*, but referred to itself as Korean Mahayana—and took the name 'Dharmapala'. The four signatories to the certificate that he was given were Lama Gambopa Pemchekov, Lama Marpacin, Parvartayogacarin Sukwang Bubsa, and Bub In Bubsa (Dharma Master). (I must admit that I am baffled by all of these, especially the first two—*lamas* with Western names in the mid-1960s are a new one on me and I wish I knew more about them.) The certificate also states that Rev. Gilbert's initiation "automatically admits the holder to clergy membership in the American Buddhist Order." This latter organization (also now defunct) was started by J. Eugene Wagner, an American who had been a monk in Sri Lanka. (That's all I know about him). Gilbert joined the board of directors of the ABO in 1968 and was ordained a minister in 1969, taking the name 'Viveka Sara'. (Samuel **Lewis** was also a member of the ABO, though I don't know in what capacity.)

obvious independence, he clearly felt the need for a lineage of some kind. Now, as a representative of the Chogye Order, it remains to be seen whether he will continue the lineage in America—especially as hardly anybody knows that it exists.[2]

Primary sources: Zen Master Don Gilbert, *Jellyfish Bones* (Oakland, California: Blue Dragon Press, 1980); *The Upside Down Circle: Zen Laughter* (Nevada City, California: Blue Dolphin Publishing, 1988)

Secondary sources: None

Centre: c/o Blue Dolphin Publishing, P.O. Box 1908, Nevada City, CA 95959, U.S.A.

COMPARE:

Other teachers in Korean Zen: Linda **Klevnick** and Linda **Murray**, Barbara **Rhodes**

Sensei Bernard Tetsugen GLASSMAN

Maezumi Roshi's principal student and his first Dharma-heir

Glassman was born in Brooklyn in 1939, the son of Jewish immigrants. His mother was Polish and his father, who was a printer, came from Russia (Tworkov, 121, 134). He first came across Zen in the mid-1960s when he was in Los Angeles designing shuttle systems between Earth and Mars for McDonnell-Douglas; he read Philip **Kapleau**'s *Three Pillars of Zen,* the first book in a Western language that actually described Zen training (as opposed to Zen philosophy). In 1968, he began practicing with Taizan *Maezumi* at ZCLA. In 1970, while practising the *koan* 'Mu' at ZCLA under the direction of Koryu Roshi, *Maezumi*'s Rinzai teacher, he had a breakthrough. "The world just fell apart," he says.

> Maezumi took me immediately to the dokusan room and Koryu-roshi confirmed the passing of Mu-ji, and Koryu and I spent about half an hour just hugging and crying— I was overwhelmed. At the next meal—I was head server—tears were pouring down my face as I served Koryu-roshi, and afterwards, when I went out of the zendo—well, there was a tree there, and looking at the tree, I didn't feel that I was the tree, it went deeper than that. I felt the wind on me, I felt the birds on me, all separation was completely gone. (Matthiessen, 124–25)

This experience of *kensho* (actually *dai kensho* or 'great *kensho*') is, of course, important in itself. But there is an added significance because it came so early in Glassman's training. In fact, the whole of his Zen 'career' has been precocious. *Maezumi* asked him to teach (again in 1970)—in addition to running the *zendo* and officiating at services. "I was too young, but that's how he trained me" (Tworkov, 142). In 1977, he received Dharma transmission from *Maezumi,* thus becoming *Maezumi*'s first Dharma-heir. He is in the 81st generation of teachers who trace their lineage back to Shakyamuni Buddha. (This biographical information is condensed from Matthiessen, 123–24, 237–39; Tworkov, 112–13, 142).

[2] I do have a reference to the Bridge Meditation Center (P.O. Box 808, Riverdale, GA 30274), which was "founded by Zen Master Ta Hui Gilbert and his disciple, Upasika Mi Ju Cozad, who is resident teacher and meditation master" and which "trains the laity in Buddhism, Zen, and Tibetan philosophy and New Thought Christ Teachings" (*Spiritual Community Guide #4, 1979,* San Rafael, California, 1978, 112) but I do not know what happened to it.

In 1979, *Maezumi* Roshi asked Glassman Sensei to establish a centre in New York and he installed Glassman as abbot of Zenshinji, the temple of the Zen Community of New York (ZCNY) in 1982. The ceremony was extremely formal, in the Japanese style, though slightly adapted to its American setting: when Glassman made his speech—in Japanese—acknowledging his appointment as abbot, he offered the merit of the ceremony to "successive presidents of the United States" (Tworkov, 129). Glassman is both the spiritual director and the manager of the centre, a dual responsibility that has led to some controversy—mainly because of his attitude to business. His main venture has been the Greyston Bakery, which he started in 1982. It is modelled on the Tassajara Bakery, set up by the San Francisco Zen Center over a decade earlier, and supplies high quality pastries to hotels, restaurants, and stores throughout Manhattan. On the one hand, the bakery is an out-and-out business. A loan of $175,000 was required to start it; its income in 1986 was $500,000; and its workers, all of whom are members of ZCNY, work long hours, sometimes having to miss early morning *zazen* at 6:00 A.M. in order to meet deadlines (Tworkov, 111–12). On the other hand, it is also a Zen business. Working there is regarded as training and workers are not paid commercial rates. All residents at ZCNY (whether they work at the bakery or not) receive $100 a month, though board and lodging are free, and the community also provides 'vacation spending monies' (Tworkov, 131).

So while Greyston Bakery competes in the market place, its workers are not there for purely business reasons. In fact, Glassman sees business as the most appropriate form of training for American Zen. When Zen went to Japan from China, he says, its most appropriate form of expression in Japanese culture was aesthetics; the equivalent in America is business (Tworkov, 121).

Another departure is his non-denominational *zendo* together with an interfaith service hall at ZCNY (Tworkov, 117). Classes are held in other Buddhist traditions than Zen, as well as Christianity and Judaism, in which the Old and New Testaments, and Kabbalistic texts are used (*Spring Wind* [the magazine of the Zen Lotus Society], 'Buddhism in India Today', vol. 5, no. 1 and 2, Spring-Summer 1985, pp. 162–64). In fact, he has given Dharma transmission to Father Robert Kennedy, a Catholic priest,[1] and to a rabbi, Donald Singer. (He also has a Japanese student, incidentally [Matthiessen, 170].) And he has even more ambitious plans. He wants to try what he calls a homeless *sesshin,* where students would live on the streets without money, food, or identification papers while asking the question 'Who am I?' (Tworkov, 151). And in response to the charge, 'But is it Zen?', Glassman replies: "All the things that people say are not Zen are the things I want to get involved with" (ibid.).

The underlying justification for this bold approach, which has practically abandoned all vestiges of its Japanese form, is that Glassman Sensei is a 'true' Zen teacher because he has been properly trained, has passed his *koan* study and attained *kensho*. Peter Matthiessen, one of Glassman's principal students, who received Dharma transmission from him in 1989, puts it very forthrightly:

> Tetsugen-sensei is the first American Zen master to complete koan study as well as priestly training. He has been recognized as a Dharma-holder in formal ceremonies at the great Soto temples of Eihei-ji and Soji-ji in Japan. More important still, he is truly enlightened, having experienced two classical dai kensho. (Matthiessen, 135) [*Dai kensho* or great *kensho* is the experience of non-separation. I have already given

[1] And Kennedy has in his turn given transmission to a Catholic nun, Janet Richardson (see table, p. 258).

Glassman's own account of the first—when he passed Mu; I don't know anything about the second.]

Elsewhere, Matthiessen describes Glassman as "an American-born buddha *(sic)*" (Matthiessen, 259).

Similar endorsements come from Japanese teachers. Nishiwaki Roshi, who was senior priest at Glassman's installation as abbot in New York in 1982, referred to Glassman's connection with *Harada* Roshi like this: "Harada's mind is now with Maezumi-roshi and Tetsugen-roshi in the United States." In short, Glassman is firmly in the lineage of Japanese Zen and can therefore be relied upon. Time will tell whether his form of the tradition turns out to be part of mainstream American Zen or tangential to it.

STOP PRESS: *in 1995, Glassman received* inka *(in Los Angeles) from Maezumi Roshi shortly before Maezumi's sudden death. He took the title 'Roshi' and the apparent intention was that he would assume responsiblility for the White Plum Sangha (that is, all the temples and centres established in the West by Maezumi himself and his nine Dharma heirs) and that he become abbot of the Zen Center of Los Angeles/ZCLA. That, at least, was what was announced in a newsletter sent out by Denis* **Merzel***'s group in Britain at the time. In fact, Glassman took rather a different direction. He gave* inka *to* **Merzel** *(who then went on to become president of the White Plum Sangha instead of Glassman) and formed his own Zen Peacemaker Order. My information is that everyone else in the* sangha *is a bit non-plussed right now . . .*

(*See* Lineage Tree 4)

Primary sources: Hakuyu Taizan Maezumi and Bernard Tetsugen Glassman (eds.), *On Zen Practice: The Foundations of Practice,* (vol. 1); *On Zen Practice II: Body, Breath and Mind,* 1977; *The Hazy Moon of Enlightenment: On Zen Practice III,* 1978. (these three volumes published by ZCLA, Los Angles; they contain transcriptions of Dharma dialogues/*shosan* by Glassman.)

Secondary sources: Helen Tworkov, *Zen in America* (San Francisco: Primary Point Press, 1989); Peter Matthiessen, *Nine-headed Dragon River* (London: Flamingo, 1987); R. Fields, *How the Swans Came to the Lake* (Boston, 1986)

Centre: Zen Community of New York, 14 Ashburton Place, Yonkers, NY 10703, U.S.A.

COMPARE:

Other Dharma heirs of Maezumi Roshi: Dennis **Merzel**, Jan **Bays**, Joko **Beck**, John **Loori**

Other Zen teachers: Robert **Aitken**, Richard **Baker**, Gesshin **Prabhasa Dharma**, Don **Gilbert**, Philip **Kapleau**, Karuna **Dharma**, Jiyu **Kennett**, Jakusho **Kwong**, Dharma Teachers **Klevnick** and **Murray**, Walter **Nowick**, Bobby **Rhodes**, Ruth Fuller **Sasaki**, Irmgard **Schloegl**, Maurine **Stuart**

Other teachers involved in business/livelihood: Richard **Baker**, Ven. **Sangharakshita**

Other teachers who are non-denominational/inter-faith (in various senses): John **Loori**, Srila **Bhaktipada**, Lex **Hixon**, Samuel **Lewis**

DWIGHT GODDARD. SEE **APPENDIX 1**

E.J. GOLD

Gold—often referred to as 'EJ'—has gone out of his way to present himself in an unflattering light. One might call him a master of disguise except that some of his disguises wouldn't fool a baby. He calls himself a Sufi and a Fourth Way teacher but his credentials for either title are problematic, to say the least. Yet he can perhaps claim to be **Gurdjieff**'s true heir; not in the sense that he was appointed (he certainly wasn't) or recognized by any of Gurdjieff's followers (they have ignored him completely) but in the opposite sense: that he just appeared, as **Gurdjieff** did, having been through the same sort of trials that **Gurdjieff** went through, and is now teaching in the same way that **Gurdjieff** did—by suggestion, allusion, and masquerade.

He is a voluminous author. But his books are often quite other than they appear. *Autobiography of a Sufi,* which appeared in 1976 or 1977 (the book itself is unclear), is an example. It is a spoof or cod version of the journey in pursuit of secret knowledge.

> Only after a long search among the inaccessible communities in hidden areas of the world did I come into contact with a certain Brotherhood . . . the existence of which was not even recorded among the surviving Ancient Brotherhoods. (*Autobiography of a Sufi,* 59; dots in the original)

Dates are rarely mentioned. One of them is 1955, the year that he says he began his search—in New York (ibid., 15, 47). This may or may not be true. (That's what happens to dates—and all 'facts'—when someone is playing a game.) Needless to say, he finds himself in some exotic places. He starts off in Jerusalem (sent there by an unnamed friend from London), where he comes across a scroll. "The last scrolls similar to this had been found in the nineteen forties, and related to certain esoteric studies of the Sarmoung Brotherhood" (ibid., 18). This is the first of many references to ideas and teachings taken from **Gurdjieff**. (The date, of course, is wildly inaccurate.) These references are often allusive or satirical. For example, he meets up with some other people who are on the same search as himself. "Since we were travelling incognito—the absolute best possible arrangement for Americans overseas—we decided to call our little group 'Sneakers After Truth'" (ibid., 25). This is an allusion to **Gurdjieff**'s Seekers After Truth; and it is probably no accident that on the next page there is a photo of EJ wearing ludicrously false hair and beard, which may well be a pictorial allusion to **Gurdjieff**'s use of 'transparent disguise' to wake people up. (See his entry.) On the other hand, it may be a coincidence after all and have no significance whatever. (That's what happens to meaning(s) when someone is playing a game.)

Later, EJ goes to Ankara, where he knows nobody. He finds himself in a narrow street and stumbles into what he thinks is a carpet shop, only to discover a series of rooms in one of which there are some dancers frozen in various positions. He asks someone what he has wandered into.

> "This is called the 'Dancing Brotherhood of Honey', he replied. "But you did not wander. Your friend from London has been shot."
> "My God, is he going to be all right?" I asked in shock.
> "Oh, yes, quite all right. He died this morning." (ibid., 29)

The book is full of incidents like this—using Gurdjieffian materials in an incongruous way, a bit like putting quotations from Shakespeare into a Punch and Judy show.

All travelogues are difficult to summarize, let alone a surrealist one. So I simply mention here a description of an unnamed Russian whom EJ met when he was a little boy.

> He smiled and I felt instantly that I was in the presence of Santa Claus. This uncanny sensation of inner warmth was so unusual for me that I resolved instantly to some-day discover the means of imparting to others that same feeling on first meeting them. And later, when I attained all those powers as a result of my searches, even they were nothing compared to my genuine wish for this single attribute above all others. (ibid., 67)

This man—who cooks exotic food and plays a small Indian organ—is obviously meant to be **Gurdjieff**. Whether EJ did meet him, I do not know.

In 1978, a year or so after *Autobiography of a Sufi* was published, EJ brought out another book with what you might think, if you did not know EJ, was a revealing title: *Secret Talks with Mr. G.* It has what looks like a photo of **Gurdjieff** on the cover (and others in the book itself), so it is easy to jump to the conclusion that Mr. G is **Gurdjieff**—especially as the entire book from beginning to end, is an exposition of **Gurdjieff**'s system. It uses his technical vocabulary and even, in the sections consisting of questions and answers, copies his broken English. But in fact the photos are of EJ dressed up to look like **Gurdjieff**. In short, Mr. G is Mr. Gold impersonating Mr. **Gurdjieff**. (And this time, unlike *Autobiography of a Sufi,* the impersonation is quite convincing.)

I have no firm details about his teaching career. (His books contain no 'straight' information at all, not even a contact address.) As far as I can make out from the few hints dropped here and there, he had a centre in Los Angeles around 1966 or so; and this was itself the proving ground for a more advanced group that was located in Crestline in the San Bernadino mountains. It was called the Institute for the Development of the Harmonious Human Being (yet another **Gurdjieff** echo) or IDHHB. At one time, EJ was known as 'Babaji Al-Wahshi'.

> Many people have asked whether Babaji was an Avatar, or a teacher, and whether other teachers recognized him as a teacher. Also many people have asked for Babaji's credentials. Babaji said that he simply was a man who had managed through the guidance of other, more Spiritually advanced Beings, to touch Spirit. He never actually claimed to teach anything, just to create conditions. (*Shakti: The Spiritual Science of DNA;* there are no page numbers in this book)

Although the core of EJ's work is obviously derived from **Gurdjieff**, he has added a few ingredients of his own. There is a reference in *Shakti: The Spiritual Science of DNA* (that's the book with no page numbers) to ashrams that are maintained "by the full renunciates of the Shakti! (*sic*) Order." The 1979 edition of the *Spiritual Community Guide* contains an entry for the Institute for the Development of the Harmonious Human Being, which describes itself as a Fourth Way Sufi Community. The 1982 edition simply says that it is "a Sufi Community devoted to our Endless Creator through the invocation of His Angels on the Planet Earth." It also says that the community trains, and issues certificates to, Terminal Midwives, who use the *New American Book of the Dead*—another of EJ's many books—for 'terminal counselling.' This must mean counselling for those who are dying. But one wonders what a Certificate of Terminal Midwifery would mean to anyone—anyone at all.

I do not know if any of these projects is still going. But it isn't the projects that matter, it is the method of teaching. Lee **Lozowick**, who is a friend of EJ's, once said to me that all teachers have to re-create their tradition.. He was not referring to EJ at the time but the remark definitely applies. So it is possible to argue that EJ is in the Gurdjieffian tradition, not because he is faithfully transmitting **Gurdjieff** but because he is 'doing a Gurdjieff'. And since **Gurdjieff** was a bit of a showman, so is EJ. (By 'showman', I mean someone, who, in the words of the popular song, is 'putting on the agony, putting on the style'.) One could say that all teachers who claim to be faithful to **Gurdjieff** would have to be. And perhaps one could go further and say that, like **Gurdjieff**, EJ is a cardsharp: the hand you get is never quite what you expected.

(*See* Lineage Tree 3)

Primary sources: E.J. Gold, *Shakti: The Spiritual Science of DNA* (Crestline, California: IDHHB, 1973); *New American Book of the Dead* (San Francisco: And/Or Press, 1974); *Autobiography of a Sufi* (no provenance: IDHHB, 1976 or 1977); *Secret Talks with Mr. G* (no provenance: IDHHB, 1978); *The Joy of Sacrifice: Secrets of the Sufi Way* (no provenance: IDHHB and Hohm Press, 1978); there are many other titles but I only list the ones I have used or mentioned

Secondary sources: S. Palmer, *Shakti: The Spiritual Science of DNA* (MA dissertation, Concordia University, Montreal, 1976 [I haven't read it])

Centre: Institute for the Development of the Harmonious Human Being, P.O. Box 370, Nevada City, CA 95959, U.S.A.

COMPARE:

Other 'fringe' Gurdjieff teachers: J.G. **Bennett**, G.B. **Chicoine**, Oscar **Ichazo**, Idries **Shah**

Other 'spiritual travelogues': **Gurdjieff** [his *Meetings with Remarkable Men*], Idries **Shah** [especially *The Teachers of Gurdjieff* by Rafael Lefort, who may well be Shah], Reshad **Feild**

Other teachers who have met inner guides or had visionary encounters: Samuel **Lewis**, Jiyu **Kennett**, Frithjof **Schuon**

JOSEPH GOLDSTEIN. SEE *VIPASSANA SANGHA*

MURSHIDA LUCY SHARIFA GOODENOUGH. SEE THE **SUFI MOVEMENT AND THE SUFI ORDER**

LAMA ANAGARIKA GOVINDA | ERNST HOFFMAN

The first Western teacher of Tibetan Buddhism

Hoffman was born in Saxony in 1898 of a German father and Bolivian mother. He was invalided out of World War I with tuberculosis and went on to study architecture and philosophy at Freiburg University. He took up painting and did archeological research on the tombs and tumuli of North Africa (*Festschrift,* 13). At the same time, he was conducting his own research into the nature of religious experience. At first, he thought that Christianity was the answer but

his studies led him to accept Buddhism as the path for him. In 1920, he published two small books: *Der Grundgedanken des Buddhismus* (later translated into Japanese and published by the Imperial University of Tokyo) and *Praxis der Meditation,* a record of his experiments in meditation using the *Satipatthana Sutta.*

Finally, in 1928, he decided to enter the *sangha* and went to Ceylon to join the small group of German monks at the Island Hermitage of **Nyanatiloka** Thera, where he took *brahmachari* or novice vows. A year later, he went to Burma (accompanied by **Nyanatiloka**) and took *anagarika* vows. He spent the next couple of years studying Pali and the *Abhidhamma* in Burma and Ceylon, and published *Abhidhammattha-Sangaha, Ein Compendium Buddhistischer Philosophie und Psychologie* (under the name 'Brahmacari Govinda') in Munich in 1931.

But in this same year (1931), everything changed. He went to Darjeeling as a delegate to an international Buddhist conference, which he attended mainly in order to "uphold the purity of the Buddha's teaching, as preserved in Ceylon, and to spread its message in a country [Tibet] where the Buddha-Dharma had degenerated into a system of demon-worship and weird beliefs" (*Way of the White Clouds,* 13). But he ended up being converted himself and was initiated by Tomo Geshe Rinpoche,[1] a Tibetan teacher who was in India on a short visit.

Govinda's account of his initiation stresses the significance of sacred power.

> On the day on which Tomo Geshe Rinpoche formally accepted me as his Chela *[note the use of the Hindu term here]* in a special ritual of initiation, in which I received my first mantra, I realized one of the most important things that hitherto had been lacking in my religious life: the impetus of a spiritual force that required no philosophical argument or intellectual justification, because it was not based on theoretical knowledge, but on fact and direct experience, and thus gave one the certainty that what one was striving after was not merely an abstract idea, a mere shadow of a thought, but an attainable state of mind, the only 'tangible' reality of which one can speak. (*Way of the White Clouds,* 36)

In fact, he spent only a few weeks with his guru after his initiation[2] but he stayed in India for the next 30 years, interspersed with a few trips to Tibet. The first began in 1933 and lasted for about a year. He started off in Kashmir, crossed over to Ladakh and then into the Tibetan highlands. During this journey, he had a number of experiences, including spontaneous *lung gom* (walking very quickly without fatigue and without having to look where one is going) when he got lost one evening. Although he gives details concerning the training that is usually required to perform this feat, he himself had no training at all.

> I realized that a strange force had taken over, a consciousness that was no more guided by my eyes or my brain. My limbs moved as in a trance, with an uncanny knowledge of their own . . . One false step or a single slip on these boulders would have sufficed to break or strain a foot, but I never missed a step. I moved on with

[1] Also known as Lama Nagwang Kulzang; a Gelugpa, I think, from the scant information that Govinda gives (see *Way of the White Clouds,* 160).

[2] It is worth pointing out that he did not take a Tibetan name and so remained Anagarika Brahmacari Govinda, as he was known in his Theravada days, even though the Tibetan tradition does not use the title 'Anagarika' (or 'Brahmacari', come to that) and I know of no other Tibetan Buddhist who has ever employed either. As for his use of the title 'Lama', this is somewhat unclear. All his early books are attributed to Anagarika Brahmacari Govinda and 'Lama' first appears on the title page of *Grundlagen Tibetischer Mystik* (where he also uses the

the certainty of a sleep-walker—though far from being asleep. (*Way of the White Clouds,* 78)

He also had a visionary encounter with Maitreya, Manjushri, and Tara in a cave (*Way of the White Clouds,* 48–54). He interpreted this as a second initiation, and also as an instance of creative visualization, which is itself the real function of sacred art (ibid., 155).[3]

On his return to India, Govinda founded the Order of the Arya Maitreya Mandala in October 1933 in Darjeeling. The introduction to his *Festschrift* (written by his disciples) says that he did so according to Tomo Geshe Rinpoche's wishes (*Festschrift,* 14) but what this means exactly, I do not know. There is no indication that any Tibetan *lama* or *tulku* ever recognized the Order. It is a striking fact about Govinda's career as a Tibetan Buddhist in India that he was never part of any community or *sangha* (although there wasn't one he could have joined anyway, of course).

The next 15 years were spent in India, lecturing, writing and painting—though he did visit Sikkim in 1938 and briefly met the Gomchen of Lachen, Alexandra **David-Néel**'s teacher (*Way of the White Clouds,* 101). Tomo Geshe Rinpoche died in 1937 (in Tibet); Govinda did see him once before then, at Sarnath in 1936, but as far as we can tell, the total time he spent with his guru between 1931 and 1937 did not amount to more than a couple of months. He was interned by the British during World War II (despite having taken British citizenship in 1940 precisely to avoid this eventuality). In 1947, India became independent and Govinda immediately took Indian citizenship. He also married the Indian painter, Li Gotami (though this is a *nom de brosse/nom de peintre*), whom he had known since the 1930s. The marriage ceremony was carried out by the Kagyu *tulku,* Ajo Rinpoche; and he also initiated Govinda and Gotami into the Kagyu lineage (ibid., 155). It appears, then, that Govinda had no Tibetan teacher—at least, not externally—between 1936 (the last time he saw Tomo Geshe Rinpoche) and 1947.

Govinda made his second trip to Tibet in 1948–49, together with his wife. Whereas his first visit had been without any formal permission, this time they had authority from Lhasa to study the architecture and art of monasteries of Rinchen Zangpo in Western Tibet—in particular, the frescoes of Tsaparang. They spent some time on the slopes of Mt. Kailas and visited a Bon monastery nearby. Govinda relates a meeting with an old *lama* in a temple which is minor in itself but may help to explain his own use of the term 'Lama'.

> "You are a Lama," the old man suddenly said to me, as if thinking aloud, 'but not from this part of the country. Are you able to read our holy scriptures?'
>
> "Certainly I am."
>
> "Then read what is written here"—and he pulled out a manuscript hidden behind one of the prayer cylinders.

name, 'Anangavajra Khamsum-Wangchuk'—I haven't a clue why) in 1956. As far as I know, he was never formally recognized as a *lama* by any Tibetan teacher—he certainly never says so and I'm sure he would have mentioned it if he had been. So I think it probable that it was his disciples who started to call him 'Lama' sometime in the 1950s. (There is some similarity here with Zen teachers like Philip **Kapleau** who are called 'Roshi' by their students although they have never actually been appointed as *roshis*).

[3] Govinda was a painter who specialized in what might be called sacred landscapes. A permanent home was found for his work in the Govinda Hall, Allahabad, in 1938. He also had a whole theory of the nature of art and its relation to *dhyana* or inner vision—that's his definition—and symbolism, and produced a number of books which were published (in English) in India in the 1930s—for instance *Art and Meditation, Stupa Symbolism,* and *The Psychological Attitude of Early Buddhist Philosophy.* They had little impact at the time but were much more influential when they were reprinted in the West (with slightly different titles) some 20 years later.

I read: "I will act for the good and the welfare of all living beings, whose numbers are as infinite as the expanse of the sky, so that, by following the path of love and compassion, I may attain to perfect enlightenment."

The old Lama's face lit up and he looked straight into my eyes, saying, as he grasped both my hands like one who has found a long-lost brother, "We are travelling on the same path!" (*Way of the White Clouds*, 234)

On their way back to India, near the border with Tibet, Govinda and his wife were initiated by a Nyingma *lama* "in the most advanced methods of Tantric Sadhana and Yoga practices" (*Way of the White Clouds,* 269), during which "all the psychic centres (*cakras*) were employed and activated." Govinda expressly states that these initiations and experiences are the basis of his *magnum opus, The Foundations of Tibetan Mysticism* (ibid., 272).

By now (1949), Govinda had been an initiate for 18 years (in the Gelug, Kagyu, and Nyingma traditions successively) but he had lived and practiced with almost no contact with the West. In the 1950s, however, this began to change as Govinda slowly began to acquire disciples (though there were no Indians among them, as far as I know—and certainly no Tibetans). The first two were a monk from North Vietnam (no details are available) and a German whose name is given as Samanera Kassapa/Ven. Hans-Ulrich Rieker (*Festschrift,* 18)—presumably a Theravadin of some kind.[4] They asked if they could open branches of the Arya Maitreya Mandala in their own countries and Govinda agreed (in 1952). The German branch is still in existence (though it has changed its location); it was the first centre of any kind in the West that was exclusively devoted to Tibetan Buddhism, and it was established by a Westerner! Unfortunately, I know nothing about the Vietnamese branch; what a pity that all record of a Tibetan Buddhist order started by a German in India and transferred to North Vietnam should have disappeared.

Grundlagen Tibetischer Mystik appeared in 1957, and English and French translations followed very shortly. It was this work that effectively established Govinda's reputation as an authority on Tibetan Buddhism. A steady stream of young Western seekers came to the ashram for *satsang.* He would give a discourse but when they asked for instructions in meditation, he advised them to start with the basics as laid out in the Order of the Arya Maitreya Mandala (*Festschrift,* 19). Unfortunately, I have no further details. He also lectured all over the world. He went to Europe in 1960 when he was 62 (the first time he had been to the West since he left it in 1928); and to America in 1965 (but it was organizations like the Esalen Institute in Big Sur and the Theosophical Society in New York that invited him, not the universities). An American branch of the Arya Maitreya Mandala, called Home of the Dharma, was founded in San Francisco in 1967.

He became ill in 1980 and went to California for treatment; he remained there until his death in 1985 at the age of 87.

What are we to make of this unusual man? His books, especially *Foundations of Tibetan Mysticism,* are clear, intelligent, and well-informed—but they are essentially works of explanation and not at all like the teachings that Tibetans themselves give. It would, I think, be churlish to deny Govinda a place in the Tibetan tradition—both as practitioner and teacher—just because we don't quite know where to put him. Yet it also has to be said that the way

[4] Rieker subsequently wrote two books: *The Secret of Meditation* (London, 1955) and *The Yoga of Light* [a translation and commentary on the *Hatha-yoga-pradipika]* (London, 1972).

he followed is no longer viable. Now there *are* Tibetan teachers who are easily available and it *is* possible to join the *sangha* (or even a lay community) if one wants to. In other words, Westerners can now follow traditional Tibetan Buddhism. Govinda could not (at least up to 1959; the subsequent 26 years are a different matter perhaps).

This may explain why he describes himself in terms of a particular dimension of the tradition that best suits his own situation:

> When I chose the way of a lone and homeless pilgrim (Anagarika means a 'Homeless One') I did so in the conscious pursuance of an aim that allowed me neither to make myself 'at home' in the security of a monastic community nor in the comforts of a householder's life. Mine was the way of the Siddhas: the way of individual experience and responsibility, inspired and supported by the living contact between Guru and Chela through the direct transference of power in the act of initiation. (*Way of the White Clouds,* 150)

This is, I think, part of the mythology (using this term in its best sense) of Lama Anagarika Govinda. He is part of a spiritual tradition that is essentially independent of established forms. So although he may know Tibetan and be recognized as a *lama* by a 'real' Tibetan *lama* (see the incident above), he is in reality a *siddha*. His disciples, in fact, go further. They refer to him as a householder Bodhisattva ('householder' because he had settled down when they knew him). And they also say:

> Working through the dimensions of consciousness step by step—unfolding the potential powers of thought, feeling and intuition as a scientist and explorer, painter and poet, mystic and initiate, as student and teacher—he has become for us the master, the guru. (*Festschrift,* 20)

There are a few branches of his Order still in existence but they have been completely outflanked by the centres set up by Tibetan teachers over the past 30 years. He has been succeeded as head of the Arya Maitreya Mandala by another German, Advayavajra/Karl-Heinz Gottman; but this transmission is somewhat apart from the mainstream Tibetan tradition. It may well be that Govinda's spiritual path is rather like one of those off-shoots that are so common on charts of the evolution of species: an experiment that did not flourish. But there is nothing to be ashamed of in that; without such experiments, there wouldn't be any life at all.

Primary sources: Ein Compendium Buddhistischer Philosophie und Psychologie (Munich, 1931) [= *The Psychological Attitude of Early Buddhist Philosophy* (Allahabad, 1939 and London, 1961)]; *Grundlagen Tibetischer Mystik* (Zurich/Stuttgart, 1956) [= *Foundations of Tibetan Mysticism* (London, 1960)]; *The Way of the White Clouds* (London, 1966); *Psycho-Cosmic Symbolism of the Buddhist Stupa* (Berkeley, 1976) [originally *Some Aspects of Stupa Symbolism* (Allahabad and London, 1940)]]

Secondary sources: Biographical sketch in *Wege zur Ganzheit: Festschrift zum 75 Geburtstag von Lama Anagarika Govinda von seinem Freunden und Schulern* (Almora, India: Kasar-Devi-Ashram Publications, 1973); R.C. Tandan, *The Art of the Anagarika Govinda* (Allahabad and London, 1940)

Centre: Orden Arya Maitreya Mandala, Stumpenhorf 23, D-7310 Plochingen, Germany

COMPARE:

Other Western pioneers in Tibetan Buddhism: Alexandra **David-Néel**, W.Y. **Evans-Wentz**, Archbishop **Tennisons**

Other Western lamas: Lama Kunzang Dorje, Lama **Osel** [for both of whom, see the group entry, ***tulkus***]

Others who have gone from one Buddhist tradition to another: Gesshin **Prabhasa Dharma** (Japanese Rinzai ➔ Vietnamese Buddhism), **Miao Kwang Sudharma** (Soto ➔ Theravada ➔ Chinese Mahayana), Ernest **Hunt** (Pure Land ➔ Soto)

Other Western teachers who have started spiritual orders: Ven. **Sangharakshita** (Buddhist); Swami **Kriyananda**/Donald Walters, Guru **Subramuniya** (both Hindu)

Murshida Saintsbury Sofia GREEN. SEE THE **SUFI MOVEMENT AND THE SUFI ORDER**

Bede GRIFFITHS | Swami Dayananda. SEE **ABHISHIKTANANDA** (P. 149, N. 2)

Simon GRIMES. SEE *TULKUS*

George GRIMM. SEE **APPENDIX 1**

Darwin GROSS. SEE PAUL **TWITCHELL**

René GUÉNON | Sheikh ʿAbd al-Wahid Yahya

Early French Sufi and influential writer on the perennial philosophy

Guénon was born in 1886 and his early interests were in esotericism. He joined l'Ordre Martiniste in 1907 and became a bishop—there was no lower rank—in l'Eglise Gnostique a year later. Then in 1912, he was initiated into the Shadhili Order by Ivan **Agueli**/Abdul Hadi, who had been empowered by his *sheikh* to give initiation to those whom he thought ready to receive it. But as I point out in **Agueli**'s entry, it is not clear what this initiation entailed. Personally, I think it was both a formal initiation into the Arabi branch of the Shadhiliyya and also—and far more importantly—a contact (but not a formal initiation) with what might be called universal Sufism that goes back to Ibn Arabi (as interpreted by Sheikh ʿAbd al-Rahman and passed on by **Agueli**). But I have no evidence to back up this hunch.

On the other hand, I think it can be argued that Guénon was looking for an authentic tradition. But he understood the term in a particular sense. First, all true religions are revelations—that is, the intelligent source of the creation gives rise to a means of spiritual transmission. Second, this transmission must have two dimensions to it: an inner/esoteric and an outer/exoteric. Strictly speaking, the esoteric consists solely in the Divine Truth itself—but its outer fringes, so to say, consist in the true teaching (the doctrinal aspect of Truth, which expresses the laws that govern creation) and initiation (which gives

direct contact with the source). The outer/exoteric consists of the 'law': all those forms which are at one and the same time religious and social, and which are both derived from, and simultaneously support, the inner dimension—in short, a religious civilization.

These inner and outer dimensions are held together and expressed by symbols (which, though 'veiled' and therefore in a sense esoteric/hidden, are simultaneously 'natural' in the sense that they are part of the way things are, and 'revealed' in the sense that they are part of an intelligent cosmos), and they are connected by the spiritual path.

A tradition thus has three levels (the Divine itself is assumed, and in any case is not strictly speaking a level at all), which are intimately related and cannot in fact exist apart from each other: the esoteric (in Sufism, *haqiqa*); the exoteric (*shari'a*); and the way that leads from the second to the first (*tariqa*). Only when all three are operative is the spiritual life even possible.

Guénon was the first Westerner of the twenthieth century to formulate this idea clearly. And the notions of orthodoxy and the perennial philosophy or Primordial Tradition fit into it very nicely. All traditions are true in the sense that they are created by the same power that created the universe, and therefore they necessarily express the laws of creation; this is the perennial philosophy.[1] And all traditions are orthodox—they maintain those forms which by their very shape enable spiritual transmission to occur. These forms are both inner and outer—orthodoxy must maintain not only the inner forms of initiation but the outer forms of the 'law' (which are themselves the basis of civilization). That is why the great traditions are in the last analysis inseparable from the civilizations that contain them (though it is simultaneously true that the tradition 'informs' the civilization).

Guénon's life as a Sufi must, therefore, be seen as part of his efforts not only to uncover the perennial philosophy but also to present it in a form that those living in the twenthiethcentury could actually enter (instead of just talking about it). After his initiation in 1912, he spent another 18 years in France before moving to Egypt for good in 1930—the first Western Sufi to do such a thing, as far as I know. He used his Moslem name, 'Abd al-Wahid Yahya and was initiated into the Hamadiyya, a traditional and anti-modernist branch of the Shadhili Order founded by Sheikh Salama ar-Radi (*aka* Sidi Salama ibn Hassan). He improved his Arabic and wrote for Moslem journals in that language (again, the first Westerner—the first practising Western moslem, that is—ever to do so, I think). And in 1934 he married Fatima, the daughter of his 'lawyer', Sheikh Muhammed Ibrahim. (I put the word 'laywer' in scare quotes because I am not sure what it means in this context.) The couple had four children (all Moslem, of course), the last of whom, 'Abd al-Wahid (the same name as his father), was actually born after Guénon's death in 1951. Guénon even became an Egyptian citizen (in 1949).

There is no doubt that Guénon was held in high esteem by his fellow Moslems/Sufis in Egypt. Indeed, Sheikh 'Abd al-Halim Mahmud went so far as to say that Guénon's work can be seen as a Western offshoot of Shadhili intellectuality (V. Danner, 'The Shadhilliyah and North African Sufism' in S.H. Nasr ed., *Islamic Spirituality: Manifestations* [London: SCM Press, 1991], p. 48, n. 18). However, we know that Guénon's participation in Islam was from the point of view of the perennial philosophy: Islam is a true form of the Primordial Tradition rather than the true tradition *per se*. So it would be wrong,

[1] This explains why Guénon wrote two books on Hinduism-cum-Vedanta—but not one on Sufism.

I think, to see him as a Moslem first and last. Instead, he was a Traditionalist first and a Moslem last; only the first and the last in this equation meet each other like the two 'ends' of the circumference of a circle.

What this meant in practice was that Guénon's main concern was to point the way for others to receive spiritual transmission; Islam was simply a proven means to that end. This explains why all his writings are what could be called trans-traditional, and why he never wrote a book about Islam or Sufism. He certainly never recommended either in print. Yet it remains a fact that most of those who were influenced by him did become Sufis[2] (and in the Shadhili Order, too—which includes its sub-branches, the Alawiyya and Darqawiyya).[3]

The main reason for this was his liason with Frithjof **Schuon** during the 1930s. **Schuon**, whose Sufi name is Sheikh Isa Nur ad-Din, was a *moqaddem* in the Alawi Order (an Algerian branch of the Shadhiliyya) and could therefore initiate people—which Guénon could not. (He was a pure 'metaphysician' and did not himself participate in any spiritual transmission.) To begin with, he was delighted that **Schuon** was available to give initiation, for as he himself put it, "without him [Schuon], matters would have remained in the state of possibility, and theoretical in a sense, and would not have come to fruition (*arriver à se réaliser*)" (quoted in Laurant, 234). Accordingly, Guénon passed on to **Schuon** all those Westerners who had read his books and managed to contact him, usually by letter, in Cairo. Robin says that this amounted to about a hundred people by the outbreak of World War II (Robin, 329). (All of them had to be fluent in French, since Guénon's books had yet to be translated— and I suspect that they werc all men, too.) **Schuon** and Guénon themselves only met twice—for two weeks in 1939 and for a few days in 1939, both times in Cairo.

At this point, then (say 1939), we have a number of Europeans, all of whom are Traditionalists in the Guénonian sense; all of whom owe their Islamic allegiance—specifically, the Shadhili Order and its off-shoots—in large part to him (though this is not to deny their loyalty to their own *sheikh,* of course); and most of whom are members of Sufi groups that meet regularly for practice. But nobody knew about them. However, considering the political climate of the time, with Fascism rearing its head across the continent, it is not surprising that they preferred to remain invisible.

But even the perennial philosophy has its hiccups. Around 1946, **Schuon** began to introduce into his teaching two elements that Guénon considered to be non-Traditional: first, doctrinally, that the Christian sacraments were still true initiations and had lost none of their salvific efficacy; secondly, as concerned practice, that meditations on symbols from other traditions—notably

[2] There were some significant exceptions, however: Anand Coomaraswamy (the son of a Sinhalese father and an English mother, and educated at an English public school), whose writings on sacred or traditional art were very influential; Marco Pallis, who remained a Buddhist; and John **Levy,** an English Jew who became a Moslem—sometime in the 1930s, I think—but later became a disciple of the Indian teacher, Krishna Menon/Sri Atmananda (a modern exponent of non-dualism), and was critical of Guénon's exposition of Advaita.

[3] It is an interesting question why it was the Shadhiliyya/Alawiyya/Darqawiyya that attracted Westerners. There are, after all, many Sufi orders, all of which were at least known to Westerners at this time—and some of these Westerners must have been seekers after truth. The answer, I think, is threefold. First, the Shadhiliyya/Alawiyya/Darqawiyya (treating these three as one entity for the moment) was rigorous in its teaching and practice, which attracted Westerners seeking a 'pure' form of Sufism, uncontaminated by modernism. Second, it was close to Europe, so contact with it was relatively easy. Third, it did not require that its Western followers be overt in their practice, so anonymity was assured. In short, it was traditional, accessible, and invisible. No other Sufi order of the time could offer the same advantages.

the Tao and the Virgin Mary—were effective means of transformation. In effect, according to Guénon, **Schuon** had abandoned Islam and introduced his own syncretism. (And indeed, the Virgin Mary has assumed such prominence in **Schuon**'s teaching that his group of initiates are now known as the Maryamiyya—and this really is the formation of a new *tariqa*.) Parallel with this development, some of **Schuon**'s disciples declared that Guénon (whose name, 'Yahya', is equivalent to 'John') merely had the function to prepare the way for **Schuon** (whose name, 'Isa', is equivalent to 'Jesus') and that he (Guénon) should become **Schuon**'s *moqaddem* in Egypt. It was at this point (in 1949, I think) that Guénon finally severed relations with **Schuon**. He died shortly afterwards, in 1951.

It might seem, on the face of it, that Guénon was not really a teacher at all since he had no formal position in the Sufi tradition. But there is no doubt that others saw him as one. According to Coomaraswamy, "René Guénon is not an 'Orientalist' but what the Hindus would call a 'master'" ('Eastern Wisdom and Western Knowledge', Chapter IV of his *The Bugbear of Literacy* [Middlesex, England: Perennial Books, 1979]). Nor was he alone in this assessment. A group in Paris regarded Guénon as the head *(chef)* of a metaphysical school; and one of his correspondents, over a period of 18 years, changed his form of address from 'Monsieur' to 'très cher et véneré Maître' (Laurant, 233). Guénon himself declined any such title. He did, in the early years of his time in Cairo, answer questions about Sufi practice (Laurant, 235)—but his real concern was always the same: the perennial philosophy, metaphysics, Tradition.

Primary sources: René Guénon, *Introduction générale à l'étude des docrines hindoues,* 1921 (*Introduction to the Study of Hindu Doctrines,* 1945); *Le Théosophisme. Histoire d'une pseudo-religion,* 1921; *Orient et Occident,* 1924 (*East and West,* 1941); *L'Homme et son devenir selon le Vedanta,* 1925 (*Man and his Becoming according to the Vedanta,* 1945); *Le Roi du monde,* 1927 (*The Lord of the World* [England, Coombe Springs Press, 1983]). See also J.S. Crouch, *René Guénon: A Check-list of [his] Writings in English, with a Select List of the Material in English About Him,* 5/12–16 Symonds Street, Hawthorn East, Melbourne, Australia, 1990 [42 pages]; J. Needleman, ed., *The Sword of Gnosi,* Arkana, London, 1986 (a collection of articles by Guénon, Schuon, Lings, Burckhardt, Pallis, and others)

Secondary sources: R. Waterfield, *René Guénon and the Future of the West* (England: Crucible, 1987); Marie-France James, *Esotérisme, Occultisme, Franc-Maçonnerie et Christianisme aux XIXe et XXe siècles* (Paris, 1981) (entry under 'Guénon'); S.H. Nasr, article on Guénon in *The Encyclopedia of Religion* (New York, 1987), Vol. 6, 136–38; P. Nutrizio in *Lord of the World* (see above), 68–70; J. Robin, *René Guénon: témoin de la tradition* (Paris, 1986: 2ème ed. augmentée); J-P. Laurant, *Le Sens caché selon René Guénon* (Lausanne, 1975)

Centre: None extant.

COMPARE:

Other Western teachers in the Shadhili Order (and sub-orders): Ivan **Agueli**, Frithjof **Schuon**

Other Western Sufi teachers (up to 1950): Murshida Rabia **Martin**, Samuel **Lewis**, the teachers in the **Sufi Order**

Others who have a teaching concerning a Universal Tradition or the Great Work: G.I. **Gurdjieff** (and his followers, particularly J.G. **Bennett**), Sri **Krishna Prem**

Other teachers who have lived in Eastern countries: Swami **Abhishiktananda**, Swami **Atulananda**, Sri **Krishna Prem**, Sri **Mahendranath**, the **Mother**, Sister **Nivedita** (*all Hindus in some sense, however attenuated*); **Ananda Maitreya**, **Nyanatiloka** Thera, Ajahn **Sumedho** (*all Theravadin Buddhists*); Freda **Bedi**, Alexandra **David-Néel**, Lama Anagarika **Govinda** (*all Tibetan Buddhists*); Hugo **Enomiya-Lassalle**,

Philip **Kapleau**, Jiyu **Kennett**, Walter **Nowick**, Ruth Fuller **Sasaki** (*all Zen Buddhists*); Mahasthavira **Sangharakshita** (*unaligned Buddhist*); **Shunya** (*independent*)

GURDJIEFF

Arguably the first really independent teacher in the West; probably the most influential; and possibly the most difficult to get to grips with

Gurdjieff is not an easy person to write about, let alone assess. There are a number of reasons for this but they all boil down to one: he did not want it to be easy. All our knowledge of his early life (his first 46 years), for example, comes from him—his 'autobiography', *Meetings with Remarkable Men*. And this is immediately problematic because Gurdjieff the teacher undoubtedly takes precedence over Gurdjieff the autobiographer; or perhaps it would be more accurate to say that the two are really indistinguishable. Hence it is more or less impossible to tell if anything that he says is straight fact or straight teaching, or not-so-straight fact or not-so-straight teaching (or a mixture of all four). And as we shall see, he had his reasons for undercutting these distinctions in the first place.

He was probably born in Alexandropol in the Caucasus mountains close to the borders of Russia, Turkey, and Georgia in 1866. (Moore discusses the alternative dates). His father was Greek and his mother Armenian. Technically, he was born in Russia but this does not mean very much; his influences were various and polyglot from the start. His family moved to Kars in 1878 (when Russia briefly took over part of Turkey) and he added Turkish to his Greek, Armenian, and Russian. He was privately taught by an Orthodox priest there.

In 1883, when he was 17, he left home and went to Tiflis in Georgia. He supported himself by a variety of jobs—a constant theme throughout his life—and met up with others who, like him, were looking for answers to life, or in Gurdjieff's own words, possessed:

> an "irrepressible striving" to understand clearly the precise significance, in general, of the life process on earth of all the outward forms of breathing creatures and, in particular, of the aim of human life in the light of this interpretation. (*Herald of Coming Good*, 13)

He became a 'seeker of truth' (which was the name of a group of like-minded people who gathered round him a decade or so later). The various episodes of this search can be found in *Meetings with Remarkable Men* (and have been summarized by Moore). I mention here only two incidents which particularly interest me: his visit to Constantinople in 1885 to study the Bektashi and Mevlevi dervishes—this is one of the reasons, though not a very strong one, for linking his teaching to Sufism—and his contact with the Sarmoung Brotherhood.

He first came across a reference to the Brotherhood in a manuscript that he discovered in some ruins in Armenia in 1886. But it is otherwise quite unknown to history and, as with everything else in Gurdjieff's 25-year search, there is no corroboration of his discovery. Yet in 1898, according to his account, he was taken to the chief Sarmoung monastery. The journey, which began at Bokhara, near Samarkand in southern Russia, took twelve days and he was blindfolded the whole time. And what happened at this centre of ancient wisdom? We do not know. All Gurdjieff says is that

The details of everything in this monastery, what it represented, what was done there and how, I shall perhaps recount at some time in a special book. (*Meetings with Remarkable Men,* 161)

This is so completely unsatisfying—and unsatisfactory—that it must be deliberate. And many Gurdjieffians regard the whole episode—if not the whole of Gurdjieff's search—as essentially allegorical; or perhaps one could say, a teaching device.[1]

The only other thing I want to mention during this period of search was a vow that he took in 1911 to lead an "absolutely unnatural life, absolutely irreconcileable in every way with the traits that had entrenched themselves in my individuality" (*The Herald of Coming Good,* 12). The significance of this vow can be simply stated: true knowledge arises when we are challenged, not when we are comfortable. It is a constant theme in Gurdjieff's life and work and we shall come across a number of examples of it.

The second phase of Gurdjieff's life begins in 1912, when he emerges on to the public stage for the first time. He appears in Moscow, gets married and gradually begins to attract pupils. And at the same time, the second player in the 'Gurdjieff orchestra' makes his bow: P.D. **Ouspensky**. His account of his first meeting with Gurdjieff in a Moscow café is well-known but still worth quoting.

I saw a man of an oriental type, no longer young, with a black moustache and piercing eyes, who astonished me first of all because he seemed to be disguised and completely out of keeping with the place and its atmosphere . . . [S]eated here in this little café, where small dealers and commission agents met together, in a black overcoat with a velvet collar and a black bowler hat, [he] produced the strange, unexpected, and almost alarming impression of a man poorly disguised, the sight of whom embarrasses you because you see he is not what he pretends to be and yet you have to speak and behave as though you did not see it. He spoke Russian incorrectly with a strong Caucasian accent; and this accent with which we are accustomed to associate anything apart from philosophical ideas, strengthened still further the strangeness and unexpectedness of the impression. (*In Search of the Miraculous,* 7)

This incident adumbrates a constant theme in Gurdjieff's teaching: that 'ordinary' life is nothing more than identification with roles that are mechanically adopted; hence one way of breaking out of them is to deliberately adopt a difficult or 'unconvincing' role. And the point is, of course, that Gurdjieff taught this by doing it himself.

In 1917, after five relatively settled years in Russia, during which time Gurdjieff transmitted his teaching in the form recorded by **Ouspensky** in *In Search of the Miraculous,* the Russian revolution took place. Gurdjieff decided that these were not the conditions in which he wanted to work, and he and his pupils started on a tortuous series of moves, eventually ending up in France (via Georgia, Constantinople, and Germany) in 1922. He was 56 years old—an age when most men are thinking of retiring. And apart from nine trips to America (the longest of which lasted over 18 months) and five months in 1935 when he disappeared completely, he never left France until his death in 1949.

However, this period of 27 years is difficult to summarize mainly because there is no obvious pattern to it. Gurdjieff seems to do everything on the wing,

[1] He also has next to nothing to say about his two-year stay (around 1905 to 1907) at a "Dervish monastery in Central Asia" (*Herald of Coming Good,* 19). Geographical exactitude was never his strong point.

as it were, improvising with the individuals and conditions that come his way: starting projects and then changing direction suddenly or dissolving them altogether. And with a few exceptions, everyone around him found this bewildering. One is bound to ask why this is so, and the 'orthodox' answer (which is the one I'm interested in at the moment because I want to tell 'the Gurdjieff story' in his own terms) is that he was working according to 'higher' laws, where continuity of form is not nearly so important as waking people up. One awake person is worth a hundred who are living comfortably—in fact, sleeping comfortably—in a cocoon.

But in order to wake people up, you have to shake them—and this explains Gurdjieff's reputation for being unpredictable and 'difficult'. For example, his Institute for the Harmonious Development of Man, founded in October 1922 at the Prieuré at Avon, near Paris, was undoubtedly a testing school. Those who attended it really had no idea what to expect and many found it overwhelming. A.R. **Orage** is a case in point.

> My first weeks at the Prieuré were weeks of real suffering. I was told to dig, and as I had had no real exercise for years I suffered so much physically that I would go back to my room, a sort of cell, and literally cry with fatigue . . . When I was in the very depths of despair, feeling that I could go on no longer, I vowed to make extra effort, and just then something changed in me. Soon, I began to enjoy the hard labour, and a week later Gurdjieff came to me and said, "Now, Orage, I think you dig enough. Let us go to café and drink coffee." . . . This was my first initiation. The former things had passed away. (Nott, *Teachings of Gurdjieff,* 28)

Yet despite all Gurdjieff's efforts (not to mention those of his pupils) to establish the Prieuré, it functioned as the centre for his work for less than two years. In July 1924, he was involved in a car crash that nearly killed him. He was alone at the time and, as far as is known, no other car was involved. At any rate, there were no witnesses and nobody really knows what happened. Gurdjieff himself typically never gave an account, let alone an explanation, of the accident (apart from a few words in *Life is Real . . .*, 30, which amount to nothing at all). It is equally typical of him, however, that he made a miraculous recovery—mainly through sheer will-power, but also helped, apparently (and inexplicably), by huge bonfires that he had made from giant trees in the Prieuré grounds. A month later, in August, he suddenly announced that the Institute was to be closed and everyone had to be gone within a fortnight. Quite a few returned after a while, and the Prieuré had a small, though fluctuating, population for several more years. But it was no longer Gurdjieff's centre of activities—though he often visited—and he ceased to have any formal pupils.[2]

Instead, he moved to Paris and turned his energies to writing. And again, this is a strange story. On the one hand, he appears to have wanted his books to be published; on the other, he made it extremely difficult for this to happen. True, his style is itself 'difficult'. But this is certainly deliberate and can be justified: the structure of language changes perception. But no one, as far I know, understands why he sabotaged efforts to have *Beelzebub's Tales* published by Knopf in New York (which would have been quite a coup). In the end, the book, which is regarded by all Gurdjieffians as a work of unique spiritual power, was published only after his death.[3]

[2] The Prieuré gradually ran down and was finally lost in 1933 when the mortgage payments could not be met.
[3] In fact, just a single example of Gurdjieff's writing appeared during his lifetime: *The Herald of Coming Good,*

Anyone who has studied Gurdjieff's life is bound to be struck by its apparent inconsistency. This can be seen as a flaw but it need not be. Fritz Peters, who lived at the Prieuré as a youngster and was Gurdjieff's personal aide, has given a striking account of A.R. **Orage** receiving a thorough brow-beating from Gurdjieff.

> Gurdjieff was standing by his bed in a state of what seemed to me to be completely uncontrolled fury . . . Orage . . . stood impassively, and very pale, framed in one of the windows. I had to walk between them to set the tray on the table. I did so, feeling flayed by Gurdjieff's voice, and then retreated, attempting to make myself invisible. When I reached the door, I could not resist looking at both of them: Orage, a tall man, seemed withered and crumpled as he sagged in the window, and Gurdjieff, actually not very tall, looked immense—a complete embodiment of rage . . .
>
> Suddenly, in the space of an instant, Gurdjieff's voice stopped, his whole personality changed, he gave me a broad smile—looking incredibly peaceful and inwardly quiet—motioned me to leave, and then resumed his tirade with undiminished force. This happened so quickly that I do not believe that Mr. Orage even noticed the break in the rhythm. (Peters, *Boyhood with Gurdjieff*, 31)

This is as good an example of Gurdjieff's role-playing as one is likely to find. Naturally, it tends to play havoc with so-called normal perception. Similarly, Gurdjieff reports that in 1928 he took a vow that "under the pretext of different worthy reasons", he would "remove from my sight all those . . . who make my life too comfortable" (*Life Is Real Only Then, When 'I Am'*, 45). This is, I think, a further instance of another essential Gurdjieff principle: that real work always requires the overcoming of obstacles—and not only for the pupil but also for the teacher.

Gurdjieff remained in Paris throughout World War II and, as one would expect, seems to have thrived in the 'difficult' conditions. He worked the black market (by his own admission): no doubt just for the sheer enjoyment of making deals but also for another reason.

> My family very big . . . old people who come every day to my house are also family. They my family because have no other family . . . For such people . . . impossible even to find any way to eat. But for me, not so. (Peters, *Gurdjieff Remembered*, 92f; quoted in Moore, 276)

Gradually, he began to attract French pupils (mainly via Jeanne **de Salzmann**). Then in 1947, **Ouspensky** died and many of his pupils made their way to Paris to learn from Gurdjieff—some for the first time, some (like J.G. **Bennett**) after a gap of over 20 years. A year later, in 1948, Gurdjieff had his second car crash and, like the first one in 1924, again survived by sheer willpower. Bennett has given a graphic account of Gurdjieff's appearance just a few hours after the accident.

> The door of one car opened, and Gurdjieff came slowly out. His clothes were covered with blood. His face was black with bruises. But there was something more that made me realize that I was looking at a dying man. Even this was not enough to express it. It was a dead man, a corpse, that came out of the car; and yet it walked . . .
>
> He walked into his room and sat down. He said, "Now all organs are destroyed. Must make new." He saw me and smiled, saying, "Tonight you come to dinner. I must

which was privately published in Paris in 1933. And this was decidedly not a coup. After all, anyone who has the money can publish a book privately. Moreover, Gurdjieff called in all copies after a year (but not before it had made an unfavourable impression on the writer, Rom Landau, who described it as "the work of a man who was no longer sane").

make body work." A great spasm of pain passed through him and I saw blood flowing from his ear. I thought, "He has a cerebral haemorrhage. He will kill himself if he continues to force his body to move." . . .

The dinner that night was agonizing beyond description. The doctor had come, and said that Gurdjieff must lie absolutely still, and that he was likely to die of pneumonia if not of the injury. Gurdjieff disregarded all advice and came in to dinner. He ate a few mouthfuls and listened to four toasts. Then at last he went off to bed. Bernard arrived with the morphia . . . [but] Gurdjieff said it was no longer necessary, as he had found "how to live with the pain." (*Witness*, 241–42)

But even will-power cannot keep someone going for ever. Fifteen months later, in October 1949, Gurdjieff died, aged 83—eight days after receiving the proofs of *Beelzebub's Tales*. His last statement to Jeanne **de Salzmann** (who went on to lead the 'orthodox' Gurdjieffians after his death) was that it was essential "to prepare a nucleus of people capable of responding to the demand which will arise" (*Life is Real Only Then, When 'I Am'*, xii). He did not say what the demand would be.[4]

In summary, then, his 27 years in the West (in France and his nine American trips) amount to the following: he started the Institute for the Harmonious Development of Man at the Prieuré—but did not keep it going; he had no formal groups for long periods of time—yet at his death, he said that a nucleus (a group) was essential; he worked for years on books which did not appear during his lifetime—and produced one, *The Herald of Coming Good*, in the space of a few weeks and then withdrew it; and he constantly made difficulties, which he rarely explained, for all and sundry: disciples, sympathizers, those who were mildly interested, complete strangers—and himself.

In short, Gurdjieff was uniformly difficult. But there is another side to the story, and it should be told. The key to it is that Gurdjieff was playing a role practically all of the time—for other people's benefit. And occasionally the mask was laid aside. **Bennett**, for example, says that after the accident (in 1948),

My wife and I both observed an extraordinary change. Before the accident, he had been the enigmatic Gurdjieff that we had known, and of whom so many stories are told. For four or five days after the accident, it seemed that he either could not or did not feel the need to play a role, to hide himself behind a mask. We then felt his extraordinary goodness and love for humanity. In spite of his disfigured face and arms—he was literally black and blue from head to foot—and his terrifying weakness of body, he was so beautiful that we felt that we were looking at a being from another and better world . . .

I believe that, for a few days, we caught a glimpse of the real Gurdjieff, and that all his strange and often repellent behaviour was a screen to hide from people who would otherwise have idolized his person instead of working for themselves. (*Witness*, 243)

And there is certainly evidence that Gurdjieff was able to benefit people in an extraordinary way. In 1945, Fritz Peters, who was serving in the American army at the time, arrived out of the blue at Gurdjieff's Paris flat in a state of nervous collapse.

I remember being slumped over the table, sipping my coffee, when I began to feel a strange uprising of energy within myself—I stared at him, automatically straightened

[4] The development of the Work after his death (and that of **Ouspensky** in 1947) is a story in itself but I simply do not have the space to tell it (though there are a few hints in the next entry, the **Gurdjieff Legacy**).

up, and it was as if a violent, electric blue light emanated from him and entered into me. As this happened, I could feel the tiredness drain out of me, but at the same moment his body slumped and his face turned grey as if it was being drained of life. I looked at him, amazed, and when he saw me sitting erect, smiling and full of energy, he said quickly: "You alright now—watch food on stove—I must go" . . . He was gone for perhaps fifteen minutes while I watched the food, feeling blank and amazed because I had never felt any better in my life . . . I was equally amazed when he returned to the kitchen to see the change in him; he looked like a young man again, alert, smiling, sly[5] and full of good spirits. (Peters, *Remembering Gurdjieff,* 82; quoted in Moore, 285)

In sum, then, Gurdjieff's behaviour was consciously adopted for the benefit of others and he could have acted differently if circumstances had required it. But those around him, unable to see what was required, could not understand why he behaved as he did; they were therefore bound either to judge him according to their own perception (which was in all likelihood mechanical and therefore of little intrinsic value, whether they agreed with him or not) or to suspend judgement altogether.

This, I think, is the case for the defence. The case for the prosecution is that Gurdjieff, even if he had all the abilities that are ascribed to him, was not entirely in control of himself. Hence he could make mistakes and cause people harm. In fact, he was a dodgey geezer, a London slang term that is used to describe someone who will take you for a ride—unless you have your wits about you. It is worth knowing that *geezer,* which more exactly means 'a difficult old man', is a corruption of *guiser,* an archaic word for 'actor'—that is, someone who *disguises* himself. This exactly fits Gurdjieff's case.

These two positions can be stated in terms of Gurdjieff's own teaching: the first holds that he acted entirely from essence and never from personality (though he may have made use of personality); the second says that personality did get the better of him on occasion. Essence is what one is born with— call it heredity, innate character, what you will (*Views from the Real World,* 143). Personality is what one acquires by education and upbringing. Essence is one's own; personality is not and can be radically changed. Essence can also be developed but not in the same way as personality. Essence requires struggle or danger in order to grow, not because danger is inherently valuable but because it provides the possibility that one will act consciously.

Consciousness is central to Gurdjieff's teaching, and has four levels: sleep; so-called waking consciousness; self-remembering; and objective consciousness. Gurdjieff has practically nothing to say about the first but is implacable in his assessment of the second. 'Normal' consciousness is nearly always passive, mechanical, and automatic. It is more or less worthless and all its values are derivative and without firm foundation. Someone who is passive is incapable of real action—because he or she is not truly conscious.

Man such as we know him, the 'man-machine', the man who cannot 'do', and with whom and through whom everything 'happens', cannot have a permanent and

[5] This experience of Peters puts a famous assertion of Gurdjieff's in a slightly different light:

> The fourth way is sometimes called *the way of the sly man.* The 'sly man' knows some secret which the fakir, monk and yogi [see below for an explanation of these three] do not know. How the 'sly man' learned his secret—this is not known. Perhaps he found it in some old books, perhaps he inherited it, perhaps he bought it, perhaps he stole it from someone. It makes no difference. The 'sly man' knows the secret and with its help outstrips the fakir, the monk, and the yogi. (*In Search of the Miraculous,* 50)

single I. His I changes as quickly as his thoughts, feelings and moods . . . Man has no individual I. But there are, instead, hundreds and thousands of separate small I's, very often entirely unknown to one another, never coming into contact, or, on the contrary, hostile to each other, mutually exclusive and incompatible.

The alternation of I's, their continuous obvious struggle for supremacy, is controlled by accidental external influences. Warmth, sunshine, fine weather, immediately call up a whole group of I's. Cold, fog, rain, call up another group of I's, other associations, other feelings, other actions. There is nothing in man able to control this change of I's, chiefly because man does not notice, or know of it; he lives always in the last I. Some I's, of course, are stronger than others. But it is not their own conscious strength; they have been created by the strength of accidents or mechanical external stimuli. Education, imitation, reading, the hypnotism of religion, caste and traditions, or the glamour of new slogans, create very strong I's in man's personality, which dominate whole series of other, weaker I's. (*In Search of the Miraculous,* 59–60)

The task, then, is to become conscious, which is to say to become independent of accidental influences or to develop our essence. Gurdjieff's method of accomplishing this is often called the Fourth Way—in contrast to three other 'ways': the physical, the emotional and the intellectual. These are also the names of three centres or 'brains' which operate in all human beings, and each defines a certain kind of reality: the physical (sometimes called the moving centre—and it also includes the instinctive and sex centres) is properly concerned with sensations of all kinds; the emotional centre, with feelings; the intellectual centre, with thought and discrimination. Ideally, each centre should be engaged only in those activities that are appropriate for it. But, says Gurdjieff, they are usually out of balance so that each centre attempts to do the work that should be done by another. For example, the intellectual centre, when applied to situations that require an understanding of feelings, produces abstract systems that simply miss the point; or "the emotional centre working for the thinking centre brings unnecessary nervousness, feverishness and hurry into situations where, on the contrary, calm judgement and deliberation are essential" (*In Search of the Miraculous,* 109). And since each centre has its own associations and its own memory, this imbalance generates a reality that is constantly changing but which we either do not notice, or if we do, do not understand. This is, of course, the succession of fleeting I's, noted above.

There are also three 'ways' which are associated with each centre: the way of the fakir (the physical centre); the way of the monk (the emotional centre) and the way of the yogi (the intellectual centre). Each one emphasizes the particular qualities associated with its centre. The way of the fakir stresses strong will, especially as it applies to sensations; the way of the monk concentrates on what Gurdjieff calls 'unity of feeling'; the way of the yogi is concerned with discrimination, knowing one's own mind. But, he says, they are all imbalanced because each centre is only aware of part of what we are (*In Search of the Miraculous,* 109). So in effect, there are two kinds of imbalance: what we might call individual neurosis (derived from the fact that centres try to do the work that is proper to one of the others) and 'spiritual lopsidedness' (derived from the fact that no one centre can reveal the whole nature of man).

The solution to this lack of balance is what Gurdjieff calls 'the Fourth way'. One learns to balance the three centres and thereby become aware of what was previously hidden or distorted. This is the beginning of consciousness in the true sense of the word: one is able to act and to know what it is that one is doing. But of course, this knowledge is not of the same order as what

we normally call knowledge. And it can be applied to every aspect of life, from drinking a glass of water to playing the piano. According to Gurdjieff, the Fourth way is sometimes called "the way of the sly man" (already quoted above, n. 5). This is as good a description of Gurdjieff as one is likely to find.

Moreover, Gurdjieff said repeatedly that in order to balance the three centres, one has to *work*. It is a constant effort and requires sacrifice. He called it 'conscious suffering', meaning putting up with something that one does not like—or more accurately, something which the habits and associations based on one of the three centres resists. This is different from suffering—physical, emotional, mental—that is itself derived from one of the centres; such suffering has little worth. Perhaps this is why Gurdjieff did not mind too much if he was the cause of it. He certainly said on more than one occasion that one of the functions of the teacher is to cause friction, because it is out of such friction that the possibility for a new direction is created. Or to put it another way: friction can wake us up.

The first stage of the process of becoming aware of what one is doing is self-remembering/self-consciousness, the third level of consciousness. But its flower is the fourth state, objective consciousness, in which one sees things as they really are (*In Search of the Miraculous,* 141). Jacob Needleman (himself a practitioner of Gurdjieff's Fourth way) experienced it when, as a six-year-old, he came home after school one day.

> In the room at the opposite end of the hallway I saw my grandmother on the floor, her head slumped against the wall. I very clearly remember walking up to her; and as I walked, suddenly, two different consciousnesses existed in me, each with different sets of perception, different thoughts, different feelings. One "consciousness" knew exactly what had happened and accepted it as though nothing essential had changed or could change. The other consciousness was not sure and did not want to have anything to do with the first . . .
>
> I bolted out of the house . . . shouting that Grandmother had fallen asleep on the floor. At that moment I saw that I wished to be deceived—or, to be exact, that one consciousness had absolutely no relationship to the perceptions of the other consciousness. (*A Sense of the Cosmos,* 53)

Needleman makes a number of observations about this incident. First, that the consciousness which knew what had happened was impersonal in the sense of being unconnected with the personality. In other words, it was objective. Second, that this objective consciousness could also be called love—because it was a total acceptance of the person (his grandmother), quite unlike his 'normal' feelings about her, which "existed off to one side and were almost all coloured by fear". Third, that objective consciousness reveals so-called 'normal' consciousness as incapable of perceiving reality as it is. Hence normal consciousness finds objective consciousness unbearable. Yet it is only objective consciousness that can come to terms with death, or as Needleman puts it, "can perceive reality on the same scale upon which death exists." And by the same token, it is only objective consciousness that can truly perceive and accept that we live in an infinite universe—because such a universe has nothing to do with personality; it is impersonal.

These are deep issues: love, death, infinity, reality, consciousness. And they were Gurdjieff's real concerns, not the individual constructions of the imbalanced, neurotic personality. This brings us to his cosmology and, by extension, his anthropology: that is, what he says about man's place in the scheme of

things. And like everything else about Gurdjieff, it is complex and difficult. I know of no other teaching quite like it.

According to Gurdjieff, the universe is imbued with intelligence from top to bottom. Man is a special creation and has a special purpose: the production of a certain kind of energy which feeds the cosmos and keeps it running. However, this does not mean that man is the top of creation or that the energy he provides is the main fuel which drives the universe. Rather, he occupies a somewhat lowly position—a bit like a small part of a vast machine that needs to be lubricated to keep the machine as a whole ticking over.

This energy is the product of conscious experience, of being awake, of development of essence rather than personality—there are various ways of expressing this idea in Gurdjieff's vocabulary. And it is here that his psychology and his cosmology-cum-anthropology coincide. Human beings have to become conscious; it is a cosmological requirement. If they do not, the universe (which is intelligent) will find other ways to create this energy. Man is not necessary and if he does not fulfil his function, he will be scrapped. Gurdjieff applied this teaching with considerable vigour. **Orage**, for one, understood this. That is why he told his American pupils that Gurdjieff

> perhaps doesn't care two hoots whether you fare well or ill, provided only that collectively you serve his aim (which incidentally is not personally selfish at all). (Welch, 116)

No assessment of Gurdjieff, in my opinion, can be of much value unless it takes this notion into account. One may disagree with the cosmology that gives rise to it, but that is another matter.

This is a teaching on a very large scale—the scale of objective consciousness. It has little place for the individual in the restricted, sentimental sense that that term is used in our modern, rationalistic society: the importance of *my* ideas or feelings. These are habitual and mechanical, and therefore more or less worthless. Rather, one has a certain obligation to a higher reality. And the higher reality—the intelligent universe—has an obligation to us: to wake us up by whatever means it can. And one of these ways is by means of a teacher.

We see, then, that we can only understand what a teacher is doing if we take into account both sides of Gurdjieff's teaching: the psychological and the cosmological. And this affects our assessment of Gurdjieff himself. From the psychological side, he was clearly someone who saw it as his duty to wake people up—something he could do because he could act freely, independently of external influences. This was often not very pleasant for them. But by the same token, he subjected himself to conditions that would keep him on his toes. From the cosmological side, he had a certain task to perform, whether he liked it or not, and whether it was successful or not. On his first visit to America, in 1924, he was asked about free will. He replied,

> Free will is the function of the real I, of him whom we call the Master. He who has a Master has will. He who has not has no will. What is ordinarily called will is an adjustment between willingness and unwillingness. For instance, the mind wants something and the feeling does not want it; if the mind proves stronger than the feeling, a man obeys his mind. In the opposite case, he will obey his feeling . . .
>
> Real free will can only be when one I always directs, when man has a Master for his team. An ordinary man has no master; the carriage constantly changes passengers and each passenger calls himself I.
>
> Nevertheless, free will is a reality, it does exist. But we, as we are, cannot have it. A real man can have it. (*Views from the Real World,* 146)

I think there is good evidence that Gurdjieff was a real man.

But this statement has to be understood in a certain way. It does not mean that he was a saint, simply (though it is not so simple) that he could see life for what it is, without self-deception. And since the universe is itself something of an experiment, perhaps we could say that Gurdjieff was an ad libber, trying out circumstances (and people) as he came across them. Many have found this very notion unpalatable. But from Gurdjieff's point of view, there was no alternative.

Primary sources: G.I. Gurdjieff, *Beelzebub's Tales to his Grandson* (sometimes incorrectly referred to as *All and Everything*, which is in fact the name for the first three titles in this 'Primary sources' section; New York, 1950); *Meetings with Remarkable Men* (New York, 1963); *Life is Real Only Then, When "I Am"* (New York, 1982); *Views from the Real World* (New York, 1973)

Secondary sources: P.D. Ouspensky, *In Search of the Miraculous* (New York, 1949) [which could in many respects be regarded as a primary source]; J. Webb, *The Harmonious Circle* (New York, 1980); J. Moore, *Gurdjieff: The Anatomy of a Myth* (Rockport, Massachusetts, 1991); C.S. Nott, *Teachings of Gurdjieff* (London, 1961); F. Peters, *Boyhood with Gurdjieff* (London, 1964); F. Peters, *Gurdjieff Remembered* (London, 1965); J.G. Bennett, *Witness* (Wellingborough, England: Turnstone Press, 1975); J. Needleman, *A Sense of the Cosmos: The Encounter of Modern Science and Ancient Truth* (Garden City, New York: Doubleday, 1975); L. Welch, *Orage with Gurdjieff in America* (London, 1982); a very full list of references to Gurdjieff (ranging from multi-volume books to the odd sentence here and there) can be found in J. Walter Driscoll ed., *Gurdjieff: An Annotated Bibliography* (New York, 1985)

Centre: Gurdjieff groups do not as a rule make their addresses public but I do have one (although it is over ten years old): Gurdjieff Foundation of California, P.O. Box 549, San Francisco, CA 94101, U.S.A.

COMPARE:

Other exotic pioneers: Madame **Blavatsky**

Teachers who are associated in various ways with Gurdjieff's ideas: J.G. **Bennett**, Leon **Maclaren**, Idries **Shah**, G.B. **Chicoine**, E.J. **Gold**, Oscar **Ichazo**, Jan **Cox**, and the entry that follows this one: the **Gurdjieff Legacy**

THE GURDJIEFF LEGACY: P.D. OUSPENSKY, MADAME OUSPENSKY, MAURICE NICOLL, RODNEY COLLIN, ROBERT DE ROPP, A.R. ORAGE, JANE HEAP, MADAME DE SALZMANN

Eight teachers who have had an impact on the **Gurdjieff-Ouspensky** Work

This entry presupposed the one on **Gurdjieff**; and it should also be read along with those on **Shah**, **Chicoine**, **Gold**, **Ichazo**, and **Cox**, all of whom are distinctly on the outer fringes of the Work (though they might argue that the outer edges is where the action is); and the ones on J.G. **Bennett** and **Maclaren**, both of whom are so complex (in different ways) that they just won't fit in with anybody else.

In fact, the whole Gurdjieff legacy is complex. What follows is a group entry, which, though it would undoubtedly have produced protests of various sorts from most, if not all, of the protagonists, does at least try to bring out their similarities and differences.

The fact that these eight teachers are all together, while others, also part of the Gurdjieff legacy, are treated separately, implies nothing whatever about their relative importance. It's just that people like **Bennett** and **Maclaren** illustrate certain aspects of the phenomenon of spiritual psychology that I find particularly significant.

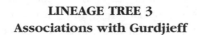

LINEAGE TREE 3
Associations with Gurdjieff

All these relationships have been the subject of much debate and the lines have various meanings (some of them apparently imcompatible). More details in the text.

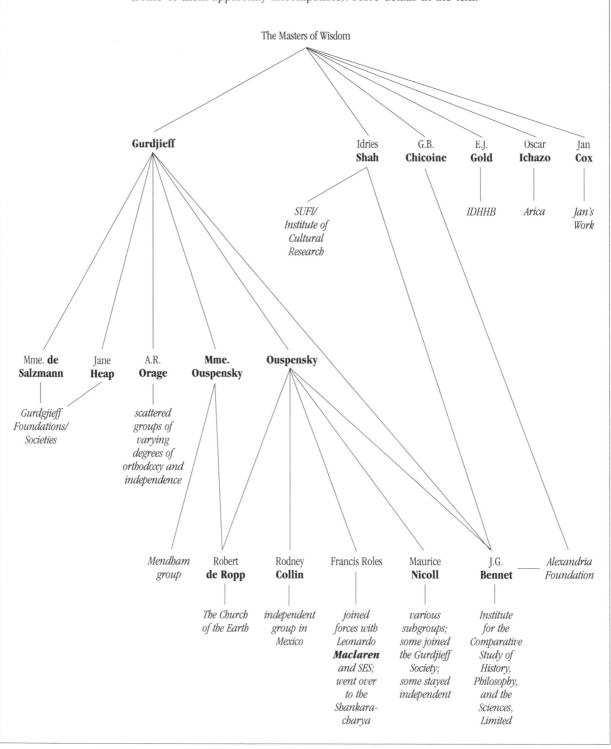

The GURDJIEFF LEGACY: P. D. OUSPENSKY

An early pupil of **Gurdjieff** and perhaps the most influential; taught independently of **Gurdjieff** for over 20 years and had his own pupils, some of whom thought that he made contact with a higher dimension just before his death

Any account of the Gurdjieff legacy must start with P.D. Ouspensky. He was born in Moscow in 1878 into a well-educated family. He was already a published author (*The Fourth Dimension* appeared in 1898 and *Tertium Organum* in 1912), had travelled in India and Ceylon/Sri Lanka, and was lecturing to audiences of a thousand or so when he met **Gurdjieff** (in Moscow in 1915). (His account of the meeting is given above under **Gurdjieff**.) He was captivated almost immediately and soon became Gurdjieff's pupil. For a period of six months in 1916, **Gurdjieff** taught a core group of six pupils, including Ouspensky, almost everything he knew; 25 years of research handed over in 25 weeks, as Moore puts it (Moore, 88). And it is worth pointing out that this was the only time he was ever systematic.

But Ouspensky did not remain a pupil for very long. In 1917, while with **Gurdjieff** in Essentuki (Georgia) during the chaos that preceded the Bolshevik revolution, he found **Gurdjieff**'s methods too abrasive and not in the interests of those whom he was supposed to be teaching. ". . . [F]rom this moment there began to take place in me a separation between Gurdjieff himself and his ideas" (*In Search of the Miraculous,* 368).

A year later, he withdrew as Gurdjieff's pupil.

> [I]t was difficult for me now to reconstruct everything from the beginning. But there was nothing else to do. Of course, all that I had learned during those three years I retained. But a whole year passed by while I was going into all this and until I found it possible to continue work in the same direction as G but independently. (*In Search of the Miraculous,* 374–75)

By a series of apparently haphazard steps, which I do not have the space to recount here, Ouspensky came to London (in 1921), where he gathered some pupils (provided mainly by A.R. **Orage**) and started to give lectures. A little later, **Gurdjieff** established himself at the Institute for the Harmonious Development of Man at the Prieuré near Paris, and although Ouspensky visited it more than once, his contact with **Gurdjieff** was more out of hope than conviction.

> [I]n spite of all my interest in G's work I could find no place for myself in this work nor did I understand its direction. At the same time I could not fail to see, as I had seen in Essentuki in 1918, that there were many destructive elements in the organization of the affair itself and that it had to fall to pieces. (*In Search of the Miraculous,* 389)

So in January 1924, he decided to go it alone. (In fact, he forbade the very mention of **Gurdjieff**'s name.)

The usual picture that emerges of Ouspensky is of an intellectual giant, strictly disciplined, rather austere and hidebound. His teaching method was unvaried: a lecture (sometimes given by a senior pupil), which might be a full-length 45 minutes or a mere five, followed by questions and answers. He regarded the interchange between pupil and teacher as more important than the lectures themselves. But on the other hand, the 'System' that he unfolded in his lectures was the foundation for the questions and without it, the questions would have been entirely superficial. But there was another side to him, and many people speak of his kindness, gentleness and courtesy. Nott says (referring to both Ouspensky and his wife):

when you study the lives of some of the 'saints', with their bickerings and limitations, you realise that the lives of the Ouspenskys were of a high order. (*Further Teachings*, 165)

In 1930, Ouspensky told a few close pupils that he was going to make his teaching more public.

> I am still as certain as ever that there is a Great Source from which our System has come. Mr. Gurdjieff must have had contact with that Source, but I do not believe that it was a complete contact. Something is missing, and he has not been able to find it. If we cannot find it through him, then our only hope is to have direct contact with the Source. . . That is why I am giving these lectures in London. (J.G. Bennett, *Witness,* 154)

A year later, Ouspensky published *A New Model of the Universe*. It consists of a number of chapters, all of which had been started—some as separate projects—before Ouspensky met **Gurdjieff** but which he had revised in subsequent years. Yet it is difficult to find anything in it that could be attributed to **Gurdjieff**; no enneagram, no law of seven or three. **Gurdjieff**'s name is never mentioned. It is as if he had learned nothing from him.[1] It was the first book on the 'System'.

The number of pupils increased from fifty to a thousand. In 1935, a large country house, Lyne Place, was bought in Surrey and used as the centre for Ouspensky's work. At the same time, **Mme**. **Ouspensky**, who had spent most of her time since 1920 with **Gurdjieff** in France, moved to England and began to take on her own pupils; and she continued to have them until her death.

In 1941, both Ouspensky and his wife went to America to escape the war. But Ouspensky returned to England in 1946 (leaving his wife and his American pupils behind). He proceeded to dismantle everything that he had worked to establish for over a quarter of a century. When he was asked if he had abandoned the System, he replied, "There is no System" (Webb, 449). In effect, he refused to play the teacher. He would not use the terminology that he had so rigorously created; admitted that he himself did not have the faintest idea how to answer certain questions; and said that he had nothing of importance to give (Webb, 450).[2]

Ouspensky's pupils reacted very differently to their teacher. Some thought he was old, ill, and failing. Others held that despite his physical ailments, which were real enough, he had entered a higher level of consciousness (Webb, 451). He did not have long to live. In mid-September 1947, he assembled his senior pupils and told them that they must construct everything again "from the very beginning" (Webb, 458, quoting Collin, *The Theory of Celestial Influence,* xxi). As his death approached, many of those around him became convinced that he was going through a grand transformation which amounted to an apotheosis: their teacher was becoming a higher being before their very eyes. (See, for example, Webb, 454.)

Ouspensky died on 2nd November 1947. Those who had remained faithful to him regarded it as a 'conscious' death. In Ouspensky's own system (if there is one), this is a very high claim indeed.

[1] He did ask to see Nott's copy of *Beelzebub's Tales* (which all Gurdjieffians regard as the last word on the teaching) but though he glanced at it, he did not read it. "It sticks in my throat," was his only comment (*Further Teachings,* 106).

[2] This, of course, is the exact opposite of **Gurdjieff,** who was constantly introducing new terms (much to the bewilderment of his pupils); never even hinted, as far as I know, that he did not know the answer to a question; and kept saying that he had something to give but where were those who could receive it?

What are we to make of this man? Assessments of him vary considerably, from the adulatory to the dismissive.[3] But it is, I think, perfectly possible to outline a basic Ouspensky myth—that is, an account that sees his life and teaching in terms of certain principles that he himself was true to. This is the myth of the teacher as seeker. As he said at the end of *Tertium Organum:* "The meaning of life is in eternal search. *And only in that search* can we find something truly new."

This was written before he met **Gurdjieff** and, according to the myth, he never deviated from it. Hence his contact with **Gurdjieff** was only an episode—important but not definitive—in his lifelong search. And according to his faithful disciples he succeeded in attaining the goal. They hold that the transformation that Ouspensky went through just before his death was in fact the result of 'inner' contact with the Source/Inner Circle of Humanity, which at the very last moment reached out and made its presence felt.

It is easy to see that the extended Ouspensky myth—that of the true seeker who finally breaks through into a higher dimension—carries an implicit critique of **Gurdjieff**: that he was mad, bad, and dangerous to know; that his teaching was incomplete; and that he had therefore failed as a teacher (whereas Ouspensky, who had stuck to his guns, had succeeded). There is a nice irony here: Ouspensky as a successful **Gurdjieff**; what **Gurdjieff** should have been like.

But of course there is a counter, Gurdjieffian critique of Ouspensky. One version of it holds that Ouspensky was more or less out of his depth from the beginning: a promising pupil who failed the tests that **Gurdjieff** had set for him in Russia (Webb, 380; Nott, *Further Teachings*, 47). (And this is the real difference between Ouspensky and **Orage**—see his section in this entry for details.) He was essentially a philosopher and lacked the ability to wake people up.[4]

We have covered quite a range: from adept and spiritual saviour, via honourable philosopher, to miserable failure. These differences depend on whether we hold an orthodox Gurdjieffism—itself a problematic notion, I hasten to add—in which there is no real place for Ouspensky, or an orthodox Ouspenskyism, in which Ouspensky made contact with the Source, independently of Gurdjieff, and could therefore—in **Collin**'s version, at least—make it available to others. These are deep waters and it is easy to lose one's bearings. Perhaps this explains why there has been no straightforward Ouspensky lineage. There are groups that are directly derived from him and could therefore claim to be his successors. But I have no details—another instance of the secrecy of the Work. More research is needed on all this. Perhaps when it is done, we will be able to place the Ouspensky cosmology in a larger context.

Primary sources: Tertium Organum (New York, 1920); *A New Model of the Universe* (New York, 1931); *The Strange Life of Ivan Osokin* (New York, 1947); *In Search of*

[3] And I must mention, just to get it out of the way, the statement of W.Y. **Evans-Wentz** that Ouspensky was an Arhat (Webb, 459). Here we have an American enthusiast of Tibetan Buddhism handing out plaudits to a Russian teacher who had no connection with Buddhism at all.

[4] And there appears to be little doubt that **Gurdjieff** himself had a low opinion of Ouspensky. Sometimes he was reasonably restrained: "Ouspensky very nice man to talk to and drink vodka with, but he is weak man" (*Further Teachings,* 107). But on another occasion, he said that if Ouspensky had not gone off on his own, he need not have "perished like a dog" (*Witness,* 252). On the other hand, he commended *In Search of the Miraculous* (Ouspensky's record of **Gurdjieff**'s teaching in Russia)—the only time **Gurdjieff** ever approved of anything written about his teaching, to my knowledge.

the *Miraculous* (New York, 1949); *The Psychology of Man's Possible Evolution* (New York, 1950 [London, 1951]); *The Fourth Way* (New York, 1957); [a full bibliography can be found in Driscoll's *Gurdjieff: An Annotated Bibliography*, details of which can be found at the end of Gurdjieff's entry]

Secondary sources: J.H. Reyner, *Ouspensky: the Unsung Genius* (London, 1981); M.E. Taylor, *Remembering Piotr Demianovich Ouspensky* (New Haven, 1978 [45 pp.]); J.G. Bennett, *Witness* (Wellingborough, England, 1983); R. Collin, *The Herald of Harmony* (Edmonds, Washington, 1984); Webb; Moore; Nott; [for these last three, see the secondary sources at the end of Gurdjieff's entry]

Centre: I have no details; addresses like this are kept secret

COMPARE:

Other 'cosmological' teachers: Madame **Blavatsky**, Omraam Mikhail **Aivanhov**, the **Mother**, James **Mackie**, L. Ron **Hubbard**, **John-Roger**, Elizabeth Clare **Prophet**

Others who have gone looking for the 'Secret East': Paul **Brunton**, Alexandra **David-Néel**

Before looking at some of Ouspensky's 'successors'—a term we should also use with care but especially in this context—we need to consider someone who has a place all of her own.

The GURDJIEFF LEGACY: Madame Ouspensky

An early pupil of **Gurdjieff** who later separated from him and taught alongside her husband—possibly as a Gurdjieffian fifth columnist

Mme. Ouspensky figures in all accounts of the lives and teachings of **Gurdjieff** and **Ouspensky** and was the only person who was close to both of them. She first appears in 1916 in St. Petersburg/Petrograd.[5] She met **Ouspensky** in that year and became a pupil of **Gurdjieff** as a result. It is doubtful if she and **Ouspensky** were ever legally married (Webb, 136) but nonetheless she is always known as 'Madame Ouspensky'.

It seems that she had a clear idea about the two men in her life right from the beginning: her husband provided board and shelter but **Gurdjieff** was the teacher. This is shown by the fact that when **Ouspensky** went to London in 1921, she and her family stayed with **Gurdjieff** and accompanied him to France. She lived at the Prieuré from its inception in 1922 until 1924, when, following his car crash, **Gurdjieff** effectively closed the place down and dispersed his pupils. Apparently, **Gurdjieff** wanted her to go to England, saying that her husband needed her (Webb, 389). But she did exactly the opposite: she took a flat in Asnières, near Paris, and resolutely stayed as close to **Gurdjieff** as she could.[6] She stayed in France until 1927 and then began to pay short visits to England every summer. She moved to England for good in 1931. At this point, all contact with **Gurdjieff** stopped; she did not see him again for 17 years. Moreover, she adopted **Ouspensky**'s rule forbidding the very mention of **Gurdjieff**'s name.

[5] Little is known about her life before then. She was born in 1874 and had a grown-up daughter by the second of her two marriages. She and Ouspensky had no children of their own.

[6] It was around this time—say 1924, though I have no firm date—that she made her famous statement (in a letter to J.G. **Bennett,** which he quotes from memory):

I do not pretend to understand Georgy Ivanovitch. For me he is X. All that I know is that he is my teacher and it is not right for me to judge him, nor is it necessary for me to understand him. No one knows who is the real Georgy Ivanovitch, for he hides himself from all of us. It is useless for us to try and know him, and I refuse to enter into any discussion about him. (*Witness,* 158)

Everyone agrees that Mme. Ouspensky was a force to be reckoned with: "she was, in every act, a great lady" (Bennett, *Witness,* 158); someone who sent less stalwart souls "groping for the smelling salts" (Moore, 92); a "terrible and vengeful mother", "shrewish", "vindictive" (Webb, 394, 445). Her method of teaching was undoubtedly derived from **Gurdjieff**. It included hard physical work, and perhaps more significantly, friction, which she often created by exposing the pretensions of those who were working with her. She said of herself (using the third person, which was her trademark, rather than the word 'I'):

> Madame is not a teacher. She always looks upon herself as a nursery governess who prepares children for school. (*Witness,* 323)

Some of her 'pupils' were extremely attached to her. **De Ropp**, for example, says that he had " a strong *guru/chela* relationship" with her which lasted over a period of several years (*Warrior's Way,* 109–110).[7]

In 1941, the Ouspenskys left Britain and went to America. But they did not stay together and each of them went their separate, yet interconnected, ways: while Ouspensky lectured in New York, Mme. Ouspensky recreated the conditions of Lyne at Franklin Farms in New Jersey. By this time, she was suffering from multiple sclerosis (according to de Ropp; Moore says Parkinson's Disease) and this may explain why she did not return to England with **Ouspensky** when the war was over. After **Ouspensky**'s death in 1947, she recommended that all her pupils, as well as those of her husband, make contact with **Gurdjieff** in Paris. This caused considerable consternation among those who had had more contact with **Ouspensky** than with her. Some of them followed her advice but others regarded her as a heretic and remained aloof. She also made contact with **Gurdjieff** herself and in 1948 he went to see her at Franklin Farms.

As far as I know, Mme. Ouspensky continued to teach at Franklin Farms (though greatly restricted by her illness). She supervised the publication of Ouspensky's *The Fourth Way* in 1957—but never wrote anything herself. She died in 1963, at the age of 89, and left no direct successor (though Mendham still continues under the direction of her grand-daughter).

Where can we place her in that extensive but somewhat ramshackled and incoherent edifice that is called the Gurdjieff Work? There are, I think, three possibilities. The first is that she really was an Ouspenskian. (**Bennett** seems to hold this view—see *Witness,* 158). But then we have to accept that Mme. Ouspensky really did leave **Gurdjieff** for good in 1931; that she applied **Ouspensky**'s rules forbidding the mention of **Gurdjieff**'s name because she agreed that it was for the good of their pupils; and that her return to **Gurdjieff** in 1948 was indeed the act of a heretic (an Ouspenskian heretic, that is). In short, we have to see her as a double turncoat: against Gurdjieff in 1931 and against Ouspensky in 1948.

Alternatively, she might have seen herself as an independent teacher—like Ouspensky. But whereas he was quite unlike Gurdjieff, she was in many respects a mini-Gurdjieff. It would follow, then, that she never went along with

[7] Since **de Ropp** considered her to be his guru, and since **Ouspensky**'s own contact with his pupils was, in **de Ropp**'s words, "quite indirect", it is not surprising that many of those who worked with Mme. Ouspensky considered her to be "the real leader of the work" (*Warrior's Way,* 108). All in all, it seems incontestable that Mme. Ouspensky was a stronger character than her husband. It is not at all easy, however, to know what **Ouspensky** thought of his wife. I am not aware that he ever made any comment about her at all; certainly none is recorded in the many hundreds of pages devoted to him and his work. He appears to have let her run things her way while he kept quiet. Whether this was out of respect, fear or indifference, it is impossible to say.

her husband's approach, which she regarded as fundamentally misconceived,[8] and adopted his rules simply because they happened to suit her. Her return to Gurdjieff in 1948—if it actually was a return—can be seen as an attempt to draw from her original well of inspiration. Bennett, always one to hedge his bets, also seems to have gone along with this view. He says that she "looked beyond Ouspensky to Gurdjieff, and beyond Gurdjieff to the Great Source from which comes every good gift and every perfect gift" (*Witness*, 234); and that after Gurdjieff's death, "she alone had the strength and courage to take up the task he had left behind him" (*Witness,* 323).

Finally, it is possible that she always regarded herself as Gurdjieff's pupil, accepted that she had been sent away by him, and tried to make the best of it. This interpretation is similar to the second except that it makes her, in effect, a Gurdjieffian agent inside the Ouspensky camp. In saying this, I am not suggesting that she and Gurdjieff were working an elaborate deception—simply that she remained true to Gurdjieff (given that he had precipitated the break in the first place). (There is an obvious similarity with **Orage** here.)

But the fact is that she never explained what she thought she was doing and we will never really know. (How very Gurdjieffian. . .).

Primary sources: Robert de Ropp, *Conversations with Madame Ouspensky: 1939-40 at Lyne* (Far West Press, 1974)

Secondary sources: Webb; Moore (for both of whom, see the end of Gurdjieff's entry); Bennett's *Witness* (see the end of his entry); Robert de Ropp, *Warrior's Way* (London, 1980)

Centre: I have never seen an exact address for Franklin Farms (Mendham, New Jersey) and therefore cannot give it. But it shouldn't be too difficult to find.

COMPARE:

Other strong-minded women teachers: Sri **Daya Mata**, Jiyu **Kennett**

We can now pass on to three of Ouspensky's pupils who became teachers in their own right.

THE GURDJIEFF LEGACY: MAURICE NICOLL

English pupil of **Ouspensky** who taught a psychological version of the System for over 20 years

If anyone can be called an orthodox Ouspenskian, Nicoll can. (See the section on **Ouspensky** for why orthodox Ouspenskyism is a problematic notion.) He was born in 1884 into a Christian family. His father, who was knighted in 1909, had a library of 25,000 books and entertained the likes of Lloyd George, Lord Asquith and Winston Churchill at home (Pogson, 25). Nicoll went to public school, got a first in the Natural Sciences Tripos at Cambridge and qualified as

[8] She did not go along with many of his ideas, particularly his notion that **Gurdjieff**'s teaching was incomplete and needed to be supplemented by knowledge hidden somewhere in the mysterious East. According to de Ropp (whom I am following here), she had little time for this sort of grandiosity and preferred the down-to-earth.

All the necessary conditions for work on Being were right there at Lyne Place in England. . . Without Work on Being knowledge amounted to nothing. Knowledge without Being would produce only a wiseacring professor, a man of many words. Madame Ouspensky had not much use for professors. (*Warrior's Way,* 109)

an M.D. in 1910. He served as an officer in the Royal Army Medical Corps in World War I, working in field hospitals in Mesopotamia. He returned to England in 1917 and made use of his war experience by pioneering a psychological approach to the problem of shell-shocked soldiers (who had hitherto been treated with electric shocks and cold showers).

But despite being a fairly typical member of the British upper middle-class, he was looking for something more. He was a member of the Psychosynthesis group, which met regularly under the aegis of A.R. **Orage**, and it was this connection that led him to meet **Ouspensky** shortly after **Ouspensky**'s arrival in London in 1921. Nicoll's response was immediate and positive: "He is the only man who has ever answered my questions" (Pogson, 70). He became a pupil and started attending meetings. So he was present when **Gurdjieff** came to London in 1922 to address **Ouspensky**'s group. And since the Home Office would not allow **Gurdjieff** to stay in Britain, Nicoll decided he would have to go to France. He therefore gave up his practice and went to live at the Prieuré, taking his wife and baby with him (thus demonstrating that he had both money and the courage of his convictions). Like other intellectuals, such as **Orage**, J.G. **Bennett**, and James Young, he was subjected to considerable onslaughts on his 'educated persona'; he was forbidden to read and worked long hours in the kitchens (Pogson, 80).

Nicoll stayed at the Prieuré from November 1922 to October 1923, with a gap of four months when he returned to England after the death of his father (Pogson, 72, 87, 92). I have never seen an explanation of why he left. Anyway, he returned to London, started up again in Harley Street and rejoined **Ouspensky**'s group. In 1931, after less than ten years as a pupil, Nicoll was authorized by **Ouspensky** to hold his own groups.[9] His pupils regarded themselves as working in parallel with **Ouspensky**'s (Pogson, 120)—a bit like a band of musicians who have formed under a leading player from another, earlier band and are playing music in the same style but with their own particular inflections.

He started slowly as a teacher and built his numbers up gradually. He had about 100 pupils by 1935 according to Nott (*Further Teachings,* 109); they included Rodney **Collin** and his wife for a short while. There is no doubt that he inspired considerable loyalty and affection. And it was often remarked how much he resembled **Ouspensky**. He had the same "rock-like integrity" and was similarly "catholic and encyclopedic in mental range, radiating wisdom" (Pogson, 249). But at the same time, he was "oddly simple and what might be called plain English" (which **Ouspensky** certainly was not).

Nicoll retired from medical practice in 1939 and devoted himself to his pupils. His numbers were growing and he moved into a series of large country houses in order to accommodate them. One of them was built by the group itself and provided many opportunities for the pupils to work on themselves. Pogson reports that during this venture Nicoll's presence "inspired us as Gurdjieff's presence had been the inspiration at Fontainebleau" (Pogson, 122). And she also says that Nicoll "reproduced Gurdjieff's Institute" with his own groups (Pogson, 92). But one has to remember that she had never been to the Prieuré—and had never met **Gurdjieff**, either. By and large, it seems that Nicoll was in the **Ouspensky** mould: a transmitter of ideas, not a dancer or a

[9] Nicoll's meetings were conducted along the same lines as **Ouspensky**'s: the group assembled and waited for Nicoll to arrive, who just sat there until somebody asked a question. It was the questions that set the tone and the direction of the meeting.

'stirrer' (that is, someone who stirs up people's lives). But on the other hand, as Webb points out, he did not have the casualties that **Gurdjieff** and **Madame Ouspensky**—those arch-stirrers—had (Webb, 399).

Nicoll was sufficiently independent of the Ouspenskys not to follow **Mme. Ouspensky**'s advice to seek out **Gurdjieff** in Paris after **Ouspensky**'s death in 1947. He said that he felt it was improper to "re-enter my mother's womb" (Moore, 293). In fact, several of **Ouspensky**'s pupils came to him because he gave "pure Work teachings". In fact, I think it is true to say that Nicoll was practically the only prominent person in the work who just carried on after the deaths of **Ouspensky** and **Gurdjieff** as if nothing had happened. He did not rush about all over the world, form any foundations of schools, link up with anybody else or try to find another teacher. In fact, the only new development was that he started to publish his writings, of which the best-known is the five-volume *Psychological Commentaries on the Teaching of Gurdjieff and Ouspensky* (published between 1954 and 1968)—over 1750 pages in all.[10] These extensive discursions were later endorsed by Madame **de Salzmann**, the upholder of Gurdjieffian orthodoxy, who wrote to Nicoll to say that they were "the exact formulation [of Gurdjieff's ideas] without distortion" and on a par with *In Search of the Miraculous* (Pogson, 263).

But the title is revealing: Nicoll was interested in the psychological side of the teachings and has little to say about cosmology; and what there is, is heavily dependent on Ouspensky's *In Search of the Miraculous* (which is itself taken from **Gurdjieff**, of course). There is nothing for Nicoll to apologize for in this. He stuck to what he knew—the psychological principles which he had learned from **Gurdjieff** and **Ouspensky**, and which he had applied to himself. There is every evidence that he had been successful in this and also that he had the skill to transmit these ideas and practices to others. But he simply did not have any first-hand knowledge of cosmology and could only pass on what he had been told (which is rather different from transmitting what you know).

Nicoll certainly was unusual but perhaps more complex than his facade of plain Englishness would have us believe. He managed to combine loyalty and independence—not an easy thing to do—and I think it is reasonable to argue that he never saw any real discrepancy between **Gurdjieff** and **Ouspensky**. To use a musical analogy: Nicoll played a particular version of the Gurdjieff-Ouspensky music, grounded in a good technique and with its own distinctive timbre. It is different from that offered by pupils of **Gurdjieff** (**Orage**, **Heap**, **Mme**. **de Salzmann**, for example), who can be regarded as leaders of small combos inside the larger Gurdjieff band and ultimately under his direction. It is also different from the music of Ouspensky's pupils such as **Bennett**, **Collin**, and **de Ropp**, all of whom produced compositions that go way beyond anything they played in the Ouspensky band—and who are decidedly not under **Ouspensky**'s direction (though **Collin** said he was). In fact, the only other person who started up her own band but still stuck to the music she had been taught was **Mme**. **Ouspensky**. But the difference here is that her talent was for energetic free-form improvisation, whereas Nicoll preferred lighter, more structured music played by a tightly-knit big band.

Nicoll died of cancer in 1953, aged 69. His group, which numbered about 600 at the time (Webb, 477), was kept going by his secretary, Beryl Pogson,

[10] His other main texts are *The New Man: An Interpretation of Some Parables and Miracles of Christ* and *The Mark*, which both present Christianity from the point of view of 'higher consciousness'.

for a while and then split up into a number of factions. They have kept themselves to themselves and I have no details. The largest group (which did not include Pogson) joined up with the orthodox Gurdjieff Society of London; a separate Ouspenskian tributary that flowed back into the main Gurdjieff river after a detour of 25 years or so, during which time it served as a way of passage for perhaps a thousand people.

Primary sources: The New Man (London, 1950; New York, 1951); *Living Time and the Integration of Life* (London, 1952); *Psychological Commentaries on the Teaching of Gurdjieff and Ouspensky,* 5 vols, (London, 1954–68); *The Mark* (London, 1954); the *Gurdjieff Bibliography* (see Gurdjieff's entry) contains other, lesser works

Secondary sources: B. Pogson, *Maurice Nicoll: A Portrait* (London, 1961)

Centre: I do not have an address for any independent Nicollian group; they do not make such things public

The second of Ouspensky's pupils whom I want to mention is about as different from Nicoll as could be. (We should not forget J.G. Bennett in all this but he has his own entry for reasons that I give at the beginning of this one.)

The GURDJIEFF LEGACY: Rodney Collin

English pupil of **Ouspensky** who developed an extraordinary mythology of both **Ouspensky** and **Gurdjieff** in which both were cosmic beings sent to inaugurate a new age; had his own pupils in Mexico for eight years before dying in mysterious circumstances

Collin (real name, Collin-Smith) was born in 1909 into a middle-class English family; his father was a wine importer and his mother a Theosophist. He took his degree at the London School of Economics and then worked as a journalist. His wife, whom he married in 1930 and who shared his interest in spiritual matters, introduced him to Eastern thought. In 1934, the two of them went to a meeting of Maurice **Nicoll**'s group in London. But they soon went on to Lyne Place, the country house in Surrey that **Ouspensky** had just acquired (perhaps at **Madame Ouspensky**'s instigation) as the centre of his—and her—activities.

It is significant, in the light of subsequent developments, that Collin very soon made **Ouspensky** the focus of the Work and developed a particularly intense relationship with him. It started when the two of them were in America during World War II but went up several gears during the last months of **Ouspensky**'s life in England. Collin was utterly convinced that he was the only one who was open enough to see what **Ouspensky** was trying to reveal. He developed an extensive Ouspenskyology, in which **Ouspensky** became transformed into a cosmic figure—part of a great spiritual drama that will transform mankind. A new Age of Harmony, which is to supersede Christ's Age of Love, has been established by the Hierarchy (which is Collin's name for **Ouspensky**'s Inner Circle of Humanity). Its messengers were **Gurdjieff**, "the Greek destroyer of men's complacency, trickster, magician, hypnotist, juggler of light and dark, new Orpheus. . . compassionate sorcerer, diabolic saint; djinn from alchemic bottle. . . " (*Herald of Harmony,* 16), and **Ouspensky**,

the Russian—firm and invisible. Compiler of wisdom; master of silent experiment, unrecognised effect; new scientist, himself his laboratory, his pupils retorts and their contents, the work transmutation. Stern guide, most loving friend. . . (ibid.)

They were equals, according to Collin, but so different that it was necessary to keep them apart.

Between these poles the lightning arked. (*sic*) "Be drawn to either pole," the Russian warned, "Cling where you are drawn. Don't play between—the current is dangerous." Men misunderstood, piously prayed the poles be reconciled. Some tempted the tension, were shocked. But most heeded the warning, and their little magnets growing polarised, the great field of force was amplified. (*Herald of Harmony,* 17)

Collin saw himself as the recipient of a series of revelations, all of which were mediated through **Ouspensky** in some way. On one occasion, shortly after **Ouspensky**'s return, Collin was seized with the necessity of going back to America to see **Mme. Ouspensky**. He was 'possessed'—this is his word (*The Theory of Eternal Life,* 116)—by **Ouspensky**, who was still alive, while on the plane and plainly upset **Mme. Ouspensky**—not an easy woman to knock sideways—by talking in the voice and manner of her husband, and implying that the mantle of the teacher had fallen upon him (Webb, 456).

He also regarded his writings as inspired by **Ouspensky**. When **Ouspensky** died, Collin locked himself into **Ouspensky**'s room and stayed there, without food or water, for six days. During this time, he received a further set of insights-cum-revelations which went into another book, *The Theory of Eternal Life*. It is concerned with what might be called 'cosmological transformation'—the movement from one world to another.

> [S]ome tremendous birth-pang, involving all parts of the universe, has taken place. A crack has been produced through all levels of matter, and through time itself by the direct intervention of electronic energy. Through this crack the perception of ordinary men may for a short time see into the higher worlds and into the past and future. And through it, for all beings, there now lies a way of escape which did not exist before. (*The Theory of Eternal Life,* 112–13)

According to Collin, **Ouspensky** is now even more available than when he was alive.

> Those who believe in him become part of his work, and he in turn becomes responsible for them. (Webb, 484)

This Ouspenskyology has obvious similarities with certain forms of Christology. And it has to be said that there is nothing in **Ouspensky**'s writings that even hints at such a metaphysic. But it is intoxicating stuff and therefore hardly surprising that a group of **Ouspensky**'s pupils gathered around Collin after **Ouspensky**'s death. In 1948, he went to Mexico (which he already knew) and started a community in Tlalpam, on the outskirts of Mexico City, along with his wife and a small number of followers. He began to hold meetings and attracted both ex-patriates (British and American, I think) and Mexicans.[11] He designed a planetarium—actually, a "three-dimensional diagram" (Webb, 485) —representing the coming Age of Harmony, with a Chamber of the Sun and a Chamber of the Moon, both hollowed out of rock.

However, it soon became apparent that he was really on a different course from everybody else in the Work. In 1954, one of his followers, Mema Dickins (the Mexican wife of an Englishman), began to receive messages mediumistically from both **Gurdjieff** and **Ouspensky**. This, of course, exactly fitted

This esoteric building immediately brings to mind another: the **Mother's** *Matrimandir.*

[11] Groups were also started in Peru, Chile, Uruguay, and Argentina (though I am not sure if all of them began during Collin's lifetime). I do not know how big they were but their mere existence is significant (and is part of the spread of the principles of spiritual psychology to South America—a subject that needs to be written up). Jorge Luis Borges, the writer and Nobel Prize winner, attended the one in Argentina; and it is possible that both Oscar **Ichazo** and Silo (*aka* Mario Luis Rodriguez Cobos) made their first contact with the Work via one of Collin's groups.

Collin's cosmology (but no one else's). He went back to Europe in 1954 in the company of his wife and Mrs. Dickins, looking for "traces of schools of the past" (Webb, 491, quoting Collin). But he finished his voyage of discovery in the heart of Europe, in Rome, where he was received into the Catholic church. Collin claimed that he had joined esoteric Catholicism and that there was therefore no contradiction with his teaching concerning the cosmic-sum-salvific roles of **Gurdjieff** and **Ouspensky** (Webb, 492). Indeed, he calls the Age of Harmony inaugurated by the two of them, the New Christianity (*Herald of Harmony,* 21).

However, just two years after his adoption of esoteric Christianity, Collin died. I summarize Webb's account here. Collin was in Lima working with his group there. Wandering the streets by himself, he came across a crippled boy, Modesto, who was begging. He took it upon himself to look after the boy, buying him shoes, clothes and food. But he did not stop there. He told his wife that he had offered his body to God if the boy could be healed of his deformity. The next day, having already been taken to the place where Modesto slept—in the bell tower of the cathedral—Collin went back there to find him.

> He sat down on a ledge below the parapet, and began to tell Modesto how he was going to arrange an operation to be carried out on his twisted leg. All the time he was talking, he kept his eyes fixed on the statue of Christ on the mountain opposite. Suddenly he stood up, gave a gasp, and lurched forward on to the top of the para-pet, grasping with his hands the two beams which supported the arch above it. Then his head struck one of the beams, and he fell into the street below. An old woman who saw him fall said that he fell feet foremost, his arms outstretched in the form of a cross, and his head canted backward as if his gaze were still fixed upon the statue. He lay on the ground in a peculiar cruciform position, with his right leg drawn up just as the cripple boy's had been. He was smiling. (Webb, 495)

Collin was 47 when he died. As far as I know, Modesto was not healed. Nor have I any firm information about what happened to Collin's community after his death. Some of them went over to Subud (for which, see **Bennett**'s entry) but it does not seem likely that there was anywhere much for them to go. Collin's cosmology—which is really a derivative of his Ouspenskyology— was so recondite and so dependent on his own peculiarly intense vision of things, that it has hardly any connection with any other teaching, whether part of the Gurdjieff-Ouspensky work or not. And who could claim to be able to follow where Collin had led? He had called to others to climb aboard the boat of salvation, designed by the Hierarchy, manned by **Gurdjieff** and **Ouspensky** as twin captains, and with himself as first mate. But the rest of the crew really had little idea of what was going on. It is hardly surprising, there-fore, that the ship drifted and got stuck in the shallows. So nearly 40 years after Collin's death, there is simply nothing substantial we can point to.

Primary sources: Rodney Collin, *The Theory of Eternal Life* (Cape Town: Stourton Press, 1950); (London: Vincent Stuart, 1956); *The Herald of Harmony* (Tlalpam, Mexico, 1954); *The Theory of Celestial Influence* (London: 1954); *The Theory of Conscious Harmony:From the Letters of Rodney Collin* (London: 1958)

Secondary sources: James Webb, *The Harmonious Circle: An Exploration of the Lives and Work of G.I. Gurdjieff, P.D. Ouspensky and Others* (London: 1980); Joyce Collin-Smith, 'Beloved Icarus', *Astrological Journal,* XIII (4), Autumn 1971, 32–41; Joyce Collin-Smith, *Call No Man Master* (Bath: Gateway Books, 1988)

Centre: I have no information

COMPARE:

Other teachers who claim to be part of a new age: the **Mother**

The third 'teaching pupil' is different again:

THE GURDJIEFF LEGACY: ROBERT DE ROPP

One-time pupil of both Ouspensky and **Madame Ouspensky** who became disillusioned with them and went on to become an independent teacher

De Ropp was born in 1913, the son of a Teutonic Knight according to his auto-biography, *Warrior's Way*. His father's mother was a Cossack and her maiden name was Gurjef (*Warrior's Way,* 3)—a nice coincidence if ever there was one. However, his mother died when he was only six, and his life thereafter was split more or less evenly between genteel British—a prep school (though I know that many prep schools are far from genteel)—and a somewhat rougher time in Lithuania and Australia. He went to the Royal College of Science in London and did his Ph.D. in plant physiology. (He was a researcher for much of his adult life.)

In 1936, still in his early twenties, he met **Ouspensky**, who told him, "Believe nothing. Test everything." This had an immediate effect: "I suddenly realized that here was the teacher I had been seeking" (*Warrior's Way* 93). He came to have a high opinion of **Ouspensky**, who, he says, was much more than just an interpreter of **Gurdjieff**. But he had an even higher regard for **Madame Ouspensky**. What he says about her can be found in the section on her in this entry and I simply summarize it here: that he was strongly attached to her—in fact, she was his guru; and that she gave him the "most direct experience of awakening and the kind of effort that awakening involves" (*Warrior's Way,* 110).

He threw himself into the life at Lyne, going there every weekend from 1936 to 1945 (even though the Ouspenskys themselves went to America in 1941). But when he met up with them there (in 1945), he was disappointed.

> I was entertaining grave doubts about the wisdom of my teachers. . . I could no longer maintain, as I had done previously, that [they] could not make mistakes. Obviously the both could and did. Their worst mistake had been deserting their group to take refuge in America. Now they were compounding the mistake by trying to run a school of the fourth way by remote control. They had lost that special power that the Sufis call baraka, but were either unaware of the fact or not honest enough to admit it. . .
>
> There was Ouspensky drinking himself into a stupor, and there was Madame, the teacher I most loved, remote and bedridden, trying to run the show through the Archangels. A fine old mess! (*Warrior's Way,* 172, 174, 175)

Having become disillusioned, de Ropp was on the look out for some alternative. In 1948, he met **Gurdjieff** for the first and only time, during Gurdjieff's final visit to America. He describes him as "the most extraordinary human being I have ever met"; "his look was strange, sad, old, utterly objective" (*Warrior's Way,* 197). But despite the obvious attraction, he remained critical. He did not like the constant atmosphere of alcohol and smoke, and was not impressed by many of **Gurdjieff**'s followers, whom he calls 'dopes'. In the end, he decided that he did not have the courage to follow "that particular branch of the Warrior's Way" (*Warrior's Way,* 202).

De Ropp developed a theory of the Master Game, his term for the ultimate human endeavour. "Life games reflect life aims. And the games men choose to play indicate. . . their level of inner development" (*The Master Game*, 12). He gives a table of the basic games, together with their aims. I reproduce it here with very slight changes that do not affect the sense at all.

Game	Aim
Moloch Game	glory/victory
Cock on Dunghill	fame
Hog in Trough	wealth/enjoyment
No game	*No aim*
Householder Game	raise family
Art Game	beauty
Science Game	knowledge
Religion Game	salvation
Master Game	awakening

(*The Master Game,* 13)

But theory is not enough; one needs a teacher. To this end, de Ropp established his own spiritual community. It was called The Church of the Earth and was based in Santa Rosa, California. It came into existence around 1967, I think, and must have still been going in 1974, when he published his final book, *The Church of the Earth: The Ecology of a Creative Community*. As far as I can tell, it was a forerunner of sorts of what might be called 'spiritual ecology' but with a hands-on approach. That is, it had practical activity—gardening, farming, fishing—at its core but saw these pursuits as inherently transforming if done with conscious awareness. 'Davy Crockett meets Gurdjieff' might be a somewhat flippant, but not entirely inaccurate, way of describing it. But by de Ropp's own admission, the community never amounted to very much. "The group flew apart, torn to bits by petty rivalries, jealousies, spiritual ambitions and games of one-upmanship. . . we lacked compassion" (*Warrior's Way,* 333).

This is commendably honest, at least. But the truth is that de Ropp never had the qualities required to keep a community going. Good shoes, using the best leather and made by craftsmen, last for years, even decades; they actually improve as time goes by. Second-rate shoes—not using the best leather and not made by craftsmen—just fall apart. But they are cheaper, of course. (I am using the term *cheap* simply in the sense of *designed to do a limited job,* not to mean *cheap and nasty*.) The West is finding out that cheap teachings, like cheap shoes, do not last very long. This is fine if all one wants to do is go for a short stroll. But long journeys—demanding journeys—require something extra.

De Ropp died in 1987, aged 74. I do not want to trivialize his achievement; he did at least design a style of shoe. But no one is wearing them any more.

Primary sources: Robert de Ropp, *Drugs and the Mind* (New York, 1957); *Man Against Aging* (New York, 1960); *Science and Salvation* (New York, 1962); *The Master Game* (New York, 1968); *Sex Energy* (New York, 1969); *The New Prometheans* (New

York, 1973); *The Church of the Earth* (New York, 1974); *Conversations with Madame Ouspensky, 1939–1940, at Lyne* (San Francisco, 1974) [just 22 pages]; *Warrior's Way: The Challenging Life Games* (New York, 1974)

Secondary sources: None

Centre: No longer extant

COMPARE:

Other leaders of spiritual communities (in various senses of this term): Swami **Abhayananda**/Bill Haines, Shrila **Bhaktipada**, Andrew **Cohen**, Master **Da**, Ayya **Khema**, Sri **Krishna Prem**, Swami **Kriyananda**/Donald Walters, Lee **Lozowick**, Leo **Maclaren**, the **Mother**, **Nyanatiloka** Thera, Elizabeth Clare **Prophet**, Swami **Radha**, Ven. **Sangharakshita**, Joya **Santanya**, **Stephen**, Guru **Subramuniya**, Ajahn **Sumedho**, Swami **Turiyasangitananda**

<div align="center">

I now turn to three of Gurdjieff's pupils who became teachers.
(They are given in the chronological order of their appointment.)

</div>

The GURDJIEFF LEGACY: A.R. ORAGE

Influential English critic who became **Gurdjieff's** representative in America

Orage (pronounced 'Orridge') was born in 1873, the son of an East Anglian farmer who had fallen on hard times through gambling and drink. The family was poor—his father died when he was just a year old—and life was not easy. Orage shone at school and would certainly have gone to university if he had been able to afford it. Instead, he became a schoolmaster (near Leeds), got married, and began the investigation of ideas which was the hallmark of his life. He joined the Theosophical Society around 1896 and (soon became a lecturer for it); was briefly acting secretary for the Society for Psychical Research; and published two books on Nietzsche (in 1906 and 1907).

However, Orage's most telling contribution to the intellectual life of his time was as editor of the *New Age*. He and Holbrook Jackson bought it in 1907 but Orage soon became its guiding light and he turned it into the best literary review in the country. Shaw, Wells, Arnold, and Chesterton were all regular contributors; and in addition Orage published new writers, most notably Katherine Mansfield (who died at the Prieuré, Gurdjieff's centre in France).

He also carried **Ouspensky**'s 'Letters from Russia' in 1919—the two men had already met in London in 1913—in which **Ouspensky** described life during the upheaval following the Russian revolution (but did not mention **Gurdjieff**, despite the fact that **Ouspensky** spent some time with him during this period). It was entirely natural, then, that Orage should meet **Ouspensky** again when the latter arrived in London in 1921. Orage was impressed with him and said that he was a man he could "believe in" (Webb, 222).

But when Orage met **Gurdjieff** (in London in 1922), he was even more impressed. "Ouspensky made one feel like an alchemist in search of gold", he said, "but Gurdjieff was the gold itself" (Welch, 24). So when Gurdjieff opened his Institute for the Harmonious Development of Man at Fontainebleau, near Paris, later in 1922, Orage was one of the first to join him. He sold the *New Age,* abandoned his life in London, said goodbye to Ouspensky (whom he never met again), and went looking for ideas of a different kind—ideas that change people. He was 50 years old.

In the autumn of 1923, **Gurdjieff** sent him to New York to prepare for **Gurdjieff**'s own arrival there. It is from this point that Orage can be seen as in some sense **Gurdjieff**'s representative. Exactly what that meant was never very clear and it was certainly a rocky ride. I cannot go into all its twists and turns here. Suffice it to say that after six years or so in New York, teaching **Gurdjieff**'s ideas as best he could,[12] he found himself on the receiving end of a particularly intense bout of Gurdjieffian 'difficulty'. In February 1930, **Gurdjieff** came to New York, heralding his arrival by sending telegrams from his ship, the *Bremen*. For example: BREMEN BRINGS THOUSAND KILOS DIS-ILLUSION; HUNDRED KILOS MOMENTARY HAPPINESS, AND TEN POUNDS RETRIBUTION. SIGNED: AMBASSADOR FROM HELL. A second read: IF LOVE NOT DISSIPATED, ARRANGE BATH AND PARTY. SIGNED: GRANDSON AND UNIQUE PHENOMENAL GRANDMOTHER. Typical 'difficult' **Gurdjieff**, one might think. Nothing unusual there. But Orage was finding that his relationship with Gurdjieff was no longer working effectively.

> One thing remains unshakeably true—the ideas are all the world to me, and I shall always be ready to cooperate in their spread provided I myself continue to increase in their understanding. What I cannot do any longer is to continue teaching without also learning—and Gurdjieff has ceased to teach *me*. (Welch, 109)

This threw his New York group into some disarray. So when **Gurdjieff** arrived on a second visit in November of 1930 (when Orage was away in England), he was asked why Orage was feeling this way. **Gurdjieff**'s response was that it was actually he, **Gurdjieff**, who was dissatisfied with Orage. (*See Life is Real. . .* , 90).

The obvious response to this criticism was immediately given by Louise Welch—to **Gurdjieff** himself.

> 'If Orage made a mistake or did not know how to go on, it was your fault. He taught us what he learned from you, and you did not give him the additional material he needed.' I was appalled at my impertinence. For a long moment I waited to be slain.
> 'Bravo!' Gurdjieff said, looking pleased, even approving. (Welch, 111)

And she goes on to say,

> At once my understanding of the whole event had to be revised. There was something in Gurdjieff's absence of annoyance that made me wonder what his underlying, teaching reason was for what seemed to us an attack on Orage. Gurdjieff was never petty. What was he trying to tell us? (ibid.)

The short answer, I think, is: play the game. That is, do not get stuck in your role.

Gurdjieff held a few meetings, with Orage (who had returned from England) present as an ordinary member, but then went back to France. He left behind him, in Orage's words, "an almost hopelessly scattered and hostile group" (Moore, 240). The two men never met again. Orage stayed on in New York for a while but his position was so ambiguous as to be untenable. He returned to England in July, 1931 and spent the rest of his life there. He went

[12] Orage's pupils—and he did have pupils, even though everyone know that **Gurdjieff** was the 'real' teacher—included Margaret Anderson and Jane **Heap,** the editors of *The Little Review,* and through them, other literati such as Waldo Frank, Jean Toomer, Gorham Munson, and Hart Crane. According to Claude Bragdon (the translator of Ouspensky's *Tertium Organum*), "His charming manner and brilliant mind did much to counteract the bewilderment in which Gurdjieff so often left his auditors" (Welch, 32).

back to his old skills and started a magazine, *The New English Review*. But it was not a great success—certainly not on a par with the *New Age*.

After a couple of years in England, Orage's heart began to give him trouble. He died suddenly, but quietly, in his sleep in 1934, aged 61, leaving behind him a young wife and a son of five. There were many tributes to him, mainly by people who were not connected with **Gurdjieff**. All of them mentioned his integrity and his capacity to inspire loyalty and affection. Even **Gurdjieff**, when he heard of Orage's death, wept and said that Orage was his brother (Welch, 137). (However, he uses the phrase "close friend" in *Life is Real. . .* , 154.)

So what did Orage accomplish? To all outward appearances, not very much. But perhaps we should rephrase the question: what did **Gurdjieff** accomplish *through* Orage? The 'orthodox' answer is that **Gurdjieff** deposited in Orage, by his demands, a certain substance that has its significance and value in the cosmic scheme of things. In fact, **Gurdjieff** was not particularly interested in individuals—or even groups—as such, but rather in what could be generated through them. Orage was well aware of this. He wrote to his pupils in 1930, when he was in England and **Gurdjieff** was creating havoc in New York,

> For he is among you who perhaps doesn't care two hoots whether you fare well or ill, provided only that collectively you serve his aim (which incidentally is not personally selfish at all) *and* at the same time are offered individually a chance, if only a bare chance, of possible 'salvation'. (Welch, 116)

This is what Welch meant when she said that **Gurdjieff** was never petty (quoted above).

According to Nott, a light shone through Orage at the end of his life (*Further Teachings,* 52). But in Gurdjieffian terms, this light was not for Orage's benefit; it was on an altogether grander scale. Hence **Gurdjieff**'s rough handling of Orage is in a way a red herring. Individual transformation is subsumed under a higher-order reality.

If we accept this, then Orage did something far more significant than lead groups—and not very large groups, at that—in New York for six years. But in order to accept it, we have to accept **Gurdjieff**'s whole psychology-cum-cosmology. If, on the other hand, we reject that package, then **Gurdjieff** is reduced from a cosmic teacher to an unusual man who was making things up as he went along. And by extension, Orage was someone who climbed aboard the ship, had an exhilarating and somewhat stormy voyage—and was made to walk the plank.

I leave it at that.

Primary sources: Psychological Exercises (New York, 1930); *On Love: Freely Adapted from the Tibetan* (London, 1932); for a detailed bibliography, see *Gurdjieff: An Annotated Bibliography* at the end of Gurdjieff's entry

Secondary sources: L. Welch, *Orage with Gurdjieff in America* (Boston, 1982); C.S. Nott, *Teachings of Gurdjieff: A Pupil's Journal* (London, 1978); C.S. Nott, *Further Teachings of Gurdjieff: Journey Through This World* (London, 1978); P. Mairet, *A.R. Orage: A Memoir* (London, 1936); Webb; Moore (for both of which, see Gurdjieff's entry)

Centre: None

The second of Gurdjieff's 'teaching pupils' actually started off under Orage's tutelage.

American follower of **Gurdjieff** who became a sort of invisible teacher

All of **Gurdjieff**'s pupils who attained any prominence in the Work—and every one of them is in this book—are unusual. They had to have a strong character to withstand the constant demands that **Gurdjieff** made upon them. Heap is a good example.

She was born in 1887—some claim 1884 but everything I say here assumes the later date—in Topeka, Kansas, of an English father and a Norwegian mother who was herself half-Lapp; and it shows in Heap's face. She had an extraordinary childhood. Her father was warden of a lunatic asylum in Kansas—both somewhat out-of-the-way places. She was an only child and very lonely.

> There was no one to ask anything. There was no way to make a connection with 'life.' Out there in the world they were working and thinking; here we were still. Very early I had given up every one except the Insane. (Webb, 278)

The one thing that sustained her were fantasies about art, and in particular, artists. She formed the idea of somehow going to Paris.

In 1916, at the age of 29, she met Margaret Anderson in Chicago. The two hit it off immediately and Heap became joint editor of *The Little Review*, which Anderson had started in 1914. It was an *avant garde* journal which came to have a huge influence on bohemians-cum-intellectuals in America. It was the New York wing of this group whom A.R. **Orage** contacted in 1923, saying that he was coming to America in advance of **Gurdjieff**'s own visit. So Heap (and Anderson) met **Gurdjieff** when he arrived in New York in January, 1924, and I think it is fair to say that she devoted the rest of her life to him (and to the Work).

Heap quickly became a leading member of the New York group—in fact, she began leading groups of her own (under **Orage**'s guidance) as early as 1926. But her real wish was to live and work with **Gurdjieff** permanently. Ever a woman of action, she accordingly left New York and arrived at the Prieuré in 1928, fully intending to become a full-time pupil. But **Gurdjieff** rarely did anything that was expected of him. He was devoting all his spare time to writing—as Heap well knew—and did not want to take on any pupils. So he sent her off to Paris to be a teacher. Admittedly this was in a modest capacity: he simply told her to give a weekly talk on his ideas (Moore, 226) and then left her to get on with it. In fact, we do not really know what she taught. She herself had never been taught by **Gurdjieff** (though she had been to the Prieuré several times) and it seems likely that she had to rely on what she had learned from **Orage** in New York.

We also know very little about her group. The only certain members were all lesbians—Margaret Anderson, Georgette Leblanc, Solita Solano, and Kathryn Hulme are the best-known—though there may have been others; perhaps even some men. Anderson, Leblanc, and Hulme were all writers. But Heap was losing her interest in 'art'. She closed *The Little Review* down in 1929, shortly after her move to France, saying in her final editorial that art was not enough and that a greater challenge would be to "take on pursuits more becoming to human beings" (Moore, 231).

Then in 1935, and as far as I can tell, out of the blue, **Gurdjieff** sent her to London to teach there.[13] She immediately made enquiries to see if she could

[13] Her more committed pupils were thus left high and dry—not the first time this had happened in the wake of **Gurdjieff**'s sudden changes of direction. A handful of them decided to approach him personally—they had

join **Ouspensky**'s group. This says something for her openness of mind; but **Ouspensky**'s response is less impressive. He rejected her outright because she was a lesbian (*Further Teachings,* 78). Nothing daunted, she began her own work as a teacher. But as in Paris, we do not really know what she taught. Her group kept to itself and, again as in Paris, its members did not meet **Gurdjieff**; at least, not until 1946, eleven years after her arrival in London, when a small number went to Paris for the first time.

Heap published nothing (like **Madame Ouspensky**) and the only indication of her approach is a collection of aphorisms in Anderson's *The Unknowable Gurdjieff*. They are arranged under headings—Three Centres, Self-Observation, Conscious Suffering, and so forth—and would be familiar to anyone who had participated in the Work.

> It's almost a desire in man to be asleep. We're so asleep that unless life becomes too difficult we don't wake up. A shock can waken you. (*The Unknowable Gurdjieff,* 53)

> Self-observation is conscious suffering. (ibid., 57)

> One hasn't muscles, only flesh, if one hasn't stress. (ibid., 66)

There is little doubt that she had her own difficulties in life. But maybe they provided her with 'muscles'. Nott gives a portrait of her as having

> the most stimulating and penetrating mind of any American woman I have ever met, and like all people with strong positive vibrations her negative ones were equally strong. She could be quite ruthless and regardless of near friend or old foe when she wanted something. She had a strong masculine side; as she said to me, 'I'm not really a woman'. (*Further Teachings,* 78)

And, as Moore points out, her "practised ability in side-stepping social norms" helped her to prepare her pupils for **Gurdjieff** (Moore, 290).

As far as I know, **Gurdjieff** and Heap never quarreled; perhaps because **Gurdjieff** never tested her (though that is hard to believe), perhaps because she would not let a quarrel develop. "Gurdjieff liked her," Nott says. A simple enough statement and apparently true—but not one that could be made about many in **Gurdjieff**'s orbit. And she said of him, "He is a multitude. But if you watch, sometimes you see the sage pass by" (Moore, 289).

After **Gurdjieff**'s death in 1949, she accepted the overall authority of Madame **de Salzmann** in Paris (and Madame Lannes in London) and her group joined up with the newly-formed Gurdjieff Society. She died in 1964 at the good old age of 76, quite unknown to the world at large but highly regarded by those who had worked with her. Perhaps her best epitaph is another of her aphorisms:

> If you develop yourself, Gurdjieff says, you become an individual instead of one of the thousand leaves on a tree. You become a seed. (*The Unknowable Gurdjieff,* 71)

Primary sources: None

Secondary sources: Webb; Moore; Nott, *Further Teachings of Gurdjieff* [for details of these three, see the end of Gurdjieff's entry]; Fritz Peters's trilogy: *Boyhood with Gurdjieff* (London, 1964); *Gurdjieff Remembered* (London, 1965); *Balanced Man* (Wildwood House, 1978); M. Anderson, *My Thirty Years' War: An Autobiography,*

met him despite the fact that he lived just round the corner, so to speak—and were somewhat surprised to be accepted as pupils. Although he had many people who came to him for advice, this was the first group he had formally taken charge of since his car crash in 1924. It was very small and composed entirely of middle-aged lesbians.

(New York, 1930); M. Anderson, *The Unknowable Gurdjieff* (London: Routledge, 1973) (paperback edition)

Centre: None

<div align="center">

Finally, we come to someone who could be said to represent Gurdjieffian orthodoxy.

</div>

THE GURDJIEFF LEGACY: JEANNE DE SALZMANN

Gurdjieff's most consistent pupil, who went on to become the leader of the Work after his death[14]

Mme. de Salzmann (*née* Allemand) was born in 1889 in Geneva. She was trained as a dancer. In 1919, she and her husband, Alexandre, a stage designer, went to work at the Opera House at Tbilisi, in Georgia. There they met Thomas de Hartmann and his wife, who were already pupils of **Gurdjieff** and they introduced him to the de Salzmanns.[15]

Both de Salzmanns remained with **Gurdjieff** for the rest of their lives. They lived at the Prieuré in France and were 'core' pupils amongst the fluctuating population that **Gurdjieff** always had around him. In 1931, Alexandre started a tiny group in Paris—the first that really had any success in attracting French people to the Work.[16] But he died in 1933, after leading the group for only two years, and his wife then took over the responsibility. This was her first foray into teaching—and she continued for another 57 years.

She moved to Sèvres, near Paris, in 1934 and established her own group, sending on to **Gurdjieff** those pupils whom she thought would benefit from the experience (Webb, 436). This particular arrangement was unique to her (at least, in any systematic way) and it may well mark the point at which **Gurdjieff** decided that she was reliable; that is, could stand on her own feet—perhaps the quality that he most appreciated in his pupils. From about 1939 (when she was 49 years old), she was "emerging as Gurdjieff's de facto deputy" (Moore, 268). Gradually, more and more French people came into **Gurdjieff's** orbit, most of them through her. She herself was given the task of answering beginners' questions from time to time and she also transmitted **Gurdjieff's** instructions to the group at large (Anderson, *The Unknowable Gurdjieff,* 173).

Gurdjieff died in October, 1949, and as he got weaker, he had more and more contact with Mme. de Salzmann. It was to her that he spoke his final words, which were in fact his parting instructions. He told her to publish the First and Second Series of the *All and Everything* trilogy—that is, *Beelzebub's Tales* and *Meetings with Remarkable Men.* Then he went on,

> But the essential thing, the first thing, is to prepare a nucleus of people capable of responding to the demand which will arise. So long as there is no responsible

[14] Strictly speaking, in order to be fair, I ought to treat Madame de Salzmann in tandem with her husband, Alexandre. But while it is true that they were both followers of **Gurdjieff**—always together—for nearly 15 years, his early death put paid to any prominence he might have attained in the Work. He was a teacher for just two years; she, for over 50. This imbalance warrants that he be included in this section.

[15] In fact, the name was simply 'Salzmann' until 1933, when the de was added by Jeanne after Alexandre's death (Moore, 367).

[16] Gurdjieff had never managed it; and Jane **Heap**'s group in Paris consisted of expatriate Americans and their French, English-speaking, friends—not the same thing at all. The best-known members of Alexandre's group were René Daumal (see Webb, 434), whose *Mount Analogue* was heavily influenced by **Gurdjieff's** ideas; and two of his friends, the writer, Luc Dietrich, and Lanzo del Vasto, founder of the Arche communities.

nucleus, the action of the ideas will not go beyond a certain threshold. That will take time. . . a lot of time, even. (*Life is Real*. . . , xi)

Mme. de Salzmann herself told a group of 50 or so of her pupils, immediately after **Gurdjieff**'s death,

> When a Teacher like Mr. Gurdjieff goes, he cannot be replaced. Those who remain cannot create the same conditions. We have only one hope: to make something together. What no one of us could do, perhaps a group can. We no longer have a Teacher, but we have the possibility of a group. Let us make this our chief aim in the future. (J.G. Bennett, *Witness*, 274)

There is some debate as to whether this aim was realized or not, and the extent of Mme. de Salzmann's contribution to its success or failure. The whole Gurdjieff Work was by its very nature fissile (all the more so when we include, as we must, all those associated with **Ouspensky**, the first and most influential of all those who split away from **Gurdjieff**) and this led to a number of breakaways after the deaths of both these teachers. Even so, it is probably true to say that the majority of those who had been Gurdjieff's pupils accepted her as their leader. What this meant in practice was, first, the organization of the various scattered groups throughout the world into a number of societies/foundations: the Gurdjieff Society in London (started in 1950 but formally established in 1955); and Gurdjieff Foundations in New York and San Francisco (both under the direction of John Pentland) in 1953 and 1956 respectively. And secondly, as the longest-serving pupil and foremost exponent of the dances/movements, she was the most experienced teacher—a position she held for 40 years after **Gurdjieff**'s death.[17]

By the time of her death in 1990 aged 101 (to be 'succeeded' by her son, Michel), she had, at least in the eyes of orthodox Gurdjieffians, created the nucleus that **Gurdjieff** had wanted her to build: "a recognizable transmission from Gurdjieff himself" (Moore, 369). Special mention should be made of her work in perpetuating **Gurdjieff**'s sacred dances, which are recorded in ten films (not publicly available). Given the importance that **Gurdjieff** himself placed upon them, one could say that they rank alongside **Ouspensky**'s *In Search of the Miraculous* as the most faithful record of his teaching.

Those who knew Mme. de Salzmann well are agreed that she could deliver a formidable voltage. Its application, however, took a surprising turn in the last decade of her life, when, at the age of 90, she seems to have abandoned the strict orthodoxy of the previous 30 years. Senior pupils were convened in supplementary meetings or 'sittings', during which they sat in attentive silence with closed eyes, cultivating the sensation of a fine energy or 'love from above' entering the subtle body through an aperture in the crown of the head, flowing down the spine and rising up again to leave at a point between the eyebrows.[18] This practice is in striking contrast to **Gurdjieff**'s insistence on effort: a principle so crucial that it goes way beyond the confines of 'personal' effort and takes on the nature of a cosmological principle. At the same time, Mme.

[17] But she was not attracted to writing. Her sole public statements consist of very short forewords/introductions to three of Gurdjieff's books (see 'Primary sources' below). (In this she is very like **Madame Ouspensky** and Jane **Heap**, neither of whom published anything at all on the Work).

[18] Such a practice is, of course, a variation of what might be called *chakra yoga*, which has a complex history as part of the wider phenomenon of Tantra. It is certainly traceable as far back as the ninth century, although its first Western proponent who had any real impact is probably Arthur **Avalon**. Apparently, the technical Yogic terminology was not used in the **Gurdjieff** groups (Moore, 'Moveable Feasts: the Gurdjieff Work', *Religion Today*, vol. 9, no. 2, p. 13). But the connections are obvious.

de Salzmann was responsible for another departure from orthodoxy: *Beelze-bub's Tales*, which **Gurdjieff** had worked on for nearly 25 years and which he had expressly told Mme. de Salzmann to publish, was revised to make it "smoother. . . lighter. . . more approachable" (C. Thompson, *Parabola* XVIII [1], February 1993, p. 98; this quotation is cited in Moore's 'Moveable Feasts' but he does not give the title of Thompson's article—or it may be a review).

So we are faced with the possibility that Mme. de Salzmann, the truest of **Gurdjieff**'s disciples, and the one that he manifestly most relied on, ended up by subverting two central elements in her master's teaching: the necessity of effort and the deliberate 'difficulty' and demandingness of *Beelzebub's Tales*. Needless to say, 'ultra orthodox' back-to-Gurdjieff groups have already formed in reaction to Mme.de Salzmann's innovations since her death in 1990. They now join the numerous heterodox groups that already exist. Slowly, the main body of the Work is splitting up like a vast log jam, which, having left the confines of a river, floats out to sea and loses its cohesion.

Primary sources: J. de Salzmann, introduction to *Meetings With Remarkable Men*, French edition *(Rencontres avec des hommes remarquables)*, (Paris, 1960); English edition, (New York, 1963); foreword to *Views From the Real World* (New York, 1973); foreword to *Life is Real Only Then, When "I Am"* (New York, 1975)

Secondary sources: Webb; Moore (for both of whom, see the end of Gurdjieff's entry); some references in J. George, *Asking for the Earth: Waking Up to the Spiritual Ecological Crisis* (Element Books, 1995)

Centre: Gurdjieff groups do not as a rule make their addresses public but I do have one (although it is over 10 years old): Gurdjieff Foundation of California, P.O. Box 549, San Francisco, CA 94101, U.S.A.

Sri GYANAMATA. SEE PARAMAHANSA *YOGANANDA* (P. 600, N. 6)

HANSADUTTA Swami | Hans Kary

One of the original eleven gurus of ISKCON who was relieved of his duties because of misbehaviour

This entry should be read in conjunction with the **Hare Krishna Gurus.**

Kary was the son of German parents who emigrated to America in 1946 when he was five years old. He came across *Prabhupada* in 1967, only a year or so after *Prabhupada* had initiated his first disciples, and immediately took initiation himself. He soon gained a reputation for vigorous preaching. He opened a temple in Montreal in 1967 (together with **Bhaktipada**) and introduced ISKCON into Germany in 1970 (along with **Tamal Krishna**). He was the first to arrange for a German translation of *Prabhupada*'s books. He did some preaching in India in 1971 (*Srila Prabhupada-lilamrta*, vol. 4, p. 181) and was successful in recruiting Indians as life members. He also engaged in a debate with an atheistic Sri Lankan scientist and Nobel Prize winner, Dr. Kovoor, in which he argued against a materialistic account of the origin of life. *Prabhupada* expressly commended Hansadutta for his strong preaching (*Srila Prabhupada-lilamrta*, vol. 5, 365) and the debate (which in fact only amounted to a few pages of text) was published as part of a book, *Life Comes*

from Life, along with some of *Prabhupada*'s own discourses. This was the first time that one of *Prabhupada*'s disciples was published in book form. Hansadutta was one of the twelve original members of the Governing Board Commission/GBC, which *Prabhupada* set up as the overall governing body of ISKCON in 1970; and was one of the eleven gurus nominated by *Prabhupada* to initiate people after his death.

But he had his troubles. In 1974, he was arrested in Germany and charged with weapons violations (*Monkey on a Stick,* 142). In 1980, he was the centre of the first guru crisis to hit ISKCON, when, on three separate occasions, California police found weapons and ammunition on property that belonged to ISKCON and was under Hansadutta's jurisdiction. He was arrested again but no charges were made (ibid., 227ff). He was also arrested in Oakland, California for causing a disturbance on a plane (ibid., 226). Three arrests, two of them connected with guns, is quite a lot for a guru.

Finally, in 1983, the GBC expelled him from ISKCON altogether because he insisted on giving *sannyasa* initiation without the GBC's permission (Rochford, 259). He joined **Bhaktipada**'s community at New Vrindaban in West Virginia for a while but then left and more or less stopped being a devotee. He has since joined the New Jaipur community (for which, see the **Hare Krishna Gurus**), though whether formally (which means sharing their theology) or informally, I am not sure.

Hansadutta has had to take a lot of criticism over the years—and one can see why. I do not want to be unfair to him but it seems obvious that he was completely unsuited for the role of guru. No doubt he has his virtues as well—most people do. But it was behaviour of this kind (and that of some of the other gurus) that eventually led ISKCON to the view that the whole notion that gurus were somehow special was misguided and should be ditched. (See the **Hare Krishna Gurus** for more details.)

(*See* Lineage Tree 5)

Primary sources: Hansadutta Swami, *Life Comes From Life* [I have no details of this book, which was possibly issued under Prabhupada's name or as part of one of Prabhupada's other books]; *Kirtan: Ancient Medicine for Modern Man* (Hopland, California: Hansa Books, 1984); *The Book: What the Black Sheep Said* (Berkeley, California: Hansa Books, 1985) [I only have the titles for the following with no details of provenance or date: *The Hammer For Smashing Illusion; Last Words of Shankaracharya (Bhaja Govinda); Fool's Paradise.*]

Secondary sources: Satsvarupa dasa, *Srila Prabhupada-lilamrta,* 6 vols (Los Angeles, 1980–83); E. Burke Rochford, *The Hare Krishnas in America* (New Jersey, 1985); J. Hubner and L. Gruson, *Monkey on a Stick* (New York, 1988)

Centre: No longer extant

COMPARE:

Other gurus connected with ISKCON: the **Hare Krishna Gurus**, Shrila **Bhaktipada**, **Jayatirtha**

The HARADA-YASUTANI-YAMADA LINEAGE

Japanese teachers of an innovative form of Zen that has been very influential in the West

*Sogaku Harada Roshi (not to be confused with Shodo Harada, a Rinzai teacher) was born in 1870. He trained in both the Rinzai and Soto schools, which was unusual at the end of the nintheenth century, and received Dharma-transmission in both (which was even more unusual). He was abbot of Hosshin-ji, a Soto temple, for more than 40 years and was renowned for the intensity of practice that he demanded from his students. Although he never visited the West, a few Westerners, including Philip **Kapleau** and the Jesuit priest, Hugo **Enomiya-Lassalle,** went to Hosshin-ji to practice for a time.*

*Harada Roshi died in 1961, having given Dharma transmission to 14 disciples—including Hakuun Yasutani Roshi, the best known in the West, who continued his master's vigorous style. In 1954, Yasutani Roshi founded the Sanbokyodan school, a lay organization which regards itself as independent of Soto and Rinzai, though it incorporates elements of both. Two prominent Western teachers, Robert **Aitken** and Philip **Kapleau** practised with him in Japan. He visited the West (primarily the United States) every year from 1962 to 1969 (when he was over 80) and taught many Westerners. He also gave Dharma transmission to Taizen Maezumi, founder of the Zen Center of Los Angeles, who has a number of Western Dharma heirs of his own.*

Yasutani Roshi died in 1973 and his work in the West was continued by his principal Dharma-heir, Ko'un Yamada Roshi (not to be confused with Mumon Yamada, a Rinzai teacher). Yamada Roshi was never ordained and lived an ordinary life: married, with a family and a full-time job as director of a public health clinic in Tokyo. He was well-versed in political and social issues and frequently referred to them in the Sanbokyodan journal. Being a layman himself, he put most of his efforts into teaching other lay people (men and women). He did not regard them as "second-class citizens" (Habito, In Memoriam, 22) and his example is a counterbalance to the monastic ideal which predominates in Japan and has been carried over to the West by many Zen teachers (including some Westerners). He taught Westerners as readily as Japanese and after his death, a list of 22 (given in Habito, In Memoriam) who had passed koan *training was found among his files. This is an unusually high number. But even more unusual is that 13 of them were Christian. (There is a brief discussion of Christian Zen in Father **Enomiya-Lassalle**'s entry.) Yamada Roshi died in 1989 and was succeeded as head of the Sanbokyodan school by Kubota Roshi.*

Primary sources:

Harada Roshi: None in Western languages

Yasutani Roshi: various lectures and interviews/*dokusan* in Philip Kapleau, *The Three Pillars of Zen* (Boston, 1967)

Yamada Roshi: Gateless Gate (Los Angeles: Center Publications, 1979); Yamada Ko'un Roshi, 'Christians and the Practice of Zen', *Dialogue* (New Series), vol .3, September-December 1976, 98–101; Reuben Habito, *Total Liberation: Zen Spirituality and the Social Dimension* (New York, 1989) [a three-way conversation between Habito, Father Enomiya-Lassalle and Yamada Roshi]; *Yamada*'s *kensho* is described in Kapleau, *The Three Pillars of Zen,* 204–07

Secondary sources:

Harada Roshi: Philip Kapleau. *The Three Pillars of Zen,* 273–36.

Yasutani Roshi: Kapleau, *The Three Pillars of Zen,* 24–26.

Yamada Roshi: Reuben Habito, *In Memoriam: Yamada Koun Roshi* ('No Longer Buddhist Nor Christian'), *Buddhist-Christian Studies,* vol. 10, 1990, 19–25.

LINEAGE TREE 4
Zen lineages derived from Harada Roshi

the various levels here do not indicate seniority in any consistent way, nor have I distinguished between different kinds of transmission and/or teaching (full, partial; orthodox, unorthodox, idiosyncratic). These matters are discussed in the text.

Enomiya-Lassalle and **Aitken** also completed *koan* training under *Yamada* Roshi; they are distinguished from the 20 others only because they have their own entries. (However, some of these 20 are included in the table on p. 258.) Similarly, the first five Dharma heirs of *Maezumi* Roshi are only distinguished from the last seven because they have their own entries. (And no doubt all these sub-lineages have grown since this tree was drawn.) Many of these people are included in E. Rommeluère, *Le Guide du Zen,* (Paris, 1997)
See **Lineage Tree 6** for **Aitken**

Harada

Nakagawa Soen

Yasutani

Enomiya-Lassalle
CHRISTIAN ZEN

Yamada

20 students
(19 Westerners
and one Indian)
who completed
koan training
(12 Christian;
eight not)

RINZAI LINEAGE

Aitken

Kapleau

Tarrant Hawk Foster Alcade

Packer Kjolhede
(Bodhin) Gifford Graef Henry Kjolhede
(Sunya) Low **Clarke**

Barzaghi
Bolleter

Names in *italics* are Japanese; all the rest (including the 19 who are not named) are Westerners: mostly American but there are also Canadians, Austrians, Philipinos, Germans, Swiss, plus French, British, Dutch, Argentinian (one each); four of them teach in Japan; there are slightly more men than women

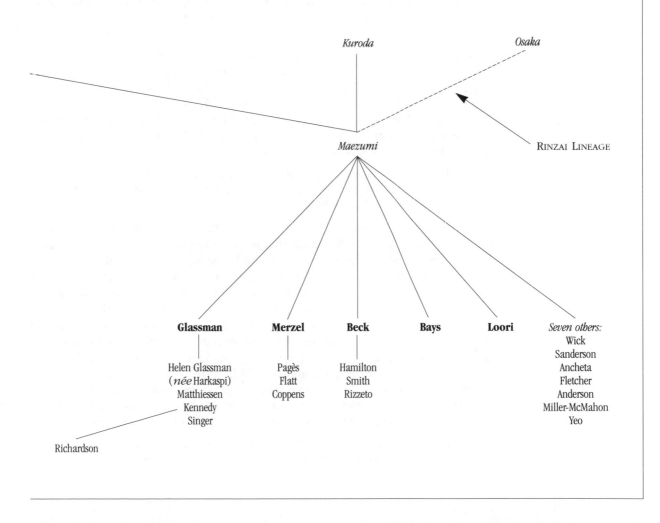

Kuroda
Osaka

Maezumi
RINZAI LINEAGE

Glassman **Merzel** **Beck** **Bays** **Loori** *Seven others:*
Wick
Sanderson
Ancheta
Fletcher
Anderson
Miller-McMahon
Yeo

Helen Glassman
(*née* Harkaspi) Pagès Hamilton
Matthiessen Flatt Smith
Kennedy Coppens Rizzeto
Singer

Richardson

Douglas HARDING

One day in 1943, at the age of 33, Harding was walking in the mountains when something happened that he calls "absurdly simple and spectacular":

> just for the moment I stopped thinking. Reason and imagination and all mental chatter died down. For once, words really failed me. I forgot my name, my humanness, my thingness, all that could be called me or mine. Past and future dropped away. It was as if I had been born that instant, brand new, mindless, innocent of all memories. There existed only the Now, that present moment and what was clearly given in it. (*On Having No Head*, 1)

Perhaps because this 'experience' was quite unexpected and therefore had no context, he accepted it as it actually happened. He continues his description:

> To look was enough. And what I found was khaki trouserlegs terminating downwards in a pair of brown shoes, khaki sleeves terminating sideways in a pair of pink hands, and a khaki shirtfront terminating upwards in—absolutely nothing whatever! Certainly not in a head.
>
> It took me no time at all to notice that this nothing, this hole where a head should have been, was no ordinary vacancy, no mere nothing. On the contrary, it was very much occupied. It was a vast emptiness vastly filled, a nothing that found room for everything—room for grass, trees, shadowy distant hills, and far above them snowpeaks like a row of angular clouds riding in the blue sky. I had lost a head and gained a world. (ibid.)

This 'headlessness' has remained the key phrase in Harding's account of his experience and what it means. However, he was unable to link it up with anything else for a very long time—15 years, in fact. He could find no other descriptions of it, knew nobody who had had the same experience, and was unable to explain it to people. He says that he was very lonely and the awareness receded into the background for long periods. Then, in the late 1950s, he came across Zen. He quotes Han-shan:

> I took a walk. Suddenly I stood still, filled with the realization that I had no body or mind. All I could see was one great illuminating Whole—omnipresent, perfect, lucid, and serene. (ibid., 29; no source given)

Harding takes 'having no body or mind' as the same as his having no head. Similarly, Shankara and *Ramana Maharshi,* respectively the most celebrated ancient and modern exponents of Advaita Vedanta, are cited to the effect that the real Self is like space, unattached, pure, infinite (Shankara); and that identification with the body is "the root cause of all troubles" *(Ramana Maharshi)* (ibid., 30). So much for the parallels that Harding has found for his own experience. As for himself, he points out that headlessness is something that can be verified under all circumstances, does not require any special training or talent (quite the contrary), and is therefore the same for all (ibid., 42–47). "There is no experience quite like it," he says (ibid., 43).

At this point, we can no longer put off the objections that automatically arise when we are asked to verify that we have no head. Essentially, they come down to four, which I give here together with Hardingesque rejoinders.

If I did not have a head, I'd not be able to see anything. I'd be dead.	Perfectly true. But that is an inference not a direct perception.

I can see my head in a mirror.	Alright. But you had to learn to recognize it. Very young children often think their reflection is another child. Besides, you see the reflection in exactly the same way as you see anything else—as an object that exists in the vast emptiness that has its source . . . where? (Cf. *On Having No Head,* 11)
I can feel my head (in both senses of the word 'feel': it has its own sensations; and I can touch it with my hand).	Undeniable. But you still *see* it in exactly the same way: without an edge, without limit; the one great Window. (ibid., 8)
I just know I have a head.	You have certainly learned how to use the word; but that isn't a direct perception either; (a very young child does not know that it has a head; but it can see.) (ibid., 9)

Harding's statement (I prefer this term to 'teaching') is simply this: just look. Do not create something that *must* be so in order that you can look. It is quite unnecessary—and possibly harmful (because identifying with a limited source of awareness itself creates limitation: in me, in others, in the world, in everything).

It is tempting to regard Harding's vocabulary of headlessness as just an alternative way of talking about non-ego, non-dual awareness and other better known terms of the non-dualistic strand of mysticism. But this is a mistake, I think. He presents headlessness as a verifiable fact and hence as something that can be 'done'. (The scare quotes are necessary, of course, since there is in fact nothing to do; it is already done.) The second edition of *On Having No Head* was subtitled, *a contribution to Zen in the West.* And while he has not made any great claims for his insight or for himself, it could be argued that he discovered, independently, the nameless core of Zen.

At the moment, the Headless Way is very modest. It may be, of course, that headlessness is to Zen *satori* as the Thames is to the Amazon. It may also be that it does not matter which river we take to the sea.

Primary sources: Douglas Harding *On Having No Head: Zen and the Re-discovery of the Obvious* (Arkana, 1986) [this is an expanded version of the original 1961 edition, which was very short]; 'The Rediscovery of the Obvious', *The Middle Way,* 61/3, 61/4, 62/1, 62/2 (1986-7) [an interview in 4 parts]

Secondary sources: None

Centre: c/o Anne Seward, Church Lane, Playford, Ipswich, England, U.K.

COMPARE:

Others who had a spontaneous awakening: **Jae Jah Noh**, Barry **Long**, Lee **Lozowick**, **Shunyata**

The HARE KRISHNA GURUS

The eleven Americans who were appointed by Shrila *Prabhupada* and the developments in the Hare Krishna movement since their appointment

This entry is a continuation of the one on Shrila Prabhupada and everything that is said there is assumed here. There are separate entries for **Bhaktipada**, **Hansadutta**, and **Jayatirtha**.

Prabhupada died in 1977, twelve years after arriving in New York and establishing the Hare Krishna movement (also known as ISKCON). The loss of the founder of a movement is always difficult for its members, of course. But in *Prabhupada*'s case, the effect was even more far-reaching than usual. In effect, the structure of the entire movement was radically altered. While *Prabhupada* was alive, he was the sole source of the tradition and the driving force behind ISKCON's expansion. No important decision was taken which he did not approve of. The Gaudiya Vaishnava tradition refers to three authorities that a devotee can look to for guidance: guru, *shastra,* and *sadhu*.[1] *Prabhupada* was all three in one. He was the guru; he translated the *shastras* (the authoritative texts); and he was also the paradigm *sadhu* (because there was no one else in the West who knew anything about the Gaudiya Vaishnava tradition at all). In short, he represented the tradition at every level: spiritual (guru), textual (*shastra*) and social (*sadhu*).

While *Prabhupada* was alive, the only issues to be resolved concerned the relation between *Prabhupada* himself and his disciples (some of whom were members of the GBC, the managerial body that he founded in 1970)—and the resolution always came back to *Prabhupada* in the end. But as soon as he died, ISKCON had to work out the relative importance of all the following: *Prabhupada;* the GBC; the individual members of the GBC (most of whom were initiating gurus); the eleven gurus themselves; the disciples of *Prabhupada;* and the disciples of the new gurus. Given this more or less instantaneous complexity, it is hardly surprising that the movement was racked with divisions. (There were disagreements even when *Prabhupada* was alive but he kept them under control.) These divisions took a few years to become apparent and were concerned with three closely related issues: the proper function of the guru; the nature of authority in ISKCON; and the standard of behaviour that leaders of ISKCON are expected to live up to. And when they did finally surface, they were decidedly abrasive, not to say violent, involving defections, expulsions, scandal, and murder. Yet the movement has to a large extent weathered this storm (although not without taking in its sails).

This brings us to *Prabhupada*'s intention in appointing eleven gurus as his successors. On two occasions in Vrindavana in India, the question of who should initiate after his death was put to him. Both conversations were taped and I give the first in full in the table opposite, together with a couple of extracts from the second. Why were these particular eleven chosen? Because they were successful preachers—and preaching is synonymous with devotional service, the ideal of Gaudiya Vaishnavism as *Prabhupada* taught it. The first column of the table on p. 322 gives a summary of each one's 'career' in ISKCON up until 1977 (in alphabetical order of their Vaishnava names).

Yet though we may be able to see why *Prabhupada* thought highly of them, it is not at all easy to understand what he intended for these men. In the

[1] *Sadhu* really means a good Vaishnava, and more generally, the pooled wisdom of those who are on the path. It is not another word for *sannyasi,* which is its usual meaning in Hinduism.

The appointment of the eleven original Hare Krishna gurus

*Transcription of a conversation in May, 1977 between Stephen Guarino/**Satsvarupa**, Thomas Hertzog/**Tamal Krishna** and Prabhupada*

Satsvarupa: Then our next question concerns initiations in the future, particularly in that time when you are no longer with us. We want to know how first and second initiations would be conducted.

Prabhupada: Yes. I shall recommend some of you after this is settled up. I shall recommend some of you to act as officiating acharya.

Tamal Krishna: Is that called ritvik acharya?

Prabhupada: Yes. Ritvik.

Satsvarupa: What is the relationship of that person who gives the initiation and . . .

Prabhupada: He's guru. He's guru.

Satsvarupa: But he does it on your behalf.

Prabhupada: Yes. That is formality. Because in my presence one should not become guru, so on my behalf. On my order, *amara ajnaya guru hana*, he is actually guru. But by my order.

Satsvarupa: So they may also be considered your disciples?

Prabhupada: Yes, they are disciples but consider who . . .

Tamal Krishna: No, he is asking that these ritvik acharyas, they are officiating, giving diksha [initiation]—the people who they give diksha to, whose disciples are they?

Prabhupada: They are his disciples.

Tamal Krishna: They are his disciples?

Prabhupada: Who is initiating. His grand-disciple.

Satsvarupa: Then we have a question concerning . . .

Prabhupada: When I order you become guru, he becomes regular guru. That's all. He becomes disciple of my disciple. Just see.

*On 8 July 1977, Prabhupada, during a conversation he had with Tamal Krishna, who was Prabhupada's secretary at the time, gave the names of nine "senior sannyasis"—**Tamal Krishna**, **Kirtanananda**, **Satsvarupa**, **Jayatirtha**, **Bhagavan**, **Harikesha**, **Jayapataka**, **Rameshvara**, **Hridayananda**—who could give initiations. I shall not give a full transcription of it but simply note the following exchange:*

Tamal Krishna: These men. They can also do second initiation. So there's no need for devotees to write to you for first and second initiation. They can write to the man nearest them. But all these persons are still your disciples. Anybody who would give initiation is doing so on your behalf.

Prabhupada: Yes.

And at the very end of the conversation, Prabhupada says:

Prabhupada: So without waiting for me, whoever you consider deserves. That will depend on your discretion.

*The next morning, Prabhupada added two more names—**Hansadutta** and **Bhavananda**—making eleven in all.*

(This is the transcript at the end of Ravindra Svarupa dasa's unpublished paper, '"Under My Order . . . ": reflections on the guru in ISKCON'; it differs slightly from that in Rochford 283 and is a fuller version of that found in Srila Prabhupada-lilamrita, *vol. 6, 345.)*

The 'careers' of the original eleven Hare Krishna gurus

Name	Accomplishments (before appointment in 1977)	Subsequent developments (after 1977)
Bhagavan/ William Erlichman	One of the twelve original members of the GBC, responsible for France and Italy; opened many temples there and had *Prabhupada*'s books translated into French and Italian.	Fell in love with a devotee in 1986 and resigned as guru; officially removed as guru by the GBC but not expelled from ISKCON; got married; continues to initiate devotees independently on a very modest scale.
Bhavananda/ Charles Backus	President of the New York temple. In 1972, he was made co-director (with **Jayapataka**) of the ISKCON temple in Mayapur, India.	Removed as guru by the GBC in 1987 for persistent homosexual behaviour but not expelled from ISKCON.
Hansadutta/ Hans Kary	Introduced ISKCON into Germany in 1970 (along with **Tamal Krishna**) and supervised the German translation of *Prabhupada*'s books; one of the twelve original members of the GBC.	Expelled by the GBC in 1983 for initiating *sannyasins* without permission (and after several arms offences); is now associated with the New Jaipur group (for which, see text).
Harikesha/ Robert Campagnola	Had great success in spreading ISKCON in Scandinavia and Eastern Europe (that is, Communist Europe, including Russia); supervised the translation of Prabhupada's books into 13 languages.	Re-elected to the 'reconstituted' GBC in 1987; still in charge of Scandinavia and Eastern Europe (including Russia).
Hridayananda/ Howard Resnick	Established ISKCON in Central and South America in 1974 (he speaks Spanish and Portuguese); had *Prabhupada*'s books translated and arranged their distribution throughout the South American continent.	Re-elected to the 'reconstituted' GBC in 1987; continues to spread ISKCON in Central and South America; he is also a Sanskrit scholar and in 1979 he was given the task of completing *Prabhupada*'s translation of the *Srimad Bhagavatam*— complete with explanatory commentaries.
Jayapataka/ John Erdman	An important manager in India: president of ISKCON in Calcutta and co-director (with **Bhavananda**) of the Mayapur temple	Re-elected to the 'reconstituted' GBC in 1987; still based in India and preaches in Bengal, going from village to village, just as Chaitanya did; speaks Bengali fluently and is now an Indian citizen.
Jayatirtha/ James Immel	Temple president in Los Angeles and Detroit; esteemed by *Prabhupada* for his managerial ability; executor of *Prabhupada's* will	Expelled by the GBC in 1982 after vowing to destroy ISKCON; murdered in 1987 by an ex-devotee.
Kirtanananda/ Keith Ham (later, **Bhaktipada**)	The very first devotee to become a *sannyasin* (in India in 1967); founded New Vrindaban in West Virginia in 1968—the first 'Vedic' village in the West.	Expelled by the GBC for setting up a rival organization to ISKCON; is presently an independent guru claiming to be *Prabhupada*'s one true successor.
Rameshvara/ Robert Grant	An expert manager, in charge of the Bhaktivedanta Book Trust; was himself very successful at distributing books.	Removed as guru by the GBC in 1987 for mismanagement of funds but not expelled from ISKCON.
Satsvarupa/ Stephen Guarino	Opened temples in Boston and Dallas; one of the first editors of *Back To Godhead*; one of the twelve original members of the GBC.	Re-elected to the 'reconstituted' GBC in 1987; presently head of a small community in Philadelphia.
Tamal Krishna/ Thomas Herzog	Took ISKCON to Germany (along with **Hansadutta**) in 1970; also active in London and Japan; one of the twelve original members of the GBC; his travelling *sankirtana* group distributed more books than any other team in the whole of America.	Re-elected to the 'reconstituted' GBC in 1987; is concentrating his efforts in Fiji, which has a high percentage of Indians; aims to make it the first Krishna-conscious country in the world (though I'm not sure what this means exactly).

first conversation, he says that he will recommend some devotees as officiating *acharyas* or *ritvik acharyas;* but a few minutes later he says that these *acharyas* will be "regular gurus". In the second conversation (when he actually gives the names of these gurus) he agrees with **Tamal Krishna** that the disciples of these gurus are still his (*Prabhupada's*) disciples; yet in the first conversation, *Prabhupada* specifically says that the disciples of those whom he would recommend are the disciples of these *ritvik acharyas*. (And I have no idea what he means when he says "They are his disciples . . . Who is initiating. His grand-disciple." *Whose* grand-disciple?) Finally, he appears to say that "whoever you consider deserves" can give initiation in addition to those whom he has just named—but who is the 'you' whom he is addressing?

These uncertainties were to have considerable consequences in due course. To begin with, however, the Hare Krishna movement as a whole (with a few exceptions, of whom Chris Butler/**Siddhasvarupa** is perhaps the most obvious) regarded the eleven as 'bona fide gurus'. This is *Prabhupada's* rendering of the term *sad-guru* and it has a particular sense in his theology. It means someone who is purified by devotional service to Krishna (this is the *sad* or *sat* part—the word means *true*) and who gives initiation (*diksha*—this is the *guru* part). Since devotional service is the highest stage that anybody can reach, a *sad-guru* is liberated by definition. He can therefore act as a link to Krishna—a pure connection, one could say. But there is also a pure connection between the guru and every one of his disciples. It is "an eternal relation" and enables the guru to lead his initiates back to Krishna. This two-way pure connection—from the guru to Krishna and from the guru to the disciple—gives initiation its power. By means of it, the disciple "becomes freed from all material contaminations." It is important to realize that the *sad-guru* does not have visions of Krishna nor even conscious awareness of Him. Everything is accomplished by Krishna *through* the *sad-guru* because of the *sad-guru's* purity. So while it may be true that the *sad-guru* is able to "consume all the sinful reactions of his disciple"—that is, take on their karma—this is not because of any specific accomplishment on his part; it is simply a consequence of his dedication to devotional service.

In 1977, then, following *Prabhupada's* death, this status of *sad-guru* was being claimed by, or on behalf of, eleven Americans (none of them much more than 30 years old), who were authorized, empowered and blessed by *Prabhupada* (and, by extension, by the entire lineage of gurus going back to Krishna himself). It is hardly surprising, then, that the new gurus saw themselves as duty bound to follow in *Prabhupada's* footsteps and do as he had done. In fact, they copied him in every particular: they had special 'seats' in the temples under their jurisdiction and were worshipped by their devotees just as they had worshipped *Prabhupada*. And I think this understanding of their status and function would have held sway if they had been able to live up to *Prabhupada's* high standards. Unfortunately, this was not to be and there were a succession of guru crises in ISKCON which led to a radical reappraisal of what *Prabhupada* really meant when he made the appointments and therefore what the new gurus should really be doing.

These crises began only a few years after *Prabhupada's* death and continued for the next ten years or so. (See the second column of the table on p. 322.) I cannot give a blow by blow account of every single one but I am interested in the different aspects of the ISKCON tradition that were involved: its basic moral principles, its theology and the relation between the authority of the gurus and that of the GBC. For example, **Bhavananda's** homosexual

behaviour straightforwardly contravened ISKCON's principles (which apply to all devotees, not just gurus); so did **Bhagavan**'s having an affair when he was a *sannyasin*. But the reason that **Hansadutta** was expelled was not because of his various brushes with the law (see his entry) but because he initiated several devotees as *sannyasins* without consulting the GBC (Rochford, 259). This may look like a minor managerial matter but in fact it was a major theological issue because it concerned the relative authority of the GBC and the individual gurus. The GBC took the line that any deviation from GBC policy was in direct contravention of *Prabhupada*'s express wishes; **Hansadutta**, on the other hand, said that he did not need anybody's authority to give *sannyasa* initiation (and this is indeed the traditional Gaudiya Vaishnava position).

Jayatirtha's case was somewhat similar. The GBC temporarily deprived him of his guru status in 1980 because he was crying and shrieking while chanting in the London temple and the GBC suspected him of taking LSD. **Jayatirtha**'s response was to go outside ISKCON altogether and appeal to Shridhara Maharaja, one of *Prabhupada*'s god-brothers (that is, someone who was also, like *Prabhupada,* a disciple of Shrila Bhaktisiddhanta), who was known to be against the GBC's attempts to curb the newly appointed gurus. **Jayatirtha** regarded Shridhara as a genuine guru even though he was not a member of ISKCON: Shridhara's tapes were played in the temples under **Jayatirtha**'s jurisdiction and Shridhara's photograph appeared on the altars (along with *Prabhupada*'s) (Rochford, 249). Gradually, a movement grew up—which was undoubtedly bolstered by having such a strong advocate as one of the new gurus behind it—to have Shridhara admitted as an ISKCON guru. When the GBC refused, about 20 devotees, led by Philip Murphy/Bhakti Sudhir Goswami from the Los Angeles temple, left ISKCON and joined Shridhara (in 1980), forming an organization called The Guardians of Devotion.

In 1982, **Jayatirtha** told the GBC that if they did not bring Shridhara into ISKCON as an initiating guru, he would leave ISKCON himself and destroy it. The GBC would not agree and expelled him. (More details, plus an account of his bizarre and tragic death, can be found in his entry.) By this time, it was obvious that he had initiated disciples while himself contravening the basic principles of the tradition, and the question therefore arose as to whether these disciples were really initiated or not—that is, whether a *sad-guru* who is not pure or 'clean' can actually provide a 'clean' connection with the lineage. Nobody, including the GBC, was sure, so to be on the safe side, they arranged for Jayatirtha's replacement, **Bhagavan**, to re-initiate all Jayatirtha's disciples. But when, four years later, **Bhagavan** also left the movement, having also contravened the basic moral principles, the question was inevitably raised as to whether *his* initiates were properly connected to the Gaudiya Vaishnava lineage; and more particularly, whether the disciples of **Jayatirtha** whom he had re-initiated were. Again, no one was sure. But in the end the GBC decided that it was plainly absurd that devotees should be in the position of doubting their own spiritual status because they were not certain that their initiating master was a *real* master (or *sad-guru*) and were therefore wondering if they should be initiated a third time by a third guru. In fact, this is a theological decision of some moment, taken independently of the Gaudiya Vaishnava tradition in India, and at the time it was perhaps the most far-reaching development in ISKCON since *Prabhupada*'s death.

Needless to say, all these upheavals (starting in 1980 and culminating in 1987), which looked as though they might destroy ISKCON altogether, were

deeply distressing to many devotees. Gradually, a reform movement developed which insisted that the gurus' power be restricted. It began to gather pace in 1984 and had a number of forms. One of them is associated with a group of devotees at the community of New Jaipur in Mississippi; they hold that a bona fide guru/*sad-guru* must be liberated, as *Prabhupada* had always said, and that the eleven gurus were no more than his deputies. (By analogy, though they do not use it themselves, in Britain the court rises when the judge enters because he or she represents the monarch—but the judge is not a member of the royal family.) This group has continued to hold this position and does not accept any of the gurus appointed by the GBC.

But the most influential wing of the reform movement has gone in the opposite direction. It has in effect redefined what a guru is; and it has also made ISKCON more democratic. So in 1987—the *annus horribilis* when **Bhagavan**, **Bhavananda** and **Rameshvara** were removed as gurus, **Bhaktipada** was expelled and **Jayatirtha** was murdered—the GBC agreed to be 'reconstituted'; that is, all its members, including some gurus, resigned and had to be re-elected. One of the consequences of this reform movement was that the number of gurus was greatly increased. Any devotee can now become an initiating guru provided that three members of the GBC recommend him. In effect, this means that anyone can become a guru who (a) follows the basic regulative principles—is vegetarian and teetotal; (b) chants the *Hare Krishna mantra* every day; and (c) engages in devotional service. Gone are the days of the super-special gurus as absolute spiritual authorities. In 1986, nine years after *Prabhupada's* death, the number of gurus had risen to about 25. (Some of these were Indian, a trend which has continued.) And by 1989, there were *over a hundred* (which is about one percent of the total number of disciples ever initiated in the movement from 1966 to the present day—and half of those have left the movement altogether). This is very different from the Gaudiya Vaishnava movement in India. In fact, it is unique in any spiritual tradition anywhere in the world.

So what exactly are these hundred or so gurus doing? The best answer I can give is taken from a booklet by Stephen Guarino/**Satsvarupa**, one of the eleven original gurus and the one whom the majority of devotees feel has been the most reliable and the 'purest' all along. Satsvarupa quotes *Prabhupada:*

> This Krishna consciousness movement directly receives instructions from the Supreme Personality of Godhead via persons who are strictly following His instructions. Although a follower may not be a liberated person, if he follows the supreme, liberated Personality of Godhead, his actions are naturally liberated from the contamination of the material nature. Lord Chaitanya therefore says: By My Order you may become a spiritual master. One can immediately become a spiritual master by having full faith in the transcendental words of the Supreme Personality of Godhead and by following His instructions. (quoted in *Guru Reform Notebook,* 41)

This is the foundation of the present theology of gurus in ISKCON. No one in the movement now claims to be a pure devotee or *sad-guru*. **Satsvarupa** admits that he, along with the ten other gurus whom Prabhupada appointed, allowed himself to be worshipped as if he were liberated, and that this was an error (*Guru Reform Notebook,* 5). In reality, the guru has a real, but limited, role. He gives initiation/*diksha*—but liberation is granted by Krishna. Certainly, the teaching that the *diksha-guru* takes on the karma of his disciples appears to have been dropped, as has the idea that the guru has an eternal relation

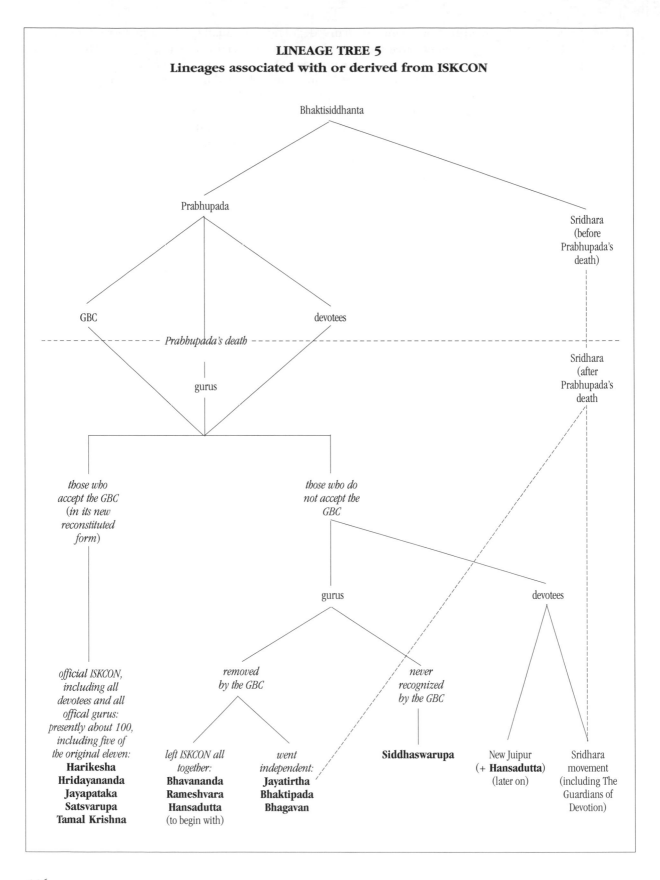

LINEAGE TREE 5
Lineages associated with or derived from ISKCON

Bhaktisiddhanta

Prabhupada

Sridhara
(before
Prabhupada's
death)

GBC

devotees

- - - - - - - - - - *Prabhupada's death* -

gurus

Sridhara
(after
Prabhupada's
death

*those who
accept the GBC
(in its new
reconstituted
form)*

*those who do
not accept the
GBC*

gurus

devotees

*official ISKCON,
including all
devotees and all
offical gurus:
presently about 100,
including five of
the original eleven:*

**Harikesha
Hridayananda
Jayapataka
Satsvarupa
Tamal Krishna**

*removed
by the GBC*

*never
recognized
by the GBC*

*left ISKCON all
together:*
**Bhavananda
Rameshvara
Hansadutta**
(to begin with)

*went
independent:*
**Jayatirtha
Bhaktipada
Bhagavan**

Siddhaswarupa

New Juipur
(+ **Hansadutta**)
(later on)

Sridhara
movement
(including The
Guardians of
Devotion)

with his disciples and leads them back to Krishna. What the *diksha-gurus* do now is provide a link with Krishna and Prabhupada.[2]

It is the GBC's job to oversee the overall standard of behaviour within the movement (including that of the gurus). And that is why the GBC, and not the gurus themselves, appoints new gurus. In this, it is acting rather like the legal profession: appointments are made by a recognized body made up of lawyers, not by individual lawyers however eminent they might be. And in fact ISKCON has effectively changed the function of the guru from a person of outstanding spiritual qualities to someone who simply fulfils a certain role—an essential one, to be sure, and one requiring a certain basic level of purity and commitment, but a role that is fundamentally operational and not really 'personal' at all. One of the consequences of this redefinition is that the role of the original eleven gurus is very different from what it was when they were appointed. Of course, they have a certain historical significance because *Prabhupada* named them—but apart from that, they are in principle now no different from any of the other gurus.[3]

I am not writing an account of ISKCON *per se* but rather of the Western gurus who lead it. But in effect the two have been practically the same ever since *Prabhupada*'s death. What this means is that a branch of an ancient Indian tradition—Gaudiya Vaishnavism—which was brought to the West just 30 years ago, is now being run at all levels, managerial and theological, by Westerners. How ISKCON will fare in the future is difficult to determine. But the possibilities seem to be these: that it will link up in some way with mainstream Gaudiya Vaishnavism in India; that it will develop as an independent form of Gaudiya Vaishnavism; or that it will continue to metamorphose and become a completely independent tradition.

Primary sources:

Official ISKCON: various internal GBC memoranda (unpublished); Satsvarupa dasa Goswami, *Srila Prabhupada-lilamrita,* 6 vols. (Los Angeles: Bhaktivedanta Book Trust, 1980–83); Satsvarupa dasa Goswami, *Vaisnava Behavior: The Twenty-six Qualities of a Devotee* (Port Royal, Pennsylvania: Gita-nagari Press, Satsvarupa dasa Goswami, *Guru Reform Notebook* (Washington, D.C.: Gita-nagari Press, 1986); Tamal Krishna Goswami, *Servant of the Servant* (Los Angeles: Bhaktivedanta Book Trust, 1984)

New Jaipur: Karnamrita dasa ed., *Living Still in Sound: An Anthology of Essays . . . on the Guru and ISKCON* (Washington, Mississippi: New Jaipur Press, 1990)

the Shridhara movement: His Divine Grace Bhakti Raksaka Sridhara Deva Goswami, *Sri Guru and His Grace* (San Jose, California: Guardian of Devotion Press, 1983)

Secondary sources:

Official ISKCON: E. Burke Rochford, *The Hare Krishnas in America* (New Jersey, 1985)

New Jaipur: None

[2] A subtle theology has been developed that gives *Prabhupada* a unique role in the dissemination of Krishna consciousness. While he was the *diksha-guru* for all those whom he initiated, he was also the *shiksha-guru* or 'instructing guru' for the whole world, everyone's eternal master. This makes him a *jagad-guru*—and moreover one who *can* grant liberation (Satsvarupa, *Guru Reform Notebook,* 62).

[3] The various relationships of those connected with ISKCON can be found in the accompanying Lineage Tree. It includes **Siddhasvarupa,** who claims to be Prabhupada's successor (see his entry) and devotees who have either left ISKCON altogether and gone over to other Gaudiya Vaishnava gurus (for example the Guardian of Devotion group) or, like the New Jaipur group, have not left the movement but nevertheless are proposing an 'unauthorized' (which is to say 'heretical') interpretation of *Prabhupada*'s intentions in making the original eleven appointments.

the *Shridhara movement:* E. Burke Rochford, *The Hare Krishnas in America* (New Jersey, 1985)

Centre:

Official ISKCON: P.O. Box 34453, Los Angeles, CA 90034, U.S.A.; Bhaktivedanta Manor, Letchmore Heath, Watford, Hertforshire, England, U.K.

New Jaipur: P.O. Box 127, Washington, MS 39190, U.S.A.

the Shridhara movement: 62 South 13th Street, San Jose, CA 95112, U.S.A.

[For **Bhaktipada**, **Hansadutta**, **Jayatirtha**, and **Siddhasvarupa**, see their separate entries]

COMPARE:

Other Western Gaudiya Vaishnava gurus: Sri **Krishna Prem**

Other Western gurus in India: Sri **Krishna Prem**, **Mahendranath**, the **Mother**

Other Western successors/representatives (in various senses of these terms) of Indian masters: Swami **Abhayananda**/Marie Louise (associated with *Vivekananda*); Sisters **Daya** and **Devamata** (associated with Paramananda); **Rajarsi Janakananda**, Sri **Daya Mata**, both **Kriyanandas** (all associated with *Yogananda*); **Rudi** (associated with Muktananda); Swami **Radha** (associated with Sivananda); the three **Devyashrams** (associated with the Shankaracharya); **Yogeshwar Muni** (associated with Swami Kripalvananda)

Other Western gurus/teachers of varying degrees of Hindu persuasion: Guru **Subramuniya**, Joya **Santanya**, Swami **Turiyasangitananda**

HARIKESHA Swami. SEE **HARE KRISHNA GURUS**

JANE HEAP. SEE THE **GURDJIEFF LEGACY**

Lex HIXON | Sheikh Nur al-Jerrahi

American Sufi teacher who explored several major traditions

Lex Hixon was an unusual man. He was born in 1941 and received the best education America can offer: a degree in philosophy, specializing in Kierkegaard, at Yale in 1963, followed by a Masters on *Ramana Maharshi* and a Ph.D. on Gaudapada (Shankara's guru) at Columbia (during the years 1966 to 1976). (For each of these last two degrees he wrote dissertations which can be obtained through University Microfilms.) Yet at the same time, he was exploring spiritual paths. At the age of 19, he studied with a Lokota Sioux mystic. In 1965, he became a student of Swami Nikhilananda of the Ramakrishna Order and started following the way of universal Vedanta that was started by Ramakrishna and brought to the West by *Vivekananda;* he has also practised with two other monks of the Order, Swami Prabhavananda and Swami Aseshananda. In 1975, he began Tibetan Buddhist practices under the guidance of Tomo Geshe Rinpoche.

presumably the reincarnation of the Tomo Geshe Rinpoche who initiated Lama Anagarika **Govinda** *in 1931*

 Then, in 1978, he met the man who was to be the most significant influence in his life, Sheikh Muzaffer al-Jerrahi, a Turkish teacher in the Khalvati-Jerrahi Order. Two years later, he accompanied Sheikh Muzaffer on a journey

to Mecca and was afterwards given formal transmission into the Order, taking the name, Nur al-Jerrahi. (Another American—a woman—received transmission at the same time and took the name, Fariha al-Jerrahi; that's all I know about her.) There can be little doubt that Sufism was Hixon's first love from this time on. But that did not mean that he gave up his explorations of other traditions. In 1983, he entered the Eastern Orthodox Church under the guidance of Alexander Schmemann; and he became a senior student (*shuso*) with Sensei Bernard **Glassman** in 1985. (*Shuso* literally means 'first seat' and is sometimes referred to as the stage of head monk; it comes after the preliminary *tokudo* ceremony—see the Glossary.)

An American Sufi who is simultaneously a practitioner in Zen, Tibetan Buddhism, Vedanta, and Eastern Orthodoxy is hardly run-of-the-mill. Lex told me in a letter that

> In none of these traditions do I have special formal responsibility except in the Jerrahi Order. But in all these traditions, and this is true of sacred tradition per se, anyone who has received even the basic initiation has the responsibility to teach and to uphold the tradition, to participate in certain sacraments which make a person a full locus of the tradition, one who is radiating the tradition verbally or silently at every moment.

And he certainly lived up to this ideal. He held a Vedanta study group in New York, as part of his unofficial responsibility in the Ramakrishna Order, and also published books that cover practically the full range of traditions: on Ramakrishna (in which he made comparisons between Ramakrishna's "original enlightenment" and the "metameditation called *mahamudra* in Sanskrit, *dzogchen* in Tibetan, or *shikantaza* in Japanese Zen"); on the Mahayana *prajnaparamita;* and *Coming Home,* which, after surveying Heidegger, *Krishnamurti,* Ramakrishna, *Ramana Maharshi,* Zen, Plotinus, Hasidic Judaism, St. Paul, Bawa Muhaiyaddeen and the *I Ching* (in that order), ends by suggesting "a spiritual experiment", by which he means "universal suggestions for prayer and meditation" as distinct from "spiritual instructions given directly by a teacher immersed in one particular tradition" (*Coming Home,* 187). Lex stresses that

> Every seeker should receive traditional initiation and personal guidance from at least one authentic spiritual guide. Then one no longer *experiments* with contemplation but lives contemplative practice. (ibid.)

There is something more—something truly universal—and he devoted his life to it.

True to his own principle that the search has to be carried out from within an authentic tradition, his main energy went into his Sufi teaching. *Atom from the Sun of Knowledge* presents an extraordinary vision.

> These writings have manifested through inspiration . . . Many of them were composed during the holy month of Ramadan—fasting from sunrise to sunset, feasting and praying until one hour before the first light. This collection represents only a fraction of the spontaneous teachings that the author has presented orally during the eleven years of his responsibility as a Sufi guide, who is a friend to souls and an interpreter of dreams . . . They are not confined within any limited context of understanding, including that of the author.
>
> The mystical writings collected here are not personal but represent the universal gift of an unbroken spiritual transmission covering fourteen centuries, beginning with the Messenger of Allah in the desert of Arabia. This lineage does not, strictly speaking, originate with the prophet Muhammad, upon him be peace, since he considered himself a humble inheritor of the vast spiritual wealth of Adam, Noah, Abraham,

Cf. others who claim an unbroken transmission: **Sumedho, Jampa Thaye, Glassman, Subramuniya,** *the* **Hare Krishna gurus***.*

Isaac, Ishmael, Jacob, Joseph, Solomon, David, Moses, and Jesus, upon them all be peace. (*Atom from the Sun of Knowledge,* vi)

In short, what is being offered is "initiatory transmission" (ibid., xi). Lex compares it with that of Meister Eckhart, "whose strong teaching of omniconscious unicity or identity with the Divine is recognizably Sufi" (ibid.).

Atom from the Sun of Knowledge is in two parts. The first, 'Traditional Islamic Resources', deals with such topics as the *Quran,* daily prayers and so on. As the title indicates, it is 'traditional': "One billion Muslims on the planet today would experience agreement of heart with this presentation, regardless of subtle or obvious differences in religious and cultural emphasis" (ibid., xii). It was written in English, a fact that may seem unimportant until one compares this first part with the second, 'Sufi Inspirations', which was written in Spanish—at a time when Lex did not know a word of that language.

This is an interesting story. One of the central teachings of the Jerrahi Order is the importance of spiritual dreams and their interpretation (ibid., 7). (There is no fixed system of dream symbolism and sometimes the same dream will be interpreted in quite different ways.) At some point (I have no exact date), Lex was "directed through the dreams of dervishes to establish Sufism on Mexican soil" (ibid., 249). He therefore flew to Mexico City, armed only with a Spanish-English dictionary; he compiled "vocabulary lists" from it and this was the basis of 'Sufi Inspirations' (which was later 'translated' into English—there is an example below). This must surely be unique in the transmission of any tradition.

Lex says that he has given initiation to over 500 people since he received his own transmission from Sheikh Muzaffer in 1980. The ceremony has four stages: *shari'a,* the Sacred Law, which is associated with Moses; *tariqa,* the 'way' of Sufism, which is associated with Jesus; *haqiqa,* the 'Truth', which is associated with Abraham; and *marifa* or wisdom/gnosis, which is associated with Muhammad (ibid., 2–4). This is a profound teaching, of course, and I cannot possibly summarize it here. But as one would expect, knowing Lex's approach, his presentation of the symbolism is extremely rich. Elsewhere, he says that

Cf. what Jiyu **Kennett** *says about Zen rituals.*

In the precious sacrament of dhikr, essential Divine Energies descend through the hearts and even through the physical bodies of the dervishes. Divine Reality becomes visible and experienceable as human reality. (ibid., 11)

I saw a video—taken during an Interfaith Conference at Shrila **Bhaktipada**'s New Vrindaban—of some of Lex's students practising *dhikr* and I can see what he means. This may be connected with another aspect of his teaching that is altogether more cosmic:

Cf. the teachings of the **Mother** *and Andrew* **Cohen** *on the evolution of a new humanity.*

We are sprouting seeds of this new humanity—anointed ones, named ones, dedicated ones, the arabized friends of Muhammadan Light. Our mode of living in this confluence of humanity and Divinity is entirely distinct from the usual mode of existing in a mode that is narrow, solidified, and stipulated, in a bittersweet and capricious life that is not really worth the pain of living. We now breathe and dance without a care, barefoot and delirious, in the presence within ourselves of the new Burning Bush, the Muhammadan Light, the incomparable and immense treasure of the true human heart. Everything that has ever existed or will ever be is active within this treasure of the new humanity. (*Atom from the Sun of Knowledge,* 358; this is an example of the English translation of his original Spanish)

This was addressed to his own Sufi students, of course. But we should not forget his personal explorations into all the other major traditions—a form of

Cf. Samuel **Lewis** *and J.G.*
Bennett.

experiential comparative religion that is presently quite rare (but getting more common).

I never met Lex but I enjoyed receiving his letters. So perhaps I am prejudiced in his favour. In any event, it came as a shock to learn, as I was working on this book, that he had died (in November 1995), aged 54. Now we will never know how his 'experiment'—a 'universal' spiritual life that is yet rooted in tradition—will turn out; unless, that is, his students show us on his behalf. And that is entirely possible.

Primary sources: Lex Hixon, *Heart of the Koran* (Wheaton, Illinois: Theosophical Publishing House, 1988); *Coming Home* (Los Angeles: Tarcher, 1989) (originally published by Anchor Press/Doubleday, (Garden City, NY 1978); *Great Swan: Meetings with Ramakrishna* (Boston, 1992); *Mother of the Buddhas: Meditations on the Prajnaparamita Sutra* (Wheaton, Illinois: Quest Books, 1993); *Atom from the Sun of Knowledge* (Westport, Connecticut: Pir Publications, 1993)

Secondary sources: None

Centre: Masjid al-Farah, 245 West Broadway, New York, NY 10013, U.S.A.

COMPARE:

Other Sufi teachers (of various persuasions): Abdullah **Dougan**, Reshad **Feild**, René **Guénon**, Rabia **Martin**, Ivy **Duce**, James **MacKie**, Samuel **Lewis**, Vilayat Inayat **Khan**, and others in the **Sufi Order**, Frithjof **Schuon**, Idries **Shah**, Irina **Tweedie**

HRIDAYANANDA SWAMI. SEE **HARE KRISHNA GURUS**

L. RON HUBBARD. SEE **APPENDIX 1**

CHRISTMAS HUMPHREYS. SEE **APPENDIX 1**

ERNEST SHINKAKU HUNT. SEE **APPENDIX 1**

OSCAR ICHAZO

Bolivian founder of Arica who says he is enlightened

All our information about Ichazo's early life comes from him. He was born in 1931 and had a conventional Catholic upbringing although he says that his parents were not fervent believers. His spiritual experiences started when he was not yet seven years old: "attacks [that] were very violent, not epileptic, but like that" (*Interviews with Oscar Ichazo,* 6). He learned the martial arts and practised yoga. In 1950, aged 19, he became part of a group in La Paz that studied Zen, Sufism, Kabbala, Indian and Tibetan tantra, *kriya yoga,* and "some

techniques that I later found in the Gurdjieff work". He made three separate journeys to the East, where he was recognized by everyone "as a man who has achieved what's called the satori condition . . . I was not treated as a disciple" (*Interviews*, 80). Subsequently, in 1964 or so, he had an experience that he refers to as enlightenment.

> It's ordinarily known as a coma, but also was a state of ecstasy. My body was in a very mild state of being asleep, but I was not asleep—I was completely conscious . . . I saw how the laws have organized the cosmos itself, laws that I had already understood rationally but now which I was seeing. I had experiences of cosmology, of how the world was created. I would see the mathematical relationships between things, which put me on the track of a new calculus . . . (Interviews, 134)

In 1968 he moved his Instituto de Gnoseologia to Arica, a small town in Chile (*Interviews*, 64) and from there to New York.

I have not taken the Arica training and must admit that I can hardly understand anything of its theory and method. Somehow, in a way that I cannot follow, "we are demonstrating God by reason" by means of trialectics (*Interviews*, 34, 35). (Trialectics is a threefold logic based on the laws of mutation, circulation, and attraction.) The only aspects of Ichazo's teaching that I find comprehensible are his distinction between essence and personality; the idea that human beings possess three centres—the intellectual, emotional and vital;[1] and his use of a nine-sided figure called 'the enneagon' (*Interviews*, 9, 11, 18).[2] All of these are reminiscent of **Gurdjieff**'s teaching, of course, and Ichazo has been charged with making use of **Gurdjieff**'s ideas "usually without acknowledgement" (*Gurdjieff Bibliography*, item 449; see the end of **Gurdjieff**'s entry for details of this book). Ichazo's answer to this charge is that he came across **Gurdjieff**'s teaching in **Ouspensky**'s *In Search of the Miraculous* in the early 1950s but found nothing in it that was new. All of **Gurdjieff**'s main ideas—the essence/personality distinction; the three brains or centres; the sevenfold Ray of Creation; the enneagram; and even the idea that the earth is 'feeding' the moon—can be found in Greek philosophy: Plato, Pythagoras, the Stoics, and someone called Posidonius ('Letter to the Transpersonal Community').[3]

By contrast, Ichazo says that his is the first really new teaching since the Buddha (*Interviews*, 56); that "I am the only source of the Arica theory and method" ('Letter . . . ', 116) and "I am the root of a new tradition" (*Interviews*, 138). These are big claims. But he may find them difficult to live up to.

(*See* Lineage Tree 3)

Primary sources: Oscar Ichazo, *The Human Process for Enlightenment and Freedom: A Series of Five Lectures* (New York: Arica Institute Press, 1972); *Interviews with Oscar Ichazo* (New York: Arica Institute Press, 1982); 'A Letter to the Transpersonal Community' [my xerox copy has no details]

Secondary sources: John Lilly, *The Center of the Cyclone* (New York, 1972) [last chapter]; John Lilly and Joseph Hart, 'The Arica Training' in C. Tart (ed), *Transpersonal Psychologies* (New York, 1977)

[1] Called path, oth, and kath in Arica's terminology. (The term 'path' has no connection with the same word meaning 'way'.)

[2] This interview originally appeared in *Psychology Today*, July 1973, where the word *enneagram* is used; the version that appears in *Interviews with Oscar Icazho* has *enneagon* in its place

[3] At the same time, he says that it is quite impossible to ascribe **Gurdjieff**'s ideas to Sufism since they are essentially materialistic (like Stoicism) and hence contradict Sufism's basic teaching of the unity and transcendence of God ('Letter . . ., 114).

Centre: Arica, 24 West 57th Street, New York, NY 10019, U.S.A.

COMPARE:

Others who say they are independent of all traditions, or have created their own, or have found the root of all traditions: Madame **Blavatsky**, Paul **Twitchell**, **John-Roger**, Zen Master **Rama**, Master **Da**

JAE JAH NOH

Author of an extraordinary book which details his realization that being alive is itself the truth

I know nothing about this man. Several years ago someone lent me his book, *Do You See What I See?* It contains no information about him except the following: that he is the founder of a community in Denver, Colorado, called 'The Aspen Grove' (since defunct, I've been told); and that the copyright for the book is in the name of Edwin Smith (which is presumably his original name; I have no idea why he chose the pseudonym, Jae Jah Noh). *Do You See What I See?* is a book of metaphysical passion—and there are not too many of them. The central thesis is that simply by being human we are in the perfect position to understand life and our place in it. There is nothing to be done in addition to being alive—that is, in addition to accepting life as it is without resisting or avoiding it. There is no preparation for life, no dress rehearsal. "If you are here, you are prepared" (61).

How can one really explain the Infinite? Only an infinite explanation could possibly achieve that purpose and it is immediately available in the form of real life. The infinite explanation arises spontaneously and naturally as the form of your very life. Life is itself its own explanation, and immediately obviates the need for any other. (9)

Everybody's life, by definition, consists of things that enter and leave it. Jae Jah Noh explains this basic fact by reference to two states (which are ultimately one, I need hardly say): consciousness and awareness.

Consciousness is reality. Consciousness is That Which Is. It is God, Truth, the One. It is prior to all things. It *is* all things. It is the cosmic energy from which all things take form.

Awareness is the realm of the mind. Yet, awareness is a modification of consciousness, a limitation upon it. While consciousness is absolute, awareness is relative. One's awareness is always *of* consciousness . . .

The realm of the Absolute is not a separate realm or world. It is simply reality beyond its conditioned forms. It is Absolute Consciousness . . .

It is not possible, then, to 'expand' your consciousness. Consciousness is not *yours.* You *are* consciousness. It is not a mind-form, not something you possess, it is you, Self.

It is possible to 'expand' your awareness. It is possible to alter your awareness until awareness and consciousness are identical, at which time awareness is destroyed and consciousness abides. In a more accurate sense, though, nothing has really been expanded, nothing has changed. Awareness has simply been released from the separative activity of the mind. It has been allowed to be in its true form, which is without condition. Only the appearance of change is present due to one's tendency to identify with limited forms of what is . . .

From this perspective, something comes into existence only when it enters the field of awareness. Thus, the mind is the field of birth and death. It is the stage upon which That Which Is comes and goes in front of the pinhole perspective of the perceiver. (78, 79)

All of this is good stuff—one might even say, intoxicating stuff. And it is based on Jae Jah Noh's own experience. He starts his book with a description of what happened to him but I have left it to more or less the end because the truth stands by itself and not because it is backed up by anything. However, his experience is interesting. As a result of reading a book, he became enlightened. (He says anything can trigger it off.)

> Suddenly, a connection was made, something happened, and immediately 'everything' made 'sense' . . .
>
> I do not think I can adequately convey the sensation of non-obstruction here. Before, the pursuit of knowledge and the understanding of the relationships between various 'facts' had always been accomplished with a great amount of effort. It was very much like walking through knee-deep mud. I could think and make various connections, but it was difficult. Yet, now, I was like a skater upon a surface of ice. There was a tremendous feeling of release from the effort I had known before. It was as though knowledge existed as a totality of open passages which had visited my mind. Now I could walk through these passages, make any sort of connection without thought or effort because I was being guided by knowledge itself . . . Everything related to everything else. It was truly all one . . .
>
> This experience has slowly matured into a living reality, an on-going experience of the transcendental. I am never without it. I am never outside this living presence. (13-15)

But this living presence is always available—to everyone.

> Your entire existence has been preparation for the moment you are now living. All that is necessary is for you to consciously surrender at this moment. You are always ready for life, Truth, God . . .
>
> Since we are always ready for spiritual work, what prevents it is our belief that we are not ready, our belief that there is something still to achieve, our belief that we must attain some knowledge prior to beginning. Our belief that we are not ready is our rationale for searching, for avoiding the inevitable . . . You are ready when you are willing, not when some external condition is met. (61–62)

In the end, we are always brought back Jae Jah Noh's essential message: we already, at any given moment, have everything we need. All that is required is that we accept it without reservation.

I do not know why The Aspen Grove ceased to function or what Jae Jah Noh is doing now. But I'd like to.

Primary sources: Jae Jah Noh, *Do You See What I See?* (Wheaton, Illinois: Theosophical Publishing House, 1977)

Secondary sources: None

Centre: None extant

COMPARE:

Other Westerners who teach that one's own nature is truth: Andrew **Cohen**, Jean **Klein**, John **Levy**, Barry **Long**, Bhagavan **Nome**, Toni **Packer**, **Shunyata**

Englishman who is one
of the few Westerners
authorized to give
initiations in Tibetan
Buddhism

Osel Tendzin*, who was
Chogyam Trungpa's Vajra
regent—a variant of
Dharma regent—died in
1990.*

There are few more traditional teachers than Jampa Thaye. He speaks and reads Tibetan; he has been accepted and taught by Tibetan masters; he is part of a lineage that traces itself back to Shakyamuni Buddha; and he is a teacher who, on occasion, presents the tradition in a form that is virtually untouched by the twenthieth century.

He was born into a Catholic family in 1952. He mentions only one influence on his early spiritual search: "the poetic lineage of Kerouac, Ginsberg, and Dylan" (*Diamond Sky,* xvii), which he encountered as a teenager. It must have been close to his heart for him to refer to it in *Diamond Sky,* which is in all other respects a completely traditional, not to say conservative, exposition of the Tibetan teachings which he espouses. After his hippie phase, he had some brief contact with Theravada Buddhism before meeting Karma Thinley Rinpoche, who was to be his teacher and guru.[1] This was in 1973 and Stott was 21 years old. He took the four refuges (the Tibetan tradition adds the guru to the usual three of Buddha, Dharma, and Sangha) and was given the name 'Karma Jampa Thaye'. Two years later, he opened a centre, Kampo Gangra Kagyu Ling (which, as it name implies, was linked to the Kagyu line) in Manchester. And shortly afterwards, in 1976, still only 24, he was given the title 'Ngakpa', which is awarded to lay teachers.[2] At the same time, he was appointed as Thinley Rinpoche's 'spiritual assistant'. He also got married (after Thinley Rinpoche had carried out divination) and graduated with a degree in Religious Studies from Manchester University—the beginning of a 'Western' scholarly career that has intertwined with his scholarship in the Tibetan tradition.

Then in 1977, Thinley Rinpoche appointed him as his deputy (the Tibetan term is *sku-tshab*) or Dharma regent. This means that Jampa Thaye will look after Thinley Rinpoche's spiritual affairs after Rinpoche's death until such time as, having been reborn and recognized as a *tulku,* Rinpoche will be old enough to take up his duties again. Since the Tibetan tradition is entirely based on the *tulku* system, every *tulku* needs a Dharma regent (sometimes several) to hold the fort, as it were, until they come of age. The task of a Dharma regent is thus a significant one, and Jampa Thaye is the only Westerner who presently holds this title.

Ngakpa Jampa's responsibility as a teacher includes giving refuge and Bodhisattva vows, as well as Vajrayana initiations. What this means is best explained in terms of his own booklet, *Diamond Sky,* an introduction to the practice of the three vehicles: Hinayana, Mahayana and Vajrayana. He follows the traditional Vajrayana view that the first two vehicles are an approach to the third (which is the form of Buddhism followed in Tibet) and hence included in it, in a sense. So anyone who teaches Vajrayana, even at a relatively modest level, like Ngakpa Jampa, automatically has authority in the Hinayana and

[1] Karma Thinley Rinpoche is somewhat unusual in that he is a *tulku*—someone who deliberately incarnates over and over again in order to manifest Dharma and so help beings attain enlightenment—in two separate Tibetan schools. He was recognized as a *tulku* of the Sakya lineage when he was a child but later the Karmapa also recognized him as a Kagyu *tulku,* the fourth Karma Thinley. He is thus acknowledged as representing both schools and gives initiations and instructions from both. He left Tibet in 1959, after the Chinese invasion, and has since moved to Canada, where he has a number of centres.

[2] The term is a literal translation of the Sanskrit *mantra-dhara,* meaning 'one who holds a *mantra* in mind' and this may explain the 'translation' of *ngakpa* into English as 'lay yogin'.

Mahayana as well. (Of course, Hinayana and Mahayana Buddhists do not accept this view—but that is another story.)

In fact, he presents all three vehicles as having been taught by Shakyamuni himself: three lines of transmission that were given to different groups depending on their capacity to understand. The Vajrayana teachings were given to the most advanced disciples and passed on in secret until the fifth century (a thousand years after the Buddha) when they were revealed for the first time (*Diamond Sky,* 23). I think it is fair to say that this account of the origins of the Vajrayana, and thus of the Tibetan tradition, is literalist, even fundamentalist (in the sense that certain claims are regarded as 'fundamental' and are not susceptible to critical analysis). There is, of course, no external evidence for it—how could there be if the first thousand years of transmission were unknown even to fellow Buddhists? And it contrasts with the more prosaic explanation that the Vajrayana texts appeared in the fifth century because that was about the time that they were composed, either as a result of direct insight into Dharma (if one is what might be called an 'inspirational traditionalist' rather than a literal one) or as a result of contact with other, non-Buddhist, traditions in India. In fact, Ngakpa Jampa does accept that there have been what he calls "visionary experiences directly from enlightened sources" (*Leap Like a Tiger . . .,* 37). But he sees them as additions to the original Vajrayana that the Buddha himself gave. Ngakpa Jampa is thus an example of a particular sort of Westerner who has entered an Eastern tradition: one who accepts the whole system, lock, stock, and barrel.

> As the first generation of dharma practitioners in the West we should be sure not to impose our own perceptions or prejudices on the dharma. (*Leap Like a Tiger . . .,* 31)

The reason why Ngakpa Jampa stresses the historical aspect of the Vajrayana is so that he can establish the fact of continuous transmission.

> The Sakyapa tradition, its sub-sects and its array of textual and meditational lineages are the structures through which the transmission of the liberating teachings flow. This transmission is the movement of knowledge, in the form of an immense variety of techniques for direct insight into reality, from teacher to student in unbroken succession. It is precisely this uninterrupted nature of the transmission that guarantees its spiritual efficacy. (Introduction to Chogay Trichen, *The History of the Sakya Tradition,* [Bristol: Ganesha Press, 1983])

This would apply equally to all the Tibetan lineages. So it would make no sense at all to adapt the tradition to Western needs. He therefore presents Tibetan Buddhism as a complex and precisely engineered system like a Formula 1 racing engine. Only the most highly trained mechanics can tune them.[3] Jampa Thaye begins his presentation of the path in the traditional Tibetan way with the four refuges, of which the first is the guru. A true guru is one who "has received authority from a genuine lineage and is thus able to convey the blessings of transmission."

> It is the guru who awakens the qualities of one's basic nature and informs and nurtures one's practice through the teachings of the three vehicles. For this reason, in

[3] This analogy (which is mine, not his) can be taken further. The power delivered by Formula 1 engines is so great that it requires a special kind of skill to drive one. The vehicle is in effect in a continuous skid and has to be controlled *all the time,* not just on sharp bends or similar hazards familiar to the ordinary driver. So while it appears to be just like an ordinary vehicle except that it goes faster, in fact it is an extraordinary vehicle—and a dangerous one. An untrained driver would crash it within seconds.

order to attain enlightenment, one must rely upon a fully-qualified guru. (*Diamond Sky*, 32)

Such a guru is not only learned in the scriptures and skilled in giving the various initiations but also possesses the qualities of wisdom and compassion. Needless to say, the Tibetan tradition has developed all of this into a central aspect of its system (perhaps a bit like the carburettor in a Formula 1 engine). It is called *guru-yoga* and the guru is seen as the embodiment of the Buddha (ibid., 74, 77). In fact, all teachers who give initiations are regarded as gurus in this sense by the Tibetan tradition. This includes Ngakpa Jampa, who, being one of the few Westerners who is authorized to give Vajrayana initiations, is thus a guru. (However, not all gurus have the same degree of realization. So Ngakpa Jampa is subordinate to his own guru, Karma Thinley Rinpoche, and it is important that what he does has Thinley Rinpoche's blessing.)

Having established the centrality of the guru, Jampa Thaye gives brief outlines of the first two vehicles or *yanas:* the Hinayana teaching of suffering and impermanence; and the Mahayana teaching of emptiness and the Bodhisattva ideal of striving for the enlightenment of all beings. He then continues with a succinct account (six pages) of the Vajrayana, the third vehicle. It is superior to the Hinayana and the Mahayana because it alone has the methods for reaching the ultimate goal of attaining Buddhahood in this very life—and all of these methods are dependent upon the blessing of one's guru (*Diamond Sky*, 73). Vajrayana is very hierarchical and its texts are arranged in an ascending scale according to their power and directness: *kriya, carya, yoga, anuttara*. Only the last kind (which is itself divided into three further levels) lead to the ultimate goal. In addition, the Sakya school has its own particular series of *anuttara* teaching, one of which is known as 'The Thirteen Golden Dharmas'. Jampa Thaye received the transmission of this text from Sakya Trizin, head of the Sakya school, in a private initiation in 1986. Its practice bestows "beneficial powers like 'wealth-creation' and 'magnetising'" (ibid., 77).[4]

The culmination of the Vajrayana is, of course, enlightenment: "One is enthroned on the seat of Buddha Vajradhara, emperor of the diamond sky of ultimate reality" (ibid., 78). Yet the essential thing, as he states more than once, is that the practitioner receives true transmission from the guru: texts, guiding instructions and above all empowerment. And he quotes a verse: 'Without empowerment there can be no *siddhis* [spiritual attainments] just as one cannot extract butter from sand' (ibid., 76).

This brings us back to his own role. He is himself a practitioner who carries out certain duties, including that of teaching, on behalf of his guru. He has given refuge, Bodhisattva vows, and Vajrayana initiations to some two or three hundred people in Britain, Germany, Poland, and Bulgaria during the past 18 years. So he has his own students, who are connected, through him, with the unbroken transmission from Shakyamuni himself. He was once asked how he sees his role as a teacher.

> Well, as far as I am concerned, everything depends upon my own teacher, Karma Thinley Rinpoche. He made me his substitute and I am sustained in that position by his confidence and his blessing. I am here to pass on to people the things Rinpoche has given me, has entrusted to me. So I know many people come to me for advice

[4] These powers are two of the four 'actions' which a tantric yogi uses to benefit all beings—the others are 'pacifying' and 'destroying'—and are therefore not at all like the 'money magnets' used in the Western 'positive thinking' movement.

and for help and instruction and I try to give it to them, but what I am giving to them does not belong to me. That lineage that I have received from Rinpoche is completely—yes, completely—capable of benefitting all who wish to make a connection with it. So I am allowing people to make a connection—that's how I see it. (*Leap Like a Tiger . . ., 26*)

In a sense, then, Ngakpa Jampa's significance is only minimally a personal one. True, he is the only Western Dharma regent at the moment, which is an interesting historical fact, but there will almost certainly be others. Moreover, it is incidental to what he is really doing: helping the Vajrayana tick over. And when the right fuel is put into the carburettor, the mighty engine of Vajrayana turns the wheels of enlightenment.

Primary sources: Jampa Thaye, *A Circle of Protection for the Unborn* (1986); *Diamond Sky* (1989); *A Garland of Gold* (1990); *Leap Like a Tiger, Walk Like a Tortoise* (1994); *Some Teachings on 'The Four Dharmas of Gampopa'* (1995) (all published by Ganesha Press, Bristol). He has also published a number of papers in Western academic journals, under his original name of David Stott.

Secondary sources: None

Centre: Shedrup Ling, 15 Parkfield Road, Aigburth, Liverpool L17 8UG, England, U.K.

COMPARE:

Other ngakpas: Ngakpa **Chogyam**

Other Dharma regents: **Osel Tendzin**

Other teachers of Tibetan Buddhism: Freda **Bedi**, Lama Anagarika **Govinda**, Ole **Nydahl**, Pema **Chodron**, (Western) ***Tulkus,*** Dhyani **Ywahoo**

Other teachers who emphasize the need for unbroken transmission: the **Hare Krishna Gurus**, Ajahn **Sumedho**, Guru **Subramuniya**

JAYAPATAKA Swami. SEE **HARE KRISHNA GURUS**

JAYATIRTHA | James Immel

One of the original eleven gurus in ISKCON who eventually went off the rails and was murdered by one of his own disciples

*This entry should be read in conjunction with the **Hare Krishna Gurus**.*

Jayatirtha was a relatively early disciple of *Prabhupada,* the founder of ISKCON. He was initiated in 1967. Before that, he had been an enthusiastic proponent of Timothy Leary's LSD revolution. There must have been something about Jayatirtha that commended him to *Prabhupada:* he was an executor of *Prabhupada's* will and *Prabhupada* also named him as one of the eleven 'gurus'. (See the **Hare Krishna Gurus** for the meaning of this term.) But ISKCON literature hardly mentions him; the six-volume biography of *Prabhupada,* for example, *Srila Prabhupada-lilamrita* (written by **Satsvarupa**, another of the original eleven gurus) ignores him completely. And the reason for this silence is surely the result of Jayatirtha's subsequent career as guru. He was by no means the only one of the eleven to go astray but the path that he took was particularly unpalatable to the Hare Krishna movement.

An account of Jayatirtha's first brushes with the GBC (the governing body of ISKCON which *Prabhupada* set up in 1970) can be found in the entry on

the **Hare Krishna Gurus**. It involved him taking LSD—at least, they suspected him of doing so—while presiding over worship in the London temple, and also challenging the GBC to bring Shridhara Maharaja, a respected member of the Gaudiya Vaishnava movement in India, into ISKCON as an initiating guru. All this started in 1980 (three years after *Prabhupada*'s death), and the GBC deprived him of his guruship for a year. But it seems that he had no intention of accepting the GBC's authority and he left ISKCON in 1982, saying that he would set up a rival movement that would obliterate ISKCON completely (Rochford, 251). As it turned out, it was Jayatirtha himself who was obliterated.

In fact, his liaison with Shridhara did not last very long. To begin with, he took about 100 devotees with him but only a hard core remained with him as he became more and more isolated. He took the title 'Tirthapada' and his followers were called the Peace Krishnas. He continued to take drugs and either proclaimed himself to be the reincarnation of Christ or allowed his disciples to believe he was. In 1987, he left Victoria, British Columbia, where he was living with his wife, Bhakti, and flew secretly to Hawaii with another woman. Thereupon, one of his devotees, John Tiernan/Navarita Chaura dasa, moved in with Bhakti before being deported by the Canadian authorities (A.P. report from Victoria, BC).

The final episode in the story occurred when Jayatirtha came to London with his new 'wife'. By this time, Tiernan had become convinced that, far from being Christ, Jayatirtha was in fact the anti-Christ. In November 1987, he attacked Jayatirtha in a shop belonging to an Indian follower of Jayatirtha's and decapitated him. Tiernan has since been tried and placed in an institution for the criminally insane "without restriction of time" (*The Times*, 21 July 1988). As one might expect, given this denouement, the so-called Peace Krishnas simply evaporated and no trace of them remains.

This is a sorry tale and there seems to be little point in commenting on it. ISKCON maintains, quite rightly, that Jayatirtha's drug-taking was never sanctioned by the movement and that his behaviour after his expulsion in 1982 was also in utter contradiction to ISKCON's teachings. Yet we are bound to ask how such a person could have been appointed guru in the first place. I do not know the answer.

(*See* Lineage Tree 5)

Primary sources: None

Secondary sources: E. Burke Rochford, *The Hare Krishnas in America* (New Jersey, 1985); J. Hubner and L. Gruson, *Monkey on a Stick: Murder, Madness, and the Hare Krishnas* (New York: Harcourt Brace, 1988)

Centre: No longer extant

COMPARE:

Other gurus connected with ISKCON: the **Hare Krishna Gurus**, Shrila **Bhaktipada**, **Hansadutta**

JOHN-ROGER HINKINS

The founder of the Movement of Spiritual Inner Awareness

The Movement of Spiritual Inner Awareness or MSIA (pronounced 'Messiah') is a church with ministers who can marry and baptize people. It is allied with, but legally distinct from, the John-Roger Foundation, a charitable trust which

is in effect the secular arm of the church. It has its own training college and university; a health clinic; a number of community projects (which provide food for the homeless, for example); and a group 'transformational' programme called 'Insight', which offers a variety of personal growth seminars to individuals, including business managers. Insight has offices in a dozen or so American cities (including the obvious ones like New York, Washington, Chicago, and so forth) as well as London and Sydney. In 1992, Insight went to Omsk for the first seminar in Russia. About 100,000 people have taken an Insight Seminar of some sort over the past 15 years and the annual turnover amounts to several million dollars.

All of this has grown up, from a standing start, in less than 30 years. How has it happened? In order to answer this question, we need to tell the John-Roger story.

He was born Roger Hinkins in a Utah mining town in 1934. His parents were Mormons but he says he was not much influenced by his upbringing. In 1957 (this date is taken from *The Signs of the Times,* vol. 1, 30), he had to have an operation to remove growths on his face and eyes. He found himself

> watching the surgery from an entirely different level. The part of me that was observing was a totally loving, benevolent, fantastic consciousness . . . Within myself, I said that I would sacrifice everything to have that loving consciousness entirely present. (*The Wayshower,* 5; this pamphlet is included with the tape of the same name.)

In another publication, he says that he received the first part of the Traveler Consciousness during this out-of-the-body experience, and that he received the second part a year later, when he had to have another operation (*The Signs of the Times,* vol. 1, 30). In *The Wayshower,* however, he simply mentions the experience, as quoted above, and then says, "the years went by and nothing much seemed to happen." This is one of a number of instances where his accounts of his life and experiences vary somewhat.

He graduated with a psychology degree from the University of Utah in 1958 and moved to Los Angeles where he got a job as a highschool teacher. Then, one night (again no date), having indicated that he was ready for what was being prepared for him, he was lifted out of his body by "spiritual forces that were my guides and teachers" (ibid.). This was the beginning of a period of training in which he learned to leave his body at will.

> As I gained experience in out-of-body travel, I reached into the Soul and learned how to hold and maintain the energy of that realm. (*The Wayshower,* 7)

In 1963, he was involved in a relatively minor car crash and was concussed. But he also damaged a kidney which began to bleed several months later. Once again, he had to undergo surgery (*The Signs of the Times,* vol. 1, 32). During the operation, he was

> brought into the consciousness of the Mystical Traveler, a consciousness that is totally alive, totally dedicated, totally devoted to the supreme power that is God, that is life, that is love. (ibid.)

He also had "a conversation with spiritual forces and members of the spiritual hierarchy" in which he agreed to carry out a spiritual task: to take two people to the Soul Realm (*The Movement,* vol. V, no. 7, July 1980, 7). This was the third and last phase of his initiation into the Mystical Traveler Consciousness (*The Signs of the Times,* vol. 1, 30). In another version of this story, he says that he encountered a presence whom he recognized as John

the Beloved (the author of the *Book of Revelation*) and who entered him—hence the name 'John-Roger'.

He then spent "a couple of years" integrating this consciousness into his own. He learned how to "demonstrate the power of the Spirit"—that is, the Mystical Traveler Consciousness, which he also calls the Holy Spirit. "This started to revolutionize people's lives" (*The Wayshower*, 8). But he soon started giving teachings himself—and MSIA was incorporated as a church in 1971. According to his own account, after holding the Mystical Traveler Consciousness for several years, he completed his spiritual task. (This was in 1972 or 1973; see *The Movement*, Vol. V, no. 7, July 1980, 7).

> The time I had agreed to serve was up, and I was making all the preparations to go back to where I live in Spirit . . . Then the forces that I work closely with informed me that the one who was being trained to become the Traveler had defaulted, and I thought, "Why me? Why now?" Their response was, "That's just the way it is." (*The Wayshower*, 9)

In short, Roger Hinkins/John-Roger/J-R became the embodiment of the Mystical Traveler Consciousness or Holy Spirit.

> On the level of God comes what is known as the Mystical Traveler Consciousness. At present, that is the consciousness I carry. The Traveler is aware on all levels simultaneously. It has authority and power over everything on every level down to the physical . . .
>
> Initiates of the Traveler are given the name of the Lord in each realm as they are initiated into that level, and when the initiate chants that name, the vibration of the Lord presents It of Itself. The initiate then rides on that energy through that level under the protection of that Lord, *who is actually the Mystical Traveler on that realm.* (ibid., 41, 42)

There has always been a physical Traveler to help guide souls. Previous holders of the office include Lao Tzu, Jesus, and Shakespeare.

This whole account has been challenged, however, because J-R's teaching is full of ideas and terms that can be found in the Surat Shabd Yoga tradition of India—specifically, the writings of two lineages of this tradition, Radha Soami Satsang Beas and Ruhani Satsang (both of which I mention below). I give a few examples here: the teaching that there are inner worlds, each of which has a specific colour and sound; the Sound Current as the creative power of God that sustains the universe; 'Sat Nam' (literally 'True Name') as the name of God (*Passage into Spirit*, 48); 'Kal' (literally 'Time') as the name of the Lord of the physical universe (ibid., 72); the need for initiation from a master in order to travel through the inner worlds in order to return to one's original home; that the name of this original home is 'Sach Khand' (literally, 'True Place') (*The Sound Current*, 1); that at initiation one is given words or holy names to repeat (called 'tones' in MSIA).

These similarities are so close as to amount to straightforward identities. We are therefore bound to ask where J-R got them from. There are two answers. The first is that he took them over from Eckankar; the second, that he received them directly from Sawan Singh, a teacher in the Radha Soami lineage.

Eckankar was 'created' by Paul **Twitchell** and you can read about it in his entry. The only thing we need to know here is that he took the fundamentals of his teaching from the Surat Shabd Yoga tradition associated with Sawan Singh and his disciple, Kirpal Singh, the founder of Ruhani Satsang. It is an accepted fact that J-R was a member of Eckankar. *The Movement* newspaper

(12th May 1973 issue) says as much. And while he did not deny it in an interview he gave to David Lane in 1978, he did deny that **Twitchell** was his master (Lane, 'The J.R. Controversy'). However, Lane has argued that the similarities between **Twitchell**'s teachings and those of J-R are extremely close. And he cites one example that is particularly telling. It concerns the names of the various inner regions and the sound that is heard in each one. To begin with, **Twitchell** followed the schema that can be found in the writings of Ruhani Satsang—that is, in the teachings of Kirpal Singh, himself a disciple of Sawan Singh of Radha Soami Satsang Beas. This is given in the first column of Table 1. But a few years later, he changed it and produced one of

TABLE 1
J-R's cosmology as compared with Twitchell's

| Twitchell's first schema | | Twitchell's second schema | | J-R's schema | |
|---|---|---|---|---|---|
| | | Elam [physical plane] | *thunder* | physical | *thunder* |
| Sahasra dal Kanwal | *bell and conch* | Sat Kanwal Anda [astral] | *roar of the sea* | astral | *roaring of the surf* |
| Brahm Lok/Trikuti | *big drum/thunder* | Maha-Kal-Parbrahm [causal] | *tinkle of bells* | causal | *tinkling of bells* |
| Daswan Dwar | *violins/sarangi* | | | | |
| | | Brahmanda Brahm [mental] | *running water* | mental | *running water* |
| | | | | etheric | *buzzing* |
| Bhanwar Gupha | *flute* | | | | |
| Sach Khand | *vina/bagpipe* | Sat Nam [soul] | *flute* | Soul | *flute* |
| Alakh Lok | *[no sound given]* | Alakh Lok | *heavy wind* | [no name given] | *wind* |
| | | Alaya Lok | *deep humming* | [no name given] | *humming* |
| | | Hukikat Lok | *thousand violins* | [no name given] | *violins* |
| Agam Lok | *[no sound given]* | Agam Lok | *music of woodwinds* | [no name given] | *woodwinds* |
| Anami Lok | *[no sound given]* | Anami Lok | *whirlpool* | | |
| | | Sugmad Lok | *music of universe* | | |
| | | | | God | *HU* |

The first two schemas are given in Lane's *The Making of a Spiritual Movement: The Untold Story of Paul Twitchell and Eckankar* (Del Mar Press, 1983), 81; and the last one in 'The J.R. Controversy', 4. He cites Twitchell's *The Tiger's Fang* and *The Far Country* (no page references) for the first schema; *Spiritual Notebook* (no page references) for the second; and J-R's *The Sound Current* (the page numbers are 16–22) for the third.

his own—see the second column. Several years after that, J-R presented his cosmology—see the third column. (I have spaced out the three schemas in order to highlight the most obvious parallels.)

It is evident that J-R's is very similar to **Twitchell**'s second but fairly dissimilar to the 'original' (**Twitchell**'s first, which goes back to Sawan Singh). Yet J-R says that he received the Mystical Traveler Consciousness from Sawan Singh on inner planes (Lane, 'The J.R. Controversy'). The discrepancy between J-R's cosmology and that of Sawan Singh would give any impartial observer pause for thought, I think. But according to Lane's report of his interview with J-R, J-R only knew that the master he had met was Sawan Singh afterwards, when he saw Sawan Singh's photograph. Before that, he thought the figure was Rabazar Tarzs—an unfortunate identification since Rabazar Tarzs never existed but was invented by **Twitchell**. (See **Twitchell**'s entry for details.) This does not say much for J-R's inner knowledge.

However, MSIA literature does not emphasize the connections with Eckankar or Sawan Singh. Rather, J-R is presented as an independent teacher, who, because he is the embodiment of the Mystical Traveler Consciousness or Holy Spirit, gives a teaching that has much in common with other teachers who have fulfilled the same function.

This function is itself very close to that of the guru in the Surat Shabd Yoga tradition. Since the Mystical Traveler Consciousness is omniscient and omnipresent, there is practically nothing that J-R cannot do. "I don't know how I ever got to the hospital in the busy Friday night traffic. The answer is, of course, with J-R's help" (*Rod and Staff,* Vol. V, Summer 1987, 7). A Nigerian wrote to say that he used the sound "J-R" to help in difficult situations. "When I'm feeling that nothing is happening when chanting my initiation tone, I mentally say "J-R" and very often situations change . . . " (*Soundings: A Newsletter for MSIA Initiates,* April 1981, 6). And John Morton, of whom, more presently, wrote a general letter in the same issue of *Soundings* which seems to have remarkable theological implications:

> This is a time when God's Light is coming present [*sic*] on the planet in an ever greater manifestation. To the degree we will allow, each one of us is becoming a bearer of this Light. As you will probably realize, John-Roger is a tremendous focal point for this Light by focusing the Traveler and Preceptor Consciousness[1] through his body. However, you may not realize the toll this takes upon his body. Each one of us is a divine part of that body and responsible to the well being of the whole.

Perhaps one of the reasons why J-R's body 'suffers' is that "I take on the karma of my initiates and assist you in working it through" (*Soundings,* January 1983, 4).

Thus far, we could describe MSIA's theology as follows: J-R was divinely chosen to embody the Mystical Traveler Consciousness (which is the spiritual power that underlies and guides the whole Creation); his primary task is to initiate people and help them back to the Soul realm; but he works at all the lower levels, too: taking on his initiates' karma and directly assisting them in their lives; MSIA and the John-Roger Foundation (in all its forms: university, personal development seminars, health clinic, social service programmes) are the external sign of this inner ministry.

[1] The only information available about the Preceptor Consciousness is that it is embodied only once every 25,000 years and that J-R is the present embodiment. It is difficult not to agree with the comment that "no one knows what the hell the Preceptor Consciousness is" (McWilliams, 73).

Taken altogether, this is quite an edifice (both theologically and in terms of organization). However, in 1983, its foundations were shaken by a series of charges brought against J-R by a number of initiates, including some of many years standing who held responsible positions in MSIA. These were detailed by a researcher, David Lane, in his periodical, *Understanding Cults and Spiritual Movements,* which, though it did not have a large circulation, did cause some cracks to appear in the movement: there were some defections and excommunications. Five years later, in 1988, these same charges were printed in a major article in the *Los Angeles Times* (which was substantially repeated by *People* magazine). These articles were read by tens of thousands of people and produced a considerable upheaval in MSIA. As always in cases like this, there is more noise than clarity. But essentially, the charges come down to three: sexual misconduct, deceit, and threats. These need to be investigated.

As for the first, at least one member of the MSIA staff, Victor Tozo, has said that he had sexual relations with J-R and that J-R persuaded him that this was for his spiritual benefit. J-R denies the charge (*Los Angeles Times,* 14th August 1988). This is a straightforward matter of fact: either they had sexual relations or they did not. So one of them is not telling the truth. Although J-R has never taught that homosexuality is wrong, the mere fact that he denies the charge shows that he considers it a serious one. And it is evident that many members of MSIA do as well.

The accusations of deceit tend to be fairly general—and they are easy to make. However, two of them have a specific factual content. The first is that, like Paul **Twitchell**, J-R has passed off other people's writings as his own. (See Table 2.) There can surely be no doubt that his claim to the copyright of this material is unwarranted. Now it is true that the original copyright no longer holds (because by international agreement, copyright lapses 50 years after the death of the author). But this is a matter of who has the right to publish. Once these 50 years are up, anybody can publish a work without permission. But one cannot claim the copyright, because it no longer exists. If J-R were to publish an edition of Shakespeare's plays, I doubt if he would claim copyright for them (even if Shakespeare was a Traveler . . .).

As far as I know, this is the only instance of J-R's writing that can be straightforwardly shown to be copied from someone else. (The cosmological similarities that Lane has pointed out—see Table 1—may be convincing to some but they have to be argued for; no argument is required here.) But it only amounts to a page; and it is perfectly possible that the copyright claim was made without his knowledge. But then why not admit the error? Yet MSIA has never done so.

The second charge of deceit is that MSIA's headquarters in Los Angeles had hidden microphones in many of the rooms which enabled J-R to listen to people's conversations and, according to some, to pretend to know things by 'spiritual' means that he had in fact learned by eavesdropping. J-R does not deny that the microphones exist nor that he has used them—but says that he always tells people first (*Los Angeles Times,* 15th August 1988). There might be good reasons why someone as busy as J-R should want to be able to listen in on what is being said in one room while he stays in his office. But this can be done quite openly with microphones that everyone can see. It appears, however, that hardly anyone knew that they were there. One is bound to wonder why.

TABLE 2
J-R's use of other people's material

| Florence Scovel Shinn, *The Game of Life and How to Play It*, (Marina del Rey, California: De Vorss, 1925), 94-95 [taken from a chapter entitled 'Denials and Affirmations'] | J-R, *Affirmations* [I have seen a single sheet with this title at the top and '© 1981 John-Roger' at the bottom] |
|---|---|
| God is my unfailing supply and large sums of money come to me quickly, under grace, in perfect ways. | God is my unfailing supply and large sums of money come to me quickly, under Grace, in perfect ways |
| Every plan my Father in heaven has not planned, shall be dissolved and dissipated, and the Divine Idea now comes to pass. | Every plan my Father in Heaven has not planned, shall be dissolved and dissipated, and the Divine Idea now comes to pass. |
| Only that which is true of God is true of me, for I and the Father are ONE. | Only that which is true of God is true of me, for I and the Father am one. |
| As I am one with God, I am one with my good, for God is both the *Giver* and the *Gift*. I cannot separate the *Giver* from the gift. | As I am one with God, I am one with my good, for God is both the Giver and the Gift. I cannot separate the Giver from the Gift. |
| Divine Love now dissolves and dissipates every wrong condition in my mind, body and affairs. Divine Love is the most powerful chemical in the universe, and *dissolves everything* which is not of itself! | Divine Love now dissolves and dissipates every wrong condition in my mind, body and affairs. Divine Love is the most powerful chemical in the universe, and dissolves everything which is not of Itself. |
| Divine Love floods my consciousness with health, and every cell in my body is filled with light. | Divine Love floods my consciousness with health, and every cell in my body is filled with light. |

These comparisons are taken from David Lane, 'The J.R. Controversy'.

As for the threats, it is difficult to get at hard facts. People have stated that J-R personally threatened them (*People* magazine, September 1988). But such charges are really one person's word against another's and are rarely clear cut.

However, there is some threatening and abusive material that certainly looks as if it comes from MSIA. For example, a number of initiates who had given information to David Lane for his 1984 exposé were sent an anonymous letter.

Scum Bags:
. . . All that junk you gave Lane to write down came out of your own filthy minds and mouths and you know filthy mouths "must" be cleaned out don't you.

If I were any of you, I'd be very careful where I go and what I do and who I talk to, you wouldn't want anyone to get hurt now, would you? Don't you all have "innocent" friends visit you and live near you? . . . (Lane, 'The Criminal Activities of John-Roger Hinkins', *Understanding Cults and Spiritual Movements*, vol. 2, no. 2, 1986, 28)

Somewhat similar is a long and foul letter (also anonymous) sent to the 13-year-old daughter of an MSIA minister who had left the organization because of the 1983 revelations. Here is an extract. I have not included the four-letter words; what follows is quite explicit enough as it is.

> Your dirty mouth has reached all the way out here to California . . . You have made it a point to talk alot about what your father has had to say about members of MSIA and Insight . . . I know that your father does rolfing [a form of body therapy] . . . However, what he might not have told you is <u>he has had sex with various young men</u> that he has rolfed . . .
>
> As you can probably guess already there is much more to this than you have been told. Most of the people out here have put all the gossip behind them and are going on to other things. It's too bad that your <u>HOMOSEXUAL FATHER</u> still keeps the gossip going and spreads it on to you . . . Don't ruin your reputation anymore than you have already done. Maybe it is not too late for you . . .

Lane argues in his article that J-R was personally responsible for the 'Scum Bags' letter (and other smear letters). Needless to say, he is well aware that such accusations have to be backed up by evidence. Saying that such letters *must* be from MSIA (because who else would want to send them?) is not evidence, of course. So Lane tries to show that the same typewriter was used to produce both the Scum Bags letter and letters which Lane personally received from J-R (and which J-R signed). I refer to Lane's own work, quoted above, for further details.

The question is: are these letters representative of MSIA as a whole? There is considerable disagreement over the answer. Some, like Lane, hold that they all come directly from J-R himself. Some say that, while this sort of thing may not be done on his instructions, it is more or less inevitable that someone *will* do it because of the nature of the movement itself, which fosters an uncritical emotionalism that easily lends itself to excess. Yet another position is that while such incidents are regrettable, they are limited to a few individuals: the one-rotten-apple-doesn't-spoil-the-barrel argument. And it is also possible to deny the whole thing and say that those responsible have nothing to do with MSIA. And this seems to be MSIA's attitude. As far as I know, it has never made any real effort to investigate these letters.

Finally, we should add the charge that Lane made in 'The J.R. Controversy': that J-R's teaching is taken wholesale from Eckankar. In other words, MSIA's theology is plagiarized. The defence against this charge is that the teachings are the same because the source is the same. But even if we accept that he is a completely independent teacher, it does seem odd that he should make no reference at all to the Surat Shabd Yoga tradition which preceded him—a bit like teaching relativity without mentioning Einstein.

By and large, the consequences of all these charges have not been very great. Some people have left MSIA but the majority have stayed. No one who has remained in the organization has admitted a single charge, mistake, or error. (General admissions, such as 'We all make mistakes', yes; specific admissions, of the kind, 'Such-and-such was done and it should not have been', no.)

But there have been some changes. Some of them, such as changing the names of practically every organization, do not amount to very much. But one development was significant. In June 1988, J-R formally "handed over the keys to the Mystical Traveler Consciousness" to John Morton, a confidant and initiate of nine years.

John-Roger said that he would always be standing behind John, just as the Traveler who came before he did stands behind him. When asked a week later what it was like to have the mantle of the Traveler Consciousness, John Morton replied, "It's like breathing in and out." For those who are wondering who to write to for initiations, etc, J-R says it's "Business as usual". (*MSIA Newsletter,* vol. 1, no. 1, July 1988, 1)

This could be seen as a damage limitation exercise: MSIA can continue without J-R as its spiritual head, should it come to that. But he still continues to function as the Traveler: "Once a Traveler, always a Traveler. More than one person can hold the keys of the Traveler Consciousness at the same time" (*New Day Herald,* September 1988, 24). So he has not really given anything up.

As for John Morton, he has been asked (by Victor Tozo) whether he consciously travels out of the body at will, can take on people's karma and feels capable of leading people to the Soul Realm. He replied,

> Yes, I have had my experiences. No, they are not anywhere near the degree that J-R has experienced, if that makes any difference to you or anyone else. Amazingly, and somewhat to my surprise, it is not required in order to be the physical Traveler. (Letter to Victor Tozo, 19th October 1988)

This seems to imply that as the Traveler, he does not have direct knowledge of the vast cosmology of the Mystical Traveler Consciousness given by J-R. Nevertheless, people in MSIA continue to say that they experience the working of Spirit and that it is effected through the agency of John Morton as well as J-R. So the edifice is still standing. How sound the foundations are is open to debate. But it has survived one attempt to demolish it and may yet survive others.

Primary sources: John-Roger, *The Sound Current* (New York: Baraka Press 1976); *The Wayshower* [pamphlet included with a tape of the same name], (San Bernadino, California:Franklin Press, 1978); *The Signs of the Times,* vol. 1 [xerox copy; no date, no provenance]; *Passage into Spirit* (Los Angeles: Baraka Books, 1984); *The Path of Mastership* (Los Angeles: The Church of the Movement of Spiritual Inner Awareness, 1982; revised edition); a full list can be had from MSIA, address below.

Secondary sources: David Lane, 'The J.R. Controversy: a Critical Analysis of John-Roger and MSIA', *Understanding Cults and Spiritual Movements,* vol. 1, no. 1, 1984; David Lane, 'The Criminal Activities of John-Roger Hinkins', *Understanding Cults and Spiritual Movements,* vol. 2, no. 2, 1986; *Los Angeles Times,* 14–15th August 1988; P. McWilliams, *Life 102: What to do When Your Guru Sues You* (Santa Monica: Prelude Press, 1994)

Centre: MSIA, 3500 West Adams Boulevard, Los Angeles, CA 90018, U.S.A.

COMPARE:

Other teachers of inner sound and light: Paul **Twitchell**, John **Yarr**

Others with exotic (and uncheckable) life stories: **Lobsang Rampa**, E.J. **Gold**, Reshad **Feild**, Oscar **Ichazo, Gurdjieff**

Teachers who have received inner revelations: Samuel **Lewis**, Jiyu **Kennett**, Swami **Turiyasangitananda**, G.B. **Chicoine**

Teachers whose followers have turned against them in some way: John **Yarr**, Richard **Baker**, Master **Da**

SRIMATI KAMALA

American who represents one of the branches of *kriya yoga*

Srimati Kamala is significant in a particular way. In order to know what this is, we need to know the story of her guru, Swami Premananda, and his relation to Paramahansa *Yogananda* and the Self-Realization Fellowship/SRF.

Premananda (then known as Brahmachari Jotin) was initiated and ordained (though I am not sure what this latter word means) by *Yogananda* in India in 1920, the same year that *Yogananda* set sail for America. In 1928, *Yogananda* asked him to come to the States to act as spiritual guide to some of *Yogananda*'s disciples in Washington, D.C. Jotin became head of the Self-Realization Church of All Religions there, which *Yogananda* had founded in 1927. In 1941, Jotin took *sannyasa* vows from *Yogananda* and became Swami Premananda.

According to SRF, Premananda subsequently (I have no exact date but it must have been after 1946) incorporated the Church as an entity separate from SRF—without consulting *Yogananda* and against his wishes. *Yogananda* asked him to dissolve his Church and rejoin SRF and Premananda said that he would. But he didn't. Accordingly, *Yogananda* "asked that references to that center [the Self-Realization Church in Washington, D.C.] be removed from his book [*Autobiography of a Yogi*] as they no longer accurately reflected the situation" (letter to me from SRF). The most graphic illustration of this—and one that frankly puzzles me—is given in the box opposite.

After *Yogananda*'s death in 1952, Premananda was asked to resign from SRF since he had declined to dissolve his Church (which is now known as the Self-Revelation Church of Absolute Monism). There is no doubt that the members of the Church, all of whom are Premananda's initiates, regard him as in the lineage of *kriya yoga* gurus. Yet SRF itself equally clearly does not share this view. (See **Rajarsi Janakananda** and Sri **Daya Mata**'s entries for an account of SRF's theology of transmission.)

It is schisms like this—and no other word will do—which create unorthodox lineages. From the point of view of orthodoxy, of course, such deviations are regrettable; but looked at in another way, as part of spiritual ecology, they can be seen as diversifications which enrich the environment.

And so finally we get to Srimati Kamala (I don't know her original name). She was born in Madison, Wisconsin in 1945 and studied philosophy, language and literature at university. After her graduation, in 1968, she went to live on the Church's grounds. She was initiated by Premananda in 1973, has served as the Minister of the Self-Revelation Church since 1975 and was made a *swami* by Premananda in 1978. She is closely linked with the Indian community in the Washington, D.C. area: for example, the wife of the Indian ambassador presents awards and scholarships at the Church, all of them linked to India and often won by Indians. And she has also won awards herself from organizations run by Asian Indians.[1]

I have no other details about her. But maybe, in the last analysis, such details are not really relevant. In a letter to me, she said that "although we

[1] But she is not limited to Indian India. I have also seen a short article by her on Amerindians, in which she says,

> The entire religious experience of the American Indian—purification of mind and body, prayer and fasting, a strong personal relationship with God, meditation to learn from the "Great Mystery", its teaching beyond words—may be perfectly articulated in one word: Yoga: the ideal of union of soul with God, and the oneness of Man-God-Nature. (*The Mystic Cross,* Spring 1987, 3)

THE REWRITING OF *AUTOBIOGRAPHY OF A YOGI* (i)

(see Swami **Kriyananda**'s entry for two other instances of changes in this book)

| Original edition of *Autobiography of a Yogi* (1946) | Later editions |
|---|---|
| "Premananda," I told him during a visit to his new temple, "this Eastern headquarters is a memoriam stone to your tireless devotion. Here in the nation's capital you have held aloft the light of Lahiri Mahasya's ideals." | In 1941 I paid a visit to the Self-Realization Fellowship Center in Boston. The Boston center leader, Dr. M. W. Lewis, lodged me in an artistically decorated suite (11th ed, 1979, 551). |
| Premananda accompanied me from Washington for a brief visit to the Self-Realization center in Boston . . . The Boston leader, Dr. M. W. Lewis, lodged my companion and myself in a modern, artistically decorated suite (480-81). | |

This alteration, of course, is not just a matter of literary style. Swami Premananda has simply vanished and it now looks as if Yogananda never visited Washington at all and went to Boston on his own. (In fact, all references to Premananda have been excised from the book.)

SRF says that this change, which was included in the 3rd edition of 1951, "was revised with Paramahansaji's authorization and approval". When I pointed out that it had in effect falsified what happened, they demurred. "The revised account is simply a condensed telling, not a false one. Paramahansaji visited Washington on a number of different occasions over the years, as well as numerous other cities not mentioned in his autobiography. In fact, a great deal of the history of his time in America is not covered in that book . . . But no one would claim that the book 'falsifies what happened' because it doesn't include all the details of what he did and which individuals he worked with during his thirty years in America" (letter, 6 December 1996).

Try as I might, I cannot accept this argument. Either the episode that is being described is the same in both editions or it is not. If it is, then the later account is false. If not, then it is misleading, to say the least, to use exactly the same sentence, taken from the earlier version, to describe a quite different visit in the second, when the sole difference (apart from the omission of the words "center" and "modern") is that "my companion" [= Swami Premananda] has been dropped.

maintain no organizational affiliation with SRF, the spiritual heritage of that guru bond from Babaji to Lahiri Mahasya to Sri Yukteswar to Swami Yogananda and to Swami Premananda remains." And: "Once one is ordained as a Swami, one is fully responsible and empowered to perpetuate the life and ideal of Kriya Yoga." I cannot say for certain that she is Swami Premananda's successor—he is still alive at the time of writing but very old and in complete retirement—but even if she repudiates this title, it is clear that, according to this particular lineage, at least, she has received *kriya yoga* transmission and can transmit it in her turn.

(*See* Lineage Tree 2)

Primary sources: Srimati Kamala, *Frontiers of the Spirit* (Washington D.C.: Swami Premananda Foundation, 1982); *Mahatma Gandhi: An America Profile* (Washington D.C.: Mahatma Gandhi Foundation, 1987); [plus an undated and anonymous booklet, *Self-Revelation Church of Absolute Monism: History and Essence*]

Secondary sources: None

Centre: Self-Revelation Church of Absolute Monism, 4748 Western Avenue, P.O. Box 9515, Washington, D.C. 20016, U.S.A.

COMPARE:

Other teachers of kriya yoga: **Rajarsi Janakananda**, Sri **Daya Mata**, both **Kriyanandas**, Roy Eugene **Davis**

Other Western women in the Hindu tradition: Swami **Abhayananda**/Marie Louise, Sister **Devamata**, the **Devyashrams**, the **Mother** [something of a special case], Sister **Nivedita**, Swami **Radha**, **Sivananda-Rita**

Others who have linked Amerindian teachings and Eastern traditions: Dhyani **Ywahoo** (Tibetan Buddhism)

Bhikkhu KAPILAVADDHO | William Purfurst | Richard Randall

Pioneer Western monk; one of the founders of the English Sangha Trust and a key person in the eventual establishment of a Western *sangha* in Britain

Purfurst was born in 1906 and brought up according to the "ethics and standards derived from the leftovers of a late Victorian Protestantism" (*Life as a Siamese Monk,* 1). He discovered Eastern philosophy in his late teens, and in particular the teachings of Theravada Buddhism. He joined the Buddhist Society and over the years gained some reputation as a lecturer at the society and at various universities. I have very little information about the next 20 years or so. In 1952, he was ordained as Samanera Dhammananda in London by the Burmese monk, U Thittila (Humphreys, *Sixty Years of Buddhism,* 55); but since he was later ordained as a *samanera* in Thailand, he must, I think, have ceased to be one in England—and he does seem to have had a tendency to return to lay life, as we shall see. Two years later, in 1954, he decided to take the plunge and go to the East to become a monk. (It was impossible to take *bhikkhu* ordination in Britain at that time because there were not enough monks to make up the quorum of ten that is required by the *Vinaya*). He says that he chose Thailand because it had not been influenced by colonialism (unlike Ceylon and Burma); but the fact that a Thai friend had managed to arrange that he enter the order in Thailand must have been significant too.

He arrived in February 1954, immediately felt at home, and spent the next seven months there, during which time he had a number of unusual experiences, detailed in his *Life as a Siamese Monk.* Most of these experiences occurred during periods of intense meditation, following a method given to him by the abbot of Wat Paknam, Chao Khun Mangala Raja Muni (usually referred to by the title, Lung Poh or Great Father). Wat Paknam, near Bangkok, was a large monastery and Purfurst (known as Tan William or Phra Farang/European Monk) was a star pupil. Lung Poh said that he had waited years for a Westerner; and because Purfurst had a thorough theoretical knowledge of Buddhism, he was immediately given instructions in meditation (having first taken the five lay precepts). This method involved repeating the words *samma arahan* (meaning 'perfect *arahant*'—an *arahant* being one who has attained Nirvana/Nibbana) while concentrating on various parts of the body: the opening of the right nostril, the inside corner of the right eye, the centre of the skull, just above the uvula, the bottom of the throat, the navel, and finally a position two finger-breadths from the navel. "If you have some success," said Lung Poh, "you will be conscious of a pinpoint of light seen as if in the mind's eye" (*Life as a Siamese Monk,* 28).

Purfurst certainly did have some success—and quite quickly. Not only did he see light but also the form of Lung Poh: "he appeared to be smiling and pointing onward" (ibid., 49).[1]

> Again my mind turned to the pinpoint of light and from it bloomed forth like a flower a figure of the Buddha. It was nothing like the images which I had seen so many times. The figure was so utterly human, the face smiling and kindly. For a while it seemed to me that some interchange was going on between the figure and myself, not in words as such but in a sense of complete understanding. When the figure disappeared I knew not. (*Life as a Siamese Monk*, 49)

After his ordination as a monk, Kapilavaddho (as we should now call him) entered a period of 17 weeks of *vipassana* meditation, during which he confirmed the truth of the Buddha's teaching, particularly the 'doctrines' of impermanence, no-self, and rebirth. He went back in memory to his very early childhood and beyond that to what must be an experience of being in the womb.

> Violent and frightening flashes of shapeless colour gave way finally to utter darkness, a feeling of tearing constriction on my body and a ghastly sensation of drowning as I tried to breathe, each breath taking in liquid through my nostrils and filling my lungs, knowing that I must breathe but unable, until I felt I must die as all sensation left me.
>
> And yet to say that all sensation left me is not strictly true. There was a knowledge of agonising expectancy, a searching, a violent striving for something I knew not what. Next I became aware of a gurgling sensation in my throat followed by pain in my heart. A feeling of age descended upon me, a sense of being spent and without strength, giving way rapidly to a certainty that 'I' was alive.
>
> What a different *alive* and I it was. My whole body and mind felt different . . . I opened my eyes and found myself looking out on to a small bamboo-built hut, a hut that reeked, I knew, of myself, reeked as only the lonely aged can reek. (*Life as a Siamese Monk*, 128)

He now experienced himself as an old woman . . . went back through her memories . . . and experienced her birth. He passed through several lives in this way—all of them in Asia except for one in medieval Germany. All of them were driven by desire.

> Suddenly the thought sprang to mind: 'You silly little man, you never were born in the absolute sense. "You" is but a convenient term to describe a particular event in the relations between mental and physical concomitants, each of which is as transient as the event itself. You have no past, neither have you a future in the absolute sense . . . ' (*Life as a Siamese Monk*, 130)

[1] Lung Poh told him (when they were both in their physical bodies) that this image was the *dipaya kaya*, the double or fantasy body, "the body you use when dreaming", and that it is associated with *iddhi* (psychic or magical powers). Purfurst/Kapilavaddho also experienced three other bodies—the *rupabrahma kaya, arupabrahma kaya* and *dhamma kaya* (*Life as a Siamese Monk*, 65) but says nothing about them. This is a pity because I know of no modern practitioner of Theravada, Eastern or Western, who has anything to say about them. In fact, this whole dimension of Theravada—associated with higher states of consciousness, the layers of reality which are revealed and the bodies needed to experience them, all of them brought about by *samatha* practice—hardly seems to exist anymore (though it is an integral part of the Buddha's teaching as recorded in the Pali Canon). Lung Poh did say that his method was a mixture of *samatha* and *vipassana*, and that it was a preparation for the pure *vipassana* that Purfurst went on to as a monk. But it is certainly not typical of Theravadin meditation and I am not aware of any other account of it.

This realization enabled Kapilavaddho to reconcile the teaching of *kamma/karma* (by which beings are continually reborn) with that of impermanence and no-self (there is nothing fixed and beings do not possess any unchanging essence); and to harmonize both of these ideas with the teaching on Nirvana/Nibbana—the freedom from suffering and unrest.

> I knew . . . that this very Nibbana was not a state in relative opposition to that of the sensible world, but a state beyond all relationships. It was absolute, indefinable, nothing could enter or leave it. (*Life as a Siamese Monk*, 131)

So here we have an Englishman who has verified the essential teaching of the Buddha in something less than six months. It is hardly surprising, therefore, that, after emerging from his 17 weeks of meditation, he is told that he is no longer Phra Farang (European *bhikkhu*) but Phra Thai (Thai *bhikkhu*).

But Lung Poh had already decided that he should return to England and teach there. Kapilavaddho arrived back in November 1954, wearing his cotton robes despite it being winter time, and took up residence at the London Vihara—the only Theravadin monk in the entire country, as far as I know. His presence stimulated considerable interest among British Buddhists and three men (Robert Albison, an Englishman, Peter Morgan, a Welshman, and George Blake, a West Indian) asked if they could be ordained. Kapilavaddho was only allowed by the rules of the *Vinaya* to give them *samanera* ordination, and since there weren't enough monks in Britain to carry out full *bhikkhu* ordination, he returned to Thailand in December 1955 with the three new *samaneras*. Whilst there, he was made an Anusavanacarya—one who is well versed in both the *Dhamma*/teaching and the *Vinaya;* this is the title of one of the functionaries in the ordination of monks, and Kapilavaddho carried out this duty during the ordination of Albison, Morgan, and Blake.

Kapilavaddho returned to England in March 1956 (leaving the three new monks behind) and helped found the English Sangha Trust, which was designed to create a *sangha* for Westerners in Britain. (Note that this was 54 years after Allan Bennett/**Ananda Maitreya** tried to do the same thing.) A house was purchased in London and Kapilavaddho, together with the three recently ordained monks who had returned from Thailand, set about establishing this *sangha*. But it did not last long. Kapilavaddho himself, his health failing, returned to lay life in May 1957, with Peter Morgan/Ven. Punnavaddho officiating at the ceremony. Albison and Blake (I don't know their *bhikkhu* names) simply returned to lay life and nothing was heard of them again. Morgan/Punnavaddho, on the other hand, went in the opposite direction: he went back to Thailand and has remained there as a monk ever since. All of this had happened by 1961.

Life as a Siamese Monk ends with Kapilavaddho's return to lay life in 1957. But we do know something of his subsequent career. He got married (for the second time) and disappeared for ten years. In 1967 he reappeared again but was now known as Richard Randall (nobody knows why he changed his name). He reordained as a monk (with his wife's permission) at a Thai temple, Wat Buddhapadipa, in London (founded in 1966 and then under the direction of Ven. Dhammasuddhi, now known as Dhiravamsa), and was given his old monastic name, Bhikkhu Kapilavaddho. He then went to the Hampstead Buddhist Vihara (which the English Sangha Trust had bought in 1963) and became its spiritual director; he renamed it Wat Dhammapadipa and resumed his life as a monk (with his wife in separate quarters next door).

However, he came to believe that Buddhism could be best conveyed to the West through lay organizations and so he disrobed for the second time in 1970. He also got married for the third time—to a woman 40 years his junior—but died a few months later in 1971, aged 65.[2]

A number of issues are raised by Kapilavaddho's career. He spent just one year in Thailand, compared with six years as a monk in Britain (interspersed with a ten-year disappearance). He was very influential in the formation of the English Sangha Trust; yet though it was formed to establish a Western *sangha,* he ended up believing that lay life was more relevant to Western society. It is also significant that he claimed to have verified the truths of Buddhism for himself through his meditative experiences in Thailand. Yet the method that he used was very unusual; and despite the fact that he was taught it by a highly respected abbot, there is absolutely no reference to it in the Pali Canon (the Theravadin scriptures). Even so, he was widely regarded back in Britain as an adept at meditation and he appears to have taught this particular method to a fairly large number of Westerners over a number of years (including Alan and Jacqui James—see note below).

I think it is fair to say in conclusion that Kapilavaddho was something of a rogue Buddhist. (I am using the word *rogue* here only in the sense of one who lives apart and do not wish to imply its closely related meaning of unprincipled or untrustworthy.) Yet the Theravadin tradition is such that even this kind of mild roguishness is in a way misleading just because it is too individualistic. This is not to condemn Kapilavaddho in any moral sense; but it would be the traditional Theravadin view. And the view of the tradition needs to be heard.

Primary sources: Life as a Siamese Monk (written under the name of Richard Randall) (Wiltshire: Aukana Publishing, 1990)

Secondary sources: P.A. Mellor, The Cultural Translation of Buddhism, Ph.D. thesis, University of Manchester, 1989, Chapter 3 [on the English Sangha Trust, 1965–70]

Centre: None extant

COMPARE:

Other Western Theravadin monks: **Ananda Maitreya**, **Nyanatiloka**, **Nanavira**, **Sumedho**

Other Western teachers who had visionary experiences: Jiyu **Kennett** (the only Buddhist); Sri **Krishna Prem**, Swami **Radha**, Swami Lakshmy **Devyashram**, Father **Satchakrananda** Bodhisattvaguru (all Hindu)

[2] Nor does the story end there. In 1972, his young widow, Jacqui, married one of his former disciples from Wat Dhammapadipa, Alan James/Bhikkhu Dipadhammo, and the two of them went on to found the Monastery of Absolute Harmony in Wiltshire—later renamed the House of Inner Tranquillity. Meanwhile, the Hampstead Vihara/Wat Dhammadipa was put under the guidance of the American monk, Ajahn **Sumedho,** and was eventually sold to provide funds for Chithurst monastery.

Roshi Philip KAPLEAU

One of the first Westerners to practice Zen in Japan for any length of time; appointed as a teacher in America but never received formal Dharma transmission; broke with his teacher, *Yasutani* Roshi, and became an independent Zen teacher

Kapleau's 'career' as a Western Zen teacher incorporates many of the elements that make the whole phenomenon of the transmission of Eastern traditions to the West so fraught with difficulty. He has certainly had his problems (or challenges, if you prefer) and all of them have been concerned with the nature and responsibilities of an authentic teacher. Or to put it another way, it has not been plain sailing and questions have arisen about where exactly this particular ship (Kapleau's) in this particular fleet (Japanese Zen) is going. It is a fascinating and controversial story.

He was born in 1912 of a Jewish mother and a father who was a nominal member of the Russian Orthodox Church. He appears to have had a probing and enquiring mind from childhood. He questioned his parents' beliefs in his early teens and soon found them wanting. He became an agnostic and then progressed, at the age of 13, to founding an Atheists' Club at school. Later, after he had become a Zen teacher, he saw this as "evidence of a religious sensibility beginning to stir" (*Zen: Dawn in the West*, 261). In fact, he has never changed his view that theism is essentially flawed; hence he does not have a high regard for Christian Zen (see below).

He became a court reporter and also went to night school for a while in order to become a lawyer but had to stop because of ill health—another pattern in his life. He was turned down for active service during World War II for medical reasons but he did go to Nuremberg afterwards as a court reporter for the Defense Department during the war crimes trials there, and then asked to be transferred to Japan, where a similar judicial process was being carried out by the Allied Military Tribunal.

This was in 1948 and he began to get interested in Zen. Friends recommended that he go to visit D.T. Suzuki. Suzuki's erudition was way over Kapleau's head, as he readily admits.

> What brought me back again and again to his simple lodging was the desire . . . to experience the deep serenity that seemed to radiate from the giant cryptomaria trees, the temple buildings, the faces of the monks and laymen, from the very earth itself. (*Zen: Dawn in the West*, 263)

Kapleau left Japan as soon as his work at the Tribunal was over. But when Suzuki returned to America in 1949 (after an absence of 40 years), Kapleau attended his lectures at Columbia (in 1951; Erich Fromm and John Cage were also there). Then, in 1953, he went back to Japan to practice Zen. He was 41 and spoke only a few words of Japanese. Despite initial rebuffs from the teachers he approached, he was eventually accepted at Ryutaku-ji, the monastery of Nakagawa Soen Roshi. He stayed there for three months but Soen Roshi advised him to go to Hosshin-ji, the monastery of *Harada* Roshi, where he remained for three years. However, he had to leave "because of failing health exacerbated by the austere and tense atmosphere and the poor diet" (*Zen Dawn in the West,* 267). Soen Roshi then recommended that he practice with *Yasutani* Roshi (the principal Dharma-heir of *Harada* Roshi), who, though a married priest, did not have a temple because all his disciples were lay.

There were not many Westerners practising in Japan at this time. (Ruth Fuller **Sasaki**, certainly; Walter **Nowick**, probably; I know of nobody else although Robert **Aitken** had spent a year at Soen Roshi's monastery in 1950.) Kapleau had to struggle with harsh conditions which caused him physical and

mental pain. But, he says, he learned from this pain. There can be no compromise with truth and so his Zen teachers never let him off the hook. *Yasutani* Roshi gave him a *koan* to wrestle with. After three years of rigorous training, he finally attained *kensho* (insight into one's true nature, which is Buddha nature). It was during a *sesshin* with *Yasutani* Roshi. Kapleau went into *dokusan,* the 'meeting of minds' where the Zen master tests the disciple's insight. "The universe is One," *Yasutani* Roshi began,

> each word tearing into my mind like a bullet. "The moon of Truth . . . " All at once the roshi, the room, every single thing disappeared in a dazzling stream of illumination and I felt myself bathed in a delicious, unspeakable delight . . . For a fleeting eternity I was alone—I alone was . . . Then the roshi swam into view. Our eyes met and flowed into each other, and we burst out laughing. (*Three Pillars of Zen,* 228)

A few days later, he wrote in his diary:

> Feel free as a fish swimming in an ocean of cool, clear water after being stuck in a tank of glue . . . and so grateful.
>
> Grateful for everything that has happened to me, grateful to everyone who encouraged and sustained me in spite of my immature personality and stubborn nature.
>
> But mostly I am grateful for my human body, for the privilege as a human being to know this Joy, like no other. (ibid., 229)

This happened in 1958. In the same year Ruth Fuller **Sasaki** was made a priest in Kyoto; Nyogen Senzaki died in Los Angeles after 50 years of 'undercover' Zen; and *The Chicago Review* published a special Zen issue which included Alan **Watts**'s *Beat Zen, Square Zen, and Zen,* essays by Gary Snyder and Jack Kerouac, an article by Nyogen Senzaki, and translations by D.T. Suzuki and Ruth Fuller **Sasaki**. Western Zen was beginning to fire on all cylinders.

The final input into this engine occurred when Western teachers who had trained in Japan returned to their own countries. Kapleau was one of the first. However, his first act after his *kensho* was perhaps somewhat unexpected: he went on a trip to South East Asia, visited Sri *Aurobindo*'s ashram in India, met a Canadian woman who wanted to practice Zen, returned to Japan with her—and married her. (She also attained *kensho* under *Yasutani* Roshi's guidance—see *Three Pillars of Zen,* 254.) They have a daughter.

Kapleau continued to practice with *Yasutani* Roshi—it is a cardinal tenet of Zen that *kensho* is never final but can be deepened and refined without end—and was ordained as a monk by him in 1961. And in 1965 he went back to America, after 12 years in Japan, with *Yasutani*'s permission to teach (signified by *Yasutani* giving him his robe and a bowl). However, *Yasutani* said that he would wait and see how Kapleau handled things in America before he would consider giving him Dharma transmission. But it seems that he had high expectations of his American disciple, since he told him,

*More or less the same thing was said to Jiyu **Kennett** by her master.*

> Today there are probably no more than ten true masters in Japan . . . This unique teaching must not be lost, it must be transmitted to the West . . . It is your destiny to carry Zen to the West. (*Three Pillars of Zen,* 226)

In 1966, Kapleau founded a Zen centre in Rochester, New York. Gradually, people were attracted there, many of them—for example, Toni **Packer**—drawn by his *Three Pillars of Zen,* the first book by anyone, Western or Japanese, to give an account of Zen training rather than Zen philosophy. (Thirty years after its publication, it has been translated into twelve languages

and sold nearly a million copies.) Like all Western spiritual teachers of whatever affiliation, he has had to deal with the problem of presenting an Eastern teaching, with its own vocabulary and cultural trappings, to Westerners who are familiar with neither. Naturally, this is difficult—there is no model to follow and every teacher has to feel his or her way. Rochester Zen Center is a lay community but Kapleau would prefer that it were monastic.

> Since the celibate monastic has no obligations to family, to wife, or to children, he or she is, in theory at least, able to devote himself wholly to studying and learning and preserving and transmitting the teachings. But in practice it hasn't worked out that way. (*Tricycle* interview, 58)

He himself tried to establish an orthodox celibate monastery at Rochester but no one could maintain the discipline and they all returned to lay life.

Yet he has kept what he considers to be the core of Zen—the 'three pillars' of *zazen, teisho,* and *dokusan*[1]—within the context of a religious way of life. What this means is that Zen practice is more important than Zen philosophy; but equally, there is more to practice than just meditation/*zazen* and nothing else. Ceremonies have their own power. For example, those he witnessed at *Harada* Roshi's temple in Japan:

> [They] glow with the living Truth . . . Through these rituals [the monks] are reaffirming their link with their great Buddhist tradition, enriching it and allowing it to enrich them so that they can extend its chain to the future . . . If I likewise embrace this tradition, I can forge my own link with Buddhism and its tremendous resources for enlightening the human mind. (*Three Pillars of Zen,* 222)

Elsewhere, he says that chanting is "a unique way of engaging the deepest level of the mind", circumventing the intellect so that the meaning is absorbed spontaneously (*Zen: Dawn in the West,* 175–76). Similarly, a Buddha-figure that is nourished by the *zazen* of all those who practice near it, acquires a deep silence and radiance; it radiates compassion and wisdom which "can open you up to the buddhic forces which interact with your own Buddha-nature to inspire and strengthen you" (ibid., 194–97).

*There are certain similarities here with what Sri **Krishna Prem** says about rituals.*

These traditional forms, then, are indispensable ingredients of spiritual training (*Zen: Dawn in the West,* xviii). And they have been established at Rochester Zen Center. In addition, there are rites of passage—that's his phrase—such as weddings and funerals; celebration of the Buddha's birthday, death day and day of enlightenment; Bodhidharma's death day; Founder's Day; a ceremony dedicated to the aid of starving people throughout the world;[2] and Thanksgiving, when "Zen devotions . . . add substance to a home-grown American Buddhist holiday" (ibid., 174).

Yet some adaptation for the West is still required.

> What is needed to assimilate Zen Buddhism into Western modes of thinking and feeling? English chanting versions of basic sutras, distinctive Western dress permitting easy crossing of the legs for zazen, Western sounding Buddhist names for those who

[1] These three are dealt with at length in *Three Pillars of Zen. Zazen* has three stages: concentration, *kensho* and "actualization of the Supreme Way in our daily lives" (p. 46). *Teisho* or the 'commentary' by the master, is more than just intellectual instruction; it is an actual presentation of truth which can "illumine the minds of his hearers" (p. 67). *Dokusan* is the meeting with the master when the disciple's insight is tested and strengthened (see Kapleau's 'The Private Encounter with the Master', in Kraft).

[2] This is one of the reasons that the Center is vegetarian: not only is a non-meat diet more compassionate, healthier, more ecologically sound (and cheaper), but it also avoids the exploitation of underdeveloped countries that the huge meat industry inevitably gives rise to.

became ordained or took the precepts, and ceremonies, forms and rituals that are in accord with our Western traditions. (*Zen: Dawn in the West*, 269)

However, when Kapleau proposed these changes to *Yasutani* Roshi in 1966, very soon after his return to America, *Yasutani* did not agree. In fact, he was distinctly displeased and as a result Kapleau withdrew, very reluctantly, as *Yasutani's* student. This happened in 1967 and to all intents and purposes he has been an independent teacher ever since, with no formal contact with the tradition that he himself practiced in. He never did receive Dharma transmission from *Yasutani* Roshi—a fact which he fully acknowledges.

The central issue here is what makes a teacher authentic; and this in its turn ties in with the question of what constitutes true or authentic transmission from teacher to pupil/disciple. I deal with these issues in a larger context in Chapter 3. But Kapleau's case raises all these matters in a particularly interesting way because of what has happened in the transmission to his own students.

He has appointed five Dharma heirs (all of whom use the title, 'Sensei'): Bodhin Kjolhede is the abbot of the Rochester Zen Center since Kapleau's semi-retirement; Zenson Gifford, who was director of the Toronto Zen Center but is no longer;[3] he was replaced by Sunyana Graef, Kapleau's third Dharma-heir (who also teaches at the Vermont Zen Center); two more recent Dharma-heirs are Danan Henry (about whom I know nothing except that he was in the **Gurdjieff** Work in New York for many years) and Sunya Kjolhede (Bodhin's sister). Another advanced student—but not a Dharma-heir[4] (though he uses the title 'Sensei')—is Albert Low, a Canadian who wrote the Foreword to Kapleau's *Zen: Dawn in the West* (see below), has written his own books with titles like *Zen and Creative Management* (New York, 1976), and has a centre in Montreal. All of these are members of the Kapleau crew (to return to the image that I used at the beginning of this entry).

Some similarities with Werner **Erbard** *here.*

But there are others who appear to have abandoned ship. Toni **Packer** is a case in point. She came to Kapleau in the early days at Rochester and it is evident that he regarded her highly: he appointed her as a teacher (though not a Dharma heir) and said that he wanted to pass on the Zen Center to her when he retired. But she left him—and the Zen tradition altogether—because she came to see *all* of its external trappings as encouraging dependence rather than independence, and thus covering, rather than revealing, truth. Not for her the 'glowing, living truth' of Zen rituals that Kapleau speaks about so enthusiastically. It is somewhat ironic, of course, that Kapleau should have rejected *Yasutani* Roshi's cultural conservatism only to have his own 'liberal' position rejected by his main pupil as irredeemably limited in its turn. But having said that, I should point out that he still has a high opinion of **Packer** and says that she is a talented teacher doing good work. One of the impressive things about Kapleau is that he does not berate either his teacher *(Yasutani)* or his pupil (**Packer**) for the stance they adopted.

On the other hand, he can be forthright when he sees the need for it. And he certainly does not pull his punches in his remarks about another former pupil, Richard **Clarke**, whom, Kapleau says, is misrepresenting the facts when he claims that he has received transmission into "the Harada-Yasutani-Kapleau

[3] "In the spring of 1994, the board of Trustees of the Toronto Zen Centre and Zenson Gifford agreed to terminate their relationship" (letter from Kapleau, November 1995). He did not say why.

[4] "I felt that he was competent to teach . . . having completed his training . . . but he was not sanctioned as a Dharma Heir because I did not feel at the time that he was a Buddhist and therefore would not follow the Buddha's Way in his teachings" (Kapleau letter, November 1995).

line of Zen". According to Kapleau, **Clarke** repeatedly flouted the guidelines of *koan* study and Kapleau asked him to leave. (See **Clarke**'s entry for his side of the story.)

The right and wrongs of this particular matter are not my concern. But I am interested in the principles that are involved. We find that Kapleau's pupils occupy a considerable range on the scales of transmission and authorization. There are his four current Dharma-heirs (both Kjolhedes, Graef, Henry), who continue the tradition, so to speak (though, as this whole entry makes plain, this is a problematic notion—and it is problematic in all traditions); there is Gifford, a Dharma-heir who has 'left'; there is Low, an appointed teacher but not a Dharma-heir, who is what we might call 'an approved independent'; there is **Packer**, who was also appointed as a teacher but has repudiated her appointment; and there is **Clarke**, who says he was appointed, while Kapleau says he wasn't.[5]

And of course the immediate question is: what about Kapleau himself? He was certainly appointed to teach but equally certainly not appointed as a Dharma heir. One is bound to wonder, therefore, what exactly the status of the Dharma heirs of a non-Dharma-heir might be. Kapleau's own views are typically forthright:

> One who trains under an authentic Zen teacher inherits a whole line of teaching going back to the Buddha himself. These methods have been handed down from teacher to teacher. Each one has devoted his or her whole life to that tradition. Someone who truly becomes a personal student of the teacher inherits a long line of great Zen masters' discoveries of the human mind. (*Tricycle* interview, 58)

And even more forcefully:

> A roshi is a guide and teacher whose spirit-heart-mind is identical with that of all the Buddhas and Bodhisattvas . . . Without him Zen's past is lifeless, its future "powerless to be born". (*Three Pillars of Zen,* 89)

Elsewhere, he makes a distinction between a *roshi* and a master.

> The literal translation of roshi is "venerable teacher"—that is, one who commands respect and reverence by reason of age or great dignity. The abbot of a monastery, the chief priest of a temple, or a lay teacher beyond the age of, say, fifty could be addressed as a roshi . . . [I]t is not a title signifying completion of a prescribed course of study or in recognition of high spiritual accomplishments.
>
> The title "master" conveys something quite different. A Zen master is a person of deep spiritual insight and wisdom who has experienced the emptiness and impermanence of all things, and whose lifestyle reflects such awareness . . . Zen master Dogen defined a master as one who is fully enlightened, who lives by what he knows to be the truth, and who has received the transmission from his own teacher. By these criteria only a few roshis anywhere can be considered masters. (*Zen: Dawn in the West,* 30–31)

This is a high standard and the question naturally arises as to whether Kapleau himself lives up to it. He is not a man given to grandiose claims and as far as I know he has never said that he is a master. On the other hand, it

[5] A particularly interesting aspect of Kapleau's teaching in the West is that he has pupils or disciples in Poland. (Zenson Gifford has been involved in this work; see 'An Interview with Rev. Zenson Gifford', *Spring Wind* [the magazine of the Zen Lotus Society], vol. 4, no. 3, Fall 1984 (an issue entitled *Zen in North America*), 41–63). This is part of a general movement that is beginning to bring Eastern Europe into contact with Eastern traditions of all kinds. No one is directing it—but by and large it is Western rather than Eastern teachers who are doing it. It is a phenomenon that needs to be researched.

certainly seems that he accepts the responsibility of at least being an authentic teacher. This is his account of how he conducts *dokusan,* when students come to have their insight tested:

> Another mode of testing is suddenly to jar a student physically or verbally when I sense his mind is ripe, in a state of absolute emptiness. Before I can determine that, however, I scan him carefully with my inner eye as he negotiates the rather long distance to the mat in front of me. Is he rigid and tense, or wobbly and tentative? . . . [I]f he is in a samadhi state, he will be walking as though not walking.
>
> Again, as he sits in front of me I watch his face intently, especially the eyes. I don't think, "Should I test him, and if so, what kind of procedures should I use?" I must size him up in a split second and intuitively, unthinkingly, apply the incendiary that may ignite the dried tinder of his mind into the flames of self-transcendence. ('The Private Encounter with the Master', 51)

And his 'orthodox' students—all of whom have been through this process at his hands, of course—are in no doubt about his authenticity. Albert Low says that Kapleau

> has tenaciously and unremittingly preserved the spirit of Zen as passed to him from his teachers Harada-roshi and Yasutani-roshi . . . Here is a Westerner, both enlightened and articulate, aware of the doubts, concerns, and hopes of contemporary, technologically oriented people. Such a combination of qualities is rare. (Foreword to *Zen: Dawn in the West*)

Similarly, Bodhin Kjolhede told me in an interview that even though Kapleau did not receive Dharma transmission, his qualities are such that he is an authentic teacher. Kjolhede made a distinction between 'a mandate from above' and 'a mandate from below'. The first is formal authorization from a teacher who is himself authorized; the second is recognition by a teacher's students that he is authentic. Ideally, a teacher should have both kinds of mandate. But the first without the second is hollow, while the second without the first may be perfectly acceptable. So there is nothing wrong or misleading in Kapleau using the title 'Roshi'. In fact, Kjolhede told me, Shunryu Suzuki (not to be confused with D.T. Suzuki) urged Kapleau to call himself 'Roshi' more or less from the beginning; but Kapleau waited until he was 60 before doing so. (Kjolhede makes much the same points, though not in these terms, in his *Zen Bow* article—see 'Primary sources'.)

Kapleau Roshi—having explained the circumstances surrounding the use of the title, I shall now employ it myself—told me in a letter that he had been told in Japan that there was some doubt as to whether *Harada* Roshi, the founder of the lineage to which Kapleau himself belongs, had himself received Dharma transmission. This is a contentious issue and disciples of *Yamada* Roshi (who *was* given Dharma transmission by *Yasutani* Roshi) have reacted strongly to it; perhaps because, according to this branch of the lineage, formal transmission *is* a mark of authenticity. (See Lineage Tree 4, 'Soto Zen lineages derived from Harada Roshi' (p. 316), for the other branches of this tree.)

Again, I am not concerned here with the facts of this matter. I mention it only because of its parallels with Kapleau Roshi's own position. If *Harada* Roshi was not formally appointed, then all the branches or lineages from him are 'suspect'—but only if one places strong emphasis on formal criteria. If, like Kapleau Roshi, one does not, then it is no more than a detail—a bit like finding out that a great mathematician, though he went to college, never actually graduated—and his mentioning it does not, of course, indicate that he thinks it diminishes *Harada* Roshi's stature by so much as a whisker.

This whole discussion is germane, in a general way, to another aspect of Kapleau Roshi's presentation of the mark of an authentic teacher: that he or she preserves the teachings, the methods and the standards of the tradition. This is why he has been critical of the behaviour of certain Zen teachers, both Western and Japanese, who have broken the basic precepts and been unable to resist the lure of money, power, alcohol, and sex. Kapleau is adamant that the precepts are a necessary ingredient of the authentic transmission of the tradition. And they are not just an elementary ingredient, either—something that more or less anyone can do. "It takes samadhi power to keep the precepts" (letter).

So the precepts, the practice of *zazen,* and *satori* (or *kensho*) are all interrelated (*Three Pillars of Zen,* 125). If one of them is weak, nothing of much value can be accomplished. (And 'accomplishment' here means being able to present the truth to others—that is, to benefit beings.)

> Some enlightened people have perceived the truth that all life in its essential nature is indivisible, but because they haven't yet purged themselves of their delusive feelings and propensities, the roots of which are embedded deeply in the unconscious, they cannot act in accordance with their inner vision. (*Three Pillars of Zen,* 104)

Hence the behaviour of Zen teachers who have been unable to live up to the precepts is simply an indication that they had weaknesses that significantly affected the quality of their teaching. ('Teaching' here means 'presentation of truth as something one can perceive', not 'ideas or doctrines'.)

> If these roshis had been genuine Zen masters, they would have been able to withstand the temptations to which they had been subjected. There is something lacking in a system of dharma transmission or sanction that places moral behavior low on the list of qualifications of a teacher. (*Tricycle* interview, 57)

In other words, formal recognition is of little value if it allows such divergences from the Dharma. Or more accurately: formal recognition does not in itself confer wisdom. And this, of course, is consistent with Kapleau Roshi's general view about what Dharma transmission is (and hence what an authentic teacher is like).

Kapleau Roshi is also critical of—perhaps it would be better to say, 'presents a critique of'—a certain *form* of Zen: Christian Zen. He refers to the "sanctioning [of] Catholic priests and nuns as well as rabbis and ministers to teach Zen" as "a threat to the integrity of Zen, and in many ways the most bizarre" (*Tricycle* interview, 55). And the reason is simply that there is an inherent contradiction between Christianity—in fact, any theistic tradition—and Zen (ibid., 56). Elsewhere, he recalls the "presumptuous statements" made by ministers and rabbis that he encountered at a certain point in his spiritual search:

> "God is good," "God is almighty," "God is . . ." Many years later, after gaining some Understanding, I knew that God is neither good nor almighty nor anything else. In fact, God isn't even God. (*Zen: Dawn in the West,* 265)

This is clearly his own view—his own experience, in fact—but it is also true that he is in complete agreement in this matter with his teacher, *Yasutani* Roshi, who was himself critical of Christians who wanted to practice Zen while remaining Christian. (See Father Hugo **Enomiya-Lassalle**'s entry, which also covers Christian Zen.) Yet the Zen teacher who has done more than any other to encourage Christian Zen is *Yamada* Roshi, *Yasutani* Roshi's principal

Dharma heir. Kapleau Roshi made the point to me in a letter that it is significant that both *Yamada* Roshi and **Aitken** Roshi (who has given Dharma transmission to Father Patrick Hawk, a Catholic priest) are laymen, "never having been ordained in the Buddhist tradition." This ties in with his view that a dedicated celibate monastic tradition is needed "to preserve and transmit the teachings". And the irony is, of course, that *Yasutani* Roshi appointed *Yamada* Roshi, a layman, as his Dharma-heir, and not Kapleau Roshi, the ordained monk.

There is much to admire in Kapleau Roshi's 40 years of dedication to Zen. (He took semi-retirement in 1987, at the age of 75, leaving his principal Dharma heir, Bodhin Kjolhede, in charge of the Rochester Zen Center.) Yet as I said at the beginning, his voyage on the great ocean of Zen, both as pupil and as teacher, has not been plain sailing. The question now is: has he trained enough people to a sufficiently high standard to keep this section of the fleet on course? It is a crucial question and it is as yet too early to give a definite answer. But it is a tribute to the man that he may well have done so.

(*See* Lineage Trees 4,6)

Primary sources: Philip Kapleau, *Three Pillars of Zen* (New York, 1966); *The Wheel of Life and Death: A Practical and Spiritual Guide,* (New York, 1971); *Zen: Dawn in the West* (London, 1980); *To Cherish All Life: A Buddhist View of Animal Slaughter and Meat Eating* (San Francisco, 1981); 'The Private Encounter with the Master', in K. Kraft , ed., *Zen: Tradition and Transition* (London, 1988), 44–69; 'Life with a Capital "L": An Interview with Philip Kapleau Roshi', *Tricycle,* vol. 2, no .4, Summer 1993, 54–61; Bodhin Kjolhede, 'Roshi and His Teachers, Dharma Transmission, and the Rochester Zen Center Lineage', *Zen Bow,* vol. XVII, no. 4 and vol. XVIII, no. 1, Fall 1995 and Winter 1996 (special supplement)

Secondary sources: None

Centre: Zen Center of Rochester, 7 Arnold Park, Rochester, NY 14607, U.S.A.

COMPARE:

Other Zen teachers: Roshi Robert **Aitken**, Roshi Reb **Anderson**, Roshi Richard **Baker**, Sensei Jan **Bays**, Joko **Beck**, Roshi Gesshin **Prabhasa Dharma**, Zen Master Don **Gilbert**, Sensei Bernard **Glassman**, Roshi Jiyu **Kennett**, Roshi Walter **Nowick**, Ruth Fuller **Sasaki**, Roshi Maurine **Stuart**, Zen Master **Tundra Wind**

Others who have separated from their teacher(s) (in a variety of ways): Joko **Beck**, Zen Master **Tundra Wind**, Zen Master **Rama**, Ven. **Sangharakshita**, **Rudi**, **Jayatirtha**, Michael **Barnett**, Gesshin **Prabhasa Dharma**, Jacqueline **Mandell**

Others who are (in a certain sense, at least) anti-theistic: Ven. **Sangharakshita**

KARUNA DHARMA

American nun in the Vietnamese Zen tradition

Karuna Dharma (I don't know her original name or her date of birth) was born in Wisconsin, the daughter of the founder of a small church. She used to teach at Sunday School in her teens. Some years later, she was living in Los Angeles, a high school teacher, divorced with a young daughter. In 1968, she took a course in Buddhism at UCLA. It was taught by Dr. Thich Thien-an, who was a Vietnamese Rinzai master and monk, though he did not advertise the fact; he dressed and behaved quite normally. She was immediately drawn to him, and he to her. He told her that they had been together for many lifetimes. She

became his student and was in the forefront of his plans from that time onward.

He founded the International Buddhist Meditation Center in Los Angeles in 1970 with Karuna Dharma as his main assistant. She took her novice precepts in 1973, and full ordination, involving 250 precepts, in 1976. Thien-an was prepared to let his students take less precepts if they wanted to but Karuna Dharma "wanted as traditional and as committed an ordination as I could have" (Friedman, 199). Throughout her time with Thien-an, the United States had been involved in the Vietnam war. When American troops were finally withdrawn in 1975, there was a wave of refugees and the Center opened its doors to them. And although there have always been Americans connected with the Center, it primarily caters to the Vietnamese community. Karuna Dharma is thus one of the few Western teachers who represents an Eastern tradition for Easterners—in the West. She was appointed Thien-an's Dharma heir shortly before he died in 1980 and is currently the Center's director and spiritual head. She now has disciples of her own (both male and female, though I do not know if they are American or Vietnamese—or American-Vietnamese).

But although she is in a sense an honorary Vietnamese, she is not tradition bound. To a large extent, this is because Vietnamese Buddhism is itself nonsectarian, as she herself says (Friedman, 198). But it does seem that she favours an ecumenical approach. Despite the fact that her own training with Thien-an was in the Rinzai Zen tradition, she went out of her way to learn about Pure Land Buddhism because it was the form that the majority of Vietnamese were most familiar with. In addition, she has invited Theravada monks and Tibetan *lamas* to the International Buddhist Meditation Center (D. Morreale, *Buddhist America: Centers, Retreats, Practices* [Santa Fe, New Mexico, 1988], 122). It appears, therefore, as though what might be called inherent non-sectarianism has been extended to full-blown ecumenicism—by a Western woman in Los Angeles. This is as good an example of 'cross-fertilization breeds hybrids' as I know.

Primary sources: Bhiksuni Dr. Karuna Dharma, 'Nuns of Vietnam' *in* Karma Lekshe Tsomo, ed., *Sakyadhita: Daughters of the Buddha,* (Ithaca, New York: Snow Lion, 1988), 154–59

Secondary sources: L. Friedman, *Meetings with Remarkable Women: Buddhist Teachers in America* (Boston, 1985)

Centre: International Buddhist Meditation Center, 928 South New Hampshire Avenue, Los Angeles, CA 90006, U.S.A.

COMPARE:

Other teachers in Vietnamese Buddhism: Gesshin **Prabhasa Dharma**

Other women teachers in Zen: Jan **Bays**, Joko **Beck**, Roshi Jiyu **Kennett**, Dharma Teachers Linda **Klevnick** and **Linda Murray**, Dharma Teacher Bobby **Rhodes**, Ruth Fuller **Sasaki**, Irmgard **Schloegl**, Roshi Maurine **Stuart**

Other women teachers in other forms of Buddhism: Freda **Bedi**, Ruth **Denison**, Rev. **Dharmapali**, Ayya **Khema**, Sharon **Salzberg**, Ven. **Bhikshuni Miao Kwang Sudharma**, **Pema Chodron**, Dhyani **Ywahoo**

English teacher in the Zen tradition who was abbess of her own temple in Japan for several years; later developed a particular form of Zen after a series of visionary experiences

Any Westerner who introduces changes into an Eastern tradition runs the risk of being charged with meddling in something that he or she does not really understand. If these changes are radical, the charge tends to be radical too. Of course, every case has to be examined on its merits. But there are some Westerners of this kind who are particularly interesting: those who have been recognized (a somewhat elastic term, admittedly) as teachers by the tradition which they claim to represent. Rev. Master Jiyu Kennett, founder of the Order of Buddhist Contemplatives, is a good example.

She was born Peggy Kennett in 1924. She went to an English 'public school' (a private school) and was strongly influenced by some of the teachers, ex-suffragettes who were also conservative Christians—not a very common combination. Her first encounter with Buddhism was fortuitous: a girl at the school brought in a statue of the Buddha. Peggy found herself attracted to it (Friedman, 172). Something else that she could not explain was her strong desire to become a priest[1] (Friedman, 173). To begin with, she thought that this would have to be fulfilled within the Church of England (which seems somewhat Quixotic, given its attitude to women priests in the 1940s). She trained as an organist—she has a degree in music from the University of Durham—and managed to get herself into minor ecclesiastical posts as a result. But they never amounted to very much and when she was fired from one of them—"for being a woman," as she puts it (Friedman, 173)—she abandoned Christianity and turned her attention to Buddhism. She became a pupil of Ven. Saddhatissa, a Sri Lankan monk living in London. She also joined the Buddhist Society in London; attended Christmas **Humphreys**'s Zen class there (one wonders what she came to think of it in later years); and gave lectures on Buddhism under its auspices.

*Cf. Irmgard **Schloegl**, who was also in the class.*

Then in 1960, Chisan Koho, abbot of Sojiji, one of the biggest Soto monasteries/temples[2] in Japan, came to London. Kennett met him—she was organizing his visit—and he invited her to Sojiji. She accepted and left England by ship a few months later. On the way, she stopped off in Malaysia, where she was ordained as a Rinzai priest (*The Wild White Goose*, vol. 1, 8). This is in itself something fairly unusual (though not unique: cf. Ruth Fuller **Sasaki**, Maurine **Stuart**, and Irmgard **Schloegl**) yet it was not something that she had actively sought: the monk who had invited her to Malaysia had made all the arrangements without consulting her and she did not want to cause considerable upset by refusing. But one of the consequences is that she is one of the few Westerners who has been formally ordained in both Rinzai and Soto Zen.

*The others are **Glassman**, **Merzel**, and **Langlois**.*

The story of her life in Japan is recounted in some detail in the two volumes of *The Wild White Goose*. Although she had been personally invited to Sojiji by Chisan Koho, and he accepted her as his personal disciple when she arrived (*The Wild White Goose*, vol. 1, 35), she was the only foreigner and the only woman in an all-male, all-Japanese temple. To say that she had her

[1] Sometimes, she uses the word 'monk' instead; this sounds odd to Western ears since in the Christian tradition monks and priests are not at all the same. But the Zen tradition is very different and the interchangeable use of the two terms can be justified. The only alternative is to use Japanese terms throughout—which is quite contrary to Kennett's whole approach to Zen, as we shall see.

[2] The same remarks apply to the terms 'monastery' and 'temple' as apply to 'monk' and 'priest': they are much closer in Zen usage than they are in the West.

difficulties is putting it mildly. But she saw this situation as her *koan*—that is, an impossible dilemma that yet has to be solved.

> The koan arises *naturally* in daily life . . . That which arose *naturally* for me in the Tokyo temple was the fact that I was a woman and a foreigner in a Japanese man's temple. It was a natural problem, given the culture here, a natural koan. (*The Wild White Goose,* vol. 2, 200)

Her situation was—and still is—unique for a Western Zen practitioner as far as I know; other Western women have practiced in Japan but not in such demanding circumstances. Her difficulties were compounded by the fact that she saw her master, Chisan Koho, only rarely and therefore had to rely on others, some of whom were not well disposed towards her. In fact, these very circumstances forced her to do ceaseless training—that is, to be true to the precepts of a Zen priest regardless of the situation in which she found herself. She kept telling herself that

> the only thing that I can do in order to learn anything is to accept in blind faith everything that is happening to me, believing that it is all for my good, whatever it may be. (*The Wild White Goose,* vol. 1, 40)

She calls this "the most important sentence in the book"; and it was this faith that led her, within weeks, to have a number of unusual experiences. One day, on returning to her room after meditation, the walls suddenly "seemed to disappear" and she was in a long country lane. "Some sixth sense told me that the time was many centuries before this one." She walked to a temple where she was set upon by a priest who abused her and tried to push her over the parapet. But she was saved by the intervention of another priest. At this point, she 'returned' to her room in Sojiji again (*The Wild White Goose,* vol. 1, 37). She interprets this experience as the reliving of a past life (ibid., 174, n. 12), which is significant in the light of her later visionary experiences in California (see below).

Four months later, she had her first *kensho* (literally, 'seeing one's own nature'). She was in the depths of despair, having finally succumbed to the loneliness and the unrelenting struggle to keep her head above water in an environment where she never knew if she was doing the right thing, where she had few friends and where she was repeatedly misled and blamed by her enemies. So one night she packed her bags and left the temple. But as she walked away, a voice said inside her, "You could be wrong." So she turned round and went back; she accepted the *koan* of daily life—that enlightenment can only arise within the conditions of birth and death and all their attendant suffering. Almost at once there welled up within her a series of layers of her personality as she had been in the past: a little girl, a teenager, a young woman. And simultaneously she was seized with the perception that everything was pure and radiant.

> How simple and exquisite is this world in which we live; we bother ourselves with outside things, thinking they are all of life when they are, as was my past, but shadows in a mirror, seen through the swirling mists of our own delusions. There is nothing more than to go on doing that which has to be done for the Smile exists everywhere; the Heart in which it dwells is in all men, all things . . . (*The Wild White Goose,* vol. 1, 68–69)

Elsewhere, she describes this experience of *kensho* as "like seeing a huge panorama instead of looking through a keyhole" (ibid., 92).

As a result of this *kensho,* which she attained after only six months at the temple, she began to move up the ranks of the Soto priesthood. The first step was to become Chief Junior or Shusosho (*The Wild White Goose,* vol. 1, 82). Shortly afterwards, she received Dharma transmission from Chisan Koho (at Sojiji in May 1963). A year later, she was put in charge of her own temple— again, unique for a Western Zen practitioner in Japan as far as I know. The temple was so poor that her predecessor, a Japanese priest, had died of starvation! (ibid., 170) There she carried out religious ceremonies for the local people just as if she were Japanese; but she was also sent Westerners who had come to Sojiji in order to study Zen. This involved teaching Westerners up to the stage of Chief Junior or Shusosho and taking them through the Hossen ceremony (just as had happened to her with Chisan Koho). Having done this, she was able to move up a further rank of the Soto priesthood by going through another ceremony, that of Kessei. This was held at her own temple and at the end of it, Chisan Koho's representative announced to the congregation: "I proclaim that this is well and truly Buddha" (*The Wild White Goose,* vol. 2, 28). Having gone through the Kessei ceremony, Jiyu Kennett was "a full priest" (ibid.,).

Thereafter, she had a number of other formal recognitions of her status within the Soto lineage. She was awarded a Sei degree—a priesthood degree that requires at least five years continuous study, roughly equivalent, she says, to a Christian Doctor of Divinity (*The Wild White Goose,* vol. 1, 168, 199); she was given a certificate by Chisan Koho nominating her as the Buddhist Bishop of London, should she return there (*The Wild White Goose,* vol. 1, 169; vol. 2, 9); she graduated in Tokubetsu Sodo, which gave her the right to teach (*The Wild White Goose,* vol. 2, 148); and she received a *sanzen* certificate from the Administrative Section of the Soto headquarters (ibid., 251). (*Sanzen* is spiritual counselling with a Zen master.)

Jiyu Kennett had therefore fulfilled all the formal requirements of the Soto school and was now a *roshi;*[3] that is, someone who has received Dharma transmission, and, having attained *kensho,* can recognize it others and can therefore guide their practice. However, she was still attached to Sojiji and Chisan Koho put her in charge of the Foreign Section, which had been newly created to deal with the many Westerners who went there to learn Zen. It was in this way, I think, that she came to have a few disciples of her own. She transmitted the first one ten days after receiving her *sanzen* certificate (*The Wild White Goose,* vol. 2, 252). I need hardly add that a Westerner with Western disciples in Japan is still a rare event—and even more so in 1962.

Alongside this formal or external endorsement by the Soto school was another kind of recognition which is arguably as important—namely, confirmation of her inner attainment. Chisan Koho sent her to someone whom he

*Cf. Ajahn **Sumedho***, *who was in charge of a monastery in Thailand in the 1970s.*

[3] Like all titles taken from Eastern traditions, roshi has a somewhat variable usage in the West. Her own definition is: "'reverend master'. A title of a Zen Master . . . conferred by a Master only upon his worthiest disciples . . . Can also be used as an honorary title of respect" (*The Wild White Goose,* vol. 1, 189). She has also said that "[Roshis are] people who know the Eternal. Even if it was only for a few minutes. They know the truth. And you can never be as if you'd not known it . . . If you've had a kensho and have been trained to teach, you become a roshi. Kensho by itself can't do it. You have to be trained to teach and keep up your training. That's the main thing, to keep your training up" (Friedman, 185). Rev. Master Kennett stopped using the title in 1987, both for herself and for members of the Order of Buddhist Contemplatives. The highest title in the Order is now 'Master of the Order of Buddhist Contemplatives' (which is in many respects the equivalent of *roshi*). Eighteen have been appointed by her over the years (see the end of this entry). This is why I have not referred to her as 'Roshi Kennett' even though she used the title herself for 25 years.

called "the greatest living saint of our school"—actually, Kodosawaki Roshi (Deshimaru Roshi's teacher)—in order to confirm his own transmission of her.

> The old man looked at me for a long, long time. His eyes looked straight through me and all through me. They were incredibly beautiful eyes; they radiated a peace that I have only seen once before, on the night of my Transmission. Something within me answered the look and I loved him . . . [He said to his assistant,] "Write to Zenji Sama [= Chisan Koho], 'I have seen. I am happy'". (*The Wild White Goose,* vol. 2, 87–88)

So Rev. Master Kennett is a true Zen master, authenticated by Japanese Soto *roshis,* and fulfilling the spiritual (as well as the formal) requirements of a Soto priest: living as an embodiment of the precepts; training ceaselessly; having solved the *koan* of everyday life and experienced *kensho;* and, finally, having received transmission from her own master. This last is particularly important, for as Dogen, the founder of the Soto school, says

> Not only did the Buddha enlighten himself, he transmitted that enlightenment to the other Buddhas and patriarchs so that even to the present day the transmission has not been interrupted. As this is so, how can they who are enlightened help but be Buddhas? (*Selling Water by the River,* 114)

But as the Buddha himself taught, nothing remains stable for long. In 1968, Chisan Koho died. A year later, Kennett left Japan and travelled to San Francisco with two of her Western disciples. (She had tried to return to England but the Buddhist Society there was not encouraging.) So she set up the Zen Mission Society—an interesting name for a Westerner to use—in San Francisco, and in 1970 she founded Shasta Abbey in northern California as a seminary for Soto priests—that is, a centre for the sort of training that she had received and which she was dedicated to passing on to others. She established the Reformed Soto Zen Church in 1972; it changed its name to the Order of Buddhist Contemplatives of the Soto Zen Church in 1975.

Her career as a teacher in the West has been unusual in a number of ways and raises some important issues. All these are centred on a single point, however: what is true transmission? This is a complex matter which I discuss in Chapter 3. In the case of Rev. Master Kennett, the issue is intimately connected with her experience of the third *kensho,* which has strongly influenced her understanding of all aspects of Zen, and in particular, how she sees herself as a Zen teacher and the significance of the lineage that she has established.

A good starting point for understanding this whole matter is what Chisan Koho says in the preface to Kennett's *Selling Water By the River,*

> When a religion is carried from country to country it is only the basic Truth that will survive . . . The people of Western countries also, if Zen is ever to reach them properly, must colour it for themselves just as the Japanese did. Thus will Zen be reborn in the West. Like the Buddhist at rebirth, the new Zen will be neither completely new, being the same stream of Truth, nor completely old, as it will have new forms, ways, customs and culture . . . When the West is ready, it will find for itself its true teacher. That person may have learned in Japan, but he or she will definitely be one of their own nation and not a foreigner to them. (*Selling Water by the River,* v, xxv)

Clearly, Rev. Master Kennett fulfils all these criteria.

However, her interpretation of her role is decidedly her own. And it came about in an interesting way. In 1976, having been ill for several months, she was told by a specialist that she had perhaps only three months to live. She therefore entered a four month meditation retreat. Her experiences during this time are described in the first 71 pages of *How to Grow a Lotus Blossom or How*

a Zen Buddhist Prepares for Death; the rest of the book covers the months after the retreat when she was at Shasta Abbey.

To begin with, Rev.Master Kennett distinguishes between three kinds of *kensho*. The first is the "'great flash of deep understanding' . . . in which one *knows* one's unity with the immaculacy of nothingness", and which she had in October 1962 in Japan (*How to Grow a Lotus Blossom,* 1–2). The second, "because of its almost imperceptible growth, is not associated in the mind with any one event although certain 'little moments that make one dance' are signs of it" (ibid., 2). The third *kensho* is the subject of *How to Grow a Lotus Blossom.* Unlike the first *kensho,* which is practically instantaneous, this one takes place slowly and it starts with "a deliberate act of will" (ibid., 3). Although it is associated with the time of death, and although Rev. Master Kennett herself did actually die twice (ibid., 77, 88), this *kensho* can be experienced by anyone "who is willing to go very deeply into meditation and training" (ibid., 6).

There are 43 stages described in the book and they occupy over 100 pages. Rev. Master Kennett would go into meditation and enter another world or reality that superimposed itself on her physical surroundings. She had her eyes open and she did not leave her body. "I knew that I was in the room and at the same time I was quite genuinely moving about and doing things" (*How to Grow a Lotus Blossom,* 262). (There are some similarities with her 'waking vision' of the two priests in the temple in Japan—see above—but there the room disappeared; here it did not.)

An important part of these visionary experiences is the reliving of past lives because it allows impressions or impregnations, that have been caused by breaking the precepts in those lives, to be cleaned up (*How to Grow a Lotus Blossom,* 3).[4] Rev. Master Kennett saw herself in past lives as both a Christian and a Buddhist monk—the latter in China and Japan—and both male and female: 15 times Christian, 14 times Buddhist (ibid., 53). She also sees herself as a "sad and beautiful woman of the later eighteen-hundreds", whom she purifies by converting her to Buddhism (thus freeing herself from the karma that she had created while in this former incarnation).

In addition, she sees golden Buddhas (ibid., 105), including the Cosmic Buddha and Shakyamuni Buddha.

> The ceiling begins to go yellow, as is usual when I enter these meditations, and I seem to be looking out of the place in the centre of my forehead. I see myself on the left hand of a being whom I know to be Shakyamuni Buddha dressed in white . . . [Later] I see him rise up from where he is standing and become absorbed into the great, golden Cosmic Buddha that I now see in the sky. (*How to Grow a Lotus Blossom,* 93–94)

There are many details in the book which I cannot mention here. But what is common to all of Rev. Master Kennett's experiences is that they are direct perceptions of the Buddhist teaching. This is an extract from the last stage of all, when she sees a ball of light.

> . . . I see beings coming and going within the ball of light throughout which moves a red ribbon of light . . . The ribbon can take any shape or form, for ever turning, for ever moving. The beings are upon the red ribbon, here appearing as human, there as animal, god, insect, rising, falling, ever moving, never resting, nothing excluded. The Light of the Lord of the House, the heart-mind,[5] irradiates the infinity of space—

[4] In fact, this cleaning up can be accomplished in a number of ways (such as meditation and the mindful practice of everyday life); reliving past lives is really an indication that it is being done.

[5] 'The Lord of the House' is a term that Jiyu Kennett says she got from Keizan Zenji (1268–1325) (for whom,

within its centre I may not say that it is empty; I may not say that it is not empty. It is unstained, immaculate; I am not It, It is all of me; thus form is void and void is form. (*How to Grow a Lotus Blossom*, 182)

Not surprisingly, these visionary encounters had a profound effect upon her; not least in the way they transformed her understanding of Zen ceremonies. For example, when celebrating one of them called 'Nenju', "as each of the names of the Ten Buddhas is recited they appear before me" (*How to Grow a Lotus Blossom*, 98). One could say, perhaps, that these ceremonies are nothing less than the externalization of living realities. It is hardly surprising, therefore, that she holds very strongly that Zen is a religion and not just a way of life (Friedman, 168). This makes it relatively easy for her to translate Zen into theistic terms. She sometimes equates Buddha-nature with the soul (Friedman, 164), and says

*Cf. Toni **Packer** and Joko **Beck**, who hold more or less the opposite view.*

> Meditation has nothing whatever to do with self-improvement. It is an extraordinarily deep, prayerful experience, and its purpose is to become one with the Cosmic Buddha—or, if you like, have an experience of God. (Friedman, 164)

*Roshi Philip **Kapleau**, for one.*

This is not to say that she has rejected basic Buddhist teaching—she accepts the notions of *anatman* (no-self) and *sunyata* (emptiness), for example[6]—but she is clearly far more sympathetic to theistic vocabulary than many other Zen teachers.

Indeed, it is does not seem too much to say that her visions are essentially revelatory. They help to explain her earlier statements about the role of the Zen priest.

> The master stands in place of the Lord in relation to the disciple, and, if he knows his job, will behave as such, whilst knowing that he is not—a concept very difficult for Western people to comprehend. (*The Wild White Goose*, vol. 1, 174, n. 15)

And of herself she says,

> One day there will be a civilization under the protection of the Buddhas and Bodhisattvas. My duty is to train myself and, when the opportunity arises to establish that civilization, to do everything I can. (*The Wild White Goose*, vol. 2, 31)

So Rev. Master Kennett is claiming to have had some very unusual visionary experiences during her third *kensho*, on the basis of which she (literally) sees herself as fulfilling the Bodhisattva vow by "standing in the place of the Lord"—that is, the Cosmic Buddha. This is, as far as I know, a unique claim for a Zen *roshi* to make. It is therefore hardly surprising that it caused considerable disturbance among some of her disciples (both at Shasta Abbey in California and at Throssel Hole Priory in the north of England which she founded in 1972), who left her because they thought she was deluded.

And it is easy to see why. The Zen tradition (both Soto and Rinzai) contains explicit warnings against *any* kind of sensory experience that arises during *zazen* meditation. Such experiences are called *makyo* (which may be translated as 'illusion') and practitioners are told to regard them as transitory and unreliable—even the so-called high-level *makyo* like reliving one's

see below). Here she defines it as 'heart-mind'; elsewhere she defines it as the "Buddha in each being, Buddha Nature, Cosmic Buddha, Who is not explicable in terms of existence and non-existence or self and other" (*The Wild White Goose*, vol. 1, 188).

[6] Rev. Dazui MacPhillamy, one of her senior students, emphasized that her commitment to traditional Soto practices actually increased after her third *kensho*.

childhood, memories of past births, being filled with light, or visions of the Buddhas. According to *Yasutani* Roshi, although such high-level *makyo* appear to convey the feeling of a greater or expanded reality, in fact they are unreal and meaningless in themselves (Kapleau, *Three Pillars of Zen,* 40).

Kapleau Roshi also makes the same point himself (Zen: Dawn in the West, 97).

Now Rev. Master Kennett is well aware of all this and actually quotes Dogen's warning against *makyo* (*Selling Water by the River,* 27; Yasutani Roshi also quotes it: *Three Pillars of Zen,* 40). But she has an answer to it—namely, that it is only dangerous to see the Buddhas during *zazen* "when you feel elation . . . or cling to them" (*How to Grow a Lotus Blossom,* 98). She also says that

> It has been taught in the West that all experiences, visual or otherwise, during meditation should be regarded as makyo and taken no notice of whatsoever. Whereas this is true for *all* who have *not* had a first kensho, it is not *necessarily* true for those who have the little flashes of [the second] kensho and not true at all for those having the third kensho. The Zen masters of old did not talk about the valid experiences, however, for fear that new trainees would mistake makyo for the real thing. (*How to Grow a Lotus Blossom,* 3–4)

As far as I know, Rev. Master Kennett is the only person in the entire history of Zen Buddhism who has so much as mentioned the third and fourth *kenshos*. However, there are records of visionary experiences in the tradition. According to Rev. MacPhillamy, with whom I have corresponded on this matter, Rev. Master Kennett is in the line of 'Keizan Zen'. Keizan Zenji (1268–1325) was the fourth leader of the Soto school (which was founded by Dogen after his return from China in 1227). He had a 'dream' (the Japanese word *yume* can mean both 'dream' and 'vision') in which he met Bodhidharma, Maitreya, and Shakyamuni (in that order). Faure, who quotes Keizan's own account of the experience, refers to it as a 'revelatory dream' and says that "the dream is not, as for Dogen and traditional Ch'an masters, the hallmark of delusion, but a higher reality" (B. Faure, 'The Dharma-shu, Dogen, and Soto Zen', *Monumenta Nipponica,* vol. 42, no. 1, 25–55; this quotation from p. 49).

The argument is, therefore, that visions (*yume*) of this kind are an integral part of the Zen tradition and not a deviation from it. This is a complex matter and I cannot go into it here. I should point out, however, that in Keizan's own *Instructions on How to Do Pure Meditation,* which has been translated by Shasta Abbey under Rev. Master Kennett's direction, he describes how

> [the mind] may see the Buddha in person or some Bodhisattva. Sometimes it may bring up 'sage opinions' or 'penetrating' insights into the meaning of Scriptures and Commentaries. Experiencing various wondrous happenings such as these, along with their extraordinary characteristics, are, through and through, illnesses from a disharmony of thoughts and breathing. (Anon, *Buddhist Writings,* Shasta Abbey, 1994, 198–99)

A note has been appended to the phrase, " . . . may see the Buddha in person or some Bodhisattva":

> Seeing Buddhas or Bodhisattvas while meditating is, indeed, an impediment for the beginning meditator; however, at other times or in other contexts within training this is not necessarily the case. See, for example, *The Scripture of Brahma's Net,* p. 175 [also included in *Buddhist Writings*], where visions of the Buddha are listed as confirmatory signs . . . The matter of visions is an area where the wise discernment of an experienced master is invaluable.

According to Rev. Master Kennett, then, Keizan's own writings do not mean what they appear to mean. This is entirely possible. But equally, such an interpretation is not entirely obvious.

*Shrila **Bhaktipada** has also designed the robes at New Vrindaban.*

She has also introduced a number of changes from the way of life she learned in Japan. Some of them are fairly minor: knives and forks instead of chopsticks; a new kind of robe (which she designed herself); carpet instead of tatami mats. But others are more radical. For example, the windows in Mt. Shasta's ceremony hall are painted with scenes from her third *kensho*.[7] She states unequivocally that true realization is only available to celibates. A married person simply cannot attain the higher *kenshos*. Even if he or she remains celibate within marriage, the mere fact of the relationship detracts from the ideal of complete renunciation. "If you want to go the whole way, you must become a monk" (Friedman, 166). This statement is, of course, an implicit critique of married *roshis*—yet the Soto tradition (unlike Rinzai) allows its priests to marry.[8]

Rev. Master Kennett also differs from other Western Zen teachers in the number of pupils to whom she has given Dharma transmission: 95 out of a total of 143 monks whom she has ordained. This is a lot—but it is not out of line with the way things are done in Japan, where transmission is often given to junior practitioners, provided they have shown firm commitment to the precepts and to practice. Of these 95, 18 are Masters of the Order of Buddhist Contemplatives, of which just two have given Dharma transmission to their own pupils. In effect, then, this method ends up much like the other way of doing things—which is far more prevalent in the West—when only senior pupils are made Dharma heirs with the authority to give Dharma transmission in their turn.

I have considerable admiration for Rev. Master Kennett, who has stuck to her guns through thick and thin for over 35 years. But it has to be said that she is out of step with the rest of Western Zen. I have no doubt that this does not concern her one jot. We will have to wait several decades to see whether her form of Zen joins up with the rest or continues on its steady march in a different direction.

Stop Press: *Rev. Master Kennett died in November, 1996 just as I was finishing this entry. She has been succeeded by Rev. Eko Little as abbot of Shasta Abbey and by Rev. Daizui MacPhillamy as head of the Order of Buddhist Contemplatives. (During her lifetime, she had fulfilled both of these posts herself.)*

Primary sources: Roshi Jiyu Kennett, *Selling Water by the River: A Manual of Zen Training* (New York, 1972) [this book was later retitled, *Zen Is Eternal Life*]; *The Wild White Goose*, 2 vols. (Shasta Abbey, 1977); *How to Grow a Lotus Blossom or How a Zen Buddhist Prepares for Death* (Shasta Abbey, 1977); *The Book of Life* (with Rev. Daizui MacPhillamy) (Shasta Abbey, 1979); other works, such as *Buddhist Writings* (a collection of translations from the Buddhist tradition), have been published by Shasta Abbey but are not available in your average bookshop

[7] However, Rev. MacPhillamy has pointed out that Dogen, who is normally regarded as quite opposed to visions of this kind, did have them himself on occasion. He even commissioned a painting of one of them, which was hung in his temple. Source: T. Kouzai, 'The Life of Zen Master Dogen (Illustrated)', *in* K. Kato, ed., *Zen Fountains* (Hawaii, 1994).

[8] Again, Rev. MacPhillamy points out that though Soto monks were allowed to marry from 1872 onwards, they have only done so in any numbers since the end of World War II. "This hardly makes it a 'tradition' of long standing." In addition, female practitioners were not governed by the 1872 ruling and have remained celibate to this day. "Thus there is in Japanese Soto Zen at the moment a double standard on the basis of gender, something that is hardly conducive to application to the West."

Secondary sources: L. Friedman, *Meetings with Remarkable Women: Buddhist Teachers in America* (Boston, 1985); Sandy Boucher, *Turning the Wheel: American Women Creating the New Buddhism* (San Francisco: Harper and Row, 1988)

Centre: Shasta Abbey, Mt. Shasta, CA 96067, U.S.A.

COMPARE:

Other women teachers in Zen: Jan **Bays**, Joko **Beck** (Soto); Gesshin **Prabhasa Dharma** (Rinzai turned Vietnamese); Ruth Fuller **Sasaki**, Irmgard **Schloegl**, Maurine **Stuart** (Rinzai); Linda **Klevnick**, Linda **Murray**, Barbara **Rhodes** (Korean)

Other visionaries: Samuel **Lewis**, Frithjof **Schuon**, Swami **Turiyasangitananda**

Other teachers who envision a utopian society of some kind: the **Mother**, Sri **Kriyananda**/Donald Walters, Shrila **Bhaktipada**

Other Westerners who have introduced radical changes into the Eastern tradition which they represent: Samuel **Lewis**, Ven. **Sangharakshita**, Frithjof **Schuon**

HAZRAT INAYAT KHAN

Indian founder of the Sufi Order in the West

*Hazrat (a title of respect) Inayat Khan—not to be confused with his sons, Vilayat Inayat **Khan** and Hidayat Inayat Khan—was born in India in 1882 into a noble family, the Mashaikh Jumma Shah Khandan. He often dreamed of a man with "an expression of extraordinary spiritual beauty and strength" (van Stolk, 25). This turned out to be Murshid Madani of Hyderabad, a Sufi master of the Chishti Order, who also 'recognized' Inayat Khan (though the two had never met) and initiated him. Sometime before his death in 1907, he gave Inayat Khan the authority to teach and told him to take Sufism to the West. In 1910, Inayat Khan went to America—but as a musician, not a Sufi teacher. A number of Americans were drawn to him nonetheless (of whom the most notable was Rabia **Martin**, his first disciple). He left America in 1912 and moved to England (where he married an American) and then went to France (in 1920). He returned to India in 1926, after an absence of 17 years, and died there unexpectedly a few months later. He was 44.*

Hazrat Inayat Khan was the first Sufi teacher to settle in the West and teach Westerners. In fact, he was the only *one for several decades. He taught that Sufism "is not a religion but religion at large—the inner religious experience of every messenger and mystic of the past" (van Beek, 105). There is*

> *one God, the Eternal, the only Being;*
>
> *one Master, the Guiding Spirit of all souls, who constantly leads his followers towards the Light;*
>
> *one Truth, the true knowledge of our being within and without, which is the essence of wisdom;*
>
> *one Path, the annihilation of the false ego in the real. (van Stolk, 104–05)*

Progress along the path is accomplished by transformation of consciousness—from the false to the real or from the limited individual to the unlimited Divine—by means of meditation. Sufi meditation is a way of opening the heart to divine qualities, which culminate in love and require the guidance of a murshid or teacher. This guidance, though formally marked by initiation, in fact consists of attunement between the mureed/*disciple and the* murshid/*teacher, who, because his own ego has been dissolved, radiates divine qualities (van Stolk, 186). It was this teaching of universal Sufism that Hazrat Inayat Khan*

*presented to his Western followers. What happened to it can be followed up in the entry on the **Sufi Movement and the Sufi Order**.*

Works cited in this entry: W. van Beek, *Hazrat Inayat Khan: Master of Life, Modern Sufi Mystic* (Vantage Press, 1983); S. van Stolk, *Memories of a Sufi Sage, Hazrat Inayat Khan* (The Hague: East-West Publications, 1967); in addition, there is E. de Jong-Keesing, *Biography of Inayat Khan* (The Hague: East-West Publications, 1974) (contains much autobiographical material from Inayat Khan himself). Inayat Khan's *Complete Works* were published by Barrie and Rockliff in London over a period of several years starting in the 1950s.

VILAYAT INAYAT KHAN.　　SEE THE **SUFI MOVEMENT AND THE SUFI ORDER**

Not to be confused with his father, Hazrat Inayat Khan—*see above.*

PHRA KHANTIPALO | LAWRENCE MILLS.　　SEE AYYA **KHEMA** (IN FACT, N. 1 BELOW)

AYYA KHEMA | ILSE LEDERMANN

German Theravadin 'nun' and meditation teacher

Ilse Ledermann's early life was remarkably varied and unpredictable. She was born in Berlin in 1923 but the family had to leave Germany in 1938 because they were Jewish. She was evacuated with 200 other children to Scotland, then joined her family in Shanghai, which was subsequently taken by the Japanese. They were kept in a prisoner-of-war camp in appalling conditions and her father died as a result. After the war, she went to America—she is an American citizen—married, and had children (Bancroft, 108).

Yet she was looking for something. She tried Zen but found it too harsh and not sufficiently connected to the teachings of the historical Buddha (Bancroft, 115). She went to India and was taught meditation by the **Mother** (whom she holds in high regard). Finally, in 1964, she moved to Australia, where she established what she calls a biological self-sufficient farm and came across Theravada Buddhism. For the first time, she felt that this was what she needed. She met the English monk, Lawrence Mills/Phra Khantipalo,[1] and

[1] Mills was born near London in 1932 and came across Buddhism when he read a book by Christmas **Humphreys**—I don't know which one—while serving in Egypt in the British Army during World War II. After the war, he took *samanera* ordination from Ven. Saddhatissa in London and a year later went to India, where he learned Pali and worked with the so-called untouchables who, following the example of Dr. Ambedkar, had become Buddhists. He then went to Thailand and took full *bhikkhu* ordination. He remained there for the next eleven years, after which he went to Australia with a Thai monk in order to found a temple or *wat* in Sydney. Some years later, he spent twelve months in Sri Lanka, where he worked at the Buddhist Publication Society for **Nyanaponika** Thera. Finally, he returned to Australia and was the resident teacher at Wat Buddha Dhamma in New South Wales. He has written a number of books, including one, *Banner of the Arahants* (Sri Lanka: Buddhist Publication Inc., ca. 1980), which includes a section on what Westerners should expect if they join the *sangha* in the East. Unfortunately, I have next to no exact dates for any his multifarious activities, which makes it impossible to dovetail him in with the chronology of Western Theravada even though he played a pioneering role in it. (In 1994, he disrobed and got married.)

donated the land and buildings that he turned into the first Theravadin monastery in that country, Wat Buddha Dhamma, in New South Wales in 1978 (Friedman, 365). At some point she practised *vipassana* under the direction of Robert Hover, one of the first Westerners to be taught by U Ba Khin (J. Snelling, *The Buddhist Handbook* [London, 1987], 313). (See the group entry, **vipassana sangha**.)

She was drawn to the monastic life and was ordained as a *dasa sila mata* (see Glossary) in Sri Lanka in 1979, taking the name, Ayya Khema. In 1982, she formed the International Buddhist Women's Centre near Colombo, and, two years later, Parappuduwa Nuns' Island at Dodanduwa (Friedman, 265–66). This is open to women of all nationalities—in 1988, for example, the residents were Australian, Swiss, Sinhalese, German, English and American (Boucher 110)—and is intended to enable them to live the Buddhist life to the full. The minimum stay is for three months and everyone must take the eight precepts of an *anagarika*.[2] Those who wish to become 'nuns'—that is, *dasa sila matas*—must first keep the eight precepts for a year and then, after ordination, "make a five-year commitment to the teacher" (*Spring Wind,* vol. 6, nos. 1, 2, 3, 1986, 120).

To begin with, the teacher was Ayya Khema. But the civil war in Sri Lanka made it very difficult for a community of Western women to continue. Ayya Khema left in 1989—though she has been back since—and moved to Germany where she already had a number of students. When Boucher visited the Island in 1991, all the *dasa sila matas* had left and there were only seven *anagarikas* (S. Boucher, 'The Nuns' Island', *Tricycle,* vol. 1, no. 2, Winter 1991, 20). But the community has continued and is currently under the direction of Sister Dhammadina, a Sinhalese *dasa sila mata* who was ordained at Parappuduwa.

Ayya Khema's aim is to train women so that they can become teachers and "do what I'm doing—propagate the Dhamma" (Boucher, 111). Most of the meditation courses at her centre in Germany are taught by long-term students, who have also established 47 satellite groups. But she travels widely and has students all over Europe as well as in America and Australia.

Her teaching is essentially traditional: if the mind can let go of its attachments, even for a moment, then there is the realization of that inner peace which is always present when the truth of impermanence, suffering and no-self is seen directly. But she emphasizes a particular slant on this teaching: the universe contains infinite possibilities which can only be seen by a mind that is pliable and extended, that is open and full of joy (Friedman, 265–68).

She says that though the restrictions imposed on women in the Theravadin tradition are unjustifiable, and that full nuns' ordination should be reintroduced,[3] it is enlightenment that really matters. And for that, "purity of heart and mind" is needed (Bancroft, 110). This is achieved by meditation, which essentially comes down to application and discipline. She teaches *samatha*—that is, deep levels of concentration—as well as *vipassana;* and in this, she is different from what I call the *vipassana sangha*. (See **vipassana sangha** again.) It may well be that *samatha* practice requires a monastic life to some extent and that *vipassana* is better suited to lay life.

In any event, Ayya Khema speaks from her own experience.

*Ven. **Sangharakshita** also teaches* samatha *and says that 'pure'* vipassana *is too one-sided.*

[2] 1. not to kill any living creature; 2. not to take what is not given; 3. to refrain from all sexual actions; 4. to refrain from false speech; 5. not to use alcohol or drugs; 6. not to eat after noon; 7. not to wear jewelry or use cosmetics or seek out entertainment; 8. not to sleep in a soft or large bed.

[3] She herself took this ordination in the Chinese tradition in Los Angeles in 1987 along with 250 Chinese and twelve Western women.

After having practised meditation for about 25 years . . . [a]nd having read Meister Eckhart and St. Theresa of Avila, I find that they in their Christian approach have realized the same truth in their mystical experiences as I have come to know as meditative realities. So I have come to the conclusion that the religious practitioner of any persuasion eventually comes to the same kind of understanding even though it is couched in the words of a particular faith . . .

And I am sure that unless such people are present in every civilization and in every historical moment, we would be bereft and poorer because they give us a different dimension. It is a dimension which includes transcending the world—not by leaving it, but by seeing it as it really is. (Bancroft, 115–16)

There is something splendid about a German woman in her seventies, uprooted from her own country and having passed through Scotland, China, India and Australia, enunciating these teachings, first, to an international community of women in a Theravadin country and now throughout the world. It is part of the attraction of the development of spiritual psychology in the West that it has this global characteristic.

Primary sources: Ayya Khema, *Being Nobody, Going Nowhere* (London, 1988); [other titles, taken from the Jhana Verlag catalogue, include *Little Dust: Twelve Dhamma Talks on Practice Given on Parappuduwa Nuns Island; Where the Iron Eagle Flies: Buddhism for the West;* and *Jesus Meets the Buddha: Two Voices, One Message;* I do not have the dates but they are available from Buddha Haus (address below)]

Secondary sources: L. Friedman, *Meetings with Remarkable Women: Buddhist Teachers in America* (Boston, 1985); Sandy Boucher, *Turning the Wheel: American Women Creating the New Buddhism* (San Francisco: Harper and Row, 1988); Λ. Bancroft, *Weavers of Wisdom: Women Mystics of the 20th Century* (London, 1989)

Centre: Buddha Haus, Utterbuhl 5, 87466 Oy-Mittelberg 3, Germany

COMPARE:

Other dasa sila matas: Ven. **Dharmapali**

Other women in the Theravadin tradition: Ruth **Denison**, Sharon **Salzberg**, Sister **Uppalavanna**

Other Westerners who have taught in Eastern countries: Ruth Fuller **Sasaki**, Jiyu **Kennett**; **Nyanatiloka** Thera, **Lokanatha** Thera; Lama Anagarika **Govinda**; Sri **Krishna Prem**, the **Mother**, Sri **Mahendranath**, Swami **Abhishiktananda**, some of the **Hare Krishna Gurus**

M.T. KIRBY. SEE **APPENDIX 1**

JEAN KLEIN

French teacher of Advaita Vedanta who attained realization over 30 years ago

Dr. Klein (this is how he is addressed in Britain so I follow the convention) presents himself—though without fanfare—as someone who embodies the teaching that he gives, namely, that one's true nature is 'ultimate awareness' which exists independently of any object of perception, including thoughts. This state is utterly tranquil and self-contained. It has nothing to do with 'names and forms' or, to put it another way, with space and time. It is not surprising, therefore, that it has radical consequences for personal identity. Hence

when someone said that they would like to ask some personal questions, he replied,

> There's no person to answer personal questions. I listen to your question and I listen to the answer. The answer comes out of silence. (*The Ease of Being,* 19)

But certain facts about his life are available. He was born around 1916 and spent his childhood in Brno (in Czechoslovakia), Prague, and Vienna. He came from a cultured background and several members of his family were good musicians. He himself started to learn the violin at the age of seven and has been a talented player all his life. He had what he calls "a strong urge for freedom" as a teenager. He read Dostoyevsky and Nietzsche, and was especially influenced by Gandhi, whose teaching of *ahimsa*/non-violence led him to become a vegetarian when he was 16. He also read people like Coomaraswamy, *Aurobindo,* and *Krishnamurti* (though he found Theosophy itself too sentimental). But the person who had the greatest impact on him was René **Guénon**. Dr. Klein describes his reading of *The Symbolism of the Cross* (which, like all **Guénon**'s books, deals with metaphysics, cosmology, and tradition) as a turning point (*Transmission of the Flame,* iv).

At the same time, he had experiences that confirmed what he had read. He describes a "glimpse of oneness or self-awareness" that occurred when he was 17.

> I was waiting one warm afternoon for a train. The platform was deserted and the landscape sleepy. It was silent. The train was late, and I waited without waiting, very relaxed and free from all thinking. Suddenly a cock crowed and the unusual sound made me aware of my silence. It was not the objective silence I was aware of, as often happens when one is in a quiet place and a sudden sound throws into relief the silence around. No, I was ejected into my own silence. I felt myself in awareness beyond the sound or the silence. Subsequently, this feeling visited me several times. (*Transmission of the Flame,* iii)

He went on to become a doctor and outwardly lived an ordinary life. But there was still "a lack of fulfillment". Then he "felt a certain call to go to India" (ibid., vii) and arrived there around 1950. He says that he was not looking for a guru. In fact, he had no preconceptions of any kind—a central element in his teaching.

> . . . I was left with no reference to anything in my previous experience. In this suspension of evaluation I was catapulted into an openness, a receptivity to everything. (*The Ease of Being,* ix)

But he did meet a teacher. I do not know this man's name. Dr. Klein refers to him simply as 'Pandiji' (*sic*) and says that "I never asked personal questions and I never spoke personally about him. It was a sacred relationship" (*Transmission of the Flame,* xiv).

> My Master always pointed out to me during our life together that all perceptions need an Ultimate Perceiver. The ultimate perceiver can never be the object of perception. Once false identification with the body is understood, we are led to the question 'Who am I?'—and the one who asks is himself the vivid answer. The searcher is himself that which is sought. (*Neither This Nor That I Am,* vi)

Then one morning,

> between deep sleep and awakening, there was a sudden vanishing of all the residues of 'my persons', each having believed themselves hitherto to be a doer, a sufferer, an enjoyer. All this vanished completely, and I was seized in full consciousness by an

all-penetrating light, without inside or outside. This was the awakening in Reality, in the I am . . . I knew myself in the actual happening, not as a concept, but as a being without localisation in time or space. In this non-state there was a freedom, full and objectless joy. (ibid., vii)

This realization is regarded by those who have accepted Dr. Klein as their teacher as 'total illumination'. It therefore makes him quite independent of his own teacher. But he says that he had an "urge to communicate my experience to all other beings" (ibid., viii) and his master suggested that he do so in Europe since he was himself European. In several of his books, it is stated that he "was sent back to . . . teach Vedanta" (for example, *Neither This Nor That I Am,* ix). He started teaching about 1960.

> People came to me. I have never taken myself for a teacher, so I never solicited students. The teacher only appears when asked to teach. (*Transmission of the Flame,* xx)

Advaita is a well-established tradition in India, of course, with a long history and many of the accretions that accumulate around any social organization. But Dr. Klein is not interested in any of this. He acknowledges that he is in a lineage of teachers "in a certain way." "The way of approaching truth belongs to a certain current, but there are no entities in a line . . . It is only accidentally that I call the current of my teaching *Advaita"* (*Transmission of the Flame,* xxi, xxii).

Like all teachings that hold that our real nature is truth, what Dr. Klein says is essentially simple.

> You are primal awareness. Life is only primal awareness. Between two thoughts or two perceptions you are. You know moments in your life when a thought completely disappears into silence, but still you are. (*The Ease of Being,* 13)

This primal awareness is that which underlies all other kinds of awareness.

> At first you may experience silent awareness only after the dissolution of perception, but later you will be in the silence in both the presence and absence of objects. (ibid., 15)

Dr. Klein also calls this ultimate subject, the witness (ibid., 17) and the Self (ibid., 63). And though it may sound very removed from ordinary life, in fact it is the opposite because, no longer caught up in objects and therefore in desire and fear, it is open and free. So its true nature is love.

> But when you take yourself for somebody, all relationships are from object to object, man to woman, mother to son, personality to personality. And there is no communication, no possibility for love. (ibid., 63)

A natural question at this stage is, 'If our true nature is free and loving, where does everything else come from: attachment, desire, fear, the world itself?' Answer:

> The world of names and forms is the result of mental activity. Ignorance (Avidya) begins at the very moment when the ego takes names and forms to be separate realities. (*Be As You Are,* 15)

So how do we avoid identifying with the body and mind and all the objects that mind projects? The first stage is what Dr. Klein calls listening (*Be As You Are,* 3). He defines this as global awareness, which is not limited to any of the five sense (or the mind).

If you let your attention go to your ear, you'll feel that it is constantly grasping. It is the same with the eye, the mind and all your organs. Let the grasping go and you will find your whole body is spontaneously an organ of sensitivity. The ear is merely a channel for this global sensation. It is not an end in itself. What is heard is also felt, seen, smelled and touched. Your five senses, intelligence and imagination are freed and come into play. You feel it as being completely expanded in space, without centre or border. The ego, which is a contraction, can find no hold in this presence, and anxiety, like and dislike dissolve. (*Who Am I?*, 72)

But this is only the first step. It leads on to realization of the Self, "our true nature" which "is reached by a complete elimination of the world of objects" (ibid., 70).[1]

Given that Advaita, as Dr. Klein teaches it, is the direct approach to reality, it cannot make use of any method or technique.

All technique aims to still the mind. But in fact it dulls the mind to fix it on an object. The mind loses its natural alertness and subtleness. It is no longer an open mind . . . Meditation belongs to the unknowable . . .

The point of sitting in meditation is only to find the meditator. The more you look, the more you will be convinced that he cannot be found . . . Fundamentally, you are nothing, but you are not aware of this and project energy in seeking what you are . . . When, by self-inquiry, you find out that the meditator does not exist, all activity becomes pointless and you come to a state of non-attaining, an openness to the unknowable. (*Who Am I?*, 98, 99)

But there is an obvious question here. If there is no meditator and hence no one to find the truth, what is the function of the teacher? Answer: to make this truth manifest.

Ultimately there is no longer a subject who sees nor an object which is seen. There is only oneness. That is what I come here to communicate. (*The Ease of Being,* 1)

And he gives a splendid metaphor for this process.

[1] This "complete elimination of the world of objects" has consequences for cosmology that are quite as radical as they for personal identity (see the very beginning of this entry). Someone once asked him what significance the world can have—in the sense in which Sri *Aurobindo* (and, the questioner might have added, the **Mother**) uses the term *lila,* the divine game of the Lord—if it is seen as unreal. Dr. Klein replied,

He who aims at Ultimate Reality places no accent on the things of the world: it would seem completely futile to him since he has ascertained the unreality of things . . . The world is directed towards the perceiver, it celebrates the ultimate perceiver. He who is established in the Self is in no way interested in theologics and cosmologies. The construction of a cosmological hypothesis, such as the one which looks upon the world as a divine game, is a mental hypothesis due to ignorance, which does not understand the true nature of the Ultimate. (*Be As You Are,* 87)

Elsewhere, Dr. Klein is unequivocal in his rejection of evolution (spiritual, not physical).

This notion of evolution is one of the most characteristic errors of modern thought . . . It is the belief that more can come out of less, that better can be produced by worse. Evolution in the strict meaning of the word, is only an unfolding, a passing from what is implicit to that which is explicit, from what is not manifested to that which is manifested. It produces nothing. It never produces, let alone creates. We cannot rely on it in our search for salvation or liberation. Liberation is not a problem of evolution, for no evolution can lead to liberation, which is the result of discernment only.

We are not concerned with evolving, but we should endlessly put the question "who am I?" to ourselves. (ibid., 17)

This certainly looks to be at odds with what Andrew **Cohen,** for example, says about evolutionary enlightenment. On the other hand, **Cohen** has his own critique of the sort of 'pure' non-dualism that Dr. Klein advocates. (See **Cohen**'s entry for a brief reference.) I mention these disagreements—which are largely implicit and never raucous—simply because they are a significant element in the phenomenon of Western teachers. There are genuine issues here and it is important that it is Westerners who are raising them.

Let's say you are looking at a sculpture from Angkhor Buddhism. The smile on the face of the Angkhor statue is particularly beautiful. When your attitude is receptive, you may be completely taken by this smile . . . [T]he smile captures you and you find yourself smiling. (*The Ease of Being,* 7)

In a similar way, the teacher/guru/master embodies the quality that one is seeking and thus helps to bring it out in the seeker. But since this quality is our true nature, it cannot be given or transmitted from one to another. It can only be pointed to by one who already manifests it.[2]

The striking thing about Dr. Klein is his independence. He teaches Advaita but he rarely uses its technical terms. In fact, he has developed his own vocabulary which consists mainly of the special use of words like 'listening', 'transparency', and so on. Nor does he refer back to the tradition for any kind of confirmation. He occasionally gives a quotation from Gaudapada but nothing more. He does not mention other teachers (such as *Ramana Maharshi* and Nisargadatta Maharaj, to name only two of the best-known). His is not an approach which makes itself more persuasive by making connections of this kind.

Primary sources: Jean Klein, *Be Who You Are* (London, 1978); *Neither This Nor That I Am* (London, 1981); *The Ease of Being* (Durham, North Carolina, 1984); *Who Am I?* (Shaftesbury, Dorset, 19880; *Transmission of the Flame,* (Guernsey, Channel Islands, Great Britain: Third Millennium Publications, 1990)

[I was told after I had written this entry that *Be Who You Are* and *Neither This Nor That I Am* were translations from Dr. Klein's French and are now considered somewhat unclear; in fact, *Neither This Nor That I Am* was re-edited in 1989 into another book, *I Am* (described by Dr. Klein himself as "a clearer pointer to truth"). I would, of course, like to be as clear as possible myself; but I do not have the time to rewrite this entry, especially since I am quoting from works that were originally issued in Dr. Klein's name and are therefore part of his oeuvre even if he thinks that they have now been superseded]

Secondary sources: None

Centre: Jean Klein Foundation, P.O. Box 2111, Santa Barbara, CA 93120, U.S.A.; contact address in Britain: c/o 14 Craigwell Avenue, Radlett, Hertfordshire WD7 7EX, England, U.K.

COMPARE:

Other teachers who say that one's real nature is truth: Andrew **Cohen**, **Jae Jah Noh**, John **Levy**, Barry **Long**, Bhagavan **Nome**, Toni **Packer**, **Shunyata**

Western teachers who have some connection with the Advaita tradition in India: the **Devyashrams**, Leonardo **Maclaren**

Other teachers with a philosophy of art: Lama Anagarika **Govinda**

Harold KLEMP. SEE PAUL **TWITCHELL**

[2] Dr.Klein has extended this idea into a complete philosophy of art: 'true' works of art indicate something beyond themselves.

> All objects point to the Ultimate, and a real work of art actively brings whoever sees or hears it to his real nature, which is beauty. The difference between an ordinary object and a work of art is that the object is passive in its pointing towards the Ultimate whereas the work of art is active. (*Neither This Nor That I Am,* 10; cf. 'A Conversation on Art' in *Who Am I?*)

This is obviously connected with what he says about the smile on the face of the Angkhor statue of the Buddha.

LINDA KLEVNICK and LINDA MURRAY

Canadians appointed as teachers in Korean Zen

Korean Zen, like Buddhism generally, has tended to be male-oriented and male dominated. It is therefore significant that there are women who teach it. Klevnick and Murray are students of Samu Sunim, a Korean who came to America in 1967 and then went on to Canada, where he founded the Zen Lotus Society in 1968. (The Society has since been renamed The Buddhist Society of Compassionate Wisdom.) They took the ten Bodhisattva precepts (see the Glossary) in 1980 and received the names Sujata and Sukha respectively. Three years later, in 1983, they took ordination as Dharma Teachers—the first Westerners under Samu Sunim to do so. They have also served as directors of the Zen Lotus Society's temples in Ann Arbor (Michigan) and Toronto.

According to the Toronto temple's own description, "there is a three to five-year priest and Dharma teacher training program [which] combines traditional Zen training adapted to the North American situation with scripture studies, emphasizing spiritual cultivation in daily life and social concern . . . All training members of the Zen Lotus Society are encouraged to take active part in social issues that concern all" (D. Morreale, *Buddhist America: Centers, Retreats, Practices* [Santa Fe, New Mexico, 1988], 183). This socially concerned, adapted Korean Zen is currently being taught by two North American women.

Primary sources: Linda Sukha Murray, 'Learning Moment to Moment', *Spring Wind,* vol. 6, nos. 1, 2, 3 (*Women in Buddhism*), 1988, 80–87 [*Spring Wind* is the journal of the Society and is edited by Linda Klevnick]

Secondary sources: None

Centre: The Buddhist Society of Compassionate Wisdom, 86 Vaughan Road, Toronto, Ontario M6C 2M1, Canada

COMPARE:

Other teachers in Korean Zen: Don **Gilbert**, Barbara **Rhodes**

Other women teachers in Zen: Jan **Bays**, Joko **Beck**, **Karuna Dharma**, Jiyu **Kennett**, Gesshin **Prabhasa** Dharma, Ruth Fuller **Sasaki**, Irmgard **Schloegl**, Maurine **Stuart**

Other women teachers in other forms of Buddhism: Freda **Bedi**, Ruth **Denison**, Rev. **Dharmapali**, Ayya **Khema**, Sharon **Salzberg**, **Miao Kwang Sudharma**, **Pema Chodron**, Dhyani **Ywahoo**

JACK KORNFIELD. SEE *VIPASSANA SANGHA*

JIDDU KRISHNAMURTI. SEE **APPENDIX 1**

Englishman who lived in India for 40 years and was a guru in the Gaudiya Vaishnava tradition for 20 of them

Cf. *Mira Richard/ the* **Mother***.*

Krishna Prem was born Ronald Nixon in Cheltenham, England, in 1898. His mother was a Christian Scientist who brought him up as a vegetarian (Ashish article, 279). He was a pilot in World War I while still a teenager (ibid.). In 1918 he went up to King's College, Cambridge, to study science but switched to philosophy (or moral science, as it was called then). He was interested in Theosophy and Buddhism (as a branch of Theosophy) and studied Pali. He took a Buddhist initiation while at Cambridge (*Initiation into Yoga,* 17) but I'm not sure what this means. Presumably, it was a Theosophical Buddhist initiation since no initiations in the Eastern forms of Buddhism were available in England around 1920.

Nixon graduated in 1921 and went to India looking for a guru—not something that many Westerners were doing at the time. He took a job as lecturer at Lucknow University, whose vice-chancellor, Dr. G.N. Chakravarti, was also a Theosophist. Dr. Chakravarti had known Madame **Blavatsky** and was a friend of Annie Besant (then president of the Theosophical Society with its headquarters in Madras). Although Nixon was certainly influenced by Dr. Chakravarti, it was Dr. Chakravati's wife, Monica (an unusual name for an Indian woman in the 1920s), who became his guru: he asked her for initiation in 1924. I have no details about this initiation except that it was into Gaudiya Vaishnavism. A year later, Monica Chakravarti "received an overwhelming vision of the unity of being" and wrote a note in Hindi to Nixon: 'What you are seeking, that I have found' (*Initiation into Yoga,* 22).

In 1928, she took renunciate vows and became a *vairagi* (which is simply another name for *sannyasi*) within the Gaudiya *sampradaya*.[1] She took the name 'Sri Yashoda Mai' (sometimes pronounced 'Sri Yashoda Ma'). Shortly afterwards, Ronald Nixon took *vairagi* vows from her and was given the name 'Sri Krishna Prem'. The two of them spent the next two years looking for a place to build a temple, and during this time Krishna Prem begged for food for both of them, while observing "the strictest rules of Hindu orthodoxy" (*Initiation into Yoga,* 23). They eventually came to Mirtola, near Almora and a Sri Radha-Krishna temple was consecrated in 1931. It was the centre of the small Uttara Brindaban ashram (at the end of an 18-mile track), where both of them were to spend the rest of their lives. It was run on strictly traditional lines.

Sri Yashoda Mai died in 1944, having appointed Krishna Prem as her successor. In fact, he had already initiated at least two people while she was still alive and on her instructions: her daughter, Motirani, and an Englishman whom he had known at Cambridge, Bob Alexander, a doctor who had also become a *vairagi* and taken the name, 'Hari Das'. When Krishna Prem took over the ashram in 1944, there were only these three (Krishna Prem himself, Motirani, and Bob Alexander/Hari Das) living there permanently. Two English 'sadhus' and an unmarried Indian woman—an unusual ashram for India. There were, however, other disciples—mostly Indian—who lived nearby in cottages they had built (*Initiation into Yoga,* 23).

Krishna Prem rarely left the ashram but he did visit *Ramana Maharshi* in the south of India in 1948 and he also met *Aurobindo* and the **Mother** at

[1] This *vairagi* status was given on the authority of Acharya Sri Balkrishna Goswami of the Sri Radha Raman temple in Vrindaban (Ashish article, 282), one of the hereditary *goswamis* of the Gaudiya lineage; but the ceremony itself was carried out by her husband.

Pondicherry on the same trip. In the mid-1960s he became ill and slowly got weaker and weaker. He died in 1965, aged 67, and was succeeded by Sri Madhava Ashish, an English disciple who had been living at the ashram since 1946. (And I have been told that Madhava Ashish has designated another Westerner, the Australian, David Beresford/Dev, as *his* successor. In other words, there is a branch of Gaudiya Vaishnavism in India that has an established lineage of Western gurus.)

One of the most interesting things about Sri Krishna Prem is that he fulfilled all the outer functions of a Hindu guru. He spoke Hindi and Bengali fluently and learnt Sanskrit sufficiently well to write commentaries on the *Gita* and the *Katha Upanishad;* the former is described as being "strictly Hindu in its arrangement and inspiration" (Roy, 260).[2] He was also a *pujari* and rigorously followed every detail of temple worship.[3] He carried an image of Krishna with him whenever he left the ashram and he would sing *bhajans* before it at night (Roy, 98). He explained this *bahya-puja* (outer worship) to Dilip Roy:

> . . . Krishna is present in a brass image as He is present in all things. If special methods are adopted (i.e. *prana-pratishtha* and *puja*) He is, not more present, but more easily seen as present . . . Do you not want to see Him in all things, *outer* as well as *inner*? And what is *outer* and what *inner*? The so-called *outer* world is only seen because the inner world is in the heart just as the picture on the screen is only seen because the slide is in the magic lantern . . . There is no inside and no outside but only different states of consciousness and in all of them is Krishna. Why discriminate unfavourably? . . . In the mind worship Him with thought; in what is above the mind worship Him with what is above the mind (if you can) or with silence, and in what is *below* the mind, the so-called outer world, worship Him with what is below the mind, the so-called physical body. To Him we should offer what is His own, on all planes and in all conditions of consciousness. (Roy, 183–84)

It is hardly surprising that such a thorough-going Vaishnava viewpoint left little room for modern Western ideas. In his introduction to *The Yoga of the Bhagavat Gita,* he pours scorn on academic attempts to stratify the *Gita* and to link it with various strands of Indian philosophy.

> Let me say at one that I care nothing at all for these learned pronouncements. To anyone who has eyes to see, the Gita is based on direct knowledge of Reality, and it is of little moment who wrote it or to what school he was outwardly affiliated. Those who know Reality belong to a Race apart, a Race that never dies, as Hermes Trismegistus puts it, and neither they nor those who seek to be born into that Race concern themselves with the flummeries of sects and schools.
>
> It is by such a seeker and for such seekers that this book has been written. (*Yoga of the Bhagavat Gita,* xiv)

[2] In the late thirties, Krishna Prem wrote quite extensively. His commentary on the *Gita*, which included a translation of the text, first appeared as a series of articles in *The Aryan Path,* the periodical of the Bombay Theosophical Lodge, and were reprinted in book form in 1938 under the title *The Yoga of the Bhagavat Gita*. This was the first time such a book had been written by a Westerner who both knew Sanskrit and was also a Hindu. About the same time, he wrote an extensive commentary on the *Stanzas of Dzyan* (the *fons et origo* of **Blavatsky**'s *Secret Doctrine*) but did not publish it. He revised it in the mid-1950s with the help of Alexander Phipps/Sri Madhava Ashish and it was finally published in London over 30 years later, after his death, in two volumes (*Man: the Measure of All Things* and *Man: Son of Man,* 1969 and 1970). It is surely very odd that a committed Gaudiya Vaishnava should make use of such an unorthodox source. It would have been incomprehensible, for example, to Shrila *Prabhupada,* another Gaudiya Vaishnava, who used the *Bhagavata Purana* extensively—a text that Krishna Prem never refers to, as far as I know.

[3] He was once asked why he was quite so rigorous. Because, he replied, "this happens to be the path laid down by those who have gone before me, and reached the goal. Who am I, just entering the path, to say, 'I will do this and not that, accept this discipline but not that?' I accept the whole" (Sen, 103).

All of Krishna Prem's essential teachings follow from this passage: there is one Reality, which is directly perceivable and which can be uncovered by the one true *yoga;* this *yoga* is best learned from a guru—that is, one who has seen Reality directly; such teachers can arise in any tradition (Krishna Prem had a high opinion of Plotinus, **Blavatsky** and **Gurdjieff**, to name but three). We also find another element in his teachings: perception of Reality purifies the mind and enables it to see what might be called the occult structure of the world.

This is, of course, a spiritual psychology. And though it is interesting in itself, the real significance of it is that it was taught by an Englishman who was a Vaishnava guru. Yet he had his own very decided views. He favoured the 'lonely heights' over the 'populous valleys' (*Yoga of the Kathopanishad,* 158), and generally espoused what might be called the ideal of a spiritual elite.

Cf. **Nanavira**—*another Cambridge graduate.*

> . . . spiritual insight is inevitably esoteric and aristocratic, while the councils held to determine orthodoxy are democratic and popular. (*Initiation into Yoga,* 118)

He also had some reservations about the social relevance of the spiritual life; it is evident that he favours Ramakrishna's "explicit command to Vivekananda: 'First see God and then open your dispensaries'" (Roy, 122).

Cf. the experience that **Shunyata** *had in* Ramana's *presence.*

And for Krishna Prem, 'seeing God' had a very particular sense. When he met *Ramana Maharshi* in 1948, no words were exchanged, but, says Krishna Prem, "the Maharshi suddenly gave me a lightning glance and smiled" (Roy, 105). As Krishna Prem meditated, every cell in his body was filled with bliss. He then asked the question (inwardly), 'Who are you?' and directed it towards *Ramana.* When he opened his eyes, he found that the Maharshi had vanished and his couch was empty—indicating, as Krishna Prem says, that *Ramana* was beyond *nama-rupa* (name and form), the One beyond all *maya* (ibid., 106).

Ramana is reported as saying that Krishna Prem was "a rare combination of a *jnani* [one who knows truth] and a *bhakta* [one who loves God]" (Roy, viii, 107). This nicely fits the two sides of Krishna Prem's own teaching: that Krishna is "the Undying *Atman,* the Stainless Eternal Being that lies behind all change" (*Yoga of the Bhagavat Gita,* 59) but also the embodiment of love.

> [T]here is nothing but Him. The curves of His body are worth more than all the Infinites and Eternals and Absolutes. All the worlds are within the pores of His skin, yet there He remains, no shadowy cosmic figure, but the eternal cowherd, in yellow dhoti, peacock feathers, maddening the soul with a melody from a bamboo flute. (Roy, 143)

It is therefore not surprising that this Cambridge graduate, who, like Shrila *Prabhupada,* the founder of the Hare Krishna movement, believed that Krishna did actually deliver the *Gita* to Arjuna on a real Kurukshetra (Roy, 185), would sometimes dance until he fell senseless (*Initiation into Yoga,* 12). He also, on one occasion, had his own ecstatic vision after prostrating himself before an image of Krishna. He lost outer consciousness and saw a vast ocean of liquid light. Time stood still,

> till a breath of Love started a ripple in the hushed ocean of Light, when countless white lotuses erupted on the blue waves, one after another, and on each flower stood a lovely Krishna with Radha—She smiling and He playing His magic flute. (Roy, 104)

Krishna Prem connected these visionary experiences with an age-old Indian teaching concerning the function of 'higher' or pure mind (*shuddha manas*) or *buddhi,* which acts as a kind of lens, focusing inner knowledge and

transmitting it to the lower mind, the mind that deals with the world of forms (though this doesn't just mean physical forms or objects).

> Clinging . . . to Krishna, the mind becomes irradiated by the Light of the One *Atman* shining serenely through the *buddhi* overhead. The effect of this irradiation is that the intellectual knowledge of the mind is vivified and rendered luminously certain by the *buddhi's* direct intuition . . . No longer are things seen as separate units but as the interlinked and shining web of a vast splendid pattern . . . a Cosmic Ideation in which the Divine archetypes of past, present and future exist in one vast interpenetrative whole . . . All that is in the world is what it is because of the reflection of some portion of that glorious Being. (*Yoga of the Bhagavat Gita,* 94–95)

> When we can learn to focus our being in the true Centre of the *Higher Manas,* the world of perception down here undergoes a great expansion. A great range of experience previously hidden from us now becomes manifest and now only is it seen that the Below reflects the Above in perfect correspondence. This is the gaining of the Axiom . . .
>
> He who has known the Axiom has the Key to all transformations whatsoever. Should he desire to do so, he can transmute lead into gold with as much ease as the common test-tube chemist can produce copper out of copper sulphate . . .
>
> Such a one is indeed a *Siddha,* an Adept, Dragon of Wisdom, Master of Immortality, Lord of the Double-Axe. (*Yoga of the Kathopanishad,* 182–83)

*Another English guru in India, **Mahendranath,** also uses Hermetic and alchemical language.*

I think it is fair to say that Krishna Prem himself had this higher vision (though I don't think he ever turned lead into gold). This is certainly what his disciples think. Alexander Phipps/Sri Madhava Ashish says that "there was a range of perceptions of a different order which he had and which I had not" (*Initiation into Yoga,* 25). And it is worth remarking that *Aurobindo* said that Krishna Prem had "Pashyanti Buddhi, the seeing Intelligence" (Roy, 128).[4]

According to Krishna Prem, the function of the guru is to transmit the realization of Infinite Being:

> . . . just as life springs only from other lives, so the flame of wisdom can be lit only by contact with those in whose heart it already shines. The disciple must resort to the feet of a wise teacher, one who is an embodiment of that Teacher Who is already in his heart, the Eternal Wisdom . . . (*Yoga of the Bhagavat Gita,* 34)

And he said of his own teacher, Sri Yashoda Mai,

> my Guru will never leave me whatever I do . . . Never, never will She leave my side nor cease to guide my steps until I stand in that eternal Braja where She stands now. (Roy, 56) [Braja is the land of Krishna]

Moreover, a guru can always be found for true teachers belong to "a Race that never dies . . . [and which] is constantly renewed throughout the ages as the torch of wisdom passes from hand to hand" (*Yoga of the Bhagavat Gita,* 35).

And the really crucial point, of course, is that he himself has received this torch of wisdom—and passed it on to others. Gertrude Emerson Sen, in her *in memoriam,* remarks how, though 'foreign' to begin with, he drew so many Indians: the well-to-do, the well-born, the well-educated, as well as those with no special label.

[4] This Pashyanti Buddhi led to some statements which are somewhat startling to the modern Western mind: that the gods are "the embodiments of that one Living Power which wields the universe in Its unceasing play" (*Yoga of the Bhagavat Gita,* 64); that the river Ganges/Ganga is not just a stream of water but "an embodied Spirit born from the feet of Narayana, the dweller in the waters" (*Initiation into Yoga,* 100); that eclipses "are connected with a Dragon" (*Yoga of the Kathopanishad,* 144). All of these are part of classic, middle-of-the-road Hinduism.

Having imbibed the spiritual teaching of the great rsis and saints, handed down in this country for thousands of years, and having *lived the life*, he has awakened in them the awareness of their own spiritual heritage. That he chose to renounce the West for India touched their hearts, but they have honoured, respected and loved him because he dedicated his life to their ancient ideal of realizing his oneness with the Eternal and the Imperishable. They have lighted their torches at his flame. (Sen, 107)

*Cf. others who have been criticized for the same reason: Philip **Kapleau**, Srila **Bhaktipada**, Frithjof **Schuon** (all in different traditions).*

Towards the end of his life he became less bound by the orthodoxies of his *sampradaya* (*Man: the Measure of All Things,* 10) so that he was criticized by some for changing what his guru had established. But, says Madhava Ashish, "whether she spoke outwardly or within his heart, her voice determined all his actions, and he listened to none other" (Ashish article, 283). This is really the model that Krishna Prem followed: the true disciple had become the true guru.

Primary sources: Sri Krishna Prem, *The Yoga of the Bhagavat Gita* (London, 1938); *The Yoga of the Kathopanishad* (London, 1955); *Initiation into Yoga* (London, 1976); Sri Krishna Prem and Sri Madhava Ashish, *Man: the Measure of All Things: In the Stanzas of Dzyan* (London, 1969); Sri Madhava Ashish, *Man: Son of Man: In the Stanzas of Dzyan* (London, 1970)

Secondary sources: Sri Madhava Ashish, 'Sri Sri Krishna Prem Vairagi' [my xerox copy of this article seems to indicate that it is taken from something called *Kalyana-kalpataru,* vol. 29, 279-83, but I have no further details]; Dilip Kumar Roy, *Yogi Sri Krishna Prem* (Bombay: Bharatiya Vidya Bhavan, 1975); Gertrude Emerson Sen, 'Shri-Krishna-Prem', *The Aryan Path,* March 1966, 101–07

Centre: Uttara Brindaban, P.O. Mirtola, via Panuanaula, district Almora, Uttar Pradesh 263623, India

COMPARE:

Other Western Hindu gurus in India: Swami **Abhishiktananda**, Sri **Mahendranath**, the **Mother**, Swami **Jayapataka** (for whom, see the **Hare Krishna Gurus**)

Other Western Hindu gurus: both **Abhayanandas**, Sister **Devamata**, the **Hare Krishna Gurus**, **Rajarsi Janakananda**, Sri **Daya Mata**, both **Kriyanandas** (and other *kriya yoga* teachers in varying degrees of 'Hinduness'), the **Devyashrams**, Swami **Radha**, **Rudi**, **Shankar Das**, Guru **Subramuniya**, Father **Satchakrananda Bodhisattvaguru**; Abbot Bishop George **Burke**/Swami Nirmalananda

Other Westerners who have taught in their tradition in the East: Ruth Fuller **Sasaki**, Jiyu **Kennett**, **Nyanatiloka** Thera, **Lokanatha** Thera, Ayya **Khema**, Ajahn **Sumedho**, Ven. **Sangharakshita**, Lama Anagarika **Govinda**

Other 'visionaries': Jiyu **Kennett**, Samuel **Lewis**, Frithjof **Schuon**, **Rudi**, Guru **Subramuniya**, Joya **Santanya**

Goswami KRIYANANDA | Melvin Higgins

American 'grand-disciple' of Yogananda who teaches kriya yoga

Goswami Kriyananda (not to be confused with the other **Kriyananda**, Donald Walters, who is also a *kriya yoga* teacher) was born around 1930 and began studying with Shelly Trimmer/Shellyji[1] around 1950. According to a letter I received from the Temple of Kriya Yoga in 1987, Goswami Kriyananda has

[1] I know very little about this man. He was born around 1917 and apparently came across *Yogananda* during World War II. He spent about a year with him at the SRF headquarters in Los Angeles but then left. And though the two kept in touch by letter, they never met again. Although he has retained great affection and respect for *Yogananda,* he also acknowledges his weaknesses. "He loved to order women about—after all he was a Hindu

been "guiding souls along the pathway to enlightenment for over 40 years." Neither of these dates is very precise but it does look as if he began teaching *kriya yoga* when he was very young—and when *Yogananda,* who died in 1952, was still alive. A flier from the Temple of Kriya Yoga says: "[Goswami] Kriyananda continues the teachings of his guru's guru, Paramahansa Yogananda, by carrying the lineage of Babaji into the New Age." Like his master, Shellyji, Goswami Kriyananda "investigates the akashic records to uncover the mysteries of the past", according to a tape entitled *The Mysteries of Ancient Egypt.* His *magnum opus* is *The Spiritual Science of Kriya Yoga* (334 very large pages). It appears to be a slightly expanded version of Patanjali's *Yoga Sutras* (which is the basis of *ashtanga yoga,* or the *yoga* of eight stages, and was composed in Sanskrit in about the fourth century A.C.). There is a reference to Patanjali's 'Kriya Yoga Sutras' on p. 266; and on p. 252, it is said that Patanjali calls *kriya yoga* the *yoga* of mind action "in his Yoga Sutras." All eight stages of Patanjali's *yoga* system are covered in detail, using the traditional Sanskrit terms—but with considerable additions on the *chakras, mudras,* and so on.

Although Kriyananda does mention the *kriya yoga* lineage (Babaji ➔ Lahiri Mahasya ➔ Sri Yukteswar ➔ Yogananda ➔ Shellyji ➔ himself) in the Dedication of the book, he never refers to *Yogananda* again. (According to someone who knew both him and Shellyji, neither of them ever recommended *Autobiography of a Yogi* to their students.) It appears, then, that Kriyananda's entire approach is essentially independent of Yogananda; and it is certainly independent of the Self-Realization Fellowship in Los Angeles (presently under the direction of Sri **Daya Mata**). There are thus two parallel lines of *kriya yoga* transmission in the West (just 2,000 miles apart), with no contact and really no acknowledgement of the other's existence. This does not happen very often in the phenomenon I am describing. Usually, groups with a common ancestry either co-operate in some way or are critical of each other in varying degrees ranging from the mild to the vitriolic. A mutual stand-off like this is rare.

(*See* Lineage Tree 2)

Primary sources: Goswami Kriyananda, *The Spiritual Science of Kriya Yoga* (Chicago: The Temple of Kriya Yoga, 1985, 2nd ed.)

Secondary sources: None

Centre: Temple of Kriya Yoga, 2414 N. Kedzie, Chicago, IL 60647, U.S.A.

COMPARE:

Other teachers of kriya yoga: **Rajarsi Janakananda**, Sri **Daya Mata**, Swami **Kriyananda**/Donald Walters, Roy Eugene **Davis**, Leonard **Orr**

. . . He had a violent temper and was a little bit arrogant" (*An Evening with Shellyji,* a taped talk). More to the point, Shellyji denies that *Yogananda* had attained God-consciousness, which Shellyji himself defines as the state in which all things exist simultaneously. "I've never met anyone who had it—Yogananda didn't" (ibid.). A Temple of Kriya Yoga flier describes him as "an enlightened Master of Kriya Yoga." As far as I can tell, he began initiating people into *kriya yoga* in about 1950, when *Yogananda* was still alive, and taught until his death (around 1988 or so—I have no precise date).

Shellyji had no centre or organization, never wrote a book, and is more or less unknown. In short, he appears to have lacked spiritual ambition. This is certainly a virtue—yet traditions could not exist without an external form of some kind. Individuals who appear and disappear like shooting stars have a certain splendour. They make us gasp and say, 'Look at that!' But then they are gone. This is not a criticism, because that is their nature. But if they were the only sort of star that existed, navigation would be impossible. The question of whether fixed stars are more 'real' than shooting stars is probably a false conundrum. But what is undeniable is that they last longer.

American who became a
disciple of Paramahansa
Yogananda as a young
man but has since
established his own
spiritual community

Kriyananda (not to be confused with Goswami **Kriyananda**/Melvin Higgins) is spiritual leader of Ananda World Brotherhood Village (originally called 'Ananda Co-operative Village'), a community in the Sierra mountains of California, which he expressly set up as a result of *Yogananda*'s guidance. Like Roy Eugene **Davis**, the young Donald Walters found out about *Yogananda* from reading *Autobiography of a Yogi*. He immediately left New York and went to Los Angeles. This was in 1948, just one year before **Davis** did more or less the same thing. He was 22.

Walters had been influenced by Emerson and Thoreau (*The Path*, 69, 73) and had read Arnold's translation of the *Bhagavad Gita*. But to all intents and purposes he came to *Yogananda* as an archetypal seeker: looking for a map that would make sense of his life, as he himself puts it.

> *Autobiography of a Yogi* is the greatest book I have ever read . . . What it gave me was the conviction that in Yogananda I had found my guru, my spiritual teacher for all time to come. A few days earlier I hadn't even known this strange word, *guru*. I hadn't known anything about yoga, or reincarnation, or karma, or almost any of the basic precepts of Indian philosophy. Now, incredibly, I felt such deep, utter trust in another human being that, ignorant though I was of his philosophy, I was willing to follow him to the end of life. And while I was yet to meet him, I felt that he was the truest friend I had ever known. (*The Path*, 163)

Later, when Walters asked *Yogananda* for initiation, *Yogananda* said to him (as he had said to **Davis** a year earlier), 'I give you my unconditional love. Will you give me yours?' Walters said 'Yes', but hesitated when *Yogananda* went on to ask for his unconditional obedience.

> Desperate though my desire was to be accepted by him, I wanted to be utterly honest. "Suppose," I asked, "sometime, I think you're wrong?"
> "I will never ask anything of you," he replied solemnly, "that God does not tell me to ask". (*The Path*, 174)

Walters accepted this answer and was himself accepted by *Yogananda*.

> He made me repeat, in the name of God, Jesus Christ, and our line of gurus, the vows of discipleship and of renunciation. Next he placed the forefinger of his right hand on my chest, over the heart. For at least two minutes his arm vibrated, almost violently. Incredibly, from that moment onward, my consciousness, in some all-penetrating manner, was transformed. (*The Path*, 175)

Not long afterwards, Walters received initiation into *kriya yoga*.

> . . . Master told us all to sit upright in meditative posture. "I am sending the divine light through your brain, baptizing you," he said from where he sat across the room. I felt immediately blessed; a divine current radiated through my brain from the Christ Center [between the eyebrows]. (*The Path*, 240)

However, he practised under *Yogananda*'s direct guidance for only a short time—because *Yogananda* died in 1952. But he continued under *Yogananda*'s American 'successors', **Rajarsi Janakananda** and Sri **Daya Mata**. He took *sannyasa* vows from Sri **Daya Mata** in 1955, and was given the name 'Swami Kriyananda' (*The Path*, 567). In 1960, he was elected first vice-president of the Self-Realization Fellowship/SRF. Yet within two years, he had been ejected from SRF after a long-running battle with one of *Yogananda*'s senior disciples, Tara Mata (who was second vice-president at the time). Details of this episode

are given in *A Place Called Ananda (Part One)*. What it comes down to is that Kriyananda was convinced that *Yogananda* wanted the work to expand, while his adversaries—and this is not too strong a word (see for example, *A Place Called Ananda,* Chapter 14)—thought that SRF should consolidate. Both sides were certain that they were being true to *Yogananda*'s wishes and instructions and hence "each of us came to believe that the other had betrayed the goal" (*A Place Called Ananda,* 65). This last remark is actually directed at Sri **Daya Mata**, who, according to Kriyananda, "views Ananda, and me especially, as a threat to Master's very mission" (ibid., 222). This is highly-charged stuff and Kriyananda is still clearly affected by it. Yet he also says:

> I know now that Master [= Yogananda] wanted me out of the work for my own welfare, perhaps also for the work's, and because there were things he had for me to do that I could not have done, had I not been on my own. (*The Path,* 582)

It took Kriyananda six years to find out what it was that *Yogananda* wanted him to do, and he interprets the events during this time, which appear from the outside to be somewhat haphazard, as in reality linked by *Yogananda*'s inner guidance. In effect, Kriyananda regards himself as an instrument in Yogananda's hands. This is how he saw it when he was part of SRF and he still believes it to be so 35 years after being asked to leave.

In 1963, he was given what might be called a visionary instruction to write a book, subsequently called *Crises of Modern Thought.*

> First came an ordinary dream, in which I was discussing my proposed opus with a few friends. "To write a book of this sort," I explained, "one would have to be willing for every bone in his body to be broken!" Then with deep fervor, I cried, "And I am willing!" The moment I said this, a great surge of energy shot up my spine. I was thrown first into wakefulness, and thence into super-consciousness. An open book, which I recognized as the book I intended to write, appeared before me. (*The Path,* 593)

He has continued to write books ever since (120 in 13 languages [*A Place Called Ananda,* 229])—and even recorded albums of songs. His first, *Say 'YES' to Life!,* was released in 1965 and he has since composed over 300 pieces of music (including an oratorio).

In 1967, Kriyananda formed the Yoga Fellowship, which bought some land in the Sierra Nevada mountains of California. The original intention was to create a place of retreat but it has developed into what is now the Ananda World Brotherhood Village, with Kriyananda as its spiritual director. Ananda has grown from this original purchase of 68 acres to about 900 acres. The current population is 400 or so, of which 100 are children who attend the community's school. Subjects taught there include yoga postures, Vedic philosophy and the *Bhagavad Gita* in addition to the usual school subjects and the Bible (Nordquist, 50). The underlying aim is to try to inculcate what Kriyananda calls the essential 'arts of living': how to concentrate, how to value kindness and co-operation, how to overcome fear, anger and jealousy, how to meditate and develop the inner life, and how to appreciate the higher values of life (Nordquist, 49).

'Higher values of life' may sound rather vague but in fact it is a blanket term for the spiritual ideals that Ananda was created to establish. These ideals go back to *Yogananda*—as Kriyananda interprets him. In effect, Kriyananda says that communities like Ananda are the culmination of *Yogananda*'s teaching.

In the overall plan for his work, Paramahansa Yogananda saw individual students first receiving the SRF lessons, and practicing Kriya Yoga in their own homes; then, in time, forming spiritual centers where they could meet once or twice weekly for group study and meditation. In areas where there was enough interest to warrant it, he wanted SRF churches, perhaps with full- or part-time ministers. And where there were enough sincere devotees to justify it, his dream was that they would buy land and live together, serving God, and sharing the spiritual life together on a full-time basis. (*The Path*, 324)

Kriyananda mentions other communities, including **Stephen**'s *Farm (*The Path, *609).*

Such 'world-brotherhood colonies' or spiritual cooperative communities were envisaged by *Yogananda* to be "not monasteries, merely, but places where people in every stage of life could devote themselves to living the divine life" (*The Path*, 323). The first edition of *Autobiography of a Yogi* ended with *Yogananda*'s declaration concerning the importance of such colonies:

> In these beautiful surroundings I have started a miniature world colony. Brotherhood is an ideal better understood by example than precept! A small harmonious group may inspire other ideal communities over the earth.

This passage is taken from the first edition of the book. The third edition, supervised by Yogananda himself, omitted it but referred to "an urgent need on this war-torn earth [for] the founding, on a spiritual basis, of numerous world-brotherhood colonies" (p. 480). But even this reference was deleted in

THE REWRITING OF *AUTOBIOGRAPHY OF A YOGI* (ii)
(see Srimati **Kamala**'s entry for another significant change in this book)

Since changing the words of a teacher is an important matter, I give two other instances here—both of them furnished by Ananda (which has produced dozens of examples, most of which I find fairly minor).

| Original edition of *Autobiography of a Yogi* (1946) | 1981 edition |
| --- | --- |
| The actual technique [of Kriya Yoga] must be learned from a Kriyaban or Kriya Yogi; here a broad reference must suffice (p. 243 of original edition; p. 231 of Ananda's reprint of it). | The actual technique [of Kriya Yoga] should be learned from an authorized Kriyaban (Kriya Yogi) of Self-Realization Fellowship (Yogoda Satsanga Society of India). Here a broad reference must suffice (p. 223). |
| To this educational institution [SRF] go all public donations as well as the revenue from the sale of my books, magazine, written courses, class tuition, and every other source of income (p. 366 of original edition; p. 351 of Ananda's reprint of it). | To SRF I donated all my possessions, including the rights in all my writings. Like most other religious and educational institutions, SRF is supported by endowments and donations from its members and the public (p. 355). |

Ananda argues that these changes have been made to bolster up two of SRF's claims: that it alone can decide who is or is not an authorized teacher of *kriya yoga*; and that it has the copyright on all of *Yogananda*'s writings.

SRF vigorously denies that it has interfered with *Yogananda*'s *intentions* in any way. All changes to *Autobiography of a Yogi*, it says, were either made by *Yogananda* himself (in the second and third editions—so that would not apply in these two instances); or approved by him but made by SRF editors after his death; or are simply additional notes for clarification or to provide up-to-date information.

I do not want to go into this controversy—but people should know that it exists. And it has to be pointed out, I think, that the present edition does read as if *Yogananda* had written the words in the right-hand column when in fact he did not.

subsequent editions. Kriyananda sees this as evidence that SRF is attempting to interpret *Yogananda*'s teaching in their own way (see the box opposite, and other comments by Kriyananda, below).

According to Kriyananda,

> It has been my lot to found such a 'world-brotherhood colony', the first of what Yogananda predicted would someday be thousands of such communities the world over. (*The Path*, 5)

The implicit claim here, I think, is that Kriyananda has truly understood *Yogananda*'s wishes and is carrying them out—unlike the 'official' SRF which has got stuck in the 'mere monastery' stage that had evolved at the time of *Yogananda*'s death. And indeed, Ananda has branched out into other colonies: in Palo Alto and Cordova (both in California); Portland, Oregon; Seattle; and near Assisi in Italy. About 400 people live in these centres (in addition to the 400 at Ananda). Kriyananda has ordained about 100 ministers since 1968; and at the present time, five of them are authorized to give *kriya yoga* initiations.

Yogananda's predictions were not restricted to the founding of world-brotherhood colonies, however. According to Kriyananda (in *The Road Ahead: World Prophecies of the Great Master, Yogananda*), he also gave a stunning list of future disasters: world-wide economic collapse brought about by communism (which he described as "an instrument of satanic power"); natural cataclysms (such as a shifting of the earth's axis, the sinking of large land masses, and the rising of others); and two more world wars (one, "probably in the 1970s", which will bring India and Germany under communist rule; and one at the end of the century, when Europe will be devastated). America will emerge victorious from this Fourth World War, and "a new world will emerge, phoenix-like, from the ashes." This new world will be based on 'spiritual socialism', with a world brotherhood. Spiritual communities like Ananda are the seed of this new order (Nordquist, 70–71).

So Ananda is not just a social experiment—it is an instrument of spiritual growth. Its members liken it to an Indian village of Vedic times (Nordquist, 46) and its activities are extensive: a mixture of meditation, work (building, organic gardening, a number of businesses) and service (such as a health clinic and programmes for the elderly). The work is referred to as *karma yoga*. And because Ananda is an expression of *Yogananda*'s wishes, it is divinely supported (which is exactly what SRF says, of course).[1] Kriyananda says,

*Cf. **Bhaktipada**'s New Vrindaban.*

> From the nucleus we have here the message of Self-Realization Fellowship[2] cannot but spread to thousands—nay, to millions. The world needs this work—needs it desperately . . . Men need Kriya Yoga, and for reasons we cannot fathom Divine Mother has seen fit to choose us, out of millions, to spread the news of its liberating power. (Quoted in Nordquist, 68)

Even so, it is *Yogananda,* not Kriyananda, who is unequivocally the guru of Ananda village. To seek to join Ananda is *ipso facto* to become a disciple of *Yogananda* and therefore to practise his teaching. Indeed, many members of

[1] This is ambiguous. What I mean is that both Ananda and SRF think that they are divinely supported. Kriyananda and SRF noticed this unclarity but their reactions were somewhat different. SRF: "This could be misread as meaning that SRF says Ananda is divinely supported." Kriyananda: "I hope we are all divinely supported."

[2] Kriyananda's secretary asked that the word 'Fellowship' be removed because it implied support for the organization in Los Angeles rather than *Yogananda*'s *teaching*. This request is surely connected with the dispute between SRF and Ananda (see next note).

the community say that *Autobiography of a Yogi* has had more influence on them than any of Swami Kriyananda's writings (Nordquist, 98).

What, then, is Kriyananda's spiritual function? He is an 'interpreter' and a 'guide', not a Self-Realized *yogi* (Nordquist, 66). This may sound rather a weak claim—and perhaps, in comparison with James Lynn/**Rajarsi Janakananda** and Faye Wright/Sri **Daya Mata**, who *are* said to be God-realized, it is. But I do not think this is how the people at Ananda see it. Perhaps it would be more accurate to say that Kriyananda is seen as "the instrument for Yogananda's direction" (*Ananda Co-operative Village Membership Guidelines of 1976,* quoted in Nordquist, 46).

In effect, this means that what he does is connected with *Yogananda* and therefore has specific spiritual value. It is his *yoga* lessons, for example, that are recommended rather than those that come from the SRF headquarters.[3] But perhaps most significantly of all, he founded a monastic order, the Friends of God, in 1971. It was not an extension of the Giri Order, to which *Yogananda* himself belonged (as do all those whom he initiated as *sannyasins,* including Kriyananda). Kriyananda says that he did not want to be tied to an Indian institution, however excellent, and that the Friends of God was entirely independent. As far as I know, he is the only Westerner who has founded an order of this kind.

But in fact it only lasted for seven or eight years; all of its members eventually got married. Most of them felt as of they had failed in some way even though Kriyananda assured them that going back to lay life was no disgrace. In the end, he also gave up his vows and got married in order to show them that he meant what he said, but he has since taken up his monastic vows again.[4]

Nordquist reports one member of Ananda as saying, "I like to serve Kriyananda because he is doing what Master [= Yogananda] wants him to do. So serving Kriyananda is a way of serving Master" (Nordquist, 149). Another member (a nun of the Friends of God) said that she had a lot of faith in Kriyananda and trusted him. This is reminiscent of Kriyananda's own statement about *Yogananda,* quoted above: that he had such deep trust that he would follow him to the end of his life. Now it appears that Swami Kriyananda is being given the same kind of trust in his turn.

So while it would be misleading to say that he is a guru, he is certainly regarded as a true disciple of his master—which is the next best thing. He himself says that "my books and recordings have sold well over a million in number and brought Master's teachings to, literally, millions of people" (*A Place Called Ananda,* 229). And on top of that there is the community: a world

[3] To begin with, the 'official' SRF course was recommended to everyone. But relations between the two groups became rather strained in 1990 when Ananda reincorporated itself as the Self-Realization Church and SRF took it to court, claiming that Ananda had no right to use the name 'Self-Realization'. Members of Ananda are free to use SRF material should they wish to. But after a court action lasting several years—and it is still continuing— not many of them do. More generally, Kriyananda holds that SRF, under the direction of Sri **Daya Mata**, has fundamentally misunderstood what *Yogananda* intended; that it has become a suppressive institution which has convinced itself that it has the right, even a duty, to prevent other initiates of *Yogananda* from teaching *kriya yoga;* in short, that it thinks it owns *Yogananda* (Kriyananda, *An Open Letter to the Board of Directors, Self-Realization Fellowship,* 1992, no provenance but it can be obtained from Ananda).

[4] I only found this out after practically finishing this book. He is therefore sometimes referred to as 'Sri Kriyananda' (his title during the period when he reverted to lay life) and sometimes as 'Swami Kriyananda'. Changing 'Sri Kriyananda' to 'Swami Kriyananda' throughout 650 pages would have driven the typesetter mad, I think.

brotherhood colony that is based on *Yogananda*'s teaching and which will continue after Kriyananda's death. Other communities in this book could also say that they are independent of the person who founded them. But few are as well-established as Ananda.

(*See* Lineage Tree 2)

Primary sources: Swami Kriyananda, *The Path: Autobiography of a Western Yogi,* (Nevada City, California: Ananda Publications, 1977); [a second edition, entitled *The Path: One Man's Quest on the Only Path There Is,* was issued in 1996 by Crystal Clarity Publications, the new name of Ananda's publishing arm]; *A Place Called Ananda (Part One)* (Crystal Clarity, 1996); there are over 30 other titles, many of which have been changed in later editions—for example, *How to Spiritualize Your Marriage* is now called *Expansive Marriage.* Full details can be had from Crystal Clarity, c/o Ananda in Nevada City.]

Secondary sources: T. Nordquist, *Ananda Co-operative Village* (Uppsala, Sweden, 1978)

Centre: Ananda, 14618 Tyler Foote Road, Nevada City, CA 95959, U.S.A.; Ananda Europa, Casella Postale 48, I-06088 Santa Maria degli Angeli (PG), Italy

COMPARE:

Other Western teachers who were disciples of Yogananda: **Rajarsi Janakananda**, Sri **Daya Mata**, Roy Eugene **Davis**

Other teachers who have founded Utopian communities: Shrila **Bhaktipada**, the **Mother**

Other communities that are intended to survive their founders: the Free Daist Avabhasan Communion (Master **Da**), the Saiva Siddhanta Church (Guru **Subramuniya**), the Chithurst sangha (Ajahn **Sumedho**)

Other Westerners who have founded spiritual orders in some sense: **Oom the Omnipotent**, Swami **Abhishiktananda**, Shrila **Bhaktipada**, Ven. **Sangharakshita**, Rev. **Dharmapali**, Jiyu **Kennett**, Frithjof **Schuon**

Other teachers who have started schools: the **Mother**, Shrila **Bhaktipada**, Jetsunma **Ahkon Lhamo**

Other teachers who have produced their own music: Swami **Turiyasangitananda**, Lee **Lozowick**

Roshi Jakusho KWONG

American Chinese who teaches in the Soto Zen tradition

Bill Kwong was born in Santa Rosa, just north of San Francisco, in 1935 and has spent all his life in California. He was the fourth of five children of Chinese parents who had entered the Unites States illegally. His father was a somewhat severe man who scratched a living as a traditional Chinese doctor (Tworkov, 76). In 1960, he met Shunryu Suzuki (no relation to D.T. Suzuki), began practicing *zazen* with him at Sokoji, the Soto centre in San Francisco, and then followed him when Suzuki founded the San Francisco Zen Center (SFZC) in 1961. He took the precepts, went through the *tokudo* ceremony (see the Glossary), and served as head monk at the annual three-month retreat at Tassajara (SFZC's centre near Santa Barbara). Suzuki began to train him as his Dharma-heir but died in 1971 before Kwong could complete his transmission studies.

Kwong was then taught by Kobun Chino Roshi for several years but in the end it was Hoichi Suzuki, Shunryu Suzuki's son and first Dharma-heir, who gave him Dharma transmission (in 1978). He was installed as abbot of Genjoji, the temple at Sonoma Mountain Zen Center, in the same year. Technically, this made him a *roshi* but he did not use the title until 1984 (Tworkov, 99, 103).

What all this comes down to is that Jakusho Kwong Roshi has been formally appointed according to the Soto tradition. He has trained entirely in America and is currently the spiritual leader of a number of students at his own Zen centre. There are about 15 or 20 permanent residents, with a further hundred or so from the surrounding area who participate in the programme. There is a board of directors but, as abbot, Kwong has ultimate authority and can veto any decision that it takes. This is just as Shunryu Suzuki organized SFZC (Tworkov, 100)—an essentially Japanese model which has been slightly adapted to the American ideals of democracy and rule by consent.

Kwong Roshi's twelve years as head of his Zen centre reveal a balance of conservatism and innovation in his style. On the conservative hand, a formal 'ashes ceremony' was held at the centre in 1984, when Hoichi Suzuki brought some of his father's ashes from Japan specifically for this purpose. The place where the ashes are buried—called a *stupa*—is marked by a two-ton rock that Kwong himself selected. On the innovative hand, he is beginning to experiment with practices that are not derived from traditional Soto. He has studied with Thich Nhat Hanh (the Vietnamese Zen master and originator in the West of 'concerned Buddhism', a kind of socially-aware-cum-ecological version of the Dharma) and adapted the *gatha* walk that Thich Nhat Hanh teaches. He is also practicing with Soen San Nim (*aka* Seung Sahn), the Korean Zen master (whose disciples include Bobby **Rhodes**).

It is one of the delightful details of this whole phenomenon of Western teachers that a Chinese American should have become a Soto teacher in America under the instruction of Japanese teachers, also in America, and is now drawing extra inspiration from a Korean master living in America and a Vietnamese teacher based in France (both of whom represent Zen traditions that are closer to China than to Japan).

(*See* Lineage Tree 1)

Primary sources: None that I am aware of.

Secondary sources: Helen Tworkov, *Zen in America* (San Francisco: Primary Point Press, 1989).

Centre: Sonoma Mountain Zen Center, 6367 Sonoma Mountain Road, Santa Rosa, CA 95404, U.S.A.

COMPARE:

Other teachers taught by Shunryu Suzuki: Richard **Baker**, Reb **Anderson**, Issan **Dorsey**

Other Zen teachers: Robert **Aitken**, Jan **Bays**, Joko **Beck**, Gesshin **Prabhasa Dharma**, Bernard **Glassman**, Philip **Kapleau**, Jiyu **Kennett**, Walter **Nowick**, Ruth Fuller **Sasaki**, Maurine **Stuart**

REV. KONGO LANGLOIS

Langlois was born in Chicago around 1935. After finishing his military service in 1956, he started practising meditation with two Indian teachers, Swami Vishwananda and Sri Nerode, with the second of whom he learned *kundalini yoga*. Then in 1960 he met Soyu Matsuoka Roshi, who had founded the Zen Buddhist Temple of Chicago in 1949, and became a pupil. He was ordained a Soto priest in 1967, and when Matsuoka Roshi went to Long Beach, California in 1970 to establish a Zen centre there, Langlois was appointed his Dharma-heir[1] and abbot of the Chicago temple. Four years later, in 1974,[2] Matsuoka gave him the title 'Roshi' (described in the literature I have seen as "an indication and acknowledgement of a high level of understanding or realization"; this is not a definition that others in this book—other Western Soto *roshis*, that is—agree with). In 1987, Langlois

> was presented with the 'Inka Shomei' (seal of transmission) from Asahina Sogen, Primate of the Rinzai branch of Zen Buddhism. Thus Kongo Roshi is recognized as a master in both the Soto and Rinzai schools of Zen. (Temple flier)

A year later, he was appointed successor of Professor Huo Chi-Kwang of the Chinese Cultural Academy, with whom he had been studying meditation and Tai Chi Chuan boxing for the previous 22 years.

Langlois was one of the first Westerners to be appointed as abbot of a temple; he now has disciples of his own. I know of no other Westerner who has not only received recognition from the Zen tradition (in fact both the Soto *and* Rinzai schools) but is also a sort of spiritual successor of a Chinese meditation teacher. But he is somewhat apart from the burgeoning Western Zen scene despite the fact that he entered the tradition relatively early. I don't know why.

Primary sources: undated Temple flier

Secondary sources: entry in D. Morreale, *Buddhist America: Centers, Retreats, Practices* (Santa Fe, New Mexico, 1988, p. 144)

Centre: Zen Buddhist Temple of Chicago, 865 Bittersweet Drive, Northbrook, IL 60062, U.S.A.

COMPARE:

Other Western Zen teachers: Robert **Aitken**, Jan **Bays**, Charlotte **Beck**, Reb **Anderson**, Richard **Baker**, Bernard **Glassman**, Philip **Kapleau**, Jiyu **Kennett**, Bill **Kwong**, John **Loori**, Daino **MacDonough**, Dennis **Merzel** (all Soto); Gesshin **Prabhasa Dharma**, Walter **Nowick**, Ruth Fuller **Sasaki**, Irmgard **Schloegl**, Maurine **Stuart** (all Rinzai)

FREDERICK LENZ.
SEE **APPENDIX 1** (UNDER ZEN MASTER **RAMA**)

[1] Matsuoka has at least three other American students who teach and who may or may not be Dharma heirs: Michael Wise Sensei in Colorado; Roshi Michael Elliston in Atlanta, Georgia; and Rev. Ken McGuire-roshi in New Mexico. (All these names taken from Morreale.)

[2] The date is given as 1971 in Morreale. I don't know why there is this discrepancy.

JOHN LEVY | PREMANANDANATH

British Army officer who met his guru in India and attained realization

To be strictly accurate, I cannot state categorically that Levy did attain realization since he never actually says so. On the other hand, he does say this:

> Cursed by thought of limitation,
> I was born, yoked to time and space,
> Now unborn, freed by my Master's grace,
> I live alone, beyond compassion.
> (*Immediate Knowledge and Happiness,* 76)

Of course, one can make such a claim and still be mistaken. Even so, Levy is worth knowing about.

I have next to no information about his life. According to Waterfield, he was born a Jew but became a Moslem—and a Moslem of a very particular sort since he was an admirer of René **Guénon**. In fact, he bought **Guénon** a house in Cairo in 1939 (Waterfield, *René Guénon,* 56). But just a few years later, he had abandoned **Guénon**'s brand of metaphysics and started to practice under his guru, Sri Krishna Menon, usually known as Atmananda. This was certainly by 1943 (the earliest date given in *Immediate Knowledge and Happiness*) and Levy was serving in the Army in India at the time.

In 1946, he gave a series of talks on the Army radio in Madras—surely one of the most unlikely places to find an account of Vedanta. His presentation on that occasion (and all other occasions) was entirely traditional. There is only consciousness, which is one's true nature, the Self. It is beyond the opposites of seer and seen, and always abides. All objects are simply aspects of consciousness. They appear to exist independently only because of our identification with the the mind and senses. Part of Levy's traditional approach is that he proceeds according to argument. (He often says, 'I will now prove that . . . ') This is what he says about time and space. (Deep breaths, please.)

> If we analyse space, we find it to be the interval between any particular points. It is impossible to think of any object without thinking of space. It is impossible also to think of space without some thought of size, and size is a property of matter. Space and matter are therefore inseparable. Now, to see an interval takes time, because it requires at least three thoughts: one of each extreme and one of the intervening space. So space is really nothing but time. We might say that space is the embodiment of time, but it would not be true, because we still have to think of it. In other words, space exists only when we think of it: and just as matter is inseparable from space, so is space itself inseparable from thought. And we have already seen that thought is inseparable from time. And what is time? We saw that space is the name given to the invisible and indefinite something which contains and runs through the material universe. Is not time the name we give to the intangible and indefinite something in which our thought occur? We measure time by fixed periods or intervals which we think of as past, present or future. But the present is already past when we think of it and that is why I call time intangible. That which is always present is consciousness, whether we think of it as past or future. It is impossible to think of time without thinking of succession, nor can we think of succession without referring to time. But the actual thought appears *now* in consciousness, and that is eternal because it is ever present. Consciousness is present when there is thought and it is present when there is no thought. If not, how could we speak of there being no thought? We become aware of time when we think of it: if we don't think of it, we are not aware of it. But we never cease to be aware or conscious, for consciousness never sleeps. Thus thought and time are one, one in consciousness. (ibid., 23–24)

He goes on to say, in the time-honoured fashion of Vedantin debate, that space and time are themselves only thoughts and therefore objects of perception, and like all objects they change according to circumstances. (Time is different in dreams, for example.) Hence the world itself, with all its objects, is created by thought.

> When the sense of body goes, the world goes with it. When thoughts subside, so does the sense of time. But consciousness remains. Therefore the universe rises and subsides in consciousness. It has no existence apart from ourselves . . . We destroy it when we cease thinking of it and consciousness remains. That is myself. Or yourself. Or simply self, for it is impersonal. (ibid., 25)

It is, of course, an axiom of Advaita that since there is only the one consciousness or Self, realization of it must be immediate and not by degrees. Levy deals with this topic at length—but in an interesting context: a specific refutation of the heretical views of his erstwhile mentor, René **Guénon** (as expressed in **Guénon**'s book, *Man and His Becoming According to the Vedanta*). While Levy does say that **Guénon** is "the most gifted of men" and gives credit to him when he can, he also says that "he has never succeeded in giving a correct view of Vedanta" (partly because **Guénon** "seems often to aim more at promoting his peculiar theory of the oneness of spiritual tradition than at laying bare the truth itself"; all these quotations from Levy's essay, 'Vedanta and Liberation and the Works of René Guénon', *Immediate Knowledge and Happiness,* 98).

Levy dismisses **Guénon**'s description of a 'gradual path' or 'deliverance by degrees' (*krama-mukti*) as essentially misconceived. In fact, "there is no practice as such that can lead to realization". **Guénon**'s confusion on this point is "because he has never known the highest Guru and nevertheless, presumes to speak of Advaita" (ibid., 115). More particularly, Levy says that "Vedanta is not the heartless, aloof and repellent body that it seems to become in the hands of Mr. Guénon" (ibid., 98). And it is evident from Levy's own writings that the *person* of the guru is of inestimable value in realizing the one Self. He refers to Atmananda as his Lord and says,

> I found my Lord and lost my body and mind in the beauty of his form . . .
> Not by wisdom alone was I shown the truth but by endless love, for such is my Teacher, Sri Atmananda. (ibid., 70)

As far as I know, **Guénon** never read Levy's critique—he died in 1951, the same year that *Immediate Knowledge and Happiness* was published—so I do not know what his reply would have been. I mention it not because I want to pursue the controversy *per se* but simply to highlight the fact that it is between two Westerners. One's sympathies or convictions may be with one or the other (or with neither). But that is not the point. What is significant is that Vedanta is being discussed and debated not as something Indian, foreign and different but as an integral part of these two men's lives.[1]

[1] And the same could be said about the other non-dualist-cum-Advaitin Westerners in this book, different as they are. And there are significant differences: some of them use traditional terminology, others do not; **Jae Jah Noh** never had a teacher; nor did **Shunyata**, though he claimed to have been silently 'initiated' by *Ramana Maharshi;* Barry **Long** had more than one teacher—none of them Advaitin—but never refers to them; Jean **Klein** mentions his—a traditional Indian guru like Atmananda—but rarely and only in passing; and Andrew **Cohen** has actually repudiated his teacher (himself a pupil of *Ramana Maharshi*). Whatever one might think of their quality, all these teachers are part of a phenomenon that is now thoroughly Western.

Levy has his place in Western Vedanta, for want of a better term, although a fairly modest one. I do not know what became of him and would welcome any information.[2]

Primary sources: John Levy, *Immediate Knowledge and Happiness: Hindu Doctrine of Vedanta* (London, 1970) [this is the second, revised edition, from which all my quotations are taken; the title inside the book, *Immediate Knowledge and Happiness (Sadhyomukti): The Vedantic Doctrine of Non-duality,* is slightly different from the one on the cover; the original edition was in 1951]; *The Nature of Man According to the Vedanta* (London, 1970) 2nd ed.; I also have details of two of Sri Atmananda's books (both very short): Sri Krishna Menon/Atmananda, *Atma-Darshan—At the Ultimate* [*sic*] (Tiruvannamalai: Sri Vidya Samiti, 1946); *Atma-Nirvriti: Freedom and Felicity in the Self* (Tiruvannamalai: Vedanta Publishers, 1952)

Secondary sources: None

Centre: I have no contact address for Levy himself but Sri Atmananda's son, Sri Adwayananda, can be contacted at Atmay Vidya Educational Foundation, Malakara, via Edayaranmula, Kerala 689532, India.

COMPARE:

Other Westerners who teach that one's real nature is truth: Andrew **Cohen**, **Jae Jah Noh**, Jean **Klein**, Barry **Long**, Bhagavan **Nome**, Toni **Packer**, **Shunyata**

Other Westerners who have a connection with Vedanta via the Shankaracharyas: the **Devyashrams**, Leo **Maclaren**

Samuel LEWIS | Murshid Sam

American pioneer who was a lifelong Sufi and perhaps the first person to practice experiential comparative religion

Lewis was a visionary whose spiritual 'career' did not really take off until he was 60—and it began in the East rather than the West. He did not initiate his first Western disciples until he was 70 and he died five years later. He saw things on a large, not to say cosmic, scale, and for the most part preferred the inner life to anything the world could offer. In all of these respects, he was unusual.

He was born in San Francisco in 1896 and one could say that he was the paradigm Californian, prepared to explore any avenue. His parents were Jewish and wealthy: his mother was a Rothschild; his father, vice-president of the Levi Strauss jeans company. They did not speak to each other for 25 years and communicated via their two sons, Samuel (the elder) and Elliot. This is hardly an ideal upbringing and it is no surprise that the brothers never got on. Later in life, when he was over 60, Sam went to a psychiatrist and received his treatment free because his was the worst case she had ever come across. He had at least one 'nervous breakdown' (mentioned below); it was immediately followed by a vision (though he had had visions before). He told his American disciples in the sixties that he had been specially trained for the problems of pain and suffering (*Sufi Vision and Initiation,* 318); and he once said that the secret of his teaching was "controlled schizophrenia" (*In the Garden,* 35). In making these points, I am not trying to discredit him in any way; a good case can be made for saying that only those who have been wounded can heal.

[2] The one reference I have seen is that he had some followers in Uruguay in the late 1950s; one of them was Jeffrey Masson's mother, who left Paul **Brunton** in order to join him (Masson, *My Father's Guru* [New York, 1993], 145).

His spiritual quest began in earnest in 1915, when, at the age of 19, he came across the Theosophical stall at the World's Fair in San Francisco. He was immediately taken with the idea that religions only differ outwardly but are esoterically identical, and it was to become a major theme of his own life and teaching. He was also intuitively convinced by the notion of a spiritual hierarchy and in particular that its upper echelons contain adepts who have experienced the higher levels of reality.

But Sam was always a practical man and he soon found that Theosophy, at least in the form that he found it, was little more than talk. Then, in 1919, according to his own account (writing about himself in the third person),

> He is on Sutter Street in San Francisco, looking at a display of books. He is unaware, but soon he is upstairs facing a little dark-haired lady. She is Jewish.
> "You can explain the Kaballah?"
> "Yes, and all religions."
> "What is Sufism?"
> "Sufism is the essence of all religions. It has been brought to the West by Hazrat Inayat Khan." (*Sufi Vision and Initiation*. 14)

This lady was Rabia **Martin**, Inayat *Khan*'s first American disciple, and she was to be one of Sam's main teachers—externally, that is, since his inner life was always more significant—for the next 25 years. But the really important relationship in these early years was with Hazrat Inayat *Khan* himself. It is typical of Sam that he should have not one, but two visions of his teacher before he actually met him (*In the Garden,* 210). He was initiated in California in 1923. He says that when he entered the room to meet Inayat *Khan* for the first time (in the flesh, that is),

> there was no person, only a tremendous Light. But it was not just Light; it was a tremendous feeling of binding Love...[dots in the original]
> This first experience with Hazrat Inayat Khan stayed with me for Life and continued to encourage me and strengthen me in performing His Work. (*In the Garden,* 210)

Thereafter, Sam always regarded himself as Inayat *Khan*'s disciple despite very close contacts, which often included initiation or something similar, with many other teachers. Thirty years later, he said that "I have not met any non-Moslem superior to my own teacher" (*Sufi Vision and Initiation,* 141).

One of the teachers who had a considerable influence on Sam was Nyogen Senzaki, whom Sam brought to meet Inayat *Khan* during this 1923 visit. He reports that the two men both went into *samadhi* (*Sufi Vision and Initiation,* 74). This is a particularly significant incident in the phenomenon I am describing: a meeting between a Zen and a Sufi master—perhaps the first ever—not in Japan, nor in a Sufi country, but in the West, and at the instigation of an American (who uses a Hindu term to describe what happened). It is entirely typical of Murshid Sam (also known as 'He Kwang' when he was wearing his Zen hat) that it was he who acted as the catalyst for this event.[1]

Sam continued to have visions of various sorts all his life. But he had a particularly concentrated patch during the 1920s. In 1925, just two years after his

[1] I should record, however, that Senzaki's own version of the meeting is rather different. "Murshid," said Senzaki, "I see a Zen in you." "Mr. Senzaki, I see a Sufi in you," Inayat Khan replied. And that was the end of the interview (Taken from E. de Jong-Keesing, *Inayat Khan,* [The Hague: East-West Publications, 1974], p. 194 with a note to an article by Senzaki: 'Sufism and Zen', *The Japanese American,* 5th November 1923, reprinted in Nanshin Okamoto, *On Zen Meditation,* 1936). De Jong-Keesing also says that it was Rabia **Martin** who arranged the meeting, not Lewis.

initiation by Inayat *Khan,* "I had a complete breakdown, went into the wilderness and there experienced a number of visions and states of consciousness quite common to Sufis" (*Sufi Vision and Initiation,* 23). This laconic statement can be fleshed out from some of Sam's other writings. The wilderness was in fact the countryside near Fairfax, a small village (in 1925) near San Francisco, where Rabia **Martin** had a Sufi meeting house or *khankah,* called 'Kaaba Allah'. It was the first in America. The vision was an encounter, on three successive nights, with Khwaja Khizr, a mythic personage in the Sufi tradition, identified with the teacher of Moses (as described in the *Quran*) and also with the prophet Elijah. (See *The Jerusalem Trilogy,* 11, which contains a slightly different version of the account in *Sufi Vision and Initiation,* 30, and *In the Garden,* 211.) Sam felt him as a palpable presence. This is Sam's own account (again written in the third person):

> [Kwaja Khizr] offered poetry or music. Sam chose poetry . . . Years later, the music did come, and it is coming and with it the Dance, but these are different stories. After the third night, Sam began writing incessantly.
>
> At the end of ten days, all the health and vigor were restored, and Sam prepared an initiatory ceremony for noon . . . [I]n turn, Shiva, Buddha, Zoroaster, Moses, and Jesus appeared. Then Mohammed appeared, but double (on the left and right) and on horseback. All the others came singly. Then the six Messengers of God, so to speak, formed a circle and danced and became one, and as they danced, the Prophet Elijah appeared and bestowed a Robe. (*Sufi Vision and Initiation,* 30)

This visionary encounter with the representatives or founders of six separate traditions is again entirely typical of Murshid Sam. But one is bound to ask whether a vision which includes Shiva, Buddha, and Zoroaster can really be described as "quite common to Sufis."

In 1926, Hazrat Inayat *Khan* came back to San Francisco. Sam had six interviews with him, during which Inayat *Khan* confirmed everything that had happened in the vision just described (*In the Garden,* 211). He also made Sam 'Protector of the Message' and told him that he would be "a leader of the Brotherhood work—the efforts to build a bridge of communication between the mystics and the intellectuals" (*Introduction to Spiritual Brotherhood,* 94; this is not Sam's own writing but a short biography compiled by his disciples).

After Inayat *Khan's* sudden death in 1927, the Sufi Order split into two: a European wing under the direction of his brother, Maheboob Khan, and the American group led by Murshida **Martin**. (See the group entry, the **Sufi Movement and the Sufi Order**.) Sam acted as her *khalif* or chief assistant (a position second only to that of *murshid* or *murshida*), frequently directing activities at Kaaba Allah.

But at the same time he was actively pursuing his Zen interests. In 1926 (when Inayat *Khan* was still alive), he helped Nyogen Senzaki establish a *zendo* (somewhere where *zazen* is practised) in San Francisco. According to the chronology in *In the Garden* (p. 53), it was the first in America, and as far as I know, it was the first in the West. In 1930, Sam went to New York, where he met Sokei-an Sasaki, a Dharma brother of Nyogen Senzaki, and the only other Zen teacher in America at the time.

He practised *koans* with Sokei-an (*Sufi Vision and Initiation,* 79), just as he had done with Senzaki (ibid., 72). And he appears to have struck up a close relationship with Sokei-an very quickly—at least, he records that they had "innumerable personal and impersonal sessions" together (ibid., 95). According to the chronology in *In the Garden,* Sokei-an gave Sam Dharma

transmission (*In the Garden,* 53). What this means exactly is not clear. Usually, it signifies formal recognition by a teacher that a student has sufficient insight to be able to have students of his or her own. This is how the Zen lineage continues: Dharma transmission from teacher to student. Possibly, this is what it meant for Murshid Sam as well. If so, there is no evidence that he ever acted as a Zen teacher in any traditional way. But then he was not a traditional Sufi teacher, either.

It may well be, then, that for Sam, 'receiving Dharma transmission' simply meant 'receiving Zen teachings'. (However, he did receive formal Dharma transmission from another Zen teacher over 30 years later—see below.) I think it is prudent, therefore, to see Sam at this point as a Zen student rather than a Zen teacher in any formal sense. This does not detract from his significance, in my view; he is still one of the few Westerners at this time—the 1930s—who was seen by a Japanese teacher as being able to truly practise Zen.[2] Nor should we forget that he was recognized by both Nyogen Senzaki and Sokei-an, who, though Dharma brothers, operated at opposite ends of the country and had virtually no contact with each other. In fact, it was Sam who brought them together again (*Sufi Vision and Initiation,* 113)—an instance of a talent for unification that he demonstrated all his life.

After a very intense decade (from 1919, when he met Rabia **Martin**, to 1930, when he met Sokei-an), the next 25 years appear relatively tame by comparison. Even so, Sam continued with all his activities—Sufism (including commentaries on Inayat *Khan*'s works), Zen, prophetic writing—and also explored a number of new avenues. In 1936, he co-authored a book, *Glory Roads: The Psychological State of California,* the title of which is self-explanatory (and shows, incidentally, that alternative lifestyles were a Californian speciality at an early date). And in 1938 (not 1937, as various chronologies in his books state), he met Paul **Brunton** in New York and "quickly attained samadhi." Apparently this was confirmed by **Brunton** himself but not by "official disciples" of *Ramana Maharshi* (*Towards Spiritual Brotherhood* [not to be confused with *Introduction to Spiritual Brotherhood*], x). Sam says that

> Paul Brunton, who was one of my teachers, taught three ways to spiritual awakening: the way of breath, the way of the heart, and the way of light, or glance, which I sometimes use. (*This is the New Age, In Person,* 69)

'Glance' obviously means what the Hindus call *darshan.* So here we have a transmission (of sorts, bearing in mind that *Ramana Maharshi*'s non-dualistic teaching has no real place for transmission) from *Ramana Maharshi* to **Brunton** to Sam, who is himself an initiated Sufi, has received Dharma transmission from a Japanese Zen teacher (Sokei-an) and is about to start writing the Judaic section of his *Jerusalem Trilogy* (a work that I mention briefly below). In his mid-forties, and just before the outbreak of World War II, he is already fully committed to the simultaneous *experiential* investigation of all the major traditions. And as far as I know, he is the only person in the world who is.

In 1942, Rabia **Martin** made contact with *Meher Baba* and by 1943 had accepted him as the head of the spiritual hierarchy and hence the power behind her master, Hazrat Inayat *Khan.* (See her entry for details.) But she died

[2] It has been suggested by Sam's successor, Murshid Jablonsky, that what Sam actually received was what the Sufis call '*baraka* transmission'. This raises the question, of course, of whether *baraka* transmission and Dharma transmission are really equivalent—exactly the sort of question Sam was always bringing up.

in 1947 before she was able to meet Baba, having appointed another American woman, Ivy **Duce**, as her successor—a move that took many of her disciples by surprise, Sam among them. He found that he could accept neither **Duce** nor *Meher Baba,* and from that moment on, he was on his own, a lone disciple of Hazrat Inayat *Khan* having no formal connection with any wing of the Sufi Order—except that, in another vision, Inayat *Khan* "turned him over to Prophet Mohammed and Jesus Christ in the inner world for guidance" (*In the Garden,* 54; cf. *Sufi Vision and Initiation,* 52), and he was given the name 'A. Murad' by Mohammed (*Sufi Vision and Initiation,* 350). So he was not exactly on his own.

In 1954, he met Swami Ramdas in San Francisco (*Sufi Vision and Initiation,* 104). This was Sam's first real contact with a Hindu teacher (not forgetting Paul **Brunton**, who was not really Hindu, and Shiva himself, during his 1925 vision, who must surely count, but was inner, not outer). It was to be his strongest connection with that tradition and one that he drew on in his later years. "I am absolutely free to give with my blessing two . . . phrases to anyone to repeat: OM SRI RAM JAI RAM JAI JAI RAM and ALLAH" (*In the Garden,* 110).

But the next intense period of his life was about to begin. In 1956, he went on a long trip to the East, lasting about a year. Completely unknown and representing no one but himself, he met a large number of teachers and had many unusual experiences. He started off in Japan, where he immediately felt at home. When he visited Sojiji (the Soto temple where Jiyu **Kennett** stayed a few years later), the head monk explained the relationship between Amida Buddha and Shakyamuni Buddha, "which," says Sam, "is exactly the same as that between Allah and Mohammed—this down to details" (*Sufi Vision and Initiation,* 119). This is a typical Sam comment—and I doubt if anyone had made the connection before.

He then went on to East Pakistan (now Bangladesh), India, and West Pakistan (now Pakistan). He met Pir Maulana Abdul Ghafor, a *murshid* in the Chishti school (the same one as Hazrat Inayat *Khan* and hence of Sam himself), in Dacca in East Pakistan, and, according to Sam, was

> nominated as a candidate for the Waliyat [meaning 'friend' or mediator between God and man]. My directions with regard to the disciples of Pir-O-Murshid Inayat Khan are simple: I am to be the Shams-i-Tabriz and Vilayat [= Vilayat Inayat **Khan**] the Maulana Rumi. (*Sufi Vision and Initiation,* 143)

This is another instance of Sam crossing boundaries; in this case, Sufi boundaries: Shams-i-Tabriz and Maulana Rumi were Mevlevis, not Chishtis.

To be appointed as a representative of Chishti Sufism—this is quite something for any Westerner, especially an unknown American, however we understand the terms 'appointed' and 'representative'. Elsewhere, Sam says that

> It is entirely possible that we are performing historically a mission in the Western world comparable to [Moineddin Chishti's] of an earlier period. (*In the Garden,* 241; cf. *Sufi Vision and Initiation,* 338)

That is, just as Chishti brought Sufism to India in the twelfth century, so Sam is bringing it to the West in the twentieth.

But being Sam, he did not restrict himself to Sufism during this Indian visit. He met the **Mother**, whom he describes as "a sort of saint and to me her darshan seems effective" (*Sufi Vision and Initiation,* 153), and Swami Ramdas, whom he regarded as his guru and the embodiment of love (ibid., 154). He was initiated by him at Ramdas's ashram in South India.

Back in California in 1957, he completed *The Jerusalem Trilogy,* perhaps the most spectacular of all Sam's prophetic works. It has three parts: a Judaic section, written in 1938 (*Jerusalem Trilogy,* 29), in which Sam uses the voices of various Old Testament prophets; a Christian section, written in 1942 (ibid., 77) (when he was working for Army Intelligence during World War II![3]), which is spoken by Jesus; and a Moslem section, entitled 'Saladin', written about 1960 (ibid., 123), Book II of which was dictated by Mohammed himself (ibid., 8). It contains many typical themes. For example, Book II of 'Saladin' refers to Ram-Sita, Shiva, and the Buddha (in chapters IX, X, and XI respectively). And there are two short essays by Sam (written separately from the *Trilogy*) at the end of the book which deal with the reconciliation between Judaism and Islam, and between Islam and Christianity. Sam records that Mohammed told him to write 'Saladin' in order to bring about this second objective (*Sufi Vision and Initiation,* 246).

After three years in California, Sam went back to the East (in 1960). This time he started off in Egypt, where he was initiated into both the Shadhili and Rifai Orders (*Toward Spiritual Brotherhood,* x), and then went to West Pakistan, where he was recognized as a *murshid* in the Chishti Order by Pir Barkat Ali, head of a combined Chishti-Qadri-Sabri Order (*Sufi Vision and Initiation,* 314; *In the Garden,* 96). This occurred after two separate individuals, an uneducated old man and professor, both attained illumination as a result of following Sam's spiritual advice or instructions (*Sufi Vision and Initiation,* 314; cf. *Jerusalem Trilogy,* 125).

It is evident that Sam's spiritual life has gone up a gear or two. This may explain another new departure: that he starts to make statements about his spiritual function.

> The work laid out for me by Pir-O-Murshid Inayat Khan was of world significance; the very magnitude prevented anything I tried from being accepted. Pir-O-Murshid Abdul Ghafoor added to the above and, in addition, pointed out to me the path of the Khalandar . . . [who] have to go through unusual disciplines and often submit to bizarre or seemingly heterodox methods. (*Sufi Vision and Initiation,* 251)

> I had to be born in a Western body so I could bring Oriental teachings to America. (ibid.)

In 1962, after a two year stay (during which he seriously considered living in West Pakistan), Sam returned to California, which, as it turned out, was on the verge of the consciousness explosion that followed in the wake of the discovery of psychedelics. But there was no hint of it in 1962. As before, Sam continued his various simultaneous paths. In 1964, he met a Korean Zen teacher, Kyung Bo-Seo; three years later, he was ordained 'Zen-shi' by him (*In the Garden,* 55) and given the name, 'He Kwang', which he often used when referring to his Zen experiences (for example *Sufi Vision and Initiation,* 113). This, I think, can be regarded as formal Dharma-transmission (unlike his relationship with Sokei-an Sasaki—see above.)

*Cf. Don **Gilbert**.*

In 1968, he began to 'receive' various dances as a means of spiritual transformation. They came to be known as the 'Dances of Universal Peace' and Sam often saw them in visions (*Sufi Vision and Initiation,* 330). He said that to

[3] According to the chronology given in *Sufi Vision and Initiation,* Sam was "awarded citation for work with Army Intelligence (G2) during World War II, probably as a researcher and historian. The exact work was never revealed, but included reporting troop movements in North Africa, seen clairvoyantly."

begin with they were an integration of "the efforts of the Rafais, Bedawis, Chistis, Mevlevis—then [they] expanded" (*Sufi Vision and Initiation,* 329). This was the essential 'Sam' method: expansion from the various traditions.

Cf. **Stephen**—*another teacher for the hippies.*

Meanwhile, around 1966 or so, he started to initiate young Americans. To begin with, things went slowly. Then in 1967, when he had just six followers, he had a mild heart attack. While he was in hospital, "God came to me and said, 'I make you spiritual teacher for the hippies'" (*Sufi Vision and Initiation,* 324). In no time at all he had a hundred disciples. At the same time, he linked up informally with Vilayat Inayat **Khan**, Hazrat Inayat *Khan*'s elder son and Murshid of the Sufi Order (which Sam had effectively left when he remained loyal to Rabia **Martin** after Hazrat Inayat Khan's death in 1927). Vilayat *Khan* wanted to "organize legally", in Sam's phrase (*Sufi Vision and Initiation,* 341)—that is, set their two groups on some sort of formal footing. Sam was not against the idea but it was not his way and nothing definite was done. This was to have consequences after his death.

In 1971, he fell down the steps of his home in San Francisco and suffered head injuries. He spent two weeks in hospital, sometimes unconscious, sometimes delirious, sometimes lucid. He died a fortnight later, aged 74.

Sam was a gifted and unusual disciple who gradually—over several decades—became an equally gifted and unusual teacher. His most distinctive characteristic, both as disciple and teacher, was the ability to enter directly into different traditions. By this, I mean that he was quickly accepted as genuine by the masters of those traditions who had practised in them all their lives. I have given a number of examples and will not repeat them here. The two most important ones were Sufism and Zen: traditions, which, even today, most people would have difficulty in harmonizing. Sam evidently found no difficulty at all—perhaps because his understanding of them was experiential rather than theoretical. But more than that, he regarded all his experiences as aspects of one reality. This is shown by what we might call his 'multi-visions', in which he entered into the presence of prophets and apostles (using these terms in the sense that he gave them—see below). His 1925 vision, when he saw Shiva, Buddha, Zoroaster, Moses, Christ, and Mohammed, is an obvious example.

Of himself, he said,

> I have to assume that I'm either way wrong or I may have the testimony of God. And from what's been told me lately, which I cannot repeat, maybe the latter is true, because the effect on other persons has been glorious and great. (*This is the New Age, in Person,* 39)

His disciples certainly think so. They say he could give *darshan* as Buddha, Ram or Christ to different people, one after the other, when they came to see him (*In the Garden,* 30). And according to one of his closest disciples, Wali Ali Meyer, Sam

> did everything with an all-pervading sense of service to God and humanity. He said that the greatest Sufis and Vedantists he ever met were living embodiments of the words of Jesus Christ: "Let he who would be master, be the servant of all the rest" . . . When a man accepts responsibility for all humanity he becomes what is called in Buddhist terminology, a Bodhisattva. It becomes his purpose in life to bring the Divine Blessings into the world for the benefit of all sentient beings. (*Jerusalem Trilogy,* 13)

And **Ram Dass** (not to be confused with Swami/Papa Ramdas) likens Sam to **Gurdjieff**, Marpa, and his own guru, Neem Karoli Baba—all teachers who "transcend the rule book" (*In the Garden,* 11).

Whether or not we accept these claims, I for one am persuaded that if anyone is going to make pronouncements that have any value at all about the various traditions, it has to be along the lines that Sam adopted: namely, what I call experiential comparative religion. It is one of the arguments of this book that the West has fundamentally changed *all* the Eastern traditions by the mere fact of bringing them together and asking questions that none of them has asked before. Murshid Sam was surely one of the pioneers[4] in this movement—one that may yet transform Western culture.[5]

(*See* Lineage Trees 6, 8)

Primary sources: Samuel L. Lewis, *Toward Spiritual Brotherhood Prophecy* (Novato, California: Pressworks, 1971) [this may or may not be the first edition of a later book with a very similar title: *Introduction to Spiritual Brotherhood: Science, Mysticism and the New Age* (San Francisco: Sufi Islamia/Prophecy Publications, 1981)]; *This is the New Age, in Person* (Tucson, Arizona, 1972); *The Jerusalem Trilogy: Song of the Prophets* (Novato, California: Prophecy Pressworks, 1975); *In the Garden* (New York: Harmony Books, Cristobel, New Mexico: Lama Foundation, 1975); *Sufi Vision and Initiation* (San Francisco: Sufi Islamia/Prophecy Publications, 1986)

Secondary sources: None

Centre: Sufi Islamia Ruhaniat Society, 65 Norwich Street, San Francisco, CA 94110, U.S.A.; International Network for the Dances of Universal Peace, 444 NE Ravenna Boulevard #306, Seattle, WA 98115, U.S.A. (Email: 71763.2632@compuserve.com)

COMPARE:

Other Western Sufis: Vilayat Inayat **Khan**, Rabia **Martin**; Ivy **Duce**, James **MacKie**, Ivan **Agueli**, René **Guénon**, Frithjof **Schuon**, Abdullah **Dougan**, Idries **Shah**, Irina **Tweedie**, Reshad **Feild**, Lex **Hixon**

Other prophetic writers: Swami **Turiyasangitananda**

Other visionaries: Frithjof **Schuon**, Jiyu **Kennett**, Guru **Subramuniya**

Other teachers who practised in more than one tradition or saw different traditions as expressions of the one truth or even claimed to embody them (a very mixed bunch in strictly alphabetical order): Swami **Abhishiktananda**, J.G. **Bennett**, Madame **Blavatsky**, G.B. **Chicoine**, Master **Da**, Hugo **Enomiya-Lassalle**, René **Guénon**, Oscar **Ichazo**, Frithjof **Schuon**

Trebitsch LINCOLN | Chao Kung. SEE **APPENDIX 1**

[4] He was also a pioneer in two other fields: the green movement (in its spiritual dimension) and the relation between science and religion (from an experiential point of view). These topics are touched on in two books by one of Sam's grand-disciples, Neil Douglas-Klotz: *Prayers of the Cosmos* (San Francisco, 1990) and *Desert Wisdom* (San Francisco, 1995).

[5] Before he died, Sam appointed an American disciple, Moineddin Carl Jablonski, as his *khalif*. The group (of Sam's disciples) called itself the Sufi Islamia Ruhaniat Society or SIRS from 1971 onwards and was a formal branch of Vilayat **Khan**'s Sufi Order but under Jablonsky's leadership; it was Vilayat **Khan** who made Jablonsky a *murshid*. But in 1977, Sam's followers decided that they wanted to be independent of the Sufi Order (though they still regard themselves as a branch of the original Sufi Movement; SIRS contains all the five activities set up by Hazrat Inayat *Khan*—see the **Sufi Movement and the Sufi Order** entry). A list of Esoteric School Initiators for 1994 gives 60 names throughout America, including three *murshids* and one *murshida*; ten *sheikhs* and six *sheikhas*; and four *khalifs* and three *khalifas*. I do not have the space to deal with the development of this group and a full study would be welcome.

BARRY LONG

Australian who claims to be the only master of the West and for the West

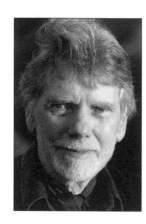

In 1985, an announcement appeared in a major national newspaper in Britain. **I AM GURU**, it said, above a photograph of a bearded man in his late fifties, **WHO ARE YOU?** This was the first public declaration by Barry Long and is typical of his style. It continued:

> Let me introduce myself. I am Barry Long, the person in the photograph. Now let me declare myself—for the person we say and think we are does not reveal who or what we are. And I do not want to mislead you.
>
> I am guru, the power behind the person and spiritual teacher Barry Long. There is only one guru—one divine or cosmic teacher—and I am that. Barry Long is one aspect of my teaching, one of my manifold lives . . .
>
> My enlightenment of Barry Long allows me to perform the extraordinary work of publicly declaring myself to the Westernized world as I am doing now in this document. There is no room for misunderstanding or debate in what I am saying. You either hear the truth of it or you don't. Whether you believe it or not is irrelevant . . .
>
> In all this I do not want you to get the impression that I am separate from Barry Long. I am Barry Long. There is no duality here, no person to come between and make a problem, a doubt.
>
> As the man I am fully responsible for what I say. I am quite able to confront the most intelligent minds and make sense of what I teach without having to resort to appeals to belief, doctrine or the experience or genius of others. I am new, every moment. Nor do I have to conceal my identity behind "my guru", "my master", "my inner voice", or any authority other than myself. (*The Observer,* 17 February 1985)

Barry was 59 when he made this statement. He was born in Sydney in 1926, where he worked in journalism. He was the editor of the *Sydney Sunday Mirror* and was press secretary to the Opposition leader in the New South Wales parliament for a time. He got married and had children. Then in 1957, while he was in his early thirties, "the truth, the pure intelligence of the universe, began to enter my body" (1994 pamphlet, 'An introduction to the teaching of Barry Long', issued by The Barry Long Foundation). This was the beginning of the process that he describes in the 'I am Guru' announcement: the enlightenment of Barry Long.

He says that teachers were "provided for me". The first, in 1958, was a Western follower of Vedanta and a celibate *brahmacarin*. Barry says he was enlightened but, being celibate, was unable to help when Barry discovered that the core of his pursuit of truth was "the consuming love of a woman" ('An introduction to the teaching of Barry Long'). He calls her his *bhagavati*, "meaning God in woman's form" and says that "she revealed herself in a vision to be just that" when he was about 36. He left his wife, family and job, and the two of them went to India. This was in 1964. But they did not stay together

for very long. She left him—he does not say why—and he struggled on alone (still in India). He was in such pain that

> I realized immortality. I passed through the level of death in the psyche and entered that realm of consciousness where the bodies of man and woman are one with the nature of the earth. (ibid.)

Elsewhere in the same pamphlet, he calls this realization "facing the truth of himself", a central term in his later teaching.

He went to England in 1966 and lived a life that to all outward appearances seems very much like the one he had left behind in Australia: he got married again and earned his living as a sub-editor in Fleet Street. But of course life was not the same. Slowly, a small group began to gather around him. He gave some public talks in 1968, and a version of his booklet, *Meditation: A Foundation Course,* was being circulated privately by 1969. But it was not until 1977 that he started to teach his small group on a regular basis at his home in London. The Barry Long Centre was founded in 1982. Fifteen years on, his teaching work—writing, discourses on tape and holding meetings—is on an international scale.

'An introduction to the teaching of Barry Long' is subtitled 'I speak only of truth, life, love, death and God'. And the first point to be made is that the reason he speaks only of these five topics is because they are all essentially the same thing. This is evident from the extracts from his teachings that are given in the pamphlet under each of these five headings (which I print in bold type).

> There is only one **truth**. It is being where you are. And where you are is where your body is.

> You are **life** itself, personified on Earth . . . Life is good because life is true.

> There is only one man and one woman. They are two principles out of existence, deep down inside every body *(sic)* . . . [T]he divine principle of **love** or God . . . is life, the life that is in every body.

> The only **death** or rebirth is now . . . You are a player in the rigorous game of living . . . The first rule is: every player dies; none knows when it's coming; the youngest and best often go first. Everyone has to play. The game goes on forever—or until you win. You win by finding death before it finds you. The prize—is life.

> There is only one I in the universe . . . I, the enlightened state of consciousness in man, am **God**.

So the teaching comes down to this. At this moment, I am in the body and so are you. I am using my body and mind—Barry often uses the word 'brain'—to write these words; you are using yours to read them. But 'I' am not the body/senses or the mind/brain. 'I' am the vast intelligence/presence that lies behind them and, at the same time, imbues them with its sense of well-being.

> In fact, it is the consciousness behind the brain now that is illuminating your physical body with the feeling of well-being. This illumination is common to all the earth's creatures. ('An introduction to the teaching of Barry Long')

The uninterrupted illumination of the body by consciousness or the one 'I' in the universe is enlightenment (ibid.). It is also life. It is God in the body (*Journal,* vol. 1, 22). "There is only one mind and that is the divine mind, God's mind, the earth's mind" (ibid., 23).

This life/truth/consciousness/I/God is love. And this includes 'making love' —an entirely 'natural' act, indeed a divine one.

> I present to you, men and women of this world, a new Way to truth and enlightenment—the Way of human sexual love one for another.
>
> Several Ways to truth and divine fulfilment have come down to us through the centuries. The best-known are probably the Ways of Buddha and Christ . . .
>
> [T]his Way of man and woman may be called a Way for the West, a Way of love for our loveless times, a gift from the beginning of time for those of you today who can hear. It is no easier than the other Ways. But at least it does not require you to meditate under a Bo tree for a year or die for your fellow man. (a declaration entitled 'A Way of Love for the West', 1982)

Barry regards his own realization, and the teaching that comes out of it, as inextricably linked with

> the divine principle of woman, I have been led by her, I have been crucified by her and most certainly I have been loved by her. I am the product of that love, as is my teaching. ('An introduction to the teaching of Barry Long')

Although truth/life/love/God is always present and can therefore always make itself known, the easiest way to know it is when it is presented by a master.

> I am here to tell you the truth and if you are ready, to demonstrate it in your experience so that you can BE the truth.
>
> I am self-realised or God-realised. That means I have real-ised (*sic*) God or life as myself. It means that every moment I have access to the profound self-knowledge or presence implicit in that reality or state of being.
>
> In other words, I know the truth because I am the truth. There is no question any seeker of truth can ask of life, death, love or truth that I cannot answer. (taken from a brochure, 'I Give You Nothing But Yourself', 1987)

On the other hand, he told me (and has said many times) that although the realization of all masters is the same, each one is unique because his mind and body is unique in space and time.

> My uniqueness is that I am a Western teacher. There are no other Western teachers. I am uniquely of the West to teach the West. An Eastern teacher cannot teach the West. (interview, 1986)[1]

In fact, his teaching has a number of levels, including a whole set of statements about what might be called the extremities of space and time.

[1] Barry has made a number of statements about other teachers, teachings and traditions. He doesn't have a lot of time for most of them. Even teachings which he accepts are true in principle can be a hindrance rather than a help.

> I only object to Zen when it is presented to the Western mind, because the Western mind cannot possibly understand or grasp or participate in the being of Zen. It is utterly impossible. (*Journal,* vol. 3, 153)

More particularly, he says that many Eastern teachers—for example, Rajneesh, Sai Baba, Maharishi Mahesh Yogi—use 'psychic magic' as a substitute for truth (*Journal,* vol. 3, 158–59). Paramahansa *Yogananda* was also a magician and not a master (*Journal,* vol. 1, 15). And a video of Master **Da**

> shows him to be a good example of the stupidity and ignorance of man, within the genius of an enlightened state of consciousness, which he is. The man encourages people (who are attracted to the being behind the man) to worship him. (*Journal,* vol. 2, 45)

I am not aware of any master that Barry approves of altogether. When I spoke to him, he mentioned several "who know the truth": Rajneesh, *Meher Baba,* Sivananda, Ramakrishna, Master **Da** and, in particular, *Krishnamurti.* "I am very like Krishnamurti," he told me. But even *Krishnamurti* has his drawbacks: he is "of the East even though he embraced the West." So his ability to teach Westerners is limited. And generally speaking, these masters do not speak the truth all the time; sometimes they do and sometimes they don't. "And that's not good enough for my fellow man" (interview).

For example, he has this to say about UFOs and ETIs (extra-terrestrial intelligences).

> The first secret of UFOs is that the intelligent beings behind them, or seen with them, are 'us' in another time. We are us in a past time . . . They are us in the present. (*Journal,* vol. 2, 109)

Statements like this are made alongside 'predictions' such as:

> Man will exceed the velocity of light and out-distance sense perception. The materiality of the universe will then vanish. [However, it is] the human brain that produces the sensory universe. Therefore, without a human brain—a brain of earth-space/time—there is no universe, no existence . . . Even the stars are terrestrial. They are forms created by the human brain. (ibid., 112, 114; cf. *The Origins of Man and the Universe,* 182, 275)

He also has a whole history of the human race that is all his own, ranging from the remotest past to the end of the world. *The Origins of Man and the Universe* is an encyclopedic myth that is intended, as he told me, to "disabuse the human mind of its beliefs". Amongst other things, it is a deliberate challenge to science. This, for example, is what he says about the origins of *Homo sapiens* (itself a sub-myth within the grand myth which is the subject of the book: the emergence of the one 'I' or consciousness in the awareness of what we call human beings).

Primitive man was essentially an animal—but an animal that

> lived mostly in his vital double: he did not realise that he possessed a physical body. His body performed on the earth in a totally instinctive way, while the vital, feeling part of him lived a completely interiorised though parallel psychic existence. (*Origins of Man and the Universe,* 15)

Modern man came into existence as a result of the effect of the sun's rays.

> On a particular day, primitive man watched the sun rise in the east. No man before him had ever seen the sun rising. He was never to be the same again. As he watched, cosmic culture was embodied in him. And the birth of self-conscious man began. (ibid., 20)

This happened about 200,000 years ago. The sun's rays are not just physical but contain more subtle energies. And it was these that dissolved a 'membrane' behind the eyes which kept primitive man at the animal level. As a result, the sun could work on the pineal gland, which acted as a transmitter to the intelligence, the 'I' within, that is the basis of self-consciousness (ibid., 24).

To begin with, there were just a handful of self-realized men. They lived in two realities simultaneously: the psychic world of primitive man (which was a shared experience common to all and therefore not thought of as 'mine') and the new world of self-realisation (which is individual and therefore can be transformed by an act of separate will). This meant that they could introduce change into the psychic world—something that had never occurred to primitive man. And since this psychic world was reality for primitive man, the ability to manipulate it brought great advantages. A 'modern' man

> could tune into [the] psychic state [of primitive men] and know exactly what each was feeling at that moment, what he wanted and what he would do. He could speak inwardly to the lesser men like some unidentifiable, all-knowing presence. He could put suggestions into him, frighten him, persuade him, instruct him—and finally, induce him to worship and serve him.
>
> The first physical-self realised men were the mythical and legendary gods. (ibid., 28)

Primitive man lived on the earth like all other animals—entirely in the now. But 'modern' man—the gods—by the mere fact that he was able to change things developed the idea that some things were better than others. This is thinking or projecting, which is itself another name for wanting. So time, in the sense of past and future, was created. Instead of just hearing or seeing 'things' (sounds or objects), man began to hear and see things that he wanted or wanted to change. This was the beginning of society—that is, a way of creating an order that is different from, and preferable to, the natural order of the earth. It was also the beginning of the end . . .

There are a number of levels to this myth: for example, an 'esoteric' cosmology which represents the earth as a cosmic being (whose mind is its magnetic and gravitational field) which is a 'thought' of the sun, and which is being 'fed' by the moon in a magnificent gesture of self-sacrifice (85, 97, 110)—shades of **Blavatsky**, Steiner and **Gurdjieff**.

I cannot summarize the whole of this extremely complex book here, much as I would like to. But I have presented enough to give its flavour. And it is evident that Barry's role as Guru is not simply to remind us that truth/life/love/God always exists and can be experienced now if only we look—what might be called his ontology. He also has a mythic anthropology—that is, a teaching about the real nature of men and women—which, like all anthropologies, is dovetailed in with a mythic cosmology: an account of the origins and nature of the universe from the beginning of time until the end of the world. He himself regards all three as an integral whole.[2]

Barry has said right from the beginning that he is practical and can "demonstrate the living truth." His method of teaching is direct encounter with people—usually a talk followed by questions. There is an excellent example in his *Journal*. During a meeting, after he had talked about how people make problems where there are none, a woman said she had cancer.

> I said, 'You indeed of all of us have what might be called a problem and the only way to deal with it, like every problem, is to be practical, straightforward, honest to yourself and the situation.'

After talking to her about the practicalities of her situation in the meeting, he kept in touch with her. Shortly afterwards, the doctors said they could do nothing more for her.

> 'What can I do now?' she asked from her hospital bed when I spoke to her on the phone. 'I don't want to die.' . . . I said, 'You must always face the fact. The possibility is that you are going to die . . . Nevertheless, I am here to speak to you, as I have done regularly over these last few months, of the fact of death and the truth of death. And I tell you (as I have always done, and you have said that you have taken

[2] This may explain his announcement of a "new focus" of his teaching in 1990: cosmic consciousness, which means having the speed of perception at which participation in the hidden life of the universe opens up. The being actually perceives and becomes a part of the universal reality which determines life on earth. The being knows and realises its part in purpose *(sic)* . . .

The divine life is what every religion and master since time began, has endeavoured to communicate to those who would listen . . . All the masters made a contribution to the possibility of cosmic consciousness on earth. Everything is an aggregate of what has come before. Cosmic consciousness is now a realisable possibility for a number of people on earth . . .

Cosmic consciousness is a reality. And I, who am cosmically conscious, can only demonstrate it every moment . . .

Cosmic consciousness is the truth that embraces all knowledge and makes it one—mythic knowledge, scientific knowledge and self-knowledge. (*Journal,* vol. 1, 1–2)

This is not quite the biggest claim made by someone in this book—that accolade goes to Master **Da,** I think—but it is close.

heart from it) that the truth of death is that there is no death. I am already in that place of death which you are going to if you die. I know it; I am it. That is why you say you receive strength speaking to me because I know not only the fact of death but the truth of it.

But the cancer took its course and she died. Barry was with her a few days before she lost consciousness.

We could only talk for about ten minutes. She was too weak. It was finished. And I wept. Not tears of grief nor of joy. I wept because there is nothing more beautiful and uplifting than to accompany another human being to the edge of existence, where death waits. The courage, the sweetness, the sheer innocence of the woman (in this case) reveals an aspect of that which can never die. The tears are of wonder and honouring, a recognition and union. Tuleka is now inside me. And I am a better man for it. That's how it is with love. (*Journal*, vol. 2, 50–53; vol. 3, 18)

This is Barry Long at his best: direct, clear, practical, generous. And he makes himself available; there is no community around him and certainly no devotees. Of course, there are those who help him in practical matters—tours, publications, and so forth—as well as those who attend his meetings regularly, but that is something different. What I mean is that he does not advocate any form of personal allegiance to him or any form of communal living for those who want to put his ideas into practice.

*Cf. the communities around Andrew **Cohen**, **Lee Lozowick**, Swami **Kriyananda**, Toni **Packer**, Joya **Santanya**, Guru **Subramuniya**— to name but six.*

Meanwhile, he continues to teach—entirely from himself and without backup of any kind. He was once asked where his motivation to teach came from. "I don't know," he replied. "I must tell everything that I discover to my fellow man" (*Journal*, vol. 3, 100). A few years ago, he made a prediction.

I am moved today to predict the future.
I'm able to do this because my heart is pure.
The future I predict is that everything I've ever done will be shouted from the rooftops.
My heart is pure since I'm not afraid of the prospect of this.
My heart is pure because a man of truth can have no secrets. (*Journal*, vol. 2, 91)

One of the distinctive things about Barry is that he puts himself on the line. He certainly has here. We will see.

Primary sources: The Origins of Man and the Universe (London: Routledge, 1984) (second revised edition, entitled *The Myth that Came to Life*, published by Barry Long Books, 1997; my citations are from the original edition); *Barry Long's Journal* (vol. 1, 1991; vol. 2, 1992; vol. 3, 1994) published by The Barry Long Foundation; I have not given details of the various pamphlets that I have quoted from because the pamphlets themselves do not include them

Secondary sources: None

Centre: The Barry Long Foundation International, Box 5277, Gold Coast MC, Queensland 4217, Australia; Barry Long Books, BCM Box 876, London WC1N 3XX, England, U.K.; Barry Long Information, P.O. Box 2042, Del Mar, CA 92014-1342, U.S.A.

COMPARE:

Other teachers who say that one's own nature is truth: Andrew **Cohen**, **Jae Jah Noh**, Jean **Klein**, John **Levy**, Bhagavan **Nome**, Toni **Packer**, **Shunyata**

Other teachers who have had successive stages of insight/teaching: Andrew **Cohen**, Master **Da**

Other teachers with a mythic anthropology/cosmology: Madame **Blavatsky**, **Gurdjieff**, Sri **Krishna Prem**

Others who have a teaching concerning 'divine sexuality': **Chris and Emma**, Joya **Santanya**

Abbot of Zen Mountain
Monastery

Loori was born in the 1940s in "a New Jersey ghetto" (*Mountain Record,* vol. 2, no. 2, Summer–Fall 1989, 12)—one of the few people in this book who comes from the working or blue-collar class. He came across Zen in the early 1970s; his first teachers were Eido Shimano Roshi and Nakagawa Soen Roshi. Then, in 1976, he met *Maezumi* Roshi and studied with him intensively at the Zen Center of Los Angeles. He must have made rapid progress because he was asked to establish Zen Mountain Monastery/ZMM in 1980. This was the beginning of his teaching duties and he has continued with them ever since. He went through the formal *zuissé* ceremony in Japan in 1987—the last stage of Dharma transmission and the one that makes someone a Dharma-heir—and was installed as abbot of Zen Mountain Monastery in 1989.

When I spoke to him in 1990, Loori said that he is the most traditional of all *Maezumi*'s Dharma heirs and the only one who is completely committed to the monastic life.[1] He agrees with most people that the three great barriers to the spiritual life are power, money and sex. He has tried to lessen their effect in the community by the following methods. There is a division of *power:* a Board of Directors deals with legal and financial matters; a Board of Governors handles general planning; and there is a Guardian Council which accepts and expels people. Loori Sensei is on the first two but not on the third. On the other hand, he does not have to accept a student unless he wants to; and he can also terminate the relationship with a student 'without cause'. But he has never done so. He also said that the bond with a student continues regardless of any behaviour: the teacher cannot abandon the student. (This may be significant given what has happened with *Maezumi* Roshi.) As for *money,* everyone is treated in the same way: all residents are given $100 a month to spend as they wish; board, lodging and teaching are free. And *sex* is kept as simple as possible: those who start training (and who must be celibate or in a stable binary relationship) cannot start new relationships; if they do, they must leave, establish the relationship, and then return.

But ZMM has social projects as well: a prison *zendo* (Loori Sensei spent time in solitary confinement in the Navy and says that the experience terrified him) and programmes for senior citizens. *Mountain Record* has carried several articles on 'Right Action'—for example by Robert **Aitken**, one of the founders of the Buddhist Peace Fellowship, on why he withholds that portion of his taxes that would be spent on arms (*Mountain Record*, vol. 8, no. 3, Fall–Winter 1989, 23–24); and by Nelson Foster, one of **Aitken** Roshi's Dharma-heirs, on how Zen "has a certain natural political bent" (ibid., 13).[2] ZMM has also hosted a number of Interfaith Retreats.

As yet, Loori Sensei has not given Dharma transmission to any of his students (unlike *Maezumi* Roshi's first three Dharma heirs, Bernard **Glassman**, Dennis **Merzel**, and Charlotte **Beck**). But he surely will. Meanwhile, his

[1] Perhaps because he was brought up a Catholic. The four Dharma heirs who preceded him did not have monasticism as part of their original religious culture: **Glassman** and **Merzel** are both Jewish; **Beck** is atheist; **Bays**, Protestant. In fact, there are only two Zen monasteries in the entire United States: Zen Mountain Monastery and Eido Roshi's Dai Bosatsu.

[2] Perhaps it is more surprising that the journal should carry a quotation from Werner **Erhard**'s Hunger Project—except that Loori Sensei told me that all of *Maezumi*'s Dharma-heirs (and perhaps others of his students as well) had been given 'scholarships' by the *est* Foundation to take the course.

'traditional' monastery, with its Interfaith Retreats and its Right Action, continues its quiet way in upstate New York.

(*See* Lineage Tree 4)

Primary sources: John Daido Loori, *Mountain Record of Zen Talks* (Boston: Shambhala, 1988); 'Lotus in the Fire: Prison, Practice, and Freedom' *in* D. Morreale, *Buddhist America: Centers, Retreats, Practices* (Santa Fe, New Mexico, 1988), 304–34

Secondary sources: None

Centre: Zen Mountain Monastery, Box 197, South Plank Road, Mount Tremper, NY 12457, U.S.A.

COMPARE:

Other Dharma-heirs of Maezumi Roshi: Jan **Bays**, Joko **Beck**, Bernard **Glassman**, Dennis **Merzel**

Other Zen teachers: Robert **Aitken**, Reb **Anderson**, Richard **Baker**, Gesshin **Prabhasa Dharma**, Zen Master Don **Gilbert**, Philip **Kapleau**, Jiyu **Kennett**, Walter **Nowick**, Ruth Fuller **Sasaki**, Maurine **Stuart**, Zen Master **Tundra Wind**

Others who provide 'social' services: the Chithurst *sangha* (prison visiting) [see Ajahn **Sumedho**], Issan **Dorsey** (AIDS/the dying), Ram **Dass** (prison, the dying and bereaved)

Lee LOZOWICK | Mr. Lee Khepa Baul

American guru who sings in his own rock 'n' roll band

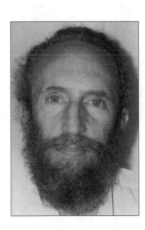

Lee is a man who attracts mixed metaphors. He plays for high stakes—and he doesn't use a safety net. He woke up one morning in 1975 and found that he was enlightened. He began to teach. Slowly, a community of devotees gathered around him; but I think it is true to say that he is more devoted to them than they are to him. His teaching style is very varied: partly serious and formal (for example, he has a traditional guru-disciple relationship with his devotees) and partly unconventional and ad-libbed (he is constantly cracking jokes, some of them fairly down-to-earth, and he is very fond of satire). He admits he can be arrogant, coarse, and presumptuous; but he also calls himself a fool of God. Not many teachers say either of these things. He aligns himself (and his community) with the Baul tradition of Bengal (and I know of no other Western teacher who does)—but he only mentioned this connection in 1985. He accepts an Indian, Yogi Ramasuratkumar, as his master—but did not meet him until a year after his own enlightenment. And then there is the rock band. He says it plays *real* rock 'n' roll and insists that the lyrics he writes (and here's a typical line: "a bitch is a bitch whether she's on the bottom or the top") are not a coded form of spirituality. But he also describes the band as "a sacred mandala" and "a tantric experiment".

So here we have a spontaneously enlightened Western Baul rock guru who says that "everything is my Father, Yogi Ramasuratkumar." This needs to be put in some sort of context.

He was born in 1943 into a Jewish family that originally came from Russia. His grandfather was a Tzaddick or religious teacher and his father, Louis, a well-known and successful artist. An account of Lee's early life, given by his students, stresses that it was "*completely* ordinary" (*Living God Blues,* 6). He collected insects, frogs and snakes as a boy, and earned his living in his twenties by dealing in stamps and coins. Then, in 1970, when he was living in New

Jersey, he discovered the Human Potential movement and quickly became an accomplished and popular teacher of Silva Mind Control. According to a student who knew him at the time,

> he was a healer, a psychic, a man of great intensity and personal power, and it was his energetic and positive approach to life which drew hundreds of people to him. (*Divine Slave Gita,* 3/4, 1983, 17; *Divine Slave Gita* is one of the Hohm community's magazines; '3/4' means 'vol. 3, no. 4')

But all this changed in 1975. Lee literally 'woke up'. This is his explanation of why.

> It so happened that from the standpoint of the all-encompassing Intelligence of the Divine Process, I possessed the required characteristic to allow Work that needed to be accomplished to be accomplished through me. Awakening didn't come to me as a result of something that I had done or learned, of a training that I had. In fact, I am nothing in it at all . . . Let's say God needed a plug and that Lee had the form and all the attributes of a working plug. That's how I found myself plugged into the engine. This is a completely impersonal process. (*Tawagoto* 5/3 and 4, 1992, 26; this article is an English translation of the chapter on Lee in Gilles Farcet's book [see 'Secondary sources' at the end of this entry])[1]

Lee has been participating in this process ever since. But his own understanding of it has developed over the years. His initial response was to shed most of the people who had been attracted to him as a Silva Mind Control teacher; to form a small community called 'Hohm' (as in 'Coming Hohm'—he is fond of puns); and to write a short but very intense book, *Spiritual Slavery* (which he has since repudiated; when I sent him this entry for his comments, he described the following quotations as "trite, embarrassing, ugly, and horrid").

> One who is realized merely lives the truth. One who is realized is just happy. Just a slave. Just happy all the time. Alive. Living God. Existing prior to all experience. Existing prior to reality. Just this. (*Spiritual Slavery,* 32)

> Just by being anything, you are God. God is wood, rock, metal, wood alcohol, rock & roll, mettle *(sic)*. God is war, death, retardation, suffering. God is love, ah sweet love, flowers, babies and your guts. So being God is no big deal. It's only living. Only living *God* is being ALIVE. And when you live God you're not free. Only ignorance is freedom. Being alive is being a slave. Being alive is having a responsibility, a commitment to all those who are merely living. God makes no judgements. God has no attributes. God doesn't give a shit whether you live or die. God isn't even conscious. None of this is sacrilege, by the way. God and I are on intimate terms. God doesn't care what I say because I live God. Anyone living God, anyone who is alive, as I am, cannot be sacrilegious. Sacrilege belongs only to the self-righteous assholes who have got religion . . . Religion is dead, it is reality . . . I am not in reality. I am Truth. (ibid., 8)

At the time, he acknowledged that the trigger for his awakening—at least in part—was the writings of another American teacher, Master **Da** (who was using the name 'Bubba Free John' at the time). Lee says that he was on the point of going to see Sathya Sai Baba in India. But

> I picked up Bubba Free John's books. I devoured them. I read every word with a

[1] *Tawagoto,* is another of the community's magazines. When I asked what it meant, I was told that Lee wanted people to find out for themselves. So I looked up the Chinese characters in a dictionary. The first one, *hsi* (= *tawa* in Japanese), means 'to play/sport/jest; a play'; the second, *shih* (= *goto* in Japanese), means 'affair/undertaking/matter/business'.

passion. I recognized truth. I didn't have to go to see him, to live with him. I am him.[2] I am Sai Baba. I am Suzuki Roshi. (ibid., 56)

And now he offers the same process himself.

> This book is me. It vibrates me. It is Alive. The very pages are Alive. The very words themselves are just happy. Every sentence is total slavery. Just this. Living God. (ibid., 56)

> The cosmic comedian, that's me. Why, I'm the jester of the spiritual circuit. I'm really very entertaining. I disarm you with my charm and then I jump inside your psyche and do my work. I enslave you (ibid., 59).

Despite Lee's later repudiation of this book—he ritually burnt it in 1991 (*Tawagoto,* 5/2, 1992, 52)—it contains the essence of his teaching. What has happened since then is really a matter of making it more available rather than adding extra ingredients (though one could say that a few extra ingredients have made it more digestible).

One could also say that more or less from the beginning Lee started looking for his place in the larger scheme of things. In 1977 (sometimes the date is given as 1976), he went to India, taking with him a list of spiritual teachers that had been provided by another American teacher, Hilda Charlton. (She should be in this book too but I just can't fit everybody in; she crops up again in **Ram Dass**'s entry.) One of these teachers was Yogi Ramasuratkumar of Tiruvannamalai (whom Hilda herself had never met), who calls himself a beggar and dresses in rags. According to Lee,

> I immediately felt a particular bond with this man . . . I realized he was my teacher, had always been, and that my awakening was, in a certain way, the fruit of his Influence, even though it hadn't happened on the level of the conscious mind but on the level of being. Starting then, I recognized him as my guru. (*Tawagoto,* 5/3 and 4, 1992, p. 23; the French original can be found in Farcet)

I shall take up the story of Lee's relationship with Yogi Ramasuratkumar later. Back in America, he brought out another book, *In the Fire,* in 1978 (co-published by Hohm Press and E.J. **Gold**'s Institute for the Harmonious Human Being; Lee and E.J. are friends). This is its first sentence: "Society is not prepared for the advent of one such as I." What he meant was that the Godman[3] or guru is the very basis of the spiritual life—and that he undermines so-called ordinary life. About the same time as he made this pronouncement, Lee introduced a formal relationship with his students.

> I can say over and over again that I am the Lord and that I exist as Grace and so on . . . Yet it doesn't really sink in when the only time that you are with me is in an informal situation, hanging out together . . . If you have to come up in a formal situation and approach me, there is a tendency to be very inhibited. Nonetheless, we are going to do it, because you need it. (*In the Fire,* 132, 133)

This formal guru-devotee relationship has remained ever since.

In 1980, Lee and the Hohm community moved from New Jersey to Arizona.

[2] But he has also been critical of Master **Da**. In 1985, the Hohm community produced a whole magazine, *Lazy Wisdom* (a skit on *Crazy Wisdom,* a magazine put out by Master **Da**'s community), which satirized Master **Da**'s way of teaching and included photos of Lee in **Da**-like poses.

[3] "The Godman is not 'under' or 'responsive' to the profound and Graceful Divine Influence or the transcendental and Inclusive God because He is It. Therefore, its effects are showered upon all who commune with the Godman even while He, the cause, may exhibit totally different, even opposite tendencies or manifestations. So it is the student's job to be vulnerable to this Influence, to accept this magnificent Gift and not to attempt to be 'like' the donor" (*The Book of Unenlightenment,* 76).

He put a huge amount of energy into his teaching. In 1980 alone he produced five books. Four years later, *Living God Blues* appeared. Apart from Lee's own writings, it contains a statement about the Hohm community by some of his senior students. Certain practices are required of those who wish to accept Lee as their master: a lacto-vegetarian diet; no artificial stimulants (alcohol, tobacco, drugs, television); daily study, exercise and meditation; giving ten percent of one's earnings to the community; following a responsible sexual relationship. These may seem restrictive but they have to be seen as a way of relating to the master:

> The conditions given to us by Lee are similar to that of any Real school . . . But because they have been offered specifically by Lee, they embody his Influence, making them different in context from any self-chosen forms of discipline. (*Living God Blues*, 29)

The practices are to be followed because "they are simply natural and appropriate aspects of our communion and friendship with the spiritual Master" and not because there is a "righteous aura of discipline or 'holiness' surrounding them" (ibid.). This means that Lee can change the conditions and they will still 'work'—because Divine Influence is still present in them. For example, meat feasts are sometimes served during community celebrations and everyone, including those who would prefer to remain vegetarian, is expected to participate. According to Lee, "You don't understand a goddamn thing about the diet if you consider the food that I serve you with my own hands 'off the diet'" (*Divine Slave Gita*, 5/4, 1985, 13).

At the time that *Living God Blues* was written, the Hohm community was made up of three levels: the Order of Divine Fools (uncommitted well-wishers); the Order of Ordinary Fools (who are following the conditions); and the Mandali—"the core of senior students who maintain the sacred space and artefacts that surround the Teacher" (*Living God Blues*, 43). It is, of course, significant that the term 'fool' is used, and that Ordinary Fools are 'higher' than Divine Fools. In fact, foolishness and ordinariness are qualities that are much prized by the community. Lee's students stress the fact that he is himself "a Master of ordinariness" (ibid., 13). And he also says that

> I *never* have any experiences. I never have any insights. I never go into samadhi. I'm never in bliss. Nothing ever happens. I just go along the same way all the time. (*Living God Blues*, 65)

But alongside this disclaimer are a number of statements that flatly contradict it. In one of his discourses, he says that Jesus was a dancer, Buddha, a sculptor and Krishna, a rogue. Then he goes on: "And I am all three . . . and then some" (*Living God Blues*, 119; dots in the original). And just in case we have forgotten, he reiterates his main principle:

> I provide an influence, a certain kind of help . . . This help is present in spite of Lee. This guy (*the Master indicates his body*) and all of his personality traits . . . have nothing whatever to do with the help I offer. (ibid., 91)

There is a photograph on the cover of *Living God Blues* of a number of Lee's students, with Lee in the middle leaning on an electric guitar. This was the first hint of his future career as a rock 'n' roller, and leads us to a consideration of his rock band, LGB (originally called the Living God Blues Band; now, using the same initials, Liars, Gods, and Beggars); his presentation of it as a Western form of the Baul tradition; and how it mediates Divine Influence.

Although LGB did not perform in public until 1986, it is evident that the ideal of going all the way, of not holding back—both of which are integral

parts of the rock 'n' roll mythology—was part of the general ambience in the community for some time before that. In 1985, they produced a pamphlet, *A Consideration of the Baul Tradition As Applicable To Our Way, the Lineage of the Church of Divine Influence*.[4] The pamphlet was a response to a remark of Lee's: "If anyone asks what our lineage is tell them we are Bauls" (*A Consideration of the Baul Tradition . . .*, 10). He pronounced it "balls"—and later his wife suggested "bowels"—but the correct pronunciation is 'Bu-ools' ('Bu' as in *butter*). No one at the ashram had ever heard of them.

And they are indeed an obscure group with something of a reputation as 'mad, bad and dangerous to know'. They arose in Bengal around the beginning of the fifteenth century and were influenced by the Sahaja tradition that was flourishing at the time. (The Sahajiyas were *tantrikas* who regarded passion as a natural expression of the Divine; the word *sahaja* means 'natural'.) They still exist today: groups of travelling musicians, ragged beggars, ecstatics; in short, hip outsiders.

Ten years after it began, therefore, the Hohm community claimed to be the Western spiritual heirs of the Bauls (*Divine Slave Gita*, 6/5, 1986, 29). This connection is essentially 'underground' rather than formal; that is, Lee did not receive transmission within the Baul tradition but rather sees himself as someone who spontaneously and independently became a Baul in America. (Though one could say that this is precisely why he is true to the Baul tradition.) Lee refers to "our lineage of beggars and fools" (*Divine Slave Gita*, 5/2, 1985, 29) and says that "I wouldn't want to be anything but a fool of God" (*Divine Slave Gita*, 2/5, 1982, p. 31).

But although the first connection with the Bauls was 'through the air' rather than on the ground, Lee soon developed contacts with them. In 1991, three of them (discoved in India by some of Lee's students) came to the ashram in Arizona. They played their own songs; but they also listened to LGB—and declared it "Western Baul music" (*Tawagoto*, 4/4, 1991, p. 48). And the leader composed a song addressed to Lee, referring to him as "guru of LGB" and "Baul of America". But he also used traditional Indian imagery to describe Lee:

> You are like Arjuna in the war of the Mahabharata
> who took refuge in Krishna,
> conquered the world and spread the dharma;
> You are like Krishna who danced in the courtyard
> when he heard the songs of Mira,
> and was overwhelmed by love for her.
> (*Tawagoto*, 4/4, 1991, p. 29)

I shall return to Lee in his 'Indian mode' in due course. Right now, I want to outline the perception of LGB as a "sacred mandala" (*Tawagoto*, 6/1 and 2, 1993, 110) and "an expression of Baul principles used in a Western context" (Hohm flier, 1989).

The band (then called The Living God Blues, Band) started performing in 1986. Its first album, *Accused*, appeared in 1989. In that same year, they went on their first tour, entitled 'Not A Pretty Sight', in the southern states of America. In 1990, a recording studio was built at the ashram. The band is very prolific—it has copyrighted more than 300 songs and brought out ten albums in five years. Everything about it is straight out of 'ordinary' rock 'n' roll

[4] We have already come across the teaching of Divine Influence; the community intended to register itself as a church in Arizona but in the event this proved too difficult and the idea was dropped.

culture: the publicity photos featuring the mean 'n' moody look; the album titles (*Love in Hell; Chthonic Boom*); the lyrics ("You walk right up beside me/Put your arms round my waist/You kiss me on the neck/With a mood I can taste . . . "). All of this amounts to what could be called 'articulate heavy rock' (though what the average rocker would make of an album called *Eccentricities, Idiosyncrasies, and Indiscretions,* it is hard to say.)

Lee constantly stresses that "we have a real rock-and-roll band . . . real blues, vital solar plexus stuff", and that there is no attempt to put over a 'spiritual' message in the songs. "We have no New Age lyrics! . . . New Age music is absolute crap. Every single piece of it" (*Tawagoto,* 2/2, 1989, 66). But what he says about the function of the band is quite different: rock 'n' roll is a way of bringing "the listener into friendship with the underworld" (ibid., 70). That is, it is a form of shamanism. A *Tawagoto,* editorial refers to "the growing shamanism of LGB as the vehicle Mr. Lee has chosen for his Work" (*Tawagoto,* 5/3 and 4, 1992, 5). And he himself has said that "the potential effect of the band has to do with Rasa Lila" (*Tawagoto,* 2/2, 1989, 84). (Rasa Lila is a term taken from a Sahajiya form of Vaishnavism and refers to the ecstasy of the gopis' love for Krishna; it is part of the Bauls' theology.)

At the same time, LGB's music is described as Workrock, defined as

> a combination of music and Mantra—of Kirtan and Koan . . . the only broadly popular cultural tool which offers the possibility of social and cultural transformation as well as release from the debased tendency of the times . . . [It] is a Compassionate action which purifies the popular music tradition and also offers the intensity of Divine Influence in an extremely attractive way. (*Tawagoto,* 3/3, 1990, 27)

So LGB is primarily concerned with making Divine Influence available—right in the middle of the most hedonistic and money-oriented sector of modern Western life. Much is made of the fact that the real test of LGB will be commercial success. It has had little so far. A short time on a German label is not what the music business normally calls success. And Lee acknowledges the difficulty: the band cannot keep an audience and it tends not to get rehired at clubs (*Tawagoto,* 4/2, 1991, 32). Yet he has predicted that LGB will be bigger than the Beatles (ibid., 29). As things stand at the moment, this is about as likely as Barry Manilow becoming heavyweight champion of the world. (No one I have played LGB's music to has been impressed; Johnny Green, who used to work with the Clash, described LGB as "like a bar-room copies band . . . no message gets through".) In the eyes of the community, however—that is, of the devotees—it is the always the larger context of the band that counts. "We the sangha must be the crucible in which the alchemical reaction of LGB takes place" (ibid., 29).

Alchemy, shamanism, Rasa Lila, sacred mandala, Divine Influence—these are perhaps what one would expect from a rock 'n' roll guru. Lee has said that there are only two ways of "accessing" him at the moment: via the band and through the traditional guru-devotee relationship (*Tawagoto,* 3/3, 1990, 28). I have dealt with the band; now it is time to look more closely at his role as a traditional guru.

The starting point has to be Yogi Ramasuratkumar. I have already told the story of how Lee met him for the first time in 1977. He has been back several times since then. On one occasion, Yogi Ramasuratkumar did not appear to recognize him (ibid., 45); on another, he was feted as one of Yogi Ramasuratkumar's favourite sons (ibid., 12) and Yogi Ramasuratkumar himself referred to Lee as 'Mr. Lee', which is the name that he now uses (somewhat augmented

to 'Mr. Lee Khepa Baul' in his latest books).[5] And in 1994, he led a *puja* held in Yogi Ramasuratkumar's honour, gave out *prasad* and blessed the Indians who had gathered there.

> The Saint from America, Lee Lozowick, Anjaneya, giving darshan in a tiny, remote and rustic samadhi/Shiva shrine in the middle of the jungle halfway up a mountain with banana and coconut groves all around. (*Tawagoto,* 7/1, 1994, 10)

The name 'Anjaneya' is another way of referring to Hanuman, the greatest of all the devotees of Ram.

One of Lee's own devotees describes Lee's attitude when in Yogi Ramasuratkumar's presence:

> . . . he is quiet, steady, never speaks unless spoken to or asked a question. His equanimity flows in equal measure to his love, which is like a clear stream, the crystal clear water of his blue eyes as they look constantly to Yogi Ramasuratkumar, whether in the form of long, loving gazes, quick, stolen glances, or simply when the eyes are lowered and the gaze is focused within. Always the eyes of the soul are turned to his Beloved. They are the eyes of Radha, of Sublime Love. (ibid., 16)

Lee himself says that when, on one occasion, Yogi Ramasuratkumar asked him to pay for a meal, this was in fact a way of "empowering me with the entire force of the tradition of Ram" (*Tawagoto,* 2/2, 1989, 49). Or to be more specific, Lee is now in Yogi Ramasuratkumar's lineage, that of the "Beggar Kings" (*Living God Blues,* 15). Again, the connection with the Bauls; and again, it is 'essential' rather than formal.

So what is Lee's function? On the one hand, he is a 'traditional' Hindu devotee.

> The first time I heard Yogi Ramasuratkumar's Name, He discovered me. The progression of my sadhana that precipitated my Teaching Work came *entirely* from His Benediction. It's the same Event that you can read about in the accounts of Ramana Maharshi, Jean Klein, Nisargadatta Maharaj, and many others. The key aspect about that Event is that it was permanent. I don't hold it in place with emotional clarity. I don't have the power and the clarity to *hold* it in place like that. It's all Him. Yogi Ramasuratkumar. It came from Him. He initiated it. He sustains it. And when He dies, it will *still* be Him. (*Tawagoto,* 7/2, 1994, 20)

But one who does not hide his twentieth century American upbringing.

> I may be pompous, verbose, exhibitionary, arrogant, presumptuous, snobbish, overbearing, cynical and exclusive among other things,[6] but my heart's in the right place: My Father Yogi Ramasuratkumar's Feet. (*Derisive Laughter from a Bad Poet,* 64)

On the other hand, he is also a 'traditional' guru.

[5]Earlier names he used include 'Saqi' (associated with the Sufi Tavern of Ruin: drunk in the ecstasy of divine intoxication) and 'EliRam', meaning 'My God, the Highest' (Hohm flier, 1984).

[6] An example might be his acknowledgements in one of his books, *In the Style of the Eccentricities, Idiosyncrasies, and Sacred Utterances of a Contemporary Western Baul,* (vol. 2), which include the following (given here in alphabetical order; the comments in brackets are his): Tenshin Reb **Anderson**, Richard **Baker** (still love the way you skewered those S.F. bums), Kirtananda **Bhaktipada** Swami, Andrew **Cohen** ("don't let the turkeys get you down"), Jan **Cox** (what can I say), R.E. **Davis**, E.J. [**Gold**] (words could never convey it all), Werner **Erhard**, Reshad **Feild** (were it not for that phone call . . . ?), Lex **Hixon**, Pir Vilayat Inayat **Khan**, I.M. **Nome** (hey Jersey boy), Leonard **Orr**, Joya **Santanya** (from loud-mouthed, street tough broad to the Mother of the Universe), **Tundra Wind**, Irina **Tweedie** (hope my sense of humor wasn't *too* offensive). And while he is critical of some teachers, he says that they still benefitted those who were open to them. "Ultimately you can get the teaching even through a flawed teacher" (*Tawagoto,* 5/1, 1992, 21).

> Whenever "I" refer to "myself", "I" never under any circumstances am referring to the limited one that everyone else sees as Lee Lozowick . . . Since the morning that there was "nobody home", since the morning that Lee died and arose as God and as the Law of Sacrifice itself, "my" references to "myself", all of them, refer to that Truth that "I" am . . . the absolute Will of God, Grace itself, and the profound Revelatory activity that is manifest as the Gift of Divine Influence through the body-mind of Lee Lozowick, the non-entity who exists as the Living Lord and connection to Infinity, the Godman. (*The Book of Unenlightenment,* 64)

Yet at the same time,

> I am making my maya so outrageous that only those who are truly turned fully to the Divine, raw and alive, will understand . . . And what is it that you are being asked to do? Only love God. Is that so unreasonable a demand? You are only being requested to love the Lord more than you love your "self". It is not an easy thing to do, yet it is so joyous, so full. For that, I prepare you so that you may know Him. That is all I do . . . (*Divine Slave Gita,* 5/5, 1985, back cover)

And this outrageousness is real. In the words of the title of an article by one of Lee's devotees: 'Just Because the Spiritual Master Lets You Call Him By His First Name Doesn't Mean He Isn't Dangerous' (*Divine Slave Gita,* 3/3, 1983, 19).

Primary sources: Lee Lozowick, *Spiritual Slavery* (Tabor, New Jersey: Hohm Press, 1975); *Beyond Release* (Tabor, New Jersey: Hohm Press, 1975); *In the Fire* (Tabor, New Jersey: Hohm Press, and Nevada City, California: I.D.H.H.B, 1978); *Zen Gamesmanship: The Art of Bridge* (Tabor, New Jersey: Hohm Press, 1980); *The Cheating Buddha* (Tabor, New Jersey: Hohm Press, 1980); *Laughter of the Stones* (Tabor, New Jersey: Hohm Press, no date); *The Book of Unenlightenment/The Yoga of Enlightenment,* (Prescott Valley, Arizona: Hohm Press, 1980); *Acting God* (Prescott Valley, Arizona: Hohm Press, 1980); *The Only Grace Is Loving God* (Prescott Valley, Arizona: Hohm Press, 1982); *Living God Blues* (Prescott Valley, Arizona: Hohm Press, 1984); [Mr. Lee Khepa Baul], *The Eccentricities, Idiosyncrasies, and Sacred Utterances of a Contemporary Western Baul* (Prescott Valley, Arizona: Hohm Press, 1991); [Mr. Lee Khepa Baul], *In the Style of the Eccentricities, Idiosyncrasies, and Sacred Utterances of a Contemporary Western Baul* (Prescott Valley, Arizona: Hohm Press, no date); [Mr. Lee Khepa Baul], *Derisive Laughter From a Bad Poet* (Prescott Valley, Arizona: Hohm Press, 1993)

Secondary sources: G. Feuerstein, *Holy Madness: The Shock Tactics and Radical Teachings of Crazy-wise Adepts, Holy Fools, and Rascal Gurus* (New York, 1991 and Arkana, N.Y., 1992), 75–79; Gilles Farcet, *L'Homme se lève à l'ouest* (Paris, 1992), 165–243

Centre: Hohm Community, P.O. Box 4272, Prescott, AZ 86302, U.S.A.

COMPARE:

Other teachers who have used 'shock' tactics: **Gurdjieff**, E.J. **Gold**, Master **Da**

Other teachers who are traditionally Hindu: **Mahendranath**, Sri **Krishna Prem**, the **Devyashrams**, the **Hare Krishna Gurus**, Guru **Subramuniya**

Other teachers who have produced their own music: Reshad **Feild**, Swami **Turiyasangitananda**

VEN. DAINO MACDONOUGH

American who was appointed as a Soto Zen teacher at a relatively early date

MacDonough was a pupil of Tobase Roshi, Shunryu Suzuki's predecessor at Sokoji, the Soto temple in San Francisco. In 1956, he founded Middlebar Monastery in Stockton, California and was made its chief priest by Rosen

Takashina, one of the leaders of the Soto school in Japan. As far as I know, this appointment was a personal one and not part of the official Soto lineage. To begin with, the monastery was affiliated with Sokoji but it became independent in 1963, when Takashina Roshi appointed MacDonough as a *roshi*—another personal transmission, I think. This may explain why MacDonough Roshi is somewhat in the margins of Western Soto despite the fact that he was the first Westerner to receive any recognition (in the West).

The monastery is "dedicated to training Americans using traditional Soto methods with Western values and language, without transplanting Japanese culture in the process . . . No retreats or facilities for women are at present available. Applicants for admission must be high school graduates, unmarried, and in good health" (Morreale, 132).

I know no more.

Primary sources: None

Secondary sources: D. Morreale, *Buddhist America: Centers, Retreats, Practices,* (Santa Fe, New Mexico, 1988), 132 (the source of this entry)

Centre: Middlebar Monastery, 2503 Del Rio Drive, Stockton, CA 95204, U.S.A.

COMPARE:

Other early Western Zen teachers: Ruth Fuller **Sasaki**, Walter **Nowick** (both Rinzai), Jiyu **Kennett** (Soto)

Other Soto teachers: Richard **Baker** (and others in his lineage), Kongo **Langlois**, Bernard **Glassman** (and other Dharma-heirs of *Maezumi* Roshi)

Murshid James MacKie

The successor of Ivy Duce as *murshid* of Sufism Reoriented

Ivy **Duce** (the information in her entry is assumed here) died in 1981, having named James MacKie (pronounced 'Mac-Eye') as her successor as *murshid* of Sufism Reoriented. The implications of this are easy to see. *Meher Baba* had promised that Sufism Reoriented would always have an illumined *murshid*. Hence the members of Sufism Reoriented were bound as lovers of *Meher Baba* to accept James MacKie as a sixth plane master. In fact, most of them have done just that—and not out of mere loyalty to *Meher Baba* but because they believe that Baba sent James MacKie to Murshida **Duce** and Sufism Reoriented, and that Murshida **Duce** knew that this was so (*Sufism Speaks Out,* 87; cf. Ivy Duce on her successor, *Gurus and Psychotherapists,* 102). The evidence for this is found both in the way James MacKie came to Sufism Reoriented and in the teachings he has given since his arrival (before and after his appointment as *murshid*).

First, his story (as he told it to me). Until the age of eight, he lived according to what he calls inner principles. That is, he did not learn to adapt to the shared reality that people construct from their personalities. Instead, he could see directly why people did things: because of the influence of deeply rooted impressions or *sanskaras*. But since other people never acknowledged these influences but spoke about their behaviour and their motives in a way which usually contradicted them, he came to the conclusion that everyone was lying. In fact, it seemed that language was designed to allow deception. So he refused to speak and as a result his parents thought he was backward. During those early years, he also had guidance from non-physical teachers. As often

happens with young children, he thought that his experience was universal—that everyone had access to inner principles and was guided by inner teachers. Then at the age of eight, he had a car crash which resulted in deep cuts in his forehead. As they healed, he became 'normal' and his perception of the inner worlds was closed off. Within two days of his physical recovery, he had learned to read.

He remained normal until middle-age. He married and had children, and became a professor of psychology, specializing in the education of unusually gifted or unusually deprived (blind, handicapped) children. Then in 1974, at the age of 42, his life changed dramatically. He found himself penniless and homeless. And one day he made an apparently inconsequential visit to two people he had just met a few hours before. They were expecting him and the door of their apartment was open. Standing in the doorway, unannounced, he saw a photograph of *Meher Baba* on the wall. He had never heard of *Meher Baba* nor had he been engaged in any kind of spiritual search. Without warning, a lightning bolt flashed from the photograph and struck him. Then the figure of a man (who was not *Meher Baba* but whom he did not recognize) emerged from behind the picture and said, "Meher Baba is God. Gather your people and take them to him." The figure then merged back into the photograph. Because of the lay-out of the apartment, the owners did not even know that MacKie had arrived and were unaware of his experience.

In the weeks that followed, a number of unusual events occurred. A book by *Meher Baba,* which he had borrowed from the people whose apartment he had visited, fell open, on more than one occasion, at passages that were almost identical to words that James MacKie had himself written some time earlier. *Meher Baba* appeared to him and told him how his life would go in the future. He was directed to teach about the spiritual path even though he had never studied it and had no external knowledge of it. He did not set out to teach; people just turned up and asked him to do so. Once, when he was alone with a psychic and healer, she suddenly said to him, "Jim, your great-grandfather is here." It was the figure who had appeared from behind *Meher Baba*'s picture. The figure was dressed in Polynesian robes and said that he was a spiritual teacher. (MacKie's father's mother was Polynesian and the daughter of this man.) The great-grandfather asked MacKie to take his name, which he has done: it is the initial 'S' in his full name and title, Murshid James S.B. MacKie. But since, according to tradition, Polynesian names are given in silence and not spoken, nobody, as far as I am aware, knows what it is. He was also told internally about Murshida **Duce** and that he was to help her in any way he could. He went to see her at the Sufism Reoriented centre and after a while, she accepted him as an emissary of *Meher Baba*. In 1979, he became one of her *mureeds*/disciples. I think it is true to say, however, that he was always an independent teacher and became her disciple only so that there should be no suggestion of rivalry between them.

There were two reasons why Ivy **Duce** was led to think that MacKie had been sent by *Meher Baba*—both of them connected with Baba's own statements. The first of these occurred when *Meher Baba* set up Sufism Reoriented and she asked him what she should teach. He replied that Sufism Reoriented would be concerned with the unwinding of *sanskaras*. When she protested that she knew nothing about this subject and asked for details, Baba replied that he would provide them when the time was right (source: James MacKie). Then in 1954, one of Murshida **Duce**'s students was talking to Baba, who told him that although she had only a few students, in future years they would

come in large numbers. Moreover, *Meher Baba* had prepared a younger man to come and help her at that time (*Sufism Speaks Out,* 10). When MacKie arrived at Sufism Reoriented, he told Ivy **Duce** that the one thing he knew about was the unwinding of *sanskaras*—and had done so quite naturally from birth but had lost this knowledge between the ages of eight and 42. (I should point out, however, that both these stories come from the Sufism Reoriented side of the disagreement that arose within the ranks of the followers of Meher Baba—see the final paragraph of this entry.)

So much for James MacKie's story. I now want to look at his teaching concerning the unwinding of *sanskaras* and the function of the *murshid* or guru. As far as the notions of winding and unwinding go, he follows the "broad generalizations" that *Meher Baba* gave in *God Speaks,* though, he says, "to my knowledge Meher Baba never released a description of the specifics of these processes" (*Sufism Speaks Out,* 23). Murshid MacKie defines winding as the learning of all possible roles; this is karma. He defines unwinding as higher learning, which involves the use of the energy stored in the winding phase. "That energy is released . . . and by spiritual living, it is reprogrammed at a higher level." Hence unwinding is the process by which one re-experiences and transmutes the countless impressions/*sanskaras* that are stored in consciousness. It is the inner journey, the return to God, the spiritual path, the reorientation of the wheel of life (*Gurus and Psychotherapists,* 9–11).

This leads directly to what Murshid MacKie says about the function of the spiritual teacher.

> . . . Gurus are identified and defined according to their expert knowledge and skill in the subject matter of winding and unwinding (*Conversations with a Western Guru,* 50).[1]

More specifically, a spiritual teacher—that is, a true guru—can actually see in every detail the structure of the ego or, in James MacKie's words, the "sanskaric structure of the personality" (which is not the same as the aura or the spiritual body). Murshid MacKie describes these subtle tissues as like "an almost translucent, flexible, loosely woven net" which interpenetrates a baby's physical body when he is born. This net of tissues acts as a blueprint or armature (the three-dimensional shape which serves as a support in large sculptures) around which are wound the impressions of that individual's life in the form of *sanskaric* threads of subtle matter. Hence, as a person interacts with his environment (which includes his own physical body and "any events that register in his internal or external world"), the ego is woven around him like a cocoon which selects a particular range of energies out of the vast number that make up the living body of the creation; and as a consequence, that person has a corresponding range of awareness that determines the experiences that he is capable of. It is this "sanskaric structure of personality" that a guru can see in every detail (*Conversations with a Western Guru,* 66–69).

The specific task of a guru is to aid in the unwinding of these *sanskaric* threads (*Principles of Human Growth [Unwinding],* tape 1, side 2). He can do this because he himself has no personality—he just appears to have one. As a consequence, he can take on many different roles at different times and places (whereas most people, who are still in the winding stage, are stuck within cer-

[1] Murshid MacKie told me that this book, which is attributed to Murshida **Duce** and himself on the title page—but to Murshida Duce alone in the Introduction (p. 7)—is in fact his work (though written at her request on topics she selected).

tain roles because of the *sanskaras* that form their personality); and he can understand every role (*Gurus and Psychotherapists*, 57, 61).

In a taped talk on winding and unwinding, Murshid MacKie makes the same point in different terms.

> The reason you can't swiftly return to God is that you have to have the energy to propel you on that journey. That energy is already coded in your consciousness [as *sanskaric* threads gathered in the winding phase] . . . It must be melted to provide the nuclear force for expanded understanding of higher learning. There is a physics to this. And some people know the physics. (*Principles of Human Growth [Winding and Unwinding]*, tape 1, side 2)

In short, the guru/*murshid* has a divine role.

> A spiritual teacher . . . does work for God . . . in harmony with the spiritual hierarchy so that that work has a global importance. (*Gurus and Psychotherapists*, 37)

And since the process of unwinding is, by definition, the removal of ego and the emergence of love,

> the only thing of value is love. It has many levels and it is the source of all qualities that are truly spiritual. The force of love is so strong that one cannot manage it on one's own. One is bound by a living channel of life to other beings and, especially, often a central being—a guru. People are tied in their awareness to that being who helps balance and channel that love . . . This love of God demands for physical survival, a guru. People who have not had this experience could not believe it. But there will come a time when they do. (*Principles of Human Growth [Unwinding]*, tape 1, side 2)

There is thus an extremely intimate relationship between all of the following: the process of unwinding, spiritual learning, travelling the spiritual path, the emergence of love, and the divine role of the guru. They are all part of the very design of the creation as outlined by *Meher Baba* (as Murshid MacKie presents it, that is).

All this is the subject matter of Sufism and of Sufism Reoriented as established by *Meher Baba*.

> The Avatar speaks his message with his heart. Spiritual learning does likewise. Sufism is just this. (*What is Sufism?* side 1)

Hence it follows that Sufism Reoriented is an instrument of *Meher Baba*'s universal work.

> Meher Baba wanted a core of Sufis to do his work and said he would provide as their integrator, a murshid, a guide, a teacher, a guru . . . Sufis have a certain charge; their leader has a certain charge. (*What is Sufism?* side 2)

It is thus a combination of three factors that has led members of Sufism Reoriented (all of whom, remember, consider themselves to be followers of *Meher Baba*) to accept James MacKie as an illumined *murshid*—just as *Meher Baba* promised. These factors are: the way in which he came to *Meher Baba* (and subsequently to Ivy Duce and Sufism Reoriented); his teaching concerning the unwinding of *sanskaras;* and in particular, the clear implication that he can see the *sanskaric* threads and therefore help people in the process of unwinding (which is, by definition, the process of returning to God).

But all this is by implication; he does not actually make these claims for himself. When he was asked, in 1979, if he had any ideas about his spiritual status, he replied "that the matter did not interest me and I couldn't imagine a

circumstance in which it would" (*Sufism Speaks Out,* 23). It is worth noting, however, that he was formally a disciple of Murshida **Duce** at this time; and he does refer to her as an "incarnate guru" (*Sufism Speaks Out,* 25).

Some of Murshid MacKie's students are much more explicit in their views, however. Not only do they accept that he must be an illumined *murshid* (a sixth plane master or Pir), but at least some of them believe that he is a seventh plane master—that is, a Perfect Master or Sadguru or Qutub (which *Meher Baba*'s Charter for Sufism Reoriented also allows for—see Murshida **Duce**'s entry again). This assessment is based on the distinction that *Meher Baba* himself made between sixth and seventh level masters in a letter to Ivy **Duce** in 1948 (actually written by a disciple but at Baba's direction).

> . . . in the domain of Perfection of the seventh plane of God-realization (the Qutub), the question of initiation and discipleship doesn't arise. Every atom of the universe is equidistant from the center, the Qutub, around which everything and everyone revolves . . . A master of the fifth and sixth planes (still laboring in the domain of duality) teaches an aspirant to earn Illumination by self-exertion, while the Perfect One, the Qutub, bestows on the aspirant by way of a gift his divine grace, for which the only condition necessary is to establish a link or connection with him by self-surrender. (Ivy Duce, *How a Master Works,* 718–19).

In a letter to me, the president of Sufism Reoriented has pointed out that while Murshida **Duce** did carry out formal initiation and prescribe spiritual practices, Murshid MacKie has done neither. Rather, his emphasis is on surrender and the unwinding of *sanskaras.* The clear implication of this comparison is that James MacKie is a God-realized Perfect Master/Qutub/Sadguru.

This is an extraordinary claim. *Meher Baba*'s teaching on the nature of a Perfect Master is that he has completely integrated divine and human consciousness so that he knows that he is God while still functioning in the creation; this state is called Baqa-Billah in Sufism or Sahaj Samadhi in Vedanta (Meher Baba, *God Speaks,* 297). The Perfect Master has infinite power, knowledge and bliss, and uses them to be simultaneously

> in all the universes and in all the worlds, on all the levels and on all the planes, living the life of 'One and All'. His life is that of living also on particular levels and on particular planes *as every creature.* [my italics] (*God Speaks,* 151)

This attribute of simultaneous infinity is shared with the Avatar (*God Speaks,* 160). Moreover, Perfect Masters, like the Avatar, "perform Universal Work . . . to free souls from sanskaras" (Meher Baba, *The Nothing and the Everything,* 189). Indeed,

> from the point of view of fundamental characteristics of consciousness and the nature of the work in creation, the Avatar is like any other Sadguru. (Meher Baba, *Discourses,* iii, 27)

There are only five Perfect Masters in the world at any one time and between them they control the universe (Meher Baba, *Listen Humanity,* 60–61; *Discourses,* iii. 27). Their characteristics are: that they love all creation, regardless of beauty and ugliness, wisdom and idiocy, health and disease; that they radiate bliss, "an atmosphere that a stranger in search of it cannot help feeling"; that they can adapt to any level of humanity, "as nonchalant on a throne as in a gutter" (*God Speaks,* 262).

> The Sadgurus work (annihilate sanskaras)
> to make other men immortal like themselves,
> meaning Realization comes to many people from their hands.

The Sadgurus maintain a continual flow of Self-Realized beings,
and this continual flow of immortal men and women
keeps the minds of others clean and pure,
especially the minds of those
in the Master's intimate contact. (*The Nothing and the Everything,* 194)

One of these Perfect Masters is Murshid James MacKie and those in intimate contact with him are the members of Sufism Reoriented in Walnut Creek, California.

This claim has not gone unchallenged. In 1980, some of those who had been closest to *Meher Baba* during his lifetime (all of them Indians, though they had Western supporters) issued a number of letters suggesting that Sufism Reoriented had lost its way and that James MacKie was a false saint (*Sufism Speaks Out,* 13). Murshida **Duce** replied to these charges and issued a booklet, *Sufism Speaks Out: Sufism Reoriented Replies to Attacks from India*—the title says it all. But she died shortly afterwards, having named MacKie as her successor. I cannot go into all the ins and outs of this dispute here. I simply mention one striking fact: that it is an American who is being presented as the one who truly understands and follows *Meher Baba*'s instructions, and Indians who are held to have misunderstood it. This is happening more and more frequently—in all traditions—and it is an integral part of the growing independence of the West.

(*See* Lineage Tree 8)

Primary sources: Ivy Duce and James MacKie, *Conversations with a Western Guru: The Termination of the Golden Age of the Ego and the Beginning of Spiritual Awareness* (Lafayette, California: Searchlight Seminars, 1981); Murshida Ivy Duce and Dr. James MacKie, *Gurus and Psychotherapists: Spiritual versus Psychological Learning* (Lafayette, California: Searchlight Seminars, 1981); [no author] *Sufism Speaks Out: Sufism Reoriented Replies to Attacks from India* (Walnut Creek, California: Sufism Reoriented, 1981); *tapes* (all available from Searchlight Publications at the address below): James MacKie, *What is Sufism?; Principles of Human Growth (Winding & Unwinding); Principles of Human Growth (Unwinding);* [works by Ivy Duce and Meher Baba are cited in their entries]

Secondary sources: None

Centre: Sufism Reoriented, 1300 Boulevard Way, Walnut Creek, CA 94595, U.S.A.

COMPARE:

Other Western Sufis: Ivan **Agueli**, Abdullah **Dougan**, Reshad **Feild**, Lex **Hixon**, René **Guénon**, Rabia **Martin**, Frithjof **Schuon**, Idries **Shah**, the **Sufi Movement and the Sufi Order** (group entry), Irina **Tweedie**

Leon MacLaren

Head of the School of Economic Science who joined the Work soon after **Ouspensky**'s death and went on to teach a form of Hinduism

This entry is based on a single source: *Secret Cult*, a book written in 1985 by two journalists, Peter Hounam and Andrew Hogg. They have little interest in either the Work or Hinduism, and less sympathy. The book is part-investigative reporting (so they have unearthed some useful material) and part-public exposé (so it is shot through with righteous indignation—staple fare in British journalism). Since I am interested in both the Work and Hinduism, I have eliminated the 'shock horror' element and stuck to the facts as best I can. Even so, an account of a teacher and his school that is drawn from such a source has

obvious drawbacks and these should be borne in mind when reading what follows.

Leonardo de Vinci MacLaren was born in about 1911 (*Secret Cult*, 36; Hounam and Hogg do not give the exact year). His father was Andrew MacLaren, M.P. for Burslem, in Staffordshire, from 1922 to 1945 (with two short gaps amounting to a total of five years) and a fervent supporter of an economic theory that held that wealth could be most easily redistributed by taxing land rather than income. Andrew Maclaren founded the School of Economic Science/SES in the mid-1930s in order to interest people in Land Reform tax.

To begin with, it appears that Leon, who was a practising barrister, had every intention of following in his father's footsteps. He stood for Parliament, unsuccessfully, on three occasions; and when his father left the Labour Party and went over to the Liberals, so did he. He also took an interest in SES and took over the running of it in 1947.

But in fact he differed from his father on one important point: he was convinced that it was human beings, rather then the tax system, that needed to be changed. He began to look for a system of thought that would achieve this aim and came across the **Gurdjieff** Work; in fact, a particular branch of it as taught by Dr. Francis Roles, a Harley Street consultant who had been a loyal follower of **Ouspensky** and his personal physician (but had never met **Gurdjieff**). Roles's group was called The Society for the Study of Normal Man or The Study Group. It was founded in 1951 (Webb, 477) and was one of the factions that sprang up after the death of **Ouspensky** (in 1947) and **Gurdjieff** (in 1949), looking for a direction. Hounam and Hogg do not give the date that MacLaren joined the Study Group but it must have been in the early 1950s. He was an enthusiastic member and quickly became a group leader himself. And the essential teachings of the Work—man is asleep and needs to wake up; the distinction between essence and personality; the need for a real 'I' that can really 'do'—were fed into the courses at SES (*Secret Cult*, 41).

One of the reasons for the splintering of **Ouspensky**'s group was **Ouspensky**'s conviction that **Gurdjieff**'s teaching was incomplete. So after his death, some of his leading followers set about trying to find the missing element, the lost chord. (J.G. **Bennett**, for example, tried Subud and Sufism, while Rodney **Collin** ended up with a form of esoteric Catholicism.) In 1959, the Maharishi Mahesh Yogi, founder of Transcendental Meditation or TM, came to London and started giving teachings and initiation. The Study Group, with Roles and MacLaren in the vanguard, went along to investigate and were soon convinced that this was what they had been looking for.

However, in 1961, both Roles and MacLaren went to India, in order to study and meditate further, and came across the Shankaracharya of the North (*Secret Cult*, 42, 193). (Hounam and Hogg do not say how.) This was Swami Shantananda Saraswati[1] and he had been a disciple, with the Maharishi, of the previous Shankaracharya, Swami Brahmananda Saraswati (who died in 1953 [Barker, *New Religious Movements*, 214]). They came to regard the new Shankaracharya (Shantananda Saraswati) as the true teacher and so transferred their allegiance from the Maharishi to him. On their return to Britain, later in 1961, they founded the School of Meditation in London for the express

[1] A book of his has just appeared: Shantanand (*sic*) Saraswati, *The Man Who Wanted to Meet God: Myths and Stories that Explain the Inexplicable* (Element Books, 1996).

purpose of teaching TM. The Maharishi saw this as a form of poaching and the relationship between himself and the Study Group ceased. But his method of meditation—the silent repetition of *mantras*—was continued. SES uses it to this day (*Secret Cult,* 101).

Some years later, probably around 1966 or so, the Study Group and SES also parted company, though both remained committed to the Shankaracharya (*Secret Cult,* 45–46).[2] From that time on, SES became an independent group, led by MacLaren, and promulgating his version of what might be called brahminical Vedanta, a term I explain shortly.

SES was made an educational charity in Britain in 1964. And it also has 'branches' in other countries: Hounam and Hogg list Australia, New Zealand, America, Canada, Greece, Cyprus, Malta, Belgium, Holland, Spain, Ireland, South Africa, Trinidad, and Fiji (*Secret Cult,* 58). It is called 'The School of Philosophy' in Holland and Australia—actually, its Dutch name is 'School voor Filosofie'—and the Practical Philosophy Foundation in the United States. None of them advertises the fact that they teach a form of Hinduism nor that they adhere to certain ideas taken from the Gurdjieff-Ouspensky Work: for example, the notion that so-called normal consciousness is really a kind of sleep (ibid., 151). Some of those who are prominent in these branches were previously in **Ouspensky** groups (ibid., 75).

The position of the Shankaracharya in SES is, of course, vital. So we need to be clear about it before looking at what MacLaren has taken from him. There are traditionally four Shankaracharyas (of the North, East, South and West), each of whom is the head of a monastery that tradition ascribes to the original Shankara in the 8th century.[3] The role of a Shankaracharya is entirely orthodox: he is always a brahmin and fulfils all the the brahminical duties and rituals; he is also a renunciate or *sannyasin,* hence the title 'Swami'. He is constantly in the public eye and has many social obligations; a bit like an archbishop or cardinal (though such comparisons should not be carried too far).

Now on to what the Shankaracharya teaches: brahminical Advaita Vedanta. The Vedanta part is simple and profound at the same time. There is only one reality, beyond all attributes and utterly ungraspable. It is called Brahman—an untranslatable term but people try anyway; 'the Absolute' is used by many, including SES. Brahman is covered by a veil of illusion called *maya.* (How this could happen, given that Brahman is one and indivisible, is a metaphysical issue of the most rarefied kind and I shall not go into it.) But *maya* is not arbitrary; on the contrary, it is entirely lawful. It gives rise to all the myriad forms of the manifest universe and imparts to them their true nature. This principle of lawful manifestation includes every aspect of human life: food, dress, social relationships, and the structure of society. All of these are specified in the greatest detail by what we could call the Shankaracharya tradition—that is, by brahminical Vedanta. The essential principles that govern human life, according to this tradition, are purity and discipline; and it is these two together that constitute the brahminical side of the Shankaracharya's teaching.

[2] At this point, I leave Roles and continue with Maclaren solo, so to speak. But Roles is worth following up. I have found a few statements about him in Joyce Collin-Smith, *Call No Man Master,* (Bath, England, 1988): that he was given "the power to initiate by Maharishi Mahesh Yogi" (143); that Roles met Swami Shivananda in India and abandoned the Maharishi for him (147); and that at some later date (which Collin-Smith does not give), he introduced the Mevlevi whirling dervishes to his groups (158). I simply do not have the time to pursue these leads.

[3] And I should say, just for the record, that according to Paramahansa *Yogananda,* who brought *kriya yoga* to the West in the 1920s, the original *kriya yoga* guru, Babaji, was also Shankara's guru—see *Yogananda*'s entry.

This double teaching—the philosophy of Advaita Vedanta and the brahmin-ical way of life—is expressed in SES by the term 'Measure'. That which is in harmony with reality is said to be 'in accordance with Measure'. This is prob-ably a version of the Hindu term 'Dharma', which has a vast range of mean-ings: 'ordinance, decree, law; customary observance, prescribed conduct'. The form *dharmena,* literally, 'in accordance with Dharma', can be translated 'according to right or rule', and thus 'rightly', and also 'according to the nature. [of a thing]'. All these ideas can be subsumed under the notion of the lawful expression of reality; and this is certainly what 'Measure' is concerned with. But it is not a translation of 'Dharma' and I do not know the full explanation of why 'Measure' is used.

In the SES community, Measure includes a vegetarian diet; a 'traditional' form of dress (long skirts for the women, dark suits for the men) made from natural fibres; particular views about the differences between men and women, and how they should behave towards each other; and an educational programme—SES has three schools—that emphasizes Sanskrit, Vedic mathe-matics and 'traditional' Hindu history and geography (*Secret Cult,* Chapter 7). (There are considerable similarities here with the schools run by ISKCON—see the entry for Shrila *Prabhupada;* this is somewhat ironic, given *Prabhupada*'s total rejection of the 'impersonalist' school of Advaita Vedanta.)

The philosophical terminology behind all this is quintessentially Hindu: the four disciplines of discrimination; renunciation; the six treasures (calmness, self-control, the self-sufficiency of Inner Being (or Atman), forbearance, con-centration, and faith); and the longing for liberation. A whole book could be written on these—and whole libraries exist in India that are devoted to noth-ing else. But all we need to know here is that these disciplines are *sattvic* qual-ities—*sattva* being the attribute of purity and lightness which automatically seeks out truth. In fact, one could say that *sattva* has been the defining char-acteristic of the brahminical culture of India for centuries. It is this way of life—restrained, disciplined and rigorously defined by Measure/Dharma—that MacLaren has introduced into late twentieth-century Western society.

A few further details concerning this way of life may be of interest. Not only is the diet vegetarian, it is practically restricted to raw food (*Secret Cult,* 20); and only four different foods may be eaten at one time (ibid., 33). Refrigerators are not used because they kill the life force. Some of this is certainly brahminical. But much of the diet is justified by reference to *The Essene Gospel of Peace,* an English 'translation' of an otherwise unknown Aramaic manuscript by Edmond Szekely, which presents Christ as teaching vegetarianism. Needless to say, this text was not known to Indian brahmins—or to anybody else, for that matter, until Szekely published his translation. (It has been argued, to my mind quite convincingly, that Szekely wrote the whole thing himself.)

SES also follows brahminical tradition in its understanding of women and children. Women are said to be incarnations of Lakshmi, according to the Shankaracharya (*Secret Cult,* 192); but on the other hand, they are also held not to develop discrimination—vital for following the spiritual path—until the age of 32. Children are to be protected from all unsavoury influences, includ-ing pop music (ibid., 210); on the other hand, boxing was compulsory at the SES schools (ibid., 189). Admittedly, this was only for the boys—but they did start at the age of four. (Cf. ISKCON again, which favours wrestling for boys in its schools because it is a 'Vedic' sport.) There is some evidence that MacLaren arranged marriages for 16-year-old girls—preferably with men who were seven years older (ibid., 147). (ISKCON does this, too.)

Hounam and Hogg suggest that although all of this is Hindu, the Shankara-charya himself probably had little knowledge of how MacLaren was making use of it. According to a defector from SES, the interviews MacLaren has with the Shankaracharya are just general 'audiences' such as one might have with the Pope, and are confined to discussion of basic principles. But MacLaren passes on what the Shankaracharya says in a particular form:

> The material which the students are given . . . is changed to fit in with the ideas of the School [i.e. SES]. Simple things such as "tell your people" will appear in the material as "tell the members of your School"; "a guru teaches his students" will appear in the material as "a guru or a School such as this teaches its members". These are very simple examples to illustrate the way in which the teachings of the Shankaracharya are used to give members of the SES the impression that His Holiness has chosen the School and is giving it special knowledge to save mankind. (*Secret Cult,* 93)

Given that this is so, there are at least three significant consequences. First, it is MacLaren who is the guru rather than the Shankaracharya. Most SES members never meet the Shankaracharya or ask him questions. And they are certainly not initiated by him. Everything is mediated through MacLaren.

Secondly, as an extension of this point, it is extremely unlikely that the Shankaracharya knows that his teachings are fused with those of **Gurdjieff** and **Ouspensky**. Admittedly, they are heavily adapted—the Law of Seven, for example (*Secret Cult,* 89), or the enneagram (ibid., 173)—but they are there. It is also unlikely that he is aware that SES teaches that the ideal human society has seven layers, including law-givers such as Abraham, Moses, Socrates, and Plato (at level 6); exponents of 'natural law' such as Shakespeare, Mozart, and Newton (at level 5); and upholders of tradition such as Alfred the Great, Winston Churchill, and Blackstone, the nineteenth-century legalist (at level 4) (ibid., 104). How many of these would have passed the brahminical *'sattvic'* test is a moot point.

The third consequence is the notion of SES's special place in the world order, which is almost certainly MacLaren's own contribution. True, traditional Hinduism does say that if the Dharma/Measure is not followed, then civilization will fall into decay. But the standards of behaviour are publicly proclaimed; there is nothing secret about them or the groups who follow them. There is absolutely no reason why there should be. By contrast, it is a decidedly Western idea—very common in esotericism—that there are secret societies whose purpose it is to keep alive something precious that will save the world. According to one defector, MacLaren holds that SES is run according to the Divine Will (*Secret Cult,* 124). And he links it with such illustrious forebears as Plato and Masilio Ficino, the Renaissance Hermeticist (ibid., 102, 109). He appears to think that there is an ancient knowledge, preserved in its purest form by the Shankaracharya tradition but also discoverable in part in Western esotericism (and that includes **Gurdjieff** and **Ouspensky**).

Yet there is a decided ambivalence in SES's attitude towards society—Western society, that is. It is in such a parlous state, having lost contact with the truth, that it is imperative that it be put back on the right track again. So SES sees itself as having that responsibility. On the other hand, SES cannot come right out and say so. It has to remain secret—because society is so off-beam that the normal institutions, such as schools, government, and so forth, are not susceptible to overt action. In effect, SES is itself a secret society, with a number of layers—some of which are themselves hidden from run-of-the-mill members (*Secret Cult,* 55).

This ambivalence explains SES's social programme: it wants to change society—but by covert, underground action. According to Hounam and Hogg, SES members were prominent in the Gladstone Club and in the Centre of Industrial and Commercial Policy, both ginger groups within the Liberal Party (*Secret Cult*, 224). But nobody knew. Whether one regards this with disquiet or mild curiosity depends to a large extent on one's general view of the way Britain is governed. It does not seem, on the face of it, that SES has had much of an effect on British politics.

But the belief in the need to change society remains strong in SES. According to one member,

> We haven't got long to put things right. We see ourselves as being ready to take over when the time comes. (*Secret Cult,* 230)

Another (as reported by a defector) said that SES (actually, the School of Philosophy, its Australian form)

> was the bridge between the inner and outer circles of mankind, and without it mankind's energy would run down. The School of Philosophy was . . . the Absolute's instrument for the salvation of humanity. *(Secret Cult,* 277)

This idea of the Inner Circle of Humanity is found in the Ouspenskian form of **Gurdjieff**'s teaching (see his entry and those of **Bennett** and **Collin**) and has been adopted by MacLaren. According to one ex-member, people in SES were led to believe that

> they were approaching admittance to the Inner Circle of Mankind which was supposed to contain such company as Jesus Christ, Buddha, Muhammad, the Maharishi and, by implication, Leon MacLaren, Dr. Roles and approved artists such as Mozart and Leonardo da Vinci. (*Secret Cult,* 149)

Given that he is a member of the Inner Circle, it is not surprising that MacLaren is called 'Master' by some SES members. In effect, he is seen as the embodiment of Measure/Dharma—itself an idea that he has turned into a hybrid of brahminical Vedanta, TM, Western esotericism and Ouspenskian philosophy.

As I said at the beginning, Hounam and Hogg's primary concern is to show that SES, as led by MacLaren, is a cult in the worst sense of that term: involving brainwashing, exploitation and just plain bullying. They quote extensively from interviews with disenchanted members who say exactly that. My aim is different, however: to show how the search for the origins of **Gurdjieff**'s teachings, itself an idea created by **Ouspensky**, led to a form of Hinduism; that a traditional and essentially conservative way of life—brahminical Vedanta—was then introduced into the West, allied to certain notions of Western esotericism; and that this way of life has influenced thousands, possibly tens of thousands, of people in Europe, America and Australia.

This is one of the most unusual voyages in this book: undoubtedly exotic but also somewhat wayward. It has great aims but cannot declare them. One is bound to say that so far it has promised considerably more than it has delivered. This is not a very large boat and it has got into difficulties more than once. (A full-length exposé, such as Hounam and Hogg's, does not make for plain sailing.) Perhaps it is not so very seaworthy after all.

(*See* Lineage Tree 3)

Primary sources: None by MacLaren—at least, nothing public that I have discovered; but I have come across *The Letters of Masilio Ficino* (in at least 4 vols), tr. from the Latin by members of the Language Dept. of SES, Shepheard-Walwyn, London, 1988 [the date of vol.4]

Secondary sources: P. Hounam and A. Hogg, *Secret Cult* (Tring, Hertfordshire: Lion Books, 1985); a few remarks in Webb (for whom, see the end of Gurdjieff's entry)

Centre: The School of Economic Science, 90 Queen's Gate, London SW7 5AB, England, U.K.

COMPARE:

Other exotic teachers of the Work: J.G. **Bennett**, Rodney **Collin**

Other teachers with tangential connections with the Work: G.B. **Chicoine**, Jan **Cox**, E.J. **Gold**, Oscar **Ichazo**, Idries **Shah**

Other Western teachers who are allied with a Shankaracharya: the **Devyashrams**

Other Westerners who teach Advaita Vedanta in some form: Paul **Brunton**, John **Levy**, Jean **Klein**, Bhagavan **Nome**

Other Western Hindu teachers: Swami **Abhayananda**/Bill Haines, Sister **Daya**, Sister **Devamata**, Sri **Daya Mata**, Swami **Kriyananda**/Donald Walters, Goswami **Kriyananda**/Melvin Higgins, Sri **Krishna Prem**, Guru **Subramuniya**, the **Hare Krishna Gurus**, Swami **Radha**, **Shankar Das**, **Yogeshwar Muni**, Sri **Mahendranath**

O.K. MACLISE | SANGYE NYENPA RINPOCHE. SEE *TULKUS*

JOANNA MACY

American Buddhist and social activist

Macy was born in Los Angeles in 1929 but grew up in New York. She has been engaged in social activism of one kind or another ever since her college days. Her first contact with the East occurred in 1964 when she went to India with her husband and their three children. She worked with the Tibetan refugees and met Freda **Bedi**/Sister Palmo, who became her first teacher. She also had a spontaneous experience in a train.

> . . . suddenly it was utterly self-evident that I did not exist in the way I thought I did . . . And the sense then was of unutterable relief, of: "I don't need to do anything with the self, I don't need to improve it or make it good or sacrifice it or crucify it— I don't need to do anything because it isn't even there. All I need to do is recognize that it's a convention, a fiction."
>
> There was an immense feeling of release, and with that release came at once, immediately, a feeling that it was release into action. Right away the thought came: "this will now permit us to risk and to act on behalf of all beings." It seemed a total fit with all the need I had seen for social justice. (Bancroft, 5)

Essentially, she sees the idea of interactive systems, which constantly influence each other, as a natural expression of the Buddhist teaching that all 'things', from galaxies to snow flakes, from civilizations to thoughts, are brought into existence, maintained in a certain state, and then cease to exist because they are supported by certain conditions. This means that the self— who we are—is constantly fluctuating depending on what kind of interaction we are engaged in. But such interaction also gives us something.

This interdependent release of fresh potential is called synergy. It is like grace, because it brings an increase of power beyond one's capacity as a separate entity. (*Tricycle*, 71; taken from *World as Lover, World as Self*)

And by the same token, we can also give something back ourselves.

Her activities over the past 20 years have been very varied. She and **Aitken** founded the Buddhist Peace Fellowship (along with Richard **Baker**, Jack **Kornfield**, and Gary Snyder) in 1978—the same year that she completed her doctorate at Syracuse on the Buddhist teaching of *paticca-samuppada* (conditioned co-arising) and systems theory. In 1979, she received a Ford Foundation grant to go to Sri Lanka and study the Sarvodaya self-help movement, which originated with Gandhi but was adapted by a Sri Lankan, A.T. Ariyaratne, in the 1950s.[1] She has also worked with Thich Nhat Hanh, the founder of 'Engaged Buddhism', and has developed ideas concerned with deep ecology—including the splendidly named 'Council of All Beings'—and what she calls 'social mysticism':

> The loving happens through me. I don't have to dredge up, out of my meager supply, enough caring and enough compassion [to do it] . . . It's there, it's inherent in the web already. (*Tricycle*, 71)

*It is the ideal of the **arya** sangha.*

This is a noble ideal. As we might expect, Macy proposes it independently of any specific organization, lineage or tradition. There is no Joanna Macy Foundation. Her teachers have come from the Theravadin, Tibetan, and Zen traditions but she herself does not teach from any of these standpoints—though she may draw on them. All this, of course, is entirely consistent with her fundamental idea of interconnectedness: there does not have to be a centre for things to hold together.

Primary sources: J. Macy, *Dharma and Development: Religion as Resource in the Sarvodaya Self-help Movement* (Connecticut: Kumarian Press, 1985); *Despair and Personal Power in the Nuclear Age* (Philadelphia, 1983); *World as Lover, World as Self* (Berkeley: Parallax Press, 1991); 'Positive Disintegration: An Interview with Joanna Macy', *Tricycle*, vol. 2, no. 3, Spring 1993, 68–73; 'Buddhist Approaches to Social Action', *Journal of Humanistic Psychology*, vol. 24, no. 3, 1984, 117–129

Secondary sources: L. Friedman, *Meetings with Remarkable Women: Buddhist Teachers in America* (Boston, 1985); Sandy Boucher, *Turning the Wheel: American Women Creating the New Buddhism* (San Francisco: Harper and Row, 1988); A. Bancroft, *Weavers of Wisdom: Women Mystics of the 20th Century,* (London, 1989)

Centre: None (see my final remarks) but the following should find her: c/o California Institute of Integral Studies, 765 Ashbury Street, San Francisco, CA 94117, U.S.A.

COMPARE:

Other women Buddhist teachers: Sensei Jan **Bays**, Joko **Beck**, Freda **Bedi**, Ruth **Denison**, Rev. **Dharmapali**, Roshi Gesshin **Prabhasa Dharma**, **Karuna Dharma**, Jiyu **Kennett**, Ayya **Khema**, Dharma Teachers Linda **Klevnick** and Linda **Murray**, **Miao Kwang Sudharma**, Pema **Chodron**, Dharma Teacher Bobby **Rhodes**, Ruth Fuller **Sasaki**, Irmgard **Schloegl**/Ven. Myoko-ni, Maurine **Stuart**, Dhyani **Ywahoo**

[1] 'Sarvodaya' means 'the uplift of all' and this is how Gandhi used it; Ariyaratne interpreted it in a more Buddhist sense to mean 'the awakening of all'. The aim of the movement was to help poverty-stricken and exploited communities by paying as much attention to environmental and 'spiritual' concerns as to clean water and decent accommodation.

Taizan MAEZUMI

Japanese Zen teacher, founder of the Zen Center of Los Angeles (ZCLA); has established an American lineage

*Maezumi Roshi was born in 1931 and studied with his father, a Soto priest, and with Koryu Osaka Roshi, a lay Rinzai teacher. Both gave him Dharma transmission. In 1956, Maezumi went to Zenshuji, the Soto temple in Los Angeles, which, like all Zen temples at that time, was frequented only by Japanese Americans. But as with Sojoji, Shunryu Suzuki's centre in San Francisco (which later branched out into the San Francisco Zen Center), the Los Angeles temple began to attract Western students. One of the first was Bernard Tetsugen **Glassman,** who started practising* zazen *with Maezumi Roshi in 1968. A year later, Maezumi founded the Zen Center of Los Angeles/(ZCLA),[1] separately from Zenshuji (which still caters for Japanese Americans). In 1970, the same year that Maezumi received Dharma transmission from* Yasutani *Roshi in Japan, he ordained* **Glassman** *a priest at ZCLA. Seven years later, he appointed him as his first Dharma-heir.*

In all, Maezumi Roshi has twelve Western Dharma-heirs: **Glassman,** *Dennis Genpo* **Merzel,** *Charlotte Joko* **Beck,** *Jan Chozen* **Bays,** *John Daido* **Loori,** *Gerry Shishin Wick, John Tesshin Sanderson, Alfred Jitsudo Ancheta, Charles Tensin Fletcher, Susan Myoyu Andersen, Nicolee Jiyo Miller-McMahon and William Nyogen Yeo. Between them, they have in their turn given Dharma transmission to nine of their own students (Kanzeon Sangha UK Newsletter, vol. 1, no. 2, Summer 1995). The collection of temples and centres which they run, together with ZCLA and other groups directly under Maezumi's tutelage, is known as the White Plum Sangha.*

But this transmission has been somewhat muddied by the fact that he was having a sexual relationship with **Bays** *at the time that she was appointed Dharma heir (in 1983). Both of them were married (Maezumi to an American) and neither marriage survived when their liaison became public knowledge. This incident, together with other affairs and Maezumi's excessive dependence upon alcohol, led* **Beck** *to sever her connections with her teacher and set up her own independent group. Meanwhile,* **Glassman** *and* **Merzel** *have both given Dharma transmission to some of their students—thus establishing an American lineage. And although none of Maezumi Roshi's Dharma-heirs condone his behaviour, all of them (except* **Beck***) are sticking by him. They all have their own centres now, while Maezumi continues to teach at the parent centre, ZCLA. Whether it will remain the parent centre or be outflanked by one of its satellites, is anybody's guess.*

STOP PRESS: *Maezumi Roshi died suddenly in Tokyo in 1995, aged 64, shortly after giving* inka *to Glassman Sensei (see his entry).*

Primary sources: Taizan Maezumi, *The Way of Everyday Life: Zen Master Dogen's Genjokoan with commentary,* (Los Angeles: Center Publications, 1978); see also Primary sources at the end of Bernard **Glassman**'s entry

Secondary sources: Rick Fields, *How the Swans Came to the Lake* (Boston, 1986) (see index); Helen Tworkov, *Zen in America,* (San Francisco, 1989) (in the chapter on Bernard Glassman)

[1] Snelling, 360, Morreale, 123, Fields, 244 all give different dates.

Sri MAHENDRANATH | Lawrence Amos Miles

English *sadhu* who had an ashram in India

Cf. **Ananda Maitreya** who also knew Crowley.

Cf. Gary **Chicoine**, who claimed to be an agent of Dattareya.

Mahendranath was born in London in 1911. He was interesested in the esoteric from an early age, and sometime in his early twenties he met Aleister Crowley, who advised him to go to the East. However, World War II came along and Mahendranath did not finally get to India until 1949. There he met Sri Sadguru Lakenath (Murray, 125; this is surely a variant on 'Lokanath'), a *sadhu* in the Adinath branch of the Nath *sampradaya* school and was initiated by him. When, I am not sure: Murray says 1953; Lokanath (that's *another* Lokanath—see below) implies that it was soon after Mahendranath's arrival in Bombay. The 'mythical' founder of the Adinaths is none other than Dattatreya, one of the most potent aspects of Shiva, who liberates by cutting through all impediments. Historically, they were founded by Gorakhnath in the eleventh century. They are a tantric order—very different from the orthodox Dasanami orders founded by Shankara in the eighth century—and they deliberately embrace the unorthodox. Its initiates go about naked and are called *avadhutas* (literally, 'those who have shaken off [worldly obligations]').

Mahendranath certainly lived up to this unorthodox tradition during his nearly 30 years as a *sadhu* in India. Another of his gurus was called 'Pagala Baba'—'Mad Baba', that is. He was also initiated into two other sects/schools, the Kaula and the Sahajiya, both of whom are decidedly 'left-handed'—meaning that they use the so-called impurities (especially desire) as a means of realization rather than eschewing them. Lokanath's article has a drawing of a initiate of this kind, with Mahendranath's features, sitting naked with an equally naked consort. He also went to Bhutan (where he was initiated into Tibetan Buddhism, though this does not make him the "first Westerner to become a Tibetan Lama", as Lokanath claims), to Malaysia (where he became a Taoist priest) and to Ceylon/Sri Lanka (where he became a Theravadin monk—but presumably not a naked one).

Around 1975 or so, he settled in Gujarat and founded an ashram (with Indian disciples), called Merlin Oracle Lab—one of the all-time great names for a spiritual centre. There he taught 'Twilight Yoga', a heady brew consisting of ingredients taken from the *I Ching,* Tibetan Buddhism, Ch'an Buddhism, Sri Dattatreya—and Western esotericism. An extract from *The Magnum Opus of Twilight Yoga* refers to 'Yoga-Magick' (note the Crowleyian spelling) and defines Will as "the faculty of power, determination and divine catalyst" and Imagination as "the faculty by which we reach beyond ourselves" (Lokanath, 12). In 1978, he chartered an East-West Tantrik Order, the Arcane Magickal Order of the Knights of Shambhala/AMOOKOS. He also issued a proclamation which considerably widened the circle of Adinath initiates from that of the traditional naked wandering *sadhus*:

> I, Shri Gurudeva Dadaji Mahendranatha, the only surviving Supreme Guru of the Adi-Natha Sampradaya—the cult and organization of the first and supreme Sacred Lords of the Cosmos—King of Shambala and Grand Lord of its Knights; Keeper of the Fifth Book of the Nine Secret Chiefs, Merlin of Cockaigne and Light of the Silver Star; do hereby ordain by that supreme authority which rests with me, that the Adi-Nath Sampradaya shall from henceforth become an international and cosmopolitan order of all worthy people, students and householders all over the age of eighteen years, who may occupy a normal life and pursuit of livelihood; provided always they accept the three basic aims and objects of the Naths—to wit—real peace, real freedom and real happiness. Therefore from naked Guru to naked Sishya, the transmission and initiation shall be given to all Noble Masters, Magicians, Alchemists, Masons,

Rosicrucians, Astrologers and Occultists of stable nature, who will bond themselves into one Grand Concord of Cosmic People and work, experiment and teach, for the weal and welfare of all mankind.

This is our law, the rhythm of the Cosmos by which the wise must live.

Mahendranath the Avadhoot
1st January, 1978
(Murray, 124)

In the same year, Mahendranath was visited by another Englishman, Lokanath Maharaj (I do not know his original name), whom Mahendranath appointed as his successor. (So both his predecessor and his successor have the same name.) According to Lokanath, Mahendranath's guru was the "last remaining Adinath Yogi in all India"—something which I for one find hard to believe—and the obvious implication is that Mahendranath became his successor; that is, the leader of the whole Adinath school. The claim that is being made, then, is that an ancient Shaivite transmission, which has been transmuted into a form of 'Yoga-Magick', is now being handed on by a Western guru—to another Westerner. Mahendranath died in 1991; Lokanath is still alive and has a website.

Primary sources: Sri Gurudev Mahendranath, *The Amoral Way of Wizardry* (a collection of his writings available from Mandrake—see below)

Secondary sources: Lokanath Maharaj, 'The Guru of Twilight Yoga', *Yoga Today*, vol. 6, no. 10, February 1982, pp. 10–12; Muz Murray, *Seeking the Master: A Guide to the Ashrams of India* (Spearman, Jersey, the Channel Isles, 1980), pp. 124–126

Centre: Merlin Oracle Lab, Mehmadabad, Gujarat 387130, India (but I don't think it's functioning any longer); Mandrake of Oxford, P.O. Box 250, Oxford OX1 1AP, England, U.K.; Email: mandrake@mandrake.compulink.co.uk; web page: http://www.compulink.co.uk/~mandrake/

COMPARE:

Other Shaivite gurus: **Rudi**, Swami **Chetanananda**, **Shankar Das**, Guru **Subramuniya**

Other Westerners who have taught in India: Sri **Krishna Prem**, the **Mother**, Swami **Abhishiktananda**, some of the **Hare Krishna Gurus**

Other Western sadhus in India: Swami **Atulananda**, Swami **Abhishiktananda**, Sri **Krishna Prem**

Other esotericists who embraced Eastern traditions: Madame **Blavatsky**, Colonel **Olcott**, **Ananda Maitreya**, Alexandra **David-Néel**, René **Guénon**, Rabia **Martin**, Yogi **Ramacharaka**, the **Mother**

JACQUELINE MANDELL. SEE *VIPASSANA SANGHA*

MARASHA | KATHIE JORDAN

Black American who says she was born enlightened

Her Holiness Sri Marashama Devi is an Avatara, the highest classification of Self-Realized Master. She is affectionately called Mataji or Mother by her disciples.

As an Avatara, Mataji has always been Enlightened. In this incarnation, however, She chose to abjure the state at the age of twelve so that She could experience apparent separation from the Divine and path back to Union (*sic*). Mataji consciously

decided to take this action because She wanted to more fully comprehend the lives and problems of the people She would one day teach.

Though not consciously Enlightened, throughout the next twelve years Mataji experienced a high degree of God-communion and many spiritual powers. One of these powers enables Her to see the great Spiritual Being, Lord Siva (who has never incarnated on this plane), as well as see each other (*sic*). Lord Siva served as Mataji's Guru.[1]

At the age of twenty-four, Mataji spontaneously regained the Enlightened state . . . (*Lila,* vol. 1, no. 2, 1984, 5)

Cf. the way Swami **Turiyasangitananda** *received her name.*

'Marasha' means something like ''Reaching death' or 'Food for death'—she herself says, "I represent Death to your egos" (*Lila,* vol. 1, no. 2, 24)—and the name was given to her 'on the other side'. In any event, some years after her 'regainment' of enlightenment—in 1980, when she was 30 years old—she began to teach. What this meant in practice is that she gave *shaktipat.* 'Shaktipat' means 'descent of energy' and is part of a certain kind of *kundalini yoga* (the hot kind). In 1986, I went to a public meeting at the Center of Being—I was the only 'outsider' there—and it was quite eventful. As soon as Marasha entered the room, everyone 'flipped' (except me): speaking in tongues, laughing, exclaiming, and adopting physical postures, which devotees call *mudras* (roughly meaning 'sacred gestures'.) All of these occurred spontaneously but were intensified when Marasha went round the room touching people—between the eyes, or on the head, stomach or back. Every one of them is standard *kundalini* fare.[2]

In 1984, Marasha enlightened 13 of her disciples. At the time, this was seen as deeply significant: "Mother is well on the way to creating the community of Enlightened beings that She says She has dreamed for this planet" (*Lila,* vol. 1, no. 2, 29). Yet since my visit in 1986, the Center of Being has closed down and she has virtually stopped teaching. She has married Jim Jordan, one of the enlightened disciples,[3] and is now known as Kathie Jordan.

Born enlightened; taught by Siva, Jesus, and Babaji; a bit of a hazard on the freeway (through no fault of her own); dedicated to establishing a community of enlightened beings but presently with only a handful of disciples—this is quite a detour even for a *shaktipat* guru; and *shaktipat* gurus are prone to detours. At the moment, it doesn't seem to be going anywhere very much. But she may yet surprise us.

Primary sources: Marasha has written no books. But there is some good material in the Center of Being's magazine, *Lila: The Divine Play of Mataji.* I have only seen two issues (vol. 1, no. 1, April-May-June 1984; vol. 1, no. 2, October-November-December 1984) but there may have been others.

Secondary sources: None

[1] I was also told that Marasha had been to India to see Anandamayi Ma, one of the great teachers of the twentieth century. They went into *samadhi,* and when they emerged, they were both crying. Anandamayi Ma said, "I can leave my body now that you are here." In addition, the Center of Being is sometimes visited by Jesus, Babaji (for whom, see *Yogananda*), and Nityananda (for whom, see **Rudi**). Marasha herself often refers to Jesus—she was brought up a Baptist—and is stigmatic (or was for a time at least; see *Lila,* vol. 1, no. 2, 11). On the other hand, it was only by chance that I found out that she had previously been a disciple of Dhyanyogi Madhusudandas, an Indian *kundalini* master who gave *shaktipat* and first came to America in 1976. I do not know why this connection is never mentioned.

[2] Nor are disciples the only ones to be affected. She does not go out much because people are drawn to her—literally—which can be a nuisance in the supermarket when they regularly crash their trolleys, and positively dangerous on the freeway when they drift towards the car that she is travelling in.

[3] And author of one of my all-time favourite 'enlightened' sayings: "It's hard to say if someone else is enlightened even when you are yourself."

MURSHIDA RABIA MARTIN

Hazrat Inayat *Khan's* first Western disciple who went on to become an independent Sufi teacher and then a disciple of *Meher Baba*

Martin was born Ada Ginsberg in 1871 in San Francisco of a Russian father and a Polish mother, and was married to David Martin in 1890. In 1898, during a very severe illness, she had a series of visions (no details available); and in 1900 she was initiated into an occult order (probably Martinism (see Lewis, 30), which is French in origin; the name is just a coincidence). Then in 1911, on Easter Sunday, when she was nearing 40, she attended a lecture on music given by Hazrat Inayat *Khan* (who was an accomplished musician). But she had already had an intimation of this meeting a year earlier.

> In the spring of 1910, I began to be conscious of a very great and illuminated intelligence overshadowing me. And all that I was directed to do was accomplished through intuition and feeling—not through seeing, and the love and blessings that poured upon my soul at that time were simply indescribably beautiful. It shaped and moulded a process which prepared me mystically for the coming of our Holy and Reverend Pir-O-Murshid. (*Notes for the Autobiography of Murshid Rabia Ada Martin*)

A week before she actually met Inayat *Khan*, she had "a marvellous mystical experience" concerning him in which she was shown "a temple in the Orient, and we entered together, and there was a Divine union like a mystical marriage" (ibid.). After the lecture, she wrote to Inayat *Khan* asking for spiritual guidance (even though he had not lectured on Sufism and had certainly not presented himself as a *murshid*).

Inayat *Khan* was also struck by Ada Martin. He noticed her in the audience, and having received her letter, had a vision during the night that the whole room was full of light. He took this as a sign that he should initiate her—and he did so, the very next day. She was his first *mureed*/disciple in the West (and possibly his first *mureed* anywhere since I have come across no references to his having initiated people in India before he left for America); and he gave her the name 'Rabia' after the famous Sufi saint, Rabia of Basra. One can hardly help noticing that this meeting between master and disciple was heralded and confirmed by visions, just as Inayat *Khan's* meeting with his own master, Murshid Madani, had been.

In the light of this intimate spiritual association, it is hardly surprising that she was called to New York by Inayat *Khan* in December 1911, and, after six months 'training' ("which was no training, it was just a divine blessing", as Inayat *Khan* said in an unpublished letter), she was appointed as a *murshida*, a spiritual teacher in her own right. According to her, her announcement of the Sufi message on 24th May 1912, in San Francisco, was the first open declaration in the West (*Notes for the Autobiography . . .*)—the implication being

that Inayat Khan's earlier public teaching had just been in hints. In subsequent letters and writings, Inayat Khan appears to confirm that Rabia Martin was indeed his successor. "The care of a grain of the Message, which was cast in the soil of America, was entrusted to her before I left the United States for Europe" (De Jong-Kessing, 126); "When I go for the life of absolute retirement, you will have to attend to my affairs in the West, also sometimes in the East" (unpublished letter of Inayat Khan, 1915).

Inayat Khan spent the rest of his life in Europe and made only two visits to the States (in 1923 and 1925), both of them arranged by Rabia Martin. But her connection with him appears to have been very strong and hardly affected by their physical separation.

> I was conscious that His spiritual power was all summed up in the principle of love . . . and that this power expanded and enveloped all things as a dissolving force . . . Thus the Sufi Message was revealed to me in its purity, and its power, and in its perfection. He was the embodiment of the Message. Such perfection inspires our souls with some knowledge of who we are and what we might become. It is the seal of the Prophet.

There seems to be a fair amount of evidence, then, that Murshida Martin was a favoured disciple; that she was entrusted with considerable responsibility in America; and that she figured in Hazrat Inayat Khan's general plans for the **Sufi Order** in the West. However, his death in 1927 caught everyone by surprise and caused a split in the Order. Murshida Martin, who had carried out her duties in America, more or less on her own, for 16 years, went to the headquarters in France, expecting to take over his work. But the disciples there would not accept her. She had had very little contact with them and Inayat *Khan* had spent from 1912 to 1926 in Europe, visiting the States only twice. So the European Sufis saw little reason to accept this American disciple as their master's successor[1] and Inayat *Khan*'s brother, Maheboob Khan, became Pir-O-Murshid of the Sufi Movement and the Sufi Order in the West. (See the general entry, the **Sufi Movement and the Sufi Order**.) She therefore returned to the States where she continued working with her American *mureeds*. She also became the *murshida* of Inayat *Khan*'s followers in Australia and Brazil, who did recognize her as his successor (Ivy Duce, *Sufism,* [San Francisco: Sufism Reoriented, 1971], 20).[2]

She continued this work for 15 years. (One of her early helpers—indeed, her *khalif* or deputy on occasion—was Samuel **Lewis**) Then in 1942, she heard about *Meher Baba* from one of his American disciples, and by 1943 had become convinced that he was a Qutub (literally, 'hub, pivot') or perfect master—namely, one who is at the highest level of the spiritual hierarchy—and

[1] In fact, she was rejected in no uncertain terms. According to an unpublished and anonymous 'Memorandum to the Workers and Candidates for Appointment in the Sufi Movement and its Activities' (undated but ca. 1956), she was one of a number of "senior students . . . who claimed that somehow they had been appointed by Pir-O-Murshid to be his successor . . . These loose allegations were so utterly repudiated—and indeed resented—as evident impostures by all Sufis that, though referred to, they were hardly regarded as matters worthy of serious discussion" (p. 5).

[2] I have been told by Ira Deitrick of Sufism Reoriented that in an unpublished letter to Samuel **Lewis**, Murshida Martin descibes how she went to India on her own in 1939 and met Hasan Nizami, head of the Nizamiyya-Chishtiyya, while visiting Hazrat Inayat *Khan*'s tomb in Delhi. He had been with Inayat *Khan* just before the latter's death and Inayat *Khan* had told him that Rabia Martin was to be his successor. Hasan Nizami therefore performed a special ceremony in order to authenticate her as a Sufi teacher. It is interesting that two other teachers associated with Hazrat Inayat *Khan*, Samuel **Lewis** and Vilayat **Khan,** both went through similar ceremonies (with different Indian Sufis) in later years.

even more than that, the actual leader of the hierarchy, known in Sufism as the Qutub-e-Irshad ('Irshad' comes from an Arabic word meaning 'guidance'). She corresponded with him, and in one of these unpublished letters he stated that

> I am not different from your murshid . . . No, Murshida, your love for Inayat Khan is fulfilled in me . . . I want you, Rabia, to explain to your Sufi pupils that I am the highest Sufi authority on this earth . . . Help your pupils to know me as the Master of the seventh plane.

On her side, Rabia Martin dedicated her Sufi school to "Baba's spiritual cause for ever" (Ira Deitrick letter). Her group had been independent of the European wing of the **Sufi Order** ever since the schism that occurred after Inayat *Khan*'s death; but her acceptance of Meher Baba severed all possible links and the two have been completely separate ever since. She died in 1947, without meeting *Meher Baba* but having appointed one of her *mureeds,* Ivy **Duce**, as her successor.

Pioneers are always independent-minded and Murshida Martin is a good example. But independence has its drawbacks; it tends to isolate people and this certainly happened to her. She countered this isolation by constant reference to inner contact with her master, Inayat *Khan*, and the lineage of Sufi teachers, culminating in *Meher Baba*. There is much to admire in this but it is also somewhat paradoxical: an independent teacher who kept the torch of Sufism burning in America for over 30 years but is also looking for a master. The independent who knows how to submit is a rare bird.

*Samuel **Lewis** was very similar (though he was never a disciple of* Meher Baba*)*

(*See* Lineage Tree 8)

Primary sources: Notes for an Autobiography of Murshida Rabia Martin, unpublished; kindly provided by Ira Deitrick, president of Sufism Reoriented

Secondary sources: some references in E. de Jong-Kessing, *Biography of Pir-O-Murshid Inayat Khan* (The Hague: East-West Publications, 1979); in W. van Beek, *Hazrat Inayat Khan* (Vantage Press, 1983); and in Samuel Lewis, *Sufi Vision and Initiation,* (San Francisco/Novato: Sufi Islamia/Prophecy Publications, 1986); plus information provided by Ira Deitrick in a letter

Centre: None extant (but see Ivy **Duce**'s entry for the address of Sufism Reoriented)

COMPARE:

Other Westerners associated with Hazrat Inayat Khan: Samuel **Lewis**, the teachers in the **Sufi Order**

Other early Western Sufis: Ivan **Agueli**, René **Guénon**

Other women who teach Sufism (apart from those in the Sufi Order): Irina **Tweedie**

Women who teach in other traditions (or in none): Jan **Bays**, Joko **Beck**, Freda **Bedi**, Ruth **Denison**, Rev. **Dharmapali**, Gesshin **Prabhasa Dharma**, **Karuna Dharma**, Jiyu **Kennett**, Ayya **Khema**, Dharma Teacher Linda **Klevnick**, **Miao Kwang Sudharma**, **Pema Chodron**, Irmgard **Schloegl**, Dharma Teacher Bobby **Rhodes**, Ruth Fuller **Sasaki** (various forms of Buddhism); Swami **Abhayananda**/Marie Louise, Sister **Daya**, Sri **Daya Mata**, Sister **Devamata**, the **Devyashrams**, Sri **Gyanamata**, Sister **Nivedita**, Swami **Radha**, Joya **Santanya**, Sri **Sivananda-Rita**, Swami **Turiyasangitananda** (various forms of Hinduism); Jaqueline **Mandell**, **Marasha**, the **Mother**, Toni **Packer**, Elizabeth Clare **Prophet**, Jeanne **de Salzmann** (various independents)

Other visionaries (in various senses of that term): Jiyu **Kennett**, Samuel **Lewis**, Frithjof **Schuon**

MEHER BABA

Indian teacher who proclaimed himself the Avatar of the age

It is probably a metaphysical crime to attempt to summarize Meher Baba in 526 words. But since one of his attributes is that he is consciously aware of every atom in the universe, I'm sure he'll understand. He was born in Poona/Pune in 1894. After a series of intense experiences brought about by a series of teachers, he 'knew' that he was the Avatar, the very first soul who realized God:

> . . . *the first individual soul to emerge from the evolutionary process as a Sadguru (Perfect Master), and he is the only Avatar that has ever manifested or will ever manifest. Through Him God first completed the journey from unconscious divinity to conscious divinity, first unconsciously became man in order consciously to become God. Through him, periodically, God consciously becomes man for the liberation of mankind.* (Discourses, iii. 14)

> *Believe that I am the Ancient One . . . I am not this body that you see. It is only a coat I put on when I visit you. I am Infinite Consciousness. I sit with you, play and laugh with you; but simultaneously I am working on all planes of existence.*
>
> *Before me are saints and perfect saints and masters of the earlier stages of the spiritual path. They are all different forms of me. I am the Root of everyone and everything. An infinite number of branches spread out from me. I work through, and suffer in and for, each one of you.* (The Everything and the Nothing, 56)

In the past, the Avatar has come as Zoroaster, Rama, Krishna, Buddha, Jesus and Mohammed (God Speaks, 199). In this age, he has come as Meher Baba.

This realization occurred in 1921. He began teaching in 1922 (when he was 28) and became silent in 1925. His first Western followers came to him in the early 30s.

Baba's teachings are extremely detailed. I can only mention one aspect here: the function of a Perfect Master or Sadguru. The creation is energized by the movement of souls through it. As a result of this movement, they gather impressions or sanskaras which cover up the original divine consciousness. This gathering or winding of sanskaras is the formation of ego which keeps us away from God. We return to God through the unwinding of sanskaras—that is, the progressive elimination of ego. When ego has been removed, then there is realization of one's true Self as Infinite Consciousness or God. How is this ultimate state reached? By contact with one who is himself free of sanskaras—a Perfect Master of the seventh plane. Perfect Masters are called Sadgurus in Sanskrit or Qutubs in Sufi terminology. They have infinite power, knowledge and bliss (Discourses, iii. 25), which means that they can annihilate sanskaras and thereby grant God-realization. And they can do this on any scale they choose. In fact, it is only possible to gain God-realization by the grace of a Perfect Master (Discourses, i. 67). It cannot be accomplished by one's own effort.

*This teaching is important because it serves as a background to Baba's relation with Sufism, particularly the group of American Sufis led, first, by Ivy **Duce** and then by **James MacKie**.*

Works by Meher Baba cited in this entry (and in those of Ivy Duce and James MacKie): Discourses (3 vols.), (San Francisco: Sufism Reoriented, 1967); The Everything and the Nothing (New South Wales, Australia: Meher House Publications, 1976); The Nothing and the Everything (Myrtle Beach, South Carolina: Manifestation, Inc., 1981); God Speaks (New York, 1973); Listen Humanity (Jersey, Channel Islands: Companion Books, 1989)

Works about Meher Baba cited in this entry (and in those of Ivy Duce and James MacKie): J. Adriel, Avatar: The Life Story of Avatar Meher Baba (Berkeley, 1971); T.

and H. Hopkinson, *Much Silence: Meher Baba—His Life and Work* (London, 1974); C.B. Purdom, *The God-man* (Crescent Beach, South Carolina: Sheriar Press, 1964); A. Cohen, ed., *Mastery of Consciousness* (Middlesex, England: Eel Pie Publishing, 1977); M. Schloss and C. Purdom, *Three Incredible Weeks with Meher Baba* (South Carolina: Sheriar Press, 1954); Ivy Duce, *How a Master Works* (Walnut Creek, California: Sufism Reoriented, 1975)

Sensei Dennis Genpo Merzel

American Zen teacher who has an international *sangha*, part of it in Poland

Merzel was born in 1944. He started practising Zen with *Maezumi* Roshi in Los Angeles in his mid-1920s and in 1980, after eight years training, became *Maezumi* Roshi's second Dharma-heir. (Bernard **Glassman** was the first.) He went to Japan in 1981 to go through the *zuissé* ceremony, after which he was a formally recognized teacher in the Soto tradition. In fact, he started teaching in Europe, including Poland. In 1987, after he had been teaching for five years, he ordained his first students: twelve took the *jukai* precepts in England, 18 in Holland, 25 in America, and 46 in Poland (*Kanzeon Sangha Letter,* December 1988). These numbers accurately reflect the interest in the various countries, with over twice as many Poles attending talks as British or Dutch. He founded the Kanzeon Zen Center (which has had a number of locations but is presently in Salt Lake City) in 1987 and was installed as abbot in 1988. Four years later, in 1992, he gave Dharma transmission to a French student, Catherine Pagès (now Genno Sensei), thus making her his first Dharma-heir. In 1993, he gave Dharma transmission to an elderly British student, John Flatt, a Quaker for 50 years, who was in the last stages of a severe illness and died within twelve months. And in 1995, he gave Dharma transmission to Anton Coppens from Holland. So here we have an American with French, British and Dutch Dharma-heirs, and a *sangha* that is predominantly Polish.

Merzel Sensei emphasizes Zen's traditional down-to-earthness, as the chapter headings of *The Eye Never Sleeps* show: 'Return to the Root', 'Strive to No Goals', 'Have No Preferences', 'Undisturbed in the Way'. Yet he can also say the following:

> I used to ask myself why I practiced and came up with the answer, "I don't know", ultimately. There is a hierarchy of reasons why we sit: to clear my mind, feel better. That's a fairly low level but I still do that. I go deeper into *samadhi* by not expecting to achieve *samadhi* when I sit. One of the two major reasons I sit is that I feel impregnated by Roshi and by the Dharma. I really used to believe that I was Buddha, Christ, God—because of my experiences. But I wasn't very clear that everybody was too. Now I feel more like Mary, impregnated by God and got to give birth. To what? To Christ, to all of you. I have to pass on what I received through Maezumi Roshi to you. I feel great joy in seeing your maturation, that you are beginning to receive the teaching. Even in the way you put your shoes out there. It was great. (taped talk, 1986)

A Zen teacher who compares himself to the Virgin Mary— this is not so traditional after all. But maybe a traditional Western Zen teacher is itself an idea we will all have to let go of.

STOP PRESS: *Maezumi Roshi died in 1995 and Merzel became president of the White Plum Sangha (in a somewhat indirect way—see the Stop Press at the end of* **Glassman***'s entry).*

(*See* Lineage Tree 4)

Primary sources: Dennis Genpo Merzel, *The Eye Never Sleeps: Striking to the Heart of Zen* (Boston: Shambhala, 1991); *Beyond Sanity and Madness: The Way of Zen Master Dogen* (Boston: Tuttle, 1994)

Secondary sources: None

Centre: Kanzeon Zen Center, 1274 East South Temple, Salt Lake City, UT 84102, U.S.A.

COMPARE:

Other Dharma-heirs of Maezumi Roshi: Jan **Bays**, Joko **Beck**, Bernard **Glassman**, John **Loori**

Other Zen teachers: Robert **Aitken**, Reb **Anderson**, Richard **Baker**, Gesshin **Prabhasa Dharma**, Zen Master Don **Gilbert**, Philip **Kapleau**, Jiyu **Kennett**, Walter **Nowick**, Ruth Fuller **Sasaki**, Maurine **Stuart**, Zen Master **Tundra Wind**

Other teachers with students in Poland: Philip **Kapleau** (Zen), **Harikesha** Swami (one of the **Hare Krishna Gurus**), **Jampa Thaye**, Ole **Nydahl** (both Tibetan Buddhism)

Bhikshuni MIAO KWANG SUDHARMA | Alexa Roy

American who has taken ordination in three Buddhist traditions

As I point out in many places in this book, Western women have not found it easy to find a place in an Eastern Buddhist tradition that is almost completely male-oriented; that is, they have found that the 'traditional' women's place offered to them, particularly their place in the *sangha,* has been somewhat at odds with the aim of enlightenment that is supposed to be the *raison d'être* of the Dharma. They have dealt with this conundrum in various ways: some of them have entered their particular *sangha* as far as they can and used it as the basis for their training without seeing the limitations imposed on them as genuinely restricting—for example Sister **Uppalavanna** and Ayya **Khema** (Theravada); Ruth Fuller **Sasaki** (Zen); **Pema Chodron** (Tibetan Buddhism); some have chosen to follow a form of the tradition that is essentially independent of the traditional *sangha*—for example *vipassana* teachers such as Ruth **Denison** and Sharon **Salzberg**; others have adapted their tradition, and its *sangha*, to a specifically Western way of life—for example Ven. **Dharmapali** (Theravada); Jiyu **Kennett** and Joko **Beck** (Zen).

Another solution is the one chosen by Alexa Roy, who, over a period of 20 years, has taken ordination in three separate traditions. In 1963, she was ordained into the Soto Zen tradition in Japan by Jiyu **Kennett** (and subsequently practised at Sojiji temple, just as **Kennett** herself had done). Ten years later, in 1973, she took *dasa sila mata,* or 'ten precept', ordination (see the Glossary) in Sri Lanka. And ten years after that, she took full *bhikshuni* ordination in the Mahayana tradition in Taiwan[1] (from which the 'Miao Kwang' part of her name derives; 'Sudharma' goes back to her Theravadin ordination in Sri Lanka). She is presently in charge of the Devachan Temple—an interesting name, with Theosophical overtones—which she founded in 1980 in Arkansas. It is an eclectic centre: she lists practices taken from the Soto, Theravada, Ch'an, and Pure Land traditions, and chanting is done in Pali and Chinese.

[1] Though the *Vinaya* used is from the Dharmaguptaka school, itself an off-shoot of the original Sthaviravadin school India (of which the Theravadins are the surviving wing, one could say). So while Chinese Buddhism is undoubtedly Mahayanist in philosophy, its *Vinaya* is much older than the rise of the Mahayana itself.

I am not aware of anyone else who has taken these three ordinations, each of which is peculiar to its tradition and is quite unconnected with the others. Miao Kwang Sudharma has gone as far as it is possible to go in all three traditions and has now brought them together—a unique development in Western Buddhism. Whether this has brought her into closer contact with the Dharma and enlightenment is another question, of course. But in the present context of multiple adaptations from the East to the West, all 'forms' need to be examined and tried out. This is one of them. (And I need hardly say that it would be very difficult indeed for an Eastern woman to do it.)

Primary sources: None

Secondary sources: None

Centre: Devachan Temple, 5 Dickey Street, Eureka Springs, AR 72632, U.S.A. (tel: 501-253-7068; this number added at Miao Kwang Sudharma's request)

COMPARE:

Other ecumenical Buddhist teachers: Ven. **Dharmapali**, **Karuna Dharma**, Ven. **Sangharakshita**

Other women who have taken full bhikshuni *ordination:* Freda **Bedi**, **Pema Chodron**

The MOTHER | Mira Richard

The first Westerner to become a guru in India

The Mother was born Mira Alfassa in Paris in 1878. Her father was Turkish and her mother was Egyptian, so she was not French by blood, but she certainly was by upbringing. Her parents, who emigrated to France in 1877, were well-off and excellent examples of the French upper middle-class: he was a banker, she was a very early Marxist (*Mind of the Cells,* 11). Mira had a brother, Matteo, who was governor of French Equatorial Africa in about 1935 (Aurobindo, *Collected Works,* vol. 25, 360).

According to her own accounts (and I am not aware of any others), she had an extraordinary childhood.

> One day the Mother was sitting in a chair. Suddenly she felt the world's weight on her head. She also felt that something expanded, expanded and expanded. Then she knew all about the constitution of the universe and could describe it. (*India and Her Future,* 83)

No date is given for this experience but the context seems to imply that it occurred when she was five. She says that she "practised occultism" when she was twelve (*On Herself,* 11). Between the ages of 18 and 20, she achieved a "conscious and constant union with the Divine Presence"—and all this by her own efforts. A little later, she came across *Vivekananda's Raja Yoga* (though the first French translation that I know of isn't until 1910) and "it enabled me to achieve in a few months something which I might have taken years to do" (*On Herself,* 24). In 1906, she founded a group of spiritual seekers in Paris, called L'Idée.

One of its members was Alexandra David-Néel (Iyengar, 30).

In 1909, she married Paul Richard (her second husband), who was also a member of L'Idée, I think. A year later, he went to Pondicherry, one of the few parts of India that was governed by the French, canvassing for a French politician who wanted to represent French India in the Chamber of Deputies (Iyengar, 46). While he was there, he met Sri *Aurobindo* and was impressed

by him. And this admiration was mutual. Aurobindo corresponded with both the Richards after Paul returned to France (in 1910, I think) and described them (in a letter to someone else in 1914) as "rare examples of European Yogins who have not been led astray by Theosophical and other aberrations" (Iyengar, 49). He also said that Paul Richard was "a Hindu in faith, a Hindu in heart" (ibid.). And in 1920, *Aurobindo* translated one of Paul Richard's books into English—the only instance I know of where a teacher has translated a pupil's work.

In 1914, Mira also went to Pondicherry to meet Aurobindo and immediately recognized him as the someone whom she had already seen in visions (although up until then she had called him 'Krishna') (*On Herself,* 43; Harper, 197; Purani, 181; Iyengar, 85). She continued to have visionary experiences when she was with him, including one of the Divine Mother: "[I] loved Thee with so intense a love that I became altogether Thyself" (*On Herself,* 45). It is, of course, no accident that she says that she has become the Mother for Aurobindo recognized her as such. In fact, she was his co-worker in an unprecedented spiritual task: the inauguration of the next stage of human evolution.

However, at this first meeting, she spent only a year with *Aurobindo* (from March 1914 to February 1915); but *Aurobindo* said that he accomplished more in this year than he could have done in ten years on his own (Prasad, 176).

> When I came to Pondicherry, a programme was dictated to me from within for my sadhana. I followed it and progressed for myself but could not do much by way of helping others. Then came the Mother and with her help I found the necessary method. (Quoted in Iyengar, 91)

Mira Richard returned to France with her husband in 1915 when he was called up for military service (Diwakar, 256). They left on 22nd February, the day after her 37th birthday, which had been celebrated by the four or five people living with Aurobindo at that time.

During the next year or so in France, Mira began to realize that she was being prepared for a spiritual task of universal significance. In 1916, she was told by God,

> I [the Lord] have chosen thee from all eternity to be my exceptional representative upon the earth not in an invisible and hidden way but in a way apparent to the eyes of all men. And what thou wert created to be, thou shalt be. (*India and Her Future,* 84)

She returned to Pondicherry in 1920[1], after which she never left it for a single day—and she lived for another 53 years. A few months after she arrived, she wrote a short account of her spiritual function in the form of a letter, entitled *How I Became Conscious of My Mission.* She says she was taught during sleep

[1] It appears that Paul Richard did not enter the armed forces because in 1916, he and his wife left France and went to Japan (Harper, 197; Aurobindo, *Collected Works,* vol. 39 12). They were accompanied by an Englishwoman, Dorothy Hodgson, who, according to Iyengar, regarded Mira as her guru (Iyengar, 182). A French couple and an Englishwoman (who is a disciple of the Frenchwoman) waiting in Japan to go on their way to India to see a guru (in 1916)—this is an unusual state of affairs. And there is another Japanese connection, which makes it even more unusual. The Richards made friends with a Dr. Okhawa, who told Iyengar in 1957 that *Aurobindo* had been his guru since he had first heard about him (from the Richards) in 1916 (Iyengar, 173). If this is so, then Dr. Okhawa must, I think, be the first Japanese in modern times (or perhaps ever) to accept an Indian—and I mean a living Indian, not someone like the Buddha—as his spiritual teacher.

Mira Richard and Dorothy Hodgson (and as far as I know, Paul Richard also, but the sources are not clear) remained in Japan for four years and then all three of them sailed to Pondicherry.

by a number of teachers, but that one was more important than the others. ". . . I was led to call him Krishna and henceforth I was aware that it was with him (whom I should meet on earth one day) that the divine work was to be done." As I have already said, this teacher was *Aurobindo*. But more significantly, perhaps, the letter is signed, 'The Mother' (Purani, 181).

From the beginning, the Mother was central to *Aurobindo*'s spiritual work, both internal and external. In 1922, she took charge of the ashram—though *Aurobindo* didn't like the term and didn't use it (Iyengar, 221)—which at that time consisted of just one house and four or five people (Prasad, 27). In 1926, *Aurobindo* sent a few disciples or *sadhaks* to her for meditation (Purani, 213). All of them were Indian women apart from Philippe Barbier St-Hilaire, a Frenchman who had come to the ashram in 1925 (Iyengar, 228, 233).

Later in that year there occurred what is called *Aurobindo*'s Day of Victory: the descent of Krishna into the physical. The significance of this has to be understood in terms of *Aurobindo*'s own teaching—namely, that f*or the first time ever,* a higher power had come down (or better: had been brought down by *Aurobindo*'s *sadhana*) to the physical level. As a consequence, human evolution entered a new phase. Before this time, all spiritual attainment had been *individual*—that is, the raising up of individual consciousness to the divine; now, a *general* transformation of humanity was possible because the physical level of the cosmos had become permeated with a higher consciousness.

But this descent of Krishna was not the infusion of the Divine itself—or, in *Aurobindo*'s terms, the Supermind or Supramental Light—but of the Overmind (which is the link between the Supermind and the lower levels of creation). The exact nature of this distinction and the details of *Aurobindo*'s cosmology need not concern us here. My main interest is the role that the Mother played in this whole process of the spiritualization of the earth, which culminated in the actual descent of the Supermind in 1956, six years after *Aurobindo*'s death.

In fact, it was from about *Aurobindo*'s Day of Victory in 1926 that he began to call her 'the Mother', though the exact date is not known (Iyengar, 233); before that, he simply called her 'Mira'. Not only that, but it was she, and not *Aurobindo*, who blessed all the disciples on that day. And it was she who recognized what he had accomplished. According to Nolini, who was already a disciple of *Aurobindo*'s when the Mother arrived at Pondicherry, *Aurobindo*'s Indian disciples (all men) had previously treated him more or less as one of themselves. "It was the Mother who opened our eyes," says Nolini (Iyengar, 217)—by treating *Aurobindo* as "Master and Lord of Yoga". I need hardly stress the significance of a Western woman redirecting the spiritual awareness of Indian men—in India.

After 1926, three special days (*Aurobindo*'s and the Mother's birthdays, plus the Day of Victory) were set aside for *Aurobindo* and the Mother to give *darshan*. (*Darshan,* which literally means 'seeing', is when a disciple looks upon the guru's physical form in order to imbibe the spiritual qualities that it embodies.) Apart from these occasions, *Aurobindo* lived in complete seclusion and was seen only by the Mother. As a result, she became the focus of the spiritual life of the ashram.

In 1928, *Aurobindo* wrote a short book entitled *The Mother*—his first since the Day of Victory. Later (in 1938), during a period when he answered many questions from disciples by correspondence, he said that this book was about "our Mother"; that she is the "'Individual' Divine Mother" who has embodied the Transcendent and Universal Power; and that she has descended out of her great love for humanity (Aurobindo, *Collected Works,* vol. 25, 47).

Given this very high claim, it is hardly surprising that everything the Mother does has significance and cannot be judged by ordinary standards. When she plays the organ, for example, she does so in order "to bring down something from the higher planes" (ibid., 366). (All these statements about her were made by *Aurobindo*, remember.) Her sleep is not sleep at all but a special state of consciousness (Aurobindo, *Collected Works,* vol. 26, p. 497); and medicines do not have the same effect on her as they do on other people because her physical consciousness (a crucial term in this teaching) is different (Aurobindo, *Collected Works,* vol. 25, p. 376). She gives names to cats "because they understand and answer" but not to birds (who don't) (ibid.). And she has "numerical harmonies" in her accounts—for example, the number seven occurring in aesthetic patterns (ibid.).

These are, admittedly, extremely minor aspects of the Mother's work. But they are worth mentioning because they are instances of an essential principle of *Aurobindo*'s integral *yoga*: divine consciousness is about to *enter* matter (as opposed to just manifesting it) and therefore those who have divine consciousness must necessarily immerse themselves in every aspect of life, however trivial it may seem. In short, *everything* has to be touched—which means that nothing is trivial, of course.

But the Mother's task is way beyond the occult sphere. *Aurobindo* says that she is not an "ordinary Guru but Divine" (*Collected Works,* vol. 25, 223). It is therefore not surprising—indeed, it's more or less inevitable—that spiritual practice or sadhana simply consists in surrender to her. Meditation is not just a technique; "[it] means opening yourself to the Mother . . . and calling in her force to work and transform you" (ibid., 259).

This transformation that *Aurobindo* refers to is the aim of his Integral Yoga and also the basis of the ashram, the reason for its existence. *Aurobindo* saw the ashram as a microcosm of the whole planet and he referred to the people in it—the *sadhaks*—as the 'Deva Sangha' (which means 'divine community' or 'community of gods') (Iyengar, 215). The Supermental Power, when it descends, "will be at first for the few, not for the whole earth—only there will be a growing influence of it on the earth-life" (Aurobindo, *Collected Works,* vol. 26, 146). More specifically, what this means is that the ashram contains representatives of humanity (Prasad, 26). An unattributed quotation (possibly by the Mother), given by Prasad says: "Every sadhaka here represents a type and serves a Divine purpose" (Prasad, 159). What individuals achieve at the ashram becomes a possibility for humanity as a whole. It would therefore be wrong to see the ashram either as a contemplative retreat or as a social experiment. Whatever is done there, whether apparently 'spiritual' (like having *darshan*) or apparently 'worldly' (like making bread), is done only as a means of transforming conditions on earth.

This idea is very similar to what Meher Baba *said about his* mandali.

Sri *Aurobindo* died in 1950, having announced shortly beforehand that the Supermind would manifest through the Mother (McDermott, *The Essential Aurobindo,* 14). This duly happened, according to her own account, on 29th February, 1956 (henceforth called the Golden Day):

> This evening the Divine Presence, concrete and material, was there present amongst you. I had a form of living gold, bigger than the universe and I was facing a huge and massive golden door which separated the world from the Divine. As I looked at the door, I knew and willed in a single movement of consciousness, that 'the time has come', and lifting with both hands a mighty hammer I struck one blow, one single blow on the door and the door was shattered to pieces.

Then the supramental Light and Force and Consciousness rushed down upon the earth in an uninterrupted flow. (Prasad, 108)

In 1962, at the age of 84, she withdrew from close physical contact with the ashram—just as *Aurobindo* had done in 1926. But she continued her work—both outwardly and inwardly. The inner work, concerning the transformation of cellular consciousness, I shall deal with presently. The outer work was (and is) concerned with the simultaneous formation of a new species of humanity and the creation of a perfect world—via the foundation of a city, Auroville. At each stage of spiritual evolution, "there is a new creation upon earth . . . This new creation begins with a model town and ends with a perfect world" (Iyengar, 96).

In 1966, the plan for Auroville was 'approved' by the General Assembly of UNESCO. I'm not sure what this means but it was the first instance of Auroville's connection with international or supra-governmental organizations. In 1968, the Mother formally inaugurated the new city, and the soil of 124 nations (pratically all the independent countries in the world at that time) was mixed together and placed in a huge urn on the site.

Like many utopian communities, Auroville is intended as a society that will develop the inner life. But it is unlike any other community, says the Mother, because it begins at a point that is beyond anything that has gone before. The Divine consciousness is seeking to manifest itself in order that it can transform human nature completely.

> [Nature] endeavours to bring out a being who will be to man what man is to the animal, a being who will remain a man in his external form, and yet whose consciousness will rise far above the mental. (*Auroville pamphlet,* 7)

This is a grand aim, entirely consistent with the teaching of *Aurobindo* and the Mother from the earliest years. According to one Aurovillian (as the inhabitants of Auroville are called),

> We are chosen to be the tiny cells of a larger body, on the scale of a city, that is doing its yoga—a corporate Yoga, a collective Yoga, the yoga of Nature and of evolution . . . (Quoted in Lohman, 16)

But the development of Auroville has not been easy. The difficulties increased markedly after the Mother's death in 1973. In effect, the disciples of *Aurobindo* and the Mother have split into two groups: those who have remained at the Aurobindo Ashram and those who are putting all their energy into Auroville. To begin with, all the finances were controlled by the ashram, and since the ashram often did not agree with what the Aurovillians wanted, Auroville was more or less forced to continue independently. But it needed the help of the Indian government to do it: two Auroville Acts were passed (in 1980 and 1988) which separated the ashram and the city completely, and they are now continuing side by side, as it were, with distinct aims and interpretations of the teaching of *Aurobindo* and the Mother.

I cannot go into all these ramifications here. But it is interesting to compare the work of two of the Mother's prominent followers, Ruud Lohman and **Sat Prem**, who can be seen as the 'theologians' of the Mother's outer and inner work respectively. In fact, Lohman (a Dutchman) actually was a theologian before he came to Auroville in 1971—he was a Franciscan for 15 years and a priest for eight—and he has since become a sort of theologian for Auroville (he died in 1986) and especially its central structure, the Matrimandir (literally, 'Mother temple'). The Matrimandir was seen by the Mother in a vision in 1970:

it is a huge slightly flattened globe nearly 30m or 90ft high, but because it is sunk into the ground, only half of it is visible from the outside (Lohman, 28, 66). It is still being built but is designed to have a lens at the top which will focus the sun onto a crystal globe 70cm or 28ins in diameter in the central chamber (ibid., 40). This globe was made by Zeiss of West Germany and is the biggest in the world.

Lohman's theology of the Matrimandir is as follows. It is the Mother's body (ibid., 30). Its four pillars were named by the Mother after the four aspects of the Divine Mother: Mahakali, Mahalakshmi, Mahasaraswati, and Maheshwari (ibid., 36). (These were the aspects that *Aurobindo* wrote of in his book, *The Mother,* in 1928, and which he subsequently said was about "our Mother".) The Matrimandir is therefore the focus of Auroville: "a transformer . . . a big, concrete-and-golden point in matter, on the Earth . . . where the flow-through, the transformation, takes place" (ibid., 60). Or, to use the language of biology rather than geometry or engineering, "Matrimandir is the first cell of the body of Mother Earth which offers itself for transformation" (ibid., 63). In other words, by its very construction, matter itself becomes spiritualized—and this is the culmination of the Mother's *sadhana* and *Aurobindo*'s Integral Yoga.

> The flexibility of even the most solid matter and of physical nature is increasing under the pressure of the Mother's Force, so that ultimately nothing is impossible at Auroville. (Lohman, 10)

This 'external' theology concerning the "the first cell of the body of Mother Earth" is complemented by an 'inner' theology: the Yoga of the Cells, as given by **Sat Prem** in his book, *The Mind of the Cells*.

A new element has entered evolution and it will change everything:

> [it] is the mind of the cells, which is in the process of disrupting our human world just as our thinking mind disrupted the world of the apes. (*Mind of the Cells*, 20)

Elsewhere, **Sat Prem** refers to this process (which is disrupting on one side but transformative on the other) as a "smiling Apocalypse" (*Mind of the Cells*, 217) —which is a nice phrase.

There are four levels of mind that are naturally within the reach of every human being: the intellectual, the emotional, the sensory and the physical (*Mind of the Cells*, 66–67); and it is the last of these that the Mother transformed even though, to outward eyes, she was very ill in her old age, and more or less blind. The following account of this transformation is taken from the Mother's own words.

"My consciousness is WITHIN things; it isn't something that 'receives'" (*Mind of the Cells,* 55); it is "a perception that is global: simultaneously vision, sound, and knowledge" (ibid., 46).

> Salvation is PHYSICAL . . . and it's right HERE . . . Everything else, including death, appears really as a falsehood, that is, something that doesn't exist. (*Mind of the Cells,* 100)

The Mother links this transformed state of matter with her own mantra, OM NAMO BHAGAVATEH (*Om. Homage to the Goddess* [literally, . . . *the Lord-ess*]). This mantra, says **Sat Prem**, "is for all seekers who would like to discover matter as it really is . . . spirit in the heart of matter" (*Mind of the Cells,* 141). And, the Mother told him, "I have heard the cells repeat my mantra" (ibid., 145)—a staggering claim.

But what is the significance of the Mother's explorations into the 'mind of the cells'? She gave the answer herself: "the quality of cellular vibrations is contagious" (*Mind of the Cells,* 56). That is, what has happened to her can now happen to others. Hence there can be "a reorganization of the earth and a new creation" (*Mind of the Cells,* 160).

This, I think, is where the theologies of **Sat Prem** and Ruud Lohman—the inner and the outer—converge. **Sat Prem** saw the Mother's body as "a symbol for the whole earth" and her *sadhana* of the body had repercussions for the world. Analogously, Lohman sees the Matrimandir as the Mother's body, and Auroville as the larger body within which the Aurovillians are the cells. And **Sat Prem** also says that the disciples around the Mother represented the earth: they were the human samples for the great evolutionary operation (*Mind of the Cells,* 192). (There is a whole evolutionary schema here which I cannot go into.)

Whatever we may think of the Mother's teaching, it raises a number of basic questions about the spiritual life. Is realization dependent in any way upon outer forms, whether 'traditional' (such as lineages and initiations) or new (such as the formation of a model city)? Or is it purely inner? Or is this inner-outer distinction itself a false dichotomy?

As we have seen, she is presented as unique. This really is an extraordinarily high claim. Yet it seems to follow that only she, by definition, can truly understand what it means. Hence her teaching is in an obvious sense 'beyond' everybody else—including her disciples. Consequently, they are more or less bound to assert truths which they have not experienced despite the fact that the very basis of the Mother's teaching is experience (and never mind the traditions that have gone before). The only alternative is to claim some sort of experience that justifies one's understanding—which is exactly what two of her disciples, **Sat Prem** and Patrizia **Norelli-Bachelet**, have done (though they do not say the same thing and in fact never mention each other, as far as I know).

In these circumstances, I think we can be forgiven for feeling somewhat at sea. But this is an inevitable consequence of any claim that redefines *everything*. The old markers do not mean what we think; and we cannot understand the new ones because they are in a new language—and I don't just mean a verbal language. So we either sink or swim—or maybe strike out in yet another new direction. But in uncharted waters, all directions appear to be the same.

Primary sources: The Mother on Herself (Pondicherry, 1971); *India and Her Future* [compiled from the writings of Sri Aurobindo and the Mother], (Pondicherry, 1971)

Secondary sources: Sat Prem, *The Mind of the Cells* (New York, 1982); R. Lohman, *A House for the Third Millennium: Essays on the Matrimandir* (Alain Grandcolas, no provenance—Paris?, 1986); K.R.S. Iyengar, *On the Mother: The Chronicle of a Manifestation and a Ministry* (2 vols, continuously paginated), (Pondicherry, 1978, 2nd ed.); R.R. Diwakar, *Mahayogi: Life, Sadhana and Teachings of Sri Aurobindo* (Bombay, 1972); A.B. Purani, *The Life of Sri Aurobindo: A Source Book* (Pondicherry, 1964; 3rd ed.); N. Prasad, *Life in Sri Aurobindo Ashram* (Pondicherry, 1965); R. McDermott, *The Essential Aurobindo* (New York, 1973)

Centre: Auroville, P.O. Kottakuppam—605104, India

COMPARE:

Other utopian communities led by Western teachers: Donald Walter/Swami **Kriyananda**'s Ananda co-operative Village, Shrila **Bhaktipada**'s New Vrindaban

Other teachers who redefine everything: Master **Da**

LINDA MURRAY. SEE LINDA **KLEVNICK**

VEN. MYOKO-NI. SEE IRMGARD **SCHLOEGL**

NAMGYAL RINPOCHE | LESLIE DAWSON | ANANDA BODHI. SEE *TULKUS*

NANAVIRA THERA | HAROLD MUSSON

English Theravadin monk who may have attained *sotapatti* (the first stage of enlightenment); committed 'spiritual' suicide in 1965

Musson was the son of a soldier (a Lieutenant Colonel with a D.S.O. and an M.C.) and was born at Aldershot barracks in 1920. When he was a child, he spent some time with his father in Burma and was struck by the Buddhist monks that he saw there. But his upbringing was in all other respects conventional. The family was well off and he had a private income as a young man. He was educated at public school (Wellington) and went up to Magdelene College, Cambridge, in 1938 to read Mathematics; he got a third in Part I and then switched to Modern Languages. But as soon as war was declared, Cambridge allowed its undergraduates to finish their degrees in two years. Musson joined up in 1940. (I don't know what kind of degree he got.) (Biographical information: *Clearing the Path,* 507, 514, 520, 536–37.)

He was a good linguist, fluent in French, German and Italian, and served as an interrogator of prisoners of war (Italians in Italy and Germans in Algeria). While he was in Italy, he translated a book on Buddhism: *La dottrina del risveglio, saggio sull'ascesi buddhista,* written by Julius (or Guilio) Evola in 1943, and published by Luzac in 1951 under the title *The Doctrine of Awakening: A Study on the Buddhist Ascesis.* This may well have been his first serious contact with Buddhist teachings.[1]

[1] If this is so, it was certainly an odd introduction. Evola was an enthusiastic Fascist who advocated what might be called esoteric racism. In 1938, he translated *The Protocols of the Elders of Zion* into Italian. This notorious work, which purports to be a secret document issued by international Zionists outlining a plot to undermine Christendom by socialism and liberalism (or failing that, by sabotage), had already been exposed as a forgery in 1921. And clearly Evola was aware of this since he is careful to say that whether the document is genuine or not, it still fits the facts. And what are the facts? That the *Protocols* contain "a plan of an occult war which has as its objective the complete destruction of everything which in the non-Hebraic peoples is [known as] tradition, caste, aristocracy, and hierarchy" (p. XII of Evola's Introduction). According to Maurice Slawinski, who kindly provided the translation, this is as anti-semitic as one can find. "It's nasty stuff."

Although not spelt out in detail, Evola's esoteric racism pervades *The Doctrine of Awakening.* In a chapter entitled 'The Aryan-ness of the Doctrine of Awakening', Evola refers to the "unity of blood and spirit of the white races who created the greatest civilizations" (namely, the Iranian, Hindu, Greek, Roman, and German) (*The Doctrine of Awakening,* 17), and says that "*Arya* stood essentially for an aristocracy opposed, both in mind and body, . . . to obscure, bastard 'demoniacal' races" (such as the Dravidians) (ibid., 18). The Buddha is a "royal ascetic" (like Caesar!) (ibid., 21), who, "in his Aryan superiority" never appealed to the irrational, sentimental or emotional elements in human beings (ibid., 23). He "had so little sympathy for the masses . . . that he speaks of the 'common crowd' as a 'heap of rubbish'" (ibid., 43).

Needless to say, the general ideal of an aristocratic Aryan civilization (though not this Buddhist form of it, which as far as I know, had no impact whatever) was very appealing to the political right. High-ranking Fascists in Italy and Germany were impressed by Evola's writings—and he knew that they were. His theories influenced

A couple of years after he left the forces, Musson met an old army friend, Osbert Moore, who was also interested in Buddhism, in a bar in London. The two of them decided to go to Ceylon and become monks. They left England in 1948 and were ordained in Ceylon in 1950. Musson took the name Nanavira and Moore, Nanamoli. The 'careers' of the two men were very different, however. Moore/Nanamoli spent the rest of his life at the Island Hermitage, the monastery for Western monks founded by the German, Anton Gueth/**Nyanatiloka** Thera, in 1911. He became a Pali scholar, best known for his translation of the mammoth *Visuddhimagga* of Buddhaghosa in 838 closely printed pages. He died of a heart attack in 1960. Musson/Nanavira, on the other hand, although he did learn Pali, was essentially a hermit rather than a scholar and much preferred the solitary life to that of a communal monastery. He started off at the Island Hermitage but left in 1954 and lived more or less in seclusion for the next eleven years.

During this time, he meditated intensively and as a result claimed to be a *sotapanna*—that is to say, someone who, though not fully enlightened, is nevertheless at a stage which must necessarily lead on to enlightenment. The evidence (if one call it that) for this attainment consists of a letter he wrote in 1959. It is in Pali and uses a formula that is found in the Theravadin texts. Its English translation is as follows.

> At one time the monk Nanavira was staying in a forest hut near Bundala village. It was during that time, as he was walking up and down in the first watch of the night, that the monk Nanavira made his mind quite pure of constraining things *(avaraniya dhammo)*, and kept thinking and pondering and reflexively observing the Dhamma as he had heard and learnt it. Then, while the monk Nanavira was thus engaged in thinking and pondering and reflexively observing the Dhamma as he had heard and learnt it, the clear and stainless Eye of the Dhamma arose in him: 'Whatever has the nature of arising, all that has the nature of ceasing.'
>
> Having been a *dhammanusari*[2] for a month, he became attained to right view. (*Clearing the Path,* 495; the Pali original is on p. 153)

Nanavira says that a *sotapanna* can be male or female, a member of the *sangha* or a layperson. But even though, having "attained to right view", she or he is bound to attain enlightenment, she or he is certainly capable of faults. A lay *sotapanna* can break any of the five precepts (which means that she or

Mussolini (Cannistraro, 189); he corresponded with Alfred Rosenberg, the Nazi racial theorist and one of the chief propagators of *The Protocols of the Elders of Zion* (N. Cohn, *Warrant for Genocide,* [Pelican, 1970], 214); and the Nazis themselves (including Himmler) seriously considered whether they could use him to strengthen their ideology (Goodrick-Clark, 190). In the end, they decide that he wasn't reliable—but this did not prevent him being invited to Germany during World War II to translate Masonic documents for the SS (which the SS itself had banned) (Waterfield, 15).

It would certainly be unfair to link Musson with Evola too closely. But as an officer in Military Intelligence, and one who was fluent in Italian, it is difficult to believe that he would not have been aware of Evola's Fascist sympathies. Hence it is somewhat surprising that he should endorse Evola's view of Buddhism as having "recaptured the spirit of Buddhism in its original form" (*The Doctrine of Awakening,* ix). Yet it is evident from Musson's later writings (as the monk, Nanavira) that he has a certain elitist hauteur himself. Perhaps he found an echo of it in Evola's work.

[*Bibliography for Evola: L'internatazionale ebraica. I "protocolli" dei "savi anzinani" di Sion,* 5th ed., (Rome, 1938); *The Metaphysics of Sex* (East-West Publications, 1983); [other works by Evola can be found in the bibliographies provided by Waterfield and Cannistraro]; R. Waterfield, 'Baron Julius Evola and the Hermetic Tradition', *Gnosis,* no. 14, Winter 1989–90, 12–17; E. Zolla, 'The Evolution of Julius Evola's Thought', *Gnosis,* no. 14, Winter 1989–90, 18–20; P.V. Cannistraro, ed., *Historical Dictionary of Fascist Italy* (Connecticut/London, 1982), 188–9; N. Goodrick-Clark, *The Occult Roots of Nazism* (Aquarian Press, 1985)]

[2] Literally, 'one who follows Dhamma'; defined in the Pali Canon as one who has attained the path *(magga)* and investigates Dhamma.

he can take life, tell lies, steal, take intoxicants, and indulge in wrongful sexual behaviour). A *sotapanna* who is a *bhikkhu* is susceptible to anger, ill-will, jealousy, stinginess, deceit, craftiness, shamelessness, and brazenness, and is capable of breaking all the lesser *Vinaya* rules (over 200 of them!) (*Clearing the Path,* 280–84).

Being a *sotapanna,* then, means two things simultaneously: that one has independent knowledge of the Dhamma and need not be guided by another; and that one may be subject to all sorts of cravings, including sexual desire. Nanavira claimed to have direct experience of both—which is why he is so unusual.

His independent knowledge of Dhamma led him to express some trenchant views about the Theravada tradition.

> In general . . . the Buddhists of Ceylon are . . . remarkably ignorant of what the Buddha actually taught . . . It is simply taken for granted (by *bhikkhus* and laymen alike) that there are not, and cannot possibly be, any *sekha bhikkhus* (or laymen) actually walking about in Ceylon today. People can no longer imagine what kind of creature a *sotapanna* might conceivably be, and in consequence superstitiously credit him with every kind of perfection—but deny him the possibility of existence . . . So long as you are content to put the *sotapanna* on a pedestal well out of reach, it can never possibly occur to you that it is your duty to become a *sotapanna* yourself (or at least make the attempt) here and now in this very life; for you will simply take it as axiomatic that you cannot succeed. (*Clearing the Path,* 281–82)

He is equally forthright about the reliability of texts. Works such as the *Digha Nikaya, Majjhima Nikaya, Samyutta Nikaya, Anguttara Nikaya, Sutta Nipata, Dhammapada, Udana, Itivuttaka,* and *Theratherigatha* "can be trusted absolutely from beginning to end" (*Clearing the Path,* 153). But no others can—not even the renowned *Visuddhimagga* (which his brother monk, Osbert Moore/Nanamoli Thera, spent so long translating). Nanavira states "categorically and on my own authority" that it is "generally misleading" (*Clearing the Path,* 251). On the other hand, he sees some modern Western thinkers as very close to the Buddha's teaching. He is particularly fond of Kierkegaard, makes frequent reference to Heidegger and Nietzsche, and clearly takes Camus and Sartre seriously.

> . . . if we want to understand the Suttas, the phenomenological approach is more promising than the objective scientific approach . . . [And if one does not have a teacher who truly understands Dhamma,] then one has to work out for oneself (and *against* the accepted Commentarial tradition) what the Suttas are getting at. And here, an acquaintance with some of [the existential] doctrines can be—and, in my case, has been—very useful. (*Clearing the Path,* 433)

He also finds significant insights in Dostoievsky, Kafka and Joyce. All of this is decidedly idiosyncratic. How many expositors of Buddhism—and Theravada Buddhism, at that—prefer *Ulysses* to the *Visuddhimagga*?

So much for one side of the *sotapanna* equation: Nanavira's independent knowledge of Dhamma.[3] The other side—what he calls his satyriasis—is, not

[3] I should mention that he had at least one pupil: a certain Sister Vajira, a *dasa sila mata* or ten precept nun, and as far as I can gather, a Westerner. The references to her in *Clearing the Path* (pp. 385–390, 531–534) are somewhat technical and disjointed. But they seem to amount to the following: that as a result of Nanavira's exposition of Dhamma, Sister Vajira's Dhamma eye had been opened and she had herself become a *sotapanna*. Whether we accept that this is what actually happened is another matter. But I know of no other case like this in the entire history of Western Theravada—that is, no other instance where this much has even been *claimed*.

surprisingly, rather different. It developed after he had taken some pills in 1962 in an attempt to cure amoebiasis—a painful stomach complaint. These sexual desires were clearly quite violent (a word that he uses more than once—and he always uses words with care), "as if I had taken a very strong aphrodisiac", and they apparently led to spontaneous orgasm (*Clearing the Path,* 524).

His situation was certainly peculiar. If he took the pills for his amoebiasis, he developed satyriasis—and could not meditate; if he did not, he was wracked with pain—and could not meditate. His solution to this affliction was suicide. But he considered it very carefully before going through with it, and its significance for a Buddhist monk such as himself needs to be properly understood.

> These disorders not only make my life uncomfortable, but also (which is of far greater consequence) leave me with little hope of making any further progress in the Buddhasasana [that is, the Buddhist path] in this life . . . As regards Vinaya and Dhamma I am well aware of the situation and do not need to seek the advice of others. Suicide, though a fault, is not (contrary to widespread opinion) a grave offence in Vinaya . . . ; and as regards Dhamma I know better than anyone how I am placed. (*Clearing the Path,* 271)

Spoken like a true *sotapanna,* one might say.

> I would a hundred times rather have it said of the Notes that the author killed himself as a *bhikkhu* than that he disrobed; for *bhikkhus* have become *arahants* [that is, enlightened] in the act of suicide, but it is not recorded that anyone became [an] *arahant* in the act of disrobing. (*Clearing the Path,* 279)

He even cites one instance in the Pali Canon where a *bhikkhu,* Sappadasa Thera, who could not rid himself of lustful thoughts, cut his throat with a razor—and became an *arahant* in the process (*Clearing the Path,* 276). This may have served as a model for Nanavira himself.

It is evident that his death was well thought out.

> If anyone is going to commit suicide—not that I advocate it for anyone—it is a great mistake to do it when one is feeling at one's most suicidal. The business should be carefully planned so that one is in the best possible frame of mind—calm, unmoved, serene—when one does it. Otherwise one may end up anywhere. (*Clearing the Path,* 238)

He meticulously considered the various methods—suffocation, the knife, poison, hanging, starvation (*Clearing the Path,* 217–18)—but in the event he inhaled ether nalin on 5th July 1965. He was 45 years old, and had been a monk for 14 years and a *sotapanna* for six.

Nanavira was clearly a loner—with all the advantages and disadvantages of that breed. The advantages are that he investigated things for himself and took responsibility for his own spiritual state (both his attainment of *sotapatti* and his suicide). This is fully in accord with an ancient and noble strand of Buddhism as the Theravadin tradition has preserved it, and I defy anyone not to be impressed with it. The disadvantages are that he was somewhat headstrong, and while he was undoubtedly blessed with clarity he may have been somewhat lacking in common sense. But then he never did believe that the standards of common sense could be applied to the spiritual life. And while the deliberate abandonment of this virtue is surely fraught with danger, if anyone can convince me that it is justified, it is this Englishman—born Harold Musson in Aldershot barracks in 1920, died (by his own hand) Nanavira in Sri Lanka in 1965.

Primary sources: Nanavira Thera, *Clearing the Path: Writings of Nanavira Thera (1960–1965)* (Sri Lanka: Path Press, 1987) [incorporates *Notes on Dhamma* and over 100 letters]; 29 of these letters (together with two not included in *Clearing the Path*) can be found in Nanavira's *The Tragic, the Comic and the Personal*, The Wheel Publication No. 339/341, (Sri Lanka: Buddhist Publication Society, 1987); his translation of Evola's *The Doctrine of Awakening* (London, 1951)

Secondary sources: None

Centre: None

COMPARE

Other Western Theravadin monks: **Ananda Maitreya**, **Kapilavaddho**, **Nyantiloka** Thera, Ajahn **Sumedho**

Other hermits: Swami **Atulananda**, Sister **Uppalavanna**, **Sat Prem**

Other Western teachers who have committed 'spiritual' suicide: Swami **Ajatananda**

NGAK'CHANG RINPOCHE. SEE NGAKPA **CHOGYAM**

MAURICE NICOLL. THE **GURDJIEFF LEGACY**

SISTER NIVEDITA | MARGARET NOBLE. SEE **APPENDIX 1**

BHAGAVAN I.M. NOME

American who claims to be identical to *Ramana Maharshi*

The absence of an individual to be 'enlightened' or 'unenlightened' is the Great Liberation. Liberation or Self-Realization is your very Being, not being this or that, just Being. Truly I AM but there is no me.

This is the only statement I have seen by Bhagavan Nome. According to a booklet put out by his organization, The Avadhut, "he speaks so that we can be Enlightened and become living Buddhas—not so that we can make books and tapes. Thus we do not publish or record any of Bhagavan Nome's dialogues" (*Welcome to The Avadhut*, 30).

Nor is there any personal information about him. An untitled collection of testimonials about Bhagavan says that a personal history would be limited to his body, "a mere dream-image that can scarcely contain the one vast background of all universes, which is Bhagavan". It does seem, however, that his name really is 'Nome'—it is German in origin, I think—though I am not so sure about the initials 'I.M.' In any event, it allows a nice set of non-dual puns: I.M. Nome = I'm no me = 'Truly I AM but there is no me'. I never saw a single photograph of him while I was at Santa Cruz; and although the Avadhut says that there are no rules, I have little doubt that anyone who took one, let alone put it up, would have something to answer for.

But there is a wealth of claims on his behalf as an enlightened sage. Here is a selection, all taken from Avadhut fliers.

Like His Guru Bhagavan Sri Ramana Maharshi, I.M. Nome enquired deeply into the nature of His Being and Realized His Absolute Divinity . . .

Bhagavan I.M.Nome is identical with His Guru, Bhagavan Sri Ramana Maharshi. He has turned within and found Peace. In the Spirit of Sri Ramana, Sri Nisargadatta Maharaj, and the Ch'an Masters, Nome reveals the Truth in a simple and direct manner . . .

Bhagavan Nome is Silent Wisdom; Love Itself. Like Bhagavan Ramana, His Presence *is* the communication of Truth. We are directed to find out who we are in the same spirit as Ch'an Buddhism and Advaita Vedanta—beyond all dualisms. Truth is Free—we are Free! There are no rules, forms, concepts or fees. Practice and Realization are of the same Nature.

In addition to *Ramana Maharshi* and Nisargadatta Maharaj, Anandamayi Ma is also mentioned now and again, and a recording of her chanting is played at *satsang*. But I have seen no quotations from her nor any photos. In contrast, there are quite a few quotations from, and photographs of, Nisargadatta Maharaj. The Avadhut says that Nome's direct transmission of truth is identical with that of all non-dual teachers/teachings. Examples given are: Buddha (the *Heart* and *Diamond Sutras*); Christ (*The Gospel of Thomas* and *John,* Chapter 17); Huang Po, Hui Neng, Bankei; the *Vimalakirti Sutra,* Saraha, the *Songs* of Milarepa, *The Tibetan Book of the Great Liberation;* Dakshinamurti, Kabir, Shankara, Yoga Vasistha, the *Ribhu Gita,* the *Ashtavakra Gita,* the *Avadhuta Gita,* Sri Atmananda of Trivandrum (John **Levy**'s guru), Brahmajna Ma.

But there can be no doubt that the most revered teacher of all is *Ramana Maharshi.* He is quoted extensively and his photograph appears everywhere. The reason for this, I think, is simply that he is Nome's guru, although the two never met. However, according to *Ramana*'s own teaching, there is no reason why they should. The 'Who am I?' enquiry is quite sufficient to lead to knowledge of the Self. The non-dual path does not depend on a specific transmission from teacher to disciple. (True to the principle that an enlightened sage has no history, the Avadhut provides no dates of any kind concerning Bhagavan's enlightenment. The earliest date that I have seen is 1979—when someone met him—so he must have managed it by then.)

The core of the practice at the Avadhut is simply association—that is, *satsang*—with Bhagavan. The Avadhut literature constantly states that there is no need for any preparation for *satsang*: no lengthy courses of study, seminars, weekend intensives, retreats, guided meditations, yoga sessions, or anything of the sort. Nor are there injunctions to tell people how to live. "Every seeker is actually responsible for discerning his own path and determining the pace at which to proceed." "Just bring an open heart, and open mind, and all your suffering and doubts will be resolved."

Bhagavan abides as the Sole existent Reality. To abide with Him is Satsang. He is Radiant Void Awareness and it is indeed Blissful to be in His Presence. (Untitled flier)

As the quotations from Avadhut sources have already indicated, there is a very strong devotional aspect to being a follower. This is also seen as part of *Ramana Maharshi*'s teaching, since he said that surrender and self-inquiry ('Who am I?') led to the same goal. There is a 40-page booklet (untitled, undated—how non-dual can you get?) which consists entirely of testimonials from devotees, who come from a great variety of 'spiritual backgrounds': atheism, Christianity, Buddhism and a considerable assortment of teachers

(Satchidananda, Chinmayananda, *Yogananda,* Yogi Bhajan, *Krishnamurti*, Roy Eugene **Davis**, **Rudi**, Guru **Subramuniya**, Jiyu **Kennett**, Oscar **Ichazo**, Master **Da**). Without exception, these devotees express *guru-bhakti* of the most extreme kind (and I am not using the word 'extreme' in a pejorative sense).

> I trust Him more than I trust my own mind.

> [He is] pure Happiness-Love flashing into this world appearance for the inspiration of his devotees . . . To him I humbly bow. I have no motivation but to become as He is . . . Bhagavan is my Reminder and my Salvation.

> The Love I feel in His Presence is exactly the same as I feel with Christ—clear and radiant, vast and limitless—and it is into this Love that am I falling and being dissolved. Being with Bhagavan is being with Christ . . .

> That day, as I entered the Hall and saw Bhagavan, I was awestruck. I fell to my knees and tears streamed from my eyes. God in all His Infinite Glory had revealed Himself in a human being.

Not surprisingly perhaps, in view of these sentiments, they all see him as the source of grace that will grant liberation.

> A permanent Guru connection with Bhagavan I.M. Nome was established when I became convinced that not only is He identical to His Guru Ramana, but that he is undoubtedly the surest means by which I also can become absorbed in the Absolute.

> The only way I can say thank you to my blessed Guru is to melt completely into Him so that only He remains.

> I now have no doubt that that I will be Enlightened in this lifetime, fully Free and at peace in Identity with Him.

I think it is fair to say that these assertions go considerably beyond anything that was said about *Ramana Maharshi*. Or perhaps it would be more accurate to say when statements like this were made to, and about, him, Ramana always undercut them with his non-dual 'position'.[1] I am not saying that Bhagavan Nome does not say the exact same thing. But the expressions of *guru-bhakti,* most of them made by young Americans with no real connection with the guru tradition of India, contrast strikingly with the much more restrained publications of Ramana's own organization. No books of testimonials for him.

There is also another important difference between Nome and Ramana. Whereas Ramana remained completely on his own throughout the 50 years following his enlightenment, Nome has recognized three of his devotees, known as 'sages', as enlightened themselves. The first two were Russ and Lane. Again, I know nothing about them, except that Lane played the flute in an East-West fusion band called Phoenix. In any event, they were both present at *satsang* on the one occasion that I attended. All three sages—Nome slight and about 35, the other two a little younger, perhaps—sat at the front of the hall, with Nome in the centre. The *satsang* began with silent meditation, followed by a tape of Anandamayi Ma chanting. Then there were questions from the 'audience' which Nome answered for the most part, although Russ also responded

[1] For example, when someone said that she needed his grace in order to realize the Self, he replied, "As for Grace, Grace is within you. If it is external, it is useless. Grace is the Self. You are never out of its operation. Grace is always there" (*Talks with Sri Ramana Maharshi,* vols. 1-3, Sri Ramanasramam, Tiruvannamalai, 1963 (3rd ed.), 248).

fairly fully on many occasions. Lane hardly said anything but when she did, it was usually at the end of an exchange.

The Avadhut literature says that people are encouraged to ask any question, and this certainly seemed to be true. Some of them were so vague as to be almost incomprehensible. But there were exceptions. A middle-aged lady asked about her cancer. (She ended by saying, "I give it all to you, Bhagavan".) Another person asked about the relationship between money and security. Russ's answer was certainly direct: "You were asking these questions nine months ago. Where have you been? Daydreaming? You already know the answer."

All the time, children were wandering freely about the hall. There was a collection of toys next to the stage so that the children were often playing right in front of the sages, between them and the audience. After an hour or so, the lights were dimmed so that a only a single candle was left burning in front of Bhagavan. Ten minutes of silent meditation followed, brought to an end by him saying, "Alright!" Russ and Lane then left the hall to talk to people in the foyer, while Bhagavan stayed behind and answered more questions. Driving back to Santa Cruz at about midnight, a convoy of eight cars, including Bhagavan's Volvo estate, which kept in contact with the other cars by CB radio, stopped in a lay-by/turnout on Highway 17 for five minutes *darshan*.

This was in 1986. Russ and Lane had got married a month or so earlier. (Nome is not married; he lives in the same house as Russ and Lane.) But Lane already had cancer and she died a year later. Just before her death, apparently, she started to call herself 'Zero'. In 1989, Bhagavan acknowledged another follower as enlightened: a woman called Helga. As far as I know, this is the current state of play.

The Avadhut has a number of 'devotee' households in the Bay Area and also organizes social evenings, called Dharma Nights, for meditation, readings and discussion. *Satsang* is held three times a week in different locations. Announcements are placed regularly in Bay Area free newspapers like *Common Ground* and over ten thousand bookmarks, which carry quotations from *Ramana Maharshi* and Nisargadatta Maharaj, and give the Avadhut's address, have been distributed.

This spreading of the word may be fairly modest but it is going on. Again, this is not something that happened at *Ramana Maharshi*'s ashram. Now, I am not saying that just because Bhagavan Nome followed the method advocated by *Ramana Maharshi* and therefore regards him as his guru, that he and his devotees are bound to copy everything that Ramana did (or, since he in fact did practically nothing, that they are bound to copy what grew up around him). There is, after all, a considerable difference between India in the 1930s and California in the 1970s. Moreover, India has a tradition of gurus while America (and the West) does not. Various external forms are being tried in the West and the Avadhut is one of them.

But there is a significant difference between Bhagavan Nome and the other Western teachers of non-dualism in this book. Barry **Long**, **Jae Jah Noh**, and **Shunyata**, for example, do not claim any connection with anybody else. Toni **Packer** and Andrew **Cohen** used to (**Cohen**, with an enlightened disciple of *Ramana Maharshi*, in fact) but don't any longer. And while both Jean **Klein** and John **Levy** acknowledge their teachers, they rarely mention them. So in effect, none of these Western non-dualists draws their authority, so to speak, from anyone but themselves.

And the same could be said of Bhagavan Nome—except that his connection with *Ramana Maharshi* is constantly emphasized. Yet he does not in fact have any contact with anybody else in the Ramana tradition, if I can use that phrase; there is no connection with Ramana's ashram in India that I am aware of. And *none* of the teachers mentioned in Avadhut literature is alive.

So Nome is unique among Western non-dual teachers in that he is both independent (as all non-dual teachers are, by definition: the one truth shines by its own light) and connected.

Primary sources: None (apart from Avadhut booklets)

Secondary sources: None

Centre: The Avadhut, P.O. Box 8080, Santa Cruz, CA 95061, U.S.A.

COMPARE:

Other teachers who say that one's real nature is truth: Andrew **Cohen**, **Jae Jah Noh**, Jean **Klein**, John **Levy**, Barry **Long**, Toni **Packer**, **Shunyata**

Others who have a connection of some sort with Ramana Maharshi: Swami **Abhishiktananda**, Paul **Brunton**, **Shunyata**

Patrizia NORELLI-BACHELET

Italian follower of the *Mother* who has become a teacher in her own right

Aurobindo and the **Mother** had a number of Western disciples.[1] Most of them remained disciples but a few became teachers. Norelli-Bachelet (her married name) is one of them. She used to be an actress; I am told she had minor parts in some of Fellini's films but I have been unable to check whether this is true. She met the **Mother** in India in 1971. But almost immediately after her (the **Mother**'s) death in 1973, she was speaking as an independent teacher. She says that her Knowledge (she always uses a capital K) was

> a spontaneous flowering and it accompanied breakthroughs in my own Yoga. That is, Knowledge flowed as a result of those breakthroughs and not otherwise . . . and from the beginning it brought its own language. (*Vishaal* [her magazine] 4/3, August 1989, p. 2)

This language is symbolic and is essentially a reinterpretation of the ancient terminologies of astrology, alchemy and numerology. She calls it 'applied cosmology' and has presented it in a number of books and pamphlets (sometimes using the name 'Thea'—I don't know why). All of them are issued by her Aeon Centre of Cosmology in Tamil Nadu, India. And the term *aeon* is deliberate, of course. It is found in Gnostic texts and one of Norelli-Bachelet's main works is called *The New Way: A Study in the Rise and Establishment of a Gnostic Society*. This New Way was inaugurated by *Aurobindo*'s Day of Victory in 1926, which ushered in the Age of Aquarius. Hence *everything* now has to be reinterpreted and re-understood—which is why a new symbolic language is

[1] By and large, they were an interesting bunch: I am thinking of Dorothy Hodgson/Datta, who awarded herself *sannyasa;* Philippe Barbier Saint-Hilaire/Pavitra (whom the **Mother** called "a great Yogi"); J.A. Chadwick/Arjava, who was once a fellow of Trinity College, specializing in mathematical logic; and Margaret Wilson/Nishta, daughter of President Woodrow Wilson. A study of them would be useful.

required. To this end, Norelli-Bachelet has made several comparative commentaries, which link together the *Rig Veda*, the *Shiva Purana*, St. John's *Apocalypse (Revelation)*, and *Aurobindo*'s own writings on spiritual evolution. And all this is alongside her own system which integrates the twelve-part Zodiac with the nine-part Enneagram. In fact, she makes much of the number nine, which she says is "based on the extended measure of the solar system" and is the key to the **Mother**'s Temple (the Matrimandir). She claims to have made "discoveries . . . in the **Mother**'s plan" (*Vishaal* 4/3, August 1989, 4) and more particularly in the **Mother**'s design for the Matrimandir. Apparently, under pressure from the architects, everyone at Auroville abandoned the **Mother**'s original design.[2] "The only ones who persisted [in executing the Mother's plan] are those who came away with me, or who, though outside the Ashram, had a close contact with my work" (ibid., 5). In other words, Patrizia Norelli-Bachelet is the only one who truly understands what the **Mother** wanted. In this sense, she can be regarded as the **Mother**'s successor (which is not to say that she claims to be the **Mother**'s equal—she doesn't).

Primary sources: Patrizia Norelli-Bachelet, *The Gnostic Circle: A Synthesis in the Harmonies of the Universe* (Panorama City, California: Aeon Books, 1975); *The Hidden Manna: An Interpretation of St. John's 'Apocalypse'* (1975); *The Magical Carousel and Commentaries: A Zodiacal Odyssey* (1979); *The New Way: A Study in the Rise and Establishment of a Gnostic Society* (1981) [I do not have provenance for the last three]

Secondary sources: None

Centre: Vishaal, P.O. Box 396, Accord, NY 12404, U.S.A. [contact address]

COMPARE:

Other disciples of the Mother who became teachers: **Sat Prem**

Others with an esoteric cosmology: Omraam Mikhail **Aivanhov**, Oscar **Ichazo**, Elizabeth Clare **Prophet**, Serge **Reynaud de la Ferrière**, Sri **Krishna Prem**

Roshi Walter NOWICK

American who was one of the first Westerners to practice Zen in Japan

I wish I knew more about this man but he is very reclusive and has kept himself to himself for the last 45 years. He was a professional pianist who had been taught by a member of Sokei-an's First Zen Institute in New York. Sometime in the late 1940s or early 1950s (though I have no firm date), he went to Daitokuji and began practicing with Zuigan Goto Roshi, who had been one of the handful of Japanese—Sokei-an was another—to spend a year or so with *Soyen Shaku* in San Francisco in 1906. There must be a connection with Ruth Fuller **Sasaki**, who started practicing with Goto Roshi in 1949, somewhere but I have not come across it. Nowick supported himself by giving piano recitals. After 17 years, he was given Dharma transmission by Goto Roshi—the first Western Dharma-heir in the Rinzai lineage. (Ruth Fuller **Sasaki** was made a Rinzai priest but not a Dharma-heir.)

[2] If one accepts that *Aurobindo* and the **Mother** have been the agents of a new stage in human, not to say cosmic, evolution, some explanation is required for the fact that its central feature, the Matrimandir, should be apparently sabotaged by the forces of ignorance (appearing in the form of architects: a much maligned species but surely not *that* bad).

Nowick returned to America (taking some Japanese disciples with him—another first and a remarkable one) and since Goto Roshi had told him to wait for ten years before teaching (*Soyen Shaku* had told Nyogen Senzaki to wait 20 years), he worked on his potato farm in Maine and also taught music at a nearby university. He founded the Moonspring Hermitage in Maine in 1969 (presumably immediately after returning to America but I'm not sure—the various timescales I have seen do not quite gel together); it was the subject of *A Glimpse of Nothingness,* an account of an unidentified Zen monastery by the Dutchman, Jan van der Wetering, another disciple of Goto Roshi. Nowick resigned as head of the hermitage in 1985 and stopped teaching—again, not something that happens very often. The centre was renamed the Morgan Bay Zendo but I do not know who its current leader is.

There is a certain splendid similarity between Nowick and Nyogen Senzaki. Each of them was a pioneer; each of them was told to wait and live an ordinary life before teaching; each of them, when they did teach, did so in a way that is almost glaringly inconspicuous. The result, if one can call it that, is something that is not even on the scale of success and failure—that is irelevant to both. And there is an obvious lesson in that.

(*See* Lineage Tree 6)

Primary sources: None

Secondary sources: R. Fields, *How the Swans Came to the Lake: A Narrative History of Buddhism in America* (Boston, 1986) 1st ed.; D. Morreale, *Buddhist America: Centers, Retreats, Practices* (Santa Fe, New Mexico, 1988), 147

Centre: Morgan Bay Zendo, Morgan Bay Road, Surry, ME 04684, U.S.A.

COMPARE:

Other Rinzai teachers: Ruth Fuller **Sasaki**, Irmgard **Schloegl**, Maurine **Stuart**, Gesshin **Prabhasa Dharma**

Other early Zen practitioners in Japan: **Sasaki** again, Robert **Aitken**, Philip **Kapleau**, Miriam **Salanave**

NYANAPONIKA Thera. SEE **NYANATILOKA** THERA (P. 460, N.1)

NYANATILOKA Thera | Anton Gueth

One of the first Westerners to become a Theravadin monk and probably the most influential Western Theravadin until his death in 1957

Gueth was born in Wiesbaden on 2nd February, 1878. He was brought up a Catholic but was also heavily influenced by German Romanticism, especially of the nature mysticism variety. He loved solitude from his earliest childhood and was always attracted to the life of a hermit. He abandoned the ceremonialism of Catholicism in his late teens and instead went to the church when it was empty. He was a gifted musician and composer and was privately tutored. He also read widely in philosophy: Plato, Descartes, Kant and especially Schopenhauer (who was himself influenced by the *Upanishads*). By the time he was 21, Gueth had given up alcohol and tobacco and become a vegetarian "on ethical grounds". He became a Buddhist, "more by feeling than understanding", after attending a talk by a Theosophist and subsequently read the

Buddhistischer Katechismus/Buddhist Catechism by Subhadra Bhikshu (actually a fellow German, Friedrich Zimmermann, who had given himself this name—he wasn't a monk), which had been published in 1888. Not long afterwards, Gueth decided he wanted to become a Buddhist monk and made his way to Bombay (not knowing that there was no Buddhism in India), arriving in 1903. He then went on to Ceylon but travelled to Burma in 1904 to take full ordination, where he was given the name, 'Nyanatiloka'.

Back in Ceylon, he composed *Das Wort des Buddha,* a compendium of extracts from the Pali Canon on all aspects of the Buddhist path—the first book of its kind in a Western language. It appeared in 1906 and was translated into English, French, Italian, Czech, Finnish, Russian, Hindi, Bengali and Sinhalese. He also became a teacher even at this early date. In 1906, he took as pupils a German, Fritz Stange/Sumana Samanera, and a Dutchman called Bergendahl whose Buddhist name was Sunno Samanera. In 1911, he founded an Island Hermitage, which was really a German (or German-speaking) monastery.

Both Lama Anagarika **Govinda** *and* **Nanavira** *lived and practised there.*

While we must full credit to the Sinhalese *sangha* for accepting him, the fact remains that the general attitude among the monks was decidedly 'conservative'—a technical term which I define in the introduction to the general entry, **vipassana sangha**. Hence Nyanatiloka was more or less bound to found his own monastery. The Island Hermitage could fairly be described as a rural retreat with a library. This is not to say that the life of the monks there was superficial. On the contrary, they lived according to the rules of the *Vinaya* and it would have been quite impossible for them to have become what Carrithers calls 'village monks'—that is, performing a largely parochial function and mostly ignorant of the *Vinaya* (Carrithers, 142). There have always been a number of options open to Westerners wishing to live the Buddhist life but this has never been one of them.

Although Nyanatiloka spent most of his life in Ceylon, he did return to the West on more than one occasion. He spent the major part of 1910 and 1911 in Switzerland, during which time he ordained a German painter, Bartel Bauer, as a *samanera* (Batchelor, 308)—the first time such an ordination had ever been carried out in a non-Buddhist country, as far as I know. He left Ceylon again in 1916 because, as a German, he was regarded as an undesirable alien during World War I, though he did not arrive in Germany until 1920 (after various adventures in China). He did not stay long but his dedication to the monastic life encouraged German Buddhists (for example, Paul **Dahlke** and George **Grimm**) to develop their lay practice; and Else Buchholz actually returned to Ceylon with him and lived the rest of her life as **Uppalavanna**.

Nyanatiloka returned to Ceylon in 1926, after a ten years' absence (six of them spent as a professor at Komazawa University in Japan), and spent the rest of his life there as a monk. He was an outstanding scholar, producing Pali grammars and anthologies, as well as some mammoth German translations of Pali texts—the *Anguttara-nikaya* alone amounts to 2,000 pages. Both he and the Island Hermitage were highly regarded by the Sinhalese. He was made "a distinguished citizen" (Peiris, 141) by the government in 1950. And in 1954, he was invited to attend the Sixth Buddhist Council in Rangoon by the Burmese government.[1]

[1] He was accompanied by his pupil, Nyanaponika Thera, who stayed on and practiced *vipassana* with Mahasi Sayadaw. Nyanaponika was one of the first Westerners to take up this form of meditation under an acknowledged teacher and the very first to write about it; his *The Heart of Buddhist Meditation*, published in 1956, had an extra chapter on *vipassana* that was not in the original German version of 1951. He was ordained at the Island Hermitage in 1937 and remained a monk until his death in 1996. He started a Forest Hermitage in

Nyanatiloka died in 1957, aged 79, and was succeeded as abbot of the Island Hermitage by another German monk, Nanaloka Thera (whose original name I don't know). The Hermitage is still going and Westerners still get ordained there. It has served as the model for two off-shoots—Nyanaponika's Forest Hermitage and the Verdant Hermitage established by the Czech monk, Nyanasatta Thera/M.Novosad (Peiris, 145). Both of them are essentially independent of Nyanatiloka's original but are still obviously derived from it; both Nyanaponika and Nyanasatta were ordained at the Island Hermitage. Bearing all this in mind, I think we can say that it is the only Western Theravadin monastery in the East that has been founded by a Westerner—at a time when the number of Western monks could be counted on the fingers of one hand—and its influence has been out of all proportion to its size. (A full study of it, and all those who have been associated with it, would be welcome.)

In general terms, it has served as the inspiration for many and shown that it is possible for Westerners to live the traditional monastic life—in the East. More particularly, it has served as a continuous stream, so to speak, in which the teachings and way of life have been transmitted from elder to novice. I hesitate to say 'from teacher to disciple', since traditional monastic Theravada is not really teacher-oriented but rather *sangha-* or group-oriented. Even so, it is not misleading to say that Westerners have tended to see the tradition in terms of personal spiritual guidance. This even applies to Western monks in Theravadin countries, some of whom have had Western disciples and are therefore spiritual teachers. Nyanatiloka is certainly one of the most important of these. Peiris refers to the Western monks at the Island Hermitage as his "bhikkhu-pupils" and I think this is a fair description. Moreover, since one of Nyanatiloka's pupils, Nyanaponika Thera, has also been a spiritual guide to some Western monks, perhaps we can go further and say that there is an incipient lineage of Western Theravadin teachers in Sri Lanka. It goes back to Nyanatiloka in the early years of this century—and I doubt if he knew what he was starting.

Primary sources: Nyanatiloka Thera, *The Word of the Buddha* (1907); *Buddhist Dictionary* (Colombo, 1952, 1st ed.), (1972, 3rd ed.)

Secondary sources: M. Carrithers, *The Forest Monks of Sri Lanka* (Delhi: Oxford University Press, 1983), Chapter 2; W. Peiris, *The Western Contribution to Buddhism* (Delhi: 1973), 139–141; S. Batchelor, *The Awakening of the West: The Encounter of Buddhism and Western Culture* (London, 1994)

Centre: The Island Hermitage, Dodanduwa, Sri Lanka

COMPARE:

Other early Western Theravadin monks: **Ananda Maitreya**, **Lokanatha** Thera, **Nanavira** Thera

*Other early Western monastics/*sannyasins: Swami **Abhayananda**/Marie Louise, Swami **Atulananda**, Sister **Devamata**, Sister **Daya**, Sri **Daya Mata** (all Hinduism); Hugo **Enomiya-Lassalle** (Christian Zen)

Other Westerners who have had centres in the East (in strictly alphabetical order): Swami **Abhishiktananda**, Madame **Blavatsky**, Hugo **Enomiya-Lassalle**, Lama Anagarika **Govinda**, some **Hare Krishna Gurus**, Jiyu **Kennett**, Sri **Krishna Prem**, Sri **Mahendranath**, the **Mother**, Ven. **Sangharakshita**, Ruth Fuller **Sasaki**, Ajahn **Sumedho**

Kandy in 1952 and founded the Buddhist Publication Society, which produces small, pocket-sized digests and translations of the Pali Canon (in English), in the same year.

LAMA OLE NYDAHL

Danish teacher in the Kagyu lineage of Tibetan Buddhism

Ole was born in 1941. I think it is fair to say that he has always been a fighter.

> During childhood he had frequent memories from his last life, battling Chinese soldiers to protect the civilians of eastern Tibet . . . While growing up he gained quite a reputation as a nearly undefeated boxer and unflinching protector of his friends. (*The Way Things Are,* 77)

Having completed his military service and taken a degree in philosophy at the University of Copenhagen, he decided to go travelling. He had just got married and in 1969 he and his wife, Hannah, went to Kathmandu. One day, they joined a queue of Tibetans and Nepalese waiting to be blessed.

> . . . [W]e stood in front of the Karmapa and he put his hands on our heads. We looked up, and suddenly he became greater than the whole sky, incredibly vast, golden and luminous . . . The power of the Karmapa had entered our lives. (*Entering the Diamond Way,* 65)

Everything in Ole's subsequent 'career' follows from this last statement.

After spending three years in Nepal, and having become the Karmapa's students, the Nydahls went back to Denmark, where they opened a centre in Copenhagen—the first Tibetan centre to be established in the West by a Westerner (*Riding the Tiger,* 21). It was inaugurated by the Dalai Lama in 1973, and the Karmapa himself visited in 1974. Over the last 24 years—from 1972 to 1996—Ole (helped by Hannah, and more recently, by two students, Caty and Tomek) has opened 180 centres throughout the world (*The Way Things Are,* 78). Apart from the places that one would expect (America; every Western European country except Portugal; Australia and New Zealand), many have been established in countries that previously had no contact with Tibetan Buddhism at all, especially Eastern Europe (Hungary, Poland, Romania, Serbia, Russia, Ukraine) and Latin America (Mexico, Colombia, Venezuela, Peru). In 1978, the Karmapa issued a letter "for the attention of all European Dharma centers especially those in Germany and Scandinavia," saying that "I have reappointed Ole Nydahl as the Head of the Dharma centres of the Karma Drub Djyling Association[1] and I have reappointed Hannah Nydahl as his deputy" (*Riding the Tiger,* 135). Ole puts it in his own way:

> We did exactly as [the Karmapa] said: I was to travel as lama and establish centers in his name. Hannah's job was to help the lineage-holders and other Rinpoches from Rumtek. She should organize for them and translate on their toursShe [also] communicated "upwards" and calmed the frequent rumors caused by my yogi style.[2] (*Riding the Tiger,* 136)

[1] The organization which oversees all the centres opened by Ole.

[2] It is perhaps inevitable that such a style, which he himself describes as uncompromising, should have its detractors. In 1984, three years after the Karmapa's death, **Osel Tendzin** (Chogyam *Trungpa*'s Vajra Regent) wrote to Vajradhatu members—at *Trungpa*'s request—warning them against "a certain Mr. Ole Nydahl" who had presented himself at various centres as "an authentic dharma teacher authorized by His Holiness the XVI Karmapa". Ole's "teaching style" is described as "contrary to everything we have been taught and have come to recognize as genuine . . . The Vajradhara [Chogyam *Trungpa*] feels very strongly that there is some real perversion of the buddhadharma taking place by Mr. Nydahl, and a definite perversion of His Holiness Karmapa's intentions and wishes" (*Riding the Tiger,* 252–53). This is strong stuff. Ole's response was to do nothing. Although "hundreds of powerful Central Europeans, who could each eat a dozen Vajra guards before breakfast" and who "felt that their lama had been attacked", were ready to jump on the next plane and sort **Osel Tendzin** out, he decided to be "a good Buddhist, who doesn't take revenge" (ibid., 250).

This episode was perhaps no more than a storm in a teacup. But it is interesting because it involved

In 1995, a certificate was issued by the Karmapa's International Headquarters which said that "Ole Nydahl is a qualified Buddhist layman-teacher or Lama."[3] He himself says that he has a vision (that's his word) of establishing a lay, yogic Buddhism (that's his phrase) that directly shows the nature of the mind. The back cover of *The Way Things Are* describes the book as "a living transmission of Buddha's deep wisdom, given by a Western Buddhist Master".

This is quite a claim. But Ole justifies it by referring to the Karmapa—or perhaps it would be more accurate to say 'the power of the Karmapa'. According to Chechoo Lama (who was actually Ole and Hannah's first teacher), the sixteenth Karmapa said (of the two of them) that "they will express my activity in the future" (*Riding the Tiger*, 492). Meanwhile, Ole continues his energetic way.

> One day we shall all really recognize the open, clear limitless space of the mind, and experience the fearlessness, spontaneous joy and active compassion of all Buddhas. Everything small, limited and blocked will fall away, and we shall realize our timeless perfection. (*Entering the Diamond Way*, 235)

It would be misleading to say that he claims to have realized this state. But he is certainly trying.

<div align="center">(See Lineage Tree 9)</div>

Primary sources: Old Nydahl, *Ngondro: The Four Foundational Practices of Tibetan Buddhism* (Nevada City, California: Blue Dolphin, 1990); *Entering the Diamond Way; My Path Among the Lamas* (Blue Dolphin, 1985); *Riding the Tiger: Twenty Years on the Road—the Risks and Joys of Bringing Tibetan Buddhism to the West* (Blue Dolphin, 1992); *The Way Things Are: A Living Approach to Buddhism for Today's World* (Blue Dolphin, 1996)

Secondary sources: some remarks in S. Batchelor, T*he Awakening of the West: The Encounter of Buddhism and Western Culture* (London, 1994)

Centre: Karma Drub Djy Ling, Svanemollevej 56, 2100 Copenhagen O, Denmark

COMPARE:

Other Westerners in Tibetan Buddhism: Freda **Bedi**, Alexandra **David-Néel**, W.Y. **Evans-Wentz**, Lama Anagarika **Govinda**, **Jampa Thaye**, **Lobsang Rampa**, **Osel Tendzin**, Lama **Teundroup**, [Western] ***tulkus***

Colonel Olcott

Co-founder of the Theosophical Society and Madame **Blavatsky**'s right-hand man; the first Westerner to champion Buddhism as a universal teaching

Henry Steel Olcott was born in New Jersey in 1832. His family was strictly Presbyterian but by his early twenties he had developed an interest in the occult: spiritualism, mesmerism, and Freemasonry. He fought for the Union in

two Westerners who were both part of the same Kagyu lineage—though in different ways—and both fully committed in their support of the Karmapa.

[3] I should point out, however, that this declaration was made at the height of the current kerfuffle concerning the recognition of the seventeenth Karmapa. (The sixteenth, who was Ole's teacher, died in 1981.) There are two rival candidates, one selected by Tai Situ Pa Rinpoche and one by Kunzing Sharmapa Rinpoche. Ole has thrown his weight behind the Sharmapa's candidate; he describes the boy recognized by Tai Situ Pa as "a fake communist Chinese candidate" (*The Way Things Are*, 78).

Naturally, this state of affairs, which is highly charged with emotion, has to be taken into account when assessing any statements—and I mean any statements, not just those to Ole—issued on behalf of the Karmapa.

the Civil War but was invalided out because of dysentery. He was then put in charge of an investigation which uncovered corruption among Army contractors and received the rank of Colonel. (He was always a good administrator.) After the war, he became a successful lawyer. He divorced his wife and became a man about town.

Then, in 1874, he heard about the spiritualistic phenomena at the Eddy farm in Vermont. He visited the farm and wrote an article about his experiences for a New York newspaper. Madame **Blavatsky**, who had only been in America for a year, read the article and went to the farm to see for herself. She and Olcott met and a year later the two of them (together with William Q. Judge) founded the Theosophical Society.

Blavatsky and Olcott were very different—almost opposite—personalities: she was stimulating, outrageous and chaotic, while he comes across as simultaneously staid and credulous. But despite their differences and quarrels, they made a good team. And as one might expect, their roles were quite distinct. She was the mouthpiece of the Masters; he was the organizer and honest broker. And whereas **Blavatsky** had personal disciples, Olcott was more of a general mentor and encourager of others' spiritual aspirations. On the other hand, he did have a major role to play in what might be called the Westernization of Buddhism.

This process began in 1875 in New York when Olcott received an account of Buddhist-Christian debates in Ceylon and pronounced himself a Buddhist (*Return to Righteousness,* 371). But it became a reality in 1880 when **Blavatsky** and Olcott, who were vigorously propagating Theosophy in India, visited Ceylon for a few weeks and formally became Buddhists by taking *pansil*. 'Pansil' is a contraction of a Pali phrase meaning 'five moral precepts'. What **Blavatsky** and Olcott did was to publicly take refuge in the Buddha, the Dharma, and the Sangha, and to declare that they would refrain from taking life, stealing, indulgence in sensuality, lying, and taking drink and drugs. This may not appear to amount to very much. After all, millions of Westerners who had never heard of Buddhism lived up to these moral standards. But Olcott saw it rather differently. "Our Buddhism," he said, "was that of the Master Adept Gautama Buddha, which was identically the Wisdom-Religion of the Aryan Upanishads and the soul of the ancient world faiths" (*Old Diary Leaves,* vol. 2, 168–69, quoted in Campbell, 83).

It seems extraordinary that Westerners in Ceylon could hold such a view—in New York or London, yes, but surely not in a Buddhist country. But Buddhism was in a very weak state in Ceylon. Centuries of Western rule—first by the Portuguese, then by the Dutch and finally by the British—had reduced the country to a subservient state, and the Buddhist community was simply incapable of dealing with the Western attitude towards it, whether this was openly dismissive, as with the missionaries and administrators, or wildly exotic, as with **Blavatsky** and Olcott.

But at least Theosophy—and Olcott in particular, who was known as 'the white Buddhist'—was enthusiastic about Buddhism. Olcott spoke to large crowds of two or three thousand (Campbell, 84; cf. Sister **Nivedita**/Margaret Noble nearly 20 years later) and worked tirelessly to further the Buddhist cause. One of the main reasons why Buddhism was so feeble in Ceylon was because the schools were run by Christian missionaries; naturally, Buddhism was never mentioned. So Olcott started Buddhist schools under the aegis of the newly founded Buddhist Theosophical Society; 60 were established in the first ten years (Campbell, 84). He also took up the cause of the Buddhists with

the British government (despite the fact that he was neither Ceylonese nor British). He persuaded the British to recognize the main events of the Buddha's life as public holidays; and in 1884 he visited London as representative of the Buddhists of Ceylon and was able to redress some of their grievances (Campbell, 86).

He was also empowered (in 1884) 'to accept and register as Buddhists persons of any nation who may make to him application to administer to them the Three Refuges and Five Precepts' (R. Gombrich, *Theravada Buddhism: A Social History from Ancient Benares to Modern Colombo* [London, 1988], 186). And we know that he did so: Franz Hartmann, an American Theosophist living at Adyar, received *pansil* from Olcott, though I don't know the date (Conway, 204). There may have been others for whom Olcott did the same, but if there were, we do not know of them. At any rate, Olcott's transmission to Hartmann, modest as it is, is probably the first instance of a Westerner in an Eastern tradition admitting another Westerner to the fold.

Yet even though Olcott was the only Westerner who had any role of any kind in Ceylonese Buddhism at this time, it would be misleading, I think, to say that he was a spiritual teacher (as Theravada understands that term). Rather, he was a liberal minded, anti-colonial American who was instrumental in freeing the Ceylonese from social and religious oppression. It's just that his efforts stemmed not from a social or political conviction but from what can properly be called a spiritual standpoint—namely, that Theosophy and Buddhism were fundamentally identical. Bearing all this in mind, I think it is true to say that he was probably the most influential individual in the revival of Buddhism in Ceylon and even today he is remembered in Sri Lanka with affection and respect. (Olcott Day is still celebrated there.) The prime minister of Ceylon summed up the matter nicely when he said, speaking in 1967, "Colonel Olcott can be considered one of the heroes in the struggle for our independence and a pioneer of the present religious, national, and cultural revival. Colonel Olcott's visit to this country is a landmark in the history of Buddhism in Ceylon" (Campbell, 84).

But in fact, although Olcott was quite sincere in his wish to help Buddhists in Ceylon, his real aim (influenced, of course, by his unwavering belief in **Blavatsky**'s Theosophy) was to establish Buddhism as a universal teaching—that is, to present a form of Buddhism that was common to all the traditions, an entirely Western notion which simply had not occurred to Buddhists in the East. In order to do this, he spent the rest of his life trying to get the different schools of Buddhism in different countries to agree to a basic set of principles that could be presented as 'essential' Buddhism, independent of, but also underlying, the various formulations that each country espoused.

One of the first people to be converted to this form of universal, international, Theosophical Buddhism was David Hewivitarne/Anagarika *Dharmapala*, who was initiated into the Theosophical Society by Olcott in 1884 (*Return to Righteousness*, xxxix). (This is another first for Olcott, I think: a Westerner with an Eastern pupil.) Olcott and *Dharmapala* worked together, as Theosophical Buddhists, for 20 years. As early as 1881, only a year after he took *pansil,* Olcott wrote *The Buddhist Catechism* (published by the Theosophical Society at the newly founded headquarters at Adyar, near Madras). He wrote it in English but it was immediately translated into Sinhalese (by Anagarika *Dharmapala*) and by the time of the 33rd edition (1897), it had been translated into 20 languages, including Burmese and Japanese. This is the first instance, I believe, of a Western work on an Eastern religion being trans-

lated into Eastern languages. All the editions contain an endorsement by Hikkaduwe Sumangala, High Priest of Sripada and Galle, and Principal of the Vidyodaya Parivena, that the Catechism is "in agreement with the Canon of the Southern Buddhist Church." The 36th edition of 1903 contains an endorsement by G.R.S. Mead (previously **Blavatsky**'s secretary), which urges that "the learned Buddhists of Ceylon [should] bestir themselves to throw some light on their own origins and doctrines." But, says Olcott, 22 years after the Catechism was first published, "I have not been able to arouse their zeal." This inability of the Ceylonese *sangha* to respond to Western interest was a primary reason why Theravadin Buddhism in the West developed in the way that it did.

The *Catechism* is a rather uneven work, it must be said. It is clearly based on Pali sources (but in translation—Olcott did not know Pali) and much of it is middle-of-the-road teachings on proper ethical conduct and the like. But there is also a pronounced tendency towards what might be called 'high' Theravada. This is shown by the treatment of the Buddha, who is represented as all-knowing, possessing miraculous powers *(lokuttara iddhi)* (including divine or clairvoyant sight with which he surveyed the world each morning to see who was ready to receive the truth) and sending forth "a divine radiance by the power of his holiness".

This Buddhology, though heavily selective, is at least defensible. The final section, however, entitled ' Buddhism and Science', is decidedly odd. The light around the Buddha is equated with the aura, the existence of which has been proved by Baron von Reichenbach; the Arhat's ability to project several hundred forms of himself is explained as hypnotism and mesmerism; and those who possess miraculous powers or *iddhi* "can, by manipulating the forces of Nature, produce any wonderful phenomenon, i.e. make any scientific experiment [they choose]." One should not expect too much of a pioneering work of this kind; but *The Buddhist Catechism* is made up, in about equal measure, of the elementary, the tendentious, and the peculiar.

In 1889, Olcott and *Dharmapala* went to Japan to get support for Olcott's universal Buddhism. And in 1891 Buddhists from Ceylon, Burma, Japan and Chittagong (in Bengal) met at the Theosophical Society headquarters at Adyar with a twofold purpose: to draw up a set of 14 beliefs on which all Buddhist schools could agree, and "to consider what steps should be taken for the propagation of Buddhism in the West" (*Return to Righteousness,* 649).

As it turned out, Olcott and *Dharmapala* split these two tasks between them. Olcott's 14 beliefs (basically the four noble truths, karma and reincarnation) were accepted by the representatives of the Buddhist schools and were added to subsequent editions of his *Buddhist Catechism. Dharmapala*, for his part, took it upon himself to spread Buddhism in the West. The two quarrelled in 1904 over Olcott's treatment of one of the Buddha's relics (*Return to Righteousness,* xxxix)—just three years before Olcott died (at the Theosophical Society's headquarters in Adyar).

When we look back, a century later, at Olcott's life as a Buddhist, we are bound to say that he was product of his times. There is no reason to think that he ever changed his belief that the Buddha taught "the Wisdom-Religion of the Aryan Upanishads and the soul of the world faiths"—a view that no Eastern Buddhist has held (except those influenced by Theosophy). And the fact that it could be held at all was only possible in a Buddhist country that had practically lost contact with its own roots. Such a meeting of confident occultism and faltering Buddhism is peculiar to that particular time and place.

In addition, it has to be said that Olcott's participation in Buddhist life in its traditional form was minimal. He may have kept the five precepts, which is itself admirable; but there is no evidence that he did anything else: no meditation and nothing that could really be called the religious life. And the reason is quite simple: these needs were met by Theosophy. Olcott was a Theosophist first and last, and can only be considered a Buddhist in so far as Buddhism can be seen as a form of Theosophy. This explains, I think, why it was *Dharmapala*, the Easterner, who was concerned with propagating Buddhism in the West, and not Olcott, the Westerner. Olcott was more interested in establishing the universal Wisdom-Religion via Theosophy-cum-Buddhism, whereas *Dharmapala*'s activities, even though he was a Theosophist, were rooted in Ceylonese-cum-Buddhist pride.

But though we may be critical of Olcott's Westernized Buddhism, I think it is fair to say that he started a process which has continued to the present day—namely, a consideration of Eastern traditions that, while it certainly wants to understand what each tradition says, nevertheless asks questions that the traditions themselves do not ask. This form of Westernization, at its best, is very powerful and all the most interesting developments of the last hundred years are rooted in it. Of course, it is presently richer and more profound than it was in Olcott's day. Yet he deserves an honourable mention in the story.

Primary sources: The Buddhist Catechism (Adyar: Theosophical Publishing House, 1881); *Old Diary Leaves: The History of the Theosophical Society,* 6 vols, (London, 1895–1935) [A full list is given in Murphet—see below.]

Secondary sources: Howard Murphet, *Hammer on the Mountain: The Life of H.S. Olcott* (Wheaton, Illinois: Theosophical Publishing House, 1972); B.P. Kirthisinghe and M.P. Amasuriya, *Colonel Olcott: His Service to Buddhism* (Kandy, Sri Lanka: Wheel Publication no. 281, [date not available]), 32 pp; B.F. Campbell, *Ancient Wisdom Revived: A History of the Theosophical Movement* (Berkeley: University of California Press, 1980); M.D. Conway, *My Pilgrimage to the Wise Men of the East* (London, 1906); Anagarika Dharmapala, *Return to Righteousness* (Ceylon, Ministry of Educational and Cultural Affairs, 1965)

Centre: None extant

COMPARE:

Other Western Buddhist pioneers: **Ananda Maitreya**, William **Bigelow**, Alexandra **David-Néel**, M.T. **Kirby**, **Nyanatiloka** Thera, Archbishop **Tennisons**

Other esoteric/occult versions of Eastern traditions: Omraam Mikhael **Aivanhov**, Elizabeth Clare **Prophet**, Yogi **Ramacharaka**, Serge **Raynaud de la Ferrière**

Other Westerners who have had a role in Eastern countries: Ayya **Khema**, Sri **Krishna Prem**, Sri **Mahendranath**, the **Mother**, **Nyanatiloka** Thera, Mahasthavira **Sangharakshita**, Ajahn **Sumedho**

OOM THE OMNIPOTENT | PIERRE BERNARD. SEE **APPENDIX 1**

A.R. ORAGE. SEE THE **GURDJIEFF LEGACY**

LEONARD ORR

American founder of rebirthing

Orr's breathing method, which he calls rebirthing, would have no place in this book—though it might in one about psychopyhysical techniques—were it not for the fact that he has linked it to an Indian master whom he calls Herakhan Baba or Babaji.

> Herakhan Baba rematerialized a human body in adult form in 1970 to make himself available to people in this age. He is a master of all forms of immortality and yoga, and has the ability to dematerialize and rematerialize his body whenever he wishes . . . He has appeared to some of us in the United States. He just appeared in full physical form in the room for a few minutes, delivered his message and disappeared. (*The Common Sense of Physical Immortality*, 37)

This is the same Babaji as the one mentioned in *Yogananda's Autobiography of a Yogi:* the 'founder' of *kriya yoga* (for whom see *Yogananda's* entry). Orr 'met' Babaji in 1977 or 1978—he has given both dates—and was told by him that 'spiritual breathing' (that is, rebirthing) was "a new yoga" (ibid.,). And I have been told, though I cannot cite a reference, that Babaji also said that rebirthing was '*kriya yoga* for the West'. Orr himself acknowledges that Babaji is the real founder of rebirthing. He refers to it as "a spiritual process"—he added the repetition of the names of God to the breathing practice after he 'met' Babaji in India—and says that one of the reasons he went to India was to "share" it with Indians (*Rebirthing in the New Age,* 142). That is, an American goes to India to teach a 'yoga' that he discovered under the guidance of a quasi-physical Indian master.[1]

(*See* Lineage Tree 2)

Primary sources: Leonard Orr, *The Common Sense of Physical Immortality* (Sierraville, California, nd); Leonard Orr and Sondra Ray, *Rebirthing in the New Age* (Millbrae, California: Celestial Arts, 1977)

Secondary sources: None

Centre: I AM ALIVE NOW IN THE WORLD, Box 163, Sierraville, CA 96126, U.S.A. *or* Bhole Baba Herakhan Universal Trust, Box 234, Sierraville, CA 96126, U.S.A. [take your pick]

COMPARE:

Others with connections to non-physical masters: Madame **Blavatsky**, Elizabeth Clare **Prophet**, Serge **Reynaud de la Ferrière**, Father **Satchakrananda**

[1] I am not sure how rebirthing/*kriya yoga* is linked with physical immortality. According to Orr, "Since meeting Herakhan Baba, I have met over seven people who are over 300 years old." However, he is at pains to emphasize that "physical immortality is a lot longer than 300 years"; and also mentions "another yogi who was 250. He was found shot to death in his cave in the Himalayas" (all this taken from *The Common Sense of Physical Immortality,* 38). As evidence, this testimony is perhaps not as watertight as it might be, especially as it appears in a chapter entitled 'Immortals Are Alive and Well'—and Babaji himself died in 1984. (Or perhaps it would be more accurate to say that he 'died' in that year.)

OSEL TENDZIN | THOMAS RICH

American disciple and Vajra Regent of Chogyam *Trungpa* who died in unfortunate circumstances

Rich met *Trungpa* in 1971 when he was already a disciple of Swami Satchitananda. He had gone to Boulder, Colorado to invite *Trungpa* to a World Enlightenment Festival. After this meeting, he wrote to *Trungpa,*

> After our talk I found myself in a state of quiescence. In itself this is not so new for me, but this calm was deeper, more weighty. The people around me remarked that I seemed different. All I could reply was that our contact was such that all my petty concerns about life became unreal . . . Someone had asked me to ask you why you smoked and drank but the question was absurd in the light of your consciousness of the truth. And like any real contact with another, I became again conscious of my infinite self . . .
>
> All I am trying to say is that I am open to you and I have been deeply touched by your divinity . . . (Fields, 336).

Rich became *Trungpa*'s disciple in that same year (1971), taking the name 'Osel Tendzin'. Shortly afterwards, *Trungpa* told him in confidence that he would become his Vajra Regent, although the formal ceremony did not take place until 1976. In *Trungpa*'s words,

> Although I would not say Osel Tendzin is an enlightened person, he is one of the greatest examples of a practitioner who has followed the command of the Buddha and the guru and the tradition of the Practice Lineage [= Kagyu] . . . He is my prime student. He has been able to commit himself and learn thoroughly the teachings of vajrayana . . . He is absolutely capable of imparting the message of buddhadharma to the rest of the world. (*Buddha in the Palm of Your Hand,* xii)

This appointment was confirmed by the Karmapa, head of the Kagyu lineage: "let everyone offer him due respect" (Fields, 338).

Osel Tendzin's book, *Buddha in the Palm of Your Hand,* published in 1982, gives an account of the Kagyu teaching as he had received it from *Trungpa.* The culmination of the Buddhist path is the Vajrayana, transmitted uninterruptedly and without corruption from the Buddha himself right down to the present Kagyu teachers. These teachers are "the embodiment of enlightenment" (*Buddha in the Palm of Your Hand,* 69). The guru is the living Buddha, devoid of the three defilements of passion, aggression, and ignorance (ibid.). The Kagyu tradition teaches that the awakened state of mind can be transmitted from guru to disciple. But this will only happen when the guru or perfectly enlightened one becomes the object of devotion (*Buddha in the Palm of Your Hand,* 92). Then everything that emanates from him is his instruction and by carrying out this instruction with faith and discipline, realization dawns. As a result, the guru is no longer just a person but the principle of enlightenment that exists in all beings (*Buddha in the Palm of Your Hand,* 99). Osel Tendzin finishes his book by saying,

*Cf. what Ajahn **Sumedho** says about the transmission of Theravada; what Jiyu **Kennett** says about the transmission of Zen; what the **Hare Krishna gurus** say about the transmission of Gaudiya Vaishnavism.*

> Look at the precious gem [the literal meaning of *Rinpoche,* the title given to *tulkus*], the guru, and see the Buddha himself . . . Have undiminished faith in the power of the lineage as the real expression of truth. This is my advice according to my own experience. (*Buddha in the Palm of Your Hand,* 102)

So far, so good, one might say. A Westerner has been chosen to continue an Eastern lineage—something that has happened in all the traditions. *Trungpa* himself, writing in 1977, painted a rosy picture.

> As I conclude my writing of this chapter, His Holiness Karmapa is with us once again . . . [He] is enjoying himself thoroughly, as if coming to America were returning home rather than travelling to a foreign country. He has given his confirmation and blessing to Osel Tendzin as Vajra Regent . . .
>
> . . . I have decided to set aside the year of 1977 for a personal retreat. During this year all of my students, headed by Osel Tendzin, will have the opportunity to continue on their own. I have no doubt that they will be able to carry out the vision of the golden sun of Dharma, energetically extending themselves for the benefit of beings and arousing the authentic dawn of Vajrasattva. (*Born in Tibet*, 264–65)

Whether this vision has been fulfilled is open to debate. After *Trungpa's* death in 1987, Osel Tendzin assumed the leadership of Vajradhatu with some aplomb. One by one, he performed functions that are usually reserved for established Tibetan teachers. In 1988, he presided over a Vajrayogini Abhisheka or empowerment—with a hat sent to him especially by Dilgo Khyentse Rinpoche (*Vajradhatu Sun,* vol. 9, no. 3, 1). A few months later, he led the annual Seminary at Vajradhatu. This was how it was described:

> On entering the shrine tent for the first time we were aware of a shift. Above the shrine . . . were the photographs of His Holiness Karmapa, H.H. Dilgo Khyentse Rinpoche, and Suzuki Roshi; but on the left there was a new presence. At the top was the Vidyadhara's teacher, Jamgon Kongtrul, under that the Vidyadhara smiling cheerfully, and at the bottom, the picture of the Vajra Regent Osel Tendzin . . .
>
> The Vajrayana teachings were presented in a clear precise way: the energy in the shrine tent crackled as we began to see the Vajra Regent in an entirely new light. He had manifested as the Elder in Hinayana, and as the Spiritual Friend in Mahayana; now we could see without doubt that he was completely willing to be our Vajra Master.
>
> In replying to a question about whether he was our Vajra Master or whether he was in some way a 'middleman', the Regent left it up to us how we related to him, but said if you treated him as a middle man, you would get middling teachings! Any doubts that had been present about the continuation of our lineage without the Vidyadhara were dispelled on the spot. (*Vajradhatu Sun,* vol. 11, no. 1, 1, 14, 15)

It is true that this rather breathless prose is the work of a student/disciple; but it clearly represents the 'orthodox' view in the *sangha* at the time. And Osel Tendzin referred to himself as "heart son of the crazy one" in the dedication of a poem he wrote in honour of the death of Kalu Rinpoche in 1989 (*Vajradhatu Sun,* vol. 12, no. 3, 10). (The "crazy one" was *Trungpa*, not Kalu Rinpoche.)

However, in December 1988 reports began to circulate that Osel Tendzin had AIDS and had engaged in unprotected sex with both male and female students without telling them. The repercussions for the community were considerable. A decision was taken to try and keep the matter 'in the family'. No public announcement was ever made by Vajradhatu. Instead, Osel Tendzin was gently eased out of his position. He went to live at Ojai, California, together with a number of loyal supporters, and continued to be the nominal head of the community but without the previous fanfare. Suddenly, no one was saying that he was a great Vajrayana teacher. In early 1990, Dilgo Khyentse Rinpoche advised him to go into retreat. He never emerged from it; a few months later he was dead.

I have been told by someone who attended his funeral *puja* that one of his students was nominated as Vajra Regent in his place. But the appointment was without any force. Those who had stayed with him at Ojai were effectively exiled from the Vajradhatu headquarters in Colorado; and besides, the main Tibetan teachers were looking in quite another direction: *Trungpa*'s oldest son, Osel Mukpo (usually referred to by the title of 'the Sawang'). It was this son whom *Trungpa* had had when he was still a monk in India and he became "the spiritual and temporal leader of Vajradhatu" (*Vajradhatu Sun,* vol. 13, no. 2, p. 1) at the request of Jamgon Kongtrol Rinpoche (one of the Karmapa's Dharma Regents) and Dilgo Khyentse Rinpoche. He will hold the fort, so to speak, until the twelfth *Trungpa* (discovered in 1992—the reincarnation of the Sawang's father, of course) is old enough to resume his duties.

There are clearly a number of loose ends here. What positions do the other members of the Mukpo family hold: Lady Diana Mukpo (the Sawang's step-mother); his real mother; his half-brothers, Tendzin Lhawang Mukpo, and Gesar Arthur Mukpo (who are *tulkus,* which the Sawang is not)? Or even Osel Tendzin's widow, Lady Lila Rich, who, according to one report, was actually appointed by *Trungpa* himself to teach the Sawang meditation! (*Vajradhatu Sun,* vol. 13, no. 2, 17). But, to change the metaphor, these are really eddies in the great river of the Tibetan tradition. The Vajradhatu *sangha* has been realigned with some of the most eminent Tibetan teachers and the experiment with the Western lineage-holder has been quietly left on one side. Just a little hiccup on the way, one might say.

Even so, a fair amount of ink has been spilt trying to understand these events. Most of it has focused on Osel Tendzin's recklessness; it seems undeniable that he put people's lives at risk. On a more theoretical level, there are obvious questions about the huge gulf between his pronouncements and his actions. But this was not an isolated incident, of course; so considerable attention has also been brought to bear on *Trungpa*'s crazy wisdom philosophy (and behaviour), which provided the framework, so to speak. And people have also had their doubts about the way in which the crisis was handled (by the Vajradhatu rank and file, by its leaders, and by the Tibetan establishment.).

I cannot go into the matter in any depth here—but see the 'secondary sources' for good references—except to summarize the main positions. Essentially, they come down to two. The first is that Osel Tendzin's behaviour (and, some would say, *Trungpa*'s as well) was unacceptable—contrary to Dharma. There are three variants of this view. The 'strong' version holds that men in positions of authority have taken advantage of dependent disciples; it's as simple as that. The middle version says that such incidents can only occur with the collusion of all the parties concerned; that those who present themselves as totally innocent are themselves playing a game; and that it is game-playing of this kind that encourages exploitation in the first place. The 'soft' version is that such things do happen but that there is nothing to be gained from being self-righteous and judgemental about them; what is required is that one continues to act in accordance with Dharma oneself; after all, what is the alternative?

The second position is what we might call, somewhat paradoxically, the 'orthodox' crazy wisdom view: such behaviour makes sense, and is therefore acceptable, from a higher perspective which limited, unenlightened minds cannot see.

These are deep waters and glib answers are of little value. What can be said, however, is that the issues themselves are now completely Western. We do not have to discuss them with examples taken from the past—and from the Eastern past, at that—but from present-day America. (It is America in this instance; in others, it is some other country.) So the 'answers', whatever they might be (and there will be several), will also be Western. And perhaps that is what really counts. One's own answers, however faulty, are worth more than other people's, however splendid.

Primary sources: Osel Tendzin, *Buddha in the Palm of Your Hand* (Shambhala, 1982); *Vajradhatu Sun* (the community's newspaper)

Secondary sources: R. Fields, *How the Swans Came to the Lake: A Narrative History of Buddhism in America* (Boston, 1986, 1st ed.); Katy Butler, 'Encountering the Shadow in Buddhist America', *Common Boundary,* May-June 1990, 14–22; Joanne Sanders, ed., 'Why Spiritual Groups Go Awry', *Common Boundary,* May-June 1990, 24–29 [this is a 'panel discussion' with a number of people, including **Ram Dass** and Joseph **Goldstein**]; Stephen Butterfield, 'When the Teacher Fails', *The Sun,* vol. 162, May 1989, 2–5 [and correspondence in subsequent issues]

Centre: I do not have an address for those loyal to Osel Tendzin; the Vajradhatu address is: 1345 Spruce Street, Boulder, CO 80302, U.S.A.

COMPARE:

Other teachers in Tibetan Buddhism: Freda **Bedi**, Lama Anagarika **Govinda, Jampa Thaye, Pema Chodron,** Lama **Teundroup,** *tulkus*

Other teachers who have been ousted by their own communities: Richard **Baker**, John **Yarr**

Other teachers who have died of AIDS (a rather different story): Issan **Dorsey**

P.D. OUSPENSKY. SEE THE **GURDJIEFF LEGACY**

OUSPENSKY, MADAME. SEE THE **GURDJIEFF LEGACY**

Toni PACKER

German-born American who left her own American Zen teacher and the Zen tradition so that she could work entirely independently

There are a number of teachers in this book who might be called 'non-teachers'. Some of them say that Truth cannot be taught or even grasped by the mind and there are thus no means by which it can be 'attained'—no grand doctrines, no sublime rituals, no magnificent art, no dedicated practice, and certainly no magical touch from the guru or transformative transmission from a tradition. In short, truth is not transferable. **Shunyata** is perhaps the ultimate exponent of this view—by which, I mean, of course, non-exponent of this non-view. But Toni Packer runs him a close second. Like him, she makes very few claims (though it would be difficult to say less than he did) and this is what makes her distinctive.

She was born in Germany in 1927. Her mother was Jewish and the family lived in constant fear throughout the Nazi period. In fact, all the children were

baptized as Lutherans in an attempt to avoid anti-semitism. Her family's unease, the hysteria of Nazism and the upheaval caused by bombing raids during the war—none of these made for a happy childhood. She was wracked by guilt (without knowing why) and was plagued by the question, 'What is the meaning of life?'

After the war, the family moved to Switzerland, where she met an American student, got married and went back to the States with him in 1951. Then in 1965, after nearly 15 years of so-called ordinary life, bringing up their adopted son, she discovered *The Three Pillars of Zen* by Philip **Kapleau**—the first book written by a Westerner who had actually practised Zen regularly over a period of years. (Others had also practised but they hadn't written any books.) It contained a description of *zazen* and Toni started doing it. Then she found out that **Kapleau**'s centre was just down the road in Rochester. She went to see him and became his student. (All this early biographical information is taken from Friedman—both her own book and her Introduction to Toni's *The Work of This Moment*).

Kapleau's story can be found in his entry. All that we need to know here is that he had spent over a decade in Japan and therefore knew the tradition very well—or at least that form of it represented by *Harada* Roshi and *Yasutani* Roshi, his main teachers; that he was sent back to America to teach by *Yasutani* Roshi; that he introduced various changes into the tradition; that *Yasutani* Roshi did not agree with them; and that as a result, **Kapleau** reluctantly decided that he had to continue on his own without his teacher's blessing. This break occurred in 1967 just as Toni began practising under **Kapleau**'s guidance.

I think it is fair to say that she was his star pupil. Not that she wanted to shine particularly but she just seemed to have a natural affinity for Zen practice. Within a few years, she was counselling other students about their personal problems—at **Kapleau**'s request—and also giving public talks. Then she began to teach Zen at the Center, mainly when **Kapleau** was away. In 1975, he told her that he was thinking of retiring soon—he was 63—and that when he did, he would like her to take over at Rochester Zen Center. She did not really want the job but the nature of the tradition as she understood it at the time led her to think that it would be selfish to refuse. So she said she would.

Over the years, however, she had been having some difficulties with the way Zen was presented—not particularly by **Kapleau** himself, though that was part of it, but the whole tradition. To a large extent her questioning attitude, if not actually started, was at least reinforced, by her reading of *Krishnamurti*. (It was **Kapleau** who first lent her a book that referred to him.) Later, she attended several of his talks but never met him. And, as she herself is careful to point out, it is misleading to say that she was influenced by him.

*Cf. Barry **Long**, who says, "I am very like Krishnamurti" —but likewise says he is independent of him.*

> It is not a matter of influence at all, but simply a matter of seeing clearly for oneself, what is pointed out clearly. This is freedom from influence. (Sidor, 26)

In any event, her doubts about Zen gradually deepened. For example, she found most of the texts unnecessarily inaccessible; she actually preferred a passage in **Evans-Wentz**'s *Tibetan Yoga and Secret Doctrines*. Why could one not use a Tibetan text if it was useful? She also began to question other aspects of what might be called formal Zen life: bowing, chanting, the *keisaku* (the hitting stick used to stop students' minds wandering during *zazen*), the *rakusu* (a sort of loose vest awarded to students who had passed the initial stages of

koan study). Were they being employed in the right way? Did they not encourage dependence and hierarchy? Were they actually necessary?

In the end, after much heart-searching, she saw that she would have to leave the Center, and **Kapleau**, altogether, not only because the Zen tradition was making her search for Truth more difficult—"the system is very supportive to *not* questioning some things" (Friedman, 52)—but because she was beginning to doubt if there was even any value in calling herself a Buddhist. **Kapleau** was reluctant to let her go but could see that there was no point in trying to stop her. In a conversation I had with him in 1990, nearly ten years after the two of them parted company, he affirmed his high regard for her.

At the beginning of 1982, she left Rochester Zen Center and set up a centre of her own in another part of the town, taking 200 students with her. To begin with, she retained quite a few Zen elements. Her first book, *Seeing Without Knowing,* was subtitled, *Writing on Zen Work,* and she kept *zazen* and the use of *koans.* But her approach was always much more open than **Kapleau**'s. *Koans* were chosen by the students, not simply handed out by her from the traditional stock; for example, 'What is love, really?' (taken by someone who had been through a number of affairs).

But even in this book, she was already divesting herself of all Zen connections.

> Although Zen has come down to us as one of the many forms of Buddhist meditation, it is also independent of this traditional context. Zen is the mind that understands itself clearly and wholly from instant to instant. It is the clarity of seeing wholly—seeing and responding freely without the limitations of self.[1] It is the emptiness of no-division, and the effortless functioning of wisdom, love and compassion.
>
> 'Zen' is also used to denote the work of looking into oneself: the action of listening, attending, questioning carefully, profoundly, and discovering truth—which cannot be grasped, explained or expressed through thoughts, words, images or symbols of any kind. (*Seeing Without Knowing,* 8)

In 1984, she told a conference on 'Women and Buddhism in America' that

> I don't call this work 'Zen' anymore, because the word is extra, unnecessary to the inquiry. (*The Work of This Moment,* 50; Sidor, 27)

In the same year, Toni and her group moved to 284 acres of untouched land near Springwater, a small town in New York state, and built their own centre. They called it, quite simply, The Springwater Center. It seemed to indicate what they wanted to say with the minimum of fuss.

Toni's central teaching is really a question:

> Do we realize that we do not attend most of the time—that we are lost unawares in memories, thoughts, reactions, dialogues and endless personal problems?
>
> Can we wake up from this sleeping and dreaming? Can we face ourselves as we are, and everyone and everything as it actually is with open eyes and ears—with an unclouded, compassionate heart and mind? (*Seeing Without Knowing,* 10)

[1] Elsewhere she says,

This 'me', this 'self', this 'I', is the accretion of all our past experiences and the memory traces these have left in the brain. It is a bundle of ideas, images and memories we have accumulated about ourselves; images of what we are, what we are not, what we should or should not be, what we want to become . . .

An untiring struggle goes on to live up to the images we have of ourselves, no matter how painful the conflict that arises between the way we *want* to see ourselves (and want others to see us) and the way we *actually are* at any one instant. This perpetual dwelling in images, with its inherent struggles and conflict, keeps us out of touch with the actual flow of life instant by instant, and divides and separates us from one another. (*Seeing Without Knowing,* 14)

She calls the process of finding out 'questioning', 'meditative inquiry', 'meditation'. One of the great attractions of this approach is that it is completely unpressurized. The question really is simple: Can one listen "to all that is going on, inside and out, without judgement?"

> You might say, "Wait . . . wait a minute. That's impossible . . . that's too difficult." But we're questioning whether it is possible. We're not saying, "Do it!" (*What Is Meditative Inquiry?, 2*)

And by extension, this lack of pressure—which is really a freedom from wanting or obsession—can be applied to issues that weigh down many of us, issues like the senselessness of war, torture, cruelty.

> What we are doing right now is meditative inquiry, inquiring into the problems that affect all human beings throughout the world. Can this inquiry be free from conclusions, from already knowing what these problems are, what the solutions are, or that they're insoluble . . . ? (ibid., 6)

In other words, staying with the question is the real discipline—not finding the answer. (The answer is a function of the way in which the question is asked.)

So Toni does not hold any particular view or advocate any specific solutions. For example, she asked Leonore Friedman, who is a student of hers (though perhaps 'listener' would be a better word), why she wanted to join a Buddhist Peace Fellowship. "This is still reaching out from within our small boundary lines" (*The Work of This Moment,* 37). And when Friedman, clearly somewhat taken aback, asked if Toni thought that there was actually a danger in founding such a Fellowship, Toni replied,

> Yes, to the extent that this reinforces, supports, or in any way maintains my identity of being 'this' in distinction to 'that'. All such self-images separate and divide. (*The Work of This Moment,* 38)

In short, the realization of emptiness, of no-self, allows the spontaneous arising of compassion.

> When all walls break down, there is a totally new freedom—a boundless energy which is whole—a loving care for all living beings and things of the earth. (*Seeing Without Knowing,* 20)

This has been the ideal of Buddhism since the very beginning, and it is now being restated, independently, by a German-American woman in New York state with the minimum of fuss and technical terminology. She told me in an interview that she regards herself as a catalyst. She has the capacity to 'see' and may be able to communicate this to other people. But she does not know if there is a causal relation between her seeing and that of others. (This could be *Krishnamurti* talking.)

Toni encourages all and every sort of question—there is no dogma to conform to—including those that are critical of her. *The Work of This Moment* includes a letter from somebody who decided to stop working with her. This person wanted to practice within a Buddhist framework and felt that what Toni was offering was Buddhist although Toni herself said that it was not. So she or he asked Toni, "What is the context within which you teach awareness work? For example, I would really like to know whether you experience these things to be true: the Four Noble Truths, the Eightfold Path, the precepts, the nature of form and emptiness as expressed in the *Heart Sutra*." Toni's answer is consistent with her principle of meditative inquiry.

*The BPF's founders include Robert **Aitken**, Joanna **Macy**, and Jack **Kornfield**.*

You ask: "What is the context within which you teach awareness work?" Awareness cannot be taught, and when it is present it has no context. All contexts are created by thought and are therefore corruptible by thought. Awareness simply throws light on what is, without any separation whatsoever.

You want to know whether I experience the Four Noble Truths, the Eightfold Path, the precepts, the nature of form and emptiness as expressed in the *Heart Sutra,* as true. No formulations, no matter how clear or noble, are the Truth. Truth is inexpressible in symbols . . .

I may be wrong, but human beings communicate, commune with each other freely and lovingly only when the mind is not anchored in any system whatsoever— when there is coming together empty-handedly. (*The Work of This Moment,* 29)

Not many teachers say that they could be wrong. The implication of what she says here is that she is empty-handed. So there is nothing to hide and no great claims are being made about anybody's attainment. There are no demands and no promises, and therefore no one to blame if it does not work out. Who said it should work out, anyway?

Primary sources: Toni Packer, *Seeing Without Knowing: Writings on Zen Work* (No provenance: Genesee Valley Zen Center, 1983); *What Is Meditative Inquiry?* (Springwater, N.Y.: Springwater Center, 1988); *The Work of This Moment* (Boston: Shambhala, 1990)

Secondary sources: L. Friedman, *Meetings with Remarkable Women: Buddhist Teachers in America* (Boston: Shambhala, 1987) [a fair amount of the material here is included in Friedman's introduction to *The Work of This Moment*]; E. Sidor, ed., *A Gathering of Spirit: Women Teaching in American Buddhism* (Cumberland, Rhode Island: Primary Point Press, 1987) [Toni's talk, 'Inquiring Without Images', is included with some modification in *The Work of This Moment* under the title, 'Freedom from Images']; A. Bancroft, *Weavers of Wisdom: Women Mystics of the Twentieth Century* (London: Arkana, 1989); it may or may not be instructive that Toni is not included in Boucher's very comprehensive *Turning the Wheel: American Women Creating the New Buddhism* (San Francisco, 1988)

Centre: Springwater Center, 7179 Mill Street, Springwater, NY 14560, U.S.A.

COMPARE:

Other teachers who emphasize listening rather than dogma: Jean **Klein**, **Shunyata**

Other Westerners who teach that one's own nature is truth: Andrew **Cohen**, **Jae Jah Noh**, Jean **Klein**, John **Levy**, Barry **Long**, Bhagavan **Nome**, **Shunyata**

PEMA CHODRON | DEIRDRE BLOMFIELD-BROWN

American director of a Tibetan monastery

Blomfield-Brown was in her mid-thirties and going through a painful divorce from her second husband (already having two children from her first marriage) when she came across Tibetan Buddhism. Her first teacher was Chime Rinpoche in England but he encouraged her to practice with Chogyam *Trungpa.* She met him for the first time in 1972 and has been a devoted student ever since. (I explain what I mean by 'devoted' in due course.) She had no particular desire to be a nun but she did want to commit herself to a way of life that would take her beyond what she had experienced so far. In 1974, she took novice ordination (which is all that exists in the Tibetan tradition) from the Karmapa and three years later he suggested to her that she take full ordination. Since this could not be done in her own tradition, she had to discover how to do it for herself. She had some help from Freda **Bedi**/

Sister Palmo, who had been ordained in Hong Kong in 1972, but **Bedi** died in 1977. Eventually, Pema Chodron received the *bhikshuni* precepts at a mass ordination in Hong Kong in 1981. She was the only Westerner there (Friedman, 95).

The Karmapa died (in America) shortly afterwards. Although she had not previously felt very close to him, she was drawn to him in the days of his illness and was with him at the last.

> I was with Trungpa Rinpoche when His Holiness passed away, and a group of us sat up with him all that night. We just sat hour after hour with Rinpoche saying almost nothing, and it felt spacious and loving rather than sad. It was . . . one of the most memorable events in my life. (Friedman, 107)

This account, simultaneously simple and honourable, has much of the taste of the spiritual life as Pema Chodron's understands it. First, the Tibetan tradition is based on respect and gratitude towards one's teachers. That is why it is hierarchical—but in a natural rather than an imposed way. She compares it to the Native American tradition. Second, her vocabulary is distinctly Trungpian; he was fond of the word 'spacious', which he invested with a particular meaning. If we put these two things together—hierarchy as the expression of respect and gratitude, and the special terminology that *Trungpa* used to explain the path—we can understand why she was a 'devoted' student: devotion is putting oneself in the way of the Dharma as it is embodied in one's teacher.

*Cf. Dhyani **Ywahoo** who is a Native American and a Kagyu and Nyingma teacher.*

Shortly after the Karmapa's death, *Trungpa* asked her to 'devote' herself to the establishment of a monastic community. She spent some time fundraising—not a traditional activity for nuns—and Gampo Abbey was opened in Nova Scotia in 1983, with Pema Chodron as its resident director. It was the first Tibetan monastery in the West. (All previous centres had been lay-based even if they were guided by Tibetan monks.) Thrangu Rinpoche, a Tibetan monk, was the spiritual director and from the first he said that Gampo could not be a monastery in the traditional Tibetan mould, if only because men and women (all Westerners) live and practice together. And while it is definitely oriented towards the Tibetan tradition, the long term intention is that it should be available as a centre for Buddhists of all persuasions. In Pema Chodron's view, American Buddhism will draw on all the traditions and at the same time broaden itself to include the laity and women (Boucher, 98). She says that the tradition as a whole, following the Karmapa's example, is encouraging women to take the full *bhikshuni* ordination so that they can ordain other women in their turn. In this way, it can be introduced into the Tibetan tradition for the first time (Boucher, 96).

If this happens, it will be the first major change in a Buddhist tradition for several centuries; and it will have happened with Western women in the forefront. Meanwhile, Pema Chodron, who was herself a pioneer in this incipient movement, continues to give her teaching of renunciation, based on her own experience as a nun and a student of Chogyam *Trungpa*. It is interesting that what she says has both a traditional and a modern side. The traditional side is that renunciation simplifies one's life: if you have a completely white canvas, any mark that is put on it is immediately evident. Similarly, if one's life is defined by the precepts, then any movement away from them is obvious (or at least more obvious than the identical action would be in the midst of a busy and perhaps chaotic life—a canvas that is packed with colour and lines) (Sidor). The modern side is taken from Chogyam *Trungpa* and his particular genius for original and arresting explanations. Pema Chodron defines

renunciation as the realization that "you can't kid yourself any longer about how you use everything to re-create yourself all the time" (Friedman, 101). In other words, the solidification of ego, which is the cause of suffering and ultimately of *samsara,* needs to be undermined. A good teacher does that—and so does renunciation. This is what the monastic life is concerned with: a letting go of boundaries, "an appetite for realization" (Friedman, 99).

As far as I know, this is as 'modern' as Pema Chodron gets. She never discusses *Trungpa*'s 'wild' side: his teaching about crazy wisdom, which he himself exemplified (and which was distinctly non-monastic). In fact, she never mentions it once in all her writings or interviews. *Trungpa* died in 1987 and there has been considerable fallout since (for which, see the entry on his Vajra Regent, **Osel Tendzin**). But it appears that Pema Chodron has continued on her path of renunciation unaffected by it all. Whether one regards this as evidence of inner strength or shortsightedness depends on one's standpoint. But personally I find it heartening that there is at least one person in *Trungpa*'s circle who does not define what she does by reference to his particular idiosyncrasies.

Primary sources: Pema Chodron, *The Wisdom of No Escape* (Shambhala, 1991); 'Obstacles As Our Teachers' *in* E. Sidor, *A Gathering of Spirit: Women Teaching in American Buddhism* (Cumberland, Rhode Island: Primary Point Press, 1987); 'Renunciation: Like a Raven in the Wind', *Tricycle,* vol. 1, no. 1, Fall 1991, 50–52

Secondary sources: L. Friedman, *Meetings with Remarkable Women: Buddhist Teachers in America* (Boston, 1985); Sandy Boucher, *Turning the Wheel: American Women Creating the New Buddhism* (San Francisco: Harper and Row, 1988)

Centre: Gampo Abbey, Pleasant Bay, Nova Scotia B0E 2P0, Canada

COMPARE:

Other women in Tibetan Buddhism: Jetsunma **Ahkon Lhamo**, Freda **Bedi**, Alexandra **David-Néel**, Dhyani **Ywahoo**

Other women who have taken 'nun's' vows in one of the Buddhist traditions: Rev. **Dharmapali**, Ayya **Khema**, **Karuna Dharma**, **Miao Kwang Sudharma**, **Uppalavanna**, Roshi Gesshin **Prabhasa Dharma**, Roshi Jiyu **Kennett**

Other women who have taken renunciate vows in other traditions: Swami **Abhayananda**/Marie Louise, Sister **Nivedita**, Sri **Daya Mata**, the **Devyashrams**, Swami **Radha**

ROSHI GESSHIN PRABHASA DHARMA | GISELA MIDWER

Zen teacher who has switched from the Rinzai to the Vietnamese tradition

Gisela Midwer was born in Germany in 1931 but has lived in America since the mid-1960s. She was a painter before she became a Buddhist, and in 1964 had a number of spontaneous experiences of a "vast openness [that] was I, myself" (Friedman, 229) while living (and painting) with her American husband in California. She became interested in Zen and started to practice with the Rinzai teacher, Joshu Sasaki Roshi (not to be confused with Shigetsu Sasaki/Sokei-an) in Los Angeles in 1967, immediately experiencing this same vast openness. She worked hard for five years, seeing her teacher every day. One morning, she 'lost' her *koan:*

> I was sitting and it just went away. Suddenly I felt drawn into this immense radiant energy inside my abdomen, which started rising and spread throughout my body. I

felt as if the sun were inside of me, not outside. So when the bell rang, I went to his room and said I had no answer. I was radiating warm feeling. He said, 'Now you are illuminating'. (Friedman, 235)

Sasaki Roshi ordained her as a teacher in 1972, giving her the name, Gesshin Myoko, and she became head priest of his Cimarron Center in Los Angeles. She subsequently spent a year and a half training in Japan with Hirata Roshi.

Yet in 1983 she left Sasaki Roshi and the Japanese Rinzai tradition and went over to Ven. Dr. Thich Man Giac, Supreme Abbot of the United Vietnamese Buddhist Churches in America. The reason for this was twofold. First, despite her acknowledged debt to Sasaki Roshi, it appears that he overstepped the boundary that should protect the teacher-student relationship. At a meeting of women Buddhists in Rhode Island in 1985, a questioner mentioned the difficulties that women have because of "direct and indirect abuse" by male teachers. In her reply, Gesshin Prabhasa Dharma said that "I went through that myself" (Sidor, 65).

Secondly, she came to doubt whether Rinzai's high-pressure approach is appropriate to Westerners, especially women and older people. She herself trained as if she was a man, with no concessions; but she found that she could not be comfortable in such circumstances (Sidor, 22).

Given these reasons for Gesshin Prabhasa Dharma's crossover from one Buddhist lineage to another, it is interesting to see what her own teaching is. She incorporates Soto and Pure Land elements in her teaching, as well as *yoga* (Friedman, 240). In effect, she has aligned herself with a tradition that is accommodating and open, and rejected one that is that she finds too unyielding. If one can find a tradition that is supportive—fine; but Zen is essentially free and not dependent on tradition. Or as she herself says, tradition is useful but not primary.

> It's not a matter of transmitting teachings, but of working unbounded, unhindered, free from traditions, directly with whatever you have. That is the essence of Zen— the awakening of Buddha-nature directly, heart to heart. (Friedman, 239)

Elsewhere, she points out that in America, all the models—monk or lay, hierarchy or democracy—are mixed up: a unique situation (Sidor, 72). And her advice is that American Buddhism should forget both the old and the new; that "tradition comes from breaking traditions" (Sidor, 20). Perhaps a new tradition of what she calls the Total Person will emerge: "the transcendental personality . . . who relies only on Dharma . . . the underlying principle of emptiness" (Sidor, 59).

This, of course, is the central teaching of the Mahayana—and some would say, of all Buddhism. And it is also what Gesshin Prabhasa Dharma herself has experienced. It is natural, therefore, that she should teach that it is equally available to all, men and women. She is adamant that women are capable of the highest attainment and rejects the view that the Buddha placed special restrictions on women because they are in any way weaker than men; on the contrary, these rules were imposed because it is men who are weak. "I have personally investigated this matter by way of meditation, and I don't think the Buddha could have said *anything* that would have been discriminatory against women" (Sidor, 40).

It is within this free Zen, which acknowledges tradition but is not tied to it, which is simultaneously direct and open, that Gesshin Prabhasa Dharma has

her place. In 1985, she received Dharma Mind Seal transmission from Ven. Dr. Thich Man Giac and received her present name and title. She is currently spiritual leader of the International Zen Institute of America in Los Angeles (which she founded in 1983). In that same year (1983), Dr. Thich Man Giac wrote a poem about her:

THE ZEN MASTER

to Gesshin Myoko

the Master walks down the road
the oversized robe carries only compassion
time has no hold on her
who fills the night with laughter. (quoted in Friedman, 243)

At the moment, Vietnamese Zen is fairly culture-bound and has not attracted many Western practitioners—at least compared with Japanese Zen. Gesshin Prabhasa Dharma was one of the first—and she has become one of the first Westerners appointed as a teacher within the tradition. There will be more.

Primary sources: Going Home (Los Angeles: International Zen Institute of America, no date available); 'Women and Buddhism in America' and 'How to Balance a White Cloud' *in* E. Sidor, *A Gathering of Spirit: Women Teaching in American Buddhism* (Cumberland, Rhode Island: Primary Point Press, 1987)

Secondary sources: L. Friedman, *Meetings with Remarkable Women: Buddhist Teachers in America* (Boston, 1985)

Centre: International Zen Institute of America, 3054 West 8th St, P.O. Box 145, Los Angeles, CA 90005, U.S.A.

COMPARE:

Other teachers in Vietnamese Buddhism: **Karuna Dharma**

Other Rinzai teachers: Ven. **Myoko-ni**, Roshi Walter **Nowick**, Ruth Fuller **Sasaki**, Roshi Maurine **Stuart**

Other women Zen teachers: Sensei Jan **Bays**, Joko Charlotte **Beck**, Jiyu **Kennett**, Dharma Teachers Linda **Klevnick** and Linda **Murray**, Master Dharma Teacher Barbara **Rhodes**

Other women Buddhist teachers: **Ahkon Norbu Lhamo**, Freda **Bedi**, Alexandra **David-Néel**, Ruth **Denison**, Ayya **Khema**, Joanna **Macy**, Jacqueline **Mandell**, **Pema Chodron**, Susan **Salzberg**, Dhyani **Ywahoo**

Others who use elements from more than one Buddhist tradition: Rev. **Dharmapali**, **Miao Kwang Sudharma**, **Sangharakshita**

Shrila PRABHUPADA

Indian founder of the Hare Krishna movement

Prabhupada arrived in New York in September, 1965, at the age of 69, with a suitcase full of literature—all his own work, I think—and $8 worth of rupees in his pocket. (Since he was a sannyasi *or renunciate, he had no money of his own, and his boat fare had been paid for by a supporter in India.) He founded the International Society for Krishna Consciousness/ ISKCON[1] in 1966. And by*

[1] As a branch of Gaudiya Vaishnavism. *Gaudiya* is an adjective formed from the noun *Gauda*, which is the ancient name for central Bengal. *Vaishnava* is the adjectival form of the name Vishnu. So *Gaudiya Vaishnavism* literally means 'that form of the worship of Vishnu that is associated with Bengal'. But in fact it has a much wider

the time of his death in 1977, he had a genuinely worldwide movement (in my view, the most widespread of any Eastern spiritual movement of modern times).

Prabhupada was a voluminous author and his teachings are very intricate. I can only mention two aspects of it here. First, there is a strong emphasis on purity. All devotees are required to follow the four regulative principles: a strict vegetarian diet (no meat, fish, fowl, or eggs); no intoxicants; no gambling; and no illicit sex (meaning that the only sex that is allowed is between lawful husband and wife and then solely for the purpose of bearing children). This way of life serves as a foundation for devotional service to Krishna: worshipping his form in the temple, taking prasadam *(blessed food), by reading about his exploits in Gaudiya Vaishnava literature, and above all, by chanting his name (the Hare Krishna* mantra*). Devotional service is an end in itself, according to Prabhupada. It does not lead to liberation; it is liberation.*

Second, devotees are also required to live according to 'Vedic' culture,[2] made up of the four varnas *(the social categories of* brahmanas, kshatriyas, vaishyas *and* shudras*) and the four* ashramas *(the spiritual categories of* brahmacharyas *(unmarried people),* grihasthas *(householders),* vanaprasthas *(those who have retired from the householder life) and* sannyasins *(renunciates)). These two together make up* varna-ashrama, *or, as Prabhupada called it,* daivavarnashrama—*divine culture. It is a decidedly hierarchical system, with* brahmanas *and, above all,* sannyasins *taking precedence over everyone else (especially women, who have a decidedly secondary role).[3]*

*Prabhupada was utterly dedicated, both in his personal life, which was scrupulously upright, and in his untiring efforts to bring Krishna consciousness to people whatever their circumstances, never being put off or discouraged. Perhaps this explains why his teaching, which was demanding and quite counter to the liberal spirit of the 1960s, attracted young people. As Thomas Hertzog/***Tamal Krishna***, an early disciple and one of the eleven gurus, puts it, "Seeing his spotless character and wonderful activities, we all aspired to follow in his footsteps"* (Servant of the Servant *[Los Angeles: Bhaktivedanta Book Trust, 1984, 128].*

Prabhupada was a good organizer and gave his Western disciples[4] plenty of responsibility. In 1970 he created a general managing body for the whole of ISKCON, the Governing Body Commission/GBC.[5] At the beginning of 1977, his

connotation. First, because it is centred on Krishna rather than Vishnu; second, because it refers to a form of devotional worship that was begun in the fifteenth century by Sri Caitanya, who is regarded as Krishna himself in the guise of a devotee. It was Caitanya who introduced the practice of the chanting of the name of Krishna, the Hare Krishna *mantra: Hare Krishna, Hare Krishna, Krishna Krishna, Hare Hare, Hare Rama, Hare Rama, Rama Rama, Hare Hare.* That is why the term 'Hare Krishna movement' is also used. Prabhupada was initiated by Shrila Bhaktisiddhanta Saraswati, leader of one of the many Gaudiya Vaishnava branches, in 1932.

[2] In fact, *Prabhupada*'s use of the term 'Vedic' is particular to the Gaudiya Vaishnava tradition and really means '(truly) Vaishnava'. This is why I have put it in scare quotes. No other group employs it in this way. It is true, of course, that "a rose by any other name would smell as sweet"; but it is probably not a good idea to call it a lily.

[3] However, I should say that *Prabhupada* did allow women to be head *pujaris* (in charge of temple worship) and head cook (responsible for *prasadam*). In India, *no* position of significance in the Gaudiya tradition can be taken by women.

[4] Despite the fact that *Prabhupada* was Indian and came from a well-established tradition, he had very few Indian disciples. According to one investigator, even in 1978 there were only 15 to 20 Indian followers (A. Burr, *I Am Not My Body* [Delhi, 1984], p. 235)—and this out of a population of about 600 million! In fact, *Prabhupada* used Western devotees to establish temples in India. This is, I think, unique for an Eastern tradition in the East: its introduction (or reintroduction, if you prefer) by Westerners.

[5] Each member of the GBC (there were originally twelve but the present number is considerably greater) is responsible for all ISKCON activities in a certain part of the world. But the way the world is divided up is extremely odd. For example, one member is responsible for South Africa, Spain, Portugal, Mauritius and Pakistan (+ co-responsibility for Sri Lanka and France); another, for Italy, Montreal and Rajasthan; a third is given Kenya,

*health began to get worse. He was 80 years old and he started to make plans for ISKCON after his death. He formally nominated the GBC as the ultimate authority for the movement but he also appointed eleven American devotees as gurus. This division of power led to a number of difficulties and you can read about them in the **Hare Krishna gurus**, which is a continuation of this entry.*

Bibliography: Prabhupada's many works include *Bhagavad Gita As It Is* (New York: Colliers, 1968) (the only book of his that was not published by his own organization; there have been many subsequent editions); *Srimad-Bhagavtam* (in 50 volumes!); *Sri Caitanya-caritamrita* (in 17 volumes). Further information can be obtained from Bhaktivedanta Book Trust, 3764 Watseka Avenue, Los Angeles, CA 90034, U.S.A. (which published all his works apart from the one noted above); and from Bhaktivedanta Manor, Letchmore Heath, Watford, Hertforshire, England, U.K.

General books on the Hare Krishna movement: J. Stillson, *Judah, Hare Krishna and the Counterculture* (New York, 1974); Steven J. Gelberg, *Hare Krishna, Hare Krishna: Five Distinguished Scholars on the Krishna Movement in the West* (New York, 1983); C.R. Brooks, *The Hare Krishnas in India* (Princeton, 1989); E. Burke Rochford, *The Hare Krishnas in America* (New Jersey, 1985)

ELIZABETH CLARE PROPHET. SEE **APPENDIX 1**

ZINA RACHEVSKY. SEE *TULKUS*

SWAMI RADHA | SYLVIA HELLMAN

Disciple of Swami Sivananda, who authorized her to teach in the West

Sylvia Hellman was born in Germany in 1911. She had 'visions', if that is the correct word, connecting her with India from her childhood (*Radha,* 101–02). In 1951, she emigrated to Canada and became a Canadian citizen. Three years later, she attended a meeting of the Self-Realization Fellowship—Paramahansa *Yogananda,* its founder, had died just two years previously—where she 'saw', not *Yogananda*, but Sivananda in a 'vision'. Having found out who he was, she wrote to him at his ashram in Rishikesh. He invited her to visit and she arrived in August 1955 for a six months stay which is recorded in *Radha: Diary of a Woman's Search*.

He told her that they had been together in previous births. One day, he said to her

> "You should have an Indian name."
> "Why don't you give me one? Any name you give me would be all right."
> He said, "Meditate on it."
> Something dawned on me and, with all my concentration, I fixed my eyes on him.
> "Give me back my old name." I seemed to have taken him by surprise.

Chicago and Gujarat; and a fourth looks after New York and China (+ co-responsibilty for Polynesia and Connecticut). This kind of division—surely unique in any organization in the world—has been present right from the founding of the GBC.

"Radha," he blurted out . . . "Radha means cosmic love. Love all who come in contact with you. Be a spiritual mother to all." He closed his eyes. Was he meditating? I did not know. I closed my eyes too. After some time I felt wonderfully light, weightless. That which seemed to be 'I' dissolved. From Gurudev came great waves, filling every cell. I seemed to become bigger and bigger, to extend in all directions. Any moment I will fill the whole world, I thought. What will happen? A feeling of uncertainty forced me to open my eyes. Mine met the Master's, which were looking at me with an indescribable expression of love. Now I know what cosmic love is, I thought. Although I had said nothing, he smiled and nodded his head, yes, yes. (*Radha,* 80–81)

Later, she received *mantra* initiation, which

joins the guru and the disciple in a divine relationship and it accelerates spiritual development. One collects a treasure of spiritual wealth, whether one wants it or not—even if one breaks away from the guru—because the guru never breaks with the disciple. The disciple may refuse the practice of the mantra, or may break the relationship with the guru. However, the guru, knowing the Divine Law, has a continuing obligation to the disciple. For his own sake, the disciple should never turn away from the guru without permission. At this moment that is unthinkable to me because of the gratitude I feel for the guidance and dedication of my guru. (*Radha,* 93)

But perhaps her most powerful experience was only indirectly linked with Sivananda. One day, she went to a ruined temple near the ashram. She had never visited it before but felt "an overpowering sense of familiarity." She began to meditate and then "suddenly became aware that there was someone nearby . . . He radiated great dignity and presence and in a flash I knew this was Babaji"—the Mahavatar who is the *adiguru* of *Yogananda*'s line of *kriya yoga* gurus and can assume a body whenever he wishes to. Babaji taught her the *mantra* (in both Sanskrit and English, though she only remembered the English) for a technique known as the Divine Light Invocation.

I could see very clearly the Light flowing into me while my eyes were closed. Babaji explained that I should practice this Invocation in order to help others and also to break the habit of thinking of myself either as the mind or as the body. He further told me that I should teach this to others. Then we fell silent. When I opened my eyes Babaji was gone. The sight of the Himalayas was dazzling—the same Light that I had seen flowing through my body was streaming forth from the living rock of the mountains.

When I beheld this awe-inspiring vista my consciousness was suddenly swept up as if by an enormous, overpowering wave to a plane far beyond anything I had ever experienced. Words could never describe this state of consciousness. (*Radha,* 175)

Shortly afterwards, she was found walking along the road by a man staying at the ashram. She was singing *Om Om Hari Om* but it was evident that "she was not her own self. Her face had a very pale look. Her eyes seemed to be glazed, her limbs were limp and she was swaying like a plant in a storm." When he asked her if she was alright, she replied, "What do you mean? I am Satchitananda. I am Paramanand." When he asked her if she knew who he was, she said, "Yes, I know you! But you do not know your own Self!"

Her face was now bright. It was actually luminous in the darkness. Her eyes were still fixed in the northern skies. Then suddenly she cried, "The LIGHT. Don't you see it?"
. . .

I looked up where she was pointing. There was nothing but the darkness of the night . . . Then happened the strangest thing in my life. I felt a sensation as if some

*Sri **Daya Mata**, one of Yogananda's closest disciples and the current president of his Self-Realization Fellowship, also 'met' Babaji in India.*

current was flowing into my body through my arms. A strange current was running into my body from Mother Radha. I felt as if I was slipping into sleep and I felt to be rising like a cloud out of my body . . . and then I saw IT! IT WAS THERE! LIGHT in the northern sky . . . bliss giving . . . shooting . . . bluish white . . . penetrating . . . strong . . . well I cannot explain it. It is impossible to do so. (*Radha,* 180)

She also visited an Indian swami in another part of Rishikesh on her way back to the ashram, "whispering a few things he could not understand, at the same time tears were pouring down her face. She gave him such a shock that he felt he was paralysed". (*Radha,* 182)

Given the intensity of this experience and others, it is not surprising that she was expected to be a teacher. In fact, a certain Dr. Sharma asked her to be "our Holy Mother" at an ashram he proposed to start (in India) (*Radha,* 185). But she refused—probably because Sivananda had already asked her

> to do some work for me in Canada . . . Start an ashram or school for the divine Teachings of yoga and Vedanta . . . Give classes in hatha yoga, teach pranayama, pray and meditate together, help people to life a divine life, inspire people to sing the Lord's name. (*Radha,* 89)

He also said that she was to initiate people on his behalf, using four *mantras* that he had given her (*Radha,* 188). And he stressed that

> "I don't want you to take a job. I want you to live by faith alone. People have to witness that God, Who created everything, can also take care of His creation . . . When you go back, you must just await developments. Everything will fall into place. Always think of yourself as Radha. When you can do this you will have incredible power at your disposal."
>
> Master handed me a fruit and I gave him my pranam and left. I could not sleep. When it was light enough in the early morning I went to the Ganges, still thinking about this order. I felt like crying, but I could not. For the first time I realized what those famous words meant, "The birds have a nest and the fox has a hole, but I have no place to lay my head." There are no family members I can ask for help. There are no friends who can understand my step into this type of life. There is nothing in the cultural tradition I come from that would support it . . . The reality of the homelessness and the loneliness of my path really overwhelms me. (*Radha,* 192–93)

She then went through a formal *sannyasa* ceremony and was given a document confirming that her initiation was according to tradition. Strictly speaking, she was now Swami Radhananda but Sivananda suggested that she be called Swami Sivananda Radha, and that is the name that she has always used. She also received another document authorizing her to give lectures, initiate others, start centres, and so on. A copy was sent to the Indian Embassy in Canada (*Radha,* 194).

So ended "an incredible half year . . . all so foreign, yet so familiar" (*Radha,* 206). It included an encounter with a Mahavatar; various experiences that appear to transcend ordinary consciousness; initiation as a *sannyasi;* and appointment as a teacher (at a time when the number of Westerners with similar authorization can be counted on the fingers of one hand).

She returned to Canada in February 1956 and established the Sivananda Ashram in Vancouver. (It moved to Kootenay Bay, just over the border from Idaho, in 1963 and was renamed Yasodhara Ashram). She found that she was more or less on her own. Many of Sivananda's disciples were opposed to his giving her *sannyasa* and she received very little help from them. In effect, she has been an independent teacher—in the sense of not being connected with the various branches of Sivananda's Divine Light Society—from the word go.

Like Sivananda himself, Swami Radha accepts all spiritual traditions "as expressions of Divine Light" (ashram brochure)—a fact that is borne out by the great range of courses that the ashram puts on. They include Hidden Language Hatha Yoga®, Kundalini Yoga, The Tibetan Wheel of Life, as well as considerable use of drawing and imagery. There is also a course called Ten Days of Yoga which incorporates Dream Interpretation, Mantra Yoga, a Spiritual Diary, the Divine Light Invocation that Babaji taught her, and two "self-growth techniques" called Life Seals and Straight Walk, which, like Hidden Language Hatha Yoga, are "registered service marks of Yasodhara Ashram". In addition, there is a three-month Yoga Development Course, based on the Kundalini System of Higher Consciousness, which includes Hatha Yoga, Karma Yoga, Mantra and Japa Yoga, Bhakti Yoga, and Jnana Yoga. The cheapest of these courses (Life Seals) is US$175; the Ten Days of Yoga costs US$635; and the Yoga Development Course, US$4,500 (in the 1996 brochure).

Before her death in 1995, at the age of 84, Swami Radha gave *sannyasa* initiation to a number of her disciples, including one, Swami Radhananda, who appears to be the present leader or senior guide at the ashram. It seems, therefore, as if a Western lineage—and an independent lineage, at that—has established itself in the West.

Primary sources: Radha: Diary of a Woman's Search; The Divine Light Invocation; Mantras: Words of Power; Kundalini: Yoga for the West; Seeds of Light: Aphorisms of Swami Sivananda Radha. All these are published by Timeless Books, P.O. Box 3543, Spokane, WA 99220-3543, U.S.A. (which gives no dates for any of them). A number of tapes are also available from Timeless Books, including chants and *bhajans; mantras;* and talks by Swami Radha on such topics as 'Guru and Disciple'; 'Renunciation: The Purpose of Letting Go'; 'Death: Gateway to the Light'; 'Yoga, Love, Sex and Marriage'; 'Helping an Alcoholic Partner'.

Secondary sources: None.

Centre: Yasodhara Ashram, Box 9, Kootenay Bay, British Columbia, V0B 1X0, Canada

COMPARE:

Other Western teachers associated with Swami Sivananda: Swami Lakshmi **Devyashram**, Father **Satchakrananda** Bodhisattvaguru

Other women sannyasis: Marie Louise/Swami **Abhayananda**, Sister **Devamata**, Sister **Daya** (all associated with the Ramakrishna Order); Sri **Daya Mata**, Sri **Gyanamata** (both disciples of Paramahansa *Yogananda*); the **Devyashrams**

Other 'visionaries': Swami **Lakshmi Devyashram**, Jiyu **Kennett**, Shrila **Bhaktipada**, Bhikkhu **Kapilavaddho**, Swami **Turiyasangitananda**, Samuel **Lewis**, Guru **Subramuniya**

RAJARSI JANAKANANDA | JAMES LYNN

American disciple of Paramahansa *Yogananda* who took over the running of the Self-Realization Fellowship after his master's death

James Lynn was a successful businessman, aged 39, with a 100-acre estate when he met *Yogananda* in Kansas City in 1932. Lynn was initiated by him, and although he continued in business—he started a new career in oil in 1938—Lynn dedicated the rest of his life to his guru.

It is evident that *Yogananda* regarded him as special. In a letter written a few weeks after Lynn's initiation, *Yogananda* said to his new disciple:

On your human life the immortals have put their invisible hands . . . I rejoice that the Spirit has taken the flute of your life to play the divine song of Self-realization and to

lure other children back to His home . . . You are a Hindu yogi of Himalayan hermitages of the past appearing in this life as an American prince, a Western maharaja-yogi who will light the lamp of Self-realization in many groping hearts. (*Rajarsi Janakananda pamphlet,* 25)

And a year later he wrote:

> When you and I have fulfilled our mission on earth, we shall be released. Then we shall be free to stay in heaven or come back here. When we are free, we may take trips to earth to load our boats with shipwrecked souls and bring them safely to the divine shores. (ibid., 28)

Yogananda called his most advanced disciple 'Saint Lynn' and said that, along with other Westerners, he fulfilled Babaji's prophecy that there were potential saints in the West, waiting to be awakened (*Rajarsi Janakananda pamphlet,* 28). Much was made of Lynn's proficiency in *kriya yoga.* There is a photograph of him in *Autobiography of a Yogi* (p. 286) sitting in meditation. The caption to the photograph reads:

> . . . in January 1937, after five years of daily practice of *kriya yoga,* Mr. Lynn received in samadhi (super-consciousness) the Beatific Vision: the Infinite Lord as the Indwelling Glory.

And under the same photo in his commemorative pamphlet (subtitled, *A Great Western Yogi*), Lynn himself is quoted:

> The love and joy of God that I feel is without any end. One can never forget it once he has tasted it; it is so great that he could never want anything else to take its place. (*Rajarsi Janakananda pamphlet,* 23)

Of his very first meeting with *Yogananda,* Lynn said:

> . . . I was aware that I was sitting very still; I was motionless; I didn't seem to be breathing. I wondered about it and looked up at Paramahansaji. A deep white light appeared, seeming to fill the entire room. I became part of the wondrous light. (ibid., 37)

Even when *Yogananda* was still alive, Lynn was referred to by Sri Gyanamata as "a channel through which [Yogananda's] power may flow to us" (*God Alone,* 238).

In 1951, James Lynn entered the *sannyas* order as a renunciate and was given the name Rajarsi Janakananda by his master. A year later, after *Yogananda*'s death, he became president not only of SRF in the West but also of the Yogoda Satsanga Society of India (just as *Yogananda* had been before him). He was the first Westerner to have responsibility of this kind in any Hindu—or if you don't like this term, Indian—lineage. In his first speech as president, he said

<div style="margin-left:2em; font-style:italic;">
The positions held by Westerners in the Ramakrishna Order—Swami **Abhayananda/** Marie Louise, Sister **Nivedita,** Sisters **Devamata** and **Daya**—are extremely circumscribed in comparison.
</div>

> I am going to address you as the children of God, the children of Master [= Yogananda], of the God that is in Master. Our guru came out of the East to the West to bring us, by the example of his life and by his spoken and written words, a divine message of conscious union with God. It was the Heavenly Father who chose Master, incarnated in him, and sent him to America, that he might bring us all closer to Him . . . We are still able to be in communion with Master in spirit . . . Master is our guru. There will be no other guru. (*Rajarsi Janakananda pamphlet,* 52)

This last statement requires some comment. It is in effect a statement of SRF's 'theology', which holds that *Yogananda* stated on more than one occasion that

> all true gurus are "living", whether in a physical body or not . . . Even when I am gone my help will always be given to devotees all over the world, if they keep in

tune . . . Those who have come to Self-Realization Fellowship[1] truly seeking inward spiritual help shall receive what they seek from God. Whether they come while I am in the body, or afterward, the power of God through the link of the SRF Gurus shall flow into the devotees just the same, and shall be the cause of their salvation. (These words were supplied to me by SRF in a letter; they appear in *Self-Realization Fellowship Lessons;* I do not know if they appear in any works actually written by *Yogananda.*)

SRF also maintains that *Yogananda* wanted the teachings to be preserved and kept pure.[2] ("When I am gone, the teachings will be the guru"; another statement of his furnished to me by SRF.) SRF believes that this will be accomplished because, again in *Yogananda*'s words (and again supplied to me by SRF), "there will always be at the head of this organization men and women of realization." This applies to Rajarsi Janakananda[3] and explains some of the fairly extraordinary statements that are made both by him and about him. For example,

Cf. what Meher Baba *said about Sufism Reoriented.*

> . . . through Master's [= Yogananda's] grace my soul has melted into his, and we are one in God. Master expresses himself through the humble instrument of this body and mind. (*Rajasi Janakananda pamphlet,* 61)

And Swami **Kriyananada**/Donald Walters records that

> After Master's passing, Rajarsi Janakananda . . . seemed almost to become Master. His eyes, by some subtle transformation, were Master's eyes. So perfect was his attunement, that our Guru's very thoughts became his thoughts . . . [He] had attained that state of consciousness where nothing of the ego remained. It was as if, through him, God and Guru spoke to us directly. (Kriyananda, 376)

According to Roy Eugene **Davis**, a visitor from India—presumably a member of the Yogoda Satsanga—said of Rajarsi Janakananda, "Not even in my native land have I seen such a full manifestation of God" (Davis, 89). Janakananda himself told **Davis** that all the gurus (Babaji, Lahiri Mahasya, Sri Yukteswar and *Yogananda*) had appeared to him in a blaze of light during meditation and that he and *Yogananda* had floated over vast throngs of people, blessing them as they went (ibid., 92). And to another disciple of *Yogananda*, Janakananda said

> I am a free soul, unlimited by the body-consciousness; I am free to roam in the all-pervading light and love of God and Master. (*Rajarsi Janakananda pamphlet,* 88)

In fact, there is every indication that those in SRF saw Rajarsi Janakananda "as a fully God-realized soul, one who by the end of his life had attained the supreme goal exemplified by Yogananda himself." (I am quoting here from an SRF letter to me.) For example, a number of messages were sent to the SRF headquarters after Rajarsi Janakananda's death: that Rajarsi Janakananda has "joined the Great Ones beyond: Jesus, the Master of Galilee; Lahiri Mahasya; Sri Yukteswar; the beloved Yogananda—that divine line of succession" (*Rajarsi Janakananda pamphlet,* 70); that after his death "our meditation was long and deep, and many of us felt his holy presence amongst us" (ibid., 73); that "we realize that he has been called to the side of Master [= Yogananda]

[1] According to Swami **Kriyananda**/Donald Waters, this specific reference to SRF is a misinterpretation of what Yogananda meant.
[2] **Kriyananda** also challenges what he sees as an implicit claim that it is SRF and SRF alone who can decide what is or is not a pure version of *Yogananda*'s teaching.
[3] And to his successor, Sri **Daya Mata**.

and that both, from above, will continue to guide us" (ibid., 75). In a way, these statements simply echo that of *Yogananda* himself, who on one occasion said to James Lynn, "You and I are one light in two bodies" (Kriyananda, 380). SRF also says that, being a *siddha* (see *Yogananda*'s entry for this term), Rajarsi Janakananda possessed the attributes of omniscience, omnipotence and omnipresence.[4] There are few greater claims that can be made on behalf of a human being.

*But cf. James **Mackie**.*

Even so, Rajarsi Janakananda was not an *avatar*. Therefore he does not have to accept responsibility for those whom he initiates into *kriya yoga*; that task will be taken on by the *avatars* (from Babaji to *Yogananda*). In this sense, then, it would be incorrect to say that Rajarsi Janakananda is *Yogananda*'s successor (in the way that *Yogananda was* the successor of the *kriya yoga* gurus before him).

However, Rajarsi Janakananda was not president of SRF and YSS for very long; he died in 1955, at the age of 63, just three years after taking up his duties. So we do not know in what direction he would have taken the organization. (But there was at least one schism within SRF during his tenure: that of Swami Premananda; it is mentioned briefly in Srimati **Kamala**'s entry.) He was succeeded as president of SRF and YSS by Sri **Daya Mata**, whose tenure was very different (if only because it has lasted for over 40 years), as you can read in her entry.

(*See* Lineage Tree 2)

Primary sources: None

Secondary sources: Rajarsi Janakananda: A Great Western Yogi (Los Angeles: Self-Realization Fellowship, 1974); Sri Gyanamata, *Only Love: The Life and Letters of a Saint,* (Los Angeles: Self-Realization Fellowship, 1984); Swami Kriyananda, *The Path: Autobiography of a Western Yogi* (Nevada City, California: Ananda Publications, 1977); Roy Eugene Davis, *Yoga-Darshana* (Lakemont, Georgia: CSA Press, 1976)

Centre: Self-Realization Fellowship, 3880 San Rafael Avenue, Los Angeles, CA 90065, U.S.A.

COMPARE:

Other Western teachers in the kriya yoga *lineage:* Sri **Daya Mata**, Sri **Gyanamata**, both **Kriyanandas**, **Shellyji**, Roy Eugene **Davis**, Srimati **Kamala**

Other Western yogis *(in various senses of that term):* Swami **Abhayananda**/Bill Haines, Swami **Abhishiktananda**, Swami **Atulananda**, **Yogeshwar Muni**

Other Western teachers in Hindu lineages: Swami **Abhayananda**/Marie Louise, Sister **Devamata**, the **Devyashrams**, the **Hare Krishna Gurus**, Sri **Krishna Prem**, Sri **Mahendranath**, the **Mother** [something of a special case], Swami **Radha**, **Rudi**, Father **Satchakrananda**, **Shankar Das**, **Sivananda-Rita**, Guru **Subramuniya**

Zen Master RAMA | Frederick Lenz. SEE **APPENDIX 1**

[4] Again, the same applies to Sri **Daya Mata**.

RAMANA MAHARSHI

Perhaps the best-known and most respected of all Indian teachers in the twentieth century

Ramana (original name, Venkataraman) was born in 1879. At the age of 17, he had a spontaneous awakening. He was convinced, beyond any possibility of doubt, that he was about to die; but at the same time realized that

> *". . . I am Spirit transcending the body. The body dies but the Spirit that transcends it cannot be touched by death. That means I am the deathless Spirit." All this was not dull thought: it flashed through me vividly as living truth which I perceived directly, almost without thought-process. "I" was something very real, the only real thing about my present state, and all the conscious activity connected with my body was centred on that "I" . . . Absorption in the Self continued unbroken from that time on. (Osborne, 8)*

Ramana's teaching is essentially simple and can be summed up in the following statement:

> *You are awareness. Awareness is another name for you. Since you are awareness there is no need to attain or cultivate it. All that you have to do is give up being aware of other things, that is of the not-Self. If one gives up being aware of them then pure awareness alone remains, and that is the Self. (Godman, 11)*

Ramana Maharshi is the best-known example in modern times (he died in 1950) of someone who teaches simply by being true to himself—which means, of course, being true to 'the' Self. Just by being realized, he revealed to others "the light of Self-Knowledge which shines as the residual reality" (Godman, 107). Such a one does not need words and has no task to accomplish. He is himself the teaching. Ramana did not give initiation and did not recognize anyone as his disciple. That is why it would be misleading to say that anybody was his successor or continued his work. Yet there have been—and still are—those who teach in the spirit of Ramana Maharshi, so to speak, including a number in this book; they are cited at the end of this entry.

Sources cited: A. Osborne, *The Collected Works of Ramana Maharshi* (London, 1969); D. Godman, *Be as You Are: The Teachings of Sri Ramana Maharshi* (London, 1985)

Teachers influenced by Ramana Maharshi: H.W.L. Poonja, Andrew **Cohen**'s guru; Bhagavan **Nome**; Paul **Brunton**; **Shunyata**; Swami **Abhishiktananda** and Swami **Arubianandam**; Sri **Krishna Prem**; Ven. **Sangharakshita**

RAM DASS | RICHARD ALPERT

American who has had a number of roles: LSD researcher, teacher, consciousness raiser, friend of the world, social philosopher, servant

The story of Ram Dass is well-known—he's told it himself many times; not because he is egotistical but because of a basic truth: all of life's events can teach us something. He applies this principle to himself.

He began life as Richard Alpert and collaborated with Timothy Leary in the Harvard LSD experiments. In the mid-1960s he lived for a while at the Millbrook estate in New York (which was a sort of centre for psychedelic

religion) together with Leary and Swami **Abhayananda**/Bill Haines. Then, in 1967, he went to India and met Neem Karoli Baba (via another American disciple, Bhagwan Dass/Michael Riggs, who also had some contact with Zina **Rachevsky**). Ram Dass says of this meeting that it

> changed the course of my life, for through him I came to perceive my life in spiritual terms. In him I found new depths of compassion, love, wisdom, humor, and power, and his actions stretched my understanding of the human possibility. I recognized in him an alliance of the human and the divine. (*Miracle of Love,* ix)

Shortly after this first meeting, Neem Karoli Baba, who spoke only a few words of English, told Alpert (as he still was then) that his mother had died of spleen (in English). The effect of this statement on Alpert was overwhelming.

> . . . I felt this extremely violent pain in my chest and a tremendous wrenching feeling and I started to cry. I cried and I cried and I cried. And I wasn't happy and I wasn't sad. It was not that kind of crying. The only thing I could say was it felt like I was home. Like the journey was over. Like I had finished. (*Miracle of Love,* 4)

In all, Ram Dass spent nearly two years with Neem Karoli Baba, off and on, before Neem Karoli's death in 1973. And I think it would be fair to say that everything that he has done since has been in remembrance of his master. Although there have been attempts to make him into a guru (see below for one of them), this is one role that he has never felt happy in. Rather, he is a traveller on the path and he simply recounts what he has found along the way. It has been a long and winding road, and it has taken him some time to find his direction.

He has written a number of books, all of them both fluent and direct at the same time—a rare combination. The best known is probably the first, *Be Here Now,* which has sold over a million copies and been translated into a dozen languages. It is a good example of the hip Hinduism that he taught at the time. It contains cameos from the *Ramayana* (which was a great favorite of Neem Karoli Baba's) and neat definitions of Hindu terms. *Vairagya,* for instance, which is usually translated, somewhat prosaically, as 'renunciation', is defined as 'the falling away of worldliness, the return of innocence' (*Be Here Now,* 76). This is fresh and original, and more to the point, clearly based on Ram Dass's own experience; in other words, he *knows* what *vairagya* is. The first part of the book tells the story of how Richard Alpert found Neem Karoli Baba and became Ram Dass, entering what he calls the yogic stage of his life. (There is a photograph of him in the classic pose of the blissful meditator and also one of Bhagwan Dass in the pose of the ascetic *sadhu,* though neither of them were *sannyasis.*)

Then there is *Miracle of Love,* a collection of stories about Neem Karoli Baba—a compendium of the homely and the miraculous, the Indian and the universal. Neem Karoli Baba taught no specific method or technique and had no particular philosophy; rather, he inculcated in others the realization of the path of love and service. One of his sayings was, "It's better to see God in everything than to try and figure it out" (*Miracle of Love,* 197). Actually, this is a hip translation of what he said, since he spoke no English.

For several years, Ram Dass was a sort of peripatetic teacher, giving talks on the spiritual life to all and sundry. Some of these talks have been collected in *The Only Dance There Is* and *Grist for the Mill.* These titles, like *Be Here Now,* sum up his essential teaching: we have to start with where we are, with what we are given.

Welcome to an evening under the breast of the Divine Mother. It's so graceful to share the journey. We've been on the journey a long time together. We've gone through a lot of stages . . . The journey passes thru the seven valleys, the seven kingdoms, the chakras, the planes of consciousness, the degrees of faith . . . It's a journey out of time, leaving behind every model we have had of who we think we are. (*Grist for the Mill,* 17)

During this time, he said that his 'dharma'—what he was required to do in this life—was to teach. But the Dharma itself "belongs to no one" (*Grist for the Mill,* 'Dedication'). It is striking, however, that there was no topic on which he was hesitant to speak: *vipassana* meditation, Jesus, the *chakras,* the Mother of the Universe. You can open his books anywhere and be sure to come across presentations of three or four ideas like this every couple of pages. He explains why this is so:

I struggled for a number of years to be a pure eclectic. That is, to be true to each tradition as I was studying it. And yet to be strong enough to be able to hold them all within myself. But what I had to do, which most of you have had to do, is compartmentalize myself into a series of conceptual groupings so that when you are with the Buddhists, you are Buddha-like; when you are with the Sufis, you are Sufi-like; when you are with the Hindus, you are Hindu-like . . .

In fact a few years ago we had a retreat at a Benedictine monastery and there was a gathering of the "big boys": there was Swami Satchidananda, Alan Watts, Sasaki Roshi, Brother David, Pir Vilayat Khan and on and on and on. We each got a chance to do our specialty and everybody participated. So at four A.M. I was sitting next to Swami Satchidananda and we were doing zazen. We were given the koan, "How do you know your Buddha-nature through the sound of a cricket?" . . . So all the time we were sitting there "being empty" I was of course planning my answer, because I didn't want to make a fool of myself . . . [So when I went in to see Sasaki Roshi and he asked me the koan], I cupped my hand to my ear like Milarepa listening to the sounds of the universe. I figured I'm a Jewish Hindu in a Catholic monastery so I'll give him a Tibetan answer to a Japanese koan. I was really just delighted with my own cuteness. And he looked at me and rang his bell and said, "Sixty percent!" He caught me good in my middle class achievement-oriented identity. We both laughed. (*Grist for the Mill,* 73–74)

In other words, being a teacher, even being someone who 'knows', is itself a role—and one that is more or less bound to be mixed up with one's personality. And that needs to be acknowledged.

He goes on to talk about how this eclectic approach is itself a phase of the journey, and how it is followed by another, where one follows a specific path (ibid., 75). In his own case this has been what he calls 'Devotional Tantra' (ibid., 76): one is consumed by the Mother of the universe *(tantra)* but one lets oneself be consumed out of love *(devotion).* This connects neatly with an interesting episode in his life.

In 1974, he met Joya **Santanya** in somewhat unusual circumstances. He had decided to go back to India but saw Neem Karoli Baba in a meditative vision, during which Neem Karoli Baba told him that, "You don't have to go to India. Your teachings will be right here" (*Grist for the Mill,* 63). Shortly afterwards, he was taken to see Joya. The details of that particular encounter can be read in her entry. But a number of aspects of it are relevant here. He says that he was intoxicated by the intensity of the atmosphere around Joya. But he has calmed down a bit since then: "I don't think that highness and freedom are the same thing . . . I'm much less romantic about the spiritual journey" (*Whole Earth Review,* Winter 1988, 30). The relationship between him and Joya

was particularly intense. She kept telling him that she was preparing him to become "a world spiritual leader"—something that he had difficulty believing even though it seemed to be a fulfilment of Neem Karoli Baba's visionary prophecy (ibid., 66). Joya and he practised 'tantric sex'—at her instigation; and he went on to explain it to others with as little hesitation as he showed with all the other subjects he tackled during this period. (For example a page-long article, 'Sexual Tantra', in *Spiritual Community Guide* 1975–76.) He doesn't mention it so often these days. He also stated publicly that Joya was enlightened—a view that he later decided was mistaken.

> [So] I came away with egg on my beard . . . I got my karmuppance because of my own spiritual materialism. If your longing for God is pure that will be your strength. Then though you may get lost for a time eventually your inner heart will hear what to do and all the impurities in your world will just become grist for the mill. (*Grist for the Mill,* 71, 72)

So we come back to his basic 'teaching': there is no point in waiting until the optimal conditions for the spiritual life appear, or in trying to set them up. We have to start with our own condition (which is in fact the *only* condition and by that very fact the optimal one). And if we make mistakes, so be it. Hence he says,

> I'm not a guru, I'm not an enlightened person; I'm just a person on the path—I don't know whether what I'm saying is true or not . . . So you have to trust your intuitive heart. (*Kindred Spirit,* vol. 2, no. 9, Winter 1992-93, 23)

Thus despite the fact that he has had a consistently high profile for nearly 30 years, nowadays he tends to play down the idea that the spiritual life depends on some special person. He says that it is not necessary to have a *sat guru* (even though he had one himself) and instead emphasizes that "everybody is your *teaching*—not your teacher but your teaching" (ibid.).

This explains, perhaps, why the central theme of his work has not been the guru but service of others. To this end, he has established, or helped to establish, various projects and foundations over the years. Even in 1971, *Be Here Now* was published by the Lama Foundation, set up, amongst things, "to water the spiritual garden around the world" (frontispiece). Two years later, in 1973, the Hanuman Foundation was established (Hanuman being the devoted servant of Ram in the *Ramayana*). The object of the Foundation is to "nurture projects designed to increase spiritual consciousness in the West" (*How Can I Help?,* last page). There is also a Hanuman temple (actually, the Neem Karoli Baba Hanuman Temple) in Taos, New Mexico; but the Hanuman Foundation is not an ashram but a focus for *karma yoga*, which Ram Dass defines as loving service. The Foundation runs programmes to help those who are dying or who have lost someone who has died, as well as the Prison-Ashram project, which is based on the assumption that prison life need not be antagonistic to the spiritual life but can actually be the spiritual life in embryo. Again: start with the conditions in which you find yourself. Be here now.

All of this is accomplished, as Ram Dass would say, by Maharajji's grace. But that is just his story and he does not insist that you believe it. He sees himself as a pointer, an indication of how one can be blessed. One American girl says of her first darshan with Neem Karoli Baba, " . . . I recognized the love that had poured through Ram Dass, that had irresistibly drawn me to India: Here was the source" (*Miracle of Love,* 6).

One could say that Ram Dass found himself in the spotlight. True, to a large extent he put himself there. But even so, he has resolutely refused to take advantage of the fact. Although he has said a lot over the years,[1] his is a teaching by example rather than doctrine, of openness rather than strict definitions. "I don't have a model of how it should be" (Housden, 143). This is what he is saying a quarter of a century after meeting his guru, when "I came to perceive my life in spiritual terms." I think it is fair to say that he used to be a bird of paradise, a virtuoso performer with a song full of trills. (No doubt this is ornithologically unsound—but never mind . . .) Now he is content with a simpler melody—but one that is easier to hear.

Primary sources: Ram Dass [though his name does not actually appear on the cover], *Be Here Now* (Albuquerque, New Mexico: Lama Foundation, 1971); *Grist for the Mill* [with Stephen Levine], (London: Wildwood House, 1978); *Miracle of Love* (New York, 1979); *How Can I Help?* [with Paul Gorman], (New York, 1990); Chapter 17 in R. Housden, *Fire in the Heart: Everyday Life as Spiritual Practice* (Element, 1990)

Secondary sources: None

Centre: Hanuman Foundation, 524 San Anselmo Avenue, San Anselmo, CA 94960, U.S.A.

COMPARE:

Others who provide 'social' services: the Chithurst *sangha* (prison visiting) (for which, see Ajahn **Sumedho**), Issan **Dorsey** (AIDS/the dying), Daido **Loori** (a prison *zendo*), Joya **Santanya**

Other teachers who are trans-transitional (in various senses of that term): Samuel **Lewis**, J.G. **Bennett**, Oscar **Ichazo**, Lex **Hixon**, Master **Da**

RAMESHVARA SWAMI. SEE **HARE KRISHNA GURUS**

SERGE RAYNAUD DE LA FERRIÈRE. SEE **APPENDIX 1**

BARBARA RHODES

American teacher in the Kwan Um School of Zen

In 1972, a Korean monk called Seung Sahn (usually referred to as Soen Sa Nim; 'Sa Nim' means 'monk') arrived in America. In many ways, he was (and is) typical of Eastern teachers who have had an impact on the West: independent and something of a maverick in his own country. His parents were in fact Christians but he became a Buddhist monk in 1948 at the age of 21. He says he received Dharma transmission from his teacher, Ko Bung—but in a dream, not in a public ceremony. He had his own monastery but taught mostly lay

1 And he continues to talk about everything under the sun. The latest newsletter-cum-catalogue from the Hanuman Foundation contains discourses on aging, business, and golf. A certain natural resonance there, one might say.

people. He also spent nine years teaching in Japan and Hong Kong before going to Rhode Island in 1972.

Despite the fact that he was completely unknown and did not advertise himself as a Zen teacher, he soon gathered a group of students. One of the first was Barbara Rhodes. She was born in 1948, the daughter of a Navy officer. She had abandoned the Episcopal Church in which grew up, tried LSD and found that it promised more than it delivered, and had just read a book by D.T. Suzuki that had convinced her that Zen was what she was looking for, when she met Soen Sa Nim (in 1972). She was looking for a room and he was living in the basement.

That initial small group was the beginning of the Providence Zen Center. Gradually, they learned Soen Sa Nim's Zen, which was fairly different from the traditional form practised in Korea. Rather than long monastic retreats that consisted mainly of 'sitting meditation', he advocated a far more active approach that combined sitting, chanting and prostrations. Together, these develop mindfulness that can be applied to life as it naturally arises. He does use traditional *koans/kung-ans* but the real *kung-an* is always 'What is this?' And the mind that asks it is the one that does not 'know' the answer—what Soen Sa Nim calls 'Don't Know Mind'. (See his book, *Only Don't Know* [San Francisco, 1982].)

In 1977, after five years of practice, Barbara Rhodes was given *inka/inga* by Soen Sa Nim, which meant that she was authorized to teach, to guide others in *kung-an* practice and to lead retreats. The requirements for receiving *inga* are threefold: to have successfully passed the principal *kung-ans* (usually the *Ten Gates, Mumonkan*, and the *Blue Cliff Record*); to have had awareness of one's Buddha-nature that is empowering; and to have integrated practice into everyday life. Barbara Rhodes was the first of Soen Sa Nim's students to receive *inga*[1] (though in 1977 these requirements were not so formally defined as they are now). She was known as a Master Dharma Teacher—the title has since been changed to 'Ji Do Poep Sa Nim'—and it is roughly equivalent to 'Sensei' in the Japanese Zen tradition. It is not exactly the same as Dharma transmission, since in the Korean tradition this is given only after a student who has already received *inga* has been formally tested and acknowledged by several Zen masters. But there are very few Korean Zen masters in America and it seems that this requirement will have to be dropped.

And generally speaking, Soen Sa Nim is developing a form of Zen that is independent of Korea. In 1983, after a number of disagreements with the parent Chogye Order, he founded the Kwan Um School of Zen: "a lay order of Bodhisattva monks and Dharma teachers who are married householders" (this wording taken from *Zen Buddhism in North America,* Zen Lotus Society, Toronto, 1986, 24). Hardly traditional. In effect, this makes the Kwan Um School an independent order. (However, it does keep its connections with Koreans in America and with Korea itself.)

Barbara Rhodes was a founding member of this order and is still a leader in it (while working as a nurse with the terminally ill). But she has had her

[1] Along with another American, George Bowman. There are presently nine of Soen Sa Nim's students who have received *inga*. The other seven (with the date they received it) are: Lincoln Rhodes (Barbara's husband), See Hoy Liau (both 1981), Jacob Perl, Richard Shrobe (both 1984), Bob Moore (1986), Robert Genthner, Andrej Czarnecki (both 1988). All of these are American and are in charge of centres in America except for See Hoy Liau (who is Chinese-Korean American and is head of a centre in Seoul) and Czarnecki (who is Polish and in charge of the Warsaw Zen Center). In mentioning them in a note like this, I am not implying that they are of less significance than Barbara Rhodes. She just happened to be the first and is still, eight years after her appointment, the only woman who has been given *inga*.

share of difficulties. She is now divorced from her husband, Lincoln (also a Master Dharma Teacher/Ji Do Poep Sa Nim), and in 1988 it came out that she and Soen Sa Nim had had a sexual relationship for five years before her marriage. This whole issue has been covered by Boucher, who interviewed several women in the Kwan Um School. The essential question is whether this relationship was in accordance with Dharma. Some of the women interviewed by Boucher say that it was not—mainly because it was kept secret and because Soen Sa Nim gave the appearance of being a celibate monk when he wasn't. Barbara Rhodes herself says that the relationship was mainly asexual and that she was not hurt or exploited by it. She was quite frank about it when I spoke to her but said she was uneasy about the matter being mentioned in a book because she preferred to choose whom she told about it and whom she did not.

Everyone agrees that she is a dedicated and caring woman who has done a lot to help others. Yet in the end I agree with Boucher: when someone is offering themselves as a spiritual teacher, the sort of person they are *is* relevant to the sort of teacher they are. So it is better that people know these things and make up their own minds than that others decide for them that they do not need to know (Boucher, 234). And if someone decides, unfairly, perhaps, and without paying any real attention to the facts, that this is not acceptable behaviour, then that's the way it goes. (It's a bit like democracy: it is quite pointless bewailing the fact that someone will vote for or against a candidate for trivial or mistaken reasons; that's how democracy works and one has to accept it.) I am not saying that condemning someone unreasonably and self-righteously for what she or he has done is alright; simply that this is bound to happen, people being what they are, and trying to control information will not, in the end, prevent it. Barbara Rhodes says, "We all make mistakes. The important thing to me is that we learn from them" (Boucher, 361).

It must be somewhat dispiriting that over 20 years of dedication to the spiritual path should be overshadowed by what appears to have been a fairly minor 'affair'—something which literally millions of people have done. But one of the lessons to be learned from this 'mistake', perhaps, is that the truth will out, like it or not. This may sound schoolmasterish and finger-wagging. It isn't meant to be.

Primary sources: 'Believing in Yourself' in E. Sidor, ed., *A Gathering of Spirit: Women Teaching in American Buddhism* (Cumberland, Rhode Island: Primary Point Press, 1987), 30–33

Secondary sources: L. Friedman, *Meetings with Remarkable Women: Buddhist Teachers in America* (Boston, 1985); Sandy Boucher, *Turning the Wheel: American Women Creating the New Buddhism* (San Francisco: Harper and Row, 1988)

Centre: Kwan Um School of Zen, 528 Pound Road, Cumberland, RI 02864, U.S.A.

COMPARE:

Other teachers in Korean Zen: Don **Gilbert**, Linda **Klevnick** and Linda **Murray**

Other women teachers in Zen: Jan **Bays**, Joko **Beck**, Gesshin **Prabhasa Dharma**, **Karuna Dharma**, Jiyu **Kennett**, Irmgard **Schloegl**, Ruth Fuller **Sasaki**, Maurine **Stuart**

Other students of Soen Sa Nim: Zen Master **Tundra Wind**

RUDI | SWAMI RUDRANANDA | ALBERT RUDOLPH

American psychic and
disciple of Swami
Muktananda who became
an independent teacher

Albert Rudolph (whom I will call 'Rudi' right from the beginning, though he did not receive the name until he was 38) was born in Brooklyn in 1928 and grew up in the Depression without a father. He had natural psychic gifts as a child. He could go into a trance and tell people's fortunes (*Spiritual Cannibalism*, 7), and at the age of six, while playing in a park,

> two Tibetan lamas appeared out of the air and stood before me . . . They told me they represented the head of the yellow hat and red hat Tibetan Buddhist sects and were going to place within me all of the energy and spirituality of Tibetan Buddhism. Some four-foot clay jars appeared next to them, which they said they would put inside me, from my belly button to my bowels. These, they said, would stay in me; and, at the age of thirty-one, begin to open. The process of assimilating this content would continue for the rest of my life. (*Behind the Cosmic Curtain*, 1)

His writings are packed with extraordinary incidents like this—and of the most varied kinds.[1]

In 1958, at the age of thirty, he went to India looking for a teacher—there were hardly any Indian Hindu teachers in the West in the 1950s—and he soon found not one, but two: Baba Muktananda and *his* guru, Swami Nityananda. In fact, Rudi spent only one day at Nityananda's ashram near Bombay (*Spiritual Cannibalism*, 169) but he says that the meeting was "of such depth that it changed the course of my life" (*Spiritual Cannibalism*, 12).

Nityananda was the classic Indian *mahasiddha*. He was in a constant state of bliss, wearing only a loincloth and living a life of extreme simplicity. He was a *sannyasi* and an *avadhut*—that is, one who is completely independent and has no ties to anyone, not even his *sannyasi* order—and nobody, as far as I am aware, knows who his guru was. He had no organization and never asked for money. He did not care whether he had pupils or not, and the only record of his teaching consists of the so-called *Nitya Sutras,* which he uttered in a trance-like state during the 1930s.

This work is well worth reading for its own sake but I only want to mention two aspects of it here. First, that *shakti,* the power of the pure consciousness of the Divine, is the creative life-force which manifests itself both as the hierarchy of the worlds and as *kundalini* within the body. Second, that the guru is one who can transmit this power to others by means of *shakti-pat* (literally, 'descent of *shakti*'). In fact, the glossary of the *Nitya Sutras* defines a guru as "a channel of the grace-bestowing power of God, a perfected spiritual

[1] Here is one at random:

> Suddenly the room turned totally black in such depth that one could almost pick it up in one's hand, like snow. In a minute or so, a beam of cobalt light appeared from the upper right-hand corner and grew in size as it came across this black wall. I felt the energy from this blue light coming into the passage between my temples. It not only had energy, but also nourishment and intelligence. I realized that this was a consciousness that I could reach for at will. I had heard many people discussing the blue world and have always seen the paintings of the Buddha with this deep and vivid blue, but I never understood it as a tangible force that could be used consciously. (*Behind the Cosmic Curtain*, 96).

It is difficult to assess all this—and he says that it is a waste of time and energy to do so. But by his own admission, his states did at times border on the pathological: "I had no doubt that I was on the brink of a complete nervous breakdown" (*Behind the Cosmic Curtain*, 7). Yet he also says that "pain is intense food" (ibid, 11). This is a central element in his teaching.

master who has realized his identity with the Divine and can impart this experience to a disciple". This is one of the strongest definitions of a guru that there is and Bhagwan Nityananda is a modern example.

Rudi's contact with Nityananda, as we might expect, was not restricted to the physical. Shortly after returning to America, Rudi was watching TV in New York when Nityananda (who was still alive) appeared before him and entered his body (*Spiritual Cannibalism,* 13). Rudi says that "it was a terrifying experience and it required all my faith not to fight it". A few years later, after Nityananda's death, Rudi was again in India and again 'saw' Nityananda, who spoke to him. Rudi circled Nityananda's tomb several times, and on each occasion he placed his hand on the edge of the tomb, whereupon the *shakti* flooded into him (ibid., 15). Rudi interpreted these experiences as part of a process whereby Nityananda's qualities were manifesting in him.

However, his principal 'external' guru was Muktananda. In 1965, he was formally initiated at Muktananda's ashram near Bombay: Muktananda gave him *shakti-pat* (that is, the transmission of divine energy) by simply tapping the top of Rudi's head (*Spiritual Cannibalism,* 16). A year later, on another visit to the ashram, and following a number of psychic experiences, Rudi was made a *swami* by Muktananda, who gave him the name 'Rudrananda'. (Rudra is one of the wild aspects of Shiva; 'Rudi' is an affectionate contraction of the name.) As far as I know, he was Muktananda's first Western disciple, and certainly the first to be given *sannyasa*.

Rudi had always been a teacher in a sense, though not in any structured way. For example, he records a typical encounter at his Oriental art shop in New York.

> One day, while I was in my shop talking to several groups of people, I noticed a middle-aged black man looking at me with tears rolling down his face. He stood there for about an hour. I consciously paid as little attention to him as possible. He was having his own experience. I just tried to stay open to him, so that he could take from my energy whatever he needed. Finally, he shyly approached me and said that had dreamt of me and felt I was a great teacher. I thanked him and said he could come back whenever he wished. He returned two days later and stayed for about half an hour. I didn't see him again for six months, when he said he had several experiences of seeing my face during his meditation. I have not seen him since.
>
> Such experiences may serve a person in depth; they may be transitory. The human contact is touching. But to speculate as to the needs of the person or my responsibility toward them is all imagination. A conscious effort can be made only if the person asks for help directly. But it has taken enormous effort over many years for me to become detached from this sort of emotional situation. It is easy to assume that when somebody reacts so strongly that you are essential for their growth. That is *your* will. God's will is that you serve people who come and ask to be served . . . The whole purpose of energy should be to nourish and free people. I am more than willing to give, without entering into an enormous illusionary relationship. (*Behind the Cosmic Curtain,* 16–17)

There is nothing here that is connected with the Indian *shakti-pat* tradition in any obvious way. And it is evident that he always regarded himself as independent.

> I consider myself a Western man and certainly an American product. I deeply believe in my country. I have no allegiance to anything else . . . It is as if I were an apple tree and went to India, Japan and China to get additional fertilizer. These are just sources

of nourishment which can feed what I am. They do not change my root system and certainly do not change what I will produce. (*Behind the Cosmic Curtain,* 99)

Yet he was also a *shakti-pat* guru, working along essentially the same lines as Nityananda and Muktananda—he did, after all, receive *shakti-pat* from both of them (though in different ways). He held 'classes', during which he would give *darshan*—that is, look into people's eyes, imparting *shakti.* At the same time, pupils would repeat the *mantra, Soham.*

*One person who attended these classes was Master **Da** (then Franklin Jones).*

In fact, this is one of the few aspects of Rudi's teaching that is patently Hindu or Shaivite (the tradition to which both Nityananda and Muktananda belonged). Rudi himself constantly emphasized that spiritual work is not a matter of mystical initiations and special conditions.

> We cannot limit our intake to qualities that are 'easy to take' . . . Everything is part of perfection and must be taken in a state of surrender . . . Life must be consumed whole—with all its tensions, pain, and joy. (*Spiritual Cannibalism,* 3)

The spiritual teacher or guru is one who, having the ability to do this himself, can bring about the same condition in his students or disciples.

> In our spiritual rebirth we are like puppies born in a sack. A spiritual teacher is like the mother who must eat the sack to free the puppy so that it can grow. Human beings, from the day of their birth, live in a sack of tension which is almost impossible for them to break through. This tension is a psychic quality which has to be taken by someone who loves them and who is willing to absorb the tensions that represent the *karma* of this life. (*Spiritual Cannibalism,* 4)

It is this quality of consuming the negative energy of others which explains the title *Spiritual Cannibalism.* And Rudi himself did just this for his students—including removing cancer from someone (*Spiritual Cannibalism,* 121ff). This is another way of saying that he took on karma.

*Cf. others about whom a similar claim is made: Sri Daya **Mata**, the **Mother**; and James **Mackie**'s teaching about the unwinding of sanskaras.*

In 1970, Muktananda visited America for the first time, with Rudi largely responsible for the arrangements. Muktananda's organization, Siddha Yoga Dham of America (SYDA), was created in the same year, and a number of ashrams were set up. Rudi was in charge of the one in New York, the Shree Gurudev Siddha Yoga Ashram (though it is possible that his ashram predates Muktananda's visit). Only a year later, however, Rudi broke with Muktananda.

> A teacher in no way is a replacement for God and I found that the person with whom I had studied was so obsessed with his being God, or more than God, that I could not respect and sustain the relationship. Anybody who teaches by tension is an insecure human being. A teacher should give love and free people from tension so that they can open to God. (*Spiritual Cannibalism,* 127)

Rudi set up his own ashram at Big Indian in New York state. Eventually, there were nine Rudrananda Ashrams in seven states (*Spiritual Cannibalism,* 196).

Rudi died in 1973 when a small plane he was using to go to a talk in New York state crashed. He was dictating into a recorder at the time. These were his last words:

> I feel the last year of my life has prepared me for the understanding that expanded consciousness can only come through expanded nothingness. This state is produced by surrendering the tensions that bind and restrict our physical mechanism from expressing the power of creation. It is God flowing through us and showing us how we are connected to Him as the expression of higher creative will and a deeper sense of surrender.

[Rudi paused. The pilot suddenly cried out, "Oh my God," as the plane came out of a bank of cloud directly in front of the crest of a mountain. The plane crashed. Rudi was instantly killed. The three other members of the party sustained only minor injuries] (*Behind the Cosmic Curtain*, 160)

There is little doubt that this abrupt end caught everybody on the hop and his pupils have struggled to continue as a coherent group. But there is a continuity of sorts—see Swami **Chetanananda**.

The underlying truth which Rudi repeats over and over again is that we have allowed ourselves to be cut off from the divine. How? By attempting to create something which is 'ours' instead of realizing that everything is a gift. This attempt leads us to live in a way that is in direct contradiction to the divine intention—as separate beings, cut off from each other by tension. And what is the solution? To learn how to absorb *shakti,* the spiritual energy that creates everything. This is accomplished by spiritual work, which to begin with *is* work (because we resist the forms of *shakti* that are 'difficult to take') but ends up as surrender (because we accept everything as manifestations of *shakti).* So we have to let go of the mind and open ourselves to something higher. As we engage in work/surrender, the tension is released and we become free. The guru is one who aids in this process (having gone through it himself); his job is not to protect us but to show us that there is no protection.

Whether we agree with these teachings or not is one thing. What I'm concerned with is something else: that they were given by a Westerner who lived them.

STOP PRESS: *At the very end of the resetting of this book, when people had been added, brought up to date, obituarized, and even deleted, a whole third of a page emerged. It just sat there staring at us blankly. So my editor asked if I wanted to add a few lines about Rudi. In a state of complete nervous exhaustion, I could think of nothing that would do Rudi justice. So I've left him his space. Seems appropriate, really . . .*

Primary sources: Rudi, *Spiritual Cannibalism* (Woodstock, New York: The Overlook Press, 1978); John Mann, ed., *Behind the Cosmic Curtain: The Further Writings of Swami Rudrananda* (Arlington, Massachusetts: Neolog Publishing, 1984)

Secondary sources: J. Mann, *Rudi: 14 Years with My Teacher* (Cambridge, Massachusetts: Rudra Press, 1987)

Centre: Nityananda Institute, P.O. Box 13310, Portland, OR 97213, U.S.A. [now under the direction of Swami Chetanananda]; this is also the address of the Rudra Press, which publishes other books by Rudi not listed above

COMPARE:

Other Shaivite gurus: Sri **Mahendranath**, **Shankar Das**, Guru **Subramuniya**

Other visionaries: Jiyu **Kennett**, Samuel **Lewis**, the **Mother**, Frithjof **Schuon**

Miriam SALANAVE

American pioneer who
wanted to bring Zen to
Western women

*Ruth Fuller **Sasaki**,
another pioneer, practiced at
Daitokuji 20 years later.*

Salanave came to Buddhism via Theosophy. In 1929, she sold all her possessions and went to Japan by herself to practice Zen, spending three months at Daitokuji, the Rinzai monsatery in Kyoto and a further two months at another monastery. How she managed this, a Western woman in the bastion of Japanese Zen masculinity, is unknown. These five months were the extent of her Zen training. She returned to America in 1930 after a pilgrimage through Japan, Korea, and China but went back to the East in 1933 with the intention of becoming a nun (whatever that may mean). However, she appears not to have been successful because she was back in San Francisco in 1935, where she founded a Western Women's Buddhist Bureau and an East-West Buddhist Mission. Apparently, she had switched her hopes to the West and wanted to turn the Bureau into a convent for a Buddhist Sisterhood. She wrote articles for various Buddhist magazines in America, England, India, Korea, and Japan, as well as *The Canadian Theosophist*. She even intended to publish a magazine of her own with the splendid title of *The Buddhist Women's Home Journal*.

But there is no evidence that her plans ever came to anything. It isn't even established that she knew of Nyogen Senzaki (who was holding his small *zendo* in Los Angeles at this time—admittedly with next to no publicity) or any other Buddhist teacher in America, come to that. The story just peters out. (All this information from *Spring Wind*).

I cannot quite explain why I find Salanave so admirable. Perhaps it is because she appears, at least at the outset, to have thrown herself into the Buddhist cause—in fact, the Buddhist *women's* cause—without any thought of the extreme unlikelihood of its success (in the West in the mid-1930s). And indeed it seems likely that she did not succeed. But on the larger scale, she was actually part of something very large, very powerful, and very influential. Some part of her intuited that and acted on it. Looking back on it now, we can see that this was so and salute her for it. But she could never have known that this would happen. Maybe this is 'deep success' (on analogy with deep ecology). And maybe admiration is the natural reaction to it.

Primary sources: Miriam Salanave, *A Buddhist Roll Call* (18 pp) (San Francisco, 1935)

Secondary sources: Spring Wind (the magazine of the Zen Lotus Society), vol. 6, nos. 1, 2, 3 ('Women and Buddhism'), pp. 230, 240, 242

Centre: None extant

COMPARE:

Other Zen pioneers: Ruth Fuller **Sasaki**

Women teachers in Zen: Jan **Bays**, Joko **Beck**, Gesshin **Prabhasa Dharma**, Maurine **Stuart**, Irmgard **Schloegl**, Jiyu **Kennett**

Women in other Buddhist traditions: Freda **Bedi**, Alexandra **David-Néel**, Ruth **Denison**, Rev. **Dharmapali**, **Karuna Dharma**, Ayya **Khema**, Dharma Teacher Linda **Klevnick**, **Miao Kwang Sudharma**, Dharma Teacher Linda **Murray**, *Pema* **Chodron**, Dharma Teacher Bobby **Rhodes**, Dhyani **Ywahoo**

Women in non-Buddhist traditions: Swami **Abhayananda**/Marie Louise, Sri **Daya Mata**, Sister **Devamata**, the **Devyashrams**, Ivy **Duce**, **Marasha**, Rabia **Martin**, the **Mother**, Sister **Nivedita**, Patrizia **Norelli-Bachelet**, Swami **Radha**, Jeanne **de Salzmann**, Joya **Santanya**, Sri **Sivananda-Rita**, women in the **Sufi Order**, Swami **Turiyasangitananda**, Irina **Tweedie**

SHARON SALZBERG. SEE *VIPASSANA SANGHA*

VEN. SANGHARAKSHITA | DENNIS LINGWOOD

English founder of the
Friends of the Western
Buddhist Order, a
non-denominational form
of Buddhism

Buddhism is new in the West and has established itself in a number of ways. One of the most interesting—and most radical—forms is a movement called the Friends of the Western Buddhist Order (FWBO). According to one of its members,

> we already have amongst us at least a few notable 'transformers', a few individuals who are able to look upon our Western world with truly Buddhist eyes, and speak with the authentic voice of the Dharma.
>
> Sangharakshita is such a man. (*New Currents in Western Buddhism,* 14)

Creating a new form of Buddhism (ibid., 9), speaking with the authentic voice of the Dharma—these are considerable claims. They need to be investigated.

Ven. Sangharakshita[1] was born Dennis Lingwood in 1925. He read Buddhist texts (the *Diamond Sutra* and the *Sutra of Hui Neng,* both Mahayana works) as a teenager and immediately realized that he was a Buddhist. He joined the Buddhist Society in 1943 and took *pansil* from U Thittila, a Burmese monk living in London (*History of My Going for Refuge,* 22). In the same year he was drafted into the army and was sent to India and Ceylon. He left the forces in 1947 and spent the next two years walking with a Bengali friend (also a Buddhist) from the southernmost tip of India to the Himalayas. Although he lived as a mendicant, he did not formally enter the sangha until 1949, when he became a *shramanera* (that is, a novice monk) and was given the name 'Sangharakshita'. Eighteen months later he took full *bhikkhu* ordination.

The circumstances of his two ordinations are worth commenting on. The first (*shramanera* ordination) took place at Kusinara (where the Buddha died) and the second (*bhikkhu* ordination) at Sarnath (where the Buddha gave his first discourse after attaining enlightenment). These were two of the sites that Anagarika *Dharmapala* had dedicated his life to returning to Buddhist hands; and they were also among the few places in India where Theravadin monks (only a handful of whom were Indians) lived permanently. However, Sangharakshita and his companion were initially refused the *shramanera* ordination at Sarnath because none of the monks there would give it to them. Moreover, Sangharakshita had to wait for his *bhikkhu* ordination because ten monks are needed for the ceremony and special arrangements had to be made for that number to be present in one place all at the same time (*History of My Going for Refuge,* 30–35). He did not, therefore, become a Theravadin monk in the same way as the other Westerners before him, such as **Ananda Maitreya** or **Nyanatiloka** Thera—namely, in a Theravadin country with a fully established *sangha*. On the contrary, he was a minority member of a tiny *sangha* that had only recently been established in a foreign country (and where all its members were themselves foreigners—that is, non-Indian).[2]

[1] Now referred to as 'Urgyen Sangharakshita'. I don't know why. I only found out after the book was finished and I never got round to asking.

[2] Ven. Sangharakshita informs me that this statement "overlooks the scores of Indian Theravadin *bhikkhus* in Assam and Tripura, with some of whom I was later in contact." A full account of the Indian Theravadin *sangha* would be very welcome.

From about 1951 onwards Sangharakshita was based in Kalimpong on the borders of India, Bhutan, Nepal, and Sikkhim, and only a few miles away from Tibet. This was and is an area with strong Buddhist influence but without a strong *sangha*—that is, there were many Buddhists but no vigorous Buddhist organization. Ven. Sangharakshita set about to provide one. He formed a Young Men's Buddhist Association, and in 1957 established his own centre, the Triyana Vardhana Vihara (meaning 'the monastery for promoting the three vehicles'), where he had his own resident disciples and where he was often visited by Buddhists from different parts of the world (Subhuti, 28).

Over the next decade or so he was editor of the *Maha Bodhi Journal* (started by Anagarika *Dharmapala* in 1892) and he also began his own magazine, *Stepping Stones.* In addition, he wrote a book, *A Survey of Buddhism,* in which both Hinayana and Mahayana are presented as essentially one tradition. And he founded and edited a small series called the Buddhist Library, which was concerned with "every aspect of the total Buddhist tradition" (*Crossing the Stream*, v) and "dedicated to the ideal of the transcendental unity of Buddhism" (ibid., vi). In amongst all this activity, he received instructions and initiations in both Mahayana and Vajrayana from Tibetan teachers: Dhardo Rinpoche (from whom he received Bodhisattva ordination), Jamyang Khyentse Rinpoche and Khachu Rinpoche (*History of My Going for Refuge,* 48–73). He also associated with a Mr. Chen, a Chinese hermit and Ch'an practitioner who just happened to be living in Kalimpong (Subhuti, 29).

During this time Ven. Sangharakshita kept in contact with other Buddhists in India, including Dr. Ambedkar, the leader of the untouchables, who was attracted to Buddhism because of its rejection of the caste system. In 1956, Dr. Ambedkar decided to formally become a Buddhist by taking the five lay precepts (just as **Blavatsky** and **Olcott** had done in Ceylon 75 years before, though for very different reasons). He wanted Ven. Sangharakshita to perform the ceremony (having first asked the Italian monk, Salvatore Cioffi/**Lokanatha** Thera, to do so) but Ven. Sangharakshita argued that Dr. Ambedkar's gesture would be more significant if the most senior monk in India officiated instead. This was the first mass conversion of untouchables to Buddhism; over 300,000 were present. Dr. Ambedkar died just six weeks later but the Buddhist untouchable movement had begun. Ven. Sangharakshita took a prominent part in it—giving talks, leading seminars, teaching meditation, conducting marriages and name-giving ceremonies. He personally officiated at the conversion (that is, the five-precept ceremony) of 200,000 people (Subhuti, 30).

Then in 1964, having lived and worked in India as a Buddhist monk—though not as part of an established *sangha*—for 15 years, Ven. Sangharakshita was invited to Britain by the English Sangha Trust to teach at the Hampstead Buddhist Vihara.[3] For a while, Sangharakshita shared this responsibility with Ananda Bodhi but they did not see eye to eye and by 1965 Ananda Bodhi had left. (One of the points of disagreement between them was that Sangharakshita thought that Ananda Bodhi's reliance on *vipassana* meditation apart from *samatha* was one-sided and maybe even dangerous—we shall return to this point later.)

In October 1966, when he had been in sole charge of the Vihara for nearly two years, Ven. Sangharakshita returned to India to wind up his affairs. But

[3] Unfortunately I do not have the space to give the history of this institution which was started off by **Kapilavaddho** and ended up under the direction of Ajahn **Sumedho**, with Ananda Bodhi (later **Namgyal** Rinpoche) and Sangharakshita in between.

while he was there he received a letter from the Trust saying that there was no longer any place for him in their plans. He therefore set up on his own in Britain, taking with him a large proportion of the lay supporters of the Trust. In 1967, he founded the Friends of the Western Sangha but soon changed its name to the Friends of the Western Buddhist Order or FWBO. A year later, he founded the Western Buddhist Order or WBO (exactly the same name as **Clifton**'s organization but there was no formal link between them, as far as I know). He did this by ordaining a number of Westerners as novices—that is, as *upasikas/upasakas* taking the ten precepts (see below). The ceremony was attended by a Zen monk, a Shin priest and two Theravadin *bhikkhus*. Nearly 30 years later there are over 400 ordained members of the WBO and many thousands who are associated in various ways with the FWBO.

To begin with, Ven. Sangharakshita was undoubtedly the centre of the movement. He performed all ordinations into the WBO (Subhuti, 36) and all its members were his personal disciples (ibid., 146). But this has now changed, mainly because of the growing maturity of the *sangha,* the WBO. They are not *bhikkhus* or monks—the WBO has abandoned the distinction between monk and lay (Subhuti 140)—but they do take ten precepts.[4] Members of the Order are given the title 'Dharmachari' (or 'Dharmacharini' for women). It means 'follower of the Dharma' and is an innovation of Ven. Sangharakshita's.

In recent years, Dharmachari/nis have begun to give ordinations, thus ensuring that the Order can continue independently of Sangharakshita. In fact, the whole structure of the FWBO could be characterized as a 'friendly hierarchy'. It is friendly in the specifically Buddhist sense of *mettata* or *mitrata*—that is, a willingness to work actively for the benefit of others. But it is hierarchical in that "those of greatest experience and understanding are able to guide and inspire" (Subhuti, 133). Ven. Sangharakshita is regarded as having the greatest experience and understanding, followed by the members of the WBO, then *mitras* (literally, 'friends'), who play an active role in the FWBO, and finally 'friends' (which means anyone who has come into contact with the movement, however minimally).

The most distinctive aspect of the (F)WBO is that it is non-denominational, both doctrinally and as an institution (though it prefers the term 'movement'). Ven. Sangharakshita teaches a universal Buddhism—or more accurately, a universal Dharma. This was already obvious in India where he wrote that "Buddhism consists of a transcendental essence and a mundane expression" ('The Meaning of Orthodoxy' 288); that there is a "fundamental unity, on the transcendental plane, between all Buddhist schools" (ibid., 287); and that the Dharma is not a product of the sixth century B.C. and therefore limited to what we call Buddhism but "comes down producing countless Buddhas and Bodhisattvas from the beginningless past" (*Crossing the Stream,* 4). At the same time as he was writing this, he took ordinations in the major Buddhist traditions, and his own *vihara* in Kalimpong was dedicated to the three *yanas.*

[4] These, like much in the FWBO, are drawn from traditional Buddhism but cannot be found in any particular form of it. They are to abstain from: taking life; taking the not-given (a rather more precise definition of stealing); sexual misconduct; false speech; harsh speech; useless speech; slanderous speech; covetousness; hatred (sometimes 'animosity'); and false views. Ven. Sangharakshita considers them so important that he has written a complete book on them: *The Ten Pillars of Buddhism.* And he stresses the positive side of all these abstentions. That is, each of them can be restated in terms of an ideal that one tries to live up to: love; generosity; contentment; truthfulness; kindly speech; meaningful speech; harmonious speech; tranquillity; compassion; wisdom.

This universalism is also at the very foundation of the FWBO. Ven. Sangharakshita provides commentaries on Theravadin, Chinese, Tibetan and Indian Mahayana texts; the *puja* that he has composed incorporates elements from more than one Buddhist tradition; and he also teaches meditation associated with the Buddhism of India, China, and Tibet. So though he undoubtedly took Theravada ordination, it would be misleading to call him a Theravadin Buddhist—a simple enough distinction, perhaps, but one that Eastern Theravada never made. In fact, he is openly critical of orthodox Theravadin monasticism, which, he says, has become grossly over-valued in the East (*New Currents in Western Buddhism*, 87).

> An incredibly exaggerated importance is attached to social and ecclesiastical observances [in all Theravadin countries] which have no essential connection with the Dharma whatsoever. ('The Meaning of Orthodoxy', 309)

The literature of the FWBO makes much of the fact that its form of Buddhism is fully appropriate to Western society. "No anachronistic dress or customs are required and no one need follow the way of life of the Thai jungles or the Tibetan plateau" (Subhuti, 184). This is, of course, an implicit critique of the orthodox monasticism represented by Ajahn **Sumedho** and the Chithurst *sangha*.

At the same time, Ven. Sangharakshita does not reject the ideal of a formal commitment to a certain way of life. He says that the WBO is an Order because it

> consists of those who have been ordained. In Buddhist terms 'ordination' means giving full formal expression, in 'concrete' form, to one's commitment to the Buddha, the Dharma, and the Sangha, and having that commitment recognized by others already committed. One can join an organization by paying the required subscription, but one can be received into an Order only by way of ordination, only by committing oneself. (*New Currents in Western Buddhism*, 82)

Similarly, the 'traditional' elements of *sila* (ethical conduct), *samadhi* (concentrative meditation) and *prajna* (wisdom; insight into the nature of things) are kept. Trying to practice wisdom by means of 'pure' insight or *vipassana*, without the foundation of *samadhi*, is a mistake.

> Any attempt to eliminate samadhi in the full sense from the schema—as now appears to be the case in some Burmese 'meditation' centres—merely means that the rational understanding of the Dharma has been substituted for Transcendental Wisdom. ('The Meaning of Orthodoxy', 300)

What we find, then, is that Ven. Sangharakshita is equally critical of orthodox 'cultural' monasticism and innovative 'rational' non-monasticism. The FWBO is apart from—one might almost say, above—these extremes.

> The FWBO is definitely a Buddhist spiritual movement. But it does not confuse Buddhism with any of its Eastern cultural forms. In the same way, the FWBO does not identify itself exclusively with any particular sect or school of Buddhism, not with the Hinayana, nor with the Mahayana, nor with the Vajrayana, nor with Zen, Shin, or the Nyingmapas. It is just *Buddhist*. At the same time it does not reject any of the sects or schools that have arisen in the course of the long history of Buddhism. It appreciates them all and seeks to learn from them all, taking from them whatever it can find that contributes to the spiritual development of the individual in the West. (*New Currents in Western Buddhism*, 63)

Although the FWBO is based in Britain and most of its members are British, there are also centres in Sweden, Finland, Germany, Holland, Spain, Australia, New Zealand, America, Mexico, Venezuela—and India. This last is interesting because *Western* disciples of Ven. Sangharakshita are promulgating Buddhism among the untouchables (just as he himself had done from 1956 onwards).[5] There are nine Indian urban centres (which offer basic courses in Buddhism and meditation classes), two retreat centres, and twelve educational hostels for children. The numbers are considerable—thousands pass through this network each year—and so are the finances: the Karuna Trust, a charity in Britain that supports the work in India, has raised nearly three million pounds over the years.

The aim of the FWBO is to be both universal and international. And if, and when, this aim is accomplished, it might then change its name to the Friends of the World Buddhist Order (Subhuti, 153). It is interesting that this universal, international Buddhism goes back to **Olcott** and Anagarika *Dharmapala;* and though Ven. Sangharakshita was never a Theosophist to my knowledge, he has written an appreciative biography of *Dharmapala*. He has also stated very clearly what his ideal of the *sangha* is.

> [It] is primarily the community of those who, by virtue of their immediate or remote approximation to Enlightenment, stand in spiritual relation to the Buddha and dwell spiritually in his presence. It is the community of those who, through their relationship with Him, are also spiritually related to one another. (*The Three Jewels*; quoted in *History of My Going for Refuge,* 66)

And this ideal, which stresses the *sangha*'s nearness to enlightenment and to the Buddha, is directly related to the formation of the Western Buddhist Order, which Sangharakshita refers to as

> a unified order in that it consisted of both men and women, who went for Refuge to the same Three Jewels, observed the same Ten Precepts, practised the same meditations and other spiritual disciplines, and who, where qualified, performed the same administrative and 'ministerial' functions. (*History of My Going for Refuge,* 85)

However, a necessary part of this process of creating a world Buddhism based on a unified *sangha* is the establishment of a genuinely Buddhist *social* ethos. That is, individual development—what Ven. Sangharakshita calls the Higher Evolution—requires a Buddhist community as a support. This is where the Western Buddhist Order needs its Friends. A spiritual community has to be self-sufficient, otherwise it will inevitably compromise with the values of those who support it. This has happened in the East (Subhuti, 161) and the FWBO wants to avoid it happening in the West. It therefore seeks to establish what it calls the New Society, based on the principle of Right Livelihood (an extension of the fifth step of the noble eightfold path). Members of the FWBO earn their living by 'positive work', meaning that it involves no harm to others, and that it serves some end which transcends the individual. This end is the transmission of the Dharma (which, as we have already seen, is defined by Ven. Sangharakshita as a transcendental truth which goes back to the beginningless

[5] Indians—and that means Indian members of the FWBO (called Trailokya Bauddha Mahasangha in that country), many of whom are therefore Ven. Sangharakshita's disciples—are also involved in the work nowadays. But the original impetus came from Westerners.

past). In practice, what this means is that the FWBO has created its own businesses—the biggest, Windhorse Trading, which imports goods from India, had a turnover of £5.5 million in 1995. They are spiritual communities as much as businesses. Members are paid according to their need; those with dependents receive more than those without.

Ven. Sangharakshita emphasizes that the development of the FWBO is not according to a fixed pattern but is organic. It has no headquarters but is instead organized locally according to the needs of each community. Nevertheless, certain patterns do emerge. One of the most striking is the separation of men and women—not for doctrinal reasons but simply because it has been found that the community works better that way.

However, it is somewhat misleading to say that this segregation is purely pragmatic. There *is* a 'teaching' behind it, and it has two aspects: that sexuality, and hence the relationships between the sexes, is largely neurotic in Western culture; and that this neurosis is inextricably linked with the nuclear family. These ideas lead very quickly to some controversial matters. According to Sangharakshita, all forms of sexuality are conditioned. Heterosexuality is not 'normal' and homosexuality, 'abnormal'. In fact, too much emphasis is put on sexual relationships at the expense of others, such as those with parents and friends. Single-sex communities free their members from dependence on a conditioned, and therefore false, ideal—the nuclear family. Hence so-called homosexual relationships could develop in such communities that were hardly sexual at all in the intense, neurotic way that is regarded as 'normal' in our society.

Moreover, such relationships can be an integral part of the spiritual life. That is, someone could be helped spiritually by the intimacy that a sexual relationship would bring. Ven. Sangharakshita has even suggested that a member of the Order might foster a relationship of this kind simply in order to become a better spiritual guide or *kalyana mitra* (literally, 'good friend').

> Sexual interest on the part of a male Order member for a male *mitra*[6] can create a connection which may allow *kalyana mitrata* to develop. (*Matter of Fact*, a television programme in Britain in 1992)

I do not think I am giving any secrets away if I say that Ven. Sangharakshita has participated in this process himself.

This is bound to upset some people. But at least he is straightforward about it. He does not present himself as an enlightened guru, living up to a romantic—which is to say, neurotic—ideal of the spiritual life. Rather, he has, by his own efforts on the path, attained what he calls the single inner sense that can perceive spiritual realities (*Path of the Inner Life*, 9).[7] This has enabled him to

[6] A *mitra* is someone who takes an active role in the FWBO but is not yet an ordained member of the Order. The word should not be confused with *kalyana mitra*, which is a well-established Buddhist term meaning 'a spiritual guide'. The form *kalyana mitrata* means 'spiritual guidance.'

[7] Perhaps it is this inner sense which informs his trenchant critique of Christianity, which he characterizes as having no respect for the individual and being based on the fear of an all-powerful God (*New Currents in Western Buddhism*, 36–37; cf. Subhuti, 177–180). The influence of this pernicious belief is so deeply rooted that it can only be eradicated by drastic measures:

> If one really wants to rid oneself of the fear and guilt instilled by a Christian upbringing—if one really wants to commit therapeutic rather than irrational blasphemy and from being an ex-Christian become a non-Christian—then a vigorous expression of one's emotional as well as of one's intellectual rejection of Christianity is necessary. It is not enough to deny in private, as an intellectual proposition, that God exists. One must publicly insult him. (*Buddhism and Blasphemy*, 22)

This is why I said at the beginning that Ven. Sangharakshita's form of Buddhism is radical: it advocates the uprooting of Christianity, the undermining of the nuclear family, and the redefinition of sexuality (and its relation to spirituality).

see not only that a *sangha* is required (just as traditional Buddhism has always held) but the form that it must take in the West. This is the "mundane expression of the transcendental essence" of the Dharma (to use his own phrase). "Real Western Buddhism will begin when people brought up within Western culture live a truly Buddhist way of life in the midst of the modern West" (Subhuti, 6). The FWBO—the friendly hierarchy—is the form that will allow this to happen.

But it is *informed* (that is, given shape) from a higher source. According to Ven. Sangharakshita, this source is the *bodhichitta,* which he calls the Myth of the Movement (*Mitrata*, 58 [February, 1986] p. 42). He describes the *bodhichitta* (usually translated as 'the thought of enlightenment') as

> a sort of 'spirit of enlightenment', immanent in the world, and leading individuals to higher and even higher degrees of spiritual perfection . . . something vast, something cosmic, something subtle, which descends into, and penetrates, and possesses, people who are receptive to it. (ibid., 8–9)

And the movement (the FWBO), though it is only "a tiny part, a very limited manifestation" (ibid., 43) of that spirit of enlightenment, is not limited to that manifestation because it has "an existence on another level" (ibid., 44). Those who are in it are "working out, say, on the historical plane, something of archetypal, or archetypal/spiritual significance. So if one can feel oneself, as a member of the FWBO, working out that myth, that will give one a much truer idea of what is actually happening or of what one is actually involved in" (ibid.). And since those in whom the *bodhichitta* arises are called Bodhisattvas (ibid., 8), it follows that everyone in the FWBO is in a sense a Bodhisattva.

This is quite a claim and I think it is fair to say that the person who makes it—Ven. Sangharakshita—is regarded by his disciples and by the FWBO generally as himself the focus of this manifestation of the *bodhichitta,* the transcendental spirit of enlightenment.

But the way this has come about—on the lower, physical level—is very interesting. Although he entered the *sangha* as a Theravadin monk, he did so in a country (India) that is not Buddhist and in which the *sangha* is not a dominant force. He therefore never had to fit in with a pre-existing model, and from the very beginning he put his efforts into establishing Buddhism on what was essentially foreign soil. In doing so, he made use of what is fundamentally a Western approach—forming societies, giving lectures, editing magazines, writing books on 'Buddhism'. But unlike Westerners before him, he was neither a lay enthusiast in the West nor a monk in a Buddhist country. Practising universal Buddhism, as a monk, in a non-Buddhist country in the East was excellent training for establishing a Buddhist way of life in the West. Certainly no other Buddhist before him had managed to accomplish such a thing. If non-denominational Buddhism continues in the West, it will be largely the result of Ven. Sangharakshita's efforts.

Primary sources: Sangharakshita, 'The Meaning of Orthodoxy: A Protest' *in* R.de Berval, ed., *Présence du bouddhisme,* (Saigon, 1959), 287–310; *Crossing the Stream* (Bombay, 1960); *The Path of the Inner Life* (London, 1975); *Buddhism and Blasphemy* (London: Windhorse Publications, 1978); *The Ten Pillars of Buddhism* (Glasgow: Windhorse Publications, 1985); *The History of My Going for Refuge* (Glasgow: Windhorse Publications, 1988); *New Currents in Western Buddhism: The Inner Meaning of the Friends of the Western Buddhist Order* (Glasgow: Windhorse Publications, 1990); Dharmachari Subhuti, *Buddhism for Today: A Portrait of a New Buddhist Movement* (England: Element Books, 1983) [these are the only books I have cited; a full list can be obtained from the FWBO—address below]

Secondary sources: P. Mellor, 'Protestant Buddhism? The Cultural Transition of Buddhism to England', *Religion* 21, 73–92 [this article compares the FWBO with Ajahn **Sumedho**'s Chithurst *sangha*]

Centre: Friends of the Western Buddhist Order, 51 Roman Road, London E2 0HU, England, U.K.

COMPARE:

Others involved in non-denominational Buddhism: Robert **Clifton**, Rev. **Dharmapali**, **Miao Kwang Sudharma**

Others who have radically altered the forms of their 'received' tradition: Jiyu **Kennett**, Frithjof **Schuon**

Others who have made business a central part of the spiritual life: Bernard **Glassman**

SANGYE NYENPA RINPOCHE | O.K. MACLISE. SEE *TULKUS*

JOYA SANTANYA

American Mother of the Universe with an ashram in Florida

Joya Santanya (*aka* Sri Mata Brahma, Jaya Sati Bhagavati, Ma Jaya or just plain Ma) first came to public notice in 1976, when the Orphalese Foundation (about which I know nothing at all) published her *Sharing Moments*. It consists of quotations from talks and conversations during 1975 and 1976 interspersed with photos of a vital and radiant woman in her thirties. The title of the book is explained by this statement:

> I am not a teacher, I am not a guru. I am a sharer. I share my moments with you. What you take from it is your business. And my teachers . . . are sharers. It is their hardship that they get caught in the power of being a teacher. We all must be humble, and know humility before God. (*Sharing Moments,* 10).

But she also says,

> I have never taught a method. My path, which is no path, consumes all paths . . . which is why every guru's son and daughter is welcome here. (ibid., 12)

*Master **Da** also 'met' Nityananda after his death.*

She mentions Nityananda and Neem Karoli Baba as representing absolute truth (*Sharing Moments,* 27). In fact, she never met either of them in the flesh. I do not know what sort of connection she had with Nityananda (who died in 1961) but we know something of her relationship with Neem Karoli Baba (who died in 1973) because it has been recounted by **Ram Dass**. In 1974, he was meditating in Pennsylvania, having decided that he should return to India, when Neem Karoli Baba appeared to him and told him that there was no need to. "Your teachings will be right here" (*Grist for the Mill,* 63). Shortly afterwards, Hilda Charlton told him that a woman in Brooklyn—Joya Santanya—was saying that Neem Karoli Baba was sitting in her basement. Ram Dass went along to see her and found her sitting in *samadhi*.

> I checked: I could find no breath or pulse. She was like a rock. She was a very unusual looking woman; she had long false eyelashes, heavy mascara, and a low cut dress. Maharaj-ji [Neem Karoli Baba] was an old man in a blanket, but after all I'd given up having models about what packages the next message is supposed to come in.

Finally, she came down, looked at me, and said, "What the fuck do you want?"

Hilda said, "Oh, dear, this is Ram Dass," which didn't seem to make any impression on this lady at all. She said, "I don't care who the hell he is. Does that old man over there belong to you?" I looked, and there was a blanket with nothing on it. So I said, "I don't know." She said, "He's buggin' me; get him the hell out of here."

Then her consciousness shifted just a bit and she went into a very light trance, and suddenly Maharaj-ji seemed to be speaking to me through her. He was talking about things that he and I had been discussing in India when I had seen him last, little matters about maintenance of the temples in India and all kinds of very picayune stuff that she probably could not know and I hadn't even remembered. She came back from that plane but, as she explained, she was not conversant across planes so she didn't know what had just happened.

And I was pleased because this experience following so closely the vision in the Pennsylvania motel seemed the answer to my prayers. (*Grist for the Mill,* 64)

My information is that Joya had been told by Neem Karoli Baba—the visionary one—that he would send her someone. If this is true, it appears that the two protagonists—Joya and **Ram Dass**—were fulfilling each other's expectations. In any event, **Ram Dass** became one of Joya's pupils (along with hundreds of others) and spent 15 months in a whirlwind of intensity.

In the beginning, Joya spent much time in trance states in which she apparently functioned as a medium. Through her came many seductively-rich teachings from Biblical, Hasidic, Hindu and Buddhist wise men and women of the past, or from beings on other planes. Her voice and language often shifted from Brooklynese to exquisite poetry that poured forth for hours at a time. I was breathless with the richness of these moments. (ibid., 66)

At the same time, she continued to converse with Neem Karoli Baba—the one nobody else could see. As a result, **Ram Dass** says, he was

ready to believe the bizarre assertion that a Jewish housewife and mother of three who was married to a very fine Italian Catholic businessman in Brooklyn was in fact Ms. Big, the creative force of the whole universe. Joya represented herself as an actual form of Kali as well as a number of other cosmic identities including Athena, Sri Mata Brahma the Mother of the Universe, and Tara the Tibetan Goddess of Tantra. (ibid., 65)

And it wasn't just a matter of identity but of action. Joya suggested that the two of them practice tantric sex—for **Ram Dass**'s benefit, to rid him of his attachment. Sex with the Cosmic Mother who says she is communicating with your guru . . . a hot number, to put it mildly. And on top of everything else, Joya told **Ram Dass** that she was preparing him to become a world teacher.

In the end, though, **Ram Dass** found that none of this was what he was looking for. It was fascinating but it was not liberating. Having stated publicly that, "as Joya had professed, she was an enlightened being", it was not easy to go back on his assertion. But he did and the two parted company: two Western teachers who had come together (it is difficult to avoid these puns) for a brief period and then gone in their different directions.

This episode has been presented from **Ram Dass**'s side, of course. No doubt Joya's side is different but I do not know what it is. But the tenor of *Sharing Moments,* which covers the time when he was with her, does seem to be in accord with much of what he says. There is constant reference to the Mother, meaning Kali, "the black Mother with the heart of gold [who] has come forth to devour evil" (*Sharing Moments,* 28). This is not the gentle Kali of Ramakrishna or Sister **Nivedita**. This Mother

is a whole bowl full of warm juices. You float in it and your body disappears . . . I will not allow suffering in this teaching. If you are suffering, then you are not on the path. There is enough suffering in the world. Don't add to it. If you are suffering, then bathe in the juices of the Mother. (*Sharing Moments*, 23, 58)

And as we know from **Ram Dass**, sexuality is an aspect of spirituality:

When your lower chakras open, it is the mother's juices flowing through. Fear not that which you think is sex, for it may be passion for God . . . [But] when Joya says make love, she doesn't mean fuck. (*Sharing Moments*, 24, 43)

This is a far cry from the ideal of the spiritual life as renunciation. But whether we agree with it or not, the significant thing is that Joya Santanya/Ma is giving this teaching from herself:

Does the Mother cover the world, or the world cover the Mother? That depends totally upon the individual. If the world covers the Mother, then man would be in maya, illusion, continuously for lifetimes and lifetimes. If the Mother covers the world, then man is in God, just like I am, free . . . You are who you are, and you are God. I am who I am, and I am you. And never mistake my calmness for sadness. For I am in ecstasy all the time, even when I'm angry or appear to be sad . . . There is no difference between me and you—just that my moments are fuller. (*Sharing Moments*, 22, 72, 78)

As far as I know, these moments are still continuing.

It is a pity that the information I have given here is 20 years old. I made several attempts to contact Ma, all of them unsuccessful. Every single lead went dead. Then just days before the book went to press, I found out that she is currently working with people with AIDS and that her ashram contains, or even is, a hospice for them.

Primary sources: Joya Santanya, *Sharing Moments* (No provenance: Orphalese Foundation, 1976)

Secondary sources: None

Centre: Kashi Ashram, 8435 Roseland Road, Sebastian, FL 32958, U.S.A.

COMPARE:

Other women in Hinduism: Swami **Abhayananda**/Marie Louise, Sri **Daya Mata**, Sister **Devamata**, the **Devyashrams**, the **Mother** [something of a special case], Sister **Nivedita**, Swami **Radha**, **Sivananda-Rita**

Other teachers who say that sexuality is part of spirituality: **Chris and Emma**, Barry **Long**

Other visionaries: Samuel **Lewis**, Jiyu **Kennett**, Guru **Subramuniya**

Others who provide 'social' services: the Chithurst *sangha* (prison visiting), Issan **Dorsey** (AIDS/the dying), Daido **Loori** (a prison zendo), **Ram Dass**

Ruth Fuller SASAKI

American pioneer who favoured a thoroughly Japanese form of Zen

There seems to be a tendency, by those who knew her, to describe Ruth Fuller Sasaki as 'a grand lady'. She was born in 1883 but I have next to no information about her early life. Apparently, she spent some time at the 'ashram' of Pierre Bernard/**Oom the Omnipotent** (Watts, *In My Own Way,* 126) but we do not know what she did there. (It is not exactly clear what *anybody* did

there, come to that.) Possibly Zen was mentioned (though **Oom** was a Hindu/Tantric teacher). Alternatively, she might have studied Sanskrit, which, according to one source, led her to the Pali language and thence to Buddhism (*Spring Wind,* 231). Later in life, she married a successful and wealthy attorney, Charles Everett, and it was in 1930, while on a world cruise with her husband, that she met D.T. Suzuki in Japan. He taught her the basic principles of *zazen*. She was 47. Two years later, she returned to Japan and practised *zazen* for about three months with a Rinzai master, Nanshinken Roshi, in Kyoto.

She became a disciple of Sokei-an Sasaki in New York in 1938—her Dharma name was 'Eryu', Dragon Wisdom—and soon became the leading light in his Buddhist Society of America (later the First Zen Institute of America). She even taught other Americans *zazen* despite the fact that she had only a few months experience. Sokei-an, who had decades of experience, was quite happy to let her do it (Fields, 189). However, Sokei-an had his reasons for not teaching *zazen* himself: Americans just weren't ready for such disciplined practice. He started off trying to get them to sit for half an hour "and in three days no one came to my place. So five minutes! And that was very long and I reduced it to one minute, and one young woman fainted!" (Mary Farkas, 'Footsteps in the Invisible World', *Wind Bell,* nos. 1–2, Fall 1969, 18).

Cf. Marie Louise/Swami **Abhayananda**, *whom* Vivekananda *allowed to teach* raja yoga *after just a few months experience.*

In the same year, 1938, Ruth Fuller Everett acquired a son-in-law: Alan **Watts**. It is difficult to know (from published sources) what she thought of him—because she never refers to him. (However, see below for a possible indirect reference.) Similarly, she only gets the briefest mention in his autobiography. Although **Watts** did practice with Sokei-an (who was briefly his stepfather-in-law) after a fashion, it seems that he and his mother-in-law lived in different worlds despite their apparent ties: members of the same family and practitioners of the same path. The closest they ever got to each other appears to have been the 1958 Zen issue of *The Chicago Review,* to which they both contributed.

In 1944, four years after the death of her husband, Ruth Everett married Sokei-an. He was in an internment camp in America—along with most other Japanese Americans—at the time and it is tempting to think that the marriage was simply a way of getting him released. But Fields records that the two had been courting in a rather awkward fashion before Sokei-an's internment (Fields, 190), so it may really have been an affair of the heart. In any event, he died only a year after they were married, whereupon Ruth Fuller Sasaki (as she then was, Sokei-an's real name being Shigetsu Sasaki) became the *de facto* leader of his Zen group. Sokei-an had charged her with the task of finding a Rinzai master from Japan to take his place so in 1949 she went to Kyoto and began to practice at Daitokuji. Her teacher was Zuigan Goto Roshi, who had come to San Francisco in 1906, along with Sokei-an, as one of Sokatsu Shaku's lay disciples; he was thus in direct line from *Soyen Shaku,* the father of Rinzai Buddhism in America (see Lineage Tree 6).

Miriam **Salanave** *had practiced at Daitokuji 20 years earlier.*

Although Goto Roshi wanted her to return to the West as a Zen missionary (Fields, 216), Ruth Fuller Sasaki's intentions were the exact opposite. She stayed in Japan and when she was allowed to build and open a *zendo* in 1956 (the first Westerner ever to do such a thing), she saw it as a branch of the First Zen Institute in Kyoto, calling it the First Zen Institute of America in Japan. Two years later, this small *zendo* was recognized as a sub-temple of Daitokuji and she was ordained priest of it—at the age of 75—by Sesso Oda Roshi, one of the Dharma-heirs of Goto Zuigan Roshi (Fields, 217; *Spring Wind,* 231; Snelling, 342).

While she did return to America from time to time—for example, in 1960, in order to instal Isshu Miura as head of the Zen Institute in New York—she regarded Japan as her base. She continued her chosen path of careful and exact scholarship at a time when 'beat Zen' was all the rage in America—as good an example of swimming against the tide as one is likely to find. And I think it is fair to say that she could be a little severe in her judgements:

> There is no need to consider the misinformation being spread about the koan by those professed exponents of Zen in the West who have never studied koans themselves. (*The Zen Koan*, 4)

She mentions no names—but Alan **Watts**, her former son-in-law, would fit the bill exactly.

She did not have many visitors but someone who did seek her out was another pioneer, Samuel **Lewis** (in 1956), who described her, with his usual hyperbole, as a living Bodhisattva of the first order (*Sufi Vision and Initiation*, 114). She died in 1967, in Kyoto, aged 84.

Ruth Fuller Sasaki was exceptional in a number of ways. To begin with, she was the first Westerner to practice in Japan for years at a time (though M.T. **Kirby** might have done also—we just don't know). She began in earnest in 1949 and was made a priest nine years later.[1] Secondly, she was firmly convinced that Zen (remember that we are talking about Rinzai Zen) could only be properly practiced in Japan. This is why she re-exported her husband's Zen Institute to Japan and also why she wrote books, published in English in Japan, with titles like *Zen: A Method of Religious Awakening* and *Rinzai Zen for Foreigners in Japan* (both published by the First Zen Institute of America in Japan, in 1959 and 1960 respectively). She also produced translations—such as *The Record of Lin-Chi* (and she was the first practising Westerner to do so), as well as more technical works—for example, *The Zen Koan,* described on the back cover as "the first scholarly examination in any language of the historical and traditional method of koan study in Zen Buddhism". This claim is a publisher's puff, of course, and overlooks D.T. Suzuki's work in his *Essays in Zen Buddhism (Second Series),* published in 1933. Even so, there is an element of truth in it—and it is noteworthy that the phrase 'in any language' obviously means 'in any language (including Japanese)'. In fact, the book was a collaborative venture with Isshu Miura (himself a student of Nanshinken Roshi, as she had been over 30 years earlier): she provided the history and the translations; he provided the 'teaching'. This division of labour is instructive, I think. Ruth Fuller Sasaki presented herself as a propagator of 'traditional' Rinzai, and it was on this basis that she was accepted by the Japanese. So maybe she did turn out to be a Zen missionary, after all, as Goto Zuigan Roshi had wanted—except that her base was in Kyoto rather than New York.

On the other hand, I should mention the view of Nancy Wilson Ross: that Sasaki was quite prepared to make herself an exception to Rinzai's *institutional* conventions. She kept her hair and her rings, saying that she had seen many pictures of Bodhisattvas with flowing locks and earrings, so why shouldn't she keep hers? Although Ross refers to her as "an abbess of great

*Other Americans such as Walter **Nowick**, Robert **Aitken** and Philip **Kapleau** also began to practice in Japan a little later.*

*Cf. the translation by another Western Rinzai practitioner, Irmgard **Schloegl**, The Zen Teaching of Rinzai [Rinzai = Lin-Chi].*

[1] It is interesting to compare this with what happened in Theravada Buddhism. There also, a number of Westerners went to Eastern countries and practiced (which in their case meant becoming monks). But there are some crucial differences: the Theravadin 'transmission to the East' began 50 years earlier; all the Western pioneers were European (whereas with Zen, they were all American); and they were all men (whereas American women were important in the early days of the Western contact with Zen).

repute", she also adds, somewhat wryly, "She was helped by having a good deal of money" (Boucher, 189).

Be that as it may, the appeal to pure, traditional Zen—that one should "know the Zen of the past for the sake of the future", in Ruth Fuller Sasaki's words (Fields, 209)—is very persuasive. One person who was persuaded by it was Gary Snyder, who arrived at the First Zen Institute of America in Japan in 1956 on a grant-cum-scholarship (arranged for him by Alan **Watts**). The new generation was beginning to take wing.

As it has turned out, the careful construction of traditional Zen that Sasaki advocated has not really taken root in the West (to mix metaphors). But who is to say that her contribution did not provide some necessary fertilizer?

Primary sources: Ruth Fuller Sasaki, *The Zen Koan: Its History and Use in Rinzai Zen* [with Isshu Miura], (New York, 1965); *The Record of Lin-Chi* (Kyoto: Institute for Zen Studies, 1975); other titles are given in Fields

Secondary sources: R. Fields, *How the Swans Came to the Lake* (Boston, 1986); J. Snelling, *The Buddhist Handbook* (London, 1987); *Spring Wind* [the magazine of the Zen Lotus Society], 'Women in Buddhism', vol. 6, no. 1, 2, 3, 1986; Sandy Boucher, *Turning the Wheel: American Women Creating the New Buddhism* (San Francisco: Harper and Row, 1988)

Centre: First Zen Institute of America, 113 East 30th Street, New York, NY 10016, U.S.A.; Institute for Zen Studies, Hanazono University, 8-1 Tsubonouchicho, Nishinokyo, Nakagyo-ku, Kyoto 604, Japan

COMPARE:

Other women teachers in Zen: Joko **Beck**, Gesshin **Prabhasa Dharma**, Maurine **Stuart**, Jiyu **Kennett**

Other Westerners who have taught in the East: Jiyu **Kennett**, **Nyanatiloka** Thera, **Lokanatha** Thera; Lama Anagarika **Govinda**, Sri **Krishna Prem**, the **Mother**, Sri **Mahendranath**, Swami **Abhishiktananda**, some of the **Hare Krishna Gurus**

Father SATCHAKRANANDA Bodhisattvaguru

American who combines Hinduism and Christianity

I know very little about this man, not even his original name; he won't answer questions about his past history. In 1973, he was 'mystically' initiated as a yogi by Shivananda (who had died ten years before) through a trio of 'female Matas' (*Mata* means 'mother') at a retreat he was attending in Washington. He was also 'mystically' initiated (exactly the same phrase as for Shivananda) by "the Yogananda/Babaji lineage" (no date is given) and he teaches *kriya yoga,* which he also calls *raja yoga* and *kundalini yoga.* In 1974, Satchakrananda founded the Raj-Yoga Math and retreat in the foothills of Mt. Baker in Washington state. Originally, it was 'semi-monastic' and had six people in it. In 1977, however, he was ordained as a priest (Jacobite-Antiochian Succession) by Archbishop Herman Adrian Spruit, Patriarch-Metropolitan of the Church of Antioch in North America.[1] At some later date, St. Clare's Hermitage was set up for "Christ oriented men-women *(sic)* ready for and willing to use monas-

[1] Spruit is one of many 'wandering bishops' who derive their title and authority from one of the dozens of successions that goes back to Archbishop Vilatte at the end of the last century. It is a 'movement' characterized by diverse theologies, some of them, like Spruit's, of the esoteric variety. See P. Anson, *Bishops At Large* (New York, 1965) for futher information.

tic lifestyle principles and practices 24 hours a day". The Math/Hermitage combines Hindu and Christian practices. Mass is celebrated regularly but is combined with Japa Yoga Sadhana, which consists of the repetition of *mantras, mudras, hatha yoga* postures or *asanas,* and *pranyama* or breath control. I have also seen a list of meditations, which include "Take up the Cross and follow ME" and "Be Here Now not somewhere else".

I assume that Satchakrananda uses the title 'Father' because he is a priest, and that the name 'Satchakrananda' derives from his connection with Shivananda or *Yogananda* (or both); *sat-chakra* means 'six chakras', which fits nicely with *kundalini yoga*.[2]

I did write to Satchakrananda to ask him whether he thought that Hinduism and Christianity were both true. His reply was: "Neither one in relation to the other. Both in relation to the ONE. And it makes no difference to anyONE in Spirit. So . . . " I did not feel encouraged to pursue the matter further. But maybe others will.

Primary sources: Yogi Satchakrananda, *Coming and Going: the Mother's Drama* (1977); *To Create No Freedom* (1983); Thomas Merton's *Dharma* (1986) (all published by the Raj-Yog Math—address below)

Secondary sources: None

Centre: Raj-Yog Math, Box 547, Deming, WA 98244, U.S.A.

COMPARE:

Others associated with Sivananda: Swami **Radha**, Swami Lakshmi **Devyashram**

Others who have brought Christianity and Hinduism together: Swami **Abhishiktananda**, Abbot George **Burke**/Swami Nirmalalanda, Guru **Subramuniya**

SAT PREM

French disciple of the **Mother** who claims to be the true representative of her 'Yoga of the Cells'

Sat Prem (I don't know his original name) was born in 1923. He came across the **Mother** in the 1950s, became her confidant, and stayed with her until shortly before her death in 1973. He taped the conversations he had with her from 1951 to 1973 and published them in 13 volumes under the title of *L'Agende* or the *Agenda*. Sat Prem's own distillation of these conversations is found in his *The Mind of the Cells, or Willed Mutation of Our Species.* (This teaching of the 'Yoga of the Cells' is given in the **Mother**'s entry.) Four years before her death, the **Mother** told Sat Prem that he was the only one who understood her (*Mind of the Cells,* 197). Yet he was barred from seeing her six months before her 'death',[1] and was subsequently hounded by the police, the courts and the Indian government (ibid., 201). "They have even printed a false *Agenda* to prevent the publication of the real one" (ibid.). I'm not sure who 'they' are—presumably the leaders at Auroville. Sat Prem seems convinced

[2] But all I know about the title 'Bodhisattvaguru' is what is said in the Raj-Yoga Math's brochure: "Now [Satchakrananda] is totally devoted to a life of spiritual growth and has been consecrated a BODHISATTVAGURU in service to lost souls seeking Divine Will and Guidance".

[1] In 1967, she told him that though she might appear to die, this was part of the process of transformation and that her body should be preserved to give her time to complete her work (*Mind of the Cells,* 198); otherwise "all the work would be lost" (ibid., 200). This instruction was not carried out.

that all the **Mother**'s disciples—except himself and the few who have followed him in his interpretation of her final teachings—are misguided.

Given that he was hounded by all and sundry, it is not surprising to learn that he has not remained at Auroville. I have been told that he lives in seclusion in America, his whereabouts known only to a chosen few. He says that he has "been before the mystery for seven years now" (*Mind of the Cells,* 156). I do not want to read too much into one phrase, but he was writing the book in 1980, seven years after the Mother's death. So the implication seems to be that he too is working on the '*Yoga* of the Cells'. For their part, 'orthodox' Aurovillians regard his efforts as essentially outmoded since it is only collective *yoga* that can be effective now; that what was the **Mother**'s efforts were intended to establish. So we have a real metaphysical clash here and one that is being expressed in appropriately opposite ways: the Aurovillians with their model international community; Sat Prem, hidden away, practicing his cellular yoga (and thereby transforming the world). This the age-old struggle between the outer and the inner—and one that was being played out in a novel way in the late twentieth century.

Primary sources: Sat Prem, *The Mind of the Cells or the Willed Mutation of Our Species* (New York, 1982)

Secondary sources: None

Centre: Institute for Evolutionary Research, 200 Park Avenue, Suite 303 East, New York, NY 10166, U.S.A. [I tried to contact it several times but it was always closed and my phone messages—left on a machine—were never returned]; Sat Prem's books are available in England from Dick Batestone, 12 Gloucester Street, Malmesbury, Wiltshire SN16 0AA, England, U.K.

COMPARE:

Other 'successors' of the Mother: Patrizia **Norelli-Bachelet**

Other 'lone yogis': Swami **Ajatananda**, **Nanavira**, **Shunya**

SATSVARUPA GOSWAMI. SEE **HARE KRISHNA GURUS**

IRMGARD SCHLOEGL | VEN. MYOKO-NI

Austrian teacher in the Rinzai Zen tradition

Jiyu **Kennett** *also attended Humphreys's same class.*

Miriam **Salanave** *and Ruth Fuller* **Sasaki** *also practised at Daitokuji.*

Schloegl is interesting because she is one of only a handful of Western women who can be said to represent the Rinzai tradition. She was born in Austria but came to London in 1950 as a lecturer in Geology at the University of London. (She has a Ph.D., which is why she is Dr. Irmgard Schloegl). To all intents and purposes, she has adopted Britain as her country; she speaks English fluently and has taught there for over 20 years. When she first arrived, she joined the Buddhist Society and attended Christmas **Humphreys**'s Zen class. In 1962, she went to Japan and spent ten years at Daitokuji with Oda Sesso Roshi and Soko Morinaga Roshi, both of them senior students of Goto Zuigan Roshi. (See Lineage Tree 6 for these various interconnections in the transmission of Rinzai Zen to the West.)

One of them, The Zen Teaching of Rinzai, *was a translation and was published a year after Ruth* **Sasaki***'s version of the same text, despite the fact that both of them were studying at Daitokuji at the same time.*

When she returned in 1972, she began teaching in a quiet way—as a laywoman. She became vice-president of the Buddhist Society, founded the Zen Centre (its first meeting place was **Humphreys**'s house), and produced a number of books, all of them short and to the point. They are essentially traditional, describing the Japanese way rather in the manner of a trained mechanic explaining how a tractor works. There is no attempt to 'translate' Zen terms into modern Western parlance or to place it in a different context so that it is easier to swallow. The training is tough but it is not arbitrary; those who want to 'adapt' it are simply missing the point. Her chapter on 'Training in a Japanese Zen Monastery', although it refers to several incidents that occurred during her time at Daitokuji, does not mention a single one that involved her. It is straight clarificatory exposition—the exact opposite, one might say, of Rev. Master **Kennett**'s account, which is heavily autobiographical. (And I am not saying that one is better than the other.)

In 1984, she was ordained as a Rinzai priest (though the term is inaccurate—see the Glossary) by Soko Morinaga Roshi and took the name, 'Myokoni'. The ceremony took place at Chithurst: an Austrian taking Zen ordination from a Japanese at a Theravada monastery in England (whose senior monk is American). Surely a first. This is ecumenicism at its best and nicely reflects Dr. Schloegl's own words:

> Truly, the Zen Way is as old as [the] Heart itself, and so is always discoverable however overgrown or forgotten it may have become.
>
> This Heart is not the possession of the Zen School. And though the Zen School has kept alive one specific Way to it, to be trodden by the indomitable, a Way which is perhaps straighter than most, it is certainly not the only Way. The Zen School is well aware of this and holds that there is the Zen of the ordinary man, the 'peasant who uses it every day but does not know it'; there is the Zen of 'other ways', of other religious traditions; there is the Zen of the various Buddhist Schools, and there is the Zen of the Zen Way. It could not be said fairer. (*The Zen Way*, 116)

Primary sources: Irmgard Schloegl, *Zen Teaching of Rinzai* (Shambhala, 1976); *The Zen Way* (London, 1977); *Gentling the Bull* (London: Zen Centre, 1987)

Secondary sources: None

Centre: The Zen Centre, 58 Marlborough Place, London NW8 0PL, England, U.K.

COMPARE:

Other Westerners associated with the Rinzai tradition: Miriam **Salanave**, Ruth Fuller **Sasaki**, Walter **Nowick**, Maurine **Stuart**

Other women teachers of Zen: Jan **Bays**, Joko **Beck**, **Karuna Dharma**, Gesshin **Prabhasa Dharma**, Ruth Fuller **Sasaki**, Roshi Maurine **Stuart**, Roshi Jiyu **Kennett**, Barbara **Rhodes**, Linda **Klevnick**, and Linda **Murray**

Other Westerners who have practised extensively in Japan: Father Hugo **Enomiya-Lassalle**, Philip **Kapleau**, Walter **Nowick**, Ruth Fuller **Sasaki**, Jiyu **Kennett**

Other Westerners who have practised extensively/intensively in other Eastern countries: **Ananda Maitreya**, **Kapilavaddho**, Ayya **Khema**, **Lokanatha** Thera, **Nanavira**, **Nyanatiloka** Thera, Ajahn **Sumedho**, Sister **Uppalavanna**, some of the *vipassana sangha* (all Theravada); Freda **Bedi**, Lama Anagarika **Govinda** (Tibetan Buddhism); Ven. **Sangharakshita** (non-denominational Buddhism); Swami **Abhishiktananda**, Sri **Krishna Prem**, John **Levy**, Sri **Mahendranath**, the **Mother**, Swami **Radha**, Guru **Subramuniya** (all Hinduism), René **Guénon**, Irina **Tweedie** (Sufism), **Shunyata** (independent)

Swiss Sufi (of the Traditionalist persuasion) who has more or less started his own Sufi order—perhaps even his own tradition

Schuon was born in Basle, Switzerland, of German-speaking parents in 1907. He and Titus **Burckhardt** went to school together. In 1920, his father died and his mother moved to Alsace in France. He was interested in spiritual subjects from an early age. He read the *Upanishads* and the *Bhagavad Gita* in his early teens and also came across the writings of René **Guénon**, which he later said served to confirm his own "spontaneous understanding of metaphysical principles and their traditional applications" (*Frithjof Schuon, Metaphysician and Artist,* [Bloomington, Indiana, 1981], 2). In 1923, he went to Paris and worked as a textile designer; but more importantly, became interested in Islam and started learning Arabic.

Eight years later, in 1931, in the midst of a long-drawn out and somewhat choppy love affair, and searching for some spiritual path that would satisfy him, he found himself repeating the name 'Sheikh Nur ad-Din' while visiting an exhibition in Paris, even though "I was not a Moslem and I was not thinking of becoming one" (*Autobiography,* 52). The significance of this name, of course, is that it was the one given to him a year later by Sheikh al-Alawi in Algeria in 1932, when Schuon did become a Moslem and entered the Sufi order or *tariqa,* the Alawiyya (named after Sheikh al-Alawi, who founded it; it is a sub-branch of the Darqawi branch of the Shadhiliyya *tariqa* and is therefore sometimes referred to as the Alawiyya-Shadhili or the Alawiyya-Darqawiyya-Shadhiliyya.) Schuon's full Moslem name is Isa Nur ad-Din.

After three months in Algeria, Schuon returned to Paris (in January 1933). Eighteen months later, on 11th July 1934, Sheikh al-Alawi died. Schuon did not find this out until a few days afterwards, but on 11th July, he had a powerful experience:

> It was morning: I was reading in the *Bhagavad Gita,* when all at once I could read no more; the Supreme Name resounded within me . . . I was in a state of inner illumination which overwhelmed me like a sea, so that almost unconsciously I groaned 'Allah, Allah.' In the evening I went out into the street and along the Seine, without the holy Name ever leaving my lips. Everything was as if transparent, fluid, infinite. Everything was within me; I was in everything . . . I thought the Shaykh had bestowed on me what is called the *tasrih al-Ism*—permission for the Name . . . The thought of [invoking the Name] had never crossed my mind, for I had no permission for it. The two preceding days, as I learned much later, the Shaykh had called my name. (*Autobiography,* 96, 127)

He returned to Sheikh al-Alawi's centre in Algeria in 1935, now headed by Sheikh al-Alawi's successor, Sidi 'Addah ben Tunes, and spent a week in a dark cell, invoking the Name.

> There I had the following dream: I saw my Shaykh, at a certain distance, walking up a slope, and many disciples hastened towards him; my feet, however, became heavy as lead, I burst into tears and melted. The Shaykh stopped, turned round and looked at me. The *muqaddam* [someone who is empowered to initiate others into the *tariqa*] then related this dream to a few of the older brethren and told me afterwards that the dream meant that I would reach the goal during my life on earth. During those days in that dark cell . . . I had in dream seen all the Prophets, and their voices were sometimes like rushing water; the Buddha Amitabha also arose, golden, before my inward eye. Sidi 'Addah ben Tunes, sitting beside the tomb of Shaykh Ahmad [al-Alawi], gave me the Shaykh's instructions. I was then appointed *muqqadam* and thenceforward had the right—and the duty—to invoke the Supreme Name. (*Autobiography,* 127–28)

Then, in 1937, while he was in Alsace,

> one morning I awoke with the certainty that I had become the Shaykh; I thought I
> was floating on air as I went out into the street. This happened, moreover, at a time
> when I least expected such a thing, and even entertained the thought of giving every-
> thing up; for I doubted the spiritual possibilites of those around me, and doubted
> myself. Not that it was only from this day on that I was what I had to be, but rather
> that from this day on I knew it with certainty. When next I went to Basle, the friends
> [that is, disciples] there told me, one after the other, that they had seen in the clear-
> est of dream-visons that I had become Shaykh. (*Autobiography,* 97)

Elsewhere, Schuon records his own understanding of what he received
from whom: from **Guénon**, he received "in my youth all the essentials regard-
ing the concepts of metaphysics and orthodoxy"; from Sheikh al-Alawi, he
received initiation and "the concepts of the Supreme Name and its invocation."

> But the Name and the Invocation as living realities I received from God Himself; upon
> the death of the Shaykh, the Name fell into my heart, and I began to invoke it . . .
> And in like manner I received from God Himself, and from no man, the immediate
> knowledge of that which others could teach me in the form of concepts; and thus, in
> all that I myself write and teach, I stand on my own ground. (*Autobiography,* 144)

If we put together all of Schuon's experiences, both inner and outer, from
1932 to 1937, what we end up with is that Schuon has a triple function. First,
that he is a *muqaddem* in the Alawi *tariqa* and can therefore initiate others
into it; second, that over and above any blessing/*baraka* that he has received
through the agency of his *sheikh* and his *tariqa,* he has been blessed by God,
directly, and has received certain spiritual gifts that both enable and entitle him
to pass on this grace/*baraka* to others; third, that one of these gifts is meta-
physical insight or intellectual knowledge which allows him to discern and
present universal truths quite apart from the Sufi tradition itself.

This last is the basis of Schuon's exposition of the Primordial Tradition or
Religio Perennis. Its fundamental principles were stated in his first book, *The
Transcendent Unity of Religions* (originally published in French in 1948).
Schuon begins by defining the only true knowledge as that which proceeds
from the Intellect.

> Since purely intellectual knowledge is by definition beyond the reach of the individ-
> ual, being in its essence supra-individual, universal or divine, and since it proceeds
> from pure Intelligence, which is direct and not discursive, it follows that this knowl-
> edge not only goes infinitely farther than reasoning, but even goes farther than faith
> in the ordinary sense of this term. In other words, intellectual knowledge also tran-
> scends the specifically religious point of view, which is itself incomparably superior
> to the philosophic point of view, since, like metaphysical knowledge, it emanates
> from God and not from man; but whereas metaphysic proceeds wholly from intel-
> lectual intuition, religion proceeds from revelation. The latter is the Word of God spo-
> ken to His creatures, whereas intellectual intuition is direct and active participation in
> divine Knowledge and not an indirect and passive participation, as is faith . . . In the
> case of intellectual intuition, knowledge is not possessed by the individual in so far
> as he is an individual, but in so far as in his innermost essence he is not distinct from
> his divine Principle. Thus metaphysical certitude is absolute because of the identity
> between the knower and the known in the Intellect. (*Transcendent Unity of Religions,*
> 9–10)

All revelations/religions are true—not only because they are the Word of
God but also because they are derived from the same metaphysical principles
(and these principles are unchangeable, by definition). But every revelation/

religion is also different from every other—because the metaphysical principles are expressed through forms, and forms are, by necessity, subject to change. Now *how* forms change is itself quite lawful and not in the least arbitrary; but change they must and hence so must the Word of God (which is not to say that the Word of God is unreliable). " . . . What constitutes every Revelation . . . is the encounter of a unique Light with a limited and contingent sphere" (ibid., 126).

This encounter creates a Tradition, which is "an integral whole comparable to a living organism" (ibid., 127) and posessing an inward unity. And it is intellectual knowledge, which understands/sees metaphysical principles, that can perceive this unity. Yet just because Revelation/religion/Tradition is a form, "every Tradition is necessarily an adaptation, and adaptation implies limitation" (ibid., 124). An immediate corollary to this principle is that

> every expressed truth necessarily assumes a form, that of its expression, and it is metaphysically impossible that any form should possess a unique value to the exclusion of other forms; for a form, by definition, cannot be unique and exclusive, that is to say it cannot be the only possible expression of what it expresses. Form implies specification or distinction, and the specific is only conceivable as a modality of a 'species', that is to say of a category which includes a combination of analogous modalities . . . A form is always . . . one modality among others that are equally possible, their supra-formal cause alone being unique . . . [and] a form, by the very fact that it is limited, necessarily leaves something outside itself, namely, that which its limits exclude . . . (*Transcendent Unity of Religions,* 34–35)

In short, Traditions are forms of truth and therefore cannot express everything.

What follows from all this is that Schuon, having immediate knowledge as a gift from God, has the capacity to see the various Traditions/revelations as species of the Primordial Tradition. He uses the refraction of light as an analogy: different religions/revelations/traditions see light of a particular colour but pure Intellect knows that light is colourless and pure luminosity (ibid., 10). Hence he can present the inner meaning of all traditions, whether he is a member of them or not.

There is no doubt that Schuon's body of work is very impressive. Even disciples who have since left him (for reasons that I explain later) accept that he received inspiration from Heaven. Another disciple, who has remained in Schuon's *tariqa,* says that

> [his] works are channels of grace (or *barakah* in Arabic) which reveals *[sic]* a living spirituality behind the thoughts and words. Schuon has stated truths which were never expounded directly in writing before. (S.H. Nasr, *Preface to Schuon's Islam and the Perennial Philosophy*)

This is a very high claim indeed.

However, the real crux of Schuon's life and teaching is not his metaphysics *per se* but the relation between his metaphysical insights and the way that he has 'expressed' them—that is, the forms that he has adopted as means of bringing truth into the world. This is a complex matter and there has been a discernible change in his teaching over the past 60 years. He began as a Sufi teacher in an orthodox *tariqa,* developed his own *tariqa,* and has ended up propounding his own version of the Primordial Tradition.

I have already outlined his entry into the Alawiyya-Darqawiyya-Shadhiliyya in 1933 and his subsequent experience of the Divine Name; his visionary contact with the Prophets and the Buddha Amitabha; and his inner conviction that he was a *sheikh* (in 1937). I also mentioned that a number of his disciples had

visionary dreams which confirmed his elevation to the rank of *sheikh*. As far as I know, all of these disciples were Western (Nasr, who is Persian, is a rare exception to this rule) and many of them were sent to Schuon by **Guénon** (who had been living in Cairo since 1930). In fact, the two men worked in tandem for many years: **Guénon** was fairly well-known, while Schuon was completely unknown; but Schuon had authority to initiate, while **Guénon** did not. According to Robin (one of **Guénon**'s biographers), about 100 people had been initiated by Schuon by 1939 (four years after he began to initiate). As an extension of his function as a *muqaddem* (and perhaps as a *sheikh;* I have no firm dates), Schuon established two *zawiya/khanqas* (centres for spiritual practice): one in Lausanne, which he led himself, and one in Paris, under the guidance of one of his disciples, Michel Valsan/Sidi Mustafa.

But around 1946 or so, **Guénon** and Schuon became embroiled in a metaphysical argument concerning the efficacy of the Christian sacraments. The details of this dispute need not concern us here. What is more to the point is that two metaphysicians (both of whom were practising Moslems) managed to disagree with another (over a matter of Christian theology), despite the fact that metaphysical truths are revealed by the Divine Intellect.[1]

Guénon himself died in 1951 and so this particular metaphysical divergence came to end. But it is interesting to see what Schuon himself says about him. The two men only met twice (for a week or two in 1938[2] and in 1939, both times in Cairo, where **Guénon** was living)—but Schuon had read **Guénon**'s works in his youth, as we have seen, and their correspondence lasted for about 15 years. In fact, Schuon credits **Guénon** with very little: "the essential regarding Vedanta . . . and the concepts of metaphysics, *intellectus purus* and orthodoxy; all of this brough sharpness and order into my perspective" (*Autobiography,* 142–43). But he says that he could have received the essentials of Vedanta from other sources; and I have already quoted him to the effect that he received "from God Himself, and from no man, the immediate knowledge of that which others could teach me in the form of concepts". In other words, he is essentially independent of **Guénon** in every respect. And indeed he implies as much when he says

> . . . there is much in the world of the spirit which Guénon did not touch on, and which is particularly close to me . . . In his presence I had the feeling of spiritual greatness, but also of a disconcerting one-sidedness . . . He succeeded in much, but not in everything. (*Autobiography,* 143)

I cannot give an account of every aspect of Schuon's teaching.[3] But surely the most significant element in it is the central position of the Virgin Mary as the patronness, so to speak, of his *tariqa*. In fact, he himself refers to it as the Maryamiyya and explicitly distinguishes it from the Alawiyya. I have not been

[1] One of the consequences of it was that a number of Schuon's disciples sided with **Guénon** and left the *tariqa* (in or around 1948). They included Michel Valsan/Sidi Mustafa, the leader of the Paris *khanqa*, together with most or all of its members. (However, I have not been able to discover what happened to him or his group.)

[2] During this visit, Schuon received "the blessing of the Tariqah Qadiriyah"—which presumably means that he was initiated into this Sufi order—from Sheikh Hajjaj (which Schuon spells 'Haggag') (*Autobiography,* 142).

[3] But I should mention his connections with Amerindian spirituality. He met some members of the Amerindian Crow tribe in 1953 when they were visiting Europe. And in 1959, he and his wife were received into the Sioux tribe at reservations in South Dakota and Wyoming. Both of them were given Sioux names. Schuon also distributed his *A Message on Indian Religion* among the Indians themselves—another instance of him understanding the inner unity of a tradition by direct perception, as it were. I do not know what the Indians themselves made of it. Apparently, they were quite flattered; there wasn't much interest in Amerindian spirituality in 1959.

able to find out when this new name was first used but Schuon sees the Virgin Mary as entirely consistent with Islamic teaching:

> The Holy Virgin is an absolute in Islam inasmuch as she is in fact the only feminine Avatara in the Semitic cosmos; hers is the only feminine name in the Koran, and not only is this name mentioned more than thirty times, but it is even the title of a sura. (*Autobiography,* 276)

Moreover, he himself has a particularly intimate relationship with the Virgin which goes back many years. One particularly vivid encounter occurred in 1965 when he was on his way to Morocco.

> I was left alone for about two hours. There I . . . sat . . . thinking of Paradise. Bringing to mind the symbols of the Koran and certain ideas of Ibn 'Arabi, I sought to explain to myself certain difficulties and to imagine, with regard to Paradise, what is imaginable; it was as if I were in a waking dream, in my consciousness nothing remained save images of Paradise. Then all at once the Divine Mercy overwhelmed me in a special manner; it approached me inwardly in a feminine form which I cannot describe, and which I knew to be the Holy Virgin. (ibid., 266)

Subsequently, Schuon developed a metaphysic-cum-theology that is based on this experience. He says that he had

> the almost irresistible urge to be naked like her little child; from this event onwards I went naked as often as possible . . . I recognized in nudity the garment of inwardness and the sign of kinship with all of God's creation. (*Sacred Nudity,* an unpublished essay)

And he goes on to develop a precise sexual symbology:

> The sexual parts . . . manifest the heart outwardly, they make visible what is innermost, and that is why they reflect in principle something of the nobleness and holiness of the heart inasmuch as it is intermediary between God and the world . . . The testicles signify the abundance of the Divine possibilities of revelation contained in the Logos, while the penis represents the generous power . . . of the Logos. The vulva on the other hand is the Logos as the strait, yet liberating, gate: it is the entrance to the pure, blissful Substance.

Finally, he says that a "sanctified man" has

> a radiance that emanates from the body . . . This mystery resides in my very nature—the mystery of experiencing bodily and existentially things which one knows inwardly through God's grace.

This is a potent brew, and no mistake. And what it 'boils' down to is that Schuon, blessed by God and the Virgin Mary, radiates grace from his body—at all times but most potently when he is naked; and that this is itself a salvific act.

This makes him a very special individual indeed. He himself says that "I was from the beginning a person different from the others, I was made from different material" (*Autobiography,* 48). An unpublished paper, *The Veneration of the Shaykh,*[4] says that Schuon is "an eminent manifestation of the eternal

[4] Written by Sharlyn Romaine/Sa. Badriyah. She is in fact Schuon's fourth 'wife' and I put the word in scare quotes because of the definition he himself gives it. His only legal wife is his first (Catherine Feer/Sa. Latifah), whom he married according to Catholic rites in Switzerland in 1949. Then in 1965, shortly after his vision of the Virgin Mary, he carried out what he calls an 'intrinsic' marriage to another of his disciples, Sa. Hamidah (who was already married to another of Schuon's disciples, Whittal Perry). Nine years later, he went through another

sadguru . . . an 'avataric' phenomenon . . . a 'prophetic' figure . . . and a great bodhisattva"; that he demonstrates the qualities of Shiva and Krishna; and has affinities with Abraham, David, Christ, and Muhammad. And of course the mere fact that Schuon has allowed these statements to be made on his behalf indicates that he does not disagree with them.

The essay goes on to say:

> Heaven [has aided us] in determining the manner of this *darshan* . . . in the beautiful and manifestly inspired ceremonies which are an aid in effectively conveying the precious emanation of the *guru's barakah,* which is a marvellous gift of the Spirit to his faithful disciples, infusing them with something of his very being, transmitted to the disciple in a manner more intimate and direct than words.

In order to explain what this means, we have to leave the official publications of the *tariqa* and make use of a number of documents that have been written by disaffected disciples. This 'intimate transmission' takes the form of Primordial Gatherings (held at Bloomington, Indiana, where Schuon has been living since 1981), which consist of Schuon in a state of semi-nakedness at the centre of a circle of semi-naked female disciples. And a key figure in these gatherings is Sa. Badriyah. She is reported to be naked most of the time and performs a sort of sacred dancing in the nude before Schuon and an inner circle of disciples. But perhaps more significantly, she also had a 'vision' of sorts, in which the Sacred Name entered her body through her vagina. This, of course, was seen as an instance of Schuon's own teaching that the Name manifests itself directly via the body. Schuon is reported as saying that she is an avataric woman and that she has something of the nature of the Blessed Virgin (Koslow, 50).

But there's more. Both Sa. Badriyah and Schuon himself have produced paintings, which are called icons, which feature Schuon and a woman—both naked. The woman is the Virgin Mary; and much is made of the fact that Schuon's Moslem name, Isa, is the Islamic equivalent of 'Jesus'. Moreover, the icons are regarded as themselves sources of grace. An unpublished article by Sa. Badriyah, *The Message of the Icons,* says:

> Beginning with the adoption of our Shaykh on the voyage to Morocco in 1965, the Blessed Virgin has chosen a most intimate way of revealing herself . . . These icons are an exact replication of her message to the Shaykh on the ship, both in standing and in kneeling . . . Our participation is a powerful descent of her mercy and a glorious ascent into Paradise.

Meanwhile, some of Schuon's American disciples report visions of the Virgin which exactly accord with Schuon's own. I have seen these reports (all anonymous and undated), which include the following descriptions:

> It was altogether mysterious: the manner in which the Virgin at one point appeared veiled to me, at another, completely nude save for her blue raiments behind her; and still again . . . she appeared partially veiled revealing her slender torso and full breasts . . . I have never seen anyone love another so much and so nobly as she loves the Shaykh.

'intrinsic' marriage with another disciple (who was also already married to a disciple); this was Sa. Aminah. And finally, in about 1987, he 'intrinsically' married Sa. Badriyah. Each of these marriages succeeded the one that preceded it, and the number four has nothing to do with the Islamic custom that allows a Moslem to have up to four wives. In fact, Schuon refers to these women as his 'vertical' wives (which simply means 'spiritual' as opposed to wives who are profane or 'horizontal'—a term I will not pursue).

I need hardly say that this is a far cry from traditional Sufism; it certainly has very little in common with the life and teaching of Sheikh al-Alawi. The justification for it has already been given: that because of his immediate knowledge, Schuon "stands on [his] own ground." But a small number of disciples have left the *tariqa*, notwithstanding these metaphysical explanations. And they fall into two categories: those who have left more in sorrow than in anger; and those who are in fact blazing with anger and outrage. The denunciations of the second group are chocabloc with accusations of all kinds, none of which I can repeat here. One of them actually convinced the Indiana police that Schuon should be prosecuted for his Primordial Gatherings on the grounds that boys and girls under the age of 16 were present. And Schuon was indicted on charges of child molestation and sexual battery by a grand jury in November 1991. But the county prosecutor dismissed the indictment, saying that the only evidence against Schuon was the statement of a single ex-disciple and that this was not enough to justify a trial. (I should also say that the county prosecutor said that the proceedings had been badly handled by his deputy, who misled the jury into bringing an indictment, and that the deputy subsequently resigned.)

The first group of disaffected disiples, however, while they do not accuse Schuon of any criminal activites, do present a considerable array of reasons why they cannnot continue to accept him as their *sheikh*.

First, that these visions of the Virgin (both by Schuon himself and by his disciples) are not visions at all but hallucinations. In the words of one ex-disciple: "whoever this personage may be, she is *not* the Blessed Virgin Mary."

Secondly, that Schuon has abandoned all pretence at Islamic orthodoxy and has instead substituted his own brand of syncretism. This was in fact **Guénon**'s charge against Schuon in the 1940s (see **Guénon**'s entry). But it was made before Schuon's addition of Amerindian rites, talk of the 'Avataric body' and the teaching of sacred nudity (all of which are mentioned by the disciples who left in 1986 and 1987).

Thirdly, that the *tariqa* has developed into a cult: specifically, an exaggerated adulation of Schuon himself; an atmosphere of fear that prevents people from speaking the truth; and a lack of compassion for those who may have transgressed. One disciple who questioned Schuon's authority was branded as mad; another was called "a natural swine"; and many others (including these two) were excommunicated. Schuon himself sent a letter to Martin Lings/Sidi Abu Bakr, his *moqaddem* in Britain, saying that there were some disciples who "do not scruple to entertain opinions contrary to my own . . . are indulgent towards the most infamous of my enemies . . . [and are not] grateful for all the gifts they have received . . . Quite evidently, I cannot consider such people my disciples." This is a bit like a father saying that he can no longer consider his children as his children. And it prompted an erstwhile disciple to ask: "how is this compatible with goodness, not to mention sanctity?"

And finally, and most importantly, that the common thread that connects all of these is good old-fashioned pride. In particular, ex-disciples point out, Schuon's claim that "I was from the beginning a person different from the others, I was made from different material" (quoted above) is contrary to the teachings of all true masters: that they are nothing before God. As one of these disciples put it: "One knows from instinct, reading, common-sense and every kind of legitimate spiritual tradition that the Path and pride cannot mix." (All these quotations by ex-disciples come from unpublished sources.)

What are we to make of this extraordinary story? Either Schuon really is an Avatara, really has been blessed by the Virgin Mary, and really can transmit grace from his naked body; or he isn't, hasn't, and can't. If we accept the second of these, then we can say either that he did once have spiritual gifts but has now lost them; or that he never had them and has only ever been a brilliant and stimulating writer. It is not for me to pass judgement on anyone. But perhaps a good guiding principle is not to accept extra-ordinary claims unless there is compelling evidence to do so.

Primary sources: F. Schuon, *The Transcendent Unity of Religions* (London, 1953); full bibliography in S.H. Nasr and W. Stoddart, *Religion of the Heart: Essays Presented to Frithjof Schuon on his 80th Birthday* (Washington, D.C.: Foundation for Traditional Studies, 1991) [His *Autobiography* is unpublished; all my citations are from a xerox copy]

Secondary sources: K. Oldmeadow, *Frithjof Schuon, the Perennial Philosophy and the Meaning of Tradition* (Ph.D thesis, University of Sydney, 1982)

Centre: (possibly) P.O. Box 2682, Bloomington, IN 47402, U.S.A. (this is the address of World Wisdom Books, which published one of Schuon's works in 1985); alternatively, try the Foundation for Traditional Studies, 12210 Bennett Road, Herndon, VA 22071, U.S.A.

COMPARE:

Other Sufi teachers: Ivan **Agueli**, René **Guénon**, Vilayat **Inayat Khan**, Rabia **Martin**, Ivy **Duce**, James **Mackie**, Abdullah **Dougan**, Idries **Shah**, Irina **Tweedie**, Reshad **Feild**, Lex **Hixon**

Other visionaries: Samuel **Lewis**, Jiyu **Kennett**

Other teachers who claim to transcend traditions: Samuel **Lewis**, Master **Da**

Other Western Avataras: G.B. **Chicoine**, Master **Da**, John **Yarr**

IDRIES SHAH

Half-Scottish Sufi teacher who appears to claim, amongst other things, that **Gurdjieff**'s teachings were derived from a secret form of Sufism of which he is the leader

Shah was born in Simla, India in 1924 of an Indian father[1] and a Scottish mother.[2] He came to England as a boy (I have no exact date) and lived with his parents and brother, Omar, in Sutton, a south London suburb. Little is known about his youth. The first time he comes to public view is with the publication of his first two books, *Oriental Magic* (1956) and *Destination Mecca* (1957). In 1962,[3] he met J.G. **Bennett** (in England) and convinced him—partly by showing him a document, entitled 'Declaration of the People of the

[1] Ikbal Ali Shah, who came to Britain in his teens, shortly before World War I. He enrolled at Edinburgh Medical School (but did not complete the course); married a British subject; involved himself, at a distance, in British politics; and wrote a book in English—*Islamic Sufism* (London, 1933). (All of these are briefly touched on by Moore).

[2] Next to nothing is known about her. Moore suggests that she might possibly have been the daughter of Sir Charles Archibald Hamilton, who became a Moslem in 1924 and changed his name to Sir Abdullah Archibald Hamilton. But her maiden name is given as 'Elizabeth Louis MacKenzie' (Moore, 7, n. 11). This is all very unclear. The significant thing, though, is that Shah, who makes much of his family tree (see next note), never ever mentions her.

[3] By this time, the first 'Shah-school' work—for which, see n. 4—had appeared. This was Foster's article, which claimed that Shah is a Sayyid—a descendant of Husain, the younger son of Mohammed's daughter, Fatima, and her husband, Ali—and thus related to the Prophet Mohammed and a member of the Hashemite family. This is true; but over a million others can make the same claim (Elwell-Sutton, 14). In later years, this claim was augmented in two ways. First, that Shah is a descendant of the Sasanian kings (sometimes 'emperors'—see for

Tradition' (see table, p. 526)—that he (Shah) had been "sent to the West by an esoteric school in Afghanistan, probably the very one which Gurdjieff describes in the last chapter of *Meetings with Remarkable Men*" (*Witness*, 355).

'Declaration of the People of the Tradition' is just one example of 'Shah-school' writings[4] that have been produced over the past 35 years, amounting altogether to well over half a million words, and which have built up the Shah myth. He is still alive and the campaign shows no sign of slowing down. What are we to make of this it? According to his detractors, such as Moore and Elwell-Sutton, it is transparently self-serving—a deception from beginning to end. But there is an alternative that is altogether more sophisticated. This holds that Shah's intention has always been to undermine the very notion that truth is unalterable and therefore easy to find or obvious.[5] What better way, then, to cut at the root of this belief than by presenting a masquerade—something that by definition has to be seen through? It is obvious, when you think about it, that a critique of entrenched positions cannot itself be fixed and doctrinal. It must be quite different—hence the creation of a myth. All myths are deconstructible. But there is a world of difference between a myth that conceals, and therefore has to be punctured by force, as it were, in the manner of Elwell-Sutton and Moore, and one that is actually made to be deconstructed—that is *supposed* to dissolve when you touch it. But 'dissolving' myths have certain consequences. Obviously, the principle of undermining the established truth is a continuous process. That is, one set position may be undermined but the 'underminer' then become established in its turn so that it too needs to be undermined. Has this happened to the Shah myth? Shouldn't he expect to be undermined, when you think about it? The last thing that is required is an atmosphere of hushed awe: 'Ah! the Hidden Knowledge! The *real* Sufism!' Hence my own attitude to Shah and the Shah phenomenon: he is worth investigating but cannot be taken at face value. His own axioms preclude the very possibility.

STOP PRESS: *Shah died, aged 72, in November 1996.*

(*See* Lineage Tree 3)

Primary sources: I cannot give all of Shah's books here; instead, I simply mention two: Idries Shah, *The Sufis* (New York, 1964); *Special Problems in the Study of Sufi Ideas* (Tunbridge Wells: Society for the Understanding of the Foundation of Ideas, 1966)

instance the frontispiece of the Penguin edition of his *The Way of the Sufis*). This may be true—if Husain married the daughter of Yezdegerd III (in the seventh century). But this is not certain (Elwell-Sutton, 14). And even if it were, all million-plus Sayyids could make the same claim. Second, that Shah is the "grandson of H.H. of Sardharna" (Brooke-White [1961]). It is true that Shah's grandfather, Amjed Ali Shah, referred to himself as the Nawab of Sardhana (a region of India). Whether he really was a Nawab or just given to self-aggrandisement (as Moore suggests), I do not know. But it does seem that the transition to 'His Highness' is stretching things a bit far.

[4] The term is Moore's. It refers to all writings, ranging from short articles to full-length books and anthologies, that feed the Shah myth. (See the list given under 'primary sources'.) They include Shah's own works and those of his known followers—but a large proportion are anonymous or pseudonymous. There's an interesting study here for someone.

[5] For example (taken from his first book on Sufism, *The Sufis*, in 1964):

> Sufism, considered as a nutrient for society, is not intended to subsist within society in an unaltered form. That is to say, the Sufis do not erect systems as one builds an edifice, for succeeding generations to examine and learn from. Sufism is transmitted by means of the human exemplar, the teacher
> . . .
> We find traces of Sufism in derelict organizations from which this element of human transmission of *baraka* has ceased; where the form alone remains. Since it is this outer shell which is most easily perceptible to the ordinary man, we have to use it to point to something deeper. Unlike him, we cannot say that such and such a ritual, such and such a book, incarnates Sufism . . . (*The Sufis*, quoted in R. Ornstein, ed., *The Nature of Human Consciousness* [San Francisco, 1973], 276; I do not have the original reference).

Three elements in the Shah myth

| **claims**
(All sources are 'Shah-school' works—
see the list under 'Primary sources'.) | **comments** |
|---|---|
| **the Sufi myth** | |
| **(A)** Shah is a Naqshbandi *sheikh* (Dervish [1976], 211). He possesses the "curative power of Bahauddin" [founder of the Naqshbandiyya] and can initiate into the Suhrawadi, Chishti and Qadiri Orders (Hallaji). | **(A)** I am not aware that any acknowledged Sufi teacher of any persuasion has ever publicly recognized Shah as an authentic representative of any order. |
| **(B)** He is the Director of the Age (Dervish (1982), 12), 'The Studious King', 'The Incarnation of Ali', 'The Presence', the *Qutb* or 'Axis' (Moore 5 [quoting Davidson]), the Shah (Elwell-Sutton, 13 [quoting either Lewin or Rushbrook Williams]) | **(B)** Terms such as 'Director of the 'Age' and '*Qutb*/Axis' are part of what might be called universal or esoteric Sufism. But again, no one outside Shah's circle has ever used them of him. |
| **the ancient knowledge myth** | |
| Shah showed **Bennett** a document that stated that ". . . there is a secret . . . knowledge accessible to man after passing through circumstances of difficulty" ('Declaration of the People of the Tradition' [© Octagon Press, quoted in Bennctt, *Witness*, 356]). | The implication is that Shah has access to this ancient knowedge (which is the foundation of every tradition, including Sufism). |
| 'The People of the Inner Court' in the Hindu Kush guard "an ancient secret knowledge from which all human higher aspirations [are] ultimately drived"; they regard dervishes who teach "through the Moslem scriptures" as "degenerate"; their *zikr* is 'Idd-rees Shaah' (anonymous article, *The Times*, 9 March 1964). | |
| Shah is "one of the Masters who maintains the progress towards higher evolution" (Burke [1988], 172). | |
| **the Gurdjieff myth** | |
| Gurdjieff left "abundant clues to the Sufic origins of virtually every point of his 'system'" (Shah, *Special Problems in the Study of Sufi Ideas* [1966], 27, n. 35 [this pamphlet later became the first chapter of his book, *The Way of the Sufi*]). | The corollary of this portrayal of Gurdjieff as having stumbled upon a form of the ancient knowledge in Sufi guise without realising that it was incomplete, is that Shah is the true inheritor of this knowledge (and therefore the only one who can breathe life into the Gurdjieff Work). |
| He learned certain "secrets", including sacred dances, at the tomb of Bahauddin [founder of the Naqshbandiyya] but did not understand them properly (Burke, [1988], 113–14). | |
| He was a gifted amateur with more enthusiasm than knowledge (Lefort, *passim*); the true way is taught by someone—unnamed—in England (Lefort, 146) | |

[which is Chapter 1 in *The Way of the Sufis* (London, 1968; Penguin edition, 1974)]; a more or less full list can be found in Shah's Octagon Press catalogue (address below)

But I do give a full list of all the Shah-school writings that I am aware of—no doubt there are others. It is arranged in alphabetical order of authors; the chronology can be reconstructed from the publication dates.

Anon, 'Elusive Guardians of the Ancient Secret', *The Times,* 9th March 1964, 12

N.P. Archer, ed., *The Sufi Mystery* (Octagon, 1980)

Selim Brook-White, 'Sufism in a Changing World', *Siraat,* Delhi, vol. 1, no. 5, January 1961 [reprinted under the title 'Dervish Assembly in the West' in Davidson]

Omar Burke, *Blackwood's Magazine,* December 1961 and April 1962 [reprinted in Davidson; I have no title for this article.]

Omar Burke, *Among the Dervishes* (Octagon, 1988)

Arkon Daraul, *Secret Societies: Today and Yesterday* (London: Muller, 1961) [since reprinted by Octagon Press; a version of his chapter on Sufism is in Davidson]

R. Weaver Davidson, ed., *Documents on Contemporary Dervish Communities* (London, 1966) [reprinted by Octagon Press, 1982; contains reprints of Burke (1961/62), Brook-White and Martin plus a version of the chapter on Sufism from Daraul's book]

Bashir M. Dervish, 'Idries Shah: A Contemporary Promoter of Islamic Ideas in the West', *Islamic Culture,* vol. 50, no. 4, October 1976, 211–18

H.B.M. Dervish, *Journeys with a Sufi Master* (Octagon, 1982) [tr. A.W.T. Tiragi; ed. A.L. Griffiths]

W. Foster, 'The Family of Hashim', *Contemporary Review,* vol. 197, no. 1132, May 1960, 269–71

Ja'far Hallaji, 'Study of Specialized Techniques in Central Asia' [in Davidson]

Seyyed F. Hossain, *The Sufis of Today* (Octagon, 1981)

R. Lefort, *The Teachers of Gurdjieff* (London: Gollancz, 1966)

L. Lewin, ed., *The Diffusion of Sufi Ideas in the West* (Boulder, Colorado: Institute for Research on the Dissemination of Human Knowledge, 1972)

Desmond R. Martin, 'Account of the Sarmoun Brotherhood', *The Lady,* 9th December 1965 [reprinted in Davidson]

Louis Palmer, *Adventure in Afghanistan* (Octagon, 1990)

E. Scott, *The People of the Secret* (Octagon, 1983)

L.F. Rushbrook Williams, ed., *Sufi Studies: East and West—A Symposium in Honour of Idries Shah's Services to Sufic Studies* (New York: Dutton, 1973) [published by Octagon Press in Britain];

Secondary sources: L.P. Elwell-Sutton, 'Sufism and Pseudo-Sufism', *Encounter,* vol. XLIV, no. 5, May 1975, 9–17; J .Moore, 'Neo-Sufism: The Case of Idries Shah', *Religion Today,* vol. 3, no. 3, [no date given but it's either 1986 or 1987], 4–8; J.G .Bennett, *Witness* (London: Turnstone Press, 1975), 355–362

Centre: Institute of Cultural Research, P.O. Box 13, Tunbridge Wells, Kent TN3 0JD, England, U.K [this address is several years old and may no longer be extant]; Octagon Press, P.O. Box 227, London N6 4EW, England, U.K.

COMPARE:

Other teachers who approach Gurdjieff from a radical perspective: G.B. **Chicoine**, Jan **Cox**, E.J. **Gold**, Oscar **Ichazo**

SHANKAR DAS | STEVE SABINE

American *shaktipat* guru currently teaching in Tennessee

Sabine was born in New York in 1943 and worked in the aerospace industry before setting out on a spiritual quest. He went to India in 1970 and became a *sadhu* (no details available). He was a follower of Guru Maharaj Ji for a time, as well as of Swami Muktananda and Dhyanyogi Madhusudandas. In 1981, he had a realization which he refers to as 'God Alone Is' while he was on a pilgrimage in India. He set up his ashram in Tennessee shortly afterwards. His book, *God Alone Is,* is a series of aphorisms to the effect that God (referred to as 'she' and 'it' but not 'he') is the only reality and cannot be limited. The guru awakens knowledge of God by means of *shaktipat*—that is, the transmission of energy which awakens the *kundalini*. There are a number of testimonies from disciples to this effect.

> Today while thinking of Sri Shankar Das I looked up into the trees and became aware that he was there. He was in the stick I picked up and in the clay, and even in the sweet warm air which embraced us as we walked. He was in each person I encountered. Everything was filled with his sweet nectar. I repeatedly said, "I bow to the ground, I bow to the trees, I bow to the clay, I bow to my family walking behind . . . I bow to thee, Sri Shankar Das." Tears of joy were welling up in me and such a feeling of divine love overtook my heart that I sang, "Jai Sri Shankar Das, Jai Sri Shankar Das." (*God Alone Is,* 91–92)

They even see him turn into Lord Shiva (ibid., 90).

This is quintessential *guru bhakti* as found in traditional Hinduism—but being expressed by Americans in America towards an American.

Primary sources: Shankar Das, *God Alone Is* (Sevierville Tennessee: Sadhana Ashram, 1989)

Secondary sources: None

Centre: Sadhana Ashram, Rte.6, Box 359A, Sevierville, Tennessee 37862, U.S.A.

COMPARE:

Other shaktipat gurus: **Rudi**

Other teachers who were followers of Muktananda: **Rudi**, Master **Da**

Other teachers who were followers of Dhyanyogi Madhusudandas: **Marasha**

Other Shaivite teachers: Guru **Subramuniya**, **Mahendranath**

SRI SHELLYJI. SEE GOSWAMI **KRIYANANDA** | MELVIN HIGGINS (P. 384, N. 1)

SHUNYATA | WUJI | ALFRED SORENSEN

Danish 'natural born mystic' who lived unknown in India for 40 years before being shipped to California to replace Alan **Watts**

Shunyata (sometimes 'Sunyata' or 'Shunya') is one of the most unusual people in this book. He never advertised himself and always said that he was not a teacher. He came from no lineage and left no successor. Yet he affected many people (while making no effort to do so). One of them compared him to a Chinese landscape painting in that he implied so much more than he said.

Sorensen was born in northern Denmark in 1890, the son of a peasant farmer. He went to school but says that he escaped 'headucation'. He preferred nature, his own company and silence.

> In our experience, consciousness is there, is here, before ego-consciousness emerges and usurps. This integral consciousness is naturally not conscious of itself as such. There is no contrast to distinguish it, but it is there and here, and is later co-existing with ego-consciousness, unirked and unclashing (2/5).[1]

In so far as he had a teaching—though it would be better to call it an experience or awareness—this is it.

But how it emerged into the world is an interesting story. When he was 14, his father sold the farm. As a result, he was uprooted—his word—and left school. He trained as a horticulturist and then went abroad. He had jobs in France and Italy for a while but ended up in England where he worked as a gardener for 20 years. No record of this time exists. But in 1929 (I have also seen the date, 1931), he met Rabindranath Tagore when Tagore was visiting Dartington Hall, near Totnes in Devon (where Shunyata was working). They got on well and Tagore invited Shunyata (still known as Alfred Sorensen) to visit him at Santiniketan, his centre near Calcutta. "Come to India to teach silence" (1/1). Shunyata says that he had no problem or question but went to India to see if the consciousness he was already aware of "was a living thing still" (1/2).

He stayed in India for 18 months—travelling on his own after staying with Tagore for a while—and found that it suited him. So, having returned briefly to the West to tie up some loose ends, he went back to India—and stayed there for the next 40-odd years. To begin with, he lived up a tree on a small island in the Ganges near Hardwar. Students from the college in the town would swim out to the island and he would climb down from the tree to talk to them (2/3). But eventually he ended up near Almora, about 7,000 feet up in the mountains near the borders of Nepal and Tibet. The Nehru family had a house in the area. Shunyata was their gardener for a time and remained a friend of the family for the rest of his life. After a few years, he was given a piece of land on the estate of an Anglo-Indian family and built himself a stone hut where he lived on his own (ibid.).

He never had a job from that moment on. The Indians accepted him as a *sadhu* and he could live on what he was given to supplement what he grew in his garden. He never asked for anything; it was always given. He was once offered 20 rupees a month but would only accept five. After living in this way for 20 years, he was offered 100 rupees a month by the mega-wealthy Birla Foundation but accepted twenty. This was his only source of income until he was taken to California 25 years later (2/22). It is evident from what people say about him that he was fundamentally uninterested in money and could not understand why people wanted it. Even in California, the land of plenty, he never asked for a donation (1/17).

Shunyata put up a sign outside his hut: NO VISITORS. SILENCE. But over the years he did meet quite a few well-known teachers of various persuasions (sometimes at his place, sometimes at theirs): Mahatma Gandhi, Sri Anirvan, *Krishnamurti,* Yashoda Mai (Sri **Krishna Prem**'s guru; her ashram was also

[1] All my information about him comes from two issues of *Sri Wuji*: vol. 1, no. 1, and vol. 2, no. 1. There may be others but I have not seen them. My references are abbreviated as follows: 2/5 means p. 5 of vol. 2, no. 1; hence 1/1 means p. 1 of vol. 1, no. 1, and 2/1 means p. 1 of vol. 2, no. 1

near Almora). He knew **Krishna Prem** as well but thought him rather earnest and "too mental" (2/23)—not qualities that Shunyata rated very highly. In fact, Almora attracted a number of Western pioneers who lived, quite independently of each other, along what came to be called Crank's Ridge. W.Y. **Evans-Wentz** had a house there, which he lent to Lama Anagarika **Govinda** when he was away (which was often). Shunyata knew them both. Perhaps the best-known visitors to his tiny hut were Anandamayi Ma and Neem Karoli Baba (**Ram Dass**'s guru) (ibid.). (I have no dates for any of these meetings.)

Yet easily the most significant spiritual encounter in Shunyata's eyes was the one with *Ramana Maharshi*. Shunyata first visited him at his ashram in Arunachala in 1935 or 1936 (both dates are given) and met Paul **Brunton** there. Afterwards, *Brunton* wrote to him to say that *Ramana* had said that Shunyata was 'a rare born mystic' (1/2). Shunyata was fond of telling this story, and also the one about his silent communion with *Ramana*. This happened a year after the first visit when Shunyata was sitting, along with other visitors, in front of *Ramana*. He had not asked a question nor made his presence known in any particular way.

> [We] awared *(sic)* a special effulgence specially radiated and directed towards our form . . . 5 English words came suddenly upon us out of Silence. These were totally unsolicited but we took them as recognition, initiation, name and mantra: WE ARE ALWAYS AWARE, SUNYATA. (2/22)

This was the origin of his name.

The Chinese term for *sunyata* (which Shunyata defined as 'a full emptiness') is *Wu*. This was a word that Shunyata was particularly fond of. His favourite dog was called 'Sri Wuji' and after his visits to *Ramana Maharshi,* he began to write (diaries and letters), creating his own vocabulary which he called 'scribble', 'Viking runes' and 'Wu language'.[2]

Then, in 1973, some members of the Alan Watts Society arrived at his door, sent there by his neighbour, Lama Anagarika **Govinda**, and ended up asking him to come to California. "I have nothing to teach, nothing to sell," was his reply (1/3). When they got back to Sausalito, they found that Watts had died in their absence. So they renewed their invitation—one of them said later that they saw in him what Watts had been writing about all his life (1/18)—and in 1974 Shunyata set out on a four-month, all-expenses-paid visit to California (during which he 'gave darshan' at Esalen and Palm Springs, amongst other places). Finally, in 1978, he moved to California for good—at the age of 88 and after spending nearly half a century leading a life of the utmost simplicity in a remote corner of India.

I think it is fair to say that most Westerners who met Shunyata in California (and elsewhere in North America) found him rather odd.

> For the newcomer it could be most confusing. Here is a man who looks to me like a woman, talking in an accent I cannot place, in a voice that is sometimes too soft to

[2] For example:

> Fancy a simple, impersonal Viking-autobiography devoid of the naughty word symbols 'I', 'me', and 'mine', a matter of no-thingness, of consciousness rather than events, of innerstances rather than circumstances, of light, intuitive and ego-free play rather than of mental and pandit-faced solemnity . . . Wu!
>
> If ye can muster Himalayan patience to peruse the spontaneous twaddle, it may help (you) in comprehending our meaning of ego-freeness, mind-freeness, and body-freeness, etc. . . . Self-controlled spontaneity is not a matter of understanding or over-standing, or of knowing, achieving, conquering something or anything—but, rather of inner-standing, in empathy and integral awareness here and now, all the eternal while. A mature awakening into conscious awaring of what IS—is all. Wu ha da! (2/5).

hear, about subjects which are both subtly and grossly removed from any view of life I am comfortable with, and who seems to be compulsive about uttering certain word formulas. The urge to see him as just another spiritual fruitcake could be overwhelming. (1/18)

The simple explanation of this confusion is that Shunyata did not think, and therefore did not communicate, in a linear fashion. Witness a letter he sent to someone while he was visiting Chicago.

In Chicago we are Mr. Nobody and Sri No-thing-ness, and certainly Sri Wuji practices the Cult of Ur rather than the physical body-cult, sensuous pleasures or so-called happiness. Nor does he identify himSelf with tools and things, concepts, precepts or percepts. Yet he seems to be on good terms with all bodies and all things, body-minds, ego-souls and even with dust and death. He awares that our identifications with tools, concepts and percepts is a fatal bar—a hindrance to our freedom, enlightenment and salvation from ego-consciousness. Ego oblivion is Self awareness, Christ-consciousness, Grace in the integral Ghostly Whole. Self awareness is pure Grace. "To the pure all is pure" is gospel truth. Why harrass or kill egoji, when one can be free in its play as a needed, useful tool—free in the divine Swa Lila's graceful Self-interplay, ji ji muge. Awake maturely to aware and intuit the intuitive Light that never was on land or sea, but ever IS. (1/17)

But for all that, he did occasionaly come up with a gnomic utterance:

Sell your cleverness and buy bewilderment. (1/14)

Don't give your love: Radiate it like the sun, and egojies may vanish like shadows in the Self Sun. (1/6)

Still, it is easy to see that he was not really a teacher, as he said himself. Even so, there were people who were influenced by him and in a sense considered themselves his followers. "He settled into our house like a feather". "We never saw him become impatient." Once, Shunyata appeared on a radio programme and evidently made a considerable impression on the host, who said, "I'm experiencing something non-verbal coming from you right now." "I'm not aware of it," was Shunyata's reply. "I don't try. No trying." And when the host said that Shunyata seemed to embody the quality of *sunyata* (which Shunyata had just defined as "full solid emptiness, no-thingness"), Shunyata simply said, "I speak out of it in a way" (1/5).

In 1984, he was hit by a car and died in hospital soon afterwards. He was 93.

In Shunyata's own terminology, he entered the 'invisible Real'. It was a reality that he himself showed forth. True to the *sunyata* principle, there is no big pay-off to be had, no great consequence, no world-shaking resonance, no sagely conclusion; just a life that blossomed, captured a few people and was plucked from the bough.

Primary sources: A few extracts in *Sri Wuji,* vol. 1, no. 1 and Vol. 2, no. 1 (the only two I've seen)

Secondary sources: No studies but there are reminiscences in *Sri Wuji* (see above); and accounts of meetings with Shunyata by Miguel Serrano in two of his books: *The Visits of the Queen of Sheba* (London, 1960) (in which Shunyata is called 'Ernest') and *The Serpent of Paradise* (London, 1963)

Centre: Sunyata Society, P.O. Box 804, San Anselmo, CA 94960, U.S.A.; this society was not set up by Shunyata himself, of course, but is a contact address; it is eight years old and may be defunct

Other Westerners who teach that one's own nature is truth: Andrew **Cohen**, **Jae Jah Noh**, Jean **Klein**, John **Levy**, Barry **Long**, Bhagavan **Nome**, Toni **Packer**

Western teachers who have had some connection with Ramana Maharshi: Paul **Brunton**, Swami **Abhishiktananda**, Bhagavan **Nome**

Others who have created their own language/vocabulary: Zen Master **Tundra Wind**, Master **Da** (sort of)

Jagad Guru SIDDHASWARUPANANDA | Chris Butler

American Hare Krishna devotee who became an independent guru, unconnected with ISKCON, after Shrila *Prabhupada's* death

As far as I know, Siddhasvarupa was an orthodox devotee while *Prabhupada* was alive. Like all other members of ISKCON, he held—and still does—that there is a direct connection between Chaitanya (who is Krishna) and *Prabhupada* (via *Prabhupada's* guru, Bhaktisiddhanta). But, he says, *Prabhupada* himself was not appointed by Bhaktisiddhanta. Rather, Bhaktisiddhanta appointed twelve men as managers of the Gaudiya Math, to take care of the institution. And *Prabhupada* did exactly the same. So Siddhaswarupa does not accept that the eleven devotees whom *Prabhupada* appointed were gurus or *acharyas* (see the **Hare Krishna Gurus**). Rather, they were

> supposed to be maintaining temples and maintaining the book distribution and the other programs that were arranged by their spiritual master, that's all . . . Actually, some of these people may be gurus, but my point is this: if they are gurus, then they are gurus because they are lovers of Krishna and because they have heard purely from their spiritual master. They are not gurus because of some appointment or diploma. (*Haribol Special,* no date or provenance)

Siddhaswarupa is himself in this lineage of pure but non-appointed devotees. The *Haribol Special* has pictures/photos of six teachers in the Gaudiya Vaishnava lineage: Lord Shri Krishna Chaitanya Mahaprabhu, Srila Thakur Bhaktivinoda, Srila Gaura Kisora Dasa Babaji Maharaj,[1] Srila Bhaktisiddhanta Saraswati Goswami Maharaj, His Divine Grace A.C. Bhaktivedanta Swami Prabhupad—and Jagat Guru Siddha Swarup Ananda Goswami Prabhupad (aka Jagat Guru Chris Butler).

This is exalted company. According to Siddhasvarupa's followers,

> Jagad Guru is a spiritual teacher for the whole world. He is enlightened . . . He answers all questions, personal and social, with transcendental insight . . . The *Gita* says, 'The self-realized soul can impart knowledge unto you because he has seen the truth'. (Introduction to *How Do I Know Who Is God's Representative?,* 1983)

And he himself says,

> I am, in a bodily sense, an American, a Caucasian, a young man, and so on. But in fact these are not my real identities. I am an eternal spirit soul, a spark of God, His eternal servant. And I am teaching His message. I am teaching the Absolute Truth, which holds good for everywhere in the world and every person in the world. (*Jagad Guru Speaks,* Life Force Series, 7)[2]

[1] These last two were Bhaktisiddhanta's gurus.

[2] Siddhasvarupa is critical of a number of teachers (whom he refers to as 'impersonalities' because they teach an impersonal philosophy: that God is beyond personality) who appear in this book: *Vivekananda,* **Ram Dass,**

Bhaktipada, who shares it to a large extent, was appointed—he was one of the 'original' eleven—but has since been expelled from ISKCON.

As far as I know, Siddhaswarupa is the only disciple of *Prabhupada* who has adopted this particular theology without any specific authorization of any kind.

(*See* Lineage Tree 5)

Primary sources: a number of books, including *Reincarnation Explained* and *Who Are You?*; there are also many pamphlets

Secondary sources: None

Centre: The Science of Identity Foundation, P.O. Box 27450, Honolulu, HI 96827, U.S.A.

COMPARE:

Other teachers in Gaudiya Vaishnavism (apart from ISKCON): Shrila **Bhaktipada**, Sri **Krishna Prem**

Other Jagad Gurus (not connected with ISKCON): Master **Da**

Other teachers who have become independent representatives of their tradition: **Rudi** (Hinduism); Jiyu **Kennett**, Philip **Kapleau**, Zen Master **Tundra Wind**) (Zen); Murshid Samuel **Lewis** (Sufism)

Sri SIVANANDA-RITA. SEE **APPENDIX 1**

SOYEN SHAKU

Japanese Zen master, responsible for introducing Rinzai to the West

*Soyen Shaku was born in 1856 and was Dharma-heir to Imagita Kosen, abbot of Engakuji in Kamakura, receiving Dharma transmission at the age of 24. This was shortly after his return from Ceylon where he had studied Pali and 'Hinayana Buddhism' (his phrase) under Ceylonese monks and had lived as a monk himself—surely the first Japanese ever to do such a thing and probably the first Mahayana Buddhist to do so for a thousand years or so. In 1893, he attended the World Parliament of Religions in Chicago, where he made the acquaintance of Paul **Carus**. He made little impact at the time but in 1905 he was invited to San Francisco by Alexandra Russell as her personal teacher and stayed for about nine months. We know very little about what he taught Russell and her friends but they certainly practised meditation of some kind and Mrs. Russell, at least, was given koans to solve (Fields, 170). More significant than this, however—though first contacts of any kind are always important—was the arrival in California of two of Soyen Shaku's lay pupils from Japan, Nyogen Senzaki and Sokatsu Shaku. They arrived at different times during 1906 and Sokatsu brought with him six of his pupils, including Shigetsu Sasaki (better known as Sokei-an) and Zuigan Goto. All three—Senzaki, Sokei-an and*

and Werner **Erhard**. And he is particularly scathing about Muktananda, whom he quotes to the effect that the search for God is really just God seeking himself.

> He's saying that God forgot. Now that's just brilliant! "God forgot who He was and now He has to meditate to remember." Only a fool could make such a statement . . . There is no question of amnesia for the Supreme Lord. (*Dear Friend, You Are Not God*, p. 5)

He also has forthright views on false gurus: "Pity the pseudo-guru who is trying to convince people that he is God's representative. There's nothing that is more of a bummer". (*How Do I Know Who Is God's Representative?*, cassette)

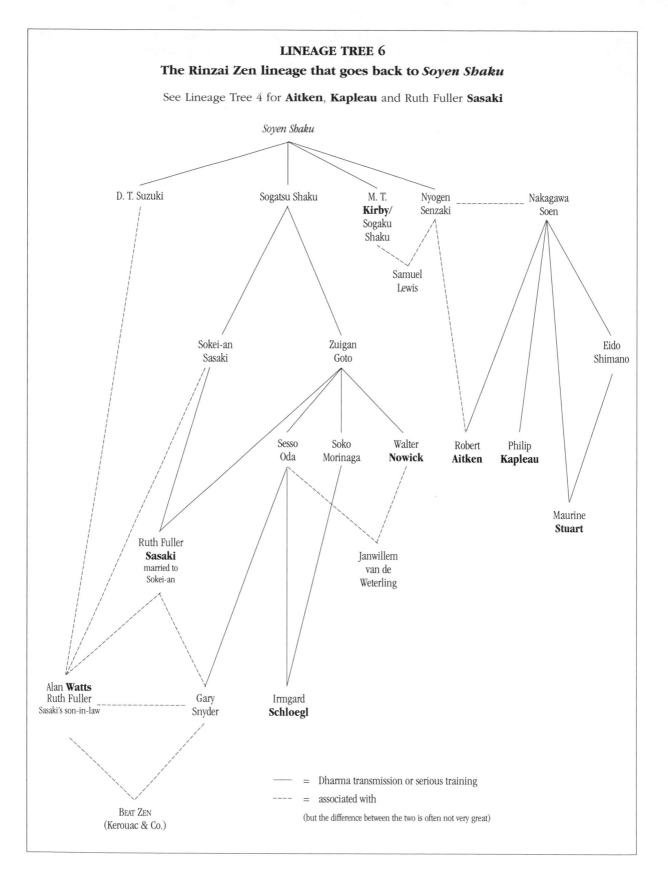

LINEAGE TREE 6

The Rinzai Zen lineage that goes back to *Soyen Shaku*

See Lineage Tree 4 for **Aitken**, **Kapleau** and Ruth Fuller **Sasaki**

Soyen Shaku

D. T. Suzuki — Sogatsu Shaku — M. T. **Kirby/** Sogaku Shaku — Nyogen Senzaki — Nakagawa Soen

Samuel Lewis

Sokei-an Sasaki — Zuigan Goto

Eido Shimano

Sesso Oda — Soko Morinaga — Walter **Nowick** — Robert **Aitken** — Philip **Kapleau**

Maurine **Stuart**

Ruth Fuller **Sasaki** married to Sokei-an

Janwillem van de Weterling

Alan **Watts** Ruth Fuller Sasaki's son-in-law — Gary Snyder

Irmgard **Schloegl**

Beat Zen (Kerouac & Co.)

——— = Dharma transmission or serious training

- - - - = associated with

(but the difference between the two is often not very great)

Goto—had considerable influence in the development of Western Rinzai. Soyen Shaku himself returned to Japan in 1906 and did not visit the West again. But the seed of Western Zen had been sown.

Primary Sources: Soyen Shaku, *Sermons of a Buddhist Abbot* [reprinted, 1974, as *Zen for Americans*] (La Salle, Illinois: Open Court Publishing Company, 1906)

Secondary Sources: Rick Fields, *How the Swans Came to the Lake* (Shambhala, 1986) [this book also has information about Senzaki and Sokei-an]; Larry A. Fader, 'Zen in the West', *Eastern Buddhist (New Series),* vol. XV, no. 1, Spring 1982, 122–145.

STEPHEN

American spiritual teacher and social idealist/reformer; founder of the Farm

In 1966, at the height of the psychedelic revolution, a young man started giving talks to a group of people in San Francisco. His name was Stephen Gaskin and his talks came to be known as the Monday Night Class.

> I had one perfect trip, where I saw how it worked . . . Now that's an outrageous thing, but I'm prepared to sit here and tell you how the universe works, and I can impart that knowledge to you: As you sow so shall you reap. It's a wiring diagram of how the universe works, and you can do anything in the universe knowing that. (Caravan, Ann Arbor, 1970; there are no page numbers in this book so I give references to the place where Stephen was talking instead.)

> I saw that Spirit was real, and I saw that karma mattered, and I saw that folks really did have communication from heart to heart and from soul to soul, and I saw that, contrary to modern psychology, you can know your brother. (. . . *This Season's People,* 48)

This 'communication from heart to heart' is what is normally called telepathy and it is the basis of the spiritual life.

> What you do is you telepathically tap in to the one great world religion, which is only one, which has no name, and all of the other religions are merely maps of that. *(Caravan,* Rhode Island, 1970)

So Stephen really was an independent teacher, quite unconnected with any particular tradition. He said on one occasion that "I teach Christianity and Zen Buddhism and Judaism, and Sufism, just for a start" *(Caravan;* reference lost). But he also said, when asked what kind of moral codes he advocated: "Pretty strong. Sometimes I get Biblical about it" *(Caravan,* Dayton, Ohio, 1970). In fact, his approach appears to have been non-sectarian Christian—but with a psychedelic tinge. One could call it hip puritanism.

In 1970, after four years of the Monday Night Class, Stephen and his followers started a trek across America in a convoy of buses, called the 'Caravan'. Eight months later, there were a hundred buses and the travelling life was becoming increasingly cumbersome. The idea grew that the community needed a permanent base. They ended up in Tennessee in 1971 and founded the Farm—1750 acres bought with money provided by a few members who had private means.

From the start, the Farm was conceived as an experiment in social spirituality—or spiritual socialism. And its philosophy came from Stephen.

> Stephen Gaskin is a spiritual teacher . . . [He] teaches the yogas of honesty, compassion, family, vegetarianism, work, and learning to trust your own God-given intelli-

gence to see what's right (entry on the Farm in *The New Spiritual Community Guide* 1975–76 edition; [San Rafael, California: Spiritual Community Publications, 1974] [that *is* the date in the book itself.])

It supported itself by growing its own food. Everything was communal: no private property and no money. All essentials were provided free.[1] But according to some ex-members at least, the community did not really work. Supplies were meagre and erratic; even fresh vegetables were not always available (on good Southern land). It came as something of a shock to learn that the Guatemalan peasants who came to learn soybean technology—in order to improve their standard of living—actually lived better than those at the Farm did ('Why We Left the Farm', 62). This was somewhat ironic, given that the Farm's Third World programme was called 'Plenty'. So the principle of 'total communalism' was dropped. It was decided that each family would take care of its own finances (*Communities,* no. 83, Summer 1994, 41)—although the land and all the buildings are still held in common. This decision was taken by general consensus and it effectively ended Stephen's role as master philosopher. But he still lives on the Farm and does not object to his reduced position. This change has been described as him 'stepping down' (ibid.). It is rare for teachers to step down; hardly any of them do it gracefully. One could say that the Farm was a misguided failure (which is a bit on the harsh side); or, more generously, an honourable attempt; or, as Stephen himself says:

> It really did happen . . . Millions of people, all over the United States and all over the world, are tuned into and communicate with this medium we are talking in now. One that assumes healing and love and truth and God and telepathy. A medium was created. (*Mind at Play,* 12)

Primary sources: I only list here the three books I have used for this entry: Stephen Gaskin, *Caravan* (New York, 1972); . . . *This Season's People* (1976); *Mind at Play* (1979) [these two published by The Book Publishing Company, Summertown, Tennessee]

Secondary sources: 'Why We Left the Farm', *Whole Earth Review,* Winter 1985, pp. 56–66; C. McLaughlin and G. Davidson, *Builders of the Dawn* (Book Publishing Company, 1985); '"I Wouldn't Trade It For Anything!"—Growing Up On The Farm', *Communities* no. 84, Fall 1994, pp. 32–34.

Centre: The Farm, 156 Drakes Lane, Summertown, TN 38483, U.S.A.

COMPARE:

Other teachers who have founded communities of some kind [not a complete list]: Shrila **Bhaktipada**, Andrew **Cohen**, Master **Da**, Jiyu **Kennett**, Sri **Krishna Prem**, Donald **Walters**/Swami **Kriyananda**/Donald Walters, Daido **Loori**, Lee **Lozowick**, the **Mother**, Elizabeth Clare **Prophet**, Ven. **Sangharakshita**, Joya **Santanya**, Father **Satchakrananda**, **Shankar Das**, Swami **Turiyasangitananda**

Other teachers whose followers were mainly hippies: Samuel **Lewis**

[1] In addition, any woman who was pregnant could have her baby delivered free of charge; and she would be taken care of before and after the birth as well. Hundreds of women came from all over America to take advantage of this free service, often as an alternative to having an abortion. The Farm was even prepared to adopt a child if the mother did not want to look after it. In fact, of the 250 women who came to the Farm for the sole purpose of having a baby, only a dozen left the child behind (McLoughlin and Davidson, 201). However, the ex-members whom I refer to later on paint a different picture: they say that a quarter of all the children "had been dumped there" ('Why We Left the Farm', 63).

Apart from this caring side of the service, many women must have found the technical side equally attractive. Caesarean births were running at a level of 10–50 percent in American hospitals—that is, in 'capitalistic medicine'; but there were only nine out of 750 births (just over one percent) at the Farm. Similarly, there was only one forceps delivery out of that 750, compared with a national average of 25 percent (McLoughlin and Davidson, 200).

ROSHI MAURINE STUART

Canadian who did much to make Zen accessible to Western women

Maurine Stuart (who was for many years known by her married name of Freedgood) was an unusual teacher in a number of ways. She was a Rinzai *roshi* who never went to Japan—appointed in a private ceremony in America by Nakagawa Soen Roshi, renowned for his eccentricity (and I use the word in the best possible sense). She was taught by two other well-known Japanese *roshis*, *Yasutani* and Eido (sometimes known as Shimano), but parted company with both of them: *Yasutani,* excellent as he was, because she found his methods too fierce; Eido, because his attitudes towards women ultimately proved unacceptable to her. Yet she was far from being an exclusively feminist Zen teacher.

She was born in Canada in 1922 but married an American and lived in the States for 40 years. She was trained as a pianist and was a good one, too. It was while she was in Paris in 1949, studying under Nadia Boulanger, that she came across Zen for the first time; but it was not until 1965, when she had three children aged nine, seven, and four, that she started practicing Zen in 1965—at the Zen Studies Society in New York, where she and her family were living. The resident priest was Tai Shimano Sensei (later Eido Roshi or Shimano Roshi). Stuart began practicing with him right away, and soon after with his two main teachers, *Yasutani* Roshi and Nakagawa Soen Roshi.

In 1970, the family moved to Massachusetts, where she met up with Elsie Mitchell.[1] She began teaching at the Chestnut Hill Zendo (actually her home in Newton, Massachusetts) in 1972 and succeeded Mitchell as president of the Cambridge Buddhist Association in 1979. Meanwhile, she had been ordained as a Rinzai priest (again, the term is inaccurate) by Eido Roshi in 1977. Yet within a few years, she had broken with him because of his poor treatment of women. The specific cause of the rift was his exclusion of women from intensive practice at Dai Bosatsu but his earlier sexual liaisons with women students, which Stuart regarded as exploitive, were a contributing factor (Tworkov, 190, 192). But she continued as a student of Soen Roshi, for whom she has nothing but praise, and he made her a *roshi* in 1982. Some of her students refer to her as 'ma *roshi*' or 'mother *roshi*' (Friedman, 77).

This transmission has a somewhat ambiguous status—and therefore so has Stuart. Soen Roshi gave Dharma transmission to five Japanese men (including Eido Roshi) but his ceremony with Stuart was informal and not recorded as the appointment of a Dharma heir in Japan (Tworkov, 155–56); consequently, Stuart did not refer to herself as a Dharma heir or lineage holder (Tworkov, 182). The use of the title 'Roshi' is largely a matter of convention and is not rigorously defined. Some elderly, respected and long-serving priests are called 'Roshi' even though they have never received Dharma transmission; but by and large, all Dharma heirs would be entitled to use the title. Clearly (if paradoxically), Stuart was in an anomalous position since, although she was of a 'respected' age, she could hardly be called a long-serving practitioner, and her appointment as Soen Roshi's Dharma heir was decidedly not in accordance with convention. Not surprisingly, therefore, there are those who do not regard her as a genuine *roshi* (Tworkov, 156).

[1] Mitchell has a minor but honourable part in the story of Western Zen. She came across Zen just after World War II, visited Japan in 1957, founded the Cambridge Buddhist Association in 1959, and became a Soto priest (though the term is not accurate—she was 'ordained' in the *tokudo* ceremony) in Japan in 1961. (More information in Boucher.) Stuart refers to her as her teacher: not in the sense of being 'officially' in the Rinzai lineage (which she is not) but as someone who helped ripen her own spirituality (Tworkov, 182).

Stuart herself, however, was happy to use the title. She makes a distinction between what she calls horizontal and vertical transmission: the first is just between teacher and student, the second is a matter of genealogies or lineages (Tworkov, 156). To put it another way, horizontal transmission is essentially personal, inner, and spiritual, while vertical transmission is social, outer and official. Stuart's own sympathies are naturally with the first:

> Zen trying to define itself is not Zen. Zen must be flexible, must respond to time, place and circumstance. In Japan, dharma transmission became too concerned with status, with real estate, and with temple properties. True transmission is about recognizing the spirit, not the totem. (Tworkov, 156–57)

In the light of these remarks, it comes as no surprise that Stuart Roshi's teaching is itself somewhat unorthodox—though in a gentle way. A good example is her use of music—classical Western music. She used it as an expression of Zen herself—"I always say to people, 'I don't do calligraphy but come up to my house, and I'll play a prelude and fugue for you'" (Boucher, 196)—and in at least one instance assigned a number of Bach pieces from *The Well-tempered Clavier* as *koans* to a pupil, a pianist who would bring them to be 'assessed' at *dokusan* (the formal interview between master and pupil).

> It was not a piano lesson; she did not critique my playing. It *was* dokusan, because I presented my koan and she directed a few words at the essence of what was coming *through* my playing. So I went back and worked on my koan some more, and she passed me and assigned me another one.
> She loves doing things that way. One reason I appreciate her so much as a teacher is the creativity and flexibility she brings to her vision of Zen practice. (Boucher, 204)

In addition to being president of the Cambridge Buddhist Association (which is non-sectarian, though actually strongly orientated towards Zen), she was on the board of Ahimsa, an organization that funds animal protection. Yet she has little regard for institutions. She has no particular interest in monastic practice despite the fact that the Rinzai tradition rests foursquare on it: all Rinzai priests and *roshis* are celibate. She even has strong reservations about residential courses—because they tend to foster an exclusive attitude to society at large, which is essentially immature (Tworkov, 165). On the other hand, she has full confidence in what might be called the spiritual devices of Rinzai: *dokusan* and *sesshin* (a period of intense practice under the guidance of a teacher). Yet even here, she is gently unorthodox: she would sometimes massage meditators' shoulders during *zazen* rather than using the *keikasu* (the stick that is traditionally used to strike people's shoulders in order to focus their attention) (Tworkov, 196).

Is this Zen? Is it Japanese? These are the age-old questions that are always asked when a tradition crosses cultural boundaries. (For 'Zen' read 'Theravada', 'Vedanta', 'Sufism'; for 'Japanese' read 'Indian', 'Tibetan', 'Persian'.) Stuart Roshi's answer is that these *questions*—not the answers, the questions—cannot be properly understood without inner knowledge: that is, a touchstone within oneself that enables such questions to be asked from the heart and not out of neurosis. As a woman *roshi,* she led *sesshins* for women only. But this was purely a matter of pragmatics and not of principle. Zen is not concerned with gender—just as it is nor concerned with titles or lineages—and she did not consider that being a woman *roshi* was particularly significant (Friedman, 66, 83); and this, despite the fact that they are very rare and that she was the only one in the Western Rinzai tradition. She had little time for what might be called

chauvinistic Zen feminism, which bewails the restrictions of patriarchy; rather, she emphasized what women *can* do in Zen (Tworkov, 157).

So the essential questions are not 'Why is Zen patriarchal? Can women be taught by men?' but 'Who teaches you? How am I taught?'—and by extension, 'What does it mean to be a teacher? What does "transmission" mean?' (Tworkov, 192). And the answer to these questions is to be found in what Nakagawa Soen Roshi called "this open-hearted, not-knowing, giving-up-your-self practice" (Sidor, 16) which has come to be called Zen. "No matter how lofty the teacher," Stuart says (following Soen), "in so far as that presence is outside of us, it's not real. It's not our own treasure" (Sidor, 15).

This is a deep teaching and until recently was being offered by an Canadian woman in her sixties (she died in 1990), who had been recognized by Japanese teachers but had never been to Japan. But then Zen isn't really Japanese at all but "the essential matter of every human being wherever you live " (Friedman, 72).

*Two years after her death, she was formally recognized as a teacher in the Rinzai branch of Robert **Aitken**'s California Diamond Sangha.*

(*See* Lineage Tree 6)

Primary sources: 'Compassion and Wisdom: Gentle and Strong', a talk (given under the name 'Maurine Myo-on Freedgood, Roshi') *in* Ellen Sidor ed., *A Gathering of Spirit: Women Teaching in American Buddhism* (Cumberland, Rhode Island: Primary Point Press, 1987)

Secondary sources: Helen Tworkov, *Zen in America* (San Francisco: North Point Press, 1989); Leonore Friedman, *Meetings with Remarkable Women: Buddhist Teachers in America* (Shambhala, 1987); Sandy Boucher, *Turning the Wheel: American Women Creating the New Buddhism* (San Francisco: Harper and Row, 1988)

Centre: Cambridge Buddhist Association, 75 Sparks Street, Cambridge, MA 02138, U.S.A.

COMPARE:

Other women teachers in Rinzai: Gesshin **Prabhasa Dharma**, Irmgard **Schloegl**, Ruth Fuller **Sasaki**

Women teachers in other forms of Zen: Jan **Bays**, Joko **Beck**, **Karuna Dharma**, Jiyu **Kennett**, Dharma Teacher Linda **Klevnick**, Dharma Teacher Linda **Murray**, Master Dharma Teacher Bobby **Rhodes**, Miriam **Salanave**

Women teachers in other forms of Buddhism: Tulku **Ahkon Norbu Lhamo**, Freda **Bedi**, Ruth **Denison**, Rev. **Dharmapali**, Ayya **Khema**, Joanna **Macy**, **Miao Kwang Sudharma**, Pema **Chodron**, Sharon **Salzberg**, Dhyani **Ywahoo**

Men teachers in Rinzai: Walter **Nowick**

Men teachers in other forms of Zen: Robert **Aitken**, Reb **Anderson**, Richard **Baker**, Don **Gilbert**, Father Hugo **Enomiya-Lassalle**, Bernard **Glassman**, Philip **Kapleau**, Jakusho **Kwong**, John **Loori**, Dennis **Merzel**, Zen Master **Tundra Wind**

Satguru SUBRAMUNIYASWAMI

American founder of the Saiva Siddhanta Church who has taught orthodox Hinduism for the past 40 years

There are various definitions of orthodoxy but perhaps the most fully-fledged is to identify it with all the dimensions of a tradition; not just the doctrines or teachings but the whole way of life down to the smallest detail: social, religious, ritualistic. This is how Satguru Subramuniyaswami[1] sees it—not that he

[1] This is his proper name and title. But it's a bit of a mouthful so I refer to him as 'Gurudeva' from now on (though this is a bit familiar). In the rest of the book, however, he is referred to as 'Guru Subramuniya'. I only

uses the term 'orthodoxy' very often—and how he presents it to his disciples. That a Westerner should adopt an Eastern tradition lock, stock and barrel is perhaps not so unusual. But what is striking is that 90 percent of his disciples are Indians.[2] This *is* unusual (though not unique).

I do not know his original name but he was born in Oakland, California, in 1927. According to a short biography, he received, "while a youth, . . . a thoroughgoing and rigorous training in meditation and the disciplines of classical yoga" under "various masters and teachers". No details are given and I do not know who these teachers could have been in California during the war years. He went on to become a dancer in the San Francisco Ballet Company.

But at the age of 20 he went to India and from there to Sri Lanka, looking for a guru. He meditated in the caves of Jalani, where, after about two years, he attained Self-Realization: awareness of *parasivam*, Siva's Absolute reality, "that which transcends time, form and space . . . the Self-God" (*Hindu Catechism*, xcvi). It is obviously important that Gurudeva should have accomplished Self-Realization on his own, so to speak—before he met his guru. But it is equally important that he should have a guru. This was Jnanaguru Yoganathan, aka Siva Yogaswami (1872–1964), a Tamil living in Sri Lanka. It was Siva Yogaswami who gave Gurudeva his name and "initiated him into the siddhar line with a tremendous slap on the back, saying, 'This will be heard in America'".

A *siddhar* (usually spelt *siddha*) is an accomplished adept in the Saiva (pronounced 'Shy-va') tradition. But in this instance, it means more than that, I think: first, that Gurudeva is Siva Yogaswami's successor and heir; second, that he is a *satguru*, "one who has attained God-realization and assumes responsibility for the spiritual life of his disciples" (*Hindu Catechism*, cvii). In saying this, I do not mean that this initiation *made* Gurudeva a *satguru* on the spot, so to speak; he went on to do several years of *sadhana* or spiritual practice. But he is referred to as "the present Sat Guru of the Siva Yogaswami Guru Paramparai",[3] and thus, by implication, in direct descent from the original gurus in this particular Saivite lineage

This notion of lineage or authorized succession is critical and needs to be explained. It is a distinguishing characteristic of orthodoxies that they derive themselves from an impeccable source. This can be done in different ways but the most palpable is via an external or historical lineage. In this case, "Gurudeva Sivaya Subramuniyaswami and his devotees are of the Nandinatha lineage of the Natha Sampradaya,[4] the Siva Yogaswami Paramparai being one stream of this ancient lineage" (*Hindu Catechism*, xciv). Siva Yogaswami was the successor of Chellapaswami (1844–1915), himself a disciple of Kadaitswami (ca.1810–1875), who was initiated by an unnamed 'Rishi of the Himalayas' (ibid., xxvii). This *rishi* "entered a teashop in a village near Bangalore in the late 1700s, sat down and entered into deep samadhi. He did not move for seven years, nor did he speak. Streams of devotees came for his darshana. Their unspoken prayers and questions were mysteriously answered in dreams or in written, paper messages that manifested in the air and floated down" (*Dancing with Siva, bhashya* to *shloka* 153).

Another branch of the Natha Sampradaya is the Adinatha, founded by Gorakhnath in the eleventh century; the Englishman, **Mahendranath,** *was an Adinatha guru.*

found out that the longer version of his name was the preferred one after the book was finished; and changing every reference, even on a computer . . . sorry, can't face it.

[2] It has been pointed out to me by the Saiva Siddhanta Church that many of them, though born of Indian parents, do not consider themselves Indian but rather citizens of the country in which they have been raised.

[3] 'Paramparai' means 'a succession [of teachers]'.

[4] 'Sampradaya' is the Hindu term for 'lineage'.

This historical lineage[5] has an obvious mythic element (in the sense that it participates in a higher reality). But there is another, which is even more 'mythic'—one that goes back to Siva himself, the founder of all *sampradayas*.

> Saivism is . . . truly ageless for it has no beginning. It is the oldest religion in the world, the Eternal Faith or Sanatana Dharma . . . [It was not] created at any point in history, but endures as the innate spirituality within every man and woman. There never was a time when people on the planet did not practice Saivism and worship Siva . . . Knowledge of Truth and the path to it are ever-existent, true for all time, past and future . . . All religions on the earth are the offspring of the Sanatana Dharma and contain elements of its teachings. (*Hindu Catechism*, 36)

It is this 'mythic' tradition—pure, complete, eternal, yet available in the twentieth century (via the initiation of a 22-year-old American *yogi* by a guru in the traditional Indian mould)—that underlies everything that Gurudeva has done since.

He returned to America in 1950, very soon after his initiation.[6] Over the next seven years he developed various *siddhis* or 'psychic powers' such as clairvoyance and clairaudience—the sign of a true Natha *siddhar*. Then, in 1957, he began his public ministry (not a misleading term in the light of his own use of Christian terminology—see below), creating a multi-faceted organization which has had many names and locations[7] but is now called the Saiva Siddhanta Church and has its headquarters in Hawaii. A temple has been built there (the first Siva temple to be actually *constructed* in America, according to the Church), where *puja* is offered to Siva daily. Members of the Church also have their own home shrines. There is a "priesthood of swamis", who are all *sannyasins*. There is also a theological seminary, and a correspondence course, the San Marga Master Course, which is distributed by the Church's Himalayan Academy in Hawaii.

It is striking that Gurudeva's organization, while undoubtedly Saivite in inspiration, is an amalgam of East and West in what might be called its institutional vocabulary. This is clearly a deliberate decision on his part. The Saiva Siddhanta Church "is the first Hindu church, organized according to the American church system" (*Hindu Catechism*, cii). It is a critical element in Gurudeva's endeavour to "preserve the ageless truths for the technological age" (ibid., iv).

Gurudeva's place in all this is absolutely central, of course. He is a Natha *siddhar*, the upholder of Dharma, the Sat Guru. The Saiva Siddhanta Church has developed under his guidance; in fact, more than that, according to his vision. In 1957, the year he began teaching, "he inwardly saw Lord Siva Nataraja dancing on the crown of his head" (Himalayan Academy Booklist, 1990). In 1975, he had a triple vision of Siva: "once from the back showing His

[5] Gurudeva traces it back to Rishi Tirumular (fl. ca. 200 B.C.), who "achieved perfect enlightenment." But the names of the gurus between him and Kadaitswami have been lost.

[6] But he had time to establish an ashram, the Sri Subramuniyam Ashram, in Sri Lanka, before he did so; it is still going.

[7] It started off in San Francisco, in 1957, with both a Hindu and Christian wing: the Subramuniya Yoga Order and the Christian Yoga Church respectively. An ashram was opened in Virginia City, Nevada—surely the first in that state. But during the 1960s the Christian yoga was dropped and in 1970 the Subramuniya Yoga Order moved to Hawaii, where it was renamed the Wailua University of the Contemplative Arts. In 1973, the Wailua University became the Saiva Siddhanta Yoga Order, and some years later the name was changed again, this time to its present form, the Saiva Siddhanta Church. Saiva Siddhanta is one of the six "main sub-sects" of Saivism. The others are Pasupata Saivism, Virasaivism, Kashmir Saivism, Goraknath Saivism, and Siva Advaita. (*Hindu Catechism*, xix)

ruddy, plaited hair, once walking among devotees in the river meadow in robes of light, and once revealing His all-loving, all-knowing face" (ibid.). Both these occasions have been commemorated in pictorial form and can be purchased as postcards (called 'Gurudeva' and 'Darshan' respectively; "great for mailing to friends or for keeping in one's personal shrine room").

The Church has grown from small beginnings to a considerable size. There are now 31 missions and branches (again, their terminology), most of them overseas.

> In 1983 alone Gurudeva was away from America for five months, speaking to over 400,000 devotees in Sri Lanka, Malaysia, Mauritius, and South India about the glories of Saivism, the need for brotherhood and solidarity among all Hindus and seekers who have embraced the Hindu path, and the urgency of living a dynamic, fearless spiritual life right here, right now. (*Hindu Catechism,* ix)

The essence of the spiritual life is restraint and purity. One of the 'Saivite Series' booklets is entitled *Saivite Virtue: A Seven-week Course on the Power of Celibacy for Hindu Youth.* And the ideal practitioner is the celibate monk. In the Saiva Siddhanta Church, it takes at least twelve years for a man to become a *sannyasin.* As for women,

> [they] may follow the age-old Saiva tradition and live the celibate life of the brahmacharini, keeping simple vows and wearing white vestments. Strictly speaking, they are not monastics. In the modern age certain swamis have initiated women into Sannyas, but this is most unorthodox. (*Hindu Catechism,* 33)

*Several of these women are in this book: Swami **Abhayananda**/Marie Louise, Sri **Daya Mata**, the **Devyashrams.***

The Saiva Siddhanta Church rests firmly on its principal congregation: Tamil Hindus. (Though the Church's headquarters is in America, its adherents are spread across the globe: Europe, Malaysia, Mauritius, Singapore—even Sri Lanka and India itself.) I have stressed its orthodoxy but I do not want to equate this term with fundamentalism. The Church is not hostile to any group, even those it disagrees with theologically. So it lives up to its own standards of charity—a quality that is never in very generous supply. Although it embraces modern technology—Gurudeva provides "telephone sermonettes" for those who need some inspiration and the Church has its own Web site on Internet—it is essentially conservative, especially in its social relations.[8] This is a direct result of its 'mythic' dimension: the whole tradition is divinely ordained from the very moment of creation right down to its present manifestation in twentieth century Hawaii.

Gurudeva, as a *satguru,* embodies this living stream of tradition. In fact, he is a 'mythic' character himself—meaning that he participates in a higher reality. There are quite a few other Western teachers about whom one could say much the same; but perhaps of all of them, he is the most deeply rooted, both historically and cosmologically.[9]

Primary sources: Master Subramuniya, *Raja Yoga* (San Francisco, 1973); Satguru Subramuniyaswami, *Hindu Catechism* (San Francisco: Himalayan Academy, 1987;

[8] This union of the technological and traditional imbues the Church at every level. An account of the development of the Church's magazine, *Hinduism Today,* refers to the acquisition of "blazing fast 9500 Mackintoshes. Every monk has robes, *japa mala,* and Power Mac." But the text is accompanied by a painting, executed in the style of traditional miniatures, of Gurudeva teaching his disciples: a rural, medieval—even timeless—setting for the propagation of Sanatana Dharma.

[9] In 1995, he named three of his *acharyas* as his successors, each to follow one another, and the third to nominate his successor before his death. This procedure is unique, as far as I know.

(9th ed.; 1st ed., 1958); biographical notes in *Hindu Catechism,* vii–ix, plus a few remarks in the glossary; *Dancing with Siva,* 4th ed., 1995

Secondary sources: None

Centre: Saiva Siddhanta Church, 107 Kahalalele Road, Kapaa, HI 96746, U.S.A.; on Internet: http://www.HinduismToday.kauai.hi.us

COMPARE:

Other Western Saivite gurus: Sri **Mahendranath, Shankar Das, Yogeshwar Muni**

Other Western gurus—a somewhat elastic term—with Indian disciples: Sri **Daya Mata**, the **Devyashrams**, Sri **Krishna Prem**, some **Hare Krishna Gurus**, Sri **Mahendranath**

Others who have brought Hinduism and Christianity together: Swami **Abhishiktananda**, Father Satchakrananda **Bodhisattvaguru**

Other teachers who have espoused 'traditional' orthodoxy: the **Devyashrams**, Sri **Krishna Prem**, the **Hare Krishna Gurus, Jampa Thaye, Ajahn Sumedho**

The SUFI MOVEMENT and the SUFI ORDER

A dual organization that crosses the border between East and West

This entry presupposes the information given in the one for Hazrat Inayat Khan *but also completes it.*

There are presently two separate organizations led by two brothers, Vilayat Inayat **Khan**, head of the Sufi Order, and Hidayat Inayat Khan, head of the Sufi Movement. Their father was Hazrat Inayat *Khan*, founder of both the Order and the Movement. And over the past 70 years, five other members of the Khan family have been teachers of various branches of these organizations. (See Lineage Trees 7 and 8.) This is a somewhat complex story and I can only give the barest outlines. But it involves interesting questions of principle that are relevant to the whole question of the function of teachers in the West.

One of the few things that all groups claiming transmission of some kind from Hazrat Inayat *Khan* agree on is his original vision: an overall organization called the Sufi Movement, which was made up of five branches or activities:

> religious activity (later known under the name of 'Universal Worship');
>
> brother/sisterhood activity (the community of all those associated with the Movement);
>
> healing activity (self-explanatory, I think);
>
> symbology activity (known as 'Ziraat');
>
> esoteric activity (the Sufi Order).

The last of these, the Sufi Order, was certainly the most important. It was intended as an adaptation of Hazrat Inayat *Khan*'s own Chishti Order.[1] But there is an immediate complication here that we need to be aware of. Although the

[1] It could therefore have been called the 'Chishti Order in the West' rather than the 'Sufi Order in the West'. But Hazrat Inayat *Khan* did not choose this option; and for two reasons, I think: first, because there was no other Sufi order in the West at that time, so there was nothing it could be confused with; second, because his universal approach, which included all religions let alone all aspects of Sufism, balked at any title that could suggest sectarianism.

LINEAGE TREE 7

Family Lineage of Hazrat Inayat Khan

Those who have been head of one of the branches of the Sufi Order in some form in **bold type** (birth and death dates in ordinary type; leadership dates in **bold**); they also figure in Lineage Tree 8: Sufi lineages derived from or connected with Hazrat Inayat Khan. More detail is given in the text.

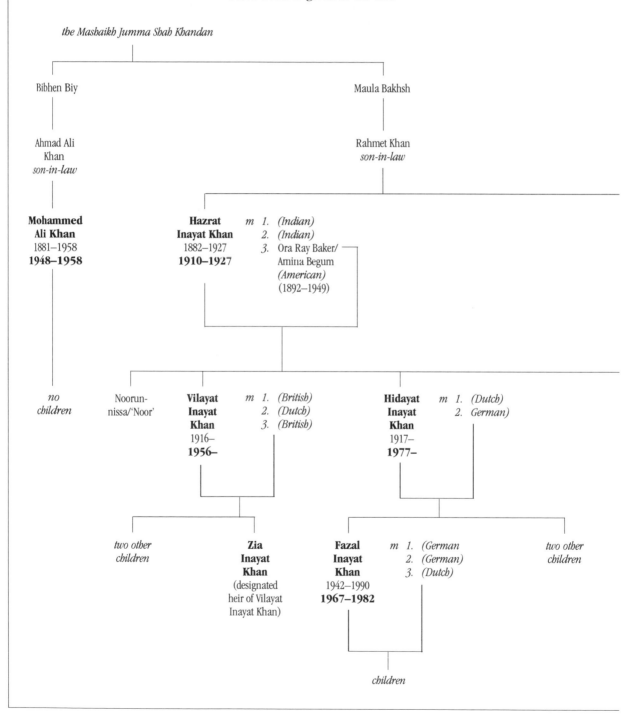

the Mashaikh Jumma Shah Khandan

Bibhen Biy

Maula Bakhsh

Ahmad Ali
Khan
son-in-law

Rahmet Khan
son-in-law

**Mohammed
Ali Khan**
1881–1958
1948–1958

**Hazrat
Inayat Khan**
1882–1927
1910–1927

m 1. *(Indian)*
2. *(Indian)*
3. Ora Ray Baker/
Amina Begum
(American)
(1892–1949)

*no
children*

Noorun-
nissa/'Noor'

**Vilayat
Inayat
Khan**
1916–
1956–

m 1. *(British)*
2. *(Dutch)*
3. *(British)*

**Hidayat
Inayat
Khan**
1917–
1977–

m 1. *(Dutch)*
2. *German)*

*two other
children*

**Zia
Inayat
Khan**
(designated
heir of Vilayat
Inayat Khan)

**Fazal
Inayat
Khan**
1942–1990
1967–1982

m 1. *(German*
2. *(German)*
3. *(Dutch)*

*two other
children*

children

In addition to clarifying the complex relationships in the family, this chart is designed to show how, through marriage, it has become thoroughly Western. The information is by no means complete. I have not, for example, indicated which wife is the mother of which child—except in the case of Ora Ray Baker. Those who are absent or not named are not less important than those who are. They just do not figure so prominently in the story of the Sufi Order and Movement.

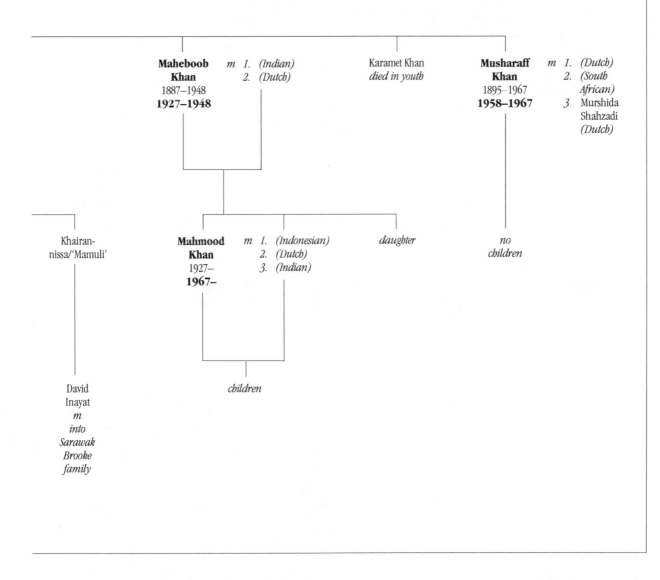

Maheboob Khan
1887–1948
1927–1948

m 1. (Indian)
 2. (Dutch)

Karamet Khan
died in youth

Musharaff Khan
1895–1967
1958–1967

m 1. (Dutch)
 2. (South African)
 3. Murshida Shahzadi (Dutch)

Khairan-nissa/'Mamuli'

Mahmood Khan
1927–
1967–

m 1. (Indonesian)
 2. (Dutch)
 3. (Indian)

daughter

no children

David
Inayat
*m
into
Sarawak
Brooke
family*

children

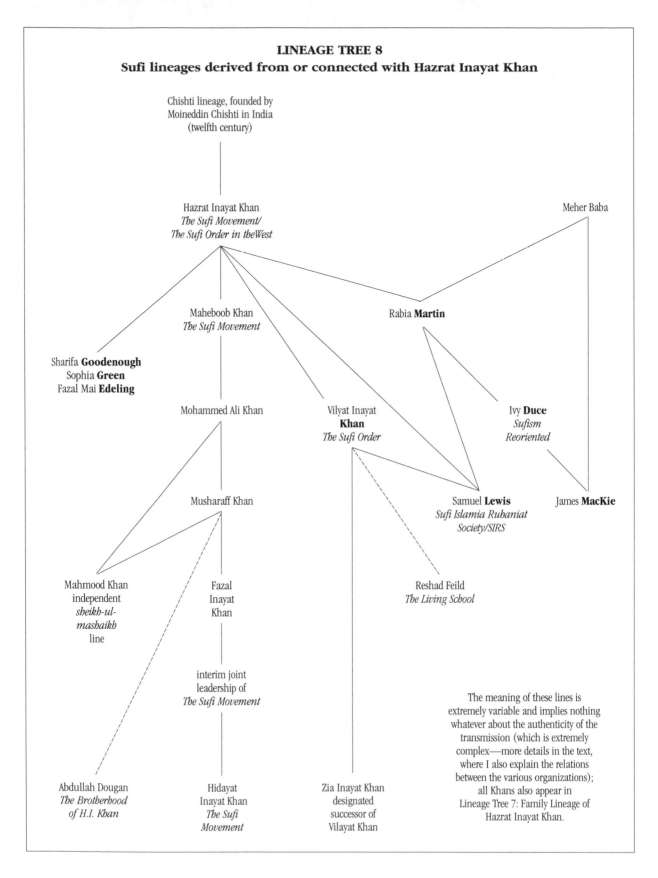

LINEAGE TREE 8
Sufi lineages derived from or connected with Hazrat Inayat Khan

Chishti lineage, founded by
Moineddin Chishti in India
(twelfth century)

Hazrat Inayat Khan
The Sufi Movement/
The Sufi Order in theWest

Meher Baba

Maheboob Khan
The Sufi Movement

Rabia **Martin**

Sharifa **Goodenough**
Sophia **Green**
Fazal Mai **Edeling**

Mohammed Ali Khan

Vilyat Inayat
Khan
The Sufi Order

Ivy **Duce**
Sufism
Reoriented

Musharaff Khan

Samuel **Lewis**
Sufi Islamia Ruhaniat
Society/SIRS

James **MacKie**

Mahmood Khan
independent
sheikh-ul-
mashaikh
line

Fazal
Inayat
Khan

Reshad Feild
The Living School

interim joint
leadership of
The Sufi Movement

The meaning of these lines is
extremely variable and implies nothing
whatever about the authenticity of the
transmission (which is extremely
complex—more details in the text,
where I also explain the relations
between the various organizations);
all Khans also appear in
Lineage Tree 7: Family Lineage of
Hazrat Inayat Khan.

Abdullah Dougan
The Brotherhood
of H.I. Khan

Hidayat
Inayat Khan
The Sufi
Movement

Zia Inayat Khan
designated
successor of
Vilayat Khan

overall organization was known as the Sufi Movement, the constitution that Hazrat Inayat *Khan* drew up in London in 1917 was for the Sufi Order.[2] Yet in 1923, having moved to Europe, he made another constitution in Geneva, this time for Le Mouvement Soufi/Sufi Movement (with L'Ordre Soufi/Sufi Order as one of its branches). At the time, this was nothing more than a terminological ambiguity, I think, and no one considered it important. But it came to have significance later, as we shall see.

Hazrat Inayat *Khan* was unusual in that his commitment to the West was so full-blooded. He married an American, Ora Ray Baker[3] in London in 1912.[4] Hence their four children, including their two sons, Vilayat Inayat **Khan** and Hidayat Inayat Khan, who figure in this story, are half-American (but were born in England and are British citizens). Of course, they are all fully conscious of their Indian heritage. So they straddle the border between East and West in a way that few others do: all their lives have been spent in the West and they know its culture intimately; but their roots are Eastern.

But Hazrat Inayat *Khan* did not just have a Western wife and family. All his disciples were Western, too; the only Indians who had any connection with the Movement/Order were his brothers, Maheboob Khan and Musharaff Khan, and his 'cousin-brother', Mohammed Ali Khan. No other Eastern teacher of this time immersed himself in Western life so completely. (In fact, very few have ever done so—they usually retain some link with their country of origin.)

My interest, as always, is in the Westerners who have played a prominent part in the Sufi Order/Movement. In fact, the most important of these have been the 'Western' members of his own family (as given in n. 4). But—and again he was unusual for his time—Inayat *Khan* initiated *mureeds*/disciples across the international spectrum: in America (see the entries for Rabia **Martin** and Samuel **Lewis**) and in a number of European countries: Britain, France, Holland, Spain, Italy,[5] and Russia,[6] and Norway.[7] All told, there were perhaps two or three hundred. Of these, four—Rabia **Martin**, Sharifa **Goodenough**, Sofia **Green** and Fazal **Egeling**—stand out because they were given the

[2] This, of course, is simply the date of the Order's formal existence. Most people consider that it was created in everything but name from the moment in 1911 when Hazrat Inayat *Khan* initiated his first disciple, Rabia **Martin,** in San Francisco.

[3] He had been married twice before in India but both his wives had died. Baker was a half-sister of Pierre Bernard/**Oom the Omnipotent** and a somewhat distant cousin of Mary Baker Eddy, the founder of Christian Science.

[4] In fact, all the Inayat Khan family have followed Hazrat Inayat *Khan*'s example and married Westerners. (See Lineage Tree 7: the Family Lineage of Hazrat Inayat Khan.) So Fazal Inayat Khan, for example, was born in France but is half-Dutch, one-quarter-American and one-quarter-Indian (and his father, Hidayat Inayat Khan, is a British citizen). Such internationalism is rare enough even today; seventy years ago it was practically unheard of.

It is perhaps invidious to classify individuals in this way. Zia Inayat Khan, when I spoke to him, said that he was an American citizen but considered himself a citizen of the world. But I think it can be fairly argued that the second and third generations of the Khan family are for all practical purposes Westerners. This is significant given that five of them—Vilayat Inayat **Khan**, Hidayat Inayat Khan, Mahmood Khan, Fazal Inayat Khan, and Zia Inayat Khan—have been teachers in various branches of the Sufi Order/Sufi Movement. I am not, of course, trying to assess people's worth by reference to their nationality. But there are various ways in which an Eastern tradition can become Western. One of them is by intermarriage. It is different from purely cultural Western-ization. And it is rare.

[5] Roberto Assagioli, the founder of Psychosynthesis, met Inayat *Khan* in Italy in 1923 and was strongly influenced by his ideas (van Beek, 174) but was never a disciple.

[6] Before the revolution, Russia was a thoroughly European nation, of course. Some of Inayat *Khan*'s books were translated into Russian and he had a number of Russian *émigrés* after the revolution who were 'secret *mureeds*'; one of them was Felix Yusupov, who shot Rasputin (van Beek, 115).

[7] This list taken from van Beek, 111. We must surely add Germany and Switzerland to it. Beyond Europe, there were groups in Australia and Brazil. The latter is one of many instances of the transmission of Eastern traditions to Latin America—a topic that requires further research.

Biographical sketches of
Murshidas Goodenough, Green, and Egeling

Lucy Sharifa **Goodenough** was born in 1876 into a good family. Her father was a professional soldier who rose to the rank of Lieutenant-General; her mother had been Countess Kinsky before her marriage. She was fluent in French and German and spoke good Italian. She discovered Hazrat Inayat *Khan* in 1916 and devoted the rest of her life to him. He made her a *khalifa* (literally, 'deputy') fairly quickly and then, though I have no exact date, a *murshida*.

Goodenough accompanied Inayat *Khan* and his family when they went to France in 1920. She was the French representative; lectured on Sufism at the Sorbonne; published books (one with the revealing title, *Soufisme d'Occident*); "became the leader of the French Movement, as secretary of the Sufi Order, the second highest position in the Movement's hierarchy" (van Beek, 124); and finally "became the Silsila Sufiya of the Sufi Order, which means the link, necessary for the transmission of initiation in the Sufi Orders. Pir-o-Murshid had a seal made, after his own drawing, and gave this to her as a token of this greater responsibility" (Guillaume). This was really an honorary post but it is still significant that he gave it to her.

She had her own pupils (Guillaume was one) and many of Inayat *Khan*'s disciples found her of great benefit to them after his death. They "recognized in Murshida Sharifa," in Guillaume's words, "a quality that was unique and found in her a reflection of the Master." She died in 1937. Guillaume records that she was "a perfect mureed", and in this he is simply echoing Hazrat Inayat *Khan*'s own assessment of her: "In Miss Goodenough . . . I found that spirit of discipleship which is so little known to the world and even found rarely in the East" (de Jong-Keesing, 141).

Saintsbury Sofia **Green** was also well-born; the de Jong-Keesing biography records that her grandfather was the first person in the family who actually had "a profession". She was a Theosophist for much of her life and, according to Inayat Khan in his reminiscences about her, "a special pupil of Annie Besant" (de Jong-Keesing 149). I do not know how or when she came to Inayat *Khan*. But he gave her plenty of responsibility. Her part in the creation of the 'religious activity' of the Sufi Movement is particularly significant. She called it the 'Church for All' to begin with but the name was soon changed to 'Universal Worship'. It was undoubtedly something close to Inayat *Khan*'s heart: a religious service that made use of all the major traditions. It was begun in 1921 (in London) and Green was its first *cheraga* or lay preacher (van Beek, 125). It is still used today in all branches of the Sufi Movement/Sufi Order. Its most striking aspect, at least to my eyes, is that it is entirely non-Moslem. This is what one expect, of course, given that it is universal. But it perhaps explains van Beek's remark that "Asians were apt to describe [the Universal Worship] rather critically because of its 'Bektashi' aspect, i.e. as Europeanised Sufism" (van Beek, 125). He does not say who these Asians were.

Inayat *Khan* also made Green a *khalifa* in 1921 and a *murshida* in 1923. A few years later, she again helped him in the formation of one of the Sufi Movement's activities, its symbology, known as Ziraat (a Mystery school based on Masonic rites but modelled on agriculture rather than architecture), by creating some of the ceremonies employed in it. She was a gifted writer and one of her books, *Memories of Hazrat Inayat Khan* (written anonymously by 'A Disciple') was published by Rider. (The date is uncertain since it is not given in the book itself—perhaps the early 1930s.) This was, I think, the first book of its kind to be issued by a major publisher and therefore easily available to the general public. She died in 1939.

The last of the three European *murshidas*, Mevrouw Fazal Mai **Egeling**, was born in 1861. She was brought up a Christian but, like Murshida Green, was attracted to Theosophy. In 1922, when she was a wealthy widow of 60, she went to a lecture by Inayat *Khan* in Switzerland. "Instantly the revelation came to me, 'This is the Master I have been waiting for . . . '" She immediately became a disciple and used her money to buy the house at Suresnes, near Paris, which became the Inayat *Khan* family home and the centre of activities after his move to France in 1920. She was a made a *shefayat* and then a *kefayat* (both ranks in the Sufi Healing Order, though it may not have been called that at the time) in 1923. Later in the same year, she was made a *murshida*—a rise through the ranks, if I can put it that way, that was positively meteoric. She died in 1939. (Most of this information taken from her own autobiographical sketch in de Jong-Keesing, 498–500.)

highest possible initiation: that of *murshida*.[8] (The word simply means 'teacher'.) All of them were women—at a time when women still did not have the vote in some European countries—and none of them was married (though Egeling was a widow). **Martin** has her own entry and I give what little I know about the other three on the opposite page. I am not making any great claims for them as spiritual giants, just pointing out that they had a particular *function* in a Western Sufi group. And it was a group that was very distinctive: universal, non-Moslem, and with an unusual prominence given to women.

All of this was Hazrat Inayat Khan's work. He may have encouraged disciples like Murshidas **Goodenough**, **Green**, and **Egeling** to contribute but the Sufi Movement was entirely dependent upon him. (In fact, it was unique to him: nothing like it existed anywhere else in the world.) Hence when he died unexpectedly in India in 1927—the first time he had been back since his departure in 1910—it caught everybody by surprise. Apparently, he did make a will but it was lost. There are various accounts of what it said—and in particular, whom it nominated as his successor. This unclarity was the beginning of the various schisms that have dogged the Sufi Order and the Sufi Movement to this day.

The first split occurred immediately after his death, when Rabia **Martin** was rejected as his successor by the European disciples. The 1923 constitution, drawn up by Hazrat Inayat *Khan* himself, laid down that the head or Pir-o-Murshid of the Movement could be elected if no nomination was made by the incumbent Pir-o-Murshid. Since Hazrat Inayat *Khan*'s will could not be found, an election was duly held and his brother, Maheboob Khan, became his successor. Twenty one years later, in 1948, he also died without having made a will. Another election was held, therefore, and this time Hazrat Inayat *Khan*'s 'cousin-brother', Mohammed Ali Khan, was appointed as Pir-o-Murshid.

Vilayat Inayat **Khan**, Hazrat Inayat *Khan*'s elder son, was then 32 years old. Although he welcomed his uncle, Mohammed Ali Khan, as leader of the Sufi Movement, and was himself a prominent member of it, he believed that he had been nominated as his father's successor in the lost will and that it was only a matter of time before he became Pir-o-Murshid himself. (He had been only eleven when his father died and could not have taken on the responsibility.) However, he became convinced over the years that he would never be offered what he considered to be his rightful position. In 1956, therefore, he revived the Sufi Order which had been created by his father in London in 1917—which was defunct but still existed as a legal entity—and declared himself to be the head of it.

It is at this point that the term 'Sufi Order' takes on two meanings. It either refers to Vilayat **Khan**'s 'revived' Order, as just explained, or to the Order that exists as one of the branches of the Sufi Movement as laid down in the 1923 Geneva convention. These two Sufi Orders have existed side by side from 1956 onwards, both claiming to be the true inheritors of Hazrat Inayat *Khan*'s 'original' Sufi Order.

The matter is further complicated by the fact that Vilayat **Khan**'s Order now contains all the other branches/activities of the Sufi Movement: Universal

[8] Two other *mureeds* are sometimes advanced as having also received the title from Inayat *Khan:* Salima van Braam (another Dutchwoman) and Talewar Dussaq (a Spaniard) (van Beek, 138). But the evidence seems to indicate that both of them were given the lower title of *khalif(a)* by him and that they were made *murshid(a)* after his death by his successor, Maheboob Khan. This does not, of course, mean that they were of less significance than the four others (except perhaps historically). Murshid Dussaq, for example, was "regarded by Hazrat Inayat *Khan* and his brothers as the one fully qualified and really accomplished Sufi mystic among their Western followers" (van Beek, 133).

Worship (the religious activity), the brother/sisterhood activity; the Healing Order and Ziraat (the symbology activity),[9] of which he is the head, and of course he is head of the Sufi Order too. In effect, then, his Sufi Order is the Sufi Movement under another name. This explains a certain ambiguity in terminology. For example, a pamphlet says that Ziraat is "an organization founded by Pir-O-Murshid Hazrat Inayat Khan . . . as the fifth branch of the Sufi Order, then called the Sufi Movement" (*The Evolution of Ziraat,* 18). And: "the Sufi Movement is the name of the original organization founded by Hazrat Inayat Khan . . . The Sufi Order came out of the Sufi Movement. Today they are separate organizations" (ibid., 4). I do not want to make an issue of this ambiguity; but people should know that it exists.

Needless to say, Vilayat **Khan** sees himself as carrying on his father's work. He is described as

> a master of meditation who has updated and integrated practices from various traditions with the relevant creative forces at work in the world today. He has evolved a holistic approach to uplift and expand consciousness. (Omega Press catalogue)

And all the essential activities continue. He initiates people just as his father did and titles like *sheikh(a)* and *murshid(a)* are still given to indicate the level that has been reached (but they are no longer used because people get attached to them).

However, although he has reproduced—or transmitted, if you prefer—all the activities of his father's Sufi Movement, he has also added a few extra elements. Some of these are his own speciality, one might say—for example, transpersonal psychology, as shown by such titles as *The Spiritual Dimensions of Psychology; Introducing Spirituality into Counseling and Therapy; Cultivating the Personality.* Others have been pursued by students under his guidance. These include a strong emphasis on women: *The Sacred Art of Pregnancy;* and a tape, *Women in Religion,* which refers to Princess Noor (Hazrat Inayat *Khan*'s daughter and Vilayat **Khan**'s sister, who was sent to Dachau because of her work with the Resistance in World War II, and died there) alongside Sita, Quan Yin, Fatima, Mary, Rabia, Hazrat Babajan, and Mother Theresa of Calcutta. An equally strong emphasis is placed on children. There is a Star Blazer Program—"an innovative scouting-type organization . . . to help children in the seven and older group develop insight, creativity and awareness" by using "inner visualizations of starships, planets and galaxies"; and children of ten or so are also initiated.

I should also mention that there is a connection with the Chishti Order headquarters in Ajmer, India. Disciples still go there and according to Zia Inayat Khan (in an interview), are accepted even though they do not follow *shari'a* (which means that they are not Moslems). Under Vilayat **Khan**'s guidance, the Order has set up the Hope Project, which focuses its efforts on the area around Hazrat Inayat *Khan*'s tomb in Delhi, providing a clinic, free milk, and a school.

So much for Vilayat **Khan**'s Sufi Order. I now return to the Sufi Movement, which we left in 1956 (the year of Vilayat **Khan**'s declaration of independence) with Mohammed Ali Khan as Pir-o-Murshid. The developments since then have been extremely complex and I summarize them in the table opposite.

[9] This was only re-established (that's the Sufi Order's term, not mine) in 1980. Vilayat **Khan** has linked his father's original idea, which was an agricultural mystery rite, to deep ecology. (See *The Evolution of Ziraat,* listed at the end of this entry.)

Later developments in the Sufi Movement
(1958 onwards)

1958 Death of Mohammed Ali Khan; he names Mahmood Khan as his successor but he is too young—actually, he is 29—so Musharaff Khan is elected as leader of the Sufi Movement

1967 Death of Musharaff Khan; Fazal Inayat Khan (aged 25) is elected Pir-o-Murshid of the Sufi Movement because that was Musharaff's wish (though there was no will); Mahmood Khan brings a court case against the Sufi Movement but loses; he and Fazal agree to go their separate ways: Fazal continues as Pir-o-Murshid of the Sufi Movement and Mahmood takes the title, 'Sheikh-ul-Masheikh' (which his father, Maheboob Khan, also used), and becomes head of the esoteric Khanate, an initiatic lineage that now continues independently of the Sufi Movement *[see note below]*

 Murshida Shahzadi, Musharaff's widow (who is Dutch), also has her own *mureeds* but operates within the Sufi Movement

1977 [approx.] Hidayat Inayat Khan (Fazal Inayat Khan's father) founds the Federation of the Sufi Message, which caters for older *mureeds* who do not care for Fazal's style of leadership

1982 Fazal Inayat Khan steps down as head of the Sufi Movement; attempts are made by the Sufi Movement to create a cooperative leadership: Vilayat Khan becomes head of the Jamiat Khas, the council of the Inner School (and hence effectively the Sufi Order); his brother, Hidayat Khan, becomes leader of the Universal Worship and the World Brotherhood; his cousin, Mahmood Khan becomes leader of the Healing and Symbology activities; his nephew, Fazal also has some responsibility, as does Murshida Shahzadi (his aunt)

1985 The cooperative leadership ceases; Vilayat Khan carries on with his Sufi Order; Mahmood Khan continues his independent Sheikh-ul-Masheikh lineage; Fazal Inayat Khan starts his own group, the Sufi Way; Hidayat Inayat Khan and Murshida Shahzadi continue as joint leaders of the Sufi Movement

1993 Hidayat is made the sole leader—and therefore Pir-o-Murshid—of the Sufi Movement

Note: *The Shaikh-ul-Mashaikh lineage has been passed down through the same Indian family for centuries. It combines an exoteric function, associated with the family/clan/caste, and an esoteric one (which could be called 'Sufi' in the most general sense). Hazrat Inayat Khan assumed leadership of the lineage in 1924 and included its initiatic levels in the Sufi Order. Henceforth, all the leaders—that is, Pir-o-Murshids—of the Sufi Movement were simultaneously Shaikh-ul-Mashaikh. But Fazal Inayat Khan voluntarily relinquished this title (in 1967) and passed it over to Mahmood Khan, who has continued to hold it ever since—sometimes within the Sufi Movement (during the co-operative leadership period of 1982 to 1985) but mostly not. What this means, I think, is that there is a Sufi group, led by a teacher who is half-Indian and half-Dutch, which caters entirely for Westerners and is based on a form of mystical-feudal allegiance linked with an Indian family tradition going back several centuries. Mahmood Khan has told me that the exoteric or family/clan/caste connection has now lapsed for all practical purposes and that only the esoteric function remains. Even so, this is one of the most unusual aspects of the whole phenomenon of spiritual psychology.*

Although the various arrangements have taken different forms, the Movement regards itself as in direct lineage from Hazrat Inayat *Khan* and continues with all five activities listed on the first page of this entry. (It also has connections with the Hope Project in Delhi.)

At the moment, then, there are four lineages—five, if we include Mahmood Khan's Shaikh-ul-Mashaikh lineage (see the table above)—that go back to Hazrat Inayat *Khan* in some way (see Lineage Tree 8):

Sufism Reoriented—itself derived from Rabia **Martin**, the first to diverge from the parent organization;

the Sufi Islamia Ruhaniat Society/SIRS—those who accept Murshid Samuel **Lewis** as their teacher;[10]

the Sufi Order under Vilayat Inayat Khan;

the Sufi Movement under Hidayat Inayat Khan.

This is a remarkable diversity and raises all sorts of questions about the nature of transmission. Sufism Reoriented was created by *Meher Baba* and sees itself as having received a transmission from him that is higher than, but also includes, that of Hazrat Inayat *Khan*. SIRS regards itself as true to **Lewis**'s many 'inner' transmissions, which also went beyond what he received from Inayat *Khan*. Vilayat Inayat **Khan** is adamant that true Sufi transmission must be handed down from teacher to teacher and cannot be the result of elections. The Sufi Movement, on the other hand, says that it is following the procedures established by Hazrat Inayat *Khan* himself and is therefore faithful to his wishes.

All four groups look back to Hazrat Inayat *Khan* in one way or another but also have *another* teacher whom they see as having a particular relationship to him. It just so happens that in the case of the Sufi Order and the Sufi Movement these teachers are brothers—and sons of Inayat *Khan*—and that the two organizations are almost exact replicas of each other.

This in its turn raises another set of questions about the relation between the form of a tradition and what the form is meant to convey. This is a general issue, of course, and not limited to the Sufi groups I am discussing here. What is significant about them is that they have all come into existence within living memory so that we are seeing sub-lineages developing before our eyes, so to speak. This is interesting in itself. But so are the factors at work in this process: the nature of transmission; the influence of great teachers or visionaries; the way in which the inner and outer dimensions of a tradition are related. I discuss these in Chapter 3, where the Sufi Order is given as a test case of the model of comparative religion that I propose there. (See especially Table 3, p. 133.)

Primary sources: Lucy Sharifa Goodenough, *Soufisme d'Occident* (Paris, 1962); Saintsbury Sofia Green, *Memories of Hazrat Inayat Khan* (London, nd); *The Path to God* (Holland, nd); Pir Vilayat Khan, *Toward the One* (New York, 1974); Fazal Inayat Khan, *Old Thinking, New Thinking* (San Francisco, 1979)

Secondary sources: W. van Beek, *Hazrat Inayat Khan: Master of Life, Modern Sufi Mystic* (Vantage Press, 1983); E. de Jong-Keesing, *Biography of Inayat Khan* (The Hague: East-West Publications, 1974); T. Dussaq, *Forty Years of Sufism* (Geneva, 1950); Rabia Clark and Mikail Davenport, *The Evolution of Ziraat*, 33 pp. (San Antonio, Texas, 1988); the unpublished biographical sketch of Murshida Goodenough was kindly provided by Ira Deitrick, President of Sufism Reoriented

Centre: The Sufi Order, P.O. Box 85569, Seattle, WA 98145-1569, U.S.A.; The Sufi Movement, 11 Rue John Rehfous, 1208, Geneva, Switzerland

COMPARE:

Other Sufi teachers: Rabia **Martin**, Samuel **Lewis**, Ivy **Duce**, James **MacKie**; Reshad **Feild**; Abdullah **Dougan**; Ivan **Agueli**, René **Guénon**, Frithjof **Schuon**; Lex **Hixon**; Idries **Shah**

[10] There have been a number of connections between this group and both the Sufi Order and the Sufi Movement. **Lewis** and Vilayat **Khan** had an informal alliance at the end of Lewis's life and his followers continued it after his death. But it came to an end in 1977, when SIRS was created as an independent organization. More recently, in 1994, Hidayat Inayat Khan proposed a formal affiliation between the Sufi Movement and SIRS, in which the activities of each group would be recognized by the other. This is still being worked on.

Other prominent women teachers in Eastern traditions: Sisters **Devamata** and **Daya**, Sri *Daya* **Mata**, the **Devyashrams**, Swami **Radha** (all Hinduism); Jan **Bays**, Joko **Beck**, Jiyu **Kennett**, Irmgard **Schloegl**, Ruth Fuller **Sasaki**, Maurine **Stuart** (all Zen); Jetsunma **Ahkon Lhamo** (Tibetan Buddhism); Ayya **Khema**, Ruth **Denison**, Sharon **Salzberg** (Theravada Buddhism; the *vipassana* tradition)

Others who unite disparate traditions: Swami **Abhishiktananda**, Samuel **Lewis**, J.G. **Bennett**, Hugo **Enomiya-Lassalle**

Other lineages that have had their difficulties: the **Hare Krishna Gurus**, the Self-Realization Fellowship (for which, start with Paramahansa *Yogananda* and work out from there)

AJAHN SUMEDHO/ROBERT JACKMAN

American who is the senior monk in the only independent Theravadin *sangha* in the West

Although Ajahn Sumedho does have significance as an individual, his real importance is a representative of the monastic wing of the Theravadin tradition. But since he is doing this in the West, which is in many respects at odds with this way of life, the age-old issue of the relationship between orthodoxy and change is raised in a particularly interesting way.

Jackman was born in Seattle in 1934. He joined the US Navy after university and served in the Korean war as a medic.[1] Then he went back to college and passed his M.A. in South Asian Studies from the University of California, Berkeley. But he had a taste for the East. He joined the Peace Corps (in 1964) and spent two years teaching English in Borneo. In 1966, he went to Thailand and became a monk a year later. ('Sumedho' is his ordination name.) By chance, he heard about Ajahn Chah, a Thai meditation teacher, and went to join him in his forest monastery, Wat Pah Pong. He was Ajahn Chah's first Western disciple—that is the term used by the *sangha,* not me—and it was to be the first of a number of firsts.

Ajahn Sumedho followed the life of a forest monk in Thailand for ten years in all. It is described as involving "a whole training of letting go—giving oneself up to the routines, the *Vinaya,* the simple austerity of the requisites of food, clothing and shelter, and to the will of the teacher" (*Cittaviveka,* 7). In 1974 he went to India for a short while and practised the strict *dhutanga* (Thai: *tudong*) rules of a wandering monk—that is, he had no monastery or fixed dwelling place to go back to at night, no regular alms round, and he was not allowed to keep food from one day to the next.

In 1975, he was asked by Ajahn Chah to establish and run an international forest monastery, Wat Pah Nanachat, for Western *bhikkhus* (in Thailand). It was at this point that he became known as 'Ajahn' (sometimes spelt 'Achaan', from the Sanskrit 'Acharya', meaning 'teacher'). This is not a formal title but is rather an indication of someone's status in the *sangha.* (It thus has some similarities with 'Roshi'.) There have been other Western Ajahns and other Western abbots of Wat Pah Nanachat—but again, Ajahn Sumedho was the first.

A year later, he was contacted by the chairman of the English Sangha Trust, which had been limping along somewhat aimlessly after severing its connection with Ven. **Sangharakshita** in 1966 and the death of the eccentric Purfurst/Randall/**Kapilavaddho** in 1971. In 1977, the Trust invited Ajahn Chah

[1] A number of other members of this *sangha*—for example, Ajahn Pabhakaro/Gordon Kappel and Ajahn Anando (I don't know his original name)—were also soldiers in the American forces and saw active service.

to Britain, along with Ajahn Sumedho and three other Western monks: Bhikkhus Khemadhammo (English), Anando, and Viradhammo (both American). Ajahn Chah returned to Thailand that same year but he left his four disciples behind at the Hampstead Vihara, telling them not to compromise the *Vinaya* (see n. 2 below) but to continue to lead the strict life of forest monks.

They followed his instructions, "having faith that impeccability of conduct would inspire interest in Dhamma and support for the Sangha" (*Cittaviveka*, 15). One of Ajahn Chah's specific injunctions was to go out on the daily alms round, however pointless it might seem. And it must have seemed deeply pointless because the *Vinaya* rules do not allow a monk to ask for alms directly—he must go out with his bowl and merely indicate that he is asking for food by pausing for a while in front of people's houses (or not even indicate at all). Since this is a convention that has to be learnt, and since the people of Hampstead were quite ignorant of it, there wasn't much likelihood of the four monks ever being offered anything.

One day, however, as they were walking through Hampstead Heath in their monks' robes, a jogger stopped and asked them what they were doing. As a result of this conversation, the jogger donated a wood in Sussex, which he had just inherited, to the English Sangha Trust. This wood, together with a large dilapidated house close-by, became the Chithurst Buddhist Monastery in 1978, run according to the forest monastery principles of Thailand. (The Hampstead Vihara was sold to provide funds for the new monastery.) This was the beginning of what I call the Chithurst *sangha* and it is seen by the *sangha* itself as proof of the efficacy of "impeccability of conduct".

The early community consisted of six *bhikkhus,* two *samaneras* ('novice' monks—those who have taken the first step towards becoming a *bhikkhu* by taking ten precepts but have not yet received full ordination), eight *anagarikas,* four women in training to become *anagarikas,* and three or four lay people[2] (*Cittaviveka*, 12). In 1981, while Ajahn Sumedho was in Thailand, he was made an *upajjhaya* or preceptor—someone who can admit others into the *sangha*—and that same year he did ordain three Westerners as monks (*Cittaviveka*, 62). Although these were not the first formal ordinations—that is, according to the Theravada *Vinaya*—of Westerners in the West,[3] they were the first to be carried out by a Westerner.

I should make clear, however, that such ordinations are not carried out by an *upajjhaya* off his own bat, so to speak, as a sort of personal transmission.

[2] Theravada is in some important respects a hierarchical tradition and this list (from *bhikkhus* to lay people) is in the traditional order of significance. The difference between them lies in two things. The first is the number of precepts that are taken. *Bhikkhus* take all 227 precepts of the *Vinaya* (the rules governing the lives of the *sangha*), *samaneras* take ten, *anagarikas,* eight, and lay people, five. The five precepts are: 1. Not intentionally taking the life of any creature; 2. Not taking anything that is not given; 3. Refraining from irresponsible sexual conduct; 4. Not speaking falsely, abusively or maliciously; 5. Not taking any intoxicating drink or drug. To these are added three more for the *anagarikas:* 6. Not taking solid food after midday; 7. Not singing, playing music, dancing, or attending games and shows; not beautifying or adorning one's body; 8. Not using a high or luxurious sleeping place. The ninth and tenth precepts for *samaneras* are arrived at by dividing the seventh into two, and adding one more: 10. Not handling or controlling money. The second difference concerns whether someone is male or female. Men are always given precedence over women in any formal arrangement—a somewhat contentious issue which I return to later (see n. 7).

[3] I know of just three others, all in London. But they were somewhat different because the requirements for ordination, which are quite complex, were met only with considerable difficulty, not to say ingenuity. In contrast, Ajahn Sumedho went to some lengths to make Chithurst a place where such ordinations could be carried out relatively easily. It was thus the first *permanent* centre in the West where ordination could occur. And since the Theravadin tradition is founded foursquare on *bhikkhu* ordination, this is significant.

At least ten other monks have to be present, and a number of other conditions, all of them laid down in the tradition, have to be met. It is actually quite difficult to fulfil all these requirements in the West. In fact, the Chithurst *sangha* is the only one in the entire Western world that can do so without having to bring in monks from outside the community or compromise in any way with the other conditions that the tradition requires. This is why I said, at the beginning of this entry, that the Chithurst *sangha* is the only one in the West that is independent. 'Independent' here does not mean 'not having any connection with the tradition' but rather, to put it rather starkly, that if every other Theravadin monk in the world dropped dead tomorrow, the Chithurst *sangha* could continue the tradition without having to break step.

I think this point is worth making even though the *sangha* itself does not put it this way. In fact, Ajahn Sumedho stresses that a *bhikkhu* is completely dependent upon others (*Cittaviveka,* 111).

> The monastic life is about non-abiding, giving up your personal possessions, desires, concerns, opinions. The only refuge from the rawness of our nature is to do good and be mindful. (*Cittaviveka,* 128)

But it is very difficult to do good and be mindful if we are attached to the 'conditions' of ordinary life that we experience. Hence the advantage of the *bhikkhu's* life is that it removes as much as possible that could be called 'mine' and substitutes for it the rules of proper conduct. "If you're committed to [the] precepts, you know when you've broken them; so you're more alert and more responsible" (*Cittaviveka,* 26). This alertness is also aided by meditation, which Ajahn Sumedho defines as "recognizing conditions as they are" (*Cittaviveka,* 98). When this is done, we realize that we are not these conditions and "we begin to be aware of the unconditioned, the space of the mind" (*Cittaviveka,* 100).

This is a natural process.

> [W]isdom arises within us when we understand the things that we are experiencing here and now. You don't have to do anything special . . . Taking refuge in the Buddha means the refuge of wisdom. It's pointing to something very real, not something idealistic, or far and remote, but that which is wise within us, that which is wise in the universe, awake and clear. (*Cittaviveka,* 51, 58)

This wisdom is here and now. Hence Ajahn Sumedho says, "Our practice is not to become enlightened but be in the knowing now" (*Now is the Knowing,* 19). This is *vipassana* or insight—simply letting go of identification with conditions (ibid., 32). Nibbana is just recognizing the world as it rises and passes away (ibid., 22). This is a decidedly modest view of Nibbana/Nirvana—and deliberately so. Simplicity, clarity—one might even say, unpretentiousness—are the ideal.

> You might want to become Maitreya, radiating love throughout the world; but I suggest you let go of this desire. Ours is the lesser vehicle/Hinayana, so we only have these simple, poverty-stricken practices. (*Cittaviveka,* 32)

Since the establishment of the monastery at Chithurst in 1978, the *sangha* has developed in a number of directions. Geographically, there are now communities in other parts of Britain as well as Italy, Switzerland, Australia, New Zealand and America. All of these are wings of the Chithurst *sangha,* regardless of their location. Various activities have also come into existence. They vary from introductory public talks and month-long retreats to Family Dhamma

Groups and a Dhamma school.[4] All of these activities are now based at the *sangha*'s new centre, Amaravati, in Hertfordshire, which was established in 1984. In effect, the original 'forest *sangha*' has adapted itself to modern Western society and is now providing what might be called Buddhist community services. But this does not alter the fact that the core of the *sangha* is still the forest tradition which began at Chithurst in 1978. This is why I refer to it as 'the Chithurst *sangha*'.

However, having a traditional core does not mean that there can be no new directions. Under Ajahn Sumedho's leadership, there has also been an exploration of other traditions—not something that the Theravadin tradition is renowned for. In 1994, an Interfaith Conference (which included a service attended by Christians and Hindus as well as Zen Buddhists) was held at Amaravati. And generally speaking, there has been an attempt at Buddhist ecumenicism: discussions with the **vipassana sangha**, for example, and the group led by the Taiwanese master, Hsuan Hua. There is considerable difference between these two. The **vipassana sangha** is entirely lay, though it does have contacts with the *bhikkhu sangha*. (Jack **Kornfield**, a leading *vipassana* teacher, was an early student of Ajahn Chah in Thailand, where he was a monk for a time; there is a photo of him and Ajahn Sumedho with Ajahn Chah in 1969 in *Seeing the Way*, 209.) Hsuan Hua's *sangha*, on the other hand, is entirely monastic but it follows a *Vinaya*—the Dharmaguptaka—which, though very similar to that of the Theravadins, is nevertheless different from it.

Even so, in 1991, Ajahn Sumedho was asked to be the *upajjhaya* or preceptor in charge of the ordinations—seven men and 45 women, all of them Eastern apart from one American man—at Hsuan Hua's centre in California (because Hsuan Hua himself was too ill). This was probably a first in the Buddhist tradition: a Theravadin monk presiding over an ordination ceremony (of Chinese) in the Chinese tradition. And though, of course, it needed Hsuan Hua's encouragement, it was no accident in my opinion that it happened in the West (with a Westerner doing the honours).

Most of the activities described above have arisen in response to the special conditions that exist in the West. But the Chithurst *sangha* stresses that it is no different in its fundamentals from any of the 80 or so other monasteries that have been founded in Ajahn Chah's name. It may hold Interfaith services—an essentially Western initiative—but members of the *sangha* also go on *tudong* walks (which is peculiar to the Thai tradition). And more to the point, it is the same *Vinaya* that is followed. It is this which unites all the various communities under one banner, so to speak.

And we now come to the crux of the whole matter. Monastic Theravada is essentially *sangha*-based rather than teacher-based. That is, teachers arise within the *sangha*; a *sangha* does not develop around a teacher. Even outstanding teachers such as Ajahn Chah are seen as exemplifying the monastic ideal rather than as exceptional individuals. Or to put it another way, an exceptional individual *is* someone who can live according to Dhamma and *Vinaya*.

It may well be that Ajahn Sumedho is on the way to becoming someone of comparable stature. He has certainly done some remarkable things—that is, things that are worthy of remark. He was Ajahn Chah's first Western disciple;

*In 1984, Irmgard **Schloegl** was ordained as a Rinzai Zen priest by her Japanese teacher at Chithurst—another first, I think.*

[4] Ajahn Khemadhammo, one of the group of four monks who first came to London in 1977, has also set up a prison visiting service. But he is now independent of the Chithurst *sangha*. (And here, 'independent' *does* mean 'not having any formal contact with the [original] *sangha*'.)

the first Ajahn; the first abbot of the international forest monastery in Thailand; the first monk to appointed an *upajjhaya* or preceptor; and the first Westerner to be given the title, Tan Chao Khun (by the King of Thailand in 1992). And according to the Theravadin tradition, which rates seniority very highly, he is to be honoured for all of these. But there are others who have been monks for nearly as long as he has and who are an integral part of the Chithurst *sangha*.[5] What really counts—again, according to the tradition—is simply that the *sangha* has been established.

It is true that it is the very first Western *sangha* in the West—**Nyanatiloka**'s Hermitage Island was the first Western *sangha* in the East—and, as I pointed out earlier, the *only* independent Theravadin *sangha* anywhere in the West. But this is just a historical accident, the product of the conditions in which Ajahn Sumedho found himself. From his point of view, what matters is the *continuity* of the *sangha,* based on proper observance of the *Vinaya* and 'impeccability of Dhamma'. It is in this, if anything, that he can be seen as a worthy successor to his teacher, Ajahn Chah. The Dhamma and the *Vinaya* come first; everything else follows from that.

In short, he is the focus for the *sangha* rather than its leader. This explains, I think, why he is intent on remaining orthodox. I quoted above his statement that the monastic life is about "giving up your personal . . . desires, concerns, opinions" and he lives up to this ideal himself. For example, he has said that he would prefer to eat vegetarian food. But the *Vinaya* forbids monks to indicate any preference about what they would like to eat at the time that they are given alms; they have to accept whatever they are given. Ajahn Sumedho is not concerned with attempting to create an independent vegetarian *sangha*. If the whole Theravadin *sangha* were to allow such a departure, so much the better. But abiding by the tried and tested rules is a higher discipline—and '*Vinaya'* is often translated as 'discipline'—than any 'personal' deviation, however well-meaning or skilfully justified. So until the rules are changed, the Chithust *sangha* will continue to follow them.[6]

Similar arguments apply to the position of women in the Chithurst *sangha*. Ajahn Sumedho has indicated that he is happy to support the full ordination of women (which existed in the Buddha's time and for nearly a millennium afterwards but lapsed in the Theravadin tradition in the eleventh century and has never been revived). But again, such a step would require the agreement of the entire Theravadin *sangha* of monks. And again, Ajahn Sumedho is not going to break away from the tradition in order that the Chithurst *sangha*— which is, after all, tiny—should establish its own independent *bhikkhuni* ordination. "It is more important that women should be able to attain enlightenment than that they should be able to use a particular label." In other words, what really counts is that the *sangha,* as it is presently constituted,

[5] This is shown by the contributors to *Seeing the Way,* which is a collection of talks by English-speaking disciples of Ajahn Chah (all of them Western apart from one Japanese). Ajahn Sumedho heads the list because he was the first to be ordained. And only four out of the other 19 have no connection at all with the Chithurst *sangha,* which could not function at all if it depended on one man.

[6] This form of orthodoxy can lead into strange waters. According to the *Vinaya,* a monk may not eat any solids after midday. The Thai tradition, however, classes sugar as a non-solid so the monks are allowed to eat boiled sweets (hard candy) after midday. But milk is classed as a solid so monks cannot drink it after noon. Moreover, anything made from beans counts as a non-solid. So the monks are allowed to eat plain chocolate after midday (but not milk chocolate, of course).

Whatever one may think about these distinctions and the behaviour which is based on them, the point is that they cannot be changed without the full agreement of the whole Theravadin *sangha,* worldwide. They are not susceptible to modification by a community of monks, however impeccable they (the monks) may be.

should be able to offer the conditions that lead to liberation. "Besides," he says, "they trust me"—meaning the *sangha* in Thailand. The implication is, I think, that if the Chithurst *sangha* is respected, it may be listened to; whereas if it is not, it certainly won't be.

Ajahn Sumedho's defence of orthodoxy can be put another way. The central feature of the monastic life is that it requires training. This brings its own strength. Ajahn Sumedho has said that a number of innovative departures introduced by Western teachers into the Theravadin tradition have lacked strength just because the individuals involved have not done the required training. This is not a personal criticism. He is not saying that these people are inferior in some way but rather that they have not been able to establish the solid foundation that is needed for the sort of changes they wanted to introduce. And that foundation can only come from the *Vinaya*. His own approach is that it is misguided to look for things to change. Change arises naturally— and so will the teachers who can deal with it, because the training of the monastic life will itself fashion them.

This, of course, is the ideal. But life being what it is, the ideal can become conditioned by what it encounters. Theravada in the West, and in particular its orthodox monastic form, has certainly found this to be so. A few of the Chithurst monks have returned to lay life—some, such as Pabhakaro and Anando, who were prominent in the *sangha,* after 20 years. The Friends of the Western Buddhist Order, a non-denominational form of Buddhism founded by Ven. **Sangharakshita**, himself a Theravadin monk, has been vociferous in its questioning of the need for all of the 227 rules of the *Vinaya*. The lay *vipassana sangha* (for which, see the group entry **Vipassana** **Teachers**) offers a profound critique of the very notion of the monastic life. And there is a growing movement, both within the Theravadin tradition and outside it, that simply will not accept the orthodox view of women any longer.[7] (See the entries for Jaqueline **Mandell**, Rev. **Dharmapali**, and **Miao Kwang Sudharma**, for example.)

Ajahn Sumedho is currently faced with all these issues. He is not making great pronouncements about their solutions. But he will not lower his standards. He is prepared to change but not at the cost of schism. The Dhamma and the *Vinaya* abide. It remains to be seen whether this rigour can be maintained in the choppy waters of Western culture. But it has survived for more than 2,500 years so far.

Primary sources: Ajahn Sumedho, *Cittaviveka: Teachings from the Silent Mind* (Chithurst Forest Monastery, 1983); *Now Is the Knowing* (no provenance, no date) [but available from the address below]; *Teachings of a Buddhist Monk* (England, Buddhist Publication Group, 1990); Anon, *Seeing the Way: Buddhist Reflections on the Spiritual Life* [an anthology of teachings by English-speaking disciples of Ajahn

[7] The whole question of the ordination of women in the Theravadin tradition is extremely complex. I have looked at it briefly in my article, 'The Transmission of Theravada Buddhism to the West' *in* P. Masefield and D. Wiebe, eds., *Aspects of Religion: Essays in Honour of Ninian Smart* (New York, 1994), 357–388. Here I simply state one of the objections to the present Theravadin position. If it is possible for women to attain liberation without the full nun's ordination, then what is the value of ordination at all? If it makes liberation easier, what cogent reason could there be for withholding it? In fact, withholding it for the past 900 years or so? It does not reflect well upon the monks' *sangha*, which is supposedly upholding the purity of the *Vinaya* solely in order that enlightenment should be possible. Women are not dharmically inferior to men and they must either be allowed full ordination or the very status of ordination will be thrown into question—and that means monks' ordination as well as nuns'.

Chah], (Hertfordshire, England: Amaravati Publications, 1989) [all these publications are made available by donations and cannot be bought in bookshops—write direct to the address below]

Secondary sources: P. Mellor, 'Protestant Buddhism? The Cultural Transition of Buddhism to England', *Religion* 21, 73–92 [this article compares the Chithurst sangha—referred to as the 'English sangha'—with *Sangharakshita*'s FWBO]

Centre: Chithurst Buddhist Monastery, Petersfield, Hampshire GU31 5EU, England, U.K.; Amaravati Buddhist Monastery, Great Gaddesden, Hemel Hempstead, Hertfordshire HP1 3BZ, England, U.K.

COMPARE:

Other Theravadin monastics: **Nyanatiloka** Thera, **Ananda Maitreya**, **Lokanatha** Thera, **Nanavira**; Ayya **Khema**, Rev. **Dharmapali**, **Uppalavana**

Monastics (meaning those who have taken spiritual vows of celibacy) in other traditions: Walter **Nowick**, Irmgard **Schloegl** (Rinzai Zen); Jiyu **Kennett** (Soto Zen—though Soto allows its ordained priests to marry); Hugo **Enomiya-Lassalle** (Christian Zen); **Karuna Dharma**, Gesshin **Prabhasa Dharma** (Vietnamese Zen); Lama **Teundroup**, some Western *Tulkus* (Tibetan Buddhism); Ven. **Sangharakshita**, **Miao Kwang Sudharma** (non-denominational Buddhism); Swami **Abhayananda/** Marie Louise, Swami **Atulananda**, Sister **Devamata**, Sister **Daya**, Sri **Daya Mata**, Shrimati **Kamala**, the **Devyashrams**, Swami **Radha**, Swami **Turiyasangitananda**, Swami **Abhishiktananda**, Sri **Krishna Prem**, the **Hare Krishna Gurus**, Shrila **Bhaktipada** (all in various forms of Hinduism); [there is no monasticism in Sufism]

Other Westerners who have taught in Eastern countries (in strictly alphabetical order): Swami **Abhishiktananda**, Madame **Blavatsky**, Hugo **Enomiya-Lassalle**, Lama Anagarika **Govinda**, some **Hare Krishna Gurus**, Jiyu **Kennett**, Sri **Krishna Prem**, Trebitsch **Lincoln**/Chao Kung, **Lokanatha** Thera, Sri **Mahendranath**, the **Mother**, **Nyanatiloka** Thera, Ven. **Sangharakshita**, Ruth Fuller **Sasaki**, **Shunya**

SUNYATA. SEE **SHUNYATA**

TAMAL KRISHNA GOSWAMI. SEE **HARE KRISHNA GURUS**

Alexis TENNISONS. SEE **APPENDIX 1**

Lama Denis TEUNDROUP

One of the earliest and most senior students of Kalu Rinpoche, and appointed by him as a teacher

Lama Teundroup (the English spelling would be *Dondrop*) was born Denis Eysserie-François in Paris in 1949. He went to India when he was 19, met Kalu Rinpoche and became his disciple. He then returned to Paris and and began to learn Tibetan at the Ecole Nationale des Langues Orientales Vivantes. He also met Chogyam *Trungpa* at Samye Ling, his centre in Scotland. He went back to India to study with Kalu Rinpoche, and also received initiations from the Karmapa and other Tibetan teachers.

In 1976, back in France again, he helped to organize the first three-year retreat for Westerners—eight men and eight women—which he himself attended. Afterwards, all 16 were given the title *lama,* which is the usual Kagyu custom. (In fact, all the French *lamas* at Karma Ling, around eight or so, have been given this title after completing a three-year retreat *à la* Kalu Rinpoche, if I can put it that way.) After this first retreat finished in 1979, Lama Teundroup (as he then was) was asked by Kalu Rinpoche to establish a permanent centre in France. This was l'Institut Karma Ling (in the Savoie region) and three-year retreats are still held there (and still 'produce' Western *lamas*). But now Lama Teundroup leads them. The first time was in 1985, a year after Kalu Rinpoche gave him the title *Vajracarya* and formally invested him with the authority to teach.

There are presently eight other centres in various parts of France that are allied to Karma Ling and are under the direction of Lama Teundroup. All of them follow the same policy of open-minded enquiry, which ranges from the similarities between Buddhism and science to the connections with other religions. For example, Arnaud Desjardins, another Frenchman who was formerly associated with Tibetan Buddhism—and before that, with **Gurdjieff** groups—but has since become the disciple of an Indian Vedanta master, regularly goes to Karma Ling for dialogues on Buddhism and Vedanta.

(*See* Lineage Tree 9)

Primary sources: Lama Denis Teundroup, *Dialogue avec un lama occidental* (Paris: Dervy-Livres, 1991); Lama Denis Teundroup and Arnaud Desjardins, *Dialogue à deux voies* (Paris: La Table Ronde, 1993)

Secondary sources: None that I am aware of

Centre: Institut Karma Ling, F-73110 Arvillard, France

COMPARE:

Other Western lamas: Lama Anagarika **Govinda**, Lama Kunzang Dorje

Other Westerners with particular responsibilities in Tibetan lineages: Ngakpa **Chogyam**, Ngakpa **Jampa Thaye**, **Osel Tendzin**

CHRISTOPHER TITMUSS. SEE *VIPASSANA SANGHA*

CHOGYAM TRUNGPA RINPOCHE

Controversial Tibetan teacher whose community in the West has been through some radical upheavals

Trungpa was the eleventh Trungpa tulku *(that is, his last incarnation was his eleventh as Trungpa). He was born in 1939 and recognized by the Karmapa, whom he always regarded as his principal teacher, shortly afterwards. In 1959, he escaped to India and worked alongside Freda* **Bedi** *for a time. He arrived in England in 1963 together with another* tulku *in the Kagyu lineage, Akong Rinpoche. Trungpa studied at Oxford for a while, became a British citizen and set up a community called Samye Ling in Scotland in 1968. But a year later, he had a bad car crash—the vehicle careered into a joke shop—after which he*

renounced his monastic vows, got married to an Englishwoman, and went to America. There, he set up a number of centres (collectively called 'Vajradhatu' with the headquarters in Colorado) and also wrote some very influential books. Meditation in Action, *published in 1969, was the first ever to be written by a Tibetan teacher specifically for Westerners. As a result, he rapidly became one of the best-known Tibetan teachers in the West. The Naropa Institute, a Vajradhatu offshoot in Boulder, Colorado, founded in 1974, attracted thousands of Americans, including teachers such as Jack* **Kornfield***, Joseph* **Goldstein***, and* **Ram Dass***. Gompa Abbey, the monastic wing of the organization, was established in Nova Scotia in 1984 with one of Trungpa's disciples,* **Pema Chodron***, as abbess.*

The Trungpa of America was decidedly not a 'holy man'. He taught that the guru's function isn't to be 'good' but to prevent his disciples from living in illusion. And if this means confrontation and giving offence, then so be it.

> *He acts unexpectedly and the atmosphere of tranquillity is disturbed, which is very painful. The physician [one who is supposed to heal you] becomes wild, which is terrifying. We do not want to trust a wild doctor or surgeon. But we must. (*The Myth of Freedom, *135)*

So the spiritual path isn't a safe journey but a running battle.

> *The guru is the archetypal warrior who has knowledge of war and peace . . . Devotion to the guru develops with the realization of the tremendous difficulty of finding your way in the midst of this warfare . . . The guru has fantastic skill in developing you and destroying you at the same time . . . (ibid., 136)*

It is difficult to know what other Tibetan teachers made of all this. One view is that Trungpa has his place in the tradition as a whole and that the support shown by the Karmapa—who bestowed the title of 'Vidyadhara' or 'Holder of Knowledge' on him, recognized two of his sons as tulkus, *and acknowledged an American disciple,* **Osel Tendzin***, as his Vajra Regent—is surely enough to indicate that Trungpa is a true teacher. Another view is that Trungpa's special genius was quite as difficult for Tibetan teachers to come to grips with as it was for Westerners—perhaps more so—and that they therefore tended to go along with something that they did not fully understand.*

Trungpa died in 1987. According to his disciples, this was a 'conscious' death (since a tulku *chooses his death just as he chooses his birth); according to his critics, it was the result of sustained alcohol abuse. He had nominated an American disciple,* **Osel Tendzin***, as his Vajra Regent—that is, as the person who would look after the* sangha *until the twelfth Trungpa is old enough to fulfil his responsibilities. And in fact, the twelfth Trungpa was found in 1992. But* **Osel Tendzin** *will not be the one who will pass on the charge—he died of AIDS in 1990. You can read this rather sorry tale in his entry.*

Sources: Chogyam Trungpa, *Born in Tibet* (Shambhala, 1977); *The Myth of Freedom and the Way of Meditation* (Shambhala, 1976); *Cutting Through Spiritual Materialism* (Shambhala, 1973); *Crazy Wisdom* (Shambhala, 1991); T. Clark, *The Great Naropa Poetry Wars* (Santa Barbara, California, 1980); G. Feuerstein, *Holy Madness: The Shock Tactics and Radical Teachings of Crazy-wise Adepts, Holy Fools and Rascal Gurus* (New York: Arkana, 1990); *Vajradhatu Sun* (the community's newspaper)

Westerners (or half-Westerners) who have been recognized as, or claim to be, incarnations of Tibetan teachers

This is a group entry. The principal 'players' are given in the list on p. 572.

The whole Tibetan tradition is based on the *tulku* system and is unthinkable without it. The word 'tulku' is the phonetic rendering of 'sprul-sku', which is itself the Tibetan translation of the Sanskrit *nirmana-kaya,* meaning 'transformation body'. According to Indian Mahayana Buddhism, the Buddha had three bodies or forms. At the highest level is the *dharma-kaya* or Dharma body, which, in the way that is typical of the Mahayana, is actually neither a body nor a form but is identical with emptiness. At the intermediary level is the *sambhoga-kaya* or Enjoyment body, which is seen by Bodhisattvas in the countless non-physical worlds that make up the universe. Finally, there is the *nirmana-kaya*/Transformation body, which is a projection into the physical realm of a form that appears human but is in fact an embodiment of 'dharmic' qualities.

The Tibetan version of this teaching takes these ideas a little further. Very advanced Bodhisattvas such as Avalokiteshvara ('Chenrezi' in Tibetan) or Manjushri ('Jampel' in Tibetan) are regarded as having such an abundance of dharmic qualities that they can manifest them in human form. In other words, certain human beings are not 'just' human at all but projections of aspects of Dharma. These are *tulkus.* They choose to be reborn and their mere presence in the world ensures that the Buddha's Dharma will be maintained—because they manifest Dharma by the very fact of being incarnated. Hence, though the *word* 'tulku' is derived from the Mahayana doctrine of the Transformation body of the Buddha, *tulkus* are not regarded as incarnations of the Buddha. It is therefore inaccurate to refer to them as 'living Buddhas' (which one often reads in the press).

The best-known *tulku,* of course, is the Dalai Lama.[1] The present Dalai Lama is the fourteenth. What this actually means is that the same 'person'— that is, the same dharmic 'force'—has incarnated 14 times. (Of course, all beings reincarnate; but the difference is that non-*tulkus* do not choose their incarnation, and are therefore reborn willynilly, as it were (as John Doe ➔ Bill Snooks ➔ W.Q. Higgenbottam ➔ Willy Nilly . . . and so on), rather than as beings with a 'dharmic mission'). Similarly, all the main teachers in all four schools—the Nyingma, Sakya, Geluk, and Kagyu—are *tulkus.* I do not know how many there are altogether but it must be over a hundred.

Normally, a *tulku* is recognized when he is a young boy. (There are female *tulkus* but their number is tiny; this is definitely a male system.) And of course he is recognized by other, adult *tulkus.* It is in the nature of this system that it repeats itself *seriatim,* as it were: *tulku* A is recognized as a boy by *tulku* B, who is perhaps 50 years old; when *tulku* B dies 20 years later, it is now *tulku* A who will recognize the child who is *tulku* B's incarnation and who will become his pupil; then when *tulku* A dies in his turn, it will be *tulku* B who will recognize his former teacher. And through all this, both *tulku* A and *tulku* B will be known by the same name each time: *tulku* A will be the seventh abbot of X, say, and then the eighth abbot; *tulku* B will be known as the tenth incarnation of B and then the eleventh. In actual fact, the procedure for

[1] Although he is the best-known, he was not the first, by which I mean that the first *tulku* recognized in Tibet was not the first Dalai Lama but the first Karmapa, head of the Kagyu school, in the twelfth century. It may be significant that in the present century it was the sixteenth Karmapa who was the first to recognize Western (or half-Western) *tulkus.*

recognizing a *tulku* is usually more complex than this;[2] but even so the principle of generations of *tulkus* leapfrogging over each other is sound.

Obviously, the advent of Western *tulkus* is a consequence of the Tibetan exile and diaspora. But it is interesting that the Tibetans themselves tended to use the *tulku* idea to explain certain Westerners to themselves long before that. For example, L.A. Waddell (a Christian missionary at the end of the last century), Sir Charles Bell (a British diplomat who spent some time in Lhasa in the 1930s) and Marco Pallis (a practicing Tibetan Buddhist since the 1930s) were all told that they had been Tibetans in previous lives. Of course, being the reincarnation of a Tibetan is not the same as being a *tulku*. Even so, Waddell was identified as a 'reflex'[3] of the Buddha Amitabha (which must have annoyed him since he had a low opinion of Tibetan Buddhism). Important Westerners, such as Queen Victoria and Nicholas II of Russia, were treated more royally, one might say. Victoria was said to be a 'manifestation' of Palden Lhamo (one of the few female *tulkus*) and Nicholas, a reincarnation of

[2] And I think it is fair to say that it is open to abuse. For example, there was a period of well over a century, from 1757 to 1895, when a succession of Dalai Lamas either did not assume power at all (the ninth and tenth died when they were still boys) or did so only for a few years (the eighth, eleventh and twelfth all died a few years after assuming office). According to Tibetan Buddhist belief, all these premature deaths must have been for 'dharmic' reasons since a *tulku* chooses his death quite as much as he chooses his birth. But it is, of course, possible to see such events in a more secular light. (Edward V of England, one of the 'two princes in the Tower', also did not live to lead his country.)

There is also a rivalry, going back several centuries, between the Dalai Lama and the Panchen Lama. Traditionally, the Panchen Lama has tended to receive support from the Chinese in his political ambitions—in the eighteenth century, for example, the Emperor made the Panchen Lamas rulers of Tsang province—and has therefore tended to support them in his turn. The ninth Panchen Lama fled to China in 1923 and never returned to Tibet. He died in 1937 and his successor was 'found' by the Chinese in 1939; but most people think that he was not the real one (especially since he was never recognized by the fourteenth and present, Dalai Lama—though the situation is complicated by the fact that they were the same age and therefore children at the same time). The tenth Panchen Lama was thus living in China when the Communists came to power in 1949, and he was made nominal ruler of Tibet from 1959 (when the Dalai Lama went into exile in India) to 1964. When he died in 1989, an extraordinary game of *tulku* bluff and counter-bluff ensued. The Chinese government dispatched a team of Tibetan monks to Tibet in order to find his successor. But this team, while pretending to work for the Chinese, in fact collaborated with another, undercover, team that the Dalai Lama had sent to Tibet on the same mission. Hence the candidate that the Chinese thought would be their appointment in fact turned out to be the Dalai Lama's candidate—the 'official' eleventh Panchen Lama—after all. (And having discovered this, the Chinese promptly 'kidnapped' him by taking him from Tibet and installing him in Peking. Such is the politics of the *tulku* system).

Another controversy—this time purely Tibetan—concerns the Karmapa, head of the Kagyu school. The sixteenth Karmapa died in 1981 and his incarnation was eagerly awaited. But it took a long time (eleven years) for him to be discovered. The task of finding him was entrusted to four Dharma-regents (all *tulkus*, of course, and all pupils of the sixteenth Karmapa, who had himself recognized them—an instance of the 'leapfrog' principle outlined above). But it appears from the outside that they did not really know how to go about it. There was a certain amount of prevarication, followed by claims and counterclaims that two of the Dharma-regents, Tai Situ Pa and the Shamarpa, had fabricated/suppressed evidence that would have led to the discovery of the seventeenth Karmapa. They even produced rival candidates (though it appears that Tai Situ Pa's has become the official one). For more on this episode, see Keith Dowman (himself a disciple of the sixteenth Karmapa), 'Himalayan Intrigue: the search for the new Karmapa', *Tricycle* II/2, Winter 1992, 29–34 (+ several letters presenting other interpretations of the events in vol. II/4, Summer 1993); Karma Tendzin Dorje, 'Golden Child', *Fortean Times*, vol. 69, June-July 1993, 30–33. There is also a mini-book, *The Karmapa Papers* (Paris, 1992; written in English; contact address: P.B. 128.16, F-75763 Paris Cedex 16, France), which gives the Shamarpa's side of the story.

These controversies are not a central concern of mine but it is worth knowing about them because we are not just dealing with a spiritual idea or teaching but a whole social and cultural reality. One is bound to ask why, if the tenth Panchen Lama was false, he could have a successor at all; or, if he was genuine, why he did the things he did. One is bound to ask what status the Shamarpa's candidate as seventeenth Karmapa now has..

Moreover, it appears that it is at times of uncertainty that unorthodox claims tend to be made. As the Tibetan tradition emerges into the world, so Westerners are beginning to enter the tradition—at all levels.

[3] This term is one of several that is used to translate 'tulku' or to approximate the same idea, though it is quite rare. Others are 'channel' (also rare), 'manifestation', 'emanation', 'incarnation' (which are much more common). But it is really best to stick to the Tibetan term.

Tsongkapa (the reformer and virtual founder of the Geluk school).[4] The case of Alexandra **David-Néel** is somewhat similar. When she met the thirteenth Dalai Lama in Kalimpong, North India, in 1912, he was amazed that she knew anything at all about Buddhism, let alone that she was genuinely interested in it. He therefore concluded that she might be an emanation of Dorje Phagmo (another of the few female *tulkus*).

What all these examples show is that the Tibetans used the *tulku* idea to place Westerners in a context that they (the Tibetans) could understand—a sort of Tibetanization of the West.[5] And it was an obvious first step towards full Western *tulkuhood,* to coin a phrase. In fact, the sequence seems to have gone something like this: Westerners who impressed the Tibetans in some way (Victoria, Nicholas II) or showed an interest that needed to be explained (Waddell, Bell) ➔ Westerners who were either extremely sympathetic to Tibetan Buddhism or actually practiced it (**David-Néel**, Pallis) ➔ Westerners who have been recognized as *tulkus inside the tradition*.

It is these last whom I interested in. And even here, the process of including Westerners in the *tulku* ranks has, to a certain extent, proceeded in stages. For instance, the very first non-Tibetan *tulkus* were actually the sons of Tibetans who had married Western women. Probably the best-known are the sons of Chogyam *Trungpa* (who are half-British): Tendzin Lhawang Mukpo and Gesar Arthur Mukpo, born in America in 1971 and 1973 respectively. The sixteenth Karmapa recognized them as *tulkus* of two important teachers in the Kagyu school: the elder was Surmang Tendzin Rinpoche, one of the Karmapa's own teachers; the younger was Trungpa's main teacher, Jamgon Kongtrul of Sechen (not to be confused with Jamgon Kongtrul of Pepung, who is also a Kagyu *tulku* but was not Trungpa's teacher) (Chogyam Trungpa, *Born in Tibet* [Shambhala, 1977], 258, 260). (This is a particularly 'close' instance of leapfrogging, if I can put it that way.) These were the first *tulkus* to be born in the West and also the first who could be called Western (and they were fairly Western— they were educated at British public schools not Tibetan monasteries). All previous *tulkus* had been Tibetan or Mongolian.[6]

These half-Western *tulkus*[7] were all recognized as young boys in the normal way. And of course they had the advantage of being the children of

[4] All this information taken from P. Bishop, *Dreams of Power: Tibetan Buddhism and the Western Imagination* (London, 1993), 72.

[5] An unusual variation of this process occurred in one of the Theosophical lineages derived from Madame **Blavatsky**. G. Barborka, in his book, *H.P. Blavatsky: Tibet and Tulku* (Adyar, India: Theosophical Publishing House, 1966), written several decades after her death, claimed that she was a *tulku* because she possessed the ability to "transmit spiritual truths" (p. 145), specifically by putting aside her ordinary self and allowing the 'Masters' to speak/write through her (p. 300). This is not how the term is used in the Tibetan tradition. It is worth mentioning this usage, however, because of Zina **Rachevsky**'s still later claim to be **Blavatsky**'s *tulku* (see below); and also because of Cyril Hoskins's claim to be **Lobsang Rampa** (which *does* make use of exactly the idea that Barborka describes).

[6] Actually, one of these Mongolian *tulkus* is himself interesting: Telo Rinpoche, who was born in America of Mongolian parents. He was part of a tiny Mongolian community that gathered around Wangyal Rinpoche, himself a Mongolian Geluk monk, in New Jersey in the 1950s. But it was quite unlike *Trungpa*'s Naropa Institute 20 years later; it was for Tibetans and Mongolians only and Telo Rinpoche was sent to Drepung monastery in southern India to receive the traditional *tulku* training. He is therefore somewhat different from the two Mukpo boys (and also different from Roshi Bill **Kwong**, a Chinese American in the Japanese Zen tradition).

[7] Other half-Western tulkus whom I know of are the present Khunna Lama (who is half-Danish; he is briefly mentioned in Ole **Nydahl**'s *Riding the Tiger,* 73), Namkhai Norbu's son (who is half-Italian) and Phendé Rinpoche's sons (who are half-French). And they come from different schools, so this is not an anomalous phenomenon that has been created by one school and ignored by the others. Khunna Lama is Nyingma and the sons of Phendé Rinpoche are Sakya (like their father). (Namkhai Norbu is an unclassifiable Dzogchen teacher and is not part of any school.) How Western they are, I cannot say. No doubt they vary.

prominent Tibetan teachers who were themselves *tulkus* and therefore part of the elite of the Tibetan tradition. But there are also *tulkus* who are completely Western. The very first was O.K. **Maclise**/Sangye Nyenpa Rinpoche (often referred to as 'OK'). He was born in Massachusetts in 1967. His father, Angus Maclise, was the original drummer in the Velvet Underground before Mo Tucker. Both his parents were attracted to Tibetan Buddhism and went to Nepal when their son was three. According to reports, he appeared to remember a monastery in Tibet where he had lived in a previous life. His mother, who was painting statues in a Kagyupa monastery, talked to the monks there and they agreed that OK could become a 'novice'. He was about six at the time. Two years later, in 1975, she wrote to the Karmapa about her son's experiences. In reply, the Karmapa sent her a map which had been given to him by an important *tulku* in the Kagyu lineage, Sangye Nyenpa Rinpoche, over ten years before. It was a map of the place of his rebirth and he had said it would be in the West. OK's mother recognized the place as Great Barrington, Massachusetts, where her son had been born. In 1976, after a few traditional tests (the candidate has to select his predecessors'—that is, his own—belongings from a collection of very similar items), the Karmapa proclaimed OK a *tulku,* the reincarnation of Sangye Nyenpa Rinpoche, himself an emanation or *tulku* of Manjushri and an important personage in the Kagyu school.

OK entered the Kagyu school's main monastery in Sikkim and followed the traditional life of Tibetan monk-cum-*tulku.* (Most of this information taken from *Sunday Telegraph Magazine,* 15th May 1983.) His parents stayed on in Nepal but his father died in Katmandu in 1979. The latest information I have is that Nyenpa Rinpoche has returned to America, has ceased to be a monk but still considers himself a *tulku* and still gives teachings. I do not know how close he has stayed to the Kagyu school.

A somewhat similar path has been taken by Elijah Ary/Tenzin Sherab, born in 1972 to Canadian parents who were students of Kalu Rinpoche, a master of the Kagyu school.[8] He had 'dreams' as a child of what he called another planet but which he now says was Tibet. He was spontaneously recognized as the incarnation of Geshe Jatse, vice-abbot of Sera monastery in Tibet, by the Dalai Lama in 1980.[9] He went to the new Sera monastery in south India in 1986, when he was 14, and spent six years there as a monk. He says that he felt completely at home and that the Tibetans saw him as a Tibetan, not a Westerner. But he left before he had finished the very long and demanding studies that a Gelugpa *tulku* traditionally follows. He is now back in Canada studying at the Religious Studies department of Quebec University. Still in his early twenties and having been back in the West for just a couple of years, he is uncertain how things will unfold in the future. And while he has no doubts about his previous life as Geshe Jatse, he does not foresee that he will have a specific role in the Tibetan tradition. (All this information is taken from Mackenzie, *Reborn in the West.*)

[8] Kalu Rinpoche was one of the great Tibetan teachers of this century. He was completely traditional but at the same time open to foreigners. In addition to recognizing Trinlay Tulku (and Zia Inayat Khan—see below), he was also the teacher of Lama Denis **Teundroup** (another Frenchman but not a *tulku*). Kalu Rinpoche died in 1989 and was discovered by Tai Situ Pa in 1992—the same year that the seventeenth Karmapa and the twelfth *Trungpa* were also discovered (by Tai Situ Pa).

[9] In fact, other Tibetan teachers such as Kalu Rinpoche and Lama Yeshe also recognized him. Lama Yeshe was himself reincarnated as a Spanish boy, Lama **Osel** (see below), and when Tenzin Sherab met the young boy he confirmed that he was indeed Lama Yeshe—an instance of one Western *tulku* 'recognizing' another.

Other Western *tulkus* have stayed in the tradition, however. For example, Trinlay Tulku, who was born in 1975 and has a French father and an American mother, was recognized as the incarnation of Khashap Rinpoche by Kalu Rinpoche. He spent some time at Sonada monastery, near Darjeeling, but is presently living at a Kagyu center in France, where he teaches. The center is under the direction of Lama Teunsang and is frequently visited by other Tibetan teachers and *tulkus*.

All these *tulkus* came into contact with the Tibetans who eventually recognized them via their parents, who were practicing Buddhists. And the same thing happened in the case of perhaps the most well-known Western *tulku* of all, Lama **Osel**. He is Spanish, was born Osel Hita Torres (that was the name his parents gave him) in 1985 and was formally enthroned as the reincarnation of Lama Yeshe by the Dalai Lama in India in 1987.

Lama Yeshe was himself an interesting man (and he appears later on in this account because of his association with Zina **Rachevsky**). He left Tibet in 1959, made his first visit to the West in 1974, established a number of centers both in Europe and America, and died in Los Angeles in 1986. But he was not born a *tulku*. Rather, he acquired the qualities in this lifetime that enabled him to choose his rebirth in the next—that is, to *become* a *tulku*. There are many stories about his yogic abilities and "tantric realizations" during his lifetime, and his death in 1984 was also accompanied by various portents. During the cremation (in California), a cloud was seen in the shape of an arrow, pointing south, together with the Tibetan letters *za, za, sa, ra*. These signs were interpreted by a Tibetan *tulku* as possibly indicating the name of Lama Yeshe's mother in his future incarnation (ibid., 20). (However, his mother's name was Maria Torres, which doesn't seem very much like *za za sa ra* in any combination.) Lama Zopa, Lama Yeshe's 'spiritual' successor, was asked about his rebirth and replied that he thought that Lama Yeshe "had karma with California". (In fact, the rebirth took place in Spain.) (All this information is taken from an anonymous *In Memoriam* of Lama Yeshe in *Wisdom [Magazine of the Foundation for the Preservation of the Mahayana Tradition/FPMT]*, no. 2, 1984, 6–37)

Seventy-two days after Lama Yeshe's death, the story goes, two of his students, Maria and Paco Torres, conceived a child at their home in Spain. He was named **Osel** and according to his parents, his birth and early months were accompanied by auspicious signs. He was born in five minutes without pain, with "eyes wide open as though he was looking, looking, checking everything". He was a quiet serene baby and once watched an hour-long video of the Dalai Lama without becoming restless. When he met one of Lama Yeshe's teachers, he did two prostrations to him "completely unprompted"; and when he was introduced to the Dalai Lama at the age of 14 months, he went over to a table, picked up a flower and presented it to him. Moreover, his parents and other students of Lama Yeshe began to recognize gestures and behaviour that were exactly like their guru's.

Meanwhile, Lama Zopa had had a dream of a baby's face which he immediately recognized as that of **Osel** Torres when the two eventually met. Subsequently, Lama Zopa submitted a list of ten children to the Dalai Lama as possible candidates for the reappearance of Lama Yeshe—this included several Western children in addition to **Osel**. Two months later, the Dalai Lama chose **Osel**, who was submitted to the usual tests, which he passed. He was formally enthroned by the Dalai Lama in Nepal in March 1987. He is presently in India receiving the sort of training the tradition reserves for its *tulkus*. However, the

fact that he is a Westerner has brought about one small change. His mother says that she will stay near him for as long as he needs her (whereas 'traditionally', the family had very little contact at all). In fact, her understanding of her son's role is an interesting one. She says he will be taught Christianity as well as Buddhism and that funds are being made available for him to have a Harvard education.

> What will happen remains to be seen. I expect Osel will spend half his time in the East and half in the West. After all, he is a mixture of the two. If Buddhism to have any meaning in the West we must extract its essence, then build our own culture around it. That was Lama Yeshe's vision. And that, perhaps, is what Osel will achieve. (*You Magazine, The Mail on Sunday*, 1st February 1987, 16–20; the article is written by Vicki Mackenzie—whose book on Lama Osel is listed at the end of this entry—and most of my information is taken from it.)

All Western or half-Western *tulkus* are unusual. But some are more unusual than others. Two of these are Perceval, the son of a Belgian *lama* (who is not a *tulku*) and Edouard, a French boy who has been recognized as the *tulku* of Western woman (though she herself was also not a *tulku*).

Perceval's father, Kunzang Dorje (I don't know his original name) went to India in 1967 and practiced under a number of Nyingmapa teachers. The first was Kangyur Rinpoche, then, after he died, Tulku Pema Rinpoche (Kangyur Rinpoche's son), and Dilgo Khyentse Rinpoche. It was Khyentse Rinpoche who appointed Kunzang Dorje as a *lama* in 1973 or 1974. Back in Europe, Kunzang Dorje set up an urban center in Brussels and a monastic retreat in the French Alps (both of which have their equivalents in Portugal, by the way). These centres are themselves allied with that of Pema Rinpoche in France, and a number of prominent Nyingma teachers (including Dudjom Rinpoche, who was the head of the school until his death in 1989) have taught at them.

Kunzang Dorje is married—the Nyingma school is not celibate—and his wife is half-African. Their son, Perceval, was born in 1982 and was recognized as a *tulku*—I do not know his Tibetan name—by Khyentse Rinpoche. It is intended that he will be his father's successor.

As for Edouard, his story is really that of Zina **Rachevsky**. If you read it in a novel, you would probably think it was farfetched. She was born in America in 1931 of a Russian father (reputed to be a relative of the Romanoffs—but that is a common claim and I do not know if it is true or not) and a fabulously wealthy American mother. She was brought up in Paris and New York—her first language was French—and went on to become an international socialite, model, and stripper. She was married several times, once to a claimant to the French throne, once to a multi-millionaire. In between, she had countless lovers of both sexes.

But at this point, the Jackie Collins plot changes. She went to Greece in the mid-1960s, became interested in Theosophy and thought she might be the reincarnation of Madame **Blavatsky**. (See p. 564, n. 5, though I doubt if she knew of Barborka's book.) She read *The Way of the White Clouds,* the autobiography of Lama Anagarika **Govinda**, and went to India, taking her daughter with her and accompanied by Michael Riggs (later Bhagavan Dass, who introduced **Ram Dass** to his guru, Neem Karoli Baba), to see if she could find **Govinda**'s guru, Tomo Geshe Rinpoche, at his monastery in Darjeeling. But she never got there. Instead she met Lama Yeshe and Lama Zopa (whom we have already come across in the case of Lama **Osel**). This was in 1965 or 1966 (I have seen both dates). She was one of their very first Western students and

used her money so that they could start a centre for teaching. She started to meditate, and worked hard under their guidance for several years. Then, around 1970, she switched from the Gelugpa practices she had been doing with them and entered a retreat with a Tibetan teacher of Dzogchen (a 'direct' path to enlightenment that is somewhat independent of all the four main schools but not in essential opposition to any of them). After about a year's intensive practice, she suddenly fell ill and realized she was going to die. She was found sitting in the meditation position in her little hut in the Himalayas in 1972.

According to Lama Zopa, another Tibetan teacher, Kari Rinpoche, predicted that Zina (and a girl from New Zealand—I don't know who she is) would both realize emptiness directly in this lifetime. After she died, yet another *lama,* Takta Rinpoche, checked where Zina had incarnated and said that she was in "a pure realm" (Lama Zopa, 'Introduction to Edouard, Zina's Incarnation'). I do not know how it was decided that she had the necessary dharmic qualities to become a *tulku*—or who decided it. (It is interesting that she reached this state by her own efforts, so to speak, just like Lama Yeshe, her main teacher, who has also reincarnated as a Westerner.) In any event, some time afterwards (I have no exact date), Edouard's mother started to have dreams of Zina while she was pregnant. (Edouard's father is a somewhat distant cousin of Zina's, which is where the connection comes from.) After the boy was born, Sakya Trizin Rinpoche, head of the Sakya school, told his parents that he was Zina's incarnation. A Western boy as the *tulku* of a Western woman—definitely a first. It has yet to be decided what part, if any, he will play in the Tibetan tradition.

It is unwise to generalize from just two cases but the recognitions of Perceval and Edouard do have some instructive features. Both of them were discovered by the personal initiative, so to speak, of Tibetan teachers and their connection with the tradition as a whole has been built up afterwards. That is, they were not actively sought by the tradition (or by a particular school). This certainly does happen in 'traditional' Tibetan Buddhism—by which, I mean the tradition as it was in Tibet before it came to the West—but not quite like this. In Tibet, where more or less everyone was Buddhist, the choices were very great—but over a much smaller area. Tibet is a large country but it is tiny compared with the entire Western world. On the other hand, the number of children who could even be *approached* as possible *tulkus* in the West is very small indeed. So the situations are practically the opposite of each other: in Tibet, a relatively small population but nearly every male child a potential candidate; in the West, a huge population but hardly any real candidates.

Perhaps this explains why both Perceval and Edouard have been located by 'family connection', so to speak. (Perceval is Kunzang Dorje's son; Edouard is Zina's second cousin once-removed.) This is a particular variation on the 'discovery of a *tulku*' theme. In Tibet, it is one of many; in the West, it is the predominant one (at the moment). On the other hand, these family connections are decidedly unusual: Perceval is part-African; Edouard is the *tulku* of a woman who was half-Russian, half-American. This sort of mixture is typically Western; it is not typically Tibetan.

One could argue that the advent of Western *tulkus* shows that the *tulku* system is adapting to the new conditions that exist outside Tibet. Nothing demonstrates this more graphically than the discovery of *adult* Western *tulkus*. Jetsunma **Ahkon Lhamo** and Ngakpa **Chogyam** are examples. They both have their own entries so I will not elaborate here. But the point is that adult *tulkus* are unheard of in Tibet; it just never happens. Yet as Penor Rinpoche, who recognized Jetsunma **Ahkon Lhamo**, said, "We cannot say for sure who

is going to be a *tulku*. They return only where they are needed. And they have the freedom to take any form they want." Both of these Western *tulkus* are part of the Nyingma school but as far as I know they have made no effort to contact each other. There is no 'Western *Tulku* Club'; the tradition has simply changed its boundaries a little bit and accommodated them.

All those whom I have mentioned so far have been recognized in some way or other by Tibetan teachers and have been acknowledged as *tulkus* by a significant section of the tradition. But there are others who do not fit into this particular pattern. They therefore tend to be 'odd men out' (using this term purely descriptively and not as a judgment of their worth).

An example is Zia Inayat Khan, son and designated successor of Vilayat Inayat **Khan**, head of the Sufi Order. (Vilayat Inayat **Khan** is half-Indian and half-American; Zia's mother is American.) About ten years ago (I have no exact date), when Zia was still a young boy, he was recognized as a *tulku* by Kalu Rinpoche. Because Kalu Rinpoche was held in such high esteem by the Kagyu school, this was particularly significant. Apparently, Zia did spend some time with Tibetan teachers in India. But when he grew older, he decided that since he could not remember anything of his previous birth, it really made little sense for *him* to say that he was a *tulku* and that he would not take any active part in the tradition. He told me that he had talked this over with the Dalai Lama, who supported his decision.

As far as I know, this is the only instance to date of a *tulku* declining his role. But then his circumstances were decidedly unusual. He already had a spiritual future, so to speak, chalked out for him. Besides, while both Tibetan Buddhism and Sufism have an admirable breadth of view and are ready to accommodate other traditions, maybe someone who actually combined the two—which would be quite unique, I need hardly point out—would be too much for either to accept.

*Cf. Lama Anagarika **Govinda**, who also moved from the Theravadin to the Tibetan tradition.*

Then there is Leslie Dawson/**Namgyal** Rinpoche, who also has links with another tradition but in a rather different way. When he met the Karmapa in Britain in 1974, he had only recently started following Tibetan Buddhism after several years as a Theravada monk in Thailand. As Ananda Bodhi (his ordained Theravadin name), he had come to London at the invitation of the English Sangha Trust to be in charge of the Hampstead Vihara (a task he shared with Ven. **Sangharakshita** for a time). There were not many Buddhists in Britain in the early 1960s, so it was natural that he should meet two young Tibetan monks, Chogyam *Trungpa* and Akong Rinpoche, who arrived in the country in 1963. He arranged for them to purchase the house that became Samye Ling, and started practicing under their guidance.

*Cf. Swami **Abhayananda**/ Marie Louise and Roshi Maurine **Stuart**, who also received transmission from Eastern teachers in private ceremonies.*

It is not at all clear what the Karmapa said or did that led Dawson to think that he was a *tulku*. Nor do I know where the name, **Namgyal** Rinpoche, came from. Presumably the Karmapa gave it to him; but if he did so, it was in a private ceremony. In any event, **Namgyal** Rinpoche has never been an integral part of the Tibetan tradition—despite the fact that he lists his lineage as 'Karma Kagyu' in the entry in D. Morreale, *Buddhist America: Centers, Retreats, Practices* (Santa Fe, New Mexico, 1988), 243. He teaches a method of meditation, developed by himself, called Holistic Cleaning Meditation. And I have also been told that he gives courses that combine Buddhism with microbiology. I have no idea what this means; I wrote to him but received no reply. My latest information is that he is in communication with ETIs (extraterrestial intelligences). Perhaps that is why is now refers to himself as 'Star One'. There is no doubt more to it than this—and I would love to hear about it—but that is

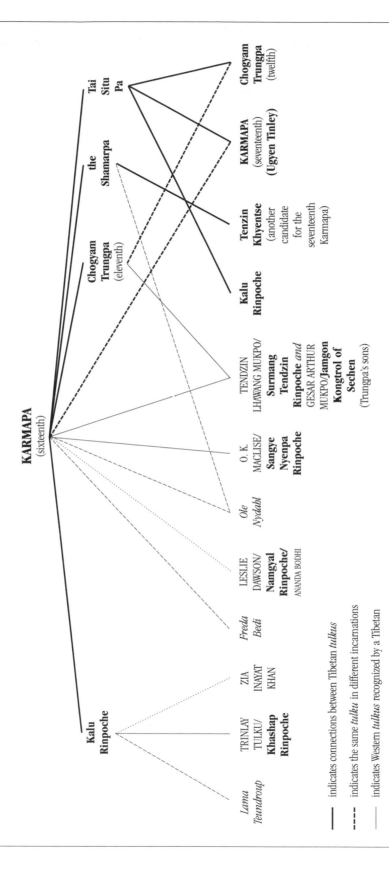

LINEAGE TREE 9
Western *Tulkus* in the Kagyu School
with some Tibetan *tulkus* and other influential Westerners

The **Shamarpa** and **Tai Situ Pa** are two of the **Karmapa**'s Dharma regents; the other two, Jamgon Kongtrul of Pepung and Gyaltsap Rinpoche, should also be on here but there just isn't room.

all I have at the moment. A number of Western Tibetan Buddhists have told me that they think it quite possible that **Namgyal** Rinpoche misunderstood whatever it was that the Karmapa said to him, and that whatever qualities he might have, they are not those of a *tulku* (which, as I pointed out at the beginning, are fairly specific).

Finally, there is a *real* odd-man-out: Simon **Grimes**, who was born in Tientsin, north China, in 1937. His grandfather, Albert Curtis Grimes, Sr, was head of the Board of Christian Missions there and knew the ninth Panchen Lama, Choskyi Nyima, who had fled to China in 1923 because of a dispute over how much tax his monastery owed the Tibetan government. The Panchen Lama remained in exile until his death in 1937 (the year of **Grimes**'s birth). According to **Grimes**, he **(Grimes)** was recognized as his incarnation by the Dilowa Kutuku, head of the Mongolian branch of the Gelug school, in 1940 (despite the fact that an 'official' tenth Panchen Lama—Tibetan but born in China—had already been recognized by the Chinese government in 1939) and was given the name Choskyi Paldan. A year later, when he was four, the family left China and went to Hawaii.[10]

These Western (and half-Western) *tulkus* certainly cover quite a range: various nationalities and ages; belonging to all the four major schools (though the Sakyapas are noticeably more reticent than the others); found in a variety of ways and in widely different circumstances; and with different degrees of integration into the tradition. What are we to make of them?

This is not really a question about them as individuals—though individual qualities *are* part of a teacher's qualifications (deliberate use of cognate terms there)—but more about the status of Western *tulkus per se*. It is obviously significant that Westerners have entered the *tulku* ranks, so to speak, because it is there that we find the heart of the Tibetan tradition. Yet there is a world of difference between Lama **Osel**, say, and Simon **Grimes** and Leslie Dawson/**Namgyal** Rinpoche. Lama **Osel** was recognized by more than one Tibetan *lama;* those who have recognized him include teachers who hold high position in the tradition as a whole—the Dalai Lama, of course, is the highest of them all; he has been publicly announced or declared; he has passed traditional tests and is receiving the traditional training (even if his mother is insisting on some basic parental rights). It is hardly surprising, therefore, that he has been accepted by practically everyone in the entire tradition (not just the Gelugpa school). The only thing that is unusual about him is that he is not Tibetan. In contrast, while **Grimes** and Dawson may have been recognized *privately* by respected teachers, they have not passed any tests nor received a *tulku*'s training. Consequently, it is equally unsurprising that the tradition has not accepted them.

In short, Lama **Osel** is as orthodox as it is possible to be (for a Westerner); **Grimes** and Dawson/**Namgyal** Rinpoche are fundamentally unorthodox

[10] Dr. **Grimes**'s career as a spiritual teacher is not limited to his claim to be the Panchen Lama, however. In 1973, when he was 37, he founded the Pansophic Institute (renamed the Institute of Theosophy in 1990) in Reno, Nevada. Its aim was to foster dialogue between religious leaders, and, more specifically, to help establish Tibetan Buddhism in the West. One of its branches was in Ghana. Encouraged by the several thousand members that the Institute had in that country, of whom the most significant was undoubtedly the head of state in the mid-1970s, General Acheampong, Dr. **Grimes** tried to establish a Ghanaian Buddhism. He was invited to Ghana as a guest of the government in 1975 and performed a number of spiritual functions: meditation classes for members of the government; energizing power centres as future focuses of enlightenment; spiritual healing; combating practitioners of the black arts. How successful he was in any of these, I do not know—but the whole venture was certainly unusual.

Western *tulkus*

(in very approximate chronological order)

| Original name | Nationality | Tibetan name or title | Recognized by; + date | School | Comments |
|---|---|---|---|---|---|
| Simon Grimes | American | (10th Panchen Lama) | Dilowa Kutuku (Mongolian); 1940 | Geluk | never publicly recognized |
| Tendzin Lhawang Mukpo | half-Tibetan/ half-British | Surmang Tendzin Rinpoche | 16th Karmapa; 1974 | Kagyu | one of Chogyam Trungpa's sons |
| Gesar Arthur Mukpo | half-Tibetan/ half-British | Jamgon Kongtrol of Sechen | 16th Karmapa; 1976 | Kagyu | one of Chogyam Trungpa's sons |
| Leslie Dawson | Canadian | Namgyal Rinpoche | 16th Karmapa; 1974 | Kagyu | was a Thevadian monk; now an independent teacher |
| O.K. Maclise | American | Sangay Nyenpa Rinpoche | 16th Karmapa; 1976 | Kagyu | has disrobed but still teaches |
| *don't know* | half-French/ half-American | Trinlay Tulku | Kalu Rinpoche; 1978 | Kagyu | trained in India; now teaches in France |
| Elijah Ary | Canadian | Tenzin Sherab | Dalai Lama; 1980 | Geluk | has disrobed but accepts his incarnation |
| *[doesn't want it known]* | half-British/ half-German | Ngakpa Chogyam | Kyabje Rinpoche; 1983 | Nyingma | lay teacher |
| *don't know* | half-Tibetan/ half-Dutch | Khunna Lama | *don't know; [no exact date]* | Nyingma | trained in India |
| Zia Inayat Khan | three quarters-American/ one-quarter Indian | *don't know* | Kalu Rinpoche; *[no exact date]* | Kagyu | has declined to accept his recognition |
| Perceval | half-Belgian/ part-African | *don't know* | Dilgo Khyentse Rinpoche; *[no exact date]* | Nyingma | son of a Belgian *lama* |
| Osel Hita Torres | Spanish | Lama Osel | Lama Zopa Rinpoche; the Dalai Lama; 1987 | Geluk | the incarnation of Lama Yeshe |
| Alyce Zeoli | American | Jetsunma Ahkon Lhamo | Penor Rinpoche; Dilgo Khyentse Rinpoche; 1988 | Nyingma | the only Western female *tulku* |
| Edouard | French | *don't know* | Sakya Trizin Rinpoche; ca. 1990 | *don't know* | the incarnation of Zina Rachevsky |

All these were recognized as children apart from
Namgyal Rinpoche, Ngakpa Chogyam, and Jetsunma Ahkon Lhamo

N.B. A few tulkus *briefly mentioned in the text are missing here.*

simply because the only criterion they fulfill is that someone said that they were a *tulku*. (And even that is not certain; private declarations that are reported by only one side never are.) This has not proved enough for them to find a place in the tradition. It does not follow from this that they are not good teachers—other criteria are required for an assessment of that claim. But they are not teachers that the tradition accepts. Hence their claim to be *tulkus* is decidedly at risk. Two against an entire tradition is not good odds.

What follows from this—at least at the moment; it could change—is that Western *tulkus* are significant *in the tradition* to the degree that they fulfill the multiple criteria of orthodoxy exemplified by Lama **Osel**. It looks as if Trinlay Tulku and Khunna Lama, for example, do fulfill these criteria. They therefore have a place in the tradition. So do Jetsunma **Ahkon Lhamo** and Ngakpa **Chogyam**—with the sole proviso that, since they were discovered as adults, certain aspects of their *tulkuhood* are unusual. But the tradition can cope with that. Hence they could only be called unorthodox in a purely formal sense (rather like George I of England was an 'unorthodox' king: he did not speak a word of English when he acceded to the throne—but he *was* the king).

It is difficult to say anything definite about the Mukpo boys, the sons of Namkhai Norbu and Phendé Rinpoche, and Perceval. Certainly, they were recognized by high Tibetan *lamas* and are accepted by a significant number of people. But the tradition itself has not defined their role very precisely (which is why it is difficult to say anything definite). Similarly with Edouard (who is still very young, of course): who will decide what part he is to play?

One element in the answer will surely be what he himself decides. Zia Inayat Khan has already made his decision, as we have already seen. So despite his recognition by an unimpeachable teacher (Kalu Rinpoche), one could argue that he is not really a *tulku* at all—except in a purely formal sense. (And again, this is no reflection on his worth or of that of Kalu Rinpoche.) Sangye Nyenpa Rinpoche (OK as was) and Elijah Ary/Tenzin Sherab are similar in some respects: they have both stopped being monks and are feeling their way in the Western world, pursuing what might be called 'lay careers' (but both accept that they are *tulkus*). These are fairly small deviations (and I use the word purely descriptively, as a river 'deviates') but it is nevertheless significant, I think. Traditionally, Tibetan tulkus 'played the game'; Western *tulkus* look as if they might change the rules.

But of course one cannot change the rules of a game unless the great majority of the players agree; otherwise, it becomes a different game. This possibility does now exist—and it is Western participation that has brought it about.

Primary sources: Namgyal Rinpoche, *Unfolding Through Art, Open Path* (Boise, Idaho, 1982); *The Dome of Heaven* (Toronto: Namgyal House, 1983)

Secondary sources: Vicki Mackenzie, *Reincarnation: the Boy Lama* (Bloomsbury, England, 1989) [on Lama Osel]; Vicki Mackenzie, *Reborn in the West: The Reincarnation Masters* (London, 1995) [contains chapters on Tenzin Sherab, Jetsunma Ahkon Lhamo, Zina Rachevsky and Edouard (whom she calls 'Pierre'), Trinlay Tulku, and Lama Osel]; Lama Zopa, 'Introduction to Edouard, Zina's Incarnation', *Mandala (Journal for Students of the Foundation for the Preservation of the Mahayana Tradition/FPMT)*, no. 10, April 1992; there are brief references to some Western *tulkus* in S. Batchelor, *The Awakening of the West: The Encounter of Buddhism and Western Culture* (London, 1994)

Centres:

Namgyal Rinpoche, The Open Path, 703 North 18th Street, Boise, ID 83702, U.S.A.

Dharma Centre, Galway Road, Kinmount, Ontario, Canada

Perceval, Ogyen Kunzang Choling, 111 rue de Livourne, 1050 Bruxelles, Belgium; Chateau de Soleils, 04120 Castellane, France; Ogyen Kunzang Choling, 17 rua de Solitre, 1200 Lisboa, Portugal [actually, these addresses are for his father, Kunzang Dorje]

Trinlay Tulku, Karma Migyur Ling, Montchardon, 38160 Izeron, France

Simon Grimes, The Institute of Theosophy, P.O. Box 2422, Reno, NV 89505, U.S.A

Namkhai Norbu, Communita Dzogchen, Corso Garibaldi 55, Milan I-21000, Italy

Phendé Rinpoche, Ngor Evam Phendé Ling, 27180 Les Ventes, France

I do not have any details for the other *tulkus* mentioned in this entry. **Ahkon Lhamo Rinpoche** and Ngakpa **Chogyam** have their own entries.

COMPARE:

Other Western tulkus: Jetsunma **Ahkon Lhamo**, Ngakpa **Chogyam**

Other Westerners in Tibetan Buddhism: Freda **Bedi**, Alexandra **David-Néel**, W.Y. **Evans-Wentz**, Lama Anagarika **Govinda**, **Jampa Thaye**, Lobsang **Rampa**, Ole **Nydahl**, **Osel Tendzin**, Lama **Teundroup**

Zen Master TUNDRA WIND | Jim Wilson

Gay American who started off in the Korean Zen tradition but has gone independent

Wilson was a disciple of the Korean Zen master Seung Sahn—also known as Soen Sa Nim—and says that he was given permission to teach by him (though he did not receive *inga/inka*). This was in the late 1970s, I think. Wilson was trying to remain celibate, as Buddhist precepts require, and finding it very difficult. When he asked Seung Sahn what he should do, he was told that he should simply satisfy his sexual desire and then forget about it. Wilson found this remark, which implies that sex is a purely physical matter with no emotional or spiritual component, too much to take and shortly afterwards he left Seung Sahn and set up as a teacher on his own. He says that Eastern teachers simply do not understand sexuality in Western culture and that Westerners will have to provide a spiritual account of it on the basis of their own understanding and not just accept what Eastern traditions say about it. Shortly after his break with Seung Sahn, Wilson had a visionary dream in which a wolf appeared to him. He recognized this wolf as part of himself and it bestowed on him the name Tundra Wind. So now Jim Wilson is Zen Master Tundra Wind.

> I, Tundra Wind, announce a new manifestation . . .
> I, Tundra Wind, proclaim a new speaking, creating a new worlding . . .
> The primary truthing of the multiverse resides in the relentless/unstoppable/ utterly free and freeing becoming/begoning/fluxing/rivering worlding. This truthing (not this truth) transcends any and all realms and any and all experiencing . . . Therefore, abandon 'being' and enter 'outshining', the ever present Wind. (*Proclamation,* undated—but some time in the mid-1980s)

Tundra Wind's fundamental view is that everything traditional will have to be reformulated. For example, he gives the third of the ten traditional precepts (rendered by **Aitken** as 'Not misusing sex') as 'Express the sacredness of sexuality.' And for him, this includes homosexuality. Few people would deny that Eastern Zen has been noticeably reticent about conventional sexuality and completely silent about homosexuality. The reason for this is obviously cultural; and equally obviously, Western culture is neither reticent nor silent about

<div style="border:1px solid">

Zen Master Tundra Wind's rewording of a passage from Master Da's
Scientific Proof of the Existence of God Will Soon Be Announced By the White House!
(he gives no reference)

| *Master Da* | *Zen Master Tundra Wind* |
| --- | --- |
| Who or What is Truth? | Who or what Truths? |
| Truth is not a person, or a thing, or a knowable object or a thought. | Truthing does not exist as a person, or a thing, or a knowable object or a thought. |
| Truth is a process. | Truthing processes. |
| Who or What is "I"? | Who or what "I"-s? |
| "I" is a process. | "I"-ing processes. |
| The Process that is Truth and the Process that is "I" are one and the same. | The Process that Truths and the Process that "I"-s identicle (*sic*). |

</div>

these matters. It was therefore only a matter of time before someone asked how Westerners should approach them. Zen Master Tundra Wind is not the only one who has raised the issue—Robert **Aitken** and Issan **Dorsey** have also done so[1]—but he was the first to do so having left the tradition that he originally espoused. This in itself raises basic questions about tradition and how it can be transmitted. And anyone who makes us ask questions is valuable.

Primary sources: None (apart from unpublished material)
Secondary sources: None
Centre: the latest address I have is Box 429, Monte Rio, CA 95462, U.S.A.

COMPARE:
Others who have a teaching concerning sexuality: **Chris and Emma**, Barry **Long**
Other teachers connected with Korean Zen: Don **Gilbert**, Bobby **Rhodes**

Swami TURIYASANGITANANDA | Alice Coltrane

Former jazz pianist who has received a number of revelations direct from God and now has a 'Hindu' ashram near Los Angeles

Alice Coltrane was born Alice McLeod in Detroit in 1937. Her family were Christian and she was brought up in a religious atmosphere. She began her musical training at the age of seven and later played the piano and organ in church. In her mid-twenties she met the great jazzman, John Coltrane, one of the three or four most influential sax players since Charlie Parker, and became his second wife. At the end of 1965, she replaced McCoy Tyner as pianist in Coltrane's group. But she hardly made any recordings with her husband because he died of cancer in 1967.

She continued as a bandleader in her own right for a while but her interest was already turning towards spiritual matters and she did not remain in the jazz world for long. In fact, neither of her two books mentions jazz at all; and

[1] I have a further reference to Norman McClelland/Vajra Dharma of the Gay Buddhist Group in Los Angeles (D. Morreale, *Buddhist America: Centers, Retreats, Practices,* [Santa Fe, New Mexico, 1988], 53)

she only refers to John Coltrane once. But although she calls him "a great musician and composer", she is clearly more interested in him as a spiritual man. She gives his name as 'John Coltrane Ohnedaruth' (which was revealed to her after his death) and she says that he could see akasha (that is, the Akashic Records), that he could leave his body and that he would occasionally "speak of his interspheric travels" (*Monument Eternal*, 32).[1]

Her career as a spiritual teacher began in 1968 when she began to receive "revelations" direct from God (*Monument Eternal*, 7). But having said that, I must immediately qualify it because many of these revelations concern her spiritual life in the past—and I mean 'the past'. She says that she has been instructed by the Supreme Lord "for more than 600 million years of human life" (*Monument Eternal*, 15); but elsewhere the Lord Himself refers to eight billion years (*Endless Wisdom*, 197). A time scale of this magnitude tends to render ordinary dates like 1968 somewhat insignificant.

Her travels through other planes and to other worlds have been extended and frequent. She has had a number of encounters with beings on the astral plane (sometimes referred to as *Svar*, the Hindu name for 'heaven' [*Endless Wisdom*, 169]). One was with Swami Sivananda, who died in 1963 (*Monument Eternal*, 33) and she has also met Fatima, the Virgin Mary, Ramakrishna, and *Aurobindo*, as well as Buddha and Christ (*Monument Eternal*, 49).

On one occasion, she saw Brahma.

> The Lord who is the Supreme controller of everything, who controls the memory and forgetfulness of all living beings, recalled my memory to a time many eons ago before the dawn of this creation when He caused an impenetrable darkness to cover the whole of space. The darkness also sufficiently concealed His wonderfully brilliant effulgent light which was radiating the brightest illuminations in all directions.
>
> The Lord then directed my attention to a place where I saw a helpless figure of a human-like being stalking around in the dark. He appeared to be the pitiable result of severe tapas. He looked bewildered and pathetic. The Lord said to me: . . . "he has just completed 1,000 celestial years [= 31,536,000,000 'ordinary' years; 1 celestial second = 1 year] of *tapasya*. He is My instrument. He will be the Creator of the universe". (*Monument Eternal*, 16)[2]

Back on the physical plane, Swami Turiyasangitananda associated—her word—with Swami Satchidananda (one of Sivananda's disciples and founder of the Integral Yoga Institute). She has been to India eight times and visited the ashrams of Shrila *Prabhupada* (the founder of ISKCON) and Sai Baba (letter, August 1987). Sai Baba is described by the Lord as "one of my sacred embodiments" (*Endless Wisdom*, 34).

However, despite all these spiritual 'contacts', Swami Turiyasangitananda is adamant that her guidance has always come directly from God. It was He who

[1] It does appear that Coltrane had an interest in 'higher' things. He was introduced to the teachings of *Krishnamurti* by the pianist, Bill Evans, around 1958 or so (Bill Cole, *John Coltrane*, [New York, 1976], p. 110). And his later compositions, such as *A Love Supreme*, are unlike any form of jazz that preceded them—and I am not forgetting gospel and its great influence upon jazz when I say this. It may be that Alice had something to do with this new direction (although it started before she joined the band).

[2] Swami Turiyasangitananda has been through her own *tapas*, which she defines as "mortification . . . the taking upon one's self of a voluntary suffering for some spiritual good" (*Monument Eternal*, 15).

> During an excruciating test to withstand heat, my right hand succumbed to a third-degree burn. After watching the flesh fall away and the nails turn black from the intense heat, it was all I could do to wrap the remaining flesh in a linen cloth to keep it in place. (*Monument Eternal*, 18)

She went to the doctor (who "recoiled" at the sight of the hand) and he gave her medicine. But she would not take it. The Lord had given her the injury and He would take it away—which he did, by means of His "life-breath" (ibid., 30).

initiated her into the Shakti Order (*Monument Eternal,* 15) and gave her her name (ibid., 51). Part of her work is to receive and pass on God's words. But in order to do this she had to be purified—hence the *tapas.*

> Inasmuch as I had invited you to return unto the earth to be the messenger-bearer of My revelations and deliverances, it was incumbent upon you to undergo a torture-ment of days of rigorous austerities and sacrifices. (*Endless Wisdom,* 195)

Swami Turiyasangitananda's second book, *Endless Wisdom* (actually, *Endless Wisdom,* vol. 1—surely one of the all-time great titles) is an unusual mixture of *Old Testament* rhetoric and Hindu terminology.

> I, God, am the judiciousness of My Law, and all Power is in Me, and whomsoever it shall be that shall reject My Law, shall be rejected by Me. (*Endless Wisdom,* 90)

As an example of His judiciousness, he descibes 38 regions "in the nether worlds" that await those who "have sinned and committed evil deeds". For example:

> They that shall perpetrate evil acts of violence, and shall engage in Kshatriya-terror-ism in the world, shall, after death and the judgement, go forth unto a region wherein beasts shall hunt them for their prey, and shall terrify them and break them asunder with their maw until remission of sin has been granted. (ibid., 95)

The antidote against this 'transgression against the law' (*Old Testament*-style) is pure and disciplined living (*sattvic,* Hindu-style):

> A serious disciple who engages in dedicated, devotional service daily, who is selfless, moral, meditative, tranquil, disciplined, and reverentially given unto the recitation of japam, mantram, and prayers, I shall sanction it be that such a soul may go forth onwards unto achievement of the Supreme Goal of divine realization. (ibid., 70)

The primary example of this way of life is Swami Turiyasangitananda her-self. She wears maroon robes (modelled on the normal *sannyasin* garb), is vegetarian and teetotal. She has a small centre, Shanti Anantam Ashram, near Los Angeles (founded in 1983), where her followers (whom she initiates) live. All religions are honoured (*Endless Wisdom,* 1) but Hinduism is predominant. This is particularly evident from her *Bhajan Songbook,* which is entirely in Sanskrit and devoted to songs of praise to Krishna, Rama, Shiva, Lakshmi, Vasudeva, and so forth. She has also made recordings of these chants, which are clearly regarded as 'divine music'. The Lord says,

> As it was in the beginning, let your music forevermore be an expression of My Divinity in a sound incarnation of Myself as nadabrahman . . . one of My many Forms Whose sacred sound shall render all hearts unto light, peace, and understanding. (*Endless Wisdom,* 199)

Swami Turiyasangitananda's teaching is very particular to her. One could call it a form of independent Hinduism except for the *Old Testament* Jehovah that is the source of it. This disparity is brought starkly to the fore in an exchange between her and the Supreme Lord, in which she is asked a ques-tion, replies, and is then corrected.

> "What is destroying the state known as ignorance-sleep?"
> "Enlightenment?"
> "No, Turiya, chastisement". (*Endless Wisdom,* 45)

Such an idea simply does not exist in Hinduism. The ideals of purity, auster-ity, obedience, yes: they are part of a very old and well-established way of life;

but not the notion of chastisement as a spiritual force. On the other hand, more or less everything else that Swami Turiyasangitananda says—the complex cosmology, astral travel, *kundalini,* the constant transformations of perception and consciousness, not to mention *Kshatriya*-terrorism—is entirely foreign to the strict paternalistic monotheism that imbues her writings.

This union of opposites produces a novel spiritual path: a very demanding form of purification which leads to an extraordinary range of experiences. In other words, the purification does not become deeper and deeper until it merges into the 'original purity' but rather opens out into a universe of almost unimaginable size and richness. (There is some similarity here with the Gaudiya Vaishnava tradition as exemplified by Shrila *Prabhupada* and the Hare Krishna movement, but with one crucial difference: Krishna, the source of that tradition, is the 'All-attractive One', whereas Swami Turiyasangitananda's Supreme Lord, in true *Old Testament* style, has no face.)

Whether this path will establish itself or not, I do not know. It seems to me to be the product of very particular circumstances that are not easily repeated. Meanwhile, it is being offered by a black woman in an ashram just north of Los Angeles.

Primary sources: A. Coltrane-Turiyasangitananda, *Monument Eternal* (Los Angeles: Vedantic Book Press, 1977); *Endless Wisdom,* vol. 1, (Los Angeles: Avatar Book Institute, 1981); *tape: Divine Songs*

Secondary sources: None

Centre: The Vedantic Center, P.O. Box 7434, Thousand Oaks, CA 91359, U.S.A. [but recent letters have been returned undelivered]

COMPARE:

Other Western women who teach a form of Hinduism (using that term very broadly): Marie Louise/Swami **Abhayananda** (and others associated with Swami *Vivekananda,* listed at the end of her entry); Sri **Daya Mata**; Swami **Radha**; the **Devyashrams**; Joya **Santanya**; the **Mother**

Irina TWEEDIE

Russian-born disciple of an Indian Sufi teacher who was sent back to Britain to transmit what she had received

Mrs. Tweedie went through the classic ordeal by fire at the hands of her teacher. She was in her mid-fifties when she met him. Born in Russia in 1907, she was educated in Vienna and Paris. Then, having married an English naval officer, she went to live in England. When he died suddenly, in 1954, she was devastated, and seized with a desire to find out more about life. She discovered Theosophy, was encouraged by its teachings, and went to its headquarters in Adyar, near Madras, in order to study it in more depth. This was in 1959. A friend of hers, Lilian Silburn, was the disciple of a teacher who lived in Kanpur and suggested that Mrs. Tweedie go to visit him. She arrived in October 1961 and stayed for 18 months. Her experiences are recorded in her book, *Chasm of Fire,* which is based on a diary she kept during that time. (All quotations are from this book, with the page number in brackets at the end, unless otherwise stated.)

Guru Bhai Sahib, as her master was called, did not have an ashram but lived at home with his family. Disciples would come to see him when they could. Mrs. Tweedie lived near by and went to see him nearly every day. There was no routine for her to follow, just the events of daily life that were

somehow transformed on occasion into something compelling. As Guru Bhai Sahib said (in English, though his first language was Hindi),

> We do not teach; we quicken. I am stronger than you so your currents adjust themselves to mine. This is a simple law of nature. The stronger magnetic current will affect, quicken, the weaker. If you let flow an electric current through two wires, side by side, one a strong one and one a weak one, the stronger will affect the weaker. It will increase its potency. It is so simple. (103)

But while it may simple for those who understand, it did not appear that way to Mrs. Tweedie. She had to find her way as best she could. Sometimes Guru Bhai Sahib gave her teachings, sometimes he was silent. He could be tender, indifferent, or harsh. He would often go into higher states when she was with him; but at other times he appeared completely ordinary and quite as caught up in the petty round and common task as anybody else.

Not surprisingly, she oscillated between overwhelmed awe and rebellious doubt. For example, just a fortnight after her arrival, she went to Bhai Sahib's house and found him asleep.

> . . . I became aware of a great power in the room. A tremendous power. I could scarcely breathe; the force was terrific . . . I sat with closed eyes, trying to endure it, for it was difficult to bear. The mind? It was hardly present at all. Lost somewhere, swallowed up, dissolved, or rather absorbed by the charged atmosphere of the room . . .
>
> After a while, his wife came in and told him that tea was ready. He took the small towel which he always carried with him and went out. Not a word was spoken. (20–21)

Yet five days later:

> Went in the evening. His wife was talking non-stop all the time. There was nobody except myself. It is all so empty and banal. Who is he? How can I know? (22)

These extracts capture the flavour of the book. She was all at sea; half the time fearful that she would drown, half the time intoxicated by the sheer magnitude and ineffability of what she had discovered. And it did not take her long to realize that these two extremes are only aspects of each other—and that she was caught.

> What a difference there was between that world which had been mine not so long ago and the world of the Master—obscure, disturbing, still unknown to me, a dark *terra incognito,* full of enigmas, disquieting mystery and God knows what secret suffering. This was my world from now on. I myself have chosen it. (63)

Guru Bhai Sahib did let slip a few remarks about his form of Sufism.

> We are called Saints but it is the same as Yogis; in Wisdom there is no difference. The colour of our line is golden yellow, and we are called the Golden Sufis or the Silent Sufis, because we practise silent meditation. We do not use music or dancing or any definite practice. We do not belong to any country or any civilization, but we work always according to the need of the people of the time. We belong to Raja Yoga, but not in the sense that it is practised by the Vedantins. Raja means simply 'Kingly', or 'Royal'—the Direct Road to Absolute Truth. (18)

There are Hindu Sufis, Muslim Sufis, Christian Sufis, he explained (13). And, referring to the Naqshbandiyya as the 'Nakshmandia', he said,

> The Nakshmandia Dynasty—the Golden Sufis—descends from the Prophet. The first Deputy was the father-in-law of the Prophet; but Sufis were before the Prophet.

Sufism always was: it is the Ancient Wisdom. Only before the Prophet they were not called Sufis and did not come to be called so until a few centuries after his death. (148)

True to this 'higher' Sufism, Bhai Sahib used both Sufi and Hindu terminology. He practiced *dhyana,* which he defined as "a complete abstraction of the senses . . . a Yogic state" (17). But when Mrs. Tweedie heard an inner sound, she was told that it was *Dzikr,* "the preliminary step to *dhyana*" (37). Yet at the same time, Bhai Sahib used *dhyana* to open the *cakras* (33). And he said of *kundalini,*

> When it is awakened by Hatha Yoga, it becomes a great problem. It is a difficult way. One has to know how to take it up and take it down again through all the chakras, and it is troublesome. But with us, we begin to notice it only when it reaches the heart chakra: it means peace, bliss, states of expanded consciousness. (27)

But ultimately, the spiritual path cannot be 'explained' in terms of experiences. In fact, it cannot be explained at all. For this is the path of love, "created by the spiritual teacher" (34), which is beyond the mind, beyond reason, beyond explanations and understanding, as Mrs. Tweedie found out.

> And so it came . . . It slipped itself into my heart, silently, imperceptibly, and I looked at it with wonder. It was still, small; a light-blue flame trembling softly, and it had the infinite sweetness of first love, like an offering of fragrant flowers made with gentle hands, the heart full of stillness and wonder and peace. (45)

Guru Bhai Sahib told her that she was "the first woman to get the training according to the Ancient Tradition" (123). (Not the first Western woman, mind—the first woman.) Not long afterwards, he said that she should return to England.

> There you will come into contact with people who knew you before and, if they see you have everything but are indifferent about everything, they will wonder and they will respect you and follow you. (161)

A month later, in April 1963, she packed her belongings. Guru Bhai Sahib sent his son and another man to move her furniture. They scratched her wardrobe and she lost her temper with them. When she went to say goodbye to him, he displayed his harsh side.

> "How did you dare to speak in such a way to my son! He is a man and you are only a woman! . . . What do I care about the wardrobe? You idiot old woman! I am glad that you are going at last! You have no respect towards my children! You are good for nothing, old and stupid!"
> I was so taken aback at this unexpected attack that I sat down, stunned. I don't even remember whether I cried or not . . .
> "Go!" Bhai Sahib shouted. "I don't want to see your face again! Go away!"
> I went and, when in the street, looked back. He was still sitting in the same place, bent double as though weighed down with a heavy burden.
> The last impression of him in my mind . . . (165)

She spent the next two and a half years in London. I do not know what she did there—except that she wrote to Guru Bhai Sahib regularly, two or three times a week. "I never had a direct answer; just a few lines . . . very rarely; about unimportant matters" (165).

She returned to Kanpur in December, 1965 and stayed with him until his death the following July. Shortly before he died, he spoke to her about their Sufi way.

He told me important things about the Nakshmandia Dynasty. To my question if in the Chishtia Dynasty they also have Param Para (spiritual succession) he replied:

"Yes, of course they have. And in all Sufi Systems the surrender to the Teacher is demanded. Chishtias are very magnetic, because many things they do through the physical body. So the body becomes very magnetic. It is the body which attracts the body and through it the soul. In our System, it is the soul which attracts the soul and the soul speaks to the soul . . .

Then I asked if, in the Chishtia System, love is also created, as in our System.

"No. This is done only with us. Nobody else has this method". (192)

It appears, then, that Mrs. Tweedie has received some authority to teach in this 'higher' Nakshbandi lineage, the Ancient Wisdom that is older than Islam. And she does it in the manner that she received it from Guru Bhai Sahib: by quickening rather than systematic teaching. She says that after he died,

I thought he had taken everything away from me—my possessions, my money, everything—and he didn't give me any teachings. But in a moment of meditation I found I could suddenly reach my teacher. He had no physical body any more, he was a circle of energy. And I was so full of awe. And the spiritual training began from there, on a different level of consciousness, in a different space, and it has continued throughout these last twenty years in the West. (Bancroft, 139)

During this time, people have gone to her house in London and sat with her, either in silent meditation or just talking, doing ordinary things. According to those who have been with her, there is something palpable in her presence. Guru Bhai Sahib has a good explanation of why this should be so: "Only the things we understand through realization are really ours" (*Chasm of Fire,* 120). It appears that Mrs. Tweedie is transmitting something that is really hers.

She retired from active teaching in 1991. I have been told recently that Llewellyn Vaughan-Lee "has been named as Mrs.Tweedie's successor in this lineage of Sufism" (letter from The Golden Sufi Center in California) but I do not know what this means exactly. He can be contacted at the address below.

Primary sources: Irina Tweedie, *Chasm of Fire* (Element Books, 1979) [the unabridged version, which is twice as long, is *Daughter of Fire* (Element Books, 1985; California: Blue Dolphin, 1986)] ; *Mystics Teach Simple Things* [no details; available from the Golden Sufi Center—see below]

Secondary sources: A. Bancroft, *Weavers of Wisdom: Women Mystics of the Twentieth Century* (London: Arkana, 1989), 129-139; R. Housden, *Fire in the Heart,* (Element Books, 1990), 161-67

Centre: The Golden Sufi Center, P.O. Box 428, Inverness, CA 94937-0428, U.S.A.; The Golden Sufi Center, 5 Ranelagh Avenue, London SW13 0BY, England, U.K.

COMPARE:

Other Western Naqshbandi teachers: Abdullah **Dougan**, Idries **Shah**

Other Westerners operating within a 'higher' tradition: Ven. **Sangharakshita**, Swami **Turiyasangitananda**, Samuel **Lewis**, J.G. **Bennett**

PAUL TWITCHELL

American founder of Eckankar, a teaching which he took from an Indian source without acknowledgement

Eckankar is fairly well known and has tens of thousands of followers throughout the Western world. Twitchell claimed that he was a master in this tradition—the 971st and the first Westerner. In fact, he took it lock, stock and barrel from the writings of others; in particular, the works of Julian Johnson (of whom, more presently). And when I say 'took' it, that is exactly what I mean. Compare the passages in Table 1: in the first column there are two separate passages from Johnson, in which, following his own master, Sawan Singh, he discusses the Sound Current (the first passage) and defines Kam (*Kama* in Sanskrit), the first of five defilements that hinder the spiritual life (the second passage). The second column is Twitchell's version. This is straight copying and no two ways about it.[1]

It is evident, then, that Twitchell is not the 971st Eck Master, as he claimed to be. Even so, his is an interesting story. And it has already been told by David Lane; everything that follows is taken from his work.

Twitchell was probably born in 1909 in Paduch, Kentucky. (Lane, 10–12, covers the alternatives.) We know next to nothing about his early life. He went to Western Kentucky Teachers College in 1933 and presumably completed his course (since he left in 1935) but I have no details, not even what he studied. In 1942, he went into the Navy; he also got married. After the war, he and his wife lived in New York. She says that he constantly read books on spiritual subjects and spent a lot of time meditating (Lane, 15).

Around 1950, the two of them joined Swami Premananda's Self-Revelation Church of Absolute Monism in Washington DC. (Premananda was an Indian disciple of Paramahansa *Yogananda* and taught a form of *kriya yoga*.) But in 1955, Twitchell (but not his wife) went on to another Indian teacher. This was Kirpal Singh, who made his first tour of America in that year. Kirpal Singh, who was a disciple of Sawan Singh (like Johnson) but had founded his own independent organization, Ruhani Satsang, taught Surat Shabd Yoga, a spiritual discipline involving contact with inner light and sound, the removal of the soul from the body and its ascent into inner worlds or regions. It is a form of Sikhism and thus goes back to Guru Nanak, the first Sikh guru, in the fifteenth century. However, as the quotation from Johnson given above shows, the path of sound and light is regarded as universal and is referred to in *St. John's Gospel*. It is likely that Twitchell came across Johnson's writings as a result of joining Kirpal Singh's Ruhani Satsang.

Surat Shabd Yoga requires that its practitioners are initiated by a master who has already contacted the inner light and sound and made the inner journey. Twitchell was initiated by Kirpal Singh during the 1955 visit (Lane, 22) and claimed that he had met him in non-physical form.

> I have talked with and taken down the words of Kirpal Singh who appeared in my apartment in Nari-raup, his light body, although his physical body was six-thousand miles away in India. (Twitchell, 'Eckankar: The Bilocation Philosophy', *Orion* magazine, January 1964; quoted, Lane, 23)

[1] Both *The Path of the Masters* and *Letters to Gail* have gone through a number of editions, each of which is slightly different. What is certain, however, is that Johnson's book was published some 30 years before Twitchell's. Lane gives references—though because he does not cite editions and page numbers, they are not exact—to over 400 paragraphs from two of Johnson's books which Twitchell incorporated into his own works (Lane, 134).

TABLE 1
Twitchell's use of Johnson's material

| **Julian Johnson** | **Paul Twitchell** |
|---|---|
| *The Path of the Masters* (Punjab: Sawan Service League, 1939) | *Letters to Gail* (Las Vegas: Illumined Way Press, ca. 1973) |

| | |
|---|---|
| This great truth or fact is significantly spoken of in the first chapter of the Gospel of John: "In the beginning was the Word, and the Word was God. All things were made by him and without him was not anything made that was made." | This great truth, or fact, is significantly spoken of in the first chapter of the Gospel of St. John: "In the beginning was the Word, and the Word was God. All things were made by him and without him was not anything made that was made." |
| Here it is definitely stated that something which is called "Word" is identical with God, the Creator. | Here it is definitely stated that something which is called the Word is identical with the Alone (God), the Creator. Although it isn't understood by Christians, this statement is an important announcement of the stupendous fact of the Eck, or life stream. It is often called the Sound Current, but that is not a good name for it, because it is not sufficiently definitive. The Indian name Shabda simply means sound, but this isn't specific enough for there are sounds. Logos was the Greek term used by the Neoplatonists—whose masters were familiar with portions of the eastern wisdom. Logos means the divine word. |
| Although not at all understood by the Christian church, this statement is an important announcement of the stupendous fact of the Audible Life Stream. It is often called the Sound Current. But that is not a good name for it because it is not sufficiently definitive. The Indian name is simply Shabd, meaning sound. But that is not definitely clear. There are many sounds. Logos was the Greek term used by the Neoplatonic school, whose masters were familiar with portions of the Eastern Wisdom. Logos means the divine word. | |
| Kam or lust is a normal function but allowed to run into an abnormal demand, it becomes destructive, degrading. In its broader meaning Kam includes all desires. It may include drugs, alcoholic drinks, tobacco or even tasty foods which are eaten simply for the sake of enjoying their tastes. Any sort of appetite which seeks indulgence for the sake of enjoying a pleasant sensation—in some respects this is the strongest of the five and so the most deadly. It is dominant over the vast majority of mankind. It holds them as if by iron chains . . . Last of all, when you have wasted your vitality in its indulgences, it tosses you upon the rubbish heap. It coarsens its victims to the level of the animal. It clouds his perceptions and dulls his wits. | Lust is a normal function allowed to run into an abnormal demand where it becomes destructive and degrading. The broader meaning includes all abnormal desires, if the Indian word Karma is used. This might include drugs, alcoholic drinks, tobacco, or even tasty foods which are eaten simply for the sake of enjoying their taste. Any sort of appetite which seeks indulgence for the sake of enjoying a pleasant sensation. In some respects this is the strongest of the five and where this is the case, then the most deadly. This true of a vast majority of mankind, and holds them as in iron chains. So when you have wasted your vitality in its indulgence, it tosses you upon the rubbish heap; it coarsens its victims to the level of the animal, clouds his perceptions and dulls his wits. |

(Notice the mistaken use of Karma *for* Kama*)*

These comparisons are taken from Lane, 69, 71; he does not cite page numbers nor the editions he used.

Twitchell says that he was given teachings during these 'appearances'. He put them in one of his first books, *The Tiger's Fang,* which he began to write shortly after his initiation. Kirpal Singh himself confirmed that Twitchell wrote to him saying that he was putting this 'inner' teaching into a book (Lane, 22, 26).

But Twitchell severed all contact with Kirpal Singh during Kirpal Singh's second American tour in 1963 and struck out on his own. In that year, Twitchell wrote a newspaper article in which he mentioned Eckankar for the

first time, saying that it was "a new religion"(Lane, 31).[2] In 1964 (the year he married Gail Atkinson—hence *Letters to Gail*), Twitchell wrote another article, in which he acknowledged his debt to Surat Shabd Yoga. He says that he formed Eckankar "out of my own experience."

> It is based on Shabd-Yoga, a way out form of yoga. The word is the Hindu locution for the cosmic sound current which is known in our vernacular as the cosmic river of God. (*The Psychic Observer,* July 1964; quoted in Lane, 32)

At this point, then, Twitchell is presenting himself as someone who has practised Shabd Yoga himself, under the guidance of an Indian master (Kirpal Singh), and developed his own form of it. But he did not rest there. From about 1967 onwards, he started to say that he had received training and instructions from an Eck master called Rebazar Tarzs, a Tibetan monk who 'appeared' and taught him personally. In order to maintain this fiction, he systematicaly rewrote various of his own publications. Lane has given several instances of this process. For example, *The Flute of God* was originally published in serial form in *Orion* magazine in 1966. It mentions various teachers by name. Four years later, in the 1970 book version published by Eckankar's own Illustrated Way Press, all the names have been changed to so-called Eck Masters. (See Table 2)

The only consistent thing in this whole farrago is Twitchell's presentation of Eckankar as 'the ancient science of soul travel'; that is, as a discipline by which one consciously leaves the body so that the soul, guided by inner sound and light, can travel in higher spiritual regions. In this, of course, he was simply following what he had learned from the works of Kirpal Singh and Julian Johnson, substituting *Eck* for *Shabd* or *Sound Current,* and 'Sudar Singh' and 'Rebazar Tzars' for a combination of other masters such as Guru Nanak and Kirpal Singh.

There seems little point in giving any further details of Eckankar,[3] which has the same relationship to the original Surat Shabd tradition as plastic flowers do to those that someone has actually grown. ("That's a good copy! Fooled me until I got up close.")

This is an unedifying tale, whichever way one looks at it. But people should know about it—and for three reasons. First, because Eckankar is an example of spiritual psychology: it contains all four principles of *consciousness,* a *spiritual practice,* a *teacher,* and a form of *transmission.* Second, because at least one other Western teacher, **John-Roger** Hinkins, started off in Eckankar (and his teachings are obviously influenced by it, though he denies

[2] According to Twitchell, *Eckankar* is a Hindu term meaning 'union with God' In fact, *eka* means 'one' and the *ankara* part is a form of *onkara* or *omkara,* literally meaning 'the syllable *om*' but also used as a name of the divine. 'Ek-onkar' is the very first in the list of the names of God given in the *Japji,* a Sikh scripture published in English translation by Kirpal Singh's Ruhani Satsang (Lane, 6, n. 2).

[3] Just to finish the story off, I note the following developments:

1971 Twitchell dies. Succeeded as Eck Master by Darwin Gross following a dream by Gail, Twitchell's widow. Her former husband appeared in his Nari Sarup or light body, she said, and declared that Gross was to be the new master. Shortly afterwards, Gail Twitchell and Darwin Gross were married.

1978 Gross and Gail divorce.

1981 Gross hands over the Eck Mastership to another initiate, Harold Klemp—no one quite knows why—but continues as Eckankar president.

1984 Klemp expels Gross from Eckankar and removes all his initiations. Gross starts his own organization, Sounds of Soul. It has not been a rousing success. Klemp continues as Eck Master.

(All these events are covered by David Lane in the issues of *Understanding Cults and Spiritual Movements* cited at the end of this entry.)

TABLE 2
Twitchell's use of his own material

| *The Flute of God* (*Orion* Magazine, 1966) | *The Flute of God* (Las Vegas: Illuminated Way Press, 1970) |
|---|---|
| I have studied under many teachers, and may yet have to study under more. Like Meher Baba, the Indian saint, who was said to have nineteen teachers to help him gain his place in the universe, I have so far had seven, including Sri Kirpal Singh, of Delhi, India. | I have studied under many Eck Masters and only they have led me to the highest truth. Like Fubbi Quantz, who was said to have nineteen teachers to help him gain his place in the universe, I have also had several, each outstanding, one being Sudar Singh of India. |
| Each has a place in my growth towards the spiritual goal; each are equally great in their work for mankind. However, I have felt a close kinship and friendliness to Kirpal Singh, who has shown me a lot of the other work during my first year or so under him. Since we have parted he keeps an impartial view toward me and my research. | Each has a place in my growth towards the spiritual goal; each are equally great in their work for mankind. However, I have felt a close kinship and friendliness to Sudar Singh, who has shown me a lot of the other work during my first year or so under him. Since we have parted he keeps an impartial view toward me and my research. |
| Christ said, "Blessed are the pure in heart for they shall see God." Guru Nanak said, "Be pure that truth may be realized." | Jesus said, "Blessed are the pure in heart for they shall see God." Rebazar Tarzs said, "Be pure so that truth may be known." |
| One of my experiences while serving under the Yoga Satsang line of masters was that I found one of the masters in the guise of a beggar. I had been in difficulty for some time, and was very unhappy over the fact that nothing could be found to solve my problem. | One of my experiences while serving under Rebazar Tarzs was that I found one of the ECK masters in the guise of a beggar. I had been in difficulty for some time, and was very unhappy over the fact that nothing could be found to solve my problem. |

These comparisons are taken from Lane, 69, 71 and 127–132; he does not cite page numbers nor the edition of *The Flute of God* he used.

it—see his entry). And third, because it is a cardinal principle that teachers' claims should be put to the test. What we find here, of course, is that one cannot get honey from plastic flowers.

Primary sources: Paul Twitchell, *The Tiger's Fang* (1967); *The Flute of God* (1970); *Letters to Gail* (1973) [all these books published by Illuminated Way Press, San Diego, California]

Secondary sources: David Lane, *The Making of a Spiritual Movement: The Untold Story of Paul Twitchell and Eckankar,* (Del Mar, California: Del Mar Press, 1983); David Lane, ed., *Understanding Cults and Spiritual Movements,* vol. 2, no. 1 (1986) and vol. 2, nos. 2 and 3 (these last two a double issue), 1987—an irregular periodical issued by Del Mar Press; David Lane, *Fubbi: Adventures with Peddar, Dap, and Wah Z,* vol. 1, no. 1, 1995 (available from Del Mar Press)

Centre: Eckankar, P.O. Box 3100, Menlo Park, CA 94205, U.S.A.; Sounds of Soul [Darwin Gross], P.O. Box 68290, Oak Grove, OR 97268, U.S.A.

COMPARE:

Other Western teachers of the path of inner light and sound: **John-Roger**, John **Yarr**

VIPASSANA SANGHA

Lay Westerners, of all nationalities, who form the core of a new Buddhist community

The Western *vipassana sangha* really requires a book of its own. It is extremely varied and is developing in several directions simultaneously. The reason for this is simply that there are various forms of *vipassana* being taught in different ways by a large number of teachers.[1]

I shall take up these matters later. But first, some historical background. *Vipassana* literally means 'insight'—specifically, insight into the three marks of all conditioned existence, namely, impermanence, suffering and no-self. Anyone who has this insight is incapable of attachment and craving, and is thus liberated from *samsara*. In short, *vipassana* is the means to enlightenment; perhaps not the only means but certainly one that the Buddha himself discovered, practiced and taught. He also inaugurated the *sangha,* which consisted of both monks and nuns and which practised *vipassana*. But the laity, both male and female, also practised it and there are accounts in the Theravadin texts of them attaining enlightenment as a result.

However, the Theravada that Westerners discovered was very different from this. Carrithers reports that as late as 1950 very few monks in Sri Lanka had any experience in meditation to speak of. In fact, it is generally accepted in Sri Lanka that the meditation tradition had been lost around the fourteenth century! Instead, what might be called a 'conservative' *sangha* grew up, which was concerned with strict observance of the *Vinaya* rules; paid little, if any, attention to the laity (so they could not practice meditation either); had no place for women; and regarded meditation as a secondary matter, an option reserved for specialists. Carrithers describes the attempts of one monk, Nanarama, to rediscover the principles in the 1950s. He was ultimately successful—but he had to rely on texts and on a Burmese monk who was staying in Sri Lanka at the time. He simply could not find a Sinhalese monk to teach him. (For details of Nanarama's search, see Carrithers, Chapter 11.)

Yet an alternative to 'conservative' Theravada did exist. It could be called 'inner' Theravada and it held that there is no compelling reason why the methods of *vipassana*/insight (into the three marks of impermanence, suffering and no-self) should not be applied to the twentieth century, by lay people as well as members of the *sangha,* and by women as well as men; nor is there any reason why this practice should not lead to enlightenment. Where did this ideal come from? The short answer is that we don't really know. But we can at least trace it back to nineteenth century Burma. King Mindon (1853–78) encouraged monks to tell him about vipassana practice (Houtman, 40), though whether they actually taught it to him, I do not know. But his interest appears

[1] I do not have the space to mention them all. I have therefore concentrated on a handful—mainly because they have some historical significance and/or exemplify particular points that I want to make about the Western *vipassana sangha* as a whole. The fact that I have chosen them does not mean that they are the best teachers; nor does the non-inclusion of others mean that they are of lesser value. Some of those whom I have not mentioned include (in alphabetical order): James Baraz, Sylvia Boorstein, Howard Cohn, Christina Feldman, Michele McDonald, Mary Orr, Larry Rosenberg, Steven Smith, Fred von Allmen; plus the Thai teacher, Dhiravamsa. This list does not include those, like Stephen and Martine Batchelor, and Stephen Levine, who are not primarily *vipassana* teachers but do teach it. There is an extended Dharma circle here which could do with further research.

Burmese *vipassana* teachers

| Name | Status | Notes |
|------|--------|-------|
| | | *First generation teachers (meaning the first whom we can actually name; there were others before that but we don't know who they were)* |
| Ledi Sayadaw (1856–1923) | monk | *started practice:* 1887 (northern Burma—apparently independently of U Narada) (Houtman, 43)
claims about attainment: no information
attitude to the laity: taught lay people (for example Saya That Gyi, who was U Ba Khin's teacher)
pupils mentioned in this entry: U Ba Khin (see below) |
| U Narada/ Mingun Sayadaw (1868–1955) | monk | *started practice:* 1905 (southern Burma—apparently independently of Ledi Sayadaw) (Houtman 43)
claims about attainment: many believed that he had attained *arahantship*—that is, enlightenment (Nyanaponika, 86)
attitude to the laity: had lay pupils; one pupil who was a monk, U Pandidama, reverted to lay life in order to establish meditation centres in the 1930s (mainly in Burma but some in Thailand and Indo-China) (Houtman, 44)
pupils mentioned in this entry: Mahasi Sayadaw (see below) |
| Sunlun Sayadaw/ U Kyaw Din (1878-1952) | started as layman and then became a monk | *started practice:* 1919
claims about attainment: went through the first three stages of enlightenment (*sotapanna*/stream-enterer, *sakadagamin*/once-returner, *anagamin*/never-returner) as a layman, then entered the *sangha* and attained *arahantship*/enlightenment) (Kornfield, *Living Buddhist Masters*, 83–85)
attitude to the laity: no exact information (but his teacher was a layman [Kornfield, op. cit.])
pupils mentioned in this entry: none |
| | | *Subsequent generations* |
| U Ba Khin (1899–1971)

[grand-pupil of Ledi Sayadaw] | layman | *started practice:* 1937
claims about attainment: no information; (was Accountant-General of the Burmese government)
attitude to the laity: starting in 1941, taught lay people regardless of sex, status or nationality; one of them was the Burmese Prime Minister, U Nu; established the International Meditation Centre in Rangoon in 1952, which was run by a woman, Mother Sayama, for some years
pupils mentioned in this entry: S.N. Goenka, Ruth Denison, John Coleman |
| Mahasi Sayadaw (1904–1982)

[pupil of U Narada] | monk | *started practice:* ordained in 1914; went to practise with U Narada some time after that
claims about attainment: no information; (was *pucchaka*/'chief questioner', the most prestigious role, at the World Buddhist Council in Rangoon in 1956)
attitude to the laity: starting ca. 1949, taught lay people, over half of them women; also taught children (Houtman, 149, 155)
pupils mentioned in this entry: Anagarika Munindra, Dipa Ma, Freda Bedi, Nyanaponika Thera, E.H. Shattock, Jack Kornfield, Joseph Goldstein, Sharon Salzberg, Jacqueline Mandell |

to have given rise to a movement. The accompanying table gives a summary of some of the most important individuals in it. (It should be read in conjunction with Lineage Tree 10 on p. 593.)[2]

There are two aspects of the lives of these men that are significant. The first is that they were looking for enlightenment. Whether we should accept the claims that U Narada and Sunlun Sayadaw attained it is not the issue here. The point is that they were made at all. The second is that they were open to the laity.

The numbers affected by the *vipassana* movement in Burma have been considerable. Mahasi Sayadaw alone had 293 centres in 1981, which had taught over 600,000 people (Houtman, 140). The fact that the Prime Minister, U Nu, was a pupil of U Ba Khin must surely have helped to introduce the practice of *vipassana* into Burmese prisons in 1957.

But perhaps more significant than sheer numbers (at least as far as the development of a Western *vipassana sangha* is concerned) is that Burmese practitioners have developed a new vocabulary. Laypersons refer to themselves as *yogis* and claim to be 'true' members of the *sangha*. What they mean is that they are members of the 'ultimate *sangha*' (*paramatha thanga* in Burmese; *paramatha sangha* in Pali), by virtue of their meditational practice, rather than of the 'conventional sangha' (*thamokthi thanga* in Burmese; *sammuti sangha* in Pali), which perpetuates itself by formal ordination (Houtman, 76). And it is assumed, of course, that the 'ultimate' *sangha* is more significant than the conventional one. Moreover, modern biographies of Burmese *vipassana* teachers who are monks include a 'lineage of practice' in addition to the traditional 'lineage of preceptors'—that is, the other monks who were present at the time of ordination (Houtman, 91).

Even in this brief outline, it is evident that the Burmese *vipassana* movement is quite complex, and was so more or less from the beginning. I should also say—just to thicken the plot—that there is not just one single *vipassana* method common to all teachers, but several. (Houtman says that there are at least two dozen.) Together with the hundreds of centres and hundreds of thousands of practitioners, this gives rise to many *vipassana* traditions, not one (Houtman, 14). Even so, the most significant thing about the introduction of *vipassana* as the focus of the spiritual life has been that it has brought about fundamental changes in the Theravadin tradition. These changes are really threefold:

First, the laity has been included in the tradition in a way that it was not before; although *vipassana* was first taught by monks and monks still teach it, laymen also practised it in the early years of this century (as the story of U Kyaw Din/Sunlun Sayadaw shows) and they also went on to become teachers—and so did laywomen some time later.

Secondly, claims were made (and still are), for both monks and lay people, that, as a result of their practice of *vipassana*, they attained some of the earlier fruits of the path and even enlightenment/Nibbana/*arahantship* itself (though this last is not claimed for laywomen, to my knowledge).

[2] Just to complete this historical sketch, I should say that at some point during the past century—certainly as early as the 1930s, as we know from U Pandidama/U Myat Kyaw's efforts (see table under U Narada)—the Burmese *vipassana* method spread to Thailand (and much later to Sri Lanka, as the story of Nanarama, mentioned above, shows). Thailand, in its turn, has produced its own meditation masters, of whom the best known in the West are probably Ajahn Chah and Buddhadasa. Jack Kornfield includes twelve teachers in his book, *Living Buddhist Masters*: six Burmese and six Thai, and all monks apart from U Ba Khin and Ajahn Naeb, a Thai woman.

Kornfield

Thirdly, and following on from the second point, this form of Theravada is really teacher-oriented rather than *sangha*-oriented; it is no accident that **Kornfield**'s book about various Eastern *vipassana* teachers is entitled *Living Buddhist Masters*.

In short, there is a direct way to enlightenment; there are masters who can teach it; and it is open to everyone.

It is against this background—of a teacher-based, lay-oriented, enlightenment-seeking movement—that Westerners made their entry into the *vipassana sangha*. We should, however, give full credit to the Burmese teachers whom I have already mentioned for encouraging foreigners to practice *vipassana* in the first place. As early as 1914, Ledi Sayadaw wrote a commentary (in Burmese) on the *vipassana* method 'for the benefit of European Buddhists' (Houtman, 30). This was doubly innovatory: not only because he was interested in foreigners but because he actually wrote his ideas down; traditionally all teaching was given orally. As far as I know, this book had no real impact. But what is significant is that it was written at all. And once U Ba Khin had set up his International Meditation Centre in 1952, he regarded the teaching of foreigners as one of his main tasks. By the time of his death in 1971, 300 of the 3,500 whom he had personally taught were foreign (Houtman, 213).[3]

Western practitioners were extremely varied from the beginning. Freda **Bedi** and **Nyanaponika** Thera went to Burma quite independently of each other, in 1952 and 1954 respectively, and both practised with Mahasi Sayadaw. It is typical of the *vipassana* movement that these two—the first Westerners I know of who practised with an Eastern teacher—should have been so different: a woman who later entered the Tibetan tradition and took full *bhikshuni* ordination, and a Theravadin monk.

They were followed by two unusual Americans: E.H. Shattock, an admiral and Chief of the Allied Fleet, who also practised with Mahasi Sayadaw (in Rangoon in 1956); and John Coleman, who worked in Thailand for the CIA from 1945 to 1957, and began his practice with U Ba Khin, also in Rangoon, in 1958. Both these men subsequently wrote books (see 'Primary sources' at the end of this entry), and Coleman was also appointed as a *vipassana* teacher by U Ba Khin (though I do not have the date) (*The Quiet Mind*, 226).

Then in the early 1960s, a new ingredient was added to the Western *vipassana* pie: Westerners began to enter the *bhikkhu* or monk's *sangha* in Thailand. (There were also some in Burma to begin with but the military coup in 1962 effectively closed the country to foreigners.) It is, of course, significant that Westerners have become monks and practise *vipassana*. But though they have a contribution to make, their first commitment is to the *bhikkhu sangha* and they follow its rules (the *Vinaya*). That is why they are monks. In contrast, the *vipassana sangha* proper, which is predominantly lay, is developing its own rules and guidelines as it goes along (see below).

Some *vipassana* teachers, such as Jack **Kornfield** and Christopher **Titmuss**, both ordained in Thailand in 1970 (but independently of each other),

[3] But 'foreign' does not necessarily mean 'Western'. In fact, it is one of the interesting features of the international *vipassana* movement that three of its earliest members were Indian. Dipa Ma, a Bengali woman, practised with Mahasi Sayadaw as early as 1950 or so. (This date is worked out from the information given about her in *Inquiring Mind*, 6/2, 1990, 18; if it is correct, she was the first foreign—that is, non-Burmese or non-Thai—practitioner that I have any record of.) In 1955, S.N. Goenka, an Indian born in Burma and part of the small Indian community in that country, started practising with U Ba Khin. And in 1957, Anagarika Munindra (though he was not an 'Anagarika' at the time) went to Burma to practise with Mahasi Sayadaw—and stayed for seven years. These three Indians went on to become significant *vipassana* teachers; and all of them had Western pupils who became teachers in their turn.

Goldstein

have in fact been monks but have since reverted to lay life. But the majority of Western *vipassana* teachers have been laymen or laywomen from the beginning. Joseph **Goldstein**, who started practising with Anagarika Munindra at Bodh Gaya in India in 1967, is an example. All his main teachers were lay and he considers what he received from them to be "an authentic transmission."

> I'm not so concerned with any labels or the cultural forms of the tradition, although I do appreciate the many ways the dhamma has evolved in Asian cultures. Instead, what inspires me is the connection with the original teachings of the Buddha—with what, as far we know, he actually taught during his lifetime . . . What I would like to be doing, and what I hope I am doing, is teaching what the Buddha taught based on my own experience of it . . . ('Possibilities of the Path: An Interview with Joseph Goldstein', *Inquiring Mind* 6/1, 1989, 1)

Goldstein and **Kornfield** have worked together for the past 20 years. Having practised independently of each other in the East, they also returned to America separately and began to teach separately. They actually met at Chogyam *Trungpa's* Naropa Institute in Boulder, Colorado, in 1974. **Kornfield** had been asked to teach there by *Trungpa* himself (when they met at a cocktail party in Cambridge); **Goldstein** had been invited by **Ram Dass** (when the two of them met at a restaurant in Berkeley) to help in a course that Ram Dass was giving at Naropa on the *Bhagavad Gita.*

The story of these encounters (taken from Rick Fields's *How the Swans Came to the Lake: A Narrative History of Buddhism in America,* 318–320), involving a Tibetan Buddhist and an American devotee of an Indian guru, is typical of the whole phenomenon I am describing in this book. And it is also typical of the *vipassana* branch of it that, despite their different track records, **Kornfield** and **Goldstein** are regarded as equals. People do not think that one is superior or inferior because he has or has not been a member of the traditional *bhikkhu sangha.* It is depth of *vipassana* practice that counts, not how one got there or where one comes from.

This principle that the only credentials that are of any value are practice and experience explains another distinctive feature of the Western *vipassana sangha:* the prominence of women; not only as practitioners but as teachers. (A much larger proportion of the *sangha* are women than in any other group in this book). Many of them are distinctive.

Ruth Denison, for example, was born in East Prussia in 1922 and was imprisoned more than once (having escaped) in Russian labour camps during World War II. She emigrated to America in 1956, married a man who had been a *swami* in the Ramakrishna Order for several years, and found herself mixing with people like *Krishnamurti,* Gerald Heard, and Alan **Watts**. She then heard about U Ba Khin and went to Rangoon in the early 1960s to practice *vipassana* under his direction. (This was the same time that Jack **Kornfield**/ Bhikkhu Sunno was a monk in Thailand under Ajahn Dhammadharo.) She subsequently (from 1964 to 1966) trained in Japan with a number of well-known Zen masters: Nakagawa Soen Roshi, *Yasutani* Roshi and *Yamada* Roshi. (She has also done *koan* training with *Maezumi* Roshi at the Zen Center of Los Angeles—but I have no dates.)

In 1969, U Ba Khin authorized her to teach. She now has her own centre in California and I think it is fair to say that the way she presents *vipassana* is very different from the method that she learnt from U Ba Khin in Burma. The vast majority of her pupils are women, many of them lesbian. One of them referred to her as providing "a pioneering feminist contribution". She herself has said that she is interested in "the transformation of society", and she is

Salzberg

prepared to use any method that will achieve greater awareness. "When there is strong awareness, one can be creative. A new approach is no problem." (All this information is taken from Friedman, 135–146.)

Sharon **Salzberg** was also a pioneer. She started practicing with Goenka (see n. 3) in India in 1970—when she was just 18 years old. She met Joseph **Goldstein** while she was there and over the next few years practised with **Goldstein**'s own teacher, Anagarika Munindra, as well as with Dipa Ma (see n. 3 for these two) and Mother Sayama (see table, p. 587). She has also been a pupil of Kalu Rinpoche, one of the most respected teachers of meditation in the Tibetan tradition. In 1976, when she was 24, she helped found the Insight Meditation Society. She taught widely and intensively over the next few years. Then, in 1984, she met U Pandita, Mahasi Sayadaw's 'successor' in Burma, when he came to IMS in Massachusetts to lead a three-month retreat. The moment she saw him, she says, she felt as if she had been "hit by lightning". She has since practised with him at his monastery in Burma. (All this information is from Friedman, 213-226.)

Jacqueline **Mandell**, on the other hand, has followed a different path. She was a teacher at IMS in the early days; and, together with **Kornfield**, **Goldstein** and **Salzberg**, was formally appointed as a *vipassana* teacher by Mahasi Sayadaw at a special ceremony at Taungpulu Monastery[4] in California in 1979. Her main teachers were Mahasi Sayadaw in Burma and Goenka in India. She has also been ordained twice: as an eight-precept 'nun' in Burma in 1980, and as a ten-precept forest 'nun'[5] at Taungpulu Monastery in 1981. And she has also trained with the Japanese Rinzai Zen master, Joshu Sasaki Roshi. All of this shows a considerable dedication to practice. Yet in 1983, she resigned from the teaching staff of the Insight Meditation Society and effectively left the Theravadin tradition altogether because of its innate discrimination against women. By this, she does not mean that she was discriminated against by her own teachers—she expressly says that she wasn't—but that Theravada as a tradition treats women as inferior.

> For thousands of years it's been patriarchy. Now we're in a time when there can be change, there can be a shift. But it means letting go of certain kinds of behavior, of standards that don't need to be accepted anymore. (Friedman, 260)

> I could no longer stand before women and say that I represent a tradition which does not recognize a woman as an equal being. (Sidor, 23)

She is now an independent teacher: "I don't represent anyone" (Friedman, 259).[6]

These three women—**Denison**, **Salzberg**, **Mandell**—are typical of the Western *vipassana sangha* in that they have all practised with a variety of teachers (male, female; lay, monk; in more than one *vipassana* lineage; and in more than one Buddhist tradition). Yet they are clearly very different from each other. **Denison** and **Mandell** are particularly women-oriented (though not in

[4] Taungpulu Sayadaw is a Burmese monk who, like Mahasi Sayadaw, was taught by U Narada.

[5] I put the word 'nun' in scare quotes only because, strictly speaking, a Theravadin nun—without scare quotes—should follow the 311 precepts according to the Theravadin *Vinaya*. But as I pointed out at the beginning of this entry, this nun's *sangha* disappeared in Sri Lanka and Burma centuries ago and has never been revived.

[6] Compare Toni **Packer,** who left Philip **Kapleau** in 1982 and does not even consider herself a Buddhist anymore; Joko **Beck,** who left *Maezumi* Roshi in 1983 and set up her own Zen Center in San Diego; Gesshin **Prabhasa Dharma,** who resigned from the Rinzai lineage, also in 1983, and joined the Vietnamese tradition; and Ayya **Khema,** who did the opposite from all these women, and extended the Theravadin tradition by establishing a Nun's Island in Sri Lanka in 1984. All these incidents took place within the space of three years.

Titmuss

the same way); and both are committed to the lay life (**Mandell** after trying the life of a Theravadin 'nun', which **Denison** has never done). **Salzberg**, on the other hand, has strengthened her ties with the monastic *sangha* through her relationship with U Pandita. Yet while they differ about the relevance of traditional structures, customs and terminology—**Salzberg** teaches using the *Satipatthana Suttanta*; **Mandell** says that "there's no text to give to a woman living on a ranch in Texas" (Boucher, 42)—they are all tried and tested *vipassana* teachers. This is how the Western *vipassana sangha* works: there is no central control and individual teachers and groups all have their contribution to make.

This raises the question of how *vipassana* teachers become teachers in the first place. All of the ones featured in this entry were encouraged to teach by their Eastern teachers: **Goldstein** by Munindra (in 1974); **Kornfield** by Ajahn Chah; **Titmuss** by Ajahn Dhammadaro and Ajahn Buddhadasa—who told him, "Only teach Westerners the Ultimate Nature of things" (letter to me from Christopher Titmuss). And I have already mentioned U Ba Khin's appointment of Ruth **Denison** and John Coleman;[7] and Mahasi Sayadaw's appointment of **Goldstein**, **Kornfield**, **Salzberg** and **Mandell** in 1979. But this last was three years *after* they had started the Insight Meditation Society. Yet no one, as far as I know, has suggested that it would have been better if they had waited for this formal ceremony before they started teaching.

In fact, public ceremonies such as this are the exception rather than the rule. The vipassana tradition simply does not put stress on such things. Of course, it is important to know who a teacher's teacher was. But the difference between being authorized to teach and 'just' being a good student and good teacher, is often a fine one (see Lineage Tree 10). This would be a problem for traditions for whom formal authorization is central. But it isn't for the *vipassana sangha*. When it comes down to it, it is the effectiveness of the teaching that counts, not formal transmission. Or to put it another way, the proof of the pudding is in the eating, not in the chef's lineage.

This principle applies equally to Westerners who are now being trained by 'first generation' teachers like **Titmuss** and **Kornfield**. Whether these 'second generation' teachers will be accepted or not will not depend on any special authority that **Titmuss** and **Kornfield** possess but simply on whether a significant section of the *vipassana sangha* regards them as effective teachers. Moreover, at least in the case of the teachers who are training under **Kornfield**'s overall supervision, their apprenticeship includes training "with a wide variety of recognized meditation teachers" (*Inquiring Mind*, 7/1, 1990, 22).

So while there are *vipassana* lineages, they are not exclusive. It is typical of the *vipassana sangha* that these 'practice lineages' are intertwined. This is the rule rather than the exception. People often practice with teachers from both the Mahasi Sayadaw and the U Ba Khin lineages. And some of them have also practiced meditation with teachers from other Buddhist traditions. All the Western teachers featured in this entry are examples of this 'crossover' principle in one way or another. [8]

[7] U Ba Khin also appointed four others: Robert Hover, Lyon Right, J. Amersfoort, and Za-lin Lan-Di—who is obviously not Western but is still part of the international *vipassana sangha*, which U Ba Khin himself helped to inaugurate. (These names taken from Houtman, 297; I have no other information.)

[8] This explains why the list of retreats and courses offered by *vipassana* centres are so varied. For example, among the courses offered at Gaia House in England (founded in 1984 by Christopher **Titmuss** and Christina Feldman) were just one by a Burmese monk; and the following by Westerners: by a couple of ex-monks (and they had been in the *bhikkhu sangha* for over 20 years); by Ayya **Khema**, a Theravadin 'nun' and one of her

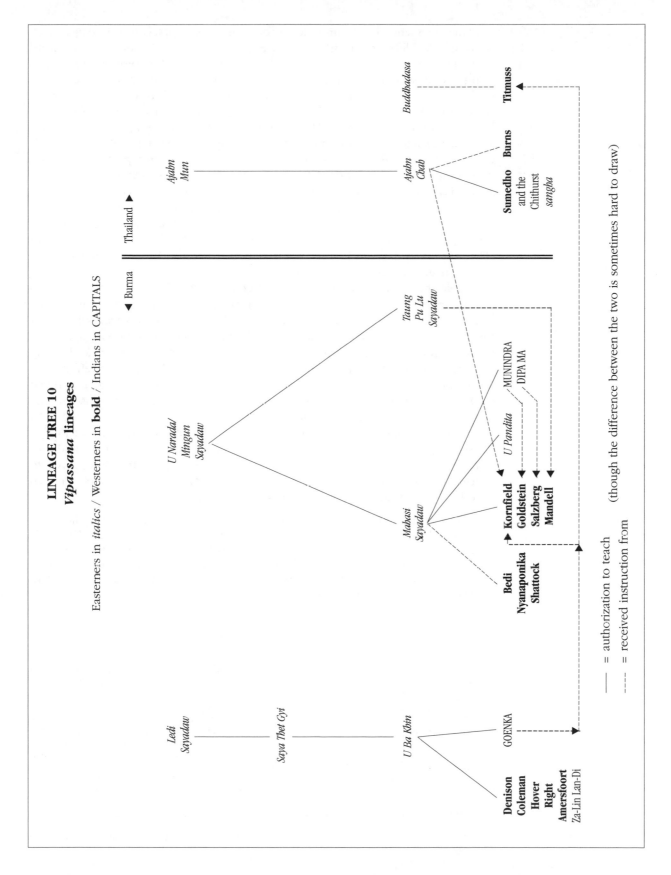

LINEAGE TREE 10
Vipassana **lineages**

Easterners in *italics* / Westerners in **bold** / Indians in CAPITALS

▼ Burma Thailand ▼

*Ledi
Sayadaw*

Saya Thet Gyi

U Ba Khin

GOENKA

**Denison
Coleman
Hover
Right
Amersfoort**
Za-Lin Lan-Di

*U Narada/
Mingun
Sayadaw*

*Taung
Pu Lu
Sayadaw*

*Mahasi
Sayadaw*

U Pandita

MUNINDRA
DIPA MA

▶ **Kornfield
Goldstein
Salzberg
Mandell**

**Bedi
Nyanaponika
Shattock**

*Ajahn
Mun*

*Ajahn
Chah*

Sumedho
and the
Chithurst
sangha

Burns

Buddhadasa

Titmuss

——— = authorization to teach (though the difference between the two is sometimes hard to draw)
- - - - = received instruction from

This crossing of boundaries—both between *vipassana* lineages and between Buddhist traditions—is typical of 'inner' paths. When a certain state of awareness/consciousness is placed at the centre of the spiritual life, everything else is seen as secondary and can therefore be fitted round it. Hence we find a number of 'Right Livelihood Groups' at Spirit Rock (the Californian wing of the Insight Meditation Society, which was set up, with Jack **Kornfield** as a leading enthusiast, in 1989). These are formed by *vipassana* practitioners who share a particular vocation and want to put it in the context of their experience of *vipassana:* for example, health care; the helping professions; psychotherapists; and parents. All of these are lay, of course. And when Jack **Kornfield** writes an article entitled 'Parenting as Practice' (*Inquiring Mind,* 5/2, 1989, 12), this is obviously not a subject that a monk could address with any degree of conviction. Similarly, **Titmuss** has participated in groups that investigate such topics as 'Ecology and Spirituality' (with the Dalai Lama) and 'The Toxic World' (with Joanna **Macy**). He has also stood as a Green Party candidate in general elections in Britain.

All of this is crossing boundaries, of course. (Or to be more accurate, it is a combination of extending *and* crossing boundaries.) Yet at the same time, after a series of revelations about unacceptable conduct by various Buddhist teachers (both Eastern and Western, and in all the major traditions), *vipassana* teachers have established guidelines (in 1991) about how they, as leading members of the Western *vipassana sangha,* should behave. In effect, the guidelines involve nothing more radical than clear and unequivocal adherence to the five basic precepts: refraining from: killing; stealing; sexual misconduct; false speech; and intoxicants. Of these, the most important, because the most frequently infringed, are probably the second (stealing in the sense of misappropriating funds) and the third (sexual relations between teachers and students). An Ethics Committee was set up, which has certain procedures to follow if there is a complaint against a teacher. All of this is entirely lay-oriented. As Jack **Kornfield** said in an article on the subject,

> this is the first time in the history of Buddhism that there is a large Buddhist community led by lay teachers. The monks who are the main teachers of the Theravada lineage in Asia take on 227 vows and follow strict Asian customs. However, these conduct guidelines for Asian monks and nuns are not appropriate for lay teachers in the West. Without monastic vows and Asian customs, we see a need for clear Western lay guidelines. (*Inquiring Mind,* 8/1, 1991, 19)[9]

pupils; by someone who has been a monk in the Tibetan tradition and in the Korean Zen tradition but is now a layman; by a layman who had been authorized to teach Ch'an Buddhism by his Chinese teacher but is also a teacher of humanistic psychology; and by lay teachers (both male and female) who have practised both *vipassana* and Zen, or both *vipassana* and Tibetan meditation.

[9] However, as I pointed out above, some *vipassana* teachers have been monks or 'nuns'. It may well be, therefore, that the Western *vipassana sangha,* even though it has great respect for the monastic way of life, will become what **Titmuss** calls 'post-monastic.' Perhaps this view could only be taken by someone, like **Titmuss,** who has been a monk and therefore, as he himself told me, knows its drawbacks as well as its strengths. (He is not advocating a post-monastic tradition for the West but simply noting that a number of Western *vipassana* teachers have had experience of the traditional *sangha.* It is I who am suggesting that post-monasticism may actually develop.) One of the reasons I think so is because post-monasticism is pan-Buddhist: there are other Westerners who have left the sangha in other Buddhist traditions (predominantly Tibetan and Zen). They are relatively few in number but still significant, I think, for the simple reason that they are sharing their experiences. This is something that could hardly happen in Eastern countries. Burmese or Thai monks, say, who have left the *sangha* do not meet Japanese, Korean or Tibetan monks who have done the same. In fact, they really have no contact with other Buddhist traditions at all. This only happens in the West. (And it may give rise to what might be called an **ecumenical *sangha***).

What we find, then, is a predominantly lay movement that is based on a specific meditational practice (though there are a number of *vipassana* methods), and which allows, and even encourages, independence and variety. In 20 or 50 years time, the Western *vipassana sangha* may well be very different. Change is not to be avoided. As long as the practice continues, the qualities of wisdom and compassion will continue—and so will the *sangha*.

So we come back to where we started: there is no reason why insight *(vipassana)* into the true nature of things should not be possible today, just as it was when the Buddha was teaching. As **Goldstein** puts it:

> . . . [M]editation can help develop a real openness to the suffering that exists, whether it's ecological or political or personal, so that there's a compassionate response to it. At the same time meditation enables the mind to maintain a deep equanimity with regard to the whole unfolding show, knowing that it's all a process, and that it involves enormous cycles of time and universes, and that suffering is not going to come to an end except through the purification of the mind. (*Inquiring Mind,* 7/2, 1991, p. 11)

This is expressed in completely modern speech, with a minimum of technical terminology, and addressed to people who are dealing with a world that, externally at least, has little in common with northern India 2,500 years ago. But it could be argued that the issues he is addressing—which really come down to wisdom and compassion—are central to human life at all times and all places. (And he is not just talking about them but also teaching a method that will radically transform our perception of them.)

It is these issues that the Western *vipassana sangha* is concerned with. It is international, open and prepared to ask challenging questions about the nature of the Theravada tradition, and beyond that, of the Buddhist tradition itself. In this, of course, it is typically Western.

In short, *vipassana* is beginning to permeate many aspects of Western culture. The quality of its practitioners may be variable—but they are already there, doing it.

Primary sources: [in alphabetical order of the names of the Western teachers featured in this entry]

John Coleman, *The Quiet Mind* (London, 1971);

Joseph Goldstein, *The Experience of Insight: A Natural Unfolding* (Santa Cruz, California: Unity Press, 1976) [since reprinted by Shambhala with the sub-title, *A Simple and Direct Guide to Buddhist Meditation*];

Jack Kornfield, *Living Buddhist Masters* (Santa Cruz, California: Unity Press, 1977) [also reprinted by Shambhala];

Goldstein and Kornfield, *Seeking the Heart of Wisdom: The Path of Insight Meditation* (Boston, Massachusetts, 1987);

Jacqueline Mandell, *Women and Buddhism,* audio cassette (Northampton, Massachusetts: Dharma Seed Library, 1984);

Sharon Salzberg, *Loving Kindness: The Revolutionary Art of Happiness* (Boston, 1995);

E.H. Shattock. *An Experiment in Mindfulness* (London, 1958) [Shattock's later books, such as *Mind Your Body: A Practical Method of Self-healing* (1979) and *Power Thinking: How to Develop the Energy Potential of the Mind* (1983) (both Turnstone Books, Wellingborough, England) indicate that he has moved from *vipassana* to positive thinking];

Christopher Titmuss, *Spirit for Change: Fourteen Interviews on Engaged Spirituality* (London: Green Print, 1990); *Freedom of the Spirit: Fifteen More Interviews on Engaged Spirituality* (London: Green Print, 1991); *The Profound and the Profane* (Totnes, Devon: Insight Books, 1993); *The Green Buddha* (Totnes, Devon:

Insight Books, 1995)

Secondary sources: [on the background of the vipassana sangha] M. Carrithers, *The Forest Monks of Sri Lanka* (Delhi: Oxford University Press, 1983); R. Gombrich, *Theravada Buddhism: A Social History from Ancient Benares to Modern Colombo* (London, 1988); R. Gombrich, 'From Monastery to Meditation Centre: Lay Meditation in Modern Sri Lanka', in P. Denwood and A. Piatigorsky, eds., *Buddhist Studies: Ancient and Modern* (London: Curzon Press, 1983); G. Houtman, *The Tradition of Practice Among Burmese Buddhists* (Ph.D., School of Oriental and African Studies, University of London, 1990); Nyanaponika Thera, *Heart of Buddhist Meditation* (London, 1969); A. Solé-Leris, *Tranquillity and Insight* (London, 1986); W. King, *Theravada Meditation* (Pennsylvania State University Press, 1980); [on the Western *vipassana* teachers] L. Friedman, *Meetings with Remarkable Women: Buddhist Teachers in America* (Shambhala, 1987); S. Boucher, *Turning the Wheel: American Women Creating the New Buddhism* (San Francisco: Harper and Row, 1988); E. Sidor, ed., *A Gathering of Spirit: Women Teaching in American Buddhism,* (Cumberland, Rhode Island: Primary Point Press, 1987);

Centres: (Ruth Denison) Desert Vipassana Meditation Center, Dhamma Dena, HC-1 Box 250, Joshua Tree, CA 92250, U.S.A.;

(Joseph Goldstein, Sharon Salzberg) Insight Meditation Society, Pleasant Street, Barre, MA 01005, U.S.A.;

(Jack Kornfield) Spirit Rock, Box 909, Woodacre, CA 94973, U.S.A.;

(Christopher Titmuss) Gaia House, West Ogwell, Newton Abbot, Devon TQ12 6EN, England, U.K.

COMPARE:

Other Westerners who have done intensive meditation practice in the Theravada tradition: **Kapilavaddho**, **Nanavira**

Westerners who have done intensive meditation practice in other Buddhist traditions: Philip **Kapleau**, **Jampa Thaye**

Westerners who have done intensive meditational practice in other traditions: Swami **Abhishiktananda**, **Rudi**; Samuel **Lewis**

Swami VIVEKANANDA

Pioneering charismatic Indian teacher of 'universal Hinduism'

Vivekananda met his master, Ramakrishna, in 1881 at the age of 18, just five years before Ramakrishna died. " . . . I learnt from my Master . . . that the religions of the world . . . are but various phases of one eternal religion" (Collected Works, *vol. 4, 180). And: "I began to go that man, day after day, and I actually saw that religion could be given"* (ibid., 170). All of Vivekananda's lectures and writings can be seen as variations on these basic ideas. In fact, he taught a quintessential spiritual psychology: the true nature of man is divine con-sciousness; it is to be realized by spiritual practice of various kinds; it requires the help of a spiritual teacher or guru, who can transmit this realization. "Realization is real religion, all the rest is only preparation" (ibid., 232).*

Vivekananda attended the World Parliament of Religions in Chicago in 1893 and made a considerable impact.[1] He also gathered a number of Western

[1] And not just among the delegates at the Parliament. There is a delightful story of him lecturing on an upturned tub somewhere in the American West while cowboys fired gunshots around his head to see if his teachings about calmness and self-control were rooted in experience. They were (B. Foxe, *Long Journey Home* [London, 1975], 19).

disciples to whom he taught the rudiments of Advaita Vedanta and raja yoga. He died unexpectedly in India in 1902 at the age of 40; and while the Ramakrishna Order did continue in the West, it never again recaptured the original freshness that he brought with him and which laid the foundations of Western Hinduism (or at least a particular form of it).

Westerners connected with Vivekananda: Swami **Abhayananda**/Marie Louise, Swami **Atulananda**, Sister **Devamata**, Sister **Nivedita**

Alan WATTS. SEE **APPENDIX 1**

Sir John WOODROFFE. SEE **APPENDIX 1** (UNDER ARTHUR **AVALON**)

YAMADA Roshi. SEE **HARADA-YASUTANI-YAMADA**

John YARR | Ishvara

Irishman who claimed to be a perfect master but whose organization was disbanded by his own followers after accusations of sexual misconduct

I have already written an article about Yarr and will only summarize it here. He was born in 1947 and joined the British Army at the age of 18. In 1974, while still in the Army, he came across Divine Light, the organization set up by Guru Maharaj Ji—known as 'the boy guru' when he first came to the West in 1971 because he was only 13 years old—and was initiated. Guru Maharaj Ji's teachings were precise—and demanding. Initiates were requited to follow certain conditions (vegetarian diet; no alcohol, drugs or tobacco; and sex to be confined to lawfully wedded couples), and also to meditate daily on inner light and sound. But the foundation of the spiritual life was not just a certain lifestyle nor even a particular meditative practice but Guru Maharaj Ji himself: it was his grace that enabled initiates to advance on the inner path. Within a few months of his initiation, Yarr claimed to have attained enlightenment. This claim was not accepted by Divine Light and so Yarr left to set up as a teacher on his own (and also left the Army). He took with him four women who were all Divine initiates. By 1976, two of these women had themselves become enlightened as a result of meditating on the Lifewave—inner light and sound— and the grace of Ishvara (as Yarr was now known). Ten years later, he had perhaps 500 committed followers (all of whom were members of his organization, also called 'Lifewave'). Forty-six of them were adepts—that is, enlightened— and carried out all initiations on Ishvara's behalf. Enlightenment itself was defined as "complete knowledge of the infinite, endless and unchanging aspect of man" (*Lifewave News,* vol. 1, no. 3, 1984), "unity with the omniscient Self", "the absolute identity of man with God" *(The Sacred Mirror).* According to one adept, "I know that I am a Divine Being, that the entire universe comes

from me" (*Lifewave News,* vol. 1, no. 1, 1984). This is certainly a very high claim. But what was said about Ishvara left it standing: he is the Supreme Being in human form, the Messiah, the Liberator of mankind, the world Saviour, the Kalki Avatar. His power is limitless (*Ishvara;* pamphlet; no date, no provenance). He himself said,

> Because I have never been born and never die, I have no guru or spiritual teacher . . . The initiate travels to Enlightenment within my aura . . . I have the power to enlighten millions and millions of people. (*Insight,* 1986, no. 1)

However, in September 1986, Lifewave groups were told that the organization was being dismantled. Yarr had had sexual relations with a number of female adepts. In order to keep this a secret, he had consistently lied—not only to the whole organization but the women themselves, each of whom was ignorant of his interest in the others. A meeting was held on 28th February 1987 at which Lifewave voted itself out of existence. Within the space of a few weeks it had split into a number of factions. At least five separate individuals claimed to be able to carry on in Yarr/Ishvara's place; some 'conservative' adepts said that nothing essential had changed and that they would continue to initiate in his name; other adepts suddenly announced that their enlightenment was independent of Ishvara (despite the fact that they were saying the opposite before his exposure); some even admitted that they had never been enlightened at all. This is complete disarray. Common sense leads inexorably to the conclusion that whatever realization these people may have had, it falls far short of the claims that were made for it. It does not bestow wisdom, or, in the majority of cases, compassion. It allows self-deception and out-and-out deception of others. (The two are obviously related.) Whatever it may be, it is surely better not to call it 'enlightenment'.

I have little information about the past few years. Apparently, Yarr tried to offer his services as a spiritual master on a consultancy basis, whatever that may mean. In 1988, *Private Eye* reported that he had moved to Brazil, where he still had some loyal followers. This may or may not be true (like much of what *Private Eye* says). Initiates in Tanzania were also reported to be loyal. I have no idea what happened to the other factions or the individuals who said they would initiate. Everyone seems to have gone very quiet. This is understandable. If you were given a sword, made from a 'special alloy' that made it invincible, and it turned out to be painted cardboard, you'd probably keep quiet too.

Primary sources: Apart from *The Fullness of the Void: Aphorisms of Ishvara* (no provenance, 1986) (which consists of one or two sentences per page), and *Insight* (1986), no. 1 (a short pamphlet outlining his teachings), Yarr himself wrote nothing. Nearly all Lifewave literature was produced by adepts. Some of it, usually short pamphlets, was for the public; some of it, mostly memoranda and newsletters, was for initiates' eyes only, sometimes for adepts' eyes only. Since none of this literature is now available and dates and provenance are rarely given, I have not listed it.

Secondary sources: A. Rawlinson, 'The Rise and Fall of Lifewave', *Religion Today,* 4, nos. 1 and 2 (October 1987), 11–14; a number of press reports, all of them of the 'shock horror' variety

Centre: No longer extant

COMPARE:

Other Western Avatars: Master **Da**, G.B. **Chicoine** (actually another ex-Avatar)

Other teachers of light and sound: Paul **Twitchell**, **John-Roger**

Other teachers who were rejected by their followers: Roshi Richard **Baker**

Paramahansa[1] YOGANANDA

Indian founder of the
Self-Realization Fellowship

Yogananda was born in 1893, was initiated by his master, Sri Yukteswar in 1915, and founded Yogoda Satsanga[2] in 1917. He arrived in Boston in 1920 to address a conference of religious liberals and apart from one return visit to India, spent the rest of his life in America. To begin with, he gave talks entitled How Oriental Methods Can Help Occidental Business *and* Recharging Your Business Battery Out of the Cosmos *(Ferguson, 315).* Scientific Healing Affirmations *and* The Law of Success *are still available from the Self-Realization Fellowship/SRF, which he established in 1925 at his headquarters in Los Angeles.*

However, Yogananda's theology is far more exalted than titles such as The Law of Success *would suggest. He is the last of a line of* avatars,[3] *all of whom are superhuman, capable of transcending time and space, and who have been sent into the world to liberate vast numbers of souls (Kriyananda, 430). Krishna and Christ were both avatars but Yogananda's particular lineage goes back to a certain Babaji—the guru of both Shankara (eighth century) and Kabir (fifteenth century)* (Autobiography of a Yogi, 347).[4] *Yogananda was chosen by Babaji to "spread the message of kriya yoga in the West" (ibid., 402). His mission is therefore of cosmic significance and he is fully on a par with the* avatars *who preceded him: Babaji, Lahiri Mahasya and Sri Yukteswar (this last being his own master). In fact, when Kriyananda asked him if he was an* avatar, *he replied, "A work of this importance would have to be started by such a one" (Kriyananda, 430).*

Yogananda has a whole chapter on spiritual practice in his autobiography. The 'science of kriya yoga' begins with breath control which enables the practitioner to make direct contact with the life energy that is normally scattered throughout the body. This has a number of consequences: the subtle energies of the universe, which manifest in the body but are normally obliterated by the coarseness of ordinary consciousness, can be utilized so that spiritual evolution is speeded up many thousands of times; inner light and sound can be contacted; and death can be conquered. One also acquires the so-called

[1] This is how the word is usually spelled. But according to Ananda (for which, see the entry for Swami **Kriyananda**/Donald Walters), Yogananda himself used the spelling 'Paramhansa'. The difference of one letter would not seem to most people to be worth arguing over. But it is an element in the dispute between Ananda and Self-Realization Fellowship—so I feel bound to record it.

[2] *Yogoda* was a term coined by Yogananda and means 'that which *yoga* imparts'—self-realization; *Satsanga* means 'divine fellowship' or 'fellowship with Truth' (*Man's Eternal Quest*, 484).

[3] Also called 'Gurus' (with a capital G). This is sometimes confusing because SRF also uses the term 'guru' (with a small g) in the sense of 'spiritual teacher'. (See for example, the glossary in Yogananda's *Man's Eternal Quest*.) Hence not all gurus are *avatars*; but all *avatars* are Gurus.

[4] Babaji has appeared in a number of guises in the twentieth century. Omraam Mikhael **Aivanhov** claimed to have met him (but called him Maharaja Nimcaroli Babaji); Leonard **Orr**, the founder of Rebirthing, says that Babaji appeared to him and told him that Rebirthing is a Western form of *kriya yoga;* and there are two apparently unconnected accounts from India: Baba Hari Dass, *Hariakhan Baba: Known, Unknown,* (Davis, California: Sri Rama Foundation, 1975); and Anon, *Teachings of Babaji,* Shri Herakhan Baba Prachar Sangh, P.O. Herakhan Vishva Mahadham, via Katgodam, District Naintal, 263126 India, 1983. These identifications require further research.

miraculous powers—telepathy, knowledge of past lives and future events, materialization of bodily forms (whether while still living or after death), raising of the dead, etc. These are all signs of progress towards the goal of kriya yoga: *the realization of oneself as soul, a divine spark of God.*

But kriya yoga *is not a mere technique; it requires genuine transmission from guru to disciple to be effective. Yogananda gave this transmission to his American disciples and made very high claims for some of them: that they would become* jivan muktas *and* siddhas *(Kriyananda, 247) A* jivan mukta *is one who has eliminated ego and thus become liberated* (mukta) *while living* (jivan). *Such a person does not generate new karma (because there is no ego to create it); but the influence of the karmas of innumerable past lives is still operative. When this has been removed "by the action of Spirit", the soul becomes a* siddha. *Being entirely free of karmic traces, a* siddha *cannot be reborn— except by Divine Will (Kriyananda, 427–432). In a letter to me, SRF defined a* siddha *as one who is "unconditionally one with God, partaking of all God's attributes, including those of omniscience, omnipresence and omnipotence".[5] Whether we accept it or not, the claim that Westerners might be at this level is surely significant.[6]*

Yogananda died in 1952. His body remained without any signs of decay for 20 days, "a case unique in our experience" in the words of the mortuary director (Autobiography of a Yogi, 575). It is the most celebrated of his miracles and is seen by the members of SRF as yet another sign that he was a true avatar *on a divine mission. How this mission fared after his death can be seen by following up the entries of those listed below.*

(*See* Lineage Tree 2)

Works cited in this entry: Paramahansa Yogananda, *Autobiography of a Yogi* (Los Angeles: Self-Realization Fellowship, 1975) [this is the 11th edition—and there are significant differences between some of the editions, as I explain in Sri **Daya Mata**'s entry]; Swami Kriyananda, *The Path: Autobiography of a Western Yogi* (Nevada City, California: Ananda Publications, 1977); C.W. Ferguson, *The Confusion of Tongues* (London, 1929)

Westerners associated with Yogananda: Rajarsi **Janakananda**, Sri **Daya Mata**, Sri **Kriyananda**/Donald Walters, Roy Eugene **Davis**

YOGESHWAR MUNI | CHARLES BERNER

American who left Scientology, started a new religion and then became a teacher in the Shaivite tradition

Berner was born in 1929. He came across Scientology as a young man but left it in 1965 in order to found Abilitism (described as "a new religion" but it contained many of the elements that are found in Scientology). He had also 'studied' Zen for many years (Love, 216) and was therefore familiar with *koan*

[5] Somewhat confusingly, the definition of a *siddha* in the glossary of Yogananda's *Man's Eternal Quest* is "one who has attained Self-realization".

[6] He also made very high claims for one of his first disciples, the Canadian Edith Bissett (*née* D'Evelyn) (1869–1951), who took the name Sri Gyanamata when he initiated her as a *sannyasini* in 1932. She was a devoted Christian and said that Christ had appeared to her on several occasions (*God Alone*, 31). Moreover, she was seen as fulfilling the ideal of Christian sainthood even after becoming a disciple of *Yogananda*. She was very ill at the end of her life but Yogananda said that her suffering was not the result of her own sins but because of the sins of many others who had become saintly through her life. "Such is the mystery of God" (ibid.,

practice. In 1968, it occurred to him that *koans* could be answered by using what is known as the 'diadic' method: two people sit facing each other and take it in turns to ask a question which the other person tries to answer as fully and honestly as possible. Berner assigned the question 'Who am I?' to his students and "was as happy and surprised as anyone to find that within a period of just a few days his students were having enlightenment experiences identical to the ones described by those who had been practising Zen meditation for up to ten years" (Love, 217).

This was the beginning of the Enlightenment Intensive.

> Participants have a question, or koan, which they contemplate throughout the Intensive . . . 'Who am I?', 'What am I?', 'What is life?', 'What is another?' . . . The aim is not to find the answer to the question but to directly experience the Truth of who one actually is or what life actually is. (brochure)

According to those who have taken one of these Intensives, there are degrees of enlightenment. For example, the first degree of self-enlightenment (which is the focus of the question, 'Who am I?') is the realization, 'I am me', or 'I am'. (These words, of course, cannot convey the realization, just as the word 'yellow' does not convey the colour of a buttercup.) The second degree is the realization that 'I am the source of me', 'I am the God of my universe' or simply 'I am God'. Similarly, the first degree of life-enlightenment (which is the focus of the question, 'What is life?') is 'Life is!' or just 'This!'; while the second degree is 'Life is the relationship that all beings have with one another' or 'Life is love' (Love, 236–238). And according to Love, "Although the participants do not have conversations in the normal socializing way, they are in the act of revealing themselves to others. This is a good definition of love: to reveal yourself to another and accept unconditionally what another reveals to you . . . This process of opening up to others is what makes the Enlightenment Intensive work so rapidly and deeply" (Love, 235).

Sometime in the early 1970s, Berner changed gear once again: he became a disciple of the Indian teacher, Bapu Kripalvananda[1] and took the name 'Yogeshwar Muni'. Another brochure describes him as "a Yogic Master, the head of a lineage in the Hindu tradition" but I am not sure what this means.

Yogeshwar Muni's progression from Scientology to Abilitism to *kundalini* yoga is certainly unusual. So is his teaching method: a combination of Eastern and Western, Hindu and Zen. There are not many who bring *tantra* and *koans* together. This is certainly eclecticism, a term which ranges in its connotation from superficial shopping in the spiritual supermarket to an open-minded welcoming of excellence from many sources. Such evidence as I have seems to

43). He also said that she was an accomplished *yogi* (ibid., 51) and that her spiritual attainment ranked with the greatest of the Christian saints (ibid., 38).

By and large, Western gurus/masters/saints/*yogis* tend to be a high profile bunch. It is therefore something of a relief to come across those few, like Sri Gyanamata, who are naturally retiring and modest, who make no waves and who do not even claim to be doing anything very unusual. Those who stay in the background also have their role to play.

Further reading: Sri Gyanamata, *God Alone: The Life and Letters of a Saint* (Los Angeles: Self-Realization Fellowship, 1984)

[1] Kripalvananda's life and teaching—he died a few years ago—are given in a book written by another of his disciples, Rajarshi Muni (who is Indian). He is described as an enlightened master of *shaktipat kundalini yoga*, also known as *siddha yoga* or *kriya yoga*, which involves the transmission of *shakti* or divine energy from the guru to the disciple by means of touch, word or thought. The *kundalini* is then awakened, with all the manifestations that normally attend this experience: creative and intuitional abilities, psychic powers, healing, spiritual visions and sounds (Rajarshi Muni, *Light from Guru to Disciple* [Pennsylvania: Kripalu Yoga Ashram 1974], 67). (Amrit Desai, an Indian teacher living in America, is also a disciple of Kripalvananda.)

indicate that Yogeshwar Muni is at the open-minded welcoming end of the spectrum. So perhaps he is what might be called an independent eclectic—because what he has put together is based on his own investigation and practice. And it could be argued (though I cannot do it here) that such an approach is particularly suited to the West. The notion of a tradition that grows slowly over centuries, like an oak, may itself be an Eastern ideal, one that arose because Eastern traditions developed in countries/cultures that tended to be separate. This is not the world we live in now and it perhaps requires a different kind of teaching and a different kind of teacher: people who have made explorations across boundaries rather than within them.

Primary sources: Charles Berner, *Abilitism: A New Religion* (No provenance: Institute of Ability, 1970); *Enlightenment* (Luverne Valley, California: Institute of Ability, no date); *A Guide Through the After Death Experience* (Luverne Valley, California: Causation Press, 1967); [I am told that all his work since he became a disciple of Kripalvananda is in the form of manuals that are used in his workshops, and none of them is publicly available]

Secondary sources: Jeff Love, *The Quantum Gods* (Tisbury, England, 1976), 213–242; Jake Chapman, *Tell Me Who You Are* [available from the author, The Old Manor House, Hanslope, MK19 7LS, England, U.K.]

Centre: c/o The Dyad School, P.O. Box 529, Mount Barker, South Australia 5251; c/o The Old Manor House, Hanslope, MK19 7LS, England, U.K.

COMPARE:

Others who have gone from a Western teaching to an Eastern one: Leonardo **Maclaren**

Others who could be called independent eclectics: J.G. **Bennett**, Reshad **Feild**, Lex **Hixon**, Samuel **Lewis**

Dhyani YWAHOO

Native American who has been recognized by Tibetan teachers

Perhaps the most significant thing about Dhyani Ywahoo (pronounced 'Da-hah-nee Ee-wa-hoo') is not that she has been acknowledged by Tibetans but that she acknowledges them. She is a Tsalagi (which has been 'Caucasianized' as 'Cherokee') who was teaching in her own tradition long before she even knew that Tibetan Buddhism existed. But there were prophecies amongst her people that a red race would come across the sea; and she (along with other Native Americans) realized that the Tibetans fulfilled this prophecy. According to Boucher (who is reporting Dhyani Ywahoo's own statements), her particular clan, within the Tsalagi nation, "have always communicated, in their meditations, with monks and nuns meditating in Tibet" (Boucher, 168). I must admit that I do not know what this means.

Her centre, the Sunray Meditation Society, is described as "a spiritual society dedicated to planetary peace. Its purpose is to manifest the Native American ideal of Caretaker Mind, so that we may create a world of beauty upon earth and throughout the family of life" (D. Morreale, *Buddhist America: Centers, Retreats, Practices* [Santa Fe, 1988], 270). In 1983, it was recognized as a Nyingma centre by Dudjom Rinpoche (who was head of the Nyingma school at the time). Three years later, Drikung Kyabgon Chetsang Rinpoche declared that her teachings were in accord with those of his own Drikung Kagyu lineage. She has thus been accepted into two Tibetan schools—but as an

independent, not as someone who has gone through their particular practices. This is unique, as far as I know. She certainly says that her group is "part of Vajrayana Buddhism" (Boucher, 167) and that the Sunray teachings teach "practical methods to realize Caretaker Mind and Bodhisattva action" (Morreale, op.cit.). She also uses Vajrayana terminology on occasion: saying, for example, that the Prajnaparamita or Perfection of Wisdom is depicted as female and that "innately the stream of wisdom and the emptiness of unmanifest potential is the void within each of us" (ibid.). But all in all, her teaching is Native American, not Buddhist. And her book, *Voices of Our Ancestors,* does not mention Buddhism once (even though it came out in 1987, after she had made contact with the Tibetan tradition). True, one of the shrines at the Sunray Meditation Society is Tibetan. But the ritual that is enacted there (at the centre, that is, not the Tibetan shrine) is derived from Native American mythology.

The majority of Dhyani Ywahoo's students are white. She herself does not consider this significant. (And there are students in Turkey and Nigeria, as well (Boucher, 171).) She has also taught gay men and women—but again does not think that their sexuality is important. On the other hand, she does say that "after the first class, all of the students are able to practice telepathically. That is one of the gifts . . . in this lineage" (Boucher, 172). This is quite a claim—and of course she is talking about the Tsalagi lineage. This telepathic communication is augmented by crystals. They are used in the 'Peacekeeper Mission', which is designed to promote peace in the world by means of prayer and meditation.

*Jetsunma **Ahkon Lhamo**, the American tulku, also uses crystals.*

> There is really just one road . . . We are all walking that road together, and it's a road that leads to understanding, and yet we don't need to go anywhere because wherever we stand on it the face is clearly reflected. (Boucher, 173)

This is an age-old message—but Dhyani Ywahoo is the first person to give it with a Native American-cum-Tibetan flavour.

Primary sources: Dhyani Ywahoo, *Voices of Our Ancestors: Cherokee Teachings from the Wisdom Fire* (Shambhala, 1987)

Secondary sources: Sandy Boucher, *Turning the Wheel: American Women Creating the New Buddhism* (San Francisco: Harper and Row, 1988)

Centre: Sunray Meditation Society, P.O. Box 398, Bristol, VT 05443, U.S.A.

COMPARE:

Other women teachers in Tibetan Buddhism: Jetsunma **Ahkon Lhamo**, Freda **Bedi**, **Pema Chodron**

Others who have brought different traditions together: Swami **Abhishiktananda**, J.G. **Bennett**, Lex **Hixon**, Father **Enomiya-Lassalle**, Samuel **Lewis**, Frithjof **Schuon**

APPENDIX 1
Mini-biographies

The 30 people in this section are those who, for reasons of space, I have had to treat very cursorily. Most of them are pioneers who have a certain historical significance. Others illustrate a particular facet of the phenomenon of Western teachers which I think is significant. One or two are here simply because they are well enough known for you to expect them to appear in a book of this kind.

Sources are kept to a minimum and I have only given addresses for those who have centres that are still going concerns

SWAMI ABHAYANANDA | BILL HAINES (1928-1985); AMERICAN

A member of Sri Ramamurti's Ananda Ashram in Monroe, New York, who was expelled (along with others) in 1966 because he was using LSD, then a very new drug. The group, under Abhayananda's leadership, founded their own Ananda Ashram on the estate of the Hitchcocks (young millionaire relatives of the Mellon family) at Millbrook, New York. Also on the estate were Timothy Leary's League for Spiritual Discovery (LSD) and Art Kleps's Neo-American Church, both of which claimed to be religious organizations that used LSD for spiritual purposes in order that they might be protected by the constitution from prosecution for taking it. (This claim was not accepted by the courts.) Richard Alpert (later **Ram Dass**) also stayed at Millbrook on and off. This brand of psychedelic Hinduism only lasted a few years. When Billy Hitchcock finally booted everybody out (sometime in the late 60s), Abhayananda moved to Arizona and started to teach what appears to have been a fairly traditional form of Patanjali's yoga: abstention *(yama)*, observance *(niyama)*, posture *(asana)*, breath-control *(pranayama)*, sense-withdrawal *(pratyahara)*, concentration *(dharana)*, contemplation *(dhyana)* and absorption *(samadhi)*.

Whatever one may think of Abhayananda's flirtations with LSD, the fact remains that he was the leader of an ashram in America for 20 years and taught a form of Hinduism. There haven't been many Westerners who have done that.

Sources: Art Kleps, *Millbrook,* Oakland, California, date unclear: 1975 or 1977

OMRAAM MIKHAEL AIVANHOV (1900-1986); BULGARIAN

Disciple of the Bulgarian esotericist, Peter Deunov. Came to France in 1937 and founded the Universal White Brotherhood. His work—acting on behalf of the spiritual hierarchy in order to inaugurate a new Solar civilization—was

squarely in the Western esoteric tradition. But there was an unusual element as well. In 1959 he went to India and met a sage called 'Babaji'. According to the Brotherhood, this is the same Babaji as "the Hindu author Yogananda has written about in *Autobiography of a Yogi*." Aivanhov refers to him, however, as Maharaja Nimcaroli Babaji. Clearly, 'Nimcaroli' is a variant of 'Neem Karoli' and it is possible that this Babaji is the same person as Neem Karoli Baba, **Ram Dass**'s master (who was quite unknown in the West at that time). But I am not aware that anybody else has suggested that Neem Karoli Baba is *the* Babaji. In any event, the meeting between Babaji (whoever he was) and Aivanhov is linked with certain prophecies in the *Puranas* (ancient Indian texts), which say that in the Kali Yuga a Solar Rishi will appear who "will save the world and bring in the new Solar Culture." He will be born "in a foreign land" and his initials will be MA. He will come to India and "the words OM and RAAM will give him new power." (These extracts, which were never intended for the public so you will not find them in any library, are all in English; there are no references to the Sanskrit editions so it is impossible to check the translations.)

There are many ways in which a Westerner can link himself or herself to the East. But to my knowledge, Aivanhov is the only one who claimed to have fulfilled ancient Hindu prophecies.

(See Lineage Tree 2)

Sources: P. Renard, *The Solar Revolution and the Prophet: The Role of the Sun in Spiritual Life* (Editions Prosveta, 1982); A. Lejbowicz, *Omraam Mikhael Aivanhov, Master of the Great Universal White Brotherhood* (Editions Prosveta, 1982); C. and O. Popenoe, *Seeds of Tomorrow* [Chapter 11: 'Le Domaine du Bonfin: Living by the Light of the Sun'] (San Francisco, 1984); Georg Feuerstein, *The Mystery of Light* (Salt Lake City: Passage Press, 1994)

Address: Fraternité Blanche Universelle, B.P. 12, 83601 Fréjus, France; The Universal White Brotherhood, The Dove's Nest, Duddleswell, Uckfield, East Sussex, TN22 3JJ, England, U.K.

SWAMI ATULANANDA | C.J .HEIJBLOM (1869-1966); DUTCH-AMERICAN

Became a member of the Ramakrishna Order in 1899 or so (different sources give slightly different dates). Went to India in 1906 and became a *sannyasin* in 1923. Lived as a hermit for the last 30 years of his life.

As far as I know, Atulananda was the only Western *sannyasin* in the entire length and breadth of India at this early date. It is true that he had no disciples and founded no school or organization. In fact, he never intended to set anything up. Yet when we look back, we can see that he has his place in the greater context of the development of the phenomenon I am describing—the lone meditator who is participating in something much, much bigger than he realizes.

Sources: Swami Atulananda, *Atman Alone Abides* [no details available]; *With the Swamis in America and India* (Advaita Ashrama,India: Vedanta Press, 1989); H. French, *The Swan's Wide Waters* (New York, 1974); J. Yale, *A Yankee and the Swamis* (London, 1961)

High Court judge in Calcutta who was initiated by Sivachandra Vidyarnava (perhaps around 1910). Collaborated with a fellow initiate, the Indian Atal Behari Ghose (who insisted on remaining anonymous, which is why Woodroffe used a pseudonym) in producing a series of volumes about tantra—the first translations and explanations in a Western language. But a treatise on *kundalini* published in 1919—*The Serpent Power*—is not going to make much of a splash when it has to compete with the fallout from the First World War.

Woodroffe was never authorized to teach in the sense of taking pupils and he never did. Yet he kept going despite the fact that he had a lonely row to hoe. It isn't easy to plant a seed that no one else takes seriously and which will not flourish for another 50 years.

Sources: Arthur Avalon, *The Tantra of the Great Liberation (Mahaparinirvana Tantra)* (London: Luzac, 1913) [and many others]; Kathleen Taylor, 'Arthur Avalon: The Creation of a Legendary Orientalist', unpublished paper delivered at the 1993 conference of 'The Sanskrit Tradition in the Modern World' at the University of Newcastle, England

WILLIAM STURGIS BIGELOW (1850–1926); AMERICAN

One of a number of cultured, well-to-do East-coast Americans at the turn of the century who were enthusiastic about Japanese art and culture. Went to Japan in 1882. In 1885, he and his friend, Ernest Fenollosa, were initiated into an esoteric form of Tendai that was heavily influenced by Shingon (the Japanese form of Vajrayana). Unfortunately, we do not really know what this initiation involved. Returned to America in 1890 and taught the meditation that he had learned in Japan to George Cabot 'Bay' Lodge, son of a senator and aspiring poet—Bigelow's one and only pupil.

Bigelow was one of the first Westerners who actually practiced Buddhism of any sort more or less according to the tradition that they espoused (as opposed to making it up themselves). And he was a teacher of sorts himself. True, this particular seed did not sprout and could therefore be said to be a failure. But there was an element of courage and nobility in the attempt, and it should be recognized.[1]

Sources: W.S. Bigelow, *Buddhism and Immortality* (Boston, 1908); R. Fields, *How the Swans Came to the Lake: A Narrative History of Buddhism in America* (Boston: Shambhala, 1986) revised ed., Chapter 9; T.J. Jackson Lears, *No Place of Grace* (New York: Pantheon, 1981), 225–34; Carl T. Jackson, *The Oriental Religions in American Thought: Nineteenth Century Explorations* (Connecticut, 1981)

[1] And there is an interesting postscript. When the American government set up an Office of Buddhist Affairs during the Vietnam war, the Secretary of State responsible for it was Henry Cabot Lodge, from the same family as Bay Lodge. He already knew something of Buddhism and was well disposed towards it. So maybe Bigelow's efforts were not wasted after all.

TITUS BURCKHARDT | SIDI IBRAHIM (1908–1984); SWISS

Son of Carl Burckhardt, the sculptor, and great-nephew Jacob Burckhardt, the art historian. He and Frithjof **Schuon** went to school together in Basle. Sometime in the 1930s—perhaps 1934[2]—he went to Morocco and was initiated into the Darqawi Order there. He was subsequently appointed by Schuon as a *moqaddem* of the Alawi Order (though I do not know when exactly) and continued to fulfil this function for several decades. Immersed himself in Arabic and translated the works of Ibn 'Arabi and Shaikh al-Darqawi. In 1972, advised UNESCO in its attempt to preserve Fez; and was subsequently advisor for the planning of a new university near Mecca.

Although he was a *moqaddem,* which is itself significant, Burckhardt was really a 'practitioner scholar'—that is, someone who is knowledgeable both theoretically and practically. S.H. Nasr, himself a student of Frithjof **Schuon,** refers to "present-day exponents of traditional doctrines such as Schuon and Burckhardt" who "discipline their souls in order to become themselves embodiments of the Truth" (Nasr, *Islam and the Plight of Modern Man* [London, 1975], 64, n. 15). I do not know if Burckhardt himself, who by all accounts was a modest man, would have claimed to have lived up to this ideal. But one should at least know that it was made on his behalf.

Sources: T. Burckhardt, *Mirror of the Intellect: Essays on Traditional Science and Sacred Art* (State University of New York, 1987); *Sacred Art East and West* (Bedfont, Middlesex: Perennial Books, 1967); *An Introduction to Sufi Doctrine* (Wellingborough, England: Aquarian Press, 1976); *Letters of a Sufi Master (The Sheikh al-'Arabi ad-Darqawi)* (London: Perennial Books, 1973)

PAUL DAHLKE (1865–1928); GERMAN

Was drawn to Buddhism via the writings of Schopenhauer. Went to Ceylon in 1900 and became a lay Buddhist—which is *very* early for Western participation in Buddhism of any kind. Was taught by Sumangala Thera, who also wrote the introduction to Colonel **Olcott**'s *Buddhist Catechism.* He learnt Pali; translated the *Dhammapada* into German; wrote article and books on Buddhism; and at some point (perhaps in 1924, although none of the sources is precise) built a Buddhistische Haus in the garden of his house in Berlin.

He falls in the middle of the spectrum of Western Buddhist practitioners of his day—between Western monks in the East, such as **Nyanatiloka** Thera (for whom the monastic life was central), and general lay Buddhists like **Carus** (who fitted their practice in where they could rather than shaping their life round it).

Sources: P. Dahlke, *Buddhist Essays* (1903); W. Peiris, *The Western Contribution to Buddhism* (Delhi, 1973), 103–07

[2] He met Schuon in Fez in that year when Schuon was himself visiting Mulay 'Ali ad-Darqawi (F. Schuon, *Memoirs and Mediatations* [1982], privately printed, pp. 3, 95).

ALEXANDRA DAVID-NÉEL (1868–1969); FRENCH

Became a Buddhist in 1904 after reading Buddhist texts. She was living in Paris at the time and knew no other Buddhists; in fact, she says, she might have been the only one in the entire city. Went to India in 1911 and met the thirteenth Dalai Lama, then living in exile in Kalimpong on the Indian/Nepalese border, in 1912. Claimed to be the first non-Tibetan woman to do so and she is probably right. Learnt Tibetan with Lama Dawa Samdup (**Evans-Wentz**'s collaborator a decade or so later) and practised intensively with the Gomchen of Lachen from 1914 to 1916. (She refers to herself during this period as a *gomchenma*—that is, a female *gomchen*.) Was the first Western woman ever to go to Lhasa (in 1924, disguised as a *naljorpa* or wandering ascetic and accompanied by her adopted son, Lama Yongden). *Voyage d'une Parisienne à Lhassa* was published in 1927 and made her a celebrity. She was nearly 60 but lived for another 42 years, producing a steady stream of books.

Strictly speaking, David-Néel was not a teacher in the usual sense since she was never appointed by any Tibetan master or school. But in effect, her books were a form of teaching, not only because they explained the Tibetan tradition but because they were based on her own experience—and no other Westerner at the time could claim as much.

Sources: A. David-Néel, *My Journey to Lhasa* (London, 1927); *With Mystics and Magicians in Tibet* (London, 1931); B. and M. Foster, *Forbidden Journey: The Life of Alexandra David-Néel* (San Francisco: Harper and Row, 1987); R. Middleton, *Alexandra David-Néel: Portrait of an Adventurer* (Shambhala, 1989)

ABDULLAH DOUGAN (1918–1985); NEW ZEALANDER

An ex-soldier who came across the teachings of **Gurdjieff** in 1953 and later, Sufism. He joined the **Sufi Movement** in 1968. But he was always guided 'from within' and in that same year he was 'led' to Afghanistan, where he became a Moslem and was initiated into the Naqshbandi Order. Back in New Zealand, he started a Sufi group called 'The Brotherhood of H.I. Khan'. Returned to Afghanistan in 1974, underwent a forty-day fast, and received permission from his *sheikh* to teach the Naqshbandi method.

His teachings were a mixture of **Gurdjieff** and Hazrat Inayat *Khan*'s Universal Sufism, and very distinctive. He was on intimate terms with spirits or *djinns* but remained a soldier to the end: on one occasion he told his group, who had asked about the effect of negative emotions, "Yeah, let's give that a flog this year and really beat the shit out of it" (Sharp). A one-off if ever there was one.

(See Lineage Tree 8)

Sources: Abdullah Dougan, *40 Days: An Account of a Discipline* (London: Gnostic Press, 1978); *Probings* (London: Gnostic Press, 1979); Iain Sharp, 'Inward Promptings', *New Zealand Outlook* [I was sent a copy of this article but have no date for it; its page numbers are 58–61]

W.Y. EVANS-WENTZ (1878–1965); AMERICAN

A 'gypsy-scholar' whose *Tibetan Book of the Dead,* published in 1927, was the first complete translation of a text that is central to the Tibetan tradition. (Previous translations, by Western scholars, had been of non-tantric texts.) His translator and collaborator—on this and all his books—was Lama Kazi Dawa Samdup (who had earlier taught Alexandra **David-Néel**). But there was more to this relationship than mere collaboration, as the very first sentence of Evans-Wentz's preface to *The Tibetan Book of the Dead* makes clear: "In this book I am seeking—so far as possible—to suppress my own views and to act simply as the mouthpiece of a Tibetan sage, of whom I was the recognized disciple". Unfortunately, we do not really know what Evans-Wentz did as a disciple. It is striking that the introduction to *The Tibetan Book of the Dead* is by Arthur **Avalon,** an expert on Hindu *tantra,* and that Evans-Wentz's notes and comments are heavily laced with Hindu and Vedantin terminology (for which he alone was responsible, I suspect, since Dawa Samdup died in 1922, five years before the book was published). Appropriately, the text itself was used at his funeral: "Oh nobly born, Walter Yeeling Evans-Wentz, listen. Now thou art experiencing the Radiance of the Clear Light of Pure Reality . . . "

Whatever reservations one may have about him—more dedicated adventurers may question the extent of his explorations, more rigorous scholars may demur at his scholarship, and more committed Buddhists may query his knowledge of the tradition—he made a form of teaching available that had been previously unknown, and he should be recognized for it.

Sources: W.Y. Evans-Wentz, *The Tibetan Book of the Dead* (Oxford University Press, 1927); *Tibet's Great Yogi, Milarepa* (Oxford University Press, 1928); *Tibetan Yoga and Secret Doctrines* (Oxford University Press, 1935); *The Tibetan Book of the Great Liberation* (Oxford University Press, 1954); K. Winkler, *Pilgrim of the Clear Light,* (Berkeley: Dawnfire Books, 1982)

DWIGHT GODDARD (1861–1939); AMERICAN

Went to China in 1894 as a missionary but ended up a Buddhist. In 1925, spent a few months at Karl Reichelt's Christian-Buddhist Monastery in Nanking. Went to Japan in 1928 and entered a Zen monastery, Shokuku, as a novice monk (aged 67) and practiced under the abbot, Roshi Taiko Tamazaki. Convinced that Buddhism, and in particular Zen Buddhism, was the answer to the West's spiritual problems, he decided to become a 'reverse missionary'—that is, a Western convert who would convert other Westerners in the West. Returned to America and in 1932 began a magazine, *Zen,* and also privately published his *magnum opus, A Buddhist Bible* (which made its public appearance in 1938). In 1934, he set up the Followers of the Buddha, which had centres in Vermont (at Goddard's own home) and California, and was made up of a peripatetic group of 'brothers' who would lead lives of meditation, study and teaching. But as far as we can tell, this proposal remained an idea only; Goddard died before it ever got started.

It would be easy to see Goddard's venture as a failure. But sometimes a very small pebble, dropped into a very large pond, produces significant ripples.

Sources: D. Goddard, *Was Jesus Influenced by Buddha?* (Thetford, Vermont, 1927); *Buddha, Truth, and Brotherhood* (Santa Barbara, 1934); *Buddhist Practice of Concentration* (Santa Barbara, 1934); *A Buddhist Bible* (Thetford, Vermont, 1938); R. Fields, *How the Swans Came to the Lake* (Shambhala, 1986); J. Gordon Melton, *Biographical Dictionary of American Cult and Sect Leaders* (New York: Garland Publishing, 1986), 99–100.

GEORGE GRIMM (1868–1945); GERMAN

Entered the priesthood but never finished his training. Led to Buddhism by reading Schopenhauer. Never went to the East but learnt Pali and argued in his main work, *The Doctrine of the Buddha*, that the Buddha taught a doctrine of 'Self' (despite the fact that the Pali texts themselves say the exact opposite). In 1921, shortly after **Nyanatiloka**'s visit to Germany, Grimm founded a Buddhist community, Das Altbuddhistischer Gemeinde, which was intended for lay practice and whose aim was nothing less than the attainment of *Sotapannamagga* (literally, 'the path of the Stream-enterer', the first of the stages of enlightenment).

At the time, this was as much as any Westerner who wanted to follow the Theravadin tradition in the West could aspire to.

Sources: George Grimm, *The Doctrine of the Buddha* (London, 1915); W. Peiris, *The Western Contribution to Buddhism* (Delhi, 1973), 96–102

L. RON HUBBARD (1911–1986); AMERICAN

No one knows where the founder of Scientology got his ideas from. Wallis points out similarities, on the practical side, with abreaction therapy, as found in Pavlov and Watson, and in a modified form, in Freud. Cosmologically, the notion of the *thetan* as an essentially free being trapped in matter has much in common with the teaching of the metaphysical movement that thoughts are things and actually create 'reality'. But there is no reason to think that Hubbard got his ideas from Eastern traditions.[3] So it can be fairly argued that he was an original *thinker* (while accepting that nobody is absolutely original), who came up with a worldview and a form of spiritual psychology that is independent of any Eastern tradition. The worldview contains the four dimensions found in all religious traditions: *ontology* (an account of reality); *cosmology* (how 'the world' came into existence and the laws that govern it); *anthropology* (an account of the real nature of human beings); and *soteriology* (a teaching concerning the way to liberation—to 'go clear' in Scientology terminology). And

[3] True, later Scientology publications point out similarities between Scientology and Buddhism—particularly the pragmatic, humanistic aspects. (See Frank K. Finn, 'Scientology as Technological Buddhism' in Joseph H. Fichter, *Alternatives to American Mainline Churches* [New York: Rose of Sharon Press, 1983], 88–110.) And an article in a Scientology journal in 1974 even suggested that Hubbard was Maitreya Buddha (Wallis, 250). Wallis also points out similarities between Scientology and Samkhya-Yoga (Wallis, 112). But all these comparisons are after the event of Scientology itself.

this worldview can be expressed in terms of the four aspects of spiritual psychology: it gives an account of man in terms of *consciousness;* it has a *spiritual practice* that it claims can transform consciousness; there is at least one *teacher* who it is claimed has achieved this transformation; there is a means of *transmission* whereby others can achieve the same (or similar) state.

One may dispute whether Scientology's version of any or all of these is actually valid but one cannot, I think, deny that it does contain them. And that in itself makes it significant and justifies Hubbard's inclusion in this book.

Sources: L. Ron Hubbard, *Scientology: The Fundamentals of Thought* (1956); Roy Wallis, *The Road to Total Freedom: A Sociological Analysis of Scientology* (New York: Columbia University Press, 1977); Russell Miller, *Bare-faced Messiah: The True Story of L. Ron Hubbard* (London, 1987)
Address: Church of Scientology International, 6331 Hollywood Boulevard, Suite 1200, Los Angeles, CA 90028-6329, U.S.A.

Christmas HUMPHREYS (1901–1983); English

A general lay Buddhist *par excellence.* Ardent Theosophist who founded the Buddhist Centre, later renamed the Buddhist Lodge, as part of the Theosophical Society in 1924. And although the Lodge severed its formal connection with Theosophy in 1926 and finally changed its name to The Buddhist Society in 1943, Humphreys never felt the need to renounce his own form of Theosophical Buddhism. (He knew Anagarika *Dharmapala* and the two essentially shared the same views.) His *Buddhism* was probably the most accessible book for the general public of the time. (It sold half a million copies.) Also taught Zen, though he had no qualifications, apart from enthusiasm, to do so. (Yet it should also be said that two Western Zen teachers, Irmgard **Schloegl** and Jiyu **Kennett**, began their Zen careers in his Zen Class.)

As President of the Buddhist Society for several decades, he helped foster a non-sectarian approach to Buddhism as a universal truth, variously modulated through the different schools.

Sources: C. Humphreys, *Buddhism* (Penguin, 1951) [there is a full checklist in *The Middle Way,* vol. 58, no. 4, 230]; memorial issue of *The Middle Way* (the journal of the Buddhist Society), vol. 58, no. 3, August 1983

Ernest Shinkaku HUNT (1878–1967); English

Went to Hawaii with his wife, Dorothy, in 1915; the two of them became Pure Land Buddhists in 1924. Hunt succeeded M.T. **Kirby** as head of the 'English Department' (which was actually for English-speaking Japanese) in 1927. However, he was dismissed in 1932 by a new Japanese bishop who did not want foreigners in the Pure Land school. He thereupon transferred his allegiance to Soto Zen. Ordained a Soto priest by Rosen Takashina in 1953 (when he was 75) and ten years later was given the title 'Osho'—the first Westerner ever to attain this formal rank.

In many ways, Hunt (and his admirable wife) is unique: an official Buddhist for over 40 years at a time when very few Westerners could claim to practice Buddhism, of any kind, in any way at all.

Sources: Louise Hunter, *Buddhism in Hawaii* (Honolulu, 1971); J. Gordon Melton, *Biographical Dictionary of American Cult and Sect Leaders* (New York: Garland Publishing, 1986)

M.T. KIRBY (EXACT DATES UNKNOWN); PROBABLY BRITISH, BROUGHT UP IN CANADA

An obscure figure who may have gone to Japan in 1913 and become a Pure Land Buddhist and then moved to Engakuji, *Soyen Shaku's* Rinzai Zen monastery in Kamakura, where, he said, he attained *satori* and was given the name 'Sensei Sogaku Shaku'. If this is true, it would make Kirby the first Westerner to attain *satori/kensho and* the first to be appointed as a teacher (which is what *sensei* means). But it is impossible to verify his claims: our only source is Samuel **Lewis** (*Sufi Vision and Initiation,* 66), who is himself reporting what Kirby told him. Back in America, in 1920, Kirby officiated at a Pure Land temple in San Francisco—the only Westerner with any kind of formal Buddhist function anywhere in the West at the time, as far as I know. Later went to Hawaii (where he was head of the Pure Land's 'English Department') and then Sri Lanka.

A maverick Buddhist with no spiritual progeny.

(*See* Lineage Tree 6)

Sources: Samuel Lewis, *Sufi Vision and Initiation: Meetings with Remarkable Beings* (San Francisco, 1986); L. Hunter, *Buddhism in Hawaii* (Honolulu, 1971)

Jiddu KRISHNAMURTI (1895–1986); Indian

It is probably a sin to try and condense someone like Krishnamurti into a couple of paragraphs. But he never recognized that sin existed—so that's alright. His early life was certainly extraordinary. In 1909, at the age of 13, he was 'recognized' by C.W. Leadbeater, a prominent Theosophist and right-hand man of Annie Besant (who had herself succeeded Colonel **Olcott** as president of the Theosophical Society), as the next World Teacher. Krishnamurti apparently accepted this role with some reluctance. Even so, he made pronouncements in which he appeared to speak as 'the Lord': "I belong to all people, to all who really love, to all who are suffering. And if you would walk you must walk with me" (Lutyens, *Krishnamurti: The Years of Fulfilment*, 12). Yet just a couple of years after saying this, in 1929, he repudiated his role as World Teacher: "I maintain that truth is a pathless land, and you cannot approach it by any path whatsoever, by any religion, by any sect" (ibid., 15). This was the beginning of the independent Krishnamurti who steadfastly held, right up until his death over 50 years later, that there was no 'means' by which truth or reality could be attained—not even himself. Instead, what was required was the acceptance of life in all its facets, without trying to pin it down or possess it.

He called this acceptance 'choiceless awareness'—a recognition of truth that is beyond all concepts and forms. In 1934, he wrote: "Imagine the state of the man who wrote *Song of Songs*, that of Buddha and Jesus, and you will understand what mine is" (ibid., 33). And towards the end of his life, he described his encounter with what he called the absolute: "It is not a state, a thing that is static, fixed, immovable. The whole universe is in it, measureless to man . . . This is the ultimate, the beginning and the ending . . . incredible vastness and immense beauty" (ibid., 238).

Many people were touched by Krishnamurti—his beauty, serenity and goodness—so it came as a shock when, after his death, a book written by Radha Rajagopal Sloss revealed that he had had a long-term liaison with her mother (including two abortions)—despite the fact that her father had once been very close to Krishnamurti and that her parents were still married (though not very happily) for much of the time that Krishnamurti and her mother were together. None of this had been public knowledge—Mary Lutyens either knew nothing about it or chose not to mention it in her biography—and there are inevitably those who think they have been deceived. Others continue to regard him as the embodiment of the truth that he communicated. The dust is still settling on this one.

Krishnamurti had no successor—such a notion made no sense to him since truth cannot be transmitted— but he is important for three reasons. First, as the back cover of my edition of Lutyens's *Krishnamurti: The Years of Awakening* puts it, "he belongs neither to the East nor the West; he is a true international" (though Barry **Long** doesn't agree). Secondly, he represents *Cool Unstructured* teachings in perhaps their most pronounced form.[4] And thirdly, two Western teachers in this book, Barry **Long** and Toni **Packer**, who are quite independent of each other, have much in common with him. (See their entries.)

Sources: J. Krishnamurti, *The First and Last Freedom* (New York, 1954); *Freedom from the Known* (New York, 1969); M. Lutyens, *Krishnamurti: The Years of Awakening* (India: Krishnamurti Foundation, 1975); M. Lutyens, *Krishnamurti: The Years of Fulfilment* (New York: Avon Books, 1983); S. Holroyd, *Kridhnamurti: The Man, the Mystery and the Message* (England: Element Books 1991); Radha Ragagopal Sloss, *Lives in the Shadow with J. Krishnamurti* (London, 1991); S. Weeraperuma, *A Bibliography of the Life and Teaching of Jiddu Krishnamurti* (Leiden, Holland: E.J. Brill, 1974)

Trebitsch LINCOLN | Chao Kung (1879–1943); Hungarian

I have no space to do anything but mention his conversion from Judaism to Christianity; his year as deacon in the parish of Appledore-with-Ebony in Kent; his election as Liberal MP for Darlington in 1910 (described by Wasserstein as "one of the oddest aberrations in British political history"); his attempts to spy

[4] However, a rival is another Krishnamurti, U.G. Krishnamurti (no relation), who was once close to Jiddu Krishnamurti but has since repudiated him (and all other teachers):

> My talking comes out in response to the questions that are asked. I cannot sit and give a talk on the natural state—that is an artificial situation for me. There is nobody who is thinking thoughts and then coming out with answers. When you throw a ball at me, the ball bounces back, and that is what you call an 'answer'. But I don't give answers; this state is expressing itself. I really don't know what I am saying, and what I'm saying is of no importance. (U.G. Krishnamurti, *The Mystique of Enlightenment* [Goa, India: Dinesh Vaghela, 1982], 47)

for both Britain and Germany; and his involvement in the Kapp putsch in Germany in 1920. But his Buddhist career is worth a few lines. In 1922, he went to China, had what appears to have been a mystical experience and became a Buddhist. He was ordained a monk at Pao-hua Shan monastery near Nanking in 1931, taking the name 'Chao Kung' (which he used for the rest of his life). He said he was the first foreigner to do such a thing and he may be right. He gathered some European disciples (French, German, English, Austrian, Italian) and installed them in a 'Buddhist' house in Shanghai—but they drifted away over the years.

Lincoln was a pioneer—as those who will not, or cannot, accept the normal confines of society often are. He was also a decidedly dodgey character. But the fact of the matter is that the total number of Westerners who made any kind of inroad at all into the Chinese tradition during Lincoln's 18 years as Chao Kung probably did not amount to more than a couple of dozen—and half of them were his disciples. That counts for something.

Sources: B. Wasserstein. *The Secret Lives of Trebitsch Lincoln* (Penguin, 1989); H. Welch, *The Buddhist Revival in China* (Cambridge, Massachusetts, 1968), 186–190.

LOBSANG RAMPA | CYRIL HOSKINS (1911–1981); ENGLISH

In 1955, Hoskins persuaded a major British publisher that though he looked and sounded completely English, he was in fact a Tibetan using a Western body to give an account of his life in Tibet. *The Third Eye* duly appeared and has been a best-seller ever since. But the whole story—and all those that he wrote afterwards—was an invention. He only got away with it (to begin with) because the number of Tibetans in the Western world in 1955 could be counted on the fingers of one hand.[5] If he had claimed to be Chinese or Mongolian, say, he would have been found out in no time. In fact, Rampa is not part of Tibetan Buddhism at all.

We may admire his direct, punchy style, his imagination and his sheer cheek. But compared with what the tradition itself has to offer, it is weak stuff.

Sources: Lobsang Rampa, *The Third Eye* (London, 1955); *The Rampa Story* (London, 1960); Christopher Evans, *Cults of Unreason* (London, 1973), 240–251; Agehananda Bharati, 'Fictitious Tibet: The Origin and Persistence of Rampaism', *The Tibet Society Bulletin,* Vol. 7, 1974, 1–11; Bob Rickard, 'T. Lobsang Rampa', *Fortean Times,* no. 63, June-July 1992, 24–26

LOKANATHA THERA | SALVATORE CIOFFI (1897–1966); ITALIAN

Educated at Columbia University in New York and subsequently did chemical and medical research for the Rockefeller Institute. Gradually became convinced that Buddhism was both scientific and true. Went to Burma in 1925 and

[5] I only know of two for certain: Albert Arnold Yongden, Alexandra **David-Néel**'s adopted son, in southern France, and Geshé Wangyal, in New Jersey. The former died in 1955, the latter arrived in America in the same year; neither was readily available, therefore.

became a monk. Attracted to ascetic practices, partly in Burmese monasteries and partly on his own in caves and forests; slept in the sitting posture for the rest of his life. From 1933 onwards, devoted himself mainly to missionary work, both in the West (he went on a world tour in 1947, visiting Singapore, Malaya, Hong Kong, Shanghai, Hawaii and Europe) and in Burma itself (he conducted a campaign in Burma calling for special treatment for monks in hospitals: that they should have separate wards and only be treated by male nurses.)

I need hardly say that Westerners who have acted as internal missionaries in Eastern countries are extremely rare.

Sources: W. Peiris, *The Western Contribution to Buddhism* (Delhi, 1973), 222–24

Sister NIVEDITA | Margaret Noble (1867–1911); Anglo-Irish

A Socialist with an interest in progressive education, Noble met *Vivekananda* when he visited England in 1895 and 1896, and was initiated by him in India in 1898. He told her: "You have to set yourself to Hinduise your thoughts, your needs, your conceptions and your habits. Your life, internal and external, has to become all that an orthodox Hindu Brahmin Brahmacharini's ought to be" (*The Master As I Saw Him,* 255). He said nothing like this to his Western disciples who remained in the West. In fact, it seems likely that she was the only Westerner whom he asked to live in this way. She opened a school for Indian girls in 1898: a single room in her house in a poor section of Calcutta. She also nursed the sick and dying during a plague that struck the city, while at the same time lecturing on Kali, the goddess of destruction (and plagues), to audiences of thousands. One of these occasions was actually at the Kalighat itself— quite something for a Western woman in 1899 and surely a first for any Westerner. Left the Ramakrishna Order in 1902, shortly after *Vivekananda*'s death, because her political activities on behalf of Indian independence were deemed to be incompatible with her status as a *brahmacharini* (that is, someone preparing for the renunciate life). She spent the rest of her life in India working on behalf of Indian women—and way, way ahead of her time.[6]

Sources: Sister Nivedita, *Kali the Mother* (London, 1900); *The Master As I Saw Him* (London 1910); Barbara Foxe, *Long Journey Home: A Biography of Margaret Noble* (London, 1975); H.W. French, *The Swan's Wide Waters: Ramakrishna and Western Culture* (Port Washington, New York, 1974); Swami Gambhirananda, *History of the Ramakrishna Math and Mission* (Calcutta, 1957)

OOM THE OMNIPOTENT | Pierre Bernard[7] (1875–1955); American

You have got to admire a man who, in addition to coming up with an extraordinary name, founds the Tantrik Order of America in New York in 1909 (he taught *hatha yoga* combined with *tantra yoga,* which may or may not have

[6] I have been told recently that a close disciple of Master **Da** (who has developed a particular theology concerning Ramakrishna and *Vivekananda*) has clear memories of her life as Sister Nivedita.

[7] The uncle of Theos Bernard, author of *Heaven Lies Within Us* (London, 1939); *Penthouse of the Gods* (New

included sexual practices), coaches a heavyweight boxer (Lou Nova, in his fight against Max Baer, former heavyweight champion of the world, in 1939—Nova lost), arranges such events as a wedding banquet eaten off coffins, and ends up a millionaire and the president of a bank in Pearl City (some accounts say Pearl River), New Jersey. Granted, this is all showmanship. But *tantra* has always held that *everything* is a show, including itself. He got that right, at least.

Sources: Anon., *International Journal of the Tantrik Order,* vol. 5, no. 1, external issue, (1906);[8] M. Dockerill, *My Life in a Love Cult* (New Jersey: Better Publishing, 1932); Francis King, *Sexuality, Magic and Perversion* (London, 1971), 155–57; W. Seabrook, *Witchcraft: Its Power in the World Today* (New York, 1940), 318–19; P. Sann, *Fads, Follies and Delusions of the American People* (New York, 1967), 189–191; J. Gordon Melton, *Biographical Dictionary of American Cult and Sect Leaders* (New York: Garland Publishing, 1986), 32–33.

ELIZABETH CLARE PROPHET (1940–); AMERICAN

Leader of the Church Universal and Triumphant (previously known as the Summit Lighthouse). Acts as the sole Messenger for the Great White Brotherhood, which is defined in Church literature as "a spiritual order of Western 'saints' and Eastern 'masters.'" The latter include Maitreya Buddha, Zarathustra, Kuan Yin and Ramakrishna. In 1977, Padmasambhava (for whom, see Ngakpa **Chogyam**'s entry) "formally bestow[ed] the office of Guru upon the Messenger Elizabeth Clare Prophet".

While the Eastern connection may be minor, it is there—part of a general Easternization of Western esotericism that goes back to Madame **Blavatsky**.

Primary sources: Elizabeth Clare Prophet, *The Great White Brotherhood in the Culture, History and Religion of America* (Summit Lighthouse) [I have neither provenance nor date]
Address: Church Universal and Triumphant, Box A, Livingstone, MT 59047-1390, U.S.A.

ZEN MASTER RAMA | FREDERICK LENZ (1950–); AMERICAN

Previously Atmananda, a disciple of Sri Chinmoy. Around 1985, began to call himself 'Zen Master Rama' and started teaching Tantric Zen, a combination otherwise unknown in the Buddhist tradition, which he says he discovered himself. A couple of years earlier, in 1983, he listed his previous lives as a master in Japan, India and Tibet; yet in an earlier book he had said that he did not remember any of them (*Lifetimes,* 17). Runs Rama Seminars Inc., a for-profit corporation.

Makes a profit.

York, 1939) [reprinted as *Land of a Thousand Buddhas* (London: Rider, 1940]); *Hatha Yoga* (Columbia University Press, 1943). **Oom** was also the half-brother of Ora Ray Baker, the wife of Hazrat Inayat *Khan*. Ruth Fuller **Sasaki** spent some time at his 'ashram' when she was a young woman (Alan Watts, *In My Own Way,* 126).

[8] This information is taken from the Library of Congress catalogue; I have never seen any mention of the other volumes. Melton (see the last entry in this list) refers to a book by him: *In Re Fifth Veda, International Journal of the Tantrik Order* [New York, ca. 1910])—which may or may not be the same as the Library of Congress volume. Further investigation is required.

Sources: Frederick Lenz, *Lifetimes: True Accounts of Reincarnation* (New York, 1979); Rama-Frederick Lenz, *The Last Incarnation* (Malibu, California: Lakshmi Publications, 1983)

Address: Rama Seminars Inc., 1015 Gayley Avenue, Suite 1116, Los Angeles, CA 90024, U.S.A. [this is the latest address I have (1986)—and it was just an office, not a centre as such; it is extremely unlikely that it is still functioning]

YOGI RAMACHARAKA (NO PROPER DATES OR NATIONALITY CAN BE SUPPLIED FOR REASONS GIVEN BELOW)

'Yogi Ramacharaka' was the pen-name of an unusual alliance formed at the turn of the century between an American New Thought writer, William Atkinson, and an Indian, Baba Bharata (not to be confused with Baba Premanand Bharati, a Krishna devotee who arrived in New York in 1902). Apparently, Yogi Ramacharaka was Baba Bharata's guru—but we don't know anything about him and it is perfectly possible that he was invented, either by Bharata himself to impress Atkinson or by the two of them together to impress the American public. Ramacharaka's first book (in fact a series of monthly lessons) is typical of his many titles: *Yoga Philosophy and Oriental Occultism.* It includes a number of 'mantrams' such as "I Absorb from the Universal Supply of Energy, a Sufficient Supply of Prana to Invigorate my Body—to Endow it with Health, Strength, Activity, Energy and Vitality."

This is an East-West hybrid but one that is only tangential to Hinduism; that is, touching it but not inside it.

Sources: Yogi Ramacharaka, *Yoga Philosophy and Oriental Occultism* (Chicago, 1904); *A Series of Lessons in Gnani Yoga* (Chicago, 1907); *A Series of Lessons in Raja Yoga* (Chicago, 1905); *Hatha Yoga* (Chicago, 1905); *Hindu-Yogi Science of Breath* (Chicago, 1905) [and many more]; J. Gordon Melton, *Biographical Dictionary of American Cult and Sect Leaders* (New York: Garland Publishing, 1986), 14–15

SERGE RAYNAUD DE LA FERRIÈRE (1916-??); FRENCH

In 1947, according to his own account, he was entrusted with a mission by Master SUN W.K., a Messenger from the Superior Power of Tibet, to make available "Initiatic principles . . . for the general public" and was "consecrated as Venerable of the Universal Great Brotherhood." Went to Venezuela in 1948 and was received by a group who had been awaiting the Avatar. They became his disciples and referred to him as the Kalki Avatar. He then went to India, where he lived as a *sannyasin* and was known as Mahatma Chandra Bala Guruji. Koot-Humi and Maha Chohan (both members of the Great White Brotherhood according to **Blavatsky**) proclaimed him a Satguru and a Bodhisattva. I have no information about his death—the publications I have seen never mention it.

Whatever one may think of his claims, I think it is fair to say that the transmission of a teaching from Tibet to Venezuela via a Frenchman is an unusual one. But that is what happens when traditional boundaries dissolve.

UNITED STATES POSTAL SERVICE

```
***** WELCOME TO *****
        ASTRODOME
  HOUSTON, TX 77025-9998
       12/27/03 08:45AM
```

```
Store  USPS        Trans      16
Wkstn  sys5007     Cashier  KHO105
Cashier's Name     BARBARA
Stock Unit Id      WINDOWWB
PO Phone Number    18002758777
```

```
  1. First Class                    0.55
       Destination:      73072
       Weight:           1.20oz
       Postage Type:     PVI
       Total Cost:       0.55
       Base Rate:        0.55
  2. Priority Mail                   5.15
       Destination:      83888
       Weight:           2lb 3.20oz
       Postage Type:     PVI
       Total Cost:       5.15
       Base Rate:        4.30
              SERVICES
       Insurance              0.85
         Value: 50.00
```

```
Subtotal                           5.70
Total                              5.70

CreditCard                         5.70

Number of Items Sold: 2
```

```
          THANK YOU
       HAVE A GREAT DAY
```

UNITED STATES
POSTAL SERVICE

***** WELCOME TO *****
ASTRODOME
HOUSTON, TX 77025-9998
1212/1102 0A:45 PM

Store USPS Trans : C
Wkstn sys5007 Cashier: KH0105

1. First Class 0.55
 Destination: 75072
 Weight: 1.2oz
 Postage Type: PVI
 Total Cost: 0.55
 Base Rate: 0.55
2. Priority Mail 5.15
 Destination: 87266
 Weight: 5lb 2.2oz
 Postage Type: PVI
 Total Cost:

THANK YOU
HAVE A GREAT DAY

Primary sources: Anon., *Biography of the Mahatma Chandra Bala/Dr. Serge Raynaud de la Ferrière: Supreme Ruler of the August Universal Great Brotherhood, Highest Dignitary of the Maha Sat Khumba Shanga* (Ojai, California: Educational Pub-lications of I.E.S., 1982)
Address: Universal Great Brotherhood, Box 9154, St.Louis, Missouri 63117, U.S.A.

Sri SIVANANDA-RITA (1904–1979); Australian

Started doing yoga at the age of 20 even though she had never even heard the word. Discovered Sivananda's books in 1952 and opened her first ashram in Brighton-le-Sands, a suburb of Sydney, in 1956. (In fact, it was her home, where she lived with her mother, a cat, a dog, and a parrot called Sam.) Sivananda wrote to her, saying, "You have yourself become a Guru for the students there." Her first disciples were Australian and Indian[9] but in 1971 'missionary' work (that is their term, not mine) was started in West Africa. It came as something of a surprise to me to read letters from Ghanaian disciples which are concerned with *hatha yoga* and *pranayama,* address Sivananda-Rita as 'Gurudeva' (and themselves as 'chelas'), and contain such phrases as 'Let me abide at Thy Lotus Feet'.

An Australian woman who was recognized by an Eastern master (without the two ever meeting) and with disciples of her own (some of them African)—this is way out of the ordinary.

Sources: Sri Sivananda-Rita, *Divine Life* (no date, no provenance)
Address: Divine Life Yoga Training School, 19 Acacia Avenue, Leura, 2781 NSW, Australia

Archbishop Karlis Alexis TENNISONS (1873–1962); Latvian

Became a disciple of a Lithuanian aristocrat called Kunigaikshtis Gedyminas (about whom we know nothing at all) and was ordained in 1893 at the Burkhutchinsky (Barguzin) Monastery in Transbaikalia, just north of Mongolia—the first Westerner to formally enter a Buddhist *sangha* of any kind. Went on to do missionary work among the Samoyeds, Zyrians, Yakuts and Eskimos. Helped supervise the building of a Buddhist temple in St.Petersburg (started 1905, opened 1915, completed 1925)—the first in Europe—and was made its first 'bishop' or 'Lord Abbot'. Appointed Sangharaja or 'Archbishop' of Lithuania, Estonia and Latvia by the thirteenth Dalai Lama in 1923. Left Russia sometime in the 1930s and ended up in Burma in 1949, where he died.

Teaching Mongolian Gelugpa Buddhism to Eskimos at the turn of the century and then taking it to Burma in the 1940s—this is pioneering out on a limb and no mistake.

[9] One of the Indians said that "Divine Mother Kali has condescended to the world Her *(sic)* own Sister who after reaching the state of God-consciousness is known as Holy Mother Sri Sivananda-Rita, the real Incarnation of Love and Spirituality! May the Enlightened Rita save our poor souls" (*Divine Life,* 12).

Sources: J. Snelling, *Buddhism in Russia: The Story of Agvan Dorzhiev, Lhasa's emissary to the Tsar* (England: Element Books 1993); S. Batchelor, *The Awakening of the West: The Encounter of Buddhism and Western Culture* (London, 1994), 291–92

Sister UPPALAVANNA | Else Buchholz (1888-1982); German

Went to Sri Lanka with **Nyanatiloka** after his visit to Germany in 1920 and became a *dasa sila mata* in 1928—the first Western woman to do so. Spent the rest of her life there, the last seven years virtually as a hermit in a two-room hermitage near Kandy, where she meditated intensively. When she died, at the age of 94, she had been a practising Buddhist for 54 years.

She wasn't really a teacher in any public or 'appointed' sense—rather, she was simply a member of the *sangha,* living the life which the tradition advocates and which is itself the best way of attaining liberation. Yet as far as I know, she was the only Western woman who took it up. And she remains unique to this day: still the sole Western woman who has lived the Theravadin life to the full in a Theravadin country, year in, year out, for such a length of time.

Sources: a few remarks in W. Peiris, *The Western Contribution to Buddhism* (Delhi, 1973), 149

Alan WATTS (1915-1973); English

Influential writer on Eastern traditions; for my money, one of the four best of the twentieth century. (The others are D.T. Suzuki, Chogyam *Trungpa,* and **Ram Dass**—quite a team.) Often criticized as someone who wrote about Zen, Vedanta, and Taoism as if he understood them intimately, whereas in fact he never undertook the discipline that they require. But even if he was not strong on practice, he certainly knew what he was talking about:

> . . . quite suddenly the weight of my own body disappeared. I felt that I owned nothing, not even a self, and that nothing owned me. The whole world became as transparent and unobstructed as my own mind; the "problem of life" simply ceased to exist, and for about eighteen hours I and everything around me felt like the wind blowing leaves across a field on an autumn day. (*This Is It,* 29)

This is surely a form of *kensho:* seeing into one's own nature, which is Buddha nature. But it appears that he was content with this general 'cosmic consciousness' (that's his phrase—borrowed from Richard Bucke—not mine) and felt no need for traditional roots.

All in all, one cannot fault Stuart's assessment of him:

> Even though he had never spent a day in a monastery, or carried a monk's begging bowl, or spoke more than a handful of words of any of the exotic languages to which he referred—somehow the magic came across. (Stuart, 40)

(*See* Lineage Tree 6)

Sources: Alan Watts, *This Is It: And Other Essays on Zen and Spiritual Experience* (London, 1978) (contains a full bibliography); D. Stuart, *Alan Watts* (Radnor, Pennsylvania: Chilton Book Co., 1976); M. Furlong, *Genuine Fake: A Biography of Alan Watts* (London, 1986); 'Alan Watts, 1915–73: *In Memoriam', The Middle Way* vol. 58, no. 4, February 1984, 210–223

APPENDIX 2
Things I'd Like to Know

The phenomenon of Western teachers has many facets and a great deal of work still needs to be done.

I have references to another 30 individuals who could easily be included if I knew more about them. (No, I won't give their names because a name without a context is no good to anybody.)

There are a number of matters which I have either mentioned in passing or which have occurred to me while I was writing, but which require further research:

what happened to Swami **Ajatananda**, **Jae Jah Noh**, and **Sat Prem**?

what are Paul **Brunton**'s followers doing these days?

does anyone know the whole **Sufi Movement and Sufi Order** story?

is there anybody working on the **ecumenical *sangha*** and the ***arya sangha***?

did Ivan **Agueli** initiate anybody else apart from René **Guénon**?

how does the Arabi lineage fit into the larger Shadhili tree?

who was Titus **Burckhardt**'s *sheikh*?

what happened to those Western Sufis who did not follow Frithjof **Schuon** after he and **Guénon** parted company?

there must be other Westerners who give *kriya yoga* initiation. Who are they?

does anybody know anything about the Unreformed Buddhist Church of America and the American Buddhist Order (see Don **Gilbert**'s entry)?

is there a full account of the Christian Zen movement (and its distant cousins, the Christian Vedanta and Christian Yoga movements)?

What is the *full* Babaji story (see *Yogananda*'s entry)?

can anyone give a full account of the various branches of the **Gurdjieff-Ouspensky** Work?

We need proper histories of Western Hinduism and Western Sufism—I have hundreds of pages on both but could not include them because of lack of space—as well as accounts of the various Eastern traditions, and the men and women who represent them, in Spanish America, Africa, and Eastern Europe. And we could do with a study on Chinese Buddhism and Taoism in the West.

Then there is the whole question of those aspects of Western culture which have enabled Eastern traditions to take root:

occultism (which has provided many alternative cosmologies);

the metaphysical movement (which could be seen as a kind of Western monism);

empiricism (whose do-the-experiment-and-get-the-result approach has favoured various kinds of spiritual practice);

and some forms of Christianity (of the 'interior' variety).

This is a rich field.

GLOSSARY

anagarika | lit. 'homeless one'; in the Thai Theravadin tradition *anagarikas* take eight precepts: the five 'lay' precepts (see *pansil*) plus the following three: 6. not to eat after noon; 7. not to wear jewelry or use cosmetics or seek out entertainment; 8. not to sleep in a soft or large bed.

bhikkhu(ni) | lit. 'beggar/mendicant'; *bhikkhu* is the masculine form and therefore often translated 'monk'; *bhikkhuni* is the feminine form and therefore translated 'nun'; sometimes the forms *bhikshu* and *bhikshuni* are used; both follow the *Vinaya*.

bodhisattva | one who works for the enlightenment of all beings.

brahmachari(ni) lit. ' | one who follows the excellent way'; *brahmachari* is the masculine form, *brahmacharini* the feminine; in Buddhism, it refers to one who follows the precepts (however defined); in Hinduism, it is used of one who follows a good moral life, usually celibate.

dasa sila mata | lit. 'a woman/mother who takes ten precepts'; these are the same as those of a *samanera* but a *dasa sila mata* is not considered part of the Theravadin *sangha*.

diksha | initiation.

dokusan | the formal meeting between a pupil and a Zen teacher, often after *zazen*, when the teacher tests the pupil's degree of insight or *kensho*.

inka/inga | the formal acknowledgement of Dharma transmission from Zen master to pupil; carries with it the authority to teach.

jukai | Zen ceremony at which the participant takes the 16 Bodhisattva precepts: the Three Treasures (to be one with the Buddha, Dharma and Sangha); the Three Pure Precepts (do not commit evil; do good; do good for others); and the Ten Grave Precepts (1. do not kill but cherish all life; 2. do not steal but respect what belongs to others; 3. do not be indulge in wrong sexual relations but practice restraint; 4. do not lie but tell the truth; 5. do not use any artificial stimulants but keep the mind clear; 6. do not talk about the faults of others but be understanding; 7. do not praise oneself but overcome one's shortcomings; 8. do not withhold spiritual and material aid but be generous; 9. do not become angry but exercise control; 10. do not revile the Three treasures but uphold them). There are various formulations of all these.

kensho | lit. 'seeing into one's own nature'; a Zen term that means 'Buddha nature' and hence enlightenment.

koan | a conceptual paradox (for example *Mu* or 'What is the sound of one hand clapping?') which can only be 'solved' by a radical shift of awareness (in fact, by *kensho*).

kundalini | lit. 'coiled serpent'; a reference to the spiral of energy that can be seen in the body; gives rise to many spectacular phenomena, both physical and mental.

lama | lit. 'high one'; a title of respect in Tibetan Buddhism.

moqaddem/muqaddam | one who is authorized to initiate others into a Sufi order.

monk | a term that is used in very different ways by different people: in Buddhism, for Theravadin *bhikkhus* and those who have gone through the *tokudo* ceremony; in Hinduism, for *sannyasins*.

Mu | one of the most famous of all *koans*; it cannot be easily summarized but, like all *koans*, it is 'solved' when the student's response is immediate and not dependent on a strategy that has worked out the 'right' answer (as **Ram Dass** tried to do—see his entry).

mureed | a disciple (a Sufi term)

murshid(a) | a teacher (a Sufi term)

nun | much the same can be said about this term as about 'monk': it has various meanings depending on who is using it. These disagreements usually centre around the number and kind of precepts that are kept.

ordination | another very flexible term which covers everything from *jukai* to taking the full number of precepts according to the *Vinaya*. Cf. monk/nun/priest.

| | |
|---|---|
| *pansil* | lit. 'five precepts'; taken by lay(wo)men in the Theravadin tradition but they also figure in the precepts of other schools (see *jukai*): 1. not to kill any living creature; 2. not to take what is not given; 3. to refrain from all sexual misconduct; 4. to refrain from false speech; 5. not to use alcohol or drugs. |
| *pranayama* | breath control; a component of various kinds of *yoga*. |
| precepts | different numbers of different precepts are taken by different people in different Buddhist traditions; see *anagarika, bhikkhu(ni), dasa sila mata, jukai, pansil, samanera, Vinaya*. |
| priest | a term used in different senses in both Buddhism (see under *tokudo*, for example) and Hinduism (a priest performs *puja*, for instance). |
| *puja* | worship; temple ritual. |
| *rinpoche* | lit. 'precious one'; a title used by *tulkus*. |
| Rinzai | one of the two prominent Zen schools in Japan; fiercer and more direct than Soto. |
| *roshi* | lit. 'old/venerable master'; used in Zen of any respected teacher (monk or lay, man or woman). |
| *sadhana* | a Hindu term meaning 'spiritual practice'. |
| *sadhu* | = *sannyasin* |
| *samadhi* | a high state of meditation in which both subject and object disappear. |
| *samanera* | usually rendered 'novice monk'; in the Theravadin tradition, *samanera* ordination precedes *bhikkhu* ordination; *samaneras* take 10 precepts: the first 8 are the same as the 8 *anagarika* precepts but the seventh is divided into two (thus making numbers seven and eight, so the eighth is now the ninth) and one more is added: 10. Not handling or controlling money. |
| *sampradaya* | a Hindu term meaning a lineage of teachers; often denotes a sub-tradition. |
| *sangha* | lit. 'community'; normally a Buddhist term, the meaning of which is determined by the people who make it up—hence *bhikkhuni-sangha, vipassana-sangha*; but non-Buddhists like Andrew **Cohen** also use it. |
| *sannyasi(ni)* | in Hinduism, one who has renounced all possessions. |
| *sanzen* | = *dokusan*. |
| *satori* | = *kensho*. |
| *sensei* | lit. 'teacher'; often used in Zen as a title that precedes *roshi*. |
| *shaktipat* | lit. 'descent of energy'; either spontaneously or as a form of *diksha*; associated with *kundalini*. |
| *siddha* | lit. 'accomplished one'; in Hinduism, a master of *kundalini yoga*; in Buddhism, one who has attained mastery over the body and mind. |
| Soto | one of the two prominent Zen schools in Japan; gentler than Rinzai and less concerned with attainment (because Buddha-nature only needs to be uncovered). |
| *swami* | title used by *sannyasins*. |
| *tokudo* | Zen ceremony in which the head is shaved. This has led some to see it as a form of monk's ordination (e.g. Peter Matthiessen, a pupil of Bernard **Glassman**, defines it as "monk-ordination ceremony" in the glossary of his *Nine-Headed Dragon River*). John **Loori**, on the other hand, defines it as "ordination as a trainee for the priesthood" in the glossary of his *Mountain Record of Zen Talks*. Yet both these men belong to the exact same lineage. |
| *tulku* | one who, imbued with wisdom and compassion, voluntarily takes birth in order to benefit all beings. |
| *Vinaya* | lit. 'discipline'; the set of rules/precepts governing a *bhikkhu(ni)/bhikshu(ni)*; different Buddhist schools have different numbers of rules; in the Theravadin school there are 227 for *bhikkhus* and 311 for *bhikkhunis*. |
| *vipassana* | lit. 'insight'; a form of Buddhist meditation. |
| *zazen* | sitting meditation; the fundamental Zen practice. |
| *zendo* | a place where *zazen* is practised. |

Photographic Acknowledgements

A book of this kind relies on other people's goodwill. I am therefore very pleased to be able to acknowledge the generosity of all those listed here, who agreed to have a photo included in the book (whether on the feature pages—see the *Contents*—or alongside their own entries) and took the trouble to send me a print. The following list is in alphabetical order. Copyright is that of the individual named unless otherwise specified.

Jetsunma **Ahkon Norbu Lhamo**, Roshi Robert **Aitken** (© Tom Haar), Roshi Richard **Baker** (© Barbara Lubanski-Wenger), Michael **Barnett**, Paul **Carus** (© Carus Publishing Company), Ngakpa **Chogyam**, Andrew **Cohen**, Sri **Daya Mata** (© Self-Realization Fellowship), Roshi Issan **Dorsey** (© Michael Martin; © Morgan Alexander; © Barbara Lubanski-Wenger), Murshida Ivy **Duce** (© Sufism Reoriented), Joseph **Goldstein**, Ngakpa **Jampa Thaye**, Roshi Philip **Kapleau**, Ayya **Khema**, Jack **Kornfield**, Swami **Kriyananda**/Donald Walters, Murshid Samuel **Lewis** (by kind permission of Murshid Moineddin Jablonski), Barry **Long** (© Ambyr Johnston), Murshid James **MacKie** (© Sufism Reoriented), Murshida Rabia **Martin** (© Sufism Reoriented), Meher Baba (© Sufism Reoriented), **Miao Kwang Sudharma**, Ole **Nydahl** (© Karma Decsen Ozel Ling, Budapest), Toni **Packer** (© John Phelps), Swami **Radha** (© Yasodhara Ashram), Urgyen **Sangharakshita** (© Clear Vision), Sharon **Salzberg**, Satguru **Subramuniyaswami** (© Himalayan Academy), Christopher **Titmuss**, Swami *Vivekananda* (© Carus Publishing Company)

INDEX

Individuals with their own entry are given in **bold** (for Westerners) and *italic* (for Easterners). (See the Preface.) Information about an individual given only in that person's entry is not included in this index (but it is if it occurs anywhere else).

You will see that some names have one, and only one, page reference given in **bold**. This is the first page of their entry, where 'entry' means their main entry in Part II; or their entry in Appendix 1; or a unique passage inside someone else's entry (for example, Bede **Griffiths**'s **bold** page reference is **149, n. 2**, inside the main entry on Swami **Abhishiktananda**; in effect, this note is **Griffiths**'s 'entry'). This **bold** page reference system applies to all teachers, whether Western or Eastern.

I have adopted the convention in which names beginning with *de* and *von* are treated as if they do actually begin with *d* and *v*, and not with the first letter of the 'real' name that follows.

All conventions concerning alphabetical order have advantages and disadvantages. I treat names and titles (of people and books) as if they were a single word, ignoring all apostrophes, hyphens and spaces. So '*kriya yoga*' is read as if it were '*kriyayoga*' and thus comes after '**Kriyananda**' and not before it. (Or look at the positions taken up in the Index by three Burmese gentlemen whose names all begin with the honorific title, U: U Ba Khin, U Kyadaw and U Narada.) But I have not followed the principle absolutely rigidly. Sometimes words have a natural affinity that should be respected. Hence the three entries, 'Age', 'Agenda' and 'Ages', which are given here in 'strict' alphabetical order, have been entered as follows: 'Age', 'Ages', 'Agenda'.

You know it makes sense.

Amaravati, 244, 556
Ambedkar, Dr., 372, n.1, 502
Ameer Ali, 41, n.8
American Buddhist Order, 267, n.1
Amerindians, 348, n.1
Amerindian spirituality
 Schuon and, 520, n.3
Amersfoort, J., 592, n.7
Amida/Amitabha Buddha, 154, 400, 517, 563
 and Shakyamuni, 400
Amrit Desai, 601, n.1
anagamin, 587
anagarika, 5, 274, 373, 554
Ananda
 Church of Self-Realization, 235
 World Brotherhood Village, 386
Ananda Ashram, 605
Ananda Bodhi, 502, *see also* Dawson, Leslie; **Namgyal** Rinpoche; Star One
Ananda Maitreya, 4, 40, 42, n.9, 42, 47, n.17, 50, 57, **159**, 200, 352, 501
Anandamayi Ma, 31, 435, n.1, 454, 530
Anando, Ajahn, 553, n.1, 554, 558
Ancheta, Alfred Jitsudo, 432
ancient knowledge myth
 re **Shah**, 526
Ancient Wisdom
 and Sufism, 580
Andersen, Susan Myoyu, 432
Anderson, Margaret, 307, n.12, 309
Anderson, Reb Roshi, 7, **162**, 170, 246, 417, n.6
Angkhor, 378
Anguttara Nikaya, 451, 460
animals, protection of, 538
Anirvan Sri, 529
Anjaneya, 417
An-Nadi/Il Convito, 150
annihilation
 Dürckheim on, 253
Anson, P. (*Bishops At Large*), 199, n.1, 513, n.1
Antaiji, 167
anthropology, 408
 Gurdjieff's, 289
anthropology/ontology/cosmology/ soteriology, 102ff
anti-Christ, 338
Antioch, Church of, 513
Anusavanacarya, 352
anuttara, 337
Anuyoga, 204, n.2
Apocalypse/Book of Revelation, 458
Apocalypse, smiling, 447
'applied cosmology', 457
Arabiyya-Shadhiliyya, 150, n.1
arahant/arahantship, 350, 587, 588, *see also* Arhat
Arcane Magickal Order of the Knights of Shambhala, 433
Arche communities, 311, n.16
archery, 253
architects, 458, n.2
Argentina, 302, n.11
Arhat, 466
 Ouspensky as, 295, n.3

Arica, 332
Aristotle, 200
 "Aristotle hath said it", 245
Ariyaratne, A.T., 431
Arjava/J.A.Chadwick, 457, n.1
Arjuna, 382, 415
Armenia, 282
Army Intelligence (G2), 401, n.3
Arnold, Sir Edwin, 159
Arnold, Matthew, 306
Aro Yeshe, 205, n.4
art
 Baker on, 173
 Chogyam, Ngakpa on, 206
 Govinda on, 275, n.3
 Klein on, 377, n.2
 sacred, 275
Art game, 305
'arts of living', 387
Arubianandam, Swami, 51, 55, 146
Arunachala, 147
arupabrahma kaya, 351, n.1
Ary, Elijah, 565, *see also* Tenzin Sherab; Geshe Jatse
arya, 449, n.1
Arya Maitreya Mandala, 44, 182, 275
Aryan Path, The, 381, n.2
arya sangha, 13, 58, 62, **164**
Asahina Sogen, 393
asana(s), 514, 605
Aseshananda, Swami, 328
ashramas, four, 481
ashtanga yoga, 15, 385
Ashtavakra Gita, 454
'a-Shul Pema Lengden, 205, n.4
Aspen Grove, The, 333
Asquith, Lord, 298
Assagioli, Roberto, 547, n.5
Assam, 501, n.2
Assisi, 389
Astottara Arcana, 241
astral plane/realm, 231, 342, 576
astrology/astrologers, 433, 457
Atheists' Club, 354
Athena, 509
Atiyoga, 204, n.2
Atkinson, Gail (later Gail Twitchell, Gail Gross), 584
Atkinson, William, 618
Atmananda, Sri/Krishna Menon, 19, 236, 394, 454
Atmananda/Lenz, 617
Atom from the Sun of Knowledge, 329
Attar, Farid al-Din
 Le Langage des oiseaux, 65
Atulananda, Swami, 135, **606**
Aum, *see* Om
aura, 466
Aurobindo, Sri, 15, 19, 40, 47, 51, 128, **165**, 355, 375, 377, n.1, 380, 442, 444, 457, 576
Aurobindo ashram, 446
Auroville, 446, 458, 515
 Auroville Acts, 446
Australia, 18, 304, 437
Autobiography of a Sufi, 271
Autobiography of a Yogi, 348, 385, 386, 468
Avadhut, The, 453

avadhut/avadhuta, 433, 496
Avadhuta Gita, 454
Avalokiteshvara, 562
Avalon, Arthur, 40, 42, 55, n.23, 312, n.18, **607**, 610
Avatar/Avatara, 250, 434, 439, 522, 598, 618
 Chicoine as, 203
 in Self-Realization Fellowship, 599
 Yarr as, 30
avidya, 376
awareness,
 global, 376
 primal, 376
 Ramana Maharshi on, 489
Axiom, the, 383

B

Baba Bharata, 618
Babajan, Hazrat, 550
Babaji (*adiguru* of *kriya yoga*), 55, 118, 128, 233, 234, 236, 349, 385, 426, n.3, 435, n.1, 468, 483, 486, 487, 513, 599, 606
Babaji Al-Wahshi, 272
Bach, Johann Sebastian, 538
Backus, Charles, *see* **Bhavananda**
Bacot, J., *Le poète tibétain Milarepa*, 72
Badriyah, Sa., 522, 521, n.4
Baer, Max, 617
Baha'is, 151
bahya puja, 381
Bailey, Alice, 197
Baker, Ora Ray, 547, 616, n.7
Baker, Richard Roshi, 7, 8, 35, 56, 58, 99, 135, 162, 163, 164, **166**, 246, 417, n.6, 431
Ba Khin, U, 373, 587ff
Balkrishna Goswami, 380, n.1
Bangladesh, 400
Bankei, 454
Banner of the Arahants, 372, n.1
Baqa-Billah, 423
baraka, 23, 399, n.2, 518
Baraz, Jamie, 586, n.1
Barbier Saint-Hilaire, Philippe/Pavitra, 444, 457, n.1
Barborka, G., 564, n.5
Bardo, 154, 195
Barkat Ali, Pir, 401
Barnett, Michael, 25, 29, 34, 58, **175**
Batchelor, Martine and Stephen, 586, n.1
Bauer, Bartel, 460
Bauls/Baul tradition, 32, 411, 414, 415
Bawa Muhaiyaddeen, 329
Bays, Jan Chozen Sensei, 62, **179**, 410, n.1, 432
Beatific Vision, 486
Beatles, 416
Beat Zen, Square Zen and Zen, 52, n.19
Beck, Charlotte Joko, 8, 62, **180**, 410, 432, 441, 591, n.6
Bedawis, 402
Bedi, Freda, 11, 52, 59, **181**, 430, 477, 560, 589

and awareness, 333
as part of spiritual psychology, xv, 34
cosmic, 408, n.2, 620
Da on, 224
divine, 445
God, 384, n.1
master, 208
objective, 289
Consciousness, Preceptor, 343, n.1
Consciousness, Traveler, *see* Traveler
 Consciousness
conservative Theravada, 52, 460
Contemplatives, Order of Buddhist, 366
'controlled schizophrenia', 396
'conventional' *sangha*, 588
Convito, Il/An-Nadi, 150
Cool/Hot/Structured/Unstructured, see
 ch.3 *passim*
Coomaraswamy, Anand, 280, n.2, 281,
 375
Cooperative village, **Kriyananda**'s, 58
Coppens, Anton, 440
Coppolani, X., *Les Confréries religieuse*
 musalmanes, 69
Cosmic Buddha, 368
cosmic consciousness, 408, n.2, 620
cosmological transformation, 302
cosmology
 'applied', 457
 esoteric, 408
 Gurdjieff's, 289
cosmology/ontology/anthropology/
 soteriology, 102ff
Coulomb, Emma, 194,n.2
Council of All Beings, 431
cowboys
 and *Vivekananda*, 596, n.1
Cox, Jan, 27, 132, **220**, 417, n.6
Cozad, Mi Ju, 268, n.2
Crane, Hart, 307, n.12
Cranks' Ridge, 530
Crazy Wisdom, 413, n.2
crazy wisdom, 471, 472
Creation, Ray of, 332
creative visualization, 275
Crestone Mountain Zen Center, 172
Crockett, Davy, 305
Crowley, Aleister, 159, 433
Crow tribe, 520, n.3
crystals, 154, 603
Cultivating the Personality, 550
'cultural' monasticism, 504
Czarnecki, Andrej, 494, n.1

D

Da, Master, 20, n.11, 24, 25, 32, 35, 58,
 99, 135, 202, n.1, 218, **221**, 406,
 n.1, 412, 413, n.2, 455, 575
Dadaji, *see* **Mahendranath**
Dada Narayan, Rishi, 203
Dahlke, Paul, 460, **608**
Dai Bosatsu, 410, n.1, 537
dai kensho, 268
Daitokuji, 167, 458, 500, 511, 515
daiva-varna-ashrama/divine culture,
 481
dakini, 153

Dakshinamurti, 148, 454
Dalai Lama (various), 40, 59, 182, 206,
 255, 462, 562, 565, 566, 569, 594,
 609, 619
Dalenburg, Ananda, 164
dances, sacred, 312
Dances of Universal Peace, 401
Darqawi Order/Darqawiyya, 608,
 517
darshan, 399, 402, 444, 456, 498, 522,
 530
Dartington Hall, 529
Dasanami Order, 433
dasa sila mata, 244, 373, 441, 451, n.3,
 620
Datta/Dorothy Hodgson, 457, n.1
Dattatreya, 126, 433
Daumal, René, 311, n.16
David, King, 330, 522
David-Néel, Alexandra, 9, 40, 42, 43,
 44, 45, 50, n.18, 275, 564, **609**
Davis, Roy Eugene, 18, 20, 54, 130,
 231, 234, 386, 417, n.6, 455,
 487
Dawa Samdup, Lama, 45, 195, 609,
 610
Dawson, Leslie, *see also* Ananda Bodhi;
 Namgyal Rinpoche; Star One
Day of Victory
 Aurobindo's, 444, 457
Daya, Sister, 17, 19, 41, n.6, 47, **238**
Daya Mata, Sri, 18, 19, 33, 35, 44, 51,
 54, 109, 110, 118f, 129, **232**, 239,
 385, 386, 390, 487, n.3, 488
Dear Friend, You Are Not God, 533,
 n.2
death, 165, 289
 conscious, 295
 Long on, 405
'Declaration of the People of the
 Tradition', 524
Dede, Suleiman, 265
Dedekind, Richard, 200
deep ecology, 431, 550, n.9
'deep success', 500
de Koros, Csoma
 works on Tibetan Buddhism, 64
del Vasto, Lanzo, 311, n.16
Demiurgic Intelligences, 185, n.3
Denison, Ruth, 5, 441, 590
Depont, O., *Les Confréries religieuse*
 musalmanes, 69
de Ropp, Robert, 27, 297, 300, **304**
dervishes, 266, n.4, 282, 283, n.1, 426,
 n.2
de Salzmann, Alexandre, 311, n.14, 311,
 n.16
de Salzmann, Madame Jeanne, 27, 44,
 48, 51, 63, 132, 184, 285, 300, 310,
 311
de Salzmann, Michel, 312
Descartes, René, 459
Deshimaru Roshi, 366
Desjardins, Arnaud, 560
Destination Mecca, 524
Deunov, Peter, 605
Devachan temple, 441

Devamata, Sister, 17, 19, 40, 41, n.6,
 46, **238**
Deva Sangha, 445
developers, deviants, literalists
 Bennett on, 184
devotional service, 320, 481
Devotional Tantra, 491
Devyashram, Swami Lakshmi, 17, 20
 see also **Devyashrams**
Devyashram, Swami Parvati
 see **Devyashrams**
Devyashram, Swami Saraswati
 see **Devyashrams**
Devyashrams, 17, 20, 58, 60, 62, 109,
 110, 118, 129, **239**
dhama/place of pilgrimage, 190
Dhamma, *see also* Dharma (in all com-
 pounds)
Dhammadharo, Ajahn, 590, 592
Dhammadina, Sister, 373
Dhamma eye, 450, 451, n.3
dhamma kaya, 351, n.1, *see also*
 dharma-kaya
Dhammananda, Samanera, 350
dhammanusari, 450
Dhammapada, 200, 451, 608
Dhamma school, 556
Dhammasuddhi, Ven., 352
dharana, 605
Dhardo Rinpoche, 502
Dharma, 491
 in *arya sangha*, 165
 transmission of, 505
 universal, 503,
 see also Dhamma (in all
 compounds)
Dharmachari(ni), 503
Dharma circle, 586, n.1
Dharmaguptakas, 441, n.1, 556
Dharma heir(s), 458
 Christian priests as, 8
 in Western Soto Zen, 7
dharma-kaya, 562, *see also* dhamma
 kaya
Dharma Mind Seal, 480
Dharmapala, Anagarika, 39, 40, 41,
 n.4, 42, 48, n.17, 50, 161, 196,
 200, **243**, 465, 501, 505, 612
Dharmapali, Ven., 5, 12, 57, 62, **244**,
 255, 441, 558
Dharma regent, 335
Dharma Sangha, 172
Dharma school, 154
Dharma teachers, 379
 Western, 58
Dharma transmission, 357, 399
 'nominal', 163
 Beck on, 180
 in Zen, 8
dhikr/dzikr, 266, 330, 580
Dhiravamsa, 352
dhutanga/tudong, 553
dhyana, 275, n.3, 580, 605
'diadic' method, 601
Diamond Sangha, 63, n.30, 158, n.1
Diamond Sky, 335
Diamond Sutra, 454, 501
Dickins, Mema, 302
Dietrick, Luc, 311, n.16

[1] Yes, that's right: a marmot.

609
Vrindaban, 380, n.1

W

Waddell, L.A., 37, n.2, 563
Wagner, J. Eugene, 267, n.1
Wailua University of the Contemplative
 Arts, 541, n.7
Waldo, Ellen/Sister Haridasi, 145
Wali Ali Meyer, 402
Waliyat, 400
Walters, Donald, *see* **Kriyananda,**
 Swami
Walton, Georgina Jones, *see* **Daya**
'wandering bishops', 513, n.1
Wangyal Geshe/Rinpoche, 45, n.11,
 564, n.6
Warren, H.C.
 Buddhism in Translations, 68
Warrior's Way, 304
Warsaw Zen Center, 494, n.1
Washington, D.C. *vihara*, 244
Wat Buddha Dhamma, 372, n.1, 372
Wat Buddhadipa, 352
Wat Dhammadipa, 352
Wat Pah Nanachat, 553
Wat Pah Pong, 553
Wat Paknam, 350
Watson, John B., 611
Watts, Alan, 52, n.19, 135, 229, 355,
 511, 512, 530, 590, **620**
 Alan Watts Society, 530
way of sexual love, 406
Way of the Heart
 Da on, 224
Way of the White Clouds, The, 567
Way of Understanding
 Da on, 224
WBO, *see* Western Buddhist Order
 (**Sangharakshita**'s)
wealth-creation, 337
Webb, Alexander Russell Mohammed,
 40, n.8
Weitsman, Mel, 163, 164
Welch, Louise, 308
Well-tempered Clavier, The, 538
Wells, H.G., 306
West, as the only 'open' direction,
 60
Western *bhikkhus*, 553
Western Buddhism, 442, 464
Western Buddhist Order
 Clifton's, 51, 54, n.21, 211, 255
 Sangharakshita's, 58, 255, 503
Western culture, xvii
Western esotericism, 28, 428, 433
'Western Hindu teacher', meaning of,
 15
Western Hinduism, development of, 55,
 n.23
Western *lamas*, 267, n.1
Western *maharaja-yogi*, 486
Western Rinzai tradition, 205, 538
 see also Western Soto; Western
 Zen
Western *sangha*, 161, 353
Western Soto teachers, legitimacy of,

59, n.26, *see also* Western Rinzai;
 Western Zen
Western teachers, 406
 and Buddhist traditions, 13
Western Theravada, *sanghas*, 57
Western *tulkus*, *see* **Tulkus**
Western Women's Buddhist Bureau, 500
Western Zen, 253
 lineage(s), 58, 158
 see also Western Rinzai; Western Soto
Whalen, Philip, 172, 247, n.1
'What is love, really?', 474
whirling dervishes, 426, n.2
'white Buddhist'
 Olcott as, 464
White Plum Sangha, 270, 432, 440
White Tradition (Nyingmapa), 204,
 n.1
'Who Am I?', 19, 197, 375, 454, 601
 in Zen, 269
Wick, Gerry Shishin, 432
Wilber, Ken, 229
Wilhelm, Richard, 251
Wilkins, Charles, 37
Will, 433
Wilson, Jim, *see* **Tundra Wind**
Wilson, Margaret/Nishta, 457, n.1
Wilson, Woodrow, 457, n.1
Windhorse Trading, 506
winding and unwinding of *sanskaras*,
 420, 439
wisdom, 330
 Sumedho on, 555
Wisdom Religion
 in Theosophy, 28, 195, 464
Wise, Michael Sensei, 393, n.1
witness, 376
women
 as *lamas*, 206
 as *vipassana* teachers, 5
 in Buddhism, 479
 in Hinduism and Buddhism, 17,
 n.9
 in ISKCON, 481, n.3
 in **Sufi Order**, 549
 in Sufism, 24
 in the phenomenon of spiritual
 psychology, 60
 in Theravada, 5, 558, n.7
 in Tibetan Buddhism, 11, 154
 in *vipassana sangha*, 590
 sangha of, 5f
 teachers in Zen, 8
'Women and Buddhism in America',
 474
Women's Dharma Monastery, 244
Woodroffe, Sir John, *see* **Avalon**
Woof, Master, 267
work, 'positive', 505
work/surrender, 499
Work of This Moment, The, 475
world brotherhood colonies, 388
World Enlightenment Festival, 469
World Fellowship of Buddhists, 161
World Parliament of Religions, 39, 40,
 200, 244, 533, 596
 no Sufis at, 41, n.8
worlds
 hierarchy of, 496

inner, 341
Wort des Buddha, Das, 460
Wu/Wu language, 530
Wuji, *see* **Shunyata** (and his dog)

Y

yama, 605
Yamada, Ko'un (not to be confused
 with Yamada, Mumon), 156, 257,
 315, 359, 590
 Zen-Christian lineage, 259
Yamada Mumon Roshi (not to be
 confused with *Yamada* Ko'un
 Roshi), 262
Yarr, John/Ishvara, 25, 30, 58, 63, 135,
 597
Yashoda Mai, 380, 529
Yasodhara Ashram, 484
Yasupov, Felix, 547, n.6
Yasutani, Hakuun Roshi, 8, 156, 180,
 257, **315**, 354, 359, 369, 432, 537,
 590
"Yeah, let's give that a flog this year
 and really beat the shit out of it",
 609
Yeats, W.B., 159
Yeo, William Nyogen, 432
Yeshe, Lama, 565, n.9, 566, 567
Yeshe Tsogyel, 205, n.4
yoga, 14, 266, 331, 382, 479, 605, 619
 ashtanga, 15, 385
 bhakti, 15, 485
 chakra, 312, n.18
 Christian, 199
 collective, 446, 515
 guru, 337
 hatha, 485, 514, 580, 619
 in Western esotericism, 28
 integral, 19, 445
 japa, 485
 jnana, 15, 485
 karma, 389, 485, 492
 kriya (*see* kriya yoga)
 kundalini, 15, 55, 485, 513
 mantra, 485
 of honesty, 535
 of nature and evolution, 446
 of the cells, 19, 51, 447, 515
 raja, 40, 41, n.5, 513, 579, 597
 surat shabd, 341, 582
Yoga Fellowship, 387
Yoga-Magick, 433
Yogananda, Paramahansa, 15, 18, 42,
 43, 47, 48, 51, 55, n.23, 129,
 231, 232, 236, 348, 384, n.1, 385,
 386, 406, n.1, 426, n.3, 455, 468,
 482, 485, 513, **599**
Yogananda, Swami/Dr. Street, 145
Yoganathan, Jnanaguru
Yoga of Synthesis, 240
Yoga of the Bhagavat Gita, The, 381,
 381, n.2
Yoga Order
 Subramuniya's, 51, 55
*Yoga Philosophy and Oriental
 Occultism*, 618
Yoga Sutras, 385

Yoga Vasistha, 454, *see* Siva Yogaswami
Yogeshwar Muni, 18, 20, **600**
yogi/yogin/yogis, 390, 588
 lay, 335, n.2
yogi, way of, 288
yogi and Light
 Da on, 224
Yogi Bhajan, 455
yogic Buddhism, 463
Yogoda Satsanga (plus
Ashrama/Society), 232, n.1, 486, 599
Yongden, Lama Albert Arnold, 609, 615,
 n.5
Young, James, 299
Young Men's Buddhist Association, 502
Yuho Seki Roshi, 253
Yukteswar, Sri, 234, 236, 349, 385, 487,
 599
Yukuts, 619
yume, 369
Ywahoo, Dhyani, 11, 62, 129, **602**

Z

Za-lin Lan-Di, 592, n.7
Zarathustra, 617
zawiya, 520
zazen, 44, 46, 252, 253, 257, 356, 360,
 432, 473, 511

and Tibetan teachers, xvi
ZCLA, *see* Zen Center of Los Angeles
ZCNY, *see* Zen Community of New
 York
Zen, 24, 107, 318, 406, n.1, 535, 600
 and Christianity, 269
 and Judaism, 269
 and Kabbala, 269
 and New Testament, 269
 and Old Testament, 269
 and Sufism, 402
 and Theravada, compared, 512, n.1
 business, 58, 168, 269
 Christian, 55
 Christian, **Kapleau**'s critique of, 360
 essence of, 479
 Korean, 8, 58, 379
 masters and abbots in, 171, n.5
 of 'other ways', 516
 of other traditions, 516
 strategies, 181
 universalized, 157
 Vietnamese, 8, 58, 480
 Western form of, 253
 Western lineage, 158
Zen (magazine), 610
Zen: A Method of Religious Awakening,
 512
Zen and Creative Management, 357
Zen Buddhist Temple of Chicago, 393

Zen Center of Los Angeles, 179, 268,
 410, 432
Zen Centre (London), 516
Zen Community of New York,
 269
Zen: Dawn in the West, 357
zendo, 398, 511
 Catholic, 257
 non-denominational, 269
 prison, 410
Zen Institute of America in Japan, First,
 50
Zen Koan, The, 512
Zen Lotus Society, 379
Zen Mission Society, 366
Zen Mountain Monastery, 410
Zen Peacemaker Order, 270
Zen-shi, 401
Zenshiji, 269, 432
Zen Studies Society, 537
Zimmermann, Friedrich/Subhadra
 Bhikshu, 460
Ziraat, 543, 548
zodiac, 458
Zopa, Lama, 566, 567
Zoroaster, 398, 439
Zuigan Goto Roshi, 511, 533, *see also*
 Goto, Zuigan Roshi
zuissé ceremony, 163, 410, 440
Zyrians, 619